THE
ANDY
WARHOL
DIARIES

EDITED BY
PAT HACKETT

WARNER BOOKS

A Warner Communications Company

Warner Books, Inc., 666 Fifth Avenue, New York, NY 10103

 A Warner Communications Company

Printed in the United States Of America
First printing: May 1989
10 9 8 7 6 5 4 3

LIBRARY OF CONGRESS CATALOGING-IN-PUBLICATION DATA

Warhol, Andy, 1928-
 The Andy Warhol diaries/edited by Pat Hackett.
 p. cm.
 ISBN 0-446-51426-8 : $29.95
 1. Warhol, Andy, 1928- —Diaries. 2. Artists—United States-
-Diaries. I. Hackett, Pat. 11. Title
N6537.W28A2 1989
700'.92'4—dc19 88-40565
[B] CIP

Book and endpaper design by Giorgetta Bell McRee

*My deep thanks to Steven M.L. Aronson who helped me edit the Diaries
and who proved once again —as he did in the past on books with Andy and me—
that he is diligent, vigilant, and brilliant.*

P.H.

ACKNOWLEDGMENTS

Jamie Raab at Warner Books was an astute and sympathetic editor. She combed the book so carefully and gave such unfailingly good advice for the many decisions that had to be made in a work of this size and scope that it's hard to imagine how this could have been done without her.

Also thanks to: Vincent Fremont, Ed Hayes; Helen B. Childs, Rob Wesseley; Bob Miller, who got the project started at Warner Books; Lee Seifman, who worked so fast and with intelligence and good humor; Tony Bugarin, Allen Goldman, Heloise Goodman, Suzanne Gluck, Lew Grimes, Margery King, Harvey-Jane Kowal, Jesse Kornbluth, Gary Krampf, Jane Krupp, Alex Neratoff, Barbara O'Connell, Jay Shriver, David Stenn, Allison Weiser.

Deep gratitude to my parents.

And last, thanks to Frederick W. Hughes, the executor of the Warhol Estate and Andy's longtime business manager and friend, who understood that candor-of-the-moment is the essence of the diary as a literary form and was the first to champion the candid spirit of *this* diary—even when Andy's candor embraced Frederick W. Hughes.

P.H.

INTRODUCTION

I met Andy Warhol in the autumn of 1968—eight years after he painted his first Pop art canvases and just three months after he was shot and nearly killed by a woman who had appeared for a moment in one of his "underground" movies. During the previous spring the art-making/film-making/hanging-out setup known to sixties legend as the "Factory" had moved from its original location, a silvered loft on East 47th Street, to a white and mirrored loft that took up the whole sixth floor of 33 Union Square West.

Andy loved Union Square—the trees in the park and the loft with its view of the stately Con Edison tower, its clock face shining like a neighborhood moon, giving the time day and night. Always considered an unofficial boundary between uptown and downtown, Union Square was near the bargain-shopping area on 14th Street. To the south, the West and East Villages and Soho were all within easy walking distance.

And, of course, a block away on Park Avenue South was Max's Kansas City, the breeding ground for so many of the characters that wound up in Factory movies. Every night, celebrities of the art, fashion, music, and "underground" filmmaking crowds jammed themselves into favorite corners of the back room at Max's and monitored each other's clothes, makeup, wit, and love interests while they received "exchange" celebrities from out of town—directors and producers from Europe or Hollywood—and waited to be taken away from "all this" (New York notoriety) and put into "all that" (global fame). Andy's art hung on the wall.

I was an undergraduate at Barnard at the time, and going down to the Factory to see if Andy Warhol needed a part-time typist seemed like a good way to inject some glamour into my college years. I introduced myself to Andy, explaining that I was going to school, and he suggested I work for him just whenever I could. So I began going down to the Factory a few days a week after classes. He and I shared a 4' × 10' office piled—as in time I discovered *all* his offices, whatever their dimensions, would be piled—with clutter. He would read the newspapers and drink carrot juice from Brownies, the health food store around the corner on 16th Street, while I transcribed tapes he'd hand me of phone conversations he'd had while he was in bed recuperating, first in the hospital and then at home in the narrow four-story Victorian house on Lexington and 89th that he lived in with his mother.

Andy had come to New York from Pittsburgh in 1949 and at first he shared apartments with other people. Eventually he could afford a place of his own. Then his mother suddenly arrived in town and moved in with him, her youngest son, saying she wanted to look after him. She may have decided—or just as likely, he may have told her—that he was working so hard he had no time to find a *wife* to take care of him, because when I met Julia Warhola one afternoon in 1969 she said hello, thought for a second, then concluded, "You'd be nice for my Andy—but he's too busy." (Andy's mother lived with him in his house on 89th Street and Lexington Avenue until 1971. By then, apparently suffering from senility, she required constant care and Andy sent her back to Pittsburgh to the care of his brothers John and Paul. After suffering a stroke, she died in a nursing home there in 1972, but to even his closest friends who'd often ask him, "How's your mother?" Andy continued for years to say, "Oh fine.")

In my first weeks at the Factory, friends Andy hadn't seen since before the shooting—superstars

like Viva and Ondine and Nico, or Lou Reed or the other members of the Velvet Underground—would drop by the Union Square loft to ask him how he was feeling. He'd usually assure them, "Oh, good" or, occasionally he'd joke, "With my hands." Brigid Berlin, a.k.a. Brigid Polk, the eldest daughter of longtime Hearst Corporation chairman Richard E. Berlin, had starred in Andy's movie *Chelsea Girls* and now she would come by to make pocket money by letting Andy tape record her talking about, say, what had happened in the back room at Max's the night before or about who she had talked to on the phone that morning from her tiny room at the nearby George Washington Hotel; when she was done he'd take out his checkbook and reward her for the performance with $25 (sometimes negotiated up to $50). For each of these post-shooting reunions with his friends, something in Andy's expression said he was amazed that he was still alive to see them. At one point in the hospital, just before they succeeded in reviving him, the doctors had thought he was gone and Andy, in a state of semi-consciousness, had heard them say words to that effect; from June 1968 on, he considered himself a man who was officially "back from the dead."

Andy and I didn't talk much at first. For weeks I just transcribed and he just sat there, a few feet away from my manual typewriter, reading and taking phone calls. Most of the time, his face was impassive. There was definitely a weird feeling about him—for one thing, he moved in a strange way. Eventually I realized that this was because his chest was still wrapped in surgical tape—blood from the wounds that were still healing sometimes seeped through onto his shirt. But when Andy laughed, the weirdness disappeared and his whole face changed—then, he was appealing to me.

Andy was polite and humble. He rarely *told* anyone to do things—he'd just ask in a hopeful tone, "Do you think you could . . . ?" He treated everyone with respect, he never talked down to anyone. And he made everyone feel important, soliciting their opinions and probing with questions about their own lives. He expected everyone who worked for him to do their job, but he was nonetheless grateful when they did—he knew that *any* degree of conscientiousness was hard to find, even when you paid for it. And he was especially grateful for even the smallest extra thing you might do for him. I never heard anyone say "Thank you" more than Andy, and from his tone, you always felt he meant it. "Thank you" were the last words he ever said to me.

Andy had three ways of dealing with employee incompetence, depending on his mood. Sometimes he'd watch for minutes at a time and then, raising his eyebrows and closing his eyes philosophically, turn away without saying a word; sometimes he'd rant and rail for half an hour at the offender, though nobody would ever get fired; and sometimes he'd suddenly break into an impromptu imitation of the person—never a literal one, but rather *his* interpretation of *their* vision of themselves—and it was always funny.

The worst things Andy could think to say about someone was that he was "the kind of person who thinks he's better than you" or, simply, "He thinks he's an 'intellectual.'" Andy knew that a good idea could come from anywhere; his head wasn't turned by credentials.

What was he impressed with, then? Fame—old, new, or faded. Beauty. Classical talent. Innovative talent. Anyone who did anything *first*. A certain kind of outrageous nerve. Good talkers. Money—especially big, old, American brand-name money. Contrary to what readers of social columns might guess after seeing Andy's name in print so many times over so many years at so many events with European royalty, foreign titles didn't impress him—he always got them completely wrong or, at the very least, badly mispronounced them.

He never took his success for granted; he was thrilled to have it. His uniform humility and courtesy were my two favorite things about him and, as much as he changed and evolved over all the years I knew him, these qualities never diminished.

After a few weeks of volunteer typing, I had my midterm exams to study for so I stopped going downtown. I assumed that Andy probably wouldn't even notice I wasn't around (I hadn't figured out yet that his passive expression didn't mean he wasn't noticing even the smallest details) so I was shocked when someone knocked on the door of my dorm room to say I had a call from "Andy." I couldn't believe he would even remember what school I went to, let alone which dorm I lived in. Where was I, he wanted to know. And to make sure I was coming back, he "sweetened the pot" by offering to start paying my subway fares to and from "work." A ride was then twenty cents.

The major activity at the Factory in the years 1968–72 was making feature-length 16mm movies (they would be blown up to 35mm for commercial release) with the offbeat people who hung around Max's or who came by the Factory to be "discovered." During the summer of '68 when Andy was home in bed recovering from his gunshot wounds, Paul Morrissey, a Fordham graduate who had once worked for an insurance company and who up until the shooting had assisted on Andy's "Factory" movies, filmed a movie of his own, *Flesh*. It starred the handsome receptionist/bouncer at the Factory, Joe Dallesandro, as an irresistible male hustler trying to raise money for his girlfriend's abortion, and in the fall of '68 *Flesh* began a long commercial run at the Garrick Theater on Bleecker Street.

Assisting Paul on *Flesh* was Jed Johnson, who had begun working at the Factory in the spring, shortly after he and his twin brother Jay arrived in town from Sacramento. Jed's first duties at the Factory were stripping the paint from the wooden frames of the windows that looked out on Union Square Park, and building shelves in the back of the loft for film-can storage. In his spare time he taught himself how to edit film on the Factory's Moviola by playing with reels of *San Diego Surf* and *Lonesome Cowboys*, both of which had been filmed by Andy on a Factory filmmaking field trip to Arizona and California just before he was shot.

Once the Factory moved to Union Square, Billy Name, the photographer who had been responsible for the silver look of the 47th Street Factory and for its amphetamine-centered social life, began living in the small darkroom he set up at the back of the loft. Over the course of a few months in '68 and the beginning of '69, he retreated from the daytime activities of the Factory and began emerging from his darkroom only at night and only after everyone had gone. Empty take-out food containers in the trash the next day were the only indications that he was alive and eating. After over a year of this hermitic, nocturnal life, when Jed arrived as usual one morning to open up the loft, he found the darkroom door wide open—Billy had gone.

Gerard Malanga, one of Andy's first painting assistants in the sixties and a performer in some of the early movies like *Vinyl* and *Kiss*, shared one of the two large desks at the front of the loft with Fred Hughes, who was just evolving into his position as manager of Andy's art career. Fred had entered the world of art connoisseurship through working for the de Menil family, art patrons and philanthropists from his hometown of Houston. Fred made a big impression on Andy in two major ways: First, in the short term, Fred had introduced him to this rich, generous family; and second, in the long term, he had a rare understanding of and respect for Andy's art and a flair for how, when, and where to present it. From his half of the desk, Gerard answered the phones

while he wrote poetry, and in 1969 when Andy decided to start a magazine called *inter/VIEW*, Gerard was for a short while its editor before he left New York for Europe.

The other large desk belonged to Paul, who sat with color blowups of some of the "superstars" behind him, including two "Girls of the Year," Viva and International Velvet (Susan Bottomly). Paul went on to make *Trash* ('70) and *Heat* ('71). *Women In Revolt* and *L'Amour*, made during the same period, were a collaborative Factory effort with Andy, Paul, Fred, and Jed all involved in the casting, shooting, and editing. Then in 1974 Paul went to Italy to direct two movies for Carlo Ponti's production company which were ultimately "presented" by Andy—*Andy Warhol's Frankenstein* and *Andy Warhol's Dracula*. Jed and I went to Italy to work on them, and after they were finished Paul stayed on in Europe, in effect ending his role as a major influence at the Factory.

Fred by now was setting up all the office deals and helping Andy make his business decisions. Vincent Fremont, who had driven cross-country to New York from San Diego and begun working at the Factory in the autumn of '69, was now general office manager.

In the summer of '74 the Factory moved from 33 Union Square West to the third floor of 860 Broadway—just half a block away. Around this time, Andy instructed the receptionists to stop answering the phone with "Factory"—"Factory" had become "too corny," he said—and the place became simply "the office." Bob Colaciello, who had graduated from Georgetown University's School of Foreign Service and had come to the Factory by way of writing a review of *Trash* for the *Village Voice*, was working by this time mainly for the magazine (now, with a slight title change, called *Andy Warhol's Interview*), doing articles and writing his column, "OUT," which chronicled his own around-the-clock social life and dropped a heavy load of names every month. In 1974 Bob Colacello (by then he'd dropped the "i") officially became the magazine's executive editor, shaping its image into a politically conservative and sexually androgynous one. (It wasn't a magazine with a family readership—one survey in the late '70s concluded that the "average *Interview* reader had something like .001 children.") Its editorial and advertising policies were elitist to the point of being dedicated—as Bob himself once explained, laughing—to "the restoration of the world's most glamorous—and most forgotten—dictatorships and monarchies." It was a goal, people pointed out, that seemed incongruous with Bob's Brooklyn accent, but this didn't stop him from going on to specify exactly *which* monarchies he missed most and why.

When Andy decided to start the magazine, in '69, the idea was that it be oriented toward the movies. He wanted stars to just talk—their own words, unedited—and, wherever possible, to be interviewed by other stars. This was something new in magazine publishing. And since Andy's business philosophy was always to start things on a small budget and build slowly—do the early financing yourself so that later when the business is worth more, you, and not a backer, own more of it—the magazine was published on a very low budget. To give an idea of just *how* low the budget was: In the first issue, an interviewee had referred to a well-known movie critic who had just appeared in a Hollywood movie about a transsexual as a "drag queen." It was only after the issue was already off the presses that a lawyer advised that "drag queen" was libelous but that just plain "queen" would be fine. So Andy, Paul, Fred, Jed, Gerard, and I, plus whoever happened to walk in the door, spent about six hours sitting in the front of the loft going through bundle after bundle of *inter/VIEW*s and crossing out the word "drag" with black felt-tip pens, while Paul complained, "This is like doing penance—'I will never call him a drag queen again, I will never call him a drag queen again. . . .' "

At 33 Union Square West, the magazine offices had been two rooms on the tenth floor, four floors away from the Factory, but after the move to 860 Broadway they were on the same floor as Andy's office and painting area, separated from these only by a wall. Andy seemed to regard the employees of *Interview* as stepchildren, different from the people who worked directly for him, who were "family." (One visitor, noticing the psychological distance from Andy between his personal employees and the staff of his magazine, observed, only half-joking, "I get the feeling that if the people who work for *Interview* were asked to name the one celebrity in the world they'd most like to meet, they'd all say, 'Andy Warhol.'" There were exceptions: Crossovers who worked at *Interview* but were also Andy's personal friends who went out with him socially—people like Bob Colacello and Catherine Guinness, a member of the Anglo-Irish brewery family—but generally, to Andy, the *Interview* people were part of his business life but not his emotional life. He referred to them as "them," and to us as "us."

While Andy's social life in the late sixties and early seventies was steered mainly by Fred, by 1975 Bob Colacello was also initiating many social occasions and some business deals. (All deals, however, had to be cleared with Fred.) From the growing circle of rich people he was becoming friendly with, Bob delivered a lot of portrait commissions, and he also got Andy publishing contracts. On the first book, *The Philosophy of Andy Warhol (From A to B and Back Again)*, I did eight separate interviews with Andy on the basis of which I wrote chapters 1 through 8 and chapter 10. Then, using material from conversations Andy had taped between himself and Bob Colacello and Brigid Berlin, I wrote the introductory chapter and chapters 9, 11, 12, 13 and 14. It was the first major project Andy and I had worked on together, and after the book was published, in 1975, he asked me to co-author the second book with him—his memoirs of the sixties, which we decided to call *Popism*.

From 1975 on, the magazine was a great source of activity for Andy. That was the year he bought out newsprint manufacturer/art collector Peter Brant to become full owner and publisher, with Fred assuming the title of president. Until this point Andy had remained pretty much aloof from the day-to-day operation of the magazine, but now suddenly he was running in to look at art director Marc Balet's layouts or scheduling lunches in the conference room to pitch *Interview* to prospective advertisers.

It was the magazine more than anything else that kept Andy from passing into sixties history. Meeting creative new people—especially young kids—was always important to him; he thrived on it. But he knew that people only come to you if they think you have something to offer them. In the mid-sixties when he was cranking out his early, cheap, "underground" films at the rate, practically, of one a week, it was the possibility of getting into Andy's movies that drew people to the Factory. By the 1970s, however, with the price of making commercially exhibitable movies becoming prohibitive, Andy had few roles to offer people and not even the certainty that the movie being discussed would ever actually get made. *Interview* magazine more than filled the void.

Circulation had been growing every year. By 1976 *Interview* had a cachet of sophisticated self-mocking silliness that made celebrities actually *want* to be in it. Often Andy, usually with someone on the staff, did the cover interview himself. Every issue had to be stocked with people, and this was the new supply of fresh faces now coming by the office constantly. "We'll put you in the magazine" replaced "We'll put you in a movie" as Andy's most frequent promise. The terms "Interman," "Viewgirl," "Upfront," and "First Impression" were all *Interview* page headings for pictures of young, never-before-seen-in-print male and female beauties. *Interview* became the most

glamorous magazine around. I once heard Bob on the phone reassuring a society matron: "Don't worry about your photograph—we retouch anyone over *twenty.*"

1976 was also the year that *Andy Warhol's Bad* was shot in New York, in 35mm and with a union crew. The cast was a combination of our own "studio stars"—people like Geraldine Smith from *Flesh* and Cyrinda Foxe from around the corner on East 17th Street—and Hollywood professionals like Carroll Baker and Perry King. Jed directed *Bad*—I had co-written the screenplay—and it was well-received. (Vincent Canby's review in the *New York Times* said it was "more aware of what it's up to than any Warhol film . . . to date.")

Despite the movie's critical success, after making *Bad,* Jed never went back to work at the Factory—"the office"—again. He began buying and selling antiques, and then started his own decorating business, although he continued to live on the fourth floor of the Federal-style townhouse on East 66th Street that he had found for Andy and that Andy had moved into in 1974. Fred, meanwhile, had moved from his apartment on East 16th Street into the house on Lexington that Andy had just vacated.

For most of the seventies and continuing right up until Andy's death, finding people to commission him to do portraits was a major activity, since it brought in a big share of his annual income. No matter what other canvases he was working on for museum and gallery shows, there were always portraits in the works in some corner of the loft. Anyone—gallery dealers, friends, or employees—who brought in a commission *got* a commission. As artist Ronnie Cutrone, a dancer with the Exploding Plastic Inevitable in the sixties and Andy's painting assistant in the seventies, once put it: "Pop Art was over, and there was a bunch of new movements. Meanwhile he had an office to keep running and a magazine that he felt still needed subsidizing from him. After doing his Pop celebrity portraits in the sixties—the Marilyns, Lizzes, Elvises, Marlons, etc.—it was a natural evolution to do portraits of private—or at least non-show business—people, therefore making them equal, in some sense, to the legends." And actually, even in the sixties, on a much smaller scale, Andy had done some commissioned portraits of non-star subjects like art collector Ethel Scull, gallery owner Holly Solomon, and Happy Rockefeller. Fred Hughes adds: "The art establishment found the idea of Andy doing commissioned portraits very unconventional—artists weren't supposed to be *doing* this kind of thing. But Andy was always unconventional. And the fact is, he *liked* doing them—after we got the first few commissions he said to me, " 'Oh get some more.' "

Andy's procedure for making a portrait was elaborate. It began with the subject posing while he took approximately sixty Polaroid photos. (He used Polaroid's Big Shot camera exclusively, and after that model was discontinued he made a special arrangement with the company to buy all the unused stock they had.) Then, from those sixty shots he would choose four and give them to a screen printer (he worked exclusively with one printer at a time—before 1977, his silkscreener was Alex Heinrici; after that, it was Rupert Smith) to make into positive images on 8″ × 10″ acetates. When those came back to him he would choose one image, decide where to crop it, and then doctor it cosmetically in order to make the subject appear as attractive as possible—he'd elongate necks, trim noses, enlarge lips, and clear up complexions as he saw fit; in short, he would do unto others as he would wish others to do unto him. Then he would have the cropped, doctored image on the 8″ × 10″ blown up to a 40″ × 40″ acetate, and from that the screen printer would make a silkscreen.

To always be prepared for the steady stream of portraits, Andy had his assistants prepaint rolls of canvas in one of two background shades: flesh tone for men's portraits and a different, pinker flesh tone for women's. Using a carbon transfer under tracing paper, he'd trace the image from the 40″ × 40″ acetate onto the flesh-tone-painted canvas and then paint in the colored areas like hair, eyes, lips on women, and ties and jackets on men. When the silkscreen was ready, the detailed image would be lined up with the prepainted colored areas and the details of the photograph would be screened onto the canvas. It was the slight variations in the alignment of the image with the painted colors underneath that gave Warhol portraits their characteristic "shifting" look. The portraits, as a rule, cost approximately $25,000 for the first canvas and $5,000 for each additional one.

Keeping to his beloved weekday "rut" was so important to Andy that he veered from it only when he was forced to. After "doing the Diary" with me on the phone, he'd make or take a few more phone calls, shower, get dressed, take his cherished dachshunds Archie and Amos into the elevator with him and go from the third floor of his house, where his bedroom was, to the basement kitchen where he'd have breakfast with his two Filipino housekeepers, sisters Nena and Aurora Bugarin. Then he'd tuck some copies of *Interview* under his arm and go out shopping for a few hours, usually along Madison Avenue, then in the auction houses, the jewelry district around 47th Street, and the Village antique shops. He'd pass out the magazine to shopkeepers (in the hope that they would decide to advertise) and to fans who recognized him in the street and stopped him—he felt good always having something to *give* them.

He'd get to the office between one and three o'clock, depending on whether there was a business advertising lunch there or not. Upon arrival he'd reach into his pocket—or his boot—for some cash and send one of the kids out to Brownies down the block for snacks. Then while he was drinking his carrot juice or tea he'd check the appointment books for that afternoon's and night's events, return calls, and take some of the calls that came in as he was standing there. He would also open the stacks of mail he got every day, deciding just which letters, invitations, gifts, and magazines to drop into a "Time Capsule," meaning one of the hundreds of 10″ × 18″ × 14″ brown cardboard boxes, which would be sealed, dated, put into storage, and instantly replaced with an identical empty box. Less than one percent of all the items that he was constantly being sent or given did he keep for himself or give away. All the rest were "for the box": things he considered "interesting," which to Andy, who was interested in everything, meant literally everything.

A written communication from Andy was a rarity. You'd often see him holding a pen and his hand would be moving, but it was almost always just to sign his name, be it as an autograph or on a work of art or at the bottom of a contract. He did scribble phone numbers on scraps of paper but they were never organized into an address book. And when he wrote a note it was rarely more than a phrase—something like "Pat—use this" attached to a newspaper clipping that he thought would be helpful for a project we were working on. An exception was when someone would dictate words they wanted him to write—on a gift card, for example—and then he would be happy to keep writing, but only until the dictation stopped.

He'd stay in the main reception area for an hour or two talking to people around the office about their love-lives, diets, and where they'd gone the night before. Then he'd move to the sunny window ledge by the phones and read the day's newspapers, leaf through magazines, take a few more random phone calls, talk a little business with Fred and Vincent. Eventually he'd go

to his working area in the back part of the loft near the freight elevator and there he would paint, draw, cut, move images around, etc., until the end of the day when he would sit down with Vincent and pay bills and talk on the phone to friends, locking in the night's itinerary.

Between six and seven o'clock, once the rush-hour traffic was over, he'd walk over to Park Avenue and get a cab uptown. He'd spend a few minutes at home doing what he called "gluing"—washing his face, adjusting the silver "hair" that was his trademark, and maybe, *maybe* changing his clothes, but only if it was an especially "heavy" evening. Then he'd check to make sure there was film in his instant camera. (From the mid-sixties to the mid-seventies, Andy was notorious for endlessly tape-recording his friends. But by the end of the seventies he'd gotten bored with random taping and usually would record people only for a specific reason—that is, if he felt he could use what they said as dialogue for a play or movie script.) Then he'd leave for the night—sometimes to multiple dinners and parties, sometimes just to an early movie and dinner. But no matter how late he stayed out, he was always ready for the Diary again early the next morning.

For a few years before 1976 I had kept a general and very sketchy Factory log for Andy. I'd make a list of the business visitors who had come to the office during the day, and then another list of the main events of the previous night—even if I'd been to some or all of them myself, I'd have different people give me their versions of the same dinner party or art opening. The point was simply to determine what had happened, who was there, and how much it had cost Andy in cash expenses—not to get Andy's personal view of it. Very often I'd just ask him what his expenses had been and leave his contribution to the log at that.

In 1976, after the filming of *Bad*, I told Andy that I didn't want to work at the office anymore but that I would still write *Popism* with him. He asked me if I would continue to keep the log and itemize his personal expenses—"It'll only take you five minutes a day," he said. I told him that I didn't want to have to continue calling everyone at the office every day to find out what had happened the day before—that if I were going to do that, I might as well still be working there. So we agreed that from then on, the daily accounts would come from Andy himself. At this point the log became Andy's own personal narrative.

In the fall of 1976 Andy and I established a weekday morning routine of talking to each other on the phone. Ostensibly still for the purpose of getting down on record everything he had done and every place he had gone the day and night before and logging the cash business expenses he had incurred in the process, this account of daily activity came to have the larger function of letting Andy examine life. In a word, it was a diary. But whatever its broader objective, its narrow one, to satisfy tax auditors, was always on Andy's mind. The record he kept included even the ten-cent calls he made from street payphones. It wasn't that he was being overly cautious—the IRS had subjected his business to its first major audit in 1972 and continued the scrutiny every year right up until his death. Andy was convinced these audits were triggered by someone in the Nixon administration because the campaign poster he'd done for George McGovern in 1972 featured a green-faced Richard M. Nixon and the words "Vote McGovern." (Philosophically, Andy was a liberal Democrat, although he never voted because, he said, he didn't want to get called up for jury duty. He did, however, offer his employees bribes of Election Days off if they gave their word they'd vote Democratic.)

I'd call Andy around 9 A.M., never later than 9:30. Sometimes I'd be waking him up, sometimes he'd say he'd been awake for hours. If I happened to oversleep he'd call *me* and say something

like, "Good morning, Miss Diary—what's wrong with *you*?" or "Sweetheart! You're fired!" The calls were always conversations. We'd warm up for a while just chatting—he was always curious about everything, he'd ask a million questions: "What are you having for breakfast? Do you have channel 7 on? How can I clean my can opener—should I do it with a toothbrush?" Then he'd give me his cash expenses and tell me all about the day and night before. Nothing was too insignificant for him to tell the Diary. These sessions—what he referred to as my "five-minutes-a-day job"—would actually take anywhere from one to two hours. Every other week or so, I'd go over to the office with the typed pages of each day's entry and I'd staple to the back of every page all the loose cab and restaurant receipts he'd left for me in the interim—receipts that corresponded to the amounts he'd already told me over the phone. The pages were then stored in letter boxes from the stationery store.

The Diary was done every morning Monday through Friday, but never on the weekends even if Andy and I happened to talk on the phone or see each other. The Diary would always wait until Monday morning when we'd do a triple session and he'd recount Friday-Saturday-and-Sunday's activities. I made extensive notes on a legal pad as we talked, and right after we hung up, while Andy's intonations were fresh in my mind, I'd sit at the typewriter and get it all down on paper.

When Andy was out of town, he'd either call me from where he was, or scrawl notes, usually on hotel stationery, and he'd read them to me over the phone when he got back, often having to stop to decipher them—and on these occasions the going was slower, so I usually had time to type them as he read. (Occasionally he'd talk into a tape recorder and give me the cassette when he got back.) When *I* went away, the arrangements would vary—sometimes I would call him periodically from where I was and he would read me the notes he'd kept. Whatever the procedure, no day was left un-Diarized.

The Diary calls weren't, necessarily, the only times Andy and I would talk to each other during the day. If we were working on a project together—writing *Popism*, for example—we might speak a few times during the day and evening. And business aside, we were friends, the kind of friends who would call each other whenever we felt like it—when something funny happened or when we were mad about something. (Actually, arguing and laughing are the two things I remember doing most with Andy.) Many times during these non-Diary calls, and occasionally in person, Andy would add to or correct something he'd told me during the regular morning call and he would tell me to "put that in the Diary."

Andy changed so much over the years that some who knew him in the sixties and early seventies may very well wonder why certain aspects of his personality that they experienced (and that were widely written about) don't show up more in the Diary—particularly a cruel, maddening way he had of provoking people to near-hysteria with comments calculated to do just that. The answer is in two parts: first, and most obviously, this is a *diary*—one man's perspective—and the diary form itself precludes dramatic confrontations between two or more people; second, Andy gradually outgrew the impulse to make trouble. He'd had a late adolescence—in his twenties he'd worked very hard at his commercial art career; he didn't take much time out to have fun, really, until he was in his thirties. So he terrorized people the way, for instance, the most popular girl in high school could—creating cliques and setting up rivalries just for the "entertainment" value of watching people fight for his attention. But toward the end of the seventies he started to mellow. Very rarely would he deliberately provoke someone—in fact, he tried to pacify more than to

incite. And the personal and emotional problems he himself went through during the years covered by the diaries left him looking for comfort, not drama, in his friendships. By the last year of his life, he was kinder and easier to be around than at any time since I'd met him.

A few idiosyncrasies to bring to the reader's attention: Andy's conversations were full of superficially contradictory remarks—he'd describe someone as a "cute little creep," or he'd say, "It was so much fun I had to leave." (And naturally, as in any diary, his opinions about any particular person or thing may fluctuate greatly over time.) He exaggerated quantities—he'd describe a 5'2" person as 2', or a man who weighed 250 pounds as 400. "Eighteen" was a favorite number—if there were multiple events on his evening schedule, he'd say he had "eighteen parties to go to." He used the terms "fairy" and "dyke" loosely, as when describing even slightly effeminate men and loud-speaking women. "Boyfriend" and "girlfriend" he used just as freely. When Andy worked long hours as a freelance commercial artist in the fifties, doing drawings at home at night and dragging his portfolio around Manhattan during the day, he met hundreds of people in advertising and publishing and retail sales; and after he'd left commercial art and become a Pop painter, it became a running joke that he'd refer to every one of them as "the person who gave me my first job"—that was just his way of describing anyone from that period of his life. It was often written about Andy that he used the "royal we." To an extent, that was true—it was "our movies," "our magazine," "our party," "our friends"—but that only applied to his post-Factory days: anyone he knew before he rented the first Factory was simply "a friend of *mine*." And anything related to his art, of course, was always described in the first person singular: "my painting," "my show," "my work."

Going broke was Andy's biggest fear. That, and getting cancer—a headache or a freckle was always a possible brain or skin cancer. Ironically, it's apparent now in retrospect that when he was *really* worried about a health problem he scarcely mentioned it—episodes like a lump in his neck in June of 1977 which doctors finally pronounced "benign" and the gallbladder problem in February of 1987 which led to his death.

So that the Diary could be published in one large volume, I've distilled its original length of 20,000 pages down to what I feel is the best material and the most representative of Andy. This naturally entailed cutting whole days, occasionally even entire weeks, but most often, just parts of days. On a day when Andy went to five parties, I may have included only a single one. I applied the same editing principle to names: to give the diary a narrative flow and to keep it from reading like social columns where the reader is deluged with lists of proper names that often have little meaning to him, I've cut many names. If Andy mentioned, say, ten people, I may have chosen to include only the three he had conversations with or spoke of in the most detail. Such omissions are not noted in the text since the effect would serve only to distract, and slow the reader down.

The Diary does not include a glossary because simplistic explanations of who people were in relation to Andy would go against—if not actually betray—the sensibility of what he was about and the unstructured world he generated around him. Andy was about *not* putting people into categories—he was about letting them cross in and out of categories. The people in his sixties "underground" movies were called "superstars," but what exactly did that mean? It could refer to the most beautiful model in New York or the delivery boy who brought her a pack of cigarettes during filming and wound up in front of the rolling camera.

To Andy, putting things in a format that made sense was enough of a compromise. He'd get exasperated when I'd occasionally make him repeat or rephrase something until I understood it. His first "novel," *a*, published in 1968, actually had been a literary experiment—transcripts of conversations that he'd taped of his superstars and friends as they operated in the amphetamine and pansexual subculture of New York were "transcribed" by amateur typists who, guessing at words and phrases when they couldn't be certain, perpetrated technical and conceptual mistakes galore that Andy then made sure were reproduced, typo for typo, as the published text.

Another concern was keeping the editorial explanations, which appear occasionally in brackets, to a minimum so that the flow of Andy's own voice with its peculiar locutions could be preserved uninterrupted. I felt that, although explanatory matter could have been provided in many editorial asides to occasionally make a reader's job a little easier, the benefits gained from these intrusions would be small in proportion to the jarring effect they would have on Andy's personal tone and the needlessly distancing effect they would have on the reader. The exact nature of some of the relationships between Andy and various characters in his diary can be grasped only after some effort, it is true, but I believe that having to *work* a little to understand things is part of the unique experience of diary-reading—watching life unfold naturally, with its occasional confusions. To keep these confusions to a minimum, however, *the diaries should be read in sequence.*

Finally, in editing the Diary for publication I've eliminated the interpersonal dimension of Andy's and my discourse—his direct references to me or to things that would have meaning only to me. In the relatively few instances where I did leave in personal references, I took the liberty of translating myself into the third person, using my initials, PH: My aim was to make it possible for the Diary to be read in the same casual and intimate spirit in which Andy gave it to me every morning, so that the reader would always be the "you" on the other end of the phone.

PAT HACKETT
New York
January 1989

THE ANDY WARHOL DIARIES

Wednesday, November 24, 1976—Vancouver—New York

Got up at 7 A.M. in Vancouver and cabbed to the airport ($15 plus $5 tip, magazines, $5). This is the end of the trip to Seattle for the opening at the Seattle Art Museum there, then we'd gone to Los Angeles for Marisa Berenson's wedding to Jim Randall, then to Vancouver for my Ace Gallery show opening there. Nobody in Vancouver buys art, though—they're not interested in painting. Catherine Guinness *[see Introduction]* didn't get edgy till the last day when she started this annoying thing the English do—asking me over and over, "What exactly *is* Pop Art?" It was like the time we interviewed that blues guy Albert King for *Interview*, when she kept asking, "What exactly *is* soul food?" So for two hours on the plane she tortured me (cab from La Guardia $13, tip $7—Catherine was grand and gave him the whole $20). Dropped Fred off. Got home. Ate an early Thanksgiving dinner with Jed *[see Introduction]*. He'd gotten the car serviced for the drive down to Chadds Ford in the morning to Phyllis and Jamie Wyeth's.

Thursday, November 25, 1976—
New York—Chadds Ford, Pennsylvania

Fred called at 8 A.M. to find out when we were leaving. Barbara Allen called and said that if we were leaving after 12:00 she would come (film $19.98). Cabbed to 860 *[860 Broadway, at 17th Street, at the northeast corner of Union Square Park, where Andy rented the entire third floor for both his offices and the offices of* Interview *magazine]* to pick up some things to take. Left around 1:00 (cab $3.60, gas $19.97, tolls $3.40). Beautiful day.

Jed somehow drove straight to the Wyeths' door, with just one phone call for directions (phone $.10) at a turnoff right near the place to get the last bit. Arrived around 4:00. The traffic was okay. Barbara Walters didn't come after all.

Andrew Wyeth, Jamie's father, was there. Frolic Weymouth was there, a neighbor—his wife who's Andrew Wyeth's niece had just left him for an antique dealer or something after lots of married years—he's a du Pont—and he was depressed, so he was over for dinner. And Andrew's two sisters, one nutty who looks like she drinks and paints.

We sat for hours and hours at dinner, it was perfect, so good. Lots of drinks. I was still so tired from all the traveling at the beginning of the week. Jed went to bed around 2:00, everyone else stayed up until around 4:00.

There was a romantic interest going on. Robin West—he's a neighbor of the Wyeths, too, he works for the Pentagon but he'll be losing his job soon because Carter's coming in—he was there, and Catherine talked about shit and piss for him and about the Anvil S&M bar, and he seemed to like that and got interested. He's looking for a rich girl to marry, he asked me where oh where was his tub of butter on the other side of the rainbow, and I told him it could be a tub of Guinness beer if he played his cards right. He said he'd take us for a ride in an aircraft carrier before his job gets given to a Democrat.

Friday, November 26, 1976—Chadds Ford

Went on a tour of Winterthur in the morning (tickets $24, books $59). Then Phyllis Wyeth got the buggy together, we had an all-American breakfast, fed Archie and Amos [see Introduction], then we went out for a ride. We went across the Brandywine River in it, it wasn't so deep.

Jed went to meet Vincent [see Introduction] and Shelly and Ronnie [see Introduction] and Gigi at the train station. Went with Jamie to the Brandywine Museum and we were photographed and had a press conference. Went back to Jamie and Phyllis's and there were cocktails. Mrs. Bartow who I bought the East 66th Street house from was there and she asked when I was going to sandblast it and why was I never home because it always looked dark. Carter Brown was there and Jane Holzer with Bob Denison.

Rode to the museum. I introduced Gigi as "George"—I'd told this guy she was a drag queen and he didn't know I was kidding, he got excited—and then she said, "No, it's *Georgette*," which coincidentally is her real name—I didn't know it. So everything was coming out right—I mean it was just what a drag queen would say, so that was funny. And the guy really liked her and she didn't have a clue it was because he thought she was a boy.

Saturday, November 27, 1976—Chadds Ford

Went in the carriage again. This time Frolic had his carriage out, too. He was drinking all day. He took his drinks onto the wagon with him and he was riding around drinking. Jamie took me to his aunt's house to see a 5' dollhouse. It was like an old-fashioned Christmas.

Then went over to the museum where an antique dealer was having a benefit for an opera school, and I really enjoyed that, they were singing an opera. They passed a hat around and Frolic gave Catherine $20 of his own money for her to drop in and I dropped in $20, too. Didn't get to bed until around 4:00.

Sunday, November 28, 1976—Chadds Ford—New York

Catherine called New York, to Jodie Foster's place, to confirm the interview she and I were supposed to do that afternoon, and Jodie's mother hedged saying Jodie was sick and maybe she couldn't do it, but to call when we got back to town. Got back at 12:30 (gas $16.50, tolls $3.40). Dropped Catherine and Fred. Catherine called Jodie again and she said okay.

It was a beautiful day, in the sixties again. Picked up Catherine and walked over to the Pierre Hotel to meet Jodie. Said hello to lots of people who said hello to me. At the Pierre I saw a beautiful woman staring at me and it turned out to be Ingrid Bergman. While I was talking to her, Coco Brown started waving and yelling from a car. Ingrid's I think husband came for her and then Catherine and I went into the restaurant to wait for Jodie. She came in with her mother and a guy they said they'd picked up I think in Liverpool, and I couldn't tell if it was a bodyguard or the mother's boyfriend. Jodie had on high boots and a hat and was really cute and we loved her ($30 with tip).

Then we all walked over to F.A.O. Schwarz and looked at toys. Bought some for Jodie ($10). She signed autographs. On the way back to the Pierre a guy was selling big candy canes and he gave Jodie one and me one.

Went home. Nelson Lyon called from L.A. and told me about his Thanksgiving—Paul Morrissey had invited him to dinner at Chase Mellen's house and then called back to disinvite him saying it was going to be "small and intimate" and that he'd made a mistake inviting anyone. As soon as Nelson hears that anything is "small and intimate" he gets paranoid he's not invited and goes crazy to get there, so he put his mind to it and got there through someone else. It turned out to be *thousands* of people there so when he saw Paul he said, "Small, intimate world, isn't it?"

Brigid Polk *[see Introduction]* called and said she's down to 197. Ever since she saw herself in *Bad [see Introduction]* weighing 300 pounds and went on a diet, she's so boring to talk to—she never *does* anything, she never *thinks* anything, she just *lies* there in bed in her room at the George Washington Hotel and waits for the fat to roll off. I told her I'll give her a job—that she could let some roll off around the Factory while she answers phones, but she won't. It's taken her thirty-nine years to lose weight and it'll probably take her another thirty-nine years to get to work.

I was too tired to meet the Vreeland crowd for dinner. Watched twenty-five years of Lucille Ball on TV instead.

Victor Hugo, Halston's "art adviser," called me from San Francisco because I'd told him I loved the display window he did of turkey bones at Halston's Madison Avenue store, and now someone broke in and *took* the turkey bones, so he thought it was *(laughs)* me.

Tuesday, November 30, 1976

Daniela Morera, our Italian *Interview* correspondent, came by the office with Olivier Coquelin who invited me to Haiti for the Nima Farmanfarmian-Chris Isham wedding in January. He owns that resort there. He should be interviewed for *Popism*—he's the one who owned Cheetah in the sixties, the big discotheque on Broadway and 53rd.

I don't want to talk long this morning, I want to get over to Bloomingdale's before it's too crowded.

[NOTE: Andy talks every morning in the past tense about the previous day's events; therefore, when he speaks in the present tense or uses words like "now" or "today," he's referring to something happening right while he's talking or that he expects will happen on the day he's giving the diary. For example, a Tuesday's diary would be given on a Wednesday morning, so "last night" would mean Tuesday night, "this afternoon" would mean Wednesday afternoon, and "tomorrow" would mean Thursday.]

Wednesday, December 1, 1976

Got into the Christmas spirit and started buying business gifts (cabs $8). Ran into Jean Kennedy Smith in Bloomingdale's in the men's shirt department. We had the same salesgirl. Cabbed to Union Square ($4). Amos was down at the office and Ricky Clifton took pictures of him in costume as the pope.

Left to go down to the Ileana Sonnabend Gallery to the David Hockney opening. He wasn't showing new stuff, just portfolios. Took Amos (cab $2.50). Ran into Gerard Malanga [see Introduction]. Gerard wrote to Fred asking why he wouldn't let him do photography for Interview, I guess he just wants a press pass. Fred won't have anything to do with Gerard because we're still getting repercussions from all the fake Electric Chairs we think he did, they're being resold and resold and each time the money involved gets bigger, so Fred isn't about to give Gerard anything. The opening was jammed. Didn't see David Hockney, he must've been in another room.

Changed and went over to dinner at the Iranian embassy. Not really the "embassy," but you know what I mean—it's where Mr. Hoveyda, their ambassador to the U.N., lives (cab $3). China Machado was there and she said she's known Ambassador Hoveyda for ten years or more from when he and her husband were in France hanging around the French filmmakers in the sixties. We talked about how horrible Avedon is, she said he gets what he wants out of a person and then drops them. I agreed and then everybody screamed at me that I do the same thing.

Pat Kennedy Lawford was there and a du Pont lady who lives next door to the embassy who said it was so nice not to have to go far for a meal and so she was late. She was wearing a black and gold dress with a jewel collar that she said always gets impounded at customs. The food was good, but the caviar only came around once.

Thursday, December 2, 1976

They're screening Bad in California this week to try to get a distributor for it. Sue Mengers is helping us out. None of the distributors want to put up advance money.

Sent Ronnie to buy brooms ($20). Dropped off Catherine Guinness (cab $4) and went home to change, then picked her up and cabbed down to 18 West 38th Street ($3.60) to the opening of a new club that Helen Bransford had invited us to, it's sort of trying to be a new Reno Sweeney's. Helen goes around with John Radziwill now. Fred thinks she's great and that we should be nice to her. Tim Hardin was singing there.

Maxime de la Falaise was there with her new maybe-boyfriend, Craig Braun. I worked with him on the Rolling Stones album cover.

Barbara Allen was there and she's moving into Fred's house on 89th and Lexington for a while, because she rented her apartment on East 63rd Street to Catherine and then Catherine let her stay there but she and Catherine living in the same apartment got to be too much.

Went home and watched the news, it's all the Gary Gilmore thing, every night they have him on saying he wants to die, he wants to die.

Sunday, December 5, 1976

Went down to the Players Club on Gramercy Park for a dinner for Kitty Carlisle Hart. It looked like a stag party except for Arlene Francis and Peggy Cass and Dena Kaye who came instead of her husband Danny, who had Concorde-lag, and Irene Selznick, who was the chairwoman of the evening, or whatever they call it. Peggy and Arlene are Kitty's sidekicks from "To Tell the Truth."

The dinner was to honor Kitty for being named the new head of the New York State Council on the Arts by Governor Carey.

My doctor, Doc Cox, was there and he took me upstairs for a tour of Edwin Booth's bedroom and it was musty and dusty, same as in the old days.

Dinner was served and it was everything creamy I'm not supposed to eat because of my gallbladder, so the Doc was embarrassed that he was seeing me eat it because it was putting a damper on a social occasion, so he told me, "I won't look." Met Alfred Drake who was on Broadway, that big handsome star of *Carousel*.

Everyone made speeches and then Kitty got up and she was the best. She was wearing black and pearls, looked very chic. She says she still wants to work a lot and I remember that Diana Vreeland once told me that Kitty had to "work like a nigger" because she doesn't have that much money. The Doc dropped me off.

Monday, December 6, 1976

Freddy Eberstadt called and invited me to something at La Grenouille tomorrow night and I said that I had a date with Bianca Jagger and could I bring her and he said sure.

Left the office early to go home and dress for a formal evening. Dropped off Catherine ($4). Walked over to Halston's. Victor had said there was room for me at Halston's table at the Metropolitan opening we were all going to, of Diana Vreeland's Russia show. When we got to Halston's Mrs. Henry J. Kaiser—Aly—was there, she was in a blue-green Halston with emeralds, and she seemed very interested in me, and when Halston saw us getting along he suggested I take her upstairs to show her the portraits I did of him. After the trip upstairs, though, she dropped me, I guess she saw me in the light.

We were all waiting for Marisa and her new husband and Bianca and her date, Joe Eula. The acupuncture doctor they all use was there, Dr. Giller, so he's on their party list now. Barbara Allen was there, the only one of the ladies not wearing a Halston. She had on a beautiful off-the-shoulder Christian Dior. It was from her shopping spree in Paris last month when Philip Niarchos was buying.

Marisa came and she had her hair piled all on one side of her head like a beautiful old-time star. Bianca had her purple fox with her, the one she's had around the past month. When Joe walked in he and Halston "shook hands" and when Halston felt what Joe put in his palm he said, "Oh, you've saved my life."

Victor took me into the garage to show me his latest artwork—he's *(laughs)* making Mona Lisas wearing Halstons, and that's really funny, so I encouraged him. Then we went to the Met in four limos. This was the biggest one of these things the museum has ever had. When Diana walked through we all kissed her. I talked to Mrs. Kaiser and got to know her. She's about sixty but she looks forty, and she says she's looking for a fuck. I told her it's the wrong town, everyone's gay, and she said she didn't care—"they tumble well. I've had some good luck here." She lives at U.N. Plaza. It turns out she's a very good friend of Brigid's mother, Honey Berlin. She said that when she was at their house old Dick Berlin was so senile he walked in and rushed over to the mirror and tried to shake hands with himself but she saw

what he was doing and went over and was the hand for him to shake. I left right after dinner, Mrs. Kaiser dropped me.

Oh, and also at the dinner table Bianca took off her panties and passed them over to me and I faked smelling them and then tucked them in my handkerchief pocket. I still have them.

Tuesday, December 7, 1976

Met Bob Colacello [see Introduction] and Fran Lebowitz, and we went down in the rain to the Biltmore Hotel to the Overseas Press Corps lunch. Bob had told them weeks ago when they invited me that I would come and just be present but that *he* would give the talk on *Interview* and they said fine. After Bob's speech, though, they asked questions all directed at *me*—and I wasn't prepared so I just said yes or no. But afterwards I regretted doing my same old shy act, when I should have used the situation for practice—I'd love to be able to talk more and give little speeches. I want to work on that.

They asked Fran only one question, why her column in *Interview* was called "I Cover the Waterfront," and she said that it was because Tennessee Williams was on a talk show once and they asked him if he was a homo and he said, "Well, let's put it this way: I cover the waterfront." And Fran's answer was a lead balloon, nobody laughed. In the cab downtown she said she'd rather have her appendix out than go to something like that again.

Bianca called and invited me to a screening of *Silver Streak*. Didn't get home until 7:00 which was exactly when I was supposed to be at the Pierre to pick her up—she and Mick just rented a house on 72nd Street but it's not ready to move into yet. Went over to the Loews Tower East. The movie was kind of funny. Bianca looked beautiful. Afterwards outside the theater when we couldn't find the limo a black guy with a black scarf was pressing himself up against Bianca and he was crazy, he was saying, "You think you're the only one with beautiful clothes in the world?"

Finally we found the car and went to La Grenouille. Isabel and Freddy Eberstadt and Mica Ertegun arrived and with them was Isabel and Freddy's beautiful daughter, Nenna. I kept staring at her and saying how beautiful she was, and Isabel sort of kept us apart. I couldn't figure out why they had asked me to this dinner because if I hadn't asked to bring Bianca, there would have been just *me*. Mica was very sweet. She kept saying that Joe Allen was so attractive, that how could Barbara Allen leave him.

The Eberstadt daughter didn't say anything during dinner but then she finally blurted out that she used to go to Union Square and stare up at the Factory, so that was thrilling to hear from this beautiful girl. I told her she should come down and do interviews for *Interview* and she said, "Good! I need the money." Isn't that a great line? I mean, here Freddy's father died and left him a whole stock brokerage company.

We said our good nights and thank-yous and I hope I remember to send flowers.

Friday, December 10, 1976

Sam Bronfman's kidnappers were found innocent of the kidnapping charge today.

Brigid came to the Factory for the first time since she started her diet in August—she's down to 190, was last seen at 260. She really looked good and everyone fussed over her, I took pictures. Barbara Allen found herself a new apartment on 77th off Fifth.

Sunday, December 12, 1976

I read the Ruth Kligman book *Love Affair* about her "love affair" with Jackson Pollock—and that's in quotes. It's so bad—how could you ever make a movie of it without making it a whole new story? Ruth told me she wants me to produce it and Jack Nicholson to star.

In the book she says something like, "I had to get away from Jackson and I ran as far as possible." So do you know where she went? *(laughs)* Sag Harbor. He lived in Springs. So that's—what? Six miles? And she was making it like she went to the other side of the world. And then she said, "The phone rang—how oh how did he ever find me?" I'm sure she called hundreds of people to give them the number in case he asked them.

Monday, December 13, 1976

Victor Hugo picked me up and we went to U.N. Plaza for Mrs. Kaiser's dinner for Halston (cab $3). But then we realized we'd forgotten Bianca so we had to go back to pick her up at the Pierre. Victor gave her some coke but she didn't want it.

The first person we saw at Mrs. Kaiser's was Martha Graham, and C.Z. Guest was there. Paul Rudolph had done the apartment, and he was there. White on white. She has a bedroom as big as 860 with one bed in it, and a floor-to-ceiling glass window with a view, just what terrifies me, but it was beautiful. Marisol and Larry Rivers and Elsa Peretti and Jane Holzer and Bob Denison were there. Polly Bergen and I talked about the topic on her TV show that morning—androgyny.

Tuesday, December 14, 1976

In the afternoon I got a letter from our editor, Steve Aronson, that said he's leaving Harcourt Brace Jovanovich, and that he'd asked Mr. Jovanovich himself to take over on *Popism*.

Walter Stait from Philadelphia took me to La Grenouille for lunch, he told Maxime and Loulou de la Falaise to meet us there. On the other side of the room was the new skinny Truman Capote. He looks now almost like he did when I first knew him. Truman didn't answer my hello but then halfway through lunch he put on his glasses and waved, and later he gave me his personal phone number. All of the chic girls were in YSL fur hats.

Worked at 860 all afternoon, then François de Menil arrived to take me out to Norman Mailer's in Brooklyn Heights. He used to live in a whole house but now he lives on just the top and rents

the bottom out and he's had the front part made all glass looking out over Manhattan and it's beautiful.

Wall to wall, it was an intellectual party like from the sixties. Arthur Schlesinger, Mica and Ahmet, the girl who wrote the book on LBJ. Norman looks good now, white hair, looks Irish. His little mother was there. And Jean Kennedy Smith and her husband. Sandra Hochman told me I'm a chapter in her upcoming book, she talked to me about the women's movement and junk like that. She said, "I have your picture on my mantel," but I just know she doesn't.

Isabella Rossellini was at Norman's, she's working for Italian television, she's doing a thing on boxers, that's probably why she was there, because José Torres was there. She said she ran over to see me when she saw her mother, Ingrid Bergman, talking to me at the Pierre a couple of weeks ago but that I'd gone. She couldn't find her coat when she was leaving Norman's and just left without it. Norman was sweet and he and François must be really friends because they hugged and kissed and punched a lot. François drove us back in his grey Mercedes, he's a good driver.

Saturday, December 18, 1976

Went shopping for office gifts at Bonwit's and Bendel's, then went over to Quo Vadis for lunch to introduce Robin West and Delfina Rattazzi to each other. I had thought Catherine liked him from the weekend at the Wyeths', but she said she didn't mind, that she wanted to give him up to Delfina or something. And Delfina liked him, she was aggressive—it was the first time I ever heard her say, "My family is in the airplane manufacturing business," because usually she pretends she's so poor. Robin's a flier. Saw Karen Lerner and Sisi Cahan having lunch and I figured out it probably was Karen Lerner who just sold her Flower prints, because David Bourdon just got some cheap at Parke Bernet.

Went home and Bianca called and said she was going to be packing at the Pierre and then taking her stuff over to her and Mick's new place on 72nd. Went to the Pierre and she packed and packed and around midnight she was done and we went up and she turned off the alarm and we went in. It must be costing them a fortune, this little house. The people had just had it redone and it was all painted and with new furniture and I'd like to see it after the Jaggers have it for a year.

After we were there for a while Bianca turned on the alarm and went out to the airport to get a plane for Montauk, she wanted to get back out there because it was so beautiful. ["Montauk" refers to the oceanfront property in Montauk, New York, at the easternmost tip of Long Island, that Andy bought in partnership with Paul Morrissey in 1971. The property included one main lodge-type house with three smaller ones, plus the home of the caretaker, Mr. Winters. Mick and Bianca Jagger were at this time renting the place from Andy and Paul.] Jade was still out there.

Sunday, December 19, 1976

Went to work (magazines and newspapers for week $26). Lou Reed called and that was the drama of the day. He'd come back from a successful tour, he was a big hit in L.A., but he said Rachel had gotten kicked in the balls and was bleeding from the mouth and he wanted the name of a

doctor. Lou's doctor had looked at Rachel and said that it was nothing, that it would stop, but Lou wanted another doctor to check. I said I'd get Bianca's. But then Lou called back and said he got Keith Richards's doctor to come over. I told him he should take her to the hospital. I was calling Rachel "she" because she's always in drag but then Lou calls him "he."

Monday, December 20, 1976

Jamie Wyeth had invited me to Les Pléiades for lunch. Cabbed to 76th and Madison ($2.25). Jamie was there with Lincoln Kirstein and Jean Kennedy Smith. They asked me to turn off my tape recorder, natch. So Jamie is now the Carter court painter. He'd just been in Plains for a week. Isn't that interesting? It seemed like Jean Kennedy Smith really has a crush on Jamie because she asked me to go to the coat room with her and when we got there she pulled out an American quilt and asked me if it was real, and I said yes, and then we went back and she gave it to Jamie. I reminded her that I saw her in Bloomingdale's the other week when we both were in the shirt department, and she said, "Oh yes, those shirts were Christmas presents for my family." So it was just regular old shirts for her family, but for Jamie it was an American quilt.

She was the first to leave, and then we we relived the *faux pas* that Lincoln had made in front of her; he forgot she was a sister and when they were talking politics he said that John Kennedy was "corrupt," and she just said, "No, he wasn't."

After lunch we went down to Lincoln's house on East 19th Street and he showed us his art, it was good paintings—Lincoln's brother-in-law Paul Cadmus, George Tooker, and Jared French, all Realists who'd done paintings of muscle boys. He didn't have anything of mine.

Walked over to Union Square. Worked the rest of the afternoon.

Tuesday, December 21, 1976

Met Victor, went over to Halston's store, it was really un-busy, but then everything is so expensive that if they just sell one little hanky they can have dinner. While I was there, Jackie O. came in and was whisked up to the third floor. Victor told me that she doesn't buy much, just a few little things.

Went around Fifth Avenue looking for ideas for art projects (cabs $5.75). Went to 860 for lunch with Todd Brassner and Rainer Crone, but I couldn't spend too much time with them, I was painting in the back. Todd was asking Rainer questions about some paintings of mine he was interested in because Rainer wrote the Praeger art book on me and he knows who owned which canvases.

Catherine called Dustin Hoffman who said that the screening was at 5:45 at 666 Fifth. Dustin had filmed his wife Anne doing a Balanchine dance, his kids were in it, and I think he got a very good guy to cut it because it looks very professional. When it was over, Dustin invited us back to his house on East 61st Street. It's back to back with Phyllis Cerf's house. Dustin was nervous, really nervous about his house, and he was taking me around and showing me every little thing. His taste was oak, but not good oak, so it was funny.

Wednesday, December 22, 1976

A car came to take me to be photographed for a Merce Cunningham thing to help it get publicity. Up to 660 Park Avenue. *Newsweek* and other photographers were there. When I got there they said they'd take me home in the car, but then when I was leaving I realized they'd used me up and sent the car away, so I just walked home.

In the afternoon Jane Holzer stopped by my house to drop off the grey kitten who's going to be a Christmas present from her son Rusty to Jade Jagger. I'm supposed to keep it until Christmas, it's really cute.

Changed, and Jed drove us out to Peter and Sandy Brant's *[see Introduction]* house in Greenwich. Philip Johnson and David Whitney were there, they're leaving tomorrow for San Simeon to see some Hearst and to look at architecture in California. Dinner was Chinese, not that great. Bunty Armstrong started using her society teeth. I gave Sandy a 1904 desk set for Christmas. Jed gave her a Fulper pot and she gave him one back. Actually it was a Van Briggle, and the one she gave Jed was better. Joe Allen didn't bring his girlfriend Jenny, because he's still in love with his ex-wife Barbara. Barbara had dislocated her back—"sleeping," she said, and we were trying to figure out with who. A horse fell on top of Peter and so he was walking around with a cane. Peter just bought ninety acres in back of his house, he's going to make a racetrack and polo grounds.

Thursday, December 23, 1976

Office Christmas party. Maxime de la Falaise arrived late, to pick up a Mao painting. Mike the super came in off the freight elevator with his wife and son but maybe the son is a stepson, I'm not sure. He's cute. John Powers came by and wanted me to sign two Flower posters that he had, they weren't authentic but I was going to just sign but Fred wouldn't let me and so we gave John two authorized ones from the back. Ronnie and Gigi were there, everyone was really diving into the caviar and champagne. Marc Balet the *Interview* art director and Fran Lebowitz were there.

Andrea Portago had called that afternoon and said that if we could get her a ticket to the premiere of *A Star Is Born* she would get the limo, so we did and she did. I couldn't figure out why she wanted to go so much until we got to the movie and she rushed up to Kris Kristofferson and said, "Oh darling, it's so good to see you again." Sue Mengers had tried to fill up the whole place. They'd said it was going to be very hard to get in, but then there were so many empty seats. Sue said everyone had to say they loved it or Barbra would be upset. I didn't like it. The old Judy Garland one gave you goosebumps but this one was just a nothing rock and roll story. But Jed loved it. Then went over to the party at Tavern on the Green.

Streisand was wearing a black tuxedo. Elsa Peretti was there and she was saying how wonderful it was to be with me and not be *on* anything, that she didn't take anything anymore. I admired a light bulb she had in her purse, a tiny one that lit up when you put a penny next to it, and she gave it to me, and then Victor liked it so I gave it to *him* and then Elsa saw that and took it away from Victor and shook her finger at me and put it back in her purse.

Andrea was just sitting there waiting for Kristofferson to notice her, but he was busy.

Friday, December 24, 1976

Went with Jed to Fred's Christmas dinner at 1342 Lexington. Jed's brother Jay *[see Introduction]* and his sister Susan picked us up. Fred had invited Carroll Baker and she was there with her daughter, Blanche, who's gotten to be a beauty in the last few months, she slimmed down. Anselmino, one of our Italian art dealers, was there and Chris Makos the cute photographer we met from Dotson Rader and Robert Hayes the assistant editor at *Interview* and it was an office Christmas Eve.

Mick Jagger was there and he was in a good mood, he asked me what I thought of *A Star Is Born* and I told him and he said that he was so happy he'd turned it down, that he didn't want to play a has-been rock singer, even for the million they offered him. Mick was asking for coke and finally got some from Anselmino. Fred's housekeeper Hazel made turkey and ham and brussels sprouts. Paloma Picasso and her entourage were there.

Then we went downtown to Fernando Sanchez's and Halston was there and Kenny Jay Lane and André Leon Talley and that new really rich English kid in town who "has no money"—one of those—Nick Scott, offering to sell his body to the highest bidder. Kenny Lane offered $35. Maxime de la Falaise upped it to $36.

Saturday, December 25, 1976

Went out to Westbury to C.Z. Guest's for lunch. It was a magazine Christmas—the decorations and the food and the house were just like a spread in *McCall's* or *House and Garden*, like what a house should look like on Christmas. But you'd think with all C.Z.'s involvement with flowers and gardening that she'd have *real* stuff, but when you looked close the wreaths and things were half plastic. C.Z. gave everyone her bug repellent for gifts.

Ninety-year-old Kitty Miller was there, she's still putting blue shoe polish in her hair. The pies were great—apple, mince, and plum. The turkey had already been cut up like a magazine would tell you to before it got to the table, so it was like a Turkey Puzzle. Kitty was drunk and when the Spanish ambassador said a few words she screamed, "I can't speak Spanish."

It started to snow a little. Said thanks and left to go home to get ready for the Jaggers'. Got to East 66th and glued *[see Introduction]*. Went up to East 72nd (cab $2.50). We were one of the first to arrive. Nick Scott was at the door, working. This was a job he'd come up with to earn money—being the Jaggers' houseboy. Only he was supposed to get there at 8:00 in the morning to help and he didn't arrive until 6:00 at night. I gave Jade the grey kitten from Rusty Holzer. She looked at it and said, " 'Lydia?' . . . No. Harriet." I felt sorry for the cat, though, because I think it's going to have a horrible home. I don't know.

Mick sat down next to Bob Colacello and put his arm around him and offered him a pick-me-up, and Bob said, "Why yes, I am rather tired," and just as he was about to get it, Yoko and John Lennon walked in and Mick was so excited to see them that he ran over with the spoon that he was about to put under Bob's nose and put it under John Lennon's.

Halston and Loulou de la Falaise put a lot of the pick-me-up in a covered dish on the coffee

table and when someone they liked would sit down they'd tell them, "Lift it up and get a surprise." Paloma Picasso was there. Jay Johnson brought Delia Doherty. The dinner was terrific. Mick and Bianca forgot to bring out the dessert, though.

Monday, December 27, 1976

Got the invitation to President Carter's inaugural. It was addressed to *(laughs)* "Mr. and Mrs. Andy Warhol." Don't you love it?

Wednesday, December 29, 1976

Hoveyda brought the Iranian ambassador to England to the office, they came to see the portrait I did of the empress, and they liked it, so it's going to be shipped out.

Vincent drove out for the hearings on the Montauk property, wetlands commission.

Friday, December 31, 1976

Worked at the office until 7:00. Went home to change for Kitty Miller's party. Walked over to 550 Park. Fred was there. Elsie Woodward, my Kitty-date for last New Year's, had called and cancelled because she said she was dizzy and that she can't fight it—"I'm old."

Princess Minnie de Beauvau was there with her father and stepmother and her sister Diane. She introduced me to her grandfather Antenor Patino who I then realized I'd just met at C.Z. Guest's. He's little. He looks like one of Paloma Picasso's little boyfriends. He's the tin king of Bolivia.

I overheard Kitty describing me to somebody and I guess somebody must have talked to her about me because what she was saying was sounding like somebody had told it to her—"He's one of the furthest off-Broadway, and a far *(laughs)* head of his time," and things like that. Maybe it was Billy Baldwin or somebody like that she got that stuff from.

I missed Kitty's regular butler, the one that had the fight with Diana Vreeland's maid. He was fired for being too familiar, but I really liked him—he's the one who told me to watch those A.E. Coppard stories on channel 13.

And after dinner, I sat underneath Goya's "Red Boy." Kitty has this most famous painting right there in her house, it's unbelievable.

Kitty's parties used to be the biggest thing in New York with every Hollywood star there and now it was down to just her friends. Aileen Mehle—"Suzy"—didn't even RSVP this year.

Diane de Beauvau took my hand and we ran into the next room right as midnight was coming on. I sort of wanted to stay and kiss the old bags like I did the year before because actually it was so much fun to do—to kiss ninety-year-old Elsie Woodward and say, "Happy New Year, darling." Then Minnie de Beauvau came in and got Diane and told her she had to go back in

and say Happy New Year to their father and stepmother—because she knows where their bread's buttered.

And the food at Kitty's—it was the canned frozen stuff again. At first you think that maybe these rich people don't know any better because they've been going to charity dinners all their lives, but then they *do* go to La Grenouille, too, and *that's* really good food. So they must notice the difference. And there were six servants serving the canned food.

Right after midnight it was everybody grabbing their coats, they couldn't wait to go on to the next party. Fred was really drunk. We got out on the street and he thought he was the "It Boy"—he gave Minnie his coat—the wind-chill factor was making it around twenty below—and he was just in his top hat, kissing everyone on the street. We walked Diane to the Westbury to pick up her boyfriend who'd stayed home to write a script, but when we got there he was in the nude waiting to fuck her, so we left her there.

Went home. Called Brigid. Called PH [*see Introduction*]. Nobody was home yet. At 6 A.M. Jay Johnson woke me up calling to speak to Jed. He was drunk and I hung up on him and he called back and let it ring twenty times.

Monday, January 10, 1977

Fred had to go to a meeting at our lawyer Bob Montgomery's about the New World distributing deal for *Bad*. Roger Corman himself hasn't seen *Bad* but Fred says that doesn't matter because Corman doesn't pick the movies, that this other guy Bob Rehme does. They'll try different ways of opening it around the country to see what works best before bringing it into New York.

Bianca called and invited me to a dinner that Regine was giving for Florence Grinda, and Catherine and Victor got on the phone and said they wanted to come, too, so she told them to come for coffee.

Andrea Portago had called me earlier and asked me to take her to the dinner, and I told her it wasn't my invitation so I couldn't, but to call Bianca and she did and Bianca was thrilled, because she's after Andrea's brother, Tony, and Andrea and Tony would come together. Andrea picked me up with her brother. We went to Regine's.

Bianca was wearing a strapless Halston dress. There were South Americans at a lot of tables. The dinner hadn't started yet, and while they were still in pre-dinner, at the bar, Catherine and Victor walked in for "coffee." When dinner started they were put at a separate little table, and when Victor pointed at my table and said he wanted the same thing, they said, "You'll have to pay for it," and he said fine. The food was awful. Regine was sort of rude to Victor and Catherine.

Diane Von Furstenberg was there. She'd called me to be her date for a CBS filming of her on Thursday, she thought we'd make an interesting TV couple, and I told her I'd be out of town— I'm actually not leaving until Friday—but to come down to my party on Tuesday night with her TV crew. But when Regine invited me for Thursday night dinner DVF overheard me say yes— it's for Russian Easter—and said how dare I have lied to her, so I was caught and I just said I'd made a mistake.

Victor gave out fake poppers. Regine said they smelled like feet and I told her they were called "Locker Room" and she liked that. Bianca started to giggle and she was carrying on over a popper

with Tony Portago, and they were sort of making out, but she pulled herself together, she realized that she couldn't do that in public, but she's the most beautiful when she giggles, and she loves those poppers. Some fans came over and I signed autographs. When Victor and Catherine and I left it was around 2:30 and the Portago driver dropped us.

Then at 4 A.M. Tom Cashin called to talk to Jed because Jay had cut his arm and was bleeding and so Jed went to take him to the hospital. And then Jay called from the hospital, and that drama went on until 9 A.M.

Tuesday, January 11, 1977

At six o'clock everyone was still at the office waiting around to go to my opening down at Castelli, so we went and at first it was empty, but we grouped around the bar setup drinking champagne and then it started getting jammed. There was the big "Hammer & Sickle," and eight small ones. David Whitney, Philip Johnson, David White were there. Paulette Goddard arrived, she said she wanted me to do her a Hammer & Sickle pin. Victor was there, performing, cutting up a shirt. Bianca arrived in the dress from Halston's window that Victor had foot-printed. And Catherine was wearing the red outfit that Victor had also foot-printed. Tony Portago and his mother Carroll Portago arrived. Paulette and Carroll are old friends. Bianca wanted poppers but nobody had any. Halston came in with a little painting Elizabeth Taylor had done for me because she didn't come down—he'd just been with her. When I think about that I'm really disappointed—it would have been so great if Liz Taylor had come to the opening. That would have made it something, wouldn't it?

Bianca and Tony Portago look really in love. This started over the holidays. C.Z.'s son, Alexander Guest, was there. Giorgio Sant'Angelo, Sylvia Miles, Ronee Blakley, Francesco Scavullo and Sean Byrnes, Irving Blum and Charlie Cowles. Moët Chandon champagne. The *Soho News* guy Michael Goldstein was there, being awful. I gave Jed money to entertain at dinner afterwards ($200) because I had to go up to John Richardson's.

I was disappointed with John Richardson's because it was oldies. Marion Javits, Françoise and Oscar de la Renta, Marella Agnelli, Babe Paley—I guess she really was a beauty once. Babe and Marella raved to me about my paintings, they'd seen the show on Saturday.

Sat next to Marion Javits. She told me how happy she was about Clay Felker losing *New York* magazine last week to Rupert Murdoch. Felker's the one who exposed her Iranian connection last year.

Catherine and Victor arrived for after-dinner. Victor had glued parts of his shirt together.

Nima Isham's mother and father came to the opening, and I couldn't believe it—here *they* were back from their daughter's wedding in Haiti that past weekend and Bob *still* isn't back yet!

Wednesday, January 12, 1977

When I got to 860 a big CBS crew was filming Jamie Wyeth with Arnold Schwarzenegger posing for him for a show called *Who's Who*. Cabbed up with Jamie and Arnold to a lunch at Elaine's for Arnold's movie *Pumping Iron* ($5). Stopped at the Ritz Towers, had to wait five minutes for Paulette

Goddard to come downstairs. She was wearing all her jewelry and was funny. She said, "If you'd played your cards right, these could have all been yours"—to me. God, when I think of how many hours Bob and I spent taping her, trying to get the real story of her life out of her for that book Mr. Jovanovich wanted . . . I mean, if *I'd* been a big Hollywood star and married to Charlie Chaplin and Burgess Meredith and Erich Maria Remarque I think I could've come up with a few hot stories.

At Elaine's Delfina Rattazzi was there. She works at Viking now as a reader for Jackie O. Victor was there and Paulette was falling in love with him because she was calculating all the Halstons she could get out of him. Pat Patterson came and sat with us, and Charlotte Curtis from *The New York Times* was there, too.

Dropped Jamie at the art store ($5). The office was jumping, Vincent was going crazy. Bianca called and said she was having a birthday dinner that night for Joel LeBon who works for Pierre Berge. Potassa the drag queen was at the office in a homemade black and gold fantasy dress and Jamie got fascinated and painted her in the dress with her cock showing. He'll be painting at 860 for about two months. Then Victor got Potassa to pose in the nude. Nenna Eberstadt is now working for us, she was typing up an interview. John and Kimiko Powers came in with a lot of art things for me to sign. Alex Heinrici *[see Introduction]* came by with some acetates.

Worked until 7:00 and then went up to Bill Copley's to sign a painting he'd bought. He'd just made dinner for his little daughter, Theodora. A great dinner—hot dogs, ketchup, Coke, and vanilla ice cream.

Dropped Fred off at Lee Radziwill's ($2.75). Went to the party for Joel. Bianca was wearing the same dress she wore the last time—it's strange to see girls who really dress up wearing the same thing twice.

Friday, January 14, 1977—New York—London

Arrived in London and didn't expect anyone to meet us, but Lady Ann Lambton was standing there with a chauffeur and we were really happy to see her. She had a broken neck, it was in a brace.

Stayed at the Ritz (tipped $5 for bags).

Ann called her sister Rose and Oliver Musker and we decided to meet them at Morton's. Had orange and champagne to drink, and a steak sandwich which was horrible ($55). Left for the Ritz, Jed and I, thought Ann would stay in Fred's room but she didn't because he had a small bed. Felt itchy and found a crab. Looked for more.

Saturday, January 15, 1977—London—Kuwait

Up at 7:00 for the flight to Kuwait. Tired. Packed, showered. Looked for crabs, still. Sent the hotel bill to the Mayor Gallery (tips at hotel $10). Picked up James Mayor at his place. He'd gotten us second-class seats, I was really mad, but there was one first-class one and I got it. Kuwait Air. The plane had to stop at Frankfurt and lots of people got on there. Read *The Users* by Joyce

Haber, very boring, about a homosexual husband. Joyce was married to Doug Cramer, he's a producer. There was a sheik on the plane up front with bodyguards in an even further front cabin. Took a pill. Fell asleep.

Woke up when the plane was landing. Arrived 11:00 late at night. Met at the airport by some Arabs. There was a girl Nadja, from the Council for Culture, who'd arranged the show. They made us drink some strange coffee at the airport.

Sunday, January 16, 1977—Kuwait

Up at 9:30. Breakfast toast and tea (tip $2, laundry $1). James called, meeting downstairs at 12:00. We were taken to a place that looked like some dump, but then everything here does, and it wasn't until days later that we realized it had been a chic place. Outside the sun was warm with a lot of cars going by—big Rolls Royces, big American cars. They gave us two cars but we only used one. Went back to the hotel to try to buy A-200 to kill the crabs.

Bought Nick Carter mysteries ($4). At 4:00 had to meet Nadja and James again. Went to *souk* for local color. Ladies in black hiding their faces, big marketplace, bazaar. It got very cold. Got an outfit to give to Victor as a gift (hat $4, dress $26). Spent time looking for antiques, but there are none in Kuwait—just a few old pots from a couple of years ago. We were the only foreigners in the marketplace.

Went to Nadja's gallery. Had some more of the sweet funny coffee they offer you all the time, you go crazy. We didn't know that if you don't shake your cup they keep pouring it in.

Bought five more copies of the Kuwait *Times* ($1). Calligraphy beautiful, no Pop there. Went to different drugstores looking for A-200. To hotel. Ordered dinner before dinner (tip $2). The people we were having dinner with sent a silver Cadillac limousine. Arrived at Qutayba al Ghanin's, a rich young Peter Brant type. His house was on the gulf, a little out of town. Land there was really expensive. He made it chic by moving there.

Kuwaitis don't serve hard liquor or beer or anything, it's against the law, but the rich ones have some hard liquor, Jack Daniel's or something.

Read Nick Carter. Really good—sex and girls.

Monday, January 17, 1977—Kuwait

Visit to the National Museum, there's no history to this place, it goes back twenty-five years. There were like eight rooms, one had three coins in the whole room. Think there was one room that Alexander left some pots in. Alexander the Great—three pots and four coins. A room with yesterday's dresses. More tea and coffee with the director. Just sat there, there was nothing to do. Carred over to see the secretary-general of the Council for Arts for more tea and coffee and ceremony. Dirty handprints on the wall, as if they killed somebody and it was a work of art or something. Guys standing around.

Everybody says the same routine: Where are you staying? How long have you been here? How long will you be here? When are you leaving? When are you coming back?

Carred over to see a rich collector named Fahad al Dabbous. Chubby and cute. He had a lot of paintings around on the wall, some Dalis, one sort of big one, lots of male friends there, most in costume, a couple of wives. They had drinks *there*, also—only the rich, remember? A big spread on table, nothing compared to Iran's big spreads. The men looked fat, but usually in costume you couldn't tell too much. But this one was chubby. He had bought the Marilyn and the Flower prints. He was wearing a girl's diamond-studded watch with a blue face. The Kuwaiti food was greasy—greasy roast.

Bought crab soap ($6). At 8:00 we were picked up by Mr. Bater, who was the cultural attaché from the United States to Kuwait, and taken to see the American Ambassador Morandi who was giving us a dinner. His wife was from Seattle, talked so much it drove us crazy. They were Democrats. Dinner was served at 10:00. Left at 12:00, bored. Used the crab soap, it didn't work. Fell asleep in the bathtub. In bed couldn't sleep. Read the Ruth Kligman book again, she was driving Jackson Pollock crazy in the car and *that's* when he ran into the pole. Gave it to Fred to read.

Tuesday, January 18, 1977—Kuwait

Up after restless night at 9:00 (tip $1, laundry $2). James Mayor urgently calling—we were always late because it was always so boring we weren't in a hurry. Visited a Kuwaiti artist atelier. Three artists in each room. This time tea or orange pop. Visited each stall, had to. One guy painted in Picasso-Chagall style. Not one original style. They sit on the floor and paint on rugs and pillows, it looked like hippie streetwares, like the sixties. It was the only nicely designed building in Kuwait because it was a copy of the Ford Foundation. Got a tour of the building. The man said it was very Kuwaitian.

Picked up at 4:30 for the opening of the exhibition in the Arts Council Hall. We had to meet the minister of state there. I think his name was Ahmad Al-Adwani—have that name written down. But maybe that name goes with someone else. I had sent him a copy of the *Philosophy* book [*see Introduction*] and he said he'd read it and that it had clever ideas, he was old and cute. There was a red ribbon in front of the door, I had to carry a pair of gold scissors on a red pillow to cut the ribbon. A lot of TV and press there.

Wednesday, January 19, 1977—Kuwait

Went to the exhibition for a tea party and had to drink more tea and then we were invited by the English ambassador to drop by. His daughter was there, she was seventeen and drew cartoons about fags. She was cute and funny. Had her father's chin, which was no chin. There were a lot of English people there who'd been living and working in Kuwait for years. Left. Big rainstorm.

Picked up by Nadja and had a fight with Fred about not going to Germany. He said I had to go because "you're a fading star there." It was the *way* he said it that got me mad.

Dinner at Nadja's house. There were sixty people. The best party the whole trip. She had eight or ten brothers and a mother and sisters and all the men dance together, looks like the twist. The food was really good. Then men began dancing with Fred. Someone gave him $40 for dancing

so well. Had to stay until everybody left—2:30. James admired somebody's robe and they gave it to him. Jed admired someone's nose ring and he got it. I didn't know about the custom, so I didn't get anything.

Thursday, January 20, 1977—Kuwait—Rome

Alitalia flight. Five and a half hours. Read the Rome *Daily American*. Carter inaugurated. Disgusting drunks on the plane. Airport empty, disorganized. While standing there ran into Marina Cicogna and Florinda Bolkan coming from St. Moritz (cab to the Grand Hotel $20). Hotel suite wasn't ready so we had to have lunch in the dining room. While we were there we ran into Helmut Newton and Patrick the makeup artist. And Suni Agnelli came in.

Had the suite Man Ray stayed in, he just died—he'd had a big opening in Rome right before. Fred said to forget what he'd said about me being a fading star in Germany, he sobered up, said that I didn't have to go.

Sunday, January 23, 1977—Paris

Up at 10:00. Staying at Fred's apartment. Made a lunch date with Peter Beard. Went out shopping and ran into Mick Jagger.

Went to Schiaparelli's show (cab $3). They gave us a good seat and lots of attention. The show was awful, based on "The Three Graces" by Botticelli. One dress was worth $2 million or something and the best thing was the armed guards around it.

Monday, January 24, 1977—Paris

People kept coming in and out of the apartment all day starting at 5:00. Mick arrived so drunk from an afternoon with Peter Beard and Francis Bacon that he fell asleep on my bed. At 11:00 we tried to wake him up but he was too asleep. Club Sept ($120) with Peter and Mona Christiansen and Jed (cab $2, back $2).

Saturday, January 29, 1977—New York—Nashville

Catherine off the plane first, given a bouquet, and then everyone was. About eight cheerleaders were there to greet us in blue outfits with "W" on them, pom-pom girls, doing Warhol-Wyeth cheers.

Staying with a guy named Martin and his wife Peggy who are the Jack Daniel's people.

Went backstage at the Grand Ole Opry, went into the dressing room. Marty Robbins was practicing.

Sunday, January 30, 1977—Nashville

The museum opening of the portraits by Jamie and me was at 6:00. The tour organizer took Catherine and me around the Fine Arts Center at Cheekwood. We tried to grab hot dogs, we were so hungry, but he whisked us away. There was a staircase there brought from England. The popcorn machine was at the top of it and Catherine and I went to get some, we were eating and talking and we noticed that the stairs were lined with people and then we realized that they were lined up because they thought it was a receiving line to meet me, because they saw me at the top. We filled up some bags with popcorn and tried to get out, but then someone asked for some and I gave them a bag, and then I wound up giving autographs for an hour and a half. Then dinner was served.

A few of the locals came, and Don Johnson, that cute actor we know from *Magic Garden of Stanley Sweetheart*, he's a friend of Phil Walden's.

Suzie Frankfurt came down to Nashville to social-climb. She'd pre-written thank-you notes before she even got there and she made out well, she got on the front page with me instead of Catherine who didn't step forward fast enough.

Monday, January 31, 1977—Nashville—New York

Vincent heard that Joe Dallesandro's *[see Introduction]* foster mother died on Long Island last week. This is two weeks after his brother Bobby died, and Joe's still here in this country—he hasn't gone back to Europe yet.

Worked until 7:30. Went to Regine's. Warren Beatty was there looking a little older and heavier. Jack Nicholson was there looking a little older and heavier. Anjelica Huston and Apollonia the model were there. I like Apollonia now, she's really sweet. And Catherine Deneuve was there, who the party was for. Warren was dating Iman, the black model.

Barbara Allen and her beau Philip Niarchos were there and James Brady and the *Women's Wear Daily* guy, Coady. He was carrying on at Barbara and Philip's table and Philip was trying to be charming, and Coady was with a beautiful girl—I couldn't figure out how he would be—and they left early. Barbara Allen came over and told me that Coady had been saying, "I hate everything here. I hate Jack Nicholson, I hate Warren Beatty, I hate Andy Warhol, I hate Diana Vreeland, and most of all I hate James Brady."

Oh and the food. He also hated the food.

Philip was drinking and getting cuter. Barbara really seems like she wants to get married, I think she wants to have children with him.

Ruth Kligman had called me that afternoon and I told her I was seeing Jack Nicholson and would talk to him about starring in the Jackson Pollock movie. She asked me if I could take her to meet Jack and I said no. *(laughs)* I wouldn't take her *anywhere* after reading her book. She actually killed Pollock, she was driving him so nuts.

A fifteen-year-old girl Philip knew from St. Moritz was there with her father and she was talking to Philip and Barbara was nervous because when you saw them together you could really see that girls like Barbara and Apollonia had lived—they looked old—and this fifteen-year-old's charm was that she was so young and like a little girl, like she hadn't been used yet.

Jack stopped by the table and I said I was going to send Ruth Kligman's book and he said she'd already called him.

Tuesday, February 1, 1977

Joe Dallesandro came by 860 for lunch. I asked him how his brother Bobby had really died, and he finally changed it from the "accident" he said it was originally to what really happened. Bobby hung himself. Joe was quiet at lunch.

Finally got to bed early for a night. The cold wave is the big news. And the gas shortage they're playing up.

Wednesday, February 2, 1977

Ronnie and I had a fight. He was upset when I said I didn't want the Hammers & Sickles cut and stretched the way he'd done them while I was away, and he said that he'd done all the work for nothing. I asked him what he would have been doing if he hadn't been doing that, anyway, so what did it matter if it wasn't necessary. I said I never know what I want until I see what I don't want, and then he said well then that was okay if I "bounced off that," that it was worth the effort, that he just resented it if he'd done it for absolutely no reason.

Worked late, didn't leave until around 7:30. Talked to PH about *Popism*, she told me about her interviews with Jonas Mekas and Kenny Jay Lane the day before. Jonas had been good, Kenny was lousy.

Dropped Catherine off (cab $3). Went home and did some work, then at 11:00 Catherine and I went over to Regine's to interview Michael Jackson of the Jackson 5. He's very tall now, but he has a really high voice. He had a big guy with him, maybe a bodyguard, and the girl from *The Wiz*. The whole situation was funny because Catherine and I didn't know anything about Michael Jackson, really, and he didn't know anything about me—he thought I was a poet or something like that. So he was asking questions that nobody who knew me would ask—like if I was married, if I had any kids, if my mother was alive. . . . *(laughs)* I told him, "She's in a home."[*see Introduction*]

We tried to get Michael to dance and at first he wouldn't but then he and the girl from *The Wiz* got up and did one dance.

Thursday, February 3, 1977—New York—Denver

At the airport in the morning I ran into Jean Smith, who was on the same flight. She was with her son, who was sort of big and heavy. She asked about Jamie Wyeth. In Denver there was a blonde girl driving a Rolls Royce, she had on a chauffeur's cap and gave a tour of the city. Dropped us at the Brown Palace Hotel, an old hotel with a new annex but I decided to stay in the old part. The lobby looked better than the room, service very fast, lots of extras like showercaps, a new TV, and soap. Room had a basket of fruit. I called my nephew Father Paul and said I'd meet

him the next day at my opening. Picked up at 6:30 for the preview for the patrons. Fred got really drunk. He got mad at some tough ninety-year-old lady and told her that he was only there for the money, honey, and I tried to shut him up, but he just hated the whole thing so much, and he decided that next time I did personal appearances he would stipulate that they had to buy something. All the women too ugly for portraits.

Friday, February 4, 1977—Denver

Weather beautiful, fifty or fifty-five, blue skies. Tried to walk as much as possible. Walked to museum at 2:00, had to do some press interviews. They were boring.

The opening was at 7:00 but we decided to go at 8:00. We were getting the Rolls Royce again. At 7:30 Father Paul arrived and my niece Eva. Ordered double drinks and Father Paul got a little high and they wanted to ride with me so they got into the Rolls Royce, full of girls. Father Paul tried to convert them. Crowded at the museum. Dreadful dinner, sold *Interview* shirts and *Philosophy* books and posters.

Got handed some mash poems.

At 10:00 they let the $10 people in, they were all the freaks of Denver, a lot of cute boys and nutty girls.

Sunday, February 6, 1977—Carbondale, Colorado—Denver

Went with John and Kimiko Powers to the forty acres I bought out near Aspen. Ran into two girls on the property riding horses. They said it was the most wonderful country they'd ever spent time in.

Caught a flight to Denver. Took forty minutes. Checked into the Stouffer Hotel near the airport.

At 3:00 in the morning thought I heard the doorknob being turned—it was the little brats in the room next door listening to TV. Scary.

Monday, February 7, 1977—Denver—New York

Woke up at the crack of dawn, went to the airport. There was a guy cleaning the windows of the plane as I was going on, and some people can just look up and say, "Hi, Andy" so casually, and he was great, he did that. Later he came to find us and asked for an autograph for his high school teacher.

Cab in from the airport ($20). Dropped off the bags and Fred (called Vincent from the airport $.10). Sent Ronnie for supplies ($10.80). Went to 860 (cab $4). Jamie Wyeth was there, talked to him (tea $10). Lester Persky called to invite me to dinner in honor of James Brady, who's the new editor of *New York*.

Geraldine Stutz was there. It turns out she's on the same council as Jamie, the American Council

for the Arts, that gives money to artists. I think it's disgusting the artists they give the money to. They always pick the ones that are very "serious." Walter Cronkite was there.

Lester started getting drunk and was really funny, telling me how great it was that we were still friends, even though he'd never done anything for me and never would. And then he did his "I'm so rich now and I'm still unhappy" routine. Really, does he do it at every dinner every night? He must.

A famous male model came and sat down, from Zoli. He'd just had a baby in Alaska. I met the editor of the *Daily News*, Michael O'Neal. I'd never met him in all these years, and I was thrilled to meet him. When I found out the guy knew all about *Interview*, I really loved him. He was big and Irish with lots of hair, grey. I introduced Catherine as the "editor" of *Interview* just so they could talk, but she was being in a funny mood and didn't really answer his questions. Jamie Wyeth had gone off to Elaine's. Catherine said she wanted to take a cab home. She must have made a date with someone, maybe Jamie.

An English kid came over from the bar where he'd just been talking with Lester Persky and asked if Lester was really *the* Lester Persky the big producer, and I *(laughs)* had to say yes.

Larry Freeberg from Metromedia who first proposed that we do a TV show, and then turned it down when Bob handed in our budget, was there, but I didn't recognize him and stared at him blankly when he walked in. But that was good—maybe he'll think twice about what he did to us.

Tuesday, February 8, 1977

Leo Lerman called in the afternoon and commissioned a portrait for *Vogue's* one-time-use only of Queen Elizabeth.

Friday, February 11, 1977

Cabbed up to Suzie Frankfurt's and there was a lot of traffic ($5). Suzie is designing clothes for women who're over the hill, and it's a funny idea, they're the wrong colors and they emphasize the wrong places, she's going to try to get into that business on Seventh Avenue and she's also trying to go into antiques as a business. She's going to go with us to California on Wednesday—Norton Simon, remember, is her cousin.

Wednesday, February 16, 1977—New York—Los Angeles

Arrived in sunny California. Dropped Suzie Frankfurt off at the Simons' on Sunset Boulevard in glamorous Beverly Hills. Called the Beverly Hills Hotel but they were out of rooms so we had to stay at the Beverly Wilshire. Catherine called her half-uncle Erskine who was in town, he's just a little bit younger than she is. He's been traveling around the world all year with his cousin Miranda Guinness, the twin sister of Sabrina. Went to Allan Carr's. He has a great house. As soon as we

got there he wanted us to leave because he was having a dinner and his guests were arriving and when we turned the corner Jed and Catherine almost fainted because they saw the Fonz sitting there. Allan gave us a tour of the house, he said Ingrid Bergman built it and Kim Novak lived there after her. Took us to every bathroom and closet, showed us how the bed went up and down like a barber chair. Meanwhile Suzie was talking to the Fonz. She asked him what he did, he said he was "An Olympic swimmer," and Suzie was so excited because she'd "never met one before"—she kept asking him what year and if he knew Mark Spitz and everything. By this time the Fonz sort of got annoyed and couldn't believe anybody didn't know who he was. She still didn't know who he was after I said, "He's the Fonz." The Fonz talked very serious, he tries to be very heavy. He told me how much he liked me because of "famous for fifteen minutes," and something about closets from the *Philosophy* book—empty spaces and things like that. I was so excited meeting him that I couldn't think of anything to say.

The David Begelmans arrived. We had to leave because the dinner was about to start. There were white orchids on the girls' plates. Allan took us in and showed us the table and the food before he kicked us out. That was funny.

Thursday, February 17, 1977—Los Angeles

I went to tour the Gemini Gallery with Sidney Felsen and his partner. At Gemini I got an idea. They can now print 10′ × 10′ and I'm going to think about it. Done an hour earlier than supposed to, decided to walk around, the shops just so exciting.

A person ran after me and it turned out to be Jackson Browne. He invited me to come to the recording studio across the street to hear his new record. He was adorable.

The cab strike was on so Catherine and I found a limo outside, had to meet Tyrone Power's daughter Taryn at 5:00 at the Imperial Gardens restaurant on Sunset (limo $10). Back for Fred, had to give him money ($5). He went off to Paul Jasmin's cocktail party for Divine where he met Tab Hunter.

At the Imperial Gardens with Taryn taped for about two hours. Had some sake and food ($20 with tip). She took us next door to her boyfriend Norman Sieff's house. He was so ugly and she was so beautiful—I was disappointed. He said he'd met me in Max's years ago. He has Taryn under his influence. We wanted to get her away from him so we asked her to go to the dinner that Doug Christmas, the art dealer, was giving for me at Mr. Chow's. She had wheels and drove us back to the hotel.

Got dressed and driven over to Mr. Chow's. Lots of people there. Bianca Jagger, Russell Means, Polanski, Tony Bill, Allan Carr, Pat Ast. Russell Means had an Indian girlfriend. George Hamilton, Marcia Weisman, Nelson Lyon, who was telling me about some producer who drank the piss someone gave him and he didn't know.

Jed had invited Tab. Jed felt guilty because we didn't cast Tab as Carroll Baker's husband in *Bad*—he'd really wanted the role. Peter Lester from *Interview* arrived with Maria Smith and he kept apologizing for being late but nobody cared. Geraldine Smith *[see Introduction]* was with Johnny Wyoming. Perry King, Susan Tyrrell, Allan Carr sitting talking with George Hamilton.

Sat next to Tony Bill and Bianca. Polanski across the way from me. We'd run into him in the lobby of the hotel and he was going to see *Rocky* then and so he was just back from seeing it, said he loved it.

The big people, Sue Mengers and Ryan O'Neal, didn't arrive, they told Bianca that they couldn't "be seen at tacky places like Mr. Chow's." Bianca took us to the Top of the Rox, owned by Lou Adler. When we got there it was Ringo Starr and Alice Cooper. I'm not saying they were the only *celebrities* there—they were the only *people* there, and *they* were in the john. Whoever *is* there is in the john taking coke. Bianca introduced me to Ringo. Alice came over to say hello.

Bianca left because she was staying out in Malibu and Mick was coming in and then leaving town the next day so she wanted to get home early to see him.

Friday, February 18, 1977—Los Angeles

Rode out to the Ace Gallery in Venice to do a press conference. Called the office in New York in the morning and Ronnie told me it was Andy Warhol Day on *The Gong Show*. Back at the hotel I had lots of messages. Dinner at Marcia Weisman's (cab there $4). Ryan O'Neal was there and Sue Mengers. Ryan was leaning against the Morris Louis and put a big dent in it. He was sour. I had all the Guinness kids with me—Catherine, Erskine, and Miranda—and it turned out Miranda's twin sister Sabrina had been Tatum's nanny and Ryan's secretary when Ryan was filming *Barry Lyndon* in England, and Ryan hated her, so he was taking it out on Miranda, and she went to the bathroom to cry. Sabrina is actually a groupie, even though she's a Guinness.

Sue looked terrible and so did Ryan. They left early because, I think, they thought "nobody" was there. Hollywood people are rotten. They all play these games with their A, B, and C groups and it's just too stupid. That's why when they come down, they *really* come down. One thing about Bianca, she really has class because she'll go *anywhere*.

Saturday, February 19, 1977—Los Angeles

Suzie Frankfurt arrived with Marcia Weisman. They had a Rolls Royce so we Rollsed over to the hospital, Cedars-Sinai. Lots of people waiting, I sold $1,500 worth of stuff for a benefit. Marcia was very pushy. If anyone took a picture they had to pay $10. If I signed a can they paid $5. She told them that my prices would go *up* in the afternoon to $100 a poster, when actually they were going to go *down* to $6.

Dropped back at the hotel. Picked up by Doug at 1:30 and a camera crew filmed us in the limo on the way out to Venice for my opening. Before the opening we went to see Tony Bill's apartment, he bought a building across from the Ace Gallery with the money he's making from either *Taxi Driver, The Sting,* or *Shampoo*.

The Ace Gallery was very crowded, people around the block waiting to get in. Russell and I signed the Russell Means posters. Viva and Paul Morrissey were there. There were a couple of other people from the old days—Cockettes.

I got so tired of signing posters all afternoon that I skipped out at 5:00 to the limo. Suzie

invited us along to have a drink in Bel Air at her model friend Cheryl Tiegs's and her husband Stan Dragoti, who works for Wells Rich Greene. Fred was bitten by a big dog when he opened the wrong door when he was looking for the bathroom, but he didn't say anything about it until there was lots of blood coming down his leg. He just put some alcohol on and then we left at 7:30.

In the lobby ran into Annie Leibovitz and Jann Wenner. Susan Blond left a message saying she was with Michael Jackson at Top of the Rox. Jann and Annie had just gotten back from there, the Grammys had just finished up, so everyone was drunk. A couple of boys in the lobby tried to pick me up.

Sunday, February 20, 1977—Los Angeles

Doug Christmas's P.R. woman, Esther, arrived from church with an autograph from Jane Wyman, she'd asked for it while Jane Wyman was kneeling.

First supposed to have lunch with Bianca Jagger, but Wendy Stark said we could all have lunch at Coco Brown's and I didn't want to but Fred thought it was a good idea. The first car left, we were in the second, and we had a house number 36912 in Malibu. When we got there we couldn't find it, but then the first car came along with Richard Weisman in it and he went to knock at 36910 because there *was* no 12, and the person who opened the door was "Mary Hartman," with her funny braids on.

She said *she'd* have a party for us if we couldn't find the party we were going to. But just then Coco Brown came by in another car with Wendy Stark and they said it was just down the block, that Wendy'd got the number wrong.

We got to the house and Bianca was there. She'd had a fight with Mick and he'd left that morning for New York—she'd accused him of an affair with Linda Ronstadt.

Walked down the beach with Bianca past the house of Larry Hagman, and he was standing on the beach in a funny uniform like a foreign-legion outfit, doing funny hand things, and I guess he's gone off his rocker. While we were going by the sea came up and wet my shoes.

Spent three hours trying to make dinner plans. Bob Ellis, Diana Ross's ex, and Alana Hamilton seemed too drunk, Bianca didn't want to be with Miranda because she was the sister of Sabrina, Jed said he was hungry and he'd eat anywhere, and Wendy wanted us to go to Max Palevsky's because she thought it would be good for us—he was going to have us over to see his art collection.

And so finally when we got together we went to a restaurant called Orsini's, Italian food. Fred screamed at Catherine and told her how rude she was to him in front of everybody.

Monday, February 21, 1977—Los Angeles—San Francisco

Got up, packed (cab to airport $20, tip to baggage guy $4, magazines $8).

United flight 433 arrived 1:05. Met at the airport with champagne and limo by Mark from the gallery where my show was, had royal treatment. He dropped us off at the Mark Hopkins, had lunch at the Top of the Mark.

Then we walked to the gallery three blocks away down a steep, steep hill. The space was very large, and it was just around where we used to stay with the Velvets [*see Introduction*]. The hanging was just wild. Rotten, badly hung. Unbelievable. Bad taste. Mark's mother just horrible.

Press conference, TV show with a guy who was a beauty but he didn't know anything and didn't really like me and so I was being awful, too. I took him over to a piece of sculpture and told him that I'd done it, which I didn't—didn't get found out until afterwards. Mark took us to the back where there were magic mushrooms. He took us for a ride across the Golden Gate Bridge. Under the bridge there were surfers. Very strange. All the boys wearing black suits, wetsuits, scary and nutty. Touring in Sausalito really fun. When we arrived back at the hotel Jed and his family were there, he has a new fat stepfather. And Mrs. Johnson thanked me for being so nice to her son and made me blush.

I had to stay around the gallery until 9:30. Mark's mother really made me work. Trader Vic's was just up the block. Walked there.

Oh, and Carol Doda, the stripper, came to the opening, and I was so bored that I talked about her a lot and so Mark said we'd go to the strip joint. Brought the limo back, went to the strip joint, Carol is now just as wide as high, saw three naked girls rubbing their asses and cunts against the floor, and Carol Doda came down on the piano and went up to the ceiling on it. She was so old that they only had blinking lights for her. Catherine and I were falling asleep (drinks $35). Fred had disappeared, he was out cruising.

Tuesday, February 22, 1977—San Francisco—Miami

Took five hours to get to Miami. Paid for Catherine's ticket ($72.53). It was night in a minute, a long flight. Charlie Cowles met us in a great car, warm and wonderful, but it was 11:00. Time changes. Past the Fontainebleau, things like that. Took us to his mother's place on Indian Creek Island on the grounds of a private club, had a lot of waterfront property. Met the mother and father, Mr. and Mrs. Gardner Cowles. Had sandwiches. Fred and I were in the guest house, Catherine was in the main house. Read *Artforum* which Charlie Cowles owns and went to bed.

Wednesday, February 23, 1977—Miami

Overslept and got up around 10:30 and breakfast wasn't served by then, but there was coffee. Started taking pictures of Gardner—they call him "Mike"—he adopted Charlie, owns TV stations, sold some of his magazines to *The New York Times*, used to own *Look*.

At lunch Mrs. Cowles said she was losing her two Argentinian housekeepers—rich people usually talk about servants at dinners and lunches. Then Charlie took us on the tour.

Fred told Catherine why he had yelled at her—because when he went to wake her up she had screamed, "Don't touch me, don't touch me!" and she said she was sorry she did it.

Charlie wanted to know if we wanted to go to Fort Lauderdale where the boys are. Went to the gay places there and Charlie took us down the boardwalk. The first place, forget the name,

the bartenders were in dresses with mustaches and beards. The first one said, "I'm a friend of Brigid Berlin's."

I really had to pee. Fred came back from the bathroom and I asked him if there was anybody in there and he said no, that it was empty. I went in and was peeing and suddenly there was someone next to me saying, "Oh my God, I can't believe I'm standing next to you, let me shake your hand," and then he realized and said, "No, I'll wash my hands and then we can shake." I lost my concentration and had to stop peeing. And then more and more people started coming in and saying, "Is it really you?" I got out.

The waiters said that there were only waitresses some nights, the place alternated. It sounded like Paul Morrissey's idea for the Western he was going to do, where the town is half men and half men-in-drag because there were no women ($5).

Went to a place down a ways with pinball machines and played them for a while ($10).

Saturday, February 26, 1977—New York

Jamie Wyeth had invited me to lunch for Ted Kennedy's birthday party, but in the morning he called and said that Rose Kennedy was only having a small one and he didn't realize that, so I couldn't go after all, but I think it was just maybe Jamie changing his mind. Went home at 8:30.

Saw on Metromedia that they took the idea from our proposal that they turned down and then went and did it themselves—they had *Dinner with Bella Abzug* on TV. But *they* did it boring and corny and it made me so mad.

Monday, March 7, 1977

Woke up very cranky, left the house early, around 9:30, cabbed to Chembank ($3.30). Got a letter at the office from the White House from Jimmy Carter. I wish I'd talked more last month when I met him, but I was so nervous. He's really nice, though, a really nice man.

Jamie Wyeth still was painting Arnold Schwarzenegger who was still posing. Lunch for Jamie and Arnold ($16). Alex Heinrici came by to touch up something. Worked all afternoon.

Picked up Bob Colacello and cabbed to 45 Sutton Place South. A book party for Anita Loos given by Arnold Weissberger. I had forgotten my tape and camera and there were lots of celebs. Arnold Weissberger and Milton Goldman have the longest-running gay marriage in New York. Arnold is seventy-something, the biggest old-time show-biz lawyer and amateur photographer. He takes pictures of everyone who comes to his house. He had a book out last year called *Famous Faces*. He had the book on the dining table at the party and he was making the famous faces sign it next to their pictures. Milton Goldman is sixty-something and a big agent at IFA. Bob noticed that he was the only person under thirty there—barely—and I said that Arnold must be afraid to have young kids because he might lose Milton. All the butlers and bartenders were over sixty. They brought one drink at a time and the tray shaked.

Paulette Goddard was there, she told me that she didn't sell one rug at Parke Bernet because the dealers, she felt, had ganged up on her. And they probably did, because those rugs *are* great.

Talked to Rosemary Harris, Martha Graham, Cyril Ritchard, Rex Harrison, Sylvia Porter. Milton introduced everyone three times.

Cabbed to Elaine's ($3.25) to meet Jamie and Arnold and Rudolf Nureyev. Jamie was having a meeting of their minds. On the way in the friend of Lester Persky's who always feels me up grabbed me and introduced me to Neile McQueen, and she was actually pretty. He whispered, "Ex-wife, Steve McQueen" in my ear.

Arnold walked in with three little girls, one of them was a sportswriter on *The New York Times*, and she's in love with him.

Then the most fascinating thing happened. A guy who Elaine introduced me to did his card tricks, and it was where he flashed the deck and then said think of a card and then he guessed the card *eight times!* I couldn't get it out of my mind, I thought about it all night. I've just *got* to know how he did it, because if you can do that, you can do anything. Dropped off Catherine and Uncle Erskine and Miranda ($3).

Tuesday, March 8, 1977

It was a pretty day, walked around uptown, then went to the office. Jamie and Arnold were there. I thanked them for a good time the night before (art supplies $5.85). Jamie said that Nureyev had fallen in love with Erskine, and that Erskine had almost given in, but didn't, and that Nureyev's last words *(laughs)* were, "We can just watch TV." He gave autographs to Erskine and Catherine.

Was picked up by Bob at 8 P.M., cabbed to the Iranian embassy. Bob made me go in black tie, but we were the only formal ones and then his excuse was that we were invited to so many parties he didn't remember. We're starting to feel used by the Iranians. It started in Washington a couple of weeks ago when we realized that Ambassador Zahedi isn't "in" now with Carter—he was so Nixon- and Ford-affiliated, but now he wants to be in with the Democrats and needs help and that's us. It was a heavy dinner for the Swedish ambassador.

Our excuse for leaving early was that we had to go to François de Menil's party for Princess Marina of Greece who had an opening at the Iolas Gallery (cab to François's on 69th Street $2.25). It was jumping—Arman and Corice, Larry Rivers—great party.

Gigi was there and she just broke up with Ronnie and went off with Spyro Niarchos, and so Ronnie was depressed. Earlier she'd been telling me that it was on the rocks for her and Ronnie —she said they haven't talked to each other for three months now. He's getting jealous of her making more money and traveling around, but he's not ambitious and she is, but she says she loves him but that they have to break up because it can't go on. That's the gist of it. Gigi had told me she was going to. Barbara Allen was there with Philip Niarchos, they're back in town.

Dennis Hopper was supposed to be there, but I missed him. He's living with/staying with Caterine Milinaire—they're *(laughs)* "together." Ronnie's friend Tony Shafrazi was there, just back from Iran. He's the one who defaced Picasso's painting at the Modern. The "Guernica."

Hoveyda told us that Sidney Lumet is coming to Paulette's dinner at the embassy next week and we said, "That's nice." I hear that Sidney Lumet goes around town calling me a racist just because *Mandingo* was my favorite movie of the year.

Wednesday, March 9, 1977

Read an item in the newspaper that Liz Taylor was selling her diamonds on Madison Avenue secretly to help her husband's campaign with money, so I kept an eye out. Walked over to office. Ronnie wasn't at work for two reasons—first because Gigi had run off with Spyro Niarchos the night before at the party, and second because Wim Wenders was shooting a movie down at his loft—Dennis Hopper is the star of it.

Lee Radziwill and her son Antony came down for lunch. Antony has gotten even bigger. Thicker. She said that since she didn't go down to the Washington dinner Zahedi gave me the other week he reacted by sending her champagne and caviar, and when she sent a thank-you note, he sent more champagne and caviar, and when she sent another, etc. etc. So he's really going after her.

Walter Stait from Philadelphia had called to ask if I wanted to have dinner with him and Ted Carey and I said yes. Ted Carey was having health problems and he went to Dr. Cox, and Doc Cox was a good doctor because he recognized the symptoms Ted had and said it was syphilis of the throat. The Doc must have other patients with that problem, probably. So he sent him for treatment, and the only problem left is that Ted keeps getting worms, they keep recurring. At dinner, Ted was very good to talk to for *Popism*, we reminisced about when we posed together for our Fairfield Porter portrait.

Thursday, March 10, 1977

Barbara Allen was bringing Princess Firyal of Jordan, who's dating Stavros Niarchos, down to the Factory.

The big drama was the Ronnie-Gigi-Spyro triangle. Ronnie called the Waldorf Towers late last night looking for Gigi and the desk wouldn't put the call through to the Niarchos apartment so first he left a message saying that "Gigi's husband called" and later he left a message saying that "Gigi's brother died."

So this morning Spyro called Ronnie and asked if it was all right if he came to Firyal's lunch, he said he hadn't known that Gigi and Ronnie were "together," etc. Ronnie said he could come, but that if Spyro said so much as hello to him, he would beat him up.

Spyro told Bob that Gigi had just walked up to him at the de Menil party and said, "Remember me?" and he didn't, so she refreshed his memory and then said she wasn't with her boyfriend anymore and since they were both alone why didn't they be together for the night. Spyro told Bob that now he thought Gigi was awful to involve him in her mess with Ronnie. So she blew it.

Anyway at lunch everyone was sitting down and Ronnie came in and started filling his plate and then he said, "Where's my seat?" And I got scared there'd be trouble because he was acting kind of hysterical, so I told him that somebody had to answer the phones and anyway, that if he sat down there'd be thirteen at the table. Worked until about 4:00. Barbara looked very very thin, she said that Peter Marino was doing a wonderful job designing her apartment. Cabbed up to pick up Victor to take him to Suzie Frankfurt's open house—"Suzie Frankfurt at Home" (cab

$5). Fred was there and so was Francesca Stanfill from *Women's Wear Daily*. Mayor Lindsay was there. Suzie had good tea sandwiches, I ate around forty.

Marvin Davis who was at I. Miller and gave me my first job was there, and when he saw my old shoe drawings that Suzie has he said it was like being in the time machine. Suzie got nervous because nobody bought anything—clothes, furniture, antiques. The idea was "Antiques in a Setting." It's a cute idea. She can probably deduct three-quarters of the house. Dropped Suzie's ex-husband Steve Frankfurt off ($3). Went to the East Side antiques show ($2.50). Walked home.

Bob and I picked up Elsa Martinelli at the St. Regis to take her to the Iranian embassy. It was a buffet, jammed. In honor of the new American ambassador to Italy, Mr. Gardner, and his wife Danielle.

I got stuck talking to the Baroness de Bodisco. Hoveyda tried to rescue me and said to her, "I think there's someone upstairs it would be nice if you came with me to meet," and she said, "No." And then Hoveyda said she wouldn't be invited back again, and she said, "I don't care."

Friday, March 11, 1977

I had a talk with Rick Li Brizzi at the office, told him he was selling my Maos and Soup Cans too cheap. Went home to change, picked up by Catherine, went to Nima Isham's for a birthday party for Firooz and her husband Chris Isham ($3).

The apartment was decorated with streamers and balloons. I was playing around, attaching some of the helium balloons to people who didn't know it. Bob kept getting annoyed, brushing his balloon away, he didn't know it was tied to him. After the dinner two cakes were brought out and somehow the whole table collapsed and both cakes went on the floor.

And Ronnie and Gigi are back together.

Saturday, March 12, 1977

Up early, beautiful day. Went down to Subkoff's Antiques to see ideas (cab $3). Walked over to the office. Bob was there, looking through pictures for the photo book Bob and I are doing. Vincent went out and got the paper, and that's where the headline was: "MOVIE DIRECTOR CHARGED WITH RAPE." Roman Polanski. With a thirteen-year-old girl he took to a party at Jack Nicholson's house, and when the police went over to Jack's the next day after the girl's parents called them, they searched the house and Anjelica got arrested for coke.

Victor had told me that I absolutely had to watch the *Dinner with Halston* show on channel 5 —Metromedia.

This is the idea that we submitted to Larry Freeberg at Metromedia and they turned down, and now they're doing with other people. Halston's guests were Bianca, Joe Eula, the acupuncture doctor—Giller, Jane Holzer, Victor. It was very boring. They'd asked me to go on this show and I said no because they'd ripped off my idea.

It was a live dinner with a seven-second delay. Joe Eula said "bullshit" once and it was cut. The only real-life thing missing at the table was coke, and no runs to the bathroom. Victor was

the life of the dinner, he took his fake mustache off. He used to have a real one but he'd shaved it off probably because he hates the acupuncture doctor who has one, but he put one on for the show. He also had a plastic chicken with him and kept talking to it, telling it to "say hello to Andy." Joe Eula and Victor had a tiff at the table, something about me. Joe told Victor, "Let Andy speak for *himself*, why he's not here," and that's when Victor—on Metromedia—said that Metromedia had ripped me off. So he was great.

Jane didn't have the right makeup on so she didn't look good, and they kept referring to her as "the renowned fashion model." The dinner degenerated into throwing drinks. Maybe they'd decided on that because they're supposed to be the "wild set." Jane threw champagne in the air and then everybody started but it looked so lame, and so Victor poured his in her lap. Victor and Halston were having a quarrel—you could tell because Victor announced that he wasn't going to do Halston's windows anymore, that he was now "an artist for hire," and the camera went close on Halston's hard face. At one point Halston or Bianca or somebody actually said, "Let's take this hour and a half and just *go* with it!" And that's when most people probably shut their TVs off, the thought of something like that dragging on for an hour and a half must've made them gag.

And meanwhile who should Fred be at dinner with but Larry Freeberg, who'd stolen the idea from me in the first place. They were all at the Hermitage, at a dinner for Nureyev, and Freeberg was with Lee Radziwill—they're planning to do a channel 5 dinner with her, too.

Halston was having a "cast party" at his place after the show. When I got there, Mick had come by. He was cute—he told Bianca how good she was on the show, but around 4:00 he wanted to leave and she didn't so she stayed. Everyone was mad at Victor, saying he'd ruined the show, so he'd already left to go barring.

Sunday, March 13, 1977

Fred says I should stop telling people the TV dinner show was our idea because the show they came out with is really awful. He thought Halston and everybody made fools of themselves. He said Mick actually had hated Bianca in it.

It was raining hard all day long. Went to church (newspapers and magazines $14). Paulette called and we talked about *Dinner with Halston* and I told her it was ripped off from me and she also said better not tell anybody, it was so bad. The thing is, I guess, in that long amount of time, everybody's real personality just comes out and it's too revealing of how boring they are.

Jane Holzer called and wanted me to pick her up for the Gilmans but I begged off. It was raining and I had to bring up a painting to Sondra Gilman. Barbara Allen called and invited me to dinner with Stavros Niarchos. Richard Turley called twice to say he had both of my unlisted phone numbers, he said he was going out with Tennessee Williams and wanted me to come along.

It was a party the Gilmans were giving for some horse people from France. They had a new Lichtenstein, the tough ones, the still-life of the bathroom door. Everyone loved the portrait of Sondra, they seemed to be saying that I really flattered her. They had caviar going around out of a big tin. Sondra introduced me right away to Adela Holzer and she was wonderful, she has a hit now with two one-acters, one is James Coco eating himself to death and the other is Siamese

twins, it's called *Monsters*. She invited me to lunch next week. She said she's going into the TV business so I was after her.

Monday, March 14, 1977

Brigid called yesterday, says she's down to 161. She's coming by tomorrow to pick up her Christmas present and her birthday present from last September which she said she didn't want to pick up at that time. The reviews came from England and they were bad for *Bad*. Stupid people like Frank Rich can write four pages on some nothing movie, but about *Bad* they just describe what it is and leave it at that. Don't they know what their *job* is? To say what something *means*? I read the reviews and it sounds like the censors didn't take out the baby being thrown out the window the way they threatened they were going to.

Ahmet and Mica Ertegun called to invite me to dinner at Gallagher's that night for the Traamps, a thirteen-member black group on Atlantic that was going to be playing at Roseland. So we went there and the best thing at Roseland was a girl with real gold—like 14K—fingernails that you buy and she got my number so she's going to call to get interviewed in *Interview*. She's a famous singer.

Tuesday, March 15, 1977

The girl singer with the gold nails from last night called, Esther Phillips. I just *know* she's a good singer, I can tell. She said she was going out to California and we're going to try to get together out there.

Victor came down with a nude pose-er. I'm having boys come and model nude for photos for the new paintings I'm doing. But I shouldn't call them nudes. It should be something more artistic. Like "Landscapes." Landscapes.

Dropped Catherine and Fred ($4). Changed, got ready for Carrie Donovan's black-tie dinner at "21." Joseph Brooks, the president of Lord and Taylor, invited me (cab to "21" $2.50). Diana Vreeland was Fred's date for the evening, and they stopped at "21" and then went over to the Iranian embassy where I had to go later, too. The "21" thing was fun (cab $2.60). The Iranian thing was a dinner for Paulette Goddard and Bob had done the list and the seating, but it was everybody and everything the way Paulette wanted, and I was bored because she hadn't invited any interesting people or any beauties, just her friends. But there was lots of fresh caviar. I was next to Carroll Portago and Gisela Hoveyda, the ambassador's wife.

Bob never wanted the Lumets in the first place, and then they pulled out an hour before the dinner and he had to do the seating all over again.

Diana Vreeland was having a great time talking to a man named Dr. Lucky, the head of New York Hospital. Anita Loos was there and I told her she had a beautiful dress on. She's so tiny I asked her if she went to the children's departments to get the long dresses and she said that they didn't have any evening dresses in the children's department, that this was a Madame Grès, and

I asked her if it was half-price because it was so small and she said, "No. I get a fur coat and Kate Smith gets one and we pay the same amount of money."

I asked Anita how the really glamorous women went to bed with men, what did they do, and she said that the only one she really knew about was somebody out in Hollywood who, when the moment would come, would kneel down on the floor and pray to God to forgive her and then the guys would get turned off and ashamed of themselves and they'd give her jewels.

Anita told me that she's managed to stay friends with Paulette by never asking her a direct question. I said I made my big mistake saying, "What was your sex life like with Chaplin?"

Wednesday, March 16, 1977

Had to leave the office early to go home and change because I had to be at Aly Kaiser's place at U.N. Plaza. She's about sixty years old, but looks younger. She was the nurse and he was Kaiser Aluminum and he married her. She had a limo, and the big French poodle sat up front with the chauffeur's cap on. We went over to Bergdorf Goodman's. Halston was giving a fashion show/benefit for Martha Graham. It was everybody that you always see at Martha Graham benefits. I didn't have to buy the $100 ticket, Aly did. Met Andrew and Mrs. Goodman, the owners of Bergdorf's, and they live upstairs over the store. She's Cuban. Saw Pat Cleveland with Esther Phillips. Mrs. Kaiser fell in love with Esther.

Then we all went over to Regine's. Mrs. Kaiser, Esther, and her hairdresser boyfriend. Fred came in with Suzie Frankfurt in a Grès. C.Z. Guest was there with Prince Rupert Loewenstein. Everybody was impressed with Esther. For the first time, I danced. It was the first time in public. Esther took me on the floor and taught me how to disco, she thought it was funny and I did, too.

Then the kids wanted to smoke and Aly brought them back to her apartment which was being painted so it was a little messy. She brought out a bag of marijuana. They started smoking. I really like Esther.

Friday, March 18, 1977

Sent Ronnie for photo supplies ($19.31, $12.78, $7.94). Lester Persky called and invited me to dinner at his place for Baryshnikov but I was going to be with Nureyev at the Iranian embassy for his birthday party. Cabbed with Vincent down to Frank Stella's studio ($2.75), a party for Leo Castelli's twenty years in the art business. Fred said I'd have to go—just the kind of party I hate because they're all like me, so similar, and so peculiar, but they're being so artistic and I'm being so commercial that I feel funny. I guess if I thought I were really good I wouldn't feel funny seeing them all. All the artists I've known for years are with their second wives or girlfriends—Claes Oldenburg had a new girlfriend, so did Rosenquist. Roy was with Dorothy, Ed Ruscha was with Diane Keaton, Leo had his ex-wife Ileana Sonnabend there and his wife Toiny and Barbara Jakobson—all the girls fall in love with him for some reason. David Whitney was cute, helping. I borrowed film from one of Leo's secretaries.

The artists did a "you sign mine and I'll sign yours" thing and I got a couple of signatures—

Claes, and then Keith Sonnier, who I like. Nancy the checkpayer from Leo's was there. The place is on Jones Street, and it reminded me of when I used to live there and my roommate, Lila Davies, picked up a Chinese guy and brought him home thinking he was nice and he pulled out a knife.

Went home, slept a little, then crawled out of bed to go pick up Andrea Portago to go to the Iranian embassy. Andrea looked lovely, she's back to wanting to be a movie star, her mind lapses for a while and then she picks it up again. Paulette was there, she sold the rights to the novel Remarque wrote about Andrea's father, *Heaven Has No Favorites*—an awful title, Paulette said. She got $100,000 plus 10 percent of the movie from Paramount. It's called *Bobby Deerfield* now and stars Al Pacino as Andrea's father, Fon de Portago, the race-car driver.

After dinner Andrea wanted to be taken to Baryshnikov's party at Lester Persky's but as we were leaving, Bianca and François Catroux came in and said they'd just been there and not to go, that it was awful, so we went back to Nureyev's party and then had to go through the "you're backs" for a while. But then Andrea decided Bianca was only telling us that Lester's was bad to stunt her career, that it was probably a great party and that Milos Forman would be there so it would be good for her, so we went after all.

Cab to the Hampshire House ($3). Lester is high up, and as we sat there talking the chandelier kept moving, a big one. I was nervous about it. Baryshnikov was so sweet. Milos was cute, telling me we had the same kind of shoes. Brooke Hayward was there and threw her arms around me and said, "I'm so successful, I don't know what to do." I think she's nutty.

Lester had works by Rosenquist and Rauschenberg, but just one Cow I *gave* him and a Marilyn. He should have bought my stuff early on. I'm trying to get some Dollars on his wall, though. Lester's is cozy. Dropped off Andrea (cab $3).

Monday, March 21, 1977

Fred was having trouble with Ileana Sonnabend who was being rotten, not wanting to give some drawings of mine back.

Bianca came to lunch at the office and Jamie asked her if she was *(laughs)* from Uganda—because she was talking about loss of human rights and secret police killings in "my country"—and she nearly killed him. She said, "Nicaragua, Nicaragua."

Worked in the afternoon. At 6:00 left to go to Adela Holzer's (cab $3.50). Bob was being crazy and didn't want to go, said she had no money. But she has a whole house, 216 East 72nd Street, and I liked the way it looked. She was entertaining James Coco and his boyfriend.

When I got home the phone rang and it was Philip Niarchos and he wanted to come over to see my house but I didn't want him to so I said I was already in bed.

Tuesday, March 22, 1977

As I went out the door the phone rang and it was Brigid after all these weeks saying that she wanted me to come over to her mother's right away and see her. So I walked over to 834 Fifth Avenue to Honey and Dick's and Brigid came down the staircase looking gorgeous, like a version

of Honey. I offered her a job at the office. We talked for twenty minutes about what happened to her ass, it just isn't there anymore. I told her she should never see *Bad* because if she did and saw herself that fat and with the farting sounds, she'd be furious at us.

Went to Mortimer's for a party for Edie Vonnegut's picture-drawing that she did of "Mortimer." Is there really a Mortimer? And I couldn't believe the drawings would be that bad. Kurt Vonnegut was there, gave a little speech about how talented his daughter was. Remember she was married to Geraldo Rivera?

Ruth Kligman kissed me and I didn't know what she was doing, she started talking all about a love affair she said we had together, apologizing for breaking it off, kissing me, and it was all a fantasy, so I thought that if she could do that with me, then she'd probably never had a love affair with Pollock. She looked good, she was in a velvet Halston. Fred's date was Edna O'Brien. Barbara Allen was there. She said that she'd wanted to wear the diamond earrings Philip had just given her but that he made her put them in the vault.

Wednesday, March 23, 1977—New York—Los Angeles

Met at the airport by Susan Pile with a limousine and a lot of promo material and she said she was giving a big screening and a party on Thursday for *Bad* and we told her she should have told us before, that we were already booked for Thursday.

Checked into the Beverly Hills Hotel and they gave us the most horrible rooms. We all sat around Suzie Frankfurt's room while Susan Pile was doing some business with Fred in his room on another floor. Suzie's friend Joan Quinn came by, she invited us to dinner at a Mexican restaurant, picked us up in two cars. Really great food. Met Joan's husband, Jack the lawyer.

Went to bed around 1:00.

Friday, March 25, 1977—Los Angeles

Up at 7:00. Todd Brassner called and said he just saw Muhammad Ali in the Polo Lounge, and that he also saw Charles Bronson in the lobby. Fred and I had to go to a meeting at Roger Corman's office, so cabbed there ($5). It was a brand-new building, met all the young kids who work for him. Fred said Roger was "very shy and never gives interviews" but he's not shy, I noticed, and he's been giving a lot of them lately.

Diana Vreeland had a limo and we were going out to George Cukor's with her. George wouldn't let me take photos. I was disappointed. He said he loved *Bad*, raved about it. He'd seen it the day before with Paul Morrissey at Susan Pile's big screening at the Picwood Theater—Jack Nicholson and Warren Beatty and Julie Christie went, 750 people.

Fred and I went back to the hotel to get ready for Sue Mengers's dinner party in Bel Air. Picked up Diana. Ryan and Tatum were at Sue's, and Barbra Streisand and Jon Peters. Diana went over and told Barbra off about something. Candy Bergen and Roman Polanski were there. It was a party for Sidney Lumet. He hates me and his wife Gail doesn't know whether she does or not, but she follows what her husband does so she's cold. Sidney runs around kissing everybody and

then stops when he gets to me. Film directors used to be such macho guys, and now they're these little fairy-type guys running around French-style double-kissing but still thinking they're macho.

Joanne Woodward and Paul Newman sat with Fred during dinner and they said they wanted to come down to the office. Lillian Hellman was there. Roman said Gene Hackman wanted to meet me, but Diana didn't know who he was and didn't want to go over. She told Roman that Gene should come over and he did, and he was darling, and Diana still couldn't place him although she'd seen *The French Connection*.

Marisa was there with her hubby, the gossip was that they'd had a big fight and broken up. But the big event of the evening was when the maid came in with extra food and fell completely across the room. Sue looked concerned but I think she was just worried about getting sued. It was just like watching a movie. The food was flying all over everybody. She must have really hurt herself but she got up and pretended nothing had happened. She was around fifty, glasses.

Then went to Alana Hamilton's party for Mick Flick, and she had everybody there. Diana was getting drunker and drunker, and Fred, too. Valerie Perrine, Tony Curtis, and Nelson Lyon, sober, were there. Ron Wood invited me to Top of the Rox but I wanted to go home. Diana was getting jealous because Fred was with Jacqueline Bisset, he didn't know Jackie's French boyfriend was there with her. Diana told Fred time to leave and he said no, and she got really upset and left and I took her home and she wanted me to go up and discuss Fred with her over drinks and I just said no and ran out. She thinks she has something going with him.

Saturday, March 26, 1977—Los Angeles

Read the rave review of *Bad* in *The Los Angeles Times*.

Went to Susan Tyrrell's party, it was really great. Tatum was there, and her little brother, and Ryan's brother, Kevin O'Neal, and Chu Chu Malave, the boxer, and Tim Curry from *The Rocky Horror Picture Show*, Garfunkel, Art "Murph" who wrote the *Variety* review, Barry Diller, Buck Henry who really loves *Bad*, Arnold Schwarzenegger, Fred Williamson, Tere Tereba, Corinne Calvert and her son, Ronee Blakley and her brother, Sally Kirkland, Don Rugoff, Paul Morrissey, Thelma Houston, Ed Begley, Jr., Martin Mull the wife-beater on *Mary Hartman*—200 people like that. Michael Bloomfield who did the *Bad* soundtrack came as we were leaving. Ron Galella was taking pictures.

I had to leave to go to the *Bad* screening. What was so great about seeing the movie at Filmex was that everything had such big significance, suddenly, because the screen was so big, so much more Pop—like that Santa Claus knick-knack on Carroll Baker's refrigerator. I want to rent a big theater for a screening in New York. Got back to the hotel about 3:00.

Sunday, March 27, 1977—Los Angeles

Met Esther, Doug Christmas's PR person, at the Polo Lounge and she invited us to the French consulate for the Film Festival, and I invited Doug Christmas and at 7:30 we went. Met King Vidor who said he knew all about me. Bobby Neuwirth was there and I talked with him about

his old girlfriend, Andrea Portago, and Edie Sedgwick. Viva was there with her daughter Alexandra who was sucking her thumb. Seeing Alexandra was sad—a big "rug-rat" hanging off Viva—she'll probably turn out a mess. Viva will do everything the opposite that her parents did and it'll be just as bad.

Monday, March 28, 1977—Los Angeles

Up at 7:00. Watched the *Today Show*, air crash with over 550 people getting killed, two 747s crashing. Fred went to see Paul Getty's ear transplant at Cedars-Sinai Hospital. Peter Lester called and made a date for us to interview William Katt, the star of *Carrie*, and his press agent at the Polo Lounge at 1:00.

Talked to William Katt. His father was movie star Bill Williams and his mother Barbara Hale was Della Street on *Perry Mason*. A good interview.

Then sat in the lobby for a second and met Liv Ullmann.

The place was really jumping with stars all getting ready to go to the Academy Awards. At 4:00 I went to Fred's room to photograph Willie Shoemaker the jockey. Richard Weisman's commissioned me to do a series of athletes' portraits. Richard will keep some of the portraits and some will be for sale and the athletes will get to keep some. So Willie was the first athlete. Had to get some film (cab to Schwab's $3, film $15.30—lost slip). Willie's wife called from the lobby and she came up with a girlfriend—but without Willie. He didn't show up till ten after 5:00 and when he saw her, he couldn't believe she was there. He'd been in court getting a divorce from her, that's why he was late.

Willie's ex-wife of one hour was one of the tallest women I've ever seen. She was dressing Willie for the picture and he looked like an eight-year-old kid. And guess what he was wearing—little Jockey shorts! Ordered martinis, and the wife was drinking. She kept asking him for a date to celebrate the divorce and he kept turning her down, he said, "If I'd known you were going to be here I wouldn't have come."

Alana Hamilton called to invite us to an Academy Awards party at Dani Janssen's. I missed Ronee Blakley's invitation to go to the Oscars ceremony with her because I was in Fred's room.

Got picked up at 7:45 by Alana Hamilton. Drove to Century City. They were having a $10 bet pool on the Academy Awards and it cost me $20. Brand-new apartment building, very rich, overlooking all of Hollywood. Dani's getting a divorce from David, Alana's getting a divorce from George.

Jack Haley said Liza was in Detroit with her show and coming back the next day. Dick Sylbert was there. Valerie Perrine told me her life story, she was once a chip hustler in Las Vegas and on the verge of marrying some rich guy after eight years but he shot himself accidentally. Her eyes teared up, she was unhappy. When Martin Scorsese came in she ran over to rustle up a job.

Burgess Meredith came with his date. *Rocky* got Best Picture. Peter Finch got Best Actor, but he's dead. Nelson Lyon was in the audience as the date of Mrs. Finch, Eletha. She's very black. The Academy asked Paddy Chayevsky go up to accept Peter Finch's award. Burgess and I talked about his ex-wife, Paulette.

Brenda Vaccaro was upset because her ex-fiancé Michael Douglas was there with his brand-new

wife that he met at the inauguration. James Caan was there with his boyish wife, a beauty. They're all marrying younger girls who look like they're thirteen, the Hollywood thing. Roman was there, he's out on bail now for the thirteen-year-old-girl. He jumped on Alana's ass and said he was going to rape her.

Martin Scorsese with his wife, Julia. Jackie Bisset. Lee Grant. Burt Young from *Rocky*. A girl from *Big Valley*, Linda Evans, really beautiful. Tony Curtis was giving people puffs on his marijuana.

Julia Scorsese said that Martin would take me and Fred in his limo. She was drunk, screaming something about death threats, but I didn't know what she was talking about.

As we got into the car Martin said he had a bomb threat, the note said that he would die one minute after midnight if Jodie Foster won the Academy Award. It was 2:00 now and he was going to MGM to work on *New York, New York* in the dark and deserted MGM lot, alone. I was paranoid. Esther Phillips was calling me at the hotel but I didn't answer the calls because she's started to scare me—one of her calls was at 2 A.M.

Tuesday, March 29, 1977—Los Angeles—New York

Got the American 1:00 plane to New York. Noticed Paddy Chayevsky being driven on a little cart to the plane while we walked. Lots of people from the Academy Awards getting on the plane. The first class took up practically half the plane—first time I saw it so full, really interesting. John Travolta from *Welcome Back, Kotter* walked by, sort of said hi to me, sat in front of me. Paddy Chayevsky told the stewardess he wanted to sleep all during the trip, not to wake him up, but he woke up five minutes after the plane was in the air.

John Travolta kept going to the bathroom, coming out with his eyes bright red, drinking orange juice and liquor in a paper cup, and he put his head in a pillow and started crying. I saw him reading a script, too, so I thought he was acting. Really cute and sensitive-looking, very tall, comes off looking too fairy-ish, like too many people around now, but very good-looking. You can see the magic in him. I asked the stewardess why he was crying and she said "death in the family" so I thought it was a mother or father, until I picked up the paper at home and found out that it was Diana Hyland who'd died of cancer at forty-one, soap-opera queen, his steady date.

Dropped Fred and Todd Brassner (cab $27). Cab fares had gone up.

Thursday, March 31, 1977

Lunch with Victor ($16), then we walked over to the loft building on 19th and Fifth that Maxime's moving into and that Victor is thinking of buying a floor in, too. I tried to discourage him, saying that it was really too small. It was. I can't figure out why Maxime wants to go there, it's no bigger than her apartment. She says, "I just want one big room," but when she moves all her furniture in, it won't even look or feel big at all. And it costs $32,000.

Victor and his boyfriend walked me back to the office. A fortune teller told Victor's boyfriend that he would be hit by a cab. Then she said maybe that wasn't right, that she'd better read the

tarot cards, too, so she did, and then she said, "It's going to happen even quicker than I thought." So now the kid is really worried. She charged him $5 and first he said, "I'm not going to pay you for telling me that," and she said he had to so he did. How could a person do that! I mean, that's the kind of thing that really really really stays in your mind. The reason the kid went there in the first place was because his friends had told him she was so good. To make him feel better all I could think to say was that maybe she could see he was a careless person and had told him that to make him more careful.

I was invited to Diane Von Furstenberg's dinner for Sue Mengers. Went home, glued myself together, cab to DVF's ($2.25). It was a very heavy newspaper-reporter dinner. Mr. Grunwald from *Time* magazine, Nora Ephron—didn't see her husband, Carl Bernstein, though—Helen Gurley Brown and her husband David, Irene Selznick, and DVF's boyfriend, Barry Diller. I was feeling very talkative so I talked and I talked, but nobody listened to anything I said, they just ignored me. I know that Diller doesn't like me, so I worked hard to change his mind but he was still awful to me.

Bianca was there. I thought she'd already left for Paris. She was saying out loud everything I was thinking—what two bitches Diane Von Furstenberg and Sue Mengers were—and she said, "At least Sue can be funny sometimes." Sue was on her way to Europe to meet her husband, who only lets her see him once every couple of months, I think.

I told Irene Selznick that I'd seen a great picture of her at George Cukor's. I was raving about California so much that everybody thinks I'm moving there.

Helen Gurley Brown sat at my feet and I talked to her about California. Bianca was talking about how boring all these people were to Mr. Grunwald, she didn't know who he was, and then after he went away I told her. They were all two-faced people there, and Diane only invited me to pay me back for the *Interview* cover, and I mean, who cared. Diane is very skinny. Dino De Laurentiis came late with his wife, Silvana Mangano, she was wearing a white Oscar de la Renta and said she was cold.

Egon Von Furstenberg came in with his girlfriend, the one that used to come to the Factory who I can't stand, and I guess she finally realizes that I hate her, because she didn't say anything to me. Her name starts with M, something like Marita. He'll never marry her.

Bianca said she wanted to go dancing and called her answering service but there was nothing on it so she stayed. She was wearing a thrift-store dress that she got in California that was really beautiful. When the De Laurentiises walked by us to leave she said, "They're full of shit." I left alone. Had a horrible time.

Friday, April 1, 1977

Went to Halston's birthday dinner for Victor at Pearl's, he didn't want to do a big thing at the house. Joe Eula was there. And Aly Kaiser. She has two bodyguards now because of her Greek husband that she's divorcing—she has one bodyguard driving her and one at home.

She had as a present for Victor a bag of Hawaiian marijuana that a couple of fag friends who have a ranch there mailed to her in a box of perfumed shirts so you wouldn't smell the marijuana. She said she gave some to one of her bodyguards and he was passed out at home.

She says she'll let me take pictures of her as soon as she gets her divorce. Before it was "as soon as I get the plastic in my face from Dr. Orentreich." I talked to Dr. Giller, he seems so sensible. He said that only fish and chicken and fresh vegetables were good for you, even though he himself liked Chinese food. He told Mrs. Kaiser where she could get fresh chickens kosher on the Lower East Side, and she said she'd send one of her bodyguards down for some, she's been sending him out to do her shopping. She was wearing twenty carats on each ear and a diamond bracelet, too. She's really nice. She had a car out front, too, with her dog who wears the chauffeur's cap.

Monday, April 4, 1977

Rod Gilbert the Canadian hockey player came down to be photographed for the Athletes series. He had 100 scars on his face, but I couldn't see them, really. He autographed a hockey stick for me and I autographed *Philosophy* books for him, but made a mistake and put "Ron" instead of "Rod." Bought light bulbs ($4.02).

Tuesday, April 5, 1977

Worked until 7:45. At 9:00 cabbed to Fred's ($2.25). Rebecca Fraser was there. She's the daughter of Antonia Fraser who's now going with Harold Pinter. Rebecca is checking hats at One Fifth. She's going to be a "View Girl" in *Interview*. She's really cute, she nodded out while Fred was talking to her a few times. Diana Vreeland was there, Mick Jagger arrived. Camilla and Earl McGrath, Jean Van den Heuvel, Tom Hess who did the good review of my Hammers & Sickles in *New York*. Caroline Kennedy was there. Her face is so beautiful, but she got really fat, her behind is so big—as fat as Brigid's was. She's on Easter vacation from Radcliffe. She was the first person to leave, I think she has to be home before midnight, on a schedule, because once when she was at Fred's she stayed until 4:00 and Jackie got mad.

The dinner was to say goodbye to Erskine Guinness and his cousin Miranda, they're leaving for Ireland.

Wednesday, April 6, 1977

Took "landscape" pictures of an ex-porno star Victor brought down who it turns out has a shop on Madison Avenue that sells Lalique. Dropped them off (cab $3).

There was something in the *Post* today about Adela Holzer, she's getting sued for keeping investors' money in a bank in Jakarta and not paying them back.

On TV I got a big mention when Barbara Walters interviewed the empress of Iran. In with the other art they did a big closeup on my Mick print and Barbara said, "And surprisingly, they have a painting of rock star Mick Jagger by Andy Warhol," and the empress said, "I like to keep modern."

Thursday, April 7, 1977

Some people from Joseph Papp's company came to lunch, we were trying to get them to advertise in *Interview*. Cabbed up to the Sherry Netherland with Bob to interview Sissy Spacek for *Interview* ($4). We brought copies of the Carroll Baker *Interview* with us. Carroll's name is spelled wrong on the cover. Sissy's mother was there and she said hello and went into the other room to read *Interview*, and then Bob got nervous because he thought Sissy was fifteen and her mother would see the nude photograph we ran of Yul Brynner when he was young—that famous old photo. But Sissy's really twenty-seven and she's married, her mother was just *with* her, not chaperoning her. We're going to have to research better.

She's Czech, from a Czechoslovakian town in Texas which I'd never heard of. And I couldn't believe it when she said she'd been an extra in the "crowd" scene in our movie *Women in Revolt* —the bar scene that we filmed in Paul Morrissey's basement on East 6th Street—and she said she was also in the background singing on that *Lonesome Cowboys* theme song record that Bob Goldstein wrote and Eric Emerson sang! She folded her legs up under her on the chairs. She has beautiful skin.

Friday, April 8, 1977

Went with Jed to see Sissy Spacek in *Carrie* (cab $2.50, tickets $3). Loved it. Finally somebody did slow motion right.

Saturday, April 9, 1977

Brigid called and started screaming because she found out that *Bad* was X-rated for violence just because a baby gets thrown out a window! You don't even see it land! Brigid was yelling for "getting me into another X-rated movie." I can't believe the distributor—Corman—didn't fight that, it's just so ridiculous.

Sunday, April 10, 1977

Went to early mass, a beautiful day, warm and sunny (newspapers and mags for the week $20). Cab to Kitty Miller's for Easter lunch ($2).

Then cab to 135 Central Park West with Fred to Marsia Trinder and Lenny Holzer's ($3). Marsia was having an Easter party. Mick was there with Jade. Bianca didn't come, she said that Fred would give her the gossip anyway and that it would just be "a bunch of English whores" there, and she was right—it was all the English boy and girl whores.

Rebecca was passed out there. Earl McGrath was there. Jade took my camera and was taking pictures of people, mostly of her father, Mick. Marsia had hidden eggs all around the apartment,

like unscrewing the light bulb and putting an egg there, and under pillows, and the kids went looking. Jade found most of them and threw them on the floor. The real eggs, not chocolate. Andrea Portago was there and this is a secret—she's the new Nina Ricci girl. They're reviving that Rich Girl promotion idea for perfumes, they've been looking for a long time. Remember last year when they interviewed Barbara Allen?

Andrea said she was out with Dennis Hopper and they went up to Elaine's and she started playing backgammon with Elaine and she won one and Elaine won one, and then they started a third game and Andrea was losing and then she won, and Elaine got mad and called her a "rich bitch" and told her not to come in there again. Elaine doesn't like to lose.

Monday, April 11, 1977

Cabbed down to Chembank and walked over to the office (cab $3.25).

Ronnie and Gigi had another fight and he cut up her clothes. I remember René Ricard once did that to the girl he married. I had lunch with Ronnie and gave him my "there's always somebody else around the corner" philosophy, and Ronnie said yeah, that he had six girlfriends now. He said, "I'm not coked up, I'm not upset, I'm fine, I'm fine."

Worked very late, a little after 8:00. I was going to the movies but then it got too late. Wound up taking the dogs for a long walk with Jed up to 80th and back down, had a good time.

Tuesday, April 12, 1977

Mick wants me to do the cover on his next album. I'm trying to think of ideas, how to do "Rolling Stones," one of those little plastic games where you have to roll the stones into the holes.

Victor called and said that it was getting too heavy at Halston's and that he *was* moving into the loft on 19th and 5th, renting with an option to buy. Until he moves in in May he'll be sleeping around, he said.

Wednesday, April 13, 1977

I was going up for cocktails and then dinner for Jean Stein at her sister Susan Shiva's apartment in the Dakota. I thought it couldn't be anything great so I was forty-five minutes late ($3). The first person I saw when I walked in the door was Jackie O., looking beautiful. Then Norman Mailer. Jackie was talking to Jean's boyfriend who works for the Smithsonian. Delfina Rattazzi who still works for Jackie at Viking was there with such a complete new look I didn't recognize her—curly hair and a sexy dress.

Sue Mengers was there, and she came over to me and said her knees were buckling, that she'd never been to a party like this. Babe Paley and her chairman-of-CBS husband went by, and later

when I saw Sue and Paley sitting together I remembered what Sue had told me in California, that the only job she ever wanted was Paley's.

I told Norman Mailer I loved him on the Academy Awards and he said he'd just seen a video of how fast he'd come down the ramp—Billy Friedkin had told him to do it that way. Renata Adler who writes for the *New Yorker* was there with Avedon. She said she's going to law school now at Yale but she thinks she'll maybe drop out. She says it's so hard, and that she can't remember anything.

I had the first really nice talk with Jackie O. but I don't remember too much what it was about. The Magic of People in the Movies, or something. Sue Mengers was running around this party bragging the same thing that she always brags—that she could offer President Carter a three-picture deal at $3 million a picture and that he'd take it, because *everybody* wants to be in the movies. So I pointed at Jackie and told Sue to go prove it, but she was afraid, she wouldn't go over to her and make the offer. Andrew Young from the U.N. and another black guy were there. Sue was thrilled to meet them.

Dennis Hopper told me he's directing *Junkie*, the William Burroughs bio, and I made a *faux pas* by telling him he should use Mick for the star because then Dennis said that *he* was the star.

A son of Nick Dunne was there, trying to be an actor now. Then Earl took me into the back rooms of the house, and there were ten girls around seventeen or eighteen, full-grown, the age of Jean's daughter who's in college, and they were like having a slumber party, guessing at who was out there at the "grownup" party! But these girls were so old, it was funny. They were thrilled to see me, I signed the TV, the armoire, their hands, everything. Every half-hour they'd let one girl out and into the party.

Dropped off Nick Dunne's son on 90th and Central Park West (cab $5).

Friday, April 15, 1977

We had our first nut at 860 yesterday—Diane Coffman came up. We've had nuts before but not one that we knew. She was in our play, *Pork*, in '70 or '71. The director, Tony Ingrassia, must have discovered her. She kept saying, "You know how to spell Coffman? C-O-F-F-M-A-N." Had to give her money ($10).

Lunch was for Diana Vreeland and an Argentinian woman, and Bob had invited Michael and Pat York. Carole Rogers and Sally from *Interview* had invited a hi-fi girl to try to sell her ads. The girl was impressed with Diana and the Yorks, she thought she was just going to have lunch with Carole and Sally. Diana was saying that she'd discovered the museum had turned the lights up and the music down on her Russian costume show—they said it was because some people had complained they couldn't see anything and the music was too loud. Diana said that you don't go change something because somebody asks you to, that that's the trouble with this country, they want to "give the public what it wants." "Well," she said, "the public wants what it *can't get*, and it's up to museums to *teach* them what to want." And she said that's the trouble with *Vogue* magazine and all the other magazines today—except for *Interview*, she said.

Sunday, April 17, 1977

Went to church and while I was kneeling and praying for money a shopping-bag lady came in and asked me for some. She asked for $5 and then upped it to $10. It was like Viva. I gave her a nickel. She started putting her hand in my pocket. She looked like an older version of Brigid with straight hair.

Gave autographs outside. Cabbed down to the office ($4). While I was at work Diane Coffman called and I told her I was the janitor and she believed me. After I gave her the $10 on Friday, incidentally, she went out and bought some stupid flowers with it. She came back and showed me.

Read lots of old *Vanity Fairs* for ideas, they looked so beautiful.

And Fred has been much busier than me—after the big de Menil party on Saturday he went to Lally Weymouth's party which was for lots of heavies, and I was complaining that I wasn't invited and Fred said, "*You* didn't sleep with her."

Wednesday, April 20, 1977

On the way downtown I ran into Lewis Allen, who invited me to the opening of *Annie*, and then ran into Alan Bates who's been in town for a couple of months to work on a Paul Mazursky movie. I always say to them that I'll call them and interview them, but I've got to stop staying that because it's ridiculous—like I'm so sure they want to be interviewed.

At 8:15 went to the Iranian embassy (cab $3). Hoveyda seemed nervous. It was a party for a man who used to be the chief editor of *Newsweek*, Osborn Elliott. I was next to Mrs. Astor, and on my other side Frank Perry. Mrs. Astor said she wished she had a tail so she could shake hands with people and hold cocktails and put on lipstick all at once.

Thursday, April 21, 1977

Went with Bob to pick up Bianca to take her to a dinner that Sandy Milliken was giving at his loft in Soho and Jade came downstairs and said, "Andy Warhol, you never come to see me anymore." Jade asked us if we wanted something to drink and we said, "Two vodkas on the rocks," and she said to the Spanish maid, "*Dos vodkas con heilo.*" I wanted her to sing, and so she did "Frère Jacques," and I asked her to sing "Satisfaction" and she'd never heard of it. She sang "Ring Around the Roses" but she said, "Tissue, tissue, all fall down." I asked her to make up a song about her day and she started to sing: "I invited another child at school to come for dinner/ But they wouldn't come/They think we're crazy/But *they're* crazy."

Bianca came down in a white cotton skirt and blue blouse, but then looked at us dressed so formal and went back up and put on a gold and black lamé dress and gold shoes.

As we were leaving, Jade said, "Now Andy Warhol, I want you to visit more often." Then she kissed everyone but she forgot about Bianca, and Bianca said, "What about me?" and Jade crawled

over on the floor and kissed her, too. Cabbed to 141 Prince Street. Very fancy loft building. I got jealous that I didn't buy more buildings down there when they were cheap—lots of them.

Monday, May 23, 1977

Tina Fredericks called and said that Tommy Schippers wouldn't be renting our place in Montauk. His wife died of cancer and now he has the *same kind* and that scared me—I guess you *can* catch it from other people.

Wednesday, May 25, 1977—Paris

Arrived in Paris around 9 A.M. Went to Fred's apartment on Rue du Cherche-Midi.

All Fred's chic antiques are looking more and more like just junk covered in rags.

William Burke arrived with breakfast.

Did interviews with *Le Monde, Le Figaro,* and *Elle* that'd been arranged by Flammarion, our French publisher. Then it was time to go to the Beaubourg to sign *Philosophy* books at their bookshop (cab $5).

Shirley Goldfarb came, and Daniel Templon came, he's giving the Hammer & Sickle show next Tuesday, and about 100 dirty kids in punk clothes.

Pontus Hulten, the director of the Beaubourg, showed up and took us on a tour. First we went into the big Tinguely sculpture being constructed in the middle of the ground floor. He took us to a storeroom stuffed with chocolate and gave us some. It smelled so good, the chocolate room.

Then we saw the Kienholz show and then the Paris/New York show opening next week and then the permanent collection. This took two hours and Bob was passing out but I had energy and wanted to just rush home and paint and stop doing society portraits.

Thursday, May 26, 1977—Paris—Brussels

Went to lunch with Clara Sant of Yves Saint Laurent and Paloma Picasso at Angelina. Clara looked good, thinner, and Paloma, too. Clara's suffering through the marriage of her boyfriend Thadée Klossowski to Loulou de la Falaise. She first found out by an official notice in *Le Figaro* placed by Thadée and Loulou. She's getting her sense of humor back now so she's getting over it. I said Clara and I should announce our marriage in *Le Figaro* to outdo them.

Cabbed to train station ($8). Had our own compartment. Fell asleep. Arrived Brussels at 7:00. Mr. LeBruin, the art dealer showing my pictures, greeted us with a couple of hippie boys. Checked into the not-chic Hotel Brussels. We all had duplex suites which was crazy, because whenever the doorbell rang you'd be upstairs in the bathroom and you'd have to rush down the floating staircase to answer it.

Rushed to Galerie D. A mob scene. Stuck in a corner signing autographs and books. Sold 120.

The kids here were cute, sort of hippie. Around 9:00 made a fast chic exit through mob into

our chauffeured Chevy and expected to be whisked away but then we saw that there was nobody in the driver's seat. A kid offered me an ice cream cone and I said no, so he splattered it all over the roof of the car and it dripped down the windows. The kids started laughing at us, just sitting there for twenty minutes. Finally the chauffeur arrived and said he'd been peeing.

Stopped at Leon Lambert's. He lives in the penthouse of a ten-story building above his bank. The place is unbelievable, so simple and so much art from Van Gogh to Picasso to—Warhol. Saw his bedroom behind a bookcase in the library. Secret apartment with two bedrooms, one for his regular boyfriend, one for one-night stands. After dinner in a little bistro in the Galleria we walked down the arcade. Stopped at a gay bar and Bob asked the most beautiful boy in Belgium to dance so they did, but when Bob gave him a peck on the neck and that led to the lips Fred and I got embarrassed because everyone said boys don't do that in public in Brussels—even in *gay bars!*

Friday, May 27, 1977—Brussels—Paris

Slept on train. Rented a car ($20) to take us to William Burke's gallery where he was having a show of photos of me and also a book signing. Paloma was waiting in the alley for us. Nico [*see Introduction*] was there with a young kid with a big bulge in his pants, she asked Bob to photograph him. Bob already had. Nico looked older and fatter and sadder. She was crying, she said, because of the beauty of the show. I wanted to give her some money but not directly so I signed a 500-franc note ($100) and handed it to her and she got even more sentimental and said, "I must frame *this*, can you give me another one, unsigned, to *spend?*" ($100, cab to Regine's $4). Barbara and Philip were there, Regine and her husband. Then Maria Niarchos arrived. Regine was all excited by the success of her punk party the night before, said she served chocolate mousse in dog dishes. Got tired of waiting for Bianca so we sat down to dinner around 11:00. Dinner was crayfish, goose, fruit plates—very good. A beautiful English girl was putting down Maria as "amoral" because she was showing off her cleavage where I'd signed it. Fred was very drunk and started defending Maria and saying, "What is morality anyway?" and they fought for the rest of the night. It was so French.

At 3 A.M. just when we decided to leave Bianca called and said to please wait for her. She arrived a minute later looking great and the party started all over again. She was wearing a beautiful Fabergé amethyst. Around 6:00 when the waiters started sweeping up we left.

Saturday, May 28, 1977—Paris

Went out to dinner at Monsieur Boeuf. When Bianca arrived she passed out some Locker Room poppers and Barbara Allen didn't want Philip Niarchos to take any so she hid them and later when Bianca ran out of them she begged Barbara for them back. Meanwhile some creepy girl recognized me—we were dining *al fresco* because it was a beautiful night, clear sky and big moon—and she started screaming in French that she loved me but that I abandoned the underground and that she was a necrophiliac just released from a mental institution. It sort of ruined dinner. Fred was tired and went home. We dropped Philip and Barbara at the Ritz, Bianca had a

car. In the car after we dropped them Bianca said she didn't know what to do, because Barbara had asked her if she knew if Philip slept with any other girls when he was down in the south of France last week. Bianca told us he'd been with Anouk Aimée's daughter, Manuela Papatakis, and Bianca didn't know whether to tell Barbara the truth and hurt her, or lie and have her find out from someone else and then think that Bianca wasn't her real friend. Barbara had refused to go to the south of France with him because she had a "screen test" with Jack Nicholson.

Monday, May 30, 1977—Paris

Dead in Paris, it was Pentecost. Got up to meet Bianca to go to the tennis matches. Bob and Fred were in the crabbiest moods ever.

Fred called Bianca and she said she was running late, so we ran late but we were still early when we got to the Plaza-Athénée (taxi $4). James Mason was in the lobby.

Then Bianca appeared in white slacks, black halter top with an amethyst pinned to it. She said she had been up until 5 A.M. at the Sept just talking to the tennis player who never makes it with anyone but his wife. She said he wanted to make it with her but she hates affairs because they get "too complicated." Who's she trying to kid?

Tuesday, May 31, 1977—Paris

Cabbed to Plaza-Athénée ($5) to meet Bianca to interview Ungaro. Bianca had a small but beautiful suite with a terrace facing the courtyard filled with geraniums and red umbrellas. Read an English newspaper. Ate an orange that was there while we waited. She was looking all over for her Fabergé amethyst and when she couldn't find it she said she couldn't do the interview with us and she ran out to Castel's to crawl on her hands and knees looking for it—she thought she lost it there the night before.

Bettina was the first to arrive for lunch so we interviewed *her*. She works for Ungaro now. She was wearing a Bulgari snake watch and white Ungaro suit. Then Ungaro finally arrived. He was wearing a white suit, too.

Then went to his place. Princess Grace and Caroline of Monaco ran out of Ungaro Couture when they heard we were next door at Ungaro Homme. Bob bought a suit. Then we went to the Rue Beaubourg for my Hammer & Sickle opening at the Galerie Daniel Templon. All the same punks were there plus São Schlumberger in a blue Givenchy. She was on her way to Florence Van der Kemp's dinner in Versailles.

Barbara Allen came early and told us all her own gossip—she and Philip Niarchos had a big fight last night. He accused her of having affairs with Jack, Warren, and Mick. She didn't deny it even though she says she hasn't. He admitted to her his affair with Manuela Papatakis in the south of France plus one other plus three hookers. In three weeks. They made a pact that when they are together they are "together," but when they're not, they're "not."

Some punks had a fight and a tooth got knocked out. They started screaming my name loudly

so I was locked into the office. Then it was time to leave for dinner. On the way out a drunk creep kissed me smack on the lips and I almost fainted.

Oh, and Bianca was in a great mood because they'd found her amethyst. She had threatened to bring in private detectives. So they questioned the help—they've all worked there for years—and the oldest man was the one who'd found it when he cleaned up and kept it.

Wednesday, June 1, 1977—Paris

Barbara Allen called and said we were invited to meet at the Brandolinis' for drinks. Then Maria Niarchos called and said she wanted us to see her father's palace (cab $3). We walked in through the garden and went into the marble foyer then down the gold-on-gold-on-gold hallway and into a salon covered in great Impressionist paintings, all lit in the dark—they almost looked fake. Maria made us drinks and then we toured the grand bathrooms and bedrooms and sitting rooms and Philip's office, which is so grand in order to scare the people he does business with. Then we cabbed to the Brandolinis' ($4). Everyone—except me—went into the bathroom all at one time. Bob will probably say that I had a little bit of coke, too, but I did *not*. But I did kiss Roberto out on the balcony overlooking Van Cleef and *(laughs)* he said, *"Please*, I'm married and have a kid."

Got home around 4:00 (cab $3).

Thursday, June 2, 1977—Paris

Joel LeBon was shooting me for the *Façade* cover with Edwige, a girl punk (cab to the studio in Trocadero $8). It took Joel three hours to do one shot under very hot lights.

At night I stayed home. Bob escorted Bianca to Castel's where he said they ran into Maria Niarchos and her youngest brother Constantin, who's sixteen, losing his baby fat, and he'd been to his first whore that afternoon—Barbara told them that but said not to tell. She said that Philip sent the whore from Madame Claude's, the best place in Paris. The girl was not too tall, not too short, not too light, not too dark—all on purpose, so that Constantin wouldn't get stuck on any one type.

Friday, June 3, 1977—Paris

We went to Castel's (taxi $4). The same old crowd was there, having Caroline of Monaco's secret engagement dinner to Philippe Junot. We weren't asked.

Sunday, June 5, 1977—New York

Made lots of calls around town, catching up. Vincent was in Montauk showing Louis Malle the place, hoping for a rental. We're trying to rent the main house for $4,000 a month during July and August—$26,000 for six months. Two thousand a month for the small cottages, but we'll

deal. Mr. Winters wears his *Bad* T-shirt and his Rolling Stones denim jacket while he takes care of the place. He needs a new Jeep—he has a door hinge for an accelerator pedal. He handed Vincent a magazine clipping that said I buy a new car for myself every year, to help make his case for a new Jeep.

Tuesday, June 7, 1977

Dennis Hopper and Caterine Milinaire and Terry Southern and a photographer from *Time* came by. Her job was to follow Dennis around, and he wanted to come to the Factory and have her follow him there. There was just an article in *Time* or *Newsweek* on the *Apocalypse Now* movie that Coppola is finishing. Dennis is playing a crazed hippie photographer in it. The photographer from *Time* took pictures of Caterine taking pictures of Dennis taking pictures of me taking pictures of Dennis.

Chris Makos brought down a "landscape" but then Victor brought down two and he made me do his first. Chris's was from the Harvard Drama School.

Dennis Hopper came and was watching me photograph the nude boy, but Victor didn't know who Dennis was and threw him out.

Thursday, June 9, 1977

Got to the St. Regis at 11:30 for the Jewish Anti-Defamation League testimonial to Elizabeth Taylor. Liz and Halston weren't there yet. I met the president of Cartier. Eugenia Sheppard was there. Hermione Gingold was there. A woman who didn't even have to say she was Bob Feiden's mother came over to me and said that, because she looked just like Bob Feiden but with jewelry. John Springer and Liz and Halston arrived. There were two or three Liz lookalikes there, one introduced herself to Liz.

I was next to Mary Beame, the wife of Mayor Abe Beame. There were a few anti-defamation people on the dais, and Hal Prince and Mike Todd, Jr. Liv Ullmann led the prayer, and Diane Von Furstenberg was there. Livia Weintraub who was good-looking gave a speech about being in a concentration camp, and she ended it with a plug for her new perfume, "Livia." She gave Liz one of the first batch of 50. Dore Schary was there, he founded the league. It was rotten food— gold salmon.

Then they gave Liz the plaque which had raw amethyst all over it—the stuff ashtrays are made of—it was of Mt. Sinai and at the top in gold was the Ten Commandments. Liz was in river purple, she got up and gave a little speech, very breathy and sincere, like, "I'm just like all of you—when I care about something, I do something about it, we're all like that, thank you so much." John Warner was there. Then she and Halston got up off the dais to make a trip to the bathroom and one of the ladies at Bob's table wondered, "Why are they *both* going to the bathroom?" And another lady said, "Maybe she ripped her dress and Halston's going to sew it for her."

Cabbed downtown because we had to meet Bella Abzug at the office to photograph her for the cover of *Rolling Stone* ($4.25).

Bella was there with her daughter, *(laughs)* another dyke. Oh I'm kidding, but you know what I mean—a chip off the same block. I took pictures of Bella smelling a rose. Jann Wenner came down.

Cabbed to La Petite Ferme, a little restaurant in the Village where George Mason was having a dinner for me. Catherine and her brother Valentine were waiting for us out in the rain. All the boys in the family are raving beauties, but the girls are like Catherine—just cute.

Then I talked everybody into going up to Studio 54 for the party for *Beatlemania*. Aerosmith was there, and Cyrinda Foxe from *Bad* who used to live with David Johansen but now she lives with one of Aerosmith. She said that a picture of me with a Campbell's Soup Can was in the light show of *Beatlemania*.

Saturday, June 11, 1977

Most of the office went to Montauk. I'm going to try to arrange for a Toyota for Mr. Winters, so Vincent is happy that he can tell him the good news. Mrs. Winters is trying to get him to move down to Florida, and Vincent is scared we'll lose him.

Looks like the place won't be rented until maybe August if Bianca wants it. People don't like it that all the rocks make swimming difficult, and that Montauk is so far away. It's not for sissies.

Thursday, June 16, 1977

I waited for Fred to pick me up to go over to Sloan-Kettering to see Dr. Stone to go under the knife for a biopsy. No, Dr. Strong. I got local anesthesia. They did it for half an hour, and then they said to go to work. I'm still worried, they don't know what it is. You get up your nerve to go for a test—you pop the question—and then pretty soon it can be all over, they give you the answer and you pop off. So I'll let My Dear Diary know soon if the days are numbered.

Went to the office ($4) with a bandage on my neck. Bob was interviewing Barbara Allen, the next *Interview* cover girl, on Men, Women, and Love. Tom Beard [*a member of Carter's inaugural committee*] brought a really interesting guy called Joel McCleary, who's the treasurer of the Democratic National Committee, and he's around thirty-five. He was the national finance chairman of the Carter campaign. He's trying to get the Dalai Lama back into this country. He said a lot of Tibetan monks work in a prophylactic company in Paterson, New Jersey, that they take the bus and go make prophylactics. And Barbara Allen said, "You know, that's true, a lot of prophylactics *do* say 'Made in New Jersey.'"

Went over to visit Victor at his new loft, which just has a bed in the middle with big jars of different kinds of Vaseline around it—he's so much like Ondine.

Saturday, June 18, 1977

Victor said that it was a good day to go around looking for ideas, so we went down to the Village. But it was like *Suddenly, Last Summer*—I was his prop to go cruising, the boys would come over to talk to me and Victor would get them. We sat at the Riviera Lounge for four hours having coffees and teas ($7).

Went home, called Julia Scorsese at the Sherry Netherland—she'd called me—and she said to hold on and then she was gone for ten minutes. Then she came back on and said to hold on some more and was gone for another ten minutes. Then Liza Minnelli got on the phone and said, "This is Liza, let me have your number and she'll call you right back." And then Julia called and said to come over for dinner. I said I was with Catherine and her brother that evening and she said to bring them.

Cabbed to Sherry ($2). As we were going in, a guy with a beard was getting into the elevator. Mr. and Mrs. Scorsese, Martin's parents, were there. They're taller than he is, which is unusual, because kids are usually taller than their parents. There were a couple of agents. His parents live downtown right below Ballato's. There was a nurse with a beautiful baby. It was a nurse that Julia had just hired, and she'd gotten lost in the airport so Julia was worried that she wasn't a good one. There was a Negro girl with a baby, too, and the guy with the beard turned out to be Bobby De Niro and this Negro girl was his wife, Diahnne Abbott.

Marty's skinny now, he's been on a diet. Jack Haley was running around. Liza was wearing the dress Halston made out of fabric based on my Flower paintings. Marty came out in a white outfit and then changed into a black outfit. Everyone went downstairs to eat. Roger Moore was with them, and a girl from U.A. who was doing publicity, she was kissing Roger.

Roger Moore was wonderful and charming. He showed us what he called his three expressions: "worried," "eyebrow up," and "eyebrow down." He's been married three times, he's married to an Italian woman now.

Bobby De Niro came in after dinner with an agent with funny glasses, didn't say much. Marty's parents were there really late.

Everybody got really really drunk. They were wanting me to make a toast, and I was so drunk I actually stood up and said something and it came out right I guess because everybody kept saying how *moving* it was, but I was so drunk I can't remember what I said. Liza kept saying, "I'll tell this to my grandchildren—and I've forgotten *everything* else!"

It was the best party. I stole a copy of the record album of *New York, New York* because Valentine wanted it, and Roger Moore had written backwards on it, and then I felt bad because they saw me do it. I was popping painkillers because of the neck operation from last week, the biopsy. I haven't found out yet. When we left the Sherry it was dawn outside, six o'clock (cab $3.50).

Sunday, June 19, 1977

Victor and I went down to have drinks at Windows on the World (cab $5). Drank and talked and looked out the window ($180). It was beautiful. Then we walked around the Village. In the old days you could go over there on a Sunday and nobody would be around, but now it's gay gay gay as far as the eye can see—dykes and leather bars with the names right out there in broad daylight—the

Ramrod-type places. These leather guys, they get dressed up in leather and go to those bars and it's all show business—they tie them up and that takes an hour. They say a few dirty words and that takes another hour. They take out a whip and that takes another hour—it's a performance. And then every once in a while you get a nut who takes it seriously and does it for real and it throws it all off. But it's just show business with most of them. Dropped Victor off ($5), stayed home and watched TV. Thought about the whole Scorsese scene. They're riding high, they're really riding high.

Monday, June 20, 1977

I called the doctor and he said to come by at 12:00. I was late because I was nervous. It was good news, it wasn't what they thought it might be. But now my neck is swollen and it hurts, I guess I shouldn't have had it done. Right after the doctor's office I went to church to thank God.

Then I went to Tony the florist to send flowers to Liza and Julia for the fun time on Saturday. I wanted to buy this one tree that looked beautiful, and at first they said they wouldn't sell it to me because it would only live one more day, but I said that was all it had to do—I knew Julia and Liza wouldn't be in town long.

Cabbed downtown and then walked to office ($3.50). Julia Scorsese called to say thanks for the wonderful tree, she said it was their most memorable evening, too. She invited me to go up to their room after the *New York, New York* screening.

Picked Catherine up and her brother, and the three of us went to the Ziegfeld ($2.75). Sat up front. Catherine and Valentine thought the movie was boring, but I liked it, thought it was one of Liza's best movies. Bobby De Niro's wife is in it. She sang a song and looked beautiful, but it didn't belong in the movie, had nothing to do with it.

Went to the Sherry and the party was jammed. Every time we wanted to leave, Julia said to stay. She was saying things like, "Please be Martin's best boyfriend because he doesn't have friends." Somewhere in his New York days Martin must have gotten something into his head about me, because it seems to mean something big to have me there and be together, it's like it symbolizes something, but I can't figure out exactly what yet.

We'd told a friend of Valentine's to meet us at the party but he never showed up, so we took a cab to the Stanhope to find him ($2.50). Room 15-something. We knocked on the door and he said, "I'll be there in a minute." This went on for a while. The room is 2′ × 2′. Valentine was getting so nervous he was beating his head. We decided to leave. The friend never made it to the door (cab $3, dropoffs).

Tuesday, June 21, 1977

Robert Hayes came in saying that he thought Diahnne Abbott should be the cover girl, and we called and asked her. She said that she was thrilled, but she'd need "a day to think about it," so I guess she thinks Bobby might give her a hard time.

Later that night I went to the premiere of *New York, New York* and seeing it the second time I

fell asleep around ten times. Victor was taking coke in the seat next to me, though, so that woke me up at the end—a little of it drifted over. Walked over to the Rainbow Room.

There was a black guy at the door of the Rainbow Room who didn't know me and wouldn't let me in and then another guy came to the door and it turned out to be this guy who always tells me that he wants his lobster pot back. He came to my house with a bunch of people once and says he brought a lobster pot that he cooked in and then he says it's still at my house and I don't ever know what he's talking about. I go crazy every time this guy starts up because it's always the same routine! If he sees me in thirty years it will still be: "Give me back my lobster pot." So he came out and said, "Oh, come right in, Mr. Warhol," and at first I didn't recognize him and as soon as we got in the door he turned on me and said, "Where's my lobster pot!" and I thought, *Oh this just can't be happening to me again. Oh no, oh no no no no no no....* Then the guy had to go back to the door and we got away.

We didn't go into the main room because I didn't know what happened to it, I didn't see it. We went into the side room and then Julia Scorsese came over and said, "Hold on to me, grab me, talk to me," like come here/go there/turn around/don't leave me—she's just like Susan Tyrrell and Sally Kirkland, sort of that type.

Then she said, "Don't look now, there's Martin's first wife, and I just get crazy when she's around." And the girl was very beautiful. I didn't know that Martin had been married before, I was surprised because he's so Catholic and always has the priest around and everything. The girl said, "You don't remember me, but I met you when I was the head of the Erotica Gallery." Then we left her and I introduced Julia to Earl Wilson.

I noticed that in the movie were lots of the people who actually work for Marty. Like the woman in the car who has the fight with Bobby and Liza is the wife of the agent. That's why it's good—the parts were written for the people.

Julia asked me to sit at the main table with her and Marty, but there was a big crowd and noise so I sort of pretended I didn't hear that because I wanted to slip away—it wasn't *my* night, it was *their* night.

Victor left and I was so worried about him, he was strange, and seemed bored, and for the first time since I've known him he seemed real. Like he was very tired and a normal person and wanted to go home. And he did.

Went over to Studio 54. The band struck up "New York, New York" and they carried Liza in. Halston did photos with her. Then a little later they played "New York, New York" and Martin walked in, and I think maybe they carried Liza in again or picked her up again, but I was leaving. Dropped Valentine ($3). It was 3:00.

Thursday, June 23, 1977

Went to the dentist. Asked Dr. Lyons not to take X-rays and he got mad. He said that I hadn't had one in ten years.

Then went down to the ninth floor to see Dr. Domonkos the skin doctor. Kitty Carlisle Hart was coming out in a sort of disguise and I asked the doctor why she was there and he said he was sending her somewhere else, so I don't know what *that* meant. Had a pimple squeezed. He told me to come back next week.

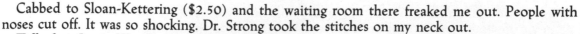

Cabbed to Sloan-Kettering ($2.50) and the waiting room there freaked me out. People with noses cut off. It was so shocking. Dr. Strong took the stitches on my neck out.

Talked to Jamie Wyeth who said we could go late to the president's fund-raising thing at the Waldorf. When we got there, there were picketers outside and it was like a bad movie. If you saw it in a movie you wouldn't believe it. They had sections for gay protest and sections for abortion. And they had a garbage can with abortions in it.

We were up in the balcony. When the president came in he went around and shook every single person's hand in the whole place and that took a few hours. Ann Landers was kind of nutty-acting. She told me that her daughter had a lot of Warhols and she wishes she'd gotten on the bandwagon early, too. The president made speeches and he had a good writer because the jokes were all good.

"I want my vice-president to be an active one, so if any of you have questions on"—he gave a list—"abortion, gay rights, downtown parking, Northern Ireland, the Concorde . . . just write him letters and he'll be happy to clear it up."

Is that the first time a president has ever said the word "gay"? It may be—because of Anita Bryant. Andrew Young told me he'd seen me the day before walking along Park Avenue.

Then we left and went down to see Bryan Ferry at the Bottom Line. Then everyone went to Hurrah's for the party for Bryan Ferry that Jerry Hall was having. Ronnie was there with a date, and Gigi was there with a date, and that was a drama. Ronnie said later that Gigi threw a drink in his face and he swears he hadn't said or done anything to her, but that then he retaliated by ripping the front of her dress.

Friday, June 24, 1977

Ronnie was drinking heavily at the office all day because he'd been woken up by Gigi at the door with two policemen and a restraining order, something like that. So since he was drinking, he was bossing me around, giving me art ideas, which was good.

Nobody was around the office to go interview Diahnne Abbott except Catherine Guinness, so I went over with her. It wasn't a good interview, I felt bad about it. It degenerated into me interviewing her little girl of around nine from before she married De Niro, and I take the blame for the bad interview because she's a friend of Nelson Lyon's so she must be intelligent, and I just didn't do a good interview. Dropped Catherine ($4).

Gave Jed $20 for car expenses and he drove us to Montauk. We're now trying now to rent the place to François de Menil or Earl McGrath.

Sunday, June 26, 1977—Montauk—New York

Sunny. Mr. Winters was thrilled all weekend because we told him he was going to get a new Jeep.

Earl and I discussed the cover of the Rolling Stones album that I'm doing. He wanted me to put some writing on it. I was down by the beach, Vincent was surfing, and there was a guy walking his big dog. I ignored him for a while, and then realized it was Dick Cavett. We talked a while

and he was fishing for an invitation so I invited him over for lunch. Peter Beard came over with Margrit Rammè, who was kissing Peter in front of Barbara Allen, his old girlfriend, but the two girls got along okay.

Dick Cavett told a Polish joke—put dots on his hands and then put his hand by his ear—"What're you doing?" "Listening to the Ink Spots." And then Margrit told one about the Polish police lineup where the guy rapist steps out of the line and says, "That's the girl!"

Barbara was upset because Jack Nicholson gave the part she "auditioned" for to an unknown girl who did some New York theater things.

I left early with François. He's a good fast driver—got us from Montauk to East Hampton in ten minutes. Jann Wenner had John Belushi at his place. Jann gave us a tour of the house. If he'd rented Montauk, he could have had something great, but I guess he and his wife Jane just wanted something "adorable." I was thinking about an idea all weekend that I got from the Liz and Dick book about doing a love affair between two parallel streets that can never meet. Dylan Thomas had once told Richard Burton he wanted to do that, but then he died. It would be a good thing for me to do, a good art idea.

Philip Niarchos kept calling Barbara from his car all weekend from London. He went to a big ball there, all the rich kids were at it.

Monday, June 27, 1977

Looked through the new issue of *Interview*. Barbara Allen really hates her cover, she says it makes her look fat. Jann Wenner sent the paintings of Mick back, they must have been too much money for him. Catherine was putting *Interview* down and we had a fight when I told her she was lazy. Nenna Eberstadt at the office sewed up Valentine's pants, but then last night they split again, so she didn't do a good job. I made a mistake of mentioning a lisp Valentine has and he got upset because he said he went to therapy for four years to get rid of it and thought he had.

Tuesday, June 28, 1977

Went down to the office where *Interview* was having a lunch for the Schenley's liquor people. I was in and out of the lunch because I was painting with the sponge mop in the back. I haven't peed on any canvases this week. This is for the Piss paintings. I told Ronnie not to pee when he gets up in the morning—to try to hold it until he gets to the office, because he takes lots of vitamin B so the canvas turns a really pretty color when it's his piss. Answered a few phone calls myself. A couple of cute kids from Sweden came by. Sent Ronnie for photo supplies ($5.95).

Cabbed to "21" ($5.50). Vincent picked me up. It had just started to rain. Dinner was with Peter Beard and his friend Harry Horn from Kenya. People were streaming upstairs for a dinner that Diane Von Furstenberg was giving for Egon's birthday. I was surprised when I saw Diane's mother—she didn't look Jewish, she was small and blonde. Then Mick in a lime suit came in with Jerry Hall. I thought things were fishy with Mick and Jerry and then the plot started to thicken. Mick was so out of it that I could tell the waiters were scared he'd pass out. His head

was so far back and he was singing to himself. The top part of his body was like jelly and the bottom half was tapping 3,000 taps a minute. He was putting his sunglasses on and off. Mick started going after Vincent, but it was just a ruse, because I found out later from Fred he's really passionately in love with Jerry, and it looks like there's trouble for Bianca. Jerry was saying, "I really have to go," and when Peter was going to go with her to get a cab she said, "Oh, that's all right, Mick will drop me off."

Then we went next door for a continuing party for Egon, this one given at New York/New York by Diane de Beauvau. Franco Rossellini was there with a big black and blue nose, and you couldn't see anything but that, but I wanted to be discreet in case somebody had hit him, so I ignored it until Franco said finally, "By the way, have you noticed my nose? My little dog bit me." He has a dachshund, so I got nervous. He took it to a funeral and the dachshund, Felix, got upset and bit his nose and wouldn't let go.

Wednesday, June 29, 1977

Worked. Victor came by after his trip to Fire Island. He had some come samples with him and I told him to start coming on the sheets and bring them in and we'd have an exhibit together in Victor's loft—his Come paintings and my Piss.

Thursday, June 30, 1977

George Mason called and invited me to dinner on Atlantic Avenue in Brooklyn. Stan Rumbough was going to the dinner, too, and that got me excited, he's the young rich Post Toasties son of Dina Merrill. Dina is in *The Wedding*, the Robert Altman movie that they're filming in Chicago. It just has a little bit of a storyline. Altman's doing all the things we tried to do in the late sixties and early seventies.

George Mason picked me up. Stan Rumbough is very big, about 6'3", and he's handsome, but he talks like a fairy. I've seen him a few times with cheap, sort of Oriental-looking girls. He's got a high, nelly voice, but I guess he likes beautiful girls—he was disappointed that Candy Bergen cancelled out, he said he'd gone swimming with her when he was seven years old and wanted to see her again.

It was an Armenian-Turkish-African-Arabian-type restaurant. Mashed chickpeas, mashed eggplant, three guys playing music. George had his model girlfriend Maret from Finland there.

Barbara Allen was there. She still just really hates her *Interview* cover. The man with the new model agency came, he brought about five girls and boys. Valentine was in heaven. The owners came over a lot and took pictures. A nun came over to me to autograph a bottle but my pen didn't work. She said she'd just gotten out of an operation and that seeing me was the most exciting moment of her life since she won $500 in the church lottery. (*laughs*) I mean, if these are high points for a nun . . .

Stan Rumbough seemed to like Barbara and was saying something that sounded like "blow job" a lot and blowing into a bottle. Philip Niarchos is probably not going to marry her, so she should

get him worried, or something like that. She should live with him and get more things before he drops her.

Stan says he's a "photographer." These rich kids, it's so funny to hear them sit there and say, "I have a job, oh yes, doing pictures for a catalogue, I work for a man who does catalogues, and this is the second time I've been to Brooklyn—the first was yesterday, I came here to pick up some wax fruit to shoot...." I asked him if he wanted to do pictures for *Interview*. I mean, Dina interviewed herself just to get Stan's picture of her published. And he said, "I'm in a busy time now, what with the catalogue work...."

Then on to Earl McGrath's party for the *Star Wars* people—Mark Hamill, Harrison Ford, Carrie Fisher, and another girl, but by the time I got to 57th and Seventh they were gone (cab $8).

MacKenzie Phillips asked Vincent, "Got any blow?" Jann Wenner was there and I introduced him to Stan Rumbough, but Stan is so stupid-sounding and I forgot to clue Jann who he was, so Jann probably thought he was just some kid who took pictures of waxed fruit, because that's all he was talking about again.

Good food. Fran Lebowitz and Marc Balet were there, they may have come with Jerry Hall and Bryan Ferry. Jerry seemed to be back with him.

Earl showed a videotape of the Sex Pistols.

Barbara and Stan and I left together, and when I left them they were still together.

Friday, July 1, 1977

Suzie Frankfurt and Jed left early for Montauk in order to spruce it up for the prospective renters.

Victor invited me over to Halston's house for dinner. Halston had gone to Joe Eula's for the weekend in upstate New York, and he lets Victor use his house on 63rd Street while he's away but he never tells him when he's coming back, just to keep Victor on his toes. So Victor invited lots of people for dinner with me. One of them was Peter Keating, a top male model. His hair is receding, but he didn't start to get popular until it started to recede, he thinks it's because this way he doesn't "pose a threat" to men.

Victor made a chicken. The house was freezing and I was the only one cold because everyone else was taking coke. Halston has a freezer stacked full of vodka, so it's like drinking liquid oil. I had about four small glasses. Also there were a couple of John Waters people from Baltimore. The one guy who looked like a heavier John Waters said that he was Divine's roommate. I asked if he and Divine were lovers and he said, "Well, after all these years, you really fall in love with the *mind*...." Victor said he'd made it with someone in a van in front of Halston's, because they weren't sure when Halston was coming back.

Saturday, July 2, 1977

Victor called and said he wanted to take me to dinner in the Village. I picked him up (cab $4). We went into porno magazine stores for research materials for the "landscapes" ($36) and another one where the guy wouldn't give us a receipt ($17). Bought a "fairy shirt" that has my name on

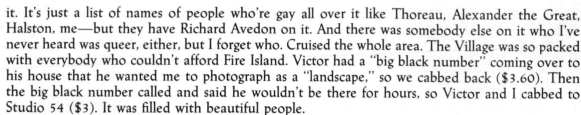

it. It's just a list of names of people who're gay all over it like Thoreau, Alexander the Great, Halston, me—but they have Richard Avedon on it. And there was somebody else on it who I've never heard was queer, either, but I forget who. Cruised the whole area. The Village was so packed with everybody who couldn't afford Fire Island. Victor had a "big black number" coming over to his house that he wanted me to photograph as a "landscape," so we cabbed back ($3.60). Then the big black number called and said he wouldn't be there for hours, so Victor and I cabbed to Studio 54 ($3). It was filled with beautiful people.

Went back to Halston's, Halston wasn't home, waited for the "landscape." Took pictures when he got there until I ran out of film. When I opened the door it was bright daylight. I was surprised. Home at 7:00.

Sunday, July 3, 1977

The kids called from Montauk, everybody was out there. Jan Cushing, Jackie Rogers, François de Menil and Jennifer Jakobson, Barbara Allen. Mick had moved over from Peter Beard's and spent time in one of the bedrooms with Barbara.

Walked over to Victor's-at-Halston's. I ran into Stevie of Studio 54 on the street. Victor was trying to call his big black number again. Halston came in just as I was leaving, and that was awkward, really awkward.

Victor is my new Ondine, he even uses a TWA flight bag like Ondine used to. But it's getting kind of too heavy, seeing him so much. He should get his art career going, but he thinks he doesn't have to have sex with somebody to get ahead. I told him, "You've got to fuck your way to the top." Then I told him the Barbara Rose/Frank Stella Story.

Some blacks recognized me a few times this weekend, and I'm trying to figure out what they recognize so I can somehow sell it to them, whatever it is.

Tuesday, July 5, 1977

Rupert came by. He was wearing a lady's jumpsuit. Ronnie had told me that Rupert wasn't gay, that he lived with a girl, so I teased him and said, "What are you wearing *that* for? Are you a *fairy*?" and we all fell over when he said, "Yes, I am." Ronnie's eyes popped out. Suddenly it all started to make sense—the blond hair poofed up, the walk, the women's clothes—he was gay!

Victor called. He said that Halston threw him out, accused him of stealing the coke. Victor says Halston keeps most of the coke in the safe but he doesn't know that Victor can open the safe. He also detected that Victor had had a gang bang because there were greasy handprints on the walls and come on the Ultrasuede.

Wednesday, July 6, 1977

Victor came by the office to loaf. Halston took back the key to his house because of the gang bang. Or maybe it was because he caught *me* there. We'll see if he's mad if he starts sending the paintings back.

Cab ($4) to Elaine's for dinner with Sharon McCluskey Hammond, and her favorite cousin who she just met for the first time a week ago, Robin Lehman. My ears perked up, because he's the son of the guy that left the Lehman wing to the Metropolitan Museum.

Steve Aronson said he wanted to look at the menu but Sharon told him, "If you ask for the menu, Elaine charges twice as much." Steve flashed a wad of money and said, "I can afford to hear the menu. There isn't a menu in the world I can't afford to *hear.*" Sharon said, "Okay, Steven, have it your way. Waiter? The menu." Later, when Steve and Catherine were leaving, Steve threw $40 on the table. Valentine said oh no, no, that that was too much for two people and that we shouldn't take it. Then the bill came and it was $148! I hadn't even had anything to eat. Robin had a steak. Sharon had spaghetti. Steve had spaghetti. And nobody even drank.

Thursday, July 7, 1977

Bob and I cabbed to the Pierre Hotel for the lunch in honor of the empress of Iran. There were demonstrators out front and it was scary, they wore masks, but they were Iranians, you could tell, because their hands were dark. We were special, so we went to shake hands with the empress— the, you know, queen. Governor Carey and Mayor Beame were in the receiving line, and Zahedi.

The queen was reading a prepared speech and it was going along okay, and then a woman in a green dress in the press section stood up and screamed, "Lies, lies, you liar!" and they dragged her out. The queen kept on reading her prepared statements and then afterwards apologized to everyone for the noise and demonstrations that were going on because of her. She said that women's rights in Iran may not seem so much to Americans, but in Iran it was big steps.

Cabbed to meet Ronnie ($2.50) and look at uncut stones for my Diamond paintings. Then cabbed down to the office ($3).

Cabbed up to the Iranian embassy ($2.50). There were no demonstrators out in front. Inside I saw Otto Preminger again and it was the second or third time in a few days, so he asked me what we were going to do tomorrow. I posed for pictures with the queen in front of my portrait of her. She said she was jealous of Hoveyda because he had eight Warhols and she only had four. The queen is taller than me.

Cab to Marina Schiano's for dinner ($3). Françoise de la Renta was there, she put the Shah down saying he was greedy and awful but she said she liked the queen. She said he had twenty-five mistresses an hour. Suzie Frankfurt was there. Bob was in the bedroom where there was coke. Giorgio Sant'Angelo came in and then Suzie and I were sitting right there and Giorgio says to Bob, "Who is this Suzie Frankfurt?" This is that thing that people on drugs do. It's just like they do in Hollywood when they don't like somebody—they talk about them as if they weren't there. In a way it's great—if it could only happen more. Marina and Giorgio are the ones who really do it a lot. I said, "Suzie, they're talking about you!" Bob said to Giorgio, "She's a good friend of Andy's, it's all right." "But who *is* she?" Giorgio said. "She's very rich," Bob said. This is all with us sitting *right there*, with Giorgio and Bob acting as if we *couldn't hear.* Finally I said, "Oh come *on,* Bob. You're talking about people in front of them."

Dropped Suzie ($2.70).

Barbara Allen told Bob that Mick is very unhappy, he says it's over with Bianca, that he has

no feelings for her. He thinks she uses him and he doesn't want to go to St. Tropez where she is. Barbara says she just thinks of Mick as a friend, the way she thinks of Fred and Bob, and that she has sex with him only because he's lonely now.

Friday, July 8, 1977

By the way, Valerie has been seen hanging around the Village and last week when I was cruising there with Victor, I was scared I'd run into her and that would be a really weird thing. What would happen? Would she want to shoot me *again*? Would she try to be friendly? *[see Introduction, Valerie Solanis is the woman who shot and nearly killed Andy in 1968.]*

Went to Nippon with Marina Schiano, and Franco Rossellini was there. Franco was saying that he doesn't know how the story about Imelda being "married" to Cristina Ford got all over the world—"because I only told one person and it wasn't my story anyway." But he did tell everybody in the world—it was his joke story-of-the-week once. So now I think Imelda and Cristina are mad at him.

They dropped me off, and it seemed like they wanted me to invite them in, but I didn't.

Sunday, July 10, 1977

Was going to go down to work but the phone rang and it was Julia Scorsese. She was with a girlfriend, a writer who's working on a series. Julia said they were going to meet Barbara Feldon at Serendipity, so went to the Sherry to pick them up.

Julia was driving me crazy, sometimes when I'd catch her eye she looked just like Valerie Solanis, and then she also acts like Viva. She got it in her head that I "saved" her the night of *New York, New York*. She said that she wasn't next to Martin at the table and I went over and sat her down there and that that squelched rumors that her husband was having an affair with Liza Minnelli so the papers didn't get it. She went on about that a lot and she was walking sort of drunkenly on blue high heels and her pupils were dilated.

When we got to Serendipity, Barbara Feldon was there. Julia started doing what I hate more than anything, patting my head all the time. She drove me crazy. And she kept trying to fix me up with her girlfriend who was tall and kind of pretty, and it was them saying, "You're so wonderful wonderful wonderful" to me for hours, and I didn't know what to do. Since I told her they didn't have liquor, she brought champagne. I don't understand these girls, they talk and say things and I don't know what they're doing.

Barbara left and we cabbed to Elaine's. We ordered, and it was more "Aren't you wonderful"s. Julia said she wanted to set up a date for me to meet the writer of *Annie*, she said it would be nice for me to meet some real men, and I didn't know what that meant, if she was saying "real men" and the real men meant fairies, or what she was talking about. Julia told me how they do things on Marty's movies—they rehearse the people, do videotapes, then Julia picks out the best things and they have the people redo them that way on camera later during the shooting. She

said they change the plot and twist it during the shooting. Like in the original story of *New York, New York*, Bobby De Niro goes into the record business.

She said that Marty has coke problems and he got blood poisoning and now he takes medicine to clean himself out. He's cutting three movies now. She said she wrote a lot of *Taxi Driver*. I started saying people act like it's the directors and the producers and the writers who make a movie when it's actually the *stars*, and she took offense saying her husband had *created* Bobby De Niro and Harvey Keitel and some other people. But I said they were new faces and people always want to see new faces. Marty is now in Chicago doing a musical called *Shine It On* with Liza.

She said that she gave Robert Altman the idea to film *A Wedding* in Chicago, to take it out of L.A. and give it a different atmosphere. The producers gave her three days off, she said, so I took that to mean she must have been driving them crazy. Julia was getting a little too drunk. She dumped her pocketbook on the table and all the credit cards spilled out. She went to the bathroom and I put them back in (dinner $70).

Monday, July 11, 1977

Forgot to say that on Friday Paulette Goddard called. She sounded a little drunk, cranky. She's very mad at Valerian Rybar who's decorating her apartment in the Ritz Towers—he made it all pink and blue and even though she approved those colors she said she doesn't know how she could have.

Wednesday, July 13, 1977

Cabbed up to Rockefeller Plaza to the Warner Communications offices to see Pelé, the soccer player who was being photographed for *Interview*. He was adorable, he remembered meeting me at Regine's once. We were on the thirtieth floor. He's sort of funny-looking, but then when he smiles he looks beautiful. He has his own office up there, and they're making Pelé T-shirts and hats and cartoons.

Mark Ginsburg had called and said the interview with Irene Worth was on for that night, and I said I'd meet him at the Vivian Beaumont where her play *The Cherry Orchard* was. We were going to see it first.

Irene's voice was good, and that's all that really matters—everything she says sounds like real acting. The lights went down and I thought it was the end of the act, but it wasn't. It was the Blackout of '77. They kept acting on stage in the dark, and the girl who played the daughter announced, "Isn't this fun? Let's keep going!" A guy came on stage and said that anybody who wanted to leave would be shown the way out, and that they'd just keep going with the play, they had guys on stage holding candles.

So everybody was a real trouper, and this was the moment these actors had been waiting all their lives for—to make the show go on.

Then after the play, as Mark and I were walking backstage to see Irene, a man said, "This is

the most thrilling thing that's happened to me, passing Andy Warhol in the dark." Irene changed and put on bluejeans and turned out to look young. She served champagne. I had enough tape for three or four hours' taping. A Lincoln Center guy was saying, "Stay in the crowds, they're mugging people all over" (cab $4, big tip).

For some reason it was so simple to get a cab, we just walked out and got in one and went with a friend of Irene's who I also know, Rudy, to his apartment on 67th and Lexington, right on the second floor. He had candles all over because he always eats with candles. He made omelettes on his gas range, it was all so easy. They were delicious. Did the interview with Irene.

The phones were sort of working—you had to wait for a dial tone, but then it was okay.

Thursday, July 14, 1977

My power on 66th Street went on about an hour ago [*Friday, 8:00 A.M.*] On TV the reporters showed the looting, they had TV crews right there, filming the looters, and the lights from the TV enabled them to see better to steal more. It was like the TV people asked them where they were going to steal next so they could set up. On TV they're all chained together and they're all black and Puerto Rican. It looks like *Roots*.

Maxime de la Falaise called the Factory to see if there was electricity there. She's been moving down to her loft on 19th Street from the Upper West Side all week. She tried to save money by getting hippie movers, and it's taken a week instead of a day. The hippies carry things out leisurely and look at chairs and ask each other, "How old do you think this is? Eighteenth century?" Professional movers just crate up dead bodies, if that's what you have in your apartment, they don't miss a beat.

Had dinner with Sharon Hammond and Robin Lehman and afterwards we walked down Eighth Avenue through the drag queens and transvestites and whores over to Studio 54. Steve Rubell was thrilled to see us and let all ten of us in free. He reminded me that I'd asked him to marry me a few weeks ago, and I couldn't believe he would remember something casual and offhand like that. I said it *once* and didn't even think he heard me. I mean, he's a young kid doing well, being successful—I'm so tired of working I propose all the time to people who're doing well. Why would he remember that as if it was serious?

Saturday, July 16, 1977

Son of Sam is still out on the loose, and that's an old-style crime—notes to the police, an M.O., killer on the loose, all that. People seem sort of happy to see a pattern. Son of Sam is nostalgia, almost. Goes after long brown-haired girls.

Up very early. Had lunch at the office for Victor and a kid he knows from NBC, Andy Wright, and Victor's new beautiful girlfriend who gives him coke, from Greenwich, Connecticut, Nancy something, who models. He's been fucking her to get the coke.

Monday, July 18, 1977

I'm reading the Evelyn Keyes book *Scarlett O'Hara's Younger Sister*, and she describes everything in detail in her sex life, it's great, sex with King Vidor and with John Huston—how he put it in and everything. And she says that Paulette Goddard was her idol, that she copied everything about her, her hair, her voice.

Called Paulette and told her about the book, how much Evelyn loved her. She said, "Oh yeah, she loved me so much she stole all my boyfriends, and when she stole my last boyfriend, I dropped her."

Cabbed up to Suzie's ($2.35). Sandra Payson who's married to George Weidenfeld was there and as I sat talking to her, a cockroach was running on her. I didn't know if I should say something or not. But then maybe she knew because she stood up and said, "Shall we get moving?" And that knocked it off. What would Emily Post do?

I decided to really really hustle so I took Lady Weidenfeld home. We walked a little, and then she was overheated and we cabbed to 25 Sutton Place ($2.50). We talked about Diana Vreeland's nose. She popped the question about how much a portrait is and I said, "Oh, I can't talk money, talk to Fred." That effect.

On my way home, a cab stopped and I really wanted one, but since it had stopped for me I was suspicious to get in and didn't. Went to a magazine store ($4).

Tuesday, July 19, 1977

Stanley Siegel had looters as guests on his TV show and also Adela Holzer to defend herself against the fraud charges. She said that the investors had started to worship her and so they expected to make a fortune and when they didn't right away they got mad. She kept correcting Stanley that she'd been "booked, not arrested."

All day was preparing for the *Interview* advertising party at 5:00. People started coming around then and by 6:00 it was jammed. Everybody likes Gael Malkenson, who just started working full-time for us now that she graduated from college—she's aggressive and everybody thinks she should really be the one selling ads.

Ruth Kligman came by and kissed me smack on the lips and told me she was off Jack Nicholson for her Jackson Pollock story, and the new he-man screen-man of her dreams is Bobby De Niro, he's all she could think about.

Wednesday, July 20, 1977

Tom Seaver came down to pose for an Athletes portrait. Richard Weisman came, too, in a limo that parked downstairs. Tom Seaver was adorable. Athletes really do have the fat in the right places and they're young in the right places. The person taking the photographs was Mr. Johnson, a nice man who did the story on Jamie Wyeth and me once. He wanted Tom to wear a Mets hat, so they went out and bought one, and then he wanted Tom to do a Cincinnati-uniform-

with-a-Mets-hat picture, half and half, but he refused. Tom's wife Nancy was calling on the phone. He hates the Mets now. He'd just bought a new house in Connecticut and everything when they traded him.

I haven't been feeling well for the past two weeks, I think it's the pimple medicine. I'm going to the pimple doctor again early in the morning.

Thursday, July 21, 1977

After the pimple doctor I went to the office. Lunch for Christopher Wilding and his stepsister, the adopted Liz Taylor-Richard Burton girl, she was pretty but not a raving beauty, about sixteen, shy. Firooz Zahedi was there, and the Blondie girl was being interviewed and photographed by Chris Makos. Her real name is Debbie Harry, she's been around for a long time, sort of on the fringes. She knows everybody. If she had a body like Cyrinda's she'd be really great, although her body's okay, like a Sandra Dee-Tuesday Weld-type body. She's small.

Allen Midgette came up earlier to show his wares, he's making leather clothes, and he really works hard on them. He stayed for lunch. He keeps in shape dancing. We reminisced about the sixties when I sent him on that college lecture tour with Paul and Viva to impersonate me and then the places found out and made me redo the whole tour.

Monday, August 22, 1977

Cabbed to Chembank ($3.40). Walked over to University Place to look for things to paint.

Then cabbed to Richard Weisman's with Susan Johnson and Jed ($4.50). Susan needs a new man—the Billy Copley affair didn't work out. When we got there, everyone was already watching the Wimbledon match between Bjorn Borg and Vitas Gerulaitis. Those last two weren't there yet, they were having dinner together. The match went on three hours, and somewhere in there Vitas came in with a girlfriend but Bjorn had gone home from dinner. The joke is always that Bjorn sleeps for four hours then plays tennis for two, and that Vitas plays tennis for two hours then discotheques for four. Now Vitas has just discovered New York/New York. Susan Johnson was hurt, all the butch athletes had girls that were tall, slender, blonde, long-haired. She's just cute and little and brown-haired.

There was a lot to drink, no cocaine. Everyone teased Gerulaitis that he was wearing his gold coke-cutter razorblade around his neck in the match. He's in training now, he left early and only ate a plum.

Tuesday, August 23, 1977

Dinner to interview Diahnne Abbott was at Quo Vadis. Picked up Catherine. Bob began asking Diahnne (laughs) in many different ways how it felt to be colored. "Are you really colored? How do you feel about your skin? Do you like to dance?" And then he got it down to what did it feel

like to be colored and in bed with Bobby De Niro. Then I think she must have slipped Bob some coke—he went into the bathroom and came back a zombie.

Diana Vreeland was there for dinner with Alessandro Albrizzi from Venice, at a table behind us. Then later as we were leaving, I introduced Diahnne to Diana and Diana said, "I'm madly in love with your husband." We went over in Diahnne's car to Studio 54. Fred and Ahmet Ertegun and Earl McGrath were there. Earl said he was thrilled that Fred had agreed to so little money for the billboard I'll be doing for the Stones.

Diahnne didn't like the music that was playing, it wasn't right, she wanted to leave. Went up to Elaine's. She played some songs on the jukebox that she wasn't able to hear at Studio 54. Bob continued the questioning on how it felt to be colored.

She told about her waitressing jobs in the Village at the Left or Right Bank, places like that. Then Bob asked her about politics, and she said she didn't think about it, and then Bob brought up *Idi Amin!* I mean, *everything* he said was colored (Elaine's $50).

Then Diahnne invited us down to her apartment. It was peculiar, it was like this meant she was really accepting us or something. Barrow Street. She had clothes all over, she was buying lots and lots of clothes. They're looking for a new apartment and I suggested Park Avenue, but she said they have an image to protect. She served Dom Perignon, showed us baby pictures. She let the limo go, which was tacky, and we had to cab home. As we passed the Studio 54 neighborhood, Bob screamed, "Let me out, let me out" (cab $5).

Tuesday, August 30, 1977

Up early to go to see Dr. Lyons for a teeth-cleaning. Went to Park Avenue to get a cab downtown and one pulled up and the door opened and it was lovely Barbara Rose saying, "Let's share a cab downtown." The fare on the meter was already past $3, I noticed. She's now going with Jerry Leiber, the Leiber-Stoller guy who wrote "Hound Dog" and so she talked about Elvis, although I don't think Leiber went to the funeral in Memphis. She said she and Leiber are writing or have written a play and they want Al Pacino to play Elvis. God, I just hate her. She's so awful (cab total $7).

They're saying that the article Caroline Kennedy did on the Elvis funeral for *Rolling Stone* made fun of the local people, but I can understand that—Caroline's really intelligent and the people down there really *were* dumb. Elvis never knew there were more interesting people.

When I got to 12th Street I walked around University Place for ideas. Then over to the office. Sandy Brant was there with Jed going over decorating schemes for Peter Brant and Joe Allen's office building in Greenwich that Philip Johnson designed. Jed's in the decorating business now.

Cab to Alkit Camera ($3) on 53rd and Third. The cab driver didn't even turn around to look at me but he knew who I was. I asked him how he could tell. He said that he'd been buying art since he was twenty and just "stacking it around the house like the Collyer Brothers." He went to auctions and places for art bargains, and he was thrilled to have me in the cab. I got a new camera because I had to take pictures of Chrissie Evert later in the afternoon. For the Athletes series.

Had Bettina, the famous Chanel model from the fifties, to lunch. She's the beautiful one who

was in the car with Aly Khan when he died. She's here to open an Ungaro store on Madison around the corner from my house. She was wearing a purple dress.

Chrissie said she and Burt Reynolds were talking about me recently, and that's why she wanted to do this. Victor came in and he started dragging out the Shadow paintings of cocks and assholes that I've been doing—the paintings all the "landscapes" have been posing for—and somebody had to tell him not to. I gave her a copy of the Burt Reynolds issue of *Interview*.

Thursday, September 1, 1977

Went to the eye doctor and tried about another fifteen pairs of soft contact lenses. Finally a pair that was very very thin, the thinnest, felt the best.

Sunday, September 4, 1977—Paris

Got up late and went back to sleep and I still wasn't ready when Fred was ready to go at 1:00. Taxi to YSL's for lunch. Fred had to lie and say that I was a cripple so that the driver would take us such a short distance. The driver looked me over and said, "Yes, I can see that" ($2).

Pierre showed us his birthday present to Yves: a sixteenth-century vermilion lion with ruby eyes. Yves also had on a lion ring. I taped the entire lunch. They spoke a lot of French so we stared around a lot. After lunch we went to the garden and the dogs were let out and Pierre played with them. He told us that he uses a cock ring. Pierre said that they were putting silicone in cocks now so that they stayed hard all of the time. Yves said he hoped everyone would do it so he could design new pants.

Tuesday, September 6, 1977—Paris

Went to Castel's for dinner. As we were going upstairs Fred noticed that Joe Dallesandro was there so he went down to ask him to come up and join us but Joe said no and that began to bother Fred. So then Fred began drinking champagne. Lots of people there—Caroline of Monaco's fiancé Philippe Junot, Florence Grinda's brother, and Pam Sakowitz who's getting divorced. Fred kissed her hand. Then Fred had an argument with a waiter about the fish forks. I asked Fred why he was so upset, if that meant he'd had an affair with Joe, and he didn't answer me. We learned more about Fred with every new champagne bottle. Then he decided to go and make Joe come up. Joe looked so dirty, his teeth were so dirty, like licorice. He talked loud, said he drinks a bottle of bourbon a day. He's making a movie with Maria Schneider—they're playing zombies. He put down his girlfriend Stefania Cassini who left him. Said that he bought her $5,000 necklaces that she'd hide in the safe and then go run around Rome calling herself a Communist. Now he's having affairs with boys and girls—just anybody, he said. He asked us to join him downstairs because he had a table. We said that we'd be down. Later he came back and screamed that they were taking away his table so we should hurry up. He had some rich illustrator paying for it all. Joe

started dancing with two black guys, and Fred was getting drunker and started dancing with them, too. I got so embarrassed that I left.

Wednesday, September 7, 1977—Paris

Phone rang. It was Paloma for Fred but he wasn't in his bed. Decided that I couldn't worry about him anymore. Paloma had a lunch date with him and said that she'd call back. About 1:00 he arrived and she called back so we all got ready to go meet her. Cabbed to Angelina's ($2). Paloma was wearing all red YSL. Talked about old romances and old happenings out of the past. Paloma picked up the check.

Friday, September 9, 1977—Paris

Bob got Liza Minnelli to do an endorsement in the Puerto Rican rum ad that'll run in *Interview* and he's now working on Jack Nicholson.

Someone called New York—found out that Bella Abzug lost, Cuomo won.

Monday, September 12, 1977—Paris—Venice

The Air France flight to Venice took two hours and we took a boat taxi to the Danielli ($20). Checked in and then we went out for lunch at La Colomba ($25). Went by Autillo Codognato's jewelry shop. He's working on my show here with Doug Christmas. Ran into Nan Kempner. The show is Friday but the paintings are still in customs in Rome. While we were on the launch we saw Graham Sutherland signing prints.

Tuesday, September 13, 1977—Venice

We had breakfast and then moved to another hotel where we had a pretty room with a balcony and I liked it better (tips $10, cab $10). Autillo had invited us all to lunch at Harry's Bar. Had chicken with peppers and listened to Doug and Autillo talk about the customs problems still. They're going to call the ambassador in Rome to try to speed things up.

Wednesday, September 14, 1977—Venice

There was a storm in the night but woke up to a beautiful day. We were supposed to visit Peggy Guggenheim's collection so we started moving. In the lobby there was a photographer who began to take pictures of me and continued all during the trip back across the *laguna*. Doug then took us to Il Prisione where my show would be. It's not a prison, it was a fancy men's club, it's next

to the Doge's Palace. It's a good space with high ceilings but not too big. The white board for hanging went all around the wall but Doug wanted to paint it flesh-colored. The man in charge there took us up to the roof to show us a big cloth banner that said ANDY WARHOL and the dates of the show, 16 September–8 October. There was another one in San Marco Square under the clock and another one on the way towards Accademia. Jed photographed them.

At Peggy's we looked around at everything. John Hornsbee, the curator, asked Peggy if she wanted to receive us and she said no. She's sick. And we didn't really want to see her anyway.

Thursday, September 15, 1977—Venice

At 4:00 I had to go over to the prison to sign some posters in advance. Some high school art teacher from San Francisco had left a can of Campbell's for me to sign for him.

Jed and I went to the paper store to try and find some office gifts. We picked out some good designs of Venetian handprinted paper ($60). Went home to rest up. Thomas Ammann arrived from Zurich.

Friday, September 16, 1977—Venice

Jed and I got up and did some sightseeing and some more last-minute office shopping (gifts $29, $49, $39). We all met for lunch at Cipriani and Doug didn't seem at all nervous even though the pictures hadn't arrived yet. After lunch I went over to check and they'd finally arrived. The flesh color was a little off on the walls but it looked all right anyway. They all started to work. The Italian workers had already started hanging the paintings. Doug's assistant, Hilary, told me the workers were surprised when they saw that my paintings were closeups of naked bodies and I guess they didn't think that was good art because they started to make jokes and compare the cocks with their own and they didn't do much work. She said that she and Doug had to do most of the work themselves. If Italians laugh at you and lose respect, you can't get work out of them—that was the trouble Paul Morrissey had in Rome when he was shooting *Frankenstein* and *Dracula*—I guess the crew decided he didn't know what he was doing, because they'd just stand around and sort of snicker.

We went back to the hotel to rest. Then went to the show at about 7:30. After an hour or so we went to Florian's for a drink and everyone took photos. Then went to Autillo's apartment on the second floor of a big *palazzo* on the Grand Canal. The big hall was all set with tables for 100 people. Autillo showed us his collection. He had my Flowers and Jackies and lots of good art.

At dinner I was beginning to feel my chair slip out from under me and was holding on to the table when a waiter told me I should change chairs. But I guess he put the bad chair at another table because in a few minutes I heard a crash and saw a white-haired man getting up from the floor.

After coffee we drifted around a little and looked at the collection some more. I was getting tired and was ready to go but it was by then pouring rain. Fred was drunk and he was very quiet. We waited downstairs for the boat taxis. They didn't come right away so we decided to walk. We

held our coats tight around us. Fred slipped once but we got him home all right. Right after I got in bed I felt the entire building move.

Saturday, September 17, 1977—Venice—New York

I told Jed that there'd been an earthquake the night before and he said it had just been the wind, but when the floor shifts and everything starts to slide you know it's an earthquake. It turned out it was—Autillo said a painting fell at his house.

Got a speedboat taxi to the airport, zipping over the waves ($25 plus $5 tip). At the airport ran into Johnny Nicholson of the Café Nicholson. Bought magazines ($10). On the plane I found a good review of *Bad*—twenty-five movies opened in Paris this week and *Bad* was the one getting all the publicity, they're saying it's the first "punk" movie. They're calling me the Queen of Punk.

Sunday, September 18, 1977

My opening at the Folk Art Museum is tomorrow night. Everybody who's been giving me freebies all over town now expects to be invited to this, but it's so embarrassing because the museum isn't giving me any free tickets, it's a $100 benefit. It's just so horrible, these people let you in free all over town and you can't even invite them. I just kept telling them that it isn't anything and that it's going to be boring. Which it is.

Monday, September 19, 1977

Went to see Dr. Poster (cab $2.50) because when I plugged in my contact lens cleaning machine in Paris it was the wrong voltage and it blew out.

Richard Weisman was coming to the office at 2:30. When he arrived he said I had to go to Columbus tomorrow to take pictures of Jack Nicklaus. Richard and Fred had a meeting about the series of sports-star portraits Richard commissioned, and I wished I'd stayed in the meeting longer because after I left they decided there would be the show in December of the ten Athletes portraits we finally settle on to exhibit and I think January would be much better.

Chris Makos came by and gave me a copy of *White Trash*, his book of photos, and it looked good, he did a good job.

Left the office early. Doc Cox said he was picking me up in his Rolls Royce and I cringed, because I just *hate* to be seen in that car. But he arrived in a cab and I was secretly thrilled when he told me the Rolls had broken down. But I changed my mind when we arrived at the Folk Art Museum because there were photographers all over and actually, for once, the car *would* have been a big hit because just getting out of a crummy taxi was a bomb.

Ultra Violet was there and now, thinking about it, she must have had a facelift. She looked like the first day I met her, really great. Really really great. She was wearing a dress with gold coins pinned to it and she was selling them. She already sold the good American ones. I think

she got the idea of owning gold coins from me in the days when she thought that whatever I did must be really smart.

We went over to the Four Seasons. There were cocktails in the lobby before dinner. I was seated in between Sandra Weidenfeld and Estée Lauder. Estée was really nice, she'd put perfume on the table for free samples. Peter Duchin's orchestra was playing.

Marina Schiano didn't like the end of the table she was at—she was upset she wasn't with Fred, Diana Vreeland, and Diane de Beauvau—and she said that for $100 she should be able to sit next to her husband, Mr. Hughes. [*Marina was married to Fred Hughes for a few years although they maintained separate residences.*] She went over to Bob who was at another table having a miserable time, and told him that she was going home—this is 10:15—and to pick her up for the Studio 54 party in about an hour. She said that she could have been out with Marvin Gaye instead of at this thing.

Doc Cox was really drunk, drooling over Bob's Kevin. Kevin Farley. I signed things for people and felt bad because they were my friends and I went blank and couldn't remember their names—people I'd known for twenty years who gave me my first job.

And then afterwards Alana Hamilton was giving a birthday party for Mick Flick at Studio 54. I was so happy to go to a big fun party after that horrible dinner (cab $2.50).

Peter Beard was at Studio 54 and for the first time I saw him so drunk that his words were slurring. He told me he was glad after the Montauk fire burned his mill-house down that he wouldn't be doing diaries anymore, that he was actually relieved they'd all been destroyed. I told him *not* to be relieved, that he *had* to do more. Sterling St. Jacques was there, he said he has a part in *The Wiz*—he and Pat Cleveland have broken up. He brought me over to Shirley Bassey and she seemed thrilled to meet me.

Stevie Rubell was nice to me and kept bringing me vodkas, but the vodka there is the cheapest and I hide it. But when Bob came over it was just what he drinks so I gave it to him, but Kevin shook his finger and said that it was a "no-no"—he doesn't want Bob to drink. It's so sick, Bob letting himself be henpecked.

Tuesday, September 20, 1977

Watched *Stanley Siegel*. Brooke Shields didn't show up so he did a live telephone interview with Sophia Loren, who's in town at the Pierre. Her English is good now. But you know, seeing her on TV this morning, she's just . . . trashy. She said she wouldn't let *her* daughter be in a movie like Brooke Shields's *Pretty Baby*, and I mean didn't she just fuck her way to the top? Who's she kidding? She's so pretentious. I'm supposed to see her on Thursday. Oh, and Monday afternoon at the office I stood there and listened to an unbelievable conversation—Vincent on the phone with our lawyer discussing if I should serve a *summons* on Sophia Loren when I went to have dinner with her! This is for the lawsuit we're bringing against her husband Carlo Ponti, who produced *Frankenstein* and *Dracula* [*see Introduction*]. They were completely serious. Now see, it wouldn't be direct—there would be this little man with me and when Sophia opened the door, the little man would slap her with the summons. Then she and I would have dinner as if nothing happened. This is what they were working out for me! I just watched Vincent's end of the discussion on the phone and my mouth was open.

Catherine said we had to go to the screening of the Sophia Loren movie since it was especially for us because were going to interview her. Cabbed to 1600 Broadway ($2.60).

It looked like a 1950s Italian movie. Beautiful settings. Sophia is a housewife with cute fat Italian kids, and on a day when Hitler's in Italy, the whole building goes to his parade. Her bird that talks gets away and she's intrigued by Marcello Mastroianni, the man across the way. Then I fell asleep. When I woke up he was telling her that he was a fairy and he couldn't get it up for women. Then I fell asleep again. When I woke up she was on top of him and they were making it but they had their clothes on. It was all mostly in one room. Then she's home and everybody comes back from the parade and she sees the light go out across the way and two guys have come to take him away and send him to, you know, Fire Island or someplace because that's where they sent his boyfriend.

Wednesday, September 21, 1977—New York—Columbus

On the plane Richard Weisman said that Vitas Gerulaitis had just been to Columbus and staked out the best motel and the best girls to call.

As soon as we landed Richard called the girls' number and they arranged to meet at midnight in Richard's room. Then we went to the motel Vitas said to. It was almost a dump but it was okay, like every other motel, like being at a Holiday Inn, with a pool and everything.

As soon as we checked in there, we went to another motel, the one that Jack Nicklaus owned, to meet him.

We waited while he talked on the phone. He looked fat, but Richard said that he was once 280 and was now down to 180. He was very suntanned, but his eyes, around them, were white where his sunglasses were, and his hands were tiny and white, he wears gloves on the course. His hair was blond, and he said something about needing a haircut, but I had the feeling that his hair was just the way it always looked, puffed just-so over the ears, like it was "coifed."

I started taking pictures but none of them were coming out good. It's so hard taking pictures of suntanned people because they come out so red. He was being friendly and Richard was trying to be friendly but somehow the situation was strained, he didn't understand what was going on. And I had my tape recorder with me and was taping, but when I sort of realized that he wouldn't understand that, I just quietly shut it off. Richard's secretary Claudia showed him pictures I'd done of Tom Seaver, Muhammad Ali, and Pelé, but he still didn't really understand why we were there taking pictures of him. Richard had sent him a book showing my paintings but he didn't understand the style.

And then he got another phone call, and we were getting nervous and I took some more pictures and he didn't like any and we didn't like any. Not getting good pictures made things more and more awkward and finally he said, "Well, you know what you want—you don't tell me how to tee off on the green," and I felt more uncomfortable and everyone just wished we could leave. Then finally he liked one but it was just nothing, a front shot, and I didn't see any difference between the rest of them and that one, but he said he didn't want to be looking—what's the word? It's like cocky, but it's a short word—he didn't want to look like that, and he thought this one made him look like a nice person. He talked about his wife and his kids.

Forgot to say that when I was taking the pictures, there wasn't a golf club around, they were all down on the course. He went around to some of the offices asking if anyone had clubs and finally came back with some that he said were just like his, and I didn't know that golf clubs have hats on them with drawstrings.

We ran out and dished the whole thing in the car and that's when it suddenly occurred to me that he actually had looked like he might be lonely and maybe we should have invited him out with us, but he hadn't suggested anything himself, and nobody just knew what to do, so nothing happened. We looked around for a place to have dinner. Fred and I wanted to go back to New York right after taking the pictures but the only flight out went to Atlanta first.

We saw a building with about twenty floors and there was a restaurant at the top that moved around in a circle. We decided not to go to that, and then decided that we would go there after all. It had some name like River House. It was next to a Howard Johnson's. We went up in the elevator and sat down in the restaurant, and it began to revolve. There were ladies there playing harps.

Then we went back to Richard's room with him to wait for the girls that were coming at 12:00 and had tequila with him. When the girls called on the phone he asked them to bring some jeans and a T-shirt for Claudia, because they would all go nightclubbing and she hadn't brought anything to wear.

Claudia used to be an airline stewardess and I guess that's where Richard met her. She's very pretty and she's the best secretary. She just does everything.

The girls arrived and they looked like New York models, very tall and blonde and pretty and they were wearing the same kind of clothes, jeans and T-shirts.

One of the girls was more the hustler and she went after Richard. All they could talk about was Vitas so they called him in New York. The clothes they brought for Claudia fit perfectly.

Fred and I went to our rooms. They were big and clean and everything, but you'd wake up every half-hour because of the air conditioning. I slept in my clothes because I knew there was a six o'clock wake-up call.

Thursday, September 22, 1977—Columbus—New York

Valentino was at the office for lunch. Barbara Allen and Joe Eula were interviewing him. Suzie brought Paige Rense who said, "I might as well ask you right now and get it over with—can I do a story on you in *Architectural Digest*?" I said no, and she said, "Okay, I accept that," but still she offered to show me a good time in Los Angeles when I went. She said she fell asleep with her soft contacts in and ruined her eyes for a while, and she can't find her glasses. Joel Grey's daughter Jennifer was there, too. When Valentino heard I was going up later to interview Sophia Loren he said that she was the stingiest person, that she went to his place and wanted a 70 percent discount and he said goodbye.

Cabbed up to the Pierre with Victor and Robert Hayes in rush hour ($4). Went to the thirty-sixth floor to see Sophia. On the way in the cab I warned Victor everything he shouldn't talk about, like that we were suing her husband.

John Springer met us. Sophia came out looking beautiful. Then she kept telling us how poor

she was, it was so ridiculous. Like we asked her if she wore Valentino clothes and she said oh no, that they were much too expensive for her, and she said she wouldn't be able to afford to stay at a place like the Pierre herself—that the movie people were paying for it. Like she didn't mention that she could have stayed right down the street in her own apartment in the Hampshire House. But Victor was fun, he opened champagne and said he saw all her movies in Venezuela when he was a baby. I'd told Victor he couldn't say any dirty words, because when we went to Carlo Ponti's villa in Rome a few years ago they told us that Sophia didn't allow any dirty words in her house and that we'd get kicked out if we said any. Well, the running thing while we were at the Pierre, it turned out, was that Sophia kept saying "fuck." She and Marcello Mastroianni are on the front page of the Post for being on the new Dick Cavett interview show on channel 13 and Marcello said, "You have to fuck a lot," when Dick asked him how do you be a Latin Lover. Sophia seemed to think that was so "cute," so she was repeating it. After about an hour she wanted to get rid of us, and we ran out.

Friday, September 23, 1977

Another cousin of Catherine's was in town, Evgenia something, a Guinness, and she came by to get a copy of the issue of *Interview* that has Erskine as an "Interman." I asked her what she was doing in town and she said she'd come "for a funeral," and I asked who died and she said her stepfather, Robert Lowell. He'd just come in from Ireland and got a cab at the airport and had a heart attack. He was sixty-one. I guess he was the number-one poet since W.H. Auden died.

Sunday, September 25, 1977

Had a bad night. Woke up at 6:00, fell back asleep, up again at 8:00 and 9:00, turned on the TV and watched all the cartoons. Archie and Amos were still away, they'd gone out to Montauk with Jed—we're still trying to rent the place.

Diana Vreeland called and said someone should talk to Fred about his drinking problem, to tell him he's so attractive but that when he's drunk he's so unattractive.

Stevie Rubell called and said he had tickets to the Lillian Carter dinner at the Waldorf. I had to get into black tie again but the bottoms always itch so much, that's why I wear bluejeans usually with the black-tie top. But tonight I innovated something, I put the black pants on over my bluejeans and it didn't really look lumpy, it worked, so I walked out of the house in two pairs of pants at 6:15. Cabbed to the Waldorf ($2.50). When I got there Stevie was nowhere around.

A boy took me to a small room on the side where there was a reception for Miz Lillian. She was wearing a blue sort-of-nightie and she was really thrilled to see me, she loved the pictures I'd done of her, and she invited me to the party in her room afterwards. She told me it was 7-N. Finally Stevie came in, he'd just had a joint, he said, because these things made him so nervous. He said he'd never been with so many other Jews before. It was the Synagogues of America—something like that—giving a medal to her.

Then we went into the big room. I was at table 3. There were about thirty-five Jews on stage.

The Edgar Bronfman guy—the kidnappee's father—paid for the dinner. He talked very classy—if you closed your eyes you thought it was Dick Cavett—and he was the only one who had a pretty young wife who didn't look Jewish. Andrew Young came over and shook my hand, he looks like a butch Johnny Mathis. Then we had gefilte fish, and it was a dairy dinner. While we ate they gave speeches and they sang "God Bless America" in English and Jewish. The cantor had a very good voice. It went on for hours. Andrew Young gave a speech about the United Nations and freedom. The food looked like airplane food. The best line of the evening was when Miss Lillian said, "I've never met so many Jews in my life. I must tell Jimmy." Everyone was so shocked they laughed. She was good, nervous. There were autographed copies of her book *Away From Home* at every place and I stole an extra one because Richard Kiley hadn't shown up.

So Stevie and I left the Waldorf and went out to look for his car, parked on Lexington. A $30,000 Mercedes. He says it's his only big enjoyment in life, having a car and parking wherever he wants to, spending money on parking tickets. He said he has money in shoeboxes. He says we should go around to discos together because he has to pick up boys to work at Studio 54.

Bob Weiner is doing his first big story for *New York* and it's on Stevie and Studio 54. Bob Weiner seems like he's in love with Stevie. *(laughs)* Deeply. Bob used to be so straight, producing Broadway plays and then around '69 he became a hippie type and started listening to rock and roll and writing for that dirty newspaper that was like *Screw*.

At the party at The Ginger Man for the opening of the New York Film Festival, Leticia Kent was there and John Springer who gave the party, and Marcello Mastroianni and Gerard Depardieu who looked wonderful. He asked me for a French cigarette and I told him I didn't have one but that I could get him a Quaalude, so I went over to Stevie and he gave me one to take and I broke it into fourths and then didn't take it. But Stevie kept saying, "You didn't take your Quaalude." They don't forget—people on drugs really do remember. So I let him see me taking part of it.

Then I saw Howard Smith from the *Voice* so I went over to say hello. Howard's been writing letters to Valerie Solanis, that's the latest thing, he must have run into her in the Village. He told me he was sorry he'd started that, that he doesn't know how people that crazy are out in the streets. I told him maybe it was because she worked for the CIA.

Stevie wanted to go to the Village to the clubs, he wants to open one down there. The first place we went to was the Cock Ring. The area has changed, they got rid of the back rooms and the bars are really crowded. Stevie is Mr. Big down there, he recruits all his waiters from there. Right before we went into the Cock Ring I took my outer black formal pants off and went in my jeans underneath. It was jammed with cute kids dancing.

Then Stevie gets bored right away everywhere and wants to leave. Went to 12 West and I wouldn't dance, so Stevie danced with a pillow. He kept getting poppers and putting them under my nose. Bob Weiner saw Stevie holding the poppers and me sniffing and went out to the car. Later he said that his whole clean innocent image of me was blown, that there I was on Quaaludes, taking poppers and drinking. I said, "Did you actually *see* me take a Quaalude?" Then I showed him the bits of the Quaalude still in my pocket and I informed him that I hadn't been inhaling when Stevie put the poppers under my nose. Then he said okay, but that I was *drinking*, and I said, "I *always* drink."

Then to the Anvil for a minute. There was a colored guy at the door who didn't want to let Stevie in, he started screaming that Stevie hadn't let him into Studio 54 and who did he think

he was now, trying to get into the Anvil, but then he saw me and he waved me in, and he finally let Stevie in, too, but he made him pay. Upstairs there was "entertainment." It was a drag queen. Richard Bernstein was there, he told me that Valentino had ordered forty portraits from him, then only took two. Remember, he's the one who called Sophia Loren the cheapest person in the world for wanting a 70 percent discount! A part of the show that I did think was funny was a boy taking off fifty pairs of jockey shorts.

Stevie said he had to get up at 8:00 because the restaurant meatman comes on Monday mornings and he has to pick out the meat. He lives in a new building on 55th Street. We got into the car and Stevie dropped me home and I kissed him in front of Bob Weiner so that Bob would have something else to write about. That was around 5:00.

Tuesday, September 27, 1977

Ahmet Ertegun called and invited me to a testimonial dinner for Pelé that evening. I spent the rest of the day calling people to be my date but nobody wanted to go. Dropped off Vincent and Catherine (cab $4). Changed, then took a cab to the Plaza ($2). Met Howard Cosell and his wife and was surprised he was so tall. I liked him, he was fun.

My portrait of Pelé was going to be presented. Pelé's mother and father were there and they were cute, and his wife, who was white, but everybody in South America is all different colors—his parents were different colors, too. After the dinner we went over to P.J. Clarke's ($2.50). Tucker Frederickson, the football player that I like so much, was there. He's so adorable I kept telling him he should do more TV, but he said he didn't want to. Had a bowl of chili.

Thursday, September 29, 1977

Talked to Fred. We were arranging to go up to meet Nenna Eberstadt who worked at our office all summer for lunch at her school uptown on 83rd Street—Brearley.

Before I left the house I happened to talk on the phone to David Whitney. David said he hadn't even started on the Jasper Johns show. Then he told me something that scared me when I heard it, and scared me even more as the day went on. He said that when Rauschenberg was down in Texas for a show, all the art people were on a chic art-people charter bus and it stopped at a gas station and the men's room was locked so Rauschenberg peed on the side of the bus and two Texas Rangers appeared and arrested him and took him to jail! I mean if you're walking along the street in New York, what if you really have to pee or shit? What do you do? Do you have to do it in your pants? Will they arrest you if you do it in the street? And if you can prove that you really had to go, will they let you go but will you have a criminal record? I guess you have to do it in your pants.

Cabbed up to Brearley with Bob and Fred. Left from the office so I took a stack of *Interviews* up with me. When we got to 83rd and First Avenue (cab $5) we walked in and left the magazines at the front for the girls to take. I forgot that this wasn't all a high-school-age place. I was just thinking that all the girls were older, like Nenna. Well, Nenna came to meet us and she looked

like she was suddenly ten years old! I couldn't believe it! In a little black uniform and one of those skirts, you know that's short, like—what's the name? Like the ladies wore in the sixties . . . a miniskirt. And her friend was in a uniform, too, a very beautiful girl who also looked ten years old. And Fred told us a secret, that Mick Jagger had called Nenna and Freddy Eberstadt answered and started screaming at him, "How dare you call a young girl like my daughter? You, an older man of forty!" Mick took offense and said "I am not forty. I'm thirty-four. And Nenna goes out with Mr. Fred Hughes, who is also thirty-four. And besides, I don't go around ringing people's doorbells at 4:00 in the morning." Which was a reference to Freddy Eberstadt ringing Mick's doorbell at that hour looking for Nenna.

As I looked around at how young the girls were, all I could think about was the *Interviews* upstairs and about Rauschenberg getting arrested in Texas and about Roman Polanski, how the poor guy could make a mistake because these young girls could be as young or as old as they wanted to look.

Tina Radziwill was there at Brearley, too. She's changed a lot since that summer Lee rented Montauk. She has so many pimples now. I mean, you'd think they would have found a way to cure pimples. If a girl like Tina who can spend all the money in the world to get rid of pimples can't get rid of them, then there's no hope for me.

Nenna introduced us to another one of her girlfriends and she looked forty! She had tits *so* big and an ass *so* big. She was white, but there were a couple of coloreds around the school, too. Then they gave us a terrible tour of the library and the gym and where the twelve-year-olds eat. All I could think of was the magazines with maybe nude photos in them. I had Bob run upstairs to take them back, but they were gone. I told Nenna she just had to tell the headmistress that we'd just left them there meaning to pick them up on the way out and she said she'd try to fix it. Cabbed back to the office ($5).

Mick arrived twenty minutes late in a really good mood—I was photographing the Stones. Then everybody started arriving—Ron Wood and Earl McGrath and Keith Richards who I think is just the most adorable person, I love him. I told him I was the first person to meet his wife, Anita Pallenberg. In the sixties.

Richard Weisman was sending down tickets to a party for Ali, if Ali won his fight with Shavers.

Suzie Frankfurt called. She's been seeing Sam Green all the time and I said to her, "Do you think that Sam Green doesn't talk about you?" She said, "No, Sam *loves* me." I said, "You mean you think he doesn't go all over town repeating to everybody what you say?" She said, "But he doesn't talk about *you*." I said "Yes, and that is because I never never *tell* him anything."

Dropped off Catherine and Peter Marino. Peter and Catherine got friendly in Montauk. I can't figure Peter out, he's nutty. I told him how he owed his whole life and architecture career to us—how we gave him his first job—took him out of his business knickers and gave him his long pants and he said that well now he was in Armani suits and that we sure didn't put him in *those*. He was funny (cab $4).

Changed at home. Ate some of Archie's food then started walking up to 730 Park Avenue to a dinner for a Swiss guy who's in town, who said he's been dying to meet me. After dinner I went down to 66th Street to wait for my date, Kevin Goodspeed, who I'd met at Studio 54. He's big and he's like my old crush from the sixties, Rodney La Rod, and at first I thought he'd be a good bodyguard until later in the evening when somebody stepped on his camera and beat him up.

Cabbed to the party for Muhammad Ali at the Americana ($2.50). It was one of those parties

where you're Waiting for Nothing. Ali never came, they said he was too badly hurt in the fight. But one great thing happened. I met a black lady boxer. She invited me to go see her box.

Then Richard Weisman wanted to go dancing so we went over to Studio 54. Walked. Stevie Rubell is madly in love with me. And Victor was there and got jealous of my date Kevin. Victor was wearing "punk pants" and they had a normal fly that was zipped and everything but at the bottom of the zipper was a hole for his cock to hang through, and you didn't even notice it at first, everything looked like it was in order. He was also wearing a sequined Halston bandanna like the kind he gave me. Then Kevin and I went down to Kevin's neighborhood on Third Avenue in the 30s to Sarge's, the all-night coffee shop, and after we had coffee I left him with some people he knew there. It's supposed to be the best coffee shop (breakfast $10). When I got out on the street a kid in a Mercedes pulled up and said he used to live on my block on 66th Street. I made him describe the street and he did know it so I got into the car and he dropped me off. By then it was 5 A.M.

Friday, September 30, 1977

The nightlife is running me down, I can't even drag myself up on the pillow. And I'm still worried about getting arrested for leaving the *Interviews* up at Nenna's school. What if there was a naked picture in that issue? I'm afraid to look. They only arrest the publisher. I'm the publisher, Fred's the president. Oh God. I don't want to think about it. What was Larry Flynt when they arrested him? The publisher? Why don't they arrest the president—or the *editor*? Bob could just write his "Out" column from jail. It would be a new scene for him to cover.

And speaking of scenes, Steve Aronson read PH's first draft of *Popism* and said he will edit it for us, after all—that it needs work but that it's fascinating because it's a scene that hasn't been shown yet.

Paul Jenkins came to the office. He's a painter who puts paint on canvas and lets it roll, and his work is like somebody else's but he does it well. I think he's interested in a portrait. He's with the rich du Pont girl, Joanne.

Saturday, October 1, 1977

Went to the bus at Rockefeller Center to go out to see the Cosmos soccer team play (cab $3). The bus was loading with Nan Kempner and Jerry Zipkin and related types. The White House people, Tom Beard and Joel McCleary, were getting into a limo and invited me into that. The Carter son who isn't married was supposed to be coming, that's why the limo, but he didn't come.

In about forty-five minutes we were out in Jersey at the stadium club. We got the VIP treatment, up to have brunch and bloody marys. Robert Redford and Muhammad Ali were there. Also Gordon Lightfoot and Albert Grossman, who used to manage Dylan. He told me again that *he* has my silver Elvis, but I don't understand that, because I gave it to Dylan, so how would Grossman get it?

Kissinger was there waving his hands around like the pope. There were lots of Secret Service around. Then at 1:30 they made them go out to the game.

I went over to Muhammad Ali and said hi, but he looked at me blankly, he didn't seem to know

who I was or remember that he met me down at his training camp in Pennsylvania. His people who tell him who's who and what's what weren't around and he was just alone, eating, so I got embarrassed and backed away.

In the stands I sat next to Robert Redford's two kids, about twelve and thirteen. Everybody said this was the first time Redford was out in public letting himself be photographed. There were empty seats all around me where the Carter kid was supposed to be but he never showed. Muhammad Ali was in front of me and they'd put the Carter kid next to him. Ali's wife and kid were there, too. Elaine of Elaine's was there, too, she told me she was on a high-protein diet. But later I saw her stuffing herself with rolls.

Pelé played on one side and then on the other side. When it started to rain, they passed out raincoats to the VIPs and it was nice in the rain, it made it more exciting. Seventy-five thousand people there. The parks commissioner invited Ali into his glass box so he wouldn't get wet. When we were getting really soaked we jumped into somebody's box and the little girl in it said her father owned the Giants.

Kissinger shook my hand, but he shook everybody's. The men from Ali's Pennsylvania camp recognized me and asked if I'd talked to Ali and I lied and said no.

Monday, October 3, 1977

Went to see Dr. Poster about my red eye and he said it was just a broken blood vessel, to put hot compresses on it. But I forgot to.

Catherine and I went over to Gleason's Gym to interview the girl boxer, Jackie Tonawanda (cab $2.60). Lots of good-looking fighters went by. I asked about how you can own a fighter and Jackie said it would cost mostly to pay her, because she would manage them, and that would be $150 a week, and then some more to rent a locker at Gleason's. Catherine fell in love with a 6'5" black fighter who was jumping rope. I tried to get her interested in a cute Irish kid but she said he was too ordinary-looking. Jackie wasn't too good an interview because I'd mentioned something about a movie and that was all she would keep bringing up. She's ready to go to Japan and fight a 6'3" Japanese-Irish girl.

Then we cabbed up to the William Morris Agency ($3). We went up to the thirty-third floor. A guy there, Steve Pincus, had been calling the office a lot wanting me to come over and talk to them about representing me. The meeting was fun, he had other guys in there and they were telling me they'd get me American Express TV commercials and Broadway shows and starring roles in movies, and Catherine got so impressed, and God it was so boring, you'd think I hadn't heard all this for years, going up to William Morris and then after the Big Meeting, nothing happens. But I enjoyed going there. They were all married but they looked like closet queens. Catherine told me not to call her a "rich bitch" because it was undignified. So now I finally know what to call her.

At dinner at Peter Luger's Steakhouse I told Diane de Beauvau who was with her boyfriend Pierre that when I was leaving the house it was on the radio or the TV that a five-year-old Patino girl had been kidnapped. Diane burst out crying hysterically and everybody turned on me and said I'd spoiled the party. Stevie went to the phone and called the wire services to get the story,

and it was only a *distant* relative. But Diane was still hysterical, and they were saying, "To cry is a good thing, it brings out feeling," and in the middle of all this the cute Irish waiter came over and told me that he had an Art Deco radio in his room—that he knew I collected them.

Timothy Leary told about how in the early seventies Diane had chased him around Switzerland and sent him notes and letters and he said that it was actually Diane carrying on like that that got him locked up. He told me I was one of his most favorite people of always. Bob Weiner was there, still researching his article on Steve, and I'm sure it's going to be so bad because 1) it's *him* writing it and 2) he didn't pay any attention at dinner while all these great things were happening and with all these great people together—he said it was "boring." And every time Stevie would pick up a boy Bob would turn the other way. And then Stevie started rushing everybody—that's all he likes to do is rush to get someplace and then rush to leave. But Tim told him that for years—in prison—he'd been rushed and told what to do, and he wasn't going to rush anymore.

Then we went to Elaine's. Stevie was too zonked to drive, so Diane's boyfriend, Pierre, drove. First we had to stop at Stevie's house and he went in to get more Quaaludes or poppers or something, I think. Margaux Hemingway was with us. Her marriage to the Wetson hamburger guy is splitting up and Tim was after her, I guess. Then Stevie wanted to go to the Barefoot Boy and the Gilded Grape.

Tuesday, October 4, 1977

Lady Isabella Lambton, Ann's sister, is now answering the phones at the office while our receptionist Laura goes to Berlitz to finally learn English.

After a benefit fashion show of Madame Grès, went up to Diane de Beauvau's new showroom to see her first collection. I had to start lying immediately and tell her it was all great, but especially after seeing all those beautiful Madame Grès and all the Halstons, her stuff just looked so bad. She acts like a businesswoman—she doesn't take much coke in the day—but I don't know, I think it's going to be a disaster.

At dinner later at Quo Vadis, Tim Leary was really sweet, he talked some more for the tape about how Diane writing him those love letters and taking acid when she was fourteen got him in jail in Switzerland. He said the jails in Geneva can be like a good hotel—if you pay them they bring you pastries on a tray. And I can't believe it, he remembers each time he ever saw me in the sixties and then in St. Moritz—what I was wearing, everything—and I didn't even know at the time that he would be noticing. Like when we went to his lecture and light-show things in the East Village. He said that if he had it to do all over again he wished he were with the Velvet Underground because they did so much and were really creative.

I just think he's so intelligent. He probably really was with the CIA, because he was *the* one at Harvard, and now they're showing that the government was using LSD so far back, and Tim was the master, and when you're a master they do approach you.

Diane de Beauvau and Pierre were on a couch arguing. She wanted him to think she was in love with Tim Leary and that they'd had a romance, so to do that she made a point of telling Pierre that there was absolutely nothing going on, that she *wasn't* in love with Tim. So then he had to do the thing of caring because that was how she would be happy.

Thursday, October 6, 1977

Woke up with a sore throat and I think it's from kissing all those funny girls who come running over to me. I never used to do that, but they're just there and you don't want to be rude.

I just love all the boys at Studio 54. They're like Rodney La Rod was in the sixties—all jangling nerves and they're all hustlers and they *(laughs)* prey on movie producers, they want to be famous and they can't wait.

Friday, October 7, 1977

I was invited to see the Four Seasons in their goodbye concert at Radio City. They thanked the original producer, Bob Crewe, which is how I knew them in the sixties. Frankie Valli came over after the concert to say hello, I'd given my program over to be autographed by him, and he said that Bob Crewe had been hit by a car in California and that he might lose his leg and that I should give him a call because he was really down. I always thought that Frankie cared so much about Bob, but then he didn't seem too upset. He was concerned, but not as concerned as I would have thought.

Don Kirshner was there and we three had our pictures taken together. Then we went over to Studio 54. Stevie introduced me to Roy Cohn who was with four beautiful boys, but butch-looking. A boy is "butch" if he weighs over 170 and he's an all-American football-type, a spilling-out masculine man. A butch person looks like—well, we don't have one at our office. Maybe the building super. Yeah, a thinner version of Mike the super, that's "butch."

Monday, October 10, 1977

Cabbed to Diane de Beauvau's ($2.25). She told what she'd just learned about Barry Landau, that creepy guy we can't figure out, who somehow gets himself around everywhere with every celebrity. She thought he was a friend doing nice things for her, when suddenly she got a bill from him for $2,000 for getting her on *The Mike Douglas Show!* Barry had asked her if she wanted to go on and she said sure. He probably sends Stevie Rubell bills, too.

Went to Elaine's ($3.25). Bob Weiner was there, upset because *New York* magazine had rejected his article on Stevie. He was sort of passed out but with his eyes open.

Tuesday, October 11, 1977

Cabbed up to Parke Bernet, got a few catalogues because they seem to be the best reference books (cab $2, books $24). Ran into Kenny Jay Lane who's put his whole house and furnishings up for auction—now that he's getting divorced from Nicky Weymouth he can present it as something he's doing "for the settlement." When you see all his junk together, it really looks bad.

Went to Chembank ($4). Steve Aronson was at 860 looking around, he had a beautiful girl

with him. He says he can't start editing *Popism* until next week. Vincent was off in Montauk, checking on the place—Jay Johnson and Tom Cashin are still out there roofing and repairing. By closing time Vincent still wasn't back, so I locked the place up myself. And when it's my responsibility, I get so nervous I do things like pull out the plugs to the Xerox machines so they won't start a spontaneous combustion; I decided I would risk leaving the refrigerator on. When I got home there was a message from Barry Landau, somehow he'd gotten my number. So now the three worst people to have your unlisted number have mine—Bob Weiner, Steve Rubell, and Barry Landau.

Lester Persky called and invited me to a screening of *Equus*. I loved Peter Firth, he was wonderful and Richard Burton was wonderful. The movie has the longest nudity. Usually when they photograph a cock they make it fall in the shadows and the shadows always fall where the cock is. But in this movie the cock always falls right where you can see it. Peter Firth's dick gets in the way when he moves. It's the biggest cock on screen and not circumcised. As big as Joe Dallesandro's.

Peter Firth came over to me, he'd imported a girl from England for all the publicity and she was there and we had a good time. There was lots of food, but I'd already eaten. Then Peter Firth wanted to take the girl dancing so we walked over to Studio 54 for the Elton John thing. Stevie invited us all up to the booth where Michael Jackson was and Michael was sweet—in his high voice he asked me about art. David Hockney was there. The photographers were there and wanted Elton John and me to pose for pictures together so I asked Elton if I could kiss him, but he didn't answer me so I didn't. Maybe he didn't hear me. He was wearing a hat because of his hair transplant.

In order to get out of Studio 54 alone, I had to avoid all the boys I've been accepting rides and dates from lately. I had to look nervous and run around so no one would follow me—you know, the "frantic" technique.

Friday, October 14, 1977—
New York—Springfield, Massachusetts—New York

Up to Massachusetts to photograph Dorothy Hamill for the Athletes portfolio. It was nice to photograph someone really pretty. Dino Martin's sister was with her.

Barbara Allen's name was linked with John Radziwill's in "Suzy's" column. Philip Niarchos and Barbara have broken up and he's got a new girlfriend. Barbara's letting all these rich guys slip through her fingers, but I guess she's working hard, wanting to be an actress.

Saturday, October 15, 1977

Ran into John Weitz, the fashion designer, on Madison with his wife Susan Kohner, the actress who gave up acting to be married to him. He was going over to Fraser-Morris, so I went with them.

They wanted to invite me to a party, they said, and asked for my number. They wanted the

home number I guess and I gave them the number down at the office and I don't think she liked that.

Went to Studio 54 and it was jammed. Victor and Halston were there together. It was a party *(laughs)* to show that Victor wasn't blackmailing Halston. Victor said that Bobby Zarem had called and said there was a rumor that one of Halston's employees was blackmailing him, so they should appear together to squelch the rumor and have lots of pictures taken. Then later Chris Makos took us to a bar on 52nd called Cowboys, a hustler bar where Ara and Zoli go to pick up beautiful kids for models. Left about 4:30, got newspapers and magazines ($5).

Sunday, October 16, 1977

David Whitney called about going together to the Jasper Johns opening that night at the Whitney—Philip Johnson was going with Blanchette Rockefeller.

Pretty day. Cabbed downtown ($3.50) then walked to work. Richard Weisman and his little kids arrived and Margaret Trudeau was with them. She's really split up with her husband now so she lets herself be photographed with anybody, and I guess she's been dating Richard for a while. She was primping the kids' hair. I didn't have enough light bulbs though, and they fought over the teddy bear.

Cabbed to the Whitney ($2). Bob Rauschenberg blew me a kiss in the elevator and then later came over and said it was silly to *blow* a kiss so he kissed me. Jasper was drinking Jack Daniel's. It was a small party, just for lenders, old people. I ran downstairs to get a catalogue and then I looked around to have Jasper sign it, but I couldn't find him so I had Rauschenberg sign it, and then I did find Jasper and he rubbed out Rauschenberg's signature and signed "To a Lender."

John Cage was there with Lois Long, de Antonio's first wife. Jack and Marion Javits were there, and Jack gave a speech. Robert Rosenblum was there, and he just got married. I guess it's another Nicky Weymouth-Kenny Jay Lane-type thing. He's from the gay old Henry Geldzahler crowd. Mrs. Irving who's the president of the museum whose mother is a Whitney was there. She lives down the street from me and I've asked her a few times if I could rent the garage space in her carriage house for the car. I want it so badly, but nothing ever happens. At the Whitney she said that she definitely would call me—and I think it's because I ran into her husband going into the garage that morning.

When we sat down to dinner there were packages of Philip Morris cigarettes at each place— they were the sponsor—and when nobody was taking them I took them "for the box." *[see Introduction]* There was one red one but I couldn't get it.

Monday, October 17, 1977

Cab to see Chris Makos's show at the Andrew Crispo Gallery on 57th Street, it was closing tomorrow (cab $2.15). The gallery was closed but they opened it just for me. I thought it was really great. He did two photos framed in the same frame—things like I used to do—and it looked beautiful. I told Bob we should give Chris two pages a month in *Interview* to do whatever

he wants. Andrew Crispo came in and said that there were very few photos sold from the show but that it looked good.

Cabbed to Chembank ($3). The office was busy. Kevin Goodspeed came up for lunch.

Yesterday I saw a roach go into the water cooler, in between the jar and the stand, then I saw it magnified (reimbursed Ronnie for cabs $2.10, $3.05, $2.25).

Some African sculptor named Eugene, a friend of Joe Eula's, was at the office doing a sculpture of me. He says he needs to look at me but I think he just wants a free place to work in. He sees me as a hermaphrodite. He's a terrible sculptor and it doesn't matter if I pose for him all day or not, it's just going to come out like an African totem pole anyway.

Then Boris Tinter called and I wanted to escape the office and catch up on the jewelry business so I went up to 47th Street (cab $2.80). Boris had just been to Parke Bernet and had some good new pieces. I love to sit with Boris in his cubicle and see all the strange people who come in. And I love Boris's fake hand.

Tuesday, October 18, 1977

Woke up after a good long night's sleep. I needed it to clear up some pimples. When you don't sleep you really have them.

Doug Christmas didn't send a check yet and I told Fred to tell him I wasn't going to Paris unless we got it.

Wednesday, October 19, 1977—
New York—Buffalo, New York

The plane ride was an hour (cab to LaGuardia $7, toll $.75, tip $2.25, magazines $3.10). I asked Richard if he remembered to tell O.J. Simpson to bring a football to the motel where we'd arranged to meet. He hadn't. We asked the manager to find one for us, told him that it'd be autographed by O.J. Simpson and Andy Warhol. O.J. arrived. He remembered Regine's and asked about Marisa Berenson—they presented an Oscar together last year—and was so sweet. He had a five-day beard and I thought the pictures would be awful but Fred said no, that they'd be sexy, and he was right, they were. O.J. is so good-looking.

Saturday, October 29, 1977—New York

Barry Landau called and said he had tickets for Liza Minnelli opening in *The Act*.

So we picked up Diana Vreeland and Jamie Auchincloss, the half-brother of Jackie O., and Ruth Warrick, who I know from years ago. She was on *As the World Turns*, and now she's Phoebe in *All My Children*. She was Orson Welles's first wife in *Citizen Kane*. She's very good. The first thing she said when she saw me was, "Your Soup Can changed this country." We got to the theater and I've never seen a crowd that big, not for anyone, so many people.

Liz Taylor and Halston sat behind us, Sammy Davis was in front of us with his wife, Altovise. Liza was on for the whole show. The Halston clothes were beautiful, they really were. I asked Halston to make me up a black sequined tuxedo with light blue shoes, too. It was so beautiful, the boy suit. Everything was sequins in all different colors. Liza's lost a lot of weight.

Martin Scorsese's parents were saying hello to me. He directed *The Act*. Victor was putting down the clothes saying there was nothing creative about them, which surprised me, that he would put down Halston's stuff. But he's into punk now. When the show finished, people were doing the "bravo" thing. Sammy Davis was standing up doing that.

Liz Taylor yelled at me for leaving Diana alone. She was glaring at me for some reason, giving me that look like she'd scratch my eyes out. And Liza came over and was kissing Liz so much for the photographers that I didn't talk to her. She and Jack Haley weren't accepted into River House yet, so they're at the Park Lane Hotel. Jack Haley was sweet, he told me that Liza may want a portrait.

We dropped off Diana and then Victor and I went over to Studio 54 ($4). It was jammed with beautiful people. Now Studio 54 has its liquor license. Stevie took me over to meet Vladimir Horowitz and his wife who's the daughter of Toscanini. He was thrilled to be there, in his seventies about, but chipper, but when he got up he tripped. I wanted to get out of Studio 54 because there were so many beauties trying to get my phone number and I was inviting everybody down to the office, so I had to leave.

Sunday, October 30, 1977

At Elaine's Stevie Rubell told me he's very rich, but that all his money's in assets or hidden away. People on drugs, you think they don't notice things, but they notice *everything*: Elaine had new menus and Stevie noticed the new prices right away. I only noticed because it was clean.

Oh, and after he confessed how rich he was, he started to worry that I only liked him for his money, and I mean, what can I say?

Monday, October 31, 1977

This week's *New York* has a big article about Stevie in it by Dan Dorfman. It said that he has $25 million and dirty fingernails—which isn't true at all, they're not dirty—and in it Stevie called Nan Kempner a "pisser," and Joe Armstrong, the editor, told me that she's already called up the magazine to ask, "What's a pisser?"

There was a Halloween party at Studio 54, Stevie kept giving me more drinks and then somebody shoved a Quaalude in my mouth and I was going to shove it to the side but it got stuck and then I drank vodka and it went down and that was a big mistake. My diamond choker was pinching my neck—I hate jewelry. How do ladies wear it? It's so uncomfortable. I went home by cab and got in around 6:30 somehow. My boyfriend Peter came up and found me with my boyfriend Danny so I introduced them as my boyfriends and that got them interested in each other so they went off together.

Tuesday, November 1, 1977

Actually slept through PH's call. Woke up at noon when Jed came in to shake me. The nightlife is taking its toll.

Kevin Goodspeed called from San Francisco. There were about fifteen really important calls that I never called back. Lucie and Desi Arnaz, Jr. called—I'd seen them at a party the other night—and I haven't returned their call yet.

I dropped Catherine (cab $4). I think she's having a secret affair because she's always busy now.

Wednesday, November 2, 1977

In the morning I didn't feel so well so I went over to see Doc Cox and got the surprising news that for the first time ever my blood pressure was up from seventy-eight to ninety-seven. But I don't know what that means. The nurse didn't seem upset.

Friday, November 4, 1977—New York—Los Angeles

There was a problem with the plane to L.A.—it was stuck on the runway for three hours. Victor was also on the plane going out to California for a couple of weeks, but he was back in tourist. I read John Kobal's Rita Hayworth book and loved it.

Cab to Century City to meet Kareem Abdul-Jabbar. His manager was good-looking and had a bull's hat, like a cowboy hat but 100 times bigger. Kareem was so big, I could walk through his legs. He was fun and he was easy to photograph, the way I guess Negroes are. Everybody always forgets the *ball*, though, and somebody had to go get one.

Went to the Beverly Wilshire. They were going to put me in the old part but I wanted the new. Called New York. Nelson Lyon called. Don Simon whose wife is dying of cancer in Texas called, and Fred invited him for dinner.

Went over to the Polo Lounge.

Saturday, November 5, 1977—Los Angeles—New York

Victor called and he was on an acid trip. I asked him how he could take acid. Don Simon called to say he had a lot of fun the night before. We ran into Marisa in front of the hotel, and she's going to have her baby in two weeks. She's going to do *The Vivien Leigh Story* but I don't know how she's going to do it—she can't act. I mean, they went through so much to get a good actress for *Gone with the Wind* and then now they're having *Marisa* play her?

Then as we were waiting, trying to get a cab to the airport, a whole big limo filled with Vuitton luggage pulled up and a person with dark glasses was in it. It was Francesco Scavullo, and he gave us a ride.

Sunday, November 6, 1977

David Bourdon called to say that Valerie Solanis had just called him, so she's still around town. He said she wanted the address of someone who had put her S.C.U.M. Manifesto into their book on women's lib, she wanted to shoot them or sue them or something. Victor called from California, not quite over his acid trip. He wants to stay out there, I told him he'd be wanting to come back soon.

When I got to the Iranian embassy (cab $2.50) it was full of movie directors and producers— Elia Kazan, Elliot Kastner, Milos Forman, Lester Persky, Barbara Loden—thirty or forty people.

Ambassador Hoveyda said we should do Polaroids right then for the portrait of Princess Ashraf, and get it over with, so we went into a room. It was so easy. The Iranians have the best plastic surgeons in the world and every picture—if you keep it very white—comes out great. The princess said they've seen and done everything in town—every movie, every play, even *Outrageous*. Dinner was great, the best ever there. The princess ate a lot, but the queen when she was there didn't eat much at all, maybe because she was afraid of poisonings, although the food is pre-tasted. Then everyone went upstairs and in barged Barry Landau with Margaret Trudeau. He got in by saying he was my very best closest dearest friend. But it worked out fine. And Bella Abzug and her husband Martin came with Shirley MacLaine. Milos, who I really like, offered Margaret a part in *Ragtime* as Evelyn Nesbit, but she'd have to go nude, he said, and she's thinking about it. I told Milos that I wanted a part in *Hair* and he said that if Margaret and I were in Central Park tomorrow morning at 9:00 we could have bit parts. I told him I wanted to be in *Ragtime*, too.

Monday, November 7, 1977

Raining very hard. It was a bad day, "family" problems. Jed came by the office and was in the back in my working area and when he saw the stacks of Polaroids of all the "landscapes" I photographed for the Shadow paintings—all the closeups of cocks and things—he began screaming that I had degenerated so low to be spending my time that way and he left, really upset, and it ruined my afternoon.

Oh something I forgot to tell the Diary! Somebody told us Jack Haley was a fag! Oh I wish I could remember who it was who told us! I thought Liza had married a real man. He doesn't seem gay, I was shocked. I don't think it's true, though. I really don't.

Anyway, I was upset about Jed being upset so I decided to treat myself to junk food and gave Ronnie money to go out for tea from McDonald's for him and Chris Makos and Bobby Huston ($10). We sat on the couch by the window in the conference room with the pouring rain talking through tea about the movie Bobby Huston is writing that I assigned about kids who commit suicide. Rupert came and helped me work. Barry Landau called. I called Jed and he hung up on me. Then we all left the office and a wonderful thing happened: the rain was so penetrating you were soaked in two feet's walk. It felt so exciting!

Later, at the Studio 54 party for Diane de Beauvau, Diane's name was up in lights. And I went over and screamed at Jay Johnson and Tom Cashin for not telling Jed the things I asked them to to calm him down. So I screamed and didn't have a good time. Chris Makos and Bobby Huston

were there, and Robert Hayes saw Christopher and left, said he didn't want to run into him. They live together but they fight. Christopher said he hadn't had sex for three days so he was laughing and trying to rip Bobby Huston's clothes off. I didn't have my camera, I wasn't in the mood. Then I went home and took the dogs out and they wouldn't pee.

Tuesday, November 8, 1977

Richard Weisman came down and he had just gotten back from the Ken Norton fight. He was in a nervous mood, and when he saw that I was doing a new style of painting he got upset, he didn't like it that I did the Chrissie Evert in lots of little pictures instead of the big ones, but then he saw that the *Newsweek* girl who was there interviewing me loved it, so then he kept calling me back all day to say he was sorry.

At Richard's party later for Vitas Gerulaitis Margaret Trudeau was there with two girlfriends from Canada. One was just divorced and she had three kids and she was fat and big and looked older than Margaret because she was fatter, and she decided to put the make on me—she came over and put her hands on her hips and gave me the best lines, I mean, you really could fall for it! Nobody's ever said anything like it to me, just the right thing, something like: "You are so much more than I ever expected!" I told her that Margaret should go back to her husband and go into politics and she was thrilled to hear that, that's what *she* thinks. She had a beautiful stole on, in that deep purple color—"aubergine," is it? They always say it in the fashion shows and I never know what it is.

Lacey Neuhaus was there with François de Menil and she said that she just met the number-one cowboy in the world and she was going to interview him for *Interview*. Frank Gifford was there with a woman, maybe his girlfriend, maybe his wife—she had so much makeup on, lots of white all over her face and lots of eyeliner, but very beautiful. He loved his painting. The owner of the Giants was there.

Wednesday, November 9, 1977

I forgot to say that one of these late nights, I watched the *Tom Snyder* show. He had Roy Cohn on. Roy Cohn is now Stevie Rubell's lawyer. Also Carmine Galante's. He was incredible, such a creep. He was saying Archie Bunker things like "If I could get my hands on the Son of Sam I'd kill him myself" and talking about the "reds," and this crazy-looking person goes into courtrooms, he looks like such a creep. You could just imagine him like down at the Anvil in black leather, he would look so perfect. I bet he *does* go to those places. He would. Or maybe he's just the opposite. Yeah, he's probably just the opposite—he wears dresses. But the things he was saying, like "Put everybody in the chair"—it was like hearing Paul Morrissey talk. . . . Yeah, they asked him how he could defend Mafia people since he's so concerned about everything, and it was that "rights" thing. It always is, you know—"They have a right to say they're not Mafia and to be defended."

I was the centerfold of the *Post*, a photo in front of the Sports paintings with a text by Jerry

Tallmer. But I keep saying the wrong things. I said that athletes were better than movie stars and I don't know what I'm talking about because athletes *are* all the new movie stars. And here we're getting all this publicity and it's a month ahead of when the opening is. I think it should be more toward the opening.

I read John Simon's review attacking the way Liza looks. He was just so awful. I mean if she ever saw that it would just crush her so badly. And she's actually nice-looking, I mean, I see her, she's not hard to look at. What does John Simon think he's doing? His philosophy must be that only good-looking people should entertain and I guess that's what I think, too. But *Liza isn't ugly!*

I was also on the front page of the *Voice*, photographed next to the empress of Iran for an article about torture in Iran.

Fred had tickets to the International Center of Photography benefit that Jackie O. was putting on at the museum up on Fifth and 94th. I asked Jed if he wanted to come but he said he was too tired (cab $2). Big mansion. The dinner was a horror. They put us at such a nothing, nobody table. You can't imagine—I was sitting next to *Fred!*

So here we were in this room where we didn't even *recognize* anybody except each other and this girl comes over to me and says, "I know you have a camera, and you can take pictures of everyone here except Mrs. Onassis." I didn't think too much of it right then, I just thought she was one of those nervous-type girls who run these events. And then that rich old guy Nate Cummings was screaming at Fred to open a window, and at first Fred was offended—Nate Cummings somehow picked him to scream at—but then Fred figured out he was turning senile, so he decided to be a nice boy and do it, and then the girl started screaming at Fred not to. And Fred's going to call her up and really tell her off, because things got much worse. We got up and left that room and Fred went to find Diana Vreeland and when we walked into the *other* room, there was *everybody we knew!* Peter Beard was having fun with Barbara Allen and Lacey Neuhaus. I mean, Catherine was sitting at Jackie's table! But that's not the most incredible thing. When we walked into this room there were 4,000 photographers taking pictures of Jackie. And that horrible girl had come over to tell me *I* couldn't! Fred's really going to scream at her. It was like a Bobby Zarem event, there were so many cameras flashing.

I cabbed with Fred and Diana Vreeland to Sutton Place to Robin West's party for Jamie Wyeth. I didn't have any change so I gave Fred $5. He gave the money to the guy, the fare was $2.80, and he told him to keep $.60 and the guy said, "How much is that?" and Fred started screaming, "I can't do your adding for you." And all the way down in the cab Diana and Fred had been fighting like they were a screaming old married couple. And the cab driver was butting into the conversation with, "Wasn't that Peter Beard's opening I picked you up outside of? Wasn't he on the cover of the *Sunday Times?*"

I talked to Carole Coleman from New Orleans. She's Jimmy Coleman's sister. Then Bo Polk came into the room and it got crazy. He'd met Carole at a bar and they'd gone out, and now he said things like "I want to eat your pussy," and on and on like that, they were just talking in front of me and Carole wasn't even embarrassed. I was surprised because she's older than most of the girls Bo Polk goes after. She has beautiful eyes and she's rich and never married, she could have been like Jennifer O'Neill, but she has problems, I guess, and not too many boyfriends, but very attractive. And he was saying things like "I want to lick your toes and up to and into your cunt," and then he'd turn to me and say, "I want you to be there and take pictures, Andy," and oh, he's just nuts.

I went to say hello to Phyllis Wyeth and then Bo Polk and John Larsen came over and Bo yelled to some girl that he'd put some coke on her clit and John laughed and called him a coke tease. And then Bo and Carole left. But then in a few minutes they came back in and talked about if they should leave and she wanted to know what they were going to do and that went on and on.

And then Carole and Bo and Jay Mellon and Catherine and I left and walked. We passed a place that had Famous Amos cookies in the window. I had never seen the package. It was the most beautiful picture of a cookie that I've ever seen, and I went in and bought it, but when I opened the package, the cookies were really little. It was the first time I was ever deceived! They *tasted* good, but they weren't big and beautiful like the one on the package.

Thursday, November 10, 1977

Got a cab downtown, saw the driver's name and I liked it—Vincent Dooley. He was a really cute little boy, so good-looking. He said, "I don't want to be rude, but what does it feel like to be in Iran?" He had the *Voice* with my picture on the front page on the seat next to him, the article about torture that also mentioned Raquel Welch, Liza Minnelli, and Farrah Fawcett-Majors. I got flustered and then told the kid that he was so good-looking, why was he a cab driver. He said, "Well, the closest I ever came to acting was I bought Joe Dallesandro's dog." He meant Caesar, Joe's big dog that was in *Trash*, that Paul brought back from Hollywood out of Jack La Lanne's dog's litter. What he actually said was, "My girl and I bought his dog." The kid had a high voice so I had high hopes he was a fairy until he said that. He said that he's still with the girl and they still have the dog. I was embarrassed about Iran so I gave him $5.

Cabbed to the bank ($3) then walked to the office. Then Rupert came by and he'd had a facial all morning from the famous health lady—he's more interested in having his hair dyed and facials than in working. And if you're going to go for facials you have to go every day, and anyway, you might as well do it yourself, all a "facial" means is that you take more than five minutes to wash your face. Jay and Tom stopped by for a while, they were mourning Michelle Long, their drag queen friend who just died.

Went to Regine's dinner for Ira Von Furstenberg (cab $2). Regine never showed up. Talked to Ira. And then her son came in and he was so good-looking. We did his brother for *Interview* recently, Kiko Hohenlohe, but this one was even better-looking. Ira said, "I could be the best stage mother in the world." But his father wants him not to be an actor. Princess Ira has always wanted to be a movie star. Always. She's been in lots of movies that never made it. I saw on TV the other night the Darryl Zanuck movie that he made for his girlfriend, Genevieve Gilles, and Ira was the second lead.

François Catroux was there with his wife Betty, and they were sitting with Ahmet Ertegun. And in a case like that who do you say hello to first—you go to the table and who do you kiss first? I know Ahmet was offended. Princess Ashraf was there with her boyfriend who likes polo.

Catherine was talking to a beautiful woman and it turned out to be Princess Elisabeth of Yugoslavia who seemed to know me, and she asked why I wasn't at Sharon Hammond's cocktail party the day before. She's trying to get a green card and so is Ira, everybody wants a green card.

And an interesting thing is that how she knows Sharon is that Mr. Oxenberg, Princess Elisabeth's first husband, left her for Maureen McCluskey, Sharon's sister, and I can't figure that out.

But anyway, Ira's son was so handsome, he had the slight kind of accent, just the right kind, like a kid that you would want to go out on a date with.

Friday, November 11, 1977

Sal Marciano from channel 7 *Eyewitness News* came to the office. They shot about five or ten minutes' worth in front of portraits. Then the people on the fifth floor called and said there was someone stuck in the elevator around the second floor named Victor. Vincent and I went out in the vestibule and heard a little voice calling for help. The fifth floor had called the Tenth Precinct, but they should have called the Thirteenth. The Tenth was over on the West Side. When the police arrived the first two were emergency-unit types, with ski jackets and baseball hats, like SWAT-looking. Then two uniformed cops came.

They were doing everything by the emergency regulation rulebook. But one kidded and said, "Do you have any dynamite?" in a loud voice. One was peeking down into the shaft and the other was holding onto his coattails. Finally from the third floor they lowered a rope ladder down to the car and brought Victor up through the hole in the top.

Then afterwards they washed up in the bathroom and one took off his belt and holster, and it was lying on the table, the gun in the holster, while he washed up. They were both 6′5″.

Sunday, November 13, 1977

Victor called from San Francisco, he was getting dressed for a leather party. He said he'd been to a party the night before where it was a bunch of "straight" carpenters inviting a bunch of gay faggots. I don't know what that means.

Cabbed with Bob up to 94th Street to Paul Jenkins and Joanne du Pont's house. Ran into Linda Eastman's father, the lawyer, and his wife on the street.

Paul Jenkins is nutty. He told Bob and me, "I nearly fainted when you called today to say that you couldn't stay for dinner because you weren't *invited* for dinner. You're invited *next* week." Instead of just not saying anything and we would have thought we'd been invited twice.

The du Pont lady told me that the first time she met me was at Mica Ertegun's and we were in front of the fireplace and the screen exploded. She happened to be wearing the biggest diamond in the world, one of them. She just got it from a sultan the day before, and when she got back to the hotel that night—she wouldn't say which hotel—she put it in the safe, and that night, she said, they switched ice on her, gave her a piece of glass.

Paul Jenkins showed us his collection—American Indian and Indian Indian stuff. When I was in India I could've gotten anything for nothing, but it's one of those things I just don't understand. Like Chinese stuff—I can't tell which is the good stuff, it all looks like the same junk. And he told us, "Lincoln Kirstein had his annual birthday freakout, but this time he physically threw his boyfriend out of the house," so Paul was setting the guy up in a little apartment, he said, that

belongs to Zero Mostel's son. I really want to do people like Lincoln Kirstein in *Interview*. I think it'd be so fascinating to do him our way and do it really good.

Sunday, January 1, 1978

I felt like my fever was coming back. I've taken lots of the drugstore pills, and it's scary.

Monday, January 2, 1978

I cabbed down to University Place and it was bubbling and bustling (cab $4). It was a half-holiday. I got to the office and I was a secretary, answering the phone. Robert Hayes and Marc Balet came in to work on *Interview*.

I called Bianca and she said to come right over to Halston's, so we did and Dr. Giller the cute doctor was already there. We cabbed to *Saturday Night Fever* ($3) and when we got there it was all sold out. So then we cabbed to the other theater where it was playing and that was sold out, too (cab $3). Then we decided to try to see the Buñuel film, *That Obscure Object of Desire* (tickets $14, popcorn $4). It was really good, more modern than his early ones because every once in a while when it would get quiet, they would look out the window through the venetian blinds at the Paris street, and a bomb would go off—somebody would be blowing something up. But none of us could understand the movie. It's one role played by two girls, and they never explain why.

Larry Rivers and his girlfriend came in and they sat near us. Larry told me that he did Aly Kaiser's portrait, and she's the one that said she wanted me to do her portrait and Victor kept telling me to call her and I just didn't. So Larry did her portrait, and I think he must have had to fuck her, I don't know.

So we walked back to Halston's, and he'd fixed those pastas with meat inside them, not ravioli but maybe they're called cannellonis? And he'd made a chicken, and we had lots of drinks. And Stevie Rubell was there, and Bianca got upset because he reads the London papers and he quoted something Mick had said. It was in Earl Wilson's column here today about him and Jerry Hall, so it probably was Stevie who gave it to him—I mean, he pretends to be so friendly, and then he calls up the papers. And there were so many English reporters outside Halston's waiting for a statement from Bianca or Halston.

Bianca and Halston seem like they're a couple now, they really do. It's like a romance. But Bianca is so upset about Mick, and I'm surprised that she is, because she could get somebody rich in a minute. Somebody said to Halston, "Why don't you marry Bianca?" and he put his hands on his hips and said, "Because *I'm* the hostess here."

And then we all went over to a place called the Ice Palace on 57th and Sixth. It's lesbians and hustlers. Bianca was dancing around, but she's so unhappy, and she and Halston were trying to get Jed to go home with them, and they were asking me if this was okay. She said, "Nobody likes me." Everybody was wet from drinks getting spilled on them.

Tuesday, January 3, 1978

There's an article in *People* about my Athletes show that's on now at the Coe Kerr Gallery.

When I got home from the office I made a lot of phone calls, then walked over to Halston's to pick up Bianca, she was cooking like a Puerto Rican, and she had the whole house smelled up with onions and hamburgers, she had them out on the counter. We cabbed up to 86th Street ($2.75) and we finally hit *Saturday Night Fever* at the right time and were able to get in. Well, the movie was just great. That bridge thing was the best scene—and the lines were great. It's I guess the new kind of fantasy movie, you're supposed to stay where you are. The old movies were things like *Dead End* and you had to get out of the dead end and make it to Park Avenue and now they're telling you that it's better off to stay where you are in Brooklyn—to avoid Park Avenue because it would just make you unhappy. It's about people who would *never* even think about crossing the bridge, that's the fantasy. And they played up Travolta's big solo dance number, but then at the end they made the dance number with the girl so nothing, so underplayed. They were smart. And New York looked so exciting, didn't it? The Brooklyn Bridge and New York. Stevie Rubell wants to do a disco movie, but I don't think you could do another one, this one was so great. But why didn't they do it as a play first? What was this first, a short story? They should have milked it—done it as a play first and it would have run forever.

Bianca fell asleep. Somewhere in the theater we found Dr. Giller. But he had related to the movie so well that he wanted to see it again, so we left him there and went back to Halston's.

Halston and Bianca were in the kitchen together cooking, and he said he had so much energy he wanted to go dancing. He told me lots of gossip—he said that the night before when the doorbell rang it was Liza Minnelli. Her life's very complicated now. Like she was walking down the street with Jack Haley her husband and they'd run into Martin Scorsese who she's now having an affair with, and Marty confronted her that she was also having an affair with Baryshnikov and Marty said how *could* she. This is going on with her husband, Jack Haley, standing there! And Halston said that it was all true, and he also said that Jack Haley *wasn't* gay. You see? I was right, I didn't *think* so. Halston said Jack *likes* Liza but that what he *really* goes for is big curvy blonde women. So when the doorbell rang the night before, it was Liza in a hat pulled down so nobody would recognize her, and she said to Halston, "Give me every drug you've got." So he gave her a bottle of coke, a few sticks of marijuana, a Valium, four Quaaludes, and they were all wrapped in a tiny box, and then a little figure in a white hat came up on the stoop and kissed Halston, and it was Marty Scorsese, he'd been hiding around the corner, and then he and Liza went off to have their affair on all the drugs.

Then Dr. Giller arrived from his second viewing of *Saturday Night Fever*. Bianca had been fighting with Victor before he came, because Victor was eating all the hamburgers she'd made and she was saying to save some for Dr. Giller. But I think she just wanted them herself—her ass has gotten really big.

The Sex Pistols arrived in the U.S. today. Punk is going to be so big. They're so smart, whoever's running their tour, because they're starting in Pittsburgh where the kids have nothing to do, so they'll go really crazy.

And Bianca loves Jed. She keeps calling the house, but he was off in Connecticut with Judith Hollander and Sandy Brant for his interior decorating business.

And they wanted to go out, but Halston didn't like the way Bianca looked, so he put three feathers in her hair. Oh, and Victor had just come over to get an extra bottle of Vaseline from upstairs.

Wednesday, January 4, 1978

In the afternoon Edwige, the Queen of Paris Punk, came down for lunch, and she brought a hairdresser guy down with her. She just got married and her husband sent her on a honeymoon, she said. He stayed home. She's a lesbian and he's a fairy.

And Edwige doesn't have any hair, and the hairdresser had hair down his back. Then about twenty kids that I'd met at Studio 54 and invited up came by, so they saw Brigid the Fat Lady. Then they saw the Lesbian. Then they saw the Hairdresser. Then the tour was over. But we got rid of lots of *Interviews* on them. They're from Southern University, something like that.

Cabbed to Bianca-at-Halston's ($2.25). Bianca wasn't there. She'd slept all day and was out at her exercise class. Halston was on the floor having a fit and he told lots of gossip. He said that once Liza and Bianca were both at his house, they were in the bathroom peeing together—you know how girls like to do that, have people to talk to while they're in the bathroom—and Bianca said that she had bigger muscles than Liza, and so they dropped their tops and were comparing muscles in the mirror and Halston walked in on them. And while Halston was telling me this, Bianca came in from exercise class and Halston had her show her muscles, so she dropped her top and showed them, and she really does have a good body on top. Then she made another Puerto Rican dinner.

And then Dr. Giller came in and he'd slept a few hours after being up all night dancing, so he was refreshed, and he started trying to find Halston's energy center, and while he did that, Halston was having white powder, so finally when Dr. Giller announced that he'd found Halston's energy center Halston had had enough white powder so that he did have energy. Then Bianca brought the food in and the doorbell rang and it was Victor in his underwear.

And then it was time to dress Bianca for Studio 54. Then over to Studio 54 and it was full of pretty people.

Thursday, January 5, 1978

Bianca had slipped her number to Nastase at the tennis matches that afternoon and when I got to Halston's the phone was ringing and it was Nastase, and Bianca told him to come over. He arrived with a boyfriend, just one of his friends, and he was intimidated by the place—Halston was dressing the Disco Queen in a coat he'd made for her that day, and she came down the stairs and Halston was saying *[imitates]*, "Come on, Disco Queen." He talks like baby talk. He didn't

put any feathers in her hair this time. I told him he couldn't, that the newspapers wouldn't take her picture if she put one more feather in her hair.

And then Nastase's boyfriend decided not to come to Studio 54 with us, and when we got in the limo Halston was yelling at the driver because he couldn't find the black radio station, he said, "What do you mean you don't know where the black station is—you're *black*, aren't you?" And then the driver said he couldn't see, meaning the radio dial, and Halston said, "What do you mean you can't see, you're *driving*, aren't you?" and then he told me that you have to yell at the help or they don't respect you. He has over a hundred people working for him and they're all so terrified of him, they're always asking each other what kind of a mood he's in.

And I noticed something—Bianca had two blemishes on her face! She's never had a blemish! I guess she's depressed about Mick, discoing the night away. She stays out until 6:00 then gets up for her 8:00 exercise class.

Friday, January 6, 1978

Victor came over to the office a few times because he was nervous about his party that night. Richard Weisman called and said Pelé was coming up to the Coe Kerr Gallery and so I had to go up there to sign (cab $5). Pelé's nice, he invited me down to Rio as his guest (cab home $4).

Changed and went down to Victor's loft (cab $4). Victor had a security guard at the door, and his loft was all set up, he had lots of liquor and beautiful boys I'd never seen before. And Chris Makos came and he just got a free camera from Polaroid so he was getting all the kids to do funny things, taking off their shirts and posing. And there was a drag queen there, a former Cockette named I think Jumpin' Jack and he had about 18 pounds of tit. And Diana Vreeland came with Barry Landau and Bill Boggs and Lucie Arnaz. They'd just seen the Mary Martin show. Larissa was there and Edwige. Edwige was unhappy because she came to New York to see Patti Hansen, who wouldn't see her again, so at the party Edwige put a four-inch cut in an X on the back of her wrist—later Victor found blood in his apartment.

And then, my dear, it was like a story-book fairy tale. Halston arrived in white, with Bianca on his arm in white fur, with Dr. Giller in white, in a white limo, with a white driver.

Saturday, January 7, 1978

The maid at Halston's said Bianca was still upstairs asleep but that I could go up there. I woke Bianca up and she jumped up and put her clothes on over her pajamas, and that's when I realized that Bianca doesn't really take drugs—just a few poppers and maybe some coke once in a while, but otherwise she's not on drugs, she's normal.

Sunday, January 8, 1978

Got to Madison Square Garden for the tennis matches. The photographers were snapping, and Bianca told Jade to put her hands over her face, which is really funny, that Bianca has her trained, and Jade said, "But you have *your* picture taken, Mommy." Bianca just wants all the attention for herself. The match was Connors against Borg. Connors won.

I read *The New York Times* at Halston's, he was at the office. Someone called Bianca and she was on the phone for an hour talking about her problems and I wished I'd listened or taped, but I was just reading. For the first half-hour she was talking about someone who she said was using her in London just to get their picture in the papers—she's so funny, because that's all she ever wants herself—and then the other half-hour she was talking about what a stupid blonde Jerry Hall is. I think she's really worried that she's getting her permanent walking papers from Mick. While Bianca was on the phone Jade asked me for candy and I gave her some M&Ms and then she said, "You've *got* to give me my supply for the night." So I gave her a few and she said, "You've got to give me some more, we'll go to the bathroom," and I told her that her mother would think it was strange if we went all the way to an upstairs bathroom and she said, "Well, come under the stairs, then." I slipped the M&Ms to her and she took them like drugs.

Monday, January 9, 1978

Worked a little at the office with Rupert and then with Alex Heinrici. I'm still using Heinrici to print screens but I'm giving more and more work to Rupert. Cabbed up through the snow. The whole ride was long and hard ($10).

Liza had sent six tickets for Bianca who wanted to see *The Act*. Bianca disinvited Victor because she wanted to invite Stevie Rubell and her dancing teacher who was in from London. Bianca kept calling Stevie but she couldn't get him. It came out later on that Bianca only wanted to go because she'd heard Jackie O. would be there and she wanted to get photographed.

Jed and I went over to Bianca's, thinking she'd have a car, but she didn't. Jade was coming, too. When we got to the theater, everyone was staring, looking around for Jackie O. *The Act* was good again. Bianca was putting it down, but toward the end when she knew we'd have to go see Liza she started putting it up, saying it was great. Jade had to pee. Jackie and Swifty Lazar and Jack Haley and Bianca all had their pictures taken and everyone was staring while they did. And afterwards we went backstage to see Liza. I pointed my tape recorder in Jackie's direction and I hope I got a little breathy talk (tickets $60).

Then we cabbed back to Halston's ($3) and when we got there, he was just going to bed. You could see he was really ready to go to bed, he had Linda in his arms and everything. Linda's his dog. Then Bianca got on the phone and made calls to find out who was where, who was at the Ice Palace, who was at Elaine's, and then we went up to Elaine's (cab $2.75).

After the show Liza's group had gone to "21," and Bianca was calling there leaving messages about I guess coke—calling it "the book." Like, "I haven't got the book for her yet."

Halston hadn't dressed Bianca before she went out so she looked really awful when we went to the theater, but nobody had wanted to tell her. But when we got back to Halston's he finally told her how terrible she looked. He had her take off the turban and put on dark lipstick, and *then* she looked good. But then she realized how bad she'd looked for the photographers at the theater. Jade was wearing a long dress.

Then Peter Beard came in with a guy who had a beautiful glove on and a bottle of coke in the other hand, and then later he showed us his hand which was a stump, it looked like in the movies when they show the fiendish ghoul—he lost it in a plane crash, his third plane crash, a DC-10 that he owns. He passed the bottle of coke around (dinner $130.38, tip $20).

Then we went to the Ice Palace (cab $3) and it wasn't so crowded, just a few hustlers, and then around 3:00 Jed and I slipped out.

Tuesday, January 10, 1978

I walked over to Halston's and when I got there Jane Rose, Mick's secretary, was there and she was calling Mick so that he could sing to Jade before bedtime. Then we tried to get Fred on the line but it was busy for four hours. I wanted him to come out with us because I wanted to be able to duck out early.

Bianca was telling her side of the marriage story. At first she was saying that she never cheated on Mick, but then she said he was splitting from her because she had so many affairs—she had one with some guy named Llewellyn and now she's having one with Mark Shand. But she said she never flaunted it publicly. She told me that she wanted to be somebody on her own, and that she'd always wanted to make it on her own so that *(laughs)* she could buy any waiter. She said she's giving Mick his divorce and I told her that they shouldn't break up. She said she and Mick hit rock bottom, that she can't go to bed with him because she just doesn't think he's attractive. And she said Mick was "rude," putting her down recently, she said she's never put *him* down. She said she couldn't be "free"—like a free spirit—with Mick because of who he was, and she was a nobody. And she talked about her trip to Hollywood coming up and she talked in that lub-luh-luh voice about her "role" in this movie with Tony Curtis and Lionel Stander and Gloria Grahame. She said they were rewriting the part for her, that she'd told them certain things she wanted. It takes place in Costa Rica. And she's scared because "the Critics are waiting to tear me down." And I don't know if she can do it. I mean, she tells me she can dance, too, and then last night I made a point to watch her and she's no Rita Hayworth, she's no Rita Hayworth.

She was happy because the *Daily News* finally ran the pictures of her with Liza and Jackie O. from the night before at *The Act* in it (cab to Studio 54 $3.50).

I'd given some beads to Jade earlier, and Bianca was saying that now this breakup is taking its toll on Jade, but Jade looks okay to me. Bianca is such a tease, she's always going after guys and getting them all excited, giving them her phone number and then when they call not doing anything.

Wednesday, January 11, 1978

Paulette called a few times to say not to be late. I dropped off Catherine and Fred ($5) and picked her up at the Ritz Towers at 8:15 (cab $1.50). I asked her where the new Halston she bought was, and she said, "I brought it back, it made me look too fat." She was wearing the dress that looks good on her, the YSL, and she had on her rubies, about a million dollars around her neck—I know, because I saw a stone like that that wasn't even as good and *it* was a million.

We drove to the Waldorf Towers and the driver went around the other way to avoid the anti-Iranian demonstrators. Some creep asked us what I thought about the torture in Iran and Paulette said, "Listen, Valerian Rybar is torturing me here in New York." He's still decorating her apartment, she was complaining that it's been a year.

The du Pont lady and Paul Jenkins were there, they'd just stepped off the Concorde. "Suzy" was there, and her apartment is also being done by Valerian Rybar and she told Paulette not to take it personally—that he'd been doing *her* place for two and a half years. I told "Suzy" I loved her column that day because there was so much dirt in it about Mick and Bianca, and how Mick has left Jerry Hall, and about Liza and Baryshnikov and Scorsese. Hoveyda and Zahedi were there, Barbara Walters was there with Roone Arledge. I was so excited to meet Roone, we talked about Art Buchwald. And Mayor Koch was there with Bess Myerson, and she's really tall and handsome and he's about the same height. And Governor Carey walked by and I said hello to him a couple of times but he didn't say anything, he was with the Ford girl. And Beverly Sills was there, she's tall, too. This was a thing for "artists" and tomorrow the queen is opening an Iranian exhibit at Asia House. Shirley MacLaine said hello to me a few times. And Mollie Parnis was there, and Jerzy Kosinski.

Then they started the speeches. Zahedi, then the—empress, the queen. Then Koch, then Carey, then Kissinger—and he talked for almost forty-five minutes, so long-winded. They flew in violets for the ladies, and the caviar was called Pearls of the Caspian Sea and Paulette had about a pound. It was white and not too salty. The violinist from Lester Lanin asked for Paulette's autograph. Paulette wanted to leave so we did and she said she'd go out of her way to drop me at the door, it was so cold. I mean, you *know* it's cold when *Paulette* gets considerate.

Thursday, January 12, 1978

Interviewed Lucie Arnaz at Quo Vadis, and it was nothing really startling. She's so tall, she eats everything, she's a little fat and she was wearing jeans so she looked fatter, but she has a beautiful face. We brought up Jim Bailey the female impersonator and Burt Reynolds. She dated both of them. She said Burt was sweet and devoted. These girls are brought up strict, they think you shouldn't put out.

Went uptown ($6) to pick Catherine up at 7:50 and walked over to the Copa for the Bette Midler opening that Mica Ertegun sent tickets for. Ron Galella was there and he had his own camera crew—a TV thing was being done on him. It was the same Mafia-type people at the Copa like when we had our party there last year. Richard Turley was standing in the doorway and he asked if he could try to slip in with me, and I didn't know what to say, I said he could do whatever

he wanted to but that it was Mafia and that he'd never make it, and he didn't. Chessy Rayner was there, and Peter Tufo and Lee Radziwill were there together but she was at a different table from him, and I'll get to that in a second.

I couldn't see anything, just the top two inches of Bette's head when she finally came out. And Catherine was sitting so that she faced Peter Tufo and pretty soon I felt his leg rubbing against mine and I guess he thought it was Catherine. They were really flirting hot and heavy, and he said to her, "Why don't you get up on the table and boogie?" and I was surprised because he's usually so sour. He was yelling things like *(laughs)* "Colored sounds!" at the black girls singing.

I kept hitting Catherine to turn around and look at the show, but she was telling about going to Plato's Retreat the night before. She said she didn't know if she'd been penetrated or not while she was there, and hearing this got Peter Tufo hotter, and she spilled a drink on his pants, but that just made him hotter, too, and he slipped her a note that I found out later said just *"When?"* and all I could think was that it was a repeat of our friend Barbara Allen taking Peter Beard away from Lee, and now here our friend Catherine was stealing Peter Tufo.

I just wanted to run out, it's a firetrap there, I hate to be in places like that. And then everybody left, Catherine went back inside to get the *"When?"* note and we got separated, and she went over to Quo Vadis in the Erteguns' limo, and I walked over and when I was walking in Lee and Peter Tufo were fighting, but Lee stopped fighting to wish me Happy New Year with a kiss. We were at Ahmet's table. Dinner was a little pigeon. Lee left first and I thought Peter Tufo would stay for Catherine, but he left with Lee, so Catherine was safe. And Ahmet was loading up with cognac and being funny. And afterwards we were all invited up to the Cotton Club, which they were reopening with Cab Calloway in Harlem, and Catherine and Mica and Ahmet wanted to go, but I don't think anybody else really did. I walked Catherine home, and it was early.

Also today, got back my photographs of Edwige cutting her wrists at Victor's party the other night, and Victor said that her scars would be punk jewelry.

And Bob met today with the Rums of Puerto Rico guy from Kenyon & Ekhart and the guy who's from something like the Puerto Rican Chamber of Commerce, and they want to have a party at the office to unveil the Liza portrait I'm doing because Liza's endorsing Rums of Puerto Rico, and so they're giving *Interview* three months of rum ads. They're trying to get Burt Reynolds for this campaign, and I'd be doing his portrait, too, but the two people he wants to be in the ad with him, the agency didn't think they were "cosmetically right." So Bob called Burt's manager in L.A. and had to ask if they could submit some other possibilities, and the manager said, "Listen, Burt's endorsement is worth a million dollars and he's only even *considering* it because he wants a Warhol portrait, and if Burt sent a midget and a dwarf over to be in the ad with him, Rums of Puerto Rico and their ad agency should be thrilled." And Bob said the people Burt wants aren't even bad-looking anyway.

Friday, January 13, 1978

Lunch for Bloomingdale's at the office. It was a big thing that Mr. Traub himself came down. And Cal, the friend of Robert Hayes's who was at Bonwit's and gave us ads there, is now at Bloomingdale's. Bob gave a big impressive speech about *Interview*, and then he turned to Carole Rogers,

Interview's associate publisher, and said, "Carole, could you give us some statistics, please?" waiting for her to reinforce the figures that he'd given—that *Interview*'s circulation is 80,000 and that 20 percent of that is subscriptions—but instead she said, "Our subscriptions are 7,000," and everyone turned red and gasped, and Bob couldn't believe it. Afterwards Cal called and said that was the first thing Mr. Traub brought up in the car after they left, so that might have blown it, but they'll give *Interview* something because they do think it reaches the right people. All the Bloomingdale's people were in blue suits.

Saturday, January 14, 1978

Went to a screening of *The Leopard* that Suzie Frankfurt was having at her house. Victor was there with a really good-looking little seventeen-year-old high school kid from New Jersey, all-American *Happy Days* type of good looks, and I was thinking how can he come to New York and do things like meet me, and know Victor, and go to the Ramrod and come to Suzie's for a screening of *The Leopard*, and then go back and sit all day in high school.

Monday, January 16, 1978

We found out Andrea Portago is marrying Mick Flick this weekend in Switzerland. And then Barbara Allen came by with Lacey Neuhaus. Barbara was just back from Acapulco, and she was very tanned. When she heard the news about Mick Flick and Andrea, she tried not to look shocked—she recovered in a second and said, "I only had one date with him and he was so boring that I left before the espresso."

At around 4:00 Margaret Trudeau arrived, and Marc Balet and Robert Hayes took her to be photographed. Arranged to meet her at 9:00 at Quo Vadis. Worked until around 8:00, then dropped off Catherine (cab $4).

Went home, glued, and then walked over to Quo Vadis to meet Bob and Margaret Trudeau. She did a really great interview. She had five margaritas. Her family sounds like Viva's, she has a lot of sisters, too, but then she's more intelligent and more beautiful than Viva and her family, because she's not so crazy. She hitchhiked in 1969 in Morocco. And she had us turn off the tape and she told us that she sat next to Nixon at dinner and he didn't talk to her the whole time until he turned around and told her about the sex life of a panda, and that was it.

Margaret was wearing a new designer's dress. She said she was just on the list of the worst-dressed women in the world. She told us that wherever she goes, no matter who else is around, the photographers always go after her and keep snapping. Then we went over to Studio 54 for Scavullo's birthday party and it was true (cab $3.25). Margaret was dancing and the cameramen went crazy. Stevie had said there would only be one photographer, but there were twenty to fifty. When they brought in the birthday cake, which was in the shape of a camera for Scavullo, they didn't even notice the cake—they were still going after Margaret.

Tuesday, January 17, 1978

We went to the Vincis' dinner for Lina Wertmuller at the Italian embassy. She coughed all over me and then said she was just getting over the flu. But I found that lady Cappy Badrutt and she was fun—I really like her, she's so beautiful, like an elegant courtesan. She told me about some of her affairs. When I left Bob stayed on so Fred dropped me off.

Wednesday, January 18, 1978

John Chamberlain and his new wife Lorraine came to the office for lunch. She's really pretty, a lot younger than he is. He said he was tired of living in lofts—he's looking for a small apartment in the Dakota. He's still doing the same sculpture things, but they still look great—the car crashes—and people are still buying them. I did some photographs of him and his wife.

Thursday, January 19, 1978

Went to the auction of Joan Crawford's costume jewelry. Saw PH there bidding on a huge pink necklace and when it went over her limit she dropped out, but then I bid some more and got it and gave it to her. She was so grateful she took me down to the Village to Sixth Avenue near Waverly and showed me a secret store she'd discovered on the second floor where a man sells all the Diors and Balenciagas that belonged to his sister who's now dead. It was the greatest place and I bought about five dresses. Everything there is size 14, though, because the sister was fat. The store is called Fabulous Fashions, and it has hats and handbags and umbrellas, too, and it's all *cheap*.

I went home to change for dinner, but I forgot that Sandra Payson—you know, Lady Weidenfeld—had told me it was black tie. So I glued myself and went over there. Cabbed to Sutton Place ($2.25). It was a small dinner party and when I saw I was the only one not in black tie, that's when I remembered that she had mentioned it. When they saw how bad I looked everybody ran away from me and they didn't come back until they were drunk. I was trying to make it better with conversation, so I just started telling them about how I was buying lots of dresses now, and they just backed away. And Mrs. Payson invited me, I think, because she wanted a painting, but she never mentioned a thing about it so I guess she was so shocked by my clothes that she decided against it.

The party was for a ballerina whose name I forget, but who was the big ballerina at the same time Margot Fonteyn was—not a Russian, though. She told me about every cat she'd ever had and how each one died. She had a Siamese who jumped onto a ledge and then fell five stories, and she said she could still see the claw marks that it left on the ledge, and that was sad—it tried to turn around and it slipped.

Friday, January 20, 1978

This was the morning of the big blizzard that had started the evening before. Biggest snowstorm since '69.

Down at the office I looked out the window and for about an hour a black man was trying to get his car unstuck. He went down into the subway and came back with a shovel and he tried to dig himself out, and whenever he'd get back into the car to try it he'd take the shovel inside with him—I guess so it wouldn't get stolen. After an hour, a bigger Negro guy with a bigger shovel walked by but he didn't help him. McDonald's closed early. Chemical Bank closed at 1:00.

Saturday, January 21, 1978

Cabbed over to Studio 54, and then when we got there, the place was packed. Ken Norton was there. It was jumping for a snowy night, Stevie couldn't believe that so many people came out in the blizzard for it, he was turning away people at the door as usual. Then we wanted to go down to a place called Christy's Restaurant on West 11th Street where there was a *Saturday Night Live* party for Steve Martin. We went outside to try to get a cab but we couldn't. Then along came a white guy and a black girl in a car who offered us a ride anywhere we wanted to go, and we took it. They said that Stevie wouldn't let them in to Studio 54 because they didn't look right, but they looked okay to me—I mean, he looked like a fairy and she looked like a drag queen, it was the Studio 54 look. As we were going along Catherine looked out the window and said wasn't that Lou Reed on the street, and it was. He was with a Chinese chick, and they got in and he was very friendly. When we got to Christy's, Steve Martin was great, he seemed thrilled to meet me.

Sunday, January 22, 1978

Sam Beard was giving a fortieth birthday party for his brother Peter in his apartment on 92nd and Park. It was an exciting party. Jackie O. and Caroline were there. Caroline asked me what I thought of totalitarianism and I couldn't pronounce it so I tried to joke about it and she said, "No, I'm serious." Mary Hemingway was there, and Jonas Mekas filmed her being a lion attacking Peter Beard.

Fred was there with Lacey Neuhaus and Stevie Rubell was there. Victor arrived in a torn T-shirt with spurs on his arms, with a present for Peter—it was something that looked like he might have found in the street or maybe used in Halston's display window, like a part of a machine. And he had a present for me, too—a used jockstrap. It was great. Barbara Allen was there with Philip Niarchos, he's in town. Ronnie and Gigi and Walter Steding were also there, and Jennifer Jakobson who doesn't seem to be with François de Menil anymore. And Steve Aronson. He's a real charmer, he speaks so beautifully and wears those great clothes. Peter was very happy because all of his old girlfriends were in one room.

Then we all went over to Studio 54, and they had an elephant cake for Peter come down from

the ceiling because Peter took all those great African elephant pictures. Arnold Schwarzenegger was there. I left around 2:00 just as Halston and Bianca were coming in. They were both in elephant masks, but the photographers didn't care, they're tired of Bianca. She better get out of town for a while.

Tuesday, January 24, 1978

Suzie Frankfurt called and said her facelift was very painful.

Since it was nice weather I walked down to work. Victor called and said that he'd done "something terrible" but wouldn't say what it was on the phone, that he would come over (lunch for Victor $5.29). But he still wouldn't tell what he did. Later when I was talking to Bianca I got it out of her, so I called him up and said, "Gee, Victor, I had a dream last night that you were painting on top of *my* painting. Isn't that crazy?" And he started to freak out that I really had dreamed it, and then I said not to worry, that I knew what he'd done and that I'd give him another one.

Later that night at Studio 54 there were two little kids from Caracas there, and Victor got jealous when I was talking to them, and they knew exactly where Victor was from when they heard him talk—it turns out Victor has the "Brooklyn accent" of Caracas.

Philip Niarchos arrived with Manuela Papatakis. Bianca was thrilled that Barbara and Philip seem to have broken up.

Wednesday, January 25, 1978

When I walked into the office, the lunch for Carole Bouquet, the beautiful French actress, was going on, but she wasn't there because she was still filming her movie. Peter Beard was there, though, and Mona, and it was half from William Poll, half Brownies. The cute guy with the burned hand, Peter's friend Tom Sullivan, was there. We liked his boots so he asked us our sizes and called this place in Georgia to send three pairs up. He's been living in a suite at the Westbury for months waiting to have skin grafts on the hand he burned in his plane crash. I think Catherine has a crush on him.

Worked on some paintings in the back. I'm really tired, though, I'm not getting enough sleep. Bianca stopped by and five minutes later Mark Shand did. And Brigid told me, "All day long Lady Isabella Lambton picks her nose and eats it, and if you say something to her about it, she just laughs and goes right on doing it. She told me that at night she and her boyfriend pick each other's noses. It's hard to take."

Went up to the Olympic Tower to see Halston's new offices (cab $3). It's on two floors and it looks out on St. Patrick's steeple. We had some drinks. We dropped Catherine off and she didn't have any shoes on so Peter's cute friend carried her up six flights.

Thursday, January 26, 1978

When I called Catherine at home in the morning before I left a man answered and said she'd already left for work, and it was Tom Sullivan from the day before. He said he was just there dropping something off. He shouldn't have answered the phone. When I told Catherine later that he had, she said, "Well, you got me," and she was slightly embarrassed.

The boots arrived at the airport and Peter Beard brought them down. Mine fit perfectly, I'd told Tom to get me 8-D—the only thing wrong was that I had said round toe and they came with the pointy toe. And they'd all come in a big box and Peter had taken the shoes out of the box because it was so big, and thrown the box away, and then we found out that one of Catherine's pair was still in the box, and so Tom's driver went back uptown looking for where they'd thrown out the box, and he did come back with it, so Catherine was thrilled. They're cowboy boots made out of elephant ears.

Lunch for Isabella Rossellini (supplies $7.13, $16.41). John Richardson was there and gave me a present of a picture of his cock. Bianca was wearing white with a purple Halston stole and she and Tom Sullivan, Brigid said, "were practically fucking against the wall, it was really disgusting"—and Isabella Rossellini, Robin West, and Claus von Bulow were there. Dinner was at Bianca-at-Halston's, it was veal blanquettes. Diana Vreeland was there with Fred, and Stevie is so funny, he said to me she was "fascinating," and then later in the evening he said she was so boring he didn't know how to get rid of her. And you know, I've come to realize lately that Diana Vreeland is just a person. I realized it a few months ago when I was thinking again about the thing in the sixties with Viva at *Vogue*, when Diana killed the pages on Viva that would have made Viva's career. Diana does do things for her "career"—she listens to people who tell her if something's a bad thing to do, if she'd suffer professionally, and then she does what they tell her. Somebody must have told her that if she ran the Viva photos it would be a bad thing for her. You think that she doesn't think that way because she's Diana Vreeland, but then you suddenly realize that she does.

Friday, January 27, 1978

Went over to Halston's. The Halston crowd coordinate themselves, they talk to each other and decide what color themes are on for the evening. It was back to black and red this night. Pat Mori the model was there in black and red, and Halston had his red socks on with his regular black and white.

We went over in the limo to Studio 54. I was there until around 6:00 in the morning but all I remember is Catherine and her new boyfriend Tom Sullivan who I do think is a coke dealer. Bianca said she got a movie part opposite Jeff Bridges.

Saturday, January 28, 1978

Picked up Bianca and went over to the Dakota for Susan and Gil Shiva's party ($2.50). Lina Wertmuller and her husband, Enrico Job, were the guests of honor. He was the production designer on our movies *Frankenstein* and *Dracula*. Her movie *A Night Full of Rain* with Giancarlo Giannini and Candy Bergen is opening. Neil Sedaka was there. People kept bringing Woody Allen over to meet me so I met him four times. And Betty Bacall was there, she lives in the Dakota, too. And Judy Klemesrud the nice girl from the *Times* was there, and that Nancy Collins, the one who used to be at *Women's Wear* who's now in Washington, and Candy Bergen was there. Also at Gil Shiva's, Andrea Portago and Mick Flick, back in town after their wedding, and Bianca said, "He wanted to make me at Studio 54 last night, he attacks me now that he's married—he never attacked me before."

Then we left for Studio 54. Catherine was there with Tom Sullivan, and they were going to the Brasserie for cheeseburgers and invited me, and so I went.

Forgot to say the most exciting thing about the evening, When we left the Shivas, Bianca wanted to stop back at Halston's to pick something up. When we got there, there was a pretty boy in a fur coat standing outside, and when we walked in, there was Liza Minnelli talking to Halston. She wanted to know if she and Baryshnikov—it was him outside—could spend some time at his place. So we weren't supposed to see this. And Liza and Baryshnikov were taking so much cocaine, I didn't know they took so much, just shoveling it in, and it was so exciting to see two really famous people right there in front of you taking drugs, about to go make it with each other.

Liza is just back from the rest cure in Texas, and she's going to start doing *The Act* again.

Sunday, January 29, 1978

Barbara Allen called and she wanted me to take her to the New York Film Critics dinner, and she sounded down in the dumps. She told me that it's really getting to her that Philip and Manuela are around. Everybody's calling Barbara and saying, "We're inviting Philip and Manuela—do you still want to be invited?" She's unhappy.

At 8:30 I went over to Halston's. Bianca was wandering around with her tits showing. Mark Shand's left town.

We cabbed up to the Iranian embassy ($2.50). Maximilian Schell was there and he'd gotten a supporting role award for *Julia*. I had never met him before and I was disappointed that he was fat, but he was really sweet. He said that I did great things for him in Germany, that he'd seen *Flesh* and hated it and then gone back to see it again and again and loved it, and that he thought, *If this is a movie, then I can make a movie, too.* I didn't know what to say, so I decided to give him Bianca, and they went crazy over each other from then on. I'd always heard he was a fag, but the way they were carrying on, that image was fading. And Sissy Spacek introduced me to her husband, he was very nice, and Bella Abzug's campaigner—what's her name? Shirley MacLaine told me she had the picture I did of Bella on her bureau. And John Simon was there, he was intrigued by Bianca. She had her hair in big pincurls that she said was a Nicaraguan

style, but it looked Puerto Rican. S.J. Perelman was there and I wanted to talk to him because Nelson always said he's the funniest man in the world, but I didn't.

Bianca came running over and told me that for the first time she'd fallen for an older man. She said she had to leave, that she had to go home and cook a dinner for Halston, and I guess I laughed out loud because I remembered when Amanda Lear told me that the reason Mick's left Bianca is that she never made him a meal. When she's after somebody, though, she's a real coquette, out to prove she can do all the things. So we went back to Halston's. Maximilian let his car go, I guess he was cheap.

Stevie called and said come to the club. Victor and I had a feast in the kitchen—we made popcorn and I had orange juice and vodka. We left Bianca and Maximilian hugging and kissing in the other room. Halston took Linda and went to bed. Then we went over to Studio 54 and it was jumping.

Monday, January 30, 1978

I was supposed to interview Fran Lebowitz on her new book at lunch but Bob said that she couldn't have her regular column plus an interview, too, in the same issue, so Fran got upset and cancelled.

Catherine got a call from Tom Beard and Joel McCleary inviting us to a dinner they were having at Elaine's with Bill Graham, formerly of the Fillmore, who gave us—gave the Velvet Underground—our first big break in the sixties but then kicked us out.

Dinner wasn't until 9:30, and Catherine's been out so late, she falls asleep all day, so she wasn't ready until 10:00 and I picked her up. She was packing her tote bag to go over to the Westbury because Tom Sullivan is out of town and told her she could stay there and order room service, so all she could think about was sausages and eggs in the morning. He left her a limousine, too. She's really in love with him. She wears his clothes, his Valentino coat and leather jacket. She said his father died when he was very young and left a lot of money, that he'd made a lot of money on a radiator part (cab to Elaine's $2.60).

There were a lot of famous people there that I knew, but I didn't go to say hello—Candy Bergen, Joel Schumacher. Fred was already with the Carter people—Tom Beard and Joel McCleary. Bill Graham and I got right to the central incident of our relationship—him kicking the Velvets off the bill at his San Francisco Fillmore in I guess '66—and it finally came out after all these years that what made him really hate us wasn't the Velvets' music—it was that he saw Paul eating a tangerine and throwing the peels on the floor of the theater! *(laughs)* Can you believe how *long* it takes to get the real story? So then everyone at the table thought we hated Bill Graham and didn't talk to him—Bobby Zarem was there, too, with us, and he's getting fatter and fatter—but it wasn't that we were mad, I was just dead tired. But they thought there was "tension at the table." Dropped Catherine at the Westbury ($3).

Tuesday, January 31, 1978

Rupert was at the office. Maximilian Schell came by and the minute he walked in the door Brigid immediately asked him for five autographs and Catherine asked for eight, then Chris Makos was snapping away, too, and poor Max was bombarded. They did need one picture, though, to go with the interview we were doing. He was calling a girl to meet him down at One Fifth.

At dinner at "21," Jody Powell was with a girl. The whole idea of the dinner was to interview Joel McCleary, but then my tape recorder was doing funny things. I sat next to a girl, Lynn, who said she and Joel were first sweethearts but that they never got married because he was a hippie and she was a Marxist. It was fascinating to see two hippies who couldn't make it because they were different *kinds* of hippies. She said that Joel used to be so skinny, but now he's gotten fat, but that fat was better for politics, that it was better to see a big hunk of man up there. She said her guru told her that if you're a man and you're thin, then you turn homosexual, and I'm thinking I agree with that because of all the models. She said she and Joel meet once a year and tell each other off. So I guess people do do that. I told her that was what the couple does in that Broadway play *Same Time Next Year*.

Lynn said she's involved with that Pillsbury guy's foundation, but when I asked her for money she said she's only able to give it *(laughs)* to "people in New England."

Wednesday, February 1, 1978

Victor picked me up and we went to Chinatown. I hadn't been there for years. I still think they have the one kitchen in the back of Chinatown with the one big pot that they all dip into. We ate at some dump on Canal Street. We went to a lot of Chinese stores, and one Chinese girl recognized me. Then we took the limo to the Spring Street Bar and had drinks ($6) and I realized we should have come there for hamburgers, that would have been the better thing.

We stopped in at the O K Harris gallery and Ivan had just put a new show up and it was really crowded. Then we went around the corner costume-hunting to a store where a boy who was a camp sold $2,000 capes made out of gold thread. Then we went over to Fabulous Fashions.

Victor thought it was the most fabulous place I'd ever taken him. He bought things for Halston there. And then after Fabulous, he dropped me off at the office because I had to meet the Hoveydas there, they were bringing a famous Iranian and his wife down and then we were all going down to Ballato's. Mr. and Mrs. Ghaferi.

Ballato's was very exciting because John and Yoko Lennon and Peter Boyle and his new I think wife were there. Catherine asked John for his autograph and he said no, because he said he just read that Robert Redford doesn't give autographs, so he wouldn't either. And Calvin Klein was there with that girl who gave me my first job at *The New York Times*—Carrie Donovan. The food was really good and Mr. Ballato was there, and I paid the check with a check and then it was so early, 10:30, but they dropped us home.

Oh, and in the middle of dinner I told Catherine how Brigid and Chris Hemphill were both refusing to transcribe any more of the interviews that she does because they said they were so bad, and I told Bob he'd have to straighten it out. And later he told me he doesn't know what to do, because on the one hand Catherine's interviews *are* really bad—I mean, she asked where the Bronx was in one of her interviews, and then even left it in the article because she thought that was "fascinating"—but on the other hand Brigid and Chris shouldn't be allowed to decide what they'll transcribe.

And at dinner the Iranians told me that when I paint the Shah to go easy on the eye shadow and lipstick. They said, "Keep it casual but conservative."

Thursday, February 2, 1978

When I got to the office, Brigid was still embarrassed because Lucio Amelio, the art dealer from Naples, had arrived earlier for an appointment with Fred and when he got to the reception desk he stared at her for a long minute and then said, *"Brigid Polk? La actress famosa di Chelsea Girls?"* And Brigid was mortified that now she was a receptionist so she told him that she'd just appeared in *Bad*, too. He was so excited, telling the people with him how famous she was and acting like he'd just met Greta Garbo and *(laughs)* poor Brigid had to keep answering phones.

Ran into Robert Mapplethorpe near the office. He told me he has a show opening in San Francisco and he's going there for a month for a "sex vacation" because "San Francisco is the best place for sex in America."

Went home to change and then went to pick up Barbara Allen to go to a party at Diane Von Furstenberg's (cab $2.60). I wasn't invited—Barbara invited me as her date. Her ex, Philip Niarchos, was going to be there with Manuela.

We got to 1060 Fifth Avenue about 9:00, and it was a super party. Diane has a big apartment, huge, with fabric on the walls. She has a bathroom as big as a living room. Barry Diller lives there now, too, when he's in town. She had wood painted white and then painted wood-grained, like Art Nouveau. I made a *faux pas*. I walked into the room where everyone was eating, and Carl Bernstein was talking to Helen Gurley Brown, and he looked up and said to me, "Do you think Bob Colacello is attractive?" and I didn't know what was going on, and I guess I put my foot in it, I said, "Well, he's not *my* type," and she got up and walked away. And then he told me that she'd mistaken him for Bob Colacello, and when he got insulted she was telling him how attractive Bob Colacello was and I blew it.

Barbara is really unhappy—Bianca's got herself a movie career and Manuela has Philip. She had a good long talk at Diane's with Philip. And Manuela isn't good-looking at all.

Barbara said the same thing that Bianca did, that Mick Flick was after her.

Friday, February 3, 1978

Had to get up early—at 6:30, the sun rises after 7:00—to call Catherine and tell her I wouldn't be going to Mardi Gras.

The lunch at the Lachmans' was at 1:30. Jaquine Lachman wants a painting but she wants

a bargain price. I mean, her husband owns a third of Revlon! Bob is going to tell her no bargain.

When we got to the Lachman apartment, I could see that Mrs. Lachman was this French lady who's really so bored with her husband. His daughter from another marriage told her father he should paint, so now all he does is stay home and paint all day. He paints one painting each in the style of every artist. And he follows his wife around the house, he literally bumps into her when she stops.

While we were there one of her friends called her and said she was too tired to go fur-coat shopping. So Jaquine was upset.

Tuesday, February 7, 1978

Catherine called, she's still down in Tampa with Tom Sullivan.

I think Peter Beard's in love again, with Carole Bouquet, the girl from *That Obscure Object of Desire*, the Buñuel movie that's out now. He called and said he was having dinner with her up at Elaine's and invited me. When I got there Elaine was jitterbugging with a guy from the bar. Lorna Luft was there. She said she's got a part in *Grease*.

And the Calvin Klein daughter kidnap is still in the papers. He gave an interview to Eugenia Sheppard about how brave his daughter was when she was kidnapped. Left around 2:00, dropped Bob (cab $3).

Wednesday, February 8, 1978

Before I left the house my nephew Paulie who's been in Denver for years called from New Jersey and said that he was leaving the priesthood and going to get married. I told him to come by the office in the afternoon and we'd talk about it.

When I got to the office ($3.60) Bob Colacello and Robert Hayes were having an important business lunch and so I went to sit in on it because I knew I was supposed to. But whenever it's a sort of important lunch, it's so stupid in that room, because Brigid will walk into the bathroom or Ronnie will wander through or someone will come to the door and say, "Barry Landau is on the phone for you" or "Crazy Matty is here to see you"—they don't seem to know what's important, and so it's silly in there.

My nephew arrived. He told me that he'd given up his parish in Denver. You're still a priest even if you give up your parish, but after he gets married he'll be excommunicated. I told him he should see *Saturday Night Fever*. Because remember the part where the brother's leaving the priesthood? I didn't know what else to say, he wasn't listening to me anyway. He even said, "I'll just do what I'm going to do anyway, so let's not even talk about it." But then he kept bringing it up. And after 5:00 when the rates were down he called Denver and had me talk to his Mexican-American fiancée who's thirty-seven—older than he is—and she did actually sound nice.

It was Ash Wednesday.

Thursday, February 9, 1978

Bob called in the morning and said that Suzie Frankfurt was becoming a Roman Catholic and that she was getting baptized this morning and that we should go up to the church (cab to 83rd and Park $3). It only took a minute, Suzie got baptized and her hair got wet, and we went back to her house for coffee.

Cabbed down to Union Square ($3). Anselmino was calling from Italy all day, screaming hysterically about forgeries of my paintings that he was being offered. And my nephew was there all day writing letters and making phone calls. I worked until about 7:00.

Friday, February 10, 1978

Anselmino called to say, "They weren't forgeries after all—they were stolen from me and cut down to a smaller size." He must have just sold them for coke once and forgot.

My nephew was at the office again all day making phone calls. He had a friend with him and Brigid said that he'd been making martinis (laughs) the new way with gin, scotch, and vermouth. He told me he's staying with someone and there's five people in one room and I guess he's sleeping on the floor. I wanted to keep working late, so I told him it would be easier if he left with Vincent when Vincent locked the door. I think he got mad at me because he left without finishing his martini.

Saturday, February 11, 1978

Okay, the fire.

I got up in the morning and I thought I smelled a wood-burning fireplace. I went upstairs and there was no fireplace going and I still smelled burning so I went up to the room on the fourth floor where two kids have been working, restoring furniture for Jed's decorating business. I opened the door. There was a dropcloth all over the room with a big burned hole about ten inches across in it, and underneath the hole was a quarter-inch hole in the floorboards. I started to shake. My biggest fear had happened. There were open cans of turpentine around, the windows were closed, and the heat was on. I just don't know what started it, and I just don't know what stopped it. It must have happened while I was asleep because I didn't smell anything when I came in. Do you think . . . ? I mean, it was like *The Exorcist*. Should I put a cross up there? I'm going to have a cross blessed and put it up there. Because in the same room once the whole ceiling had a flood on one wall, and now this. And then I was thinking that I was mean to my nephew the priest and that was bothering me. And when I looked at where the fire had been, right in the center of the room, it was like to show what would happen . . . I was absolutely shaking. The dropcloth had vein lines going out from the hole, and the floor underneath had vein lines. It was so weird.

Then I spent the whole morning cleaning up. I called Judith Hollander for the phone number of the boys who were "restoring." I called them up and screamed at them to come

and get their junk out of there fast, and when they came I wouldn't talk to them, I was so angry.

I was so exhausted from this ordeal in the morning with the fire that after work I just went home and drank some wine so that I'd be able to sleep and not think about the possessed room upstairs. Remember when Tom Tryon used to live across the street and I would watch him in his window writing? Now I'm living a nightmare like one of his stories.

Tuesday, February 14, 1978

I couldn't believe how many people were out celebrating Valentine's Day this year. It was *really* a celebration, a big holiday. Paulette picked me up to go over to the "I Love New York" party at Tavern on the Green. Bella Abzug came in. Today was the election to see if she could win the seat Mayor Koch vacated. She's running against Bill Green.

A lady who works for the governor came over and wanted to meet me, she said she read my *Philosophy* book and that it's her favorite book, it's her bible. She asked provocative questions about should kids at thirteen see pornography and what about Roman Polanski, and Stan Dragoti who was there said that he used to live next door to Roman in Hollywood and that Roman actually did date eleven-year-olds. We concluded that Roman is now trying to relive his childhood. He's is now in Paris where he can't be extradited back. There were a lot of empty spaces at our table. Stan Dragoti is married to Cheryl Tiegs the model. He made it sound like they were really together, and I had to catch myself every time I started to say something about Vitas, because his wife Cheryl and Vitas are the hot couple lately around town, but I didn't slip.

Picked up Catherine to go over to Vitas's Valentine's party at Le Club. Catherine had her boots on (cab $3). Peter Beard and Tom Sullivan arrived. Tom and Catherine have a pact that each of them can go anywhere and do anything with others, and so he was with a ravingly beautiful sixteen-year-old model and she was *(laughs)* with me.

Jerry Hall was there and she said that she was looking for a house for Mick and that she and he were going to live in together for six months. I think I told that later to a reporter but I don't care. Nobody likes Jerry Hall, they think she's plastic. But I like her. She's so cute.

We went over to Studio 54 and just everyone was there.

Wednesday, February 15, 1978

Hung over, couldn't get out of bed.

The Joan Crawford pre-auction exhibit was on from 9–12:00 at the Plaza Galleries—the second one.

When we got there, they were taking the show down, getting ready for the auction the next day. The girl at the gallery was wearing one of Joan's sweaters. Everything was for sale—there was lawyers' letters and a collection of schoolteacher letters, all the things she'd saved. I really ought to auction off some of my time capsule boxes [*see Introduction*], that

would be a good thing to do in an art gallery. But I would try to make every box a little interesting. I'd throw in one of my dresses, or an old shirt, a pair of underwear—something great in each one. The Negro guys there were rotten to us, screaming not to touch things, and we left. And Bella Abzug lost to Bill Green.

We had to go up to Denise Bouché's for her party for the chairman of the Guggenheim Museum, her cousin Peter Lawson-Johnston, who's a Guggenheim (drinks $20). Bill Copley was there, he was drunk and fun. When he did that play a few months ago he hired a whore to be in it, and then he kept her on after the play, at $200 a week, to live in his house on 89th Street. And now she's taken it over. He once told me he originally furnished his place so that no woman would ever want to live there—that he wanted to make it like a bar—he left his ex-wife in their old apartment on Central Park West. But then the kind of girl he found is the kind of girl who would like to be in a place that looks like a bar—that's where a hooker would feel comfortable, so he picked the right girl. He said he's starting to be nervous about her being there, though. She's taking over and buying him funny presents and things. But he thinks it's interesting, but now he's not so sure about it. I told him I wanted to tape them fighting, and I wanted to start this weekend, but I have to go to Dallas. They don't fight in public, but he'll do it for art.

Picked up Diana Vreeland and went to Doubles (cab $2). I talked to Norman Mailer and his schoolteacher redheaded new girlfriend from Arkansas. I was at table 9 with Diana and Lee Radziwill and Peter Tufo, and one of the Toni twins. Bob was next to Gloria Swanson! She has really grey hair. I told her, "You look so beautiful." She said, "Say it again." I said, "You look so beautiful." Mrs. Vreeland was fighting with Peter Tufo. Then she started screaming and belting me, and she really *hurts!* And she does the same thing to Fred. She screamed at me, "You should know better than to OPEN YOUR MOUTH!" I just didn't know what to do. She beats you to a pulp. She said that she just couldn't stand to be around old people, including herself.

Friday, February 17, 1978

Liza came to the office to have her portrait done. She was a little nervous to begin with, and then Chris Makos went over and showed her a picture of his cock that I'd taken, and that made her more nervous, but she was wearing the right makeup and all the pictures came out good.

John Lennon came by and that was exciting. He's lost weight. Rupert's working on some art thing with him. And he was sweet. He'd refused Catherine the autograph in the restaurant the other week, but Paul McCartney's picture was in the paper the other day, and when she asked him again he drew a mustache on Paul and signed it.

Meanwhile Catherine had invited two boys she met in the men's room at Studio 54 to lunch, brothers from Washington, D.C., who have a rock band called Star, they're staying at Bob Feiden of Arista Records' house. And they were whispering to each other saying, "Can you believe this? Liza Minnelli, John Lennon—she calls this *work?*"

Victor arrived and started screaming at some girl, calling her cheap and a whore and oh—just—all I can think of is someday he's going to get mad at me and it's going to get crazy.

Monday, February 20, 1978

Monique Van Vooren was having a sit-down dinner at Premiere at 9:30 and I'd said yes, I forgot that Tom Sullivan had tickets for wrestling because he'd met Dusty Rhodes the wrestler at an airport and they'd become friends. Then Fred called and said Camilla McGrath was having a cocktail party for someone, but I can't remember who.

Catherine picked me up at 7:00 and we went over to Camilla's and it was very exciting there, a whole crowd of people. The Johansen boy, David Doll, was there, he looked unhappy, I guess it's still from Cyrinda Foxe leaving him for the Aerosmith guy. And I met Stephen Graham, the *Washington Post* kid, and he was nutty, he was with Jane Wenner, who'd broken her leg skiing.

Tom picked us up there at 8:30 and we went over to the Garden and there were like 26,000 people there! I thought wrestling was a dead sport, I didn't know so many people went to it. Dusty Rhodes was wrestling a Japanese guy. They all wear sequins, all of them. I guess they got their style from Gorgeous George, he really influenced them. And they strip on stage. Catherine went to take pictures, but the fight was over in eight minutes. And now they're getting good-looking wrestlers. Dusty Rhodes said he'd be right out, but he didn't come out until about twenty minutes. He wore lots of jewelry, gold things, and he had dark glasses on but when he took them off it looked like he still had them on, he had huge dark rings around his eyes, and he had lots of bruises all over. We took him with us to Monique's dinner (wrestling tickets $16).

Then we went to the Lone Star and then they wanted to go dancing. Up to Hurrah's. Dusty was a little apprehensive when he saw all the fairies and he asked for a girl. The owner got a girl from someplace behind us and fixed him up with her. Then after Hurrah's we dropped Dusty and the girl at the Sheraton, and Catherine and Tom picked up hamburgers at the Brasserie and went to the Westbury. They dropped me off.

Tuesday, February 21, 1978

I went down to the office (cab $3.25).

Brigid was training the new employee, Robyn Geddes, a kid I met at Studio 54. She told him, "The thing is, when you're at home, you let the phone ring twice, and then you answer. But here, you get it on half a ring. There's only one thing that Andy expects and that's that you get five calls a minute, if it comes to that." She was making it all up. He asked her if McDonald's delivered. He said he was getting his master's at the New School and Brigid said, "Oh, so you're going to school and this is part-time? Are you a volunteer or will we be paying you?" He said he didn't know. His mother is the head of the New York Cancer Society chapter. She married Amory and they live at the River House.

Thursday, February 23, 1978

Went to Regine's. Andrea Marcovicci was there. And Tom Sullivan. Someone was saying that Andrea Marcovicci looked like Margaret Trudeau and I was saying oh yeah, and then I turned around and there was Margaret Trudeau, I didn't know she was there, and Tom said, "I thought

you knew." And Tom was sad because he couldn't be with Margaret, she was staying in the background so she wouldn't be photographed with him because she's still married. But then this photographer guy who was there with a foreign accent said to Tom that he saw him fucking Margaret in the balcony at Studio 54 the other night, and the reason he saw them was that he was up there fucking a girl, himself. And finally Margaret came and she talked to me so she could be near Tom, and the photographers took pictures. And Catherine was unhappy because Tom was in love with Margaret.

Friday, February 24, 1978

Robyn, the new kid, said he was going out to his parents' place in Tuxedo Park to be a butler for $10 an hour for three hours this weekend, but that he got an advance so he could go dancing at Studio 54. He was reading the scrapbook and when he got to '68 he couldn't believe it—he said to me, "Somebody *shot* you?"

Roy Cohn's birthday party was at Studio 54 behind the curtain. We missed the good heavy Democrats, they'd already gone, like Carmine DeSapio. There was a big birthday cake for Roy, and Margaret thought it was a cushion and sat on it, but she got up quickly and nobody seemed to notice. The cake was about 3' × 4'. With a face like a 1920 cheap pillow, you know, like they had then for the World's Fair. It was in the paper that the party was costing Stevie $150,000, but I don't see how it could have, they were charging people to get in just like always.

Saturday, February 25, 1978

Catherine called and said that Tom would pick me up in his car but I said I'd rather walk, it was just to Diana Vreeland's dinner for Cecil Beaton. When we got there Peter Beard was there in black tie, he said he'd had to rent it for Friday so he figured why not keep it for the weekend. Carole Bouquet was with him, she's leaving for Paris in a week. Then Fred arrived with Cecil Beaton. Cecil had been staying with Sam Green but that got too hard so he moved to the Pierre, he was leaving town in the morning. He can hardly walk, he's paralyzed on one side. He'd taken photographs of Carole and signed them for Peter with his left hand, which is great, that's the hand he draws with now. He doesn't talk much, he just said things like "Oh my" and "Yes." And I guess Diana looking at him was afraid something like that would happen to her because she overreacted in the other direction, she was running and jumping and dancing and humming and pushing forward with her tight body and her beautiful clothes.

And Consuelo Crespi whose daughter Pilar is married to a Colombian, Echavarria, was also at Diana's. Tom knew all about Colombia, so I just don't know about him. He said that Pilar's husband was the biggest smuggler in Colombia, but what does that mean he smuggles? For sure, cocaine? Or money? Echavarria owns an airline there, a small one. We were talking about plane crashes and Tom was telling about his—the one that wrecked his hand that he wears the glove on, and Consuelo said, "If you crashed in an airplane, you were probably in Colombia, right?" And he was. Tom doesn't seem to take coke too much but I think he was missing Margaret

so he was snorting some. He's so free with it, it's not like a dealer, he gives it away like it's candy.

The front page of the *Post* announced Liza's separation from Jack Haley, Jr.

Sunday, February 26, 1978

Went to church, then cabbed to work ($4) to meet Rupert. Worked there all afternoon and took phone calls. Then went home at 7:00.

Tuesday, February 28, 1978

Catherine went to Halston's to pick up her dress, but later she made me call him to say that she'd wanted one slinkier, and he's going to do it. He thinks I'm paying for it, I guess, but I'm not, Tom Sullivan is.

Cabbed ($4) to the office and arrived for the lunch for Sam Spiegel. Sam was charming—he was talking about Carole Bouquet and it turns out that her passport or papers expired. When he sees a pretty face he'll do anything, and he called a friend in Immigration.

All afternoon Catherine and Bob were getting the party list together for that night's dinner at Reginette for Margaret Trudeau. Catherine was trying to get O. J. Simpson, but he'd left town.

At 9:00 Catherine, Tom Sullivan, and Margaret picked me up to go to Regine's (cab $3.50). When we got there we were so early the photographers hadn't even gotten there yet. Margaret was just sitting at the bar, and if any photographer had come in he would have gotten great pictures, but they weren't there.

Studio 54 is making Regine desperate.

Margaret told me how much she loved Tom. And she said that she didn't like Tony Portago, she didn't like his line. And then she told me Tom's line and it sounded exactly the same. Tom's lines were: "I want to thank Pierre Trudeau for making you such a fascinating woman," and "Good night, Mrs. Trudeau." And Tony, she said, had said, "Margaret Trudeau, can I dance with you?" And *that* one she didn't like. So *(laughs)* I don't know. And she said that when she was up in Canada this weekend the prime minister, who's still her husband, said that her interview in *Interview* was the best she's ever done.

Monday, March 6, 1978

Jamie Wyeth called and invited me to dinner at "21."

Picked up Catherine and went. We had a really great time gossiping about Jamie's trip to Europe with Bo Polk and Nureyev. Andrew Stein was at the next table with his girlfriend. Catherine ordered Guinness and champagne—a black velvet. Ossie Clark came by. Tom Sullivan

arrived just up from Florida where he'd gone with Margaret Trudeau. She was outside in the limo.

When we got to Studio 54, I thought it was just going to be about fifteen or twenty people for Liz Taylor's party, but it was more like 2,000, so if Halston was paying, it cost a fortune. It was a good work night for me, because I saw Mrs. Kaiser—Aly—and she said her face would be okay next week to have her picture taken, and we talked about the Joan Crawford sale.

Liz looked like a—bellybutton. Like a fat little Kewpie doll. John Warner said hello to me. Rod Gilbert was with the cutest new hockey player, a blond, who Catherine fell in love with the other night, and she says she's going to try to get him but she doesn't think she's going to be able to, but she's going to try. He was with a girl with big tits. And Margaret and Tom didn't get much fanfare from the photographers, I guess they're an old couple by now. And Bianca paid no attention to me at all, but then she wanted me to dance with her so that it would be the new kind of picture for the photographers. She was wearing black and white, that's the current Halston thing, but she just really doesn't look good in his clothes. And Bianca kept telling me to call Chris Wilding over, and then when he came, she would act like she hadn't had a thing to do with it, so he'd look at me and say, "Yes?"—like "What did you want?"—and I didn't have a thing to say, and Bianca would act disinterested, and it was just so dumb.

Truman Capote was there and he and Bob were dancing all night and the photographers were taking pictures. Truman looks so thin. Diana Vreeland was there, and people were being brought over to Liz—she was the queen. I met a quarterback.

Bob was watching Bianca take poppers and he said to Diana Vreeland, "It really becomes more like pagan Rome every day," and she said, "I should *hope* so—isn't that what we're after?"

The decorations were fabulous, vases as big as people, filled with flowers, and they did a tribute to Liz with pictures on the wall.

And Monique was there, and we reminisced about the time I met Liz for the first time in Rome around the time we were there making *Frankenstein* and *Dracula*.

Tuesday, March 7, 1978

The front page of the *Post* said that Aly Kaiser was robbed of her jewels last night after she went home from the Liz Taylor party. I'm so glad I didn't talk jewelry with her like I was going to, or I'd be a suspect. But she only has the best, the simplest and the best. It said the necklace was $500,000. What I liked best in the article was that they called her "a divorcée." I haven't seen that word in years. I wonder if maybe she was picking the guy up—I wouldn't be surprised. Like that night when we all went to her house and the two Negro kids were with us—Esther Phillips and the guy she was with—she didn't just have them because they were with *us*, I think she had us because we were with *them*. But Paulette has to be careful—she's next, because rubies are much more in demand now than diamonds.

I want to invent a new kind of fast food, and I was thinking, what about a waffle thing that had the food on one side and the drink on the other—like ham and Coke? You could eat and drink at the same time.

Friday, March 10, 1978

Stayed uptown in the morning because I was going to interview Kirk Douglas at Quo Vadis for lunch. Nicky Haslam was there with Sybil Burton Christopher, but I didn't recognize her because she has a different-color hair now. Kirk Douglas looked good. He was charming, so adorable. Lally Weymouth came over and she was Kirk's best friend and he was stroking her in the lobby. Bobby Zarem surprised us and forked up for the lunch. Kirk said he wanted to go to Studio 54 that night and asked if we'd call and leave his name at the door. For the interview Kirk talked about how Hollywood had at first wanted to putty up his dimple.

After work dropped off Catherine (cab $4) and changed, then we went all the way down to the Bottom Line (cab $5) to see Lou Reed's act. There was a line around the block, but then inside it wasn't crowded, it was nice. Ronnie and Gigi and Clive Davis and Bob Feiden were there, and they wanted to confiscate Catherine's tape recorder at the door, but she only gave them the batteries. A girl was on before Lou, and then he was late coming out, but then he did and I was *(laughs)* proud of him. For once, finally, he's himself, he's not copying anybody. Finally he's got his own style. Now everything he does works, he dances better. Because when John Cale and Lou were the Velvets, they really had a style, but when Lou went solo he got bad and was copying people like Mick Jagger. But last night he did his song "I Want to Be Black"—which never was good before but now it is.

Saturday, March 11, 1978

I had a lot of dates but I decided to stay home and dye my eyebrows.

Sunday, March 12, 1978

Got up and went to church.

Liza's birthday party was at Halston's spread in the Olympic Tower. Catherine was wearing her new Halston, a tight white one, and she looked really good with her hair up. The party wasn't that great. It was missing people. Muhammad Ali never showed up and Liz Taylor didn't either. But Carol Channing popped around the corner with Eartha Kitt who she said was dying to meet me, but then we didn't have anything to say to each other. Melba Moore was there. It was a nice party, though, a live band. Jane Holzer and Bob Denison was there, and a couple of hustlers from Studio 54 who weren't in black tie, they were in white jumpsuits. Liza was wearing a gold Halston, and she got upset when Dr. Giller pulled down on it because she'd just been in the bathroom to fix it to stay up. It was a funny dress, open from the crotch down to the floor in a V. And the Halston crowd has a new accent, they're now all talking in a tongue-tied lisp. It's the new thing. And they all say *[imitates]* "pussycat." I met David Mahoney who runs Norton Simon that bought Halston, and Martha Graham took me into a corner and said she'd like to have tea with me. All the pretty girls were in Halstons.

Diana Vreeland was there and Truman Capote with Bob MacBride. He's the person that was

with Truman even back when I did the *Rolling Stone* interview with him in 1973. He looks even weirder than ever, there was always something strange about him. But Truman told me that he couldn't go for the young ones, meaning that it had to be this type. Bob MacBride is still taking notes—even when I first met him with Truman he was taking notes, but I don't know what for. He still has the wife and six kids. He's lost a lot of weight. Actually, he's lost everything—he looks strange.

Al Pacino was there and he looked handsome—we've heard through the grapevine that he might be interested in renting Montauk, so we'll see about that. De Niro was there, he looked fat, and Scorsese was with them.

Ken Harrison the porno star was at my table. Bianca and Stevie brought out a big birthday cake and Liza started singing "New York, New York" but then Sterling St. Jacques went over and joined her singing and *(laughs)* she got upset and moved over to another microphone and sang some more. And then I asked Marty Scorsese if he'd ever met Margaret Trudeau and he said no, and so I went and got her, I was pushing her as an actress. Marty told me Julia sends her love. I told him they should get back together and he said he couldn't, that they were just friends now. He's so short. God. Halston was kissing Liza and Bianca was lost somewhere with Federico De Laurentiis, and the photographers were photographing and it looked unreal, like a big movie scene.

Monday, March 13, 1978

The *Post* had a picture of Halston and Liza and Ken Harrison. But all I could look at was the way Ken Harrison was holding his glass. Because I have nude pictures of him with Victor. And Fred said what was wrong with Halston's party was that it looked like the funny restaurant that you walk into when you're out of town in some city, and you find it on top of a building—that's what Halston's office place looks like, all the mirrors. I spent most of the party out in the hallway because I couldn't find Catherine. Someday somebody is going to walk smack into a mirror there. The mirrors are what made the party seem so full.

Cabbed down to Chembank ($4) and then walked over to the office where Mr. and Mrs. Carimati were coming for lunch. Bob is staying longer at the office these days because Kevin's out of the picture now, so I dropped him and Catherine off (cab $3.50). Then Charlotte Ford called me and invited me to a party for her book at some restaurant on 58th and Third, and that sounded like work so I invited Bob. The party was at 7:00 but we didn't get there until 8:00 (cab $2.50). Charlotte said that it wasn't actually for her whole book, just for the part of it that had just come out in the *Ladies' Home Journal.* And then a lady came over and said "I'm Mrs. Hershey, and I used to work at *McCall's*, I remember you and your drawings." And I asked her what she was doing now and she said, "Listen, I'm *giving* this party, I'm the editor-in-chief of *Ladies' Home Journal.*" The party was a lot of squares you never see around. It was black tie and Bob and I were in black tie, but Tom Armstrong wasn't, and I'm noticing that a lot of people don't come in black tie when it says to, so I'm giving that a lot of thought.

I turned around and there was a beautiful beautiful lady near me, and it turned out to be Rocky Converse, and Bob was next to her husband. We had a really really good time, I talked to her and Bob talked to her husband. She was married to Gary Cooper and she's the mother of

Maria Cooper Janis. She said she doesn't believe in the mystic ESP stuff that her daughter does, though. She said her husband's had three heart attacks, but that he's still the best plastic surgeon in town, and that he was going to die with his boots on. She said that Pat Buckley told her she should wear her hair pulled back and she pulled it back and she looked beautiful. It was like looking at Joan Crawford.

Wednesday, March 15, 1978

Cabbed down to University Place to look around ($3.50). Walked over to the office, arrived at the same time Rocky Converse did.

Lunch at the office was for her and some other chic people, and Gigi saw Bob being nice to this older woman, so she decided to pitch in and help out, thinking that it was someone we were hustling to get their portrait done. She was giving her all this attention and special treatment and finally Bob said, "What are you *doing*? This is my *mother*." It was so funny.

Thursday, March 16, 1978

I forgot to say something that Aly Kaiser was telling me when I saw her at the Joan Crawford auction—that Joan Crawford was madly in love with her, and that she had mash letters from Joan to prove it. I've never heard that about Joan and it's hard to believe, but I didn't want to say that, because she said, "I'll show you the love letters, you can see for yourself." So I just— maybe she doesn't know the difference between lesbian and . . . Oh, I don't know. It's good gossip, that's all.

Friday, March 17, 1978

The St. Patrick's Day parade was starting up so the traffic was bad. Everybody was wearing green and staggering and it was like seeing the old days of New York when everybody used to be drunk all the time instead of on drugs, swaying down the street.

And have I said in the Diary yet that we didn't get a deal for our TV show? The project Vincent was trying to get a deal for. They didn't think I was big enough for Middle America. ABC turned it down.

Sunday, March 19, 1978

Palm Sunday. I went to church, but some lady had gone around and taken all the palms. Walked down to Laurent on 56th Street for lunch. Chris Makos was just in a leather jacket and his boyfriend didn't have a tie, and it looked like a good restaurant, but they were prepared for Dali's crowd so they didn't care.

Ultra Violet was sitting next to Dali and she did something great—she wore the exact same outfit as the day we met her in the sixties—a pink Chanel miniskirt suit with the same boots and her hair the same way. And she had a bracelet that was a Brillo pad, she said that after she was done using it as jewelry she would clean her pot with it. And she had another bracelet made out of eight inches of the corrugated cardboard that they wrap bottles in, sprayed gold, and glued together. It looked great. I guess Ultra is creative in a way. She said I told her the last time I saw her that she should start a new look—"Park Avenue Punk"—and she said that's what gave her the idea to do "Christian Punk"—and now she sings the Lord's Prayer and puts in the word "asshole" which I think is disgusting. She's going to do her act at the Riverboat, and I told her she should start at CBGB. I'd brought two copies of the Dali book so Dali could sign them and it turned out that one of them had already been signed "To Fred" so Dali re-signed it to me. Dali is so full of ideas, and he's ahead in some things, but then he's behind in others. It's odd. He was telling me about a book that's just been written in Paris about a brother and sister who were so in love that the brother (laughs) ate her shit. He said that my idea of piss-painting was old-fashioned because it'd been in the movie *Teorema* which (laughs) is true, it was. I knew that. And then he said something great—he said that the punks are the "Shit Children," because they're descendents of the beatniks and the hippies, and he's right. Isn't that great? The Shit Children. He *is* smart. Dali told me that he was looking for "beautiful freaks" and I told him (laughs) I'd send him Walter Steding. Walter was performing on his "magic violin" later that night at Max's. And Dali was really sweet, he'd brought a plastic bag full of his used-up palettes as a (laughs) present to me.

And I've got to get some holy water for the house. I forgot. They give it to you free in the church lobby.

Tuesday, March 21, 1978

Bob was working on Truman to host the party that *Interview* is giving for Polaroid on the night of the Academy Awards at Studio 54—Truman said he'd only do it if he didn't have to do any work, if Polaroid would give him a movie camera and if he didn't have any "old bags like Gloria Swanson there, trading off my name." He said, "Get me Candy Bergen!"

And Bob showed me a review that Fran Lebowitz's book got in *The New York Times* by John Leonard, and I can't understand it. Is her writing funny? Some girl we know gave her a long rave in the Sunday *Times*, and now John Leonard and I mean, her stuff—all the put-downs and complaining—it's just not my sense of humor. I don't know what's the point. So Bob wanted to prove that other people don't feel like I do about it, that she's an asset to *Interview*.

Thursday, March 23, 1978

Yesterday I watched the Flying Wallenda on the news fall from the highwire and get killed. You saw it all—he was walking, and he got to the middle, and a wind came from Miami, and—he was just—he fell, and then the cameras went close in, they showed him lying there.

The BMW company wants me to paint the outside of a car—Stella's done it and Lichtenstein.

Sunday, March 26, 1978

Easter Sunday. It was raining really hard, cold and windy. I didn't watch the Easter parade because there wasn't any. But television is smart, they showed Easter parades in England, where the people were doing what people are supposed to do—walk around in their hats.

Went to church. I took a peanut jar with me to get holy water and I spent a couple of hours doing that. You go in and you press a button and holy water comes out and you fill up your jar and take it home. It took another couple of hours to put it all over the house.

And Nelson called me from L.A. He said that he'd been in the hospital because on St. Patrick's Day he and Bobby De Niro started eating a five-pound cheddar cheese with Jack Daniel's and day by day that's all Nelson was eating until finally he had pains and he went to the hospital and they said that the cheese had turned to rock and they gave him a laxative to break it up. He wanted to find out when we were coming out there. In May, I guess.

Thursday, March 30, 1978

Did I tell about Jay Johnson's cat dying? He picked her up and she was just—dead. This was Harriet, the kitten Jane Holzer gave Jade Jagger for Christmas. Jay felt so bad.

Friday, March 31, 1978—New York—Houston

To Houston for a show of my Athletes portraits at Frederika Hunter and Ian Glennie's gallery. The gallery was big and beautiful, in an old compound, and Ian had designed its space.

Monday, April 3, 1978—New York

Tom Sullivan came by with Margaret Trudeau in a red dress and we picked up Catherine and then we went to Studio 54 for the Academy Awards party that Polaroid was giving, that Truman Capote and I were the hosts of.

I'm never going to let my name be put on a party again because all it does is get you in trouble with the people you forget to invite or who don't get in for some reason. The invitations got all screwed up. I mean, a hand-delivered invitation from me to myself arrived at the office in the afternoon.

We went upstairs and found Truman sitting on the landing on the couch and we went to see Mick and Jerry and Diana Vreeland with George Trow and Margaret and Tom.

Danny Fields was next to me and he had a great idea for a movie like *Saturday Night Fever*, about a boy who's straight but wants to be the best faggot in town because he sees all the fags having such a good time and he thinks it would be more fun. It's the Ronnie Cutrone story.

I hated the Awards, I hated the whole thing. I hated every nominee and I hated everything that won. I must be really out of it. But nobody good like John Travolta won. I mean, Richard

Dreyfuss? I mean, if he's a sex symbol, I don't know what the world is coming to. And there was Vanessa Redgrave doing her same stupid Communist routine up on stage that she did for us at 860 once. And I can't stand Woody Allen movies. I guess that says something. I ran into Jim Andrews of Polaroid. Yul Brynner was there, and Eric Clapton, and I kept looking for Doc Cox but I didn't see him. Bob came and told us that all the people who counted were down in the basement—Halston and Apollonia and Tom Sullivan and Margaret and Barbara Allen with Ryan O'Neal who's in town shooting *Oliver's Story* with Candice Bergen. I introduced Ryan and Margaret, and she seemed interested. I told her that *Paris Match* wanted her to do photos for them, to work for them, but she said she didn't like *Paris Match*, that it was *(laughs)* too gossipy.

Bob thinks that Stevie threw away the list of old people we gave him to invite, because Aileen Mehle—"Suzy"—and Ahmet and Mica had been cold to him and he found out they hadn't gotten their invitations. And after this party with everybody mad at us, we've hit rock bottom.

Halston might want to rent Montauk.

And let's see, who else was there? Sylvia Miles, Earl Wilson, Mariel Hemingway, Brooke Shields and her mother, Maxime, Lily Auchincloss, Geraldine Smith and Liz Derringer, David Johansen, PH, Steve Paul, Tinkerbelle, Glenn O'Brien and his girlfriend Cheryl, Charles Rydell, Clarisse Rivers, Roz Cole, Steve Aronson, Chris Makos, Robert Hayes, Earl McGrath, Richard Bernstein, Andrew Wylie, Peter and Sandy Brant, Joe Allen and his girlfriend, Jed, Jay, Ed Walsh, Gael Malkenson, Jackie Rogers and Peter Marino and Eduardo Agnelli.

Tuesday, April 4, 1978

Louis Malle called and asked if I was coming to the screening of his movie, *Pretty Baby*.

There was only one mention in the papers about the party, in Earl Wilson's column. And it didn't even mention Polaroid. I think all those Polaroid guys are going to get fired there for spending $30,000 on a party like that. And *Interview* will probably lose all their ads. Swifty Lazar's Oscar party got all the big mentions. Bob should have made sure Liz Smith was invited, and Rex Reed. And now that I'm thinking about it, I bet the reason all the society people didn't show up was because it was given by Truman! They're probably all mad still at him.

I went home and glued and Barbara Allen called and said she didn't have anyone to go to the screening of Louis Malle's movie, *Pretty Baby*, with, so she picked me up at 7:45. We cabbed to the Paramount building in Columbus Circle ($2.50). The screening was a lot of well-to-do famous people. Frank Yablans thanked me for all the nice things he heard I'd said about his movie, *The Other Side of Midnight*, but I was only kidding. Brooke Shields was there and Mariel Hemingway. Barbara met Baryshnikov and had him sit next to her and she dropped me for him. She asked me, "What're you doing later?" And when I said going home, she said *(laughs)*, "Great."

It was a cute idea for a movie, but nothing comes off—like they had pickets picketing against the sin in New Orleans, but nothing happened because of it. Afterwards a friend of Louis Malle's came up and said that Louis really wanted to know what I thought and I said it was "wonderful," "interesting," "strange." Then we had an exciting elevator ride down because it was Baryshnikov, Barbara, Milos Forman, Frank Yablans, Diane Von Furstenberg. And Milos was peeking under Baryshnikov's jacket—"looking for the little girl." And Baryshnikov has such a great body but his

hair is so funny. He wears it puffy, one of those bubble hairdos. He should get a haircut that makes him look more masculine with his good Russian face.

Wednesday, April 5, 1978

Victor came by and pissed on some drawings for me. Gave Ronnie money ($2) for papers at the newsstand to check if the Polaroid party was ever covered. Actually, everyone was calling to say it was a great party.

Thursday, April 6, 1978

Marguerite Littman and her husband Mark who's the queen of England's lawyer came to lunch. Doc Cox brought them in his Rolls Royce. Then Billy Kluver, and Julie Martin and Lucy Jarvis came up. They brought a Negro guy named Chris who they want to back a musical of my life (coffee $.76, $1.89). Fred had invited Regine and Diana Vreeland had had a lunch date with Regine, so she came along, too. Diana didn't know who Doc Cox was, so she thought *he* was the one to be nice to, so *(laughs)* she missed the point. She kept asking Regine, "Tell me, *why* am I being nice to this man?"

Billy Kluver had told me that Chris was a "scientist," but it didn't seem like it. He was fascinating. He started at seventeen, whatever he does. He told me about owning beachfront property in California. He said he had a coffee business in Brazil, but I don't know, it sounded like smuggling. I mean, a couple of good cocaine loads and you've made a few million. He looks so young, and anything you mention, he's "thinking of buying it." He said he wanted to buy Radio City Music Hall and turn it into the world's largest discotheque. That would be such a great idea. New York needs the world's biggest discotheque.

Then Tom Sullivan arrived and this Chris made Tom seem like peanuts. Then Gianni Agnelli came in and Chris said he was thinking of buying Fiat, so I went over to where Gianni was talking to Regine and Diana and said that I had a buyer for Fiat and his ears perked up. The two of them went over into a corner, but then *(laughs)* Gianni left really fast.

Then Tom Sullivan pissed on some paintings for me and left.

Doc Cox was thrilled, talking to Regine and Diana and then meeting Gianni Agnelli.

Saturday, April 8, 1978

I'm still looking for a way to paint the BMW. David Whitney said why didn't I get one of those paint rollers that you roll flower designs on the wall with, so I went to paint stores and finally one place could have one for me on Monday, so I'll send Ronnie up (cabs $2.00, $2.15, $1.60).

Bob said let's take Mick and Jerry out and entertain them, and so we invited them for dinner at La Grenouille. We had a good time, we got drunk (dinner $320). Then we went with Mick back to the Pierre because he wanted to take his sneakers off—why is everybody wearing sneakers?

Why don't they make them in dark colors so they could be dress shoes, they'd be so comfortable. Jerry complained that the Pierre made a big point of calling her Miss Hall all the time, and finally she and Mick were deciding that they should really go to a new place. Because Mick had always been at the Pierre with Bianca. It took them long enough to figure that out. Anyway, they're going to move to the Carlyle.

Mick wanted us to hear his new record, and we were going to bring it over to Studio 54 but it was at Earl McGrath's house, so we went over there (cab $4). Jann and Jane Wenner were there and Stephen Graham who had something wrapped in foil in his pocket. It looked like drugs, but it turned out to be a Rice Crispie cookie.

We went to Studio 54 and when we got there it was already so late, I didn't realize it. And Jane and Steve Graham had said they would do anything for a Quaalude so I got some from Steve, but then I got scared—I'm never going to do anything like that again. It's bad image. And by the way, Bob says he saw me put a little coke on my gums when we were in Mick's room, but I didn't really. I mean, my finger was in my mouth, but, uh ... okay, so I didn't leave there until 4:00. When I got home the dogs woke up and started barking, and so they notified Jed what time I was coming home.

Monday, April 10, 1978

Mr. Ballato is in the hospital and they're operating on him tomorrow. He's lost fifty pounds in a month and they don't know what's wrong with him. He said New York Hospital was so bad to him. He went in for tests and when they were over he had a black eye. His wife is running the restaurant.

Tuesday, April 11, 1978

Watched the *Today Show* with Gene Shalit interviewing Fran Lebowitz in the morning and waited for the word *Interview* but she only mentioned *Mademoiselle*, and it's not like she isn't calculating enough to work it in if she wanted. Gene Shalit thinks she's hysterical.

And then Averil Meyer came to the office because she wanted to meet Ruth Carter Stapleton who was coming with Dotson Rader at 3:00 (cab $4). But they didn't get there until 4:00.

Brigid was offended that Dotson said "fuck" and "shit" in front of Ruth, and she said, "There's nothing left to respect in life if he can say that in front of the president's sister. It just shows you that Nixon should be back in the White House." And Ruth Carter Stapleton was sweet, and Dotson was disgusting as usual. She wanted a Polaroid of us and naturally there weren't any bulbs, so Ronnie went out to get some and Vincent took a Polarvision movie and showed it and that was the entertainment. I gave her a *Bad* T-shirt.

And the guy from the hamburger place came by. I'm doing a portrait of a hamburger, Frank Fowler got me the job. I can't remember the name. Not McDonald's, not Burger King, not Wendy's, not Wetsons—something else.

Toni the girl I met from *High Times* magazine and her girlfriend Carole were picking me up in

a limo at 8:30. So I waited until 10:00 and finally they arrived, then we picked up Brigid. I wanted to tape them and see if I could make a play out of it. Toni was wearing a T-shirt of two guys making it.

Well, we went down to 10th Street between First and Second to Princess Pamela's restaurant, something like that. Carole was in a fur coat. We rang the doorbell and Princess Pamela answered, a colored lady in a bright red wig. She looked like a drag queen, so you get the idea. They'd expected us at 8:30. Well, we went up the stairs to the second floor and there was nobody else in the place but two Negro girls, waitresses—entertainers. It was three little rooms and a white piano in one room. And the two girls were about thirty-five and sort of intelligent, but like black Valerie Solanises. It was a restaurant with readings in between courses. The place started out fifteen years ago, and Craig Claiborne gave it a couple of stars in 1966 when it was on the ground floor. And they had pictures of Norman Norell on the wall and he's dead already of throat cancer, probably from eating there. I thought I heard her say something about Idi Amin flying over from Paris once for a party at her place but I don't know, *that* I may have heard wrong.

Toni and Carole—all they talk about is 1966. I kept asking them what happened between '70 and '75, and they were off drugs, I guess, so they said, "Nothing."

The princess put on a gown and was singing, and she brought in a 2' × 1' peach cobbler made out of a canned peach and it was so sad because nobody had been there, it wasn't even cut into. She said, "I made it just for you." And I didn't want to eat it, so to make it look used, I put it on Brigid's plate, and Brigid gave me one of her mean "Honey" looks, like her mother Honey gives *her*, and said how dare I. And the princess had a brochure about the place that had something about Joe Franklin in it.

Brigid was just in love with the place, you know how overboard she goes. She's going to start going there all the time. And then I couldn't take it anymore, I just had to leave, so I went downstairs. Toni paid the bill.

Wednesday, April 12, 1978

Suddenly TV cameras arrived to photograph me painting the model of the BMW car I'll be painting later on. Well, it was a mess. I was going to roll the paint on with a roller with the flowers on it, and I was going to do it in pink and black but then Chris Makos had me change it to yellow and black, and I started to roll it on, and the paint was shiny and it slipped, and it wouldn't stick to the car model, and Victor Bockris was there and I rolled it on him, but it was a bust. Leo Castelli came by and almost got sick, it was such a mess.

Thursday, April 13, 1978

Interview lost the Halston centerfold ad, maybe. For weeks someone's been telling me it's on the way, and then yesterday they called and said they didn't know anything about it, so we don't know. Victor's so out of touch with the Halston house now. Stevie is Halston's new best friend —he's over there every night instead of going to work at Studio 54. Victor always said that you

did have to watch Halston—that he could turn on you—that you had to stay more unattainable and that would make it more glamorous for him.

The best thing that happened was a kid arrived with a singing telegram for Marc Balet's birthday, but Marc wasn't there yet, so they came to get me to show me. He had a red uniform and it said "The Singing Messenger." I asked him for a free sample and he sang "I'm So Glad You Came Out of the Closet Today," which he said is one of their most popular songs, so that was funny.

Friday, April 14, 1978

Went with Richard Weisman to the Hotel Americana for a banquet for the Yankees. The master of ceremonies was Howard Cosell, and they marched the whole team in. Everyone was trying to get Reggie Jackson's autograph. And it was funny because Averil Meyer's grandmother, Mrs. Payson, owns the Mets, and Averil kept saying, "I own the Mets," and everybody thought she was crazy. She wrote Yogi Berra a note and passed it on toward him, but someone didn't pass it along and so she got up and went and took it back. He used to be with the Mets. The note said something like: "Remember when you bounced me on your knee, then gave me a hot dog in the dugout?" And Mickey Mantle got his award—that's what it was for. And Howard Cosell was introducing people from the dais and he introduced me, he called me a Pop artist—I guess Richard is pushing to get the paintings sold.

I talked to Suzy Chapstick and she said that she's noticed that most girls who get famous are tomboys when they're little, and I said that I'd been a tomboy.

And then at the office there was the big problem with Halston. He called Fred to say that Victor's been going around saying that if Halston didn't pay us the money he owes for the paintings he bought from us, that he, Victor, would repossess them and sell them to Elsa Peretti. Halston asked Fred if we'd put Victor up to it. Fred said no. And Halston's fired everyone at the house —Lorenzo and the maid, too. All since last weekend. And he's having trouble with his line, he can't work, he's been so upset. The other night in the basement at 54 there was a huge fight that Elsa started—she was attacking Stevie and calling everybody faggots and it was really bad, I guess. I wasn't there. Bob finally got her to leave with him. It's enough to make you want to stay home for the rest of your life. She was smashing glasses and everything. So between Victor and Elsa, Halston's really a wreck.

The other big event at the office in the afternoon was when Ronnie opened the door to the bathroom in the conference room—that lock doesn't really work—and there was Margaret Trudeau sitting on the toilet with her pants down and a coke spoon up her nose. He said, "Excuse me," and backed out. She'd come down with Tom Sullivan.

Saturday, April 15, 1978

I don't know how to handle the Victor situation. He called and I talked to him on the phone and he was telling me the philosophy his mother gives him, and it's so great, it's just like my philosophy, I wish I could remember it all. He follows her advice and creates all these problems

—just to make life more interesting. Like, she bought a small apartment house because she didn't have anything to do and she thought if she could get nervous every month over whether the tenants were going to pay her the rent that that would make life more interesting. Isn't that great? And Victor says he just makes all these problems in his life just to *feel* something. I tell him, "Why don't you just pretend to be nice? You could get along so easily with Halston." And he says, "I can't, I have Latin blood. I can't pretend, it's nice to fight. It makes it more exciting." It gets so wild with Victor on the phone.

Sunday, April 16, 1978

The gossip from Saturday night at Studio 54 before was that Jack Nicholson came in and Ryan O'Neal was there with Barbara Allen and everyone was trying to keep Jack and Ryan apart so they wouldn't see each other. Barbara thought it was because of her, but it was the situation with Anjelica—she's been seeing Ryan lately. And Stevie called and said how hard he worked, that it was so much fun keeping them apart. And Tatum was dancing with Mona Christiansen. And Stevie said that Liza was dying for Marty Scorsese to get back to town, because Baryshnikov just sees too many girls.

I worked all afternoon and then I watched *Holocaust* and kept making myself more fresh grapefruit juice and vodka and kept passing out. They gassed the little girl. I was thinking everybody really is in their own little world. They tell you to do something, and you don't know what's going on, they're the ones who know, you're at their mercy. So maybe the Germans were saying the Jews were really bad so they had to kill them—oh, but then, no, they'd been living together with them so long, they were right next door, so they knew they weren't bad. But it's like when you go to a hospital—they take you and they do anything with you, because you don't know about their world. Or it's like investing in art, you trust people, or investing in stocks, you don't know, so you accept what they say is good or bad, or even sports. Or terrorist groups, they're out in the street handing you things and they're in their own world.

But still, today, if somebody said, "We have to do this to the Puerto Ricans," I mean, could you do it? You couldn't. So how did they do it? I mean, think of some German you actually know: could *they* do it, or . . . But if you do it once, you can do it again and again, that's for sure. So after they did one, I guess it was easy.

Monday, April 17, 1978

Closed up early because we had to go see Tom Cashin open in *The Best Little Whorehouse in Texas*, the musical down on Second Avenue and 13th Street (cab to theater $2.30). I had to pay for the tickets, they weren't free ($23). Tom's number was right before intermission and he was good, he was cute. He got a big hand. I got out at 8:00.

Then I stuck on a black tie with my bluejeans and rushed over to Lee Thaw's. It turned out I was early, and then a little later when Bob and Fred came, they were making excuses for me, that I'd be late, before they realized that I was already there. This was a dinner for

the Van der Kemps from Versailles, and the Herrings from Houston were there and Mary McFadden and Tammy Grimes. I made a *faux pas* and said to Tammy, "You're wearing one of Mary's dresses," and she said, "No, a Fortuny." I said Mary's name first because the last time I said to someone, "Oh you're wearing a Fortuny," the person said, "No, it was a Mary McFadden." Then Mary showed me the difference—hers had a machine-stitched hem and the Fortuny's hem was hand-stitched.

And then there was a party at Hurrah's for Tom's play so we were going to go there, but we stopped at Studio 54 for a minute (cab $3). And when we were there Halston tapped me and said that Liza and Baryshnikov were there and wanted to go right then to see the portrait of Liza. So we went to the Olympic Tower, and they loved the paintings. They did look great. Baryshnikov talked about them for hours. And Baryshnikov told me that his mother when he was eight was getting him interested in art and music and makeup and dress designing, and he had *Harper's Bazaar* around and knew about the art director Brodovich. . . . I don't know what city in Russia, it must have been a big one. And I brought up Chrissy Berlin who was the one who actually helped him defect, and he said that she was just someone he liked for a minute, that he only likes every girl for a minute. He said his first love was Makarova—she left her husband for him, and then changed her mind and went back, and last year when she got married again he went to her wedding in San Francisco and he didn't feel a thing. He was the best man, she married some rich guy.

Tuesday, April 18, 1978

I finally got a BMW painted, black with pink roll-on flowers. Maybe they'll read meaning into it. I hope so.

Some kids from Alabama brought me up some of the Space Dust candy that was on the front page of the *Post* today. It explodes and crackles inside your mouth.

I talked to a lady who said she goes to hospitals and makes flower arrangements for cancer patients, and I told her I'd like to, too. I *wouldn't* like to, though. I was going to ask her wasn't she afraid she'd catch cancer, but I don't know, maybe a little bit of flowers does make a dif— Oh, I don't know. Flowers wouldn't make *me* feel better if I were a patient. Only that you'd know that on a certain day a person was coming in to *do* the flower. Isn't it funny that they can cure diseases and still not know what causes them? Like they cured polio, but they still don't know how you get it. And all those kids dying in New Jersey of cancer. I guess it's the water.

Wednesday, April 19, 1978

Called John Reinhold and he invited me to lunch. Went out in the rain and got a cab ($2.50) to 46th and Fifth. I went upstairs and looked at stones, he's teaching me all about them. He said that he never buys hot stones or cheap stones, that he just waits for the good things and pays the price. We walked over to Pearls in the rain for lunch, and it was fun. On the way in we saw

Corice Arman waiting for Arman who was parking the car. John and I talked about *Holocaust* and I always thought that John was born in Europe because he has sort of an accent, but he was born in the U.S., I guess he needs the accent for the diamond business. Pearl made a good lunch, we had whiskey. John had a kid staying with him and his wife who—he'd reminded me of René Ricard when I met him—I said was a creep, and then I had to explain how when I say "creep" it doesn't mean that I don't like them, and that took an hour. After work I had to leave for Eleanor Lambert's cocktail party for Bernadine Morris, the *New York Times* fashion writer who's done a photograph book with a girl photographer on fashion.

I was talking to Calvin Klein and he said he was going on vacation and I said where, and he said, "And I'm not telling anyone, and just alone alone alone, absolutely no one, and it'll be so wonderful." And then I went across the room and Giorgio Sant'Angelo was saying the same thing, that he was going for two weeks alone alone alone to the Greek islands and I said, "Are you sure you're not going with Calvin Klein?" and he said, "Oh, you know *everything*," and I said no, that I'd just put two and two together.

And Diane Von Furstenberg was there and she lives in Eleanor Lambert's building so she invited Bob and me down for dinner and to watch *Holocaust*. So we went down and Diane's mother was there, and Marina Cicogna. Diane's mother had been in Auschwitz, and when the concentration camps came on she was laughing—she said that they made it so much more glamorous than it was when she was there, that all the women had crewcuts and it was a lot more crowded, that where the movie had 20 people there were really 300,000. And it was weird to be seeing this with Marina Cicogna whose family was so involved with Mussolini. Before it was over, Diane was ready to go out, she was calling for a limousine.

Friday, April 21, 1978

Milton Greene was at lunch at the office and he said that I'd given him the idea to do a Marilyn Monroe portfolio, so he's selling ten photographs of her for $3,800. Fred told him he thought that was high, but he said he's already sold a few to museums. But I don't know, the photographs aren't even that good. And it seems like they were all taken in the same sitting. He and Marilyn had that company together, they did *The Prince and the Showgirl*. I know Milton because he and Joe Eula were the nicest to me on the first day I came to New York—he and Joe were close for years but then later Milton married Amy. Somebody had given me their names, to look them up, and I did and they told me I could use their phone and everything, but I never took them up on it because *(laughs)* they were so nice it *scared* me.

And Matt Collins the big male model came by. He's so good-looking, and Brigid got a kiss out of him. And Margaret Trudeau was there and said she'll do the Rums of Puerto Rico ad for me.

I wanted to go home, but Carole of Toni and Carole wanted us to see her new apartment, so we went over to, I think, 79th and the Hudson River. And it was a nice apartment. It was really neat, and it looked rich, and she and her girlfriend said their most treasured possession was a Warhol over their bed, and we went to look at it, and it was so sad, because it was a fake. And I knew it, and Brigid knew it, and Victor knew it. She said it was part of her "divorce settlement" from Toni. Should I tell her? It was so sick.

Saturday, April 22, 1978

Went up to the Carlyle where Jerry Hall is registered as "Miss Philips." On the way we got film (cab and film $5). Jerry was ready to go as soon as we got there, she came down in a second. Cabbed to Quo Vadis ($2). She's so beautiful, everybody looks at her. She's only twenty, I didn't know she was so young. We avoided talking about Mick. She said she left Texas and went to Paris when she was sixteen. Her first roommate was Tom Cashin and then she met Antonio and he drew her and everything. Oh but Mick and she are going to have beautiful children, and I guess Mick really does want children—he had Jade, and Jade's pretty, but the kids he'll have with Jerry will be stunning. Maybe a beautiful boy. I think he wants someone who'll stay home now that he's not going to be on the road too much. He wants a wife who'll be there and Jerry's willing to give up her career.

Then after we left Quo Vadis we walked along Madison back to the Carlyle and had champagne and orange juice. While they stay there Mick pays the hotel and Jerry pays room service. She makes good money, $750 or $1,000 a day. She showed us a love letter from Mick, it said, "I love you"—it was signed "M" with an "X." We didn't have any more tapes so I said, "Why don't we tape over one of Mick's?" You know, meaning one of his new originals. I was kidding, but wouldn't that have been funny? Jerry wants to be an actress. She's taking lessons.

Sunday, April 23, 1978

Bob said he and Kevin had had dinner with Diana Vreeland and that Diana was saying that I wasn't avant-garde anymore. She said that the book Bob and I are doing, the photography book—Chris Hemphill brought it over to show her—wasn't avant-garde, and she said that Jackie O. had said I wasn't avant-garde, either. So it's all just Chris Hemphill saying these things, blabbing to both of them, and then them repeating it. Because *they* don't even *know* what I do. And Diana was saying how great Saul Steinberg was, and Bob told her, "He's just an illustrator." She must be mad at Fred or something, and that's why she's putting me down, because I can't believe it, we had such a good time together that night last week, she was so much fun. And Chris Hemphill is doing her book for her. Fred set that up.

Then Stevie called and told me to ask Bob to invite Elsa Peretti, he said he didn't care about that fight in the basement, that he didn't care that she called him a kike.

So I picked up Catherine and we went over to Halston's. Then the doorbell rang and Joe Eula came back and said that it was Barbara Allen—I'd told her about Halston's party—and Halston got offended and said, "This was supposed to be a *small* party!" And then Barbara came in with Gianni Agnelli and Baron and Baroness Von Thyssen, who I didn't recognize, but I guess they thought I was ignoring them because of the painting they sent back a few years ago. And Bianca and Dr. Giller had gone to the Erotic Bakery and gotten a big marzipan cake of a cock fucking an ass, and then another one of just a cock. Over on 70th and Amsterdam. They have the stuff in the windows, and the cookies are chocolate tits. And Bianca brought the cake in and she put the cock and balls up against her, and it was coffee-colored so she looked like Potassa the drag queen. Halston was pretending to eat it and suck it. And Catherine

made a *faux pas* and said the chic thing would be to cut the cake and eat it, and he said, "No, that would *not* be chic." He was high and he wanted to leave it uncut. As I sat there looking at Bianca I started getting more and more nervous about *Interview*'s cover story next month on Jerry Hall.

We stayed at Halston's until about 1:00 drinking, then we went over to Studio 54 in limos. Gianni Agnelli didn't come with us, he went home to wait for a call about the Moro kidnapping—he's somehow involved with working out a ransom deal with the terrorists. The baron and baroness came, and somehow we got lost from Stevie. They didn't understand about going to the basement. And Stevie had the basement decorated now, with scarves and candles and popcorn, but it's *(laughs)* like going to a St. Mark's Place hippie pad.

Tuesday, April 25, 1978

The Rums of Puerto Rico have cancelled their entire ad campaign, they said the FCC is giving them too much trouble and that Margaret Trudeau would be too hot to do, for sure. So then I had Bob call them and ask about our money, and they said we'll get it.

Chris Makos called about me being interviewed by a psychiatrist who's doing a book on IQs and I said I wouldn't do it unless I got paid, and he called back and said, "$1,000," and I asked Fred and Fred said it sounded like fun, so then I said okay.

The Ungaro party was at Doubles. Then dinner—Quo Vadis—Margaret was being so sweet, she was gossiping and saying that she knew *(laughs)* she could tell me anything because I wouldn't tell anybody. She said that Pierre Trudeau was in town and that she'd introduced him to Lacey Neuhaus and she was thrilled that they'd hit it off.

And Margaret is so in love with Tom Sullivan. They were just in Georgia and she said that Tom was riding so fast on a horse that she had to hide behind a tree and close her eyes, that it was the fastest she's ever seen anyone go. He does take chances, Tom.

Wednesday, April 26, 1978

Closed the office early because Fred and I were going up to his place to wait for Averil to pick us up and go to the Mets game (gave Fred $4). I forgot how expensive cabs up to 89th Street are.

Drove out to Shea Stadium with Fred and Averil in her mother's mini-Cadillac—she's a fast driver. Fred had given me a winter coat and I really needed it, it was freezing. At the end of the eighth inning when we left it was 0–0 and on the way in on the radio it was still 0–0 (toll $.75).

Averil dropped her mother's car off at the 52nd Street garage, and then we got a cab for Elaine's. Bob was having a dinner for Baron Leon Lambert from the Belgian bank, so he had Chris Makos and Catherine Guinness, and Catherine was wearing a T-shirt that said "Where is Palestine?" Her great-grandfather was Lord Moyne of Palestine who got assassinated there in 1944 by the Stern

Gang. She asked Leon if he was Jewish. And he's half-Jewish, his mother's some kind of Rothschild. And Catherine said, "I don't give a damn. Do you realize that if Hitler had won the war, my step-grandfather would be dictator of England?" Sir Oswald Mosley. The founder of the British Fascist Party. But Bob said Catherine and Leon seemed to hit it off anyway.

Then Chris's boyfriend arrived, Peter Wise. So we went over (cab $3.25) to Studio 54's anniversary party. We got out on West 53rd Street and went in the back way because there were mobs out front. We went to the basement with all the gold pillows and the ceiling sounded like it was going to fall through from the dancing. Halston said we should *(laughs)* rehearse for later when they brought the cake in and we had to give speeches, so he rehearsed *his* speech. Truman had a tin-foil hat band around his black hat and I was talking to him when YSL walked in with Marina and he gave Halston a really big kiss, so that was Fashion News. Yves looked like he could have been on something.

Then we went upstairs and sat on a piano in front of the curtain and the cake never arrived and Halston made a speech about how much Studio 54 has done for New York and he was good, and then he said, "And now I'll pass the mike to Andy." But I already had a mike in my hand, and it's bad enough not having anything to say when you're holding *one* mike, but I just said, "Uh, uh, oh, gee, uhhh . . ." I don't know, I just made sounds and you couldn't have heard it anyway, and people laughed, and then Bianca said something and it might as well have been in Nicaraguan because you couldn't understand it, and then she passed the mike to Liza, who was wearing a red Halston, and she sang something like "Embraceable You" but it was from *The Act* and it had lines like "Forget Donald Brooks/Halston has all the looks." And Bob said that he hadn't heard such self-indulgence by a clique since Hitler in the bunker. Left with Catherine, dropped her off ($3.50).

Wednesday, May 3, 1978

Nelson called, he's still plugging away at his screenplay. He said he had to take a Valium when Fran Lebowitz made it so big—they still don't speak—and his old friend Brian DePalma has *The Fury* out.

We were invited to John Richardson's for a dance. We limoed over and it was so chic. Lynn Wyatt was there and Nan Kempner, and—The Empress. If Bob calls Diana Vreeland "The Empress" or me "The Pope of Pop" in his "Out" column *one more time* . . . Diana took out her compact and brushed on an inch of rouge and said, "Is it Kabuki enough yet?"

Bianca's being really awful to Barbara Allen, getting back at her for Mick, and now she's got Halston against Barbara. But I got back at Bianca—I told her she missed the best fashion show, Ossie Clark's. I said, "Oh Bianca, it was all just *made* for you, my dear—a beautiful bat-wing dress and a Wonder Woman outfit that you should run right out and get *immediately*." *(laughs)* Because you see, she's *stuck*. She's Halston's friend and Halston's clothes just aren't right for her—they make her too short and they cut her body the wrong way. They look like a bad diaper. I mean, I like Halston's things because they're simple, and that's what American clothes *should* be, but they just don't look good on Bianca, she needs to wear more of a costume.

Saturday, May 6, 1978

Then Arman called and said he'd sold eight Flower fakes of mine, because, he said, he didn't know they were fakes. But I said, "You must have known or you wouldn't have hid them away for all these years, and you must have bought them cheap off somebody like Terry Ork or Soren Agenoux." So those fakes really did damage and Gerard is still swearing up and down he didn't do them. They made my prices go down because people are now afraid to buy paintings because they feel they could be buying fakes.

There's an auction coming up of paintings that Peter Brant is selling—a big Electric Chair, a big Soup Can, a big Disaster, a big Mao, and a small Soup Can.

Sunday, May 8, 1978

Only two tickets came for the David Bowie concert and everyone wanted to go.

Bob spent the whole day on the phone about his birthday party. It's funny, some people actually want to have big birthday parties. Tauruses always do. Bianca's the same way. Bianca had called and said that she had two tickets for David Bowie for me, so I gave my two tickets to Catherine who was wanting to go so badly.

Doc Cox called and said he was giving a party for me June 7. For *me*, right? He said he has some pills that I should come in and get that'll dissolve the stones in my gallbladder without an operation.

Dropped Catherine off ($3.50) and went home to get ready. Jed had Tom Cashin there and we walked over to Halston's and Halston had a limo and so did Stevie. We waited for Bianca to get dressed and then rode over to Madison Square Garden.

The music was too loud, and then Dr. Giller screamed in my ear, "DID YOU GET DEAF YET?" and that did it for me, I think that's what finally made me deaf. We went backstage and had drinks and Bianca was in David Bowie's dressing room and when she came out she said that we were having lunch with him at 1:00 tomorrow at Quo Vadis. Then he went on stage again.

Then we went up to 1060 Fifth to the birthday party Diane Von Furstenberg was giving for Bob. Kevin opened the door. It wasn't too crowded. Bob's mother and father were there, and I never noticed before that Bob's father is attractive. I've met him before, but he really looked good. Bob kissed me for my gift, and that was embarrassing. Catherine was with Tom Sullivan and somewhere along the line Tom said to Bianca that he'd rented Montauk for the summer, and then Bianca wasn't talking to me and left without saying anything, so I think my romance with Halston and Bianca and Stevie is over. Stevie said, "Bianca's upset." See, Vincent called Mick to see if he'd pay for the place if Bianca took it and Mick said no, so . . . I don't know what to do. I wonder if I'm still having lunch with David Bowie. Should I call her up?

Tuesday, May 9, 1978

I called Bianca and the guy that answered gave me a funny answer, so I didn't know if she was standing there. Then she finally called back and said that David Bowie was busy and couldn't have lunch, but that we should do it tomorrow. So I guess she wasn't mad.

And Chris Makos called about the interview with the psychiatrist who's doing a book on famous people's IQs and he wants to give me the IQ test but I've decided I'm not going to take it. I mean, why should I let anyone know how stupid I am. And the release this guy sent was too much—it practically said he'd own my brain cells. So now Chris is mad at me for backing out.

And have I said that I met a boy at Studio 54 who told me that he had an affair with Vladimir Horowitz? I said, "How could a seventy-nine-year-old man get it up?" I just don't believe it.

And Doc Cox called for me, he's been calling for a couple of months saying he's giving a party for me and asking for my list of people, and then suddenly he said, "Do you mind if it's also a party for Larry Rivers?" Isn't that odd? Does that mean he's mad at me? Larry's out of the hospital, he'd had heart palpitations again.

And today they found Aldo Moro's body dead in Italy.

Wednesday, May 10, 1978

Fred gave me a letter from Paloma. It said she was sending her article in to *Interview*. She said her wedding was strange because there was everybody who hadn't talked to each other for years— Yves and Pierre and Karl at the same table. And André Leon Talley did four pages in *Women's Wear* on it and Fred's picture wasn't in it.

I found out Bianca was out with David Bowie the night before.

I dropped Vincent (cab $4) then had to go up to Hoveyda's for a party in connection with the Brooklyn Museum for Helen Hayes. Fred and I were the only different kind of people there, the rest were museum types. And Helen Hayes looked beautiful. She's gotten to be a good-looking old woman. She wears the right shades of blue. This time I didn't hate her. I used to because in the fifties one time she was going to have a bunch of us Serendipity kids out to her house in Nyack for a swimming pool party and then she got sour and didn't.

I told her that I loved her TV movie with Fred Astaire—although I actually hated it—and she told me that it was the best thing to say to her because *she* loved it so much.

Thursday, May 11, 1978

Victor called in the morning from San Francisco and said he hadn't been able to sleep all night and he was checking into the Baths there. Brigid says she watches him when he's at the office, spraying chloro-something on his shirt and then sucking on it. The stuff they use to freeze when they operate.

Catherine and I were going up at 3:15 to Martin Scorsese's at the Sherry Netherland to interview him and Robbie Robertson from *The Last Waltz*. And Catherine was so in love with Robbie Robertson

and Martin Scorsese that she had Gigi come by and do her makeup—lipstick and blush-on and eye makeup—but actually she looks better without makeup. We were late, so I gave Ronnie money ($5) because he had to get a Checker cab, he was bringing a big painting uptown, and Catherine and I went alone (cab $3.50).

Marty had a big suite and he's so adorable. The lady publicist who's doing *The Last Waltz* was there. Robbie Robertson didn't get there until 5:00. A kid named Steven Prince was there, he played a creep selling guns in *Taxi Driver*, and he's really like that, so he was real. Marty said that now he's doing a full-length movie on Steven Prince's face where he tells stories, he said he got that idea from me. Marty said he and Robbie were looking for a house, so I told them places to go. So that's his roommate and he's got a butler, too, and it seems like he's starting his own Factory. He must be really in the dough, because they're going to spend about $500,000 for it. Marty was shaking like crazy. I guess from coke. We sat down and had lunch and it was funny because the publicity lady had just come back from lunch so she sat at the other end of the table, watching, so it was like a movie. I couldn't even look at her, though, I was so starving that I ate. I hadn't eaten lunch at the office because I was trying to diet. We gossiped a lot, I don't know how much of it we'll be able to print. Robbie said he knew me from the Dylan days. I asked him what ever happened to the Elvis painting that I gave Dylan because every time I run into Dylan's manager Albert Grossman he says *he* has it, and Robbie said that at some point Dylan traded it to Grossman for a *couch! (laughs)* He felt he needed a little sofa and he gave him the Elvis for it. It must have been in his drug days. So that was an expensive couch.

Bob called and said we had to go to Liz Smith's book party at Doubleday's, so we left and went over there. We rode up with Geraldine Fitzgerald who was really sweet, she looked like a nice witch. Her hair. And I said hello to Iris Love. Then I dropped Catherine ($2.50) and went home and glued. Jed was going with me to the premiere of *The Greek Tycoon*. He was a little late and we didn't get there until 7:45 (cab $2.00). It was so incredible to see a movie where they cast people to look just like the people who they're not supposed to be. Anthony Quinn really looks like Onassis.

When we got to 54 Stevie said he'd just driven Bianca to the airport. He said he's so in love with her, and that if he weren't gay he'd really fall for her, but he just couldn't get it up. But *(laughs)* I think he was glad she was gone. I think Halston's glad, too. It's so much. Stevie said they went walking in Central Park at 8:00 in the morning like kids.

Sunday, May 14, 1978

Worked all afternoon while it poured outside. I wasn't supposed to eat anything because I was having a gallbladder test in the morning, but I had a piece of bread.

Monday, May 15, 1978

Got up at 8:00 to go over to Doc Cox's to start the new treatment where I take medicine to get rid of the stones in my gallbladder. It was windy, I was late, walked over fast. Some girl took X-rays and couldn't find the dye on them, so I have to go back again. And I was screaming about

taking X-rays. I don't like to get them, I think they give you cancer. All the Doc could think about was the party he's giving for me and Larry Rivers. George Plimpton was in the waiting room with hay fever when I went out.

Paul Morrissey came down to the office.

We slipped out around 10:00 and went over to Reginette's where Federico De Laurentiis was giving a wrap party for *King of the Gypsies* and it was the kind of party where it's all for the television to photograph, thousands of people, such a firetrap, people jammed, bright lights—they shouldn't give parties like that, it's too dangerous. And Barry Landau was with me like glue, every step I would take he was right there, and if I'd think of a clever new step to get away from him, he'd still be right there. What makes a person do that? What kind of a person is it? It's so sick.

Mr. Universe was there—it looked like Rome. And Eddie Albert, that cute kid. Shelley Winters was drunk on the couch and she said I should buy *Neon Woman* for her, the play Divine's in up at Hurrah's. She could really fit the part. It took half an hour to make it to the door. So dangerous.

Tuesday, May 16, 1978

Cab to the Olympic Tower ($3.25). Halston had designed uniforms for the Girl Scout troop leaders. So many ladies pounced on me. I said that Halston must be making a bundle on this, but it turned out he did it all for free. It's a great way for these ladies to get a Halston for cheap—pants are only $25. He did them in a funny color green—it's not my favorite green—but then all the ladies wearing it did look pretty.

Then we had to leave, we were going to the tenth *New York* magazine anniversary party at Citicorp Center that the editor Joe Armstrong had called and invited us to. It was jammed. Joe Armstrong met us, he said they'd just had a fire in that big furniture store on the ground floor there. Bella Abzug was there, she said she was on a diet, but she was tasting everything that came her way. The owners of Plato's Retreat came over and invited us both to Plato's. The man said, "Come and just hang out for an hour or so, have a drink." And the girl said, "The vibrations are so beautiful, you won't believe the things you'll see." So I said, "Come on, Bella. *We're* a couple —what're we waiting for?" And Bella called her husband over and said, "Martin, Andy just invited me to Plato's." And Martin said something like, "Go ahead, Bella. Enjoy!" But Bella said she didn't think it'd look good in the papers.

Wednesday, May 17, 1978

Went to Doc Cox again for some more tests. The Doc had to give his own blood test, the nurse is on vacation. He said he hadn't done it himself for years.

I peed in the bathroom, left a little sample in a jar there for my physical. When I was leaving I noticed that the girl at the desk was writing *(laughs)* the invitations to the garden party the Doc is giving for me.

Went up to a lunch for São Schlumberger that Mercedes Kellogg was giving at 775 Park Avenue. Then after the lunch Mr. Bulgari—Nicola—wanted to take Bob and me to his place, so we went

down (cab $3). He showed us everything, all the vaults, and he said he'd give us advertising. There were separate little rooms where they take customers—I guess people don't like to be seen buying their jewels, like massage cubicles. He gave me just what I wanted—a little silver letter opener—but he gave Bob three *(laughs)* soundtracks from Italian movies.

Ran into Henry Geldzahler who was finally his old sixties self to me—really rotten. Henry's the Commissioner of Cultural Affairs of New York City now. Mayor Koch appointed him.

Thursday, May 18, 1978

Cab to Chemical Bank ($4). Walked to the office and there was a big lunch for Peppo Vanini and his Xenon discotheque electricians and Billy Kluver, the head of—what's it called? Experiments in Art and Technology—E.A.T.

I'm surprised that the *Star Wars* movie company didn't actually franchise discotheques of *Star Wars* all over the country, but then, now that I'm thinking about it, things like that never work. It's usually one person who stands around screaming that makes a success out of a club.

I worked all afternoon on some pictures. Everyone was talking all afternoon about the big auction coming that night, with the paintings of mine in it that Peter Brant put up for sale. And Bob was upset that he wasn't invited to Diane Von Furstenberg's party that she was having for either Sue Mengers or Barry Diller. Fred wasn't invited either, so I was going to have to go alone.

I glued myself for Diane's (cab $3).

Bob had gone to the auction, and he called me at Diane's to say that a big Disaster went for $100,000 but a medium-sized Mao only went for $5,000. That sounded okay, so I told him we could still kick up our heels, I was relieved that the paintings sold okay. I guess people don't want to buy at auction now, because you can't make a big profit.

Diane always has the same food. It's like revisited. The same Chinese guy makes the same egg rolls and the same chocolate cake and the same everything.

Friday, May 19, 1978

There was a fifteenth anniversary party for Tom and Bunty Armstrong at the Union League Club and Fred had been invited, but Bob was taking his place.

Left for 69th and Park, the Union League Club (cab $4). The people were all WASP. The invitation said dancing, and I guess people thought that meant dinner, too, so everyone was starving, but there was no food.

Leo Castelli was there, he said that the BMW people were coming out with a new car so they wouldn't be using the design I did because it was done on the old car, but that they want me to go to Paris on June twelfth to paint the new one. Peter Brant was there looking happy, really happy, now that he's gotten rid of all my paintings. And Leo told me that the de Menils had bought all the paintings at the auction—François bought the Soup Can for 95, Mrs. de Menil bought the Disaster for 100, and Philippa bought the Funeral for 75. So that was good. And Jed

was there. The WASP women all looked so badly dressed. The rooms were so beautiful, though, beautiful old paintings in them. I sat with Philip and Dorothy Pearlstein and talked about the old days. The Gilmans were there. Left at 1:00.

Thursday, May 25, 1978—Zurich

Up at 7:00 craving soft-boiled eggs, tipped waiter ($2). Got some newspapers ($1). Went to the Kunst Museum for a press conference (cab $4). I didn't have to talk, they were just taking photos. It was hard to look at a retrospective, I just pretended to look at the walls. I can't face my old work. It was old. Had to sign a lot of Soup Cans, portfolios, stuff like that. That lasted about two hours. Peter Brant never sent his pictures.

Friday, May 26, 1978—Zurich

Paulette called and said she thought the show was so exciting. And then I called Bob at the office and he was in a very bad mood, but he didn't tell me what was wrong.

Thomas Ammann took us to a gay bar called Man (cab $3.50). Drag queens singing to American records. "There's No Business Like Show Business." Fred and I wanted to throw up.

Stayed a few minutes. Then the mayor had invited me to a big party at an old castle a little out of town, so we went. All Zurich society (cab $4).

Sunday, May 28, 1978—New York

Still off-schedule from the time change. Bob called from Nantucket. He apologized for being cranky on the phone and said that he'd gotten robbed and that was why, that after Studio 54 he went down to the Cave and two boys from there robbed him of his jewelry, but then one of them brought it all back the next day. He said that he was through with drugs, and that he was drying out, too.

Oh, and I guess Marina Schiano's spread it all over, that Diana Vreeland and Fred had a big fight outside New Jimmy's in Paris. When he came back in he'd mentioned it to me, but I thought he meant they'd just had an argument. The real story is that Diana actually hit him and YSL tried to help and she said, "No, it's a fight between Fred and me!" and she was crying and everything. Because she's jealous of Lacey Neuhaus, she thinks Fred's making it with Lacey and I think she wants him to make it with *her.* Can you believe it? It's so crazy.

The new *Interview* looked good. Paloma on the cover, and it has fifteen pages of ads.

Hoveyda was giving a dinner for Mrs. Saffra at the Pierre (cab $3). We went up to a whole big chic apartment right in the hotel. I sat next to Mimi Herrera under a Motherwell. She had a forty-carat diamond on. Poor Gina Lollobrigida was the only person there who had fake jewelry, I think. Fake emeralds. She has really big tits. I should interview her. I told her she should hook up with

Dino De Laurentiis. She said she didn't know him, that she was doing photography as a profession now. That guy we knew in the sixties, Carlos, the one who always said Edie stole his leopard-skin rug, gave the toast. I remember he sent a contessa down to the 47th Street Factory to try to get the coat back. But you know, now that I think about it, I guess Edie probably *did* steal it, but only in fun.

Monday, May 29, 1978

Went down to David Bourdon's to get some art gossip (cab $2). David's building is on 10th Street, in the middle of the street art fair going on in Greenwich Village, and David was upset by it—too many Howdy Doody men.

We walked over to have lunch at One Fifth, and on the way we saw Patti Smith in a bowler hat buying food for her cat. I invited her thinking she'd say no, but she said, "Great." When we walked in, there was the number-one bestseller Fran Lebowitz sitting with Lisa Robinson. One Fifth is pretty—bright and chintzy.

Patti didn't want to eat too much, so she ate half my lunch. She said she only loves blonds and that she wanted to have an affair with a blond. All I could think about was her b.o.—she wouldn't be bad-looking if she would wash up and glue herself together a little better. She's still skinny. She's with a gallery now, doing drawings and writing poetry. The Robert Miller Gallery.

She had a baby, she said—that's why she originally left New Jersey, and she said that the baby was adopted on Rittenhouse Square. She called it "it" and David asked her what "it" was and she said a girl. She reminds me a lot of Ivy—everything was put on. She said she was in Italy the day Moro was kidnapped and that she and Moro were the big things on Italian TV that day. She said she didn't take drugs in the sixties, that she'd only started recently, and just for work.

Anyway, I missed my girl-lunch with David, I didn't get any gossip (lunch $35). Patti lives over One Fifth and so she went upstairs and David and I walked over to Mays to get some supplies for the office ($32.89, $2.79). I got tired from walking in the sun.

And the hot water here on 66th Street is overheating and leaking and I have a vision of an explosion and the guy won't come.

Tuesday, May 30, 1978

I called Doc Cox and wanted to ask about the gallbladder medicine, but he wasn't there, I guess he's too busy with his garden party.

François de Menil called and invited Fred and me for dinner, but then later on he called and said he had to make it for just drinks. He's just back from Hollywood where he signed a deal with a woman named Hannah Weinstein to produce four movies and so we were going to talk movie-talk with him (cab $4). François looked heavier and happier. He told us his mother was starting a museum, that she was giving $5 million. God, it's so incredible, to have that much

money, it's so abstract. You just sit there and try to think of how to be creative with it. We stayed there until 8:30.

I began watching *The Valachi Papers* on TV with Charles Bronson, and then I fell asleep, and then I woke up and ran to the window when I heard a voice say, "Open up, it's the narcotics squad," and then I realized it was on the TV. It was scary to think that when you dream, you're dreaming what's on TV, and it's so real. I really thought the narcotics squad was right there.

Wednesday, May 31, 1978

There was an event up at Gracie Mansion. Left at 6:30 and the traffic was bad, it took an hour to get there (cab $5.50). The Mayor wasn't there yet, but Arts Commissioner Henry Geldzahler was, and the first thing he said was, "I don't have any of *your* art up here." He had Bob Indiana there, and George Segal, and a lot of creepy people. It looked like the people who work at the city Welfare Department.

Thursday, June 1, 1978

It turned out it was Catherine's birthday. And Robbie Robertson from The Band called, wanting me to do a poster for *The Last Waltz*, and so Fred and I were going up there to meet him at his place at the Sherry Netherland to talk about it, and when Catherine found out, she said that that could be her birthday present. So we all cabbed up at 6:30, traffic was bad ($4).

We went up to the Scorsese-Robertson suite—Marty was in Rome visiting *(laughs)* the grave of Roberto Rossellini. Robbie gave us champagne, and then it was the same thing, they always say, "Well, will you do this art poster for us and then we will sell it for you and isn't that wonderful?" And it's mixed in with hippie talk and phrases, and then everyone was too embarrassed to talk about money, so finally Fred said, "Look, man, what's in it for Andy?" *(laughs)* Yeah, he really said "man." Oh, and the butler who answered the door was that kid Marty's making the movie about, Steven Prince.

Then cabbed up to Suzie Frankfurt's ($3.10). Fred and Catherine had a big fight because she was putting down the Jews saying again that if only Hitler had won . . . Fred told her how could she say that because she was in a Jewish house. I honestly don't know if Suzie's Jewish or not. I mean, she's Catholic now—she got baptized this year. But why would she turn Catholic unless she were Jewish? I don't know, I think she's just crazy.

Cabbed to the Eberstadts' ($2.00). When we got there only Lord "Brookie" was there, Harrison Ford and Earl McGrath. Fred was chasing me, trying to kiss me, I don't know why, he was acting out of it, weird. And Keiko Carimati broke an antique nutcracker they had, it was in three pieces, and we didn't know whether we should say anything or not. And then Catherine dropped a champagne glass and within a minute Fred dropped one, too, and there was champagne and glass all over and it was embarrassing. They'll probably never ask us over again.

Friday, June 2, 1978

Robert Kennedy, Jr. was on TV for the tenth anniversary of when his father was shot, so it's ten years since I was shot, too—he was the day after me. He's been staying at Fred's house for two weeks, Robert. With the Fraser girl, Rebecca. They're heavy in love.

Saturday, June 3, 1978

Ran into Dino Fabio on the street, the one who sold the house in L.A. to the Arabs, who I met in Milan where he had the house with machine gunners around it. While I was talking to him about five cars of people yelled my name so he was impressed. One of them said, "I'm Andy Anka and I'm personally inviting you to the Copa." He's Paul's brother, but I don't know what he does yet.

Fred told me about his scene with Freddy and Isabel Eberstadt after I left on Thursday. Freddy started picking on him about Nenna or something, and Fred started crying uncontrollably, he couldn't stop. Isabel and Freddy had to take him home. Fred was in such a strange mood that night.

Averil Meyer told me she was bored, she said she wanted something to do, so I invited her to a job at the office. I asked her to be a volunteer. She's supposed to come in on Monday, but she won't show up. She's too rich.

Sunday, June 4, 1978

Watched the Tonys on TV on the phone with Brigid. Liza was there with Halston, and she won for Best Singer in a Musical, and when they called her name Stevie Rubell jumped out of his seat next to Halston. Liza was running against Eartha Kitt in *Timbuktu* and Madeline Kahn in *Twentieth Century*.

Catherine called and said that Steve Aronson came over to her house the night before—the lady he was going to visit in Southampton wouldn't let him bring his big dog so he didn't go at all—so he and Catherine were both depressed together. Catherine is in love with Tom but doesn't want to go out to Montauk and be a maid and Tom doesn't want to be serious, and she once told me that she would never get serious about it but she is, so she was depressed. And Margaret Trudeau's run off with Jack Nicholson or something. And we're upset if there was a party for Liza and we weren't invited. Yeah, I'm sure there was.

Monday, June 5, 1978

Walked along Madison handing out *Interviews*. People really know me now, they think I'm the regular newspaperman (cab $3.50). Worked till 6:40 then went home (cab $3.50) and glued myself and went to the Carlyle (cab $2.25) to pick up Jerry Hall to take her to the dinner Hoveyda was giving for the Shah's brother way down at Windows on the World.

Mick opened the door. I thought he wouldn't be there. He was on his way up to Woodstock. I asked him if it was true that he'd bought 200 acres up there and he said no, that he was just living upstairs from a dump. He showed me their new album and the cover looked good, pull-out, die-cut, but they were back in *drag* again! Isn't that something?

After we left the Carlyle I told Jerry I thought Mick had ruined the *Love You Live* cover I did for them by writing all over it—it's his handwriting, and he wrote so big. The kids who buy the album would have a good piece of art if he hadn't spoiled it. And Stevie got it into Earl Wilson's column that Bianca was "so touched" by the "Miss You" song that she "slowed down divorce proceedings," but Jerry said the song was really written about *her*. She was wearing the same green Oscar de la Renta dress she wore the last time I went out with her, and when we got into the elevator I noticed that she had underarm b.o., like she hadn't taken a shower before she got dressed. So I guess Mick must like b.o. I didn't have a limo but she didn't mind. I told Jerry that Barbara Allen had called from England where she went with Bryan Ferry. Bryan never gave Jerry her clothes back after she left him for Mick—he said he was keeping them because he knew she'd come back—and after Barbara had been over there once, she told Jerry she'd been trying on her clothes, and that did upset Jerry, but she said she hopes Bryan and Barbara make it as a couple (cab $10). Down at the World Trade Center the wind was really blowing so that's when I was really noticing the b.o. . . . We went up to the 107th floor and our ears popped. The Secret Service was there because of the Shah's brother, and Peter Beard said the waitress and the bartender were S.S. because he'd heard them talking on the way in. Hoveyda really fell for Jerry, making her kiss him on the lips.

The food was rotten but the sunset was so beautiful. Everybody was trying to make Jerry. On the way home in a limo we picked up out front, she told me her philosophy of How to Keep a Man: "Even if you only have two seconds, drop everything and give him a blow job. That way he won't really want sex with anyone else." And then she said, "I know I can tell that to you *(laughs)* because you won't tell anybody." She's so funny, she says such stupid things. But then she'll be able to rattle off the names of every single person she met when she was in Iran. It's what talking to Jane Forth used to be like (limo $20).

Tuesday, June 6, 1978

Adrianna Jackson and Clarisse Rivers and Princess Marina of I guess Greece came to lunch (cab downtown $3) and they told about going the night before to the enema doctor who Sam Green and Kenny Lane and Maxime have been going to who also *(laughs)* does readings. And they all looked into the crystal ball the guy had and nobody could see anything because there was so much shit and dirt and candlelight. The guy told Nicky Weymouth he saw a plane crash but later she got on the Concorde anyway, although she was shaking, and it didn't crash. But they all say they're going back to him anyway. How can people go back when they know that what the person said didn't happen?

Christopher Sykes came by, too, and he sang the newspaper in falsetto and opera, which I've always wanted to do. He sang the story about the girl going to the erotic dentist and another story about a chicken. I told him I would manage him and book him at Reno Sweeney's and Trax, but he said he only performs for friends. He's another poor-rich English kid.

At Trax, Tom Sullivan told Catherine that yes, they're boyfriend and girlfriend, but that they shouldn't let it show in public because it cramps his style with other girls.

Rupert's assistant told me that blonds aren't big in the gay world anymore, and it's true—it's the hot tamales like Victor who make out now.

The new club called Xenon is opening tonight. Stevie called Bob and asked him to spy there for him.

Wednesday, June 7, 1978

In the morning a guy with a foreign accent called the office and said there'd be a "bomb at the party" that night. But we didn't know *(laughs) which* party. So I started getting a headache. We were going to parties at Fiorucci and then Barbetta's and then MOMA.

The cover of the *Voice* this week is "Studio 54 and the Mafia," and when Bob called Stevie to invite him to dinner, Stevie made it seem like he was doing us a big favor—"Oh yeah, I'll come, I'll do anything for Andy."

We ended up the night at Halston's (cab $4). Stevie was going to be there and Catherine had said we should show loyalty on the competition's opening night. Stevie said, "Let's go to Studio." It was jammed.

And forgot to say that the other day Doc Cox told me that Dr. Jacobs said I couldn't take this new medicine after all—the one that dissolves gallstones—because my stones are too hard on the outside.

Sunday, June 11, 1978

Went to church, got magazines ($6) and went to the office (cab $3) because Rupert was bringing by the Flower things. I decided I won't sign the fake ones that're turning up all over Europe— the ones the people told us they bought from Gerard. Maybe I should do new ones and make good on the fakes in Europe. I don't know, I'll see. I dropped Rupert (cab $3.50) and stayed home.

And I forgot to say that last week when Jed and I were walking on Madison we ran into Dustin Hoffman in his beard with his little girl. He was carrying lots of record albums from the house that he and his wife, Anne, live in behind the Cerfs' house, carrying them up to 75th Street. I didn't know then that he was leaving home, which I just read in the paper.

Tuesday, June 13, 1978

When I got to the office Phyllis Diller was already there with Barry Landau eating lunch. She looks really old, but she was great. I don't think the facelift did much for her, but then again, maybe it did. Averil had invited her mother Sandra Payson and her brother Blair Meyer, and John Reinhold was there, too.

Dropped Vincent (cab $4) and then cabbed with Jed ($4.50) to the opening of *Grease*. Edd

Byrnes came over and said hello, and Randal Kleiser, the director. It turns out he's the kid who wrote Jed letters from California and then was the assistant assistant director on *Heat* when Paul and Jed filmed it in L.A. in 1972.

Fatso Allan Carr was there. What a butterball—if you pushed him over he'd roll. Catherine was there with Stevie Rubell who was cool to me, I guess because he read in *New York* magazine that I was standing in line to get into Xenon, which I wasn't. The movie's great, Travolta's so good. In some camera angles he looks like a turtle, but with the right ones, he looks like the new Rudolph Valentino. Stockard Channing is actually pretty but one side of her face is much better than the other.

We walked over to Studio for the *Grease* party and went in the back door where all the fifties cars were parked and the waiters were siphoning the gas out of the tanks because I guess you're not allowed to bring cars with full gas tanks into buildings. John Philip Law was behind us. They were giving out hair pomade, and the place smelled so good—just hot dogs and hamburgers, everything from the fifties. Met Mr. Nathan of "Nathan's," he and his wife were doing the hot dog stand.

Sunday, June 18, 1978—London

Staying at the Dorchester in a big ugly Spanish-style suite overlooking the park. Ran over to Sotheby's to see the Von Hirsch collection, the biggest since Scull.

Monday, June 19, 1978—London

Lunch at La Famiglia. Chris Hemphill came for coffee. He always manages to say that one wrong thing. With Bianca sitting right there he asks me, "When is Jerry Hall's cover coming out?"

Walked on the King's Road. Fred was hawking, trying to sell Bianca's autograph and mine for 50p but no one was interested. Bianca got very embarrassed.

At the Turf Club Ball Fred evidently flipped out—he started crying about the passing of the nineteenth century—how there were so many beautiful things done in it and how the people who did it were now all gone—and a girl took him into a room alone. I was upstairs with Bianca. Later we found out that Fred stopped in a bar on the way home and met five Scots and they ended up stealing his shoes from outside his door.

Tuesday, June 20, 1978—London

The phone operators at the Dorchester were so great, very sharp. One said, "There's a fake Mrs. Jagger on the line. Do you want to talk to her?" I said, "Okay," but when I said hello the girl hung up. The operators screen every call and they know where you are every minute, they don't have to look it up. I mean, if the whole world were British it would run so great. London this

time was so much fun, better than New York in the sixties. But all the great people only were there for these two big weeks of events, so...

At lunch we were teasing Bianca that it had somehow made it into the newspaper that Fred was trying to sell her autograph on the King's Road and that nobody had wanted it, and she believed us and got upset all over again.

Nicky Haslam gave us a memorable party, really paid us back for entertaining him in New York. It was at Pat Harmsworth's on Eaton Square. Her husband owns *Esquire* and *Soho News* and the *Evening Standard*. The English girls are so beautiful, I don't know how the English made so many aristocratic-looking people. Had a good time talking dirty to Clarissa Baring and talked to a guy who said he invented the waterbed, but that now everybody's copied it so he's on to a floating cloud bed. The Gilmans were in town because of Ascot, and Sondra was talking about *(laughs)* "meeting Elizabeth." I talked to the widow of Laurence Harvey. Jimmy Connors was cute, going around asking every girl if she wanted to go home with him and fuck. Fred keeps on being so peculiar—trying to kiss me and crawl in bed with me, so goony.

We went over to Nona Gordon Summers's party on Glebe Place. She bought a row of houses behind some other houses and turned it into one big one with a one-way glass roof. I never used to like her, but I do now. She's elegant and nice. Her party was for Bob Dylan, and Bianca was raving about him and how he's after her. He had his bus parked outside. Nona told him he should buy a painting of mine and he came right out and said he'd already had one—the Silver Elvis I gave him—and that he'd traded it for a sofa. So what Robbie Robertson told me a few weeks ago was true. And then Dylan said that if I ever gave him another one, he'd never do it again. He kept introducing me to the girls around him—really beautiful, dykey girls who were lying all over Nona's floor. Like Ronee Blakley types. It was sort of like *Arabian Nights* because that's the kind of house Nona's is. Later on, Bianca was complaining that Dylan had wanted to take her in the bus, and how insulted she was that he hadn't gotten a limo for her.

Wednesday, June 21, 1978—London

Sat around reading newspapers and we couldn't believe it—the *Evening Standard* actually *did* have an item about Fred trying to sell Bianca's autograph. Room service didn't answer.

Cabbed to the ICA press conference ($4). Huge crowd, the show looked really terrible. Did twenty interviews and some pictures. Then we went to Marguerite Littman's for lunch to meet Rock Hudson but his plane was delayed and I had to leave to do more interviews. Marguerite invented something great for dessert—chocolate soup! It's orange juice and Grand Marnier and chocolate, hot. Back to hotel (cab $4).

The ICA opening. Lots of punks. Ann Lambton and I went to sit where the punk band was in the cafeteria and we had fun. Then Fred was arranging a small party back at the Dorchester in one of the restaurants there but it turned into forty-five people. Rock Hudson came in with his big butch sixty-year-old boyfriend. It's so funny when they have boyfriends older than they are. Thomas Ammann took a picture of Rock and Rock didn't like it, but Fred said Rock was a bore, anyway. Jack Nicholson came, he's in London doing *The Shining*, and I guess we forgot to invite

Shelley Duvall. The kids were smoking joints and went out to the clubs—the Embassy Club, Tramps, Annabel's. But I was too tired.

Thursday, June 22, 1978—London—New York

London was just so much fun that I had to leave. Fred and Bob stayed on. Nicky Haslam gave a nice dinner for Fred at a restaurant on the King's Road. And I think Fred's really seeing a lot of Diana Vreeland. I mean, we see a lot of her, and then he stays on and sees even *more* of her. And I can't figure out why she doesn't have cancer yet. She's been dyeing her hair now for, what, seventy years? And I asked her why she doesn't have wrinkles and she said that her philosophy is to do exactly what she does.

Took the Concorde with Richard Weisman. Got home and glued myself, went to the bank (cab $5). Tired all day long. Vincent had been out to Montauk, said Mr. Winters wants to quit—he doesn't like Tom Sullivan being out there, I guess.

Victor called and said he was back with Halston, that they were back being really good friends, that he had the limousine and he was out shopping and life was wonderful all over again.

Monday, June 26, 1978

Have I said that I ran into Cyrinda Foxe recently? I think she made a big mistake leaving David Johansen for the Aerosmith guy because David's going to be so big.

I sent Chris Makos out for a Konica camera ($175.55)—it's a built-in flash, I think it's going to be great, built-in focus.

Cabbed to Martha Graham's thing at Lincoln Center ($3). Martha came out and made an hour speech, she must love to talk. She had on a beautiful dark green Halston with bright green underneath, but the white gloves she wears to cover her hands distract. I guess Halston is probably trying to figure out what to do about that.

The first number was boring, but the sets were by Noguchi. Went for drinks ($10). Then back for the second number—the sets were by Noguchi again, they were the best thing—but that was boring, too. Drinks again, this time doubles and triples ($20). Then the third number was "The Owl and the Pussycat" that Liza was doing. It was a good number and if she'd sung, it would've been better. Halston ran up on stage afterwards.

Tuesday, June 27, 1978

Had a meeting with Mr. Kahn about his portrait. He has a big nose and I made it smaller but when he saw it he thought that he would like to have his really big nose, that I should do it up really big. He asked his wife, "What do you think, darling? Should it be my big schnoz?" and she said, "Darling, it's *your* big schnoz, and I love it, and whatever *you* think."

Thursday, June 29, 1978

Had a date to have lunch with Truman and his boyfriend Bob MacBride to discuss *Interview*. Cabbed to La Petite Marmite which is on 49th in the Beekman Towers ($4). Truman said he's starting to be normal again and when I believed him he told me I was *(laughs)* "too naive."

Truman was throwing his hands all over the place. I taped, and we dished the whole lunch.

He said that after lunch he was going to his analyst and I asked why someone like him would go to an analyst and he said because it was an old friend and he didn't want to hurt his feelings by not going.

Truman is so silly-looking, open-toe shoes and no sweater, and he said he just decided that he's going to start wearing *anything*. He said that Issey Miyake sent him a coat and he just threw it on immediately—he was written up in the papers when he wore it to Studio 54 with a white hat. We had lots of drinks and it was fun, and then it got down to what Truman had invited me for. Bob MacBride who he always said was a writer but who we could never figure out what he did is now doing sculpture. He's left his wife and kids.

We went back to Truman's place in U.N. Plaza. He's redecorated, but the bulldog's torn off the buttons and the fringes from the furniture. And Bob MacBride brought out his—toys. His art. It was little cut-outs, like you make in kindergarten. You know? Like circles, and then you paste another circle over it, and you make hexagons and things. That's what he does. And they wanted me to help him get a gallery. I said he'd just missed Leo Castelli, that he just went out of town, but that when he got back we'd make a lunch for Leo and him, and Leo will think that's fun—lunch with Truman Capote.

I told Truman I would tape him and we could write a Play-a-Day, he could act out all the parts himself. *(laughs)* He could really do it—play his grandmother and everything.

He gave me all the dirt, we dished Lee and Jackie. Lee's got a new really rich boyfriend in San Francisco, that's why she's spending time there.

Truman said the *Ladies' Home Journal* offered him $10,000 to review a movie but they wouldn't tell him which one it would be, and then he found out it was *The Greek Tycoon* so he turned it down. I think Truman likes me because I like everything he doesn't. He's so nuts, you're embarrassed sitting there with him. And he's always talking about how he's getting a hundred thousand for this and a million for that, but who knows.

He was thrilled, he said, with his *Tom Snyder* show a couple of months ago, thought it was really one of his best. I don't know why he doesn't go on *The Gong Show*.

Home to glue. Then picked up Catherine and went to Doubles to get the bus to see Lucie Arnaz opening in *Annie Get Your Gun* out at the Westbury Music Fair. Barry Landau was in charge, and I think he *(laughs)* invited all the people in his apartment building. I really think he did. People were going in for drinks and Gary Morton couldn't get in because he didn't have a tie. The doorman was so dumb, I told him, "Don't you know that's Mr. Lucy?" Lucille Ball looks so old but she has a beautiful body, and she really was a beauty.

On the ride out, Bill Boggs did some announcing, and then Gary Morton did some announcing, like, "Here we go by a garbage can," things like that, and finally after an hour and a half we arrived. The place looked empty, but then when they saw Lucy, every old lady in pantsuits came

swarming. God, why do Americans dress so bad? Do they want to look unattractive so they won't get raped, or what? When did it start?

But Lucie Arnaz was good, and I just love Harve Presnell, he's the one I always really loved. He's 6′5″ and Tammy Grimes had an affair with him. The show was really long, I don't know why.

Oh, a woman came up and asked for my autograph and she said, "I'm Gloria DeHaven," and I looked at her and it was. So I think maybe there were a lot of old stars that you just couldn't tell. A kid was throwing up, and it was funny because we all just stood there and watched him.

Friday, June 30, 1978

Prince Rupert Loewenstein said that Catherine's stepmother or stepfather or something had just inherited $50 million and they hadn't told Catherine about it yet, the English don't bother. Catherine was going to meet Prince Charles at dinner at her mother's in London, her mother thought it might be a nice match (newspapers and magazines $16).

Halston and Stevie said that Bianca's living in Mick's Cheyne Walk house in London, but she's not supposed to be there, so it's boarded up, but she's still inside. They said it's really small, just one room on top of another room—smaller than Fred's in New York.

Went over to Halston's and Liza arrived around 12:00 with her new boyfriend, Mark, the stage manager. They just met, after six months of working on the show. He asked her if she wanted to see paradise, and she said yes, she asked him where it was, and *(laughs)* he said in his room, so they went there and fucked. He does sculpture in marble. He's very good-looking and very big—either Jewish or Italian, I can't tell which. Halston was sweet, trying to get Stevie to start an art collection and trying to convince Liza she should have me do a nude portrait of her, so she was doing her number, saying how could she go nude with her body, and she was taking her tits out and the guy was getting turned on, and then she was saying, "How would I cover my fuzzy?"

Saturday, July 1, 1978

It was a pretty day. I worked all afternoon and then Victor came by and we went propping in the Village, we went to Utrillo's, the used clothes store, and left *Interviews* there. They said that they could sell *old* issues there if we sent some over. Then we went into the second-hand shops along 6th Avenue and one guy said, "Oh, you're the one I sold the stuffed dog to." And then I went into another shop down the street and the woman there said, "Oh, you're the guy I sold the stuffed dog to." Actually she sold it to Fred. So I said, "How could two places sell us the same stuffed dog?" and she said, "Oh, we used to be partners." These people just know the price of everything, every little piece of fifties junk has a price that they know! And I mean the easiest thing would be to just buy something new and stay in business for ten years and then sell it as

an antique. Victor bought these clear plastic chairs from '65—or maybe even later—for $150. Was that a good price? What would something like that sell for new now? And they're nice-looking. Molded. It's things like old Mickey Mouse stuff. Why not just get it new now and don't use it and then you'd have it new in ten years instead of the old beat-up things they sell (photo supplies $16.96).

Sunday, July 2, 1978

It was a pretty day out but I stayed home, worked on some drawings.

Victor called all day long, wanted me to come down and see the dog he wants to get, and go cruising and propping, but I thought it'd be a good chance to relax and *(laughs)* think. Have I ever said *that* before? I had a soggy mind. I'm working on invisible sculpture now, and paintings that look like they move, like Duchamp's "Nude Descending a Staircase." I think I'll move some fruit around.

Oh, and Truman called me. He said he loves my idea of doing a Play-a-Day and that he's *(laughs)* already done eight. He said that by Wednesday he'd be out of the hospital—he's there for a blood check—and that we should have lunch.

Tuesday, July 4, 1978

The Fourth of July. Raining out, watched *The Brady Bunch* then went to the office (cab $3.50). Victor was calling, wanting me to see his dog-to-be. I tried to talk him out of getting it. I told him he was a dog himself.

At 4:00 Victor and Rupert picked me up and we walked over to McDonald's to have lunch and hand out *Interviews* (lunch $9.50).

Talked about silkscreening while we cruised. The people in the Village were so unattractive, God. They were all the leftovers who didn't get taken away to Fire Island for the holiday. Dropped Victor at the Morton Street pier ($4.50).

Wednesday, July 5, 1978

Cabbed to Chembank ($4.50) then walked to the office and made some phone calls. Then cabbed to La Petite Marmite ($3) to meet Truman and Bob MacBride. They were on the wagon but I had orange juice and vodka. I taped his ideas for plays, but oh God, *(laughs)* they were so boring. He said to me, "I have so many ideas, I've just got so many I'll tell you three plays right now," and then he told me the first one. He said [*imitates*]: "It's called *The Greek Ideal*, and it's about a young man and his mother, and he's a Greek scholar and he's going to Harvard and he's maybe a little crippled. His mother gives him a present before he goes away, she takes him to a Greek island and it's just the son, the mother, and a maid"—I guess there was a maid—"and they're sitting on the island and suddenly the mmmoooooon rises and out of the moon come hundreds

of little rats and they eat him. And the mother is in a black hood." Well *(laughs)*, I didn't know what to say, I said, "Oh, that's great, Truman, but does it have to be rats? I mean, there was *Ben* and *Willard* and everything. . . ."

And then Bob said to me, "Don't you know that's from Truman's old short story, 'Walk Around the Block,' which he did years ago and everybody's *copied* it?" And then Truman told the second play, which was not as bad *[imitates]*: "A young man of sixteen down South marries a girl of thirteen for her money, and he's precocious and paranoid. . . ." I didn't really get that one. And when he got to the third play he said *(laughs)*, "It will be improvised and we can do ANYTHING! It'll be called *Deep Holes*." So then I said, "But gee, Truman, can't I just tape *you*, the real thing, and do plays about *real* people? Can't I go to your gym with you?"

So we have a date for Friday at 11:00.

Then after lunch we went over to his apartment and there were two copies of *The New York Times* magazine article on him that's going to be out this week, an advance copy. And the picture with it didn't look like Truman, it looked just like his mother. He was in a straw hat and a bedsheet that made him look pregnant, standing in the grass. And the article says just exactly what he did in his life, that he only likes men who have a wife and lots of kids, because they were the family that Truman never had, that he likes to become close to the kids. And it described Truman's boyfriend John O'Shea, the one that Bob and I met in Monte Carlo a few years ago. It was funny, it wasn't even talking about Bob MacBride and there he was fitting the description, reading about it. Truman said, "No, not six kids, just four or so is plenty." Then Truman read the article and Bob took me into the bedroom to show me more of his artwork. And Truman read for about an hour. Then Bob said he needed a nap, then Truman said he had to leave, so I asked him if he were going to his psychiatrist and he said no, to the gym. His gym is right where the old Factory used to be, 47th and Second.

On the way out, in the lobby of his building, he held up the picture of himself in the article for the elevator people. He said, "Look, it's me. How d'ya like it?" And he was talking about the article, it said the word "decline," and he said, "Decline? What decline? I'm the most written-about writer in the world." I guess he's confusing written-about with writing.

Thursday, July 6, 1978

The woman from Detroit called and said the Henry Ford portrait is on for later in the month. Oh God, Detroit. Maybe Henry Ford's neighborhood will be okay.

When I got home Barry Landau called and said he was uptown and he'd pick me up to see *Timbuktu*. We went backstage and I gave Eartha some *Interviews*, told her we'd like to take pictures of her daughter, Kitt McDonald, and do an interview with her. We saw the show, drinks at intermission ($10). Barry's been walking Eartha's saint bernard and he didn't tell her but he and his friend Greg or Craig took the saint bernard down to Christopher Street for a gay walk.

Went over to meet Truman at U.N. Plaza at 11:00 (cab $3). He came down in the elevator. I had the tape on. He was talking about Babe Paley, she just died and he was upset, he'd been calling around trying to get lilies of the valley for her. He said he hated Bill Paley for being mean to her or something.

We walked into the gym and people were looking at us, we looked peculiar. Then we went into the room for Tony to massage him and Truman took off his clothes and I *(laughs)* took pictures. He's fat but he's losing weight. On the way over, his pants were falling down, like a loose diaper—you could see the crack in his ass.

Then after lunch Truman took Bob MacBride, who was with us by then, and me to his psychiatrist. Truman had told him that I was going to be taping so there *(laughs)* was Truman on the couch, and he was talking about his father and his mother and his stepfather and how his father took his money and all that crap and the psychiatrist was saying all the things that they say in the movies—"Now let's get back to that dream you had." And Truman got up and looked out the window and then at us, and he had tears in his eyes, he was sort of crying, and then when he was finished he bounced up and said, "Wasn't that wonderful acting?"

Then they were going home for "a little nap" and I finally realized that "a little nap" must mean sex with Bob—they must do it every afternoon and I guess I've been interfering—but I think Bob likes it better that I am, it gives him an excuse not to.

So we went back to U.N. Plaza. I was outside the door trying to tape Truman in the bathroom pissing, but he closed the door.

Then Bob said it was time for dinner. It was just like a vacation, like being in the country—right after lunch you have dinner. Truman does really eat only one meal a day, though, I've watched him.

Before we left Truman had a stiff vodka. Then we went over to the restaurant across the street called Antolotti's. Bob fell asleep at the table and Truman told him to go home.

Truman told me that his fantasy is to make it with the psychiatrist, that that would get their relationship to a "new level"—that then *he* would be "in power." I was going to ask him didn't he think it was so old-fashioned to be thinking that way, but I didn't, I'll save that for *(laughs)* another session.

He told me that he blew John Huston forty times and then he told me about Humphrey Bogart. He said that Bogart was "reeeally scared" of him and that one night he carried Bogart up to bed, and tucked him in and said to him, "You've *got* to let me do it, Humphrey." And *(laughs)* he said Bogart was really nervous and said, "Okay, but don't put it in your mouth." So then Truman said to him, "Listen, Humphrey, we went to the same school, Trinity, and I *know* you must have done it there." But I don't think they *did* both go to Trinity. Truman makes up so much. Then later, Truman said, they became best friends and he said once they were staying together at somebody like David Selznick's house, and Bogart jumped into his bed with a hard-on. But Truman said he told him it was *(laughs)* just too early in the morning.

Oh, and he said that John O'Shea stole the whole *Answered Prayers* novel, that that's why it wasn't done, but I think he's making that up, too.

And he says he doesn't want to live in the present because his book ends in 1965 and he's trying to finish it. But when could he work?

Oh. And what gets him really upset and nervous is anything anal. If I ask him about fist-fucking he gets so upset. He says he doesn't want to talk about it.

But I mean, how could anybody make it with Truman? God, I mean *I* could never do it with Truman. *(laughs)* God . . . (dinner $52.15).

Saturday, July 8, 1978

Victor called and said he had parasites. He was staying up at Elsa Peretti's, she was just back in town, and he was seeing Dr. Brown, the boy-disease specialist.

Sunday, July 9, 1978

Truman called and said he missed me, to come for dinner. This was the day his picture was the cover of *The New York Times* magazine section. He said he had the phone off the hook, but I don't know whether to believe that. At 7:00 I went over to U.N. Plaza, took eight tapes with me and a camera (cab $2). I talked to Bob MacBride for a while and then Truman made a phone call to Jack Dunphy so I could tape it. Jack was his boyfriend for thirty years. But he hadn't seen the article in the *Times* yet, so he didn't have any comments.

Truman also told me he'd talked to Gerald Clarke, the guy who's been writing the book on him for something like five years, and Clarke wanted to know how the girl who wrote the article got Jack Dunphy in it when *he* couldn't, and Truman said it was because she'd run into him on the beach, it was an accident. Truman said Clarke called *him*, but I think Truman probably called Clarke. Anyway, if Clarke did call him, then his phone wasn't off the hook, so either way he was lying.

Then we went over to Antolotti's and got pizza. And the drinks there with the vodka and grapefruit juice really do put weight on you, I've noticed. I was getting drunk. Then I walked him home, I had Truman on my arm. It's funnier to see Bob MacBride walk him home on *his* arm—that's *really* creepy. But when I walk him on mine, it's creepy, too. And he's weaving, and he's so strong he was pushing me over. Went home (cab $3).

Got three full-sided tapes out of the evening.

Monday, July 10, 1978

Cabbed up to 44th and Sixth Avenue with Vincent ($3) to the studio of Sire Records to do a commercial for the Talking Heads. I had to do it about twenty times. Afterwards I told Vincent that I can never be an actor—I just don't have it, I get tongue-tied, something happens. All I had to say was: "Tell 'em Warhol sent ya," and it came out like I was reading it every time.

Victor called and said he had to stay in a wheelchair for a month. He had all these doctors

and his leg just kept getting more swollen, until he got an eighty-year-old South American who gave him a shot, so he was ordering an ambulance to take him to Studio 54 for the party for Elton John.

Tuesday, July 11, 1978

Victor was at the office waiting for me in a wheelchair, acting very peculiar.

He had a friend with him, Andreas, a rich kid from South America who was telling him the same things I was—that he should go home and stop running around. He shouldn't be letting the blood run all over his body, he should keep his leg up.

Friday, July 14, 1978

Went over to Doc Cox to show him the pills Jay Johnson brought back from Japan. They sell them over there, they're pills people take to make their liver digest food. He looked at it and he couldn't read Japanese so he said, "Take them, I guess."

Picked up Bob to go meet Truman and Bob MacBride at La Petite Marmite (cab $3.50).

Truman brought another Sunday *Times*, the one coming this week, the second part of the article on him, but this time it wasn't the cover—he'd said it was going to be but it wasn't. I had him autograph it and give it to me. He says he's going to give another party for his 540 best friends and it'd be in a loft and the women would wear veils. Truman picked up the tab.

Cabbed to the office ($3). Susan Blond sent a limo for Truman and me to go to the Palladium to see Rick Derringer and another act. They took us upstairs to a dressing room where we found a bottle of Jack Daniel's and some milk and cookies, and Truman fixed himself a Jack Daniel's with milk and this rock and roll manager-type came in the room and started screaming, "Clear the room. Clear the room, we have to talk money." So everybody left but us, we didn't know where to go, and he said to Truman, "Didn't you hear me say to clear the room?" And so I said, "But he's Truman Capote," and Truman said, "But he's Andy Warhol." And the manager said, "Oh, sorry."

Sunday, July 16, 1978

Barbara Allen called me in the morning to go out to Forest Hills to the tennis matches. Richard Weisman had to go out early because of something to do with ABC television. I was going to go but when I saw how foggy and grey it was I decided I'd watch it on TV and get some work done at home. But I went to church, then came home and watched the matches on TV. It was Nastase vs. Vitas Gerulaitis. I was for Vitas and he did win.

Then Barbara and Bob called and said that Vitas was having a dinner for everyone out at the River Café in Brooklyn, on the barge, and they talked me into going. They said they were coming to pick me up. At 10:00 they did. Barbara was showing us the ring Nastase gave her. Then Nastase

came in with a beautiful girl, a model, and Barbara went upstairs and cried. And then Richard Weisman was saying how silly Barbara was to be upset when she knew Nastase was married with kids and everything anyway. Truman said he had a really rich guy for Barbara and that she'd have three planes and all the money in the world and a house in Mexico, and that cheered her up.

We were there until 2:00. Vitas paid. He said he'd just been in London and while he was in a club talking to Ringo Starr, Stevie Rubell kept pulling on his arm and saying, "Come on, Vitas, we have to go, Bianca wants to leave," and Ringo said, "Who's the little midget you're taking orders from now?" Vitas said Stevie's really insecure when he's not in his own club. And Stevie doesn't know about Europe at all—he still thinks Gianni Agnelli's name is "Johnny Antonelli," that's what he always calls him. Once he said, "Johnny Antonelli, he's the one who *really* owns Fiat—not all those Rattazzi kids."

Monday, July 17, 1978

I had to think about what drag to go in to Halston's party later on, so I sent Robyn out for a wig and he came back with the perfect one—a grey Dolly Parton ($20.51), and I put it on and wore the dress I'd once designed for a Rizzoli art fashion show that was parts of six different designers' dresses all sewn together. Went over to Halston's. The first person we saw was Stevie who was dressed like Liza—he thought—in red sequins, and he looked awful. All of the waiters who look so good in Studio 54 just looked like tramps at Halston's. Stevie kept pulling out his cock from under his dress and I was surprised, it was big. Barbara Allen was the best, she came as a man in a jockstrap. With a jacket and a mustache. Stevie's boa caught on fire and he would have disintegrated if some fairy hadn't put it out. Halston in drag looked like Diane de Beauvau. I guess now it's easy to see why he liked her so much, that's the look he likes, sort of fat-faced and chubby.

Tuesday, July 18, 1978

Truman's picture was in the paper from going on *The Stanley Siegel Show* drunk. I didn't see the show. He'd told Stanley not to ask him anything about drinking but then he went on the show drunk.

Thursday, July 20, 1978

I went to a doctor in the morning for one of those terrible once-a-year physicals where they do *everything*. When it's the same nurse it's not so bad, but Rosemary is away and Doc Cox has a male assistant, and so *(laughs)* it felt like you were at the Anvil. First I got a pelvic X-ray and then a proctoscopy, that's what it's called, and it was too embarrassing. Doc Cox went out of the room to see a lady patient and she spilled water on him so when he came back it looked like he'd peed on himself. The Doc was sweet. Then I picked up some things for the office ($15.21) and got

down there by 2:30. The lunch was for Eartha Kitt, and Barry Landau had brought Polly Bergen down, too.

Brigid had already done her Eartha Kitt imitation for Eartha and Ronnie was looped, saying it was his "last day" on the job—Fred had screamed at him the day before that the place was too dirty, that he wasn't cleaning up enough. Ronnie and Eartha were fighting and nobody pulled him out of the room. The fight was over James Dean's personality and whether he was "difficult." I guess Eartha was thinking she was a rebel, too, so she was standing up for James Dean, and it's not the same thing at all—she did it for civil rights and James Dean was just a person not showing up for work. And the fight wouldn't have been bad if Polly Bergen hadn't started sticking up for Ronnie, saying he was right, and then when Polly left the room Eartha said something like that she was full of shit, and then when Eartha stepped away once Polly said something like the same thing about Eartha, but not in those words.

Bob thought Eartha was interesting enough to do a story on, but I don't want to hear about the White House, that story's so old I don't want to hear about it. We made a date for the next day at Quo Vadis to have lunch with her and her daughter, Kitt, and I gave Bob the assignment of keeping Barry away. And Ronnie decided to stay on. Victor didn't come by to see me, so that was like a vacation, but he sent me over a present—a cock ring, his.

We tried to get Truman on the phone, but he didn't answer.

Got dressed and picked up Catherine. Her English friend Jamie Neidpath was with her, he's a land baron. He looks twenty but he's thirty. He dresses in funny clothes, long stringy silk ties like the Beatles used to wear and frock coats, and I asked him why he dressed funny and he said because he just decided once that this was the way he was going to dress forever, and so he has.

Cabbed to the Bottom Line ($6). Steve Paul was there, I think he manages David Johansen. Lou Reed was at the next table and Catherine was madly in love with him, that was why she wanted to come to this thing. And Fran Lebowitz was at another table with her arm around some girl *(laughs)* so I got a few snaps of that. And oh, David Johansen is so cute, he's just so adorable. The only thing he does wrong is jump around, he should learn not to do that like Lou learned not to. Lou invited us over to his place.

It's on Christopher Street, between Sixth and Seventh, sort of where the *Voice* used to be, upstairs from a bagel store. When we were going in the kids around were whispering, "There's Lou Reed." He tells them, "Go kill yourself." Isn't that great? The two dachshunds he got after he saw me with mine are so adorable—Duke and Baron. He's sort of separated from Rachel the drag queen but not completely, they have separate apartments. Where Lou is, it's actually more of a house. It's a rent-controlled thing he got from a girlfriend, six rooms and he only pays $485 a month. The best room is a long skinny bathroom, 2′ × 12′ and he said he was thinking of changing it but I said not to, that it's really great that way. And oh, Lou's life is everything I want my life to be. I mean, every room has every electronic gadget in it—a big big big big TV, a phone answerer that you hear when the phone rings, tapes, TVs, Betamaxes, and he's so sweet and so funny at the same time, so together, it's just incredible. And his house is very neat. He has a maid come in . . . well, I guess it does smell a little of dog shit, but . . . Then he was on the phone and he ran a tape of his concert and it was him trying to get the old Billy Name Factory Foto look, very contrasty. Catherine went downstairs and got grapefruit juice and bagels and orange juice. Lou only had a funny pint-size bottle of scotch.

Friday, July 21, 1978

Bob MacBride called me and said he wanted to see me, but I didn't want to see him alone without Truman and I said I'd call him back but I didn't, so now I'll have to lie and say I tried but I couldn't get him.

Monday, July 24, 1978

Bob MacBride came for lunch, and I had McDonald's ($4). He's worried about Truman, he says he's sure he's going to commit suicide. He says Truman is checked into a private hospital room in the same building as my dentist, Dr. Lyons, at 115 East 61st Street, but that nobody knows it. Truman's upset because everybody's saying he's washed up. Bob said that on the morning of *The Stanley Siegel Show* he dropped Truman off there himself and he was fine, so he thinks Truman must have taken a Thorazine or something. Truman says he doesn't remember anything about the show. I keep trying to get it out of him if Truman is writing the *Answered Prayers* book or not, and he won't say yes or no.

C.Z. Guest sent her husband over yesterday, Bob MacBride said, to try to convince Truman to go to a hospital in Minnesota. I didn't know if he wanted me to give him advice, or what. I didn't know what to tell him so I just said, "If Truman goes to the hospital, when you go to visit him, try to get me in." I'll tape it. Because you can't stop people—if he's going to kill himself, he's going to do it.

Tuesday, July 25, 1978

Forgot to say that the night before what I watched on TV was the Miss Universe pageant.

Miss USA was actually the best, she was from Hawaii and she looked like Jerry Hall, but when it came to the question, "What do you think of the United States?" instead of saying something serious like "It's the most free nation that glues together everything" she blew it and she said something like "Oh, I love the beaches!" Miss South Africa won, she looked like a brunette version of Miss USA but she gave a serious answer, and Miss Colombia was too stoned to talk. *(laughs)* No, I'm only kidding, she wasn't . . . but they had around seventy-five girls and most of them were from South American countries you never heard of. The ex-Miss Universe looked really black, but maybe it was my TV.

I cabbed to the office to pick up Vincent, we had to go to a lunch for 600 people at the Plaza given by Gerry Grinberg the head of the North American Watch Company. The paid speakers were Art Buchwald and ex-President Gerald Ford (cab $4).

And Mr. Grinberg took me over to see President Ford and he said, "Nice to meet you." And I told him that he'd already met me at the White House and he said, "Oh yes, of course." He looked sort of out of it. I asked him *(laughs)* how his wife was, and he said she was out shopping and I said, "At Halston's?" and he said *(laughs)* yes, that maybe she was there. But once he got

started on his speech he didn't seem so out of it at all, he remembered the whole speech. It was a good lunch, steak and potatoes.

And on the way out we went into the Teuscher candy store in the lobby of the Plaza—the one where they fly the candy in every day or something—and I wanted to sell them an ad in *Interview*, but I wound up buying $200 worth of candy instead.

I talked to Ronnie. He told me he's now going to one of those halfway houses to stop taking drugs and drinking. He said he hadn't slept at all in a week. I asked him if he was having trouble with Gigi and he said that well, yes, that she'd thrown the wedding ring out the window. I don't know why she ever got married, she's always going to run around, and Ronnie wants her to be like his mother in Brooklyn who never leaves the house. Now she's styling or doing makeup on the Brian DePalma movie and that's going to lead to other things, so . . .

Went home and called Truman, but there was no answer, I should have called before I left for work.

Wednesday, July 26, 1978

Went to meet Truman and Bob MacBride at La Petite Marmite. Truman's just checked out of the hospital. He said that the Guests are taking him to Minnesota to a hospital there to dry out some more. He said he got about 100 letters about his *Stanley Siegel Show* and he read me the one from Stanley Siegel, which was so disgusting, saying how great Truman had been and you just know if he really cared he wouldn't have let him go on, and this one show really put Stanley Siegel on the map, it got him national attention.

Thursday, July 27, 1978

After work I just stayed in. Watched *20/20* and instead of saying, "In the future everyone will be famous for fifteen minutes," it was so funny to hear Hugh Downs say, "As Andy Warhol once said, in fifteen minutes everybody will be famous." People on TV always get some part wrong, like—"In the future fifteen people will be famous."

Oh, and I forgot to say that Truman really is looking more and more like his bulldog. He sits there and rubs his eyes as if he were kneading dough, and then he takes his hands away and they're all red—the whites are red, the rims are red, he really looks like his dog, really drooping.

Friday, July 28, 1978

It was a slow day at the office. We sat around eating lots of fruit that we'd gotten for lunches so it wouldn't go bad over the weekend.

Saturday, July 29, 1978

Jed and I walked over to the Pierre and then we went to the Oyster Bar in Grand Central and it was closed and then to La Petite Marmite and it was closed, and then we cabbed to Woods but it was closed ($3). So we went next door to La Relais because we wanted to see if it was good and when we went in, it seemed like everyone was there—Charles Collingwood, and Helen Frankenthaler and she was awful, she always is and she always was. She was with a European gallery owner. Denise Hale was in the restaurant and I asked Helen if she'd like to meet her and she said, "Why? Would it give Denise a thrill?" I asked her if she were going to Washington on Wednesday for the Mondales' party for artists whose work is in the vice-president's house, and she said she was. I'm going down with Fred. I asked her how her big silkscreen was—I heard she'd done a big one—and she said, "I don't do silkscreens—I leave that to you." And so I was confused if she did one or not, so then I said, "I mean for your multiples," and she said, "I don't *do* multiples." She was awful. Well, she married Motherwell to get a start. Her work's terrible.

Went to the movies (cab $3) to see Patti D'Arbanville in *Big Wednesday*. She had three lines: 1) "Oh my God" 2) "Uh-uh-mm" 3) "Eh-oo-oo."

Sunday, July 30, 1978

Bob called, just back from Montauk where he said Catherine drove him crazy.

I guess Tom really is in love with that Danish model, Winnie. And Ulli Lommel is going to shoot a movie out there, *Cocaine Cowboys*. He's married a rich wife, Sukey Love.

Wednesday, August 2, 1978—New York—Washington, D.C.

Life really does repeat itself. The old songs come back in a new way and the kids think they're new and the old people remember and it's a way of keeping people together, I guess, a way of living.

We got the Washington shuttle, after getting magazines and newspapers ($3). The shuttle was packed, it always is. Paid for Fred's and my ticket ($81). Then got a cab to the Madison Hotel ($6.50), checked the baggage ($3). Cab to the Mondales' ($4). Everything is so expensive. It started me noticing inflation for the first time, because everything on the menu at the hotel was actually double. A minute steak that used to be $7.50 is $15 now. And all your life you're taught—you're brought up on money, on pennies and dollars, and the inflation used to come in pennies, but now a dollar is like a penny, things go up in dollars.

Washington was hot and sticky. Joan and Fritz Mondale didn't have any real big artists. Just Helen Frankenthaler and me. And the reason I was included was because they had the Southwest collection and my Blue Flowers was in Mrs. de Menil's gift.

They live in the same house the Rockefellers had when they were vice-presidents, but of course their Max Ernst bed is gone from the place now.

Joan put me on her left and an Indian guy on her right. And then Joan was a little drunk, I think, and she started being very sad and saying, "Well, this is probably the last time we'll see each other because you're a famous artist and you're going to be around for a long time, but they just took a poll in New Jersey and we're the lowest we've ever been, we're lower than Nixon right before they got him out, and we're slipping fast." I told her that things would pick up.

Then we saw the treasury guy over in a corner and I said to Joan that he should make dollar bills that have braille for the blind newsdealers like they do in Switzerland and she said that was a wonderful idea, that I should tell him, but then she got to him first and told him herself. The dinner was so bad. What ruined food in America? Was it those magazines like *Good Housekeeping* and *Family Circle* and *McCall's*? They could have great simple steak-and-potatoes dinners and instead they have these fancy concoctions. Like veal with tuna sauce on top of it and capers. It was a "tented affair," and that always costs so much, every time you put up a tent. And they had every kind of hard liquor, which you don't get now at the White House. Then around 10:00 Helen Frankenthaler slipped a note over asking us if we wanted to leave.

Then we had to go back to the hotel, and I'd been telling Fred how horrible Helen Frankenthaler was, how awful she was to me last weekend, and then suddenly she was changed. She said, "I've been so awful lately, I don't know what's wrong. I'm really going to be nice tonight." And then she *was!* Isn't it amazing how a person can just change like "that" because they decide to?

And we had drinks with her in the hotel. Fred was bored with her but he paid for the drinks anyway. She was talking about her maid wanting $300 for four days' work, she's live-in. She probably just wants to leave Helen. Helen has three or four people working for her, she said. And she hated the wine, although Fred didn't see anything wrong with it.

Thursday, August 3, 1978—New York

Went to the office, everyone was zonked. After Ronnie's whole speech that he was going to A.A., there he was, zonked. And when he gets that way he's so nutty.

I was photographing Bob Colacello and Ronnie would take up the pictures and say, "Bob, these are awful. You have three chins," and Bob said, "No I don't, I've lost two of them, I look good today." And it was true, Bob did look good, but Ronnie was going on, picking up each one and saying how horrible it was.

Brigid was depressed. Only Vincent was happy because some checks came in.

Victor came by, his hair was carrot blond and he was going to go for white to be like me, but with dark eyebrows. He's been up for three days because he bought some good coke.

I got back some of my pictures of Truman, lying on the psychiatrist's couch. He looked like he doesn't have teeth in my pictures. Does he have teeth?

Friday, August 4, 1978

Brigid was back transcribing the Truman tapes. I haven't called him out in Minnesota yet.

Saturday, August 5, 1978

I cabbed to the nail place ($3.20). Getting my nails done was $46.80 plus I gave a $10 tip to the Cuban lady who told me all about herself and did a rotten job on my nails. They serve drinks there to the customers, and one boy who works there said he did Candy Darling's first perm when she was fifteen. I wonder how old Candy was when she stopped being Jimmy Slattery and just wore dresses all the time.

Walked back to the house. Catherine called from Montauk and she was sober. She said that Tom had about thirty people out there shooting *Cocaine Cowboys* and that the toilets were backing up. She pretended to know that Tom had just married Winnie.

And Mr. Winters called Vincent, going crazy about all the people. Tom moved out to the hotel at the yacht club, so Catherine was happy—she spent the day there ordering from room service and watching TV.

Sunday, August 6, 1978

It was my birthday but I didn't think of it until Vincent called and reminded me.

I thought I was going to see *Ain't Misbehavin'* for the Actor's Fund but I was a week too early. So I called Tom Cashin and we got tickets to the *American Dance Machine* (cab $3, tickets 4 × $13 = $52). Raining. A few fans handed me notes.

Monday, August 7, 1978

Victor told me he had a secret—that Halston was giving me a surprise birthday party and it included a great gift that I would love. Then he left to go dye his hair.

Glued myself and went to pick up Catherine at 8:50 but as we were leaving her place Tom Sullivan called and said he'd pick us up on the corner in his limo and we waited there but he didn't come. Then we had to leave to be at "21" (cab $2).

When we got to "21" Jay Mellon was sitting there, alone, no one had arrived for my birthday dinner. Then we had drinks for an hour, and still no one had arrived. The dinner was supposed to be at 9:00 and it was 10:00 already and still nobody was there. Catherine went upstairs to see if maybe they were in the room up there, but they weren't. Then I went out to call Eartha and see where she and her daughter, Kitt, were, and Kitt answered the phone and she said her mother had gone out with Barry Landau! So I mean, I said thanks a lot and hung up.

Finally about 10:00 Lou Reed arrived, he gave me a great present, a one-inch TV, and he was so adorable, so sober, and Jay and I were in dark suits but everybody else was light—Lou had a whole suit on with a bow tie.

Then Fred arrived with Nenna Eberstadt, and they were both in white and Nenna was a little embarrassed, she gave me a little present. And then Tom Sullivan arrived and gave me the shirt

off his back and made me wear it. And Winnie isn't really that beautiful, I was surprised he would *marry* her. She does need a green card, though. But Catherine does, too.

Halston arrived with Dr. Giller and Stevie, all in white. And everyone was nervous because it did just look like all family, and we went to a room and it was really pretty, and Catherine put people together well, and it was thirteen people I think. I was drunk and nervous. The dinner was good, Catherine had ordered duck and Senegalese soup, and at a certain point Stevie said that he knew Lou from Syracuse University and he said all these details, so that was funny they went to school together, and they're both from Long Island, too.

Then a cake came and the waiter sang "Happy Birthday." Victor never showed up, I think he was embarrassed about his hair, and then Halston excused himself to go to his house, he said that he just wanted to get ready for drinks, to meet us there, and we went over I think in Tom's limousine, I can't even remember, I was so drunk, and when we got to Halston's it was a big crowd and I got a singing telegram from a lady in a bowler hat from Bill Dugan and Nancy North, and she really belted it out, she was a good singer.

And there were Barry and Eartha! I couldn't believe it. She's so stupid. I guess that's her problem—she didn't know the difference between dinner and this, and that's what's wrong with her—I mean, she works hard, but she wouldn't have to work so hard as she does to get what she wants if she weren't so stupid. It was the nicest kids there. Pat Ast was there, she's in town, and everybody from the office. And the first present was Stevie brought in a garbage can and it was filled with 2,000 one-dollar bills, and he dumped it on me and it really was the best present. Victor gave me a hardhat.

And Halston gave me a white fur coat but then he said it looked small and he took it away and said that he'd give me another one later, so I don't know. Jed was trying to fix his sister Susan up with Jay Mellon. Susan is looking so pretty now.

Left about 4:00, left everybody at the party.

Tuesday, August 8, 1978

Ronnie came in to work in the morning, late, and then afterwards Gigi came in screaming what did he do with her cats, and he shocked the office. He said that when he got home from Halston's he found the two cats and one of them was choking on a sponge that it had tried to eat because it was so hungry, and the other was clawing at the one who was choking, so he took them into the bathtub and drowned them and then threw their little bodies in the incinerator. He said he was going to go down and divorce Gigi. He said he hadn't fed the cats or himself in five days because he didn't have any money, and when Brigid said why didn't he just borrow some, he said he was "too proud." I think he starved them to get back at Gigi. I knew they never should have gotten married. How could you kill two innocent cats? I couldn't even look at him.

Then the Carimatis called and invited us for dinner, but it was the Italian style of "I'll call you and you call me before 5:00 and then I'll call you and you call me back before 6:00." They said they could get us 40 percent discounts on anything on Madison Avenue because it was all Italians now.

Wednesday, August 9, 1978

Went to Halston's at 10:00 to be photographed for *Newsweek* in the white fur coat. Fred picked me up and carried the garbage can full of money out into the street for me. As we left, about fifteen Negro kids with brooms were going to the park to sweep up, some city clean-up program to give them jobs, I guess. They didn't look too happy. One of them had a shovel and was cutting down every flower when he got to it. They were pretty brooms, too. New. They didn't recognize me except for one little girl who ran all the way back and kept saying, "You're Andy Warhol, you're Andy Warhol," and staring at me and at Fred with his garbage can (cab to Olympic Tower $3).

Saturday, August 12, 1978

The Pope died, and Brigid was calling, wanting me to watch the funeral on TV with her. When they brought the Pope's body out, everybody standing around there in Rome clapped, all these people, because it was such a good production. There've been 262 popes already. Isn't that a lot? They're usually so old when they get to be Pope that they only last about fifteen years.

Sunday, August 13, 1978

Went to church. It was hot and muggy. Got tickets for the Actor's Fund performance of *Ain't Misbehavin* (6 × $17.50). Cabbed to theater ($2) to meet Jay Johnson, Tom Cashin, Amy Sullivan, and Ricky Clifton. Ricky was asked to leave Halston's the other night when Halston found him looking in his closets. He wasn't stealing, he was just poking around, and he was drunk and fresh with Halston, it was 4 A.M.

Saw the show. And now the Negroes know how to do satires on themselves, and when you get that sophisticated, it means you're part of the community, so now they are.

Wednesday, August 16, 1978

The big drama was Mr. Winters calling and saying there were three detective cars and three police cars out in Montauk. The townspeople hate Tom because he rides a horse into town and the band has drugs. Finally it turned out it was really nothing, that the plumber's assistant had told the police he saw so many guns around, and so Tom had to talk his way out of it, telling the police about the movie they were shooting and that they needed the guns for it.

Thursday, August 17, 1978

Martial law was declared in two cities in Iran, so the festival we were supposed to go to on September 8 is cancelled and I'm so relieved.

Sunday, August 20, 1978

I went out and walked Archie and Amos. The new dog-shit pick-up law isn't so bad. It was pretty easy, they did it next to the trash cans and I just threw it in.

Monday, August 21, 1978

It was such a pretty day. Hot and dry and breezy. Started walking downtown handing out *Interviews* over on the East Side. Stopped in some shops and bought some ideas for drawings. (Sarsaparilla $49.00) It was Monday so most places were closed. I was looking for plastic fruit, that's what I'm drawing. Then cabbed to office ($2.50).

I was supposed to go out to Montauk on Wednesday to be in *Cocaine Cowboys* but it's been changed to next week. My role is to play myself inteviewing Jack Palance in the movie.

Tuesday, August 22, 1978

Walked over to the office, and Brigid was transcribing away. She'd just come to the Humphrey Bogart part of the Truman tape, and the John Huston affair. Oh, and the Sam Goldwyn affair. According to Truman, Sam Goldwyn went after him one day and said, "You've been teasing me for years," and then he gave Truman a big long tongue kiss. He wanted Truman to go down on him, but Truman wouldn't, but now he thinks it might have been fun. Truman said he said, "What about Frances?" And that Sam Goldwyn said, "Forget Frances."

And when I was recording this tape I'd purposely talked nice about Brigid so she'd hear it while she typed—I said she used to be 350 pounds and now she was 125 and beautiful. So she was a happy worker.

I was painting in the back when I heard a big commotion and it was Bob screaming at Catherine, he had freaked out. He was checking the galleys for the new issue and saying that she hadn't corrected Fran Lebowitz's writing, and she said that Fran didn't *want* anyone to correct her. Bob said if Catherine wouldn't do it, *he* would. He was holding a glass of vodka in his hand.

Wednesday, August 23, 1978

At 12:00 Bob wasn't at the office so I called him at home and I woke him. I told him how did he expect any of the kids at *Interview* to work hard when he was still in bed at noon, and then he said that he'd rush right down. Later I heard him telling Brigid that he'd met a deaf-mute and that he was with him when I called.

Brigid was typing away and then I caught her eating candy and when I did, she went crazy, she felt so awful, I had to quiet her down. I told her, "Now, now, it's not so bad, you only had fifteen pieces, the day's still young, just take it calm and easy."

Picked up Catherine and Jed in a cab ($4) and went to Madison Square Garden to see Bruce

Springsteen (tickets $19). We'd gone on Monday night, too, but only saw the last few seconds of the show. So this time we got there right before he started and we sat right down in the orchestra, 30,000 kids in the place. They were all young and cute and why doesn't *Interview* appeal to them? It should, it's young and modern. My head must not be in the same place because they were all jumping up and screaming for Bruce and I was the only one who didn't.

Oh, and Susan Blond called me earlier and said that a girl had called her up because she was upset because Bruce Springsteen was upset because he said I'd taken his picture on Monday night. She said that he doesn't like *anybody* to take pictures—that his girlfriend's a photographer and even *she* can't take his picture. But the funny thing is, I'd just gotten my contact sheets back and I was sitting there trying to figure out what night I was looking at and who I'd taken a picture of—I didn't even recognize that it was Bruce Springsteen—I thought it was Al Pacino. I'd forgotten where I went! Why is Bruce Springsteen big, though? He talks the dumb way. Like Sylvester Stallone. Is that why these people are big? Because they talk that way and people identify? He does work really hard.

Friday, August 25, 1978

The main event was Catherine Guinness crying, telling me that she was leaving *Interview*, that she got a job at *Viva*. And she's fat again, so she'll be leaving as fat as she came. But then I found out she cried for everyone, so it wasn't special that she cried for me. I guess she's maybe scared, because she's going to be senior editor over there. It turns out maybe it's the job they offered Bob last year. They came after her and then she went after it. Jonathan Lieberson and Steve Aronson helped her write a paper on how she would change their magazine. Everyone at *Interview* is so thrilled to see her go. I was surprised—I didn't know they felt that way.

Saturday, August 26, 1978

Went over to the Plaza to interview Shaun Cassidy. The interview was terrible because he's got to keep it really clean because his fans are young. He has dark circles under his eyes so we think he has a secret life. He's very tall. He gave stock answers. We kept asking him how it felt to be an idol with thousands of girls screaming, and he was insisting that it didn't change you, and then we walked through the lobby, through the screaming girls, and (*laughs*) he changed. He was *so different*. The limo came and he had a whole different personality.

We went downtown because he was going to be photographed for *Interview* by Barry McKinley. Shaun just turns into something else when he's being photographed, something just happens to him, he just falls in love with himself. And Barry has a different style of saying things when he's photographing—instead of saying things like Scavullo and those people say, like, "Marvelous, marvelous," Barry says (*laughs*), "Give it to me, motherfucker. Push it *out*. Push out all you can." "What kind of drug are you on, motherfucker?" It was so unbelievable that I went and taped it.

Later at Madison Square Garden in Shaun's dressing room there was a beautiful girl there, his

girlfriend, and he had on stretch pants with his big cock showing, and he brought the band in to give them a lecture on when to go slow and how to turn on the thirteen-year-olds. It was funny.

When we went out to our seats Shaun's mother Shirley Jones was there and I bent over to say hello where she was sitting and she looked scared, but then I said, "I'm Andy Warhol" and she grabbed my hand and was sweet and she introduced me to her husband Marty Ingels. Then Shaun came on. He jumped through a hoop like a lion and the girls went crazy. They took me on stage and it was the first time I was ever on stage at the Garden. Smart little girls were screaming: "Andy." And he does sexy things with the microphone, he puts it between his legs and he touches his cock a little, and he's like a Mick Jagger for the young kids.

Monday, August 28, 1978—New York—Montauk

Went to the dentist. Dr. Lyons gets sort of mad because I keep putting off the X-rays. I told him about the dentist on TV who said it was silly to take X-rays, but Dr. Lyons said he didn't care, that if I wanted him to be my dentist, I had to do what he wanted.

Oh, and Bob MacBride called and said that Truman says he's been cured in Minnesota and that he's coming back this week, but I can't see how, he'll just get out and do the same things. And Brigid and I are thinking all the time that maybe Truman never did write any of his own stuff, that maybe he always had some butch guy there to do it. To do rewrites. Because I mean, Truman showed me a script he did, and it was just awful, and when he shows you these things you can't imagine that he could even *think* they're any good, they're so bad. And I mean, he went with Jack Dunphy for years, and these guys are all supposed to be "writers" but you don't really know what they write, and now Bob MacBride gets his name on things, but he's not good, so maybe that's why Truman's work has gotten so . . . because he hasn't done anything in ten years, and that's a long time. And I mean, the things Truman *says* are interesting, so somebody else could find clever ways to make them good on paper.

The car picked me up at 3:50 and Catherine and I rode out to Montauk, it was a nice ride. We stopped at Burger King and picked up a couple of steak sandwiches for Mr. Winters ($5). When we got to Montauk I gave Mr. Winters and his wife Millie the sandwiches and a painting I brought him, an abstract—it was a Shadow. I also brought some *Interviews* and I think his wife liked the magazines better than the sandwich, and I think Mr. Winters liked the sandwich better than the painting. I thought he could put it away and keep it. I tried to get Mr. Winters to be in the movie, but he didn't want to be in it. There are so many kids at the place. Twenty were out shooting and there were still so many. Said hello to Winnie, Tom's Danish wife, who I see is actually beautiful, after all.

Went over to the yacht club hotel and checked in. Tom brought his Betamax by. Ulli and his wife Sukey came. We had dinner at the yacht club and it was terrible, the place was rotten. Jack Palance who's in Tom's movie was staying there at first but he hated it, they were so rude.

Then at midnight we went to Southampton to one of those beautiful movie houses to see the rushes from the day before, and the movie looks sort of good, lots of airplane shots and Jack Palance, and Tom is sort of good, and the band plays in the movie, so I guess that's what he's actually making the movie for, to introduce his band. They drove me back to the yacht club and I fell asleep with my clothes on.

Tuesday, August 29, 1978—Montauk—New York

Catherine came to my room and Tom picked us up and drove us over to the house for breakfast. Then Jack Palance came in and he'd been out all night drinking. He's fifty-five and looks thirty. He's there with his dog, Patches, and his girlfriend. I think he's half Russian and half Ukranian. I'd asked Tom how they thought to cast Jack Palance and he said they were thinking about Rod Steiger—they wanted somebody butch, an old butch actor—but Jack had a farm in Pennsylvania and they called him and he'll do anything, he said he just likes to drink, so he takes any role.

Jack played a character named Rof, who used to be Jayne Mansfield's manager, and Tom plays one called Destin, who's a singer with a band. We went outside to do my scene where I'm taking pictures without knowing it of the people who run off with the coke. They decided to put me in the beginning of the movie and gave me some lines, which I'm terrible at. I just don't know how to be real.

I interviewed Tom at dinner and his real life story was just like his character's life story in the movie—how he burned his body in a plane crash in Colombia and some people found him and took him in a private plane to New York.

I passed out in the limo on the way back in, and we got to the city around 2:30.

Wednesday, August 30, 1978

Talked to Brigid who was typing the interview we did with Shaun Cassidy and she said it was no good, that nobody said anything.

Thursday, August 31, 1978

Bob had a fight with Fran Lebowitz on the phone, she said she wasn't going to write for *Interview* anymore because he changed some of her words, and I mean, why would Bob want to *change words*? Is it drugs?

Friday, September 1, 1978

Catherine's leaving on Monday for her job at *Viva*. Her salary will be $30,000 and her new date is Stephen Graham. They went to his mother's house on Martha's Vineyard, so I guess she'll be offered the editorship of the *Washington Post*, too. Wait till they find out she can't do anything.

Fred's been invited to Avedon's dinner before his show at the Met. He's buttering up to Fred. He wants something. I still hate him. He wouldn't give an interview to *Interview* because he said it wasn't "right" for him. After he got Bob to do publicity on him in *Interview*, he turned around and said that. I mean, he's just somebody who worked for *Bazaar*. He took those pictures of my scars and of all the Factory kids and we signed releases for him and everything and then he never even gave us prints. Viva's in his new book, but at least she got some prints.

Saturday, September 2, 1978

Went out and bought props for drawings (fruit $23.80).

Got a load of 1950s used shoes down on Canal Street for $2 a pair. It's just the shoes I used to draw, all the Herbert Levine shoes with the creative lasts. Shoes first got really pointy in '54–55, and then they got round in '57.

I went in the back and I tried to paint but my painting wasn't too good. I was working on a German guy.

Sunday, September 3, 1978

I worked on the Fruit drawings and Diamond drawings and watched TV, and my painting had improved from the day before, I was back into it, it had been so bad on Saturday. And I got paint on my shoes and here I am trying to grow long fingernails and I get acrylic on them and I guess acrylic attracts acrylic because it gets more and more.

Tuesday, September 5, 1978

When I got to the office, Brigid was sitting there at her typewriter looking her age which was going to be forty tomorrow. What can I give her? Some chocolate? I'll give her another tape to type.

Wednesday, September 6, 1978

Went to the garment center with the girls from *Interview* to sell copies of the magazine there, even though I was nervous because on the news the night before there was a new outbreak of Legionnaires' Disease on 35th Street between Sixth and Seventh, that now they think is caused by a bacteria that forms in air-conditioning systems.

Blue Cross called to say that Ronnie sent them a doctor's bill he wanted compensation for—when he was murdering the cats they struggled against him and he got scratched.

Toni Brown came up and she wants me to do the cover of *High Times*. I told her she shouldn't have told Carole that I said she was crazy, and then I had to call Carole and say, "I didn't say you were crazy, I said you were *crazy*," and then *(laughs)* she understood. It's so funny when you just say the same word but in a heavier way and *then* people understand.

Cabbed to the Waldorf ($3). There was a party in honor of me because this was the day we were supposed to leave for Iran, but then the civil war broke out. The Hoveydas looked really suntanned and healthy. Mrs. Hoveyda said she didn't know anything about what was going on in Iran because her husband wouldn't tell her, and he just said, "If things were really bad, would I be sitting here tonight?"

Thursday, September 7, 1978

Called Truman's apartment and Bob MacBride answered and said Truman had just gotten back from Minnesota an hour ago, that they'd practically just walked in the door, and Truman was going over to Dr. Orentreich's to get his face scraped or sandpapered.

Met Catherine at La Folie for the Joan Fontaine book party (cab $4). I introduced her as the new senior *Viva* editor, and what a difference that made. Everybody was suddenly, "Oh right this way—oh here you go," and they really hustled. She was Miss Big.

I dropped Catherine off and near 63rd Street we ran into her new editor, the girl who hired her, and *(laughs)* she's so thrilled to be getting Catherine.

Bob got a car and we picked up Fred and went out to Alex Guest's party for his sister Cornelia who's going off to Foxcroft. There was a girl there named Lisa Rance who's after Robyn Geddes, but she's chubby and I told her. She was wearing a white Valentino and some kid came and threw "invisible ink" on it, and it did disappear but I'll bet it's not really gone, that in a different light you can still see it. I think the dress is finished.

Friday, September 8, 1978

Had lunch with Truman. He wasn't drinking so he was boring. I paid for lunch because he looked like he was out of money ($60). I taped, took pictures, and then we went over to his bank, the Midland Bank. Bob MacBride went home, he had an allergy. As we were walking together, someone said, "Look! Living Legends!" And at the bank Truman was getting $5,000 in cash in fifty-dollar bills and the bank guy asked him was he sure he wanted it like that since he'd taken out $25,000 eight months ago in hundreds and lost it. Truman's checking account had $16,000 in it and his savings $11,000 and he took $10,000 out of the savings to transfer so that made $36,000 in his checking. So he does have money, the money does come in. And then we walked and it was starting to rain and this girl from Radcliffe came up to us, she said she was working on the Brian DePalma movie and that she would be so honored if she could let us use her umbrella so we walked with her for a little while.

Sunday, September 10, 1978

Picked up Bob and we walked over to U.N. Plaza and the dogs actually made it walking the whole way, I was surprised, they loved it.

Truman wasn't drinking so he was boring again. He had a guy there from California who wore bluejeans, and I can't stand people with 38" waists who still wear bluejeans.

Truman had told me we'd be having caviar and potatoes, but instead he had bad quiche. Truman was listening to records, Donna Summer, I think.

The guy from California had joints and he and Bob and Truman smoked them, and Truman said that after the joint he would be really exciting and interesting but he wasn't. I was talking about the Gay Bob doll. Robert Hayes had one at the Factory, it's a doll that comes out of a

closet and it's wearing an earring and a necklace and a plaid shirt and bluejeans and a handbag and a big cock, and I guess I said the wrong thing because everybody there was named Bob, but if you ever want to get anybody anything, get them that, it's so funny.

Monday, September 11, 1978

Rupert came over. Worked on some Fruits and "landscapes" and Jewelry. Catherine called from over at *Viva*, she's nervous, she was having lunch with Delfina Rattazzi who still works at Viking to try to pick her brain. Catherine was trying to find out how you find new writers. And today she's having lunch with Victor Bockris to try to pick *his* brain. So she's scraping the bottom of every barrel.

Oh, and I forgot to say that on Saturday my house shook. They bombed the Cuban embassy on 67th between Fifth and Madison and when I looked out the window, across the street where the girl with the crewcut who works for YSL lives, her boyfriend was leaning out the window and he was naked and good-looking.

Tuesday, September 12, 1978

I discovered that Archie and Amos both are covered with fleas and what I thought were mosquito bites on me turned out to be flea bites, so now they're wearing flea collars and I should be wearing a flea collar, too.

Thursday, September 14, 1978

Ran into Barry Landau. It's so great to have him not calling me. Bob told him I was mad at him and amazingly that made him stop. I think that's the bee that sticks in his bonnet, when someone tells him, "You have to cool it." Then he does. Like Stevie told him that once. I guess so many people have told him.

We went to Halston's and got into limos to go over to Studio 54 for Dr. Giller's birthday. There was a cake with a syringe *(laughs)* that said "Dr. Feelgood." I ran into Barbara Allen and she was laughing. She said that she'd just been up in the balcony with one of the Robert Kennedy sons—the one with buck teeth who looks really like his father—and he took out a joint so they could smoke it and when he lit the match he paused and looked into Barbara's eyes and said, "When I look into a flame, I see the face of my uncle." You know, the Eternal Flame. I left, and the bouncer got me a cab and I tried to give him $10 but he wouldn't take it (cab $2.50).

Saturday, September 16, 1978

Walked over to meet Bob and Joanne du Pont and Paul Jenkins on the corner. Drove out to New Rochelle where there was a birthday party for Mr. Kluge who is chairman of Metromedia. Everybody there was really, really rich. The house was on the beach and painted yellow. They had a tent

for food and a tent for dancing, and lots of security people. I sat next to a lady who said she had a sore thumb and I asked her if it was a "murderer's thumb." She was awful. She said she was "Mrs. Goldenson" and I asked her who she was and she said, "If you don't know, I'm not going to tell you," and I'd ask her another way and she'd say, "You should know, so why should I tell you." Later on I found out her husband is a chairman at ABC, Leonard Goldenson. But she was so rotten, I didn't talk to her for the rest of the night.

Then Bob found me and said that Mrs. Potamkin—Luba—who does the TV ads for Potamkin Cadillac was dying to meet me so we went and found her. And Bert Parks was there and I was so excited, Bob and I had been sitting at his table, and I started talking to Mrs. Bert Parks and she got a little fresh, she pushed her tits against me. And then Bob saw I was getting into trouble and came over and put his arm around her to distract her and she squeezed his ass, and then Bert saw that she was getting fresh and said, "Let's go dance, darling."

I think everybody must have been somebody. Everybody was rich and straight, a new crowd. All rich old people and attractive young girls for the old fogies. They started serving breakfast at 1:00. They had huge seashells made out of ice. Bob was telling me that everybody wanted portraits, but I was so drunk I didn't care.

Monday, September 18, 1978

Got up early. Slept with my clothes on so I wouldn't get bitten by fleas. I have about forty bites all over me and they came on different days, you can tell by when they disappear.

We haven't heard from Doug Christmas and if he doesn't pay us I'm not going to California tomorrow.

Tuesday, September 19, 1978

Passed out *Interviews* in the morning. Called Vincent and asked if Doug Christmas sent us the check. He didn't. Called Fred and threatened not to go to California. So here it is now Wednesday morning and I *still* don't know if I'm going, the plane's at 12:00. I can't decide.

Wednesday, September 20, 1978—New York—Los Angeles

In the morning we were waiting for the check to arrive from Doug Christmas to see if we were going to California or not. It didn't come in the morning so we didn't get on the flight at noon. But right after 12:00 it arrived, so the driver picked me up at 860 and then we picked up Fred and drove out to Newark to get a plane. The driver was nice (tip $10).

The plane left on time. What we were really having to go out there for was a dinner that Marcia Weisman was giving. That meant we'd be missing the big glamorous YSL Opium party in New York on the Chinese boat downtown at the South Street pier.

Checked into our hotel, L'Ermitage. It's for people who don't want to be discovered—if you're having an affair, that's the place to go. There's no lobby, and it's chic in a funky way. It was very elegant. When you pick up your key you get to pick a four-number combination, so I was 1111 and Fred was 2222.

Thursday, September 21, 1978—Los Angeles

Went to Getty Museum. It was thrilling. A reproduction of a building they haven't excavated yet in Italy—they know where it is but there's another building on top of it. Bought a book on painting ($17).

Bob arrived in L.A. and described the YSL Opium party for us. Then Joan Quinn arrived in fuschia hair and lots of matching amethysts. Fiorucci sent a limo in exchange for us going to their opening. We went to pick up Ursula Andress first. She's staying with Linda Evans. The house is very big, English country-style, a pool and tennis courts. Ursula was wearing a YSL scarf over the cast on her broken arm. She was surfing in Malibu with Ryan O'Neal when Hurricane Norman hit her and broke her arm, tore it out of her socket. Joan whispered that everyone in L.A. wonders if it was Hurricane Ryan that actually did it.

We went to Fiorucci where we ran into Ronnie Levin with Susan Pile and Tere Tereba. Susan screamed that the party was cancelled but we thought that was just a joke and started to get out of the limo but a cop pushed us back in and said we were blocking traffic, that the party was cancelled by order of the Beverly Hills Fire Department. A transvestite handed us business cards through the window.

Then we went back to the hotel and then I went with Sue Mengers and everyone else waited around for Mick Jagger to call. Sue is really fat again. And God, her attitude is so cheap. There was no dinner, so she suggested we stop at Burger King on the way to Diana Ross. It was so abstract, you talk into a machine. She ordered a double Whopper but then she worried that maybe two separate hamburgers would have been cheaper.

Sue treated the driver like dirt and I know that if I ever said one little remark to her that she didn't like, she would never speak to me again. She said she'd introduced Isabella Rossellini to Martin Scorsese and that they've been living together for two months. She hates Jerry Hall because Jerry told Bob Weiner that Sue wanted to take an acid trip with Timothy Leary. "What do they think I *ammm*." Like it had ruined her reputation. So vulgar. God. Arrived backstage and she said, "I'm Miss Ross's agent." A cute little waiter was serving meatballs. She said, "If we knew there would be meatballs we wouldn't have had to stop at Burger King." I got myself really drunk drinking straight Stolichnaya. Sue told me she'd just been really after John Travolta, to represent him, but he reminded her that she'd turned him down when he was on TV in *Welcome Back, Kotter* and she didn't remember it. But then, she said, sitting on the toilet seat one night she remembered it.

Then Diana Ross came out looking really lovely. Thrilled to see me, kissed me. Then she went on stage. She had a shot of brandy in her coffee before she went on.

We were sitting in the seventh row. Universal Amphitheater. A plane went over with lights on it that said, "Welcome to my show." Laser beams on the stage. She came out of a big screen,

down an elegant staircase. Her brother is cute. I want him photographed in *Interview*. She told me she got the whole idea for her show from the *Interview* photo of guys carrying her down a staircase.

Diana didn't say she liked her cover and I just know it's because it made her look too black. At the end of the show she did a *Wiz* number and she apologized for the music being too slow, and said, "Forgive me, audience," which she didn't have to say because no one knew the difference.

Afterwards, backstage, Diana started to cry. She wanted to have another rehearsal tomorrow. Then Berry Gordy and Diana had a fight, he told her he wasn't going to spend the money on another rehearsal. Diana wanted Sue to take her side, but Sue said it wasn't her area and then she said to me, "Let's get the hell out of here."

Friday, September 22, 1978—Los Angeles

Back to Fiorucci. This time it really was opening. There were 3,000 kids on the street dressed in every form of punk possible, but it's clean-cut Los Angeles punk. And we were pushed through the crowd, just like going to Studio 54 on a big night. I went behind a counter where they had 300 copies of *Interview* and I autographed them all. A star of *Roots*, Levar Burton, asked for one. He was covered in sweat from dancing. They turned the whole thing into a discotheque.

Saturday, September 23, 1978—Los Angeles

Wendy Stark picked us up and we drove out to Venice. Went to the Ace Gallery for my Torso show. It was a beautiful sunny day, 100 degrees but dry. The show looked good—cocks, cunts, and assholes. They had 1,000 copies of *Interview* ready to be given away.

I did two interviews—one with *Connoisseur* magazine, and one with *Society West*. Wendy did them with me, and Fred was being funny and lied and told everyone that the shaved vagina in the painting was Wendy's.

Then we went to Polly Bergen's house in Holmby Hills. Polly's house is very modern and well-decorated. There were *Architectural Digests* everywhere. And her dressing room looks like a department store, with racks of blouses and skirts and dresses and gowns, and she has a telescope that's for looking at the stars, but she uses it to look at the stars' houses, and we looked into Danny Thomas's house across the canyon, but nothing was happening there except a few geraniums were growing.

Then back to our dump (room service tea with tip $3, breakfast $2). Wendy made a phone call to Stan Dragoti to invite him to the opening—he's really unhappy about Cheryl Tiegs running off to Africa with Peter Beard. Then it was time to go off to Julia Scorsese's and she told Fred on the phone to be sure no one we brought had any drugs on them because she's trying to get more straight.

We got to Julia's and everyone was sitting around smoking joints. Tony and Berry Perkins, Firooz Zahedi and his fiancée, a lot of young writers and composers. Tony asked us how was Chris Makos doing these days, he said Chris was the biggest hustler, but that he was so seductive

you ended up giving in. He asked me if I liked L'Ermitage, and I said it was a good quiet place to have an affair, and he said, "But could you have *two* affairs there?"

And Doug Christmas told us earlier that Ronnie Levin had had a friend keep the receptionist busy while he walked in, took one of my drawings out of the frame, rolled it under his arm, and walked out. Then he had the nerve to try to sell it back to the gallery, and they pressed charges and the police said he had a record a mile long.

Fred's outfits on this trip were his new shirts from London—they're really long so they look like Indian tunics—and Sue Mengers said to Fred, "In New York your hair is slicked back, you wear beautiful suits and gorgeous ties, and in L.A. your shirt's hanging out, there's no jacket, no tie—oh I know you, you probably said, '*This* is good enough for those Hollywood Jews.'"

Sunday, September 24, 1978—Los Angeles

We went to pick up Ursula Andress and when we got to Venice I was dragged through the crowd. Marisa was wearing a gold sequined beret and a gold sequined jacket and skin-tight black stretch pants—you could see her pussy—and her sister Berry was wearing a blue and white-striped cotton dress. Sue was wearing a flowing hot pink chiffon gown. Three thousand, five hundred people showed up. Then we got it all coordinated so that I got into my car real quick and was taken to the restaurant, Robert's, where the party was. It was on the beach.

A guy came over and said that he had the biggest cock in L.A., so I offered to sign it and Marisa got so excited she leaned over to look at the cock and her hair caught fire in the flames of a candle—it was like instant punishment. And Ken Harrison was at the opening but he got lost in the shuffle, and Sue was dying to meet him. Everyone was dying to meet him because of his big cock in my show.

Monday, September 25, 1978—Los Angeles—New York

The new *Interview* arrived from New York and Fran's column was so boring I told Bob we should fire her. So we had a fight. Then Wendy picked us up and she took us to Giorgio's in Beverly Hills to sell some ads and Fred and Gale Hayman who own it were thrilled to see me. And now they're selling mink V-neck sweaters and I said, "Oh I'd love one." and he said, "I'll sell it to you wholesale." And then I realized I'd really stuck my foot in it and I said, "Oh no no no. I'll just pick one up the next time I'm in town."

Johnny Casablancas was checking into the hotel and a bunch of Rastafarians were out in front because Bob Marley was staying there (maid tips $30, concierge tips $20, bellboy tips $10, limo driver $10, Redcap tip $5, magazines for the plane $14.50).

The plane sat in the airport for five hours having its fuel system repaired. Meanwhile, the talk of the town was the air crash in San Diego that morning that killed 150 people.

Tuesday, September 26, 1978

Dropped Fred. Truman was coming to the Factory at 3:00 for the *High Times* Christmas cover photograph of him and me. Truman was early, 2:30. Bob MacBride peed on one of the Piss paintings in the back for me, and he kept going back to see if the colors had changed. Truman told Brigid about the drying-out place, and she interviewed him, and that's where her sister Richie is, too.

Paul Morrissey was down, and he and Truman talked all afternoon about scripts and things. Then Toni arrived four hours late, she had a Santa costume for me and a little girl outfit for Truman. But Truman wasn't in the mood to go into drag, he said that he was already dressed like a little *boy*. Truman was really drunk, hugging around.

Truman was pleading with Brigid to get him a drink and not tell Bob—this is after she caught him drinking in the kitchen. Ronnie was trying to make the makeup girl. My makeup wasn't working, it was no use, I had too many pimples.

Wednesday, September 27, 1978

Some German photographers came. Rupert came and helped with the Fruit drawings.

The lineup for the evening:

5:30　Roberta di Camerino's at "21"
6:00　Barneys for Giorgio Armani
6:30　MOMA for the *Rolling Stone* anniversary
7:00　Cocktails at Cynthia Phipps's
8:45　Dinner at La Petite Ferme
10:30　Joe Eula's party
11:00　Halston's
12:00　Studio 54 for an animal benefit
1:00　Flamingo's for a tit-judging party that Victor arranged for me to go to.

Thursday, September 28, 1978

Bob was in a grouchy mood because the doctor told him he couldn't drink anymore, and now he's bored by absolutely everybody he sees, he's a camp. He only perks up when there's royalty around. He's as bad as Fred.

Saturday, September 30, 1978

Went home and was picked up by the limo to go to the Jack Nicholson-Ara Gallant screening of the movie Jack directed, *Goin' South*. The one Barbara Allen "auditioned" for.

The movie—I'm not sure, I think it was a light comedy. It didn't say anything, though. It's

good in the beginning and you think something's going to happen, but it doesn't. The new girl, Mary Steenburgen, is okay—she's good, but not beautiful. She looks a little like Anjelica and you just know that's why he did it, and he just should have used Anjelica, but that's when they were having the Ryan O'Neal troubles.

And you know, I was thinking the other day about commercial movies and then all the great art movies, and I've decided something: Commercial things really do stink. As soon as it becomes commercial for a mass market it really stinks. I know I always rave and say my favorite movies are things like *The Other Side of Midnight* and *The Betsy*, but I guess I'm . . . going to change my tune. You have to do stuff that average people don't understand, because those are the only good things. And even though the arty foreign movies are boring to sit through, at least they try to do creative things. So I'm going to start going to the New Yorker and seeing strange movies again. I'm missing so much, going to parties.

I was a little drunk and I went over to Jack and said I really really loved it, because Fred told me those kind of things really do make a difference to people.

Afterwards Catherine and I went into this place on 54th Street that said "Female/Male Nudes," and there were almost naked girls on like a big long banquet table with men sitting around and it's so abstract. They put their tits and asses into the guy's faces, an inch away, and the guys just sit there like zombies. And there's a sign that says "Do Not Touch." And one of the hookers looked at me and said, "Oh my God, oh my God." And then the girls came over and one said, "Oh will you buy me a drink?" And I did—I *(laughs)* didn't know yet that the drinks were $8.50 apiece. And then more girls came and they made me feel really good, like I was straight, and they kept saying to come upstairs, that upstairs was really really really fun. What do you think was up there? Is that where they do it? And the girl told Catherine she would really like it up there, too, she was trying to make Catherine, and I bought drinks for the other girls so that's 3 × $8.50 plus $5 tip ($30.50) and then 8 × $8.50, plus $20 ($88) until I ran out of money. Then we left and went next door to a gay porno movie. Catherine wanted to see it and it was a glory-hole movie and it was too peculiar and we just stayed for ten minutes (cab $3).

Sunday, October 1, 1978

Brigid and I talked about old times. She was on amphetamines for twenty-three years. Isn't that something? I mean think of it, twenty-three years. Then we started to watch *The Users* on TV and we called each other about five times. Jaclyn Smith was so good. They had her hair commercial on, too.

Monday, October 2, 1978

Doug Christmas wants to show the Piss paintings in Paris after we go to Denmark, so I'll have to drink more water and make more. I can do two a day now, and Fred told me to put two of them together, that they look more interesting that way.

Monday, October 9, 1978—Paris

Went to Loulou de la Falaise's party. Shirley Goldfarb was there, and she's just beat her cancer. She's 106 again—she'd been down to 78 pounds. She only lost a little bit of hair from the chemotherapy. She's back being just as obnoxious as ever and now that she's better, people treat her badly again. Her husband was there. Wished I had a tape recorder to tape her. She was happy, looking good. Loulou's got a duplex with a balcony. There was a birthday cake but I didn't have any, I was so involved with Shirley.

Tuesday, October 10, 1978—Paris

Club Sept invited us to a private dinner ($40 to chauffeur). We got there and our table was actually reserved for Bette Midler. Saw Isabelle Adjani, so beautiful. Bette came in and got an ovation. She saw me and made me kiss her hand. Told her we just missed her in Copenhagen, she said she knew all about it. I tried to talk to her but she reminds me too much of Fran Lebowitz—like she's afraid you'll steal her material. We just don't hit it off.

Valentino was there and he and Bette chatted, she asked him how the shmatta trade was, and what did Jackie O. buy and she wanted four of them and what was the new look. She gives everybody the Sophie Tucker answers. Then she left and the party kept going on.

Thursday, October 12, 1978—New York

Went over to Bob MacBride's new studio and guess where it is—33 Union Square West! On the tenth floor! So I got pangs going over there, riding up in that elevator to the floor where *Interview* used to be. Bob MacBride has the room next to that. It's too bad we didn't buy that building, though, because it's narrow and *Interview* could have had four floors already. Bob's stuff, now I really like it, I honestly do. It's bent wood sculpture. Truman was bouncing around. I don't know if he's drinking or not.

We got a call—the call I didn't want to get—saying that we had to go to Paris next week, the twentieth, Friday, for the Piss paintings.

Dropped Bob on Park at 7:00 ($3.20). The police just arrested Sid Vicious for stabbing his twenty-year-old manager-girlfriend to death in the Chelsea Hotel, and then I saw on the news that Mr. Bard was saying, "Oh yeah. They drank a lot and they would come in late. . . ." They just let anybody in over there, that hotel is dangerous, it seems like somebody's killed there once a week. I was tired so I stayed home, did some drawings, worked, watched TV, snoozed. Then the alarm system went off and I was afraid to go down and look, but finally I got brave and took Archie under my arm and went down to the kitchen but there was nothing there. I watched TV but kept worrying that there was someone in the house. *All Fall Down.* When Brandon De Wilde kicks the picture of Warren Beatty and Angela Lansbury grabs it and holds it close, it's so good, you know? Who wrote that movie? Was it the one who committed suicide who was like Tennessee Williams? The one who wrote *Picnic* . . . Inge.

Sunday, October 15, 1978

Picked up Bob and we cabbed over to U.N. Plaza for lunch ($2). Truman was in the kitchen. He said that he was cooking but I think everything was actually bought. It was really hot in the kitchen, the oven was on and the sun was pouring in, but nothing was cooking. I think he was actually just in there drinking, *pretending* to cook. There was a bottle of Stolichnaya in the refrigerator. He offered some to Bob, who had to turn it down, and then he insisted that *I* have some, and he took one of those double wine glasses and poured it three-quarters full and then put in a drop of orange juice. I took it but just kept it in my hand. I went to the other room and talked sculpture with Bob MacBride but I kept running into the kitchen to check on Truman. He had some tomatoes sitting around the kitchen. He showed me a pie he'd baked, he said, but I don't think he had. I think it was bought because it had cardboard under it. But he let me take a picture of him holding it, like he had just baked it. He was talking about what a great cook he was, how he'd made veal stew the night before.

Eventually he stole my drink. He served black bean soup, and he insisted it had to be served lukewarm, so after all that cooking in the kitchen the soup was cold. And it looked grey. I didn't really eat any of it, but Bob—Bob Colacello—thought it was great. I dumped my bean soup in the bathroom. Nobody saw me. I had to run around the apartment a little before I finally made it to the bathroom with the soup so they wouldn't notice. Truman was getting more and more loaded. I taped all afternoon. He told us he went one night to Flamingo with Liza and Stevie and there were all these sex acts with boys in cages and they went into the owner's office and it was a really straight-looking guy about thirty-five and Truman asked him, "Why did you start this place?" And before he told us the guy's answer, Truman looked at us and really built it up, he said, "This has got to be the greatest line in history." Then he said, "The guy looks at me and says, 'Sometimes I get horny.'" And Truman kept repeating that all afternoon and laughing at it (cab $2).

Sunday, October 16, 1978

I was invited to dinner at Le Premier by the daughter of the Bruno Pagliai man who was married to Merle Oberon, Marie-José Pagliai (cab uptown, dropped Rupert and Todd $4.50). The invitation said 8:30 so I thought there would be drinks first and I took my time and got there at 9:00, and I was so embarrassed, everyone was sitting down already. Marie-José was scared that I wasn't going to show up at all. Andrew Young and his wife were there.

The thing that was most interesting—it was all I could think about once she told me—was Marie-José's dogs. She was talking about her black and white scotties and she confessed that the black one was a scottie but that the white one was just a dog done up to look like a matching scottie! She had the hair done that way, she said it was something she'd always wanted.

The dinner party was for Marie's father, Bruno, who never showed up because it was raining.

Tuesday, October 17, 1978

Well, I spent the evening with Dolly Parton. She's a Halston girl now, she's on the arm of Halston.

The Thurn und Taxis guy and Pierre de Malleray picked us up to go downtown to dinner at Ballato's. The Taxis guy got drunk and he told a lot of stories. He's the richest guy in Germany, he's got a great body but his face is a little puffy, he's old. He said some Negroes came up to him by his hotel and started to follow him with a baseball bat, they were calling him a faggot, and he turned around and said, "Listen here, you black niggers," something like that, he told them off and they were so stunned that they went away. He said you have to fight back or you don't survive.

We went to Halston's and Dolly was there wearing the most horrible dress, a Halston that just looked awful. She's fat, she likes to eat.

Thursday, October 19, 1978

Watched Steve Martin on the *Donahue Show*. He looked good. I wonder if he asked for that angle.

Thursday, October 26, 1978

Our limo driver showed us a clipping of himself from the newspaper. He'd been acquitted of kidnapping a bar owner's cat who was a lookalike for Morris the Cat who'd just died. The bar was on Ninth Avenue in the 50s. The driver said that he just fed the cat, then let it out like he always did, only this time the cat didn't go back to the bar and the owner accused him of trying to sell it as a replacement for Morris. The jury deliberated for three hours before finding him innocent, so he felt he was a celebrity.

Saturday, October 28, 1978

Thomas Ammann called. He's staying at Fred's house. We went to Christie's and got catalogues, because some of my old drawings are up for sale. They're from Bill Cecil, who was killed in a car crash. His family was in the American antiques business. I think that's how I started collecting American stuff—I got my first cupboard from them, the cupboard that's now in the *Interview* office, the one they keep the pencils and rubber cement in (catalogues $6, $22, $8, $10).

Victor said that Halston had been trying to reach me to invite me to the benefit for John Warner that Liz Taylor Warner was having that night. Liz looked very fat, but very beautiful. Chen, her secretary, was there. But John Warner wasn't even there. Liz was upset at how awful the party was. Halston told her he would have just *given* her the $10,000 if that's all she was getting from it. Some face doctor that said I'd met him in California three years ago started talking to me, he said he was screwing all day and had come seven times. I don't know why he was telling me. He asked me how old I was and I said, "Thirty-five," and he said I looked forty-five. He said

(laughs) that if I go to him I can look like "a normal thirty-five-year-old," because he would do nutrition and things. I guess that's why he was telling me he was screwing, that I could come seven times if I went to him, too.

Then Aline Franzen who was in charge of the party decided to do her auction thing but nobody at this thing was about to buy anything—they were all just wearing the teentsyest jewel you could buy at Bulgari, or something. Aline said, "This is my painting that I did myself with my whole heart and who will bid on it?" And nobody did. Finally Liz hit me and said, "You *better* bid on it," and I said no, that I wanted to bid on the two tickets to Studio 54, and finally Liz screamed, "All right, I'll take it myself," and Aline said, "No, Liz, you *can't,*" and Aline threw herself on the floor and was crying and it was such a comedy and then Liz's secretary Chen said *she* would take it, and Liz screamed, "No, Chen, you *can't,* you don't have any money." And Lee Grant was an auctioneer, too, she auctioned off two teeth, porcelain ones I think, for $2. I'm telling you, nobody in this crowd was going to buy a *thing.* Oh, poor Liz. And Aline said, "You rich people are being cheap." And then John Cabot Lodge got up and made a peculiar speech because he talked about the Red Enemy, and it was so weird. Then Halston and Liz said they would meet afterwards at his house.

So Halston and I went to his house together. Liz sneaked in later and he gave her some coke and she got high and happy. I told her, "Look, you've got nine days until the election, you've got to really get down and talk to the Negroes." I said, "This lady stuff isn't going to work." And she said, "Oh lawdy lawdy lawdy." And I told her, "Listen, if you lose the election and you leave your husband, I want you to play Truman Capote for me on Broadway." So she started laughing and went into a trance and tried to talk like Truman, but she couldn't remember how he talked.

Then Victor and I went into the kitchen and I fed Linda potato chips under the table which I wasn't supposed to do, which was fun, and Halston and Liz were talking intimately in the other room and he told me later that John Warner wasn't fucking her.

I told her, "Elizabeth"—you really do have to call her Elizabeth—I said, "Elizabeth, it would be so great to see you in the White House." And she was cute, she said, "Oh but I just want to be a senator's wife, I mean, can you imagine me in the White House? A Jew and married seven times?"

Sunday, October 29, 1978

Woke up at 10:30 but it was really 9:30. Daylight saving time.

Then Bob called and said he was at Averil's and that we were supposed to meet Mike Nichols and the "Dr. Warhol" that Nichols was insisting I had to meet who was from Poland who said he was my long-lost cousin. I didn't want to go—I can't stand Mike Nichols—but we had to go because Ara Gallant had set it up. We were supposed to have Sunday lunch at the Carlyle, but then it was moved downtown to Lady Astor's.

I went to church and then picked up Ara and Bob and Averil ($5.). When we got there Mike Nichols had left. His assistant said Nichols was mad because we were fifteen minutes late. What nerve to leave after making me go down there, and oh, it was awful—this doctor guy telling me

I'm Polish. He spells his name W-a-r-c-h-o-l. This Polish fairy asking me questions like did I live alone. He invited us to Poland next September. Mike Nichols met him because he collects Arabian horses—he has 120 horses in Connecticut—and when he goes to Communist Poland every September to get more this Dr. Warchol helps him.

I went to bed early. Talked to Jed's decorating-business partner Judith Hollander about furniture restoration and about the fights I've been having lately with Jed.

Wednesday, November 1, 1978

Tom Sullivan came by to show *Cocaine Cowboys* to us on a Betamax. He was smoking marijuana, and it was funny to smell it at the office. Paul Morrissey watched a little of it and said it was too slow, and Brigid was in and out and thought so, too, but I liked it.

And I decided I'm not so bad in it. They only let me do one take and I think if I'd been able to do more I would have gotten better. But I was better than in "my first film," *The Driver's Seat*. And *Cocaine Cowboys* has some good music in it. It's a dumb story, though. These dealers drop cocaine from a plane and a maid and a secretary find it and steal it. Tom said it cost him $950,000 to make it, but I don't see how, it was non-union.

Ed Walsh came by to show us architectural plans for the building we own on Great Jones Street *[Andy bought this carriage house at 57 Great Jones Street as well as a four-story building around the corner —referred to as "342" or "the Bowery"—in 1970]*. We're going to fix it up and then maybe rent it out.

Friday, November 3, 1978

The Elvis at the Parke Bernet auction on Thursday went for $85,000. It was estimated to go between 100 to 125. The market's peaked for contemporary art. Todd Brassner said the Mao was about to go for $4,000 and he bid it up to $5,000 and then somebody else got it so he was thrilled.

Thomas picked me up in the limo and we went to La Grenouille. I saw the lady who runs La Grenouille and she said that her son was getting married. Her son went to school with my nephew James at Carnegie Tech, my brother Paul's son. James is in New York now trying to be an artist, and I won't help him out. Because, well, I never liked the mother, so I would feel funny helping the kid. I took him out to Montauk a few times, and he just . . . I don't know.

Saturday, November 4, 1978

After we saw *Platinum* we picked up a limo outside the theater ($15) and guess who was our driver! The catnapper!! The one from a couple of weeks ago!

Monday, November 6, 1978

Rupert came by and we worked on the Grapes. Cab down to Maxime de la Falaise's loft on Fifth Avenue and 19th Street ($4). Everybody'd been eating dinner. Susan Bottomly—International Velvet—was there. São was there and Patrick O'Higgins, and John Richardson and Boaz Mazor and Amina came in from a fashion show benefit at Studio 54 and she looked beautiful. She said she was writing a play about men who put themselves down in a bar and I told her that everybody does that, why not make them fashion models who put themselves down at a fashion show, and she said that was a great idea, that she'd just make the men girls.

Ricky Clifton gave me the most beautiful earrings, little John Travolta earrings. And this guy who I've met before who did a movie about people who drill holes in their heads was there with his girlfriend and they'd both drilled holes in their heads.

John was telling me that Boaz, when he first met him, was the star of Oliver Stone's first feature movie. It was called *Michael and Mary*. Boaz was Michael. They were shooting it on weekends and John said it was like Cocteau—beauties falling all over the place—and Oliver's mother, Jacqueline, gave all the kids in the movie poppers to make them act better. Boaz said it was shown at the Thalia for a couple of weeks once.

Susan Bottomly looks very skinny. She's left her boyfriend in Wales, she said she couldn't take it anymore. He wanted to have a baby and she didn't.

Tuesday, November 7, 1978

It was Election Day, so many places were closed. Catherine called and wanted to do something. We stayed at the office until 6:30 or 6:45 and then went up to 725 Fifth Avenue to the Robert Miller Gallery for Juan Hamilton's opening there (cab $4). And just when I got there a guy came in and served Juan papers. It was charges from the woman that used to work for Georgia O'Keeffe for years, saying that he was conspiring to get all Georgia's paintings.

I left Rupert on 66th and went home and glued. I'd invited the Hoveydas out, things are so bad in Iran, and the du Pont girl and Paul Jenkins. And then Bob invited Lily Auchincloss—her husband Douglas just left her for Kay Kay Larkin.

We went over to Quo Vadis. Hoveyda got a phone call and they told him that the phone lines from Iran to Paris and New York were out, and the Shah's put the military out stronger. The Hoveydas looked worried.

Then around the corner we saw Truman. He was fixing Barbara Allen up with a millionaire. I think it was actually his Jewish lawyer or something. And Truman is a completely different person from last week. Do you think they've found a new drug to give him? Really, this week he's so dapper and last week he was an alcoholic.

Wednesday, November 8, 1978

Dotson Rader is on TV right now on one of the morning shows. He's awful. I've always thought he worked for the CIA and I still do. I just can't take it. Hold on, I'm going to shut it off.... There, I feel so much better now.

Cocktails at Tatiana Liberman's were fun. Barbara Rose was there, sitting in all these clothes that were so expensive, but she still has no style. I told her we'd rent her a fag and he could take her around and tell her what to buy and how to put it together. I said, "Well, you're living in a chic building now, Barbara"—in the Galleria—"so you should really start to *look* chic." I tried to be diplomatic, but everything just came out like the truth.

C.Z. Guest had a dinner at Le Cirque. Kim D'Estainville and Hélène Rochas were there, they said that they'd just been in California and they drove miles to the Venice galleries because they wanted to see some "regional" art, and then when they got there, there was my porno show! So they had a good laugh. They loved Big Sur.

Oh, and David Whitney called and said he was going out to California and Philip Johnson had given him a first-class ticket and he said, "Oh Philip, you shouldn't have. I don't need it," and so Philip cashed it in for coach!

At dinner I was next to Doris Duke. She was great. Then afterwards everyone was going to Studio 54 and Bob took most of the ladies in his silver limo, and Doris Duke had a station wagon, it was so chic. We got into that. Then when we got there she wanted to leave—she didn't want her picture taken—so I took her to her car and went back. I saw the John Scribner boy and Robyn, and James Curley—he's a Mellon—he's the cute kid whose father was ambassador to Ireland. Catherine was there and she's unhappy with her job at *Viva*. She said she wished she were back at *Interview* with Bob screaming at her, she said every article has to have a dozen meetings about it. I said I'd take her home. It was around 2:00 (cab $4).

Friday, November 10, 1978

Adriana Jackson came down and I took some pictures of her and a Swiss lady for a portrait. Gigi did the makeup, so we now have someone making the faces white so the wrinkles don't show and they print up better and make up into better screens and also it seems to the people like you're doing something more special for them. The pictures really do come out better. The Swiss lady didn't like her nose, which actually was a nice one, so it was hard to take a picture that she liked her nose in.

Bob Markell from Grosset & Dunlap came to the office. He said the photo book Bob and I are doing should be out by May 31, and then he started talking about me going on TV and I just looked at him and ran out of the room. He'd been saying how everyone in Europe loved all these "intimate pictures" of the people we know, so then I got nervous—*(laughs)* what if they *are* intimate?

Monday, November 13, 1978

I think I may try *brushing* the piss on the Piss paintings now.

Went over to Jamie and Phyllis Wyeth's at 1 East 66th Street for Phyllis's birthday party that Jamie had called that afternoon to invite me to. Joanne du Pont's name came up. I don't think Jamie likes her much, but I don't know why not—I mean, *he* married into the du Ponts, too.

Nan Kempner arrived. Bo Polk arrived and everyone was thrilled that Barry Landau wasn't with him. Then Barry arrived. And Bo should really be careful, because Barry even takes Polaroids now, and it could hurt the people if someday somebody showed pictures of everybody at his bathtub parties. Because at the time it's just all fun, but if it got printed in the papers it would look like something else.

Tuesday, November 14, 1978

Truman Capote stopped by, he was visiting Bob MacBride in his studio at 33 Union Square. Truman may be on Lithium, because suddenly he's happy. But my real theory is that he went out to Long Island and saw Jack Dunphy and that Jack Dunphy finally agreed to write *Answered Prayers* for him. And he had the most chic coat on. Courrèges. One big zipper and two zippers for the pockets. He said it was a few years old. But his hands are cold. Which drug is that?

I worked at the office until 7:30. Rupert was helping me try to paint with a brush, the piss on the brush, but it was hard. Dropped Rupert ($4).

Ann Lambton's in town. She's about to go cross-country visiting the Americans she's met in London the past couple of years. It's incredible what a figure she has now.

Wednesday, November 15, 1978

After work we decided to open a bottle of champagne at the office and get drunk. This was 6:30. So Averil and Vincent and I got drunk, and then we left. Averil stopped a limo and asked how much it would be to take us to Bloomingdale's and he said $10, so we got in. Averil said that all the Kennedy kids would be at this opening of the Superman shop. We got there to the Superman shop and it looked like the sixties again. How many times are they going to bring back camp?

Thursday, November 16, 1978

At the T-shirt promotion thing for *Viva/Penthouse* at Tavern on the Green the blond Smothers Brother—they're on Broadway in *I Love My Wife*—came over and said, "Hi Andy, how are ya." And then later when I went to the phone and tried to call the office, he was waiting for the phone, too. He talked about himself and said he didn't feel he was creative anymore and that it was probably because he was secure, and he asked me how I felt, and I said that I wasn't creative since I was shot, because after that I stopped seeing creepy people. Then a kid said to him, "Don't

you remember me? I was so-and-so's chauffeur and also the first houseboy to work in the Sharon Tate house after the murders." Isn't that a great line.

There's a rumor that *Viva* is about to fold.

Saturday, November 18, 1978

It was a beautiful day, in the seventies. I watched people on pogo sticks in the park.

Sunday, November 19, 1978

Stevie Rubell had called me earlier and asked if I wanted to go with Diana Ross to a midnight concert at the Palace that a couple who wrote songs for her were giving. Ashford and Simpson. We limoed to the Palace Theater and went to the dressing room. The husband is really good-looking and the wife is cute. When the audience saw Diana, the whole place mobbed her. There were four bodyguards with us, all the blacks just love her. *The Wiz* is a big hit, I didn't know that. The concert was sensational, there were bravos.

Then there was a Valentino party at 54. I guess Stevie was trying to make it a really bad party, because he had the waiters dressed up like Pilgrims and he was serving turkey. He said he had to explain to Valentino why he was doing it that way. He said he told him, "Well, you know America was discovered by an Italian," and he said that they *(laughs)* understood. The front of Studio 54 was decorated like the front of a boat. I lost Halston but I found him a little later eating a turkey leg, and he made me have some. The last place you want to eat meat from is a discotheque, but later I saw Stevie eating the turkey, too, so I guess it was okay. Barbara Allen was there, going home to meet Bryan Ferry.

Monday, November 20, 1978

Truman's going on *The Stanley Siegel Show* again, but only because it's taped this time.

Viva magazine did fold and now Catherine's out in the cold.

Tuesday, November 21, 1978

Thomas Ammann had called and invited me to dinner with Cy Twombly. And then Bob got invited. Thomas asked me where we should go. I told him about the Palace—that restaurant on 59th Street in the Sovereign that's been in the papers for a year or so, that's supposed to be so expensive—I told him it was $300 per person and he laughed and said it couldn't be that much, that that was fine and that's where we'd go. And then Thomas called Barbara Allen and she was with Taki Theodoracopulos so they came.

The Palace had a crocheted curtain in the window, it looked like a place that gave palm readings.

We were the only ones in the place, but there were about eighteen people running around to serve. The look was like going to the tackiest person's apartment who's trying to put on the dog. Like going to Barbra Streisand's house. West Side taste. Every table was under a chandelier, and the dishes had gold trim on them, that kind of thing. But the food was good. There were eight courses. The bill came to $914 and I think it shocked Thomas. I really think he was really shocked. Because after he saw the bill, he stopped making fun of the meal.

Wednesday, November 22, 1978

The big news for the past two days is the mass suicide in Guyana of a cult led by somebody named Jim Jones. It's costing the U.S. government $8 million to remove all the bodies and bring them back. They'd put cyanide in grape-flavored Kool-Aid. *(laughs)* Just think, if they'd used Campbell's Soup I'd be so famous, I'd be on every news show, everyone would be asking me about it. But Kool-Aid was always a hippie thing.

Thursday, November 23, 1978

I watched the Thanksgiving Day parade on TV. I guess New York really is booming—when you think that every member of every marching band has to stay in a hotel room overnight. I glued myself together and went down to work (cab $3.50). There was nobody around.

I went over to Halston's for Thanksgiving dinner.

And meanwhile all this holiday they're still finding more and more bodies in Guyana. They must have known that there were 900. Why were they covering it up in the beginning? How come we didn't hear about these people before?

Sunday, November 26, 1978

I called Bob and he was grouchy, he said he couldn't talk because he was writing his "Out" column. I don't know what he's so grouchy for, it's the only writing he does all month.

I went to church, it was so beautiful and cold out. Then I worked. I drew earths and moons and watched TV.

Monday, November 27, 1978

The exciting news story was that the mayor of San Francisco was shot and it sounded at first like it was something to do with the Jim Jones cult, but then it wasn't, it was by a good-looking guy who even looked like a newsman.

Wednesday, November 29, 1978

Went to the Coronet Theater to a screening. *The Deer Hunter* was the new kind of movie—three hours of watching torture. It took place in Clairton, Pennsylvania, where all my cousins are from, and in the movie they said it was Russian-Polish, but that was just to make it more something, because it was really Czechoslovakian. It had John Savage, and lots of good-looking kids.

It starts off, it's three buddies drinking. For a whole hour it's the Polish wedding, and they could have cut it, but it was fun—so real and so beautiful. It shows a new kind of people in the movies that haven't been shown before, so it's really good. Then they go shooting some deer, so you know that from there it's going to cut to Vietnam. In the end Chris Walken puts the gun to his head and shoots himself dead and Bobby De Niro grabs his hand and says, "Oh, darling, I love you, I love you," holding his bleeding head, something like that.

I saw the *Daily News* girl, Liz Smith. No photographers took pictures of me, so I guess I'm not so much now.

Oh, and Arthur Miller was at the screening. It was interesting to see him. He's very good-looking. I guess people like that work at it, the rich-kind-of-Jewish look. Like I saw on one of the morning shows this twenty-six-year-old kid named I think Schwartz who talked like a Kennedy, he was a councilman or something. Arthur Miller looked refined, and a straighter face than Richard Avedon, but like that. Like a Lehman. I guess they marry good-looking wives and get good-looking children.

The news the night before showed pictures of all the houses that people had signed over to the People's Temple when they joined. Oh God, that's the hardest thing, how could people give away their *things*?

Thursday, November 30, 1978

I was invited to Valentino's dinner for Marisa Berenson. Walked over to the Mayfair House to Le Cirque. Lee Radziwill and Peter Tufo were there and André Oliver and Baryshnikov. The card next to me said "Jessica" and it turned out to be Jessica Lange, who's now going with Baryshnikov. And when she arrived I said, "I've heard so much about you," and she said the same thing. She was good friends with Cory Tippin and Jay Johnson and Tom Cashin and Antonio Lopez. She said she'd stayed out in our Montauk house when Tom and Jay were out there painting and roofing. She said that Dino De Laurentiis didn't even offer her another part for a year and a half after *King Kong*, so now she's going to do a part in the new Bob Fosse film—it sounds like it's just a small part, though.

Friday, December 1, 1978

Everyone was working, getting ready for the cocktail party Bob was giving at the office before his dinner for Elizinha Goncalves at 65 Irving. They were rearranging furniture and clearing things off and Vincent went out to stock up. Tommy Pashun came down with flowers.

Stevie gave me a Quaalude and Halston said, "For the box, for the box." Victor's told him about my system, how I drop everything people give me or that I get in the mail into a box at the office. Victor used to bring me some of Halston's notes like from Jackie O., but then Halston realized he should start saving them himself. These ladies really do write notes—when do they find time? And I'm invited to Jackie O.'s Christmas party again. We must be on somebody else's list, though, not hers. Because we weren't invited to the party Jackie gave last week. Robert Kennedy, Jr. told Fred that they had a big question about whether to invite us and decided not to. Jackie really is awful, I guess. She invited Jann Wenner and Clay Felker. Them she invited.

Sunday, December 3, 1978

Taki had told me that Barbara Allen made him so jealous on the phone implying that there was somebody there with her, that he went over to her house in the middle of the night and knocked her door down, and there was nobody in there. She did that to somebody else, too, that nice English guy who came all the way over here because he saw her picture and he beat her door down and there was nobody there then, either.

Halston and Stevie Rubell gave Bianca a beautiful fur coat. Dr. Giller paid for the collar, and Halston and Steve paid for the rest of the coat. It cost $30,000 or $40,000. I'm surprised they didn't ask me to give her an arm. *(laughs)* And Halston said, "I think everyone should have furs, jewels, and Andy Warhol paintings."

Tuesday, December 5, 1978

Doug Christmas came to the office with a rich lady named Connie from Texas. He'd flown in just for the day to take her back because he feels real money there. Cabbed to meet them ($4).

She wants a life-size portrait. Her girlfriend is the lady with the Kimbell Museum that I did, I can't remember her name, and she says she doesn't want a big head like I usually paint—she wants something different, a life-size portrait. She said she turned down Jackie O.'s portrait guy —what's his name? Is it Shickler? And she said that if I'm going to do her portrait we have to "get to know each other." OH GOD, OH GOD! She invited me to the $3 million house she's building in Fort Worth. When she kept talking about getting to know us, I finally ran away. Then Fred ran away. But then we came back.

Victor called and said he was on his way to Caracas and I told him, "Don't do it, Victor, don't do it." I think he might get stopped at the border, it's too dangerous. I'm afraid he's going to try something.

I was invited over to William F. Buckley's for music at 6:00, they have things like that.

Wednesday, December 6, 1978

These kids we hire at the office are just hopeless. For the first four weeks Robyn's worked there he was depositing his paycheck by mistake back into the office's account! He has his checking account in the same bank, and instead of writing his own account number on the deposit slips,

he was writing the account number off the check he was depositing onto his deposit slip! Vincent had to explain it to him.

Friday, December 8, 1978

Jackie Curtis came up. He made this point of calling a week in advance to make an appointment to come up and see me, and he was supposed to bring one other person. Well, it was like old times. Jackie arrived with fifteen people. Two were photographers and he had David Dalton who's writing a book on him, and Jackie had no teeth and he's fat, and he's on amphetamines again. But he's still so clever. Somebody clever *has* to do something with him, figure out how to use his talent. I thought maybe now that we have Ivan Karp and Truman writing for *Interview* that we could serialize Jackie's book, but I brought them in to see Bob, and Bob was so cranky, he'd been up all night thinking about his liver, and he said, "Give the book to one of my assistants." So we gave it to Brigid and she read it later and called me and said it was sort of boring, that it was just tapes, and she had no suggestions, she was just being negative.

Monday, December 11, 1978

There was a party at Xenon for the *Superman* opening. At the office in the afternoon I saw Bob in a corner moping, looking blue. I mean, he can't be that unhappy, and he can't be overworked. I mean, all he does is go to parties (cab $3). Tinkerbelle and I started talking shop. She just did an interview with David Warner for us. Tinkerbelle is so great, I don't understand why she hasn't made it to the big time.

Wednesday, December 13, 1978

Chris Makos called and said that Donahue had a show on about singles over *(laughs)* fifty. He was calling because we were supposed to go out looking for a new camera. Cabbed to meet him at the camera store on 44th and Madison ($5). Then we walked around Grand Central Station and I got nostalgic—it was like twenty years ago when Grand Central used to be the central point for me when I worked for *Vogue* and *Glamour*, which are right around there, and my bank was right there, too.

Thursday, December 14, 1978

We went down to the office and the traffic was bad (cab $4). The *Daily News* had just called wanting a quote from me, they said that fifty agents had gone in and raided Studio 54 for income tax and that they'd busted Ian Schrager for two ounces of coke.

A cute guy was in the office, a friend of Averil's, and he didn't know he'd walked across the painting I'd just done, it was still wet. It was funny.

Friday, December 15, 1978

Bought two *Daily Newses* because Steve Rubell was all over them. Bianca was on the cover (cab $4). Went home to glue, then over to Halston's. He was having a dinner because it was decided that Steve had to eat because he hadn't in three days—I *(laughs)* don't know who decides these things. It was "Stevie has to eat, he needs his nourishment." Does that mean Dr. Giller whispered in Halston's ear, "Stevie needs nourishment?" Who starts these things? So Halston was cooking short-order himself. Steak, french fries, and salad. It was the first time I've ever seen everybody at Halston's eat. He's had so many dinners where nobody eats anything, but this time everybody was eating because *(laughs)* "Stevie" needed his nourishment. [*NOTE: After the bust at Studio 54, Andy began referring to Rubell as Steve, not Stevie.*]

This was about 9:30. And it was just family so Bianca wasn't allowed to invite her new Martha Graham dancer-boyfriend. Steve told us all about the bust. He told eighteen different stories. He's not going to have Roy Cohn be the lawyer because he's too conspicuous. They didn't go there to arrest anybody, just thirty-six IRS guys with guns to seize the books, but when they found the coke on Ian they arrested him. Now Steve says it was just a little, that it was just a Christmas gift, and he was blabbing all these comments about "unwashed money." I was surprised.

Saturday, December 16, 1978

Halston said I was invited up to Dr. Giller's and that he'd pick me up. Put my contacts in and Halston arrived in a cab. I told him it was the first time I ever saw him in a cab, and then he got embarrassed, and then I was embarrassed, I said that *I* always take them, that cabs are great, but then he explained for the rest of the ride how he takes cabs a lot but that I just don't see him, because having the car sit around all day is expensive, and then I was even more embarrassed. And he told me that any time I see his car outside 54 when it's late, to just take it home. Dr. Giller's place is an exact miniature copy of Halston's. The same paintings, the same layout, the same colors.

What Halston's been most upset about in the Studio 54 bust is that the IRS agents discovered another little room that nobody knew about, and Halston is hurt because he's such a close friend and Steve hadn't told him about it. Steve says it was an inside tipoff because nobody knew about the room except the people who work there. But Steve and Ian are kind of mean when they fire people, so it could have been anybody.

At Studio 54 later, I asked Potassa if she'd ever had sex with Dali, and she said, "No, he just picked my cock up once and kissed it." She said Dali was coming back to town and that we had to resume our friendship. And Potassa only drinks champagne. *"Schom-pon-ye."* She said when Dali kissed her cock he said, *"Magnifico!"*

Monday, December 18, 1978

Brigid's down to 140 and looks good. Charles Rydell is staying at her apartment and she's so mean to him. She really is mean. He can't watch her TV, he can't put his feet up, he can't go to the bathroom. After everything he's done for *her*—I mean, he gave her handouts for years.

Truman called. He's going to do some long slice-of-life pieces for *Interview*. We're going to tape him, and then Brigid will transcribe the tapes, and then Truman will turn them into articles.

Tuesday, December 19, 1978

I'm watching Calvin Klein on *The Phil Donahue Show*. Halston said that "Halston" perfume is the number-one seller in America. Can that be true? The last time I was in Macy's I didn't see anybody at his counter. Oh, but maybe I didn't really look.

And Barbara Allen said Halston told her how much fun I am without Bob and Fred around, that when I'm with them I don't say anything and let them take over, but that when I'm alone I talk and have fun. Halston has such an odd idea of me. I should have called him yesterday. It's so hard being completely involved, though.

We went to Irving Blum's gallery on East 75th Street to see the show of my early stuff, and one of the Soup Cans was a fake. Irving was embarrassed when I told him.

Victor called, he's back from San Francisco. You really can't kid with him, because you say a word and that word goes deep into his brain and he keeps thinking about it and he gets crazy. I called him "paranoid" and then he started brooding over it.

I finally decided what I'm going to give all the Halston family for Christmas—Halston and Steve and Dr. Giller and Bianca—paintings of a free drink ticket from 54.

Cabbed to Tom Armstrong's ($3.50). Merce Cunningham was there and John Cage and Jasper Johns, but they were just about leaving. Leo Castelli was there trying to dance with his drunk wife. I took pictures. Hilton Kramer was there, the art critic. I'd never met him, so I met him. He's the one that hates my work. Mark Lancaster was there, I had fun with him.

Oh, I read a great column in the *Times!* It was something like "Funky, Punky, and Junky," and they had been talking about it at Tom Armstrong's—it was about "silly people" and it *(laughs)* had me in it a lot. No mention of Steve Rubell, no Halston—just me, Marisa, Bianca, Truman, Lorna Luft—the silly people and the silly places. And later, at Halston's, Halston said he's glad he wasn't mentioned because he said *[imitates]*, "I'm! Not! Silly!" And then everyone started calling Bianca "silly pussy, silly pussy." And Marisa came over and when she heard about the "silly" column she was upset to be "silly."

Oh, and have I said that Bob said that when he introduced Jerry Hall to Tennessee Williams down in Washington a few weeks ago Tennessee told her that she was the prettiest girl he's met since Candy Darling.

Wednesday, December 20, 1978

I'd accepted Marisa's dinner at Mortimer's but just as I was leaving the office I noticed in the book that it was the night of Jackie O.'s Christmas party and I invited Bob and he said he was thrilled, that it made his day, that it was a little something to look forward to. Cabbed to 1040 Fifth ($5). When we got there it was sort of getting over with. Lee was there, leaving. Caroline has turned into a raving beauty—she's thin, her face is thin, her skin is perfect, her eyes are beautiful. We were talking to her and then a cute guy came over, Tom Carney. I asked her if it was her boyfriend and she said yes. He writes for *Esquire*, he did the article on Tom McGuane. She asked about her old flame from London, Mark Shand.

Jean Stein was there with the Russian poet she wanted to introduce to society—some name like Andre Bosh-in-eck-shinsk. She's still writing her book on Edie. Cocktails were from 6:00 to 8:00 and then dinner was being served for the people who didn't leave. It was really good food —baked ham and some new potato salad with red lettuce from Cape Cod—she always goes to the best shops. Warren Beatty and Diane Keaton were there, and Bob heard—*overheard*— Jackie saying that something Warren did in the hall was "disgusting," but we were never able to find out what it was. We left around 9:00. Got the elevator down with Pete Hamill and the Duchins.

Cabbed to Mortimer's for Marisa's dinner ($2). Marisa looked beautiful in silver, and Paul Jasmin was with her. She's finally leaving town. She's mad at Barbara Allen because Barbara was seeing her husband, Jim Randall, out in California, so Barbara wasn't invited. Steve told us that Warren had fucked Jackie O., that he talked about it. Bianca said that Warren had probably just made it up, that he made it up that he slept with *her*, Bianca, and that when she saw him in the Beverly Wilshire she screamed, "Warren, I hear you say you're fucking me. How can you say that when it's not true?" and she said she embarrassed him. But then Bianca said that Warren had a big cock, and Steve said how would she know, and she said that all her girlfriends had slept with him. Oh, and Diana Ross was at the dinner, she was fun.

So then after dinner everybody wanted to go to Studio 54. Steve had his Mercedes, and Diana Ross was afraid to drive with him, but I assured her that he was a great driver, which he is, even in his drugged states, and so she squeezed in between us. Got there and it was jammed—some party for CBS Records. Steve's been having open bar since the bust. James Curley was there with a girl he said he's going to marry so he was cool to me. He was in white tie and tails, he'd just been to a debutante ball—they're all this week.

Oh, and Bob was in heaven when we left Jackie O.'s party, raving about how nice she'd been to him, pronouncing his name correctly and sharing her glass of Perrier with him when the butler forgot to bring his—she said, "It's *ours*."

Thursday, December 21, 1978

Yesterday Jackie O. kept calling me at the office. She called three or four times. But I didn't call back, because the messages were complicated—they were like, "Call me at this number after 5:30, or before 4:00 if it's not raining." And then finally she called me at home—I wonder how she got the number—and that was strange. She sounded so tough. She said, "Now Andy,

when I invited you, I invited *you*—I didn't invite Bob Colacello." She said she was upset because Bob "writes things." And now that I think about it, Caroline made some comment like that at the party. And I mean, there were lots of journalists there—Pete Hamill and Caroline's new boyfriend. I told her not to worry, that Bob wasn't going to write anything. So something must have happened there that she doesn't want written about. She was thinking about it all day, I guess.

Catherine wanted to go to Cowboys (cab $2). It's so great going in there, a black hole with all boy beauties and all available. And then every other person there is somebody. Charlie Cowles was there. Henry Post was there, he's one of these kids that I like that everybody else says is terrible, but there's something nice and intelligent about him. I asked him what he was doing there and he said he was doing research for a story.

Friday, December 22, 1978

Bob picked up Paulette Goddard and then they came and picked me up. When we got to the Iranian embassy I gave Hoveyda a print. And it was in the papers that the Shah's going to abdicate and his son's going to ascend. Paulette was acting nutty—I think she's losing her marbles—she was talking about her legs getting machine-gunned. And then when we were inside at the table the wind blew the doors open and Paulette got up and was crawling out of the dining room toward the doors to the buffet room . . . well, not really crawling, but she got up and tried to flee the room, and Hoveyda said, "Where are you going?" And she said, "I want to hide." It was peculiar. She kept saying that the evening was so "morbid" because all the Iranians were looking for new jobs.

Bob dropped me home. When I was in bed, already asleep, around 2:00, Victor called and told me to come over to Studio 54, that it was fun, that they had snow all over the floors. But I didn't.

Saturday, December 23, 1978

Talked to Tinkerbelle and she was saying how she makes out with everybody she interviews, that she was making out with Christopher Walken and that his wife was getting upset. She said she cut her arm falling on the glass from a skylight—she'd broken into a friend's apartment—she thought they had some drugs in there. I guess Tinkerbelle's really wild.

Sunday, December 24, 1978

Up early. New York was so unbusy, there were lots of cabs. Everybody must have gone away because it was great, everything was open and nothing was crowded. Then cabbed to Union Square ($3). I got Rupert to come up and help me work, I decided to do prints of the Ali paintings.

Oh, and in the morning I called David Whitney to wish him a Merry Christmas and Philip Johnson answered the phone and said he was cleaning up because the big winds had blown in a

sheet of glass—he was at the Glass House in Connecticut—and it could have cut him in two. Isn't that scary? David wasn't there, he was down at the greenhouse. Truman called and said he was alone because Bob MacBride had to spend Christmas with his kids. I worked all afternoon, left at 5:00, dropped Vincent and Rupert ($4.50).

Tom Cashin came over to the house for a fast turkey dinner before we went to Diane Von Furstenberg's. And Diane didn't invite Bob Colacello to her party. Now everybody's saying that they only like me when Bob and Fred aren't around with me, that's the new thing. Everybody's being mean to Bob. But they'll be turning on me soon, too, probably.

But when we got to Diane Von Furstenberg's she had a guilty pang and started saying, "How could I be so evil? How could I be so rotten to Bob?" and then she called him, but he was already going to Adriana Jackson's, but he said he'd come after dinner.

It was really raining when we were going over, really hard. It was a horrible Christmas party with horrible people—about fifty of them—so I didn't see why she couldn't have invited Bob in the first place.

Barry Diller was there and I guess the reason he and Diane are a couple is because she gives him straightness and he gives her powerfulness. He's *very* powerful. And that producer Howard Rosenman was there, and someone screamed, "Rosenwoman!" and that was funny. Truman was having fun talking to Cappy Badrutt. She was the only fun person there.

Then we left for Halston's. Catherine was there and I gave her a painting with some of my come on it, but then Victor said it was *his* come, and then we had a fight about that, but now that I think about it, it *could* have been Victor's.

Halston had a big fish. I had red wine and was getting so tired that when Tom Sullivan put a crystal of coke on my tongue for the first time it really worked on me. Just one little piece and it really woke me up. We were going to Studio 54 and I knew that we'd be up until 5:00.

Monday, December 25, 1978

Went to church. Tom Cashin called to say Merry Christmas.

The turkey at Halston's was ready at 9 P.M. It was really good. We reviewed the night before. Halston revealed that Steve had spent the whole day with Roy Cohn and that he was only coming over for a while, he had to go back to see him some more.

At Studio 54 the IRS found a room full of cash. And now, when I think about it, hearing how much money Steve actually had, he could have been treating us so wonderfully. He could have been so generous and spending so much, and he just wasn't. He did take us to La Grenouille once, but it could have been so much more.

And they were talking about Bianca's divorce, Steve saying she should hire Roy Cohn and sue Mick for everything, but the thing's so complicated—Bianca wants to get the divorce in London and Mick wants it in France because France is where she signed the paper saying she wouldn't get anything in a divorce settlement.

Wednesday, December 27, 1978

Halston called inviting me to dinner for Diana Ross at his house. She was in the tightest black pants, like she was poured into them, and she's so skinny—they were so tight she could hardly sit down. She was sitting next to me and she talked the whole night, touching me, I guess she was on something. She said that she told Cher she wouldn't do her TV special, that Cher flew up to Vegas to see her last week about it, but she turned it down. She said, "That's not my scene right now." Diana uses the hip lines, she said, "I don't mind the girl, but ..." Weren't they best friends once?

Sunday, December 31, 1978

Fred's in the Amazon—no, wait. The Andes. I talked to David Bourdon, he was going to go to Rosenquist's New Year's Eve party. Rosenquist was hiring a live band again. It was so successful the year before that he's doing it again.

I worked all afternoon at the office. It was nice working on New Year's Eve, I painted backgrounds. Walter Steding came over to help me. Ronnie was having an Alcoholics Anonymous New Year's, and Brigid stopped by to pick up some tapes.

I didn't know the evening at Halston's was going to be so chic, my dear. I'd asked if I could bring Jed and Halston said fine so we went over. Catherine brought Tom and Winnie—Halston'd said fine to that, too. Tom told me that he was giving Catherine and me points in the movie, and that they had to reshoot a little more, that somebody had just given $150,000 so they could. Bianca was in a Dior.

Oh, and Vincent called earlier and said that Mrs. Winters had called and said that Mr. Winters had what they think was a heart attack.

Diana Ross looked beautiful. And she had asked Halston over the phone if he was going to serve black-eyed peas at midnight because it was good luck. So Steve went around town getting soul food. And when she got there Halston was cooking ham hocks and ribs. A few people said to her, "Don't you want to check on the black-eyed peas?" They knew the peas were her idea, and they were just trying to be nice. I guess she took it as an insult, though, because she said, "No, thank you, darling, I think I've checked them enough."

And Mohammed the houseboy had a girlfriend there and she was Jake LaMotta's daughter. He's that boxer Bobby De Niro's playing in the new Scorsese movie. She's pretty.

While we were sitting at Halston's we had the radio on and it was "live from Studio 54," and we heard the announcer saying, "Oh yes! Here they come! Halston, Bianca, and Andy Warhol! They're walking in the door right now!"

Then we all did go to Studio 54. They had decorated it great, put silver glitter on the floor, and they had someone on a trapeze, and white balloons. And they were saying that Bobby De Niro had been there since 10:00. They'd been having a press party.

The whole night was spent losing and finding and looking and finding and looking. John Fairchild, Jr. has a crush on Bianca so we were looking for her, and then losing her, and then losing him and finding her, and then losing me, and looking for me, and losing him. . . .

I was sober. I had lots of Perrier. The place was still jumping at 7:00. Went outside, it was warm out, and people were still waiting to get in, as if it were only 1:00. Only the light was different.

Monday, January 1, 1979

Maxime said she was giving me a dinner party, which I didn't want. So I told her to invite Bianca and the Herreras and I picked up Catherine. And I also invited Allen Brooks, the porn star. Cabbed to 19th and Fifth ($5). Gloria Swanson was there with her new young husband. Gloria used to be married to Maxime's ex-brother-in-law, the Count de la Falaise. And she started saying, "I smell terrible fumes. I have to go to the window to get away from them. Where are they coming from? Check your stove. I have a very good nose and I know there are fumes escaping." And I just knew it was the perfume I had on that she was smelling. It was jasmine from Shelly Marks. PH and I are doing research for a new perfume line and I was trying it out. And so I didn't want to go near Gloria. I went into the bathroom and tried to wash it off, and then for the rest of the night I stayed about four feet away from her even when she was trying to talk to me. I ran over and talked to Sylvia Miles. Gloria looked good, though, with short grey hair. Maxime served spaghetti.

Mario Amaya, that person who stopped by the Factory in '68 and wound up getting shot in the arm by Valerie Solanis when she was shooting me—he was there and he just quit his job at the Chrysler Museum in Norfolk.

Tuesday, January 2, 1979

Went to meet Truman at Dr. Orentreich's office on 72nd and Fifth to tape the two of them for Truman's first "Conversations with Capote" series in *Interview*. We went in the back door, and Dr. Orentreich gave us free samples, and he thought it was an interview so he began babbling, saying everything he's doing. Then he removed the veins from my nose. I've had it done before, by Dr. Domonkos. It doesn't last, but for a while it looks great. For about three months, then you have it done again. He said that the doctor who sandpapered my nose twenty years ago had done a bad job, gone too deep.

Truman's getting a facelift, but Dr. Orentreich isn't doing it himself—somebody in his office is—it's just going to be "supervised by" Dr. Orentreich.

Friday, January 5, 1979

Bianca had invited so many people down to the office to see the pictures I'm doing of her that it turned into a big lunch. And I'd invited all the kids who come after me in Studio 54, I figured that when you see somebody in the light all the glamour's gone so it'd be a good way to end it all, let them get a hard, cold look at me in the daylight. I invited Curley, and Justin, and Pecker

who got fired as a waiter at Studio 54 for serving drinks in the ladies' room. But since the ladies' room there is always full of men, anyway, I don't know why they cared.

Bianca had tickets for the John Curry ice ballet show at the Minskoff Theater. After the show we went backstage to see John Curry. The dressing rooms at the Minskoff are new and beautiful, air-conditioned and everything. Jade was with us. There's something so good-looking about John Curry, he's so adorable, and when I was leaving he kissed me on the mouth. They're thinking of closing the show because he really hurt himself, but they're going to run it for another week.

Saturday, January 6, 1979

Walter Steding called and wanted to freelance, so I had him deliver a Shadow painting up to John Curry (cab $10).

Vincent was calling Montauk because Mr. Winters was failing, and Mrs. Winters was upset. I just couldn't believe that anybody who looked as good as Mr. Winters did was in bad health. But he *has* been really cranky, I think last summer with Tom Sullivan out there really made him cranky.

Then Bob called and said that Rod Stewart and Alana Hamilton wanted to see us for dinner, and that sounded like a fun thing. I worked at home until 10:00, and then Bob picked me up and we went to Elaine's (cab $2.50). It turned out to be actually Swifty Lazar's dinner party, and the Erteguns were there, and Rod's manager, I think, or assistant, he was funny, talking gay with Bob. Well, the party was so stuffy, poor Rod looked miserable, you could see he really wanted a good time, and they all wanted blows and nobody had any. And then Françoise and Oscar de la Renta left and suddenly—it was incredible—everything picked up. Who would think that just two people leaving could do so much—the whole mood of the dinner changed.

Rod and Alana had the most beautiful coats. He had black mink and she had a matching white mink. He looked so great—he looked better than she did.

Then we went to Studio 54. Truman was there. He goes up into the crow's nest where the DJ plays the records and it's like his private office. People come up to see him, and he stays until 8:00. Truman said that Ivan Karp had seen Bob MacBride's art and said he'd put him in a group show in December of next year.

Rod and Alana were in the back, I introduced them to the manager. It's hard to get coke there now, they're not really selling it. And some guy was sort of bothering me and John Fairchild, Jr. came over and asked if I wanted the guy beaten up, and I really should get to know him better because he must have a bad temper which is always interesting.

Sunday, January 7, 1979

It was raining hard. As I was leaving the house John Curry called to thank me for the Shadow painting I sent him. Went to Elaine's to have dinner with Phyllis Diller (cab $2.50). Barry Landau arranged it so he was there.

Phyllis was cute, she's a happy divorcée. Right as I was talking to Phyllis she finally realized that I was the person who'd asked if I could draw her foot in around 1958. She was just starting

out then—it may have been at the Bon Soir or someplace, and all these years she never put it together that that was me and this is me, and so she said, "Oh, *you're* the foot fetishist!"

Phyllis didn't eat much. Tommy Smothers was with us and so was Tommy Tune. He said that Elaine's had the best food he'd had in so long, and everybody looked at him like he was nuts. He must be.

Then Adolph Green started coming toward the table with his arms out so *(laughs)* Barry Landau whispered to Phyllis quickly that she had just sent a bottle of champagne over to him. Because Barry had sent a bottle and signed it from her. And Tommy Smothers was tongue-kissing Phyllis and so I said, "If you can tongue-kiss her, you can tongue-kiss me." So he gave me a quarter of a tongue-kiss and said he'd give the rest when he knew me better.

Then we went to Studio 54 and it was very empty. John Fairchild, Jr. was there and he asked to borrow money, so I ripped a hundred-dollar bill in half and that upset him, but it was a memorable moment. And I didn't realize it at the time, that he probably had his coat on only because he didn't have enough money to check it.

And Halston *is* funny—no matter how many times we run into each other on the floor he grabs me and hugs me and kisses me and says, "It's so nice to meet you, Mr. Warhol." Paid John Fairchild, Jr. for bodyguarding me ($20).

Monday, January 8, 1979

Vincent called and told me that Mr. Winters had died.

Did I say that Fred called the office the other day? He wasn't even in Bogota yet, they were in some small town. He said that he and Rachel Ward fell out of the boat and she wasn't coming up, but then she did come up. He said it was really dangerous. He's with three or four Kennedys and Rebecca Fraser.

Tuesday, January 9, 1979

I wanted to see *The Wiz*, so Jed and I cabbed to the Plaza (cab $2, tickets $10). The movie looked so cheap, and they made Diana Ross so ugly and they made Michael Jackson ugly. Sidney Lumet must hate women—he photographed them "up," you could see right up Lena Horne's nostrils. She's his ex-mother-in-law. The play was a lot better, with the Geoffrey Holder dancers.

Wednesday, January 10, 1979

Talked to Vincent, he went out to Montauk to see Mrs. Winters. He told her she could stay on if she wanted—she has a son and Mr. Winters had a son, so maybe they can help her and maybe she can stay on there alone.

Thursday, January 11, 1979

Fred was back from his trip, very very happy because he lost twenty pounds, he's back to 120, and sporting a mustache and he looks great, very young.

He brought me back an emerald, it's the smallest one I've ever seen—blink and you miss it. It's a tenth of a carat and comes with a certificate and the certificate is really cute.

Went to dinner at La Grenouille with Phyllis Diller and Barry Landau (cab $4). A lot of people were asking Phyllis for her autograph and not me, and afterwards she *(laughs)* said to me, "Oh I'm sorry, dear, I felt so *bad* for you."

Friday, January 12, 1979

Tinkerbelle brought Christopher Walken down to lunch so that she could have a date with him. He's such a big star now that he really threw me when he said, "A couple of years ago I was Monique Van Vooren's dancing partner." *(laughs)* Isn't that something? I guess when Monique was doing her act at that room that doesn't exist anymore. Not the Maisonette, maybe the Rainbow Room. He has a mustache now. He said Monique gave him the name "Christopher."

Sunday, January 14, 1979

Went to the Eberstadts' for dinner (cab $2). Earl and Camilla McGrath were there, and Sam and Judy Peabody. Somehow Isabel sat in the wrong place, and so everybody's place card was wrong, and so then Isabel said that everyone should pretend to be the person their place card said. So I pretended to be Isabel—I had her card—and *(laughs)* I kept excusing myself to go to the bathroom. I guess maybe that was mean.

Monday, January 15, 1979

Fred went out to Connecticut to see Peter Brant about possibly buying the Muhammad Ali portfolios. Peter kept him waiting an hour, and then gave him a hard time because he and Joe Allen haven't made any money yet from their investment in *Bad*.

Tuesday, January 16, 1979

The Shah left Iran. He stopped in Egypt and he's going to Texas where his son is training for the air force, and then the television said he's going to stay with the Walter Annenbergs in California. I don't know what they think they're doing—they practically showed a road map on television, aerial views of the place.

Tinkerbelle said how could I tell people that she'd given Chris Walken a blow job and I told her I didn't tell anybody, that I didn't even know.

Thursday, January 18, 1979

It was the first time I ever saw people actually flying around the streets, it was so windy. Cabbed to Union Square ($3) and that's where I really saw people in the air. If you were on the sunny side of the street it was nice, beautiful, but then when you'd hit a corner you'd get blown away. People were holding on to things. Went to the office. Stephen Mueller and Ronnie were finishing stretching Shadow paintings for my show next week.

Saturday, January 20, 1979

Bob had Brigid helping him all day, writing the text for the photo book, and I mean, they're crazy—they called me up and read me some of the stuff and they have me talking about Lee Radziwill and Jackie O. in the book as if they're my best friends. I wanted to throw up. Worked and watched television.

Sunday, January 21, 1979

I watched the Superbowl and it was exciting, really good. Jo Jo Starbuck's husband is Terry Bradshaw of the Steelers and he got two touchdowns in fourteen seconds. She's the female star in the John Curry show. Then the Cowboys got two more. But the Steelers won. Then Tom Cashin and Jay Johnson came over and they were going to a movie, but I didn't want to go.

Tuesday, January 23, 1979

Cabbed down to Heiner Friedrich's gallery on West Broadway ($5). Fred wasn't there yet. Ronnie and Stephen Mueller were there hanging pictures. The show looked good, the gallery's so big.

Got to the office about 4:30. Bob was upset because *The New York Times* had called and said they were interested in reprinting Truman's column and Truman has the copyright, so Bob is worried that now Truman will start doing it for the *Times* instead of *Interview*. But I don't think Truman would. He probably wants to turn them into a book eventually.

And Tom Sullivan came by and he was acting crazy. He kept saying that he wanted to give me 25 percent of his business, just for nothing. But what *is* his business? And he kept saying that everybody thinks he made his money in heroin or cocaine but that it wasn't those two, that it was something else. But I mean, what else could it be? Marijuana? Catherine's getting her green card this week. It took three years.

When I got home Mrs. de Menil had called and left a message that she was very very touched by seeing my show at Heiner's gallery.

Thursday, January 25, 1979

Brigid was down to 120 but I caught her eating in Bob's office, everything that's bad for her—fried potatoes, fried scallops, mayonnaise. She was getting ready for the Shadows opening all day, she went home and put on all her jewelry.

People kept wandering in and out all day. They were sending a limo for me and it came at 5:00. I glued, and took some of the kids down there with me. It was snowing a little.

It wasn't too many people at first. Actually, it was a big business gathering. Barbara Colacello had gotten free champagne and Seagram's and Evian and some other free liquor and drinks, telling them that the society people would be coming down.

But it turned out that out of the 400 people Bob invited, only 6 came. Six out of 400: Truman Capote, the Eberstadts, Fereydoun Hoveyda, who just resigned as ambassador, and the Gilmans. So 394 of our best friends were no-shows.

No Halston—he was in Mustique.

No Steve—he was, too.

No Catherine.

It turned out to be more of a punk opening, all the wonderful usual fantasy kids that go to openings like that. And René Ricard was there. Mrs. de Menil came, and she was sweet, and François, he was sweet. But Addie and Christophe de Menil didn't come. David Bourdon and Gregory Battcock, it was fun to see them, but we didn't get a chance to talk.

A lot of kids had their own cameras, they were looking in vain for celebrities to take pictures of. Victor was the only well-dressed person—an umbrella and black pearls.

The bathroom was crowded, I guess people were coking up. We got a group together to go to dinner—Jed, John Reinhold, John Fairchild, Jr. and his girlfriend Belle McIntyre, William Pitt, and Henry Post. Bob was mad at me for inviting Henry Post, he says he does those exposé-type articles, and maybe he's right, maybe I *will* get myself into trouble.

We were limoing to 65 Irving Place to "65 Irving." And on the way, near Washington Square, we saw a dog get hit by a cab and a woman was screaming, and we offered her the limo to take the dog to the hospital, but she said her husband was getting the car, and it ruined the whole night. It made me feel funny.

Philippa invited René Ricard—her Dia Foundation just signed him up for benefits as the first poet—so he arrived at 65 Irving and was saying that my work was just "decorative." That got me really mad, and I'm so embarrassed, everybody saw the real me. I got so red and was telling him off, and then he was screaming things like that John Fairchild, Jr. was my boyfriend—you know how horrible René is—and it was like one of those old Ondine fights, and everybody was stunned to see me so angry and out of control and screaming back at him. And do you know that René has an *agent* now? And do you know who that agent is? Gerard Malanga. And I mean, René acts as if he's such a wonderful writer, but he just has one idea and he keeps repeating it over and over—about how he's wined and dined by the rich and how you should get things for free, that same old stuff. Luckily Henry Post missed this fight, he was at another table.

I have another opening on Saturday, this one was just a preview. The show only looks good because it's so big.

Friday, January 26, 1979

Jenette Kahn—she's the president of D.C. Comics, a friend of Sharon Hammond's—called and invited me to see the Knicks on Monday because she wants me to paint the floor of the Knicks' basketball court.

Paul Morrissey called from California and said that Carlo Ponti called him and offered him a script and Paul said—Paul *said* he said—that he wouldn't do a movie for him until he straightened out the money he owes me over *Frankenstein* and *Dracula*. Ponti probably thought he could buy Paul off by offering him a movie. Which I'm sure he can. Paul was calling about Bobby De Niro wanting to maybe rent Montauk, and Paul was saying to give him a cheap price so he'd be sure to take it because it'd be great to have him there, but I think we should *raise* the price—we're not making enough renting Montauk to run it.

Saturday, January 27, 1979

This was the day I had to go back to Heiner's gallery for the real opening.

And it's so great, such a great feeling, when people ask me how many of the paintings have been sold, to just be able to say, "They're all sold."

Governor Rockefeller died.

Sunday, January 28, 1979

Got up early and my bones ached from standing so long the day before, greeting 3,000 people. Fred called and invited me to mix with the Kennedys at his place at 10:00 before the Studio 54 party for Pilar Crespi. And Tom Cashin came by to take me to a models party, but I was too worn out.

I saw a little of *Taxi Driver* on TV and the guy at the end reading the letter from Pittsburgh really sounded like he was *(laughs)* reading from Pittsburgh.

Oh, and on the news the lady who hijacked the plane said she had nitroglycerin and wanted Charlton Heston and Wonder Woman to read her letter on TV? She looked like a normal schoolteacher ... she was from California. There were some famous people on that flight—the Jackson 5's father and the guy who was with Mary Martin in *Sound of Music* on Broadway.

Monday, January 29, 1979

Rupert came to the office and I gave him a talk about going around telling people that he does my paintings. But he's drinking too much so he still thinks he does them. Went to Madison Square Garden (cab $3). Jenette Kahn wanted me to meet Sonny Werblin who is the president of Madison Square Garden to talk to him about painting the floor for the Knicks. Just like Bob Indiana did for his home team out in Indiana. We talked to Sonny and he said it sounded like a good idea. He asked to see the floor that Bob Indiana had done and Jenette has already sent away for pictures of it. The game was boring. The Knicks are slow, they're a good team but they're too slow, they miss so many baskets—the other team got every basket they tried for.

Then I had to take Jenette to dinner and she said she'd like to go to Trader Vic's. Had to do small talk for a couple of hours. I think she has a crush on me. She's intelligent and glamorous with big tits, a good head. And she's very organized. She can spell things out. I'm convinced that if you can spell things out very simply and say everything clearly right away, you'll be a success in business. Like Bob Denison can do that. And Jenette does it with charm, she comes right out direct and says things—like what we wanted from Sonny Werblin.

And on that plane that was hijacked was also Joe Armstrong, Sue Mengers, Max Palevsky, Theodore Bikel, and Dino Martin, Jr. How did they avoid the camera? Sue had the best line: "If anything happens to me, take care of my coat."

Tuesday, January 30, 1979

I gave Rupert another talk about saying he does my paintings for me and he decided that he shouldn't drink again for a while.

David Whitney was telling me that the house on 54th Street where Nelson Rockefeller died was the house he used for having fun. Diana Vreeland was funny the other night, she said, "Of *course* Nelson was with a girl—he was *always* with a girl. Nelson wanted everyone to be *happy*. And why not? He was a Rockefeller—he could make *everybody* happy." Then somebody said, "But what about Happy?"

Wednesday, January 31, 1979

I worked all afternoon. Then cabbed all the way down to Delia Doherty's fashion show at Lafayette and Canal Street ($5). She had paper clothes made out of tubing. The girls had to be rolled in, they couldn't walk or talk. It was absolutely great. Jane Forth was there, she was just back from South America doing the makeup on a movie with Carol Lynley. Jane said that she's going back to makeup school because you can make more doing scars and burns than straight makeup. She's got a fat ex-lady cop who takes care of Emerson, the baby she had with Eric Emerson. He's eight or nine now. He's taking ballet lessons, he's following in his father's footsteps.

Friday, February 2, 1979

John Reinhold called in the morning and said he'd like to take me to his wife's gallery on 78th Street (cab $2). She just went off to Europe to look for some more posters and things. The gallery had a wonderful exhibition of old movie posters, like Garbos from the twenties, the huge beautiful posters that were printed in German, they're about 8′ × 10′—things like the original *King Kong* and Charlie Chaplin. I always bought the smaller American movie posters and they're just not worth anything. The original Cassandre posters are selling for $35,000. Can you believe it? And when I think of how I let them slip through my fingers. A print of one is about $5,000 or $10,000. *Posters*. Can you believe it?

Had lunch at that place called Three Guys on Madison and 75th and it's a really good sandwich shop, a lot of kids came in, there must be a school right around there. And there was a girl behind us using "shit" and "fuck" to her mother, and whatever the mother would say to her, the kid said, "You are insulting me, mother," and you just wanted to slap her and kick her a few times —a little snot-nose. She was about fourteen and the mother was about thirty-five, and her mother was crying. You know when you get your mother and you really put the screws in? Well, this kid was doing it, she was disgusting. Then I dropped John at his office and went down to Union Square (cab $4.50).

Sunday, February 4, 1979

I was mentioned in a Victorian Art article in *The New York Times* magazine section by Hilton Kramer, who put me down.

Monday, February 5, 1979

Halston called and invited us to dinner with Liza and Liz and Dolly Parton and Lorna and so went home to change. Walked over to Halston's, but then Liza wanted to take me and Jed over to her place at 40 Central Park South to look at her boyfriend Mark Gero's sculpture. She said she'd only keep us five minutes.

He wasn't there—he was playing poker with his buddies at some Mexican restaurant on 86th Street and she was going there to meet him—but she made me write a note saying how good the stuff was and that I would get him a show. It was tits out of marble and alabaster and wood, and she was rubbing the tits while we talked. Liza hasn't moved into her house in Murray Hill yet. It's so sad to see her apartment, because she really has no taste, and Halston's trying to give her taste, trying to get Jed to do her apartment, but I think all she really cares about is working, she doesn't care about decorating.

We dropped her off at the poker game and I dropped Jed off, this was around 2:00, and then I went back to Halston's. Dolly didn't show up, neither did Liz. Halston and Dr. Giller said they were "unwinding." I don't know from what.

Thursday, February 8, 1979

Worked at the studio then had to leave early. Dropped Bob (cab $4). Went to Neil Sedaka's place, 510 Park Avenue, for cocktails before the Police Athletic League dinner. I met Leba a few weeks ago and she said they wanted a portrait. The Sedakas are subletting this place until their apartment is finished. All the talk was about how hard it was getting into a building because they're Jewish and entertainers, and an older couple was there who got them in. A lot of the people were in black tie. I looked the worst, in my old jeans and a sweater, but Neil was casual, in a sweater, California-style, although he's from Brooklyn. He seems like a fairy but he's not. I don't know how his portrait will come out, though, because he's chubby. The decorator who's doing their apartment was there with his boyfriend and we had cocktails, it was fun.

Friday, February 9, 1979

Fred was going off to Berlin and Diana Ross called and said she wanted me to do a portrait of her and her kids and that her manager would call about it, so now with Fred out of town I guess I'll have to deal with that myself.

At Studio 54 I met young John Samuels, who's really handsome, like a young Robert Wagner.

Saturday, February 10, 1979

I hadn't gotten to bed until about 6:00 and then Victor called and started talking about ideas, did I have any "sophisticated ideas." He was working, he said, and also in the middle of hosting a party for twelve kids he'd picked up at the Anvil.

Went over to Truman's for his facelifting party. He had to check into the hospital the next morning, Sunday, and have the lift on Monday, but he wasn't telling anybody which hospital. I had Janet Villella and a "Du Pont" twin with me—these two twin brothers who say their name is Du Pont but I think they just made it up. When we got to Truman's Truman wasn't happy about seeing the twin because once at Studio 54 Jacques Bellini who this twin is in love with had him go over to Truman and say awful things, and Truman remembered. The other twin is Rupert's boyfriend. Bob Colacello was there, and Bob MacBride and Halston were there, and Dr. Giller who said he'd tried to call me and gotten very jealous when another man answered the phone. Jed picked up my line. Truman was trying to get me to eat lots of chocolate, he thinks I like it so much, which I don't, really. Commissioner Geldzahler was there with his new boyfriend who's cute. Henry said he told Mayor Koch he wanted a badge for being commissioner so the mayor gave him one. He flashed it. Christopher Isherwood's boyfriend, Don Bachardy, was there.

Sunday, February 11, 1979

Mica Ertegun called and told me that the lunch at Mortimer's was changed from 1:00 to 1:30.

I went out to church and ran into Gary Wells in bright green pants coming back from church, and I was surprised to see him out so early because I'd seen him at Studio 54 so late the night before.

After church cabbed to Mortimer's ($2). The place was jammed, but I was the first person there for the lunch which was for Hélène Rochas and Kim D'Estainville. Jerry Hall was there, she was putting down Bianca now that Bianca is suing for half of what Mick's got. The case is in the California courts where all the live-in suits are going on now—like that's where the Hunt girl got support from Mick for the illegitimate kid. I told Mica we have to turn Ahmet gay so he won't be pinching all the girls. He really is funny—we were thinking of dumb ideas for musicals, like jogging—*Jogging!* And they're all surprised that I'm talking so much lately, they think I'm a new person.

Monday, February 12, 1979

Forgot to remember the most important thing—lunch on Friday at Christie's. I picked Bob up and we walked over there and this guy had all this jewelry there for me to look at and he said, "You can get it cheap." And that's when it started to dawn on me—these auction houses can put the gavel down *any time they feel like it.* Right? Right? Think about it: Like you'll be at Sotheby's and the guy will go, "Twennnty dolllars . . . thirrrrty dollllars . . ." You know, really milking it, so slow. But then some other time it'll be: "Nine thousand-nine five-ten-ten five-sold! History!" You know? So fast. So then they took us down and showed me the drawings of mine that are up for sale, and there was one fake.

And Christie's is doing a big dress sale, selling Diors and Schiaparellis and things. They'll get $8–10,000 for a Fortuny. So I've just got to track down that man who had that great shop in the Village—Fabulous Fashions. He had to move and now he's somewhere on West End Avenue, selling out of his apartment. I've *got* to find him.

And Iran really fell. It's so weird watching it all on TV, it really could happen here. And Brigid was telling me about the boy on the news whose mother died and he didn't tell anybody, he just kept her in the house for eight months.

Tuesday, February 13, 1979

Truman said he thinks *Interview* should become more like the original *Vanity Fair.* He was telling Brigid lots of ideas for *Interview,* saying he wanted to have regular Monday morning editorial meetings of the staff. But meetings like that are just a big waste of time. Other magazines do it that way, but everybody at *Interview* just sort of does their own job. Other magazines schedule those big long meetings and that's when all these people's ideas about themselves and their

positions come out—the "power" things. The meetings just bring out whether people think *they're* better or *you're* better.

Thursday, February 15, 1979

John Fairchild, Jr. called and said he would pick me up at 6:30 to go out to the Brooklyn Academy to see Twyla Tharp at a *Hair* benefit Lester Persky was putting on. He came in a limo with Henry Post and William Pitt and Marita and Teri Garr, she's very nice. The driver got lost but we were there on time. Everybody was there. Mike Nichols even said hello to me. I guess he felt he *had* to after making me meet the Polish Warhol. Dr. Warchol.

The dancing, it's a funny new kind of dancing, falling and tripping, and it looks like disco dancing. It looks like if you had a creative person on the disco floor, that they would do this (intermission drinks $10). Jack Kroll was there.

Henry Post told me that John Fairchild, Jr. snuck him into Studio 54 the other night—Henry's been barred for what he wrote in his article about the club and when Ian Schrager saw him he asked him to "leave in a gentlemanly fashion." He said he started to argue that it was a public place, but then he got scared.

I really don't know why Pat Cleveland and Sterling St. Jacques never did any other of their dancing up into an act. Although Ronnie tells me that Pat's going to be performing down at the Mudd Club. That's the latest club for young kids, it's down around White Street. Ronnie's the *oldest* one there—he's booking a reggae concert. They dropped me off and it was snowing and pretty.

Friday, February 16, 1979

I called the Neil Sedakas and they were out but the decorator was in, and he invited me up first to his office on 81st and Park and then to go over to see the Sedakas' apartment that he decorated before they move in, on 85th and Park. I went up to the decorator's and he has like a private entrance in a big building. It's a beautiful office but it's decorated horribly. He had paintings like I've seen at other people's apartments, they're just like scribbles and I don't think *he* paints them, but it's somebody's paintings. I just couldn't face asking him whose they were. I'm going to, though. He wears Christopher Street clothes, army boots and a leather jacket and chinos, and he has a mustache and a beard. He looks like Victor, like a Gay Bob doll. Then he took me upstairs to see his partner's apartment, and she had a duplex with more scribble paintings.

Then we went over to the Sedakas' apartment. The renovation job looks like it's costing $3 or $400,000 and they're doing things like moving a door one inch. But they're putting in saunas and things.

Cabbed to U.N. Plaza ($3). Truman looked like Dr. Frankenstein had just finished with him. He had scars up and down and across his face. He looked like he had the little screw missing. Then we cabbed over to Dr. Orentreich's office ($4) and we slipped in the back way. It was like sneaking in with Garbo. Okay, let me describe Truman's costume: He had a scarf over his head,

then a funny little hat with folds in it and a babushka and a jacket and a scarf over his mouth and dark glasses and a leather jacket and a coat. I mean with these scarves and funny hats draped all over him, he was so conspicuous. Otherwise nobody would have noticed him and he would have been just a strange person with blood leaking down his face.

And he decided he wanted more done—he wanted more pain, I guess—so he was going to have the fold on the bridge of his nose done, too, right then. It's an operation that Truman says he invented and that Dr. Orentreich has rehearsed on two women first, and now he was ready to give it to Truman.

There were eight really beautiful nurses. It was like watching Hugh Hefner and his Bunnies. And they said to Orentreich, "What a great sewer you are, doctor." When he was done tucking Truman's furrow—the furrow had been about a quarter-inch and the scar was about three inches—they glued him up. Truman was awake, and he said it didn't hurt, but I don't see how it couldn't have. He made an appointment for Monday to take the stitches out.

Then we cabbed back to U.N. Plaza and Truman was talking about "our magazine." He said that in addition to the big editorial meetings, he wanted to have an opinion page and letters-to-the-editor column and now I'm just bracing myself for some letter to arrive from his lawyers.

He says his next improvement is hair transplants. He said his troubles were all because of John O'Shea and that now he really hates him. But then later Brigid told me that he had her send O'Shea a subscription to *Interview*.

Saturday, February 17, 1979

I told Susan Blond I'd meet her at the Palladium Theater down on 14th Street to see an English group called the Clash (cab $5). Ron Delsener took us to a little room. We sat around there and then a couple came in who I didn't recognize but it turned out to be Carrie Fisher and Paul Simon. I never recognize him. Bruce Springsteen came in and I didn't recognize him, either. He was sweet, he said, "Hello, remember me?" and he took off his glove to shake hands. I met him at Madison Square Garden when I took a picture of him that I wasn't supposed to.

Blondie—Debbie Harry—was there and when we got backstage there was Nico! With John Cale! And she looks beautiful again, absolutely beautiful, she's finally thin in the face. Her hair's dark brown, but John's having her dye it bright red. They're opening at CBGB and she's going to sing "Femme Fatale" from the first Velvet Underground album and John's going to play his violin. She's staying at the Chelsea.

The Clash are cute but they all have bad teeth, sticks and stumps. And they scream about getting rid of the rich. One of them said he didn't want to go anywhere downtown—that he wanted to be shown uptown. So I said okay, we'd go to Xenon and Studio 54.

Monday, February 19, 1979

George Washington's Birthday, it was twelve inches of snow,
 Had lunch with Peter Beard and Cheryl Tiegs. She's a toughie, so she'll probably make Peter marry her. I've decided Peter's just a playboy, though. He's really looking great, he never ages (lunch $100, tip $30). Cheryl said she wants to be in movies, so I told her she'd have to lower her voice, like Betty Bacall did—talk from the lungs, not from the nose. She said that people like her the way she is, though. They'd let their limousine go, so they walked home.

Wednesday, February 21, 1979

Before I left the office Mrs. Neil Sedaka called and invited me to a party for Neil, so I cabbed up there ($5). Everybody was thrilled I came. When I saw Neil, I couldn't help it, I like him so I told him he was just too fat to have his portrait done and that he *had* to lose weight. I just can't face painting him so fat. He said that fat was his image, that people like him fat, but I mean, I'm sure he overeats. He said he'd just had three vodkas. Maybe I went too far. I'm supposed to do him next week.

Saturday, February 24, 1979

Got up early. Brigid called, she was all the way up to 150 pounds. It was warm and rainy outside and I wanted to go down to Heiner's gallery early so I could pass out 1,000 *Interviews* that afternoon (cab $6). Got there about 12:30 and I started working. I can't believe that I actually gave out 1,000 but I did. Rupert and the Du Pont twins came by and for a break I took them and the gallery kids over to Robata, the Japanese restaurant around the corner ($90). Left the gallery around 6:30. A girl who said she went to high school with me was there and she'd brought a copy of the school yearbook and asked if I wanted to see it and I told her I'd like it better if she didn't show it.

Sunday, February 25, 1979

Went to church, bought batteries ($12.22). Cabbed to U.N. Plaza ($3). Truman was having a lunch for Buckminster Fuller—Bob MacBride just did an interview with him for *Interview*. He's eighty-three, he can't hear so well, he was cute. Truman looks great. He's going for hair transplants this week. He's going down to Georgia to do an interview for us, but he won't say who it's with. I issued him a tape recorder and a camera. Two travel agents were there and Bill Lieberman, the curator of drawings and prints at MOMA for years, he's an old friend.

Monday, February 26, 1979

Cab to Chembank ($4). I worked all afternoon painting faces' backgrounds at the office. Joe Dallesandro called from Paris. He says he drinks a bottle of whiskey a day. He wants money, and I don't know what we're going to do with Joe. We were warned he'd call because Terry Dallesandro came by the other day. She's still living on Staten Island, and she looked good, she had makeup on. She said Joe wasn't sending her any money. I wonder if she's on welfare? Little Joe wasn't with her, he was in school. He's eight now. She still doesn't have any interests. She said she never even picks up something to read, and she said she can't really do anything, she doesn't even know secretarial stuff, and she only has a tenth-grade education. I asked what little Joey was interested in, and she said he was *(laughs)* taking karate lessons.

Joe said that he had a "film on the fire," but that's what he said the last time. Oh, and Terry said that six months after Joe's brother Bobby hung himself, another boy who lived in that same foster home on Long Island that Joe and Bobby grew up in also committed suicide.

Rupert called—both of the Du Pont twins have moved in with him on White Street.

Thursday, March 1, 1979

Walked to the office and I ran into John Head and Lorne Michaels coming in for the meeting that we were having with them to talk about a TV show. They said they'd give me a show if we could give him the right look. I think they just wanted to come and get ideas, though, because when you do a TV show, you do run out of them. But unless you're the producer of your own show you never make money so I think we should start at the bottom and do it ourselves and learn everything that way.

Went home and changed and cabbed to the Plaza ($2) to meet John Fairchild, Jr. and Belle McIntyre, and William Pitt and Rupert (drinks $70). John had invited a bunch of fairies so that he wouldn't have any competition for Belle. They have a strange relationship—I don't think he's going to bed with her, but he somehow feels that he is and gets jealous.

We walked to Regine's. It was so beautiful out. Belle started dancing with one of the twins and John got so jealous and he was going crazy and I just tried to hold him in my arms—he was so schizo—and then William Pitt said that the only way to stop it was to leave, to go to Studio 54. So we did (cab $4).

Friday, March 2, 1979

Brigid was eating and eating and when I tried to stop her we had a confrontation. She said, "I'll eat whatever I want to and don't try to stop me, I'll go over 150 if I want." So then I just took all the food and lined it up next to her on the table and told her, "Go ahead. Eat."

Went uptown to a meeting with Bob Guccione. He wanted to talk to me about photographing nude girls for twelve or thirteen pages. He lives in a sort of Renaissance Italian place on East 67th Street. It looks awful. Everything looks so dirty, that look, that feeling.

Sunday, March 4, 1979

One of the Du Pont twins told Susan Blond that he's so in love with me. He told her all these nutty things, and I mean, all I do is *(laughs)* hold his hand and feel him up.

Then Jim, the agent or manager of the Beach Boys—he's interested in art—invited me to the Beach Boys concert at Radio City, and I invited Tom Cashin. Then the phone rang as I was leaving, and I thought it was Dennis Wilson when he said, "It's Dennis," but then five minutes into the call I realized it was Dennis Hopper when he said, "The Beach Boys? They're in town? Where're they playing?" I told him to meet us at Radio City (cab $3).

I was sitting having fun with the kids on one side of the stage and then Dennis Hopper called me over to the other side where he was being crazy and silly with the girlfriends and wives. Groupies, really. It's so funny to see groupies in their thirties—their *late* thirties.

I slipped out at intermission and then later on someone told me that they made a big announcement from the stage that I was there, so now they must hate me. We were going over to Laurent, where Dali had invited us for dinner, he had about forty people there. He's really generous with these kids. Then the kids wanted to go to the Xenon party for Pelé. New York is so filled with Brazilians that it's like Carnival here.

Monday, March 5, 1979

Went to Mercedes Kellogg's lunch for Ralph Destino of Cartier's. Gossiped about Barbara Allen. She was spotted down in Florida or Barbados with Bill Paley. One of those places. Nicky Vreeland saw them and told Diana, and Diana told Bob. I was back home at 12:30 and I passed out because of the heavy rain.

Tuesday, March 6, 1979

I cabbed down to Union Square and handed out *Interviews* (cab $4). And then I walked over to the office, 1:00. Neil Sedaka arrived and he's just adorable, he's great. We had Jane Forth there to do the makeup and little Emerson was with her. Neil posed, and it was hard to get a good picture, his face is so fat. We worked an hour on it.

Thursday, March 8, 1979

Jean Stein called Brigid at the office, she wants to interview her for the Edie Sedgwick book that she's still doing. It's such a camp now, she's got like eighteen people working on it—she has George Plimpton editing it. So she called Brigid and Brigid had Robyn Geddes say she wasn't there, and then Dennis Hopper called a few minutes later and Brigid took that call and they were talking and Brigid was putting down Jean Stein saying she was pestering her, and it turns out that Dennis is staying with Jean. Then later on Viva called from California and started trouble—she

told Brigid that if Brigid didn't cooperate with Jean that Jean would put everything horrible about her in the book and that Brigid couldn't sue because it was all true.

And Dennis probably hates us, too, because I didn't go to his cocktail party. I didn't go because I forgot, but I knew I was never going to go and that's why I didn't remember. But Dennis is wanting me to go to Mexico to meet some friends of his, and Dennis and his group always did know all the rich people, but they're so sixties and they're crazy.

I tried to work on the text for the photo book with Brigid and Bob, but every time I made a suggestion Bob would scream at me at the top of his voice that it was great the way it was and then Brigid would scream it was great, too. Bob raises his voice so much I really do think he's nuts. So I don't know what they want me to even read it for, anyway, since they feel they're doing such a wonderful job and that it's all so great great great great. So I left them alone with their greatness. Actually, it's stinko. I do like the title, though—we're calling it *Social Disease*— and the photographs do look really good.

Sunday, March 11, 1979

Finished the Joan Crawford book by Bob Thomas. She seems like she would have been a lot of fun, and really easy to get to know in the end. I wish we had remembered she was around.

Brigid called and said she's overworked. Truman's now got a tape recorder and he's doing all these interviews with everybody and Brigid has to transcribe them. I mean, he could be getting $70,000 to do big interviews like this, and here he's doing it for nothing for *Interview*, but then he keeps the copyright, so he'll be able to make them all into a book.

Watched *All in the Family* then cabbed to Judy and Sam Peabody's to see Nureyev (cab $2.50). Nureyev arrived and he looked terrible—really old-looking. I guess the nightlife finally got to him. His masseur was with him. The masseur is also sort of a bodyguard. And I didn't know this before I went over there, but Nureyev had told the Peabodys that if Monique Van Vooren showed up, he would walk out. He says she used him. But he's terrible. When he was so cheap and wouldn't stay in a hotel, Monique gave him her bed, and now he says *she* uses *him*. He's mean, he's really mean. At 1:30 the Eberstadts wanted to leave and I dropped them off (cab $3.50).

Monday, March 12, 1979

Went to Lester Persky's *Hair* premiere at the Ziegfeld. Then got into the limo and went over to the pier building where the party was and it was the biggest party in the world—they had trees hanging and the whole place looked like Central Park, but without the muggers. Elizabeth Ashley was there and she was sweet and adorable and friendly. She said she saw me at the Knicks game about a month ago.

Oh, and the weirdest thing. Oh, this was so ridiculous. This old man comes running over to me and kisses me on both cheeks and my lips and it was just disgusting and it turned out to be Leonard Bernstein, and he was carrying on, everyone was looking, saying he's been desperate to meet me for twenty-five years and that we had to get together and talk, and that we desperately

must see each other tomorrow. Really, everybody was staring. And then Doc Cox came and said he wanted me to meet his new boyfriend, so he took me away and then Leonard Bernstein found me again, and it was more of the same, and it was such a camp. I mean, I remember in Pittsburgh this friend of mine saying a queer conductor was in town trying to pick up boys, and that was the first I heard of Leonard Bernstein. And he was hugging me and kissing me more, then putting me down at the same time. Like he'd say a big compliment and then the next sentence would be a put-down. Things like, "I always wanted to meet you but everyone told me you're a creep." Things like that. I finally got away from him.

Wednesday, March 14, 1979

The BBC was at the office doing a story on Fran Lebowitz and then on us interviewing Jessica Lange (pastry $17, $2.77).

Jessica wants to be a serious actress. She's thirty and she's pretty but she has caps on her teeth, I think. They asked me where I found Fran and I said, "In the gutter." And then they asked me if I'd read her book, and I said no. I hope it came out right. What they were actually saying was that since she's so good, how come she writes for you. I asked Fran to help us interview Jessica, and she said she didn't do interviews. And then she didn't have her column for us, so we were upset. She actually did give funny lines, though, this time. She told Jessica she loved *King Kong*, and Jessica said she hadn't seen it. And Jessica said to Fran, "I loved your book," and Fran said, "I haven't read it."

Picked up Jed and Paulette Goddard and we limoed to the armory for the Cartier party that Ralph Destino was giving to celebrate the anniversary of the Santos Dumont wristwatch that he got Bob to help get celebrities for. Truman was there in his sailor's cap—he looks like he's lost a lot of weight. It's strange. It's as if they took his face and chiseled off some of it. It's not like he looks younger. It's just thinner. And his scars are all gone. The only one left is the one from the fold on his nose. And Monique Van Vooren was there, she said that Nureyev was coming. And I said are you sure, and she said, "Don't worry, if he's getting a free watch he'll be here." And right then he walked in. He really looks so old.

Mr. Destino spent so much money to get the airplanes into the armory—the wristwatch was invented for a pilot—and the whole party probably cost about $100,000, but it just didn't work.

Robyn Geddes's mother, Caroline Amory, was there, and Lynn Wyatt, and Joanne Herring. And Catherine was there, she's very fat but she looks beautiful. Like a sexy English fatso, a beautiful body, but all filled in. Like a jelly jar.

Paulette was wearing so much jewelry it must have been $3 million worth of rubies, and she was saying she wants to sell off her paintings, and she was saying how much money she had. She decided she didn't want the woman's watch, that she wanted the man's watch, and she told Mr. Destino and he said fine. The watches they were giving were $1,300 watches, and they gave eight of them, and I guess they cost them $600 apiece. Marion Javits didn't know who Mr. Destino was and she said to him, "These watches are crap," and he said, "I'm the president of Cartier." And so she was going crazy because she couldn't get out of it—literally going crazy. Finally I told her, "Well look, Marion, it'll be a memorable evening for him—he'll never forget it."

Bob and I took Paulette home. And Bob was gushing and sentimental and telling Paulette he loved her, and so just to make things lighter I said, "Gee, Bob, you never tell me you love *me*." And so I go home and fall asleep and the phone rings and it's Bob saying that he's never said so but that he does love me, and I mean, what's *wrong* with him? Is he flipping out?

Thursday, March 15, 1979

Paulette and I were in the *Post* standing next to the airplanes. The airplanes got lots of publicity.

I called John Fairchild, Jr. and invited him to *Elephant Man*, and he said he'd go, and I said that he'd probably cancel later and he said no, if his life depended on it he wouldn't do that. And then I got home and sure enough there was a long note, cancelling, saying that "a friend came unexpectedly to town." And I just don't know how to handle that. What should I do? Because I just knew he would do it. Should I tell him I never had tickets anyway, that I just wanted to see what he'd do? Should I tell him that? Or just say I didn't care, or maybe I should go to the other extreme and make him feel really really guilty because I just know he feels terrible about it. He probably didn't sleep all night, but I mean, he knew he wasn't going to go and no friend came to town, so why did he say yes in the first place?

Elephant Man is *Equus* with an elephant instead of a horse, but I couldn't stand *Equus* so how could I like this? But all the actors are good.

After the play we went to Mortimer's to pick up Catherine. When we were leaving, Sam Green insisted we come and see his new place before we went down to Studio 54, and so we went there, and Sam's really got a great place. You open the door and there's these big stairs, and I was kidding around telling Catherine right in front of Sam that he was a big cocaine dealer and he didn't say anything, so now I don't know if it's true. It's the new kind of place—empty with nothing in it but a rug, and then that photo of him with Garbo at the King Tut thing. And Sam really does get around, he traveled all over with John and Yoko, talking to the Dalai Lama and things. Catherine broke her shoe, she really is fat.

Then as we were leaving, across the street there was a party for *China Syndrome* going in and they yelled to Sam, "Can Andy Warhol come to the party?" So we went over, and we saw Jim Bridges and he's really the hottest new director now. He said that Jack wasn't there—Jack Larson, our old friend Jimmy Olsen from *Superman*—that he was back in Hollywood. Jim is a big star director now, so he wasn't as friendly, he was acting more Hollywood. He's on Easy Street now.

Oh, and Bob was all upset in the afternoon because he was expecting Mr. Destino to call and give him a Cartier watch, but he didn't.

Friday, March 16, 1979

Cabbed down to Chembank ($4) then walked to the office. Fred told me I have to go down to Washington on April 6 to teach crippled kids how to paint, and I'm not looking forward to it. It's for Phyllis Wyeth. Fred went down to Leo's because Leo just sold a painting of mine, so that comes right when we have to pay more in taxes—it eased the blow for a second.

David Mahoney was giving a St. Patrick's Day party at Halston's. I picked up Catherine, and we went to the Olympic Tower (cab $3). Curley was waiting for us. He said he'd been invited, but he wasn't, really, he just got in using our name. The Kissingers were just leaving and I told Nancy I'd just met her aunt and she said, "Oh yes, the crazy one." We talked to Governor Carey and he liked Catherine.

It was wall-to-wall celebrities. Truman was there. Steve Rubell was not so friendly to me, he's being cool, somehow, I think because I'm friendly with Henry Post. Walter Cronkite said hello, he was cute, and he introduced us to his daughter who's an actress. And I met the kids of Mahoney who're good-looking now. The girl used to be heavier and dumpy, but now she's pretty. She was in the same green Halston as the year before.

Monday, March 19, 1979

Halston picked me up and we went over to Martha Graham's studio on I think 63rd, to watch her rehearse. Martha arrived and she's so great, so young. She has a guy who looks after her. Then we went over to Halston's for dinner. Martha's going to England to do a command performance, and to Egypt, and to Lisbon. Her Iranian performance was cancelled, naturally, but I don't see how she can do it at her age, it's so hard, traveling like that. We talked about cosmetic surgery. I remember somebody telling me once that when Martha was down and out, a kind couple took her in and gave her a facelift and then her career revived. Now maybe she'll get a hand operation, too, she said, because really her hands are just like little stumps.

I told her I saw her dance in Pittsburgh in 1948 and she said she was from Pittsburgh, and Halston was surprised, he didn't know that, he said they'd never really talked. Halston gives her clothes, and somebody else gave her money to redecorate, but instead of redecorating she bought one expensive thing instead of doing the basics, but she said it was just because she didn't have time to do the basics, that she'll get to it. Halston served caviar and baked potatoes. And when Halston serves baked potatoes and caviar, it's always with like a pound of caviar. I don't know if it's really caviar these days, though, because with all the trouble in Iran, where can they be getting it? They may be just making it up.

And the Du Pont twins called me at Halston's, they were calling all over town for me, and I wouldn't take the call, and then they had the nerve to ring the doorbell and they were drunk and giggling and I went to the front door and told them off.

Oh, and Halston's mad at Bianca because she never arrived from London, and it was supposed to be Mohammed's day off and Halston had him wait at home all day, and when he called her in London she said that she had food poisoning, but he didn't believe her because he'd heard her use that excuse over and over again on other people while she was staying at his house.

Tuesday, March 20, 1979

Fred saw *Cocaine Cowboys* and he thought it was just terrible, he said he was so embarrassed for me. But then I don't know, Fred doesn't know what's good with movies.

Friday, March 23, 1979

I stayed uptown because I was going to Brady Chapin's at 225 Central Park West for lunch, it was a cute little building. It was a reunion for Scavullo and Nancy White and me, because we used to work together at *Harper's Bazaar*. And John Tesh came, the 6'4" newscaster on channel 2, and he's so handsome. He didn't eat anything, and he brought a girlfriend. Brady knows him from jogging in the park.

Saturday, March 24, 1979

Got up early. Thomas Ammann called and he picked me up at 10:30, he wanted to see the new New York things with me. We went to some shops, it was fun (kitchen supplies $50). Then went home and glued myself for Fiorucci's, went there at 1:30 and began signing *Interviews* and I was there all afternoon. Paulette showed up and Keith Richards and Ron Wood, and it was the first time I was seeing them in the daylight and they looked so old and beat-up. Their girlfriends looked young and fresh.

Paulette was sweet, she said she does all her shopping there now. The kids who were waiting on her didn't know who she was. It's so strange to be famous in one category and then other people don't know who you are. But I explained to them that she'd been married to Charlie Chaplin and they connected with Charlie Chaplin. I was there until 6:00 and then took some of the kids to Reginette ($70).

Sunday, March 25, 1979

I have to go to Monique Van Vooren's party at Studio 54. She called a few weeks ago and invited me to her party, but I guess in an abstract way she was telling me she wanted me to *give* the party, because when I asked her when it was, she said, "Any day, at your convenience"—that was how she was inviting me to the party, but I didn't get it. Then she gave the same pitch to Bob and he got the message and explained it to me.

Monday, March 26, 1979

It was a nice day but colder. I went out passing *Interviews*, and I stopped in at Primavera and ran into Audrey the owner and decided she would be a good person to go around to the new places with and to learn about new categories from, so we ran around town and we had fun. Audrey said that a lady brought in a Castellani and she gave her $100 and now it's worth $10,000. Well, that's what you do, that's the antiques game. If it's an old person selling it you give them a break and give them a *little* more, but it's like if you go to a flea market and you see something that's really worth a lot, and the person selling it doesn't know—you don't tell them. And categories disappear. It's like Deco—you hardly ever see a Deco piece anymore. People just get them, and

then they put them away, and they're all collected up, categories go (catalogues $8). Then we were in Suzie Frankfurt's neighborhood, so we rang her bell. Suzie looks good. She's in sort of a floozy look lately—her hair frizzled and pulled back on one side. And really really big shoulders. Extreme. That's how she looks best. And she looks really rich.

Tuesday, March 27, 1979

Brigid called and said she was freaking out, she said she feels like a garbage can—she was over 152—and she doesn't know what to do, and I told her she should go to church and pray to God.

Friday, March 30, 1979

I cabbed up to Parke Bernet where I was meeting Suzie Frankfurt and Mark Shand, but it was just Suzie, it turned out (cab $2). Suzie wanted to go to 47th Street, so we cabbed there ($3). Suzie said all the good antique jewelry is in London, but then we ran into a guy from the Philips Gallery in London buying something on 47th Street, and he was bringing it back to London, and then Suzie goes *there* and buys it and brings it *back*. He said he comes over here all the time to buy things.

Saturday, March 31, 1979

Went to Studio 54 with Catherine and Stephen Graham. Catherine had also invited Jamie Blandford, the good-looking marquis who'll be the next Duke of Marlborough. Jamie introduced me to Gunther Sachs's son—it must have been from before Brigitte Bardot, he looked in his twenties. The place was crowded, it was like a subway. Stevie came over and told me a couple of stars that were there, but I can't remember who they were. One was "the new Shaun Cassidy," a blond kid, Leif something, he's making millions, they say. Garrett. Then I had John Scribner talking in one ear about John Samuels IV, and in the other ear Cindy the Hustler from Columbus talking about John Samuels IV. And she was jealous because he'd dropped her for Larissa.

Studio 54 was a lot of fun. I went up in the balcony and Halston was there with Lester, and if you say, "This is Lester Persky the producer of *Hair*," these boys just get down on their knees. They absolutely get down on their knees. And then Halston invited me to the next night's birthday party for Victor. Jamie wanted to go to the basement, but Catherine and I didn't go with him.

Sunday, April 1, 1979

Jamie called and said everybody down in the basement at Studio 54 was in different corners, having coke. They're doing it there again. I was giving Victor a Money painting for his birthday

and money in the kosher pickle jar that makes a burglar-alarm noise when you open it. When Catherine and I got to Halston's there were just a few people there, just sitting around—Halston, Nancy North, Rupert and his boyfriend who lives with him. Victor wasn't there yet. Halston showed me the birthday cake and it had money all over it and Halston was going to burn the money, but I said no, that everybody should get the money with a piece of cake when you cut it, so Halston made flowers out of the bills for on top of the cake, he really is clever. Then Victor arrived in the green Halston fur coat that *Interview* photographed Sophia Loren in. He brought his Chinese friend from San Francisco, Benjamin, the one who was in drag the other night at Xenon and he really looked like a pretty girl.

Arman and Corice were there and they gave Victor one of those language computers that have different tapes and you push good morning and it shows you *bonjour*. Victor wasn't too impressed with any of the presents, and instead of cutting the cake nice with each piece having money, he grabbed up all the bills and put them into his shopping bag. He was disgusting. Catherine and Dr. Giller were making out.

Everybody hands me Quaaludes and I always accept them now because they're so expensive and I can sell them.

Thursday, April 5, 1979

Picked up Catherine and we went over to Regine's. Paloma Picasso was there with her husband and her boyfriend. Or his boyfriend. Or their boyfriend, I don't know how that one works. Neil and Leba Sedaka and their two little boys walked in and Paloma fell madly in love with Neil. She said when she was ten, in Argentina, that they used to sing "Sweet Sixteen" in Portuguese and Spanish, and then she sang it for Neil that way and he loved it, he was so impressed with her.

And Regine was cute, she now has a "back room." Everybody wants one just like Studio 54 has—Xenon copied it, too—but as usual, Regine has it all wrong. Hers is too big and too plush and too far away from everything.

Monday, April 9, 1979

Fereydoun Hoveyda's brother, the prime minister under the Shah, was hanged in Iran over the weekend.

Everyone's in town for Cy Twombly's opening. And I'm surprised that I wasn't invited to the dinner that Earl and Camilla McGrath gave for him.

Glued myself to go to the Whitney for the Cy Twombly dinner. David Whitney had called and said he and Philip Johnson wanted to pick me up, but I said I was running late and David said they always went on time. Cabbed there in the rain ($2). The show was great. Marilyn and Ivan Karp were there and Marilyn told me that the psychic she'd recommended to Truman who Brigid went to who was in *Interview* called Marilyn up and asked what about this Fred Hughes who wanted

to see him and was he "Fred Hughes the actor." She told him that she didn't know about any Fred Hughes the actor—that *this* Fred Hughes worked for Andy Warhol. I guess that's how they find out all about the person in advance so that when the person gets there for the reading they know all about him already.

Lily Auchincloss said she'd sent Mr. Hoveyda flowers because of what happened to his brother, and she asked me if I did anything, and I said no, because Bob was away and I didn't know what to do.

Tuesday, April 10, 1979

Christophe de Menil invited me to a blues concert at Carnegie Hall (cab $4). I invited Curley and he met me there. The place was jammed. Allen Ginsberg gave me a big kiss, he was with Peter Orlovsky. We had good seats. Everybody loved the show. Blues could really be big now. The black blues guys are such gorgeous dressers—hats and beautiful clothes and gold teeth that you can really see, and jewelry, and they just let people *do* things for them. They must be really big stars.

Curley was obnoxious—he called some boy to come and meet him, so I got mad and I'm never going to take him anywhere again. He's just a rich freeloader.

Wednesday, April 11, 1979

Time magazine called and said they accepted my design idea for their cover of the three Fondas. It has to be done by 4:00 Thursday. They were going through their old covers and saw that I'd done one of Jane. I sent Rupert out to get stats and he didn't come back with the stuff until 7:30 so I yelled at him. Bob got back from California in the afternoon. He said he'd gotten the John Savage interview, finally, so that's really great. He said he's never given an interview before, so now maybe we'll be able to get the heavier types who say *Interview*'s too frivolous.

At Ahmet and Mica Ertegun's party I played backgammon with Ahmet and lost four paintings to him, we'll have to see which ones.

Thursday, April 12, 1979

The Du Pont twins were at 860—Richard and Robert—and Brigid and I were trying to figure out how they got there, and Brigid finally found out that *Fred* had invited them! And Brigid took Richard home with her and gave him $25 to clean the stove, and then she spent all night eavesdropping while he made plans on the phone to go to Studio 54, arranging to have his brother iron his light green pants—Robert irons for Richard, because that's the only thing he does really well. He's the twin who lived with Rupert and left Rupert for Fred.

And Truman came down to the office. He loved the new title for our photo book, *Over-Exposed*.

Bob got that title out in California when he talked to Irving Mansfield. I like the title *Social Disease* better, though, because if we're not going to be commercial anyway, we might as well always be something that people will avoid.

Truman's facelift is the first one I've ever seen that really did work. His chins are totally gone, and they were just hanging there for years. The only thing that's wrong is that the scar over his nose is still two inches thick. I think that one was a mistake. Since the operation he wears a piece of plastic over it, and he could have just *(laughs)* done that in the first place. Oh, and Truman asked for the originals of his articles back, and we were trying to keep them. I'll try to give him a Xerox.

Cabbed back to the office ($3) and everyone was waiting for me. Lloyd called, the Mafia-type kid who worked at 54, and he wanted to have dinner with Catherine and me. He said to meet him at a place called York's on 38th and Second (cab $4).

York's was a funny little place. Then we dropped Catherine and cabbed to Regine's ($3). I think he had a Rolls Royce parked near York's but I don't think he wanted us to see it. He said he wanted to meet Regine but when we got to Regine's he knew everybody. He knows everybody everyplace, and it's so strange, he's so young—eighteen—but he acts like forty. I had half a drink and he had three more. Then he told me he was bi. And that got me scared because I always thought he was after Catherine, but then I didn't know. He told me about his family. He said his father works for Roy Cohn, but he sounded more like a money collector to me. He said his "pop" gets up at 6:00 and goes to the post office every morning to pick up the money that's come in from the debts he makes people pay up on. He has a seven-year-old sister that will be a beauty, he says—he buys her presents.

Regine's husband came by and I introduced them. Then he didn't charge us. And then Lloyd still wanted to drink some more so he said why don't we go to the Playboy Club, so that sounded like fun. He likes Bunnies. He has a philosophy about women—he only likes them if they're very beautiful. He's Jewish and I asked him why he wasn't home for Passover and he said they aren't religious. At the bar three guys were staring at me, but it turned out they worked at "21." It was strange. Lloyd had two more drinks. He said that his mother is beautiful—she's only thirty-eight—and that she never wears a dress twice, or shoes, either. He wants to take us to a really great restaurant in Westchester. He said, "It's better than Elaine's." Isn't that funny? Of all the places to pick. "Better than Elaine's," he said. "If you don't think it's as good as Elaine's I'll take you to dinner for a year, but you have to be honest."

Oh, and Steve Rubell got taken to jail. It hasn't been in the news yet. It was for fighting with some photographers. Lloyd said the only time Steve ever hurt him was when Steve was on Quaaludes and Lloyd said, "Gee, Stevie, I'm glad you like my mom and pop," and Steve said, "I don't. They're nothing. They're nobodies—it's you I like." He said that really hurt him. This was when he was driving Steve home once.

Friday, April 13, 1979

I was reading the Margaret Trudeau book. She writes like Viva. If Viva had met interesting people in her life, she would have written a book like this.

Went to the Copa for the Mork show. Robin Williams. He was terrific. Jed's sister, Susan, was

our waitress (tip $10). Then Mork's wife invited us to the Sherry, so we went over there and Lucie Arnaz was there, too, and everybody was sitting around a big table of bagels. Mork has a hairy chest and arms but pretty blue eyes.

Monday, April 16, 1979

Did I say that the other night Nureyev was in Elaine's? I never know what you're supposed to do there when you see somebody. Be very cool so you don't bother them? Or should you throw your arms around them because I mean it *is* great when Diana Ross does it.

I didn't go to Steve Rubell's getting-out-of-jail party. In the paper it said that while he was in his jail cell he wrote his diary on Studio 54 cards that he had in his pocket. Isn't that great? He said the cell was disgusting and that the first thing he'll fight for is jail reform.

Tuesday, April 17, 1979

Called Mork's hotel. They said to come right over. Cabbed to the Sherry ($2.50). We thought they'd have a limousine because there were twelve of them but then we had to get three cabs down to the Village. They wanted to pay for the cab, but I did ($6). We met on Christopher and Bleecker and then went to a used-clothes store and they had a good time. Mork can tell in a second what will fit him. He picked out three suits and he put them on and they fit perfectly. His wife's name is Valerie and she's really nice. She said she'd been down to Bleecker Street already that morning and gotten French provincial furniture that morning to send back to L.A.

We went though the back streets, and it's funny—when kids see Robin they just say, "Hi, Mork" without getting excited, it's like seeing somebody they know. It's the grownups who get excited. We walked over to Lady Astor's. Then we went to meet Michael Sklar, who I haven't seen in years who was in our movies *Trash* and *L'Amour*. He looks thin in the face. He's a friend of theirs.

Robin's going to do the Popeye movie. Sue Mengers just became his agent. Valerie said that when she saw Robin was going to get famous and they'd been living together for two years, she told him she didn't want to go through life and the newspapers as Robin Williams and Guest, so she made him marry her. They're nice and they're *(laughs)* "real." You know? So they don't have limousines. But a limousine would have been so much easier.

Did I tell the Diary about Henry Post's bad accident? He was driving his new car out to Southampton and he woke up in the hospital. He doesn't remember a thing. He hit two poles. And then I slipped and said something dumb—which I shouldn't have because when you're on pills and painkillers and things you get paranoid—I said, "Maybe because of the exposés you write, maybe somebody sabotaged you."

Wednesday, April 18, 1979

It was a sunny day, walked over to Lexington, passed out *Interviews*, and then went over to the Russian Tea Room to meet Joan Hyler, my agent who's going to get me movie parts. She has John Savage and Meryl Streep for clients.

John Fairchild, Jr. called and invited me to see *Manhattan* on his father's tickets, but I looked in the book and saw I had a dinner at Alice Mason's. She's the real estate person in New York who got Carter elected president. Dropped Rupert (cab $4). Went to 150 East 72nd Street.

And I wanted to see her apartment, because after all, she's the big realtor, and when I saw it you couldn't believe it, it's just nothing, on a sixth floor with *(laughs)* paint peeling. Nothing special at all.

But it was a heavy-duty party. It was all big, tall, beautiful intellectual girls and old, rich bachelors. A room full of heavies. Bess Myerson, John and Mary Lindsay, John Kluge. Jaquine Lachman who was so thrilled that Mr. Lachman died, but now Rita, an ex-Mrs. Lachman, is giving her problems.

The daughter of Alice Mason brought me into her mother's bedroom where my Carter portrait was and other photos of her with Carter. They had funny art around the house. At around 12:15 I slipped out.

Thursday, April 19, 1979

Had to go to the memorial service for Ambassador Hoveyda's brother who was executed in Iran. Cabbed to Riverside Drive ($2.50). Everybody was there. We took our shoes off. There was a rug in the middle of the floor and no one wanted to step on it because it was like stepping on the body because there wasn't a body there. There was Iranian music. It was like the best cocktail party but with no drinks.

Steve Rubell's suing Ron Galella, I read in the papers—for starting a fight at Studio 54, he says. And I'm invited to Ron Galella's wedding on Saturday. I think I'll go.

Friday, April 20, 1979

Talked on the phone to Henry Post. He's getting better. They restructured his nose.

Tuesday, April 24, 1979

The papers were full of Margaret Trudeau walking off the *Today Show*—she really knows how to get the publicity—and then showing up at Studio 54.

Cabbed downtown ($3.50). Passed out *Interviews*. Walked over to the office where I was meeting

David Whitney and David White and Fred at 12:00 to go through all the portraits I've ever done for the show at the Whitney.

Sunday, April 29, 1979

Cab to Ruth Warrick's on Park Avenue. I was a little late. Lucie Arnaz had already left. I was standing there and this really good-looking guy came over and then I realized it was William Weslow who used to be with the Ballet Theater twenty or thirty years ago. I was introduced to him a few times and he always ignored me, he'd never talk to me because I was nobody then. He's a masseur now, Henry Geldzahler goes to him. He was fired from Balanchine in about 1970. He said that Balanchine said, "Listen darling, you're too old, we've seen you too much around, and you're through, darling. I hope you're not going to commit suicide, darling, are you?" And he said he told him not for somebody like him—he wouldn't give him that much pleasure. Balanchine doesn't like boys, he only likes tall girls.

So now he's a masseur. Dick Cavett uses him, too—he said Dick's sent him about forty people. He made me feel his legs and *(laughs)* I giggled.

It was such a weird party. When you go to places where people are sort of nobodies and you have to think of what to say to them, it's so hard. I met Kay Gardella, that's who I met. The newspaper television critic. And she's really fat. She's the fattest person I've met in years—most people aren't fat anymore, they're chubby. Nobody's really fat anymore.

Monday, May 7, 1979

Went up to Hoveyda's exhibit at the Bodley Gallery. Hoveyda had a letter in the *Times* yesterday about his brother, a letter to the new regime that said his brother didn't run away from the country like all the other ministers because he believed in Iran, and Hoveyda called it murder, he said that the new prime minister could look forward to getting murdered, too. It was a good letter (cab $4.50).

Bob had a big lunch where he got lots of Lee Radziwill gossip. Everybody thinks she was just too drunk to make it to her own wedding. In San Francisco. She left the groom waiting at the altar. But I think she's probably just depressed because she got so skinny that her chemical balance changed and she doesn't know what she wants.

Wednesday, May 9, 1979

The Du Pont twins came in and Brigid told them that Freddy von Mierers had called and put out the word that he was going to send the police after them if they didn't return his two sweaters. They turned bright red, and she told them not to come around anymore since they steal. Dropped Rupert (cab $4).

Thursday, May 10, 1979

222

It was another really hot day in the nineties. Paul Morrissey's out in California. He wants to do *Trash II* where Holly's an entertainer and Joe's living in the Bronx, still shooting up, and their son is selling drugs in school. Nelson Lyon's in town, he said he gave Paul the idea.

Saturday, May 12, 1979

Got up. Nelson called and wanted to know why I'd left Studio 54 so quick the night before—he said did I go to a "better party." Can you believe it? *(laughs)* The same old paranoid Nelson.

Halston and Steve Rubell aren't getting along so well anymore—there was a picture of Steve in the front row at Calvin Klein's fashion show.

Sunday, May 13, 1979

Went to church in the afternoon. I hadn't gotten any calls from John Fairchild, Jr. for five or six days so I tried calling him. Curley keeps calling, telling about his escapades at Studio 54.

Nelson called from Tarrytown where he's working on the trailer for *Apocalypse Now*. And Bobby De Niro says he might be able to get money for *Trash II*. Nelson's writing it with Paul.

Oh, and I've been running into Crazy Matty on the street a lot again. I told him to come by the office. I want to tape him and have that be my abstract movie. He said he's staying at the Grand Union Hotel on East 32nd Street.

Saturday, June 2, 1979

Truman called and he was so mad at Lee Radziwill for giving the deposition against him in the Gore Vidal lawsuit. It was so scary. He said she'd be "shitting razor blades" after he goes on *The Stanley Siegel Show* on Tuesday to "really let her have it." And he kept saying, "Well, don't you agree? Don't you agree? What's the matter, you're not saying anything." It was really horrible. He said, "She's going to wake up and hate herself. Don't you agree? Don't you agree?" And I said, "Well, Truman, she's so weak now, she might commit *suicide*." And he said, "Too bad." He said, "If I told you all the things she's said about *you*. . . ." I said I didn't care, that I never thought of her as a friend, that I've always known what kind of a person she is, that she was just somebody who was renting our house in Montauk, so whatever she said, it didn't bother me, I knew all about it already. It was scary how vicious he could get over someone he was best friends with. When Truman turns, he really turns.

And Halston's going to rent Montauk, we think. Vincent was out there this weekend showing the place to him. Victor was with him and I got scared about that, visualizing Victor painting red footprints all over the main house.

Sunday, June 3, 1979

Nelson called and told me the plot for *Trash II*: Joe's working in a pizzeria, and Holly wants them to move from the Lower East Side to a better place—*(laughs)* Lodi, New Jersey, the town with the chemical spills—but they don't have the money until one of the kids gets hit by a cab and they sue the cab company and they're able to buy a house.

Oh, and everybody seems to like the *Popism* manuscript. Bob and Fred and Rupert. They were reading it in Paris.

Tuesday, June 5, 1979

Watched *The Stanley Siegel Show* in the morning. Truman went into a "Southern Fag" character and began telling all the embarrassing things that Lee had told him over the years about people—that Peter Tufo looked like a ferret and was publicity-crazy riding on her coattails, and that Newton Cope who she's engaged to marry, still—even after calling off the wedding a few weeks ago—was "no great catch," except for maybe he would be, in a "provincial town." And he told how she tried to seduce William F. Buckley, Jr. by asking him for spiritual advice and then when he didn't respond she accused him of being queer. If Lee was drinking *before* this feud with Truman, can you imagine *now*? Oh, Truman's making such a fool of himself. He should at least be drunk.

Liz Smith called *Interview* to say that she was going to do an item on the channel 4 news show at 5:45 about our interview with the Mondale kid because of the part where he said that in the vice-president's house where his parents live now, when Nelson Rockefeller used to live there, he had a trap door put in that connected his bedroom with the guest bedroom.

Halston said he was all for Truman, that Lee deserved what she got. Then we were talking about Steve Rubell and Halston said that confidentially he thought Steve was going up the river. Then Steve arrived and said his lawyers told him he could get off if he gave evidence to the government about the Washington people that've come to Studio 54 and taken drugs and things. Then he went to pick up Diana Ross to take her to Studio 54.

Wednesday, June 6, 1979

Truman called and told me that all the Washington papers and the California papers had his thing on the *Siegel Show* on the front page. But the New York papers haven't really played it up.

Daniela Morera gave me a black linen Giorgio Armani jacket and it's too small, but it's beautiful, no lining, the way the Italians are making them now.

I had to autograph a copy of the *Philosophy* book and I was rereading it and I wonder why it didn't make it big—it's got a lot of good lines in it.

Thursday, June 7, 1979

Truman called. He said he got a telegram from a fan congratulating him on *The Stanley Siegel Show* saying that it was the best thing on TV since Ruby shot Oswald. Steve Rubell said that his flower guy was at Lee's to deliver and she wouldn't answer the door.

At home I put on my new black linen Giorgio Armani jacket. It's the stiff fine linen like what used to be under crinolines.

Anyway, the big party Studio 54 gave for *Interview* last night got ruined for me because Jed had trouble at the door with Mark, the doorman. And I mean, it's confusing, because Steve said he let Jed in, but Jed says that Steve *saw* him and *wouldn't* let him in.

Sunday, June 10, 1979

Worked at home. Went to church. And I'm just remembering, John Fairchild, Jr. told me that William Pitt went to an EST conference in New Hampshire and flipped out and now he thinks he's God. He'd already gone through EST and this was like a refresher course, and it was supposed to last for eight days but he flipped out in one. Pepe Balderago was with him there and confirmed that he absolutely flipped out and "realized he was God" and left. So when I went downstairs at New York/New York and I saw him, I said, "Hi, God," and he called me a genius for knowing. And it's true, he actually does think he's God. So I walked with Pepe Balderago and God over to Studio 54. I talked with God as we walked. When we got to Studio 54 I saw John and told him that God was on the dance floor, and he ran away.

Monday, June 11, 1979

As I was talking on the phone to Brigid, they said on TV that they might come on with a news bulletin, but then they didn't, and then later on the regular news they said that John Wayne died.

Tuesday, June 12, 1979

Cabbed down to Chembank ($3.75), walked around Union Square then went to the office. Oscar de la Renta and his friend Jack Alexander, who does the advertising, were there. It was a business lunch to talk him into advertising in *Interview*. Bob was telling Oscar that young kids don't know about him. Oscar reminded him that Jerry Hall was young and *she* wore his clothes. And Barbara Allen stopped by and she came and sat down and she made the lunch more interesting. She's going to Maria Niarchos's wedding, and she talked Bob into going over for it, too.

A lady Ivan Karp sent over came to see if she wanted to have her mug done. If you closed your eyes you'd think it was Lee Radziwill talking, so I guess she went to the same school as Lee and Jackie. She said her original idea was to have Scavullo do a photograph, and since that was

going to cost $5,000, she thought why not go all the way and see about a Warhol portrait. I doubt if she'll ever get it done. I think she just wanted something to do for the afternoon. Then Oscar left and Brigid and I rushed out and went to Mays to get some supplies for the office ($11.55, $22.68). It was such a beautiful day. Then rushed back to meet Famous Amos the cookie man. He's good-looking, sort of like that black record guy who managed Nico at first—Tom Wilson. But I do think he has chops. His teeth looked too perfect. He doesn't look good-looking on the package, though, because the picture makes him look like a pickaninny. He brought his white girlfriend Christina—they live in Hawaii. And he brought his son Gregory, about sixteen or seventeen. While we were talking Amos ate some cookies, but I'm sure he must be so sick of them. I asked why the cookies inside don't look like the ones on the package and he said because it took too long to bake to make them look like that.

Ran into Pepe Balderago who said he just doesn't know what to do with Bill Pitt, that he's still flipping out thinking he's God. And so Pepe called Bill's father and said, "Look, you're the family, you have to put him in the hospital." I told Pepe to take him to a steambath—in case it was LSD in his system, to sweat it out—and then he said he'd tried that but Bill wouldn't go in when they got there.

Wednesday, June 13, 1979

Bill Pitt called and he thinks I'm Walt Disney. I told him he should get some rest, really go to bed and stay there for a while. Curley called up and invited me to his birthday party. I called Henry Geldzahler to invite him because he said he wanted to go. I couldn't get Curley back because his father'd given him a box to answer calls.

Vincent called Doug Christmas and he's so awful. They swear up and down that the check was sent and give you the bank number and everything and when you call back they're "out to lunch." The girls at his gallery there must feel horrible having to say things like that. If he'd just say, "I can't pay you," you'd know where you stood.

And Philip Niarchos is still going with Manuela Papatakis who I never liked at first, but she's really sweet and classy—one of those short girls who make themselves look tall. You know, they wear those high shoes and I just don't understand how they walk in them, you're always on your toes. I've put some on and that's how I don't understand it.

Bob Weiner called and accused us of having an anti-Semitic newspaper because of some line in Truman's interview about stuffing all Jews and putting them in the Museum of Natural History. He said he'd read it to five people and they all agreed.

Thursday, June 14, 1979

Henry Post called from out in Long Island where he's still recovering from his car crash. He said that his bones were all set and he'd gone back on crutches but then when the doctor was examining him he suddenly flipped him over and by mistake rebroke every bone that'd been set. He's in terrible pain.

And Pepe Balderago put Bill Pitt into St. Vincent's Hospital, he's really out-there.

John Fairchild, Jr. called and invited me to go roller skating Friday night.

Cabbed to Pearl's for Curley's birthday ($2).

We had a round table with ten boys at it so I had to tell Pearl it was a stag office dinner. Everybody was blond except for Henry Geldzahler and me who were grey. Henry was being very funny, showing his commissioner's badge, and it was one one-liner after another. He's so funny, so bright. I took pictures. Then we went over to Studio 54 and my birthday present to Curley was getting them all in.

Friday, June 15, 1979

Some kid I met asked me if I could get him and his friend into Xenon that night and I said oh sure, that it was so easy. So when I got to the office I called Xenon. I told the girl who answered who I was and she said, "You don't sound like Andy Warhol." I said, "Well, it is." She said, "How do I know it's you?" And this went on and it turns out she was just setting me up, I guess, because she said, "I'll call you back to see if it's you." So the phone rang and I said, "Hello, this is really embarrassing, I mean ..." And she said, "Well, we had eighteen Angela Lansburys call this week, so ..." And I said, "Well, so what, I mean the place isn't that busy, and here I'm telling you about two cute kids who want to come and *pay!* And one even wants to be a member, so ..." And then she said, "Just a minute, I'll have to call you back." So then in a few minutes she called back and said, "We decided over here that we don't want to ever see you again at Xenon." I said, "Whaaat?" She said, "We're all upset about what you did the other week." Meaning the party *Interview* gave at Studio 54 on the same night as the Xenon anniversary, which we didn't even know about until afterwards. I mean, I don't know if the girl's crazy and she was just embarrassed because she didn't believe who it was at first and had to prove something, or if she asked Howard Stein and *he* said that, because if Peppo Vanini were in the office I don't think he would be that mean, and besides, I think Peppo's over at Maria Niarchos's wedding. But I mean, they're turning away $30. It was such a shock, and then I realized that I should never call places myself. But then it could have been worse, she could have said, "Fine, send your friends over," and *then* not let them in.

So I *(laughs)* called the kid up and said, "You won't believe this, but I can't get you in— they told me they never wanted to see *me* there again, either. I'm sorry." And he was embarrassed. I guess somebody else would have made up some story, to save face, but I just told him.

Went to 55th and Broadway with John Fairchild, Jr. and Belle McIntyre. It's this brand-new roller skating place run by Negroes that nobody knows about yet, and it was great. They let us in free and gave us skates, which they don't usually do. It was great to skate, so much fun. I'm going to buy skates today.

Then we went to the Stage Delicatessen and had good Jewish Celebrity sandwiches. The "Diana Ross" was the worst, though—liver with jelly and peanut butter. Then we stood on the corner and John went to 54 with Curley and I dropped Belle (cab $4).

Saturday, June 16, 1979

Got up and called Curley, he was too tired to go out to Manhasset with us to the Brentano's bookstore where we were taking Blondie to autograph *Interviews*.

Barbara Colacello picked me up and then we picked up Rupert at the Pierre because it was near a subway stop. Then went over to pick up Blondie. She lives in the great building on 58th and Seventh. Blondie—Debbie—was sweet, her hair was fixed up, and you'd never believe she's in her thirties—no wrinkles and so pretty. She said her grandmother lived to be ninety-five and all her family looks young. She spends all her money on makeup. She must not have been pretty all these years, though, or I would have noticed her. She must have tried to look bad or something. But I guess some people look better, actually, when they get a little older. I didn't know what to call her. I guess I call her Debbie. But when I introduce her, I call her Blondie. But Blondie is the name of the whole group, so . . . She was really great on the ride out, she didn't complain about anything and she didn't want anything.

So we got to Brentano's and the thing was a big dud. The store didn't advertise that we would be there until that same day's papers, which didn't come out until one, and so even if people did read it they wouldn't rush down, probably. But the kids who came all came just to see Blondie, they didn't care about me, they were a whole new young crowd. What they did was go next door and get copies of her record and had her autograph that.

Then Debbie had to get back to rehearse for her new album. We got back around 5:00. After we dropped her, Rupert and I went for a late lunch.

We had aquavit and caviar ($70). We were getting drunk talking business, and we didn't pay attention when a guy next to us was down on the floor screaming, and finally he said, "Oh, can I have your autograph?" and it turned out to be John Lennon! And I just wished we'd noticed him before—he was with Yoko and her mother and it would have been so much fun. John's very skinny now. I don't know what kind of diet he's on, maybe rice. They live at the Dakota. Then I went home, and I was drunk so a movie was out. I really can't drink in the afternoon.

Thursday, July 19, 1979—Paris

Such a pretty day, walked around, stopped at Fauchon ($20). Went past the Beaubourg. Bought some magazines and *Vogues* ($8). Went by the Flore but it was closed. Made dinner plans to meet Anthony Russell and Florence Grinda at Castel's. He's still working on his rock and roll. Cabbed to Castel's ($3).

There were Florence and Anthony and Florence's brother and a big beautiful model named Margo. Mick and Jerry arrived. Mick has a beard. Jerry's wearing some pearls that he gave her. And he's making a record. They were talking about Anita Pallenberg's seventeen-year-old boyfriend killing himself on the bed. Jerry was in between going back and forth to Houston, working in the John Travolta movie, *Urban Cowboy*. She was thrilled about that, said John was just adorable. We all chipped in for dinner. Fred walked me home. Sat up reading, called Curley to find out what was happening in New York—he was off to Bermuda because his family's caretaker there died.

Friday, July 20, 1979—Paris—London

Up very early. Fred arrived at 8:30 A.M. and pretended that he'd been in bed and just gotten up. Later, he said he'd been with Jerry Hall and I don't know if he was kidding. He was so tired he fell asleep, I had to get him up at 10:30 because we had to pack and go to London. We had to buy some tickets ($600) at Lufthansa (tips $20, cab to airport $25). Took British Airlines, it was okay, a really big plane, jam-packed, one of those DC-10s, I think. Cabbed from airport to the Savoy ($30). At the airport while waiting for bags, we heard the people talking about Martha Graham coming in, that she's old, and they should send a cart for her. We waited for her a little while but she never arrived.

Checked in at the Savoy and Martha arrived with Ron Protas, they were coming in from Denmark. Ron is Martha's right-hand lady. So Martha and I stood there talking, it was fun, she was very tired. Learned Dr. Giller had checked in, tried to get him, but he was out. Liza and Halston hadn't arrived yet, they were coming in on the Concorde (tip to porter $5, room service $5). Read the Martha Mitchell book, slept an hour.

The rooms at the Savoy were small and dinky, on the courtyard, but not really a courtyard. Small. So expensive. Then Nick Scott, the good-looking rich English kid who was the butler of Bianca during the period when he thought he'd lost all his money, invited us to have dinner with him and his wife at the Savoy Grill—he's in the bucks again. Sabrina Guinness was at dinner, and she's been going out with Prince Charles a lot, and we think she fucked him. Fred met Halston in the lobby so he told him I would call him as soon as I could.

We had a really good dinner, the Grill was great, and Sabrina and I went up to Halston's room and I started taping Liza for her *Interview* interview. Steve Rubell was there with Randy and they had a bedroom and a sitting room, and Halston had an adjoining bedroom with Victor Hugo, and the next room was Dr. Giller. He had the prettiest room—it was purple and white overlooking the river, and it was fun to see everybody in a new place. Steve wanted to go discoing, he was carrying his portable radio around, turning it up and down. Victor was changing his clothes, putting on different outfits. Bianca was in another room with Peter Sparling, the dancer with Martha Graham.

Saturday, July 21, 1979—London

Got up early and checked in with the Halston crowd. Halston had a car and he decided to take us out sightseeing. Went to a couple of shirt stores with him. Then we wandered around, bought some film and tapes ($60). Then came back to the hotel and Fred wanted to go to the King's Road and I wanted to take Victor, but Halston didn't want to go with Fred.

We all went to Mr. Chow's for dinner. It was terrible food. Then we decided to do the discos. Halston was the most fun person on the trip. He would call up every place and say, "Hello, this is Steve Rubell, the owner of Studio 54. Can I get in free?" He was just camping the whole time—the tour guide. Bianca had to wear all her Halstons while he was in London, and she was unhappy because Mick had called her and had a fight about Jade. He said he can have more children and she can't, and she got insulted and said she could. They do use Jade as a prop, and

they make each other really unhappy. He wanted Jade to come over for his birthday, but Bianca didn't want to let her, she said it was bad publicity with the Pallenberg boyfriend's suicide.

Then we went to Tramps, stayed about half an hour, it was fun. Went to the Embassy. And at all the discos Steve takes on the role of being the host. The first thing he asks is: "Would you like to have a vodka?" They wanted to go to more places but it was about 4:30 so we decided to get home.

Sunday, July 22, 1979—London

The night before I'd talked to Catherine Guinness on the phone and she invited us out to her mother and stepfather's place in Essex—Kelvedon, a huge estate. Catherine really is on Easy Street. It was so beautiful. Drue Heinz and her husband were there. And Guy Nevill's parents. About thirty-five people for lunch. Then Halston, Steve, Victor, and Randy. Catherine's stepfather, Paul Channon, he's a minister in Mrs. Thatcher's government. He's a Guinness, too, but an even richer Guinness than Catherine's father. I sat next to Catherine's mother, Ingrid, and Halston sat on her other side, and Victor sat nearby. Really fun, lots of wine, got really drunk. Halston had to get back to London to Martha's rehearsals. Victor went back, too. Catherine gave me a tour. Beautiful. Steve played tennis and he plays really good.

After you see how rich Catherine is, it seems so silly that she should ever have had a dump in New York and worked at a regular job. It was wonderful, they showed us a good time, people were all so friendly. Lost my contact lens and Catherine helped me find it. It was lying on the sink, I was putting it in and it fell.

Monday, July 23, 1979—London

Went to some punk stores with Victor and Catherine, one was called Seditionaries. We got shirts that were made out of Nazi symbols and that you could tie yourself together with, And a T-shirt of two cocks pissing on Marilyn Monroe's photograph, saying the word "Piss." Catherine knew a little Italian restaurant where her family goes on Sunday. Nice Italian lunch ($100), and after that we got some flowers for Catherine's mother ($20) and Catherine took us to see her stepfather's mansion on Cheyne Walk. Whistler lived there once.

Victor and I went back to the hotel (cab $7). It was Martha Graham's opening at Covent Garden. We all got ready and met in Halston's room—John Bowes-Lyon, Dr. Giller, me, Randy, Steve, Victor—Fred went off with his date, Sabrina Guinness. Liza went on before us. We all had front-row-balcony seats.

They did three numbers and then Liza came on with "The Owl and the Pussycat." Then Martha gave a long speech, about half an hour. They were all wearing beautiful Halstons. Lynn Wyatt was next to Fred, then moved up next to John Bowes-Lyon.

Then backstage, hello to Liza and Martha, and then a little cocktail party in the bar part of Covent Garden. Covent Garden was very beautiful, it looked like the old Met. Then drinks, and then we all walked to the Savoy—Halston was giving a private party. We were upstairs and we

didn't know the party was upstairs *and* downstairs. The downstairs party had Princess Margaret and Halston, Liza, and everybody, and when we finally realized we were missing it, we went downstairs. Halston was nervous but his party was terrific, had the best time.

Victor wanted me to meet Princess Margaret, and I didn't but I got two pictures. Victor got two photos of Princess Margaret and Roddy Llewellyn. They didn't want to be seen together and they wanted to take his film away, but then Fred said not to, that Victor was with Halston.

Left the party about 4:00, went to Liza's room. She was wearing a really beautiful see-through fabric dress with her hair brushed back like her mother used to wear it—that's the way she wears it in "The Owl and the Pussycat." It was a wig but I couldn't tell.

Then Halston and I left Liza's room and we began taking everybody's shoes from in front of their doors and moving them to other places. The funniest thing I ever did. Then to bed and read a little bit more of the Martha Mitchell book.

Wednesday, July 25, 1979—London

Halston called and said he wanted to go to an awful lady's shop to see the jewelry. He's very grand, I was sure he was going to buy $50,000 worth of the jewelry but he was just playing. Victor was putting the jewelry in his mouth and in his ass and I was photographing it. He lay down on the floor and when he saw an electric surveillance eye looking down at him, he asked what "that ruby up in the sky" was. Halston asked for a discount and when they only offered him 5 percent he was shocked. They probably had the place bugged and listened to everything we said when they were out of the room.

Thursday, July 26, 1979—London—Paris

Got up early—had to pack, had to get everyone together. Halston was the leader and Steve just didn't know who to tip, he was just bad at it, being so ungenerous—he really is a cheapo. He *knows* exactly how much things are worth, he just doesn't want to give it—he wants to *keep* it, I think. I just can't understand that. After Halston paid his bill he screamed, telling the guy how dirty and unbeautiful and how did they really think a hotel could go on like this with service so bad. I asked him how could he do that and he said, "You've *got* to do that, you've got to always keep them on their toes and pretend you're rich, really really rich." He kept screaming at the place, and nobody wanted to give any tips. We snuck out because we're never going to stay there again, a dump. I mean, it was $2,600 for two people in two dumb rooms without even ordering up anything.

We got to the airport in time, the Savoy had a nice man waiting there to check you in. I gave him $15.

Got on the plane, very easy. Then we arrived in Paris, forty minutes away. Victor forgot to get his visa, so he was stuck at customs. We waited for him. Steve said, "Isn't that Jerry Hall?" She was just coming in from Houston from the John Travolta movie. It's Mick's birthday in a few

days and she was going to take him to some chic restaurant. Finally Victor got out of customs. Limo waiting there for us (baggage $5). Hotel Plaza-Athénée. Weather beautiful. Very beautiful best suite. The only thing Halston wanted to do in Paris was get his dog a piece of Vuitton. Luggage for Linda.

Victor fought with driver. He screamed and jumped out and said he'd never see us again.

Halston was fun buying shoes at Hermès, he said he never shops, which he doesn't—he really doesn't have time.

Limoed to Club Sept. Victor called me there and said he'd calmed down, said he'd come in a costume, but he came normal.

Then limoed to the Palace. Halston had called ahead and said, "Mr. Steve Rubell of Studio 54 will be coming by your club tonight—of course you'll want to let him and his party in free." I got the driver in with us because I felt bad for him because of Victor's fight. Victor got one of the waiters to loan him his outfit and so Victor went around taking everyone's orders.

Friday, July 27, 1979—Paris—New York

I'd just gone to bed at 6:00 but at 7:30 Halston was knocking on my door. He hates being away from New York and he wanted to get back, but it was a horror trip getting up. And the hotel was just so beautiful, it had the geraniums in the window and red awnings. And Steve didn't want to get up and go, either, but after a half-hour of coaxing he did get up. We had to sit and eat breakfast but it was torture. Victor had his own room upstairs that he'd gotten after having an agitation, and he was cranky.

Halston really enjoys screaming. When he's paying he gets so grand and yells and tells everybody off about how rotten the service is for what he's paying, and when he pays the bill he makes you feel—well, he's like *me*, only worse. He tells you how he has to go back to New York to slave so hard so he can make money so you can go on spending it all, and oh, God!—he makes you feel so funny about it. But then it *is* just incredible what hotels cost now.

Finally Victor and everybody was in the car and we got to the Concorde on time, and Steve wasn't tipping the driver who hadn't even slept, he'd been out with us all night, so I gave him a fifty.

As soon as we got on the plane everyone fell asleep. The stewardess woke Halston up and he screamed at her that she better not wake him up again.

I wanted to get the Concorde silverware, and I wanted to wake Victor up and ask him to ask for food so I could get more settings—I'm working up to a twelve-piece setting—but I didn't wake him up so I only got one set. It was an easy flight. Then we went through customs and the customs guy used to be a cabdriver who had me in his cab once, so he sailed me right through. Got home and went to the office. Cab fares had gone up ($4).

It was a hot day and when I got to the office nobody was doing a thing. Brigid was waiting for the cake lady from New Jersey to deliver a cake for her mother's birthday, she was taking it out to the country for her later on.

David Whitney called and said I had to get some of the portraits to Paris, and I called Fred but I couldn't get him. Worked till about 7:30 with Rupert. Read my mail.

Sunday, July 29, 1979

Do you know what Jean Stein did? She called up my family in Pennsylvania and wanted to go down there and interview them for her book on Edie—she told them she was doing "a book on the sixties." What *nerve!*

And I talked to Henry Post. His leg's still in a cast, but the car insurance company got him a nurse to type for him, that's what they do. We talked about John Berendt getting fired from *New York*—Henry said he knew it was coming because they hired a girl three weeks before they fired him. Henry says there's a list of people who bought drugs at Studio 54, that that's what the prosecution is following.

Curley called and wanted to go to dinner but I was too tired and exhausted, still.

Monday, July 30, 1979

Got up early and watched the *Today Show*. It was so great, so good to see good American TV again. Then I walked around passing out *Interviews*, and that was great to do again, too. I walked around midtown and then up toward the Pierre Hotel where the North American Watch Company was having Ronald Reagan speak at lunch. I was meeting Vincent there. I thought I was early so I stopped in Tiffany's. I thought they'd have cocktails for an hour first and then start about 1:00, but it turned out they got right to it, so when I arrived at 12:55 Vincent was pacing and we went in. Barbara Sullivan from the watch company was sweet, she introduced me to Ronald Reagan as "Andy Warhol, the artist." But the photographers were behind us, so they didn't get any pictures. Right next to Ronald Reagan was Harry Platt, the president of Tiffany's, and so I told him that the reason I was late was because I was shopping at Tiffany's. And he loved that. I was on a diet, so I just had steaks. Art Buchwald gave a speech, and he's really funny, he should be on TV. And then Ronald Reagan gave a speech and the Republicans are going to play it cool and let the Democrats fight it out among themselves and then Teddy Kennedy will probably take over. Ronald Reagan looks absolutely great if he's sixty-nine. He called Governor Jerry Brown "flaky." What does "flaky" mean? Then they whisked him off the stage and he didn't mingle, and I think that's terrible.

I worked till about 7:30 and then dropped Rupert ($4). I called Barbara Allen and asked if she wanted to be my date, and she said she was free. So at 8:30 we cabbed to Le Club ($4). When we walked in, Vitas wasn't so thrilled, he's been cold since the article on him in *Interview* came out because of the picture of him with no shirt with his arms around a guy.

Barbara was wearing somebody's pajamas, but it looked good. She's moving to California, she said. She showed me a necklace from Cartier that Bill Paley gave her, a gold one, and she says all these guys like Gianni Agnelli and Bill Paley are in love with her.

Oh, and there are so many Arabs in London. If only we could get Arab portraits to do. They haven't really come to America yet, but they're all over England. And they're filthy rich—if only we could get started on that.

Tuesday, July 31, 1979

Ron Feldman added Harry Guggenheim's name to the list of Famous Jews he wants painted for the series. We discussed doing Woody Allen and Charlie Chaplin, but we didn't know if Chaplin really was Jewish.

I went home and then walked over to meet John Fairchild, Jr. at Le Relais. Ralph Lauren was there.

John's got an older girlfriend now. So does Robyn Geddes. Forty-year-olds who boss them around (dinner $190).

Wednesday, August 1, 1979

John Reinhold gave me a platinum loupe for an early birthday present. But I couldn't tell him it had the wrong date inscribed—instead of 8-6-79 it said 8-5. Last year he did the right date.

Thursday, August 2, 1979

I sent Rupert to UPI to look for photos for the Famous Jews series.

At home I started watching *Brief Encounter* and at first I thought it was really good, but then I started thinking what a stupid story about a lady who would give herself a problem when she had a happy marriage, and it was just dumb and I hated it. And then Lisa Rance called and asked if I'd watched it and wasn't it beautiful so I told her off and hung up on her.

Saturday, August 4, 1979

Picked up Rupert down at his place on White Street. Rupert's trying to buy the building his loft is in. Actually it's two buildings—the one he's in and the one next to it. I guess Rupert has plenty of money or he wouldn't be thinking about buying buildings. His mother's from Palm Beach, but she just looks like a mother. When Rupert went in drag to a party once, he looked just like his mother. Rupert Jason Smith.

I went out and got cheese and candy for my birthday on Monday and then went back upstairs and worked with Rupert for about four hours. Then we cabbed down to Christopher Street ($2) and wandered around there seeing what's new.

Monday, August 6, 1979

My birthday. When I got to the office I cut the cake right away, so that I wouldn't have to do it in front of everybody. It tasted awful. Brigid ordered it from the woman in New Jersey. I told her to be sure it was a *wedding* cake. It was three tiers. In the end, though, it really wasn't big

enough. People came in and out all day and ate the cake. I usually ignore my birthday and order everyone not to mention it, but this year I was in a party mood and didn't want to fight it. I actually arranged the party myself and invited people over.

Jackie Curtis called me on the phone and Mary Woronov. Suzie Frankfurt came down and de Antonio came by, he looked a little skinnier.

Honey Berlin called and every time she finds out I'm a Leo she's surprised. Madeline Netter came by and was sweet and fun and then volunteered to help clean up and then we went over to 65 Irving. Fabrizzi gave us free birthday drinks. And then we cabbed to Brooklyn ($5) and had a steak dinner under the Williamsburg Bridge at Peter Luger's. Got home early.

Tuesday, August 7, 1979

Worked until 7:30. Halston was giving me a birthday party. He knew my birthday was the day before but I guess he just didn't want to have to do it on a Monday. It was nice, just for the kids from the office. Truman was there and D.D. Ryan told him that she liked the Siamese Twins interview he did with himself seven or eight years ago that was just like the one he did in this month's *Interview*, and he got very embarrassed and at first he denied he'd ever done one like it but then later he admitted that he had.

Ronnie came with a girl dressed as a nurse who's a bartender at the Mudd Club. Then out came the birthday cake which was a huge baked cookie, like a Famous Amos, only it looked like a big plop of shit, it was funny.

Halston didn't give me the kind of expensive presents he did last year, I guess he thought it was too hard to go through that and do it every year, so he broke the tradition and gave me twenty boxes. One had skates, another had a helmet, another had a radio, and then earphones, and then kneepads, and then gloves, and a *How to Skate* book. And Victor had his own skates, too, so we went outside and skated in front of the house. It was fun. Jane Holzer and Bob Denison came late. Then we ordered limos to go to Studio 54. Oh, and Steve gave me a good present. A roll of 5,000 of the new free drink tickets he'd just had printed up for the new year.

Wednesday, August 8, 1979

Commissioner Geldzahler called and said he was upset because Raymond was leaving town. Fred brought in the pictures of Liza and they were horrible. I mean, they were clear and sharp, but Liza's not fat and they made her look fat, and like a drag queen. The expressions were wrong, too. Richard Bernstein's going to have to do a big creative job on them for the *Interview* cover.

Later that night we cabbed to Studio 54 ($4). Steve was at the door and he said that Valerie and Robin Williams were inside and he brought me over to them. There've been stories in the papers that they were getting divorced, but Valerie said it wasn't true. Cheryl Tiegs came in with Peter Beard and I guess she wanted to have her picture taken with Robin but Valerie said no, no pictures. Valerie's very tough, she runs things, and then she turned to me and asked if I thought it was okay that she was that tough, if she should be. She said that Robin was invited to Fire

Island for the weekend but she didn't want him to go. She said, "It would be too big a strain on both of us." So then I thought that maybe she's afraid he could be a fairy. She said she wanted them to go someplace like Nantucket instead.

I introduced her to a cute waiter named Robert who wasn't working, and she seemed sort of hot for him and they danced but then she got nervous—maybe she'd just wanted to get Robin jealous for a minute. He's still wearing the clothes we bought that day down in the Village. He's got such a funny-shaped body.

Steve was smoking a joint and when the person who gave it to him wanted it back, Steve started screaming.

Sunday, August 12, 1979

I'd taken the *Popism* manuscript home with me to read and so I worked on that all afternoon and then called PH and discussed it. Went to church for a few minutes. The weather was awful, it was pouring.

Friday, August 17, 1979

Went to the Gulf + Western building for a meeting with Paramount Pictures to do the poster artwork for the movie *The Serial*. I didn't realize it was such a big meeting, I was fifteen minutes late and there were twenty people there. Fred was there with a hangover, really sick, so he was no help. The guy—his name was Cohen with a "K"—Kohen, he pointed out the window, he had a corner view, and said, "You've got to do a good job so I can keep the office." He kept saying, "I'll know it when I see it." It was so old-fashioned.

After we left the meeting Fred and I walked a lot because he felt so sick. We thought that it wasn't really a good thing to do, so he'll just tell them a really high price, and if they say okay then I'll do it.

Read in the *Post* that Truman lost round one of the court battle with Gore Vidal, the million-dollar lawsuit. The judge decided not to throw it out of court.

Monday, August 20, 1979

Cabbed to Irving Place, got out at Gramercy Park ($1.50). Saw a squirrel eating a nut. Went to 65 Irving and de Antonio and his wife were already there. We asked him to write for *Interview* and he's going to find someone to interview.

While the lunch was going on, the owners of 65 Irving were interviewing for new waiters off in a corner. Left lunch about 4:15 (lunch $67).

Ran into Barry Friedman on the street and he gave me the cold shoulder, I don't know why. He was with a girl, and either he was drugged or wigged-out or gone up in the world, I don't know.

Tuesday, August 21, 1979

Worked until 7:30 (cab $4). Went home and did some drawings. Not one single person called. I guess everyone must be on vacation.

Sunday, August 26, 1979

Barry Landau called and said that *The New York Times* had been over at his place asking him if he'd seen Hamilton Jordan in the basement of Studio 54, and he said that he'd told them yes, that he couldn't lie. I went to church.

Monday, August 27, 1979

There was no lunch on, and I was being good and not eating, but then Fred wanted to try out the new thing in the McDonald's commercial—the beef and onion sandwich. It tasted like cardboard and it was in pieces like it had already been chewed. The onions were the only good thing, they were real. That was strange, having real onions and the rest of the stuff phony. The sauce was good, but it was really sweet.

There was a big thunderstorm in the afternoon.

Tuesday, August 28, 1979

On the front page of the *Post* was a big picture of Barry Landau saying that he saw Hamilton Jordan at Studio 54 asking where he could get coke.

Wednesday, August 29, 1979

Got up and cabbed to Union Square ($3.50). Walked to the office. Fred had the papers and we were reading about Studio 54 and really laughing it up. Then the phone rang and it was the FBI and we stopped laughing. I wouldn't take the call, I had Fred talk to them, and they're coming to see me today. Then Halston called and said the FBI had just been to see him, too, but he said he wouldn't say over the phone what happened. It's funny, they're wasting their time on this stuff. Don't they have a Ten Most Wanted list anymore? I mean, they're trying to find Barry Landau who everybody else is trying *not* to find!

Rupert and I worked on the Ten Most Famous Jews series. I haven't been told for sure yet who's in it. Sarah Bernhardt. Maybe Woody Allen. Charlie Chaplin, Freud, Modigliani, Martin Buber. Who *is* Martin Buber? The Guggenheims. Oh, and Einstein. And Gertrude Stein. Kafka

(photos for research $2.20). I think they were considering Bob Dylan but I read that he turned born-again Christian.

Thursday, August 30, 1979

Cabbed to Union Square ($3.60). Walked to the office. Made some phone calls, had a little lunch. There was a crowd of models there that Barry McKinley was taking photographs of, mostly male models, they were so good-looking. Why are there so many to choose from now? Because there's nobody in the army? Wouldn't it be great to do a whole movie of nothing but good-looking kids—the butcher, the baker—all models.

Friday, August 31, 1979

The *Interview* arrived and it's the Liza cover, there's lots of smudges on it. I was disappointed because it didn't seem that thick. Only forty pages of ads, the issue was only eighty-eight pages. And *Vogue* this month is so fat it looks like a telephone book.

I had to meet my agent Joan Hyler at Elaine's so I could meet the guy who might get me a guest appearance on *The Love Boat* (cab $3). Elaine was there looking very slim. It was Joan Hyler, Bob Feiden, Steven Gaines, and this guy Tim from *The Love Boat*. At the next table was Jerzy Kosinski and his girlfriend Kiki with a Polish kid, an assistant cameraman who just defected and he was overwhelmed, it was his first day in New York and he was meeting *me*. Because he'd read the *Philosophy* book in Poland. He hadn't actually defected yet. You can't defect on a holiday, so he had to wait until Tuesday.

Then we went to Studio 54 and Mark let us in, and I made Curley dance with Tim to show him a good time. We stayed until 5:00 and then I took the kids to a coffee shop and we had tea ($15) and then I got a cab. Steve Rubell was at Studio 54, sober, and he said wasn't it great what Barry was doing, and for a second I forgot Barry was doing it for Steve and so I started to say how horrible Barry was, but I caught myself. It's Steve's deal with the government—if he gives them names he'll get a better deal. So Barry's helping him give names.

Tuesday, September 4, 1979

Bruno Bischofberger still is after me to give him a lot of my early photos for his photography collection. When did I start taking Polaroids? 1965? Bruno wants me to paint the Statue of Liberty and I haven't decided yet if I'll do it. I tried to talk him out of the Statue of Liberty and get him interested in the Heart paintings that I've been doing.

Ran into Diane Von Furstenberg who said she's not going to go to Studio 54 anymore because she thinks it's wrong of Steve to be naming names.

Wednesday, September 5, 1979

It was the beginning of hurricane weather outside, grey. I wandered around, passed out *Interviews*—the Liza new ones—and thought about Montauk. They said this hurricane is traveling the path of the one in 1938, and that's when Montauk took a beating. I ran into Charles Evans and he gave me a ride, and we had a good talk about all the girls he knows.

Picked Bob up at 7:45 and went to the Magno screening room to see *Yanks*. I invited Curley and he and Bob loved the movie but I couldn't stand it. It was a forties movie, and if you want to see a forties movie they're on TV all the time and you can have great-looking people like Tyrone Power, not Richard Gere! The movie had no war and no bombing.

After the movie we went to a Claude Montana fashion show at Studio 54. It was just finishing. Larissa said that Claude Montana was a genius and she asked me if I wanted to meet him. I'd seen the big photograph of him out in the front, this eight-foot figure, and she pulled over this little twerp of five feet with a mustache and American clothes and said it was him and that he was shy.

Thursday, September 6, 1979

I got up and David was around—Hurricane David. I guess it rained all night, that's what must have gotten me up in the middle of the night.

Went out and passed out *Interviews*. On the street I ran into David Kennerly, the White House photographer, he was in town to promote a book, he said. Only I didn't recognize him at first, then finally he said something about the White House and it was able to dawn on me who he was.

Walked down a little ways and wandered into all the usual places. The hurricane never really happened. It stopped raining. The trees in the park were sort of down, but not much.

And the headlines are about David Kennedy going to Harlem to buy drugs. He's the crazy one who had the fight with Fred at Xenon. It was cute when he said to the police, "I'm David Kennedy, please don't tell my family, I just want to go to Hyannis."

Saturday, September 8, 1979

Drove to Forest Hills. Had good seats. Went to the locker room. Billie Jean King said hello. Watched Martina Navratilova and Tracy Austin play, but I hate watching girls play, I hate the way they play, they just don't play that well, I can't stand it.

McEnroe and Connors played each other, and they're the same kind of people, the same type.

Tuesday, September 11, 1979

I was taking Marina Schiano to Charles Evans's dinner and I had to walk over to the armory to pick her up. She was at the antiques fair there with Jed. Admission was $35 which I stupidly paid because nobody told me that it was put on by the Folk Art Museum that I'm a trustee of. I met up with the guy who runs the museum, Bishop, who thinks my collection's no good. He's stupid. I hate all that American Primitive stuff now anyway, the jazzy painted stuff—it looks like junk —the toys and dolls and merry-go-rounds and Indian baskets.

At Charles Evans's dinner Bo Polk was there, and he knew every single girl in the room. He and Stephanie McLuhan are broken up, but she was there, too. Bo accused me of being the one who introduced him to Barry Landau, but really he knows I really warned him.

Saturday, September 15, 1979—
New York—Chadds Ford, Pennsylvania—New York

Suzie Frankfurt picked us up in a limo that belonged to a decorating client of hers. A beautiful day. We went straight to the Brandywine River Museum and then someone there took us to Frolic Weymouth's house. He had a tent over the whole place and good chicken salad. All the right people were there. Lady Bird Johnson, Henry and Shirlee Fonda, rich old ladies who look like bulldogs.

Then we went over to Jamie Wyeth's who spent the whole time giving an interview to *WWD*, and Phyllis was in the pool. I talked to Shirlee Fonda. She said they sold their East Side New York house on 79th Street to David Brenner, but then he backed out at the last minute, he said that he was too famous to own a house. She said that if Henry Fonda could own a house, David Brenner could, too. But she's very happy because now they're renting the house for $5,000 a month and making more money that way. When she was cleaning the place out, she found a big gold cross worth about $20,000 behind the bookshelves and they're going to try to find out who it belonged to. She said that she wouldn't have felt right keeping it. I could see that Suzie really wanted it badly, she likes gold crosses.

We went back to Frolic's to change. The girls got into their ball gowns. Oh, and Henry Fonda has all his teeth. He was eating green apples. I'm sure they're his because they're sort of darkened.

Suzie was rolling a joint and it was embarrassing. I had one of those peppermint drinks, mint julep, and I threw it out. Suzie forgot to feed the driver and that was terrible.

At the museum Frolic introduced me to Governor Scranton and his wife and some old ladies. Had a few drinks, pictures, dinner. Marina Schiano and Jed changed placecards so they'd be next to each other, they weren't happy. I was next to Nancy Hanks on one side and the sister of Henry McIlhenny, Bonny Wintersteen, on the other side. Nancy Hanks is the head of the National Endowment for the Arts, I guess, she got Jamie on her advisory committee, The National Council on the Arts. Bonny Wintersteen was fascinating and fun. She's fat with grey hair pulled back very tight. She sold her ten most famous paintings to the Japanese a few years ago when they were going for very high prices, she said she got tired of people showing up at her house and demanding to see them.

I met a lot of kids in black tie who said they met me twenty years ago at the University of Pennsylvania when Edie and I went there for my show. We left at about 10:30 and I fell asleep in the car.

Sunday, September 16, 1979

Went to Lester Persky's *Yanks* party at Trader Vic's. It turned out to be a really intimate dinner for only about fourteen people. Lester arrived with Richard Gere, and John Schlesinger arrived and Tommy Dean. Lester has a thin mustache now. Richard Gere asked me how Lester and I had met and I told him that we met in the gutter ten years ago, and this time Lester didn't like that, so it was my first *faux pas*. Richard Gere said that ten years ago he came in on a bus from New Jersey and went to see our movie *Bike Boy* in the Village, and he said from then on he's been trying to be an actor—it took him eleven years, he said. He's big and good-looking. We were talking about girls and he was talking about meeting the most beautiful girl in Rome—Dalila DiLazzaro—at a party in Zeffirelli's backyard and I told him we discovered her—that Paul Morrissey had seen her doing a soap commercial on Italian TV and made her the star of *Frankenstein*—and he was impressed. He's going to be in a new play called *Bent* which is an English one about homos in concentration camps. I asked him if he was Italian and he said no, that he was French and Irish.

Steve Rubell came later. When Steve's normal, he's so distant. Lester told funny stories. Then I made another *faux pas*, I said that it was so much fun there, nobody should leave. And Steve was sitting right there. And I wasn't even thinking about the party at 54, I was just wanting to make Lester spend more money entertaining us because he's always so cheap. John Schlesinger gave a speech.

Monday, September 17, 1979

Cab to Union Square ($4). There was a lunch for Jack Kroll from *Newsweek* and I had invited two friends of his, too, one who made a movie that Jack liked called *Anti-Clock*, and I didn't know if the girl was his girlfriend or if she did P.R. It's a small movie, an art movie. They told me, "It's *your* kind of movie" *(laughs)*, so you can imagine what it's like.

Bob told me the reason he's after *Newsweek* is so they'll do a cover story on me, but I don't want one. I mean, what're they going to say? Reporters will just rehash. "He lives on the Upper East Side with two dachshunds and he's a sometimes walking-stick for Paulette Goddard." Well maybe they'll feel the same way I do, too, that it's too boring. I mean you have to do something different like get married and have a couple of kids or take a few drugs or lose a few hundred pounds or die, to be good copy.

Dropped Rupert and Bob ($4) and went home and got into black tie. Robyn's mother, Mrs. Amory, invited me to the Cancer dance. I invited Gael Malkenson. I went over to Gael's and she was in a bright green dress. We had a drink there. Her boyfriend is out of town. He works at a

cheese company, and she's gotten fat because he brings home all this cheese. Cabbed to Lincoln Center ($2.50).

They had an orchestra and all the old bags were out on the floor doing the foxtrot, and there's always that one seventy-five or eighty-year-old lady who gets out there and is the first to start really jumping. These old bags still want men to go to bed with them. They look like the ladies at Bonnie & Clyde, that dyke bar downtown where every table it's women who look like anybody's mother.

The Gilmans were there, they're now best friends with Robyn's mother, they have a house next to her in Tuxedo Park. And I asked Sondra whatever happened to Adela Holzer, and she said, "My dear, you won't believe it, she's been staying with me at my house for eight months and she's going to come out of court victorious." That's a good friend, I guess. But then if she's such a good friend, why did she let her sit in jail for four days?

The raffle was a trip to Milan. Why would someone want to go to Milan?

Gael and I spent the night talking about the magazine, and Robyn and I tried to get her to dish Bob, but she said she wouldn't talk about her boss, she just said she goes to the other side of the room when he screams.

Tuesday, September 18, 1979

Forgot that Halston was on the *Donahue Show* so I missed it.

Ronnie was working, getting ready for his two weeks off when he goes to California to visit Gigi.

Wednesday, September 19, 1979

Got up early because there was a big lunch down at the office, Brigid had invited Stanley Marcus from Neiman-Marcus. Cabbed to Union Square and walked to office (cab $3, kitchen supplies $125). The building had just finished painting the downstairs lobby. They made it Puerto Rican colors and you just hate to walk into it.

Mr. Marcus was a funny little man. I was trying to sneak some cole slaw and he caught me eating. We were expecting Fred back from Europe, but he never arrived. Rupert came by. Curley came and took the umbrella I'd borrowed from the Heinzes a few nights ago back to them. Jack Heinz had called about it and said it was his favorite one.

I told Carole Rogers at *Interview* to try to register the word *Out* as the title for a magazine, and she said the only way to register it is to actually do up a dummy of a magazine with that name. Because I want to start another newspaper—one that's *younger* than *Interview* because *Interview*'s so established now. Dropped Rupert ($4) and got into black tie and went to pick up Suzie Frankfurt and Bob.

We walked to the Pierre for the Gianni Versace fashion show. Gianni Versace was at our table, but not until after the show. And Carrie Donovan was there who always gave me my first jobs. André Leon Talley was next to me and he's just such a camp. And that guy who doesn't like us

from *Women's Wear*, what's his name? Michael Coady, he was at the table with his I guess girlfriend and this time he was nice, actually. And Ludovic who runs Regine's.

The fashion show had Joe MacDonald and European girls. It was funny fabrics—lace and suede and leather. The clothes he makes this year are very feminine, though, kind of draped and ugly. At the end he got emotional and *(laughs)* cried.

Ludovic invited us to Regine's, but we were going to first go to a party Nelson had invited us to for Michael O'Donoghue who wrote *Mondo Video*, a movie that's coming out. I paid for a limo we got ($15) to Tango Palace on 47th and Broadway and the place looked like the old Factory with silver tinfoil on the walls. And the dime-a-dance girls now cost $20-a-second. A lady with breasts as big as Geri Miller's in *Trash* was there, vulgar, dancing. The party was disgusting, the creepiest kids came over and talked to me. A band called The Clits was playing. Richard Turley was there and he loved the place.

Thursday, September 20, 1979

I had to go to a screening of that movie *Anti-Clock* that Jack Kroll's friends made, they were giving it just for me and I didn't want to go alone, so I invited John Reinhold and Curley, and Thomas Ammann because he's interested in art movies. We went to 48th and Broadway (cab $3). I was five minutes late and they'd started the movie. It was out of focus, it only went into focus about four times. It was a double screen, filmed in video and transferred onto film, it had a girl masturbating in a shower. Then the film looked like it broke and we didn't know if it had or if it was the end of the movie, and none of us dared to ask, so we just sat there in the dark, and then finally when a guy came out of the projection booth carrying the film, we knew it was really over. We didn't know what to say and the girl showing it wanted us to say something, so finally I said, "I liked it," and she was relieved.

Friday, September 21, 1979

Got up and wandered around, passing out *Interviews*. I went to Manolo Blahnik's new shoe store on 65th and Madison, next to Kron's, really beautiful, one-of-a-kind shoes. Went to Kron's ($58.68). It was raining so it was just impossible to get a taxi, everybody was waiting. But Gene Shalit came along in a car and said he'd drop me and I said that it was way way too out of his way, and he said that anything I wanted wasn't too much. His line is that he doesn't smoke or drink or take drugs—all he does is work. He said he got Meryl Streep for an interview and I asked him what his secret was, that we'd been trying to get her for our magazine, and he said he just got her by working hard. He said he picks up the phone himself, that he never has an assistant do it. He dropped me all the way downtown and I worked all afternoon, then dropped Rupert off (cab $4).

Then I got myself together, I was Sharon Hammond's date for a party for Alexis Smith at a restaurant called Dukes, before they took *The Best Little Whorehouse in Texas* on the road. Sat between Mrs. Long and Twyla Tharp, and Twyla was saying that she was a has-been, that her

movie career was over, that Lester and *Hair* ruined it because they didn't use enough of her dancing, but I don't see how they could have used *more*. She had her good-looking younger boyfriend who she's been living with for years with her. She tried to pretend that she didn't have anything to do with the Judson dancers—the dancers in Judson Church in the Village in the sixties—and when I would mention one of their names she wouldn't really say she knew them, she said she was just down in the basement or something, but then after she'd had a few drinks, she began telling things about the dancers that she'd pretended she didn't know. And her boyfriend had even said to her, "Why are you pretending you had nothing to do with the Judson?" I guess she was just a dumb dancer who must have picked up what they were doing and just made it, somehow. I don't know how. She acts like she feels she's more important than them now. It was fun to talk to her.

Geoffrey Holder was there, and Geraldine Stutz, all the old-timers. It was a nice party. And then we went to New York/New York. Lester Persky was there and he was fun, and Jack Martin, I always have a great time with Jack Martin, he's so much fun. He said that the Marilyn portfolio that I gave Joyce Haber was getting mildewed in her basement, and that once he was able to get Rona Barrett to give him the Marilyn poster I'd given her by saying, "Oh Rona, what do you have that stupid thing for?" and so she gave it to him. Jack knows about art, he has a few things. I gave Joyce the Marilyn portfolio after she wrote that big article on us in the *L.A. Times* in the late sixties and she'd just broken up with her husband, Doug Cramer, so I thought the portfolio would cheer her up and it was before I knew how much they'd be worth. They're so expensive now.

Saturday, September 22, 1979

Down at the office. I went across the street to the farmer's market and got some things for the kitchen ($8). *Interview* was working.

Thomas Ammann picked me up in his limo and we went to Nippon to meet everybody. It was Wilson Kidde and Billy Kimball—he's a friend of Wilson's who goes to Harvard—John Reinhold, Robert Hayes, Curley, Keller Donovan the decorator, Rupert and his new friend—there were ten of us, all boys, so it was embarrassing. I heard an older couple at the next table say *(laughs)*, "Oh it must be a prep school with their headmasters," because John and I looked the oldest and the kids were all in ties and jackets. We had a good time (dinner $300). Then we decided to go to Cowboys and after that we went to Rounds. A guy there said he met me in Tennessee and he asked if he could sit with us to see what New York was really like ($105). Joe MacDonald was there and said that Flamingo was reopening so we went, and the guy let us in free because I'd judged a male beauty contest there. Flamingo was great because it was brand-new, and then at 3:00 Thomas Ammann dropped me off.

Sunday, September 23, 1979

I went to church and then went home. I glued myself together and Curley picked me up and we went to 42nd Street to the WPIX radio station for the *John Ogel Show*. I'd invited Walter Steding to play his magic violin on the air, he was good and he sounded intelligent when he was interviewed.

Then Lou Reed rushed in and said how glad he was to see us. Lou told me one of his dachshunds had had an operation on his back. I told him to come down to the Mudd Club with us later because they were having a Dead Rock Stars Night, and he said he would go as himself, but I told him he looks too good for that now.

We stopped for dinner at One Fifth (cab $3). When we walked in Jackie Curtis—he's back to dressing as a girl—was at the bar with, who else, Taylor Mead, who happened to be waiting for, who else, Viva. And then they were all on their way down to the Mudd Club. Had drinks ($45.14) and then it was 11:30 so we went to the Mudd Club, too (cab $3). They had a room where Janis Joplin was putting needles in her arm, and they had a Paul McCartney room—I guess because of the rumor that he died once—and they had Mama Cass choking to death with a plate of ham sandwiches in front of her and you could take the sandwiches and eat them. It was really sick. Vincent and Don Munroe were there videotaping.

Viva was reading poetry but I missed it, I didn't see her. François de Menil was there. The ex-Mr. Viva was there. They had girls in black crying, and then outside a hearse pulled up. I was really tired. Dropped everybody off (cab $15).

Tuesday, October 9, 1979

Went to Union Square at 12:45 to meet the Newhouses, the mother and son, Si and Mitzi. They brought pictures of the husband who just died, but they weren't right so they're going to send down some more for a portrait. She might want her portrait done, too. Nobody was around, so Victor served. She's a short little woman, she's eighty-two years old. I asked the son about *Self* magazine—he said they survey everything by computer every month, that's how they know what's happening.

Had to go to Richard Weisman's party for Governor Brown that Catherine had arranged. Curley was with me, Fred had invited him. Bad traffic, Castro's in town (cab $3.50). Bo Polk was there, and he invited me to a George Bush party. Then Pat Hickey the hockey player arrived with his girlfriend and he looked like the Tareyton ad, his eye was all black. Governor Brown came and he gave a speech and I taped it and afterwards he asked what I taped it for and all the kids told him, "For nothing—he just throws the tapes in a box." He didn't say much, but when you give speeches all the time, what's left to talk about?

Stephanie was back with Bo Polk, Stephanie McLuhan, but I noticed she made a beeline for the governor when he arrived and kissed him, although she didn't know him. And then after the speech she got up and asked an involved question, I guess to show she was intelligent, but she was stupid and he was stupid. He came around afterwards to shake my hand and get my vote, he said something referring to the art thing, I guess—the legislation that would make artists get royalties or something when their paintings are resold—but it didn't make sense to me. Diane Von Furstenberg told him he'd gotten too skinny, that he'd lost his "love handles" and that she'd liked them. I wanted somebody to ask, "Is Jerry a fairy?" and Diane said no, that he wasn't, that Jerry's no fairy. Judith Hollander and Jed were there, they came by on their way to Tom Cashin's birthday party at "21." I just wanted to go home but Catherine wanted me to go to Elaine's with Rod and Judy Gilbert and Pat Hickey and his girlfriend.

Elaine was sitting at a table with five girls and one I think was Candy Bergen because later people said that it was but it didn't look like her and I looked at her and she looked at me and we didn't say anything. If it was her, she looks older. Pat Hickey took his girlfriend home and then came back because Catherine had been flirting with him all evening. Richard was trying to get me to drink tequila, and about 2:00 I left (cab $3).

Thursday, October 11, 1979

Got up and it was raining, cold again. Somebody ran into Truman in New Orleans, so evidently he didn't go to Nebraska. Maybe he just needed some money—he asked us for $6,000 to go to Nebraska to do a story for *Interview* and we gave it to him.

I worked all afternoon in the back.

Fred was in one of those moods, mussing people's hair up, and he invited Curley to go to the Larry Rivers show at Marlborough with us.

Larry's show is like a retrospective of all his work. It's funny, it's like he ran out of ideas and decided to repaint everything. In the elevator I ran into the Greek woman whose portrait I just did, but I didn't recognize her. And I also ran into Rupert who said my Gem screens came out okay. At the opening a guy said, "I'm Larry's brother-in-law and I own the building your office is in," and he said that he'd just rented the ground floor to a discotheque but that we shouldn't worry, that it wouldn't interfere with us because it wouldn't be going on during our business hours. I told him thanks a lot. So, I mean, isn't that great? The Mafia discotheque fires will only burn the place to the ground *after* office hours. Isn't that wonderful, a discotheque for a neighbor.

Then I went to dinner at the Gilmans' where I met a lawyer who's in New York to go to tax-shelter school.

Friday, October 12, 1979

It was raining, another awful day. Michael Zivian called in the morning and asked me to come up and sign some of my Spacefruits, so I walked up Madison to his place.

Henry Post called and I talked to him, but I was afraid he was taping me, so I didn't say anything. He'd sent me an article he wrote on Quaaludes for *New York*. He's still out to get Steve Rubell.

Sunday, October 14, 1979

I went to church and it was pretty out. Then met Bob at about 5:00 to go up to see the Dalai Lama at St. John the Divine Cathedral on 112th Street and Broadway. We picked Fred up and went uptown (cab $6). The Dalai Lama gave his speech, it was so boring, he had an interpreter but I don't know why because later he talked English very well. He was wearing an orange and

red dress. Then there was a party in the back and everyone was standing around shaking hands. Bob said he wasn't impressed with the Dalai Lama because he wasn't as good as the pope.

Then we left, got a cab, dropped Bob off, and we went to meet Richard Weisman and Catherine at Madison Square Garden where they were going to retire Rod Gilbert's number 7 (cab $7). Catherine has to go to the hospital to have the nerve in one of her hands retied because she still can't feel it. Her mother's coming to town and Catherine hopes she won't notice anything. Only her brothers Valentine and Jasper know what happened.

Monday, October 22, 1979

Priscilla Presley came to the office and we interviewed her. Her boyfriend was with her, Michael Edwards, the model. She admitted she'd never had caviar in all her years with Elvis because he hated fish and would have thrown her out of the house if he saw her eating any. God, what a beauty. I wonder if she had her nose fixed, though. It looked a little wider in the early pictures you see of her.

Monday, October 29, 1979

I have to do a portrait for the Whitney show, so we thought since it's portraits, I should do myself up in drag. It was Fred's idea. I've got to get Gigi in to do my makeup. And Ronnie's all nervous because he has an art show coming up downtown—he constructs cages as art now.

Tuesday, October 30, 1979

I ran into Juan Hamilton who was coming down to the office later. He and Georgia O'Keeffe are at the Mayfair (cab $3.50). As I got to the office Joseph Beuys, the German artist, was getting out of a car with his children and Heiner Bastion—about eight people. He kissed me on the mouth and I got nervous. I didn't know what to talk to him about. Heiner Friedrich and Philippa de Menil came by. And Robert Hayes had Sally Kellerman and Barry Diller and Barry McKinley there, and there was no room to sit down. And Heiner Bastion said I should photograph Beuys for a portrait. Then I was photographing Georgia and Juan in the back. It's too hard with famous people at the office all at the same time because nobody can understand why anybody else is there. I worked until 4:00 with Georgia. Finally they all left.

Later I went to the horse show at Madison Square Garden. I went over with a bunch of horse people to the Statler Hilton for scrambled eggs and bacon, I guess that's what horse people like to eat. It was good. I stole some silverware and then it was embarrassing because it fell out and everybody saw it. It was Statler Hilton silverware from the forties.

At Studio 54 after that I ran into Steve Rubell who said that on Friday he was going to be sentenced to two months in jail, that he'd made a deal with the government—they'd dropped

the drug charges and he'd pleaded guilty to income tax evasion. He asked if we'd come and visit him.

Wednesday, October 31, 1979

Bobby Zarem was having a lunch for the photo book—Bob and I ended up calling it *Exposures*—at 1:00 at Maxwell's Plum. So I stayed uptown in the morning and then met Elizinha Goncalves and Bob at the Mayfair House and we walked over to Maxwell's Plum and when we were half a block away Bobby Zarem ran toward us and screamed that we were late and how dare we and that people were going to leave. But it was actually good timing that we got there late, because people were waiting to see us. It was crowded, we had to work our way in. Karen Lerner was there filming for the segment she's doing on me for 20/20. She attached an invisible mike to me so I had to remember to watch what I said. It was a press party and it was basically everybody Bobby wanted to pay back for favors, I guess.

They had big AW initials in ice, three feet high, but it was melting. I didn't eat anything. Everybody got a free book, at least 100 were given out. The waiters stole lots of books and then asked me to autograph them in the kitchen, but I didn't mind because they were nice.

Catherine was asking Steve Rubell personal questions, like, "You mean you actually *did* take all that money?" but he didn't seem to care. Now he's saying he made a deal with the IRS where he'll be going to jail for two days a week doing community service—teaching people how to make discotheques on army bases for the soldiers. What a brilliant idea. Next they'll teach them how to be fairies and take drugs, right?

Later we went over in a cab to Studio 54. Halloween was so big this year, people were really dressed up in the cars, outfits with lights blinking. At Studio 54 the place was done up just great. You walked in and there were ten doors on each side and you had to go through each one, and there were mice in plastic running under your feet. And another room had a hole and you looked in and there were eight midgets having dinner and you could talk to them. They were eating chicken bones. And then in the next room there were all these rubber gloves and some were real hands. It was better than an art opening, better than a gallery show. There were some other rooms I didn't go into. It was all great. Jammed, wall-to-wall people, beautiful, I don't know where they came from.

And Esme the top model was there with Allen Finkelstein, but I wouldn't have recognized them if Tommy Pashun the florist hadn't told me, because they were dressed as Hasidic Jews, and they said that they were so amazed, that everyone was being so mean to them. A makeup guy at one of the Broadway plays had made them up. Dropped Catherine at 3:00 (cab $3.50).

Thursday, November 1, 1979

Cabbed downtown to Ronnie's art opening ($3). I talked to Larry Rivers. His article on the fifties is on the cover of *New York*. All the sixties regulars were there, like René Ricard who doesn't say anything, he just runs around saying things. And Roger Trudeau who said he was an interior decorator now. Then Fred and I had to go to the German embassy dinner for Beuys.

At dinner I sat with a German girl who'd accosted me on the street earlier for an autograph, so that was funny. We got there a little late and we missed the speech. They said it'd been about excrement, and how Beuys uses it so well.

We were in the papers for the Bobby Zarem thing, a lot of little mentions in Jack Martin and Liz Smith and "Suzy."

Monday, November 12, 1979

Halston had invited me to dinner but then Catherine called and said that Steve Rubell and Ian Schrager wanted to take us to Pearl's first. So I went there. Steve told me that Liza's pregnant and she's going to get married but that it was a big secret. We should have let Steve order because he gets cranky. We ordered while he was in the bathroom, and then nobody ate anything. Catherine had a slice of pork, she's got her thin beautiful body back again. I'm down to 132.

Then we left and we got into the car to Halston's. Halston had dinner ready. He took me aside and told me that Liza was pregnant but not to tell anyone, that it was a big secret. Catherine was trying to make out with Ian. And she was drunk, asking Steve again how much he really stole.

Tuesday, December 4, 1979

So tired after three weeks on the road with Bob and Fred to promote the *Exposures* book. The tour began so chicly in Washington when I sat in President Carter's box at Kennedy Center but it wound up in the gutter on Hollywood Boulevard in that B. Dalton's bookstore that used to be Pickwick Books. While I was signing there a woman with a knife wound in her stomach came in screaming, "This isn't Andy Warhol! I went to bed with Andy Warhol and he's 7'8, he can't fit through doors, and he wouldn't be standing here like this in a bookshop because he's too paranoid!" *(laughs)* And that may actually be an accurate quote. And at Neiman-Marcus in Dallas where they had a great party for us in their boiler room, all the kids there said the book was "neat" and "cool." And the Texas people were all so gracious and considerate, they say things like, "It's so kind of you to come all this way to see us." I wish I could talk like that—I can't think of those beautiful lines. Oh, and a big nice man in Dallas even insisted on personally taking us to the discotheque afterwards because, he said, "I'll tell you what, you fellas will need some protection —it's a pret-ty gay atmosphere. Of course, I guess you might be used to it, coming from New York City and all." And we laughed and looked to make sure he was kidding and he wasn't.

Tuesday, December 18, 1979

Had a limo for the day. Picked up Paulette to go to Halston's show. She was stunning, all in a white fur coat. At Halston's I was next to Martha Graham who really looked old for the first time. I guess maybe it's just that she always wears makeup and didn't have any on. The *Daily News* took

a lot of pictures of me with Liza. I told her that I didn't know what to say about her miscarriage but she said she was okay.

We had lunch at the office for a photographer friend of Alexander Guest's who was going to take pictures of Bob and me afterwards for *Penthouse*. A girl made me and Bob up with black eyes and bleeding lips. It looked good, real. Then they took us down to Avenue C and 4th Street to a school. The whole area looks bombed out. And then the school let ten kids out *(laughs)* to pose as kids who just mugged us. It was so cold. And a kid yelled at me, "Don't go to too many parties." They said they were allowed out of their typing classes. I don't know exactly what kind of school it was—they had karate classes there, too. The kids were cute. We posed against real graffiti. And I mean, I couldn't believe a school was letting kids out to pose with pussy in *Penthouse*, and then I found out that they weren't even getting paid! And I told the guy in charge he was horrible for not paying them and he got really funny about it but then they took down their names. Then we went back to the office.

Wednesday, December 19, 1979

The ABC *20/20* camera crew was coming to the office to film. I worked until 7:30. Then at home I glued myself together. Bob called and said he was exhausted but he really wanted to go to the Alice Mason dinner, so he picked me up and we walked to 72nd Street and Lexington. I was next to Norris Church Mailer. I told her we were still interested in doing something with her for *Interview* but she said she'd put on weight and that she really liked eating better than staying thin for modeling. Then we got a cab to El Morocco, Norris and Norman and Bob and me (cab $5). It was a party for Margaux Hemingway's engagement. I ran into Jamie Blandford there and had a fight with him, I don't know why, I just always do, I hope I didn't *(laughs)* offend him. And Mimi Trujillo was there. She was married to the son of that dictator and she's a fashion designer. Victor sees her stuff then tells Halston about it—I mean, she does stuff like Halston, but she does it sort of first.

Millie and Bill Kaiserman were there. I introduced Norris to them, but I think I did it in a strange way, I guess I said, "This is Norris Church, she wants free clothes." But they *should* have good-looking people walking around in their clothes for free. There were lots of funny young people, El Morocco's back on its way again.

Thursday, December 20, 1979

Cabbed to 47th Street ($3). I walked around to the office for the office Christmas party. Then went home and got together. Went to Tom Armstrong's at 72nd and Park, and Leo Castelli was there, and Iris Love and Robert Rosenblum who said he didn't understand why everybody gave my show at the Whitney a bad review. Bobo Le Gendre was there, and I was mean to her because she's so phoney baloney. She's a friend of de Antonio's. She's a carpet heiress. They had shepherd's pie but I'd eaten already.

Then I took John to Richard Weisman's at U.N. Plaza. Ron Duguay was there, and Rod Gilbert

came without Judy, and Fred was there, and Whitney Tower, and Averil who was going back to miniskirts, wearing one of her mother's, and she got a hole in it. Peter Beard was there, and Cheryl Tiegs, and I think Duguay finally got hot for Catherine after he was looking at her topless picture in the *Exposures* book. Vitas and the cute boy we photographed with him in Paris were there, and John McEnroe. And just when the party was getting good, John Reinhold dragged me into the closet and got so serious. He was just wacko, saying I was his favorite friend and that when I don't call he goes crazy. I don't know what he meant, he was just wacko.

Catherine Oxenberg was there, and lots of stewardess-looking girls and when girls get drunk they get obnoxious. I had a limo waiting, so Catherine and I and a couple of the stewardesses got in it and we dropped Catherine, and then me, and I tipped the driver ($40) and he took everyone else home. And I missed Fred Mueller's party and Eleanor Ward's party and Keller Donovan's party and the *Rolling Stone* party.

Friday, December 21, 1979—New York—Vail, Colorado

We got to Denver at 5:30. Catherine and I got drunk on the plane and had fun with a lady who collects big jewelry who used to live in the Ritz Towers. She lost a silver ring on the plane but she didn't care about it because it was just silver. She was on her way to Taos.

There was a kind of van waiting to take us to Vail. A beautiful Redcap girl carried our heavy bags (tip $10).

Got to Jed's house at 7:40. The altitude really got to me, I got terrible chest pains. I think it's because of when I was shot. It wasn't bad in Denver because Denver's lower, and when I was in Mexico City once I felt it but not this bad. The whole house looks like a big sauna. This is the house Jed bought with Peter and Sandy Brant. It's by Venturi. It's all wood and simple and clean. The second floor is bedrooms. The kitchen is on the third floor, the living room on the fourth. The furniture is all Stickley.

We walked into town to the Left Bank restaurant (drinks $30, dinner $200). Fran and Ray Stark were there, and Bob knows they're Republican so he told Kennedy jokes and he invited them over for cocktails Monday. Ray's high on Paul Morrissey, Paul's writing a script for him. I signed the restaurant guest book, and Betty and Gerald Ford were in it and Bob Hope, and then we walked up the hill and it was just horrible, the walk, I felt so light-headed and really really horrible.

Monday, December 24, 1979—Vail

Aurora cooked a ham and a turkey but nobody came to our cocktail party. Mercedes Kellogg called and said she had a cold, and the Starks just didn't show.

Tuesday, December 25, 1979—Vail

The Fords shake hands with absolutely everybody. Betty Ford doesn't look as good as she did in the photos after her facelift, she just looks sort of the same. But now she's a blonde. Before she had brown hair, didn't she? It's a sort of honey-blonde now. At first I thought it was Mrs. Nixon. Bob wanted to meet them so badly, but he would shove me out first and I would shrink back, so it never happened.

Passed out *Interviews*, there really were great places to do it. Three people asked for my autograph. Everybody stares at me because I'm wearing my wolf parka by Halston.

We went to a bar that shows ski movies, you drink beer and watch skiers. Nobody came over and asked for our drink orders, so we didn't drink anything and just watched the movie and then left. We were having dinner with Nan Kempner. I began reading *Dress Gray* and it had the right names that sounded real. Like the main guy is called Ry.

Wednesday, December 26, 1979—Vail—New York

Got home just in time to catch Vincent still at the office, at 6:00. Rupert had gone away for Christmas so he didn't get much done. Talked to John Reinhold and he suggested Trader Vic's to discuss jewelry ideas. Got a cab, thought it would be easier, but then the driver didn't move, he said he was stunned to have me, and he missed the light and I said, "Do you know where you're going?" and he said yes, to the Plaza on 59th and Fifth, but then he missed 59th Street and at 57th Street I gave him $3 and got out quick.

John was already there and then Curley arrived, above the weather, and he wanted to go to Studio 54 around midnight, sort of early (cab $4). Then I got nervous, he said there was a picture of me and Steve Rubell on a couch in *New York*. At Studio 54 Bianca arrived with John Samuels who was home from Harvard for the holidays. He seemed so in love—he's taking her to the sun for a few days.

Thursday, December 27, 1979

Oh, I'm trying to lose weight, and we've got a lot of cheese everywhere. Gael Malkenson's boyfriend imports it so she gets it for us half-price.

Ronnie and Gigi had had a big fight and she packed and left so he was in a bad mood. They fought because he was buying her presents and she didn't have the money to buy him some and she got mad. She's like a bad forties movie.

We got sent a copy of Steven Gaines's book, *The Club*, the "novel" about Studio 54. And it has a chic Seventh Avenue designer named *(laughs)* "Ellison" who works in the Olympic Tower and who has a Peruvian boyfriend named "Raoul." The names are so bad.

Friday, December 28, 1979

I walked around passing out *Interviews* and then I cabbed ($3) to 245 Park Avenue for my meeting with Bob Denison to talk about investments. I walked into the building and got the elevator to the twenty-seventh floor, the door opened and I smelled something burning. I walked into Bob's office and he was running around trying to find out if what was burning was one of his machines. Then the secretary came running in and said the building was on fire, that we should leave.

Bob wanted to take the elevator, but I said no, to take the stairs. The exit door was locked. Just like in *Towering Inferno*. But we found another exit that wasn't locked and went into the staircase. People said the fire was on the thirty-fifth floor. At the twenty-sixth floor more people got on the stairway and on the twenty-fifth more got on and the twenty-fourth and every floor was the same story. So it was getting slower and slower because there were so many people being added. But nobody panicked because we knew the fire was *above* us. A couple of people almost fainted, though. When we reached the bottom there were hundreds of people on the street. Bob Denison and I went over to have our meeting at the Trattoria. And I just couldn't believe the way I'd walked into the building and the elevator people just let me go up there when they already knew there was a fire! They *must* have known by then! And I could have walked onto the blazing floor. Those elevator people just stand around like morons.

The man at the Trattoria came over and said that I always used to come there a lot, and what happened to me. I was too nervous to really eat. I just had coffee.

Saturday, December 29, 1979

Bianca called and Suzie Frankfurt called, but I couldn't remember their numbers so I didn't call them back. I should really keep an address book. And then I had a glass of wine or so, and I watched a little TV, and I was tired so I fell asleep.

Monday, December 31, 1979

I decided to make it easy and just go to Halston's for New Year's Eve. I wrapped gifts for Jade. Went over at 10:00. It was small there, black tie. Bob Denison and Jane Holzer were there, so I guess they've made up. Nancy North and Bill Dugan. Victor called from California and said he was having a good time out there. When the New Year came in we did kisses and ate. Dr. Giller was there. It was just so nice. Jade loved all the presents I brought her. Steve Rubell was there. Then at 3:00 Bianca wanted to go to Woody Allen's party at Harkness House on 75th. John Samuels had a car and double-parked.

Woody's was the best party, wall-to-wall famous people, we should have gone earlier. Mia Farrow is so charming and such a beauty. Bobby De Niro was there and he's so fat. Really really fat. I

know he gained weight for the boxing movie, but wouldn't it be funny if he could never lose it? He looks so ugly. He must be crazy, because he's *really* fat.

Mick came in with Jerry, and Bianca ran over and was charming. I don't know how she did it but she got it over with, she broke the ice, they talked for about half an hour. She wanted to get Jerry nervous, which she did. Mick shaved off his beard so he looks really good.

We went over to Studio 54 and the look was "ice." Ice wall-to-wall and dripping down the walls. Then Steve said, "Let's go down to the basement," so we did. He just about said, "Anybody have any cocaine?" He wanted it to be like the good old days. It was so filthy down there, with the garbage and everything. Winnie was there, without Tom Sullivan—she said he's in Hawaii.

Then upstairs Duguay and the other hockey guy came in and I was trying to introduce them to Marina Schiano, but they said their real girlfriends were there, from Minnesota or Indianapolis or something, so they couldn't do anything. Then it was 6 A.M. and Marina and I left, and there was a riot outside, people still wanting to get in. Jack Hofsiss who directed *Elephant Man* went by in a limo and gave us a ride, there were about twenty boys in it. And I got out at Marina's, because I knew if I stayed in it they'd invite me to go with them, and I wanted to get up and go to work.

Marina invited me up for pizza and I went. I always hear that she gets the best food from all over the city, that she has the people who work for her bring salami from Brooklyn and pizza from Queens and things like that, so I wanted to try it out. It was sort of good, a really cheap kind of pizza, all dough and a little ketchup and a little cheese. Like the cheese doesn't come away when you eat it, there's not much. And when I was there I noticed that she had a pile of food on the stove, and she said it was for good luck, you're supposed to have it piled on the stove on New Year's. So I was there and we talked, and she was asking me about my house, and I told her how much it cost to run it, and she felt that I was being "real" and that she'd really gotten something out of me and that this meant we were friends or something, I don't know. I was waiting for it to get light out, and it never did. I mean, it was 6:30 and it was still dark, and I thought the sun came up at 6:00, but I guess that last year when I left and it was light out it was 7:00, not 6:00.

Tuesday, January 1, 1980

Got up late, at 11:00, but I hadn't drunk so it wasn't so bad. I glued myself and got Rupert on the phone. He said he'd come in to work at 12:00.

I brought *Interviews* with me but I had a hard time passing them out because nobody was around. Got to the office and worked for three or four hours, and then went down to Heiner Friedrich's gallery where they were doing a repeat of Walter de Maria's Dirt show (cab $3). Robert Rosenblum was there with his new baby and he had it with a cloth around it. It was the same show, but with new black dirt filling the gallery up.

Later, sat around at home and worked. Marina called and said to come over and have the food that was piled on her stove the night before, gallons and gallons. So I did, and it was just the

kind of food I wanted—parsnips and leeks and things like that. Walked over there. John Bowes-Lyons was there, I brought a present for him because the other night he'd said that he was bringing one for me, but he must have just done that so I'd bring him something, because he just had an old tie for me, he's so terrible.

Wednesday, January 2, 1980

Gigi came by 860 and she did a really good job with the makeup on me, but the wig she got wasn't good. This is for the Whitney poster. Ronnie was out sick. Gigi told me that she's pregnant and that if Ronnie wants the baby she'll stay in New York and they'll have it, but if he doesn't she'll get a divorce and leave.

Whitney Tower called and said that Kenneth Anger threw paint at Fred's door up on 89th and Lex again. He must think I still live there—he's been saying I'm the Devil or something, I don't know what his problem is.

Thursday, January 3, 1980

I wandered around, passing out *Interviews* (cab $3.50, art supplies $54.88). Cabbed to Union Square and then walked to office. Lunch was for Lewis Allen the producer and somebody who works with him, and I'd invited Princess Pignatelli and her husband when we'd run into them at Mr. Chow's. And Bianca called and said she was coming down with John Samuels to meet Lewis Allen.

Lewis Allen was seeing me because he wants to produce a Broadway "evening" with me, like an "evening" with the Beatles, you know? One where I sit and read from the *Philosophy* book. In the sixties Lewis Allen tried to buy the rights to *Clockwork Orange* for us to make into a movie. He produced *Annie* and things, and his wife is Jay Presson Allen, she writes screenplays like *Funny Lady*.

Friday, January 4, 1980

Stayed uptown because I was taking Bianca to meet my agent Joan Hyler, who's also John Samuels's agent—the four of us for lunch at the Russian Tea Room. I picked up Bianca and we cabbed over ($3). The Weissberger guy was there with Anita Loos, Maureen Stapleton, and Imogene Coca, and that was thrilling, seeing queens of comedy. Frank Perry was there, a little fatter. Oh, and John doesn't use the name Samuels. He's "John Stockwell" now—Stockwell's his middle name and that's what he's decided to use for his acting career. It was funny to hear him being introduced to people that way. And I didn't recognize that it was John in the new Armani ad. They saw him in *Interview* and asked him to be in their ad.

And Joan told me she had a part for me in *The Fan*—a walk-on in the party scene. She's a camp. She said she's a good agent because she knows what she wants and makes quick decisions.

I guess people really act like what they are—agents act like agents and actors act like actors ... Oh but I guess artists act like artists.

I went to Union Square (cab $3). I worked all afternoon with Rupert. Worked till 8:00. It was snowing and it was startling to see snow, and it was pretty, it was nice, sticking.

Saturday, January 5, 1980

Worked all afternoon until 6:00 on the German ladies and some backgrounds and the Jewish Geniuses. John Samuels invited us to the ballet with his father who's chairman of the board at City Center. Got to the theater and we had good seats in the grand tier or the dress circle. Peter Martins danced and he was good. Bought drinks at intermission ($20). Mr. Samuels took us backstage and the girl who didn't marry Balanchine was there. What's her name? Shelly? Shirley? Suzy? It was fun.

Went to the Russian Tea Room for dinner ($210).

Monday, January 7, 1980

Walked over to Doc Cox's for my yearly checkup. Took some *Interviews* with me for the reception room. Talked to Rosemary. She and Doc Cox were fighting while she took my blood, she was complaining that she wanted a career change but that she was too old to train to be a brain specialist. I told her she should go into fashion, do makeup. I was there till 2:00, and then I wandered around with some *Interviews* for a while. Cabbed to Union Square ($5) and walked to office.

Got the newspapers. The Russians are invading Afghanistan.

Tuesday, January 8, 1980

Suzie Frankfurt came down with Gianni Versace, and Jane Forth was there to do the makeup on him. I photographed him for an hour. A German from *Stern* called and I gave him a phone interview. Bianca just dropped John Samuels and he's crushed.

Wednesday, January 9, 1980

I was dropping Catherine off after dinner and we saw two limousines out in front of Halston's, so we decided to crash. Inside it was just Steve Rubell with a cold, Halston with a cold, and Bianca with a cold. They were going to Studio 54 and they made us come with them.

Studio 54 was empty, but fun. Sly Stallone was there, looking around the place for how to shoot a movie there. Susan Anton wasn't with him, he was after Bianca and it seemed like they

were going to go fuck in the basement. Anyway, they disappeared, we couldn't find them. Stallone looks good, he's lost weight and he looks really handsome.

Friday, January 11, 1980

Thomas Ammann had invited us to La Grenouille for a 10:00 dinner. Bianca was supposed to meet us there, but she never came, and Mary Richardson had called and I guess was hinting that she wanted me to invite John Samuels, but I didn't get the hint, she should have just said something. It was confusing, everyone was playing different games.

Then Catherine arrived with our art dealer Heiner Bastion. She'd taken him to the tennis matches for me, and when they came in I just accidentally said something like she hadn't had the good seats for him, and she was upset and actually cried a little, saying, "I took *your friend* to the matches and now you're ruining his whole evening saying I didn't have good seats." But I think she was just upset because McEnroe lost.

Saturday, January 12, 1980

Ran into Peter Beard and Cheryl Tiegs on the way to Le Club and they gave me a ride. Cheryl was in a cast, she'd fallen down in Montauk, and I bet Peter pushed her. I had a fight with Peter in the car—it was his car—we were talking and he said that "everything is coming down." And I said that Cheryl should look more glamorous and beautiful when she goes out if she's going to be the number-one top beauty in the world. She looked good, but plain. She wears the worst, funny clothes.

Sunday, January 13, 1980

Got up early, dead tired. Catherine called and wanted to go to the matches but I was tired and they make me too nervous. Went to church.

I took a gallbladder pill with wine, you're supposed to take it with water, and I wasn't supposed to eat anything for twenty hours before going to the doctor, which I was doing at 9:00 on Monday morning.

Monday, January 14, 1980

Up at 8:00 to glue myself for my appointment with Doc Cox. Went over there. He and Rosemary were fighting again. The waiting room was rich ladies like Dorothy Hammerstein. The fat girl gave me my X-ray but she couldn't find the gallstones. So I took the white stuff and sat around and waited. I took a new breathing test where you blow in a container that goes around in a circle.

I was finished by 11:00 (cab $4). Went to the office to meet with David and Sam Aaron who own Sherry-Lehmann, the liquor store. They want a portrait of a bottle of wine.

Then two guys from the IRS came in, and they were really horrible, screaming and carrying on and saying they wanted to see me, and I hid in Fred's office area. There was a tall one who was really horrible and a short one who said he liked my paintings, telling me how good they were. But the tall one was terrible and rude. We called Bob Montgomery our lawyer, who was coming down for a 5:00 meeting. He said not to talk to them.

By this time they said that what they were after was Rupert Smith. Fred said I still shouldn't talk to them. The little one was trying to get me to say something. Finally they gave me a summons and left. They just want records, cancelled checks or something. They were rude and awful, though. And Bob Montgomery cancelled and rescheduled.

Tuesday, January 15, 1980

Lewis Allen came by to talk about the musical—he wants to have puppets on stage with a recording of my voice saying things from one of the books—the *Philosophy* book or *Popism*.

Interviewed Ron Duguay for three hours and then we brought him to Halston's for a dinner for Martha Graham. Victor is back living at the house now, I think he sold his loft. Steve Rubell was there, and they were supposed to sentence him, but they postponed it, he said, because they want him to testify in court that Hamilton Jordan was at Studio 54 taking coke and he said he wouldn't, and Halston said, "But you already said it on TV," and Steve said, "Yeah, but that's not the same as saying it on a Bible," and I mean, I agree—it's not.

Thursday, January 17, 1980

Interview gave a screening of *American Gigolo* at the Gulf + Western building (cab $4.50). Richard Gere was really good and Lauren Hutton was great. She's a senator's wife who gives the hustler his murder alibi. Richard Gere has a sex scene where you see him completely nude. Nando did the art direction and at the end of the movie there's a scene where a pimp is being thrown off a balcony by Richard Gere and you see my three posters in the background, the Torsos. The scene is played against them.

After the movie I dropped Catherine, but right when I did, Halston's limo pulled up and he and Bianca said they were going to Studio 54 for Steve Rubell's farewell party before his sentencing, so my cab followed their limo ($3.50). When we got there we stood around, and they were taking pictures. Halston was smart, he disappeared, but I didn't realize what was going on. It was really crowded and it was early. I dropped Catherine off at 2:00. Somebody said that they'd put locks on Steve's safety-deposit boxes.

Friday, January 18, 1980

Steve and Ian got three and a half years each.

Monday, January 21, 1980

I tried to find new spaces in the back of 860 for *Interview* so they can expand their office space. Bob says they need more because it's hard to lie to advertisers when other people are listening. But I don't think that's what's hard to do with other people listening. I think what it's hard to do with other people listening is make personal phone calls.

Rupert came by and he'd made the Shadows two inches smaller than I'd said to—he just decided he would—and he had no right to do that and I screamed at him and now the stretchers have to be smaller.

Tuesday, January 22, 1980

Worked in the back on the Beuys portrait. Ronnie was going around saying that he hated himself and that he was going to go with Brigid to the A.A. meeting on Park Avenue that she was going to. And Gigi called and said she wants a divorce. She told him that she'd had an abortion. That's what she told him, but you can't tell with these girls. Who knows if she was ever really pregnant.

Thursday, January 24, 1980

Victor Bockris came over with William Burroughs. I introduced Bianca to William Burroughs. Bianca's hair is really short now, like a crewcut, it looks terrible. Jade was painting in the back with me and she sat on her first painting. I gave her some diamond dust to throw on the canvas.

Friday, January 25, 1980

Marina Schiano called about the dinner Mica Ertegun was giving that night. It got complicated because Bianca wanted to come but at first she didn't want to come if Mick was going to be there and then she *did* want to come if Mick was going to be there—it was complicated.

Glued myself together. Catherine said we could go to Halston's and go from there. He had a limo. Bianca got a call in the middle of getting ready from some friend of hers who said that on cable channel C they were doing my astrology chart, so we turned it on and it was a like a maharajah doing my chart and saying funny things from newspaper clippings, and it was so weird. He looked like Jerry Colonna. Or like Gene Shalit, but Indian. I didn't want to watch it, it was too weird. There he was doing my chart with two girls discussing it, it was really nutty.

Then we went to the Erteguns' and it was great. Mick was there. Jerry's out of town. And it was like he and Bianca were courting. They were together flirting. Bianca was touching him, it was exciting. Bianca had called Bob and made him get John Samuels invited for after dinner, to get Mick jealous, I guess, but Mick was being so nice to her that when John Samuels called there, she told him he couldn't come because Mick was there and it would get "complicated."

Then we went back to Halston's house and Bob threw up in Halston's sink, he'd had too much

to drink. Then Bianca said she'd take him home, and after an hour she still wasn't back. So we went out to see where the car was, and we couldn't believe our eyes—the driver was getting out of the back of the limousine, and about half a minute later, Bianca got out. And she looked dazed. I mean, she *could* have been asleep. But was she giving him a blow job? Was he going down on her? Was he trying to rob her? We didn't know. Barbara had said that Bianca probably went to see Mick who'd left before her. But it was too weird. We were stunned. And the driver wasn't good-looking or anything, so we just couldn't figure it out.

Saturday, January 26, 1980

John Samuels is going to California, he was upset because Bianca told him not to come and pick her up the night before. Bianca said she might go back to London.

I dropped Rupert (cab $3.50). I glued myself together and called "Suzy," the columnist—Aileen Mehle—and asked if she wanted to walk to the Metropolitan Club, and she said, "Walk? What do you mean, 'walk'?" And I didn't have a car, so I went out and hunted for a cab and it was hard to get one. Then when I got to her building I had my contacts in, so I couldn't see which bell to ring (cab $5). We were going to what used to be called the Diamond Ball until one of the ladies coming home from it got robbed of her diamonds, so now it's called the Winter Party. It's for some kind of international education for kids, I think—a benefit. It was so many old fogies, "Suzy" said she hadn't been to it in five years and that now she knew why.

Frolic Weymouth from the Brandywine Museum was there with a lady who looked just like all those D.A.R. ladies. "Suzy" said she really needed a drink. The old fogies were coming over and saying who'd just died. That day. We were at a table with the Zilkhas and an ambassador from Turkey. Then "Suzy" wanted to leave. She agreed to walk home. She said that I had to come and have Chinese vodka with her. Someday.

Monday, January 28, 1980

Got up, it was a nice cold New York day. I did my work at home, made calls on the phone (cab $4). Walked over to the office. It looks like the construction on the "Underground" discotheque is almost finished. *(laughs)* The Underground, I'm not kidding, that's what they're calling it. They're making it look like a fortress. They're putting in the big air-conditioning machines. I hear it's the same people who had Infinity which burned to the ground.

I sent "Suzy" some flowers for being my date the other night.

Wednesday, January 30, 1980

Went to Joanne Winship's for dinner (cab $2). Went to 417 Park Avenue, a building I didn't even know was there. It's the only building below 57th Street on Park where people still live now, it's on the corner of 55th.

Patrice Munsel was singing at the piano with a vice-president from Benton & Bowles. She wore an outrageous hat and I've never seen anything like it—like two big Mickey Mouse ears. Mary McFadden was there with a boyfriend, a German boy who was just so good-looking. The big star of the evening was Polly Bergen, she lives in New York again, and we did the running routine about Barry Landau of "How's your friend?" "I thought he was *your* friend." "He's not *my* friend, I thought he was *your* friend." Barry's been calling the office but they tell him automatically that I'm out.

And Joanne Winship has that tough society voice that just drives you up the wall! She talks nonstop and it makes you crazy. And Mr. Winship works for Associated Press. And he looks like Mr. Milquetoast, he has that shape and he's so calm. I went to this dinner because I just really wanted to because Joanne's so nutty that I knew I would love it.

Thursday, January 31, 1980

Picked up Ina Ginsburg to go with her and her son Mark to see *A Lady from Dubuque*, the new Edward Albee play opening with Irene Worth. The play is three couples, arguing a lot. Irene was really good, but somehow she just can't get a big hit. One of the best lines in the play was when somebody says, "How can you have that Jasper Johns on the wall?" and the big black guy says, "It's better than having a crappy Andy Warhol," and everybody turned around to look at me.

Friday, February 1, 1980

I was going to Diane Von Furstenberg's birthday party for Barry Diller. I'd invited Catherine, and we were picking up Truman, too. He's like a different person now, he's very distant, not friendly. He said he'd have something for *Interview*'s April issue. I tried to tape him, but he didn't have anything to say. It's strange, he's like one of those people from outer space—the body snatchers—because it's the same person, but it's not the same person. And he's looking older, he either gained weight or lost it or something, but he isn't thinking about the way he looks. I can't figure it out.

We got to Diane Von Furstenberg's. Diana Ross was there, she looked great. Diana Vreeland was there, too, and Diana—she's getting too tough to talk to.

Richard Gere was there, and everyone was talking about the Vincent Canby putdown of *American Gigolo* in the *Times*. But he said he was cheered up because there were lines around the block, so maybe it'll be a hit.

Paul Schrader was there, and Catherine got a thing for him and stayed after I left, but then it turned out she only stayed just a little bit, so nothing happened with that. Berry and Tony Perkins were there. Mr. and Mrs. Helen Gurley Brown were there and she got Truman into a corner. He left the party early, he said he was (*laughs*) tired of people telling him their personal lives.

Monday, February 4, 1980

I had to rush down to the office at 11:30. Jean Kennedy Smith was going to be there with Kerry Kennedy to pick out Ted Kennedy campaign posters (cab $4). Had to be photographed, they had the whole press there.

Sunday, February 10, 1980—Zurich

At the Dolder Grand Hotel Bruno Bischofberger woke us up at 11:30. He was waiting to take Fred and me to my first portrait job. We went to this small little house—it was like going into some Lower East Side house—and there was a mother and three children and Fred said one of them was really cute, but I didn't notice. They had corduroy pants on and torn shirts. Fred asked for orange juice and they gave him canned orange juice. The mother was just a little mother. The furniture was old and worn. There was not one thing in the place that looked rich. It looked so poor I just wanted to give them the portrait free. They were very nice but I just couldn't believe they could afford this. We were all stunned, but Bruno was saying you can't tell about the Swiss, the Swiss hide all their money.

Monday, February 11, 1980—Zurich

Slept late and then Thomas Ammann woke me up to do a portrait. A beautiful wife with a fat husband. I said she didn't need makeup. She was easy to do because she was a raving beauty. Her husband tells her she's ugly—Thomas says that's how Swiss people treat their wives because they never want them to get too secure. We gave them a book and an *Interview* and we sent out the film. It's so hard to find anything but SX-70 film here, they're phasing the other out. We bought English papers which I paid for ($5).

We had lunch downstairs in the restaurant with Loulou de la Falaise Klossowski and her husband Thadée and Thomas. We signed for it. The food was good. The place was so beautiful with a view of the lake and the mountains. We were the only people there and the sun was beating through the window on our backs. It'd been hailing in the morning. The weather has been so strange. Loulou told us that YSL really was such a genius that he just can't take it, he has to take a million pills and the whole office gets so depressed when he's depressed except for her. She said she acts happy no matter what. That's why she gets sick, because she's always trying to act happy and it's really a lot of stress on her liver. She hasn't had a drink in a year and a quarter but she doesn't think cocaine is bad. I do, though. We talked about her stepfather, John McKendry. She said he had so many boyfriends. His idea of marrying Maxime was fantasizing that her son Alexis was going to live at home with them and that he could have an affair with him. But the son immediately got married and moved to Wales. Then he envisioned Loulou being there bringing home pretty boys every minute that he could fuck. And actually he did steal her boys.

Loulou said John McKendry was actually killing himself slowly because he'd always fantasized how great and romantic and wonderful and literary the aristocracy must be. Then when he met

them, and married a countess—her mother—and got to meet Jackie O. and people like that every day through his job at the Met, he realized they were just normal dumb people like everybody else. There was nothing left for him to live for. Of course I think that Maxime just drove him crazy. I couldn't say that to Loulou, though. Then we took a cab downtown ($10.50).

Thursday, February 14, 1980—Düsseldorf

We had to take Hans Mayer's car and drive out to the country to a small town to photograph a German butcher. His company is called Herta, it's one of the biggest sausage companies in Germany. He was a cute guy. He had this interesting building. You could see all the employees. He had my Pig on the wall. Junk everywhere. A lot of toys. A lot of stuffed cows, stuffed pigs. Pigs, pigs, pigs all over the place. And there was art. There were funny things hanging from the ceiling. There were water-dripping paintings. He buys a lot of art, he said they sell more sausages that way because the people are very happy. Then he gave us a white smock and white hat. We went through and watched the ladies make the sausages. It was really fun. You could smell the sauerkraut cooking, but they didn't give us any hot dogs there. He had the whole portfolio of Picasso that I did the Picasso print of Paloma in. We looked at that, then we had to look at more pigs and more salamis and more hams and more ham art.

Then we took Polaroids for the portrait and had some tea. And his wife came by. They didn't offer us lunch. Then all of a sudden he asked us if we'd like to try one of his hot dogs. They cooked some up and we had two apiece. One white one and one black one. They were really good. We had them with mustard. He said he had to go have lunch back at the lunch room. We had to go off without lunch which we thought was really strange. We got in the car and drove to a restaurant in a place called Bottrop.

As soon as we came in they told us it was this crazy day where all the women chase the men. They cut off your ties. But since we knew that was happening—we saw these drunken ladies running around—we took our ties off and hid them in our pockets. But then they got my shirt tail and they cut it off and it was my good shirt and I was so mad. These women were really bullies. We got back in the car and drove back to Hans's gallery. I was so tired, and I was really upset about my shirt.

Monday, February 18, 1980—New York

I was jetlagged and overslept. I made the kids come in to work on the holiday because they'd been loafing for two weeks while I was gone, but it turned out the building wasn't open and the heat wasn't on. And the discotheque on the ground floor is still being built, they had the nerve to send me an invitation to the opening. They broke the elevator and it wasn't working, and I think the no heat is something to do with them, too.

Ronnie's trying to memorize his big role in the Walter Steding extravaganza performance coming up soon somewhere downtown, and since I'm Walter's manager, I should find out where it is.

It was great to be back. I thought it'd be forty degrees, but it turned out to be still twenty. I

wandered around and passed out *Interviews*, then got a cab to Union Square ($3.50). The heat finally came up in the front, but it was still cold in the back. Brigid was working on the same piece of paper she was working on when I left. I mean, she thought I wouldn't recognize it?

And I just don't know where to paint anymore now that *Interview* has taken over my old room. David who works for *Interview* was finished painting it ($50 to David for paint).

Tuesday, February 19, 1980

I got up before 9:00 to watch the *Today Show* and try to figure out why Gene Shalit hasn't used the thing he did on me. He'll use it after I die, he'll say, "I spoke with Andy Warhol in 1980 and here is that clip." I must be a really terrible guest. I mean, I must be too weird for TV because it's always the same thing—they never know what to do with it. Well, the 20/20 thing that Karen Lerner shot during the *Exposures* tour is supposed to be on next week. The twenty-eighth.

We had office pizza lunch ($5).

Oh, and this guy from *New York* called about the first part of *Popism* that they're running on the cover. Wouldn't it be great if the book was a big hit and we didn't have to work to promote it?

Ron Feldman came down and we looked at the Ten Jews. It's really such a good idea to do that, they're going to sell. And all the Germans want portraits. Maybe because we have a good person selling there, Hans Mayer. How come we don't get many American portraits?

And I forgot to say that when I was walking along University Place a kid stuck his head out of a car window and said, "Aren't boys cuter in *cars*?"

Thursday, February 21, 1980

Did I ever say that a couple of weeks ago Bianca asked us about the night she gave Bob a ride home from Halston's after he threw up in the sink? Bob was sort of shocked that she would bring it up. This is the night we saw the chauffeur getting out of the back part of the limo. Bob said he told her, "Well, Bianca, you just took me home. Everyone called me up the next morning and said how it was nice of you to stay with me for an hour and a half. I said you hadn't been with *me*. They told me they found you and the chauffeur in the back seat together." She said that she just passed out after she dropped Bob off because Mick had given her three vodkas in a row at the Erteguns' house and that she got so excited at seeing him there that the vodkas just made her black out. She said that the chauffeur was in the back with her really just trying to wake her up. And Bianca told me she was never jealous of Jerry, that she knows Mick is with Jerry because he's into a real sex trip right now. And I said, "Well, Jerry told us that she gives Mick a blow job before she lets him out of the house," and Bianca said, "Why didn't you put that in her interview?" I said, "Because you were mad enough at us for putting her in *Interview* in the first place, let alone if we had her talking about sex with Mick." Bianca said she wouldn't care, she said the only girlfriend of Mick's she ever got jealous of was Carly Simon, because Carly Simon is intelligent and has the look Mick likes—she looks like Mick and Bianca.

Richard Weisman asked me if I wanted to meet Stallone and have lunch with him on Friday on the set of his movie. He said Stallone may want his portrait done.

Some Japanese journalist came by. He'd gone with us in Japan from Tokyo to Kyoto, copying me by taping the trip, but nothing was said *(laughs)*. The Japanese Warhol. So he was in town and I thought I would give him some material to write about since his last time with us wasn't much, so I took him with me and we went to Madison Square Garden to the antique show (cab $3). And in the cab I said, "Where's your tape recorder?" and he pulled it out of his bag—it was the only thing in the bag, this tape recorder running—but it turned out that it was running slow and the batteries were no good, and he was just crushed, he couldn't believe it and he said, "Oh Jesus Christ, oh Jesus, oh Christ, oh Jesus, oh God, oh Christ," and I said, "Well, there's your interview." But it was sad, he felt so bad, and I said, "Oh, you can remember." Anyway, we got to Madison Square Garden and it was really great, I couldn't believe all the junk (tickets were 2 × $4 = $8). Ran into Tony Bill.

Friday, February 22, 1980

Richard Weisman called and said lunch with Stallone was on for 12:30.

Oh, and I forgot to say that Truman called. He said that he was hit by a fat skier when he was walking across a ski slope in Switzerland. He sounded more like his old self. I guess he's in a good mood because Lester gave him $450,000 for his thing from *Interview*, "Hand-Carved Coffins." We don't get anything out of it, though.

We went to where Stallone was shooting on First Avenue, they had about 300 extras. The movie's called *Hawks*, I think, and Martin Poll is the producer, he's the one who took Stallone to my Whitney portrait show. Martin and his wife were there. They had huge crowds there. The set decorator came over and said that he'd been the set decorator on *Bad*.

We went to a restaurant near there. I guess they sent one person out all morning to look for a quiet place for the director to have lunch. It was Richard and Martin Poll and his wife and Stallone and me. Stallone is so cute, so adorable. I guess he's lost sixty pounds. He's sexy. All the stars usually think they should have their portraits done free, though. He's intelligent, he's taken over directorship of the movie and now he's in trouble because the union has a film of him saying, "Lights, action!" It's going before a board. Stallone was telling stories about how much trouble he's had with the union, how there's this little Irish guy that he just wants to beat up so badly. He said he had this one shot all set up, everybody was in costume and makeup with blood and everything for a fight scene and it was snowing, just perfectly and they said, "Okay, stop, everybody break for dinner," and he said he practically got down on his knees pleading, "Please, just let's get this one shot, please, I'm a fellow worker, please, I'm Rocky!" and they wouldn't let him. They broke for dinner and then he had to start all over again.

I said to him how could he go and tell the papers the truth—that he *wasn't* having an affair with Bianca. I told him he should have said he *was*, that he should have gone for the glamour. He said he and Bianca were "just breaking each other's balls." I don't know what that means. He told us that he'd gone over to pick her up and she was wheezing and had a cold and she looked so horrible that the romance fell apart right there. But he probably doesn't like Latin types, I

think he likes big blondes. His manager loved us because *Interview* had just done a story on his only other client, Ray Sharkey. Then we left (cab $3).

Afterwards Martin Poll's wife called, she said she was calling for a favor to Stallone and wanted a discount, but I mean, he's so rich.

Monday, February 25, 1980

I picked up a couple of fans in the morning. One said he wrote in for me in the last presidential election.

I ordered some *Popism* books from Harcourt Brace, they make good presents. I worked all afternoon waiting for Philippa de Menil and Heiner Friedrich to come to dinner. They wanted to have a candlelight dinner at 860, they said. I can't figure them out, they're strange, they don't like to go out. We're trying to sell them some new stuff. Rupert brought some prints by. Heiner and Philippa came. I showed them the work. Robyn brought food from 65 Irving and put it in the stove. He stayed on to be the butler. Philippa doesn't eat anything, but at this dinner she ate everything, so either she's nervous when she's out at restaurants and doesn't eat or she was nervous at 860 and did eat or else she was just hungry for the first time. I can't figure it out. She even ate two pieces of banana pie. She was fun. Robyn got a good assortment.

They asked why we didn't come to La Monte Young's concert, their Dia Foundation supports him. I didn't tell them that I just couldn't face hearing one note. Heiner and Philippa are just back from Turkey. Oh, and they sent the whole Whirling Dervishes to Dr. Giller for acupuncture. *All* of them. They said they still haven't found a good building for a Warhol museum. The Dia Foundation is going to make one. The owner of the red building next door to us wants $300,000 just to *rent*.

Wednesday, February 27, 1980

Truman called the other day and said he wouldn't be giving in any more articles. He said it was because he was going to give us *Answered Prayers* when it was finished in October. I told Bob he was just lying. He's a different person now, Truman, he's dropped us and I can't figure out why.

At the office Jill Fuller called and said she'd rented the helicopter to take us out to the Nassau Coliseum to see Pink Floyd, they're friends of hers. I called Catherine who's working for Richard Weisman now and she got excited about the helicopter so I got my courage up and thought it might be fun.

And the guy downstairs said the disco is opening on Thursday night and he was leaving my name at the door. They turned the music on yesterday and it was so loud, everything was just shaking, and I could hear them through the elevator shaft screaming, "Louder, louder!" and it was just so loud *already* you couldn't believe it.

Picked up Catherine (cab $4). Went to Jill's. Jill gave us a bottle of champagne and we took a cab to get the helicopter (cab $3). It was a beautiful beautiful ride, we drank the champagne. Four limos were waiting.

Then they started the show and this show is so complicated and expensive that they're only able to do it in California, New York, and London. It's big statues like the Macy's parade.

Thursday, February 28, 1980

Picked up Catherine, cabbed to Harry Bailey's on East 72nd Street ($2). It used to be George Gershwin's apartment. Barbara Rose was there with her husband, the "Hound Dog" guy, Jerry Leiber, and she's so horrible. She's the worst person, she comes over and says things like, "Oh, I love your new writing style that you didn't write." I mean, what makes people do things like that? They must be sick. She was just the worst-dressed woman there, she looked so awful. I should have said to her, "I love your clothes." I've got to start thinking faster. I don't know why Harry would want to have dinner with Barbara Rose unless he thought she knew what art he should be buying.

Friday, February 29, 1980

We had Toiny Castelli and her assistant and Iolas and Brooks and Adriana Jackson at the office for lunch. Toiny wants to give me a print show. And Iolas is opening a new gallery.

Studio 54 lost its liquor license—they had pictures in the paper of Sylvester Stallone getting the last drink from the bar—and Steve's other restaurants on Long Island lost theirs, too.

Saturday, March 1, 1980

Victor Bockris called and said that the dinner with Mick Jagger at William Burroughs's was on. Victor's doing a book on Burroughs. Decided to stay at the office and not go home. The driver passed 222 Bowery, he was going too fast (cab $3).

We went upstairs and I hadn't been there since 1963 or 1962. It used to be the locker room of a gymnasium. There's no windows. It's all white and neat and it looks like sculpture all over, the way the pipes are. Bill sleeps in another room, on the floor. I don't think he's a good writer. I mean, he wrote that one good book, *Naked Lunch*, but now it's like he lives in the past.

A girl who was there—Marcia was maybe her name—said she's been photographing Kenneth Anger at his place on 94th Street. I told her not to mention my name or he might beat her up, that he thinks I'm the Devil. She said the apartment is all red, and he has everybody's picture up and he puts everybody down. Bill was asking Mick about the "drug culture" and the "revolution" and all that and then Mick and Jerry left. I stayed there for a little bit. Then Victor Bockris walked me down and we waited for half an hour before a cab came (cab $5). Home at 11:00.

Sunday, March 2, 1980

It was very cold out. I went to church. Then I had to be ready at 2:30 to go to the Regency to take photographs of Sylvester Stallone. Fred was waiting. Suite 1526. Sylvester was looking good. He's back with his wife, Sasha, she was there, she's cute and smart, she looks very young. I don't know why he would leave her for Susan Anton.

I made him take off his shirt and he was wearing some kind of medal. I used ten rolls of film, because he's really really hard to photograph. From the front his neck is skinny, then from the side it looks three feet wide. From the front he has a huge chest, and from the side no chest at all. His hands are pretty, I used his hands, but sometimes they look tiny and sometimes they look huge. He's like Rubber Man.

He had the bodyguard who was the bodyguard Tom Sullivan used in *Cocaine Cowboys*, so we talked about Tom. Sylvester talked about the Academy Awards, he said he hated *All That Jazz*. He said the Academy Awards ignored him and Woody Allen this year.

He said he's about to go to Hungary to do a movie, an action movie, and then after that he wants to do the Jim Morrison story. I told him we were really good friends with Jim, and that Tom Baker was his good friend and that he should talk to Tom who's in town, by the way, and he's calling me.

I told Stallone he should do the Linda Lovelace book. He said that he was worried, I guess, that he was a one-movie person, and he named a few people that were one-movie people. He named somebody from *The Boys in the Band*.

We were there for about an hour. His wife had gone into the other room and she didn't come out to say goodbye, I don't know why.

Monday, March 3, 1980

Cab to Union Square ($2, supplies $8.10, $20.50). I was meeting Carol, a cousin of mine from Butler, Pennsylvania. She drove me up the wall because she talks so slow. Then she left and I worked all afternoon. I made Rupert come up. I needed someone to go with me to the Ted Kennedy poster signing. So we went up there, to Madison Avenue (cab $4) to the Brewster Gallery.

But Ted Kennedy didn't show up, he was in Massachusetts. It would only have been good if he was there signing, too. I'd been signing all afternoon. All the Kennedys were there. Kerry and one of her sisters, and Kerry's prettier. They're all funny-looking, those kids. Pat Lawford was there, and they posed us together. She was nervous so she was drinking and she gave a speech. It was hard work. Kerry went around selling the posters. They were $750 and $2,000.

Tuesday, March 4, 1980

Catherine Oxenberg came for her cover *Interview* lunch at 1:00, and she's only eighteen so she was nervous and really blabbed everything about her mother sleeping around and how Sharon Hammond's sister Maureen was married to her father, but how Maureen is now living with

Catherine's half-*brother* who's maybe nineteen and she must be about forty, I guess. Her mother's Princess Elisabeth of Yugoslavia. It was a Balducci's lunch, it was a good interview. Tom Baker came to say goodbye, he's leaving town. I told him about Sylvester Stallone wanting to play Jim Morrison and he said Stallone was too old to do it.

Wednesday, March 5, 1980

Picked John Reinhold up and we walked over to lunch at Pearl's. We talked about diamond dust. The dust is actually just like powder, but the *chips* are what would look pretty and they would make a painting cost $20,000 or $30,000. It was nice to see Pearl again.

Thursday, March 6, 1980

Lunch was for Richard Gere and his girlfriend Silvinha, who's in this issue of *Interview*. Fred invited a couple of Swedish people, and Chrissy Berlin and Byron the pool player who's somebody Zoli fell in love with, but he doesn't want to be a model—he plays pool and thinks modeling is too frothy. He knows everything, like that at British Airways on Tuesdays and Thursdays on Park Avenue, you just sign in and there's free shrimp buffets.

Amina, the black model who's writing a play, kept saying, "Where is that Richard Gere? He's supposed to be here!" But then when he came he didn't pay attention to her, so she didn't like him anymore and she came over to where I was signing Kennedy posters. Robyn brought the lunch from 65 Irving, but then Brigid ate every bit that was left, so he didn't have any.

Then it was a beautiful day so I said why didn't Brigid and Chrissy and I go over to University Place to see if Bea was in her antiques shop. We passed out *Interviews* to the junkies who've moved from Park and 17th to the corner of 14th. Then we were all in Bea's and Brigid said she'd be right back, that she was going across the street to get a pack of cigarettes. And a second after she left, I heard a big noise and a thud, and I just knew. I ran out, and there was Brigid lying in the street with a truck one inch away from her fat belly. Then she got up and she was laughing and she said, "No no, I'm all right." It was a truck from an art restorer. The kid was sweet, he wanted to take her to the hospital, but she was so relieved she was all right that she said no. She was just scared out of her wits. Chrissy was so nervous she had to go home.

I was so happy Brigid was alive that I told her she could have anything in the world so she had ice cream cones ($.75 × 4 and $.90 cookies from Greenberg's and then cake $12, Big Macs $8.52). We walked around for an hour to make sure she was okay. All we could think about was here today/gone tomorrow. I hope it taught her a lesson to be more careful.

Then we went back to the office. I told her she could have the rest of the day off but it turned out they needed her. She went to an A.A. meeting and then came back. Fred was really drunk at the office, he'd been to the Cecil Beaton memorial thing. He was talking like Diana Vreeland and making business calls, so I just hope he called the right people.

Monday, March 10, 1980

Got up and watched the *Today Show* and the weather guy I liked so much they just got rid of. The Ryan guy, he was so great. Then the *Donahue Show* had four fairies on. Again.

Sent Brigid to the bookstore to buy eight copies of *Popism* ($94.56).

I stayed downtown and cabbed with Vincent and Shelly to Charles Maclean's party, it was in Jennifer Bartlett's studio on Lafayette Street. It was a big party for English kids. Clare Hesketh, the wife of Lord Hesketh, said, "Oh, isn't Fred wonderful, he stayed up until 11:00 this morning with me." I said, "Oh *really*? That's very interesting. He came to work at 11:15."

Tom Wolfe was there and Evangeline Bruce and the McGraths. Oh, and also Steve Aronson, and he introduced me to a lot of writers.

Tuesday, March 11, 1980

Kenny Lane called me and invited me to lunch at his place to meet a Kuwaiti sheik (cab $3). The place was really pretty. Kenny introduced me to the sheik and his wife—they call the women sheiks, too—and she said, "My husband is short, so if he comes over to talk to you he may stand on a chair." She buys modern art, and he's out to buy $200 million worth to stock his museum with—like Kuwaiti rugs.

Marion Javits was there and she did the funniest thing, she said to Bob, "Ask me questions the way a newspaper reporter would, and let me see how I would answer." And so Bob asked her why did she smoke marijuana in public and why does she go to Studio 54. And Marion said, "Because it turns me on." And Bob said, "But you can't say that, Marion." And so then she said, "Well, perhaps you're not aware that my husband introduced legislation to legalize marijuana."

Then we had to go back to the office (cab $3).

Rupert came, I closed up at 7:00.

Dropped Bob off. Glued myself together and walked over to Diana Vreeland's. Elizinha Goncalves was there and Fernando Sanchez and Sharon Hammond, and I taped Mrs. Vreeland. She told us the funniest story about going to see *Deep Throat*. She has this friend who lives on top of her building who lost her eyesight but one day she called Diana up and said, "Diana, I can see. I have my eyes back, and I want to go to a movie." Diana said, "So I took her four blocks to see *Deep Throat*. And we got to the theater and the ticket lady said, 'Do you two ladies realize what you're getting yourselves into?' And my friend was so excited she was going to the movies she kept saying, 'I'm so thrilled, I'm so excited.' So we get into the theater and like in all pornographic movie theaters, there's nobody there. Just about twenty men, most of them asleep, they've slept through the thing seven times and don't know where they are, and the movie comes on and my friend's eyes were popping out of her head. She hadn't seen anything for ten years and now she was getting *Deep Throat*. And for days after that she called me up saying, 'Diana, do you think that girl's hurt her insides? How did she do it? Her throat must be all bruised.' And I said, 'Well, I don't really think about things like that—to me the whole movie was a romance.'" And Bob said, "Diana, how could you do that to an old lady?" And she said, "What else do you take someone to see who hasn't seen anything in ten years? It gave her a lift!"

Then she took us to Quo Vadis.

Wednesday, March 12, 1980

I bought a hundred *Popisms* from Harcourt Brace.

Gregory Battcock came down, I gave him some books. Gerard called up for two copies of the book. We still need an idea for the next cover of *Interview*. I gave Brigid the tape of Diana Vreeland and Sharon Hammond, but I forgot that for about ten minutes Sharon and I were talking about Brigid on it. I had told Brigid about Diana Vreeland going to *Deep Throat*. So that sounded funny, that's what I thought I was giving Brigid and that's what she thought she was getting. But as Brigid had the earphones in and was listening to the tape she got ten different colors on her face. Sharon was saying things like, "Well yes, if Brigid leaves her job, yes, I'd love to take it over." And then Brigid thought I was being mean, giving her the tape, but I just forgot we'd said anything about her on it. She got so upset she called her sister Chrissy to come over and hold her hand. On the tape I was saying that she got hit by a car—whammo—and that afterwards I'd bought her five ice cream cones, and Brigid got hysterical when she heard that—she said it was only three cones, that the other two were mine. But I think I convinced her she had four. I named the flavors. Chrissy's weight is going up. She's 145 and Brigid is 166½. Brigid was in a state of shock for the rest of the day, she stayed until 6:30.

I called Brigid when I got home. She and Chrissy had just gone to dinner and had dessert. I had to think of a way to get Brigid to lose weight and so I told her I'd give her $5 for every pound she lost, but that she had to give me $10 for every pound she gained. She's bringing her electric scale in to the office tomorrow.

Saturday, March 15, 1980

Farrah Fawcett called and said she was on her way down to Union Square, and she arrived in half an hour with Ryan O'Neal. They looked at her portrait and I didn't think Farrah liked it, but then she studied them for about half an hour and finally said she loved it. I had Bob come down because I thought he could talk them into doing a cover, and she said she would. And she looked pretty, her hair was all washed, and she looked very very nice. She's sweet. So then they left and I stayed alone with Rupert. Dropped him off (cab $4). Then glued myself together because I was invited to Prince Abudi's dinner for Marion Javits.

His place was just around the corner, at 10 East 68th Street, and as I'm walking in, in comes Ultra Violet, wearing the same dress from the sixties, with the same gold coins, and I said, "Gee, Ultra, you shouldn't do that—it might have been a camp when a gold coin was worth $35 but now they're, you know, worth $775 *apiece*, so you should be careful." But she said she's had to sell most of the good ones, she was just wearing her pesos, very heavy pesos. And it was really fun seeing her again, I kept asking her, "Well, who invited you, how did you get here?" I think she's a good friend of Marion's. I have a funny feeling that maybe she services people or something, I have a funny feeling that maybe that's it—like when there's a guy, an older guy maybe, she'll go out with him or something. But she was fun. I spent the whole evening with her because it was a really awful party. Abudi was very quiet. Although he's a Saudi Arabian prince he didn't have any young princesses there, so it was just all the people I know, like Sam Green and Kenny

Lane, and Marion's boyfriend who makes holograms. And she likes him. I don't see what she sees in him, but he's the mistress. What would you call a guy who a woman sees? A "lover?" A gigo —no, a lover, I guess.

And who else was there? Oh, the Bulgaris came, but I didn't get a chance to talk to them, because Ultra Violet went to the caviar dish and she said it smelled like a tin and then Kenny Lane came over and said it was the best caviar you could buy, so then she decided to eat half a pound of it. And she said she was going to write her memoir. Oh! And she finally told me how she got sick. It was all over Ruscha, the artist, Ed Ruscha. She had fallen madly in love with him and he had a wife and he just couldn't handle it, and she just went too crazy because she was too in love with him, she let her whole nervous system fall apart. And that's when she was eating a piece of gold every day—somebody told her that Indian people eat gold or something like that, and it ate a hole in her stomach.

And now Ruscha doesn't have the wife but it's not the same. And she's looking for another young somebody. It ended up we were there until 3:00.

Sunday, March 16, 1980—New York—Washington, D.C.

Went to Washington to the Goldman Fine Arts Gallery and Judaic Museum at the Jewish Center in Washington. To the gallery. And they had *Popism* and *Exposures*. It was hard. Every single person would think that they had to ask me an intelligent question: "Did you use all these different pieces of paper to show all the different facets of Gertrude Stein's personality?" I just said yes.

Monday, March 17, 1980—Washington, D.C.—New York

Well, it was St. Paddy's day. Bob ordered breakfast up. I didn't have a good sleep. We watched the *Match Game* and it was a fast round where the answer was "Andy Warhol" and one person was guessing "Peter Max" and then "Soup Can" and then "Pop Artist."

Our breakfast was cancelled at the White House. I guess the Carter administration doesn't want to see us anymore because I did the Ted Kennedy poster. But we were glad we didn't have to get up so early to be over there at 7:30. We slept till 11:30.

A girl came and took us to Kramerbooks, it's a bookshop/coffee house, and so everybody was drinking. Bob loves the place because it's where he picked kids up when he was at Georgetown. People were shoving everything at me to sign and I signed it all—underwear, a knife. Oh, *(laughs)* and I signed a baby.

We had to get the shuttle at 9:00 (tickets $153). Bought some newspapers and a *Newsweek* ($2). And *Newsweek* had a great review of *Popism*.

And I forgot to say that at the bookstore in Washington Sargent Shriver went out of his way to come by and say hello. He used to be so handsome. And oh God, it's just so hard to talk to old ladies like I have to sometimes—they're so old and their teeth are crooked and all you see is their mouths, and it's just so hard to stand it, and I guess that's about all the philosophy for now. Went to bed, had a glass of wine, fell asleep.

Tuesday, March 18, 1980

I'd invited Ultra Violet for lunch, and in the daylight she really looks like an old woman, but at night, with makeup, she really looks gorgeous.

Then Divine was at the office. He said he had $2,000 to spend on a birthday present for Joan Quinn, and I told him we didn't have anything that cheap. But then afterwards it occurred to me that I'm sure he was just getting something for Joan's husband to give to her, that he had given Divine the money, so he was playing games. Because I mean, Divine wouldn't have had $2,000.

And I don't know why Divine is so fat, he had one sandwich and then I offered another and he said, "Oh no, thank you." And Divine really is the only one who you can't tell if it's a boy or a girl. Because of the long earrings, maybe. Like Edie Sedgwick earrings. And actually his face is the Edie type of face, but fat.

Rupert came by and helped out.

Bob was nervous, he was giving a lecture at Bard College that night, and he left at 4:00. His first lecture on gossip.

Karen Lerner called and said that the 20/20 segment was put off for two more weeks. But I'm thinking, I don't really want it to go on, anyway, because when you get publicity on TV it just makes too *many* people aware of you. I think I'm just doing okay with the little bit of publicity that I get, anyway. Because also, they use you up. And it's scary. Yeah, I think you can just get along on a steady little bit of publicity.

Carmen D'Alessio called and said she visited Steve Rubell in jail and that he sleeps, eats, and plays handball. He's talking to Neil Bogart about buying Studio 54. He says when he gets out he wants to do something completely different.

Then I left to meet Richard Weisman and Catherine at the Mayfair House. Catherine's been working for him and they were spatting. It came out that she'd just told him she quit. It was an easy job—he just was sending her out to buy his presents for him, I think (drinks $20).

Cabbed to Diane Von Furstenberg's ($4). I had a fight with the cab driver, he wanted to go the way he wanted to go. Richard wasn't invited but he was Catherine's date. The first person I ran into was Laverne of *Laverne and Shirley*, and we talked about the "L" painting I was going to do for her. Richard was acting like a host—he always does, somehow. He's very insecure and he does drive you up the wall, but he's nice. He thanked Diane for inviting him, but she hadn't. Harry Fane was there, and Barry Diller. It was a party for Nona Summers and her husband, whose name I always forget, so they think I'm wigged out. That's the new thing they're calling me. Like in *Newsweek* they called me that.

The same people as usual . . . Berry Berenson and the Niarchos kids, who it's so funny to listen to after you've heard Fred imitate them, the lisps. And Barbara Allen was running around saying that all her boyfriends were there—Mick Flick, Mick Jagger, Philip Niarchos, and Bryan Ferry. Barbara looked gorgeous.

DVF said she couldn't wait to read *Popism*, and that everybody loves it. And then Silvinha arrived with Richard Gere and said that I was her sixties, so she'd try to be my eighties. Silvinha takes painting lessons from Mati Klarwein the painter, who has the kid with Caterine Milinaire.

So Silvinha and a girlfriend were talking and Silvinha said she was making it with Max DeLy's friend, that Italian kid Danilo—she was saying this when Richard wasn't nearby—and then she

said, "I don't know what to do about Richard, we stay out till 4:00 and then sometimes we have sex and then sometimes we don't, and I want to expand his mind and take him to art galleries."

François de Menil was there, I didn't even know it. And in the bedroom they were all taking stuff. And Harry Fane was putting the make on Silvinha or her girlfriend that she was talking to, he put on the "Fuck Me" look. And Barbara Allen was running around saying who should she go home with. And then just as I was quietly slipping out, Richard Weisman saw me and was screaming, "Andy! Andy! Are you *leaving*?" And then he wanted to leave, too, and he does his thing of saying goodbye to everybody, just what I didn't want to do. And then in the car he said, "Do you think I made a mistake the other night, going to bed with Catherine?" I said, "What?" I mean, I knew that he and Catherine had had sex once a while ago, but now here he was saying that they *just* had it, and I mean, I can never bring it up to Catherine because it's too embarrassing. And Richard was saying how he felt guilty and did I think that was why Catherine quit, because when you do it with somebody you work for, then you think you *always* have to do it.

Wednesday, March 19, 1980

We were going to see *Heartaches of a Cat*, the play that Kim D'Estainville produced. At the Anta Theater.

I went over to pick up Paulette and we went over to the theater. Paulette signed autographs. The play was so cute, so unusual. Really beautiful masks of the animals. All the actors have animal faces, like the toy things in old French books. Everybody loved it. It could be a hit. I mean, if the kids love *Peter Pan* they'll just love this. It's the Argentinian group that broke away from Paloma's husband.

Claudette Colbert was with Peter Rogers, and for some reason she's always so happy to see me. Jerome Robbins was there, I think he helped with it.

When they did the speeches in French it must have sounded so elegant, but in English, Miss Piggy speaks so much better.

Then we went across the street to Gallagher's for the after-the-show party.

Bianca, it turned out, never came because she had to wait at the airport for three hours to pick up a painting for Thomas Ammann and she was mad ($10 to the limo).

A nice lady came to ask Paulette if she would give her daughter her autograph and Paulette took the lady's hand and lifted it off her shoulder and said, "I hate greasy hands on my white dress."

Saturday, March 22, 1980

Worked till 7:30. Then cabbed to Si Newhouse's ($4) on East 70th Street—a big wide house. An art party. Bruno Bischofberger was there. And Mel Bochner the artist who was married to Dorothea Rockburn the artist and got ideas from her. And Mary Boone who said she'll give Ronnie a show, but he's not interested because she calls him every night at 4:00 in the morning. Carl Andre was there. I invited the Newhouse daughter to lunch on Monday, she's just a shy girl, but then I

found out that her parents were divorced when she was little, so I don't know if she's in the bucks or not. Mark Lancaster was there.

Bianca had called me before I went to the Newhouses' and invited me over to Halston's later, but I couldn't bring Mark because Halston gets upset when you bring another person. So cab to Halston's ($1.50).

Bianca was talking on the phone to Steve Rubell in jail, and Steve was having to put in nickels every three minutes. Because you can't call them and you can't write them letters, or he doesn't want you to or something. Somebody asked him if the phone was tapped and he said, "No, no." But then somebody else was saying that when they talked to him before, they could hear a guy warning him to watch what he said. Another inmate giving him advice.

Steve said he's having a wonderful time, that he's put on eleven pounds, and he had sloppy rice for dinner. He said that if he can get his liquor license back for Studio 54 then he'll liquidate, because it'll be easier to get rid of it with a liquor license.

He said that the top people were there. I think he said Sindona, but I'm not sure. He said Ian sleeps all the time. Bianca was saying all these things to him, like that she was going to Magique later to try it out and that she'd been at Xenon the night before. I guess she thinks that kind of talk—that that's the kind of talk that'll excite him. He kept putting nickels in. Bianca had John Samuels there, he got a haircut, and he looks fifteen.

Monday, March 24, 1980

I bought *Wrestling* and *Petland* and *Jet*—lots of different magazines—to see what they were like to get ideas for *Interview* ($8.50, cab $3).

I had to be photographed by some ad agency and they did their whole setup and then asked me why I was so creative, and I said, "I'm not." So that blew their whole thing, they didn't know what else to ask. Then I took the car up to Bloomingdale's. I was forty-five minutes late and they were mad. I autographed a lot of books. Then the car drove me home. It was raining.

Went to La Boîte to the dinner Bob organized for *Popism*. And there were terrible speeches by Henry Geldzahler who said I was the mirror of our times, and Ahmet who said everybody loves me. Richard Gere was sweet and said he'd read the book and loved it. Stallone crashed with two girlfriends, and he and Bianca had a big fight because he heard her putting him down. Everybody sang "Happy Birthday" to John Samuels who turned twenty. And our editor Steve Aronson was there and he kept his whole table laughing.

Sunday, March 30, 1980—Naples

Lucio Amelio put us in the Excelsior Hotel and kept saying he got us the "Elizabeth Taylor" suite. But they gave Beuys the bigger suite upstairs—that's why they kept pushing the Liz Taylor business to me. But the rooms were big, really big, looking over the black-market people who sell cigarettes.

Then we rested and were taken to Graziella's brother's who lives on the waterfront and they made us some dinner. There was an old ex-movie star and an ex-fashion designer. They served

all this food but Graziella and her brother didn't eat anything themselves, and that does make you feel very peculiar, so I learned my lesson—from now on when we invite people to lunch I'll eat.

Monday, March 31, 1980—Naples

We had to do TV in the streets, in the slums of Naples. Suzie hid her jewelry. We toured and it was great to see that old-time thing of clothes hanging in the street from one window to another.

We went back to the hotel to meet Joseph Beuys and then we had dinner with Beuys and his family at some funny little Italian restaurant. He was sweet. Really a lot of fun.

Tuesday, April 1, 1980—Naples

Up at 10:00, interview with *Expresso* again. Lucio picked us up and took us to the gallery because we had a press conference with 400 people. Joseph Beuys loves the press now because he's running for president of Germany under the Free Sky Party and with me he can get more coverage—no, it's the Green Party, that's it. Then São Schlumberger arrived and we invited her to lunch at this waterfront place. Then we were picked up for the opening and there were at least 3,000 or 4,000 people there, you couldn't get in, it was horrible, and finally we slipped away, they were giving us a party at a place called something like City Hall, a drag nightclub. Finally after three hours of waiting, this drag queen with hair on his chest came in and I was talking so she told me to shut up, she did a couple of numbers and then all of a sudden pushed me aside and stormed out and we didn't understand what had happened, but somebody said she was too emotional because she was singing for me, she gets that way. But it was too boring. Fred got insulted because the TV lights were shining on us too long, and told Lucio off, that it was the most ridiculous evening, and that Lucio had wasted our time because that kind of evening wouldn't sell pictures, and that he was just using us to get into show business. We didn't get into bed till about 4:00.

Wednesday, April 2, 1980—Naples—Rome

Fred and I had to leave for our private audience with the pope by 10:00 so we left Naples at 7:00. When we came to the outskirts of Rome the driver didn't know how to get into the city. We had to follow a cab to take us to Graziella's office to pick up two tickets to have a private audience with the pope. Suzie was very upset because it was too exclusive for her to go, so she gave Fred her cross to have blessed.

We got our tickets and then the driver dropped us off at the Vatican. When we saw 5,000 other people standing around waiting for the pope, too, I just knew that Graziella hadn't gotten us a private audience. But Fred put on airs and went up to the guards and said that we had a private audience with the pope and they laughed.

They finally took us in to our seats with the rest of the 5,000 people and a nun screamed out,

"You're Andy Warhol! Can I have your autograph?" She looked like Valerie Solanis so I got scared she'd pull out a gun and shoot me. Then I had to sign five more autographs for other nuns. And I just get so nervous at church. And then the pope came out, he was on a gold car, he did the rounds, and then finally he got up and gave a speech against divorce in seven different languages. There was a bunch of cheerleaders saying, "Rah-rah, pope." That took three hours. It was really boring, and then finally the pope was coming our way. He shook everybody's hand and Fred kissed his ring and got Suzie's cross blessed. He asked Fred where he was from and Fred said New York, and I was taking pictures—there were a lot of photographers around—and he shook my hand and I said I was from New York, too. I didn't kiss his hand. The people next to me were giving him a gold plate, they were from Belgium. The mobs behind us were jumping down from their seats, it was scary. Then Fred was going to take a Polaroid but I said they'd think it was a machine gun and shoot us, so we never got a Polaroid of the pope. As soon as Fred and I got blessed we ran out.

We decided it would be fun to make up a good story to tell Suzie, so we went to have lunch on the Piazza Navona ($45). We made up that we'd had a private audience with the pope and that he liked Fred so much that he asked us to lunch and then he forgot to give us back Suzie's cross.

Saturday, April 5, 1980—Paris

We went to Kim D'Estainville's new shop near the Arc de Triomphe. A funny neighborhood. Kim's recuperating from his play folding on Broadway. There was nobody in town to try to sell ads to. We had dinner at Club Sept (cab $4).

We had a big table and we were disappointed, there were models there, but all the good-looking ones had been invited off to glamorous places and the ones leftover in town weren't that good-looking. We were there for an hour, about, and then Francesco Scavullo and Sean Byrnes came in and they sat down with us, we invited them to dinner. And then Francesco told me about all the dirty things he heard I did at Studio 54 and I just couldn't believe it, all the boys he heard I brought home to the house, and I just was shocked, I mean, I don't know where he got his information, and I was just trying to find out where he got his gossip from so I could figure out why they'd say all those untrue things.

Oh, and he told me Studio 54 shut down—that was the first time we got the news. Steve and Ian sold it. So the end of an era.

And we also heard that Halston went to Xenon with Bianca, so that's a first. And Bonds clothing store is going to reopen soon as a discotheque on Broadway. Scavullo paid for dinner—I didn't want him to because I'd invited him, but he did.

Sunday, April 6, 1980—Paris

Easter. I had a horrible night. I had two nightmares about planes cracking open and the people falling out. Fred went out and ran into Shirley Goldfarb, she said her eighty-eight-year-old mother in Miami Beach just sent her the $25 she sends her every Passover for matzoh balls.

Monday, April 7, 1980—Paris—New York

Got up at 8:00 in Paris. Had a restless night because I thought I heard Fred slip out. I heard the door shut and the things click that would all mean he had slipped out. But then when I asked him in the morning, he said that he hadn't, so I don't know. All I would've had to do was look, but I didn't. And I get so scared when I'm alone someplace, and I don't keep people's phone numbers—I should, but I don't. But I will from now on.

We got to the airport, Charles DeGaulle, really really fast so we had an hour and a half before the plane. Then there was a black guy in the waiting room and I wondered *(laughs)* how he could afford to be getting on the Concorde. And then he said to me, "You haven't photographed me yet." But I still didn't know who he was. And then suddenly I figured out he was Dizzy Gillespie! He'd just been in Africa and he said things were great down there. He was adorable, so cute. He said he loved Africa, that there was a lot of dirt on the ground, that he liked that.

He said he'd been photographed by a famous photographer once, and at first he didn't remember who, but then I think he said Carl Van Vechten, and that made sense because he was in the Somerset Maugham biography I just read and he was jazzy, he always had these jazz people. Dizzy said he had a new book out and we said we wanted to interview him, so we took his number in New Jersey.

Andrew Crispo was also on the plane. He's bought all of somebody's Art Deco collection. He had a Dunand vase with him, and he was with a cute boy.

Didn't see Dizzy get off the plane (tips $10). We went through customs easy because the customs guy was really impressed with the picture of us with the pope on the top of the bags. We got out and our car wasn't there, so we jumped in a cab ($.75 toll). All the way in, even though it was the middle of the transit strike, there was no traffic! The driver kept saying he didn't believe it. We sailed right in. But at 89th Street when Fred got out, a lady jumped in our cab who didn't speak English because there's a rule on that you have to have at least two people in a car during the strike. I saw a cop making a girl with a car give some kid a lift. So everybody's meeting people.

It was really a beautiful, beautiful day. There were so many people out walking because of the transit strike. Wandered to the office. Brigid and Robyn were there. I worked all afternoon, waited for Rupert who didn't arrive till 6:30 because he walked. Brigid and I went out passing *Interview*s. A bag man started screaming that if I would only stand still he could get a picture of me. He was really screaming, looking through his bags for his camera. And then I asked him if I could take a picture of *him* and he said no, but I did, anyway. He really had a camera with a flash that worked. Maybe he was a playwright or somebody doing an article on what it's like to be a bag man. He was about forty.

Tuesday, April 8, 1980

Rupert came in and we worked on the Jewish Geniuses. Truman called and he sounded like his old self, he said he'd been working hard. He said that his *Chameleon* book is going to be in the Book-of-the-Month Club, and I asked him how you got that and he said *(laughs)* from being a good writer.

Karen Lerner called and said that Hugh Downs was going to do an update on the *20/20* story and that it was for sure going to run this Thursday. She thinks it's going to be thirteen minutes, and I'm just so scared, I just think our whole business is going to fall apart after that kind of big network exposure. That's what I've really come to decide.

I watched the *Today Show* where there was a forty-seven-year-old black man who was a boxer and then became a dentist for seventeen years and now he's decided he's going to be a boxer again, and it was such an up story.

I bought some garlic pills because I just read a book that said garlic is against sickness, and I believe that, it seems right. Forgot to say that at a cocktail party the other night a woman came over and kissed me on the lips and then said, "I'm so sick, I'm dying." Why do people do that? Are they trying to pass their disease on to somebody so *they* won't have it anymore?

Wednesday, April 9, 1980

Walked in the rain to the office. Transit strike still on. Worked all afternoon. Locked up at 6:00. Gael Malkenson's boyfriend Peter Love had a truck and it took us forty minutes just to go around the corner. In the truck was Robyn, Aeyung from *Interview*, Bob's sister, Bob, and Tinkerbelle. And Tinkerbelle was putting down the Jews and we said, "Are you Jewish?" and she said, "Oh my God, no, of course not!" I said, "But Tinkerbelle is a Jewish name. I mean, 'belle.'"

When I got home I cancelled out on a Regine's thing, my sore throat was getting so bad. It was from that woman who kissed me the other night and then said, "I'm dying." I took a sleeping pill and went to bed, but it didn't help, my throat still got worse.

Oh, and Carmen D'Alessio told Bob about visiting Steve in prison once a week. They have meetings in the waiting room where all the other prisoners are having their meetings. She met the right-hand man of Sindona who stole a lot from the Vatican. She said everyone's really nice in the prison except for one guy with tattoos who's the bowling-ball murderer. Carmen signed a contract with Mark Fleishman, the new owner of Studio 54, to continue doing parties and publicity. He thinks he'll have a liquor license within twelve weeks.

Thursday, April 10, 1980

They were going to film me for another ABC show, *Omnibus*—they're reviving it—and the car was picking me up at 10:00.

The *Omnibus* people arrived at the office at 7:30, they'd worked it all out with Vincent the day before. This was a show on Carly Simon getting her portrait painted by me and by Larry Rivers and by Marisol. I'd said that I wouldn't do one more thing without being paid, and Vincent worked out a contract with them—Carly was going to pay for most of it.

I was in the limo alone, and we went down the West Side Highway. I had a camera with me because I've decided to take pictures everywhere I go to prove that I really do go to all these places every day. The windows of the car were black so to do it I had to roll them down. A few people on the West Side Highway said, "Hi, Andy." Then we got off the highway at 23rd Street

and this black kid said, "You filthy white rich person, all you think about is money." And there were a few of them, and I got scared. Fred told me later that I should have screamed back, "All *you* think about is money! And mugging to get it." And they kept following the car. It scared me so much.

I got to the office and they wired me and sent the car back for Carly Simon.

Carly was too nervous to come up until we sent some wine down to the car. Then she came up and was sociable. We made her put on lipstick and then after we worked she was hungry and we sent to Brownies for health sandwiches and she loved that. I taped it all (Brownies $8.30, $23.44). And then Ara Gallant came with Susan Strasberg and she twisted Bob's arm to interview her, she's just written a book.

At 6:00 Jodie Foster came to 860. She looked beautiful. With her mother. She and her mother are a team. It's like a marriage—Jodie's the father. She's very intelligent and she's gotten into all the colleges she's applied to except she hears from Harvard, Yale, and Princeton on Monday. In case she goes to Harvard we were telling her about John Samuels and how cute he is, but I don't know what type she'd like because she dresses really like a boy—all in Brooks Brothers.

While we were there Brigid called the restaurant to say that the *20/20* segment on me had just been on TV and she said it was great. Hugh Downs narrated it. And Brigid's so critical of me, so I was relieved. I mean, if even she couldn't find anything wrong with it, it must've been okay.

They're selling Kitty Miller's everything. Christie's is. I mean, her used underwear, her used potholders, everything. She has (*laughs*) three unused Halston shirts. And she's got a few Revillon furs that cost $80,000 that'll probably go for $3,000. Furs have no resale value . . . I know killing animals to make coats is sad, but look, even when you think about killing cows to eat they're so big and beautiful and *everything's* alive—the plants are screaming.

I'm still weighing 140, I don't understand it, I'm not eating that much, my metabolism must have changed. I should be 136. But now I'm eating the nuts and chocolate and things that I'm not supposed to eat because of my gallbladder, because I think the gallbladder pills are helping so that I *can* eat them. But I'm getting fat so for that reason I'll have to stop.

Walter Steding is performing at the Squat Theater on 23rd Street—that theater where they did that thing called "Andy Warhol's Last Tape."

Friday, April 11, 1980

Henry Geldzahler came by to talk about me doing a poster for New York City and Fred thought it was a good idea. Then Henry wanted to go right out and photograph a tree for the poster. He needs it in two weeks. But I'm just beginning to think Henry may be crazy. He said Ellsworth Kelly wanted to paint on top of my portrait of him, and I said sure, but then he admitted that he wanted me to print another one so he was just trying to get a free painting out of me for Ellsworth Kelly to paint on. He still wears his badge that Mayor Koch gave him under his lapel.

Rupert came in and we were numbering portfolios. The Ten Jewish Geniuses portfolio really sold, so now Ron Feldman wants to do Ten Rock Stars, but that's corny, isn't it? Or Ten Phantoms, like Santa Claus. But I think the Jewish Geniuses only sold because they were *Jewish*, so we should do Ten Jewish something else. Like Ten *Jewish* Rock Stars.

I called Harcourt Brace and screamed at them for not delivering the eighty books that I paid for. Jackie Curtis came up to get one and heard me screaming on the phone at them and got the message and backed right out. And I screamed at a few people, and finally the girl said, "Well, you paid with a personal check and we had to wait to see if it cleared." Can you believe it! I think Jovanovich must be so petty himself because he runs the worst company, they're small-time, they've got a name, Harcourt Brace, but that's all. So that screaming took all afternoon.

Saturday, April 12, 1980

Got up early and watched the cartoonies. I had to carry a portfolio downtown for a lady who's trading for an ad (cab $4). And then she went through them all and found a smudge mark on one of them, she was an anal retentive. I got that from Rupert, he called her that. She went through them from cover to cover.

I called and asked Brigid how she was coming with transcribing the Jodie Foster tape, and she said she'd been working on it for hours, that it was great, great. And I asked her to be more specific and she said she was at the part where Jodie was looking around the office and I mean, we were only at the office for the first two minutes, so I knew she hadn't done anything, and I screamed.

Random House wants to do 400 of a special edition of the portrait catalogue. They'd make a lot of more money off it than I would, though, so we were trying to think of what to do.

Monday, April 14, 1980

Went out on the street with some *Interviews* and I was curious to see if people were still recognizing me all the time from the *20/20* TV show, but they weren't. So this means that TV makes you famous for one day and then it fades. Passed out *Interviews*, wandered, and took a couple of cabs but was shocked out of my mind—the fare increase was in effect (cabs $4.05, $5.05). It really does seem to be a lot more. I'm just going to tip a small amount from now on and not even worry about it. I guess I'll have to walk to work. Halfway to work. Eventually got to Union Square.

We were having lunch for Henry Geldzahler. The eighty *Popisms* finally arrived from Harcourt Brace in the morning and I gave them out to everybody, but I'm going to be more stingy with them now, with inflation. Henry wanted to take me out to photograph the tree for the city poster, but just as we were having lunch it started to rain.

Oh, and I forgot to say that during lunch Fred came in and told me there was a roommate of Steve Rubell's from prison there who wanted to see me, and I said no! I mean, why would Fred even come and tell me that? Why would I want to talk to somebody like that? And Fred said that he thought I should see him, so I went out there, and this absolute creep is saying things like, "Steve says he can't talk on the phone because it's bugged"—like I talk to him, anyway, right? And he said, "Steve wants an Italian dinner." So Bob finally said, "Well what're *you* here for?" and the guy said he wanted money to buy the Italian food for Steve. So Bob gave him $20 and he said, "That's not enough." So Henry gave him another $20 and I had to pay them both

back later ($40). But he was just shaking us down. And after he left I screamed at Fred for being so stupid, he should have just gotten rid of him. I mean, Fred must have stayed out all night and not had his brains right or something.

Then we went up to Polly Bergen's apartment on Park Avenue (cab $3.50). This was the Academy Awards party. We were just in one TV room and we didn't see all the others. Ex-Mayor Wagner and his wife Phyllis who used to be married to Bennett Cerf were there, and the Helen Gurley Browns.

And Dustin won. Poor Bette Midler didn't, and she gave that part everything she had, right down to the last—fart.

Tuesday, April 15, 1980

Did I say yet that David Whitney said that the townspeople have been seeing Truman's car parked at Silver Hill and did some checking around and he's there? He's going into the local stores there buying those little doodads that he buys.

Went with Henry Geldzahler to the Village where the Women's House of Detention was, which is now a locked-up park. The trees there were just perfect to photograph for the poster. I gave an *Interview* to the lady with the key to the garden. Then Henry left me in the Village and I was stopped by a kid who said he grew up in the foster home with Joe and Bobby Dallesandro and he said he was really good friends with Bobby. So I had to tell him Bobby committed suicide and he was just stunned. I left him there on the street being shocked.

Back at the office Bob was in a bad mood. I dropped him off (cab $5.50). Glued myself together, picked up Catherine, and cabbed to Bill Copley's place. Bill's secretary told me that Bill left Tommy the dog, who was the sweetest thing at the party, out on the terrace by mistake on the coldest day of the year, and somebody saw him out there and called the police who had to come and get him off. I said I wanted to take Tommy home with me, and Bill might let me have him, he's thinking about it.

Clarisse Rivers was there, just back from Mexico, and Vincent and Shelly and Michael Heizer. And Christophe de Menil was with Viva's ex-husband, Michel Auder—she goes after the worst people. She looked beautiful, like one of those old-fashioned prints. Her hair was up and she has a tiny body.

Wednesday, April 16, 1980

Henry Post came by the office and we were all shocked that he would because he had his lawyer send Bob a letter saying that he could sue us if he wanted to because Bob said in *Interview* that Steve Rubell said the *New York* article Henry wrote on 54 was all lies. And Henry was supposed to be a friend. He looks terrific, he's been going to the gym. But I think he's still wearing makeup, like rouge. We were going to the Roy Cohn thing, it was for convicts who make art, prisoners who paint. There were about forty people there. Roy had borough presidents there and presidents of Revlon. And Cindy and Joey Adams were there and Joey gave a speech, he said, "I thought

this was a party for Roy's clients, Ian and Steve. How come *they* don't paint?" Andrew Crispo was an organizer of this thing and he bought a painting. It was embarrassing because I didn't buy anything.

Went home and glued myself and walked to Quo Vadis where we were interviewing Nastassia Kinski. She was very pretty and tall and spoke English well. We were afraid to ask her anything about Roman Polanski until the very end and then she told us she didn't have an affair with him. She was interesting, but not as fascinating as Jodie Foster. She speaks six languages and she could just redo every Ingrid Bergman movie. She looks like what Isabella Rossellini could look like. We dropped her off at the Navarro. She's been in town three weeks and wants to stay forever. She's staying with Milos Forman and I guess they're having an affair, because she was saying something about making dinner for him during the Academy Awards. She was telling us that he offered her the best movie role, the one of Evelyn Nesbit coming down the stairs naked in *Ragtime*, and I didn't have the heart to tell her that that's the role Milos offers every girl he's been going after —Margaret Trudeau and two others. It's his line. So we dropped her off (cab $5).

Then we went to the Tavern on the Green party for the opening of *The Watcher in the Woods*. It was a party for Bette Davis that we got a telegram inviting us to. I went over to her and I thought we were friends because once I had a long conversation with her and she knew about when I was shot and was very sweet and everything. So I went over to her to refresh it and I said, "Oh, hi—I'm Andy Warhol, remember?" And she looked at me and said, "Yeeess." And she turned around and walked away. And then later somebody at her table said, "Oh have you met Andy Warhol?" and she said, "Yes, I've met Andy Warhol." Very cold. So I don't know what's wrong.

Sylvia Miles was there and she ran to get her pocketbook with all her clippings in it from *Hammett* and from some other movie to show me. Lewis Allen was there. We're still talking to him about doing *Exposures* and the *Philosophy* book as a play.

Saturday, April 19, 1980

Fred called and said I had to pick up Lynn Wyatt, that the limo would be at my house at 8:00. The Saturday newspapers were great. There was the bathtub murders, the guy says he kills things and doesn't remember—things like his wife and daughter—and that it used to happen to him with animals, too, that he'd wake up and look around and they'd be dead. And the full Barry Landau story, how he's Miz Lillian's best friend and he's going down to Washington to testify again.

Left the office at twenty to 8:00 and when I got uptown the limo was already waiting there (cab $5.50). So I went in and glued and Lynn Wyatt called and said that Jerry Zipkin was having cocktails first, at 95th and Park, and I told her it was Harlem. But we went up there.

Then we went to the St. Regis where François de Menil was having his thirty-fifth birthday party bash and we went up to the roof. François had his new girlfriend from Texas there. And some of his old girlfriends, too. Lynn wanted to be at the table with Diana Vreeland and Fred. And François's older brother, George, who keeps a low profile.

Bob Wilson was there, he's dating the Schlumberger girl from Washington, Katy Jones. Little

Nell was there, the English dancer. Aileen Mehle was there. It was an okay party. There was no big movie star or rock star there, it was just in a funny way all his friends.

Lynn couldn't come down to 860 to see her portrait, she was going to Paris the next day.

Monday, April 21, 1980

When I got into the office I noticed that Robyn was typing up one of those things that says what you've done—what's it called? A resume.

Iolas was coming to lunch with a couple of clients and we needed a couple of boys to entertain. And I called Curley and he brought his cousin David Laughlin who works at the Coe Kerr Gallery. Iolas arrived and his contact that he never takes out of his eyes got lost in his eye and he had me look for it, but I couldn't see it. Jackie Curtis came in in full drag and pink slippers and kept interrupting me to ask if he was interrupting anything. I told him no because actually he wasn't. He didn't eat anything because, he said, he was on a diet and had already had a half a pound of ham and three eggs that morning for breakfast. He wanted some *Popisms* so I gave them to him. He was on his way to a fashion show so he left. But then later he came back again. This time he *was* interrupting and he was drunk. But Kimiko and John Powers had come by and Kimiko loved Jackie and if you can believe it, she didn't even realize it was a man. Jackie looked good, he's lost weight. He said he wanted to take Brigid's job, her typing job, and he said he'd be very good, that he'd just type in a corner. But oh, he talks right into your face. Jackie had a sequined shirt on and was wearing a bracelet he said I gave him but I don't remember. Then he gave bracelets to Brigid and Kimiko to try to buy their affections.

Tuesday, April 22, 1980

Cheryl Tiegs and Peter Beard came by. Peter naturally wanted a free artwork and performance out of me. I had to give them a tour around the place.

I had to leave early to make the 6:30 Martha Graham thing (cab $6). We got there and Martha was making her speech like she always does for an hour first. She wants to be an actress. Nureyev was terrible, he just doesn't know how to be a modern dancer.

Thursday, April 24, 1980

Got up at 8:00 because Vincent said we had to be at the TV studio at the dot of 9:00 for the ABC thing on Carly Simon where Larry Rivers and Marisol and I had to show our portraits of her. We went over there and then Larry and Marisol arrived by limousine. We met the director who had a phony high-class accent. Larry was fun. He decided to make the director work and said, "Where should I stand? What should I say? How should I look? What should I think?" and things like that. I think Carly liked my portrait the best because she's paying for it. I only had one there, but Larry had five and one of his had a Chinese couple fucking in the background,

and they made him take it out. And then afterwards they wanted to shoot us in front of blank easels listening to Carly, and Larry said no, that he'd submitted to what they wanted by taking the fucking couple out, so he wouldn't do this corny thing.

Then Larry and Marisol came to the office for lunch. Marisol was cute. She invited me to her fiftieth birthday party at Chanterelle, that very chic small restaurant downtown, but she said not to tell anybody it was her fiftieth.

Worked till 8:00. John Reinhold picked me up. Henry Geldzahler came and met us, we discussed the poster some more, and then cabbed ($2.50) to dinner at Da Silvano on Sixth Avenue. It was good but it wasn't as good as the first time we were there (dinner $98.40). The owner went out and bought the *Times* because Henry had a half-page interview with him in it and he was afraid it was going to say something unfavorable, but it didn't. Then we walked to the Ninth Circle because Henry wanted some interludes. The place was filled with intellectual fairies who wanted to talk to me about my art, but Henry told them I was too dumb to do it.

Henry thought of a good quote about *Popism*: "It's a real can opener." Isn't that great? Oh, and I'm forgetting the most glamorous thing of the day is that Jackie O. called me twice at home and missed me and once at the office, about would I give a quote for Diana Vreeland's book *Allure* that's coming out that's pictures with captions. She said, "It's like your book *Exposures*," or something like that.

Saturday, April 26, 1980

Robert Hayes has been missing a lot of work, and Bob found out it's because he's taking a lot of coke, which isn't like him at all, but the photographers and the stylists just hand it out so freely, to editors especially, because they want the work, and so he's been calling in a lot and saying he has "a cold" and doing things that he usually doesn't do.

I had to go to Lincoln Center to see *Clytemnestra*. The dance came out good, really great, and Martha was thrilled because she'd been worried about it. Nureyev danced, he was awful. Saw him in the dressing room and said hello. Bianca was wearing a Halston dress with an Ossie Clark coat. And the dress was beautiful, it was flesh-colored in a V on top so it looked low-cut.

And the best thing was Diana Vreeland eating a banana. This banana was lying around Martha's dressing room and Diana really wanted it so she peeled it and just ate it right from the peel, and it looked so funny. She's old enough to look really really funny. She loves bananas.

Afterwards we went over to Halston's and had a little supper. We tried to pick up some of the dancers and bring them with us but Halston said Martha wouldn't like it. So it was just Martha and Bianca and me and Diana and John Bowes-Lyons. And Liza and Mark Gero came over. And an English guy who said he wrote songs for Charles Aznavour. And he had a girl with him—Filipino, I think—and this girl said she'd lived with Michael Caine, and since Bianca had lived with him, too, the girl poured her heart out to Bianca and Bianca dished, too, she said she'd never talked about him before. They agreed that if he got drunk, he'd scream for hours. And this girl said she would just do everything for him, get up at 5:00 and make him breakfast, and then she'd go to the set, and then leave half an hour before he did to go home and make him dinner. They both said that sex with him was "memorable," but I don't know if they meant really good or really bad.

Sunday, April 27, 1980

Nastassia Kinski came by the office. I wasn't friendly to her, though, because it turned out she already did the cover of *Vogue* and now we don't want to use her for the *Interview* cover, but she really is beautiful. Picked up Catherine. Cab to Hector's on Third Avenue and 82nd Street ($4). It's run by Stuart Lichtenstein, the kid who used to manage Max's. This was Averil Meyer's birthday party. She didn't put us with her, she was at a table with Diana Vreeland and Mick Jagger. And we were waiting to see where she'd put John Samuels who she'd slept with the night before.

Then Fred invited all the fairies to come afterwards—Robyn and Curley and Curley's boyfriend and John Scribner and his current girlfriend. Not really fairies, but that feeling. I had a good time with Bill Pitt. I asked him if he still thought he was God and he said yes, but not as much. His father and Averil's father are best friends. He had a new camera that advances itself.

And Averil's father was hitting Catherine, really drunk, and had her dress up practically over her head, and his wife was just standing there. I thought Catherine would be Averil's new mother, but then he has no money, we found out. And Averil looked funny dancing with John Samuels because she was a foot taller in her shoes.

Tuesday, April 29, 1980

Bianca wanted to roller skate so we went to the Roxy in Thomas Ammann's limo. Bianca really wants to marry Thomas. She brings it up all the time. She's dying to have him marry her. We skated for about half an hour. Bianca skates like a little kid, and then she reminded me how she'd been on crutches because she'd pulled both her tendons when she was roller skating in L.A. once, and then I vaguely remembered because when she and Mick were starting to get divorced there were all those pictures in the paper of her going into the courtroom in California *(laughs)* on crutches.

Bianca figured out that John Samuels was out at Averil's in Manhasset. She put it together and then I confirmed it. She said that Averil always gets her leftovers, that it's so predictable. Bianca and John broke up on the night we all went to Martha's. She said, "He's a child."

Thursday, May 1, 1980

Calvin Tomkins has a big review of *Popism* in the *New Yorker* and it's a rave. I should tell Harcourt Brace to just go fuck themselves. What are they doing over there? When is the ad going to run in the *Times*?

In the morning I picked up Bianca and Victor and went to the Olympic Tower because I had an appointment with Halston to see his sportswear line ($4.50). Bianca had a great Halston top on and a blue bottom and her ass *really* was wide. She had on Manolo shoes and an Elsa Peretti

belt. We got there just in time. Halston keeps using his aging models because he feels they were loyal to him so now he'll be loyal to them.

Cabbed to 860 ($5.50). Catherine was having a lunch for Alexander Cockburn and the P.J. O'Rourke guy from the *National Lampoon*. A writer-photographer from *Stern* wanted to be photographed with me for the preface for his book, and Henry Wolf, an old friend of mine, was there to take a picture. He was the art director of *Harper's Bazaar* in 1960 and he changed the look of the magazine. It was either him or Marvin Israel, I can't figure out which, who first used ugly girls with big noses and things. And I guess Mrs. Vreeland probably encouraged it because actually it was, now that I think about it, just like putting herself on the cover.

Then the limo came at 2:30 to take us to Princeton for a book signing that Wilson Kidde set up for us. Ian Maxtone Graham from Brown came with us.

They had a place set up to sign outside. It wasn't a rich bookstore like the Harvard Coop. This was more just like a little bookstore in a building, so it was better being outside because the kids going by would see a crowd and go up to see. Then we had a tour of the campus. Really rich-looking. A naked rugby team ran by doing their numbers, just wearing jockstraps, some kind of initiation or something.

Then Wilson took us to an all-male club for dinner, the Ivy Club, and just a few girls came by for drinks. Champagne punch. All these rich kids. The grandson of Seabrook frozen vegetables. The son of J.D. Salinger, Matt. He was really good-looking. He's trying to be a photographer and he writes. A cousin of Frolic Weymouth's from Chadds Ford was there. And a kid who didn't belong to the club, Ritt, who was a model for Elite, but he didn't look like one—he had a big nose and beautiful eyes but he was short.

I bought books. One was the Liddy book ($20.92).

Dinner at this all-male club was leftovers. Like spaghetti *al dente*, cheese on top. Baked alaska with Häagen-Dazs that was 2' × 1' that Ritt made. Four bottles of wine.

Went back at 9:00, the drive was nice.

Friday, May 2, 1980

I'm still not sure if we'll take the 25 percent that that Hollywood guy, the one who works for Alan Ladd, is offering for *Trash II*, which Paul is now calling *Trash-ier*.

Worked all day. Rupert was there. Till 9:00 or 9:30. Dropped Rupert ($5). Then Jed had a temperature of 104 and thought he was maybe having a heart attack, so at 4:00 in the morning I had to take him to New York Hospital and Doc Cox was waiting there, but it was just chest pains like the flu, and he's at home but his temperature is still high.

Sunday, May 18, 1980

John Powers called and told me the prices at the art auctions, and the Triple Elvis went for $75,000 and he said he thought that was a fair price so I felt okay, but then he told me that the Lichtenstein went for $250,000 so I felt bad. Oh, and the three Jackies went for only $8,000, so that was a bargain.

Monday, May 19, 1980

I watched the *Today Show* and saw the volcano erupting. The man at the volcano who wouldn't come down must have been killed, they couldn't find him.

Gerry Ayres called and he's writing a movie called *Painting*—he wrote Jodie Foster's movie, *Foxes*. He's the studio person that brought us out to Hollywood in '69. And he wanted to meet Henry Geldzahler. And so I made a lunch with Henry for Wednesday.

I met Bob in front of his house and we walked to the Plaza for the J O B Ball—Just One Break—and we'd missed the cocktail hour. All the old bags came out for this. Nan Kempner was there with Jerry Zipkin. Robyn's mother was very sweet. She and Bob chatted, they're having the same problem—somebody is signing them up for all these magazine subscriptions and they keep coming in the mail. I sat next to Mrs. Tony Curtis. And so I said, "Oh, I wish I was home watching Tony Curtis on *Moviola*." And she said yes, that she liked Tony a lot but that they were just breaking up. They'd been married twelve years. She was nice.

Sharon Hammond was there with her new beau, Lord Sondes. She's gained five or six pounds and she was porking it up. And the lord has a potbelly, too. I couldn't believe it when I saw her eat a whole roll. I took it away from her.

All the old presidents of the ball got up there, São and Chessy Patcevitch and Sharon's mother Mrs. Long and Nan and Jean Tailer and a couple of other heavy-duty ladies. They gave door prizes.

Then Bob and I went to Linda Stein's party for our agent Joan Hyler. When we got to the party one of the photographers told me, "You're the biggest one here," so that's always a letdown. Paul Morrissey was there with his two nieces and Susan Blond and Sylvia Miles, and Sylvia said, "You've got to hear my songs," and I said, "Oh yeah, I can't wait." And she said, "You don't have to—I've got them right here in my bag." So I had Linda Stein put them on the record player and they sounded good to me but there were eight different record people there and they didn't react. And then Linda came over to Paul and said, "Oh listen, I mean, you're the only person here who realized that I'm wearing emerald earrings and have Regency furniture and Lalique, and if it wasn't for you telling them, they would think it was junk. So *thank* you."

Legs McNeil who started *Punk* magazine was there.

Wednesday, May 21, 1980

Henry Geldzahler's using the yellow and green print for the New York City poster, and he said Milton Glaser is working on it, and I hate his kind of designs. Henry was at the office for lunch so that Gerry Ayres could meet him and soak up the art world. Jerry's script that he's writing is

actually called *The Painter*—not *Painting*—and he's writing it for Jack Nicholson. I should tip Jack off that he should just buy the Jackson Pollock story.

Rupert Everett was there, he just got kicked out of the Blackstone and now he's at the L'Elysée, or vice versa. Henry had his new lover with him that he'd picked up from NYU, and he was having me take pictures of them kissing. He's going out to California soon to see his old boyfriend Raymond who's out there posing for David Hockney—Raymond takes planes just to go pose. At the end of the lunch Henry said to Gerry Ayres, "But what's the painter going to paint? I mean, *that's* the story, so what's it going to be?"

Cabbed uptown ($4.50) to glue and then walked to Sharon Hammond's. I was met at the door by Tony Curtis's wife, Leslie, who was staying with Sharon, she was really looped. She said she was a rich society girl from Boston and how could she marry an actor and a Jew. Sharon was in the bathroom. Her boyfriend Lord Sondes had just left town and they'd been eating all the time, and this was Sharon's first time in the john after all the food, and Leslie said she'd walked in on her doing her grunts. And then Sharon's so meticulous with her makeup that it takes forever, too. Sharon was surprised when I said I would have a vodka. She has big tits.

I'd brought a copy of *Popism* to give to Marty Bregman who we were seeing later because I thought he might be interested in producing a movie of it, but of course I had to give it to Leslie. Cabbed to East 57th Street ($3) to Marty Bregman and Cornelia Sharpe's apartment. We went up to the penthouse. It was one of those funny parties with aging girls and sort of funny people. I guess people there were somebodies, but stars today look so mousy you just don't notice them. For half an hour I didn't notice Al Pacino sitting in the corner.

I wasn't letting Sharon eat because she'd gained weight. I introduced her to Al Pacino, and so she liked that. He said, "Hi, Andy." Leslie picked up a guy with big hands. He was a hometown friend of Cornelia's and she said, "Don't worry"—*(laughs)*—"she's in good hands." Cornelia looked fat. And Alan Alda was there with this lady with dark circles and it turned out to be his wife. She looked like Anna Magnani. She's not the wife you'd think he would have, but she looked nice—I'm sure she must be if they're still married. We rode down in the elevator with them. We left Leslie with a stiff drink in her hand. Dropped Sharon ($3).

Thursday, May 22, 1980

A tall skinny Japanese boy came to interview me, and he was cute, he was so nervous, just shaking, he said he was meeting the star of his life. He's from *Studio Voice*, the Japanese *Interview*. He brought me a T-shirt.

I was reworking Lynn Wyatt's portrait. Sent flowers to Sharon Hammond and Cornelia Sharpe.

Gael Malkenson said she's getting married this Saturday. In a Catholic church. But she always says things that I don't know if they're true. Worked till 7:00. A kooky girl followed me to Park Avenue when I left, she was like one of those kooky girls you meet when you first come to New York. Dropped Rupert ($4) and got home around 8:00.

I looked through my things for something for Marisol for her birthday and finally decided to give her a little painting, but when I went to pick Victor up he wanted it, so I gave it to him. We went down to Chanterelle in Soho, that restaurant that everybody raves about and says how small

it is and how hard to get into. Well, it wasn't so small, it looked big, really. And the food was just okay, it wasn't so hot. Marisol kept saying this was the first party she ever gave, and Halston assured her it was really great. The first person I talked to was Ruth Kligman, and she's now a born-again Christian. And she was different. Very nice and calm, but then I began telling her about Gerry Ayres's movie *The Painter* that he was writing for Jack Nicholson, and then she was more like her old nervous self. She said, "Should—do you think I should call Jack?" and "Do you think my lawyer should call Gerry Ayres?" and I said, "It's only a fiction thing he's writing! Relax. After he does that, artists' stories will be more popular and you can really sell your book *Love Affair* for a movie." Ruth said maybe she could get Nick Nolte to play Jackson Pollock. And she explained that when you're born-again you just get a clean slate wipeout, that nothing you did before counts. So it's just like confession, that's all it is except you can go to confession every day and I guess you can only be born again once.

John Cage was there and Merce Cunningham and Louise Nevelson who came at the end of the dinner but had a special place saved for her. George Segal and his wife. Joe Brainard. It was nice to see him again after all these years, but I didn't get to talk to him much, really.

Marisol looks good for fifty. She made the birthday cake in the afternoon and it was really just beautiful—beautiful marzipan figures, beautiful beautiful figures fucking, and she gave me one and Halston one and they were like little jewels.

We told Marisol she shouldn't tell her age because people would never know and she said she thought they already knew because it's always in all the catalogues and I told her people don't read the catalogues, and she said *(laughs)* well that then only the forty people or so that were there at dinner would know.

Friday, May 23, 1980

I forgot to say the most important person at Marisol's dinner, he sat next to her—Edward Albee. He was tight-lipped, but I tried to get him to loosen up and talk, but nothing really happened. He said he read where I'd said his last play, the one with Irene Worth, was "the best play I've ever seen," and he thanked me. I guess I said it to one of the papers. I told him he should write Marisol a play for her birthday.

Lunch at the office was supposed to be for Lewis Allen, but he forgot about it. It was going to be a lunch for him to sign the play contracts, but he had a play opening the night before and got tired and forgot, he said he'd sign on Tuesday.

Monday, May 26, 1980

Memorial Day. No traffic around. Went to the office. Worked on about six or seven portraits.

Curley was back from his brother's wedding. And did I say that the other day Senator Kennedy called me at the office and I couldn't get him off the phone and I didn't know what to talk to him about. I guess he didn't have anything to do. But Fred was explaining why he's stayed in the

race—to raise money for the Democratic pot. His Smith sister called me the other day but I didn't take the call, I knew it'd be to want me to give a donation for something.

Did I remember to say that at the *Empire Strikes Back* movie there was a black kid about fifteen or sixteen sucking his thumb in the row ahead of me with his parents? I don't think he was retarded. He didn't look retarded.

Tuesday, May 27, 1980

Lewis Allen came by and he wants to do the play, *Evening with Andy Warhol*, with a dummy of me on stage saying dialogue based on the *Philosophy* book and *Exposures*.

Friday, May 30, 1980

Stayed uptown because I had to meet Nicola Bulgari at 12:30 with Bob. After we saw the jewel collection he took us to the Knickerbocker Club which was really great. It's across from where the Dodge house was that's now torn down. The food was great there, mashed potatoes and rice pudding and eggs. Bulgari was saying things like "Hide the tape" and "They won't let you do that if they see that," and he was acting like "this isn't that kind of a place, it's too high-class." Like he didn't want to get voted out. It was too corny. After lunch we went into another room for an hour. I don't know why, he just wanted to blabber. He's *(laughs)* against Communism.

Saturday, May 31, 1980

I was working at home. I watched a good old movie about skating with Dick Powell. It wasn't really about skating but it had everybody skating. It was so cute, it looked just like the Roxy. Skating was so big in the early forties, I guess, but then it died out in the fifties—no, in the sixties, I guess. *Everything* died out in the sixties.

Monday, June 2, 1980

Rupert called and said that it was raining down at his place so he couldn't bring the prints out, but it wasn't raining where I was so I didn't know whether to believe him. I had an appointment to meet Richard Gere for lunch (cab $5.10).

Barbara Allen was the first to arrive, and then Richard Gere and Silvinha, and the wife of Taki Theodoracopulos that he isn't really married to yet. Barbara's trying to arrange a surprise wedding for Taki—have him come over and have a justice of the peace there to marry them. But I thought that Barbara was going with Taki, having an affair with him, so I don't know how she got to be such good friends with his girlfriend. Oh, and also at the lunch was the psychedelic artist, Mati Klarwein.

The Japanese guy from *Studio Voice* was there, and he really is just crazy about me. He wanted me to give him a new name, so I gave him "Chuck Roast."

Went to Côte Basque for dinner. I was meeting the commissioner there, because I had to talk to him about doing more posters for the city, more ideas. I had a lot of ideas, but they weren't *(laughs)* so good. They sounded better when we were drunk—like a gold pencil sharpener. I think it's been done already. And Brooke Hayward was at Côte Basque with Philip Johnson. We stayed a little bit talking to her and nobody brought up the terrible TV movie of her *Haywire* book.

Sean McKeon came down. He's a Wilhemina model.

Wednesday, June 4, 1980—New York—Houston

We got to Lynn Wyatt's house, fifty people for dinner, and she had cream of crab soup and then barbecued filet mignon that'd been marinated for twenty-four hours and hot curried fruit and homemade Rice-a-Roni which Joan Quinn who was there said was Armenian-style. And creamed spinach and then this great dessert which was fruit ice cream piled onto a big meringue. And the dinner was for Diane Von Furstenberg and Barry Diller. There were all these crazy people from Dallas and Fort Worth. They were really rich with big rocks and they were really vulgar and funny. Divorced and out for kicks.

And then after dinner we went into the living room and everyone loved Lynn's portrait. Diane said she loved it so much that she wanted me to do her kids' portraits, but I know she doesn't mean it. And then John Travolta arrived with thirty people. He was going to come to dinner but he wanted to bring thirty people so Lynn had said no. And he's so good-looking. He had on a black silk shirt and a bright green linen jacket and black pants, and his eyes are so blue. He was with this cute little girl and a lot of bodyguards, and with Jim Bridges, who directed *Urban Cowboy*. And then there was Debra Winger who's the female star of the movie, and she's great, we want to do something with her. She told me about high colonics and that she's full of shit. Her family was there, and her boyfriend. He was cute, Jewish.

And Barbara Allen and Jerry Hall were making fun of ladies with jewels right in front of their faces. And Maxime Mesinger the gossip columnist came with John Travolta, too, and she gave him a dinner first. Then we got a ride with Barry and Diane. Barry got mad because Jerry and her sister Cyndy and Fred were so drunk they wouldn't let him out of the car at his hotel, and he wasn't in that good a mood anyway, that's just how Barry is. He told Jerry to shut up and she got really hurt. And Fred was pretending to stick his finger up Jerry and her sister and then sticking it in everybody's noses.

Thursday, June 5, 1980—Houston

We all went to the Cadillac Bar for lunch which has really good Mexican food. And I was sitting with this crowd from Dallas-Fort Worth.

I met Travolta at lunch again. Got an autograph on a napkin.

They all have these big Jerry Hall accents. And they all love Jerry because they can talk real

Texas with her. We had frogs' legs and beef and chicken and shrimps, everything barbecued and chilied and guacamoled. And it was so hot out, it was like ninety-five degrees. And the air-conditioning broke down and the Texans say, "Turn up the AC! Maybe you need some freon, Charlie." And then we went to a few Western shops to get our costumes for the *Urban Cowboy* premiere.

We finally got back to the hotel around 5:00. Everyone met in my room. Jerry was wearing a solid gold and rhinestone skintight cowboy suit with matching hat that George Hamilton gave her that he had worn in the Hank Williams movie, and she said that Alana wanted it so badly and he never would give it to her and so not to tell Alana.

Then we got into a limo and went to the Gay Lynn theater, it was named after Lynn Wyatt. And there were thousands of paparazzi and fans because they'd never had a world premiere in Houston before. And they were screaming, "Andy! Andy! Andy Warhol!" And Jerry and I were posing for pictures. And then Jerry and Lynn Wyatt were standing in front of the theater with the TV crew and Lynn was becoming like Barbara Walters: "And now we have the famous artist, Andy Warhol, and Jerry and Cyndy Hall who're stars in the movie, and say, Jerry, where'd you get that costume?" Very professional, she was wearing purple suede with her great figure. And we got in the theater and sat down and in front of us were Liz Smith and Iris Love in matching cowgirl outfits. And Liz's brother, because Liz is from Texas.

And Diane Von Furstenberg was walking up and down the aisles like she owned the place. She was wearing tight pants and a little top and a vest with a little sheriff's badge that said "Disco Sucks." And then she was wearing two tons of diamond and gold jewelry from the forties. And Barry Diller was sitting right behind us, and then in walks John Travolta with a thousand people around him, and he sat down right behind us, and everyone was going crazy with the photographers and stuff, and we were all jumping in with our cameras. And then the movie started and everyone loved it.

Afterwards we took our limo to Gilley's where they shot the movie. We left one second early so we got there before the mob (tip $20 to the driver).

There was a mob scene around where Barry Diller and I were sitting because John Travolta sat down two inches away. His eyes are just like—dyed—blue-green. I mean, really deep blue. And he has the most beautiful smile. His teeth must be polished every day. And his skin is beautiful. And he's so nice. And he says nice things to everyone. And he was talking the most to this girl he thought was with us, but she was a DVF groupie. And Diane is so desperate to be recognized that if one person says, "You're Diane Von Furstenberg, I love you," she says, "Come with me," and she makes them follow her around for the rest of the night so that she can have a following, and then she gives them presents—she carries lipsticks and compacts with her to give out, and she autographs them.

And, well, once Travolta was at our table it became really impossible because the crowd just pushed in on us, and this policeman was standing right behind trying to protect us, and he was drunk, the policeman, and I said, "Don't look now, Bob, but you have a big gun and a big cock one inch from your neck." And the policeman said, "Can I do anything for you?" and Bob laughed and said, "Just stay right here." And he did. And he had two guns in his holster, very good-looking, and he kept hugging us and bumping into us and rubbing his cock against us and saying, "Is there anything you need, anything you want?" But he was great because he kept screaming to the waitress and got all this food for us. The whole table. And all these drinks, and beer. And

he said, "You're not eating your pepper," to Bob, and Bob said, "Are you kidding? It's so hot, I only took one bite," and he said, "Well, I'll just show you how to eat a pepper," and he took the whole big thing and slipped it in his mouth and ate it and then winked at Bob.

I was the second biggest star after John Travolta. But a distant second. He got the most fans after him. They were screaming on the stage that everyone was going to have to leave if they didn't let John Travolta have some room.

Got home around 1:00. Started to read *Princess Daisy*, it's an awful book, but they mention me in it, so it's something for the box. It said Daisy was too chic to go to an Andy Warhol party in London.

Saturday, June 21, 1980—New York

A lady from Arizona—someone Edmund Gaultney had arranged—was coming to the office about a portrait (cab $5). She turned out to be a beautiful girl and she brought her one-year-old baby. The baby gave us a really hard time. Babies are so hard to photograph, they never sit still and they're teething or something so they're scrunching up their mouths and they're so cranky and I just hate them. Then Edmund called from Arizona and said that we should do the baby alone, but by then it was over—I'd only done the baby with the mother and the mother alone.

Dropped Rupert ($5). I glued myself and went to meet Alan Wanzenberg and Stephen Webster, friends of Jed's. We went to Inagiku. I've been having too much wine lately so I stuck to Perrier and had some raw fish. Alan's an architect working for I.M. Pei. And the other kid's a lawyer and I gave him the job of contesting our tax assessment because the taxes went from $400 to $12,000 when they combined both Bowery buildings together which they had no right to do, and the place is just a dump so I don't know why it's that high.

Then we went for a nightcap at Trader Vic's ($25). The headwaiter invited me to his sculpture exhibition next week. Got home about 1:30.

Sunday, June 22, 1980

Went to church. Went to meet Rupert and got a lot of work done. Redid some paintings—the church in Cologne, the castle in Bonn, a couple of Germans.

Thomas Ammann called. He asked me if I wanted to have a business dinner and I said good idea. I worked all afternoon. All the clones were filing into the Underground. They all have mustaches, alligator T-shirts, bluejeans, or the other look is leather pants and jackets and sunglasses.

Barbara Allen called for who was around and available for what. I told her Thomas Amman was in town and so she called him and got invited to dinner.

Cabbed to Mr. Chow's ($4). We were kind of late and Thomas was mad at us. Ran into Rita Lachman on the way in with her ghostwriter for *The Rita Lachman Story*. They sat next to us. Alan Wanzenberg the architect and Stephen Webster the lawyer were there, and Barbara and Fred and Jed and some other girl. Barbara sat next to me and I kept telling her to bring Bill Paley down

for a portrait. Then I happened to mention that Truman said he was writing a piece on Babe Paley, and then Barbara said she wanted to read it to make sure that it wouldn't offend Mr. Paley. She's so ridiculous. She said Mr. Paley gave her something, something really great, but she wouldn't say what—she had each of us confess something, and after we did, she still wouldn't tell us. She had a whole bottle of sake to herself. She said she's madly in love with Mr. Paley, that he's the only man she loves. But then she was falling for Thomas because she knows Bianca's so hot for him.

Monday, June 23, 1980

Got up at 8:00 and watched the *Today Show*. The new girl is too pretty, I like Jane Pauley better. She's off getting married to the "Doonesbury" Trudeau guy who won a portrait by me in a society contest and we kept stalling him and finally he came up and he wore a hat and scarf and I just did a little nothing portrait because I didn't realize who he was.

And I screamed at Ronnie because he got three forty-five-minute phone calls.

Tuesday, June 24, 1980

What's happening with Richard Pryor? Are the burns getting better or worse?

Worked till 6:30. Fred went up by subway to the Mitzi Newhouse Theater where Bob Wilson's play was opening. *Curious George*. When I got to the theater Fred was there waiting with Katy Jones and her sister. The art-world people were there. The play had water coming from the ceiling, clocks on the walls telling you what time it was and striking. It was colored beautifully, the set's by Bob Wilson. It took at least two hours and then it was over.

The party afterwards was at Leo Castelli's. We were the first ones there. The food was good but Chris Makos said I looked fat, and then I looked over at Fred who never eats and stays looking so good, so I just had one cucumber and water, and I mixed and mingled.

The Knowles boy, the star of the play, sounds so normal when you talk to him, you wouldn't know he's autistic. He answers whatever question you ask, but I guess the problem is he never says anything if you don't ask him. I talked to Jennifer Jakobson about Mr. Ballato dying. He was in his eighties. He worked at the restaurant till the last minute, he loved the business so much.

Fred tried to get Katy Jones to leave but she's after Bob Wilson so she didn't want to. We all waited for Bob Wilson so we could go in his limo. Richard Weisman was there with Patti LuPone and she was thrilled when I introduced her to Bob Wilson. She got a Tony, and she was asking me what she should do with her career and I told her to hang on and stay with *Evita* for as long as she could because she was the only big star on Broadway and she would become so huge from it. She said yes, that I was right.

Bob Wilson kept going to the bathroom a lot and coming back depressed. He dropped me and Katy. And as I was getting out of the car he was saying things like, "Take hold of my hand." And afterwards I pieced it together, that when he was saying words like, "Do you think—do you

think—" that he was wanting to know if I thought he was using Christopher Knowles, exploiting him by starring him in plays because he's autistic. Got home at 2:00.

Wednesday, June 25, 1980

A creep who kept writing me letters came up and Vincent told him I was doing an interview but he refused to leave, so I mean I knew right away that he was a creep because normal people don't do that, insist. Right? I was giving an interview to the *Miami Star*.

Chris Makos called from his darkroom. I want to go around town with him taking pictures. Nobody's done 42nd Street and the Statue of Liberty in a while.

Then, when we were leaving the office and we'd locked the elevator and we were getting ready to leave, as I was walking by the middle room the creepy kid who'd come up earlier jumped out from behind a crate. I mean, that's why I always tell Vincent to check around, because people can really hide behind things. And later Adam Robinson from Oxford who'd stopped by and who was still with us said that he'd seen the box move, but hadn't told me. So this kid was hiding behind the box while I was giving the interview to the Miami paper. He said it was "Performance Art." I mean, I could tell he was a creep from the beginning. Somehow Vincent got him out, but I was really rattled. We left, and I dropped Rupert at 7:30 ($5). When we were crossing the street to get the cab, Rupert and me, a cab stopped and it was Hiram Keller waving and I had to go kiss him in the cab and he looked absolutely beautiful, like the day we met him, gorgeous and full of life, and I just can't believe he never became a big star after *Satyricon*. Is it because there's so many beauties now?

A kid I know from Studio 54 called me up and at first I wasn't going to take the call but he said he'd had a breakdown in California and that I was the only one he was calling, so I did. He's going back out to California.

When I got home I was still tense from the intruder so I had a brandy. And that led to the candy drawer, and that led to the TV all night. I watched the *Mother and Daughter Beauty Pageant* on TV. And a rerun of Farrah Fawcett.

Bob Wilson's play got terrible reviews. And I was watching a rerun of Carol Burnett and those people were just so good, so talented, so funny. I mean, Bob Wilson has an autistic kid and does a few imaginative things, but that's all. I mean it's like when you see Carol Burnett you think how nothing a thing like Bob Wilson's is.

Thursday, June 26, 1980

There were some interesting things to look at at the P-B 84 Warehouse on 91st Street (cab $4). Met Stuart Pivar there and saw a lot of paintings. A Liz was sitting there, and there was a Pollock, too. They told me this one painting was by the "boyfriend of Seurat," but I didn't know Seurat had a boyfriend. The guys there all wanted my autograph, so I did them.

The new issue of the magazine arrived and Godunov looks good on the cover but he looks like a Christopher Street person, I don't know if it'll sell.

Steve Rubell called Barbara Allen and John Bowes-Lyons and then said he was being moved to Atlanta.

And Joe Dallesandro called Fred for money—I guess he wants to be supported for life—and I screamed at Fred, I told him to tell Joe to ask *Paul*. Joe wants money just so that he can sit around, I guess, and drink a bottle of Jack Daniel's a day.

And Vicky Leacock came by. She's Ricky Leacock's daughter. She said that her mother had just died—her mother was a model in the fifties—and that she was going up to Boston to stay with her father. She just came by because she was sort of upset. Her mother's kidneys weren't functioning well and Vicky took her to New York Hospital and the people there were awful—they were arguing with each other and while they were bickering Vicky looked and saw that her mother's eyes were open and staring, and she told the doctor and he said, "She's dozed off," and Vicky tried to revive her and then they tried but they couldn't. Vicky just stayed at the office a few minutes and then she left.

Friday, June 27, 1980

We went to John Addison's new club, Bonds, the huge clothes store on Broadway that they turned into a disco. We looked around for him but the place is huge and we didn't see him. It was free, but I tipped the waiter ($20). The stairs are musical. It's very beautiful.

Saturday, June 28, 1980

I called Bob to see if the interview with Paloma Picasso was on—it was, Lester Persky was going to do it at Quo Vadis. And Paloma really likes Patti LuPone, so we called to see if there was still a table for us at her show at Les Mouches.

I walked over to Quo Vadis. I was there first, then Bob arrived, then Lester and Paloma. I was on my diet so I just had melon and arugula, but the chicken that Bob and Paloma split looked good. What do restaurants do with the meat that's left like on the backbone? Do they throw it out or do they use it to make hash?

Lester interviewed Paloma and she's great, she just tells everything. And she said that we could do the end portion of the interview at the MOMA Picasso exhibit with her and she'll talk while we walk through. After dinner we went to Un Deux Trois, the place on 44th Street that's supposed to be like La Coupole.

Then it was too early to go to Bonds. So we went to Les Mouches. And they made Bob pay. Bob still hated Patti LuPone, but not quite as much. If she had come over and said, "Oh Bob, you're the editor of *Interview*! I love *Interview*!" he would have loved her. I'm the same way, though, I guess. And Ron Duguay was there. At first he wasn't interested in Patti—these athletes all just like the same blonde types all the time—but I told him, "She really wants you and she's great." And afterwards she came and sat with him. Patti's funny, she does these sophisticated songs and then she gets nervous so she sticks out her tongue like Donald Duck or something. I like her, I think she's great.

Monday, June 30, 1980

A little man from Munich arrived at 4:00 to see his portrait and he was startled when he saw it, it had so much character. Because Fred's been telling me not to take out the wrinkles and everything too much on these old people, that it's nice to leave some in. So the man from Munich had red veins but I made them black, and I gave him bright clothes colors whereas he underplays his clothes. I made his daughter really beautiful, though, really elegant. And Fred was really nervous when the man was looking at them because he felt responsible for the look. The guy was cute, though, really nice.

Stephen Mueller and Ronnie were there, stretching. Robyn was trying to sell a portfolio to two ladies he'd picked up the night before and he sold one print at a discount and he was thrilled. I was at the office till 7:00.

Cabbed ($2.10) to 76th Street and Fifth to Leonard Stern's. He's the Hartz-Mountain guy. He just got the house and it wasn't air-conditioned, and it was odd meeting him at 8:00 because it wasn't for dinner, although we'd thought it was going to be. He wants two very big Flower paintings for two walls and he wants them by September 16th because he's having a party then. He just left his wife. She's keeping the house on Park in the 70s which he renovated eight years ago. It was embarrassing because I called him Mr. Stein and Fred called him Mr. Stein, too. When he was finished with us we went around the corner and decided to stop in at Barbara Allen's on 77th Street. She had Whitney Tower there and he's put on weight, he's trying to be not so skinny and crazy because he wants his grandmother who's a Whitney to give him some dough. You know these rich kids go and say, "Oh Granny darling, it costs money to get married and have children and do all the things you'd like to see me do."

Tuesday, July 1, 1980

Got up early in the morning in order to meet Bob in order to meet Paloma and Lester at MOMA (cab $3). We went around the exhibit with Paloma, she was talking and Lester was being funny, and it was exhausting, it's three floors. A guy in a wheelchair asked me for my autograph, and I said, "Don't you want Paloma *Picasso's*?" And he said yes, so Paloma signed and then I signed and then we had to leave because Paloma had to get back to Tiffany's where they sell her jewelry.

Old Mrs. Newhouse came to see the portraits of her husband, but her son was with her and he fell in love with the diamond-dust ones.

Oh, and David Whitney came by, we're talking to him about maybe redoing the Jewish Museum show and I'm doing a portrait of him because he's been so nice. He brought his tux, he really looked cute in it. He invited me to Thursday dinner with Philip Johnson, he said he'll send a car for me, that anyone as big as I am should have a car—he was being funny.

Brigid went on a candy binge. She said she was going out for cigarettes but Robyn noticed that she took more money than she'd need for cigarettes, so when she got back I said, "I see chocolate on your mouth." I didn't really see any, but that worked and she admitted she'd had ice cream.

Glued myself together and went to Côte Basque to help Suzie Frankfurt celebrate—she just got almost a million for her house and she bought a cheaper one. Mr. and Mrs. Law arrived. I think

Mrs. Law is Standard Oil rich and I don't know exactly what her husband does, maybe he invests her money. That's what usually happens when you marry a rich woman. Or maybe he's rich himself, who knows. She wants me to retouch her portrait because now she's made her hair lighter. It'll probably turn out to be one of those "living portraits" where I have to to keep doing things to it.

We went over to Bonds. And John Samuels was there and he's so mean to me now. I think he *tries* to be nice, but he can't help himself, he says mean things. I'll have to ask him why. We were there for a few minutes. Mr. Law was dancing around and his wife said that he would get a heart attack. Oh, and Bob was there and he looked so sour. He feels he can't have fun unless he has a drink. And he and Fred are the same—if there's no princes, they look so bored.

Thursday, July 3, 1980

Was picked up by Philip Johnson and David Whitney to go to La Côte Basque. They had martinis and so I did, too. Philip's doing the new AT&T building at 56th on Madison. After dinner we went up to the apartment where David and Philip are living on Fifth, opposite the Met, the one that Philip did the front of. And Philip and David are unhappy with their apartment—it's small, there's no room for paintings, but they have my Cows in the bedroom and twenty Jasper Johns prints up. I like the apartment, it's neat and orderly. David's really good about throwing things out—if he buys five new shirts he throws five old ones away. And their places always have nothing in them, no knick-knacks, no flowers, no food in the refrigerator. Oh, but I did see some underwear on a chair, and I was going to say something about it because it was the first time I've ever seen a piece of clutter in their apartment. Their limo dropped us.

Friday, July 4, 1980

Cab to meet Debbie Harry at 7:30 at her and Chris Stein's apartment at 200 West 58th Street. The penthouse. It took an hour to get there because everybody was merging into Central Park for the fireworks later at 9:00. The traffic was really bad (cab $4). When we got there Chris and Victor Bockris had their tapes on. Debbie has beautiful eyes.

Debbie had worked all day trying to find an interesting place to have dinner, and *(laughs)* she did. We went up to 119th Street and Morningside Drive to that restaurant with the big view. The food was as good as La Côte Basque. I don't know how people up there can afford it, though, because it's so expensive. Maybe doctors and professors.

But first we had drinks at Debbie's. She's gotten really rich from the Vanderbilt jeans ad and they're going to buy a building. Chris wants to rent an apartment on the Lower East Side to give interviews in because they don't want to spoil their low-life image, and Debbie will have to give interviews there, too. I think he's really going to do it. But if you saw their apartment—and he's saying he doesn't want people to know how *(laughs) well* they live. It's so junky. It seems like one room made into eighteen rooms. Maybe it used to be a storage floor. There are at least 100 gold

records on the wall, I don't know why there's so many—oh, maybe duplicates, I guess. But there's a good doorman.

Saturday, July 5, 1980

Had an appointment to meet Rupert. Nobody was in town so it was an easy cab ride ($4.50). I was doing Flower paintings again and it was so sweltering and I got a funny feeling, like a flashback to 1964 because it was the same Flowers and the same heat and the same mood as when I first made them that summer. I asked Rupert how it felt to see me painting these famous sixties images. He said it didn't feel like anything. But to me it did. These are a commission. I'll do something different with them, though—maybe put diamond dust on them.

John Reinhold called and invited me to see his apartment that Michael Graves just did. It was raining like crazy. Henry Geldzahler was meeting us for dinner at a place called Petit Robert, which sounded familiar, but I didn't want to think about it. It turned out that it was the restaurant of Robert Biret who I've known since 1948. He gave me work at *Glamour* and Bonwit Teller and he was my best friend, we used to have dinner together in the fifties. I met Halston for the first time at his house. Then Robert left New York and went to Paris. This place is way over on 11th Street. I talked mostly to Robert, he looks pretty good. We talked about our mothers. I think his went back to France. There was a lot of garlic in the food. I ate cooked beef with garlic and later I was sorry, I could feel it in the morning, still.

Sunday, July 6, 1980

I got up and was trying to avoid Tom Sullivan's calls. He's been making up stories about friends being in the hospital and needing a few dollars so I think he's out of money. I think he maybe spent everything he had on *Cocaine Cowboys*. I mean, if he only had a couple of million it wouldn't've lasted him long the way he was living so high on the hog, traveling every minute.

I glued myself and went to Mt. Sinai to visit Sandy Brant who's expecting triplets, 101st and Fifth. Cabbed ($3) up Madison and it seems like they're reclaiming some of the blocks as white. They're putting up tall buildings and the whites are slowly moving uptown. They're selling apartments there for a couple of hundred thousand now.

We weren't going to tell Sandy about the fire at their stable in Greenwich that destroyed the stable and nine horses, but she told *us* about it. They think it might have been set. There's a guard there twenty-four hours a day now. They didn't have a sprinkler system. We were there about forty-five minutes, till 9:00. Then worked at home. No phone calls. I watched the all-day news on Ted Turner's station.

The weather changed and was cool and windy and beautiful, my hair was flying all over. Fred went out to Manhasset with the Paysons for a big house party that Averil was giving for the Fourth of July weekend at Greentree.

Wednesday, July 9, 1980—Paris

Went to Castel's for dinner and we sat downstairs and we ran into Jean, the boyfriend of Clara Sant, and Clara told Fred that her boyfriend had had a bad time at our studio in New York because we didn't pay much attention to him. He didn't understand that that was our style, that *everybody* gets ignored, but then I was sorry we didn't really make an effort, like have a lot of beautiful girls and interesting people for him, because when people are really nice to us in Europe we should pay them back in New York. I paid for dinner, and it was expensive ($400).

Thursday, July 10, 1980—Paris—Monte Carlo

I didn't sleep a wink that night because we left Fred drinking at Castel's and I knew he wouldn't be able to get us up in the morning so I had two cups of coffee. And then about 6:00 I heard fumbling at the door and it was Fred trying to get his keys into the lock and it took him half an hour to make it in, and I was going to get up and tell him off but I was in a stupor.

It was raining, horrible and grey and cold, really freezing. We were going to Monte Carlo for the joint show of Jamie Wyeth and me. Finally we got there and it was sunny and beautiful. And the first people we ran into were Pam Combemale—her unmarried name is Woolworth—and Jamie Wyeth, they had just come in on the Concorde. And they'd lost Jamie's clothes and Phyllis's luggage, so she had nothing to wear.

Went down to the lobby at 6:00 and saw the exhibition, they were putting it together. I did an interview for *Time* magazine, and then we went to this restaurant that looks just like Trader Vic's, called Mona's. The Portanovas were there, and Liz Smith and Iris Love, and the Larsens, and there was a lot of dancing going on and Jamie was so great, he was dancing with Phyllis and I was drunk so I went over to them and I fell down. With them. And then I was dancing with everybody else—all the girls—and it was a new thing for me. I'd had two vodkas, and that must have set me off.

Jamie's so much fun because he's a troublemaker. He's always saying mean things about people—like he said this one lady's pockmarks made her face look like a used dartboard. He just goes right down the line tearing everybody apart, he's very funny.

Friday, July 11, 1980—Monte Carlo

We picked up Jamie and Phyllis and I apologized to Phyllis for pushing her over the night before. I told her she and Jamie were dancing so beautifully that I got jealous. When I started to dance with Phyllis I didn't know that she can't go backwards so I fell on her and then Jamie fell on her, and we were all caught by somebody but it was just too nutty. So I apologized and we all got in the car and went out to Cap Ferrat to see Lynn Wyatt who now has Somerset Maugham's old house, the Villa Mauresque that I just read about in the biography, and it was just everything I really wanted to see and look at. It took us a while to get there, the traffic was bad.

Lynn was wearing a dress that was split up the sides and you could see all her breasts and she

just had a little bikini on and she looked beautiful, she has a great body. I think she was trying to get Jamie excited. And they have sort of the same last name. Everybody thinks it's her son who's having a show there.

And then Sandra Hochman walked in and she was just so boring, rattling on and on, she told me she's had a boyfriend who's just bought an apartment in Monte Carlo. She said he discovered fast food—he owns Tad's Steak Houses—and she told me any time I wanted to give a chic party there she'd fix it up for me.

I asked Lynn to do an interview for *Interview* because David Niven and his wife came in and I told David that I'd just been reading all about him in the papers because he's been suing David Merrick. He was great-looking, he was so thin, and his wife was pencil-thin. And Sandra was just yapping away about all her books and she was so pushy we couldn't understand how she knew Lynn and it turns out she went to Bennington with her.

David Niven was so cute, he told us good stories and Jamie fell in love with him. Then we had to get back to the hotel because we were meeting Princess Grace at 4:00 in the lobby to show her the exhibition, it was down in one of the dining rooms.

We went up to our rooms and glued ourselves together, and then we came down. Just Jamie and Phyllis and Freddy Woolworth and Fred were invited, Jed was still at the beach. And we had to get in line to meet Princess Grace. I was the first one, and we were just all making funny jokes about standing in line and finally when we turned around there she was, and she had a little tummy. We were supposed to kiss her hand but I refused to kiss her hand and so we shook hands, and she didn't really like me, she just liked Jamie. And then when Grace found out that Phyllis was a big du Pont, she was really social climbing, so she was really nice. And then we had to go show her the pictures, and I was trying to be funny but it just didn't go over too well. And we chit-chatted about Cousteau and the fish museum that's up near her palace and Jamie said that his father knew her father, they live in New Jersey now, they don't live in Philadelphia. And we were talking about, I don't know, just really boring things, she never let her hair down. And I told her that I heard she paints, and she said she just does collages, she had a big show in France that was a sell-out. And I asked her what else was she doing, and finally she told me that she's on the lecture circuit in the United States reading poetry. She does a circuit tour like Truman for a couple of weeks so she brings home the bucks. And finally after forty-five minutes of chit-chat she decided to go. And when she left she thought the security guard that has the revolver and watches the paintings for the Coe Kerr Gallery was Freddy Woolworth. So it was really funny, she told him she loved the show.

Fred and I had to go upstairs because I was doing a portrait. Mrs. Benedetti, who thought she looked like Marilyn Monroe. And I made her take off her clothes and put on white makeup. She kept posing like Marilyn with her mouth open and stuff and she was old, but she came out really easy, I had my contacts in and I couldn't really see but everything was fine.

Went off to a couple of cocktail parties down at the Loews, which is a hotel that was decorated by Sharon Hammond's mother Mrs. Long but they have private apartments there, too. Douglas Cooper was giving a party and this lady named Madame Plesch—Ettie Plesch—was giving one, too, and they're not talking to each other so you had to be careful and not say that you went to the other one.

Then Regine invited us all down to Jimmy'z and John Larsen was there with his wife and he's that really great guy, an old friend of Edie Sedgwick's and mine from years ago, and now he's

really Jamie's friend. He and Jamie are great dancers. And it was getting late and I was tired. And then Bo Polk arrived and he brought this beautiful girl along with him and then Phyllis saw Jamie dancing cheek-to-cheek with the girl and she went up to them on the dance floor and hit Jamie with her cane. And he got embarrassed because he was *really* dancing close.

I got home and I didn't have a key so I had to wake the chambermaid and so she put me in, it was about 3:00.

Saturday, July 12, 1980—Monte Carlo

Ran into Sylvester Stallone who cut his beard and looks great, he just flew in from Budapest with his wife, and I told him I wanted to do his portrait over again without the beard because he looks so handsome. And so he was going to come up about 6:00 so I could rephotograph him.

Then I ran into him again, on the beach, and all the people on the beach were taking pictures of him. He looked so great without clothes on, he's pencil-thin, he looks like a muscle man, like Mr. America with small biceps, and I told him not to ever put any more weight on again. But he was saying he had to because he had to do *Rocky III* and so I told him to do a fat suit. And so we left to go back to the hotel to refresh ourselves and wait for him to come. Then I glued myself together because it was time to get ready to go down to the opening of the show in the lobby. I was ready before anyone else so I decided I might as well go down and work, so I got downstairs about five minutes after 7:00 and Pam Combemale and Freddy Woolworth were standing there greeting people and I was next in line and I shook hands with everybody coming in, like a receiving line. They would introduce me and there were all these old bags, I mean, the oldest people in the world. And then Jamie came down and he was next to me and we went down the line and in it was Raymond Loewy! The guy who designed the Lucky Strike cigarette package and everything else! I was just so thrilled to meet him that I just jumped up and down and asked him if I could take his picture. And he was great. And then the old bags, there were just so many of them I couldn't believe it. I think we got some portraits to do so that's great. Then Stallone came all in white, and he looked really beautiful, and then Iris Love and Liz Smith came, and Liz said it was the chic-est party opening they'd ever been to.

Mary Richardson came and Kerry Kennedy and Mona Christiansen and a cute little girl Vicky, who's the daughter of Frank Gifford. Mona told a story of how Garbo picked her up on Madison Avenue a couple of weeks ago and took her home for tea, but then, she said nothing happened, they just compared face jaw-lines. I don't believe her but it was fun to hear. Mona was feeling up all the girls, really feeling them up.

Sunday, July 13, 1980—Monte Carlo

Fred picked me up and we went down to Stallone's room to photograph him, he'd been switched from his big suite to a smaller room and he was complaining. He was in his blue bikini. We finished the pictures, we only took three rolls, and chit-chatted and then we got a little nervous and we left. We invited him to dinner but he said he was busy.

Monday, July 14, 1980—Monte Carlo

Murray Brant just called to say that Sandy Brant had triplets and the boy weighed five and a half pounds and the two girls weighed five pounds each.

We were going to a cocktail party at Donina Cicogna's and all the girls were downstairs and it was so much fun, you run into everybody in the lobby, and so we cabbed to her place (cabs $30). And when we got there it was too crowded and Lady Rothermere was there and we picked up a real cute old friend of Fred's named David Rocksavage, he's an earl, one of the richest kids in England. Then we went to Jimmy'z.

Mona and I were bored so we decided to look for Prince Albert, we knew that he'd be around someplace, so we went searching and just couldn't find him, so I said something like, "Oh shit, we just can't find Prince Albert," and he was standing right in back of me. So Mona got really aggressive with him and said we really loved him and wanted to get to know him, she pushed her way right in, and I said, "Do you want to meet all these great girls like Kerry Kennedy?" and he said no. Then Regine caught our eye and she ran and got drinks and shoved them all in our hands, and Prince Albert sat there and drank all of his drinks and just ignored us. Then Regine was smart enough to know what to do, she went down and got the kids like Kerry and Mary Richardson and brought them up and we introduced them, and Mona stepped on Prince Albert's toe and he said, "Do it again." And then he said he was not staying, he had to meet somebody and they were going over to Paradise. And Mona and I said we'd go over and see them there, so we were really excited because we'd worked so hard to get this far. And I didn't bring my tape recorder because I was wearing Jed's jacket and he wouldn't let me put anything in it because it stretches the pockets. And so I couldn't tape.

Then we went over to Paradise and there was Prince Albert and Mona grabbed him and really tried to hustle him again but he said he had to play soccer the next day early, so he had to leave, and we were stuck.

Tuesday, July 15, 1980—Monte Carlo

São Schlumberger invited us and the girls and Rocksavage and Warren Adelson from the Coe Kerr Gallery and his wife LaTrelle and her little son to Cap Ferrat, to the little house she was renting. I was just starved, I hadn't had anything since breakfast so I just began eating everything and photographing, the house was pretty and had a beautiful view. We were there till 5:00. And Mona was going to St. Tropez and the girls were going to Venice to stay at Gianni Volpi's palace, but Kerry was having to wait for her brother and Vicky Gifford for her boyfriend. Which are the same person.

Wednesday, July 16, 1980—Monte Carlo

French TV came and asked me how did it feel to come "from the underground" to this glamorous place, and I told them they were full of baloney because I'd come here so many times and it wasn't "from the underground." And then I did a radio program and then I ran upstairs and found

that Jed had gotten the copy of *L'Uomo Vogue* with me on the cover which makes me look so awful, and there were a lot of good-looking people inside wearing bluejeans.

We divided up in cars and went out to have lunch with Hélène Rochas and Juliette Greco's sister Charlotte and her architect husband. Everybody went swimming and we had bullshots and they were so great, and then we had lunch, the best fish I ever had, the best food, it was just so glamorous, breaded fish with anise, and then we had anise down by the swimming pool and we dished everybody. And then we left around 5:00 and Rocksavage dropped us off.

There was a birthday dinner for Lynn Wyatt but I haven't bought her anything yet. Johnny Carson was going to be there and I couldn't wait to meet him. We ran into Maxime Mesinger in the lobby, she's that wonderful gossip reporter from Houston, she came here just for Lynn's birthday party.

Got dressed, cabbed to Lynn's in Cap Ferrat ($35). We thought we'd be early but we weren't. We got there and Estée Lauder was there and Lynn took me around to introduce me to people. And the first person she introduced me to was Johnny Carson. That was really exciting. He's not short. He's tall. He has grey hair and he looks so healthy. I took lots of pictures of him. And his wife Joanna is beautiful, she used to be a model with Norell so we dished the dresses and fashion and junk like that and I didn't take any pictures, I was just too—I thought it would be too much. Everybody was too scared to sit at the Johnny Carson table but David Niven sat with him and we sat with Liz Smith who was sitting at the last table by the swimming pool. And then the king or prince of Yugoslavia said he had a Mao painting of mine.

Everybody sang "Happy Birthday" to Lynn and then they had great fireworks, all the way around. A lot of sparkles and pink smoke and really loud firecrackers.

There's so much in the papers about Ronald Reagan and it looks like he's on his way to become president, it does look scary. I voted once. In the fifties, I don't remember which election. I pulled the wrong lever because I was confused, I couldn't figure out how to work the thing. There was no practice model outside, it was a church on 35th Street between Park and Lex. This was when I was living at 242 Lexington. And then I got called for jury duty and I wrote back: "Moved." I've never voted again.

Saturday, July 19, 1980—Paris

Pierre Berge never called back.

Went over to the Flore but it was closed. Deux Magots was open so we sat around there, hoping that Shirley Goldfarb would come by, but Shirley is I guess rehearsing for her big show that Pierre is giving Thursday night for her where she'll sing the menu of every restaurant in Paris. She's doing it in Pierre's theater, and he wanted us to stay on and see her. She's going to sing, in addition to the menus, songs like "Merry Christmas" and "Auld Lang Syne," and I think it's going to be a big trauma because I think she's really going to do it seriously and it's going to be so horrible. I think it *sounds* funnier than it's going to be, unless she can really do a lot of good menus.

Monday, July 21, 1980—Paris—New York

The plane left right at 11 A.M. when it's supposed to and when it does that, it's just perfect. The food is getting sort of boring, though. And they serve it too fast. You're finished in an hour and a half and you have all that time to sit around and get edgy. And I stole so much silverware and I was afraid about customs, I don't know if you're allowed to take them in or not. Got to customs, and although I didn't beep coming through the thing this guy took me to a room and had me empty my pockets and I had my vitamins on me, I don't like them to go through the beeper, and he was feeling them all up, and then he went through my shoes and pulled down my socks, and then he said, "What's that?" when he saw my other drugs, my painkillers, and when I was trying to explain what they were, he got impatient and said, "Oh, go away." I'm really going to be careful what I take with me because I can just see them going through all my wigs and asking me why I have so many.

We went from the freezing cold of Paris to 101 degrees in New York and it was a shockeroo. That's a Diana Vreeland word (cab $40).

Tuesday, July 22, 1980

I met someone on the street who said wasn't it great that we're going to have a movie star for president, that it was so Pop, and *(laughs)* when you think about it like that, it is great, it's so American. But they never talk about Reagan's divorce. I thought you weren't supposed to be able to get elected president if you were divorced.

Worked till 7:30, dropped Rupert off (cab $5). Whitney Tower called and said he wanted to talk about some movie ideas and he invited me for drinks. The rain had started. And then my bell rang and it was Whitney and Averil and Rachel Ward. I'd put the dogs to bed and that woke them up. I left the kids outside on the doorstep in the rain while I got myself together and then we walked to Le Relais. John Samuels was at the bar, he was going off to Suzie Frankfurt's for dinner—she was giving a dinner for John's father and his boyfriend.

Whitney invited me to the Adirondacks. They were up there over the weekend and they said Mick was there diapering a baby and they said he was an expert at it, that Bianca never did it, and he said he'd done Jade all the time.

Oh, and the best thing was the thank-you notes that Jerry Hall sent for her birthday presents. I got one and Jed got the exact same one and Averil got the exact same one. It's in this little baby handwriting and on flowered notepaper and it says the exact same thing on all of them, line for line, space for space, word for word. *(laughs)* I should call up everybody who gave her a present and collect the notes from them and make a book out of it. That would be funny, wouldn't it?

Thursday, July 24, 1980

Rupert brought the proofs for the prints by that he'd taken it upon himself to finish completely without ever showing them to me. He tried to be artistic and he sure was, he sure was. This is the Shoes with the diamond dust. He had them completely finished, with the diamond dust on and everything. I don't know why he did that. I'm doing shoes because I'm going back to my roots. In fact, I think maybe I should do nothing but *(laughs)* shoes from now on.

Saturday, July 26, 1980

Up at 7:30, glued myself and was meeting Rupert at 11:15 at the office (cab $4.50). I went to the farmers' market in Union Square to freshen supplies ($18). There were lots of new trucks, I can't tell which are the real farmers and which are the people who buy the stuff someplace else and bring it there. I think the real farmers *(laughs)* are the ones where the vegetables just look ugly—like beat-up and deformed and wormy—things that look like they're from your backyard. Worked at the office from 12:00 to 7:30.

Sunday, July 27, 1980

Up at 7:30, watched TV. Rupert called, I was supposed to go to work but the weather made me tired so I stayed home and went through magazines and books. Watched the death of the Shah on TV all day on the all-day cable news channel. I didn't know that one of the Shah's sisters had a house built by I.M. Pei in Tehran, they showed it and it was really beautiful with a dining room. I wonder who she gave dinners for. The palace that we were in was just a dump.

Monday, July 28, 1980

I've just been reading Gloria Swanson's book about sugar and she has me in it as the prime example of evil because she read the *Philosophy* book and interviews with me talking about how much candy I eat. She said the reason we lost the war in Vietnam is sugar, and that everywhere Americans go they bring Coca-Cola and fake orange drinks and then take the good rice and de-rice it. And it did make sense, so I'm going to try not to eat so much sugar.

The *Donahue Show* was on the flasher problem. This is a big important new problem, right? Men who flash. A wife and her husband who flashed were on, they were in the dark, and businessmen and lawyers who flashed.

At the office Arma Andon from CBS called and invited me to dinner at the Russian Tea Room and then on to see Eddie Money at Trax. Then after I said yes, Vincent told me that I had an early dinner for the North American Watch thing at the Pierre. And they usually don't take long, there's speeches and it's over quickly so I thought I could do both. Worked, then dropped Rupert (cab $5). Glued myself and walked to the Pierre. Walter Cronkite was going in with his wife, he

was the head speaker, he's on vacation from the news now. Gerry Grinberg met me and put me next to a girl who had to know who I was, I mean, my place card was there and everything, but she was saying things as if I were Truman Capote, like, "I still use your list from the Black and White Masked Ball for invitations." So either she thought I was Truman or she thought the Black and White party was mine. And I always hate to make a person wrong, so I tried to change the subject but she kept going back to it.

Then it was 9:30 and by this time I was supposed to be at the Russian Tea Room. But then Walter Cronkite started to talk and it was so interesting. He told a Rolex story about how the Rolex guy gave him a watch and he went to interview President Johnson, and all of a sudden Johnson was looking at his wrist and said, "That damn guy said that only presidents get that watch." And then after that that's all Johnson could think about and he couldn't answer any questions.

Finally at 11:00 I was able to slip away. Because the thing was I was right up front and I just couldn't leave before that. Outside I couldn't get a cab so I ran all the way to the Russian Tea Room and I almost had a heart attack and then when I got there, the man said they'd already left, but I was glad when I heard "they," it meant Arma had somebody with him, probably Fred, who I'd sent because I thought I might be a little late. So cabbed to Trax ($3) which I couldn't find and I walked all over and finally found it.

Don Mahoney, Eddie Money's brother, who's a cop, came out and introduced Eddie, and the brother is so good-looking, I really liked him. Then Eddie Money sang, and he's just great, like a singing John McEnroe. And he's so familiar, like somebody from Max's, that type, I just feel like we know him, I think. Vitas was there, and Richard Weisman. And I just know Vitas dyes his hair and sets it in rollers, he thinks he's losing it, the look. Then we met Eddie Money and he was cute, he said he was rooting for me at Columbus Hospital in '68 when I was shot because he was a cop then at the precinct right around the corner. Then Fred was tired, he'd come in that morning on the Concorde.

Tuesday, July 29, 1980

It was Fred's birthday and Richard Weisman was giving him a surprise party and the phone kept ringing all day and Robyn was having to invite people and not let Fred know, so the whole day was whispering.

Dropped Vincent (cab $4.50). Suzie Frankfurt said that I had to be at her house there on time, at 8:00, because it was a surprise party. Got there at 8:55. Every kid from the office and their date was there.

Fred came in and he was really surprised, he was shocked. John Samuels was there and he was sweet, he invited me out to his father's house on Long Island that used to belong to J.P. Morgan. John Scribner was there, and D.D. Ryan. And Eddie Money came with Vitas and Arma Andon. A girl came out of a cake for $500 and it was a big dud. A big nothing—Suzie was complaining about the price. Richard paid. Averil sent a singing telegram. She was there, though. She was drunk and tongue-kissing me and she got mad because I wouldn't tongue-kiss her back. The two Frankfurt kids were here. I sat in the kitchen eating good kosher sandwiches.

Curley was the real drunk of the party. Diana Vreeland didn't come, she was too tired. Patti LuPone was there and her brother with his wife, he's really good-looking. I tried to tape some of the birthday song but it was too noisy. Jay Johnson and Susan were there, and Tom Cashin who's leaving *The Best Little Whorehouse in Texas* this week. He's going to California to play the role out there. I got fat eating sandwiches.

Wednesday, July 30, 1980

They were having a costume auction at Sotheby's at 1:00 and one of the things in the auction was a costume I'd done in the sixties for the Dalton twins—the "This Side Up" dress. Sotheby's just had it thrown in with the other clothes, they didn't realize I'd done it. If somebody had put it in a frame it could have sold for $10,000 but somebody's probably going to get it for $25. It's the last thing in the auction.

Mr. Stern called and said he was coming down at 5:30 to look at his Flower paintings. They're diamond-dust fluorescent.

Friday, August 1, 1980

I had an appointment to meet the new Lone Ranger, Klinton Spilsbury, at the office. Robert Hayes and I were going to interview him. He's on TV tonight and I think I'll take a look. He was really good-looking. Long hair, 6'5", and a face that's a cross between Warren Beatty and Clint Eastwood. He had a bottle of wine. He was an art student, he said, out in California and he was married and had a little baby, but his wife—she was rich—she left him, he said, because he needed too much time *(laughs)* with his own thoughts. He was making movies, directing, and then he said he wanted to know how it felt to be an actor, so he took acting lessons and then an agent saw him and he went out for a part, and they gave him the first one, the Lone Ranger. But he didn't want to sign at first because it included all the extra things he'd have to do, like wear the costume and sing things, but then they took that stuff out. He said he modeled once, that he didn't really want to but someone had just asked him to, so he did. Then he was really drunk and gave me his belt. Then he started really talking, he told me that he'd been at Studio 54 and I'd gone over and said, "You have to be careful, you're dancing with a drag queen." Klinton said he's a friend of Dennis Christopher's, he fell in love with Dennis Christopher and then with that kid Bud Cort, who was in *Harold and Maude*. Then he said he'd been picked up by Halston and woke up in bed with Halston. And it was nutty, he was telling me all this and blowing his whole image.

My "This Side Up" dress went for $450 at the auction.

Saturday, August 2, 1980

There was a big rainstorm but it didn't cool off the city. Picked up John Reinhold for dinner, we went to Côte Basque. Left the place and I had a dish from the restaurant that I'd stolen and I dropped it on the street and it broke and then suddenly the police were there—they were down

the street and they thought they heard a window break. But they recognized me and said, "Oh all right, Mr. Warhol." It could have been bad. They could have taken me to the precinct.

Sunday, August 3, 1980

I got dressed and walked in the heat to church. I was going to go to work but it was so hot, I didn't want to see anybody. It was Archie's birthday and he's eight or nine or even older. I gave him a box of Hartz Mountain treats.

Tuesday, August 5, 1980

Missed watching the *Today Show* with Truman but it sounds like it was the same old thing. Brigid tried to get Truman on the phone but he had it off the hook. The review of *Music for Chameleons* in the *Times* didn't mention that some of the stories were from *Interview*.

Halston wanted to give me a party for my birthday but I said I was going to the theater with Stephen Graham. I'm going to invite Susan Johnson for him because he likes dumb girls. I wonder if they'll hit it off. No, she won't like him.

Halston gave me a whole box of ugly shoes for my birthday.

Wednesday, August 6, 1980

It was my birthday but I hadn't slept all night so at 7 A.M. I took a sleeping pill, but it acted more like an up. I really feel like an old-timer this time. I can't believe I'm so old because that means *(laughs)* that Brigid's old, too. It's too abstract. I can't even squish a roach anymore because it's just like a life, like living. I glued myself together and wanted to walk. Got a lot of phone calls about my birthday. Todd Brassner called and I told him to come down and bring me a present, but he didn't. Victor Hugo sent orchids with beautiful ribbons. From Renny, that must be a very chic place.

I had an appointment with Chris Makos at 860 (cab $5.50). Then the kids kept coming by. Curley brought me a piece of junk, an airplane light. I asked him to stay for lunch.

Richard Weisman called to say he was coming down. I said I was going to 65 Irving for lunch, and to meet us there. We went over, ten of us. Pingle—the Princess Ingeborg Schleswig-Holstein—came, who works at *Interview* now. She's related to Queen Elizabeth. And Brigid came. We were having piña coladas and then strawberry daiquiris and then Richard had the idea to have blueberry daiquiris. It was fun.

Rupert gave me 300 ties. Robert Hayes gave me a silver set of Elvis records, every record he ever made. Mimi Trujillo brought two dresses to show me and Victor made her give them to me, they're great. Then I had to go to the theater. Halston sent a singing telegram that had three people singing it. They were awful. They're trying to be in show business and I asked them not

to exaggerate it and to sing it quietly. Halston sent a big cake in the shape of a shoe and it must have been the best cake because Brigid ate all of it.

I glued and was late but then Susan Johnson was even later and I screamed at her. Stephen was already inside on the aisle when we got there. *Annie* was wonderful (cab $6). It was packed, you'd never think there was a recession. Standing room. The audience loved it, mostly old people. I was trying to keep awake. Afterwards we went backstage. I didn't see Alice Ghostley. I went to school with her husband.

We got a dumpy limo outside to go to Mr. Chow's. Mr. and Mrs. Chow greeted us. I didn't want to sign the guest book there because I wanted to do it with my own pen the next time. Tina Chow wished me happy birthday. We had champagne. Robin Williams came in and said hello, I asked him to join us but he said he was at the bar with someone, that he'd see. With some lady friend. And then I remembered that somebody told me he met a girl the day he married his wife and that they've been having an affair ever since. Anyway, he didn't come back. He had a short-sleeved shirt on and his arms are so hairy, that's how Susan recognized him. I hope *Popeye* is a hit for him because his TV show just died. Stephen invited a girl to join us for dinner, a sculptress who lives down near Rupert. She made a sculpture out of a napkin as a present for me, but then we didn't notice when the waiter took it away. Stephen was nervous and he almost started drinking. We dropped him on 57th and Second, then I dropped Susan (cab $5).

Thursday, August 7, 1980

We drove out to Old Westbury with Whitney Tower to see the studio of his great-grandmother, Gertrude Vanderbilt Whitney, to see if *Interview* might want to do some shooting there (toll $1, gas $30). The house was just beautiful, Whitney said it was designed by William Adams Delano. She had a whole room with murals done by Maxfield Parrish. Her sculptures were all around. Then we went next door to Whitney's grandmother's, Mrs. Miller, but she's in her eighties and she was "resting" so we just wandered around.

Back to the city ($1). Stopped at Philip Johnson's apartment, talked to David Whitney for an hour. He's working on the Jewish Museum project. He says the show should be plain, with no gimmicks. But I think it should be funny, I don't know, I think the designer can really make a show interesting. But I guess the museum has no money to spend.

Richard Weisman had invited me to meet Ann Miller, Patti LuPone, and Phil Esposito and him at "21" for dinner at 11:00. At "21" they looked at my bluejeans and they were about to say something but I rushed in fast. I finally talked Bob into putting Patti LuPone on the cover of *Interview*. She's so funny and Bob finally fell in love with her.

All I could do was stare at Ann Miller. Her face is flawless. Not a wrinkle, not even a smile line, and she said, "One of these days I'm going to have to get a facelift." I don't think she has, really, because her skin isn't pulled at all—her face is fat but it's unlined and not pulled. And she has tiny petite hands with long fingers. She's been married two and a half times—one was annulled. She said, "I married the richest Texans in the world, but as soon as the marriages started, the romance was over." She was cute, she ate like a Hollywood starlet on her first date—she had chicken hash. That's Hollywood style. And her nose is so fine, so perfect, it *has* to be a fake nose.

Ann said that when she was at the bottom some people dropped her and now when those people send her flowers for *Sugar Babies* she writes back, "Thanks for nothing." And the person who really did it the worst was Betsy Bloomingdale, Bob's best friend. And she said that Denise Hale was "trash." And she's known Reagan for years but said she wouldn't vote for him. But she's like me—after every putdown she says, "Oh but don't get me wrong, Reagan's wonderful, I just wouldn't vote for him."

Bob walked me home and when we got to 66th Street there was a big fire across the street from me in front of the Ugandan building. A brand-new tree was burning because someone had set fire to the garbage underneath it, and this whole family was sitting on the steps just watching the fire burn—it looked like Puerto Rico—and I just got furious—it looked like Africa—and they were just staring at this beautiful tree burning that was put in right when the one in front of my house was, and they didn't even call the fire department! And I don't understand because the doormen on the block must have seen it, too, and nobody was doing anything. So Bob and I went in and he called the fire department and they came in one second and put it out, but I don't know if the tree will make it.

Saturday, August 9, 1980

Vincent was at the office with his whole TV crew. Don Munroe and everybody. They filmed me doing some introductions to the shows he's shot, to give me a bigger presence in the programs. I think they're going to call it *Andy Warhol's TV*. It's interviews with people—just the people talking to the camera. Painted at the office till 8:00. Bill Schwartz called, he's in town from Atlanta for the Democratic convention and he asked me for dinner, he's staying at the Mayfair House.

Glued, and walked over to the Mayfair House. When I got there a man signing in said, "You painted my wife." And I didn't recognize him and then his wife was there and I didn't recognize her, either. It was awful because there weren't too many people around. She'd dyed her hair blonde and that threw me. It was Mr. and Mrs. H&R Block. And I was looking so squarely at them. It was really bad. I invited them down to the office.

Sunday, August 10, 1980

Bob called and said I was meeting him at 7:30 to pick up Ina Ginsburg to begin coverage of the Democratic National Convention with the *Newsweek* party at the Rainbow Room that Katharine Graham was giving. Went up to the Metropolitan Club where Ina was staying. Ina was in a black one-shoulder dress held up with a diamond pin that was maybe a Halston. She had on white shoes, she was nice. Then cabbed to the Rainbow Room ($3.50). Liz Carpenter was there, she used to be Lady Bird's social secretary. And she's big and fat and Texan and she was wearing an American flag dress with a watermelon across the front of it. And Peter Duchin said, "I know that dress is patriotic . . . somehow."

It was wall-to-wall everybody rich and famous and you couldn't understand how they were all in town because it was August, and then you know it *is* a great city if the convention could get

all this together. Tom Brokaw was there and Barbara Walters with her beau, and Ina knew everybody and was introducing us to everybody but I could only remember half of the names of the people *I* knew, so I wasn't so good for her.

John Tunney came over and put down Reagan and Bob got in a snit. John Tunney called me "Peter," though *(laughs)*, and he thanked me for doing the Kennedy poster. He thought I was Peter Max. And then it was funny because then somebody came up and said, "Oh thank you for doing the Carter poster." Saw Art Buchwald, and Jan Cowles was there with her husband, and Mrs. Graham we said hello to and later on goodbye to. Her daughter Lally was there with Alexander Cockburn.

Ina introduced us to a girl named Dolly Fox, a rich girl who's staying at the Ritz Towers and she's a runner but she has a pink ticket and that means she can go all the way to the president at the Sheraton. She's in high school still, but she acts like an older person. Her mother Yolanda was a Miss America in the fifties. We invited Dolly to dinner with us at Pearl's.

Pearl's was jammed with convention people. We got a table. And then Ina noticed that the Blair boy and his father, Bill Blair, the ambassador to Denmark, were also having dinner and she went and invited them to join us, but the boy said it was his eighteenth birthday and he'd like to have it just with his father and that they'd come over for coffee. Liz Carpenter was there with I.M. Pei and his wife and a woman who's the Secretary of Education, Shirley something, and she I think was drunk and tough and asked me my philosophy on education and I told her I couldn't even think, and she said, "You have to! Quick!"

We ordered dinner. Bob got screaming and crazy for a second when Ina said something against Reagan, but he caught himself and apologized. Ina and Jerry Zipkin want Bob to get them invited to Richard Weisman's lunch for Miz Lillian. Then the Blair kid came over and talked and he and Dolly sort of picked each other up. But Dolly is seventeen and acts forty and he's eighteen and acts ten. Dinner was cheap and we even had champagne for the boy ($125).

Then we cabbed to Park to a party that Ina got us invited to given for the Rhode Island delegation. A lot of rich presidents of corporations. Alice Mason was there looking like a mammy in a turban and a red dress. She came over and said she was so thrilled to see me. Bob thought she was being mean, but she was nice. Everybody thinks Carter will win on the first ballot and then they'll have to work really hard to get him reelected. There's so many Democrats around. They had good coffee—you can always tell if a party's good by if the coffee's good. This may have been the kind from a restaurant that you get in a container. I don't know.

Left there about 12:00, walked Ina back to the Metropolitan Club. Home around 12:30.

Monday, August 11, 1980

It was a busy day around the office. Mr. Stern called and said the Flower paintings were dented when they got to Hartz Mountain in New Jersey. Robyn called to find out about it.

Worked on paintings and paying bills up front where it's air-conditioned because it was too hot to work in the back. The Princess Holstein hovers around me when I work. I gave her to Ronnie so he could show her how to trace. Robyn decided to ask around about the Holsteins and found out that they've got lots of titles but no money. We put on a TV to watch the convention.

I dropped the princess (cab $4.50). She wants to help me with painting instead of work at *Interview*, but I can do it faster without her.

All the real American people from the convention are around town and it's sort of exciting. I saw a lot wearing cowboy hats.

Went home and glued myself together. Victor said he'd meet us at Halston's. I got there and Bianca was asleep under the covers in a white evening dress that I thought was a nightgown.

Halston was working late, he had to finish the collection for China, he's going to China and Japan.

I read the papers and ate potato chips.

We decided to go to Elaine's. I wanted to get the Blair boy for Bianca but I couldn't remember his first name or his phone number. Had a table in the back. Elaine's a little heavier now.

Bianca waved and Nick Roeg thought she was waving at him and came over. He was drunk and obnoxious—one of those people who scares me because they change in a second. He directed Mick in *Performance*. He just finished *Bad Timing* with Art Garfunkel. He was telling Bianca that he'd loved her for years, and I said, "Why don't you use her in a movie, you can get her." And he screamed, "How dare you, how disgraceful of you to say that, what bad taste!" and Bianca was protesting, too. She was nice to him, though, she didn't put him down. I guess she does hope she'll get work from him. He was hugging and kissing her. He said he loved *Bad*.

And then he told me he saw "my mother" on TV in England, that stupid David Bailey "documentary" about me where Lil Piccard made believe she was my mother and Nick was going on and on about how wonderful she was and how sweet and how great it was to have a mother who loved me so much and he wished his did and I just didn't have the heart to tell him that wasn't my mother. He said it was so touching it had him in tears. He was yapping and driving us crazy. He's fifty-two and he said how handsome he used to be and that look at him now, he said it all fell apart just recently.

Then he and Victor had words. Victor had his Sony Sound-about on and Nick Roeg said how dare he be so rude and not listen to the conversation. And Victor said, listen, that it was *his* table and he could do whatever he wanted, that Nick was his guest and how dare he complain when he'd barged in where he wasn't invited, and so then when he saw that Victor was intelligent he was hugging him and apologizing.

Tuesday, August 12, 1980

At 12:00 I had an appointment to meet Debbie Harry at the office (cab $4). I was early and Debbie and Chris were on time. We worked all afternoon. Debbie was sweet, every picture came out perfect. Vincent was taping her for the *Andy Warhol's TV* show and he had Lisa Robinson there interviewing her and Chris. I sat in on it so that I'd have a higher profile on the tape for the TV show. Lisa is a good interviewer. They were there till 4:00.

And I've decided I'm not going to call girls anymore and invite them places because they're too difficult. I called Sean Young, that really pretty actress who I met with Linda Stein, because I thought that Richard Weisman would like her. But she wouldn't give me her home number so I could call her back and it's too hard. I asked her if she wanted to go to a baseball game and

she said she'd been to one once already. She's in some James Ivory movie that's about to come out.

I had to leave early because I invited Bianca to the Peking Opera, she said yes, and I invited John Samuels, too. We ran into the Met Opera House and had just missed the curtain so we had to wait with Chinese people screaming why couldn't they go in. I think it's so ridiculous that the Met tries to be so sophisticated and not let you in if you're twenty seconds late. Especially with something like this Chinese opera because Chinese people talk all through their operas and make noise anyway.

Then after ten minutes we could go in. Fran Lebowitz was there with Jed. The opera was boring. Good costumes, lots of tumbling. Drag queens.

I saw Margaret Hamilton, the witch in *The Wizard of Oz*, and got so excited and went over to her and told her how wonderful she was. She does the Maxwell House commercials now. She's really small.

Bianca's trying to get Halston to get a ticket for John Samuels to go on the China trip, too. I asked her why she went on the *Tomorrow* show if she didn't have anything to say. And she said that she did, that she was in the new Burt Reynolds movie, *Cannonball II*. But big deal—she's in one scene, she worked one week.

Wednesday, August 13, 1980

Sat around the house waiting for it to be time to go to Richard Weisman's lunch for Miz Lillian. The rest of Truman's time on *Donahue* was preempted by the convention. Jerry Zipkin was picking Bob up. So I met them at Bob's and we went to U.N. Plaza. There were press people outside, they took some pictures, but there weren't any really big stars. Suzie Frankfurt and Patti LuPone were there, and a 6'11" basketball player, I don't know his name, he was white, really cute, he kept trying to be friendly. Miz Lillian was in the other room. There was so much press and not that many people.

A girlfriend of Robyn's who kept asking about him was there. She has a volunteer job with LeRoy Neiman, she carries his bag for him, I think. And LeRoy Neiman was there, he's doing a drawing of Miz Lillian for the *Daily News*. Then we went and found Miz Lillian talking to Barbara Walters. Lillian keeps saying the portrait I did of her raised $65,000 but I never heard a thing about that. They brought out a cake and I taped the "Happy Birthday." Then LeRoy said he had a car downstairs and we could ride in it, so we all left with Miz Lillian. And it was an actual car, not a limo. My tape jammed and I put in another one, and it jammed, too, so then I knew it wasn't the tape, that the Secret Service guy had done it. He was cute. People were looking and waving at the car, they had Miz Lillian balloons. She said, "Every smile is a vote."

At the hotel there were sisters and brothers and cousins from Georgia. She said, "Sis!" to one but I don't know if it was really her sister. We went up to the penthouse and then took another elevator to the next floor to her room, and she said when times were better she used to have a whole suite.

LeRoy was drawing those terrible drawings of his, asking her questions, saying anything to her. It was great. He told dirty jokes, and she told them back. Like his was one about a bear using a

rabbit after every crap to wipe himself, and she laughed. She'd left the liquor that Phyllis George sent at Richard's and someone went back for it.

Phyllis George is sending a lot of things, she wanted her husband to introduce Jimmy or something like that, but Miz Lillian said it was impossible, that it was protocol. Phyllis also sent two pictures of her baby. She also sent Miz Lillian a sequined jacket, and Miz Lillian said, "Now how could I wear that." I gave her a *Philosophy* book. I ignored Ruth Stapleton Carter because I didn't recognize her. There were a lot of Secret Service in the room because Carter was next door or a few doors down. I felt like a groupie.

Miz Lillian was putting down Harvard people, she hates them, she was just on the point of calling some Harvard guy she was in the Peace Corps with a fairy, but she didn't.

I told LeRoy he was such a good interviewer that I wished he would work for *Interview*. He said he could talk so freely with Miz Lillian because she reminded him of his own mother. I left him and took a walk down the avenue. I was signing autographs and a girl came over and handed me an "I Love New York" button, and then she asked me for money, and actually I was about to give her something but then she was so horrible and aggressive that I handed the thing back to her and she grabbed my finger and slammed it in her book and squeezed it and I was going to hit her with my tape recorder.

I passed out *Interviews* and then at 4:00 had an appointment with the H&R Blocks at the office (cab $3.60). The office was busy. They brought their daughter and I think a senator from Missouri. They're from Kansas City. They were thrilled with the office. I gave them a *Popism*. Worked till 7:30, dropped Vincent (cab $5). Had a drink and got very tired, decided to stay home and watch the convention which was boring.

Thursday, August 14, 1980

Got to the office and the Secret Service guys were everywhere, all over the block. I gave them *Interviews*. Then I remembered the Mondale kid, that I'd invited him. Liz Carpenter was there, a camp, she had her hair Bo Derek-style, just beads in it. She wanted me to give an art education lecture to the Secretary of Education.

I forgot to say that I keep running into the Robb girl, the LBJ daughter, the tall one. Lynda Bird. She could be a raving beauty but she doesn't want to be, I guess, because she wears glasses and a funny hairdo.

Liz Carpenter brought about eight people. Nancy Dickerson was there. And Wilson Kidde brought his friend from Princeton, Matt Salinger, the son of J.D. Salinger, who we've been trying to get for *Interview* but he turned us down. He said it would just get too complicated to give an interview and it was just easier not to. He's really good-looking.

And William Blair called and couldn't come to lunch and said that his father didn't want him to be in *Interview* and we can't understand it. Lunch was for Pat Ast, and we stuck her next to the Salinger boy so she had a good time. I gave a speech and I gave out *Philosophy* books. I told them I didn't believe in art, that I believed in photography. Oatsie Charles was there and she gave me a Mondale scarf. And little William Mondale was cute, he stayed through the whole thing. I asked him about the Secret Service and he said they cramp his style. He's so pretty.

Rupert came up and I did some drawings and paintings. Hans Mayer called from Germany and I have to do one of the portraits over.

Bob picked up the phone and called California and to tell them I'd agreed to do a poster of Reagan just because of some offhand kidding comment I made and now I'm having nightmares that I'll get pushed into really doing one. Those things get so tricky. Bob gets so crazy wanting to be an inside Republican.

Friday, August 15, 1980

Got up and passed out *Interviews*, now I carry a lot more with me. I leave them in cabs. And it's so easy to get away from people in the street when they stop you if you give them an *Interview*. They think they're getting something, a drawing or something. Vincent was saying the other day that I should start actually selling them instead of giving them away, that it would be more fun for me.

Tuesday, August 19, 1980

Bob was in a cranky mood all day. I told him we had to do Patti LuPone on the cover and he went into a tizzy screaming. He said it looked too similar to Paloma. They're both Latins. But oh, Bob is so immature. He does a baby tantrum when he wants something and then he does his guilty thing. It's just so predictable. Bob thinks he has too much to do. He thinks he has no personal life. He said he doesn't like going around with these old ladies, that he just does it for me, but then he admitted that he didn't mind the trips sometimes, that he doesn't mind the old girls sometimes, but that he'd rather be with his own friends. Which friends? I don't know. People he's met from work! And then on these scenes Fred is always called in, and after his own night of binging then he has to act mature and be the know-it-all and straighten Bob out.

And after weeks of Princess Holstein asking to help me I finally told her she could help me trace, and then she disappeared for an hour and I had to do it alone, and when she came back I asked her where she'd been and she said she had a phone call. She's becoming Ronnie's assistant—she sits and talks to Ronnie because he doesn't have anything to do. And then Robyn spends his days calling up his friends to look up who the princess's relatives are. So that's the state of the office.

Wednesday, August 20, 1980

Bob was acting a little better, he apologized for being nutty the day before. I met him for dinner to discuss the Patti LuPone interview, and I invited Rupert, too, because we had to discuss the Florida trip with Ron Feldman. We met at Le Relais (dinner $130).

When I got home I called Bob and we talked until 3:00 in the morning because I was waiting

for Jed to get home. He was having dinner with Alan Wanzenberg the architect—he's working with Jed now on the Brants' house in Palm Beach.

Thursday, August 21, 1980

It was Suzie Frankfurt's birthday so we were having a lunch for her. She invited everybody she wanted (party decorations $84). Lester Persky was the hit of the party. Suzie's decorating his house in Beverly Hills. He was telling everyone what a great producer he is. Renny the flower person sent a birthday boy from his place wrapped in cellophane in a box who gave roses to Suzie. Lester tried to take the cellophane off. Tommy Pashun sent an orchid plant. The whole thing was over by about 3:00 and Suzie took everything from the table home—the chocolates and the flowers. Then Tommy Pashun had to get the orchid back from her, because they send you the orchids but you don't get to keep them, they're rare, and the florist picks them up after you've had them and takes them back to the solarium. Then the next day they go on to somebody else.

Monday, August 25, 1980

Bob said Ina called and that we were going to see the opening of *42nd Street*. Went up to the Winter Garden (cab $4). The photographers and people were there and shoved us around. Mary Tyler Moore walked in right when it was starting. The show was great. Tammy Grimes was really funny as an old star. They had fifty tap dancers for the opening number. It was what shows should be, really big. The set changes. Gower Champion was in the hospital, they said.

The show was really exciting, but the most amazing thing in the show was that Carol Cook was finally a star! I couldn't believe it. Here's someone I met twenty-five years ago from Nathan Gluck and she was saying every minute that she just had to be a star, had to be one. And here it is twenty-five years later and she's finally made it. She had the Joan Blondell part. And it was the regular thing—"the show must go on" thing. And this Carol does what Brigid used to do— she looks in the mirror and she's happy because she sees a pretty face, but she never looks below her neck because if she did she'd see 500 pounds of fat. Desilu signed her once and she was in some *I Love Lucys*. She's not so fat now.

When the show was over there was all the bravo-ing, really a lot. Eighty-five curtain calls. Then there was a hush. And David Merrick came out and put his hand to his forehead and said, "This is a tragic moment. Gower Champion just died." And nobody knew what to do. The lead girl started crying. She had just moved in with Gower or something. It was like a movie, the lead guy was saying, "Pull the curtain, get the curtain down!"

And outside Joshua and Nedda Logan were in tears, and it was lots of actors acting. Then we ran backstage and they let us in. The lead girl ran out and tears were coming down her face and she said something like, "Go get my dress" to somebody and "The show must go on, and I have to be a star." So this was her big moment and she was so upset with Merrick for ruining it.

Then we went to Carol Cook's dressing room and Ina started to introduce me and Carol said, "Oh my God! Oh my God! Andy Warhol! I haven't seen you in twenty-five years! Remember

when you gave me a drawing and I gave you a cat? Oh my God!" It was such a camp. "Let's get together."

We bought the papers but no reviews of the play were in it ($1). I don't know about this new section that the *News* is putting in that Clay Felker's editing. I don't think it's going to make it. It looks too much like that Long Island newspaper—*Newsday*—and I think people do like newspapers like the *Post* more.

Wednesday, August 27, 1980

Doc Cox called and said he was picking me up for the screening of *Union City* starring Debbie Harry. Closed up early. Dropped Robyn and Fred (cab $5.50). The Doc was a little late, he finally arrived in a limo. He told me that he'd broken up with his nineteen-year-old boyfriend because the kid got too jealous. The kid was a weirdo. Charles Rydell was in the movie, he was a cabdriver. He was good. Taylor Mead was in the movie for a minute as a drunk, doing a bit. I thought the movie was great, but Bianca, Ina, Bob, and Doc Cox all hated it. And they had doctor things in the movie, so the Doc was whispering things like, "That's not right, that's not the way you do it." Then we were meeting Tammy Grimes at Elaine's. Helen Frankenthaler came to our table and she was so drunk. I said, "Would you like to meet Bianca Jagger?" and she waved her hand and said, "I don't care about that." She said she wanted me to come to her table and meet Clement Greenberg and Kenneth Noland, she said she thought it would be fascinating, so I went there.

Then Tammy came and we reminisced about the old days. I once drew her feet. She looked pretty good. I confronted her again and said, "I just know it *is* your voice on those TV commercials because nobody could imitate your voice, and you told me it wasn't you and I just *know* it is." And then she confessed that it was.

Thursday, August 28, 1980

Somebody's been calling every morning about 7:00 and letting it ring three times and hanging up. And it's on *this* line—the line that not too many people know about. I picked it up once, but I usually don't. Isn't that peculiar?

Friday, August 29, 1980

I went to look at a building to buy on 22nd Street, but it's just too expensive—$1.3. It's ten floors but it's next to those fire escapes that they made them put on that are painted bright yellow. It would be a good building for the magazine, though. I walked around looking for other buildings in the neighborhood but they've all gotten eaten up by everybody in the last couple of years, everyone's been buying.

I called Donald Ambrose, Curley's friend who lives in the Gramercy Park area, and invited him

out to dinner because we need someone to replace David at *Interview* who quit. Sassy. You never knew what would come out of his mouth. He'd been painting the office, and he had a friend from Wisconsin, Jay Shriver, helping him. Jay had just come to New York and was staying with him. So I noticed that Jay was really neat, and a good, organized worker, and I thought that he would be a good person to have working at the office, to be like a janitor but we wouldn't *call* it a janitor, and even help me with painting and stuff because Ronnie's gotten too elegant, all he does is talk on the phone all day and he's going over to Europe for a show that Lucio's giving him. Anyway, so I said to David that we would like to ask his friend Jay to work for us and he got so upset and said how could I even *ask* that. And then he quit.

Cabbed to Trader Vic's ($2). Met Donald Ambrose at the bar (drinks $20). There were a couple of hookers next to us and as we were leaving to go into the dinner place one of them grabbed David. Then Ricky and Cathy Hilton were there and I asked them to sit down, but they said no. They were with a girl who was just in from L.A. and she said she knew a friend of mine, Ronnie Levin, and I told her she shouldn't even *know* him, let alone admit it, that it would be trouble, and that made her nervous. She had all gold jewelry. She was a funny type, like the daughter of some old Hollywood person (dinner $100 plus $5 to headwaiter). The food was just awful.

Sunday, August 31, 1980

The presidential election is just too stupid to watch. I even hate John Anderson now, for one second once he seemed great. And you see Ronald Reagan in these neighborhoods with the poor people and you can just hear him saying, "Oh my God, what am I doing here?" But his hair looks really good. On my TV it really looks like good hair, not dyed.

Tuesday, September 2, 1980

Went to Halston's. NBC was doing a magazine show. David Brinkley was filming Halston's rehearsals of his people to take them to the Far East, and then the crew is going to follow Halston to China. It looked so rich at Halston's, so many orchids, so cool, the girls running around with their brand-new luggage. Halston made 500 new pieces of clothes for the trip, and some of the girls are taking the clothes for pay and some are *(laughs)* just taking money. The clothes were beautiful.

Afterwards I decided to walk to 42nd Street and ohhh, it was like a crazy play. Black guys mingling around, waiting to tear the next gold chain off. The jewelry shop guys with guns strapped to their ankles. And the black guys hanging around the stores with all the diamonds in them as if it's the neighborhood corner-grocery store. It was like a make-believe movie. Had an appointment at the office at 3:00.

Brigid lost three pounds. She's eating three meals, but all dietetic. She calls her O.A. friends— Overeaters Anonymous—the night before and they plan out exactly what they'll eat the next day and then once you plan it, you can't change it, you have to have a hamburger patty if you've said so, you can't change it to fish. They watch each other. She's down to 166.

Wednesday, September 3, 1980

Got up and the big news is that Johanna Lawrenson, Viva's old friend, Helen Lawrenson's daughter, is living with Abbie Hoffman, who just announced he's going to surrender. I doubt if Viva could have known because she would have blabbed.

The Princess Holstein in *Interview* was upset because I was doing a poster for Joseph Beuys's Green Party, she said it was a tragedy that somebody like me would do it, that it was a Socialist party, and I didn't know what to do. She told Bob she didn't know if she could continue working for a person who would make a political statement without even knowing what it meant. Fred told her it was none of her business.

Thursday, September 4, 1980

Hermann-the-German Wunsche was just in off the Concorde. He's doing a catalogue of all the prints since the beginning. Lunch for Hermann.

Brigid was trying to call Viva to find out if she'd known that Johanna Lawrenson had been living with Abbie Hoffman. Brigid was thrilled, it was the return of the sixties. Abbie Hoffman looks horrible, he doesn't look any different even though they say he had plastic surgery. And his wife just slapped him with alimony and child-support charges.

Ron Feldman called and said the Miami trip was going to be so exciting, that I was going to get three keys to the city. It sounds scary.

Friday, September 5, 1980—New York—Miami

New York to Miami is the worst line to go on, everybody's so ugly and Puerto Rican and Cuban and South American, it's just sort of disgusting. Florida's really changed, it's so different down there, it's a new world (magazines and newspapers $12).

We were picked up by a limousine and taken to Turnberry Isle, and traffic was so bad it took us an hour and a half and I had to glue myself for a cocktail party downstairs and I had three portraits to take photos for during cocktail time. They had a big buffet with all the great food and I couldn't eat anything because I had to talk to all these people who wanted me to sign autographs and I talked to this lady and she wanted her portrait done right then and there so we had to leave and go upstairs and oh she had pearls on that were a knockout, really like down to her belly and so beautiful. I just don't remember her name but she's a good friend of Liza's. She asked me if I wanted a blow and I said no, she was one of those crazy ladies. So I did her portrait, and then the lady who owned the hotel was giving a dinner downstairs, very classy. I sat between the hostess and another portrait and had a really great time.

After dinner I had to go to the room and do the two other ladies and we had Rupert as a makeup man. The first girl was all pale because she was too elegant to go into the sun and get wrinkles and the other girls were dark and suntanned so it was very hard, we had to really redo

them without a real makeup person. And so we used a lot of white makeup. And so finally we got them all over by 2:00 A.M. and we all went to bed and I was so exhausted I couldn't sleep.

Saturday, September 6, 1980—Miami

Art Deco bus tour thing with five TV stations and a hundred cameramen. We had this girl who gave a lecture on all the Art Deco hotels. Jed couldn't make the tour, he was still working in Palm Beach, he said he would come around 6:30.

Then we went to the Famous Restaurant, and each reporter came up to talk to me and there were a hundred of them, and I signed a lot of autographs and talked a lot and I had to be photographed eating everything, like gefilte fish. I'd never had it before. It was okay. That was real hard work and afterwards we were exhausted so they took us back to the hotel where we rested up for the opening. Jed arrived with Alan the architect, and we all got into limousines and went to the opening. I had to sign, do interviews, mob scene, *Popisms*, *Exposures*, posters.

Sunday, September 7, 1980—Miami

It was really hot. Got up, we had to have breakfast downstairs with the owner, Mr. Sopher and his wife—Donald and Carol. I'd done her portrait two days before, and I was a little late and when I came they were all there, two tables full of all these chic and exciting people. You had to walk the line, the buffet, but it was really really good food—salmon, you could have scrambled eggs with anything, they had roast beef and bagels and cream cheese and lox. I don't know why they spent so much money doing the food, but it was really good. Ron Feldman was there. Talked to the owner and he reminded me he was from Pittsburgh or McKeesport. He owned this whole empire, 800 acres of swamp that he made into this great place. Signed a lot of autographs and did interviews. It was just exhausting.

Went back to the hotel and watched *Stage Door* with Ann Miller and Katharine Hepburn, and that was better than watching the tennis matches because I can't stand watching anyone who might lose.

Monday, September 8, 1980—Miami—New York

The lady's Rolex that Thomas Ammann gave me as a birthday present doesn't run right, it's two hours slow. Waited around the airport lobby. Bought magazines ($8). There was a story in one of the newspapers that in Dade County where we were staying there's a murder every minute. It's the most murderous place in the world. Somebody checked into a hotel and they didn't look under the bed and the next day they did and there was an eighty-one-year-old woman strangled to death. So you can imagine what that place is like. Well, it's so hot there, I think in hot places people get nuts. It fries your brain. Finally we went up and I went to the bathroom in the airport, I was really scared to go there alone thinking of all these murders there, and there were a couple

of people in back of me, and I thought it was going to be a mugging but as I turned around—I hadn't even washed my hand—the guy just wanted my autograph and to shake my hand. He was one of the workers there. White.

On the plane the girl in the seat in front of me wanted an autograph so I signed a sick bag for her.

Had a date with Sharon Hammond for dinner and we picked up Ann Barish to go to Elaine's (cab $4). And Elaine's that night had Woody Allen, Mia Farrow, and the girl that's doing *Saturday Night Live*, Jean Doumanian. She's an old buddy of Woody Allen's, I thought she was his girlfriend but she's just an old buddy. Sharon said she couldn't drink after 12:00 because she was getting her eyes lifted in the morning by Dr. Rees and we kept telling her that she was stupid, that she didn't need it, but she said she wanted to get the fat out and it was a good time to begin. And then she's going to get silicone in her cheeks to fill up the line marks around her mouth, so she's starting early.

Dustin Hoffman was there with his girlfriend and he walked by and didn't say anything to me. David Merrick was the big hero there, everybody came up to shake his hand. And I kept telling Sharon that I was finished, that nobody would say hello to me. But then the Secret Service all came in and what's-his-name came over to say hello to me. Jack Carter. So it was a really good night there.

Wednesday, September 10, 1980

It was the Jewish holiday so things started clearing out at 3:00. Worked with Rupert until 7:30 or 7:45 on the Debbie Harry portrait (cab $5). Picked up Barbara Allen and John Samuels who are now an item. We got to Diane Von Furstenberg's and it was absolutely nobody we knew and Diane was nowhere around to introduce us, so we just sat and giggled. Then Richard Gere and Silvinha came. They were just back from Fire Island. Marina Schiano and Thomas Ammann were after Richard. They were putting down Fire Island and I said it was the greatest place in the world. I told Richard I bet nobody asked for his autograph because you know how cool those fairies are out there and Marina had to make a comment, "Well they didn't ask for *yours* but you can be sure they asked for *his*." You know Marina. And Richard told Bob *(laughs)*, "No pictures please." Food was fried chicken that could have been from the Colonel's, and chocolate cake. Diane's kids are beautiful. As we were leaving she came over and said, "Oh my dear, didn't you meet the prince of Thailand?" And she pointed out this kid that we thought was a waiter. I mean, he could have worked at the vegetable stand on the corner. But she never even introduced us! And we'd been dying to meet him. He's tinier than Rupert. Dark hair.

Left Barbara and Silvinha and Thomas Ammann staring at Richard Gere. John Samuels they dropped—he was looking around nervously wanting to go to the Ritz to see some group like "The Coconuts" or something. Had a sleepless night.

Thursday, September 11, 1980

Watched Mrs. Allison the psychic on *Donahue* talking about her "angels" that she finds—the bodies of children that are missing. It was fascinating but I don't know if I really could believe it. She would be great if she could tell you in the hour after a child was missing where he was—that would really do something. She should sit by her phone.

Glued myself together and picked up Bob and Diana Vreeland to go to the Winships' for dinner. Diana was wearing a beautiful Valentino (cab $2). Got there and it was really cozy, a dinner party for Zandra Rhodes. The Carimatis were there, and Ralph Destino and André Gregory. Ralph told me he was in love and that he was going to get married and for the third day in a row I gave somebody the lecture not to get married, which I really have to stop. And then I made a big bet with him and I'm scared to find out who's right. A portrait-sized bet. It's whether Rita Hayworth was born in Brooklyn. I said she wasn't. I asked him for a 40 percent discount at his store, Cartier. With 40 percent they still make a 10 percent profit.

Zandra Rhodes had an upsweep of purple and pink hair. The Winship lady had on a plain Zandra dress. Zandra's fiancé Couri Hay came after dinner. He's trying to play it heavy with Zandra so I brought up his wife. Oh, you know, his "wife," that boy. And he tells Zandra to be freakier and I told her she should play down the freak stuff now, that the colored hair was sort of old-fashioned. In front of Zandra he said, when I asked him why he didn't put her in his columns, he said because nobody knew who she was.

Friday, September 12, 1980

Still a Jewish holiday. It was a nice warm day and it was still pretty empty, just cabs around. Fred came in and said he'd just been over watching Milos direct *Ragtime* on Irving Place. And that it was fun with the horseshit and everything.

Saturday, September 13, 1980

Decided to go over to the Kennedy bash to celebrate that Michael was getting married to Vicky Gifford. I didn't want to go alone so I waited on the corner for Fred and Mary Richardson to pick me up and we cabbed to 55th and Sutton Place to Le Club. The paparazzis were all there, Ron Galella and everybody. Caroline and John-John were there and Eunice Shriver—I think it was her—and Ethel. The only grownups missing were Jackie and Ted. And Jean Kennedy Smith.

Fred and I were at the old folks' table. Eunice told me that she likes madonnas and I told her that I was doing Modern Madonnas and I'm going to call her to come down to the office. Michael gave a speech about how he loved Frank Gifford and it was like having a new father. And the little ten-year-old gave a speech about how when Michael was in a car and had to go to the bathroom he pissed in a beer bottle and they were all telling him to shut up but he wouldn't. And Robert Jr. gave the best speech, he'll probably be better than Teddy, he'll probably be the one. But the funniest Kennedy was the one who was dancing with his girlfriend's purse and being like a fairy. They all dance pretty good. Kerry wrote some songs and they all sang them. Mary kissed all the boys, she knew them all.

I was then invited to a boat party that Calvin Klein and Elton John were giving down at that boat called the Peking where Yves St. Laurent had the Opium party that I'd missed so I wanted to go. Elton John had given a concert for 400,000 kids in the park. Fred wanted to take Mary and Kerry and a bunch of boys, so we got a limo outside to go downtown. It was a beautiful

night. And I saw some interesting people there like Joe Dallesandro. And Archie and Amos's vet, who's so good-looking, Dr. Kritsick, was there. And John Samuels. Every model in town. Lester Persky was running around after every model there.

Sunday, September 14, 1980

Brigid said that she talked to Viva finally and that the reason, Viva said, that Abbie turned himself in was that he found out that Viva found out about it and he knew she would blab.

And Barbara Loden died. She was sweet.

Monday, September 15, 1980

Cab to the Jewish Museum where *Time* magazine was taking photographs of me ($3.10). It's the same photographer that's been photographing me for years. Ron Feldman was there.

Eunice Shriver had called in the morning and said she wanted to come in to see the Modern Madonnas that I told her about and I invited her for lunch, but then later she cancelled. The place was busy, everyone was running around. One of those boys from Las Vegas that Edmund Gaultney brought by decided to have his portrait done. We couldn't find anyone to do makeup though, so I did the makeup myself and I guess I can actually do makeup, it came out pretty good. The boy was really suntanned, I put on white.

Went downtown to Dr. Giller's birthday party. It was the pretty people, everyone we knew. Rupert crashed, and when Rupert crashes he stands there in bright red and smiles. Tommy Pashun was there. And a defense lawyer named Ed Hayes who looked like he was from *Laverne and Shirley*, like a plant that people invite to parties to wear funny clothes and jump around and make things "kooky." Sort of forties clothes, really crewcut, about twenty-nine. He said, "I can get ya outta anything."

Tuesday, September 16, 1980—
New York—Philadelphia—New York

I changed my mind about the train to Philadelphia for Jamie Wyeth's show at the Fine Arts Museum. Had Fred get a car. Bob and I cabbed to Doubles ($5). We were having lunch with Jean Tailer and Pat Buckley. I checked my bag, had drinks, and then lunch. It was a ladies' lunch, all the ladies like to go to Doubles for lunch because it's cheap and you can eat all you want and go back all the time and it's horrible food like smoked turkey and smoked ham and it gave me a sore throat. All these rich ladies who spend money on clothes but they won't buy good food. Bob was the best gossiper. Pat Buckley said she was so thrilled that *Shogun* was on TV. She said the night before she just went to bed with a tray and watched all three hours of it and had her girlfriends call her between segments—she didn't even go downstairs to see George Bush who

was having dinner with her husband. And she was so disappointed that it was only going to be on for two hours that night.

Arrived in Philadelphia and couldn't find Delancey Street, the driver was too old and cranky. Saw the cracked bell. Found Walter Stait. We told him that we wouldn't be staying over after all, that we had to do a portrait early in the morning in New York. Had tea, changed.

Emlen Etting was there in a black cape and black hat, so old, looking like one of those funny fairies. We gave him a lift to the museum. All the old bags were there. Met Jamie, did some TV. His father and mother were no-shows. His brother Nicky and his brother's wife Jane who works for Sotheby's were there. Arnold Schwarzenegger wasn't, and Nureyev wasn't. I saw Bettie Barnes who let my cat die. It's a man. B-E-T-T-I-E. I once gave him a kitten and the kitten was crying and I thought it wanted its mother so I gave him the mother. We had two cats left, my mother and I had given away twenty-five already. This was the early sixties. And after I gave him the mother he took her to be spayed and she died under the knife. My darling Hester. She went to pussy heaven. And I've felt guilty ever since. That's how we should have started *Popism*. That's when I gave up caring. I don't want to think about it. If I had had her spayed myself I just know she would have lived, but *he* let her die.

So it was Jamie's big show. I had to stand in front of my portrait. Jamie is painting bigger— more Pop—pictures now. I told him he should go even bigger and he said he didn't think you could get stretchers that big and I said you could get them as big as the sky.

Phyllis Wyeth was my dinner partner and my other dinner partner was Bonny Wintersteen, she's filthy rich.

Warren Adelson and his wife were there and she was wearing the same dress she wore in Monte Carlo and I said, "That's the same dress you were wearing in Monte Carlo," and she said that when she was getting dressed to come she said, "Nobody will remember this dress except Andy Warhol. He'll say, 'That's the same dress you wore in Monte Carlo.'" It was funny, we had fun.

Walter Stait was funny. I was having a good time until Fred told me that this place, the Fairmont Hotel, where we went after the museum, was where they had Legionnaire's Disease and then my throat started hurting more. But they said it had been completely renovated.

Then we slipped out and went back to Walter's to get Fred's bag. A two-hour ride back. I wanted to give the driver a really big tip, but Fred said you can't spoil them ($20).

Wednesday, September 17, 1980

I was tired from the Philadelphia trip.

So many Jewish newspapers are coming to interview me about the Ten Jewish Geniuses—*Jewish Day, Jewish Week, Jewish Month*—and Fred thinks I shouldn't do any more interviews for a while, that I've been doing too many. And he's right.

I walked home, glued myself together. Thomas Ammann was picking me up to go to Sondra Gilman's party. It was for Nick Roeg, but Nick was gone when we got there. It was so hot there, people were sweating. Sylvia Miles was there, and Sylvia acts so funny, she feels like we've dropped her and she says she wants to "renew our relationship." But whenever she invites me to be her date someplace, it's always someplace that I've already been invited to, so I have to tell her that

I'm already going and that I'm taking somebody. And she told the best gossip—that Joe Dallesandro is now living with Paul Jabara. No wonder he hasn't been calling for money.

Sondra had some interesting people there—like Tony Walton the stage designer. Sondra looked great in this beautiful bright yellow silk dress—the color I used on the Debbie Harry portrait— and it made her look so young, eight years old, and we asked her who made it because it was really pretty and she said, "You'll fall over if I tell you." So she told us and Bob and I did fall over—it was a Diane Von Furstenberg. Off the rack for $120. It really was pretty.

Sondra produced the new Nick Roeg movie, *Bad Timing* with Art Garfunkel and that girl I think I met there, Theresa Russell, she didn't look like anything. The food was awful. We left and Sondra was still serving quail eggs, they have a quail-egg farm.

Thursday, September 18, 1980

I went to the office and had a fight with Carole Rogers about her throwing some envelopes out. She said they only cost thirty-five cents, but I proved that they cost $2. Bob was in a better mood because he moved into his new bigger office. Jay Shriver is really good at straightening up the place.

Senator Heinz's wife called and said that I just had to come to her dinner in Washington next week because she's planned on Jamie and me and it was in my honor. Ronald Reagan, Jr.'s people called to say he'd agreed to be interviewed by me for *Interview*, which I didn't know anything about.

Joanne Winship was calling me all day about whether I was picking up Carolina Herrera to take to her Italian Boy Scouts charity dinner, which I was, but I wanted to wait to call Carolina in order to drive Mrs. Winship crazy. Mrs. Winship threatened that if I didn't let her know right then, that she was going to send a car for Carolina, which I knew she wouldn't. I picked Carolina up and she was wearing one of her creations, she has about twenty that she did herself, she's going into the designing business, that's why she's here staying in New York. We got a cab and went to the Pierre ($3). Monique Van Vooren was there and she wanted her picture taken with me, so we did, and then I walked away but then she grabbed me and said how dare I "dump" her and I said, "Oh come on, Monique, you're crazy." She said, "How could you drop me! I'm going to be so big next year."

Then Monique sat at our table and Joanne Winship said, "These disgusting people who sit where they're not supposed to!" And Monique said, "Oh you bitch." And Joanne said, "You phony, you're my guest and you'll sit where I put you!" It was so nutty, Joanne was a raving maniac. I loved it. I just wanted a tape recorder so badly.

Fred got left for a second and when he came back Joanne saw him sit back down next to Mrs. Vreeland where he'd been sitting before and she screamed, "How dare you sit in that spot!" Poor Fred, he'd just gotten up to go to the bathroom.

Then Ron Link who'd staged the fashion show before the dinner sat down at our table and Joanne screamed at him and then *he* hated her and left and then Joanne told Monique he'd left because of *her*. I mean, she's just bonkers, totally crazy. I had such a great time.

Saturday, September 20, 1980

Was picked up by John Reinhold to go to Bill Copley's wedding party (cab $5.25). The door was open when we got there. There was a tent set up in the back, Donald Bruce White was catering. I was jealous of the bride because she had on a $145,000 string of pearls from Tiffany's. This is the woman who was a real madam who Bill cast in his play that Maxime de la Falaise and Denise Bouché were also in. I left her name off the present I brought—on purpose. It was a Shoe.

It was a small party. Ludwig is Bill's new dachshund and he's different from little Tommy who was run over, but he's nice. I gave him food so he liked me. They were cutting the cake and this guy came over and said he wanted to talk to me and he took me aside and I thought he was going to say some nice things and suddenly he was so mean! He was the boyfriend of the madam's girlfriend. I don't know what was bothering him. I was afraid to get up, I thought he would swing at me.

John Reinhold and I left quickly and John said to me, "Why didn't you look at his suit, because then you never would have talked to him."

Sunday, September 21, 1980

I tried to watch TV but nothing good was on. Oh yeah, that's right, the debate. I couldn't stand to watch either one of them though—Reagan looked so old, so crunched-up. And the other guy, Anderson, looks too much like Chris Hemphill.

Monday, September 22, 1980

Raquel Welch's secretary called and said that Raquel would like to change our lunch from 1:30 to 1:00 so I stayed uptown, then walked to Quo Vadis.

Raquel was a half-hour late anyway, she didn't get there till 1:30. She looks great for forty. Her new husband is some French film producer. Raquel is sweet now that she's come down a little in the world.

Tuesday, September 23, 1980

Bob was giving a big lunch for Paige Rense, the editor of *Architectural Digest*, and it was a big success. There was Eugenia Sheppard and Earl Blackwell and Lily Auchincloss and Pat Buckley. And Lee Radziwill who Paige Rense is interviewing for *Interview*—and Cris Alexander was there to take pictures of the two of them. Jean Tailer was there and Christina Carimati and Marion Javits and Joe Eula who I haven't seen in months. Twenty-seven people.

And Victor called from Paris. Halston and the gang had gotten successfully through China. He said it was wonderful, that I'd missed a great thing.

Wednesday, September 24, 1980—
New York—Washington, D.C.

Got to the hotel, checked in. At 7:00 went to Steve Martindale's cocktail party where we saw Liz Carpenter who said she still wanted her portrait done, but then I asked Ina Ginsburg if Liz was serious, and Ina said, "Well, I think you should tell her the price." I guess she doesn't know it costs $25,000. Ina said she'll probably have a heart attack. Liz Carpenter kept saying, "You've got to Xerox me." Instead of Polaroid. "When are you going to Xerox me, darling?"

And then we went off to another party for the Dyke Women of the Year. You know, the dykey types—what's it called? "Outstanding Women." And the first person I was introduced to was this creepy guy who said that Viva was in town and that he was going to be her lawyer in a lawsuit. He was saying, "Viva's very unhappy about the situations of the past," implying that she wanted to sue us, and I was saying, "Well, Viva makes her *own* problems. I mean, they're not mine." It was very creepy, just absolutely creepy. It's just those kind of creeps who make problems. The kind that want to start trouble over nothing. Oh, but actually, when I think about it, Viva could never stand being with this guy for one second.

Then we took the brownies Ina had in the car over to Senator Heinz's. Jamie and Phyllis Wyeth were there. And then Liz Taylor came in with John Warner and she came over and was really sweet and then later she came back to our table and had dinner with us. John would bring me a full glass of wine but he'd bring Liz a thimbleful, and she'd say, "Well, what happened?" and he would say, "Oh I don't know, it was the bartender, he just didn't give me enough."

And I met Mrs. Kassebaum, the daughter of Alf Landon, the only lady senator. A lot of tough broads, but funny ones. There was a Portuguese guitarist there because Mrs. Heinz is Portuguese from Mozambique. We toured the house, a beautiful house, and they have really rich, great paintings. They have a Copley. And Mrs. Heinz made the food, it wasn't Heinz, it was Portuguese duck and rice, but I just had one helping.

Ina dropped us off at the hotel. Went upstairs and they'd left a package of Godiva chocolates and I ate the centers out of them. I opened every center. And they left a bottle of brandy so I drank that. And a basket of fruit and I ate all the kiwis. Got sugared up and I guess I passed out but I woke up an hour later.

Thursday, September 25, 1980—
Washington, D.C.—New York

On the plane I read *Conversations with Joan Crawford*. I loved the way she said "shit" and "fuck" and everything like that. Oh God, if only I could have gotten Paulette to do that when we were trying to do the book with her, it would've been so great. I'll have to ask her as a Christmas present if she'll do it now, let me tape a good juicy tape so that I can use it someday. I wonder if I can really ask her for it—"Oh, please Paulette—just a present so I can *(laughs)* jack off by it." That's a good line, right? Yeah, I think I'll tell her that.

The rain caught up with us in Manhattan. Bob had checked his bags so we had to wait a little (cab $20). We all went home to drop our bags off. 11:30.

Ron Reagan, Jr. was coming to the office. The photographers came and the hairdresser came, the stylists came, the art directors came—so the place at six o'clock was filled with like twenty-five people. And Bob was going around, crazy, saying, "Is *this* what it is to take a simple picture of a nice-looking boy?" They kept arriving—the assistants of the assistants of the assistants, and finally we said this is crazy and sent them away and then we were down to three people, four people.

Then Ronnie Reagan, Jr. came with his girlfriend, hand in hand. And a black friend who takes care of him who he called "Chocolate Boy." And Jamie Kabler who's married to Mrs. Annenberg's daughter arranged it all. He ran over to me and said, "Can you believe this? Lally Weymouth called Ron up for an interview and when he told her, 'I'm sorry, I don't do interviews—I'm only doing one interview and it's for *Interview* magazine,' she said, 'How can you work for that homosexual publication? The two of us are more the same kind of person. I mean, *I've* got top family and *you've* got top family, and you're giving an exclusive to *that* newspaper?' " Jamie said Ron got really upset and wanted to call off the shoot, but Jamie ran out and bought an *Interview* and Ron read it and it didn't look homosexual to him, and he said he didn't care anyway, that he still wanted to be in it because he wanted "to meet Andy." And go out to dinner with me. And he turned out to be a really nice kid, God he was so sweet. The only trouble was he kept pawing the little girl. He and the girl live together. The Chocolate Boy is just a close friend.

And he's very smart. He didn't say much, but then when he did it was smart. Lispy and cute. And he was sort of sitting there looking bouncy. Then they took pictures and he drank. He drank more than anybody I know, I don't know if it was just not to be nervous or what.

Then went to do the interview at 65 Irving. I didn't know what to talk to him about, I was too shy and he was too shy. But then Bob got a little encouraged and started asking about his father. And I asked him *(laughs)* on Bob's behalf, whether his father dyes his hair. He said everybody asks him that question. I blamed it on Bob. Bob then blamed it on me. Ron said no, his father doesn't, and that his mother's very sweet and very adorable. So then I got sneaky and brought *Ordinary People* up, and I told him how much I hated Mary Tyler Moore, that after I saw the movie if I saw her on the street I'd just kick her. And at that point he was almost going to say something about Nancy, but then somehow he got the drift of it and changed the subject. Because I think the mother in *Ordinary People* is just like Mrs. Reagan. Really cold and shrewd. And by the way, little Timmy Hutton, the star of it, turned us down, he won't do any interviews.

Okay, so we're at 65 Irving. I told him I'd never had frogs' legs and he was so sweet he ordered them just so I could try it. He's really sweet, a beautiful body and beautiful eyes. But he just doesn't have a pretty nose. It's too long. Big full lips. He doesn't look like anybody in the family, it's surprising. I don't know if he's a fairy. He was sitting there holding his girlfriend's leg, touching her. She's twenty-eight years old, her name is Doria, and they met in California. She invited me over for a Cuisinart dinner—he bought her a Cuisinart for her birthday. And they have a ten-inch television set, Quasar.

Then outside we ran into Annie Leibovitz and she's gotten over her "heart attack." She looked great. I took some Polaroids and gave them to them as souvenirs, and I gave them *Philosophy* books and *Exposures*. And then little Ron wrote in one to the black friend, "To my favorite nigger," and the boy said he's going to show it around when he goes to the White House. Then we were talking about Merce Cunningham and Ron said the piece Merce did with the helium pillows was his favorite and I told him that I'd made those Silver Pillows and he said that he didn't even

know, that that wasn't why he'd said it. Bob just fell in love with him, thought he was so great. Jamie Kabler had a limo and we dropped the Reagan kids off, they live on 10th Street between Fifth and Sixth. They had a really good time, they really liked us, so we'll be going off to Cuisinart dinners.

Have I said that I lost the bet to Ralph Destino about where Rita Hayworth was born—she *was* born in Brooklyn and so now I have to do the portrait of the woman he's going to marry.

Saturday, September 27, 1980

Got up at 9:00. Had to glue myself together to meet Fred Dryer to interview him at Quo Vadis. He's the Los Angeles Ram. He arrived and he wasn't wearing a shirt or tie, and he had two bruisers with him who weren't, either, but we got the restaurant to give us the back table, the one we had when we interviewed Burt Reynolds. Fred Dryer's 6'6" and he's so good-looking I fell in love with him. He wants to go into acting. I was embarrassed when he asked me what number he was and I didn't know. He had four salads and meat.

Sunday, September 28, 1980

Brigid was at EST all day. They took their watches away. She didn't get home till 5:00 in the morning. They had 200 people and it sounds smelly. They looked in people's eyes and farted. They called each other assholes, so now Brigid's a big asshole. It's just ridiculous.

Wednesday, October 1, 1980

I decided to stay at the office and get some work done with Rupert on the diamond dust. If it were real, it would cost $5 a carat and that would be $30,000 or $40,000 for each painting for the diamond dust alone. Then John Reinhold picked us up to see Charles Ludlam's Ridiculous Theatrical Company's play *Reverse Psychology* down on Sheridan Square (cab $6, tickets $32).

We had good seats and the play was good because it was so real. It's about a man and a woman psychiatrist who have a couple of patients who go off to an island and take a drug called PU which makes them love whoever they didn't, and vice versa, and it was fun, worth going to see because the fights were so real.

John and I decided to go see what Bobby Short was really like so we went to the Carlyle (cab $4.50) and Bobby was there singing away, and I was reminiscing about seeing him in the old days when John brought me back to reality—he told me that Shirley Goldfarb went to heaven. Then Bobby was starting to come over so we paid up and ran out quickly ($68.30). Got home about 1:30.

Andy's mother, Julia Zavacky, *(top left corner)*, in Czechoslovakia before her marriage to Andy's father, Andrew Warhola. With her are Zavacky family members and in-laws. *(courtesy of Amy Passarelli)*

Andy's mother, Julia, with two of her three children, John *(left)* and Andy. (Her other son, Paul, is not shown.) *(courtesy of Amy Passarelli)*

Andy on the lawn of Carnegie Tech in Pittsburgh, 1948.
(photo Philip Pearlstein)

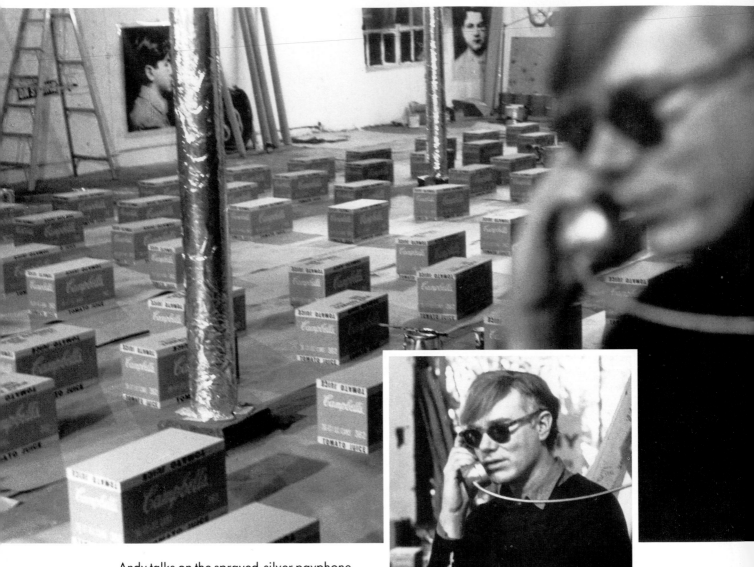

Andy talks on the sprayed-silver payphone
at the original Factory on East 47th Street
in 1964. (photo Billy Name)

Shots taken in 1968 on the set of Paul Morrissey's *Flesh*, starring Jackie Curtis (with cigarette), Joe Dallesandro, and Geri Miller. *(photo Jed Johnson)*

Body-painting a model in the sixties with Gerard Malanga and Ultra Violet.

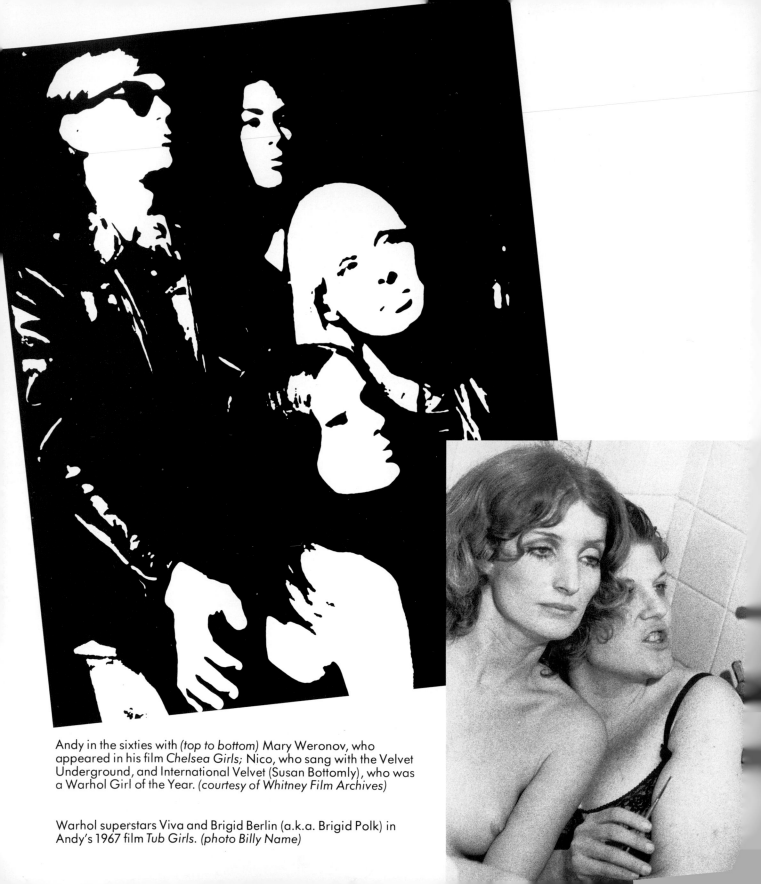

Andy in the sixties with (*top to bottom*) Mary Weronov, who appeared in his film *Chelsea Girls;* Nico, who sang with the Velvet Underground, and International Velvet (Susan Bottomly), who was a Warhol Girl of the Year. *(courtesy of Whitney Film Archives)*

Warhol superstars Viva and Brigid Berlin (a.k.a. Brigid Polk) in Andy's 1967 film *Tub Girls. (photo Billy Name)*

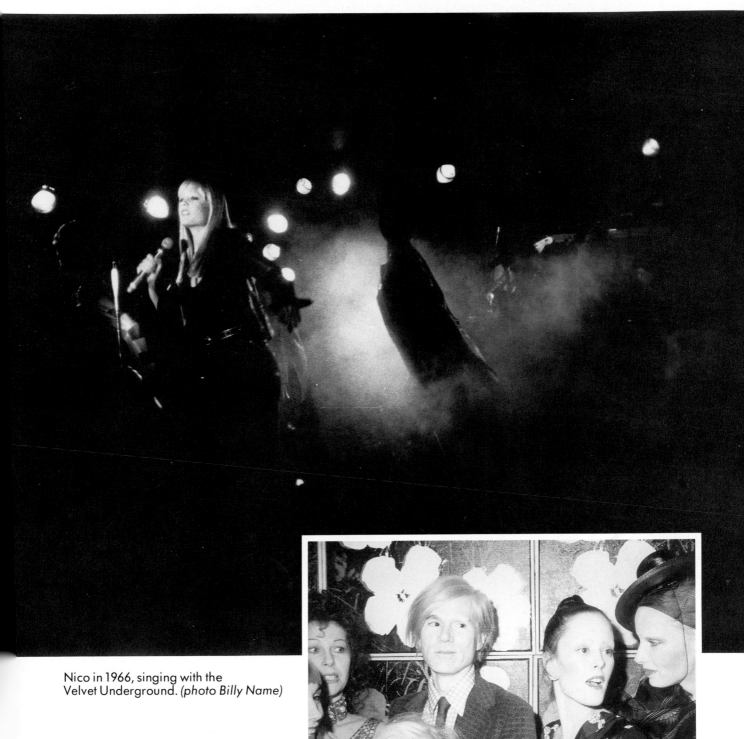

Nico in 1966, singing with the
Velvet Underground. *(photo Billy Name)*

Andy at his 1971 retrospective at the
Whitney Museum with *(left to right)*
Geraldine Smith, Ultra Violet, Andrea
Feldman, Jane Forth, and Donna Jordan.
(photo Richard Bernstein)

Andy with his dachshund Archie in the entrance hallway of his house on East 66th Street. *(photo Pat Hackett)*

Getting dressed at his house.
(photo Pat Hackett)

On one of his daily runs up and down Madison, stopping in stores both to shop and to encourage store owners to advertise in his magazine, *Interview. (photo Pat Hackett)*

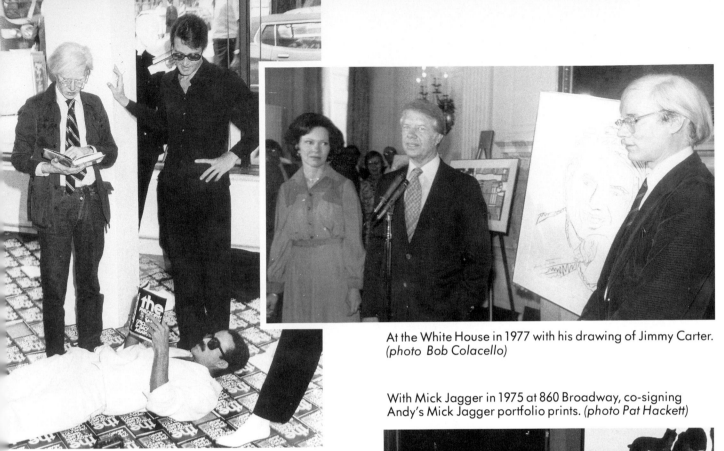

At the White House in 1977 with his drawing of Jimmy Carter. *(photo Bob Colacello)*

With Mick Jagger in 1975 at 860 Broadway, co-signing Andy's Mick Jagger portfolio prints. *(photo Pat Hackett)*

When Andy's *Philosophy* book was published in 1975, artist/window dresser Victor Hugo *(on floor)* "tiled" the floor of designer Halston's *(standing)* showroom window at Madison and 68th Street with copies of it. *(photo Pat Hackett)*

Walking in the Village with Jed Johnson *(left)* and Paul Morrissey in 1972. *(photo Pat Hackett)*

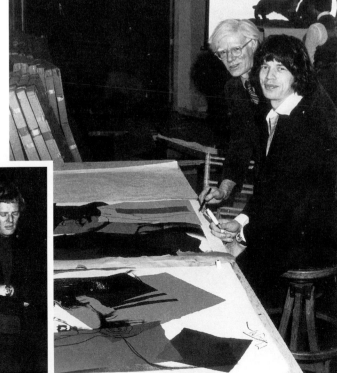

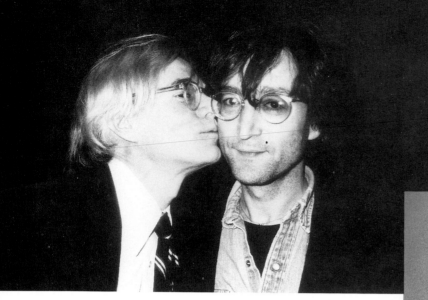

Kissing John Lennon, February 1978.
(*photo Christopher Makos*)

With Hollywood agent Sue Mengers.
(*photo Bob Colacello*)

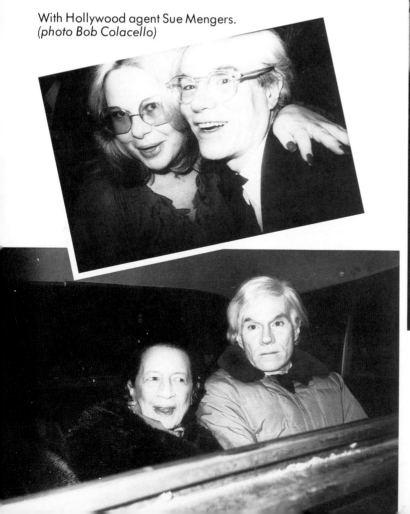

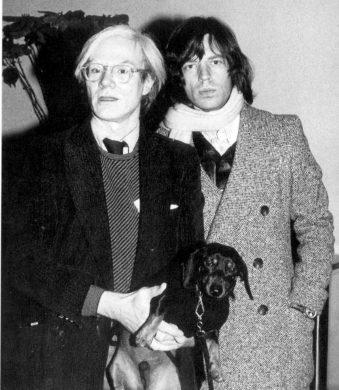

With Mick Jagger and Archie, 1975.
(*photo Pat Hackett*)

With Diana Vreeland in 1975.
(*photo Bob Colacello*)

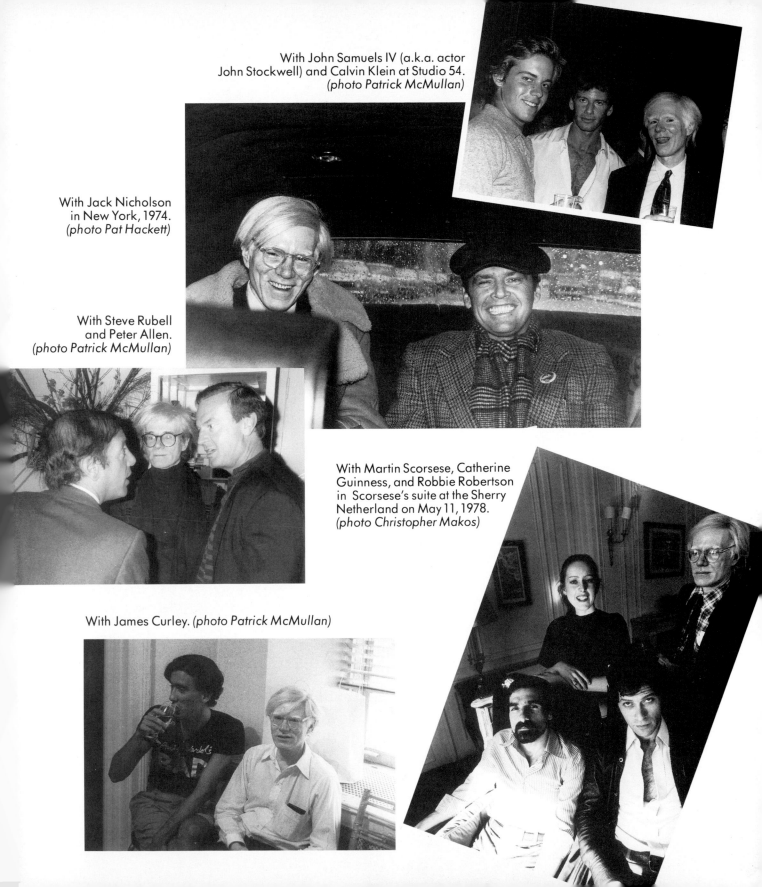

With John Samuels IV (a.k.a. actor John Stockwell) and Calvin Klein at Studio 54. *(photo Patrick McMullan)*

With Jack Nicholson in New York, 1974. *(photo Pat Hackett)*

With Steve Rubell and Peter Allen. *(photo Patrick McMullan)*

With Martin Scorsese, Catherine Guinness, and Robbie Robertson in Scorsese's suite at the Sherry Netherland on May 11, 1978. *(photo Christopher Makos)*

With James Curley. *(photo Patrick McMullan)*

Halston. *(photo Andy Warhol)*

Pat Hackett with twin brothers Jay *(left)* and
Jed Johnson. *(photo Patrick McMullan)*

Martha Graham. *(photo Andy Warhol)*

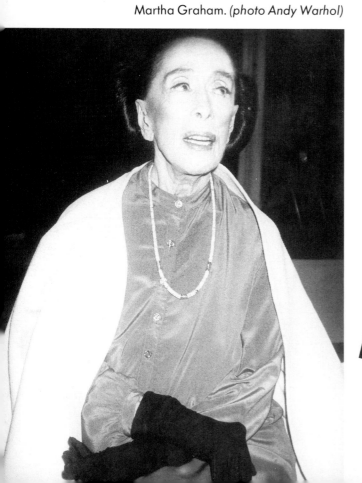

Baryshnikov. *(photo Andy Warhol)*

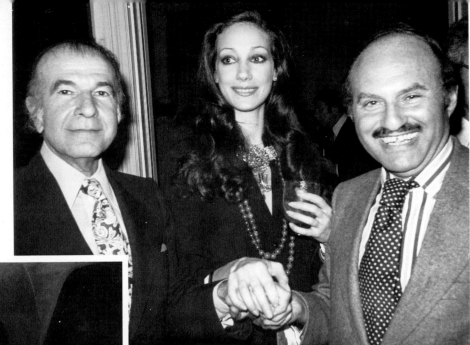

Iranian ambassador to the U.N.
Fereydoun Hoveyda *(left)*, Marisa
Berenson, and Lester Persky.
(photo Andy Warhol)

Bianca Jagger and Diane de Beauvau.
(photo Bob Colacello)

Dinner with Mick Jagger and William Burroughs.
(photo Andy Warhol)

John McEnroe and Catherine Guinness.
(photo Andy Warhol)

Barbara Allen. *(photo Andy Warhol)*

Brigid Berlin at the height of her weight, in character as "Estelle," on the set of *Bad* in 1976. With her are brother Richard E. Berlin, Jr., and co-star Susan Tyrrell. *(photo Pat Hackett)*

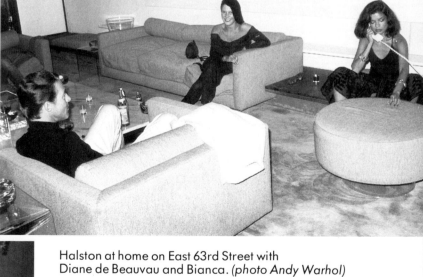

Halston at home on East 63rd Street with Diane de Beauvau and Bianca. *(photo Andy Warhol)*

Richard Weisman with Catherine Oxenburg and her mother, Princess Elisabeth of Yugoslavia. *(photo Andy Warhol)*

At Halston's Olympic Tower showroom.
left to right: Benjamin Liu, Martha Graham, Jane Holzer,
and Liza Minnelli. *(photo Andy Warhol)*

Gigi and Ronnie Cutrone. *(photo Andy Warhol)*

Suzie Frankfort.
(photo Andy Warhol)

André Leon Talley and Maxime de la Falaise McKendry.
(photo Andy Warhol)

"860"

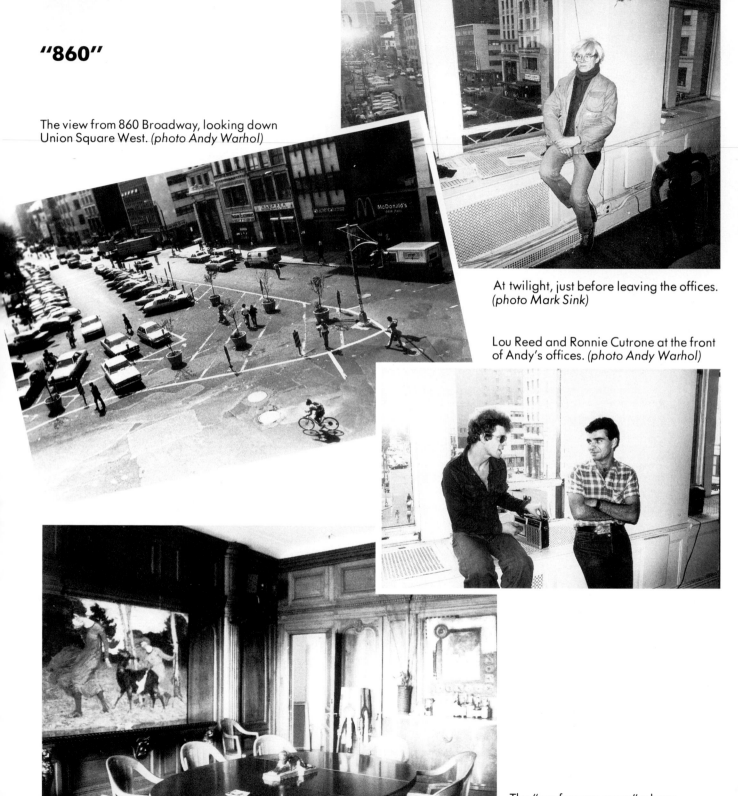

The view from 860 Broadway, looking down
Union Square West. (photo Andy Warhol)

At twilight, just before leaving the offices.
(photo Mark Sink)

Lou Reed and Ronnie Cutrone at the front
of Andy's offices. (photo Andy Warhol)

The "conference room" where
lunches were served to guests.
(photo Andy Warhol)

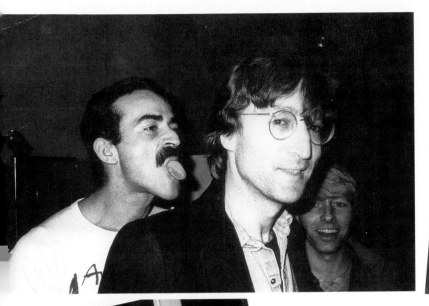

Victor Hugo, John Lennon, and Rupert Smith. *(photo Andy Warhol)*

Vincent Fremont. *(photo Andy Warhol)*

Henry Geldzahler posing
on top of the radiator grillwork.
(photo Andy Warhol)

Robyn Geddes and
Brigid Berlin.
(photo Andy Warhol)

Jade Jagger in
Andy's painting area
at the back of the loft.
(photo Andy Warhol)

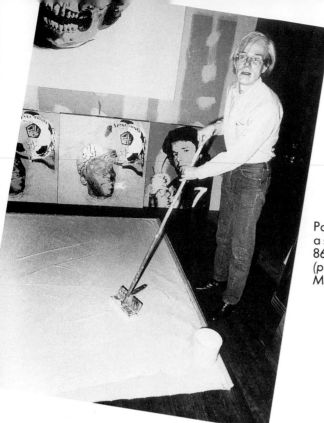

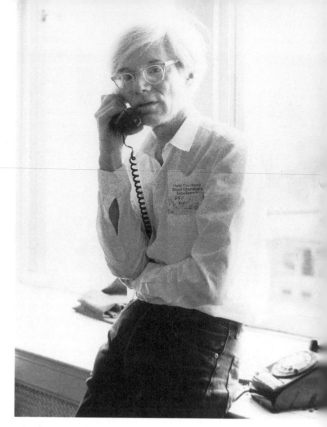

Painting with
a sponge mop at
860 Broadway.
(photo Christopher
Makos)

Andy never kept phone numbers organized.
He scribbled them on scraps of paper,
stuck them in his pockets, and used them
until he either memorized or lost them.
(photo Ralph Lewin copyright ©1989)

The sunny front of the third-floor offices at 860 Broadway. Andy did
most of his artwork in the back areas of the loft, but some art in transit
was usually stacked out front, by the doorway to the elevator and to
Interview magazine's area. (photo Mark Sink)

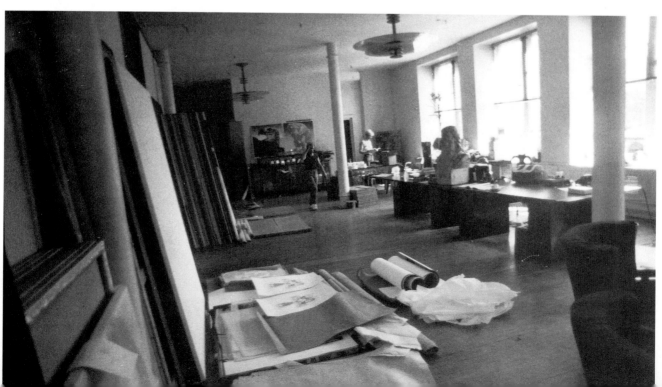

Thursday, October 2, 1980

Nelson Lyon came over with Michael O'Donoghue, the writer on *Saturday Night Live*, and he's a funny guy but he doesn't look Irish. He said that at a party I took a picture of him, but I must have been aiming at somebody behind him. He looks like he wants to be Buck Henry. I hadn't invited them for lunch and they saw all the leftover food from the big lunch Bob had just had, so I had to make some excuse, and Nelson's so paranoid, anyway.

Richard Weisman said he needed some girls for the "21" thing before the Ali fight so I invited Barbara Allen. And she wanted to bring John Samuels so I asked Richard and he said yes.

Worked till 7:30 on portraits with Rupert. I found out the fight didn't start till 11:00 so I wondered why we had to get to "21" at 7:30. I answered the phones. Then cabbed uptown ($5).

"21" was doing this special thing for its good customers, I guess, it was cocktails at 7:30 and dinner at 8:30. Then they gave us tickets to go over to Radio City Music Hall and see the fight and invited us back to "21" for a light supper afterwards. John McEnroe, Sr. was there with a friend from the Paul Weiss office who said he was our lawyer but I didn't know him. There were Ali posters and "I Am the Greatest" buttons. I was trying not to drink too much. They kicked us out when they said we were going to miss the fight. We went through the Warner's building and over to Radio City. The Spinks fight was on and then the Muhammad Ali fight came on and I couldn't watch it, I ate all my fingers on one side. The audience couldn't believe it when he lost. It was too unreal. And he had makeup on, he looked so handsome, it was like white makeup and his face wasn't shiny and Holmes's face was black and shiny. Then we went back to "21" and I introduced Barbara Allen to John Coleman. John Samuels fell in love with Walter Cronkite and was talking to him at the bar and I got John away because he was drunk.

Then Richard wanted to take us to a new singles-swingles restaurant and he invited three blonde girls along and Barbara didn't like that. She was talking about John Samuels, saying, "Oh look, he's just like Peter Beard—he walks like Peter, he talks like Peter, oh look, he runs like Peter, he eats like Peter!" I said, "What are you talking about?" Because, I mean, they're nothing alike.

And Barbara was saying she couldn't wait until Bianca came back and found her with John— "What do you think Bianca will think? What will she say? Well, maybe I'll let her have him when she gets back. What will she think, though?" And here John had just said to me, "I can't wait till Averil gets back—I'm going to meet her at the airport."

Bob had gotten Barbara a joint because she asked him and she was more thrilled with that than anything else. So we left and started to walk home, this is around 79th Street, and then we heard all these cop cars and we saw a crowd and John ran right up and into it and it was a dead person on the street. So we asked people and finally a doorman told us that three guys had just walked by and he thought they looked strange, and then they had picked on an undercover cop and tried to rob him and the cop had shot and killed one of them. And John just wanted to be in the thick of it, and Barbara was upset. And it was just awful, seeing the Ali fight, and that was violent, and then this, and so we got a cab and the driver seemed crazy to me. Barbara said he was Greek but I think he was Puerto Rican and saying crazy things because he thought it was a Puerto Rican that'd got shot. So I dropped Barbara off and watched her go into her building and

then just as we were driving past Lenox Hill Hospital the body was going in that we'd just seen lying on the street (cab $4)!

When I got home I didn't have Barbara's number to call her and tell her I got home safely, so I called Bob to get it, and he told me that Barbara had told him that everyone was after John Samuels—"especially Andy"—and I told him to call her up and tell her off—that if I'd wanted John Samuels I knew him before *she* did, and I'd only invited him to this thing because I thought it would make *her* happier. And that actually Richard had wanted *another* girl, not *her*. *So there!*

Sunday, October 5, 1980

Church. Diana Vreeland called and thanked me for buying ten copies of her book *Allure*. I walked the dog and thought I passed a lady flasher—she had on a raincoat and nothing else, you could just tell. She passed me and then came back down the block. She looked strange but maybe she'd just had a fight with somebody and left the house. If you read the *Post*, everybody starts to look strange.

Monday, October 6, 1980

Cornelia Guest came down. She was drinking and she's only fifteen but she's beautiful.

Vincent was putting together a one-hour show from six hours and it looks great, really professional. Don Munroe went off to a video conference in Nice. Worked till 5:30 (cab $7). Went home and glued myself and put on black tie. Went to C.Z. Guest's for drinks. A guy there told me, "We have someone in common." He said that his family owned all the brandy and sherry in Spain and that in the sixties Nico was the girl in all their advertisements in all the posters and subways and magazines, that she was famous all over Spain. He wanted to know where this beautiful girl was now and I said that it was a whole other person, that he'd never believe it, that she was fat and a heroin addict. He wanted to see her and I said that if she was still playing at the Squat Theater we could go see her.

C.Z. took the station wagon and drove us to the Met to the Cardin fashion show dinner. It was the longest fashion show in the world. I was so surprised, I think he's kept every dress he ever made, there were so many of them. I liked the show but the ladies were bored. I saw Bill Paley and Barbara Allen and Slim Keith. I wish I'd taken pictures, it was all the right people together.

I thought the diamonds in the eyes of São's foxes were real, but she said they weren't. She asked where she could get an inexpensive ruby bracelet and I told her I'd seen one for $42,000. She said it was for a man and I guessed Patrice Calmette, because that's who she's been seeing, she's broken up with Naguib, she said he made her too emotional.

Bob Denison was there with his new girlfriend China Machado, and I'm going to do a million *faux pas* with her because I just know I'll never recognize her. Catherine Oxenberg's mother, Princess Elisabeth of Yugoslavia, was there. She's beautiful, and I knew it was her from the moment

she opened her mouth, they talk just alike, the voice. She was wearing one of Carolina Herrera's dresses. And I talked to Paloma's mother, Françoise Gilot.

I talked orchids with C.Z. Her gardening column is syndicated in six newspapers now. I had a lot of fun. We were taking São home to the Carlyle, we were outside getting a cab when André Oliver insisted we take his limo. I saw Pierre Cardin at the end and told him his show was great—I did like it because he'd kept so many dresses, from 1950–1980.

Oh and the dinner was in the Temple of Dendur room and they gave everyone Temple of Dendur books and chocolate truffles and I squashed some truffles between the pages of a couple of the books and it looked like shit and São loved it. And a guy lost his book so I gave him mine and when he opens it it's going to look like shit. São had me autograph hers. We dropped São and then me and then Princess Polignac who does P.R. for Cardin, and then Bob. Home around 12:30.

Tuesday, October 7, 1980

Hermann-the-German said he's 90 percent sure he has the pope for me to do. And the other night at a party Mario D'Urso said, "I've been working on getting the pope for you." Everybody thinks I want to do the pope so badly. Well I do, but I'm not desperate.

I turned down doing the Ronald Reagan cover for *New York*. The papers have me down as a One-Night Republican.

Worked on backgrounds. Rupert was back from being out looking for Mickey Mouse pictures for the New Myths series for Ron Feldman—Mickey Mouse, Donald Duck, the Shadow. We'll have to do something different like throw diamond dust on them.

Glued myself together then picked up Carolina Herrera and we decided to walk to Halston's. She took her earrings off and gave them to me. We had drinks. Victor was in his samurai pants, really big. Then we got in two limos and went to the B. Altman dinner honoring American designers, it was a New York Public Library benefit. Mary Lasker was there, and Estée Lauder and Mary McFadden. I talked to "Suzy"—Aileen Mehle. She looked beautiful, she had her two tits pushed up so you could look down.

I was sitting with Halston. We decided I should only take pictures of the twenty waiters. Victor and I went to the bathroom and he took off his samurai pants and I wore them as a cape. We thought the bathroom was empty but as we were leaving everybody came out of the stalls. April Axton was there with Sam Wagstaff who looked older. I accused April of being Jewish and she said how could she be since I've seen her at my church, St. Vincent Ferrer. I brought up about how April once accused me of raping her dog in a bathroom. The dog had followed me in and then when I came out, he came out with me. She's awful but she *is* funny. I told her again that those photographs she gave Sam that I took of her in the sixties were now worth $1,000, I rubbed it in.

Then Carolina and I went to Carmen D'Alessio's dinner for her forty friends at Mr. Chow's. Lester Persky was giving millions of toasts, he was drunk. He toasted Henry Geldzahler who wasn't even there. Then he forced *me* to give a toast, so my toast was, "Free drinks from Lester for everybody."

Wednesday, October 8, 1980—
New York—Port Jervis, New York—New York

Picked Brigid up (cab $7). We were driving up to Charles Rydell's house in Port Jervis to interview him on his bit part in *Union City*. Then went to pick up Doc Cox on 72nd Street, he was late. Doc Cox was driving us up there in his Rolls. He told Brigid she couldn't smoke in the car, that it would ruin the smell of the good leather, and she started to go crazy—when she wanted to have a cigarette she had to lean her head out, so she was in a bad mood.

We got there and the Doc mixed martinis and Brigid had one, her first of the day. I took pictures. Brigid ran out to pick "fresh tom-ah-toes," but by the end of the day she was drunk and they were just tom-ay-toes. I went out and picked plums and we were eating them—even though they did have so much bug spray on them, they were so good. I had about ten. Then I picked cherry tomatoes and real tomatoes. Brigid was drinking martinis out in the tomato patch and she lost her martini glass in the patch.

Brigid and Charles kept talking about "lunch at Flo-Jean, lunch at Flo-Jean," and saying, "You've never seen anything like it in your life." And the more they kept saying that, the more you just wanted to hate it. But we got there and, well, you've never seen anything like it in your life. It's the sickest restaurant I think I've ever been to. A big rambling restaurant run by Flo and Jean and filled with baby dolls, a million of them. All colors. Because the place is very colorful. Napkins that're pink and green and yellow—just really a lot of color. Either Flo or Jean said her husband died in 1929. The food was the worst, but there was a lot of it. I gained four pounds and all I had was mashed potatoes and sweet relish. We had a lot of drinks there, Brigid went on with her martinis. Charles paid for the lunch but I bought souvenirs. Everybody had a good time. This restaurant had rooms and rooms that just went on and on, and they have weddings and parties there. It took up like a fourth of the Delaware River.

Brigid was drunk, she kissed all the waitresses. Then she began telling me food stories she'd never told before, like how she once went to the Oyster Bar in Grand Central Station and ordered a three-pound lobster and a nice waitress brought it to her but it didn't look like three pounds to Brigid. Brigid said, "I am a compulsive eater and I know my food and *this* is not a three-pound lobster." This lobster was costing like $39. The waitress said, "Oh, I'm sure it is." So Brigid said, "Then let's go weigh it, and if this lobster is three pounds I'll give you $10." So they went into the kitchen and put it on a scale and it weighed less than one pound! So the waitress was really embarrassed and said they wouldn't charge her.

Brigid was by now wacko, drunk, really drunk. I watched TV on Charles's Betamax. Charles has porno movies but they're all straight porno movies like the Debbie Dallas one. He only likes straight porno because he *(laughs)* only likes straight guys. So I watched those.

We'd finished lunch at 5:30 but Charles was taking us to dinner at 6:00.

Oh, and it turned out Brigid made out with the farmhand down the road once when she visited Charles. Charles said to her, "Did you fuck the farmboy down the road? He's been acting different with me ever since you were here." And she confessed that she had. It was one afternoon when she was alone and only 125 pounds. She decided she wanted some *crème fraîche* and that she'd go right to the cows. So she walked and walked and she came upon a farmhand. And now this farmhand acts funny with Charles because he thinks it was Charles's wife or girlfriend that he fucked.

And a hustler came by who only charges $30 because it's just a small town. It's really a gay Peyton Place.

Doc Cox drove us back and dropped us off.

Friday, October 10, 1980

Bob called and said that Jamie Kabler had cancelled going out to Brooklyn College that night to see Ron Reagan dance, so we didn't know how we were going to get there. But then Bob called back and said a limo would pick us up at 6:30. We sat through three ballets waiting for Ron. The creative crappy stuff. Then Ron did his things, he was okay. After telling Bob that he didn't do jazz he was doing a jazz number and he was good at that. He could actually be a good song-and-dance man, probably, like that blond guy who was popular during the war, you know, Van Johnson.

It was raining out. A girl from the Reagan committee came over to Bob and said she'd been calling him all day, that his interview with Patti Davis, the Reagan daughter, could happen tomorrow, so Bob was thrilled. Patti's the one who lived with the Eagles. Then she came over herself and she was tall and sort of pretty, I thought, but she was wearing funny clothes, a sweater and something. Vincent videotaped her. I said to her that when we did the actual interview, maybe she could wear some fancy clothes, and she said, "*These* are my fancy clothes." I said. "Well then maybe you could wear something with a good label in them." And she said, "No I'll probably come even more casual to be interviewed." So I gave up and said, "Oh forget it." So she looked sort of pretty to me, but then looking at her later on the video, how could these kids have missed their parents' good looks? I mean, Dad was so gorgeous.

Monday, October 13, 1980

I left the office and walked toward the big Columbus Day parade. Walked to 42nd and Sixth Avenue (cab $5.50).

The day was really depressing because I had to talk to the accountants about taxes all morning. I ate crackers and coffee.

Bob picked me up in a limo and we picked up São to go to the Jackie O. party for Diana Vreeland's book *Allure* at the International Center for Photography at 94th and Fifth. It was a small party, only seventy people were allowed. São said that a robbery was just foiled at the Carlyle. Three gunmen at 4 A.M. I scared her when I told her they were probably there because they knew *she* was. And I believe that.

Jackie O. arrived. I was afraid to take pictures so I gave one of the newspaper photographers my camera to take a picture with. Chris Hemphill who worked on the book was in heaven, he made it so that I had to sit next to him. He's just always rubbed me the wrong way. And on the jacket it said he was (*laughs*) "associated with Andy Warhol." His date was Deborah Turbeville. A trembling kid behind a stairway asked if he could take my picture. He said, "I'm an artist."

Jackie was there with the Morgan Library guy, Charles Ryskamp. She had Gloria Vanderbilt at

her table. And the de la Rentas. Oh I hate them. Françoise doesn't kiss me anymore. Good. They wanted to go home early.

Got home and the music in my house was blasting from top to toe—Aurora was entertaining a gentleman friend and I was so embarrassed that I'd come home before she expected. They were playing my new Bee Gees record.

Tuesday, October 14, 1980

It was a Paloma Picasso day. Went to breakfast at Tiffany's for her. The jewelry was pretty but I have the same stuff from the forties. It's copies of the forties. And Paloma did her little heart-shaped Elsa thing. It was expensive stuff—$27,000 for a bracelet.

After work I glued myself and went to Mr. Chow's for dinner for Paloma (cab $4). Saw Fran Lebowitz and told her she should go find a guy to have a hot love affair with because then if she ever has to write about one, she won't be blank-a-roo. Perry Ellis looked really sexy with long hair. Everybody was somebody. Thomas Ammann was in town from Argentina, he said it's so expensive there, he doesn't know how anyone lives. He had a limo and I got home at 1:00.

Wednesday, October 15, 1980

Paloma was on the *Today Show* and she shouldn't do it—talking about all the jewelry she has—she's going to get kidnapped.

Had a meeting with some South American lady to pick out her painting. She brought a couple of beautiful Venezuelan ladies with her. And the infamous Ronnie Levin came down. Somebody had warned me he was in town so it wasn't a shock. Nobody paid attention to him at the office and he walked around like he owned the place and then he left.

Thursday, October 16, 1980

Vincent was setting up to videotape the interview that John Richardson was going to do with Paloma. She came with her husband Raphael and the friend, Xavier. The Tiffany's guy arrived with the jewelry.

And David White came by with a letter from Rauschenberg—David works for him now—saying that the tables I have were done by him, because he did them when Jane Holzer was trying to go into the art furniture business in the late sixties or early seventies, and then the business fell through, and I got them. So it's great, that Rauschenberg wrote the letter saying they were by him because now maybe someday he'll sign them.

Then Juan Hamilton called and said that he and Georgia O'Keeffe were at the Mayfair and

they were coming down at 4:30, and I said to come right away because Paloma was there, so they did. Everyone was thrilled with everyone.

People thought Juan was going to marry Georgia, but he just got married to someone else and now his wife is expecting a baby. Georgia was wearing a black thing around her head. This time she seemed really old. You have to catch her every minute as if she'll sit in a chair that isn't there. But on the video Vincent made she looked young and alert. She does know everything that's going on, it's just that she moves older now.

Then they all left. Rupert came up and then I got some work done. Worked till 8:30 and Jay Shriver agreed to stay late, too. Then because they worked overtime I invited Rupert and Jay to 65 Irving and I had John Reinhold meet us there. Jay's from Milwaukee. He said his mother is all Czechoslovakian. Not from there, but a hundred percent.

Oh, and Mary Tyler Moore's son committed suicide and now *Ordinary People* is really going to do business and everybody's going to really hate her because they'll be thinking that that's really the way she is.

Tuesday, October 21, 1980

I ran into John Curry in the street but I didn't recognize him when he said hi to me—not till three blocks later. So I decided to call and get tickets to go see him in *Brigadoon*.

Oh, I ran into a boy whose job is to go shopping for John and Yoko, to buy them clothes and things. I asked him if they'd ever made him bring anything back and he said just once. I asked him if they ever *wore* any of the clothes they bought since they don't go out, and he said, "They're going to make a comeback. They've been wearing them to the studio." Oh, and the best thing he said was that when he started to work for them he had to sign a paper that said, "I will not write a book about John Lennon and/or Yoko Ono." Isn't that great? He said he loves his job. I should find somebody to help me shop—show me where all the good new things are.

Oh, and I had a fight with the real estate guy. The building I wanted so badly on 22nd Street that I told him to keep me informed on, he said went into contract on Friday. I was so mad. And then he told me that we had an appointment to look at the Con Ed building on 12th Street. And that's a great building but it's just too far downtown, I can't face it. It's $1.5 plus it'd be another million to fix up.

We missed the opening of *Brigadoon*. John Curry wasn't great, he was just adequate, but he's a good actor. I just loved the show. The guy in front of us was from George Lois with a good Irish name, maybe Callaghan, he's the one I worked with when I did that Braniff commercial with Sonny Liston. And he told me the best sick joke. What are Bing Crosby and John Wayne getting for Christmas? Steve McQueen.

Backstage I told John the show was so exciting and he said how I didn't recognize him on the street and I explained that it was the hairdo, that I recognized him three blocks later. I asked him to dinner but he said he was having dinner with friends.

Wednesday, October 22, 1980

Vincent was trying to get the Copleys down to the office because Bill Copley had suggested getting a portrait done of his new wife, Marjorie the madam. He suggested it. Bill's very happy, but she's gotten him to fire all the servants who were with him before she married him, and it's all too strange. I hope nothing happens to him.

The good-looking Glorious Food waiter who's getting his master's in psychiatry at Columbia had invited me to dinner. But then I got cold feet and told him I had to do an interview with Bob, which I didn't. He was going to show me around Columbia. But I just can't go out with people I don't know. But then, it's hard to take girls places because you have to pick them up. It's easier to go out with boys who'll pick *you* up. I'm getting like Mrs. Vreeland.

On channel 2 they had a hidden camera on some 1980 census workers drinking and taking cocaine on the job and then sitting down and making up names to fill out forms because they got $4 a name.

Saturday, October 25, 1980

It was gusting winds, stood on the corner for twenty-five minutes before I got a cab. Sean McKeon the Wilhelmina model called from Japan. It was Sunday there. Bob was working on the Ten Straight Men For São dinner that he'd promised her, still trying to find some straight guys. Every straight man cancelled. I guess they won't come out with us without Richard Weisman and the athletes. Dropped Rupert (cab $6.50).

Bob was ringing the doorbell, he had a limo with São. We went to Hélène Rochas and Kim D'Estainville's at the Olympic Tower for a drink. It was windy. São had just had her hair done and she said that she would never live there because when you walk in the door the draft is so strong that your hairstyle always goes. She said she knew a couple of women who've moved out because of that. So before she went in, we had to go in and have the guy close the inner door and that got rid of the wind and then she came in.

Then we went to dinner at 65 Irving. We picked up Franco Rossellini on the corner in our limo. We yelled, "Mary!" and he didn't hear us, and then, "Porno Queen!" and he still didn't hear us and he was wearing a cape and finally he saw us. He'd told Bob earlier in the day that he was retiring from the movie business because he'd made so much money on *Caligula*.

Sunday, October 26, 1980

Iran was supposed to be letting the hostages go. But then it seems like the Republicans are the ones that keep saying they're getting out, so that when they don't it'll look even worse for Carter. Like the *Post* has it front page and they're for Reagan. And on the news they're saying that Israel is giving parts to Iran for their military equipment. The cable TV guy in a small town said it was true but the government denies it.

I watched *Sabrina* on TV and William Holden and Audrey Hepburn looked so old. It seemed

so old-fashioned talking about Long Island and the North Shore. I walked the dogs. I watched *Hooper* and my God, it was great, just Burt Reynolds and his usual lines. He played a stunt man.

Monday, October 27, 1980

Bob and I were talking about how hard it was to find Ten Straight Men, and somebody said that that should be my next portfolio—ten men who've never had a homosexual experience.

I had to meet Marjorie Copley, who was having her picture taken for a portrait. Rupert was the makeup person. She's light, her hair was in pigtails and she took them out and it went down to her ass, she'd just washed it and it smelled good. We had lunch. She's going to school. She was a science major but she wasn't smart enough and now she wants to do social sciences and I told her oh no. Bill looks great. The only thing we're still worried about is that she did fire all the people who worked for him. She didn't seem pushy or tough like I expected, though. She just did whatever I asked her to. She was nice.

Jed bought the apartment right across the hall from Stuart Pivar's in the building on West 67th Street next to the Café des Artistes. He's going to use it as an office for his decorating business so his clients and all the workmen won't be tramping in and out of the house all day anymore, so that'll be a relief.

I called Jane Holzer. I said I'd pick her up for the Diane Von Furstenberg party for Diana Vreeland. Worked till 8:00, then cabbed ($5.50) to pick Jane up at the Volney on 74th and Madison where she's got the penthouse with Rusty now. Jane's apartment is small but nice. Rusty answered the door and he's put on weight because I guess he spent the summer with his father, Lenny, but he's so charming. It's like listening to Cary Grant. He says, "Love to you, Mommy." Jane's now in investing and real estate and movies.

So then cabbed to DVF's ($3). As soon as we got to the building Warren Beatty walked in behind us, but when he saw us he went outside again, he didn't want to go into the same elevator. I told Jane he'd come in and then gone out again and she said that if he'd seen *her* he wouldn't have done that. Right after we got upstairs Warren came in and he kissed Jane and I told him, "Oh Warren, you're so mean, you wouldn't ride up with us," and he said he was looking for someone he was supposed to meet downstairs. But he didn't come in with anyone, so . . . He looked sexy but a little older and a little puffier—his hair's that Hollywood way, you know, that looks like a hat? Richard Gere was there and I introduced him to Jane and he said, "Oh Baby Jane, you're a legend. I read about you in *Popism*." Apollonia was there and Iman and a beautiful young girl named Diane Lane—I don't know if she was with Lou Adler or not.

Thursday, October 30, 1980

At the office John Cale came over, he wanted me to do an album cover for him. He's looking good. He had a girl with him. I signed all his old record covers.

Lewis Allen came down with the dummy-makers who're making a robot of me for his play.

We had to sit around with them for an hour so the dummy-makers could study my face to see if I'd be a good dummy. And they were funny-looking, the people from Walt Disney or someplace like that. And if a dummy moves and it makes, say, three mouth movements and two eye movements, that takes 100 motors and every time you add another movement you have to add like 20 more motors inside the figure. We still haven't signed with Lewis Allen because we sent the contract up to Paul Weiss and they said it was a ridiculous piece of paper because it's so involved.

Friday, October 31, 1980

Halston had a bash in his showroom at the Olympic Tower for the birthday of Hiro. Then Victor said we should go downtown to the big new place called the Saint that's in the Old Fillmore East theater. The old Village Theater.

We went down and Victor got on his knees and begged for us to be let in. I found out that it's owned by our old friend Bruce Mailman who used to run the St. Mark's Baths and was always around with projects and things. He was probably at the Saint when we were, but I probably didn't recognize him. It's better than Studio 54. They have a room in the back and everybody looks alike—bluejeans and no shirts and mustaches, and no girls allowed, except they let Pat Cleveland in, and they let ten lesbians have memberships. There's a waiting list for two years and they said you can only get in if somebody drops out. The light show was great, like the Hayden Planetarium. Then Halston was leaving at 3:00 and I left, too.

Wednesday, November 5, 1980— Düsseldorf—Baden Baden—Stuttgart

I woke up at 3:00 in the morning and I heard the sad news of Carter losing so desperately to Reagan. It was the first time a president conceded so early. He had tears in his eyes.

I couldn't sleep and I took a Valium.

Thursday, November 6, 1980—Frankfurt—Düsseldorf

Met Dr. Siegfried Unseld, he's the publisher of Hermann Hesse and Goethe, really good-looking. I thought he was going to be easy to photograph because he was so good-looking, but he was really hard. His good looks didn't come through for the camera.

I'd brought Chris Makos on the trip to help me, but he wouldn't carry my bag or do anything—all he cared about was taking photographs for himself.

The next location was like an hour and a half away, in Darmstadt. Went to photograph a lady who's sort of a German Diane Von Furstenberg, she's a top clothes manufacturer—her company's called Tink or Fink. The house was beautiful. She was dressed really like a businesswoman, though,

in a velvet suit with hankies coming out of everywhere. She was really sweet and all the pictures came out well.

After a long drive to Düsseldorf, Chris and I had a fight because the walls at the Breitenbacher Hof Hotel are very thin and through the wall I could hear Christopher in his room making phone calls and I got nervous because I'm hearing him dial eighteen digits and I know he's calling long distance to Peter Wise in New York and it's expensive.

Friday, November 7, 1980—Düsseldorf

There was some crazy artist at the Rodney Ripps opening at Hans Mayer's gallery and I had to go into the bathroom with him, so I made Christopher go into the bathroom with me and the crazy artist made me sit in the shower with my hands on the floor and he Polaroided, and then he made me take off my shoes and Polaroided my feet and I looked like a dog on all fours and it was so stupid. They say he's the new Beuys and he's a bald-headed weirdo with plaid pants and very tall and he looked like he had a big dick. And I don't know, does that sound like he was a fairy? No, he was too serious to be a fairy.

Saturday, November 8, 1980—Düsseldorf—Paris

It took me till 11 A.M. to pack all the souvenir dishes into one suitcase and all the postcards and stuff. Had to get to the airport fast. Flew to Paris.

Cabbed to Fred's apartment ($30). Thomas Ammann arrived in town just for the day with a decathlon discus thrower. We went around to all the wonderful shops and there was so much Deco around you just couldn't believe it.

Later Jerry Hall called and said she wanted us to come to see her and Mick's new apartment on that island in the middle of the Seine. Mick was in the recording studio. She asked me to bring two bottles of champagne so I bought some ($200) and we went over there.

I talked to Thomas and I really made him tell what he knew about the Jed situation and he finally did. Thomas Ammann is the person who brought Alan Wanzenberg into the picture, Thomas knew him first.

Then Fred wanted to go dancing and I just wanted to go home so Thomas dropped me. And I came home and waited around for the phone to ring and it didn't and I was depressed and I put my earphones in with *La Bohème*.

Sunday, November 9, 1980—Paris

Thomas called from New York, he'd taken the Concorde early in the morning. The stuff he told me the night before had made me really upset. He said not to repeat anything because he doesn't like to get involved with talking about people's relationships. But he actually didn't tell me anything that I didn't already know, it was just that it was upsetting to hear it.

Monday, November 10, 1980—Paris

Philippe Morillon called and said he was bringing over some *Interview* material at 7:00.

Mick was coming over at 4:00 and I wanted to avoid him because, I don't know, what can you say to Mick Jagger? He wanted to be alone with Fred Hughes anyway—Fred's the one he talks to, I don't know what about.

Christopher and I walked to Cerutti's and *Bambi* was playing right next door and since it was a holiday the mothers were standing out there with their kids and it was the longest line of tiny little kids waiting to get into a movie. It seemed so sad that these little kids had to wait, they should've opened the doors and let them right in.

Went to the Café Flore looking for Shirley Goldfarb's ghost (cab $8). And Shirley's ghost was not around. We sat inside and didn't see anyone we knew.

Went to a bookshop and I finally came across the next idea I really want to work on—mothers with babies sucking on their tits. It's just so erotic, I think that it's a good subject. Actually Eunice Shriver gave me the idea, and the other night we saw a madonna in an apartment, a little baby on top of a sexy lady, a cherub sucking on a tit, and there's something about that that looks good. So Christopher's going to find me some mothers with babies just born.

Then Chris's hotel was right next to the Flore so he took me up to show me his room, which we're paying for and I thought it was such a dump, but he had gotten a TV and he was really thrilled.

In the *Herald Tribune* they describe the horrible death of Steve McQueen. They really went into detail.

Rocksavage invited us over to see his place. There was a big piano and I asked him to play and he just played the most beautiful music. I haven't heard good music played on the piano in so long. I didn't know—these different periods you go into, I never even get to a concert anymore.

Later Fred poured me a big glass of Mirabelle and I guess I told him I had personal problems and then we talked about art things to do. Fred thought we should do a series of Disney/Warhol, that we should do Snow White and a couple of the dwarfs, and Bambi and anything—Donald Duck. And so I was really thrilled after we decided to do that, and I hope Ron Feldman will think it's a good idea.

I was reading *Interview* and Bob really wants to drop Tinkerbelle but her interview with George Burns—who I think's had it—she somehow made very interesting. It's a good piece of writing and I think we should keep her. She gets Bob really upset, but she's one of our good writers.

Saturday, November 15, 1980—Cologne—Paris

We were going to a monastery and we had to be there at 12:00 because if we got there one minute after 12:00 we wouldn't be allowed in. Herman drove really fast in this pouring rain. After we got there we weren't allowed to say one word to each other. We went into the lunchroom and then the monk read something for twenty minutes while we ate our lunch—sour apple cider and lentil soup which tasted like canned to me but when I said so everyone just looked at me like I'm crazy, but—I think I know my soup.

There was one really good-looking priest and he was behind me. Then we left and went to Paris.

Sunday, November 16, 1980—Paris—New York

Got to New York and dropped Fred off (limo $80). I had an appointment to meet Bruno Bischofberger at the office at 11:00. He invited us to Julian Schnabel's loft on 20th Street. He's a friend of Ronnie's, an artist who's with Castelli now. We got to the place and there were three limos out front—Bruno sure knows how to spoil artists fast. Julian lives in the same building as Les Levine, and I was so jealous, Julian bought it so cheap four years ago. He's just married, he introduced me to a sort of beautiful wife. And does sort of bad paintings. He's very pushy. There's this whole group of kids doing this bad art, I think they're all influenced by Neil Jenney. Then Bruno comes along and says, "I'll buy everything," and these kids get used to big money, and I don't know what they'll do when it's all over—oh but by then it'll be something different, I guess.

I went to church, gave my thanks for the trip and getting back alive. Did phone calls, and somehow got mesmerized. I got so nervous thinking about all these new kids painting away and me just going to parties, I figured I'd better get cracking. Thomas Ammann called inviting me to dinner with Richard Gere, but I was too tired. I watched *Saturday Night Fever* on TV and it was great.

Tuesday, November 18, 1980

I was invited to lunch at the Met so I stayed uptown. All the people there were so classy and elegant and smart and when I tried to say little comments they wouldn't listen to me. They were rich and young and glamorous and English.

Had a martini with a little vodka. I needed it for courage because the people were so high-falutin'. Prince and Princess Michael of Kent arrived and they were really classy. She had on a little hat and a big dress, and she explained that she was pregnant—*she* was friendly to me. She showed me a picture of her eighteen-month-old baby. The prince had on a well-cut suit—the English know how to give you a new body with a suit, putting the stuff in all the right places. Left there and went down to work.

I'd asked John Reinhold to be my dinner date so he picked me up (cab $5). Downstairs at the Italian Pavilion. Joe MacDonald was trying to slip out because he said he had "a fuck date." We finished dinner at 12:00 (cab $4.50). After I got home John called and said his wife wasn't home, that this was the first time that'd ever happened. I didn't know what to say, I'd already taken a Valium and didn't know what to do.

Wednesday, November 19, 1980

Walked up Madison, decided to visit Jane Wyeth at Sotheby's. We have two big ads from Christie's and we're still trying to get Sotheby's. The auction business is so booming. I couldn't even carry all the catalogues I walked out with. These auction places are so fake, though. They just put things

out again if they don't sell them and then eventually a sucker who's born every minute comes along. I wish I'd thought of that line—"There's a sucker born every minute" (cabs downtown $3.50, $3).

Ran into Edmund Gaultney, his opening of my show was at night. It was a show of something you wouldn't think I'd do at a place you wouldn't think I'd be, but he didn't tell me the one great thing about it until after it was over—that it was only for *one day!* Isn't that great? But he didn't tell anybody.

I did an interview for Henry Post for a *New York* magazine article he's doing on elegance, things money can buy. I suppose he'll probably promote Jed's fancy decorating business in the article. They're friends. Fred and I had a business talk. Bob got some Washington ads because of the Reagan kids' interviews in the issues.

Went to the gallery, it's at 24 East 82nd, and it was really cute. Tom Cashin was there, he said he tried out for *Oklahoma!* and I told him he should try out for *Brigadoon*, he'd be better than John Curry. I was standing next to Paloma's husband, Mr. Picasso, but I just can't remember anybody's name, so I couldn't introduce him to anybody, and I think he was mad. Chris Makos was there with Peter Wise and a gay vice-president of Paramount, Jon Gould.

We went to the Gibbon for dinner. It's half French food and half Japanese. I like the Japanese half better. The headwaiter finally showed his true colors and was a big fairy. Dinner must have cost Edmund a fortune. Home at 12:00.

Thursday, November 20, 1980

Called the office ($.25 because I didn't have a dime). Walked down Madison. Somebody stopped me with really bad breath. I've been trying to clean Archie's teeth but it's not working. I love the natural toothpaste I get at Brownies—cinnamon and spearmint—but what I really love is Close-up and Ultra-Brite. Close-up is so good, really poisonous-looking. And when Brigid and I go to May's, you see people opening the toothpaste tubes and taking a taste. Brigid does that.

Worked till 7:30. Dropped Rupert off. Barbara Allen called and was upset with what Scavullo said in the newspaper—that he doesn't know how some people get into high society because they don't know anything, like Barbara Allen. And she had on her high-class voice (cab $6).

Then I went to Lee Thaw's party at 72nd and Park for the Maharaja of Baroda because he'd just done a book called *Palaces of Jaipur* published by Alex Gregory who publishes all the big bombs. And the maharaja said he was going to be on *To Tell the Truth* next week, which was so funny because I mean you hear people at these parties saying they're going to be on the *Today Show* and *Meet the Press* and things, and then *he* says, "I'm going to be on *To Tell the Truth.*" So they'll be guessing who he is.

I met Shirley Lord, who's English, from *Vogue*. A beauty editor. She was fun. She has big tits. And next to her was Daniel Ludwig, the richest man in the world, and he wasn't talking and she wanted to get him to, and she knew the odd kinds of information, like how scientists can now look with microscopes at babies and predict where their future wrinkles will be. And then I talked to Mary McFadden and she was such a camp. She said, "People put down your portraits, and I defend you. I tell them, 'At least they have good color!'" Home at 12:00.

Saturday, November 22, 1980

Got up early. Cabbed ($4) to the office to meet Diana Vreeland and Prince and Princess Michael of Kent.

I'd painted a background and thought it would dry before anyone got there and that I could roll it up. So I had it spread out on the floor and then suddenly they arrived and Prince Michael walked right on it, he thought it was a floor covering. So Fred asked him to autograph it. And he just signed it "Michael," he doesn't use "Prince."

Monday, November 24, 1980

Bob said that Cal—the friend of Ron Reagan called "Chocolate Boy"—called and said that Ron had just gotten married, so Bob set up a dinner the next night, Tuesday. Then Bob was being interviewed by some newspaper and he told the girl we were having dinner with them at Le Cirque and I got mad and told Bob he shouldn't have, so then he changed it to La Grenouille because otherwise they would have sent a photographer to Le Cirque. The story about the marriage made the papers by 5:30.

Fred intercepted a call for me from "Chuck Roast" because he thought it was a crazy kid, but it was actually the Japanese kid who came to interview me once who asked me to give him a name.

And downstairs the building directory was smashed right beside my name. It gave me an eerie feeling.

Tuesday, November 25, 1980

Mike the super came up and said that there wouldn't be heat over the holiday weekend. That was a big disappointment because that's when I was planning to get all my work done, that's why I was staying in town.

The Reagan kid cancelled dinner like I told Bob he would. Then it was in the papers that the Reagans were honeymooning with the Warhol crowd at Le Cirque.

Thursday, November 27, 1980

Got up and watched the Thanksgiving Day parade on TV. Happened to see Berkeley, John Reinhold's little daughter—Superman's float came up and practically touched them on the twentieth floor.

Chris Makos called, he was up in Massachusetts seeing Jon Gould of Paramount Pictures.

Worked at the office alone. Curley called and invited me to Thanksgiving dinner, he was cooking it at his parents' apartment on Park Avenue. I said that I'd come up after dinner. Then Catherine called. I asked her if she wanted to come over and make it look a little like last year. She'd just

gotten in from London and had had turkey dinner on the plane, and said she was the only one on Laker. I guess no one travels on Thanksgiving. Cabbed to Curley's with Catherine ($3).

Tuesday, December 2, 1980

Richard Weisman called and invited me to the party for the famous Hollywood photographer George Hurrell at Doubles. Got there and Douglas Fairbanks, Jr. was coming out, and I asked him why he was leaving and he said because he'd stood in front of his photograph and had his picture taken by the press so then it was time to leave.

The big stars there were Lillian Gish, Maureen Stapleton, Tammy Grimes. I met Mr. Hurrell and he's really strong and straight and Paul Morrissey had said that he was about to pop off any minute, but there he was and he knew all about me and he raved and he was sweet and I asked him if I could take a picture and he said sure.

Maureen O'Sullivan was next to me and she was saying, "Oh, I've just been throwing out so many Hurrells and Clarence Bulls, we've been moving." I asked her what it was like to get so close to Johnny Weissmuller's body and she said it was okay but that she only was interested in intellectuals, my dear. I said, "So is Mia really going to marry Woody Allen?" And she said that she really didn't know, and then I told her that I was only kidding, that I didn't care. And I met Teresa Wright and she looked good.

Diana Vreeland called and said how much she loved her cover story in *Interview*. The cover makes her look about twenty, and she said, "The only problem is I'm beginning to think I look like that woman on the cover."

Thursday, December 4, 1980

We're taking the Reagan kids to dinner on Saturday, just Bob and me, because his wife Doria wants to work for *Interview*—they're going on the road for four months and she wants to do a column for us from the road. Jerry Zipkin said that they liked Chinese or Japanese food, that that was more their style.

Friday, December 5, 1980

Catherine said she was going to France for a week because her Nazi step-grandfather just died, Sir Oswald Mosley, and her family was getting together there so she thought it would be a good thing to do for the book on the Mitfords that she's helping her father with.

And did I say that when Florinda Bolkan came down to have her picture taken, she wouldn't do a thing until Marina Cicogna said it was okay—she wouldn't even put her head down. And Marina is just like a truck driver, she pushes everybody around, and if that's what love is, I guess that's what love is.

Saturday, December 6, 1980

I called Bob to see if our dinner with Ron and Doria Reagan was on and he said it was. Rupert was there waiting at the office when I got there, and Jay came in. And then Joe Dallesandro called from California, somewhere around Sacramento, I think. He was calling for money of course, he said he was in a truck with his mother, they live in a truck or a trailer, I don't know. I told him he should go to Los Angeles and be discovered. It's so absolutely boring—he never calls and says do you want to do something together, it's just always for money.

Worked all afternoon. Decided to go Christmas shopping. Rupert took some *Interviews* and we went down to the Village. People seemed out shopping early. I think this is going to be the most gigantic Christmas for sales, I really do. Country-wide.

Ron and Doria were already at Nippon when we got there. The owner took us to one of the private rooms. Ron was in his alligator T-shirt to show off his muscles. The Secret Service jammed the place. The owner kept bringing in toys for us—he gave the Reagans this new kind of bottle-opener gun that opens up and you really could kill somebody with it. Bob asked if we could go to the inauguration in January and they said we'd be getting invitations. They said they were going to Bermuda soon, and Bob said he was seeing Lily Auchincloss so he'd ask if it was okay for them to stay at her house there. Doria's really sweet and charming. Bob was so happy. We left them with the Secret Service and got home—walked—about 12:30 or 1:00 (dinner $200). And life gets more exciting every day, but then I had to go home to my horrible home life where the situation with Jed is getting worse every day.

Monday, December 8, 1980

Walked to Halston's. All his girls were there wearing all his clothes. There were three limos out front and we went to the Met Museum, to Diana Vreeland's opening-night Costume Institute dinner. It was the 650 people you know best. Someone who came in said John Lennon was shot and no one could believe it, so someone called the *Daily News* and they said it was true. It was scary, it was all anyone could talk about. He was shot outside his house.

When I got home I turned on the TV and they said he was murdered by somebody he gave an autograph to earlier in the evening.

Tuesday, December 9, 1980

The news was the same news that had been on all night, pictures of John and old film clips. Had to take Archie and Amos down to the office to be looked at by the Lewis Allen dummy people (cab $5). When I got there Howdy Doody was waiting for me. I'm doing his portrait, he's one of the Big Myths.

After I photographed Howdy, I got into the barber's chair that the dummy people brought. They did the back of my head, they put a wig hat on me. There were two photographers and Ronnie was taking 3-D pictures. They put gook on and covered my ears and eyes. They said,

"Pinch me if you want to get out of it." It was making me sick, and I had a cold, and I had phlegm that I couldn't cough up, it was awful. They finally took the mold off but then they dropped it. They were saying, "We can save it, we can save it." But then they said they might have to do another one and *I* said, "No you're not." They stuck my hands in some more gook and that got some air bubbles so they lost a couple of fingers on that try. Then they did my teeth. And while this was going on, Ron Reagan arrived, he'd just had lunch with his father at the Waldorf. I was so out of it I couldn't really talk. Bob had given Doria the day off—she's working for him now —but she didn't go to the Waldorf lunch because Nancy still couldn't get over the idea that her son had married without her consent.

And Bob was feeling his oats because the collector's issue of the *Daily News* that had "John Lennon Shot" headlines is the one that had the big story on him in it—"The Man Behind Andy Warhol." It was a long article, but it was boring.

I watched the John Lennon news and it's so scary. I mean, the other day, the kid named Michael who's been writing me letters for five years just walked in—somebody buzzed him in—and he walked over and handed me another letter and left. Where does he live? In institutions?

Wednesday, December 10, 1980

The papers still have the Lennon news. The one who killed him was a frustrated artist. They brought up the Dali poster he had on his wall. They always interview the janitors and the old schoolteachers and things. The kid said the devil made him do it. And John was so rich, they say he left a $235 million estate.

And the "vigil" is still going on at the Dakota. It looked so strange, I don't know what those people think they're doing.

Sunday, December 14, 1980

I was in a cab with a black driver during the minutes that were supposed to be silence to remember John and pray for his soul. He had a black station on and they had a ten-minute silence and the disc jockey said, "We're up there with you, John," and the driver laughed and said, "Not me, baby, I'm stayin' right down here." So he turned to another station and *that* station was *(laughs)* talking about the silence.

Catherine was thrilled because Tom Sullivan is back in town and he's telling her he loves her, but he's full of baloney and she should be careful. She was leaving her key in the mailbox for him.

Bob said that at the Ann Getty dinner we went to last night he heard Diana Vreeland tell off "Suzy" for saying in the newspaper that the lights in her Met show were too low. Diana said, "Now listen, Aileen, just in case you didn't realize it, the Metropolitan Museum is not a department store. Nothing there's for sale, so we really don't have to light it up like Bloomingdale's." And "Suzy" was mad but she couldn't think of a comeback.

Monday, December 15, 1980

I asked autograph seekers outside the Regency who they were waiting for and they said James Cagney was staying there and that he was really hard to get.

A lady from 67th Street rang the bell and said we were flooding her house and I looked in the back and there was a lot of water, but I didn't know what to do until Jed came home. It was a water pipe broken, shooting upwards.

Tuesday, December 16, 1980

Truman was reading at Lincoln Center and Brigid decided she wasn't going to go because she felt too fat, but she made me promise to swear that she was there if he asked. Jane Holzer was sending the limo to pick me up. It was the Mitzi Newhouse Theater, we had fourth-row center, next to Halston and Martha Graham. Lester was there, and Suzie Frankfurt, and Rex Reed. It wasn't completely sold-out, but it was pretty filled. Truman was cute, he explained each thing first, he got up on his toes and snapped his fingers and it was like disco and that was the best part. He read and acted the parts out. He read the maid story, and he read "A Christmas Memory" and a couple of other ones. Then afterward everybody was telling him how wonderful he was, because it was all friends. Rex told him the reading "touched my soul." Truman was shaking. The first thing he asked me was where's Brigid and I swore she was there, and he said, "Well, then *where* is she?" and I said she had to go home, but I think he knew.

Wednesday, December 17, 1980

I was upset because two paintings cracked, I guess because of the cold. Then a limo arrived and I had to leave with Robert Hayes to go to the Mayfair to meet this German guy from Düsseldorf who wanted to meet me. We only had drinks with him, champagne. I was being funny, I told him I wanted to work on a line of "invisible clothes." And as I was leaving he said [imitates], "Just send me da particulars, I vant to vork vid you on dis line." He wasn't kidding.

Thursday, December 18, 1980

Got an urgent call from the office saying that there was a rock star down at 860 waiting to have his picture taken by me. I called Fred to find out what it was about but he didn't remember. I said I'd be right down, and it took twenty-five minutes (cab $5.50). He turned out to be Ric Ocasek from the Cars. They're from Boston, and he has an earring and capped teeth and he's not really good-looking because he has dyed-black hair, but he's sweet and as charming as David Bowie. Lunch was actually for Diane Lane who Ara Gallant was bringing down. She's fifteen and so beautiful.

Then Bob was busy on the phone, and we had to meet Doria and Ron and their friend Cal at

the movie *Flash Gordon* on 53rd Street. They were in the next-to-the-last row with the Secret Service behind them. The movie wasn't really good but it was fun to watch. Then after the movie they went in their car and didn't offer to take us so we got a cab up to the Gibbon restaurant to meet them. Those kids aren't going to have any friends, because it's just too scary being with them, with all these big guys guarding them, you think you're going to get bumped off. And the Secret Service rented a room from a lady in their building—her living room—and they sit in there and watch with the door open all the time. The Secret Service guys I guess don't like Japanese food because they just had coffee.

Cal said our invitations for the inauguration had been sent out already and Bob asked Ron and Doria if we were invited to the right parties and they said they thought so. They said they weren't going to go in a limousine, they were going to try to rent an army truck. Bob said how it was easier to just go along in the limousine.

Bob told his Liz Taylor stories, but then he started talking about the basement of Studio 54, and I don't know what he was thinking of. Doria is going to interview Adam Luders from the New York City Ballet for us.

Friday, December 19, 1980

C.Z. Guest called and I really have to make up my mind if I'm going out there on Christmas Eve. And Cornelia was at the office all dolled up, getting her picture taken. She wants to be a model.

John and Kimiko Powers came by with a present.

Saturday, December 20, 1980

Vincent was having a party so cabbed there ($5). It turned out to be a really great party. I was taking pictures of this handsome kid I thought was a model and then I was embarrassed because it turned out to be John-John Kennedy. Fred brought him and Mary Richardson. And Chris Makos was there taking party pictures. And Debbie Harry gave me a present, and she said to open it up and I said no, that I'd wait till I got home, and I'm glad that I did, because I just don't know what it is. It's this black thing. I wonder if it's a cock ring, because it's rubber with a stick on it, but it has this one piece that doesn't make sense.

Monique's getting ready to push her book, and she wants the cover of *Interview*, which actually might be fun.

Sunday, December 21, 1980

Jed's decided to move out and I don't want to talk about it. The apartment he bought on West 67th Street to work in, now he's decided he'll live in it, too.

Went to church. Worked in the freezing cold at the office and I'm not going to send in the rent.

Monday, December 22, 1980

A terrible day, no Christmas spirit at all, and it even got worse as the day wore on. I screamed at everybody, and I made them feel bad, it was like that all day. I couldn't shake it, even at night. Curley started crying and I told him he had to stop it or I was on the verge of cracking up.

I was supposed to go out to lunch with de Antonio but I didn't want to. I just ordered in and De and I ate in the conference room and the place was freezing and Mike the super, the only one who knows how to get a little heat out of the boiler, was out. I was in a terrible state, I felt a cold coming on, and I just can't work in the cold.

Hans Mayer came by to pick up some paintings and we had them bubble-wrapped. I gave Hans a painting and I gave De a painting, trying to get into the Christmas spirit, but I couldn't. I paid some bills.

I thought C.Z. Guest's Christmas Eve dinner would maybe be just the thing to get me finally in the mood, so Bob and I decided we would go out there and take Jerry Zipkin and Liz Smith and Iris Love, so that's settled. I'll take *Popisms* to give as presents.

Curley called and invited me to dinner and then Whitney Tower called and said Mick and Jerry would like to see me, and I asked if I could bring Curley and they said yes. I stayed by the electric heater all afternoon, but if I moved an inch away it was freezing.

I sent roses to Jon Gould—I want him to get Paramount to advertise in *Interview*.

Curley picked me up in a limo at 9:00, then we picked up Whitney. Jerry has a new apartment at 135 Central Park West and she just got a farm in Texas with her money and she wants a tractor. She gave me a present, just what I've always wanted—*a complete set* of china from the Concorde! And I was so surprised, I was so thrilled, I don't know how she knew I liked it. But it's so funny to get something you really really want. And Mick was so friendly for the first time, talking and talking, and it was like we were best friends, telling me all about leaving for Paris on the twenty-seventh for the Herzog movie, *Fitzcarraldo*. And telling me all about it and being really nice.

Meanwhile Curley was getting really drunk and I knew I had to get him out of there soon when he started calling Mick "Michael" and taking pictures. Curley still believes my father died in the Pittsburgh coal mines and because his mother's family, the Mellons, own Pittsburgh, he feels guilty, so that's funny. So I got Curley out of there and I thought I could sober him up a little if I took him to the Brasserie. He's drinking so much these days, and it's still fun, but if he keeps it up, it's like it's going to turn. At the Brasserie I ordered just everything ($50). Then Curley started crying and I said he had to stop so then he was good and started laughing and staggering again. He dropped me, and it was still only 1:30 and still freezing.

Tuesday, December 23, 1980

I've been having the most un-Christmas spirit of my life. Woke up with my little cold. The office called and said there was no heat down there, so I was thinking about that, and then it started to snow and the flakes were so big and beautiful but before I could get to the window with my camera it had stopped.

The office was having the Christmas party, they said they were waiting for me, they said they had turkey and ham and booze. I wanted to Christmas shop but then I decided it might be too hard later to get a cab, so I got one right then (cab $7). John-John Kennedy was at the office, and Cornelia Guest, and John Samuels, and Jimmy Burden—all these kids that I knew when they were babies, it was so strange. And Jackie O. didn't invite me to her Christmas party this year. I gave out some *Popisms*. Ronnie gave me one of his artworks, it was really great—a spear.

The article in *The New York Times* about Françoise de la Renta was just so disgusting, as if she and Oscar have this great life, when it's all just him and the friend and her suffering through it. And John Richardson was disinvited by them to Santo Domingo because he gave a quote, which wasn't even really bad. And Bob told me that it turns out Françoise wasn't born in Paris, she was born in Mozambique or someplace like that, and she's just—trash.

Wednesday, December 24, 1980

Cabbed up to Jerry and Mick's apartment for Christmas lunch. Jerry's pregnant sister Cyndy just married Robin Lehman, and so everybody was happy. Jerry's mother was there. Jerry had an apron on that when you unzippered it a big cock came out, so I was taking funny pictures of that, her cooking a turkey with a cock in her hand.

Earl McGrath was there, and Ahmet Ertegun stopped by for a second. The food was ready at 5:00 but it was supposed to have been ready at 2:00. Everything was great, though, it was the best turkey and everything was fresh, the peas and everything, so I porked it up.

The limo came at 6:30 to take us out to the Guests'. We picked up Barbara Allen who was wearing a green taffeta YSL and then we went to the "hem of Harlem"—that's what Jerry Zipkin calls his neighborhood—and picked up Jerry and he had Nelson Seabra with him. It was a sit-down dinner and the turkey was terrible. It was like canned stuff, and the cranberry sauce was canned and there were eighteen different desserts but none of them were good. I was next to "Suzy" and Bob was next to Liz Smith and Iris Love, and Iris had a kilt on and let me feel if she was wearing underpants. Cornelia looked beautiful.

Then I had to get back to Halston's in town and it had suddenly dropped from forty degrees to minus fifteen. Halston gave me a green beaded dress to hang in my closet. It's like a $5,000 dress. It's his art. But it's not really my favorite green although it's a nice green. I would rather have had a red one.

I felt another cold coming on and I wanted to go home to bed, but since the house was empty I didn't. I gave Halston a chocolate box of art candy that I made, not too great, and a Diamond painting, and I gave Victor a Shoe one. I got home about 1:30 and opened my packages. John Reinhold gave me a little TV set, a 2″ × 2″ Sony Trinitron.

Thursday, December 25, 1980

It was the coldest day ever. And I'd been afraid to go to sleep because I was alone in the house. I'd like to get Nena and Aurora's brother Agosto to be a bodyguard, although he's like only two feet high, but he's just out of the Marine Corps and it's "Yes, sir!" and "No, sir!" and he's great. I was on my way to work but since there was no heat, I decided I just couldn't.

Picked up John Reinhold and we went to Sharon Hammond's for Christmas dinner (cab $5). But there wasn't anybody good there.

Sharon took me in the other room and showed me a picture of her English lord pissing, and his cock is like a horse's. She doesn't know if she should marry him, but I told her she should, with a cock like that. He didn't give her the pillows she wanted for Christmas, he just gave her a TV for the bathroom. And no jewelry. He'd given her jewelry for her birthday and five minutes later she lost it in a cab so I guess he decided not to give her any more.

Friday, December 26, 1980

The day after Christmas and I was doing Christmas cards for next year for John Loring at Tiffany's. Since he took ads in *Interview*, I have to do it, and it's a really good idea—diamonds with real diamond dust on it, a set of nine. Each card has part of the diamond and when you put the nine together it makes one diamond. It's artistic, so if they don't like it ... What I always remember when I think of Tiffany's is how in the fifties I left my drawings there once and somebody stole them.

I called Marina Schiano to say Merry Christmas. She's going to Naples to see her mother in the hospital. She gave me her sympathies about Jed moving out. And she brought up how he's out in Colorado skiing with Alan Wanzenberg.

Wednesday, December 31, 1980

Still no heat at the office so it was hard to do things. Brigid called the landlord a bastard on the phone, he's in Florida.

Wilson Kidde called and said he'd made it with a girl.

I was busy till about 8:00, then we left. Dropped Rupert. Went home, glued, then went over to Halston's. Victor was helping his friend Benjamin Liu get dressed in drag. When he's in drag he calls himself Ming Vauze. Then we went to the Olympic Tower for Halston's New Year's Eve party. The people there said that Steve Rubell had just called and said he'd be out of jail in two weeks.

Halston was still in the same kind of down mood, so he had mostly the girls and boys who work for him. He told me he dressed all the girls in tulle to make the place seem like it was full. From the window we could see the ball in Times Square coming down, and we could see the fireworks in the park. Marisol was there looking glum. Everybody was somebody you knew so you had to kiss them all.

Saturday, January 3, 1981

Worked all afternoon. Went to Chris Makos's birthday party. Peter Wise had decided to give him a hotel room for a present, he got him one at that hotel on Central Park South that nobody seems to go to anymore, the St. Moritz, and so we all went there (cab $3). And Peter was sweet, he'd brought all Chris's toiletries and Chris loved it, he was thrilled. Jon Gould the vice-president from Paramount arrived with an airline steward. I think the roses that I keep sending him at work are embarrassing him, so I'd better stop. He tries to play it macho.

Then we went over to John Reinhold's apartment to see how the decorating job by Michael Graves is coming, and it's taken like nine months for one room—they keep making the window either one inch too small or too big so it keeps having to be redone.

Sunday, January 11, 1981

Called Vincent and woke him up. He said a lot of my paintings at the office cracked from the cold.

I watched *Giant* on TV from 1:00 to 5:30. It's so long. I even went to church in between and when I came back it was still on. James Dean's acting when he gets old is the worst thing. But they did a good thing—when he's drunk and talking into the microphone it's like a rock star, he's right on top of the microphone and it's just noises coming out and so it's abstract.

I had some wine and a couple of aspirin to try to get rid of the pain in my back. I'm also trying to take two aspirin a day so I don't become senile because I just read that it stops the hardening of the arteries. But I don't know, my mother took millions of aspirin and it didn't do any good.

Bob said the inauguration is on Saturday. I didn't realize it was so soon. Bob doesn't care about discoing now, he's just so happy with all his Republicans—with Doria and Jerry Zipkin calling him.

Monday, January 12, 1981

The sun was shining so I decided to work up front at Ronnie's desk. I had to do some Joseph Beuyses. But Ronnie was careless, he'd left some paint in the middle of the floor and I kicked it and it went all over my boot and pants and it took the whole afternoon to clean up—that was the first time that'd happened. And then the rock star from the Cars, Ric Ocasek, wanted to bring his band by to see his portrait, so he did.

Tuesday, January 13, 1981

I looked for ideas on the New Myths series. Also looked for Mother Goose pictures. But I think the best thing we decided to do is have people come and dress up in the costumes and we'll take the pictures ourselves, because that way there's no copyright to worry about.

Wednesday, January 14, 1981

I had Brigid write a thank-you note to Gloria Swanson telling her how much I loved her book and saying that thanks to her I'm trying to get off candy. The purpose of the new thing of writing notes is to get notes back—the Joan Crawford thing. Oh, and Steve Aronson did one of his good, long interviews with Gloria Swanson in *Interview*, and she called the office for his number and invited him over for tea with no sugar.

And I was looking at Bob's interview with the Borchgrave guy and Bob does do good political interviews, he knows his facts.

Tuesday, January 20, 1981—Washington, D.C.

The driver picked us up at Ina Ginsburg's at 10:00, his name was Carter and he got us as close to the Capitol as he could and then we had to walk a couple of blocks and there were big crowds of people everywhere, lots of kids, lots of troops, marines, police. And finally we got through all the checkpoints and found our seats in section E and I was complaining about how far back they were, but then we saw this black Marine march up to two white marines and salute them and they said *(laughs)*—well, we thought they'd say something like, "The heads of state will be arriving soon and security is tightly under control," but they said, "Robert Goulet and Glen Campbell are sitting in row sixty-four." And then the three of them went marching off to look for more stars. We had binoculars. I focused on Rosalyn, she looked so sad.

Senator Pell gave Ina a seat on the president's platform for the swearing-in.

During the swearing-in a Marine stopped in front of each row and said in a low voice, "The hostages have just left Tehran, in case you haven't heard." And there were helicopters everywhere just patrolling the sky. And they had bulletproof glass all around the podium.

Afterwards in the Capitol building by a staircase that said "Senators Only," we ran into Doria and Ron, so we had all these big hellos. And then they got whisked away and we went down another hall and suddenly there was a voice saying, "Andy! Andy!" and it was Happy Rockefeller and she said, "Andy, why don't you ever come and see those paintings you did of me?" She was in a mink coat. The place was practically empty by then and she had a Marine with a walkie-talkie next to her. We were actually the only people in the whole building without our own marines.

Listening to the inaugural address you get fired up and I felt like being a Republican. But then when it was over and you looked around at the faces on all the Republicans, I was glad I'm a Democrat—there really is a difference.

Friday, January 23, 1981—New York

I glued, had to meet Jill Fuller at Le Cirque for dinner. Le Cirque is the new Republican restaurant, I guess, since I saw Sirio down at the inauguration. My pictures came back, by the way, and at least I got a few good ones of the Reagan kids. I brought Curley's cute cousin David Laughlin for

Jill because I told her that every time we had a date I'd bring her another boy that I thought she might like, one young and rich and beautiful.

Sharon Hammond was there and she was with a guy who lives in the Dakota and he has a bulldog and the bulldog was having puppies and he picked her up and was rushing her to the vet and one puppy dropped out right on the spot where John Lennon had fallen shot and that puppy died.

Wednesday, February 4, 1981

I was sitting around the office with Victor and all of a sudden somebody said, "Look who's here!" It was Steve Rubell and Ian Schrager. They said they were in the neighborhood. Victor gave them the biggest hug and said that Halston was planning a dinner party for them on Saturday. They said it had to start at 6:00 because they had to be back at the halfway house by 11:00. Steve looked really tan. I don't know how he got that tan. He was wearing a lot of clothes to hide that he'd put on weight with the prison food. Ian looked really good.

Friday, February 6, 1981

Vincent and I had to go up to meet with the Home Box Office people. This came about because a girl who knew Louis Waldon, our star of *Lonesome Cowboys*, works there and she told Vincent that they were interested in doing something with our cable TV show. Well, we walked in and they started putting me down, it was just like the old days. They started saying things like, "You're too far out." And they said, "Middle America doesn't know who you are." I was just going to get up and walk out but then I thought, well, you never know who you'll meet again, and Vincent was getting mad, too, but he was holding it in, too. Finally we got up and left. They just wanted me there so that they could insult me. We went back to the office.

Saturday, February 7, 1981

Bob MacBride called and said that John O'Shea had put Truman in a hospital in Miami and did we know anybody down there to check him out of there. John O'Shea was Truman's roommate before Bob MacBride.

Tuesday, February 10, 1981

Got up at 9:00 and they keep predicting a big rainstorm but nothing happened. I stayed uptown because there was a lunch at Le Cirque that Bob was giving—actually it was a free one, from Sirio—and Averil and her husband-to-be, the doctor, Tim Haydock, were going to be there.

They're about to go on a pre-honeymoon to Thailand and Averil wanted to meet Mercedes Kellogg and her husband Fran because he's friends with the queen of Thailand.

Because it was a free lunch I forgot to give the headwaiter a tip. I always forget you still have to when it's free (coats $2). The Kelloggs had just found out this morning that he wouldn't be getting the Chief of Protocol appointment that he really wanted. Mrs. Annenberg got it. I think Mercedes is the reason they didn't get it, because she's Iranian.

Thursday, February 12, 1981

Fred was on his way to Europe but then his mother called and said that his father had just died so he went to Texas instead.

I invited Jon Gould to the Rangers' hockey game but he said I should have called earlier.

Friday, February 13, 1981

Chris Makos said to come to his place at 7:00 to talk about projects and look at photos. He was having Jon Gould over there.

I worked until 8:00 with Rupert. He dropped me off at Chris's. We talked about different projects and then went to have dinner at the Coach House restaurant. One of the waiters, it turns out, was the kid who once brought me a drawing of mine he'd bought from somebody who got it at auction at Parke Bernet. But when I saw it, I knew it *wasn't* mine, so I wouldn't sign it, but I told him that if he came by maybe we could think of something to give him instead. It's a backwards Soup Can and I just don't remember doing it, although it really looks like I did it. But I don't remember that kind of paper. And it's backwards so I would have had to photograph it and then trace it, and I don't remember doing it. I didn't do that many drawings and they were all in such a short time. But I mean, if *I* can't even really remember . . . Dinner was good ($300).

Then Jon Gould had this friend named Lady McCrady who lives on Park Avenue who's done about twenty children's books and we went to her apartment and she had a lot of friends there from like Boston schools, and it was like being in the fifties, it was that kind of apartment—all the kids were like ballet dancers and artists and witty, like Jonathan Roberts, the boy who thought of the idea for *The Preppie Handbook*. The apartment was painted sky. Jon knows most of these kids from some course in publishing that they give during the summer at Radcliffe. Jon had a job at *Rolling Stone* before he went to Paramount.

Saturday, February 14, 1981

Went to an opening at the Gray-Gaultney gallery and as we were leaving we ran into Governor Carey downstairs, and he said that I should tell the mayor to let Christo wrap Central Park in plastic, that it would give lots of Puerto Ricans jobs.

Sunday, February 15, 1981

Brigid went home from work on Friday and when she looked around for her cat, Billy, she couldn't find him. So she ran to the pet store before it closed and *bought another cat!* Can you believe a person would do that? For $300. Then she brought the new cat home and she heard a meow and opened the closet and there was Billy in a pail, so she returned the new cat.

My two nieces came over from Pittsburgh and I entertained them for a couple of hours. They look alike. And they look like they did ten years ago, they haven't aged. Went to church.

Monday, February 16, 1981

Got up at 9:00, it was a holiday. Presidents' Day—they've put Washington and Lincoln together and made it on a Monday.

Fred came in. Nobody asked him about his father's funeral.

I worked on Myths—Dracula and the Wicked Witch. I look pretty good in drag, and I thought it would be fun for me to pose for it myself, but Fred said to do myself in drag at a later date, not to use up the idea on this portfolio.

How do you not get bags under your eyes? I know it's from water collecting, but oh, I just don't want to get them.

Tuesday, February 17, 1981

Yesterday I was watching a game show, *Blockbusters* with Bill Cullen, and it was two black guys, a warden and his cousin, against a white girl and the category was "Letters" and the question was: "Andy Warhol is a 'V.' " And *(laughs)* she got the answer right, she said, "Virgin." And then Bill Cullen said, "That's right, at fifty-one." She won $500 and she got it up to $12,000.

Oh, and I got a letter from Germany written in German about *Bad*—it was official-looking and the only sentence I can read is so funny: "In this film they kill a man under a *Volkswagen!*"

Wednesday, February 18, 1981

Doria Reagan came by so that Brigid could teach her how to type up interviews. And then I invited her to stay for lunch. I didn't see any Secret Service but when Ron came over later to get her he had the five guys.

Thursday, February 19, 1981

I wanted to go pass out *Interviews* but it was too late. I had to meet Christopher Gibbs from England at the office (cab $5.50). Doria Reagan was there, typing away. And they really don't have one Secret Service guy with her, and she could be with baby. I mean, don't they care about the possible grandson?

And Brigid and I are finally going to see Mary Tyler Moore on Monday. She's trying to change her image so she's a problem—she didn't want to wear rich Halstons for the photos, and she didn't want to come to lunch with the rich Basses and she didn't want to go to rich Quo Vadis for dinner—she wants us to meet her at John's Pizza Parlor on Bleecker Street.

And did I remember to say that Faye Dunaway called the other day? She's doing *Mommie Dearest*, playing Joan Crawford, and she wanted to know if I had bought Joan Crawford's heart pin at that auction and could she borrow it. But I hadn't. Faye just picks up the phone herself and calls, so she's fun, so maybe I'll call *her* up sometime. I'll get her number from Ara. She might be good to do a story on. I just saw *Hurry Sundown* on TV and she was so beautiful.

I invited Jon Gould to see *42nd Street* because he's looking for ideas for Paramount and I want to suggest *Popism* to him as a movie, so I brought a copy. Wouldn't it be great if he got Paramount to buy it? And then I could work on it with him, he knows so much—all these facts and figures and surveys—he'd really be a good person to get to know.

Cabbed to Wintergarden ($4). From the first row, you can't see the feet tapping *(laughs)*, you can only see the knees. Then after the show we walked to the Russian Tea Room to meet Chris Makos who'd been to see *Sphinx* and loved it.

Monday, February 22, 1981

Jerry Hall called. She said that poor Mick has been down in Peru with the Herzog movie and it rains all day and he has to sleep on a wet mattress and Jason Robards was taken away with pneumonia to a hospital in New York and now he doesn't want to go back. And I invited her to lunch with the Basses from Texas.

When I was on my way home I ran into Alan J. Weberman, the "King of Garbology" who was on the corner making a phone call. I knew who he was because he handed me a resume with all his garbage credits on it. He said he'd just been through Roy Cohn's garbage and Gloria Vanderbilt's. I think he began his career with Dylan's. I was scared that he'd see where I lived so I went in the other direction.

Finally got home, glued, and walked to the armory. It was Roy Cohn's birthday party. Black tie. The Mafioso types weren't in black tie, though. Steve and Ian didn't come because they didn't want the publicity. There were about 200 people. Lots of heavies. Donald Trump, Carmine DeSapio, the D'Amatos, David Mahoney, Mark Goodson, Mr. LeFrak, Gloria Swanson, Jerry Zipkin, C.Z. Guest and Alexander, Warren Avis, Rupert Murdoch, and John Kluge. And the reason I'm able to remember so many is because Joey Adams gave a speech where he mentioned everyone in the room.

I was talking to a guy and I said how terrible it was that they wanted to tear down this beautiful armory and he said he thought it was a good idea because he was in construction. They brought out a lot of cakes—each had one letter that spelled out "Happy Birthday Roy Cohn." Roy really got the press there, the *Times* and the *Post*.

Monday, February 23, 1981

Ara called and said to meet Mary Tyler Moore at John's Pizza at 8:30 instead of 8:00 and I decided that I would just stay downtown and work until then.

Jay Shriver dropped Brigid and me off (cab $10). The place was empty because it was raining heavily. It's a small place, only about 20' × 40'. The owner had started to drink, he was nervous because we were coming. They didn't serve slices, only whole pies. Brigid was still on her diet so she just had Tabs. But the owner was offering her wine and he was showing her the sixty kinds of pizzas and she was going nuts. The temptations were making Brigid weak in the brain. The owner was smashed.

Mary and Ara came five minutes late and she was really sweet. The juke box was forties Sinatra and it was so loud. The owner had pulled up a chair and was part of the party. He'd had the *New York Times* review of the place printed on the napkins.

Well, Mary Tyler Moore is trying to be a new woman. Brigid told Mary she loved her crow's feet, which she does, but it sounded insulting. Brigid was trying to get the conversation around to plastic surgery but she let it drop there, she didn't pursue it. And then Brigid said, "There's only one thing I want to ask you—are you going out with Warren Beatty?" and Mary gulped and Ara gave a funny look, and she said, "Well, 'going out' is just, you know, 'going out.'" So that was never answered. Mary looks like an old Barbie doll. She's perfect—short hair, a beautiful body, like the mother of Barbie. She looks like Doris Day in the fifties. And she eats a lot. And later I noticed she walks fast and never looks at anybody so nobody ever stops her. She's a dynamo. Then some cops came in to pick up some pizza and they were so good-looking. I asked one of them if he wanted to meet Mary Tyler Moore and ask a few questions. This cop was really cute, he said he used to sing with a group called something like the Passions in the sixties or fifties, and that they had a few hits. He asked her if she wanted to ride on a horse outside and she said yes, that she wanted to right then, but then he got nervous that something might happen to her, so he gave her an honorary police card instead. They were flirting.

Mary's studying political science and, I mean, with that voice, she could really be the biggest thing in politics since Ronnie Reagan. She goes to a psychiatrist two or three times a week. And then she got a craving for a hot fudge sundae so I said Serendipity was the best really good place and she liked the idea of that.

When we walked into Serendipity the whole place hushed—"There's Mary." We sat under the lamp that was in my living room thirty-five years ago. I ordered half a sundae and so did Mary and Ara.

And she's so "assured of herself" it's funny. Do you know what I mean? It's almost comical.

Monday, March 2, 1981—Paris

We made a lot of phone calls to see who was in town, and then we got a car and we drove out to Chateau La Flori to this dinner that Bergitte de Ganay was giving for Charlotte Greville and her husband Andrew Fraser. They were there for the hunt. This is where the hunt has gone on since the days of old. Charlotte has forty letters of introduction, she can go anywhere in the

world. But now somebody's trying to outlaw deer hunting in France. They actually let the dogs tear the deer apart. Or they knife them to death, or something.

During the ride back Fred freaked out and it was just too embarrassing. Everything was normal, and then all of a sudden he was a different person for ten minutes, and then he was normal again. The driver got really scared, though, and almost stopped the car (car $320). And then Fred was complaining that nobody ever is nice to him. Actually, we both were complaining—I felt neglected, too.

Sunday, March 8, 1981—Düsseldorf

At the cocktail party at Hans Mayer's house last night, there were a lot of people I'd done portraits of who I didn't recognize, so I thought they were potential new portraits. *(laughs)* Oh God, no wonder people think I'm out of it.

We had breakfast with Joseph Beuys, he insisted I come to his house and see his studio and the way he lives and have tea and cake, it was really nice. He gave me a work of art which was two bottles of effervescent water which ended up exploding in my suitcase and damaging everything I have, so I can't open the box now, because I don't know if it's a work of art anymore or just broken bottles. So if he comes to New York I've got to get him to come sign the box because it's just a real muck.

Monday, March 9, 1981—Munich

Very sunny and very cold. Went to the gallery where they were having a little exhibition of the glittery Shoes, and had to do interviews and pics for the German newspaper and then we had to go back to the hotel and be picked up by the "2,000" people—it's a club of twenty guys who got together and they're going to buy 2,000 bottles of Dom Perignon which they will put in a sealed room until the year 2,000 and then open it up and drink it and so the running joke is who will be around and who won't.

It was fun because all the men were really straight and it was fun being out with them. Some of them brought their wives. And it was an eight-course dinner with a lot of different wines during each course. The first food was fresh liver, the goose was just killed in the kitchen and the liver was just taken out and cut into slices and warmed up—half warmed by the heat, and half warmed by the goose. It was delicious, but after you thought about it you wanted to throw up. The second course was soup. Then lobster with baby quail—you got the breast of the little quail, as big as your fingernail. It was really good, but just so sad, like eating the chest of a roach. Then in between courses we had some sherbet and they made it look like Jackson Pollock because they puréed fresh kiwi and strawberries and threw them on a plate. Artistic. Then they had lamb encrusted and it was the best lamb I ever had encrusted.

And the different twenty men kept changing seats so they could sit next to me because they thought they could get some good conversation, but I was just absolutely drunk.

Thursday, March 12, 1981—New York

Vincent told me that Bill Copley's wife, Marjorie the Czechoslovak madam from Pittsburgh—the one I just did the portrait of—walked out on Bill and went to Tiffany's and ran up a big bill, cleaned out their bank account. Took the two portraits. She always takes a private plane from Miami to Key West, and Bill was waiting at the airport for her with a bouquet of roses, and instead of her coming off this guy came off with a divorce summons.

Bill's body is now covered in third-degree burns. When they were down in Key West he was smoking in bed and she was asleep in another room and the two whores—friends of Marjorie's—that had flown down to Key West with her went out and when they came home at 5:00 they found the fire. He could have died. And she said she was asleep the whole time and didn't hear anything or smell anything, but the house was half burned down. The firemen had to come. Bill's been getting skin grafts and everything, he's had a few operations. It was really terrible. And he's always alone because she fired the assistant and the secretary.

Read my mail then went to the office (cab $5). Brigid was excited about getting an eye lift. She sent the money in already. And Ronnie was happy because he's got a rich girlfriend.

Johnny Pigozzi came by and he had a new camera that went in a circle and took a whole panorama, so I sent Ronnie out to get one just like it for me. And he was nice, I think because he saw me painting, and he always suspected someone else did it for me.

Cabbed at 11:30 to the Ritz ($5.50). They gave us free drink tickets, and Walter Steding went on right at 11:30 and was really good. It's so strange to see somebody who works for you as a janitor have that performing ability.

Friday, March 13, 1981

Brigid was typing up the tape of the day we went to Port Jervis to see Charles Rydell, and she said that after hearing herself she was never going to drink again.

Ara invited me to a party for Jack Nicholson at 212 East 49th Street at 11:30. It was wall-to-wall models. I told Jack how great he was in *Postman* and that everybody thinks Jessica Lange is great. I talked to a kid who worked on the crew of *Cocaine Cowboys* and he told me the real story of Tom Sullivan—how he'd been taking heroin for years, and that his mother drove a bus in Tampa. This kid said Tom's out of money now, that he'd made all his money flying marijuana—not cocaine—up from Colombia. And Winnie was at this party, she's getting a divorce from Tom. Stayed there till 3:00. Franco Rossellini was there. Bob Raphaelson was there, he's really nice. And Ara was really sweet.

Saturday, March 14, 1981

I went to the Loyola church for the 11:00 wedding of the Michael Kennedy kid to Vicky Gifford. Fred was there (cab $4). The streets were mobbed with TV crews and police.

Churches always make me dizzy. They had pretty flowers on all the pews. The bridesmaids

came in, and the funny thing with that was that when Bob was in Switzerland they were making up all the bridesmaids' gowns there and they were saying, "These are for the Kennedy wedding, they've ordered all these *nightgowns.*" So here were all these girls in what I knew were nightgowns that cost probably $75 each. Purple with pink ballet shoes. Kerry Kennedy was a bridesmaid and Mary Richardson's sister. And then the bride came in and she was the prettiest bride I've ever seen in my life. Really the best-looking bride. It made you want to get married, it really did. I'd met her before, in Monte Carlo. She's Frank Gifford's daughter.

Cab to the St. Regis where the reception was on the roof ($4). It was beautiful up there. I had to shake hands again. Robert Kennedy wanted to trade ties with me, and then he was peculiar, he wanted to trade pants. He's the other good-looking one, he was going with Rebecca Fraser. Really, these kids were all so good-looking, just a roomful of seventy-five of the best-looking boys and seventy-five of the best-looking girls, and then about twenty older people. Caroline Kennedy wouldn't talk to me, she was giving me the cold shoulder, I don't know why. But John-John was nice, he said hi and everything.

I went quickly through the receiving line. Senator Kennedy was so sweet to me and thanked me again for doing the posters for him. He and Joan were together at this thing.

I was invited to Stephen Graham's and then Franco Rossellini called and invited me to dinner at Le Cirque and we knew that President Reagan was having dinner there, too.

Walked over there and we got the worst seats, we couldn't see anything, so Franco took the best seats and he started describing to us every little thing the presidential party was doing. All of the tables had reporters having dinner to cover the president. The whole place was foreigners, Bob and I were about the only Americans.

Then we were leaving and didn't want to go by the president's table because it was too groupie-ish—everybody else was stopping at the table—so we went the other way, but then they called us over, Jerry Zipkin was yelling, and I met Mrs. Reagan, and she said, "Oh you're so good to my kids."

Then went to go to Stephen Graham's, to the Sovereign. A boy asked me to go home with him and I didn't know what to do because nobody had ever asked me that. I mean, in those words (cab $5). Bed. Then Chris Makos called. I knew he was calling from the Baths, and then he admitted it.

Sunday, March 15, 1981

It was a really pretty day. Chris invited me to brunch with him and Jon Gould but I thought the magic would be gone if I saw Jon in the day. But then I decided to invite them up to my house instead. So then I was too nervous to go down to the office—I stayed home and cleaned. Oh, and Jon told me the other night that he liked *Popism*, but to Chris he said he didn't think Paramount could do it. But maybe eventually something will happen with it. Maybe it's too soon. Oh, and Jon said to me that he thought it was "badly edited" so I don't know if he's good at reading.

I got cake and tea together. Jon brought his dirty laundry to wash while they visited because at first Jon said he couldn't come over, that he had to do his laundry in a laundromat on Columbus Avenue and I told him I had a nice clean machine at my house. I want him to feel at home here.

Janet Villella called and said she was sending a car to the ballet.

We arrived at the Met. It was star-studded. It was a benefit for the Joffrey and the ballet was absolutely boring. It was just intricate sexy dances. Got drinks at intermission ($20). Ron Reagan, Jr. was in the first part, but he didn't have much to do—he was the last boy in the last row with the last girl—but he dances a lot better, he's improved so much. And then in the second part he was sitting in the presidential box with his mother and father, and he and Doria were waving. They're going away again this month, so I don't know how Doria's going to get her *Interview* work done.

Monday, March 16, 1981

Mrs. Mahoney, who's the wife of the head of Norton Simon that bought Halston, slipped and told me that Halston was in the hospital and then said oops, and please not to tell, so I ran and called Bianca and she called Halston's and Mohammed lied and said that Halston was asleep and that Victor would call her later. I called the hospitals and they didn't have a Frowick or anything there. I wonder what's wrong with him.

It was rainy in the morning and not cold, but by the end of the day it was below zero. Mrs. de Menil and Mrs. Pompidou came down to the office, there were about six security people ahead of her and six people with her. She's tall and beautiful. And Mrs. Malraux was with them. I don't know if she was the widow or a daughter-in-law or what. I gave everybody *Philosophy* books. And Mrs. de Menil is so skinny. She's building a museum in Houston, but she said to keep it a secret. Madame Pompidou only stayed ten minutes and then she went off—I didn't find out till later in the day that where she went off to was to see Nixon. And she said, "I saw your white hair from the Reagan box last night." She's part of the inner circle.

I waited at the office until it was time to go to Mrs. de Menil's (cab $4). Then Arman and his wife Corice were giving a dinner party afterwards for Madame Pompidou.

Wednesday, March 18, 1981

Tinkerbelle called to thank me for recommending her to the video people at *That's Entertainment*, they're looking for a different Rona-type. She said she was going to have her agent call them.

I had a lunch date with Raquel Welch. She'd cancelled a few weeks ago and this was a rescheduling. She was bringing her husband this time. When we were originally having the lunch she requested that absolutely nobody else be there, but this time we already had about twenty people coming.

It was a strange lunch. Raquel and her husband only wanted to talk intellectually, so I gave them the works of PH and me—the *Philosophy* book and *Popism*.

And Raquel just sort of sat on the couch while everybody pretended not to look at her. She was interested in art so we gave them the tour. Susan Blond asked her if she'd like to go to the New Wave clubs and she said, "No, I'm trying to get the Old Wave back, because the Old Wave

represents quality, not these young kids running around doing things." I mean, can you believe it? She said she gave a lecture at UCLA.

Bob was frazzled because he said that when you give a lunch that big you don't really accomplish anything, that nobody knows why they're there, whereas if you have it a small lunch, they know they're there to be talked into buying ads. Mary Boone didn't know why she was there, he said.

Anna Wintour who used to work on *Viva* who got Catherine her job there came up to show Bob an idea for an *Interview* fashion insert that she'd worked on for three months because she thought it was a good idea, and he just looked at if for one second and said it was trash and she started crying. And she's such a tough cookie that I could never even imagine her crying, but I guess it was her femininity coming out.

Later we had to go to Bolero, the new club which advertises, so we went and it was so strange. It's like a brownstone and you go in and they put you in an elevator, and the doors close and it shakes you around and the lights go, and then the doors open and you're really on the same floor, on the other side! I guess they really wanted you to think you'd *gone* someplace. It's like a fake townhouse—paneled walls and a couple of candelabra.

And the ladies there said, "This area is sealed tight, and I think you know what that means— that means you can do *anything* in here, anything you want." It's such a camp.

Thursday, March 19, 1981

I had to decide whether or not to ask Chris Makos to come to Europe with us and help me photograph buildings, and I decided I would.

Friday, March 20, 1981

We had to do our Rex Smith interview, Bob and I, so I decided it was easier to stay uptown because it was going to be at Quo Vadis. We fell in love with him. He had the curly Vitas Gerulaitis look but better-looking.

And then we heard a voice say, "Andy!" and it was Yoko Ono. We were so stunned. She looked so elegant, like the Duchess of Windsor with her hair back and dark wraparound glasses, and beautiful makeup and Fendi furs and jewelry—an emerald ring with a big ruby in it and Elsa Peretti diamond earrings. So I said that I wanted to call her for lunch and so she gave me her phone number. It was really strange, a whole new Yoko.

Monday, March 23, 1981

The story about Halston that Victor sort of just whispers in sentences that don't go together is that he's still in the hospital—something like that his ceiling is mirrored, and the mirror fell on the bed and cut him, and then the silver from the back of the mirror got into the wound and infected it, but I don't know if Victor is fantasizing, being creative.

Chris Makos came at 3:00. We were photographing a madonna named Jackie, with a baby, such a cute little girl, a really pretty baby. The madonna was like a beautiful version of Viva, more like her sisters.

Tuesday, March 24, 1981

As Vincent and I were paying bills around 5:30 we heard a couple of bangs but it just sounded like firecrackers but then we looked out at Union Square and there was a dead person on the street, it seemed like the police had shot the person, and then the TV crews were there and the lights were so bright that we could see the red blood around the corpse from the window.

Wednesday, March 25, 1981

Brigid weighs less now, you can feel her bones. Today or tomorrow she's having her eyes done.

Vincent was looking in the paper to get the story on the murdered person in Union Square, and he finally found it in the *Post* but there must have been a lot of drugs in the car or something, for the policeman to have fired five times.

I got dressed really quick to go to the Walter Hoving dinner for John Kluge at 635 Park. Ran over there and Hoveyda was going in at the same time and it was so great to see him, I asked him to be my date. I told him I've been meaning to call. Jane Pickens Hoving greeted us and it was a heavy bunch—the Trumps, the Bronfmans. And John Kluge and Patricia Gay are getting married in May.

Everybody at the party was so old, but I liked it. And everybody was so straight and married and I was the only fairy there. I also talked to a beautiful girl from California who's dating Andrew Stein who was there talking to somebody about budgets and he's good-looking and nice and smart. And then everybody was supposed to do some entertainment. Jane Pickens and her sisters were singers, they had a really big career. And they asked me to perform and I said that I just couldn't, but I took a picture and then I bowed, and they thought I was crazy. Patricia Gay is a raving beauty; 6' tall.

Thursday, March 26, 1981

Joan Lunden called in the morning and said she was expecting me for lunch at Le Cirque with her and Barbi Benton. Barbi was in town to do Joan's show the next day. But I knew Jed would be there, so I said I couldn't. Joan was Jed's girlfriend in high school in Sacramento and Barbi was his brother Jay's.

David Hockney came to lunch and Vincent did a video of him. And afterwards he went into the other room and did the interview. David's cute, he really is magic.

Julie Sylvester from the Dia Foundation who works for Heiner came by, and she said that

Philippa is now trying to help poor people, she's giving them money, and I hope that doesn't cut into what she does for art, because she's really generous.

Barbi Benton called and invited me to *Pirates of Penzance* and I told her I had other plans, which I did, but she said, "You're turning down a Playboy Bunny? Nobody's ever turned me down! *You're* the one who wears the pants—you can do anything you *want* to do. Just *break* your plans." So I said okay, that I would. I mean, she was so aggressive—henpecking me—that I had to. I said I'd pick her up at 7:30 at the St. Moritz, and I asked if a taxi was okay and she said yes.

Got a cab fast. I discovered that I didn't have my small bills with me, just a hundred, so I had to borrow $20 from Barbi. She was seeing the play because she's determined to get the Linda Ronstadt part on the West Coast. She said that *(laughs)* Sonny Bono is going to play the Kevin Kline part.

After the show Barbi said that Joe Papp had cleared it for her to see Linda Ronstadt so we went to see her and it was such a camp, listening to these two talk. Linda wants to go into another play that's opening in the fall, and Barbi told her, "This has led your career into new and wider scopes. Now you're competing with Barbra Streisand." And they talked about how painfully shy each of them was. Rex Smith was there in his tight pants with his big cock, and he looked at Barbi and said, "*This* is my new adventure," because when we did the interview with him he'd said that he was looking for a "new adventure."

I invited Rex to dinner with us at Pearl's and he glued and rolled up a joint and turned down some phone calls and some other dates. Barbi looked so good, too, she looks really good. So we went over to Pearl's and didn't get there till 11:00, they'd already closed the kitchen but they waited for us anyway.

Rex was heavily going after Barbi and I asked him about his ex-marriage and he said it was to an older woman, that he liked older women, and he asked Barbi how old she was and she said thirty-one, and it was going happily until it came to "Are *you* married?" and she said yes, and then Rex was a deflated balloon and the dinner was sort of over.

I left Rex walking on the street, sort of turning around but then—I don't know—maybe they had made a date, because he was walking toward the St. Moritz, but I don't know. Barbi had to get up at like 5:30 to be on Joan Lunden's *Good Morning America* show.

Friday, March 27, 1981

We had another madonna and child scheduled for 3:00 and I just know this series is going to be a problem. It's just too strange a thing, mothers and babies and breastfeeding.

Saturday, March 28, 1981

I got to Halston's at 9:45. Steve Rubell was there and Ian. Halston's fifteen pounds lighter and he was drinking ginger ale. He told me the real story of what happened. He said that he and Martha Graham both shot up B-12, which I knew, but that a syringe he'd been sent was contaminated with lead, and his leg began hurting, and he went to the doctor, and the doctor said he should rush to the hospital but Halston said no, he'd just go home, but then the other leg started

hurting and he could hardly walk, and then they rushed him to the hospital, they thought he might lose the leg, and they operated. I think this is all true, because Halston doesn't make up stories, he really doesn't. He was happy that it didn't get in the papers.

Then we left there and Steve didn't tell Halston but *(laughs)* he was then going on to Calvin Klein's. Steve dropped me and I went to John Samuels's father's party at 123 East 79th Street. John Samuels, Sr.'s boyfriend, David, played the piano and he said that he practices five hours a day. Mr. Samuels met him when he hired him to be his piano teacher. They had nice flowers there and David told me, "Pluck a gardenia on your way out or I'll never speak to you again."

Sunday, March 29, 1981

There was a Greek parade going on and I don't know why it should be so big, unless—oh that must be it, Governor Carey has that new Greek girlfriend.

And oh, there was an article on Lou Reed in *People*. With his "British-born" wife. I still don't understand why I wasn't invited to the wedding. They had a big reception and everything.

Monday, March 30, 1981

It was warm and rainy. I stayed uptown because Bob and I were interviewing Dominique Sanda at Quo Vadis at 1:00. They thought we'd said a table for twelve so we had a lot of room. Bob and I fell madly in love, she was so wonderful, so magic. Bob and I were wide-eyed. And when *Bob's* a pushover, you know it's love. She giggles. And she speaks perfect English, except with a little British accent. She said that she just decided one day that she hated her last name and named herself Sanda, I think her name has a lot to do with the mystique. Then afterward she wanted to walk in the rain, so we gave her an *Interview* for a rain hat and she went off walking.

Sharon Hammond was having a birthday party. Went over there and it was really festive. I guess everybody had been so nerved up by Reagan being assassinated but he's going to make it, they were relieved. Sharon's lord was there. I heard Lester Persky talking to some other producer about *Popism* and he said he wanted to "buy it," but since it was Lester talking I didn't know if he meant the film rights or just a copy of the book.

Wednesday, April 1, 1981—New York—Paris

We dropped off Chris Makos at the Hotel Lenox at 9 Rue de l'Université, and then us (cab $50). Rocksavage was having sort of a little dinner party.

Thursday, April 2, 1981—Paris

Helmut Newton came over at 12:00 to do one of his fashion shootings, and they brought in these big bouquets of pretty flowers which they eventually let us keep, and Helmut finally came and let me take pictures of him and his pretty model.

Late that night Christopher encouraged me to call Jon Gould in California so I did, it was 5:00 there, and I was pretending to be sober, so I had this great sober voice, which I don't know how I did it, and the secretary said that he was in a meeting, and he'd be out in fifteen minutes, and he'd be sure to call me, and then she asked if it was all right to call me "Andy" because I was her god and she was so familiar that I just knew something was wrong, I knew he would never call back. But I sat around waiting for the call and I must have dozed off, but I'm sure the phone never rang. And then Fred arrived and he brought a whole gang with him, and it sounded like they were rowdy Frenchmen, they had these horrible voices and I didn't know who they were and they just went on and on and on, and Fred played "Diamonds Are a Girl's Best Friend" at top volume and I thought I would freak out. I was feeling so desperate because my phone call never came through that I almost wanted to kill myself. That's the way life goes, kiddo. Fred's friends didn't leave until 4:00 in the morning. I looked out the window when I heard them going and they didn't look so great to me, but Fred said that they were rich kids.

Friday, April 3, 1981—Paris

Woke up at 12:00 because we were having our lunch with São Schlumberger at Maxim's (cab $12). And São was sitting there alone, she was afraid that we'd forgotten about her. She gave us wonderful ties from India. She'd just been there with Patrice Calmette. She talked about how she'd been "too open" with her last friend, Naguib, so everyone said there was—that she should, uh—that the best way is—well, I guess I can't remember because nobody *knew* what the best way is.

Then after lunch we decided to go see the Gainsborough show, a lot of beautiful people and their dogs. And then we were so close to Givenchy that we all decided to go to Givenchy and Hubert came down in a white smock and showed us around and we had the best time.

Saturday, April 4, 1981—Paris

I took a Valium and almost took a nap but then there were lots of phone calls and we invited people over for drinks—like a guy named Yorgan, I think, brought two funny people from England—Vivienne Westwood who designs clothes, and Malcolm McLaren who managed the Sex Pistols.

After going to dinner and then Club 78 at 78 Rue something and the Privilege, we got home at 4:00 in the morning and I called Jon Gould at Paramount Pictures in L.A. when I was drunk and I think I said a lot of wrong things.

Monday, April 6, 1981—Paris

Saw the Christian Dior show and the Valentino show. With the male models, all the really straight-looking models are gay, and all the really gay-looking models are straight. And Christopher and I decided that we should start telling people that despite how we look and talk, that we're not gay. Because then they don't know what to do with you.

Wednesday, April 8, 1981—Vienna

I got up early. I'd dreamt about Billy Name [*see Introduction*], that he was living under the stairs at my house and doing somersaults, and everything was very colorful. It was so weird, because his friends sort of invaded my house and were acting crazy in colorful costumes and jumping up and down and having so much fun and they took over, they took over my life. It was so weird. It was like clowns. Everybody was a clown in a funny way, and they were just living there without letting me know, they'd come out in the morning when I wasn't there and they'd have a lot of fun and then they'd go back and live in the closet. And so I got up and Christopher had left all the lights on, and the windows were open and it was very beautiful.

Went to hunt for the loden coat I was trying to buy for Jon Gould. And Bruno Bischofberger said the best loden coats were in Zurich and Fred said the best were in Paris. But I think the best ones are in Vienna.

Then we had to meet a kid named André Heller who has gold records and he owns all these paintings and wants me to do a drawing for his album cover. He was taking us down underground to show us dead people who're petrified and they're all in their eighteenth-century clothes. Fred said it might be a good idea to go, that maybe we'd get ideas there.

So we met him and he gave us about twenty boxes of candy. Then we went down into the catacombs and we had to oooh and ahh at all the dead bodies, and it was really cold down there and he'd made us leave our candy behind and we didn't want to do that but we did, and this place was just hateful. I hated it a lot. Fred loved it.

Then Bruno took us back to the hotel. Fred wanted to go for another walk, but Christopher wanted to go cruising in the park, so we just threw our stuff down and walked the whole park and that was good exercise.

Thursday, April 9, 1981—Vienna

Bruno came by because we had a really punctual meeting at 10:30 at the ministry with the lady Minister of Culture in Vienna. We met the curator of my Reversals show at the Vienna Museum of Twentieth-Century Art, I forget his name, and we saw the beautiful catalogues that they printed for the Reversal show which are really long and slim. Then we went to the hotel and freshened up before the show at 6:00. I talked to Vincent in New York and he said my headsheet had come in from Zoli. Have I told the Diary I've decided to become a male model? So then Fred got so overwrought—he thinks I'm crazy to start modeling. But it's something I want to do so I ignored him. Chris said Fred's just jealous.

So we got to the museum and it was an unbelievable crush, open to the public, and I'd never been in Vienna before so this was "See Andy now or you'll never see him again." And that lasted for two hours, and I had to sign shoes and asses, and I didn't even look up once.

Then finally Christopher couldn't stand it anymore and said that we had to leave, so we ran out past all the TV people and jumped into the car and it took us to a Viennese restaurant where we had hot dogs. Then to a great club called Chaca—all young, good-looking kids. Tangos and old Elvis songs and it was just the greatest.

Chris and I took this adorable boy, Martin, back to the hotel. We got him to take his shirt off and then we got him to take his pants off, too, and he had the craziest sort of Op Art underwear on and we took pictures and he did the best poses and then we gave him the car to go home in. One thing I've learned from Chris is that if you tell anybody to do anything, they just do it. Especially models and actors. And then I saw a Telex from Jon Gould, he's back in New York, and it was a really nice note and then I felt great.

Monday, April 13, 1981—Paris—New York

I'd packed till 2:30 in the morning and then took a Valium and had a really good sound sleep. Then Fred was knocking at my door and Chris Makos called and he was rarin' to go. Chris is just the perfect companion for me. He's everything I've ever wanted. He's pushy but then he's not pushy. And he's a child. And he goes off to sex parties and comes back satisfied with his pipes cleaned, and he's so in love with his lover, Peter, he's really considerate, and when he goes places he can't wait to leave—just like me—and he gets me to go running all over and even though he's now got me carrying *his* knapsack, I don't mind because it's all exciting and he makes me feel young. I've offered Chris a reward—this wristwatch he wants—if he can get Jon Gould to fall for me. It's confusing because Jon tries to keep a straight image, he tells me he's not gay, that he can't . . . but I mean . . .

Took the Concorde, got home at 9 A.M. on the dot. I called Jon Gould and he said he couldn't talk, his tub was overflowing.

Cabbed ($4) downtown. Talked to Marc Balet, he was at the office, he designed the Zoli agency book that I'm in—the catalogue of their models. I already got some job offers, I'm officially a male model now.

Doria Reagan came to work. And then I looked out the window and I saw Ron walking along the street alone and he was wearing bright red, and I mean, if I could pick him out from the window . . . And Doria knew where everything was, she said, "There's three Secret Service in the front and four in the back." They walked up the stairs because the elevator was broken.

And then I wanted to see Barbara Stanwyck that night at Lincoln Center, she was getting the Film Society annual award, and so I called Sue Salter the publicist and she was just rotten. She said, "Oh my dear, they're all sold out," and I told her, you know, "We've really done so much for you," and she said she would try to find one ticket, but that I would have to pay, and that she could get me two tickets but that they would cost $250, so I said, "That'll be just fine." At least now they can't ask me for any more favors. Maybe the best thing to do is always pay, and then they can't ask you for a thing. But last year they gave me free tickets.

Jon Gould asked me to pick him up so Chris Makos and I did. We walked over to Alice Tully Hall and there were a lot of empty seats so I was really hating Sue Salter down to my toes. But at least the seats were good, row J. And the Barbara Stanwyck clips were great, although at the end it got boring because they used the same ones too much. At 11:30 Chris dropped me off.

Tuesday, April 14, 1981

Worked till 5:30. Jon Gould invited me to a screening of *Atlantic City* that he was giving for his crowd. Cabbed to Paramount ($7). Lady McCrady and Jonathan Roberts were there, and Katy Dobbs who was also in that Radcliffe publishing course that all those kids took.

And I ran into a guy who'd seen my picture in the Zoli book and offered me a job. Fred is still furious, he said I should be getting thousands for endorsing products, not working for modeling fees. But I think it's funny to be just another pretty face in the Zoli book. I told him to lighten up.

Wednesday, April 15, 1981

Had a sleepless night. Watched the astronauts coming back on the shuttle on the *Today Show*. They're really cute. Did you ever notice how old they look after the space flights? They send up these good-looking guys and get back these tired-looking people.

Went up to Carl Fischer's for my first Sony commercial. They were already waiting, setting up. And they were talking about the other artists they'd like to get for the series, they mentioned Duchamp and Picasso. Seriously. I honestly don't think they knew they were dead. Maurice Sendak was the only other live one they mentioned besides me. And Peter Max.

And they had some food in another room but they didn't offer me any, the execs were coming in eating cheese and saying things like, "This is a good spread," things that sound just like the commercials. And people really do talk that way, they really are like ad people.

Everyone was telling me how wonnnnnnderful I looked thin, but I feel so weak.

Went to Xenon and that was fun. I met the Moynihan girl, Maura, and her roommate Aysie, Senator Warner's daughter—her mother's a Mellon. And then my hair started to look too fake in the blue light so *(laughs)* I knew it was time to leave.

Thursday, April 16, 1981

Got up early and it looked beautiful out, but I'm in this period where I think, *What is it all about? You do this and what does it mean, and you do that and what does it mean?*

Really I'm in a strange period, I put off telling the Diary about my emotional problems because last Christmas when I was having all the fights with Jed and he moved out, I couldn't face talking about it, and now I'm living alone and in a way I'm relieved, but then I don't want to be by myself in this big house with just Nena and Aurora and Archie and Amos. I've got these desperate feelings that nothing means anything. And then I decide that I should try to fall in love, and that's what I'm doing now with Jon Gould, but then it's just too hard. I mean, you think about a person constantly and it's just a fantasy, it's not real, and then it gets so involved, you have to see them all the time and then it winds up that it's just a job like everything else, so I don't know. But Jon is a good person to be in love with because he has his own career, and I can develop

movie ideas with him, you know? And maybe he can even convince Paramount to advertise in *Interview*, too. Right? So my crush on him will be good for business.

Oh, and the most interesting thing was seeing Lou Reed on the street in the Village with his wife. She's nothing special, just a little sexy girl. I told him that I'd just been reading about him in *People* and I asked him why he doesn't come over and see us, and he said it's because he doesn't know any of the people anymore, and then he asked if Ronnie was still around, and I said yes, and then if Vincent was still around, and I said yes, and if PH was still around, and I said yes, so it was funny. Went home.

I cooked an early Easter dinner and it smelled like the old days when PH used to come up and cook me cabbage with caraway seeds and onions. Jon was a little late because he had to go to Macy's to return some sheets. He brought me an Easter basket, it was kind of plain. I gave him a tour of the whole house to impress him, and I was hinting like crazy that it could all be his, that there was a room with his name on it.

Then we went to see *Excalibur*. The sex scenes were a little corny but beautifully done. He had his armor on when they were having sex. And then the focus was so soft. And I was so confused, I always thought Camelot was a real place. So after the movie we walked back home. I'd given Jon a rabbit puppet and he was waving at people with it. He's going to his family's house in Massachusetts for Easter.

Friday, April 17, 1981

I was depressed, I decided to pass out *Interviews*. After I did that I went to the office and I ran into the Moynihan girl, Maura, who was arriving two days late for lunch (cab $5). And now that the *Soho News* had Dominique Sanda on its cover this week, it'd be too tacky to have her as our cover girl, so maybe we'll use this Moynihan girl as our cover because she's cute and smart—she went to Harvard—and she has a rock band.

Chris Makos called me from Palm Beach where it was so sunny and he was with his boyfriend Peter and that depressed me, they'd just gotten there.

Worked till 6:30. Rupert invited me to an all-boy party on Bleecker Street, but I was too depressed. Ate at the Brasserie ($40). Went home lonely and despondent because nobody loves me and it's Easter, and I cried.

Saturday, April 18, 1981

Chris Makos had called me at 9:00 from Florida and he was so happy, so he depressed me again. I'm up to ten pushups but my situps are really bad. I moped around, my mind was somewhere else. Started work at 12:30 and worked till 7:00. Rupert got thirty calls and I didn't get one.

Picked up John Reinhold and we went to meet Tom Baker at the Playhouse on West 48th Street to see Sylvia Miles's one-woman show (cab $5, tickets $45). The sets were done well, it was a reproduction of her apartment, it had my Marilyn and the play mentioned me a few times. Then afterwards we went backstage and Sylvia had telegrams up and flowers and posters and

that's just the kind of thing she loves, and I was so embarrassed I hadn't done anything like that for her, I'll have to send her champagne. Then we dropped John Reinhold at home because he felt guilty because it was Passover. Tom and I talked about Jim Morrison and Tom said they'd pick up three girls and then Jim would pass out and he'd have to fuck them all. Stayed till 4:00. Cab dropped Tom ($5).

Sunday, April 19, 1981

Easter. I was in a really depressed mood. It was Sunday so Jed had come and taken the dogs for the day. I cried three times. I decided to pull myself together and go to church.

Monday, April 20, 1981

The weather was slightly coolish so I had on a jacket and my backpack. Vincent talked to our landlord at 860 and he said the fifth floor that's vacant rents for $7,500 a month! We pay about $2,300 for our floor, so I mean, I *really* should buy a building. We need more room for *Interview* and rents are ridiculous. And when our lease is up, ours'll really go up, too.

Janet Villella called and said she'd pick me up in her limo to go to the ABT opening at Lincoln Center.

Suzie Frankfurt called and said that they foreclosed on John Samuels's father's 79th Street house. It was sold on the courthouse steps to the Brazilians.

Tried to find my black tie. Janet picked me up at 7:00.

The most jolting thing that happened at the ballet was this woman came over and said, "Hi, do you know who I am?" and I said no, and she said, "Lila Davies." I went to school with her at Carnegie Tech, and she was one of the people who we all lived together with on 103rd Street in the fifties. She had her eighteen-year-old son with her. They live in Cleveland. And then I felt old, because her son looked like she did when I knew her. I felt old and grey and tired and out of it. And I invited her to lunch at the office. And now I've been thinking that all my problems are because I'm feeling old. And I'm seeing all these young kids just budding. So I've pinpointed the problem.

Godunov sprained his back so he was out, and Gelsey Kirkland was really good. Then Misha did "Push Comes to Shove" and everybody loved that because he's a star. Afterward they were having a free dinner across the way. Sondra and Chris Gilman were there. Anna Sosenko who wrote songs for Hildegarde was there. She's in the autograph business now and when I told her how many *Interview*s I signed a day she said to stop immediately, that my signature will be worthless.

Tuesday, April 21, 1981

They just found another body in the Atlanta killings, the twenty-fifth, I think. And I was thinking about it: If I had a little kid and she was murdered, I would go out and kill the person myself, even if I landed in jail. I would do that. I'm sure of it. It's just incredible that they don't have any clues at all in twenty-five murders.

Brigid had invited Rod McKuen to lunch, he used to sleep on her sofa when he was broke. He just moved to town and he called her up. She went to Balducci's and was really putting on the dog. So we sat there and had lunch and gee, I tried to figure out what was fascinating about him, why he's so big, and I just couldn't.

And John Wallowitch called. I raved to him about seeing him playing the piano on cable TV, and I told him to come to the office. He was calling to tell me that his brother Eddie, my first boyfriend about twenty-five years ago—that he just went down to Florida to visit Eddie and found him bloated and dead in his house. He'd been drinking, gone off A.A. and had a fit. He always got depressed and I never knew why because he was good-looking and he was a photographer. John didn't want to look at the body, so a friend came over and identified it.

I went to Ashton Hawkins's dinner at 17 East 89th Street, my old neighborhood, so it made me feel funny. The real howdy-doody heavy duties were there—Brooke Astor, Laurance Rockefeller, Alice Arlen. And Mike Nichols's hair, I don't think it's fake, it looks so great, so really great. Ashton had a rent-a-maid, one of those old Irish types like from Schrafft's, the cute Irish ladies with the dykey Vassar haircuts in black uniforms and white collars. Brooke Astor said she was trying to save the South Bronx—the old people and the poor people. Mary McFadden was there with her escort, Stephen Paley, and I made believe Bob hadn't told me anything about her divorce, about the guy stealing all her stuff. I said, "You look pretty," and she said, "I'm desperate." I told her to just go out and buy herself a new Yves St. Laurent dress and she started to hit me and she's strong.

Then I asked her if she wanted to arm wrestle and we did and then she started to like me and that got strange. I felt bad because I think I hurt her hand.

Went home. I called Jon Gould at the Beverly Wilshire. Then I went to bed and had the most un-sleepful night. Woke up at 3:00 and had a big glass of brandy and a Valium.

Wednesday, April 22, 1981

Didn't sleep well, I'll have to stop drinking so much coffee and just eat more healthy food and cut out liquor, too. I did my exercises in a hurry and I'm up to ten pushups and then eight and eight situps.

Lila Davies called and cancelled coming to lunch because she had tickets to *Amadeus*.

Friday, April 24, 1981

Passed out *Interview*s this morning. Had to meet Donald Trump at the office (cab $5.50). Marc Balet had set up this meeting. I keep forgetting that Marc gave up architecture to become an art director, but he still builds models at home, he told me. He's designing a catalogue for all the stores in the atrium at the Trump Tower and he told Donald Trump that I should do a portrait of the building that would hang over the entrance to the residential part. So they came down to talk about that. Donald Trump is really good-looking. A girl named Evans was with him and another lady. It was so strange, these people are so rich. They talked about buying a building

yesterday for $500 million or something. They raved about the Balducci's lunch, but they just picked at it. I guess because they go around to so many things where there's food. And they didn't have drinks, they all just had Tabs. He's a butch guy. Nothing was settled, but I'm going to do some paintings, anyway, and show them to them.

Sunday, April 26, 1981

It was such a pretty day. Jon Gould walked me all the way downtown to the office, then he went to the gym and I went to work. I did some Madonnas. Then I went to church for a minute. Chris Makos called and I said I was just too exhausted to make reservations anywhere for dinner, so he did, at Da Silvano. Jon called and he said he was free, so I picked him up at work, and cabbed down to Da Silvano ($8). It's just expensive Italian food that they try to do well (dinner $140). And Catherine Guinness's friend Anna Wintour was there with Michael Stone, and I couldn't remember her name at first, but then I did. She was just hired by *New York* magazine to be their fashion editor. She wanted to work for *Interview* but we didn't hire her. Maybe we should have, we do need a fashion person, but—I don't think she knows how to dress, she's actually a terrible dresser.

Jon dropped me off and I got home and crawled into bed and fell asleep.

Wednesday, April 29, 1981

Brigid said "Jon Gould of Paramount Pictures" had called the office four times and she was snide about it, but I told her we were working on a script together. When I called him back he was at lunch.

And Christopher brought up two barbells and I could hardly lift them. I'm up to two sets of ten pushups and one set of ten situps. Jon called back and said his rented car was towed from 75th and Columbus and that it was my fault because I'd told him it wouldn't be. He thought it was stolen, but then the police called Hertz.

Donna, one of the girls in *Can Can*, called and invited me to the show on Saturday, and I called Tom Cashin to find out if Jed was going, because if he was I didn't want to go. Donna's the girl from *Best Little Whorehouse* who Tom was seeing during the show. She understudies the other girl, and on Thursdays she does a real role.

Faye from Halston's called and wanted to know if I wanted to be his date for the opening of *Little Foxes* on May 7, but that's Jon's birthday. So I asked Faye if I could have an extra ticket because it would solve a birthday problem. Faye didn't sound too happy, I think Halston really wanted to go with just me.

Thursday, April 30, 1981

Went to 667 Madison to Janet Sartin's for a facial. I got shoved in a room and a fat lady made me take off all my clothes. So then Janet came in and said, "This young lady will do you," and this young lady was about sixty-five. She put a hot towel on me and it was like heaven. Janet

looks good—her face is pretty—but she has a lot of crow's feet. And I think it's because she believes in astringent—I'm sure that dries it out. She told me she does Bianca and I said, "Bianca has the greatest skin," and she said, "That's *my* skin!"

Nena and Aurora's brother, Agosto, came down to the office, the one who's small and adorable who was a Marine. Vincent talked to him about a job.

Went home then picked up Jon (cab $4, tickets $60) and went to the Minskoff.

At *Can Can* we had good seats, in the same row as Ethel Merman. I told Ethel I wanted to see her back up there. And then we ran into Donald Trump and the dollar-a-year man for the city who has the building company, Walsh, and their wives. And it was so much fun to see Donald Trump again so soon in a different place. And I chit-chatted with the Czechoslovakian wife, and Jon Gould chit-chatted with Trump. I love going out with Jon because it's like being on a real date—he's tall and strong and I feel that he can take care of me. And it's exciting because he acts straight so I'm sure people think he *is*.

When I got home there was a note from Jenette Kahn to call her when I got in, no matter what time, so I did, and she said Sharon Hammond was getting married to her lord the next day at 5:00 and I was invited to the reception from 6:00 to 12:00.

Monday, May 4, 1981

I had a death threat, I'll get to it.

I ran over to Janet Sartin's for my appointment. Then she came in and said, "Oh darling, your office called about ten minutes ago, Vincent and Robyn, and they said it's very important." So I called them back and they said that that kid Joey Sutton had called forty times. And he'd sent me a note last week—Vincent didn't open it, I did—that said: "Beware of May 5, it's Live or Die." He's been hallucinating a theory that I stole Mick Jagger's song "Miss You" from *him* and gave it to Mick Jagger to record. I don't know what he's talking about . . . I don't even know if this kid really writes songs. He's . . . disturbed.

So after Janet Sartin I went to Sporting World to buy a hat to disguise myself. I got a camouflage hunter's hat ($27). Made phone calls ($2). Called Jon to tell him someone was threatening my life and when I finally got him *(laughs)* he didn't care. People were still asking for autographs, though, so I bought *more* disguises ($15.74) and then cabbed to Park and 18th ($5.50). Robyn was waiting for me there. A Detective Rooney or something like that from the NYPD came over. And Risa Dickstein, she's *Interview*'s lawyer, said she has a detective we can hire, but I'm going to hire Agosto to be my bodyguard and go places with me.

Anyway, I wrapped some presents and then was picked up by Jon Gould and we went to La Grenouille to meet Chris Makos and Peter Wise (cab $6). The place was crowded with funny Miami Beach people. We got an up-front table. And all the other people in the restaurant were jealous because we were having so much fun, they wanted to join the party. We'd brought gifts for each other and we were opening our gifts. For dessert we ordered two soufflés and champagne. And money is the best gift so I gave Jon and Peter each $100 in one-dollar bills. And I also gave Peter $25 rolls of pennies which were so heavy. And Jon I gave $80 of Susan B. Anthony dollars. Jon gave Peter a teapot and a big mixing bowl. I gave them all silver clothespins for their letters.

We were there till about midnight having a good time, and we were blowing bubbles and Marcel the captain got a little mad at that (dinner $400).

Tuesday, May 5, 1981

Vincent hired some security. He didn't want me to come to the office, but I had work to do.

Peter Wise told me that I should get a bulletproof vest, that he knew where you could get them. I was a chatterbox because I was nervous. Went down to 11th and University Place to a funny shop on the second floor (cab $6). Peter had called Christopher to meet me there and take photographs. I bought a bulletproof vest ($270). The guy was really creepy, he said his business had really soared after the Reagan thing. He had dresses and coats and everything bulletproof, and there was a sports jacket I asked him to hold for me, that I'd come back and pick up, and it seems really warm for winter, too. We asked him what else he had, and he said he wouldn't say in front of the media, because a journalist from *Stern* came there with us, so Christopher can't wait to go back there to see what he's got that he wouldn't say. Then Christopher had his bike downstairs but I couldn't even get on it, with my backpack. I called Jay Shriver at the office and he came to meet me around the back of the building. Went up in the freight elevator.

Then it was the busiest day ever. The cop we rented couldn't believe all the freaks we have up there. And there's always some new girl at *Interview* who'll buzz *anybody* in. I called Jon at Paramount, he was in meetings. Bob didn't come down to the office.

Brigid's jealous because I've lost all this weight, but she looks better with her face filled in a little. She got rid of her cat Billy because he was sick with a virus so she's heartless and cruel. I told her, "You're no good." And she just says she doesn't want to talk about it, she's waiting for a new cat to come in at the store.

Jackie Curtis came up and she just has dyed hair, but short. He'd been to Gstaad and had a really handsome boyfriend with her, I don't know how she does it, and she's fat and smelled of liquor and she was limping so it was really pathetic. She brought me a shopping bag. *[Note: when Andy talked about men who wore women's clothes or makeup, he would randomly refer to them as "he" or "she."]*

Oh, and that guy at that shop said he made a bulletproof raincoat for the pope. And disguises don't seem to work for me—I'm going to get a fisherman's hat tomorrow. I think that's the best, like Mr. Winters used to wear.

Picked up Jon on the corner of 18th between Eighth and Ninth and we went to Chris Makos's on Waverly Place (cab $9). Found a Citibank machine and Jon used it, and I've never done one before and it's so exciting, it asks you questions.

Wednesday, May 6, 1981

I called Jay Shriver at the office and he came downstairs to meet me and get me in safely, and the place was busy with people. Lunch was for Sylvia Miles and she was already there.

Jon called and said that he was trying to get a reservation for his Gulf + Western boss Charles

Bluhdorn who wanted to take Barry Diller to dinner at "87" and he wanted to know if I could help him. It's a new restaurant and it's very small and hard to get into. But I mean, no restaurant's that big a deal. So I called Henry Geldzahler, the commish, and he said that okay he would call and try but only because Charles Bluhdorn had given $2 million to the city last year. So he tried and they said it was impossible. So I called Jon back and he was thinking he was going to lose his job, but then Bluhdorn cancelled the dinner anyway.

Cab to the Ritz ($4). Neil Bogart was giving a Prom Night party. Downstairs one of those boring fans was dancing and smoking joints and acting crazy, and he wanted to come upstairs with me but he didn't have a pass. I decided to have a hot dog, it was Nathan's, it was good. And then that kid somehow got up and was sitting with us, and then Eva, the lady journalist from *Stern*, did a great thing—she started telling him that she didn't know what she was doing with the Andy Warhol double. She said she was a second-string reporter at *Stern* and they didn't even get her the *real* Andy Warhol to interview, they got her the double, and what was she doing in such a second-rate position, and somehow he believed her, he just got right up and left, and he wouldn't talk to me for the rest of the night. He thought I was a fake Andy Warhol. Isn't that great? Then we left and I invited the German lady to Xenon for Grace Jones's show.

Thursday, May 7, 1981

Cab to Mercer Street to have my pictures taken with my Myth prints (cab $8). Rupert was waiting on the street corner because he wasn't sure where to go. The people from *Stern* were already there. They just put me in front of the Myths, and I almost threw up, they looked so sixties. I'm not kidding, they really did.

Glued myself together and picked up Jon Gould and we went to the theater to see *Little Foxes*, and there was the biggest crowd. We had first-row seats, in front of Halston and Liza and Mark. Liz Taylor's mother was there, she was cute, like Janet Gaynor. Lots and lots of curtain calls, they would've gone on forever. They dragged Lillian Hellman onstage. Then we went backstage. Senator Warner said hi to me. I told the colored maid how great she was and so was Dennis Christopher.

Jon and I left and went to the birthday party that Lady McCrady was giving for him at 15 or 17 Park Avenue, which is actually the backyard of where I used to live in Murray Hill. And I was talking to this blonde girl for a while and this guy said, "I bet you don't know who you were talking to," and I said no, that I didn't, and he said, "That's Rita Jenrette, the congressman's wife who posed for *Playboy*." She said she lives smack in Harlem—I guess either she has no money or a black boyfriend. She's really kooky and really bright. Jon dropped me home and he came in for five minutes and then he left.

Sunday, May 10, 1981

Tried calling Jon several times. Then I went to Ron Link's play, and as soon as I got home, Jon called, but I was so upset by that time that I couldn't even talk. Went to bed at 12:30.

Monday, May 11, 1981

Made an appointment with Doc Cox for Tuesday because my weight is so down and I don't want to get sick. 120.

Bob had arranged for us to go to a dinner that Earl Blackwell and Eugenia Sheppard were setting up for the Sacklers. I got a limo and was asked to bring a girl so I picked up Barbara Allen and we went to Doubles. I had a black tie on but I should have worn black pants because I had jeans on and those waiters were all looking at me funny. It was a really heavy-duty dinner. All the right people were there. Andy Stein was there and I told him if he wanted to have really beautiful skin he should go to Janet Sartin, and he told me I should go to his gym place, so we're going to exchange numbers.

Then over the speakers came "Happy Birthday," so everyone thought it was Mr. Sackler's birthday, but it turned out they piped it into the wrong room by mistake. I just couldn't take another Taurus birthday, I hate them. A little dancing. Eugenia was so cute, she's a Leo and she said, "My boyfriend is a Taurus," so I guess she and Earl are a couple. I guess it's like a mother. Well, I'm in that category, too.

Then I called Jon and Barbara Allen and I went over to his apartment on the West Side and I spent an hour counting pennies with him—he was balancing his budget—and he was rereading *Popism* and asking serious meaningful questions about it and I couldn't take it, it was too dumb. Left at 1:00.

Tuesday, May 12, 1981

Got up at 7:30 and called Chris Makos to discuss the evening before with Jon Gould. I've offered Chris a reward—this one gold watch he wants—if he can talk Jon into doing something with me, but even if nothing romantic happens now, I still want Jon to move in, because then we'd see what happens from there.

I had a 10:00 appointment with Doc Cox and I decided to get exercise and walk to his office, but it wasn't a good idea, I was overwalked and tired by the time I got there. And the Doc didn't really care about me. His hair was dyed and he was pudgy and he just wanted to hear gossip. He gave me some salve, and then he said I had to get polio, tetanus, and pneumonia shots, and I didn't want to, I said I'd do it some other day, but Rosemary grabbed me on the way out and gave them all to me and she said I wouldn't have reactions, but I felt funny all day.

Wednesday, May 13, 1981

I had a lunch at 12:00, Charlie Cowles was coming with Sid and Anne Bass and when I got down there he was already there, and everybody was gathered around the TV and the pope had been shot. I started screaming, I got so mad—"We lost a portrait that day when Reagan was shot and I don't want it to happen again! Turn that TV off!"

So the Basses came and looked at their portraits, and I have to change some lips and do a whole bunch of new ones. I was down to 119 and I really got scared. My stomach's shrunk.

Ronnie came with me to Art Kane's studio at 28th and Broadway to pose for a ten-page spread in Italian *Vogue*. There was a Zoli model there who was a stand-in for me, and he had a great body. The spread was that this guy was murdering a girl with black panties over his face. The model was the grandson of Goldwater and we're doing him for *Interview*. Then the panties came off the face and it was actually me who was stabbing the girl in the pictures. So it only took an hour for me to do my part, and it was easy—she put her heel in me and it was really fun. Then we left and it was great to walk, it was really spring.

Got a call from Jon in Hollywood. Then I tried to call Bill Copley all day to make an appointment when we could tape for the play I'm dying to do on his life.

I had eight dinner invitations.

Went to Halston's and Liza Minnelli was there. They had a copy of the *Post* there that had "POPE SHOT" in red. It was great. And then we were talking about bulletproof vests. Liza said that she wasn't afraid of blacks *(laughs)* because her father had given Lena Horne a job.

Thursday, May 14, 1981

Chris Makos came up and we went up to the Trump building with Marc Balet to photograph the architectural model of the building to make the portrait from (cab $5). I was so thin I decided to have a Coke and that was such a heavy trip because my stomach had shrunk so much.

Then cabbed to Bill Copley's ($8) and Bill was sober and he's lost weight. He said that in Key West he was smoking and set himself on fire, and he went to the hospital and they treated him and released him and then the wife served him with papers. But he's still crazy about her—he's decided to buy the two surplus portraits of her that I did, I don't know what he'll do with them. Remember, this is the wife who was the ex-madam.

Sunday, May 17, 1981

We went to the Savoy, François de Menil's birthday party at his new club, and it was wall-to-wall people. There were supposed to be 600 people there and it looked like there were, and I think I knew every single person. Earl McGrath, Ahmet and Mica Ertegun, Debbie Harry who's now got brown hair and looks so normal and ordinary, she was cute. Nobody really took pictures of Ina Ginsburg's date, Godunov, I guess they just thought he was a long-haired blond hippie in a black leather jacket. Bob was with the Stassinopoulos lady, the one who wrote the Maria Callas book.

Then I kept running into strange-looking people who said they were "co-owners" of the club and I started getting worried about François.

Philippa de Menil was introducing Heiner as her husband, so I guess maybe they got married. I got drunk and got up to dance and people took pictures. Me with the girlfriend of Stephen Graham. Then the Pointer Sisters came on and sang "Happy Birthday." It was fun to see my boss, Zoli, there—I felt like a working girl. And I went up to John Belushi and said, "You never

remember me," because that's what *he* said to *me* twice when I didn't know who he was. And then we danced together, that was fun.

Got home at 2:00 and Christopher called and said he was just at the Baths. I called Jon at the Beverly Wilshire.

Thursday, May 21, 1981

There was a message for me when I got home that Jon Gould had called and said he was getting the red-eye and would be in New York at 7 A.M. and waiting at 8:00 for Christopher to pick him up to go to Cape Cod. I had so much to pack—costumes, film, cameras, radios, TV—that I didn't get it all done.

Friday, May 22, 1981—
New York—East Falmouth, Massachusetts

Peter Wise was waiting for Jon and Chris and me when we landed. The plane cost about $800, but I paid by check. Peter took us to his house and gave us a tour of the place all the way back to his greenhouse. And we got room assignments, and Vincent and Shelly were planning to come up after work and we spent all day and all night waiting for them.

I saw this big boat on the water that was half painted and it was so pretty and such a nutty boat and it looked like we could have a party on it. Then Peter and Christopher took us around to show us the town. Peter bought chowder at Mildred's Chowder House in Hyannis, which they say is the best chowder place in really all of New England. Vincent and Shelly finally arrived, it took them eight hours to drive up and it should have only taken five.

Saturday, May 23, 1981—East Falmouth

We got up around 11:00 and Peter made apple pancakes, applejacks, for breakfast and we had real maple syrup and bacon. Then we got in the car and went to the flea market in Mashpee. Went to the Thornton Burgess Museum—he wrote *Peter Cottontail*—and fed the swans and ducks with Wonder Bread that Christopher bought. Then we went and had lunch at the fried-clam place at Sandy Neck, and we all had fried clams and fried fish and lots of ketchup and milkshakes and frappés ($35 including tip). Then we drove home.

Peter and I went into another room to talk and while we were doing that we heard all this commotion in the back room and when we went in, there was a big water-pistol fight. Nobody wanted to give up until finally Christopher did give up because he was cornered in the bathroom. Shelly and Jon were winning and they were sneaks. Then Christopher went up to Jon and slapped him right in the face, and it was so dramatic, we just couldn't believe it, and he just stood there taking it, but he said it didn't hurt, that he thought it was all in fun. And he told me that he

has to win at everything, that he has to decide what's right and what's not right, and that if he wants it he gets it and if he doesn't want it he doesn't care, but he has to decide he wants it and that's all he wants. When Chris slapped him I think he really liked it. I think he really does want to get slapped. And then it all calmed down.

Sunday, May 24, 1981—East Falmouth

We went to Falmouth Harbor where we chartered that 70' boat I liked. It took an hour to get over to Martha's Vineyard. And Jon was wearing the set of pearls I gave him that go down to the ground and it looked sort of beautiful on him, he looked like a deep-sea fisherman. We arrived at Oak Bluff where all the gingerbread houses are, and we photographed a wedding. The girl was Irish marrying a guy from South America. Then we drove to Edgartown. We were very hungry. We went across the street to the Colonial Inn and the people there went and got their copies of *Popism* and *Interview* for autographs and I signed them. And one kid even came up with the Tate Gallery poster of my Marilyn (lunch $120). And then we took the ferry over to Chappaquiddick with the car ($5). And we photographed a guy giving us his whole story on where it happened and how it happened and why he didn't believe it. We retraced all the steps to see if Ted Kennedy was really guilty of this accident and we came to the conclusion that he was.

When we got home Jon called his family in Amesbury and then he said his grandfather had had a stroke and his dog had had a relapse so that instead of going back with us to New York, he wanted us to drop him off in Amesbury.

Monday, May 25, 1981—East Falmouth—New York

Took the plane ride back from Hyannis to LaGuardia. Everyone was eating peanuts and popcorn, and all of a sudden the plane actually really flipped over and I didn't care if we would have killed ourselves, because I was so unhappy. I'd thought that this trip would bring some progress with Jon, but it didn't. He'd left us to go see his family who really adore him. Oh, but from now on I can't talk personally about Jon to the Diary because when I told him I did, he got mad and told me not to ever do it again, that if I ever put anything personal about him in the Diary he'd stop seeing me. So from now on, it'll just be the business angle in the Diary—he'll just be a person who works for Paramount Pictures who I'm trying to do scripts and movies with.

I gave a tip to the airplane driver ($100). And tipped the limousine driver ($20).

Got a call from Tina Chow inviting me to a party for David Bailey and his wife Marie. It turned out it was actually a big party. Marie is really beautiful, she had on one of those slit dresses. Eric Boman and Peter Schlesinger were there. I told everybody how I was a male model now, I was trying to hustle work. Jerry Hall came over and told how to suck cock and lick pussy and she told some jokes and it was fun, and then David started telling jokes. Paloma Picasso was there and she gave me a big kiss.

Tuesday, May 26, 1981

Doria Reagan was typing letters for Bob and I didn't even recognize her, I was walking by. She was in a T-shirt and shorts, and she looked cute. I invited her in for the lunch but she said she had too much work to do, she's working four hours a day—she gets things done very quickly.

I went over to 927 Fifth Avenue to the Zilkhas' dinner for the people who own Dior. It was sweet of Cecile Zilkha to invite me because it was really a heavy-duty dinner. Happy Rockefeller was happy to see me. I should have talked to her a lot. Annette Reed had a fifty-carat sapphire on a diamond necklace that was about two inches wide. She was dressed beautifully. She's a sister of the Sophie Englehard girl who's Jane Holzer's friend, the one who's with the black football player who I met in Washington. The ladies were all statuesque. Dina Merrill was with her husband Cliff Robertson. Alex Liberman was there with his wife, Tatiana. Carolina Herrera was there, and I'd brought the new issue of *Interview* and she stole it because her picture was in it.

All the fairies were there. And it was old-fashioned kind of living. If this style of living goes on, it will be incredible. How can it last? The first course was crab meat in tomato aspic and you don't see things like that anymore. And then the chicken with fresh cranberries and rice with nuts, and chocolate mousse with hard crumbled cake, and good wine all served so beautifully. And flower arrangements up to the ceiling. Bill Blass was there and Pat Buckley in Bill Blass. But everybody looked so old. But then, I guess, I fit in. But it's funny they would think to invite me. I'm looking very good now, I could have any of these old bags. I should go after Yoko Ono but I'd probably do it at the wrong time—just when she'd just found somebody I'd call her.

I got home to no phone call from California.

Wednesday, May 27, 1981

I worked on some Lynn Revson portraits.

I finally got a call from Jon in California. I didn't think I'd ever get another one, but I decided we might as well be friendly, it's easier, so we talked about the weather.

Zoli told me how when he first came to New York he actually lived on the roof of Chris Makos's building on Waverly and 11th all one summer because he didn't have any money. There was a way to get onto the roof and there was a good sleeping chair up there.

Friday, May 29, 1981

I called Halston and told him that I'd like to save my invitation out to Montauk for another time because I had to work on paintings this weekend.

Maura Moynihan called and said she loved her *Interview* cover, that it didn't look anything like her. It's one of the best covers Richard Bernstein's ever done. Maura said that she has two boys she likes—one is straight and one is bi, and they're both in her band that she's just left, and she wants them both and they're both fighting over her and they're best friends.

Saturday, May 30, 1981

I had a long philosophy talk with Brigid and we both decided that maybe time had passed us by. When I saw myself in those home movies we took on the Cape last weekend I hated myself so much. Every simple thing I do looks strange. I have such a strange walk and a strange look. If I could only have been a peculiar comic in the movies, I would have looked like a puppet. But it's too late. What's wrong with me? I look at Vincent and Shelly and *they* look normal. And I don't look good in cowboy boots anymore, I don't think. I think I'll get sneakers. I'll have Jay take me over to Paragon to get some.

Monday, June 1, 1981

Met with Marc Balet to show him the portrait of Trump Tower that I'm doing. Marc's arranged it so that the catalogue cover he's designing will be my painting and then the Trumps would wind up with this painting of their building. It's a great idea, isn't it?

Ronnie's going off to Basel to show his work at an art fair with Lucio Amelio.

I was taping Maura for dialogue for a Broadway show I want to do called *Runaway* so we went to the building where her two boyfriends live, and it's the most incredible place, it gave me ideas. It's unbelievable—sixty different rock bands are all in this one building and some nutty guy owns it. We went up three floors and I asked the boys to show me some other rooms in the building, and so they'd knock on a door and say something like, "What do you groove in?" and they'd say, "We're the Spikes," and then another door and it'd be "Bongo and the Bears." They all pay $480 a month for a really small place. I'm going to go back there and really study the building. *Runaway* can be in this building and it'll be the story of who the girl chooses, a love story. It's such a crazy place, you're in the hallway and there's nothing but noise. The bi boyfriend said that he would dump Maura if I could get him David Bowie, and I said I would try.

Maura lives at Louise Westergaard's, who produces with Sondra Gilman—she takes care of the kids, and in return she gets to live there. And she had to get up early in the morning to get them off to school, so we went home. The straight boyfriend asked Maura if it was okay to go home with her, and she said yes. They kiss every minute and they kiss beautifully, with their hands.

Tuesday, June 2, 1981

Got up early. Chris was picking me up to go to the Whitney show of that artist who we've known for a while, the one influenced by me who does the billboardlike Polaroids of faces—I can't think of his name . . . Chuck Close.

And then we also went to look at the Guglielmi thing downstairs. His wife could never sell his paintings, and now here he is, at the Whitney with a big show. I wanted to know if she was still alive, and I was going to ask somebody who worked there and I ended up giving out *Interviews* instead. She used to have me to dinner in the fifties, she was kind of generous. She lived in the Café des Artistes.

And then we looked at the forties show and then you think how much better Chuck Close is than the painters in that show.

Then we went over to the Port Authority Bus Terminal (cab $6). They're still renovating over there. We went into Walgreen's to photograph some of the real people and then we asked the waitress if we could take pictures and she went to ask the manager and he said yes, if we didn't show the name "Walgreen's." But all we wanted to photograph was this waitress and she had Walgreen's written all over her (Walgreen's $7).

Thursday, June 4, 1981

I think I got a cold from drinking a really cold daiquiri. I can feel it, it pierced me.

I called California and was told he was too busy to talk.

Got ready to go right in the neighborhood to the party at Bob Guccione's house for Roy Cohn. Roy was great, I took pictures. I want to be friends with him, but *distant* friends. And there was a Bunny—a Pet—there, and I didn't know what to say to her so I told her she had a great body. Then LeRoy Neiman came over and he was thrilled that we're going to have a *(laughs)* one-man show together and I just—I mean—well, Philip Morris gave this guy some money to do a show of Neiman and me together. Anyway, I won't go to it. I talked to LeRoy about why does Bob Guccione dress like such a fairy with all the jewelry. He had Rembrandts and Mr. Newhouse, Clyde, told me they were reproductions, and he also had Chagalls and Picassos so I don't know if they were reproductions, too. The house has a swimming pool.

And what I forgot to say is the other night I had a blackout like I used to have when I was little. At first I thought it was because of flash bulbs, but there were no flash bulbs really right there, and it got me so scared that I'm having a brain tumor or that I'm getting the *Dark Victory* disease.

Saturday, June 6, 1981

I'm really getting to hate living with antiques, they make you look like the place. They really do.

Tuesday, June 9, 1981

Called Doc Cox's office and asked Rosemary if I could get a B-12 shot before going to Seattle for my show there (cab $3). Rosemary was going to give me a pneumonia shot, it's so you don't get colds and things in your chest. When I'd told them before that I was losing weight they'd told me I should have this shot, but I didn't think I really had to, I didn't take it seriously. I had a fever of 100 and Rosemary got mad and said I might have pneumonia and told me to go right home and get into bed and stay there for two days or else I couldn't go to Seattle. Got a chest X-ray. So I went home and got into bed although I felt okay.

Fred had to come up with papers so I could send my IRS things out. I actually might not go

to Seattle. The Doc said I had to have another chest X-ray on Thursday. I've always had this theory that I can walk through everything, but it's not working.

Wednesday, June 10, 1981

Archie's really acting sick and I don't know if it's because he's worried about me because I'm home, or if he's sick because he wishes I'd get out of the house. Well, my philosophy is, Life is not worth living if you're not healthy, and health is wealth—it's better than money and companionship and love and everything else.

I haven't said that Lynn Revson called and said she loved the portrait but that her cheekbones looked too fat. I knew she'd be trouble.

Got a call from Paramount Pictures again. He's coming to New York on Friday, just when I'm leaving.

Thursday, June 11, 1981

Got up and didn't have a fever. Had an appointment with Doc Cox (cab $3). He took X-rays, the infection was still there. He said not to go to Seattle and California. I was depressed the whole day.

Friday, June 12, 1981

The pneumonia was on the mend. The Doc told me I could go out but that I should be careful.

Jon was back in town and he said he thought I was going away so he'd made plans to go away for the weekend and so I guess my whole relationship's fallen apart. He said he'd call me and he didn't, which was mean. I have to pull myself together and go on. I have to get a whole new philosophy. I don't know what to do. I watched *Urban Cowboy*, and John Travolta just dances so beautifully. It was a really good movie. A Paramount movie, so that made me think more about Jon and I felt worse. I cried myself to sleep.

Now I'm sure I got the pneumonia from that cold daiquiri I drank. And probably if I hadn't gone to the doctor I wouldn't have known I had it and I would have gotten over it. I have a vaporizer in my room.

Saturday, June 13, 1981

Had a horrible day, so depressed. I decided I would explode if I didn't get out of the house and I wanted to go to work.

I was meeting Rupert at the office but he wasn't there yet, so I went in and pressed the elevator button and the elevator was right there on the first floor and the doors opened and standing in

the elevator were two Rastafarians. A man and a woman. It was so strange. So I backed away and went outside and Rupert finally came and then he went in and told them to leave and they just left. I guess they were stoned. They were just standing there like mannequins.

Sunday, June 14, 1981

This day was better and not so depressing. I decided to stay home next to the vaporizer and watch TV. I decided to watch cable TV and see what a Neil Simon movie is like and so I watched *Chapter Two* and it happened to hit the spot. I liked it a lot. The lines are really funny. Then the phone rang and it was Jon calling as if nothing had happened, as if he hadn't gone away for the weekend and not called once.

Monday, June 15, 1981

When I got to the office Robyn was just so out of it. He's a sweet kid, but his mind's not on his work. Jay Shriver's a good worker, though, and you can trust him.

Richard Weisman called and said that Margaret Trudeau was in town and would I like to have dinner. Jon called and I invited him and he said it would be fun to meet Margaret Trudeau. Went to meet everyone at George Martin's restaurant at 9:10. Margaret arrived and she was a little heavier. I think she should go back to her thin look, because now she looks a little older. She was with Bruce Nevins who used to say he'd give us Perrier ads, but he didn't. And George Martin came over and it was so exciting, he introduced me to Rick Cerone who said, "I want you to do my portrait." He was really nice.

Bianca was there, too and finally, for once, Jon wasn't complaining that he had to go home to work. So finally I said that I was tired and had to rest so we left.

Tuesday, June 16, 1981

Got up early, went to a 10:30 appointment with Doc Cox. I was feeling fine, took my own temperature, and it was normal. The Doc said the pneumonia had completely cleared up.

Then I went to meet Jon at Citibank on the corner of Park and 57th, where he was getting a loan. It used to be my bank and it still is, sort of, because I have a safety-deposit box there which they haven't sent me any notices about for a long time. I should see about it. I think it has my deed to the house on Lexington and 89th Street. When I used to go to this bank there was just a teller, and now there's lines around the block.

Ran into Pat York. Ran into Gene Simmons of Kiss. Ran into an old rep of mine.

Eva from *Stern* sent over the article she wrote and I just couldn't believe it. I mean, I poured out my heart to her and she wrote the kind of rehashed article, you know—"Father died in coal mines/Warhola/Carnegie Tech"—and I poured out my *heart* to her. I actually gave her a good interview because she kept saying she wanted to do something really *different*. I mean I even *told*

her that my father was a construction worker, and *still*—"Father died in coal mines." I mean, I only gave it because I liked the guy who has *Stern* who was so nice to us in Munich. The one who's doing the liquor that'll last till the year 2000. And she didn't put in any of the *young* things that we did. The modern things. I mean, we had that great night at the Ritz which was really interesting where she told the kid I was an Andy Warhol double—and she didn't even *use* that.

I went to see Janet Sartin and confessed that her treatments weren't working, that I had eighteen pimples and that I'd gone back to my Orentreich methods because he has that stuff that dries them up overnight.

Did some Gun drawings and Gun paintings.

Oh, and I heard that Jed's sister Susan is marrying Mel Brooks's son! I mean if that spoiled girl lands on Easy Street I just won't be able to stand it.

Wednesday, June 17, 1981

Fred is going off to Europe and I don't know why. He should be staying in town, seeing to business. But for some reason he thinks he's part of the London scene. For some reason he identifies with all those English kids who sponge off him. And we never get work from England from any of them. I don't know.

And Tom Sullivan died. At twenty-four. His heart failed.

John Reinhold invited us over for drinks to see his Michael Graves apartment. So we went over there and it used to be big rooms and Michael Graves turned it into a railroad flat. Really, if you've ever seen a cold-water flat, that's what this looked like. Eighteen million columns and doors that open and things that swing out and a million details, and so many different colors, it was ridiculous. I mean, it'll probably photograph well, they can make it look really big, but he took these great Robert Stern rooms and made three rooms and eight closets out of it. I mean it's really detailed, and you can't believe how detailed, but it just—I don't know what it's supposed to mean. I got tired. Went home at 11:30, had some codeine cough medicine and went to bed.

Thursday, June 18, 1981

Went over to Tiffany's. Paloma's jewelry looks good, actually. There's nothing different about it, but she does have a look. Elsa's stuff is selling. Margaret Truman's son who we met once was selling envelopes there.

Finally talked to Jon. He said it would be okay for me to come over while he packed to go to Robert Redford's Sundance Foundation. So then I got a brainstorm and I went to Côte Basque in the Olympic Tower and got lunches ($25). Cabbed to Jon's ($3). Watched him pack and he threw a tantrum because his Armani pants were one inch too small. I couldn't believe it. I decided to water his plants. He was getting a 4:30 plane so I dropped him at the Gulf + Western building and went down to the office (cab $6).

I haven't had any liquor for a while and I feel wonderful. But then, I don't know, maybe I'm high on antibiotics. I don't know what's making me feel good.

Went to the Kennedy dinner at the Metropolitan Club. Caroline Kennedy came over and she was so much fun. And Ted Kennedy came over and he was adorable. Caroline was next to a Chinese surgeon who couldn't see, but they said he was still operating. His wife was cutting his food for him.

Tip O'Neill gave a speech, he was good. He said a twenty-minute joke which actually wasn't funny, but it was great delivery. And Bill Bradley was there, he said he had Rauschenberg and me both on his walls.

Senator Moynihan's losing weight, he was great, adorable. This was a $1,000-a-plate dinner. They had folk dancing and Irish jigs. Then this Indian called Hassim wanted to dance with Caroline and she turned him down and then he said, "Well maybe you'll dance with my son," and he brought over this really great-looking son. The father said that in the early sixties he was a poet and that he'd come to the Factory and that I'd ignored him. I don't remember. Then Caroline got really interested in him because he was talking about magic things, you know, Harvard-style, like what a light bulb was before it was a light bulb. The guy's wife looked like me, but more refined. Very white skin. Like a Czechoslovakian beauty. I left and went home. I waited for a call from Jon and finally it came at 2:00 and then I could go to sleep.

Friday, June 19, 1981

Waited for a call from Utah from Jon. He called and he seemed really nice.

I'm not drinking and it feels so great, but I've got to try to stop taking Valium. And I'm losing weight even though I'm eating, which scares me, because I don't know if it's because I'm not drinking or then maybe it's also because of the antibiotics. But then, I do like being thin. Although your resistance is lower. I guess you should lose it slowly over a year.

Saturday, June 20, 1981

Fred should be around to take care of things instead of being in Europe. Fred really thinks he's English royalty, that's what it's become when he drinks. He identifies with them and I don't know why.

Chris Stein showed us some 1950 Weegee photos and they were just great. Weegee was the newspaper photographer who would get the first radio call to all the crimes and things, and so he would get those kinds of photos. Most of the pictures Chris bought were of a Greenwich Village party, and you'd think you were looking at pictures of a 1980s party—it looks just the same! It's funny that things really don't change. I mean, people think they change, but they don't. There were people wearing clothes with safety pins in them and two boys kissing in a window and a woman looking on, and then it was called "Living in Greenwich Village" and now it's called New Wave or something. But it's the same.

Sunday, June 21, 1981

I notice that my skin is better when I use the vaporizer, it keeps your nose clear and keeps your skin from drying out.

Jon called finally and said he was back from Utah, he was at the Gulf + Western building, and he gave me some song and dance about how he was too tired to come over, how he'd lost his luggage and his keys, but he had too much spunk and the song and dance was just too hard to handle—he said it was raining and it wasn't raining—and I just decided that that's the end of that. I went to bed with Valium.

Monday, June 22, 1981

The morning was just a disaster, I had the worst night's sleep ever. I shouldn't let these things happen to me, but ... And my weight loss is still scary. I mean, I like being thin, but it's scary.

Got a call from Jon and he apologized for not coming over and said that maybe we could work things out. We made a dinner date. He came over and we had a serious talk. He was in his running suit. We went to Le Relais, and they didn't mind that he was dressed that way. We sat down next to Edmund Gaultney. Then Rita Lachman came over with a Xerox of her invitation to the Prince Charles-Lady Diana wedding. Bob said she keeps the original in a vault. I just know they're going to disinvite her—say it was a mistake or something (dinner $59). If you don't drink, meals are so cheap.

I had an interesting talk with Jon. He said that I wasn't a serious enough person, that whenever he would say something significant I would make a light comment. So I'll have to try to be more serious. We talked about the movie business. He hates being caught between Barry Diller and the other boss.

I'm having a vaporizer on all the time now, I really think it's helping my skin.

Thursday, June 25, 1981

Had to sign the Gun painting for Chris Stein. Debbie Harry had given me some hair-removing wax. I'm using it all over and it really hurts.

Friday, June 26, 1981

I got my B-12 shot at Doc Cox's, only Rosemary missed and I got black and blue and a bloody shirt. On my way out a guy tried to pick me up. He said he was a record engineer and that he lived with a private investigator, and that the private investigator makes him get dressed up in drag sometimes for entrapment but that he was sick of it. I got away from him.

Then I got a call from Jon and we were supposed to go to a movie but he said he was on the verge of pneumonia, so he couldn't go out, so I said I'd bring the transcripts of my tapes of Maura

Moynihan over for him to work on while he was in bed. We're trying to see how all this dialogue can be turned into a play. So I dropped Rupert off (cab $6). Went to Jon's and stayed there a couple of hours, and got to bed at 11:30.

Thursday, July 2, 1981

One of the B-52s came to the office and bought a Spacefruit portfolio. And he always thinks I'm abstract because I never know who he is. His name's Fred. He's a friend of Jay Shriver's girlfriend, Karen Moline.

I went to Mick and Jerry's party at Mr. Chow's (cab $7.50). I had fun chatting about abortions and sex, but I have to get off those subjects and talk about politics or something, because when I read interviews that I do, the questions I ask are so awful. Stupid. Somebody besides me, if they could spend a day taping the person, would do a better job. I'm down on myself.

Saturday, July 4, 1981

It rained and rained. It was the day of Averil's wedding to Tim Haydock. Suzie Frankfurt was getting us a limo out to Manhasset.

Got a call from Christopher on the Cape. Peter wants to stay up there all summer and work on his art and take care of the garden which hasn't been taken care of since his father died. If he stays up there all summer and makes art and then comes to the city and sells it in the winter, he thinks it's a good plan, which it is, but Christopher can't stand family life and Peter's mother's up there and even though she likes the idea of Chris and Peter being together, Christopher just doesn't like family life. His father's Greek and he lives with a Chinese guy and his mother's in California, she's Italian.

Went out to Manhasset. Averil looked beautiful. The Kennedy boy who traded ties with me at his brother's wedding was there, wearing the tie I'd traded him, so he was imaginative. He said he was always going to wear it to weddings. I should have worn his. Catherine was there, she was a bridesmaid and her hair's lighter, so I guess she dyed it.

The boys had to pick up the girls and take them to their seats, and they were (laughs) about to take me until they realized I wasn't a girl, after all. They played "America the Beautiful" and everybody talked and yelled during the ceremony. Averil's whole family was there, so tall. And Fred was there in his morning coat. And Vincent and Shelly. And Rachel Ward was a bridesmaid, she just finished a movie with Burt Reynolds and now she's off to California to star opposite Steve Martin, so she's really made it. Jerry and Mick were there and Jerry's just dying to get married herself, you could feel the tension.

It was pouring rain and we went in the limo to the reception. It's such a great house. Talked to Catherine, she said Winnie wrote her a letter about Tom Sullivan dying that began: "Somebody who loved you so much is dead." Which was the exact same note she sent me. I don't know why Winnie's bothering, it was like a form letter.

And I was telling John Samuels—John *Stockwell*—that I thought he would have made it as an

actor by now, and he said, "Listen, I'm only twenty," and then I realized he was right! I keep thinking he's like twenty-five. He invited me to his father's house over on West Island in Glen Cove where a lot of people at the wedding were staying for the weekend. It's the ninety-room Morgan house and there's like thirty guests and one servant—Nona Summers was saying how she mentioned she'd like breakfast in bed and everybody laughed at her. And John Samuels told me how Michael Kennedy was swinging on the chandelier, but then when you go to *his* house they say, "Don't touch that—it'll break!" and they're pointing at some cheap chair. He says that they save all their destruction for when they go visiting, that that's why they're always so rowdy wherever they go—because they're so careful around their own things.

All the kids were dancing and swimming naked. At 8:30 it was still raining. Then we left to go home and a boy jumped in the car, sat in front, I don't know who he was. We gave him a ride home.

393

Sunday, July 5, 1981

At 12:00 Jon called and said he'd come over and we could go for a walk. He's gained ten pounds and I've lost weight. I'm back to 118 again. I should eat but I'll have to think about it, because I like being thin.

Wednesday, July 6, 1981

Victor is on jury duty. *(laughs)* Can you picture that?

Cabbed to 666 Fifth Avenue, to Halston's screening of Liza's movie *Arthur* ($7). I loved the movie. Dudley Moore is so funny. Afterwards Jon said it was a "slight movie" and I said, "But you were laughing all the way through," and he said, "Well, it's no *Raiders*."

I don't know what's happening with Jon. Things just coast along. But I just *have* to be in love now or I'll go crazy. I just have to feel something. And I'm really jealous because Jon has a family he loves and likes to see, but my family, when they try to visit me, I always say I'm out of town. Have I ever told the Diary that Jon is a twin? Isn't that sick? Just like Jed. And guess what the twin's name is: Jay.

Wednesday, July 8, 1981

Jerry Hall came by with a Halston model named Carol, and models just all talk that baby talk, the girls *and* the boys—you always know you're talking to a model.

Got a cab and the driver was complaining because the woman wouldn't pay the surcharge that's supposed to go into effect after 8:00 because they said it was one minute before 8:00. He said it was two minutes after, but I showed him on my watch that it was one minute of. I've got to start getting receipts ($6). I carry my own pad.

Everyone tells me they like my hair this new way. I cut it every day. It's almost a crewcut. Fred

said I dress like the kids I hang around with now, he likes it. I guess the preppie look really is big because of the *Preppie Handbook*. I'm wearing all of Jed's leftover clothes, the ones he left behind. I'm so skinny they fit me now.

Thursday, July 9, 1981

Halston invited me to Montauk, so I'm going at 6:30 on Friday with him on his rented plane. It's so nice to be invited to your own house by the person who's renting it—you feel at home and you're still making money. I invited Chris Makos and Jon.

Friday, July 10, 1981—New York—Montauk

When we got to Halston's house he looked at Christopher and said, "Oh, are *you* coming?" which put a damper on Chris and on me, too. I'd called Faye at Halston's and also Victor to say I was bringing him.

There's a fruit stand that some local people set up at the entrance to our property and it looks so tacky. Otherwise everything's the same, it's so beautiful.

Saturday, July 11, 1981—Montauk

Went to the kitchen for coffee in the main house. Pat Cleveland was reading her Latin books and her mind-control books. I told her about the Silver Mind Control Place in New York that Jon said he went to. What's that name? Silva. Silva Mind Control. She was after Jon, showing him how to walk like you have a dime up your ass and they did that well. She talks model talk. And she plays the flute. Only three notes. And she does yoga. All those things. She took off her clothes and they were nude sunbathing and fucking the rocks. She had a great body and Jon had one, too, and Chris is a little fat but it's a good body and I had on my white protector and I was safe except for my feet which got burned because I walked. Had lunch with Halston, he was adorable. I tried to read scripts. Took a walk on the beach over by Dick Cavett's. Jon said he had to go back to town but Chris and I convinced him to stay another night.

After dinner we watched *Grease* and at 12:30 I decided to go to bed early.

Sunday, July 12, 1981—Montauk—New York

I was tired because I'd tried to sleep on my back last night so I wouldn't get wrinkles, but it's just too hard, I'll never do it. The plane came at 9:30 in the morning. It was a beautiful day, the ride took forty minutes and we flew over all the rich estates ($500 plus $20 tip).

Brigid called me, she'd just gotten out of the hospital. She has gallstones the size of grapenuts. She said they want to operate. I told her that they *always* want to operate, that it's like doing

portraits, you don't care who you do as long as you have someone to do. Because that's where they make their bucks. I told her to ask the doctor for painkilling stuff but she said she already did and they wouldn't give it to her, they said they needed to know if she had pain so when she started having it they could give her the operation. I think she should get it in September unless it's really hurting her. Life is just too hard. Called Rupert.

Then I got the book of my old paintings out and saw all the clever things I used to do, and I just can't think of anything clever to do now. Maybe I should do Soup Cans again. Then Chris Makos called and said Schnabel was big, that abstract expressionism was coming back. And he said that he would bring a can over for me—Campbell's Won Ton soup that has the oriental lettering.

Called Jon and nobody answered. Saw a wonderful movie on TV, *Coal Miner's Daughter*, and I wished I taped it. Oh, I wish I was married to a husband like that! Oh, he's so cute, so wonderful.

Monday, July 13, 1981

Did forty pushups.

Glued myself together and picked up Jon and Catherine Guinness on the corner of 63rd and Park. She looked like a floozy. She's still the worst dresser. These English girls don't know how to dress. She had on a red floozy skirt and backless shoes and her new blonde hair and these costume jewelry earrings with diamonds that her mother gave her. She was sweet, talked and bubbled for hours. Let's see, the gossip, she said Fred was seduced by the most beautiful girl, Natasha Grenfell—Zeffirelli is her godfather, and Tennessee Williams is, too. We had a nice time at Xenon (cab $4) seeing John McEnroe at a tennis charity thing.

Wednesday, July 15, 1981

I tried to work out the Newport thing that Bob got me involved in with the Pells next weekend, it's an anti-suicide thing, and I told Bob how could he do that, since he knew I was *for* suicide, and he got crazy and didn't know what to say. He said I'd better not open my mouth. And I guess I better not kill myself, either.

I'd gotten Mary Richardson an appointment to see Halston about a job because she'd asked me to, but then she said she'd had lunch with Bill Blass in the meantime and he was going to pay her $500 an hour to model, and so she was thrilled about that and wasn't even going to see Halston. After I'd gone to all the trouble of getting her the appointment. Mary decided to give a small dinner at Fred's which turned out to be a big dinner and she invited me and Fred got mad because he said he'd have to fix the house up so I wouldn't be upset when I saw it—he's got all these English kids staying there, it's like a rooming house.

At Fred's, Steve Aronson was there with Shelley Wanger and her new boyfriend David Mortimer, who's so good-looking. Then Steve—oh God, he knows everything and he remembers just what you don't want him to. He looked at Jon and said to me, "What did you say his name was? What's that name? Isn't *he* the one you told me thought that *Popism* was badly edited?" And I

said, "Ohhh, *please*, Steve, not now." And the thing I can't understand is why I would have told Steve that and even said Jon's name to him. That's fascinating. Why would I do that? Why would I beg for trouble?

And when Steve heard that Fran was going to be on the cover of *Interview* he said that he wanted to be on the cover, too, when his book *Hype* came out. So then he was going on about how he had checked into Jon—into exactly what his job *was* at Paramount—and how he was a "vice-president in charge of inter-office memos" and finally I told him that if he didn't shut up I wouldn't put him on the cover. So then he said he just interviewed Roy Cohn and that he was going to ask him, "Aren't you a big fag?" but then he ended up liking him and he didn't, so he still had the leftover question and he asked me if *I'd* like to admit that *I* was.

Thursday, July 16, 1981

At the party after the screening of *Endless Love* I talked to Don Murray and I said that I'd just read in the paper that Liza was thinking of doing a remake of *Bus Stop* and I said that if she at her age could play the girl, then he could still play the virgin cowboy, and that he should go find her and tell her. And he laughed. He's still so good-looking and tall.

Monday, July 20, 1981

Got up. On the news was the tragedy of the weekend, the hotel walkway that collapsed in Kansas City and a lot of people were killed. Oh and I'm reading in the *Enquirer* about Kate Jackson and Andrew Stevens. Kate was out with us at Halston's in Montauk this past weekend. She was with Rock Brynner, Yul's son. Kate will do things like look at the ocean and say how beautiful it is, or go out alone and stare at the moon or walk along the beach alone and pick up a rock and throw it. *(laughs)* I'm serious! That kind of corny thing. I don't know. She's from the South, but still. . . .

I stopped at John Reinhold's office to hear the news about the new diamond discovery in Australia, and diamond prices are down. Went to the office (cab $5).

I was really upset at Rupert because he's gone away for weeks to Jamaica, and now half of his assistants are going on vacation, too, and I got really mad at one of them, Horst, because I was telling him that Rupert better watch out, and if they couldn't help me that I was going to find myself another silkscreener. And Horst was laughing at me like a German—he said, "I should have brought you a rose, so you would be in a better mood." And I said, "Look, don't tell me about *roses*—Rupert got the job in the first place because Alex Heinrici went on a vacation—a *long* vacation just like this one that Rupert's taking—and I just looked around and found somebody else. And I can do it again."

And I blew my cool all day—I hung up on a few people, but it'll be good for their memoirs.

Tuesday, July 21, 1981

Got a call from Jon cancelling out on our Newport trip.

Wednesday, July 22, 1981

Got up early, it was a pretty day. I was going to go walking with *Interviews* but I had a lunch date with Mercedes Kellogg and she brought the von Bulow guy, the one who's accused of trying to kill his wife with insulin, she's been in a coma for months. Ala von Auersperg is her daughter from her first husband and she and her brother are accusing him. He's about fifty-five, I think. He told anecdotes.

At 4:00 the Walt Disney film crew came and shot me in front of my Shoes and my Walt Disney drawings. They asked me who my favorite Disney character was and I said, "Minnie Mouse, because she can get me close to Mickey."

Friday, July 24, 1981

Jon came by and showed me his new car and we went for a ride. Still nothing's happening and I'm getting to think that I'll just relax and not expect anything, that it's enough to spend time together. I don't know.

Monday, July 27, 1981

Ran into Winnie Sullivan on the street. I thought she looked a little fat. I asked her how she was doing, did she really miss Tom a lot and she said, "He died but I'm pregnant." I asked her if it was Tom's baby, and she said, "I've been seeing a lot of Jack Nicholson." She's very calculating, Winnie. But who knows, maybe it *is* Jack's and he'll marry her. She's very pretty.

Saturday, August 1, 1981

I'm up to five sets of fifteen pushups. And I told the office that they better not be planning anything for my birthday next week, that if they did I wasn't even going to come down.

Sunday, August 2, 1981

Jon jogged over from the West Side. Chris Makos picked us up at 3:30 and we went to the Whitney to see the Walt Disney show (admission $8). It was really crowded and it was funny to see Walt Disney stuff on the walls. They didn't show it off too well, though. Mostly Mickey Mouse.

Then we saw the Georgia O'Keeffe show on another floor and she does these flowers and slashes and all she does is paint vaginas. And we saw some other people's stuff and you can tell the girls' stuff always because it's simple things, it's the easy stuff. You can tell.

Then we took a ride and we wanted to go to the River Café but they were done serving, so we stopped someplace outdoors in the Village and the food was awful ($70). But we watched

everybody, people with great chests, just back from Fire Island and people cruising in gym shorts with their balls hanging out on purpose—horrible-looking people.

Then we cabbed to the trendy West Side just to be seen—Columbus Avenue—it was eighteen deep, people walking. It's like the 1930s with people trying to be discovered, doing their acts on the street.

Monday, August 3, 1981

Walked down Fifth Avenue and when I walked into a record store they had on "Heroin" from the Velvet Underground's first album, the one I produced and did the cover for. I don't know if they saw me coming and then put it on quickly or if it was already on. It was so strange to hear Lou singing those songs and the music still sounds so good. It brought me back. Then they asked me to sign the album. It's still the original cover with the banana that you can peel the skin off. Does MGM keep reissuing it? I never got any money at all from that record.

Tuesday, August 4, 1981

The Herreras were back from the royal wedding and they invited me to dinner with Jerry Zipkin and said they'd call at 6:00. I said I'd go but I knew I'd cancel because I'm so tired of elegant people, I just wanted to be with some kids.

Then I ran out of *Interviews* and I was near John Reinhold's so I stopped in and we went into the McCreedy and Schreiber shoe store on 46th and just sat there for an hour because it was air-conditioned. I decided that being a shoe salesman is really a sexy job, sort of, even for a guy doing girl's shoes. Stopped in at Jean's and looked at a watch.

Jon has gone off to California.

Wednesday, August 5, 1981

The Trumps came down. Donald Trump and his wife and two ladies who work for him, I guess. Mrs. Trump is six months pregnant. I showed them the paintings of the Trump Tower that I'd done. I don't know why I did so many, I did eight. In black and grey and silver which I thought would be so chic for the lobby. But it was a mistake to do so many, I think it confused them. Mr. Trump was very upset that it wasn't color-coordinated. They have Angelo Donghia doing the decorating so they're going to come down with swatches of material so I can do the paintings to match the pinks and oranges. I think Trump's sort of cheap, though, I get that feeling. And Marc Balet who set up the whole thing was sort of shocked. But maybe Mrs. Trump will think about a portrait because I let them see the portraits of Lynn Wyatt behind the building paintings, so maybe they'll get the idea.

Jon called from Hollywood.

Thursday, August 6, 1981

It was my birthday and I'd told everyone at the office that if they even mentioned it they'd be fired. Brigid had wanted the day off but I was Mr. Grump. I let everyone off five minutes early. And the funniest thing was that in the morning Brigid went to the delicatessen and over the radio the DJ said, "And happy birthday to Andy Warhol who's sixty-four years old today," so she was laughing that they'd even added eleven years on.

John Reinhold sent me 500 carats of diamond dust for a present. It's like half a can of tomato soup-size. And he sent me twenty-seven roses. Diamond dust can kill you. It's a good way to murder somebody.

Got a call from Hollywood. Jon didn't remember my birthday which was great.

Saturday, August 8, 1981

Jane Holzer called and said that I should come over to 4 East 66th Street where a kid who goes to Columbia Film School and a group of his friends were filming an underground movie with expensive 35mm equipment. I went over and got depressed because here it was twenty years after *my* underground movies and here were young, pretty, rich kids—even richer and in bigger apartments than the kids who'd been in my movies. And we could hear them saying that they didn't want the old people in front. I got sort of depressed and left.

Monday, August 10, 1981

I had to photograph the Halston and Galanos things for *The Los Angeles Times*. Jon picked me up and we went to Halston's. Halston had his limo waiting but Liza was late. He was on the phone with Liz Taylor and she called him an asshole so he called her an asshole and he said that her asshole was bigger than his and that I should take pictures to prove it. It was funny hearing them talk like this, that's how they talk to each other.

Went to the Olympic Tower to the party. Hope Lange was there with John Springer. And Christopher had just told me that on *Live at Five* that afternoon Hope Lange was on with Jack Cafferty and she said, "Wasn't it Andy Warhol who once said that everyone would be a celebrity for four minutes?" And so John Springer brought that up and said that it was actually ten minutes, and then Hope laughed and said that TV was making life go by faster anyway. She was kind of great. Sort of matronly-looking now.

Lauren Bacall and Harry Guardino were there. Marty Scorsese was there with his wife Isabella Rossellini who's modeling now. I wonder what Julia's doing. How can a Catholic keep getting married? Bobby De Niro came in and I sent Pat Cleveland over because I know he likes black girls, but she was drunk and scared him away. At 2:30 I left. I'd had champagne and now I have a champagne headache, I really hate to drink.

Tuesday, August 11, 1981

Got my live-in contacts but I can't read or draw in them. Do they have bifocals you can wear with contacts? It's so scary to wake up in the middle of the night and be able to see.

Walked partway to the office (cab $3.50). I painted some backgrounds for the Diana Ross portrait—I wonder what color I should make her—I wonder if she wants to be black or white.

Then I went up to the Con Ed building that's for sale on Madison, and it turns out there's three entrances—one on Madison, one on 32nd, and one on 33rd. It makes a T shape in the middle of the block. There was a bum with no shoes sweeping up the sidewalk. They all hang around there, I guess because nobody chases them away. We couldn't get the doors open, though, so we went to 22nd Street and Sixth Avenue to look at another building. That one is $1.9. Then we went back to the office. In the awful heat.

Wednesday, August 12, 1981

I can't face *Donahue*. It's *(laughs)* Retired Gays this morning. Gay old people at a summer camp.

I'm 115 pounds now, I can feel my nerves grating against my bones.

I went to a Chinese opera at Lincoln Center and Stella Adler gave a speech. She's in her eighties but she looks young like Angela Lansbury. And she had the Chinese director's name written on her hand and every time she said the guy's name, she had to look at her hand.

Thursday, August 13, 1981

Maura Moynihan was supposed to be getting me tickets to the opening of her play, but somehow she got out of inviting me. She said her father was going to be there and I think she was afraid of me being there with her father.

I waited for Rupert to come in with the positives. I saw that in my photographs that came back from the printer there were some personal pictures of Rupert's vacation in Jamaica. I guess he sends his own pictures in to be developed with mine, but I'm not going to give them to him, they're pictures of him carrying on.

Jon went to the country for the whole weekend.

Saturday, August 15, 1981

I'd gained weight and gone up to 119, but I like the way I look better at 115 so I decided not to eat. Worked all afternoon on Greta Garbo and Mickey Mouse and Diana Ross (Brownies $15).

Sunday, August 16, 1981

I walked to church. Cabbed down to meet Rupert at 1:00 ($5). I called Fred in East Hampton and told him what a bad deal he'd made with Ron Feldman, that I was with Leo Castelli and that I wasn't supposed to be having a show with Ron Feldman in the first place and that having such a *big* show of mine would make his gallery famous, and that the pictures were too big and too awful. Ron has me down for a show on September 18th or something. I did backgrounds for Superman and Dracula. I have to do at least four a day to catch up.

At midnight I got a call from Jon, he said he'd done some work on the script and so I went over to pick it up (cab $3). I was back home at 1:05.

Monday, August 17, 1981

At 11:30 I had an appointment to see the Con Ed building on 32nd and Madison. It's a beautiful building, but buying it would be like buying a beautiful piece of art, this beautiful space. And it has a main big T-shaped room that could be a great *Interview* office, but you can't rent anything out. It goes up five floors and there's no heat, it's just like one shell, but it's so perfectly beautiful. I could put in hot air and toilets and it would be an artist's space. But then I think about the building at 895 Broadway at 20th Street and it's just a normal substantial building, and it has five floors, all rented, and then I'd have rent coming in, and we could get one of the floors to move out for us. But this Con Ed one was like a fortress and the best thing was eight pay phones in the corner newsstand where you could *(laughs)* send people to make their calls.

Susan Blond called to invite me backstage to see Michael Jackson on Tuesday and Wednesday and she wants me to get Liza Minnelli, but I haven't been able to. I'll try again, though.

Bed at 12:30. Fell asleep, then woke up and had watermelon, then went back to sleep.

Tuesday, August 18, 1981

It was a really beautiful day, the weather's still good because of the fairy hurricane. Dennis.

Picked up Jon, went to the St. Moritz to Allan Carr's penthouse. He was having a party for the two stars of *Gallipoli*, Mark Lee and Mel Gibson, and then a screening of the movie afterwards.

Cabbed to Madison Square Garden ($5). Susan got us backstage and she was screaming that Katharine Hepburn was backstage and that if I didn't hurry I wouldn't have my picture taken with her, but I missed it all. Michael Jackson introduced us to his brothers, they all said they wanted portraits. Michael's gotten so handsome since I saw him that time with Stephanie Mills.

We went out to the audience and it was hard to get our seats. We had to kick kids out of them. Michael's show was maybe the best I've seen. He's such a good dancer, and he goes into a hole and comes out the other side in a different outfit, I don't know how he does it.

I was dropping Jon off and as we passed Columbus Circle I saw Mark and Mel, the two stars of *Gallipoli*, alone, just sort of wandering, and it was sad. Their party was over and they looked lost, like they didn't have anywhere else to go.

Thursday, August 20, 1981

I worked on the Wicked Witch and on Howdy Doody, and Rupert brought Mickey and the Garbo and they look great, but I can just see the reviews, I know they're going to say, "How can it be twenty years later and he's doing this stuff *again*?" And we had to work on Ron Feldman to give us money, and finally he said that when the paintings were finished, he would, and I really can't stand doing this show at Ron Feldman's, it's just publicity for his gallery and he should be paying a *lot more*.

Marlon Jackson came down and he brought T-shirts and was so cute. He was supposed to be coming to get a portrait, but he didn't know how to bring it up and I didn't know either. We really want to get Michael on the cover of *Interview*. Marlon looks like fifteen but then he said he has a wife and three kids and she's expecting another.

Monday, August 24, 1981

Debbie Harry's *Newsweek* article came out and it was strange because the article mentioned me about eight times, quoting from the *Philosophy* book and saying that she worked at Max's. And you know, Debbie isn't really interesting to talk to, but her interviews always come out right. It's like they did with me, they pick up the right one-liners, and the words sound good in print. Debbie and Chris just bought a house on 72nd between Second and Third, so they're rolling in bucks.

Got two *Gentleman's Quarterlys* ($5) because my picture was in it as a model in the Barneys ad and I liked it a lot, it was exciting to see.

Jay's great because he finally knows how to paint like I do so he helps me out of some tight spots. Ronnie always does it so crude. I talked to Jon who I think was avoiding me. I think he wanted to do something else in the night and he didn't want to work on the scripts, but he said I could pick one of them up later on.

Brigid's working on the Maura tapes and she thinks they're interesting, but I read them and I don't. I think those kids take a lot of hallucinating drugs—things like acid and magic mushrooms.

Wednesday, August 26, 1981

I'm just so undecided between those two buildings, the one on Madison and 33rd and the 895 Broadway one. Because the one on Madison is so great and big and artistic, and it might be a goldmine, across from the Empire State Building, but then it'd cost so much to fix it up and how would you do it? But they do have a 12 percent mortgage we could get which would make it good. But then this 895 one is practical, it's $1.8 as opposed to the Madison one which is $2, but you'd have floors renting and the income coming in. I don't know. And Fred's in the same dilemma.

Thursday, August 27, 1981

There was a lunch for Sharon Hammond who's now the Countess Sondes. Lady Sharon said she has a Nautilus in her house and that we could use it. It's $20 an hour because a lady comes who shows you how to do it.

We decided to get the building at Madison and 32nd. So that put me in a nervous state. I have to sign a letter and write a check and see what happens.

Bob got Jon and me invited to Iris Love's birthday party at Barbetta's (cab $3). It was in the garden. I ran into Pauline Trigère and she said she still hadn't made a dress for me. Iris was wearing a toga with a towel around her head and Liz Smith was in a cowboy suit. Senator Ribicoff gave a speech. Diana Vreeland was there with Fred and she said I looked like a fourteen-year-old and she was thrilled about my modeling career. I met Iris's sister who has blonde hair now, she had a crush on me twenty years ago, and now she's divorced twice.

It started to rain and they kicked us out of the garden. Then it stopped and they kicked us back in.

And I was rude to Henry Geldzahler. He was there trying to get me to introduce him to someone, and I ignored him, I don't know why—well, yes I do, because Henry's hurt me so many times that way, I just *felt* like it.

Friday, August 28, 1981

I called Jon fat but I didn't really mean it.

Paramount was having a screening of *Mommie Dearest* (cab $6). Ara was there with Russell Todd. So we saw the movie and it was absolutely great. Faye was really good. Really. Oh this movie affected me so much. Movies are really affecting me lately. What's happening to me?

And you do root for Joan. Like when Louis B. Mayer just dumps her, tells her she's too old and to leave quietly. And then when Pepsi dumps her. Oh gee, it was great. I think I identified with Joan, is what it is. Okay, so then there was a light supper.

Then it was early so Jon and I walked up trendy Columbus Avenue and somebody yelled "Gay boy" at me and that was funny. Then went home, watched TV and took a sleeping pill and woke up at 9:00 feeling so depressed and miserable. Oh God, I feel like I did when I first came to New York. I'm going through the same things, being afraid to live alone and ... oh, what should I do? I'm down to 115 pounds, but that's not the problem, it really isn't. I look *better* thin. I guess I should try not to think so much about looks but I'm *not* thinking too much about looks. I never do. I *don't*. I like ugly people. I *do*. And anyway, ugly people are just as hard to get as pretty people—they don't want you, either.

Sunday, August 30, 1981—New York—Colorado

We called Jack Nicholson the minute we arrived at John and Kimiko's house and he said that he'd meet us the next day. And it was just like talking in a movie, talking to Jack on the phone. It was so exciting. God, it was exciting.

Then John Denver was coming over for dinner and we'd read all the gossip papers—*The Globe*, *The Star*, *The Enquirer*, five of them—and we'd read everything about John Denver going back to his wife and all of a sudden the doorbell rang and there they were and we said we knew all about them, that they didn't have to talk. And they thought it was funny. And they were adorable. I got drunk on champagne and later Fred accused me of name-dropping every second. John Denver said he was going to take me up on his private little airplane, he said he would fly us the next day to where we were going—Fort Collins. He said that he knew all about me and that people always tell him he looks like me.

Monday, August 31, 1981, Colorado

We called up Jack and he said he'd meet us in Aspen so we drove all the way to Aspen and it was just so beautiful and a toy town.

We went to this restaurant where Jack met us with Lou Adler, and Jack was just adorable. God, he just was adorable. The waitresses were adorable, everybody was adorable. Bob complained later that Christopher was so pushy, but I told him it's good to be pushy because it's the only way to get a good picture, and not to worry about it.

I told Jack I loved *Body Heat*. Because he's out here in the sticks and so he doesn't see anything. I said it was a real hot movie. He kept asking about the girl, Kathleen Turner, and I said that she'd never be remembered. He said she was no Jessica Lange, which she really isn't. Then we said goodbye to him and went back to the car.

We drove to the airport to John Denver's plane but the weather was bad. Then all of a sudden John Denver's father appeared. So we got in this Lear jet and his father flew it and we went up and down and up and down and we arrived in Fort Collins and were met by all these kids and were taken to the motel.

We bought a lot of *Rolling Stones* with Jim Morrison on the cover. He's literally selling more records dead than alive.

Had dinner with the president of Colorado State University whose name is Chris Christoffersen, spelled with Cs. After dinner he took us to the museum so we could see the show before anybody else did. In front of the museum they have three cans that are about thirty feet high and they look like big sculptures by Oldenburg, big handpainted Campbell's Tomato Soup Cans. One of the kids did them, I guess. And every room here at the motel is cans with flowers in them, and I mean, I'm so tired of the Campbell's Soup Can I could throw up. But the show's cute, it's just in one room and it's all prints, and we stayed there about an hour then I got back and I took a Valium and I couldn't sleep.

Tuesday, September 1, 1981—Colorado

We had to get out at 10:30, I had to do four TV shows. Went to the campus and I had to pose with a cow—they brought a cow from one of their agriculture things. So I had to hug a cow, standing in front of the Soup Cans. It was fun. And then I did all this TV. I was good, I could

answer all these dumb questions. They said that when Rauschenberg was there nobody would come and that I'm the most famous artist in the world.

At the opening, we had to go into the show the back way. All these kids pushing and shoving and I had to sit there. All I do is sign sign sign.

And the biggest shock was two hours later this girl comes up and says, "Hi, it's Eva, your niece." And I didn't know what to do with her. This is Eva who lived in my house on 89th and Lex for a few months in '69 or '70, taking care of my mother. She said, "I've been waiting two and a half hours in line." And I knew I was in Denver where my nephew ex-Father Paul is and I didn't call him, either. Eva just read it in the paper. I can't face a family, I guess.

I was signing signing signing and then a guy came with a big fat yellow snake around his neck. He was so creepy, and he said, "Sign my snake," and Christopher freaked out and said, "No snakes! No snakes to be signed!" So he said, "Sign my forehead." So here's this snake coming at me. So I put an "X" on his forehead. Because I couldn't write, I was just too nervous with the snake. We had to go through another whole hour ordeal. It looked like it would never be the end, but finally it was the end. So I guess there's always an end.

405

Wednesday, September 2, 1981—Colorado—New York

The papers were full of me and my age. They all gave my age. That school's going to become one of the best schools because they're really intelligent. They had this course called something like "Wind Tunnel," and the professor puts models of big buildings into a tunnel and blows the air through to see what happens to them. With all the wind pressure. He said there were five *very* dangerous buildings in this country, but he wouldn't tell us which ones and I kept saying *(laughs)*, "What about the Gulf + Western?"

And so then we had to go to our next stop, a class where they collect semen from a bull. And they brought the biggest bulls with flies on them that you could ever imagine. They had this poor little animal—he had his head stuck in a thing—and the guy said, "This is a steer, and when he was young, other male steers would jump on him, he's just one of these strange animals that give off the wrong hormones." And so as soon as they saw that happening they pulled him out and segregated him, and now he's being used in this experiment to get fucked by a big bull. And there was a big bull sitting there, waiting.

Christopher ran out of film and he was going nuts, he wanted to get the big cock out. So they get the bull over and let him mount the steer and he gives out some juice but they don't want *that* juice. His cock is like a two-foot pencil. It's pointed. So the guy said, "Wait, I have to get the artificial vagina." So he ran in and got the glove and everything, and then the bull mounted again and he ejaculated really fast and the whole thing was over. Then we went into the office and watched while the guy took the sperm out of the artificial vagina.

All of us slept on the way to the airport for some reason except Chris, he said he was going to spend the night in Denver and go to the Baths. Watching the bull must have got him really hot.

Got to New York, our driver was waiting for us. Dropped Fred off and he gave me my underwear which was in his bag, then dropped Bob off. Tipped the driver ($40).

Bob had the best news because he got the job he tried out for on the new Paramount TV show, *Entertainment Tonight*. Barry Diller called him up and told him.

Sunday, September 13, 1981

Worked all afternoon till Christopher brought up some photographs. He said he was in love and I had to tell him that he had no right to do that because he's already "married." He's fallen in love with Mark from Colorado. He fell in love just because he didn't have enough to do, and after he left Peter called and I told Peter that we'd have to cut off Christopher's purse strings because then he'd have to work harder because all he does now is sit around and think about romance. And isn't that what families always do—cut off the purse strings? So he'll have to go back into the darkroom and start printing for other customers again because he has it too easy, he makes so much money printing pictures up for me.

And I'm so nervous about my show. The Rolling Stones just got glowing reviews—and what they did was just a repeat of their old album. And here I am doing a show, repeating all the old Pop images. . . .

I picked up the phone and it was my first superstar, Naomi Levine, and she was saying, "Oh I hear you're having a show. I'm going to come and see you." I said, "Oh, I'm not going to be there. Oh, am I having a show? Really? Where?" The dialogue was straight from the sixties. I heard myself going, "Oh really? Oh. Oh. Really? Oh."

Tuesday, September 15, 1981

Ron Feldman was having a limo bring me down to the gallery, this is the day of the opening. Jon said he had to go to a video convention but that he'd try to come. John Reinhold was coming, and Wilson Kidde. And Rupert had arrived at the office looking like he was my son or something. Or like *he* was the artist. *(laughs)* A bow tie. White shirt. Blue blazer. Bluejeans. And cowboy boots. And then when I stared at him because he was dressed exactly like me, he got too embarrassed so he changed his bow tie into a long one.

Got there and there were so many people, all young. Nobody over twenty-one.

Chris got mad at me because he said he was really lonely and that I wasn't taking care of him, that I wasn't taking him off to any parties, and I told him I couldn't that night because Halston had invited me to dinner and I couldn't bring anybody and that was that. Chris was with the Loud girl and he just got mad and rode off in his car.

Went to Halston's for dinner before the reopening of Studio 54. Halston had wanted to give a party for Steve before the reopening, but Steve told him Calvin was already giving him one. So then Halston asked Steve to choose between him and Calvin—Steve chose Calvin. But then Calvin smoothed things over by calling Halston to invite him. Went in Halston's car and arrived to the Sovereign and went up to Calvin's penthouse and everybody was either famous or beautiful—Brooke Shields and seventy-five other models, and Jack Nicholson was there.

And Godunov was there, he came over and he looked so beautiful and sexy and he's just changed his whole personality, he's so free and talkative now. Then we went to Studio 54 and the street was just mobbed like I've never seen it, and it made my art opening look like it'd been deserted. And Calvin took Brooke. It was so jammed they must have made a fortune at $25 a head. Went to leave at quarter to 3:00. It took us fifteen minutes to get out of the place.

Oh, and I forgot to say that Truman called on Monday and his voice—I didn't even know it was him on the phone. He was saying cuckoo things, like that he'd died twice and that his brain had stopped for thirty-two seconds so that's what he was going to call his next book—*Thirty-two Seconds*. Then the next day, Tuesday, at about 6:30, he collapsed in his lobby and all the newspapers and TV reporters rushed over to U.N. Plaza. He was taken to the hospital and it was front-page news, it got the cover of the *Post* and everything, and so I think he must have gotten the press that we were supposed to get at the Feldman Gallery. Because the TV people never came.

Wednesday, September 16, 1981

Bob said he was closer to getting Mrs. Reagan to do an interview, but I think she's too old and it's old-fashioned. We should have younger people. What is there to ask her? About her movie career? Oh it'll never happen anyway. It started to rain and I got an umbrella ($5).

Thursday, September 17, 1981

The weather was rainy, walked around with *Interviews* and then went to Dr. Cott, who Ina Ginsburg said knew about nutrition, on 38th and Third, a big new building (cab $4.50). He was in 2-D and he had two secretaries. He looked like a Hollywood doctor. Wrinkled, but healthy-looking, young, white curly hair. Jewish. And he was like a psychiatrist, he asked me questions about my life and nodded and jotted things down. I told him I was born in 1931. Look, they don't know, it doesn't matter. And before I told him that I lost my pigment and hair when I was young, he looked at my hair *(laughs)* and said, "I hope you don't mind cutting off some of your hair for a check on it." So I told him I was there because of pimples because I want to model. We talked about vitamins and he told me all vitamins are chemicals and that vitamin C is made from corn. It took an hour and he prescribed so many medicines, like tryptophan because I said I couldn't sleep. And I told him I'd taken that and that it made me feel so peculiar, and he said, "Well, then just take one." And he told me that a fresh apple is the best thing to have before bed, because it has some sleeping powder in it. And I told him that I'd read that a turkey sandwich and a glass of milk was the best thing, and he said that was, too. And he told me to eat a lot of bananas because I told him I couldn't remember things or something.

Walked with Bob over to Barneys for the opening of the new top floor that that Peter Marino designed, and it's nice up there—little shops where they sell dishrags and jellies and things. We went to the Armani room for lunch. Gene Pressman, the son of the owner, told me I could get a discount on anything because of the ads I'm modeling in for them.

Friday, September 18, 1981

I had lunch with Chris. His new boyfriend's back in Colorado and Peter's on the Cape. Chris sits there with a magnifying glass looking at the eyes of his new boyfriend in the photographs he took. On a contact sheet.

Worked on the Andrew Carnegie portrait for Carnegie-Mellon. Jon was going off to Cincinnati to a *Ragtime* sneak, and then to someplace like South Carolina for the same thing. The reopening party at Studio 54 got absolutely no publicity. The *Entertainment Tonight* people had come but hadn't seen any celebrities there. But actually there were low-key stars like the B-52s there and—oh did I say that Tony Curtis came up to me and said that his new career was doing collages?

Sunday, September 20, 1981

Cab to Mortimer's for the dinner Nan Kempner was having for Ungaro ($3). I said to Diana Vreeland, "Have you seen *Mommie Dearest*?" And she said, "Have I *seen* it?! That was my life! That was the closest thing to me when I get mad, I really tear into people and that's not entertainment!" Two hours into the dinner I could hear Fred's voice so loud sounding like Diana. I call him "Dr. Hyde and Mrs. Vreeland" when he drinks.

Tuesday, September 22, 1981

I'd gotten up really early so I wouldn't be late for my appointment with Nelson Lyon at the *Saturday Night Live* place. Cabbed to 30 Rockefeller Center ($4.50). Had trouble because the 6' blonde girl downstairs didn't know who Nelson was, didn't know who I was, and didn't know what *Saturday Night Live* was. She was very beautiful but really dumb. So finally I got there. We met in this big office with the producer and the director, Jean Doumanian. They wanted me to do something one week, but I told them that if I couldn't be a regular I wouldn't do it. Nelson thinks I should do something political.

And then the meeting ended Hollywood-style—that's where the meeting's suddenly over and they ignore you and talk about other things. They don't say, "Thank you, it was nice of you to come." Suddenly they just drop you, only you're still sitting there, so it's like you're invisible. It's kind of great.

Then afterwards Nelson and I went downstairs in the elevator and I was telling him about the beautiful 6' blonde girl who didn't know who he was or me either, and he made fun of how I always get things wrong—he said it was probably a 2' *black* girl down there, and then we got downstairs and by then it *(laughs) was* a black girl. So we were really laughing and I said no no no, that it really *had* been a big blonde before.

Wednesday, September 23, 1981

I had to meet Peter Brant for lunch at the office. Also there was a woman who'd called me, she brought a portrait back because a little girl threw an apple at it and I have to fix it. So Peter Brant came and he was just awful. He picked out some prints, and now we're all settled with him on the money he invested in *Bad* and he never has to come back. Good.

Christopher picked me up and we went to my modeling job at Saks (cab $7). Took Rupert with us and they thought he was a messenger. Two of Halston's models were there—Alma, who was nice, and a blonde one who ignored me. These models are funny, I guess they think I'm taking their jobs away by being a model.

Monday, September 28, 1981

Got up early and was still half an hour late for my Janet Sartin appointment. And I noticed a pimple on Janet's face so I questioned her about that.

Made phone calls to the office before I went to my exercise class at Lady Sharon's. When I got there she was still in bed. Had an hour of exercises. I'm so tired from them that I really do sleep at night, and I get hungry from them so I eat more, too.

The office was really busy. Lucio Amelio was there. Vincent was working things out with the *Saturday Night Live* people: The deal is we're going to get $3,000 for the first week's one-minute thing and if that goes well we'll do more. We have to send them some *Philosophy* books.

Tuesday, September 29, 1981

I got up early because I had a yoga class at 9:30. And I'm so surprised I never took yoga years ago. It's just so nothing, just sitting and stretching. And that's why I gave up Martha Graham years ago—in Pittsburgh I took a class from one of her teachers who was married to an Indian.

And Nelson came down, he said he'd been up for forty-five hours, and he was trying to do dialogue for my spot which we have to film on Friday morning. He wanted me to talk about the old *Saturday Night Live* show. I said I never watched it. Belushi's staying at his apartment in Los Angeles.

Took my vitamins. Felt like I was flying all night.

Wednesday, September 30, 1981

Nelson came up with the script for *Saturday Night Live* and I was getting cold feet about the thing.

I made an appointment to see Dr. Rees the plastic surgeon. I stopped taking the vitamins and I feel much better.

Thursday, October 1, 1981

Got up early, still was late, got to Janet Sartin's at 9:30. Then ran to yoga class but since yoga is calming, I didn't want to really rush, so I ran, but calmly, but by then the girl had gone.

I was seeing Dr. Rees at 2:30. I called the office and told Brigid to meet me at Tiffany's and we would shop until my appointment.

Got to Dr. Rees's on East 72nd Street and I had to fill out forms, and I saw the doctor and he was dying to do my face. I told him what I really wanted was a few mini-lifts, that I just wanted to go in for a little bit on different days. But he said he'd have to do it all at once, that he would cut all around the ear, and he showed me how it would look. He said I'd be black and blue for a while and I'd have to stay in town for two weeks. So I told him I'd think about it.

Cabbed to meet Don Munroe ($6.50). He and Vincent were setting up to shoot me for our segment on *Saturday Night Live*. We did our lines and I was terrible, I don't think it's funny—three reels, an hour and a half of work. But then later Vincent said they really liked it and I asked if I had to go down to do any more on it and he said no. I'm scared about this *Saturday Night Live* thing. Jon thinks I shouldn't be doing it, because if it's bad, so *many* people will see it, so I'm hoping they don't use it after all.

Friday, October 2, 1981

Went over to my exercise class at Lady Sharon's. Sharon doesn't do the class with me.

Diana Ross came at 3:00 and she loved all the portraits, she said, "Wrap them up," and they all fit in the limousine, and she had a check at Bob's place by 5:00. And she wants me to do the cover for her next album.

Saturday, October 3, 1981

Called Vincent to see if he'd heard anything about *Saturday Night Live* and he said that he had, that yes, they were going to use it, that they were really happy with it. They still didn't have a guest host.

Jon picked me up in his car. Made a lot of phone calls trying to find the new Maud Frizon shoe store ($.60). And then we found out it was on 57th between Madison and Park (cabs $5, $6, $3, $4.50). Still we couldn't find it and there was a crowd of people in the street and I asked one of them if they knew where the Maud Frizon store was and they said that that's what the big crowd was looking at. They said, "Cher's in there." So everyone was looking in the store at Cher trying on shoes. So we went in and I was too embarrassed to look at her. And Sonny Bono was there, too with his girlfriend, Susie Coelho, who's really beautiful.

And I guess these people just buy clothes and shoes all day, because Rupert told me he saw Rod Stewart in Parachute buying a few thousand dollars' worth of clothes and reading *Interview*. And Sonny and Susie were trying on shoes, and Sonny had on the exact same leather Armani jacket that Jon had on, but his was in brown and Jon's was in black. And the shoes Jon liked they were out of, they said Rod Stewart had bought ten pairs the day before.

So then we were leaving and a boy who worked there asked if we wanted to go out the back door and then he said, "Cher said that she would be honored if you did her portrait," so that

was great, and Jon said I should go back inside, not let that slip through my fingers. So I did, and we talked, and she's at the Pierre.

Sunday, October 4, 1981

So many people must see *Saturday Night Live*, because instead of people on the street saying, "There's Andy Warhol the artist," I heard, "There's Andy Warhol from *Saturday Night Live*." They'd seen my first segment on it the night before.

I read *The New York Times*. They still haven't reviewed my Myths show. They're ignoring it. Roy has a show now at the Whitney. I haven't seen it. I'm sure it's good, though, he's my favorite painter after Rosenquist. Then cabbed to Jon's to work on making a play—a musical—out of the tape transcripts. We now have enough dialogue but I wish I could think of a strange story to use it in.

Monday, October 5, 1981

I had a fight on the phone with Ron Feldman, he's so awful, he didn't want to take the whole series of Myths, he only wanted to take the specific images that are selling the best and I thought he was just awful, and I wound up yelling and I hate to yell on the phone.

Tuesday, October 6, 1981

So many people keep saying they saw me on *Saturday Night Live*. I guess people do stay in, I don't know, I'm surprised.

Thursday, October 8, 1981

I had a fight with Jon so I wasn't taking his calls.

Rupert came up with some Dollar Signs, but they were looking like Jasper Johnses, sort of. Vincent had gone up to Sotheby's to the auction where they had some of my portfolios and he bought them back. Some Campbell's Soup Cans and some Maos. But not the Marilyns because the Marilyn prices have stayed up, they're around $35,000 apiece now. Mrs. Castelli's having a prints show soon, so Vincent was bidding against Castelli Graphics and I guess Leo was mad, but . . .

Nelson came down and wanted to work on the *Saturday Night Live* thing. I think for my next show I'm going to paint and talk about painting.

Friday, October 9, 1981

I finally took a call from Jon and said we could talk about the script at Joe Allen's restaurant before going to see *Nicholas Nickleby* (tickets $200).

Paul Morrissey was at the office talking about the Montauk property—about Halston and Lauren Hutton wanting to buy land, and he's trying to work out some things.

Leo Castelli came with his girlfriend Laura de Coppet and he was drinking and they were hugging and kissing and I just can't believe this old man. This is the girl who gives Jackie Curtis money. Leo's commissioning a portrait of her.

Saturday, October 10, 1981

I wanted to see Duran Duran at the Savoy because their videotape was so good, it's called "Girls on Film." When I got there the first band was still on. Duran Duran are good-looking kids like Maxwell Caulfield. And then afterwards they wanted to meet me so we went backstage and I told them how great they were. They all wore lots of makeup but they had their girlfriends with them from England, pretty girls, so I guess they're all straight, but it was hard to believe. We went to Studio 54 in their white limo and Steve Rubell was really nice to them. He took them to the booth and gave them drinks. Ran into old friends, met a bunch of new kids and got home at 5:00 (cab $5).

Wednesday, October 14, 1981

Bob warned me that when we go to Washington to interview Nancy Reagan for the cover I couldn't ask her any "sex questions." And I just couldn't believe him. I mean, I just couldn't believe him. Did he think I was going to sit there and ask her how often do they do it? And then Bob told me that I look like a fool on the runway doing my modeling jobs. I told him I didn't care, and he said that *he* cared, that it made his job harder if I looked like a fool. Worked till 7:00.

Thursday, October 15, 1981—
New York—Washington, D.C.—New York

We were early getting to the White House, we got in and then Nancy Reagan came in and we were in the same room. And a waiter brought in four glasses of water. Doria was with us. We talked about drug rehabilitation and it was boring. I made a couple of mistakes but I didn't care because I was still so mad at being told by Bob not to ask sex questions. She had an assistant who sat there and took notes, and they said they weren't doing their own tape of the interview but I'm sure they were. Bob had his tape recorder and I had mine. I took four pictures. Mrs. Reagan gave Doria a piece of Tupperware, not wrapped or anything, and she gave her three boxes of socks for Ron. Bob was telling Mrs. Reagan she was such a good mother. He asked what they

were doing for Christmas and she said they were going to stay at the White House because nobody ever stays at the White House. At 4:30 the interview was over. She and Doria talked for about fifteen minutes while Bob and I waited to the side. Then we got a cab to the airport.

Got to New York, called Jon at the office. Gave Doria $20 for the cab after she dropped me. When I walked in the door the phone was ringing and it was Brigid asking me what kind of tea Mrs. Reagan served us and then I started thinking and I got madder. I mean, she could have put on the dog—she could have done it in a good room, she could have used the *good china!* I mean, this was for her daughter-in-law, she could have done something really great for this interview but she didn't. I got madder and madder thinking about it.

Friday, October 16, 1981

I told Janet Sartin that Doria and I had just been down to Washington to interview the First Lady and she said she's just dying to do Nancy and the president. She said she can stop his skin from sagging.

Brigid got me upset, she was transcribing the interview with Nancy Reagan and she said it was awful, and so we went in and asked Doria wasn't it peculiar that we weren't offered tea or anything and that we were treated just like anybody, and Doria said she thought it was the secretary that was really the awful one, that Nancy probably was going to do it upstairs and then the secretary had her change it.

Monday, October 19, 1981

Had to go close on the building and we had to drink some champagne with the people.

Thursday, October 29, 1981

Christopher is having his photo show out in California and it's going to highlight his photographs of me in drag, so just when we finally get Mrs. Reagan this is going to be publicized, *Time* and *Newsweek* will probably pick it up and my whole reputation will be ruined. Again.

Talked to Jon in L.A., he'll be coming back on Saturday night.

Saturday, October 31, 1981

We went to the Village to see the fourth annual Village Halloween parade and it was just great, so much fun. It started at 6:00 on the nose and it went from Westbeth to Washington Square, and it was the funniest group of people, one was dressed as a table and lamp.

Picked up Jon (cab $7.50), he was cutting holes out of a hanky to make a mask. Went to Studio at 2:00 and it was the best party they've ever done. They had girls with live snakes, and a haunted

house and I didn't see Steve Rubell at all. Chris was a doctor and Peter was a nurse. Robin Williams was there.

Sunday, November 1, 1981

Slept late, till 12:00. Went to meet Jon. Went to the laundromat on Columbus with him to do his laundry.

Tuesday, November 3, 1981

It was Election Day so Jon had the day off but he'd lost his address book and couldn't remember my number so he couldn't call.

Wednesday, November 4, 1981

Chris woke me at 7:15 to turn on the TV to the space shuttle, so I did and they stopped it after thirty-one seconds. They had oil clogged in the valves and so they're not going up for a week at least.

Then we went to our new building on 33rd and Madison ($4). It was a beautiful sunny day and on the way up all the buildings looked great in the sunlight. Made two calls ($.20). We got to our building and it was just sensational, so beautiful, you just can't believe it. And the neighborhood has everything, all coffee shops, all the homemade Puerto Rican kind of food that Ronnie and Robyn like, and Jean DeNoyer is opening a new restaurant, La Coupole, on 32nd Street, and the whole area is great. There's a beautiful hotel across the street with whores that they're trying to get out. We went into the building and the best thing is the roof terrace, it's like a terrace for a beautiful, glamorous apartment.

Monday, November 9, 1981

Got into black tie for the queen of Thailand dinner for the Save the Children Fund. I didn't wear a coat because I wanted to leave early so I could meet Jon. Cabbed to the Waldorf ($4). I missed Imelda Marcos who they said had been there, she'd crashed, she was staying at the hotel. And Paloma was there talking with Clare Boothe Luce and Clare didn't recognize me at first but then she said, "You're losing weight and why are you doing that?" so I went through my modeling lines. She looks very old, but it's like a young person dressed in old drag, it's a very strange look. The food was good, the best dinner I've had there. The queen of Thailand was on the dais. I could only think about her jewels.

Wednesday, November 18, 1981

I bought three *National Lampoons* because they parodied *Interview*. ($6)

Went to my modeling job for *L'Uomo Vogue* (cab $7) on West 21st Street. Way Bandy was there and a hairdresser named Harry, an English kid, just funny and cute, and Way was wonderful, we talked about health foods and he doesn't wear too much makeup for day. He looks very good, he's had a lot of facelifts and we talked about that. He goes to bed at 11:00 and gets up at 5:00 and spends two and a half hours doing his yoga and everything. Way and the hairdresser each get $1,000 a day so I'd like to hire him twenty-five times a year to make me up for special occasions, but he says he can only fit me in six times. And then they left and two *other* people came to do me up *punk*—a black guy and a hairdresser named Mary Lou Green. And they had a Blondie wig so I would look like a girl, and then they made me up like Ronald Reagan, too.

Friday, November 20, 1981—New York—Toronto

U.S. and Canadian Customs are the worst. Conrad Black had sent a limo for us, it took us to the Four Seasons Hotel and I had suite 2910 overlooking all of Canada. I got cleaned up and dressed and we went to Mr. Black's office. It was a post-modern building, the kind with the big columns, and there was an old-fashioned lady with her hair up at an old-fashioned switchboard.

Mr. Black had read *Popism* the night before, he'd done his homework, and he reminded me of Peter Brant, but nicer. He was about thirty-seven, and sort of heavy, very nice, and a nice fortune—they have mines and supermarkets and newspapers.

Then I dressed for a dinner Mr. Black and his wife Lisa were giving for me, at the museum. And Gaetana Enders's husband, Tom, who's the Under-secretary of State for Latin American Affairs was going to be there with Gaetana—he used to be the ambassador to Canada, and he's 6'6" and Gaetana's 4'4".

I called the office in New York and I got mad because I was trying to get Jon invited to T.T. Wachtmeister's party for the king of Sweden and they said there wasn't any more room.

We met Gaetana in the lobby at 7:00 and cabbed to the museum. They had a little TV crew there, and we were putting down publicity until we found out that Mr. Black owns the TV station. And they had a cardinal there, who's just had a stroke so half of him was there, only, and Mr. Black had him saying grace. Bob was having a good time at this, finally. He's been so grouchy lately but the room full of billionaires perked him up.

So we're at the dinner and they introduced me to the cardinal and he said, "I hear you have a nephew who's a priest," and I said, "Oh yes, but he just ran away with a Mexican nun." And when I said that, Fred yanked me away and was screaming at me how could I do that to the cardinal when he was half-gone and there were only twenty cardinals in the world, and why couldn't I have just said, "Fine," and let it go, and the cardinal could hear Fred yelling at me and then they took him away and put him in a car, and he rolled down the window and said, "Andy Warhol is such an honest person, he could have lied to me and said his nephew was fine but instead he told me the truth and I love his art and I know he goes to church every Sunday."

And then I was given a tour of the Gauguin to Moore exhibition. Henry Moore gave this museum all these plastic things, nobody knows why he gave them so much. Really impressive. Like forty figures, gigantic. I mean, my work looks like nothing compared to that stuff. Oh, I'm getting to hate my—I must be—all I do is tour, everybody else works. I have to get back and *do* something. I might be well-known, but I'm sure not turning out good work. I'm not turning out anything.

I didn't have that much to drink. Drinking does put on weight and I've got to stop it.

Saturday, November 21, 1981—Toronto—New York

Customs was disgusting again. Cabbed into town ($20). We made it to the office by 1:00. Finally T.T. Wachtmeister said I could bring Jon to the dinner for the king of Sweden at Reginette's. So then I called him and he wasn't sure if he wanted to go. I was getting nervous and drinking coffee—I had an opening at 4:00, a retrospective of prints, down at the Castelli Gallery. Leo called and asked when I was coming down, he wanted to show me a photograph of me by Hans Namuth, which did turn out to be beautiful.

I hated the show. And Ethel Scull said, "Do you remember me?" *(laughs)*

And Lester Persky invited me to his cocktail party before the king of Sweden party, but I couldn't go because the only way I could get Jon to come to the king of Sweden dinner was by first taking him to Giorgio Sant'Angelo's surprise party for Marina Schiano.

Oh, and I'm forgetting the most glamorous thing of my opening. Warren Beatty walked in with Diane Keaton and I made a *faux pas* by saying, "I just read that article about you in *Playgirl*," and they said, "Oh my God!" and ran out. I don't know if they were interested in buying art or if Diane Keaton wanted to take pictures, but anyway they made quite an effort to come to this crowded thing, so that was nice.

So later at Reginette's I really liked dinner, it was fun. The cute girl next to Jon was an Argentinian, a Ford model, and she was cute because she ate the bread that I'd autographed. And *(laughs)* the king of Sweden was there. Bob said that a few months ago Diana Ross's P.R. guy wouldn't say if she would come or not to this dinner, that he *(laughs)* asked Bob, "Well who *else* is going to be there besides you, Andy, and the king of Sweden?"

I got home and went to bed and the alarm went off at 3:30 and I was scared and Aurora was there and we went around the house together holding hands and it was a false alarm, we didn't find the bogeyman.

Sunday, November 22, 1981

Decided to go up to see the Roy Lichtenstein show at the Whitney, and I called Jon and asked him if he wanted to go. Walked up Madison (tickets $4). Saw the show and it was great, I was so jealous.

Tuesday, November 24, 1981

Got to my exercise appointment at Lady Sharon's by 9:50 and had a good time, did a whole hour. The trainer, Lidija, was wearing Revlon Moondrops lipstick, pink, and Chris had been telling me that my lips are too pale, so I went to Bloomingdale's right after paying her ($30) and got some lipstick ($3.75).

I worked, painted for a while, and then after Vincent had had time to set up, went over to Larry Rivers's where Vincent was videotaping (cab $5). And Larry gave a good interview. It was weird, he said he had his eyes lifted and that he'd had a scar removed, and I just couldn't believe it, I said, "Well then why didn't you get your *nose* done?" And he said because it would have changed his character! And Larry was talking about getting old and I told him to just not think that way. He said he had to sleep with John Bernard Myers to get shown in his gallery, and gee, he's done so much, he was Frank O'Hara's boyfriend, too. Larry gave us a good video interview, but now I have to do one for him in return. Larry's strange, he's sort of a good artist but such a nutty person.

Then decided to have Thanksgiving dinner at home two days early because all my friends are leaving town on Thanksgiving day. I told Jon and Christopher and Peter to come at 8:00. Peter makes the best pies. And we played Christmas tapes, and we overate. And then we went upstairs and Chris pushed the furniture around and we played Charades.

And then around 10:30 we decided to go to Studio 54 for Bob's party for São, and we found a parking space and got there before Bob and São, and I went on the dance floor and danced every dance and the reason I've now just begun to dance is because I finally realized that nobody really notices you. I mean, I watched Jon go out there and jump and bounce and I thought, *Well, I can do that, too*. It's one thing I've picked up from him, I might as well get *something* out of it. So now I'll be dancing. And then I heard that Jed was there so I guess he saw me dancing. He could have gotten me dancing, all those years, that's something he could have done for me. And I wasn't drunk at all, either. I was just miserable because things don't turn out like you expect them to, I was in sort of a horrible mood. I had a sip of champagne, that's all. And then I danced with Gaetana and with São and with PH, and I just never knew I could do it before.

Thursday, November 26, 1981

Well, got up, depressed, had a lonely day. No calls from Jon. Ate some Bill Blass chocolates. Ate leftover turkey. I called Halston but got the wrong number. Finally at a quarter to 6:00 I walked to Liza's. It was really homey. It was Liza and Mark Gero and his mother and father and uncle and three brothers and a Polish girl and Halston and Victor Hugo.

The dinner was in the hallway with all my portraits of Liza. It looked really beautiful. And I said to Mark, "I think I've seen this apartment in some magazines," and he said, "Yeah, Batman Comics." He was funny. And he's the best-looking of the brothers. Liza got the cream. And I figured out that the mother is, I think, Polish, so that's why they have that big Polish-Italian look. One of the brothers is a teacher at Harvard.

And I was really crazy, I was nutty, plus I was drinking good red wine from the Napa Valley. I

said, "So now that we've got the whole family here, which one is the fairy?" And the Harvard one did a fairy voice and said, "Mommy, which one's the fairy?" It was funny. The mother is beautiful.

Martha Graham was there with her boyfriend Ron Protas and his boyfriend.

Saturday, November 28, 1981

Worked all afternoon. The Du Pont twins called and invited me to Cornelia Guest's eighteenth birthday party that Nikki Haskell was giving for her at Le Club. I said that I had a date with Peter and Christopher and they said to bring them.

Then they talked me into going to the Underground, the disco on the first floor of 860, which I never wanted to do. I went with Cornelia because she wanted to be photographed with me, and Peter and Chris went separately. We got there and I met the Mafia-looking guys and they were so scary. Ethel Scull was there and she couldn't believe I was dancing and making a fool of myself, and so she invited me to her birthday party the next night so I could make a fool of myself there, too, and I said yes but I knew I wouldn't go. The people who run the place brought out the Dom Perignon for us. And Cornelia's friends were so cute, so many cute girls in jewelry, all eighteen. A juggler was juggling for Cornelia and he gave me one of his juggles.

The Underground was doing very well when Studio 54 was closed but now Studio's open again....

Sunday, November 29, 1981

Fred was supposed to go to Jackie O.'s party for John-John but sixty-five people arrived at his house and he couldn't leave, and then it was Xenon, the Underground, and Paul Garcia's new place that he opened on 12th Avenue and 25th Street. Oh, and there's a new place downtown called AM/PM. I saw in the paper that Caroline and her new boyfriend Edwin Schlossberg went there the other night. And I remember our old friend Roberta from the sixties who was the Supremes groupie who taught art at Columbia saying, "Oh you've got to meet this absolutely brilliant boy, Edwin Schlossberg, he's so brilliant brilliant brilliant." Caroline likes funny people. He probably was babbling intellectually and she got fascinated, he was probably saying strange peculiar quotations or something.

Monday, November 30, 1981

Earl McGrath was having a fiftieth birthday party at Trax and he was nervous. John Belushi gave a speech, he said that Earl had given him a helping hand—"not like that fucking Laurence Olivier who never did a thing for me." He was funny. I talked to Isabel Eberstadt who's just finished her novel, and it's going to be hot hot hot, it really will be, I just know it.

Wednesday, December 2, 1981

Laura de Coppet called and I don't know, she was telling me this song and dance that one of my portraits of her that Leo commissioned had been destroyed by a lover—cut into strips. And I said, "Well why are you telling me this?" And she said, "Because it's yours." I said, "No, it's *yours*." And she said, "Well, do you want me to send it up to you?" and I said, "No. You figure it out with Leo and tell me."

Sunday, December 6, 1981

I lost my contact lens and then found it an hour later on a piece of soap, it looked like a bubble. And so I had one lifetime lens in and one overnight lens in and, actually, I saw very well.

I picked up Jon and went to the Rainbow Room to get an award from *The Best* magazine (cab $7). It was jammed with TVs and cameras. Lost Jon in one second. Massimo Gargia, the man who started *The Best*, said that since I was so late to accept, mine was the only blank award, it didn't have my name on it, and I said that was perfect. The award was crystal and penis-shaped with a chain around it that looked like it was gold, and I asked Ralph Destino the president of Cartier if it *was* gold—because it said "Cartier" on it—and he *(laughs)* said, "*Think* of it as gold."

Monday, December 7, 1981

I'm doing a fold-out page for *Artforum*. They asked me to, and I was considering a fold-out drag queen or a fold-out advertisement for my modeling career but decided on a dollar sign, since Leo already took an ad out for it. And Leo called and said that the portrait of Laura really was destroyed, and I just don't know what to say to that. I'm not going to give them a free replacement. If they want another one they'll have to pay for it. It's not my problem, it's their problem.

Fred was out all day helping Diana Vreeland because I guess she was nervous about her show that's opening at the Met.

Halston had ten of his models and six limos and so we all got in different ones and it was fun. At the museum, Marisa Berenson was doing a thing for *Entertainment Tonight* so we went into a room for photos. There were lots of photographers there. Every snazzy lady in town—Brooke Astor, Enid Haupt—everybody in glamorous dresses. And Raquel Welch was really sweet, she's so happy because she's a hit in *Woman of the Year*.

The costume show was eighteenth-century clothes. The kind of dresses with the wide wide skirts so you couldn't fit through the doorways. What is the reason for them? Was it to go to the bathroom and nobody would see you? That's what Patti LuPone told me once.

Oh, and I talked to Douglas Fairbanks, Jr., and that was fun, he's really handsome.

Tuesday, December 8, 1981

At Iolas's opening I met Werner Erhard who was with the Stassinopoulos woman, and he's so handsome! He's so handsome! He should be a movie star. And I hope his portrait comes through because then I'd get a lot of his EST disciples, they'd all want portraits.

Friday, December 11, 1981

I went to my exercise class ($30) at Lady Sharon's apartment. And Lidija said that she heard from Sharon's maid who wasn't supposed to say anything that Sharon might be about to evict us. So we're just hoping that she doesn't decide to really tell us. Sharon's in England now, but when I rode down in the elevator with her the other day she didn't seem happy. Or maybe she wanted me to go out with her more. I don't know. She's putting on weight.

Fred was invited to Mrs. Marcos's house on 66th between Madison and Fifth, the one she bought five years ago. She's in town now giving lots of parties in it. It's on my street and we got there and it's a house twice the size of mine, and she had a Christmas tree on every floor and a disco on the top floor, but there was no central heat so they had to put heaters in every socket. And that's when I remembered that I'd actually been getting the Marcoses' Con Ed bills at my house, with a notice saying they were going to turn off the electricity if they didn't pay the bill. It's something about the way the address was written, it would always come to me at 57 East 66th and I opened them. The maid gave me a tour and it was funny, security people and people in furs huddling around the heaters. Such rich people. Such grand people. All in New York. What does it mean? It's scary. It's really scary. Maybe they're here because it's Christmas, but oh it's scary.

The Cristina Ford lady was there, so grand, and Imelda was dancing with Van Cliburn. They were serving champagne like water. I heard that Imee Marcos is seeing Lupo Rattazzi again. Said goodnight to Mrs. Marcos. Then I walked home.

Saturday, December 12, 1981

Halston called and invited me to dinner for Jade Jagger. Brought Jade a Dollar Sign painting. Bianca is trying to be a Communist, she's a Nicaraguan guerrilla now. Halston was funny, telling her how beautiful she looked and how rich her clothes were, and I told her I'd just been to see Mrs. Marcos and she said how could I, and I said that if the Marcos regime fell it'd just be another Iran.

Steve Rubell was there and Ian came, and Ian is having an affair with Jane Holzer, which I didn't know about, but he thought I did so he was talking as if I knew, trying to pump me about Jane. But he was after Bianca, too, he wanted to drop her off. Calvin called a couple of times for Steve. Calvin's kind of great. He does anything he wants—he takes ads in *Interview* and in *WWD*, and he goes to 54 and to Xenon—he doesn't let anyone push him around.

Bianca's going down to testify about Nicaragua in Washington, I just don't know what she's thinking she's doing.

Sunday, December 13, 1981

Cabbed to Jon's apartment but his fuse had blown and so we went out looking for fuses because we wanted to work on scripts, and then cabbed ($4.50) to my place and watched *Apocalypse Now* which looked really good on TV—and on a small screen Dennis wasn't so bad and neither was Marlon Brando. Jon left at 11:00.

Monday, December 14, 1981

I'm just starting to get a good body. I wish I'd started exercising when I was young, I could have had a good body all my life.

It was snowing hard. I went in to *Interview* and stood there finding typos in the Nancy Reagan issue. I just don't see why there should be even one. And it's something people really notice. It's like that secretary from *Interview* saying she saw me in the laundromat on Columbus Avenue with Jon doing his laundry. It stands out, so people remember it.

Tuesday, December 15, 1981

I took a Vibromycin and later at my beauty class I got nauseous, so I had a cracker and water. It was raining out, really messy and wet. Met John Reinhold and we went to our regular place which is called Think Thin. We talked about designing jewelry.

And Bob is trying to find out who to have interview Farrah Fawcett. Gore Vidal wouldn't do it, he said, "I don't *do* interviews—I *give* them."

Bob Denison sent me this great cheese and bread from E.A.T., I've been eating it. He told me that Fred made a scene at Donina Cicogna's silver and white party, but he wouldn't tell me what it was—something about Pat Buckley's tits.

Wednesday, December 16, 1981

Got up early and went to Christie's and passed out *Interview*s. They were having an Indian jewelry exhibition and gee, that stuff is so expensive now. I guess it was Ralph Lauren who drove the prices up to $15–30,000 a belt, some of them.

Brigid was dyeing my surgical corsets for me, the ones I wear around my stomach because of when I was shot. She does a beautiful job on them. The colors are so glamorous, but it looks like no one will ever see them on me—things aren't progressing with Jon. We just work on scripts and that's it.

And as I was getting out of the cab, I tripped over myself because my bag full of makeup was so heavy and at first I felt like a little kid, but then after I thought about it I felt like an old man. And I scraped myself and I was bleeding, but nobody saw me except the cabdriver and I pretended it was nothing and skipped home.

Jon picked me up and we cabbed ($4) to 1600 Broadway to a screening of *Four Friends*, which is about these kids in the sixties with a lot of plot and subplots and it goes into hippie psychedelic times. It was like all those bad movies that came out in '68 and '69. I thought it was as bad as *Honky Tonk Freeway* but Jon got really emotional—he was crying all through the movie. So I dropped him off at 10:30.

Watched a Chuck Norris kung-fu movie on TV. He's not good-looking but he's really sexy.

Thursday, December 24, 1981

Steve Rubell wanted me to go to C.Z. Guest's Christmas thing in Old Westbury, but that would have meant an hour drive out there and an hour back. I didn't want to do anything difficult because I was so afraid I was getting sick. I could feel it in my throat. Jon called from Massachusetts and wanted to know what shirt size I wore. I was the only one home, so he had to ask me. He said he'd call Halston's at 10:00.

Got home and was too tired, had some brandy and got drunk by the time I was supposed to go out. The dogs were with Jed, away for the holidays. Walked over to Halston's. Victor had called and given me the list of people who were going to be there, about twenty names, and I'd made up some packages to give them—snot rags with dollar signs. And a piece of sculpture.

Liza was there, though, and Victor hadn't said she would be and I didn't have anything for her, so I said I'd give her a Martha, and she was thrilled, she threw up her arms. Liza'd been to Harlem all day to visit the sick kids in the hospital. And that's the best thing to do. Jane Holzer and I said we'd do it next year. Liza's here seeing her father, he's dying of heart problems. Pat Cleveland was there, just over hepatitis, and she kissed everybody and my resistance is so low I think I'll get it. Jane told me finally that she's madly in love with Ian Schrager and I said I didn't want to hear it because I'd only tell her negative things and then she'd only report them to him who I do really like. I told her that she should just get his business sense from him and that's it.

She'd had gold dimes made up, had them cast, and she gave one to me. She had them made up for Ian because he always puts dimes in his mouth for phone calls. It's such a clever gift.

At 3:00 Jane dropped me off and I took aspirin and packed and took a sleeping pill.

Sunday, December 27, 1981—Denver—Aspen, Colorado

In Denver we got two cute pilots in a jet, they had suits on, and we had cold lobster and drinks and the ride was fun and beautiful and the snow was very beautiful, and then as we were about to land in Grand Junction they said they had good news, that the storm had stopped and we could be the first plane to be able to land in Aspen ($100 × 2 = $200). The rented house was

just beautiful, clean and with a picture window on the mountains. Jane Holzer called and she's not coming until after New Year's.

My cold was starting up again, it had completely gone away the day before. But at least I wasn't having an altitude problem. I was taking antihistamines and Aspergum and cough medicine. Peter made us mashed potatoes and salad for dinner. We watched *Shampoo* on TV, then went to bed.

Tuesday, December 29, 1981—Aspen

Got up early, and by then I did have an altitude problem. Dropped Peter and Jon on the slopes, went with Christopher to get groceries, spent a couple of hours in town. Met all these people who were surprised seeing me and I didn't recognize them in their ski clothes. Tatum O'Neal came over and she looked so cute and beautiful in her white ski suit.

And then it was such a pretty day, the sun was out and it was cold for Aspen but it was the best snow they've ever had.

We went to Angelo's Restaurant for dinner and Sonny Bono came over and said he was getting married on New Year's Eve to his girlfriend Susie and he invited me to his wedding party at Cathy Lee Crosby's, and also he was having a shower later that night for Susie at Andre's, which is the only disco in town.

When we got to Andre's Cathy Lee didn't know who I was at first. It was like trying to get into Studio 54, and I just don't think any of those things are worth it. So I just said to Chris, "I just can't stand it, let's get out of here."

Wednesday, December 30, 1981—Aspen

Chris and I decided to have just simple baby instructors on the baby slope so that we could work our way up. We had a private instructor from 1:30 to 3:30 and the course was called "Powder Pandas" and it was on Buttermilk. We did about two hours of zigzagging and going up the handrail and you just sort of sit on the thing and go up the whole hill, and it was really fun. It was easy, all two-year-olds skiing with me, and if you start when you're two you can really go with the waves and relax and become a good skier, but I was so tense. I fell three times. But it was fun, the idea of falling was more fun than skiing because you fall right in the snow and it's really fun. Saw Caroline Kennedy with the Schlossberg boy. They're madly in love and they were going off to parties.

Thursday, December 31, 1981—Aspen

We went to Sonny's wedding. We finally found the beautiful church and we had to stand, the ceremony was already on, and they were singing beautiful songs, and the preacher finally came on and said, "I pronounce you, Sonny and Cherie"—he said "Cherie" instead of "Susie"—and the whole audience gasped and she said, "My name isn't Cher-ie, it's Susie," and the preacher got

very upset, he said that he just knew he was going to do that, and then he said a million times, "Sonny and Susie, Sonny and Susie" till the end of the ceremony. They had lighted candles and Chastity was the flower girl, she was kind of tall. And it was really beautiful, it was snowing outside and everybody had candles and Susie was all in white and Sonny was crying. We were invited to Cathy Lee Crosby's party for Sonny. But we went off to one of the halls where Jimmy Buffett and his wife were hosting a New Year's Eve party.

We found a corner where Lisa Taylor was and I made a *faux pas* and asked her about John McEnroe and she said she just broke up with him and she was drowning herself in drink. She was drinking tequila and Coke in a shot glass, she said it goes right to your head and you get drunk really fast. And then I said hello to Jack Nicholson and Anjelica. And in yesterday's paper Margaret Trudeau talked about her affair with Jack, and her new book is out where she talks about her cowboy Tom Sullivan and she doesn't even say that he died.

Cathy Lee Crosby's party was starting at 11:30 but I didn't want to be in anybody's house at the twelve o'clock thing, so while we were walking we just decided to stay in the square, we let all the other people go ahead and we just stood in the square because it was like a small version of Times Square. It was all the Aspen kids all drunk, sort of drooling and falling and blowing horns and stuff like that in the middle of town, and it was sort of cute, it looked like *La Bohème*, it looked more fake than the real thing.

Friday, January 1, 1982—Aspen

Decided to go to the hospital to see if my arm was broken from when I'd fallen the day before. Went to the emergency room, they were really nice there. One girl was really fun, out of Pittsburgh or my grade school or something and then while we were there I got X-rayed and while we were waiting for the X-rays they put you in these little cubicles made of bedspreads and then they wheeled a man in who said, "Am I in heaven?" and he said he couldn't feel anything below his neck, and they all got scared and they wheeled him under the X-ray machine. And there were all these kids with bones coming out of their legs and it scared me so much.

And then it was four o'clock and Jon had to meet someone named Dawn Steel from Paramount Pictures at the United City Bank.

Went to Barbi Benton's for dinner and Zev Bufman, the *Little Foxes* producer, was there. And Mrs. Bufman, who I could see would never let him have an affair with Elizabeth Taylor. Barbi gave us a tour of the house and it's sort of like the Watts Tower, all built by hand—the architect would go to the stream and get the marble to build the steps. It was sort of nice, but not with the things that Barbi put up.

Monday, January 4, 1982—Aspen—New York

Got back, called the office, I was going to go downtown to work but it was already 5:30. Vincent was going to his Lamaze class. Stayed in and unpacked.

I dropped a ring in the sink and it stuck there. Picked up Jon and went to Halston's. It was

only Steve Rubell and Victor, and Halston said that two days ago he bought 100 acres in Montauk with Lauren Hutton. So now there won't be condominiums between Dick Cavett's place and ours. And Bianca wants to rent Montauk while Halston builds. My arm was still hurting.

Tuesday, January 5, 1982

Got up early, still felt like Aspen. Sort of dizzy and floating as if I was on an LSD trip, which I've never been. My lungs are still funny from being shot, I guess.

Got a lot of invitations to dinner. Talked to Jon and he thought we should work on scripts.

He came over and we worked and he left at 9:30. Watched TV, and my arm was really aching and that's when I took an aspirin and the last news on TV was that Hans Conried just died.

Wednesday, January 6, 1982

Heiner Friedrich was having a tea party at his place on 82nd Street. You were supposed to take your shoes off but I didn't and I should have. And the driver who drove us was the best driver I've ever had, named Manny, he was sort of black. Fred told me I couldn't say anything to Heiner about loaning us money for the building. But Heiner's having another party next week and then I will. Because he's taking John Chamberlain's loft and making a museum for him there, and I think why doesn't he rent the Madison Avenue part of our new building and have the museum for me there? I would ask him but people only want to do things if they think of it themselves, so I'll just hint and hint. I did suggest that he open a bar in the building and he said no, no, that Moslems don't drink—he and Philippa are Moslems now that they're Whirling Dervishes.

Saturday, January 9, 1982

Another big opening of mine—a double—Dollar Signs at the Castelli on Greene Street and Reversals at the Castelli on West Broadway.

Bob Rauschenberg was at the opening and Joseph Beuys and Hans Namuth and it was like a busy sixties day. And I forget how attractive artists are. They really are attractive.

The stairs were the best place to stand to see people and sign things. Then went over to the Greene Street thing, and the heavyweights were there. Rosenquist didn't know what to say so he told me he loved the photograph of me.

Sunday, January 10, 1982

Not one phone call. That's what happens after being a big star the night before, not one person called all morning. Finally at 12:45 the phone rang, it was my brother. Brigid called and she said that she'd gone to the Chelsea to see Viva who'd just had her baby.

Called Jon and nobody answered. Jane Holzer called and said she was in Washington with the guy who wrote *Shampoo* and *Chinatown*, Robert Towne. His new movie, *Personal Best*, is about to come out, it's about dyke athletes. They were coming up to New York later and she wanted to have dinner. And she said, "Bring your tape because he's so fascinating, so fascinating." I don't know what she was trying to do.

At 10:20 I went to Elaine's (cab $4) and Elaine's *fat* again! So fat. After all she went through getting thin. Jane was already there with Robert Towne and they had the good table. For the first three hours I hated him. In fact I may still hate him, I'm not sure. He was just that California way. All those words that I hate like "asshole" and "bimbo." "Bimbo" drives me up a wall. He didn't want to tape, he said, because he's been working so hard on "my baby," but he said, "If *you* want me to, Jane, I'll do it."

His wife Julie was there and she gave up acting for real estate. She's good-looking but just almost at the stage where he'll trade her in. Just almost over the hill. And we were there the whole time and Jane didn't even tell me until she dropped me off that this was John Payne's daughter! I would have had a great time!

Robert Towne talked about "Warren" a lot so I said I'd just seen "Jack" in Aspen. Oh and in the beginning he quoted my line to me about "in the future everyone will be famous for fifteen minutes," only he said "ten minutes" and then it was funny because Mark Rydell the director came over fifteen minutes later and quoted me the same line and he said fifteen minutes and then he and Robert Towne argued over the time and I had to agree with Towne because I was with him. But what does this mean, that they both quoted it? So then I asked him if he'd like to buy the quote for a title and he said *(laughs)*, "No, I like one-word titles best." So then I told him I'd sell him the title "THE" that Tennessee Williams once sold me. He laughed. I thought Jane was paying for dinner but then he did and I was embarrassed. He had a limo and we dropped him at the Carlyle and then Jane dropped me and she told me that she had had an affair with him before he married Julie.

Friday, January 15, 1982

Got a call from Jon and he was coming in from Los Angeles and we were going to the preview at Radio City of the new Coppola movie. But then his plane was really late and he didn't make it.

The movie, *One from the Heart*, was boring, stinkeroo, and Frederic Forrest is one of my favorite actors and he'd gained about twenty pounds for the role. It was pretty, but looks aren't enough, it's not going to make it.

And I was putting the movie down afterward but then I saw the press coming at me, *People* magazine and *Time*, and so I changed my tune and told them how much I loved it.

Saturday, January 30, 1982

Jon picked me up and we cabbed to Sheridan Square to see Harvey Fierstein's *Torch Song Trilogy* (tickets $35, cab $7). It was at the Sheridan Square place and the theater was one of those firetraps, and it was embarrassing because there were nothing but boys going in, and so we went around the block and then when a couple of girls went up to the box office, we stood near them. The play was four hours long but it was really funny, it had funny lines and everybody loved it, everybody laughed. Like the drag queen said, "I've had so many names—Kitty Litter, Beef à la Mode...."

And when the play was over the usher said that Harvey Fierstein wanted to see me. I'd always had it in the back of my head that somehow he was somebody we knew vaguely, but I couldn't remember, and then I met him and he said, "Don't you remember me? I was that 500-pound boy who was in your play, *Pork*, and look at what I have here—a hit play!" And he's great, his voice got so low. He's appealing and really talented—he wrote and directed it and acts in it. I told him I'd try to get *Interview* to do a story on him because he's new talent.

Dropped Jon (magazines and newspapers $10, cab $6). Got to bed around 1:00.

Monday, February 1, 1982

After three weeks of planning our lunch with Mayor Koch it was finally going to happen today, then his father died, but they said he wants to reschedule. And James Brady on Page Six was so mean, because he reported that Mayor Koch had asked for all thirteen episodes of *Brideshead Revisited* on tape, to imply that that must mean he has a "problem," but it was mean to put it in the paper when his father just died.

So since our lunch was cancelled, I went down to Odeon where Leo's workers were having a surprise party lunch for him. The ride took an hour ($10).

It was just star-studded. There was a different artist at every table—Jasper Johns at one table, Robert Rauschenberg at another one, Dan Flavin at another, Artschwager at another, Richard Serra. I sat at a table with James Mayor and Mr. and Mrs. Sidney Lewis and I went over and said, "This is the table I want to sit at because everybody here owes me money." So Mrs. Lewis gave me a dime.

I gave Leo underwear and a snot rag with dollar signs and he loved it, no one else brought presents. And his wife Toiny was there and I had copies of *Interview* with me and people told me to put it away because it had the interview that showed Leo's girlfriend Laura de Coppet and she and Leo were still having an affair and people told me it'd caused a big fight—that Leo was supposed to go to Rome and Toiny saw the interview and got so mad she tore up his ticket and he had to stay in town an extra day. It was the biggest fight ever, they said.

Hans Namuth took every artist to the bathroom to take pictures and I decided to be a camp and I cuddled and felt up Rauschenberg and found out he has a bad body.

Wednesday, February 3, 1982

Talked to Stuart Pivar on the phone and we decided to do something together. So I went over to his place on West 67th and it was strange going into that building because Jed lives there. And then we decided to walk over to the auto show at the Coliseum (tickets $15). The DeLorean cars were the cutest with the doors that open the other way. They were $40,000 and now they're $20,000.

Then Stuart dropped me at the office and I worked for a couple of hours on Crosses and Valentines. Did that until 7:00. I was supposed to go out with Jon but he had to work on his new loft that he just got. Chris called and he and Peter were going to go to the reopening of Danceteria, which is now going to be where Interferon was, but I decided not to.

Thursday, February 4, 1982

The Du Pont twins sent me an invitation to the opening of a new restaurant called Jeanie's in the old Tudor Hotel, and it was a Nikki Haskell event (cab $4). Cornelia Guest came but I guess she's been reading her newspaper clippings so she only stayed a minute. The food was good and I ordered a lot. And the steak arrived and Chris had his wrapped up and ready to take home for breakfast before it was even served, practically, and they wanted to know what was wrong.

And there was a party for Pia Zadora that Frank Sinatra was even coming in for at Hisae that we could have gone to but Bob wouldn't put her on the cover, and she would have been just great to have on the cover, I just love her. It's like if Andrea "Whips" Feldman had been not crazy and had a better nose. Pia's like all those tiny girls we knew who always grabbed the spotlight.

Friday, February 5, 1982

Was picked up by Jon to go to see *Venom*, on Broadway and 46th Street (cab $5, tickets $10). Jon checked how it was doing with the manager, it was a Paramount movie. It was about 60 percent filled.

Well, it was the audience that was really the horror show. In front of us was like a family, a mother and then I think a couple of daughters with their boyfriends, and they were eating and kissing and feeling up, and it was so strange, so crude.

Then Puerto Ricans came in back of us and their feet were up and they were smoking joints and there were all these big black bruisers lurking everywhere.

Then when we left the theater I was nervous because we were on the street where somebody's been throwing rocks off buildings and killing people. We went to Studio 54 where Liz Smith and a Lumet girl were having a birthday party called I think "15 & 50." I saw Sean McKeon outside and I asked if he wanted to get in and he said yes, and so I got him in, and I introduced him to Jon (hatcheck $2).

Saturday, February 6, 1982

I went to Jan Cowles's place at 810 Fifth Avenue where she was having a birthday party for her son Charlie. Gave Charlie a Dollar Sign painting and Leo was there. Joe MacDonald was there, but I didn't want to be near him and talk to him because he just had gay cancer. I talked to his brother's wife.

At 11:00 cabbed to La Coupole ($5). Diana Ross was there with Patrice Calmette and Iman and Bianca and Barry Diller and Steve Rubell. They were just finishing dinner. I tried to make Barry Diller laugh because he never does and everybody says it's impossible, I asked him to dance but he didn't even crack a smile, so then I gave up and just told him that I loved his movie *Venom*. Then he laughed.

Then Calvin Klein invited us to see his new apartment on 66th and Central Park West (cab $6). Diana Ross went in a limo. The place is beautiful, a duplex, with a gym and modernized windows and he did it himself, all white and he has a stairway like Halston's, wooden with no banister, and it looks like a work of art and it's very scary. And everything's in order and he collects the same things I do. Stieglitz's pictures of Georgia O'Keeffe. And Indian rugs and blonde tortoiseshell.

Monday, February 8, 1982

It was such a beautiful day that I decided I wanted to stay out until the sun went down, it was so warm and sunny.

On TV was a movie *The Day the Bubble Burst* about the big crash of the stock market in 1929 and Jon asked me if I was around for it. I said no.

Thursday, February 11, 1982

The Oscar nominations came out. And Faye didn't get nominated for *Mommie Dearest*. If *that* isn't acting . . .

Sunday, February 14, 1982

Brigid's in the hospital seeing about having her gallbladder out.

Marisa was having her wedding to Richard Golub at Halston's office place and she looked great in a pink tulle Halston sleeveless, and you see how beautiful the dresses can really look when they're on somebody like that. They talked and laughed during the ceremony, that was sort of good, the bride and groom. But he's just another guy looking for a beautiful girl to get him into the papers.

Cabbed back to pick up Chris to see *Quest for Fire*. And Rae Dawn Chong was in it, the girl

who was going with Owen Bayless who used to work for *Interview*. She was naked in the movie, her role was that she teaches mankind how to fuck in the normal position instead of doing it from behind. The audience loved it. It was different. There was no dialogue.

Monday, February 15, 1982

Brigid said she was going to be operated on on Wednesday.

Walked to Columbus Avenue through the park with Jon and there was a group of five big bruisers hanging around and when Jon runs he dances and runs up telephone poles and swings on trees and he has his earphones on so he didn't hear it but this group applauded.

Wednesday, February 17, 1982

Brigid's now going to be operated on on Friday morning at Roosevelt Hospital. She said Lee Strasberg just died there and that Joanne Woodward's having a foot operation there.

Saturday, February 20, 1982

Got up early and had to meet Rupert. Brigid called and said she was walking around. She said it was hard having the operation but she was glad it was over now.

And Matt Dillon was having a birthday party, his eighteenth, at Studio 54. And that boy, Baird Jones, whose father runs *People*, was having all rich preppies from Harvard and Columbia at a party at the Savoy. He's turning into Elsa Maxwell, giving parties at a different place every week, having all the rich young preppies there. But Fred had a dinner I had to go to at his place.

Sunday, February 21, 1982

Got up early, went to church.

Vincent called and said Shelly had an 8.2-pound baby girl and that the birth was really easy and they named her Austin.

Monday, February 22, 1982

Got up early and went to exercise class. Brigid didn't call but I knew that she was okay because she checked in with the office. The Mayor Koch lunch was still on for the next day at the office—I was surprised, because he just announced he would run for governor, and I thought he'd break the lunch date.

Jane Fonda called and I tried to call her back but didn't get her so I wondered all day what

that was about. Then later Kate Jackson called and it was fun to get these movie star calls. She said she was just calling to say hello, and I told her I'd loved her movie, *Making Love*. And Chen from Liz Taylor's office called to invite me to Liz's fiftieth birthday party in London on Saturday but I think we'll be in Belgium, it's supposed to be a smasheroo.

Tuesday, February 23, 1982

This was the day Mayor Koch was coming to lunch and Vincent was all excited, and I kept saying he was going to cancel but he still hadn't, and then at 11:00 he called and cancelled. Vincent was really disappointed and now I think Koch is awful. He could have come just for five minutes. I mean, now I'm not going to vote for him. I *know* I don't vote, but so what, I mean, he's still awful. And they were showing on the news the clips of him in the past saying that he would never run for governor, so he just changed his tune and that means he's just like everybody else, he blows with the wind.

Jane Fonda called again. She wants a free portrait of herself so she can make posters from it to sell to raise money for her husband Tom Hayden's election campaign. Fred can't decide if I should do it.

Wednesday, February 24, 1982

Victor called and said he wanted to see *Victor/Victoria*—he thinks it's about him. He said Halston would have dinner afterward just for the three of us.

Tuesday, March 2, 1982—Berlin

We went over to where Fassbinder was filming this movie called *Querelle* by Genet. Brad Davis is the star of it. I got my picture taken with Brad and I got his autograph on an ashtray for Jon. Met Fassbinder and he was wearing outrageous clothes, the leopard-skin jodhpurs, and one of the guys standing there said he thought Fassbinder had dressed up like that just for me because he usually wears just plain black leather. He looked like a circus trainer. And Brad Davis looks so strange, so delicate-looking. Much better than he did on the cover of *Interview*.

Saturday, March 6, 1982—Paris

At 6:30 I had an opening at the Daniel Templon Gallery which I didn't know I was having but since I was in town I had to go to it. We got there and it wasn't so bad. It was the Dollar Signs and they looked pretty good. We ran into São Schlumberger there, and she didn't know I'd be in town. She offered us a ride back to the hotel. She was cute, wearing leather and foxtails. And then we invited lots of models to a party Lord Jermyn was giving for me—he *said* it was a party

for me but I think it was just a good excuse. That was at 9:00. We picked up Chris and walked over.

Johnny Pigozzi told me that John Belushi died from an overdose.

Then the models said they had another party to take us to and Eric de Rothschild said he wanted to come with us and that he had "a limo" outside, but it turned out he just had a Volkswagen, and so about eight of us had to fit into it. And we got to the party and it was really great, all these beautiful models, one better than the other. Dancing to beautiful tunes, American, smoking joints and cooking frankfurters with the windows open. Then the police came and we got scared, everybody had to throw their dope away. It was about 2:00 and we had to think about getting back and packing for our trip back to New York.

Chris and I left and cabbed back to Fred's apartment ($10).

Monday, March 8, 1982—New York

Victor gave me a call and said that he'd been with some Amsterdam boys and that everybody's afraid of getting the gay cancer so now they fuck with their big toe. Now it's *(laughs)* whoever has the biggest *toe*. He said, "It's wild."

Saturday, March 13, 1982

Got up early to meet Jon. It started raining but it was warm. Decided we'd go to the Met to see what the new Rockefeller Primitive Collection looked like (cab $4, admission $7). Liz Holtzman was going in to see it, too, and she was nice and charming, she came over to say hello. There were a lot of photographs of the Michael Rockefeller boy who got eaten and a boy and a girl were looking at one of them and I heard them say, "He looks like a hippie." The collection was great, it's mostly African but some American Indian and some Mexican and some South American and the installation was terrific. Walked down from 83rd Street to 44th Street and stopped at Barnes and Noble for reference books and some books that'll help with *Interview*, about Dorothy Kilgallen. Bob Bach was a good friend of hers. I just ran into him recently. He's the one who gave me the job as the hand drawing on the weather map for about a week once on CBS, during the Will Rogers, Jr. show in the fifties.

Monday, March 15, 1982

I got a letter from Billy Name and he wants me to give his photographs from the original Factory on 47th Street to Jean Stein for her Edie book, and I just hate her, I don't want him to.

And Brigid was back at work and it was wonderful, she was radiant and God, she really has a beautiful gallbladder scar, you can hardly see the staple marks. We sat at the conference table for an hour and she told me everything about the gallbladder attack and operation.

Tuesday, March 16, 1982

Paul Morrissey came down and he said that Jean Stein called him and read him something that René Ricard had said about him in her *Edie* book, and he told her that if she printed it he'd sue her, and she said she was going to print it anyway. And Fred said I should be generous and find Billy's pictures and give them to Jean, but I said, "You know, Fred, I really don't mind spending all the time it would take to find the pictures, but I hear that Jean has some rotten things about me in her book and so I just don't want to." And he said, "Well if you feel that way, why don't you just call her up yourself and tell her that." And so I told him *he* should, but then I did, I called her and said, "You know, Jean, it'd take me a couple of afternoons to find the pictures and I would do it, but I hear that you put me down in your book." And she said, "Oh well—well—well—I—I—it's tape recorded, it's taped *interviews*." And I said, "Oh so then other people put me down." And she goes, "Well I—I—didn't—I didn't really say that." "Well then can you send me a galley?" "Oh but all the galleys, I've given them all out." "Well, Jean, there's always a Xerox machine." "Well, I—I—but Billy wrote you that wonderful letter." "Yes, Billy wrote me that wonderful letter."

I mean she's just that tough type of girl—it's like Brooke Hayward. They're just—Suzie Frankfurts. You know? They're the same type. They pretend to be so *femme* and they're these tough—things. You know? And the point is, none of the stuff she has in the book would bother me, I'm sure, because I'm sure I'd think it's fascinating. But the one thing that bothers me is that she calls me a "social climber." Isabel Eberstadt let that slip out to me—and that's—that's just not true. Meeting rich kids wasn't anything to me, and being invited to her stupid parties. It bothers me because it's not true! The other things, I'm sure they'll be fascinating, whether they're true or not, but the "social climbing" thing just isn't true. Oh but *why* does it bother me so much? I don't *know* why, it just does, I don't know. . . .

Oh and Paul said he saw Ondine and that he's still traveling around the country with a 16mm print of *Chelsea Girls*, showing it and giving lectures. What is Ondine going to do when that print just disintegrates? Or if it gets lost? Now *that's* a play. And he's teaching rich kids acting at some school like Buckley so there'll be this whole group of kids who'll *(laughs)* act like Ondine. Oh and I can just see it if Billy Name comes to New York. Oh he won't, he's too shy, he won't want us to see him fat. Oh but if he does—I can just see it—he'll come on the bus with a YMCA satchel. And Tom Baker's doing the same thing, he's traveling around with a print of *I, a Man*.

And of course the big news of the day was that Claus von Bulow was found guilty in Rhode Island. I guess he'll appeal the verdict.

Wednesday, March 17, 1982

I was picked up by Jon at 8 P.M. and we went to Diane Von Furstenberg's, she was having a no-reason party but I think maybe it was for a rich Indonesian. Bob was coming after dinner because he was going to a dinner the Hales were giving for the attorney general.

Barbara Allen arrived, she said she was dropped off by Bill Paley and she broke down after I kidded her about Peter Duchin and she told me she was thinking of going back to Joe Allen.

Because she was just fired by Valentino. I didn't know that. She said she was hurt, and they owed her money, and she didn't know why they fired her. And I asked her about Peter Duchin and she said he was okay but that he'd been married for seventeen years so he already had his habits. She said she was tired of having flings, that she thought it might be time to buckle down and become a hostess. She said that she could really make all the other girls jealous with the entertaining she could do. There was Italian food and South American drinks which I had and they were so strong.

Thursday, March 18, 1982

I read that Jean Stein's book *Edie* got six figures from the Book-of-the-Month Club, and I got an idea what to do about Billy Name and his pictures—I think that if the book becomes big and Edie becomes a cult again, it would be better for Billy to publish his own portfolio of Edie pictures, he could make more doing it that way. I've got to write him a letter to tell him that because I just don't want to give the pictures to Jean. I mean, there's probably not even anything *really* bad about me in the book, but still I just don't want to.

It was a sunny cold day. Cabbed to the Mayflower Hotel ($6) to interview Cher. She has a glamorous penthouse, like a two-story house on top, and she wanted to do it in the bedroom. Her bed overlooks Central Park. It was the fourth day she couldn't eat, she couldn't even swallow a vitamin pill, and she was taking medicine for her throat and it made her face break out and swell up and so she just drinks thick rich malteds so her weight doesn't go down too much.

She was great, she just said everything. She said she has two boyfriends now, it just happened in one week, and she's so happy because they're real men, and I brought up Ron Duguay, that we'd heard she'd been seeing him and she said yes but that he was too interested in himself, he wasn't for her. She talked about anything except her father, she said that was a "No."

And Cher said that when they called and told her she had the second lead after Meryl Streep in the Karen Silkwood story she said she cried for five hours because everything she'd done up to now has been shit, except for the *Come Back to the Five and Dime* play, and she's so happy.

Dropped Bob ($3.50) then was picked up by Jon and went to Ahmet Ertegun's house. Bob said it was just for "sandwiches" but the stupid butler, he should have taken us upstairs, but he led us right in and everybody was sitting down at dinner, and Mica and Ahmet had to get up.

Then we went to the Bottom Line in a bus to see Ahmet's new act, Laura Branigan, who was absolutely great.

Thursday, March 25, 1982

Lord Jermyn was giving a dinner for Fred at the Odeon (cab $8). It's such a long ride down there. Mick Jagger arrived and that was the big moment, everybody in the place got excited. And Charlie Watts was with him. No Jerry. They were on the loose. Julian Schnabel still wants to paint me, and he says Saturday is the only day he can do it because he's going away. He gets $40,000 for a portrait, he's the Jim Dine of the eighties. He copies people's work and he's pushy and he's a

friend of Ronnie's and he's married a rich girl already. I'm going to have to sit for it. He does it abstract, anyway, but I guess I have to because he wants the inspiration.

I ordered sweetbreads which I hate so that I wouldn't eat anything. Then we went to John Samuels's birthday party at his father's big loft on Broadway. Jane Holzer was talking about Ian Schrager, she's so hot for him, she said he's the best sex, and we sat there talking till 2:00 so I missed Jon's call from California.

Friday, March 26, 1982

This was the night Radio City was having its fiftieth anniversary, and Maura Moynihan had called a few times during the day so I thought she'd be a good date, and we could continue the *Music Hotel* tapes—that's what my musical is called now—about her and her two boyfriends. So cabbed to Radio City ($2). It was boring.

Maura called her boyfriends but they weren't home. She's working at the *Post* now. She makes $100 a day and she works about three days a week, reading things and editing them, I guess.

Saturday, March 27, 1982

Got a call from Jon in L.A., he was meeting Bob and Thomas Ammann out there for lunch.

Sunday, March 28, 1982

Bob came back from California, I guess just for a jeans party in Tribeca at some new cafe. He left Hollywood for that.

I ran into Mary Richardson and she said she was getting married to John Samuels's roommate from Harvard. Carlos Mavroleon. Well that's what she says but I remember he had a lisp. It'd be funny if he's a straight person with a lisp, but I don't know.

Monday, March 29, 1982

Got up early, tried to make exercise class on time. Lidija told me that Sharon said that the woman downstairs from her complained that we make too much noise, and so that's Sharon trying to tell us we can't use the room anymore, so I guess our days there are numbered.

Bob arranged dinner with the mayor. This is the dinner for Alice Neel's birthday that was scheduled for a month ago but then it was cancelled when the mayor's father died. And Polly Bergen was having an Academy Awards party. And Lester Persky was having a dinner and party at Xenon to (laughs) "honor the stars."

Cabbed to Gracie Mansion ($6). It was all artists, sort of horrible, Henry Geldzahler was there with Raymond, and Duane Hanson and Alice Neel and Tom Armstrong were there. And everyone

was complaining because the Whitney hadn't loaned the portrait that Alice Neel did of me for the dinner, you have to give them a month's notice and I said that that was just fine with me, that it was a closet painting. And Alice had a nude of herself. Her family was there. She turns these paintings out so fast. And the mayor was nice, he made a cute speech, one-liners.

And then suddenly some creep got up and started a speech and it was Stewart Mott and it was the oddest speech. He talked about how Alice Neel had lived in the gutter for so long and didn't have a pot to pee in and how she lived on like 109th Street on the East Side and then on 105th Street on the West Side and now, as a present to Alice, would the mayor please give his views on nuclear war and disarmament. And the mayor said something like, "Now listen here, we're finished with your speech."

Bob told the mayor we wanted him for the cover of *Interview* and the mayor said, "After the election," and Bob said, "Oh couldn't it be before?" but the mayor said, "After'll be better." So that was disappointing.

And did I ever say that my favorite person is Mrs. Senator Al D'Amato. She actually talks like Judy Holliday. A real person who actually talks that way.

Tuesday, March 30, 1982

Christopher wanted to go out looking for ideas. It was a beautiful day. We went to Dubrow's the cafeteria, this is in the garment center, and they have all the red lights on the food so it all looks so good and everything is oversized and it's full of air. I thought it'd be cheap but it wasn't ($20). Then we only had time to do the bottom floor of Macy's because Chris had an appointment.

Talked to Jon, he was entertaining Barbara Allen out in L.A., she's out there with John Samuels.

Then there was a gallery opening at the Sperone Westwater Gallery for Cy Twombly. David Whitney and Sandro Chia and a couple of Italian artists were there. Then we went to Odeon. I was next to Si Newhouse who talked about the new *Vanity Fair*. He just bought a $800,000 Jasper Johns. I told him I had some Warrens and Natalies that I would part with.

Saturday, April 3, 1982

I went to Pasta & Cheese and I took out a jar from the refrigerator there and I dropped it and it hit the floor the right way to open it and the top came off and marinara sauce went all over and all over me, it was so embarrassing. They said not to worry about it. It's never happened to me before.

We went down to Lafayette to Bob Rauschenberg's party and on the way we ran into Henry Post. Lady McCrady was there and she's doing drawings at the Hellfire Club which is a straight club where girls lead the men around on leashes and things, and it's piss and shit for straights.

Left there at 12:30. Went to Studio 54 where there was a birthday party for the black star on *Saturday Night Live* who's just signed to do a movie with Paramount. Eddie Murphy. And he's sort of handsome. The place was jammed but with nobodies.

Sunday, April 4, 1982

Chris called and said he wanted to go to the P.S. 1 thing out in Queens. This thing had gotten good writeups. And Henry Post's live-in boyfriend was exhibiting. The place was packed, and it reminded me of years ago, going to places like Settlement House for these types of things. But years ago they did have better people—Oldenburg and Whitman. Brooke Adams was there, she was sweet, she said hi. And Princess Schleswig-Holstein—Pingle—who we sort of let go from working at the office because she was such an egghead, she was there and now she works at this place about one day a week. We had her give us a tour.

And we saw Henry Post and looked at his boyfriend's stuff which was okay but it was just a copy of Jedd Garet. Jon really sees things in paintings that I don't see. Like, there was an abstract painting and he saw all these figures of people painted over it. They were there but I hadn't seen them and paintings do have things to say, but I never looked at them that way.

There was a cocktail party that Henry was having at Anna Wintour's place where she lives with that Michael Stone.

And Henry put down the Rauschenberg party the day before, saying his was going to be so grand, so chic. But I'm beginning to think that maybe Henry doesn't really know what an elegant party is like, that he hasn't been to many. Because this party—I mean, they didn't even really have food. It was 6:30 to 8:30 and it was broken-up crackers. It was on Broadway and 70th and 71st. And they had big trees and three maids, but so what, because there was no food. And the reason I'm putting it down so much is because Henry put down Rauschenberg's so much, saying how much better his was going to be. And Jed was there. I'd asked Henry if he was going to be, and he said yes, that Jed was one of his best friends. And there were no stars.

Steve Rubell was there. But the strangest thing is that he was with the prosecutor who sent him to jail! And I think Henry—who actually wrote the article that started all the trouble—I think Henry got them together. I mean, it's like if somebody got you evicted from your apartment and then you decided the next year to be friends with them. Or is it trying to get involved with the guy who's smart enough to get you, and getting him then involved in what you do.

Monday, April 5, 1982

Worked all afternoon. The place suddenly got busy. I remembered I had tickets that Susan Blond gave me to the rock kid who ate the heads off bats, Ozzy Osbourne, but then Thomas Ammann called and invited me to dinner at Mr. Chow's and I gave the tickets away to Agosto. Cabbed to Mr. Chow's ($7).

We talked art. Thomas told the story of the Picasso he bought from Paulette Goddard, it cost $60,000 and he brought it to one of the Picasso kids and they said it was a fake, and he said Paulette gave him a hard time, that she was "difficult," but she did give him his money back. But when you think about it, thirty years ago would somebody really be doing a forgery of Picasso? He started to get really really big in 1950. I came to New York in 1949 and Sidney Janis and those galleries were around and the Museum of Modern Art and art became really big and Picasso became the number-one artist. But it's very early to have somebody be doing a forgery, so I don't know.

Then Thomas had invited Jerry Zipkin and he came by. He puts people down when he's "on," though, he thinks he has to entertain. I was saying that Holly Solomon and her husband owned the building that Marilyn Monroe and Arthur Miller lived in and Jerry was putting her down, the way she looks, the way she dresses. And Jerry said that what a lot of wives do is they tell their boyfriends they want a $150,000 pin and the boyfriend gives them the money and then they tell the husband the same thing, and he gives the money, and then they buy the pin and they pocket the other $150,000 and each one thinks they bought it. And also he said that a lot of husbands buy their wives jewelry in the company name so that when they break up, the jewelry belongs back to the company. But a lot of wives have copies made and sell the real ones before that.

Wednesday, April 7, 1982

We still didn't have an *Interview* cover and then I guess they decided to use Dyan Cannon, and Robert Hayes told Bob that I'd said it was okay, which I know I didn't because I would never say it, because I can't stand her so much. We had tried to get Rachel Ward but her agency said no.

I decided to go see *Cat People*. Was picked up by Jon and went to the Gemini (cab $3, tickets $10). I really liked the movie so much. I guess I really like the Scarfiotti art direction. And this time I really loved the arm being bitten off and how they did it and the snap when it came out of the socket.

Friday, April 9, 1982

It was my last exercise class at Lady Sharon's. I'm so mad at her, she got us all involved in this, and then she just dumps us out on the street and she says it's the people downstairs complaining but I know it's not. If it didn't bother them before, it's not bothering them now. So I'll be doing classes at John Reinhold's for a little while and by then the exercise equipment I ordered should be at the office.

Monday, April 12, 1982

I don't know why I should really hate Sharon so much, but I just do, I just resent her so much for getting me started on exercising at her house and then just kicking me out. I really resent her.

Billy Squier came to lunch, and also at this lunch was Issey Miyake, and he's going to start a men's line. He was saying that Japanese people spend so much on clothes and he told me about the 6' × 4' hotel rooms where you strap a TV around your head. He said that when Japanese people come to New York City they have nervous breakdowns because of "all the space," and they can only send people from the suburbs there here.

Monday, April 19, 1982

Chris called and said there was a screening of the Fassbinder movie we'd seen them shooting in Germany. I had a lunch to go to so we only saw an hour and a half of the movie and that much was okay, but it was going to go on for another forty minutes.

Tuesday, April 20, 1982

It was a busy afternoon. Fassbinder and his producer came by, I told him I loved the movie. Then they went out and the producer came back and said he'd left Fassbinder in a porno shop in the Village. He's strange, Fassbinder. He was nice when I introduced him to the boys at the office, but when I introduced him to Lidija the exercise teacher he was peculiar.

I called Edmund Gaultney because Calvin Klein had asked me to get in touch with Georgia O'Keeffe because he wanted to meet her and buy a painting. And then I called Juan Hamilton and he was being grand, he said that Calvin could fly to Albuquerque but he didn't know if Georgia would see him, and I said that Calvin didn't do things like that and he said, "That's how it goes." So I called Calvin and told him that he should call Juan himself, because really, it's all personality.

Wednesday, April 21, 1982

The limousine was picking us up to take me to Butler Aviation where I was shooting an ad for U.S. Air. They had like 100 people for this commercial and the Rockettes were in it, and Dick Cavett who had just left, and I met the director and the assistant director and I hated them, it was just like Hollywood—guys in gold chains and running shoes and bluejeans.

The makeup girl covered my pimple, then I was put on the plane next to a lady in a grey wig. My line was that I had to pick up a bagel and say, "What is art?" and I couldn't get it right— the first time I said, "What is a bagel?"—and I had to do twenty takes.

Oh and I could just scream at Paul Morrissey because I open the paper and I see that *Frankenstein* is now playing in fifty theaters and during this time when he's quibbling and nitpicking with *me* about every little dot in this formal contract he wanted made up to spell out what percentages he owns of which movies, and while he's having his lawyer, Chase Mellen, write up every little thing—like in twenty years if I'm not around what happens—here Ponti or some Mafia company or *somebody* is making a fortune off *Frankenstein*, so why wasn't Paul on top of *that*? I think I'm now going to really read the contract he wants me to sign and then I'll say that *I* won't sign things until they're even *more* spelled out—I mean, what happens if *he's* not around in twenty years? I don't want to have to negotiate with his *mother* over foreign rights. I think I'll do that. Yeah, I think I will.

And have I mentioned that Mrs. Rupert Murdoch wrote me a letter about saving the church? The one on 66th Street that I go to, St. Vincent Ferrer. It's in danger of people not going to it. It used to be the chic Catholic church, but now it's always empty.

Thursday, April 22, 1982

Halston's show was great, the simple wonderful clothes he does. And he used ten or twelve girls. He had this new fabric that's beautiful, that's like paper and silk, and people were feeling it to see what it was. It came in gunmetal grey and gunmetal green and like with a waterfall through it, like iridescent. And studs everywhere, lots of studs. Lauren Hutton was next to me and she was using the same camera that I use but she was shooting from the hip and I told her that she'd never get a picture unless she looked through it and put the circle in the right place. She said wasn't it great we were Montauk neighbors now—she and Halston and Peter Beard's brother bought 100 acres and she and Halston are going to divide up the land and build on it.

Discussed the Extinct Animals portfolio with Ron Feldman.

Sunday, April 25, 1982

Picked up Jon to go to the park. By accident ran into his boss Barry Diller who was with Calvin Klein, David Geffen, and Steve Rubell out together for a walk. It was sort of a shocking moment. Everybody looked guilty for something.

Monday, April 26, 1982

Jane Fonda called and she's coming on Thursday for me to do her portrait. I decided to do it after Fred read her husband's bio and political ideas and told me I should.

Sean McKeon called and he's back from a modeling job in Hamburg. He said he's breaking up with the girl he's living with—she has a nice apartment—and that he was up for grabs if I want him, so I said I'd think about it and call him.

Tuesday, April 27, 1982

It was nice to be in the rain with an umbrella, nobody bothers you.

Chris came by and was having marriage problems—Peter had stayed out till 3:00 and Chris got hysterical crying, and here's this person who you've only seen being strong and you would never dream that he would ever get like that, and it shocked me so much, I decided that I really liked him a lot because he's actually this marshmallow. I decided that I really had to help keep the marriage together so I invited them out to dinner.

Worked all afternoon.

Went to the Coach House and it's so fattening there—corn sticks and things, it's so good. I'm 120 now but I'd like to get back down, I don't think I'll see 115 again. I'm not anorexic anymore, but I want to be. Lidija says it's muscles making me heavier. I mean, you see these kids who've been working out for a year or so, like Marc Balet who once had a slight hourglass figure, and now it looks like he's put on a coat! It's so strange (dinner $250).

Wednesday, April 28, 1982

The marriage of Chris and Peter is recovering.

And I redid the lips on the Agnelli portrait. I wonder what's going to happen to all these portraits in ten years when the little silkscreened dots that make up the image start to flake off.

Thursday, April 29, 1982

Jane Fonda was coming down at 2:00 and I had a beauty class at 1:00. Fred and I had a big fight about the makeup person and he had to go out to cool off. Then he came back. Jane Fonda had her own hairdresser and her own makeup person with her, and she was on crutches and she was oh-so-charming because she was wanting something free. Really charming. She asked about Geraldine Smith and Eric Emerson who she and Vadim once took back to their hotel room with them after meeting them at the Factory. I told her Eric was in heaven and Geraldine was in the phone book.

I had Brigid stitching away on the new sewing machine I bought because I want to sew my photographs together, but then it turned out that the best sewer is my bodyguard, the ex-Marine Agosto, because he worked in a sweatshop in Hawaii before he went into the marines.

Wednesday, May 5, 1982

Cabbed to 720 Park Avenue which is at 70th, the very chic building. Mrs. Landau wants the color of her hair in her portrait changed from black to brown. A boy butler brought in food, mushrooms with paté, stuffed, and then peapods stuffed with cheese. What kind of food is that? Is it French? I knew it must have been handled so much but I was so hungry I ate it. And she has so many Picassos. We talked about restaurants and paintings. Then I said I had to go because Steve Rubell was picking me up to go to a black-tie Democratic dinner.

He had a girl driver in a miniskirt and blonde so she looked like Blondie but she was a slow driver and so Steve shoved her aside and took over. Went to the Sheraton Center, to the ballroom. It's so crummy there. Steve wants to get his liquor license back so he's contributing to everybody's campaigns.

Thursday, May 6, 1982

The birthday dinner for Richard Gere that Silvinha was giving wasn't until 10:00 it turned out, so I went home and worked a while (cab $5.50).

Went to Richard Gere's on East 10th Street (cab $7). It was the penthouse apartment with a big terrace, it seemed like it was almost a block long. Silvinha paints there. Diane Von Furstenberg was there and the South American kids. And John Samuels was there, he said he'd gotten the lead in *Hotel New Hampshire* with Diane Lane and Amanda Plummer, directed by Tony Richardson.

Jann Wenner and his wife were there and he looks like he's losing weight now. Stayed there till about 2:00.

Sunday, May 9, 1982

Thomas Ammann came to town and asked about the art business. I asked him if he wanted to go to the opening of the musical *Nine* with me that evening and he said yes. It was the night of Bob's birthday party at the new Club A that Elizinha Goncalves was giving for him.

I picked up Jon and we went to 333 East 60th Street to Club A (cab $7). It was really a great party, so glamorous, you'd never think it was for Bob, all these great people were there. I was next to Betsy Bloomingdale and I talked to her, she said Alfred was still sick. "Suzy" was there, and Lynn Wyatt flew in for the party, and Farrah Fawcett and Ryan O'Neal. They had these old men serving who looked like they were from those restaurants on the Lower East Side from years ago, the good kind of waiters. It must have taken a lot of work, this party, and a lot of planning. And the food was really great. They had caviar stuffed into smoked salmon so you had two courses in the same breath.

Monday, May 10, 1982

I was invited by Jon to see *An Officer and a Gentleman* with Richard Gere and Debra Winger. I can't tell if I liked it or not. Jon said he cried three times during it. Richard Gere has gotten to be a really good actor now, though. And Debra Winger is a good actress but she has this nose that just misses. If she had a nose job she could look like Ava Gardner—or anything.

Tuesday, May 11, 1982

Got up early, did the phones. Had an appointment with Doc Cox, walked up there. The receptionist lit into me about how I didn't pay my bills on time and how Vincent was so awful when she called and I was starting to tell her off but then I stopped. And Doc Cox could hear everything so I guess he was the one who told her to say those things. And Rosemary is still the big cheese over there. I had an 11:00 appointment but I didn't get out until 1:00 or 1:30.

The New York Times had a big article about gay cancer, and how they don't know what to do with it. That it's epidemic proportions and they say that these kids who have sex all the time have it in their semen and they've already had every kind of disease there is—hepatitis one, two, and three, and mononucleosis, and I'm worried that I could get it by drinking out of the same glass or just being around these kids who go to the Baths.

Thursday, May 13, 1982

At the office Ronnie was still being difficult. The day before we'd had a fight and I'd told him to cool it. It's like that time I sent him out and told him to get anything but a key lime pie and he brought back a key lime pie and we couldn't figure out why he would do that. Well he was stretching and doing it crooked and then we had a fight and he said to me, "Well you don't paint, you don't photograph, and you don't stretch—what else can you *not do?*" I don't know what he's trying to do. He's the way he was when he was drinking and taking drugs, only he's not doing that now. Worked till 6:30.

Saturday, May 15, 1982

Went downtown to the gallery where Chris Makos was showing his drag pictures of me and where there was a show of Candy Darling photographs by all different photographers. The place was mobbed, it was the opening, and people like Jackie Curtis and Gerard Malanga were there (cab $6). Dropped Jon (cab $6.50).

Monday, May 17, 1982

I went in at the end of the lunch for Jody Jacobs from the *Los Angeles Times*, and Joan Quinn and Bianca Jagger came. Bianca said she wanted to do the Steven Spielberg interview with me. And now that I'm thinking about it what made Joan Quinn look unusual was that her hair wasn't colored, the pink and green—it was regular hair. And for once she didn't ask for a painting.

Tuesday, May 18, 1982

I tried to get some background information on Steven Spielberg for the interview with him. I decided not to be mad at the horrible P.R. girl who wouldn't let me into the screening of *E.T.* the other night. She sent orchids to apologize and it's stupid to keep thinking about things like that.

Wednesday, May 19, 1982

Went to the Sherry Netherland with Bianca to interview Spielberg and he was really sweet (cab $3). He was on his bed and he invited us to have some dinner. Bianca was hot for him because she wants to be in one of his movies, and he was hot for Bianca because he liked her in *her* movie. He said that he saw my movie *Sleep* when he was about twelve and that inspired him to make a movie called *Snore*. He said it was the most fun interview he'd ever done. We were going to invite him down to the office to try to sell him some art but then he suggested it himself. He said he'll

be back in town on the twenty-seventh and I said I'd be out of town but we'd arrange something. I dropped Bianca at the Carlyle and I went to Jon's to pick up a script (cab $4). Stayed twenty minutes.

Thursday, May 20, 1982

Watched W.C. Fields with a mustache in a movie I'd never seen before.

Fred was working out our itinerary and plans for Europe. Brigid and I went over to the beauty parlor on Third Avenue and I got a pedicure and manicure. People going by looked in the window and saw me and couldn't believe it ($26).

Two girls from Visual Arts saw me and came in and then ran back to school to get their art portfolios out of their lockers to show me. Brigid ran into Gerard Malanga on the street on her way out and brought him in and he had his camera with him but the wrong lens so he was going crazy because he couldn't take a picture of me getting a pedicure. Then the Visual Arts girls came back and I introduced them to Gerard and it was like old times, seeing him go after beautiful young girls. And while I was there two men came in and made appointments, I guess because they saw me in there. One was a fashion victim. The manicurist said there'd be a three-day wait and he said, "Well, put me down."

I've gained weight. I don't know what to do, my shirts are getting too tight for me.

Monday, May 31, 1982

Talked to Brigid, she's up to 170 and people are asking her if she's having a baby. I called Jay Shriver and he came in on the holiday because it's been such a crummy weekend. Worked all afternoon. Sent Jay for supplies ($30). Did some hand-painting. Finished the Crosses. Dropped Jay (cab $5.50).

And England is winning in the Falklands.

Friday, June 4, 1982

Had a 2:00 shooting at Avedon's for a Christian Dior spread. André Gregory was there and he's in a play downtown that he wrote. He co-wrote and produced the movie *My Dinner with André*, and he told me that when he was raising $500,000 for it, they told him, "What're you trying to do? Make an Andy Warhol movie?"

Everyone was wearing Dior clothes and they wanted to shoot me painting, but I said that it'd be more modern if it wasn't, to keep it simple or it'd ruin the shot. Doon Arbus was there and it was her first time back working with him, she and Avedon had had a big fight.

Saturday, June 5, 1982

Up early. Got supplies for the office ($22.73, $33.82). I went into one of those Korean produce stores and there were about fifteen people in there, it was mobbed, and I listened to this guy rave about a pineapple for ten minutes, and by the time he was through, I was dying to get one, too. He was saying, "I want it ripe and ready! Juicy! Luscious! Ready to eat, right off the bat!" And then I turned around and it was Nixon. And one of the daughters was with him, but looking older—maybe Julie, I think. And he looked pudgy, like a Dickens character, fat with a belly. And they had him sign for the bill. There were Secret Service with him. And the girl at the cash register said he was "Number-One Charge."

Went to *My Dinner with André* (cab $4) and there was a line so I told the girl that André sent us and would she please let us in and she thought I meant for free, but I said that I'd pay. I fell asleep, it was so boring. Hippie talk. I guess the kids are thinking this is intellectual because it tells about feelings. Home, bed at 1:00 (cab $4).

Tuesday, June 8, 1982—New York—Baltimore—New York

I had to go to Baltimore to see Richard Weisman's father, Fred, present my portraits of Ten Sports Figures to the University of Maryland. By the way, does the Diary know that Fred Weisman got his skull fractured by Frank Sinatra in the sixties? At the Polo Lounge in Los Angeles. They didn't know each other. Sinatra hit him with a phone.

Decided to fly on New York Air because I'd done the commercial for them, and it was a mistake because the plane didn't take off for forty-five minutes, they said they were waiting for parts but I think they were just waiting for the plane to fill up. And nobody mentioned my commercial, not even the stewardess when she handed me a bagel.

Arrived at University of Maryland and a girl comes running up and says, "How does it feel to be at the school that graduated Valerie Solanis?" I didn't know that Valerie went there! I'd never heard that, so that was new.

Was photographed and invited to the house of the president. And so we walked over across the campus, to his house, to sit and chat with a select few, which is always so boring. Got the shuttle and was back in New York at 3:45.

Rupert came and we worked on the poster for the Fassbinder movie till 8:00.

Wednesday, June 9, 1982

Somebody stopped me on Park Avenue and said, "You're that person on that commercial," and I said yes and gave him an *Interview*, and then he said, "Maybe you can help me?" and I said what was it because I was in sort of a rush, and he said that he wrote scripts and would I look at them and then he said, "And what's your name?"

Curley had his twenty-fifth birthday, and so we sent out for things and had drinks.

Thomas Ammann just called to tell me that Fassbinder just killed himself. Well, he really was strange. When he came to the office he was reeeally strange. And when *I* say somebody's strange, you know they're strange. He was thirty-seven and did forty movies.

Dropped Rupert (cab $5). Went home and was picked up by Richard Weisman to go to the *Grease II* premiere. Jon was taking Cornelia Guest. The movie was everything I dreamed for. I loved the Pfeiffer girl and the Caulfield boy and Pat Birch's direction was great. It was so good. John Travolta is so dumb for not doing *Grease II*. What is he doing now? Can you imagine being a star and not working? Do you sit in your palace and take *(laughs)* acting lessons, or what?

Friday, June 11, 1982

Cabbed to "21." I was meeting Richard Weisman who was having a party for the Cooney-Holmes fight. Then we walked over to Radio City to watch it (tickets $30). I guess they have a new screen, the image was *so* clear, you could see the pimples on the fighters' faces. We'd made bets beforehand and I had "Holmes in the fourth" and that almost happened because he was knocked down in the second, but in the end Richard's girlfriend won. I was the money-holder. At Radio City everybody was for Cooney, all the Irish. Holmes won by a TKO in the thirteenth round and everybody booed.

Sunday, June 13, 1982

Watched *Dog Day Afternoon* on TV and who was that playing the drag queen? That was good acting. He held his hand up a little too much to his neck, that was all. Otherwise, it was really perfect, and good lines, one was like a Candy Darling line.

Tuesday, June 15, 1982

Sent Agosto up to the Madison Avenue Bookshop for copies of *Edie*, and they told him, "It's selling like crazy" ($60). And in the book is a photograph of this totally wrong birth certificate for me. I just don't understand it. For Andrew Warhola, and it's from a different city and it says October 29, 1930, I think. Where could they have gotten a thing like that? What is it? And with the mother's name blocked out. I don't get it.

Was picked up at 6:00 by Chris and Peter for *Grease II*, I was seeing it again. Saw the movie on a smaller screen and it didn't hold up. Without the blasting sound from the Ziegfeld, I could understand why the critics said it was boring.

After it was over I went to Ashton Hawkins's for dinner. Annette Reed and I sort of hit off a conversation. She said she saw Clint Eastwood's movie *Firefox* at a benefit on Monday at the Museum of Modern Art, and that Clint was there, and so was his girlfriend, Sondra Locke. And after seeing the movie they all went to the Pierre for dinner and she said it would have been so much nicer, darling, to just have gone to "some Italian joint with friends." She said Clint was

"fascinating" and the movie was "interesting" but that she would rather have been with *friends*, darling, and let the movie end the experience.

Wednesday, June 16, 1982

I decided to see *Grease II* for the third time. Lorna Luft was having a screening at Paramount (cab $5.50). But Lorna wasn't even there. Her husband, Jake Hooker, was, and he said that Lorna's seen it too much. Sat in the back row and this third time it was better than when I sat up close in the screening room.

Thursday, June 17, 1982

Forgot to say that on Wednesday, Jay Johnson brought Marianne Faithfull to the office. He wasn't drinking, but she was, and she had I guess a boyfriend with her. And when she got there she was sort of out of it, but then she had some wine and by the time they left she was bubbling. Tom Cashin's signed a modeling contract with Pierre Cardin, so he travels a lot now.

I went out with John Reinhold. We went to the Odeon and Henry Geldzahler was eating alone so we took him to dinner ($198.85). He told stories about Jean Stein and that's when we got the idea that he should tell her I was doing a book on *her*.

Friday, June 18, 1982

Brigid made Jay Shriver go out drinking with her. I think the Edie Sedgwick book has been hitting her hard because I think she thinks it should have been a book on *her*. So she took Jay out drinking at lunch and told him her San Simeon stories from when she was a little girl visiting there when her father ran the Hearst Corporation. Then she came back to the office and wanted to be entertaining, so she was rolling on the floor but it was just a fat person rolling on the floor.

Monday, June 21, 1982

Met Sean McKeon and Chris and Peter at the Mayfair (drinks $20). Chris had his car and we went over to Couri Hay's party for Cornelia Guest, a barbecue on West 81st Street. And Cornelia's coming-out party the other night that I didn't go to made *The New York Times*. I should have gone. And Cornelia's gotten so fat she looks like the Pillsbury Dough Boy.

As we were walking between Amsterdam and Broadway there was a woman walking with two dobermans and a man carrying a wrench.

And Bob Colacello has a life of his own now. I never see him after work anymore. Is he doing great things? Is he having fun?

Talked to Jon in California and he was going to stay an extra day because he's trying to move from media relations into production.

Wednesday, June 23, 1982

Jane Holzer picked me up and she looked pretty in a red Halston. We went to City Center for the Martha Graham thing. After the performance, Bianca lost Tricky Dicky Cavett and had to find him and then we went over to Halston's. And Dick was telling me about this transsexual in New Orleans that was after him and asking me what he should do and I just kept saying he should fuck her, and I don't know what he wanted to hear. And Dick was doing anagrams for a whole hour. And I went completely off my diet, I had potato chips and drank and I felt like Brigid.

Left with Dick and Jane, and Dick was pawing Jane in the car and I asked him where his missus was. Was dropped by Dick at 2:00.

Friday, June 25, 1982

Rupert and all the kids told me they were going away for the weekend, so I decided not to go down to the office, I was afraid of getting stuck in the elevator.

Talked to Jon and he was going to stay home after going to the doctor's because he was rundown.

I'd gotten tickets to the Feld Ballet in the old Elgin Theater which they now call the Joyce Theater. Met Chris and Peter there. Fun costumes and cute kids. There was one all-girl number and one all-boy number sort of like *Grease* and then one boys and girls together. The *West Side Story* number with all the boys was done sort of as if they were making out.

But dance is so disillusioning for me. If you're over twenty-five, you're finished. Because after twenty you lose that sparkle, you get too stylized. And there's always a sparkly fifteen-year-old coming along to wash you up.

Then we went to Claire's on Seventh Avenue on the West Side, it's like one of those new, bright California places, all latticework, and jammed with fairies and Way Bandy came in and he looked like death, and he just drank coffee and I told him I still want him to do my makeup when I go out on the town.

Saturday, June 26, 1982

Went down to Heartbreak, the new discotheque near Vandam near the Paradise Ballroom. It's a cafeteria in the daytime and then a disco at night, and the music is all fifties and some sixties and everybody dresses the way they want and everybody dances the way they want. If you did a movie of it, it would be so underplayed. And all the kids at Heartbreak were coming over and saying that I'd told them at Studio 54 I'd look at their work, and all I could say was, "Well, so

when are you coming down?" and even the doorman at Heartbreak I think is coming to show me his work.

Sunday, June 27, 1982

Cabbed to 45th and Broadway ($6) to see *Blade Runner* (tickets $10) at the Criterion. The movie was dark. I don't know if it's really abstract or really simple. And there's a narrative. It's like Dick Powell playing Philip Marlowe. And if I ever saw this as a script, I wouldn't know what to think. And they say these lines seriously, it's all done like it's real problems. And it's like Ronnie Tavel's plays in the sixties or Charles Ludlam's. Dropped Jon (cab $8). Watched cable till 1:30.

Tuesday, June 29, 1982

Worked all afternoon.

Went to the thing at the Plaza for Bill Blass Chocolates and a guy there told me that my sister-in-law, Ann, and his mother are religious fanatics together. And at first I pretended that I didn't have a sister-in-law because I can't stand her. But then I told him about my nephew Paul who left the priesthood and he told me about his sister who left the convent and now is fucking black guys. I had strawberries dipped in chocolate. And I left depressed after a sugar letdown.

Wednesday, June 30, 1982

Geraldine Smith came by with Liz Derringer who was interviewing me for the Southampton newspaper. Gary Lajeski is having a show of my prints or something out there, which I don't even know anything about, in a couple of weeks, and Fred thinks I should go because he says then you're in people's minds and they'll buy later.

Decided not to go to Lena Horne's goodbye party. Decided to go to Roy Cohn's third annual birthday party in his house in Greenwich. Steve Rubell wasn't driving his car because he's been drinking too much, so Ian drove, and it was me and Steve and Ian and Bob. And Bob is so sour, he doesn't talk to me anymore. I didn't wear a tie. I was wearing an *Interview* T-shirt and he got mad at that. I don't know what's his problem.

Roy's house is right near the center of Greenwich. It's a really little house. And when you go to these Roy Cohn things all everybody says is, "It's so amusing, it's so interesting, because you never know who you'll find at these things." They say you get everyone from the Mafia to the shoe repairman. Which is true, because this guy came over to me and said, "I'm the garage mechanic who worked on your car for years. I've always wanted to meet you." C.Z. Guest was there, she'd put in the roses at Roy's house, and Cornelia was with her. And I did something dumb. I guess wine is affecting me quicker now. The guy Combemale whose wife is Freddy Woolworth's sister was telling me a joke and he tore a dollar bill in half. So I took out a hundred-

dollar bill and tore *it* in half and gave half to Mrs. Bassirio and half to Doris Lilly and told them that they'd have to be friends forever because they each had the other half.

The food was really good, but the people were acting like such animals to get it. Everybody says Roy has seven boyfriends, one for each day of the week. And he must have gone to a butcher to have a facelift, because you could see the bloody scars from his latest one, they really were showing.

Tuesday, July 6, 1982

With the eclipse of the moon we got letters from the faithful nutty-letter writers, people like Joey Sutton and Crazy Rona. And Paul America called—I don't know from where—but the office has a list of "Do Not Take Calls From" people so they didn't put the call through. And they said he was saying that he was one of my superstars, but he was never even in one of my movies. Oh wait! *My Hustler!* I forgot, *(laughs)* he was the *star*. He *(laughs)* was *My Hustler*.

And Jean Stein's going to be on the talk-show circuit probably with Viva. Oh, I've got to put the bug in Viva's ear that Jean Stein is just using her.

Friday, July 9, 1982

I was invited to a surprise birthday lunch party at a restaurant on 48th Street for Phyllis Diller's sixty-fifth birthday. So I decided to stay uptown until that at 1:30.

When I walked in a lady with glasses said that she still had my mother's book, and I was trying to think of which lady in my advertising days would I have given one to, and I just couldn't place who this grandmother-looking woman was, and then someone said, "Kaye!" and it dawned on me—Kaye Ballard. And so I went running back and had to pretend as if I'd just been out of it. And she was fun, she's in *The Pirates of Penzance*. It's funny, these people were such big TV stars, and then when you lose your ratings, you're just like a normal person.

And at 2:00 Phyllis Diller arrived. She said that they told her it was a *New York Times* interview and that they wanted her to wear a bright-colored dress because it would photograph better, but she hadn't known why, since the *Times* was black and white.

Tommy Tune arrived and he's all Southern charm, he said that he still reads the *Philosophy* book, that it's made him what he is today, that he picks it up and rereads it for inspiration and he feels good again.

The press was there and they took photographs. And it was embarrassing because I'd brought Phyllis a Cow print wrapped in an *Interview* and she thought the wrapping was the art and she was being so careful with it and she said *[imitates],* "Faaabulous."

Saturday, July 10, 1982

Brigid was going through her old files, she has the whole seventies documented. She has what she did every minute written down and then on tapes. She did so much. If people found out all you could do on amphetamine, it would really get popular again.

Wednesday, July 14, 1982

Worked on the Endangered Species portfolios and talked on the phone to Ron Feldman and sent Chris down with them, and Ron was excited, really excited, and now we have to figure out how to market them. Dropped Rupert (cab $5.50).

Saturday, July 17, 1982

It was a scorcher. Went to the Whitney Museum (admission $4). Saw the Ed Ruscha show, which was interesting. Went to see *Young Doctors in Love* (tickets $10) and it was really good (cab $3). It was directed by Garry Marshall who I didn't know was an old guy. And there was a funny scene where the guy in the Calvin Klein ad is wheeled into the operating room in his jeans in the same position he's in in the ads, and so that's funny if you get it. Not everybody gets it.

Sunday, July 18, 1982—New York—Fire Island—New York

Chris called and said we were getting a 10:00 plane to go to Fire Island to take photographs. Picked up Jon and went to 23rd Street (cab $8). Got to Fire Island and had lunch at an outdoor spot. We decided to call Calvin's and he said to come right over (phone $.20). And Calvin's house is right off Ocean Walk and there's 8,000 boys around it, and a lot of girls, too, and they're all walking around wanting to be discovered for a jeans ad.

When we went home we had the same pilot and as we got to the water we heard a noise and I think something broke, and when we finally made it to Manhattan we had a very hard landing. I don't think he was a good pilot, and when we got out we saw gas leaking (round-trip $360 plus $40 tip). Calvin had said you don't have to tip them, but the pilot didn't give me my change back either time, so I guess you do.

Tuesday, July 20, 1982

Got up early. It was a hot day. Went to Bloomingdale's just to get cool. Went to Janet Sartin and John Duka the fashion guy from the *Times* was there, he looked over my face, and he's probably going to write about it, and when I was done I told him I felt like a new woman. I think my face is getting better. I'm not sure. Janet *(laughs)* was blaming it on the weather.

Friday, July 23, 1982—New York—Montauk

Landed in Montauk in forty-five minutes and got into Halston's new car. Victor was there with "Ming Vauze," who is really his friend Benjamin in drag. Bianca was out there but she was pretending not to be, because later Jon saw her on the beach and she made him swear to God

that he wouldn't tell he saw her because she was with Chris Dodd who's a senator from Connecticut who's getting divorced from his wife.

Saturday, July 24, 1982—Montauk

It was a really beautiful day. Jon had brought *Indecent Exposure* out, the David Begelman book. And everybody was reading *Edie*. It was funny to look and see everybody with that cover. And I think that as he read the *Edie* book Jon started to turn on me. But Ian Schrager as he read it got *more* interested, but the thing he kept asking questions about was Paraphernalia. Dozens of questions about Paraphernalia—who owned it, who designed it, who *really* owned it. And it's the most unimportant thing in the book. I guess he was sort of interested because of Norma Kamali, although I don't think they're still seeing each other.

The kids with beautiful bodies were playing the pinball machines in town. It looked like all the movies I've been seeing, like *Porky's*, they were just beautiful. Gosman's was too crowded with old people so we went to a local place where there were kids and models, and that was $40. Got a toothbrush ($2) at White's, the drugstore. Went back and watched TV and talked intellectual. Read the good art books that Victor always has around.

Steve Rubell and Ian had gone to East Hampton to play tennis with Steve's brother and they brought back corn and came just in time for dinner and all Steve could rave about was the corn because *he* brought it. Steve and Ian's deal to buy a hotel went through.

Sunday, July 25, 1982—Montauk—New York

When I woke up and went to the kitchen, Steve was having his morning Coca-Cola and reading the book on the Annenbergs, he's fascinated by crooks.

Christopher called and said he'd gone to Fire Island for the day. Nena went to the hospital for an operation. I asked Doc Cox to check out her doctor and he did and said that she was in good hands. I asked him to keep a close eye on her situation.

Monday, July 26, 1982

Got up at 9:00. Called Nena at the hospital, talked to her doctor, they said the operation is in the morning and it'll be intensive care for two days afterwards.

This girl from Santa Fe came by the office, she used to work at *Interview*. I can't remember her name. One of those girls like from Aspen who look deep inside you and want to know your real true meaning. She reminded me of the kind of girl that would always be visiting Jed from California, that type. And she was after Agosto and I got dead serious and told him to go in the back and not come to the front until she was gone. I mean, I'm not going to let her ruin his life by looking

for *meaning* in it! She left a note for him with her number on it, and I destroyed it, I didn't tell him about it. I'm not going to let her start trouble.

And I kept running into Doria Reagan in her muumuu and I think I kept asking her if it was a Perry Ellis. I was nervous about the fashion show that I was supposed to model in at Studio 54 at 9:30 so I was drinking coffee all day and trying to be thin.

Cabbed to Studio 54 ($4) and couldn't find the back door but a black bum found us ($.50). Inside there were twenty-five raving models and me, and they all had big baskets and tight underwear. I talked to Michael Holden and told him I couldn't believe he wasn't a movie star yet but it didn't come out right because I was nervous. I had to go out twice. I was numbers 33 and 49.

And then afterwards Chris criticized my modeling saying that since I'm older I should walk proud and show who I am and not be shy and keep my head down, but I think I have to figure out a way to be more of a buffoon, to fall down or something.

Then we went to a party at Heartbreak (cab $8). Chris and Peter were fighting because Chris wanted Peter to pick up a model and he didn't.

In the cab going home I was scared because it was a big black driver and there was no picture on the license. Got home and called Jon to tell him about my modeling experience. He was in bed in L.A.

Tuesday, July 27, 1982

Went to Madison Square Garden (cab $4) to see Billy Squier, he was just going on. Backstage there were about fifty nude girls serving hot dogs and beer and mud wrestling. Took pictures, then realized I didn't have film in the camera. And an absolutely nude girl came over and said, "I see you at St. Vincent's church every Sunday." The Queen group was really nice to us, they gave us drinks.

We went to the Palace which is the new discotheque on 14th Street where Luchow's just moved out of. And it was packed, packed, like a deathtrap firetrap. There's a lot of little rooms, I don't know what that means.

Got home and talked to Jon in California.

Wednesday, July 28, 1982

Went out with Jay to a teeth store he found, it's on 21st on the ninth floor and it's so great, all these teeth. I wanted a giant-size aluminum set, they said it was antique. They recognized me because Jay had an *Andy Warhol's TV* T-shirt on (teeth $484). Carried the big teeth in the rain. That was fun.

Calvin Klein invited me out to Fire Island for the weekend and I talked to Steve Rubell and he said that Bianca had called and asked if I was going to be there, because she was invited, too.

Thursday, July 29, 1982

Called John Reinhold and invited him to come to Suzie Frankfurt's with me but he said he wanted to spend time with Berkeley, his twelve-year-old daughter who just got back from camp. So I invited them to Serendipity and we went there (cab $8) and ordered big things just to look at. And it was fun talking to Berkeley, she's given up being an actress and now she may be a cartoonist. She left camp ten days early. It was one of those ones where you milk cows and feed chickens.

Dropped them off ($6) and then went with Curley to 33rd and First Avenue to pick up this friend of his and it was a little brownstone and he's 6'6" and sleeping on the floor and the place is a mess and it's fun to see how kids really live who go out looking so chic in Brooks Brothers clothes and velvet slippers and here they are living in a hot box. Went to Xenon (cab $6).

Howard Stein was there. And Cornelia Guest had called and invited me to a party at his place on Sunday in East Hampton. He's using Cornelia to get into East Hampton society and *(laughs)* she's using him to get into Xenon.

Oh, and Bob is being so grand, he won't tell me any inside gossip about the Bloomingdale thing. It was in the papers yesterday that now Alfred Bloomingdale's mistress Vicki Morgan is suing his wife Betsy because she said it was Betsy who made Alfred stop sending her money. Vicki Morgan said, "And after all those Marquis de Sade things he made me do." So this is the president's best friend.

Saturday, July 31, 1982—New York—Fire Island, New York

Got to the Pines and called Calvin's from the Boardwalk to tell him that Chris was with me just for the day. They said it was okay. Went over there and only Chester Weinberg and David Geffen were up. It was a grey day, had some breakfast. Then Calvin and Steve Rubell woke up and they talked about the fun time the night before.

Went to a Hawaiian party at Gil de la Cruz's down the street. In the sunlight you can really see what these people look like, you really see. Egon Von Furstenberg was the only one I knew. Although I thought I recognized the dog from the Breakstone TV ad, the one with the black spot over his eye that Sam Breakstone chases away. Then we went for pizza, and you could really see in the light who the dogs were (pizza $20). Then we went back to Calvin's but we walked in on Calvin and Steve who were with those two porno stars Knoll and Ford and so we were embarrassed and left and went back to the party down the street.

Then went home again and by this time Chester Weinberg had come back from the party, too, and he had walked in on two guys who told Chester to go away so Chester was hiding out in his room. Then we had barbecued steak and all the talking was gay gay gay. If I'd had a tape recorder you wouldn't believe it. Then what happens is everybody goes to bed about 12:00 and sets their alarms for 2:00 because "things don't get really hot until 4:00." I heard everyone getting up at 2:00 but I stayed in bed, and later I heard them all coming back from their 4 A.M. cruise.

Sunday, August 1, 1982—Fire Island—New York

Woke up in the Pines. In the maid's room downstairs. Talked to Jim the houseboy who wants to be a dancer. Put on block-out sun lotion because I'd gotten red on the grey day before. Continued to read *Indecent Exposure* and opened right to a page where they were talking about David Geffen, so I read it out loud to him.

Talked a lot to David Geffen. His father made brassieres. It turns out he was a person I didn't know, just one of those fringe people around Danny Fields, and he knew Nico when she was with Leonard Cohen. And his new Donna Summer album got the greatest review ever, it's going to make him $2.5 million by the end of the week.

Went over to Gil de la Cruz's for a minute, Diane Von Furstenberg was there. I think she loaned the fabric for the Hawaiian party.

We got on a seaplane and took off and there were screams coming over the radio that there was a door open, and it was mine, I could have fallen out ($100).

We ran into Michael Coady from *Women's Wear* where you land and he wasn't drinking so he was sweet. Then the pilot who seemed like he was from New York said, "Where can I get a cab?" And so we told him, and he walked with us, and he said, "Maybe I can help you out." I said what did he mean and he said he had the best cocaine and I said oh no no, that I didn't use it, and so then he was embarrassed and so we walked the whole three blocks together without saying anything.

Monday, August 2, 1982

Mark Ginsburg was bringing Indira Gandhi's daughter down and he was calling and Ina was calling and Bob was calling saying how important this was, so I gave up my exercise class and it turned out to just be the daughter-in-law, who's Italian, she doesn't even look Indian.

Went to 25 East 39th Street to Michaele Vollbracht's (cab $4.50). Ran into Mary McFadden on the way in and I told her she looked beautiful with no makeup and she said she'd never worn more. I told her that in that case, as one made-up person to another, it looked like she didn't have any on. Giorgio Sant'Angelo was there. The food looked really chic but I didn't have any.

Went to Diane Von Furstenberg's party for the launching of her new cosmetics (cab $4). And all the boys at the party were the same ones who had been on Fire Island. It was fun seeing Diane, she was hustling perfume. Her clothes are so ugly though, they're like plastic or something. And she had all the high-fashion girls there wearing them. Barbara Allen was there and even she looked awful in the clothes. I did get an idea for new decorating though—big boxes of color that you can put in a room and move around and change your decorating color scheme.

Thursday, August 5, 1982

I watched *Tarzan* on cable and Bo Derek is the worst actress in the world. She was eating a banana, and she couldn't even eat a banana. It was like she had no teeth.

And Susan Pile told Jon that my birthday was actually August sixth and I'd told him it was on

the fifteenth because I thought I could get by it, but now they're having a party, I think. And I had big fights at the office. Somebody left food around and I was screaming and I told Paige Powell, our *Interview* ad-seller, to go and scream at whoever it was, and it turned out to be this new kid at *Interview* who's just so cute and he's always nice and smiling to me and walks me to the corner to get my cab and stuff, and so then I was embarrassed and I denied that I'd told Paige to do it—I said that oh, she must have just been on cocaine or something—and Robyn repeated the word "cocaine" to her and she went crazy, and then I got mad at Robyn for telling her, and he blamed it all on Jay and Jay said he didn't do it and I was handing out pink slips like crazy and I screamed at Jennifer, the new receptionist girl, because I told her not to give me coffee in a coffee cup and she did, she said there was nothing else there and I screamed that there were plenty of champagne glasses and why didn't she bring it to me in one of those instead of a crummy old cup that everybody uses and God, it was one of those days.

And I introduced Robyn to Iolas, I thought that might do the trick for Robyn's art career. Robyn's such a nice kid but he has no ambition and he does want to be an artist, and so I thought that since Ronnie left and things worked out so well for him—his art career is doing really well —that maybe it could happen for Robyn, too. So seventy-four-year-old Iolas grabbed Robyn's hand and was holding his palm. They say that you get energy from that and you do, I think. So Iolas thought he'd get Robyn's energy. But I was hoping Robyn would get *his*.

Paul Morrissey is going off to Germany, he's getting offers to do all the movies Fassbinder was supposed to do. They should ask *me*!

Friday, August 6, 1982

It was a depressing day, my birthday. Wandered around the neighborhood. Called John Reinhold for coffee but he had a lot to do because he was getting ready to go on a trip to Japan. Jon was going to New Hampshire.

Ran into Robert Hayes and he said that Greg Gorman the *Interview* photographer had called and they wanted me over on 18th Street near Fifth to be in a publicity photo with Dustin Hoffman who was in drag filming *Tootsie*, and I thought that sounded like fun.

But when I got there, they said, "All right, we'll be shooting your scene soon." They actually were putting me *in* the movie. So Greg Gorman was really devious, he must have known that for that I'd want to get paid. They thought they could just get me in one second, which they did. Dustin looked great. When I think of all the lady teachers I had that must have been really drag queens! But then they thought that Dustin should be in a sexier dress to be photographed with me, so they wanted to change him and asked me to come back at 3:15.

And Ruth Morley was the costume lady. I know her because I worked on a Thurber play that Kaye Ballard was in, and I really did the costumes but Ruth got credit because of the union. In 1954 or '55. I guess I was exploited. And it was a rich-bitch producer, and you really do see people carry on and cry because the show isn't going right.

So went back to the office and there were little packages around, and they kept calling me from the *Tootsie* set. Took Susan Pile over there with me, she was in town from L.A. It was my birthday and I was trying to be in a good mood but I was a grouch. When we got back to the set, Dustin

was wearing something more gay. And it was going to be Dustin's birthday on the eighth and I told him that was mine, too. *(laughs)* Met Dustin's new wife, very pretty, who looks like Debra Winger. So many of these girls now do. But the baby looks like one of those babies Barbra Streisand would have with Elliott Gould.

Walked on Columbus and Central Park West and saw Ron Galella shooting on Central Park West and it turned out to be in front of Linda Stein's where she was having a party for Elton John after his Madison Square Garden first-night concert. Called her up ($.20) and she wasn't back yet, so went over to Jon's and called again and she said to come, just not to bring too many people.

It turned out to be 100 Zoli models. That's what Elton had asked Linda to get and she did. Timothy Hutton was there with Jennifer Grey.

Tuesday, August 10, 1982

Wandered around the East Village and that made me feel weird. It's picking up again, the places were lighted. Gem Spa is still there. I thought about the fifties when I lived on St. Mark's Place and then about the sixties when we ran the Dom discotheque there with the Velvets and Nico playing, and about going to all those psychedelic things at the Fillmore and eating at Ratner's delicatessen and everything. It was nostalgic.

Saturday, August 14, 1982

The limo driver said that he didn't know really how to get to New Jersey, but that he'd try. We picked up Christopher and Peter and went out to the Meadowlands to see Blondie, and before them on the bill was Duran Duran and also David Johansen.

We went back to see her. And Chris Stein has lost thirty pounds, he's been sick, I think it's all this bad air from some air conditioners. Debbie's so fat now, she kicked us out because she wanted to get dressed in her Stephen Sprouse clothes.

Our seats were up in the concessionaire's box, and that was fun. I took pictures of the mother, the wife, and the kid, three generations of concessionaires (hot dogs $20). And the milk shakes were so thick they must have been plastic, it was like drinking margarine. Marianne Faithful came along and read a poem she wrote and somebody put down drugs and she said, "Oh don't put down drugs, because I'm on cocaine right now." And I did like her so much, she was much different than when she stopped by the office a few weeks ago with Jay Johnson. She was so intelligent and so together. And she didn't have an English accent, she was like an American, and so alert and not out of it at all.

Monday, August 16, 1982

I watched one of the morning shows and they had Ken Wahl on and he's very good-looking but he was smart-alecky and saying all the corny things dumb actors say. Like that he could "go back to pumping gas." He said, "Well, I'm from the Midwest."

But tell me why it is that everybody is so good-looking now. In the fifties, there were the really good-looking people and then all the rest who weren't. Today, everybody is at least attractive. How did it happen? Is it because there's no wars to kill the beauties?

Friday, August 20, 1982

Christopher found a boy named Christopher on Christopher Street who said that Paul Morrissey had also just found him on the street and asked him to be in a movie he was doing in Berlin.

Saturday, August 21, 1982

Stopped at Schrafft's on 58th and Madison and the waitresses there were all saying, "Is it him?" "It's him." "It isn't him." And so when I went out I said, "It's me," and they were thrilled.

Ran into Claudia Cohen on Central Park South where she lives with forty-foot ceilings, and we decided to be Puerto Ricans and sit on a stoop and gossip. She told me that that big Joan Hackett/Marsha Mason "girlfriends" rumor that got all over town was started by Bobby Zarem because he got mad at Joan Hackett who was his client. And so then we left each other, and one minute later I saw Bobby Zarem walking along, talking to himself.

Monday, August 23, 1982

The Duran Duran kids came by and brought some bigger and taller girlfriends. Tried to stay on a diet but went off it by nighttime. The German kid who had us do the Fassbinder posters came by. It turns out that Paul isn't actually taking over any Fassbinder movies, it's that this kid hired him to do a movie, and it's going to be, Paul says, about a hustler who hustles in order to buy clothes. But isn't that why *all* hustlers do it? . . . No, I guess that isn't why Joe Dallesandro would do it.

I told the guy that Paul was nuts, that I've come to the conclusion he really believes all these wild theories he comes up with. No matter who Paul's talking about now, he'll either tell you they're really a Communist, or really in the Mafia. Before it just used to be that they were really a fairy or a lesbian.

Wednesday, August 25, 1982

Got up and it was raining. Decided to stay uptown because Mercedes Kellogg was giving a lunch and somehow I was invited and I thought it would be a good chance to corner Bob about the Bloomingdale death gossip because he'd be there, too.

Cabbed to Park and 74th ($2). It turned out to be a birthday party for Claus von Bulow. And

Doris Duke was there with Franco Rossellini. He said that Isabella's getting a million and a half for one of her modeling contracts and that she and Marty Scorsese are still trying to work it out.

So when I had Bob cornered in the cab I asked him about the Bloomingdale death, because it came out in the press on Sunday or Monday that he had died on Friday, and Bob had seen Betsy Friday night out in California, but Bob said that Jerry Zipkin knew but kept it a big secret and hadn't even told Bob when he and Bob went out to the supermarket together.

Sunday, September 5, 1982—Montauk

Bianca came by with her Senator Dodd boyfriend who is a cross between Teddy and Bobby Kennedy. He's the youngest senator, thirty-eight. Took a walk, took pictures, got back to the house. Halston was all dressed, saying goodbye to us and we were shocked because we didn't know what happened.

Then Jon found out that Halston's mother had died. Halston kept it a secret all through dinner last night, he acted as if nothing happened, but he told Victor to tell us after he left.

We had a really good talk with the senator. Robert Redford's his best friend. He's keeping his romance secret because it's only forty days left till his divorce. Bianca is all over him (dinner $120 with tip).

Tuesday, September 7, 1982—New York

Hired Benjamin "Ming Vauze" Liu to pick me up every morning and keep an eye out for me while I'm walking around the streets. He arrived late. Sat around waiting for him and got mad. Found out Richard Gere was on the new cover of *Rolling Stone*, complained to *Interview* that that was the reason he turned us down. Watched *Mr. Goodbar* and Richard Gere was in it and I hated him for turning us down. Actually he was so good in it, though. Couldn't watch the ending because it was too crazy.

Saturday, September 11, 1982

Went around with Jon who's looking for a co-op to buy. Because I've decided to do a real photo book of real apartments. Real Apartments. Not photograph houses the way *Architectural Digest* does, but do just what people really live like. Isn't that a good idea? Bianca just got a ten-room apartment at the El Dorado, it just went co-op so they're all up for sale and people are trying to make a killing. So cabbed to the El Dorado ($5). The lady showed us three apartments, and the first was two faggots who'd just bought a loft so they were selling, and then one that belonged to a lady I guess in her eighties, and she had doilies and things on the sofas. It looked like a Barbra Streisand kind of place.

Oh, and on Page Six in the *Post* a few days ago there was a headline: "Warhol Man Does Mick Jagger's Apartment," and then the item said that Jed was the director of *Bad* and now he decorates

apartments, and they said they asked him about it and he said, "No comment." And there was an article on survivors in the *Daily News* last Sunday—they asked Lester Persky about me and he put me down, he said I was a has-been, it was funny.

And I don't think I told the Diary this, but Tom Baker, our star of *I, a Man*, died. He O.D.'d. Mickey Ruskin had a wake for him.

Thursday, September 16, 1982— New York—Washington, D.C.

I was nervous all day because I knew I was going to the White House that night for the state dinner for the Marcoses. Took Valiums. I can't stand going to Washington, all those TV lights.

Arrived at 4:00 (cab $10). Went to the Watergate (tips $2, $4, $2). Jerry Zipkin and Oscar de la Renta were there. Made calls, was very nervous, ordered lunch, had more Valium, ordered a limo, and went to the White House and got in easy.

Bob and I went with our dates. My date was Frances Bergen, Charley McCarthy's *(laughs)* mother. And she wasn't interested in me at all, she got away as soon as she could.

And the Marine introduced me on the line as "Mr. World," and then the girl sergeant escorting me said that she was nervous, that it was her first time doing this. They asked me why I was invited and I said because Mrs. Marcos lived on my street.

The Valiums weren't really working, but then the dinner was outside in the garden and it was so beautiful and it was dark so it was fine. And they took a chance, no tent, and it was beautiful that way, but you get shoved and pushed so much from place to place. Only about eighty people. Then they turned on four billion lights. No TV cameras, though, so I wasn't nervous.

The president's table was right behind me. The president of U.S. Steel was at my table, and I said, "Oh I'm from Pittsburgh and my poor brother is out of work from the steel mill"—I was lying like crazy—"and he's lost his mill job and what you should do is put one of the unused buildings to use and make it into a Disney World and give tours and charge people $10 to get a little coal on their faces and see the hot lava being poured," and he said, "Oh what a great idea, why didn't I think of that?" The Vice-president Bushes were at our table, and she said that she knew somebody I knew but now I can't remember who it was.

Then the speeches came and the president made his quick and then Marcos was slow. I relaxed. And then the Fifth Dimension came on and sang "Up, Up and Away" and there's more new members than old. I asked one of the marines if there was a pay phone and everyone laughed at me. Bob wanted to stay on and dance. I got the limo and went back to the hotel. Called Jon and then fell asleep at 12:00.

Friday, September 17, 1982—Washington, D.C.—New York

Got back to New York. Went to the office, worked with Benjamin all afternoon. Went out with Chris who'd just gotten his clean "negative" results back on his gay cancer tests. I was invited to Marisa Berenson's birthday party at Mortimer's for her husband, Richard Golub, who's the man

who made Brooke Shields cry. On the witness stand. The lawyer. Karen Black came and that was fun. Took pictures. Left at 12:00 (cab $5).

Saturday, September 18, 1982

Got up early, it was a beautiful day. I couldn't work with Jon because he had to go to a gay cancer funeral at Paramount, it was a secretary there—a male secretary. And I mean, I get so nervous, I don't even *do* anything and I could get it.

I made a mistake and blurted to Maura about Bianca seeing that Connecticut senator, Dodd, who's not divorced yet, and then I realized Maura worked for Page Six, but she's a good Democrat so she said, "Don't worry, I know when something would ruin somebody's political career."

Sunday, September 19, 1982

I'd seen Robert Hayes's boyfriend Cisco going down the street with someone else the other day, and I saw Robert crying, and so I thought they'd broken up, and I asked Marc Balet and he told me that Cisco had just found out he had gay cancer but that it was a secret. But then later that day Robert told me anyway. They told him he got it three years ago and it takes three years for it to show up, but I don't know how they would know that, since they don't know anything about it or even what it is. Robert says he's been checked and he doesn't have it. But he'd been going to Janet Sartin and he was there at the same time I was, and I just know she used the same needle on me, and I don't know if she sterilizes it. I only like it when you use the needle once and throw it away. And I'm not going to go to her anymore, anyway, because I'm just covered with pimples, I don't know what good it's done.

Monday, September 20, 1982

It was a busy day but I left early to catch Lana Turner at Bloomingdale's ($8). Bought one of her books ($16). Then went up to her and she said, "I don't think I want to talk to you, I've taken you out of my prayers, you said I was better when I hadn't found God, so now I pray for you— *badly*." So I think it was something I said in the Faye Dunaway interview in *Interview*, I guess she read it. And I didn't know what to do, I was a nervous wreck, I said, "Oh no, Lana, you've *got* to pray for me, please put me back in your prayers!" And I said, "Oh won't you please autograph your book to me?" And so she finally did and wrote "To a Friend" with a question mark and then "God Bless You" with another question mark. And Lana and her fairy hairdresser and I were all there with the same hair.

Tuesday, September 21, 1982

Ran into Lynn Wyatt who was just back from Grace Kelly's funeral. She said Prince Rainier was crying and Prince Albert couldn't talk.

Went to Diane Von Furstenberg's (cab $4). Barry Diller was there and Valentino. But out of the corner of my eye I saw George Plimpton and his wife Freddy, and when she saw me she began running around me and acting just nuts. She felt guilty because George helped Jean Stein with the *Edie* book. She was like a headless chicken running around, just making all these noises. And I told her, "Look, I don't know what you're carrying on about. I don't care about the stupid book." I should have said that if she wanted to make it up to me, just send a check. And I could see Jon talking to George and later he told me he told George how could he put those things in the book about me when he knew me personally and he knew they weren't true and that Edie was away from the Factory for years before she died.

Monday, October 4, 1982

Down to meet Bruno Bischofberger (cab $7.50). He brought Jean Michel Basquiat with him. He's the kid who used the name "Samo" when he used to sit on the sidewalk in Greenwich Village and paint T-shirts, and I'd give him $10 here and there and send him up to Serendipity to try to sell the T-shirts there. He was just one of those kids who drove me crazy. He's black but some people say he's Puerto Rican so I don't know. And then Bruno discovered him and now he's on Easy Street. He's got a great loft on Christie Street. He was a middle-class Brooklyn kid—I mean, he went to college and things—and he was trying to be like that, painting in the Greenwich Village.

And so had lunch for them and then I took a Polaroid and he went home and within two hours a painting was back, still wet, of him and me together. And I mean, just getting to Christie Street must have taken an hour. He told me his assistant painted it.

And by the way, Ronnie Cutrone's art is selling like crazy, too—Steve Rubell's brother just bought a Cutrone.

Tuesday, October 5, 1982

There was a lunch and Gaetana Enders brought a politician from Venezuela and his wife. He's really good-looking, he has a cane, and his wife's beautiful. I'd met him at Halston's years ago. They got away again, though—he said that "maybe someday" he'd "surprise her with a portrait."

And then Governor Carey's wife—the Greek lady, Evangeline—came and she came prepared for a free portrait. She wasn't wearing a hat like she always does, and so I said, "Where's your hat?" and she said, "None of your girls wear hats in their portraits." So I took pictures of her and then I didn't know what to do so I called Bob in, and he talked to her, and then he told her how much the portraits cost, and I think she must have fainted because after she left, she had her guy call and say that a governor's wife couldn't spend that much on a portrait while he was in office.

But before, she'd been saying that she wanted to have it done while he was *in* office because then it would have "more prestige." So she was trying to do all these maneuvers.

And I forgot to add that with Jean Michel Basquiat the day before, he reached into his pocket and said he'd pay back the $40 he owed me from the days when he painted T-shirts and used to borrow money from me, and I said oh no, that's okay, and I was embarrassed—I was surprised that's all I'd given him, I thought it was more.

So we were busy all afternoon. And miniskirts are really back, Cornelia was wearing one at Xenon later.

Wednesday, October 6, 1982

Went to Sotheby's and ran into Mr. Dannenberg who has a shop in Paris now and he said, "I'll have to watch you, because whatever you buy is going to be the next big thing." So there was all this really beautiful David Webb stuff, but after he said that I just looked at it and turned up my nose and made sure he saw. *(laughs)*

Sunday, October 10, 1982

I think I got up with a cold. Went to church. Jay Shriver called and said he wasn't going to come in to work. He was making "a statement." So I told him he didn't have to, that I could do it myself. Benjamin Liu called and he said he wanted the next day off to go buy makeup.

Monday, October 11, 1982

Took aspirin, still trying to get rid of the cold that's beginning. Carried about thirty *Interviews* with me. Walked by Fiorucci on 58th Street and a guy was giving a lecture to a group of schoolkids in the front, so I handed out all the *Interviews*. It was a "field trip" to Fiorucci's, that's what school's come to. And then from there I went to Crazy Eddie's and looked at computers, got the Atari game to figure out what all that's about, and that was exciting. There was a Columbus Day parade (cab $7).

Worked out with Lidija and Chris Makos. I'd made a date to see Doc Cox in the evening, so I had to get people together to entertain him. Worked on a Piss painting.

Then at 9:00 Doc Cox picked me up in his Rolls, I don't know why he decided to take it, and we Rollsed off to Mr. Chow's.

Wednesday, October 13, 1982

Cabbed to meet Rupert ($5). Iolas was just leaving, he wasn't staying for lunch because he was upset because in Paris in a cab he'd just lost a million dollars' worth of jewelry. He hadn't wanted to leave it in the hotel room so he had it with him and he just forgot and left it in the cab. And

that can happen to anybody. It's so scary. He said he could never replace them, that it was all sentimental value, his whole life mementos. So lunch was just for Linda Christian's son.

Tuesday, October 19, 1982

This Retin-A stuff that's for curing acne is working, but just on half my face. Half of my face is perfect and the other half is broken out, all eruptions. It peels away your face. I went to a new beauty doctor and he gave me licorice root to take. I think maybe he just gives out things he wants to get rid of. And he's such a camp, too. These quacks. The first time he took his fingers and touched my face he said, "Doesn't this feel tense?" and the second time he took his fingers and touched my face the same way and in the same place and he said, "Doesn't this feel relaxed?"

Cab ($6) to B. Altman's dinner for the highfalutins. Ran into Sid and Anne Bass, and into Ashton Hawkins. Got drunk and said terr—said funny—I was outrageous, I guess. When I get drunk I get—outrageous. Then left at 11:00. Wanted to go see the Go-Go's but I was just so drunk.

Wednesday, October 20, 1982

The guy who's doing a TV show on our trip to Hong Kong was at work. We're going for the opening of the "I" Club that this young cute kid is organizing with Citibank. That's what we're going to Hong Kong for—the opening of a discotheque.

Thursday, October 21, 1982

I have a pain from exercises. Maybe I'm doing them too much. I think Lidija's working me out too hard.

The jewelry auction the other day went well, so that means the economy is picking up.

And Pontus Hulten called and wants a free thing, so I cabbed down to meet him (cab $6.50, supplies $7, $6.62, $2.79, $3.19). It's always the same thing—a free print for a free museum for a free benefit and he does these things that are great and then they fire him. Like at the Beaubourg, they fired him because he's not French after he did that big thing there. And now he's opening a museum in California. But I mean, he wants things for free, he thinks he's living in a Socialist country. It's like Jonas Mekas, that same type of thing.

And I forgot to say that the other day Governor Jerry Brown called and said, "Hi Andy, it's nice talking to you. We know each other and you know how I feel about art, and if you could do some art for me, then along with the other artists I could put your art up as collateral and get a loan from the bank and fund my run for the senate. . . ." I told him to talk to Fred. I mean, he could have had me do his portrait while he was governor and the city or the state could have

paid for it, they were having to do his portrait anyway. Well I mean, Marcia Weisman or somebody would have paid for it.

The pain is increasing in my lower abdomen. I'm going to have to cut down the exercise classes.

Friday, October 22, 1982

Wandered down Fifth Avenue. Passed out *Interviews*. Tried to give them to a bunch of construction workers and they laughed me off and I got embarrassed, but then another group of construction workers in the next block *asked* for some, so that balanced it out.

Later, after work, I went to pick up Chris (cab $5) to go to Calvin Klein's big birthday bash at Studio 54. Mark Fleishman had said that the best time to come was really early, at 10:00 or so. Maura came to meet us and she was dressed neatly but we all laugh because she's—kind of messy. There's always a spot or a stain someplace (cab $5).

In the entrance of 54 there were balloons and white grand pianos and stick-on bows on the floor. I felt slighted because Calvin was at a table with Bianca and some of his family people like mothers and grandmothers. I would have liked to meet them (cab $8).

Wednesday, October 27, 1982—New York—Hong Kong

Arrived in Hong Kong, evening. It was hot and muggy, Florida-type weather. Twelve hours' difference in time, so you didn't have to change your watch, which was kind of great.

Alfred Siu, our host, met us. Rolls Royce and limousines. Jeffrey Deitch of Citibank was at the airport to meet us, too, and he's adorable, such a sweet guy. He's the one who got us involved with the whole project. Mandarin Hotel. We were all on different floors—I was in 1801, Chris in 1020, Fred in 820, and his girlfriend Natasha Grenfell in 722. I had a suite overlooking the harbor, it was very beautiful, but everyone said Hong Kong was having a recession.

And then after we got straightened up Alfred wanted us to go to the I Club to look at it, it was just a block away in the Bank of America on the first floor and it still wasn't finished, they had three days to finish it. And we met the designer of it, Joe D'Urso. He said he'd decorated all of Calvin's apartments. Alfred is so pretty—a spoiled, cute kid, just adorable. And Joe D'Urso is this fat little slob but really talented. Went back to the hotel, called New York.

Thursday, October 28, 1982—Hong Kong

Up early to do the two sides of Hong Kong looking for tailors. All the kids were getting clothes except me, I'm just not a clotheshorse (cabs $4.50, $5, $6). Lunch at the I Club with Alfred Siu and about eight girls that he thought were going to have portraits done. One was an American married to a Chinese, the others were Miss America types—Miss Taiwan, Miss This and That, and they'd married rich guys from the construction business and they all hate each other and they're all beautiful. Burmese and Chinese and all gorgeous dolls dressed to kill. And after lunch

Alfred's beautiful wife took us to a place where they do fortune telling and it was like 8,000 fortune tellers and you had to pick the one you wanted, so I picked this lady and I asked how my love life was and *(laughs)* she said I'm married to a younger lady and I'm having problems.

And then Chris began taking photographs and he took some of sleeping fortune tellers and the flash woke them up and they chased us all out of the place—I guess none of them wanted their picture taken because of the evil eye or whatever it is.

Alfred had a dinner party and it was so glamorous, we took a junk out to his private boat. He imported a crew from New York to photograph us while we were there and they were awful, seven of them, and I don't even want to remember their names. We all went to Disco-Disco, a drag queen place, and an English girl came up to me and wanted to dance and I didn't want to and she said, "You're not anything like what they write about in the papers," and I said, "Well, I know that."

Friday, October 29, 1982—Hong Kong

Muggy. Took the boat across the river to Kowloon ($12 there and back). We had to meet the Sius at their house way up on the hill, you can see all of Hong Kong. We were followed by the crew everywhere, every minute.

The pre-opening party was "exclusive," my dear, really grand, lots of people. The show was okay. The gym was open and they had exercises. They got me on a machine and tipped me upside-down with all my pills falling out of my pockets and my hair almost fell off. Then went to the disco. It was just finished one minute before the opening. Danced with Natasha Grenfell, pushed her around, I was drunk. All our possible portraits fell through and Alfred was embarrassed. We sneaked out about 2:00.

Saturday, October 30, 1982—Hong Kong

Got material for ideas at the Peking Communist Store ($250). And I finally found out that Hong Kong is actually owned by the Chinese, that England just *rents* it! So now I know why everyone's nervous here, the lease is almost up.

The big opening of the I Club was 8:30 to 1:30. Home at 4:30. Called New York.

Monday, November 1, 1982—Peking

Two-hour car ride and everybody was singing great American songs. Finally when we got to the Great Wall it actually was really great. I'd been putting it down, but then it was staggering. We went on the left side because it wasn't so steep and so crowded, and all the Chinese were taking pictures of themselves. My hair almost blew off and I think they got a picture of it. Soldiers go there with their girlfriends. It's like walking up to the Empire State Building.

Then we got in a bus and went to the Ming Tombs and that was staggering, too, and that was somehow two hours away, too. It was a whole afternoon.

Went to bed with my clothes on. The Peking Hotel. The place was infested with roach motels.

Wednesday, November 3, 1982—Peking

Up at 6:30, another crew day. Went to the bird fair, that's where people get together and sell birds, that's what they do with their time—sell worms and spiders and birds. Then got on the bus and went to the Summer Palace. Met Americans we knew there—Lita Vietor who was so nice to us in San Francisco, and some Palm Beach people, they were on a tour. Stopped off at the I.M. Pei hotel and photographed it.

Went to a commune and the children came out and they sang "God Bless America" and "Jingle Bells" and it was disgusting because it was just so sad to see these little kids having to perform like animals. Another truckload of bus people would arrive after us and it would be the same routine and they would hug you, same show.

Thursday, November 4, 1982—Peking—Hong Kong

We left the hotel to catch the 8:45 flight. Had some tea ($12). You can't tip people. Everybody tells on everybody. Then we found out that if you give them a couple of cigarettes, that's what they really want. Should have done things like that, but we hadn't figured it out. So got to the airport and sat around for hours. Then a lady and her husband had lost their passport and for an hour and a half they were going through everything looking for it, and the lady was screaming at her husband, it was just such a movie scene, and then two minutes before the plane was ready to leave, the lady put her hand in her pocket and found it. They were really old, it was sad. It was so horrible. They were old and they couldn't get out of China. "Where is it?" "You had it last."

Ran into one of those English groups, like maybe the Clash, on the elevator. On the same floor as us.

Saturday, November 6, 1982—Hong Kong—New York

Took a Valium because I was facing an eighteen-hour plane ride. Read the Neil Sedaka book and the Britt Ekland book and they were both so bad. Neil's daughter, Daryl, is the biggest thing in Singapore and Tokyo.

Monday, November 8, 1982

Sent Benjamin down to Chinatown (laughs) because I hadn't gotten any gifts for anybody when I was in China. And I also told him (laughs) that he was under consideration for being fired because I was so tired of looking at Chinese people.

Did mail at the office and only got through one-third of what I have to catch up on. I began getting jetlag. Decided to stay in.

Wednesday, November 10, 1982

Bob was having lunch with Jann Wenner at Le Cirque. But I knew Jann couldn't take him away from us because Bob makes so much more money at our place. I think Jann just wants to pick his brain. And Bob said John Fairchild and James Brady were also at Le Cirque, so I guess it's the new place for gossipers.

Worked all afternoon. Decided to stay home and get rid of my cold. I watched *Dynasty* and the best thing was the baby getting kidnapped, because they used a real baby. You know how usually TV shows use a doll? Well *Dynasty* had the real baby being dashed through the streets with its head bobbing and bouncing around. And gee, everybody on that show has such awful hair.

Saturday, November 13, 1982

Chris had invited us to the Shafrazi Gallery for the closing of the Keith Haring show, he's the one who does those figures all over the city, the graffiti. His boyfriend is black, and so he had 400 black kids there, so cute, so adorable. Just like the sixties, except *(laughs)* black.

And Ronnie was there looking very chic with his girlfriend. His art's selling like crazy.

Then there was a party for the show in the basement where it was all in blue light and they wanted me to go down, but I knew my hair would turn completely blue, so I didn't go.

Monday, November 15, 1982

Jean Michel Basquiat who used to paint graffiti as "Samo" came to lunch, I'd invited him. And then I went at 3:30 to Julian Schnabel's where I was posing for him. And I had on a Paramount T-shirt which would have been good to pose in, but he made me take it off, and I was posing like that for two hours, standing there. And I took off my glasses so I could look him in the face and still look out of it.

Thursday, November 18, 1982

Had to get into black tie and go to a de Menil party for the Yves Klein opening at the Guggenheim (cab $5). I met Mrs. Klein, she's remarried. Then went upstairs and Fred was there with Natasha Grenfell. And then Jean Stein came in and I just sort of ignored her.

Then cabbed to the Guggenheim ($4). Walked all the way up the ramp and saw the show and then all the way down and saw the show. Then went home and was in bed by 10:00.

Friday, November 19, 1982

Donahue had a show on gay cancer but I didn't want to watch it, it made me nervous (cabs $3, $5, phone calls $.40).

It was busy at the office. *Interview* was giving a lunch. Worked all afternoon. Had to leave early to go to the pimple doctor, Dr. Silver.

Dr. Silver said not to use soap ($6.50).

Saturday, November 20, 1982

Tom Cashin called and said that Zoli had died of gay cancer.

Thomas Ammann picked me up in his limo and we went to the Odeon and it was star-studded with artists—John Chamberlain and Joseph Kosuth and the Christos and a lot of art dealers and Barbara Jakobson. And a creepy girl who said she's been trying to come in to the office to see me, but Robyn won't let her in. She wants me to look at her work so badly that I'm going to have to or she'll go crazy (dinner $256.80).

Monday, November 22, 1982

Did the streets with *Interview*s. The Calvin Klein issue is heavy (kitchen supplies $94.02, $9.75, $5.36, $30.85, cabs $3.50, $5, phones $.40).

Worked out with Lidija.

Worked on the cement sculpture project all afternoon. Did some painting.

Then cabbed, glued ($5.50). Went to Sandro Chia's at 521 West 23rd, he's in the same building that Julian Schnabel paints in ($7). Sandro showed me his new paintings.

Tuesday, November 23, 1982

Vincent was going away and so we stayed late and paid bills, and Jay was in a mood where he wanted to get screamed at. When he wants to get screamed at he does something wrong on purpose. Like he painted something the wrong color and he said he knew he did it. After he gets screamed at he just looks like nothing happened but he's satisfied. And we were there till late.

I'm invited to Halston's for Thanksgiving dinner.

Wednesday, November 24, 1982

This weekend Bianca accused me of telling *People* magazine about her and Senator Dodd, she said the only people who knew were me, Steve Rubell, and Halston. So I guess Steve told them. And Page Six of the *Post* had a thing saying she was now seeing Woodward in addition to Bernstein,

and she actually picked up the phone and called the *Post* and made them correct it the next day, that she's only seeing Bernstein.

Thursday, November 25, 1982

Thanksgiving. It looked cold out. The office was closed. I'd woken up at 4:00 and turned on TV and some movie with Margot Kidder was on that I couldn't figure out but it made me so scared. It was the end and the police left her alone in the house—I don't know why, because she was traumatized—I guess they thought the crimes were over, and then you hear some guy upstairs, coming down, calling her name. And you don't know what'll happen. And it got me so scared. Got up. The house was empty.

Talked to Chris and Peter. Peter's mother had come down from Massachusetts and they were cooking turkey and they invited me to come downtown.

Watched the Macy's parade on TV. They had the first woman balloon—Olive Oyl.

I called Berkeley Reinhold and she was watching it from her window. She said her mother was making Thanksgiving dinner for the first time. Her father was in Hong Kong, so I called John Reinhold there, I dialed it direct. He was at the same hotel where we'd stayed, so it was easy to remember—the Mandarin. I made a *faux pas*. I told John his wife was making a Thanksgiving dinner, and he was upset because she'd never made one before.

Watched every soap opera and for the holiday every one of the shows had every one of their characters gathered for Thanksgiving dinners. It used to be high-class people in the soap operas and now that's just on *Dallas* and *Dynasty*. Now the people on the daytime soaps are lower-middle-class—they don't have butlers and maids.

Talked to Jon in New Hampshire.

Went to Halston's for dinner and Martha Graham was there, and she looked frail, like she's on her last legs. And then Steve Rubell came, and Jane Holzer with her son Rusty, who's so handsome now. And he's smart. I talked to him the whole time. He goes to Buckley and he had the highest average and he studies all the time from after school till bedtime, and then he studies some more in the morning before school to maintain his 93 average. He said he and another kid were the only ones who knew the answer to the question "Who painted Campbell's Soup Cans?"

Jade arrived with Bianca, she goes to Spence. And I had Rusty go say hello to her, and she was aloof, she said, "Do I know you?" and he said, "Of course," and she said, "Oh yes, about a year ago," and he said, "No, two years ago," and so he was annoyed, she was putting him down, but Jane explained to him that girls get nervous and do that.

The turkey was organic, from Jane's Pennsylvania farm. I slipped out without saying goodbye to anyone.

Friday, November 26, 1982

Found out that after I left Halston's, Rusty discovered a fire that'd started in a fireplace and gone to a Marisol sculpture and into a closet, and if Rusty hadn't noticed it, Halston's would have burned.

I'm giving everyone framed underwear for Christmas. Went up to 86th Street and then down (cabs $5, $4).

Jon called, said he was back in town.

Saturday, November 27, 1982

Brigid called and I invited her to see *Cats* (tickets $200). Cabbed to the theater ($6). We had first-row seats but on the side.

The first act was so boring, but I noticed the pussies of the girls in the cat suits. I was so revolted. You could see the slits up their fronts. They should really wear pads. And you could see the hair coming from their pussies, but then they also had cat fur put on there, so it was confusing. But oh, you could just see everything! Maybe that's why all these old men are going to the show. And I finally saw what the set was, a big Pop Art thing, it was like two-feet-high Coke bottles, and two-feet-high Campbell's Soup Cans, whatever you would find in a kitchen. But Oldenburg size. And people were gesturing me to look at it. And a lady near us put her husband's coat and hat on a box in front of them, and it turned out to be a Brillo box that was part of the set and his hat got squashed when a cat sat on it. Oh, but those pussies. You could see the—cracks—and the lips—of the—the—the—vulva. Okay? That's how outlined it was.

Monday, November 29, 1982

I'd invited Pierre Restanay and his wife to lunch. He was so nice to me in the sixties I wanted to be nice to him. He's the French art critic. And his wife is very striking, 6'2"—I guess she was a model. French women if they're chic have the dykey look. Mrs. Restanay was wearing an old Lanvin men's coat.

Ronnie Cutrone came by and while I was working out with Lidija, he entertained Pierre and his wife, he didn't know who they were, and Pierre said that he'd seen his show at Shafrazi and liked it. Ronnie's selling everything he does. He could have been doing this for years. He actually was doing all that stuff first that the Italians now are doing.

And then later, I decided to go see Twyla Tharp do dances to Frank Sinatra songs. Called Jon. Picked him up (cab $6). And as we were riding up to the Rainbow Room in the elevator, we realized there was a Paramount party on the floor below.

Got to the Rainbow Room and it was star-studded. Saw Sam Spiegel and Peter Duchin who said, "This is my live-in girlfriend," and it was Brooke Hayward. That's a strange couple. And Leo Castelli was there, and he doesn't hug me anymore. He's never with Laura de Coppet anymore, either. And this performance, I guess Twyla just decided to do something just straight, she had nine couples doing nine ballroom dances, but any people at Roseland would have done it better. And afterwards I talked to Twyla for a minute. And then, as we were leaving, I saw Dick Avedon, Tuesday Weld, "Laverne," and Paul Simon and they said Ann Reinking was there and Baryshnikov and Treat Williams (coats $2).

So then the elevator stopped on the floor where the Paramount party was and Nick Nolte got

on and Eddie Murphy. And Nick Nolte's fat and his hair is over his eyes, like one of those dogs, but he's so good-looking. They say their movie is really good, *48 Hours*. And Eddie Murphy's really handsome. That intelligent look. They say he's going to be bigger than Pryor. And I was just speechless, and I said how thrilled I was, but then I remembered I'd met him at something once before. And then some girls were lined up to get Nick Nolte's autograph so I did, too, and he just kept his head down and signed, he didn't even look up to see who it was (cab $4). Bed at 12:00.

Thursday, December 2, 1982

Cabbed to Xenon ($4) for Cornelia's birthday party. And I guess she was bored because she picked us out right away. Then photographers came over and said that Stallone was on the other side of the dance floor and that he wouldn't be photographed with any girls, so would I go over there and be photographed with him. So I did, and Stallone was sweet, he said he was starting to shoot a movie in February in New York starring John Travolta, and that I really should stay in touch. He had about eight bodyguards with him at the bar. Then left. Got a fast cab ($5).

Saturday, December 4, 1982

I invited Curley to see *Tootsie*. We couldn't get in at first, they were giving us a hard time, there weren't tickets for us that Charlie Evans was supposed to leave. And if I'd known at that time that I was actually in the movie which I didn't even get paid for—that I appear on the cover of *People* magazine with Tootsie when she gets famous—I would have been pushier and said I could take in as many people as I wanted.

And the movie, they play it really straight, Dustin does. It's not really like a drag queen, it's like having an aunt that you didn't know was a man. It's something else entirely.

Then we went over to Charles Evans's. It was packed with stars, so we sat by the food so we'd see everybody. Dustin was sweet, and the director Sidney Pollack was, too. I talked to Teri Garr who was great in the movie, and we talked about Henry Post and does he have gay cancer— that's the rumor. And Curley got me to drink. I had vodka.

Tuesday, December 7, 1982

Went to the office to meet Jeff Bridges (cab $4.50). Bianca was supposed to do the interview with us but she cancelled out last week. Got there, did some videoing. Jeff Bridges is big and rugged, like 6'2", he's like a regular guy, he was sweet and hard to talk to. Then he said he was an artist and he took Polaroids of me and I showed him my painting stuff, gave him a tour, and from the Polaroids he's going to do a portrait of me.

And the kids photographing him for *Interview* didn't know how to shoot him, they had him

doing all this silly stuff—they don't know that when you have a good-looking normal man you should just let him stand there. I gave him a *Philosophy* book.

Friday, December 10, 1982

Walked to 17th Street all the way down from 77th Street. And I'd called the office and asked if I had any appointments and Jennifer, the after-school volunteer who answers the phones, told me no, and when I got there Paul Bochicchio who makes my hair had been waiting there with it for five hours so I yelled at her. And she was making wreaths out of holly, and I thought fine, okay, that she was doing it for her house, but then she started putting them up on the wall and I started to scream to get them down because the office isn't supposed to have Christmas spirit, so she got it twice in one day. And then she moved them into the bathroom. Jennifer now has suddenly picked up bad work habits from Robyn. Worked till 7:30.

Sunday, December 12, 1982

Got up early, it had snowed out. Opened all the windows. Decided it was a good day for a walk. Met Chris and Peter at the Plaza. Went to the Edwardian Room. We had a long, big lunch ($240 with tip).

 Went to Iris Love's party for Pauline Trigère at Dionysos at 210 West 70th St (cab $6). It was packed with stars—Diana Ross and some beau, and Morgan Fairchild and David Keith—he was with another girl but he's girl-crazy so he was after Morgan. The Herreras from society were there, and lots of the girls—Paloma and Fran, and Marina and Florinda. There was Greek dancing. Iris changed into a Greek toga.

Monday, December 13, 1982

Jodie Foster called and said that she had an interview with Nastassia Kinski that *Yale Daily News* didn't want and did *Interview* want it, so we're going to use that with a cover of Nastassia for February. She's so sweet, Jodie.

Tuesday, December 14, 1982

In Liz Smith's column she made that party at the Greek restaurant on Sunday sound so great! They always sound so great later when you read about them.

 Went over to the back-massage guy on Seventh Avenue and now Chris tells me that he's not really a shiatsu masseur, he's a chiropractor. And it seems now that it's just me who goes there. It's so lonely there, I'm probably his only customer. He'll probably break my back so I'll have to keep going to him (phone calls $.20).

Then went back and worked on my Alfred Hitchcock portrait for *Vanity Fair*. Waited for Rupert. Mr. LeFrak called and I've got to get to work on his portrait.

Then there was a screening of *Gandhi* and went to that at the Columbia screening room at 56th and Fifth, and the movie was just thrilling. It was three hours long, and the only thing that ruined it was Miss Candice Bergen. It's like a jolt of reality. Suddenly there she is, saying that she's Margaret Bourke-White of *Life* magazine, the photographer. She's just awful. Jarring. Like me in *The Driver's Seat*. I was so bad in that. But I could have been good if they used me good. Oh and some movie star told me recently that *Bad* was the best movie they'd ever seen. Now who was it . . . ? Oh, it was Jeff Bridges! He loved *Bad*!

Thursday, December 16, 1982

Went all the way to Chinatown from way uptown because it's so funny to hear Benjamin talk Chinese (cab $9, phone $.20). We went looking around for new ideas, but it's so hard to do these things all at the same time, all the pressure—looking for new ideas, the pressure of painting, the pressure of buying the building. It's a lot of stress.

Friday, December 17, 1982

There were about eighteen parties going on that I missed. Frankie Crocker was having a party at Studio 54 that Laura Branigan was going to sing at. Maura Moynihan was having a Christmas party then playing at Danceteria. The Ritz was having a concert for the Who that was going to be televised. Suzie Frankfurt was having an open house and Couri Hay was having a party.

Sunday, December 19, 1982

Decided to go to Vincent and Shelly's party. They had about eight babies there and all the kids from the office. Asked Jay as a Christmas present to please get me a cab.

Monday, December 20, 1982

Had to meet the LeFraks. And they hated their portrait. She said I made her look too much like Kitty Carlisle.

Worked till 7:00. Gave PH her earrings for Christmas—David Webb frogs from the forties—and she was thrilled. Then went to Dr. Silver and he said I'll be cured of pimples in two weeks.

Tuesday, December 21, 1982

Mrs. LeFrak didn't like her hair and Rupert's working on it right now. I've got to call and tell him to make the screen fluffier—more highlights in her hair, but it's probably too late.

Wednesday, December 22, 1982

Went over to the Waldorf to the debutante ball thing. And Cornelia was supposed to be there because she's doing a *How to Be a Deb* book with Jon, but she wasn't there. And then this curly-haired blond boy came over and said, "You did some paintings for my grandfather," and I asked him who was his grandfather, and he said, "Nelson Rockefeller." All the kids at this thing were so beautiful. All the boys looked like Robyn in tuxes.

Thursday, December 23, 1982

When I walked into the office everyone was in a bad mood. Brigid began putting Christopher down and said that the only Christmas present that everybody at the office would really want is that Chris never come up there again. When I told him about it later he said that maybe he should pay Brigid the $20 he owes her. She did some work for him a few years ago on a project that then *he* didn't get paid for, so he felt that he didn't have to pay *her*. And then of course he's cheap, that's really why he didn't pay her. And Robyn was so moody. Jay went home to Milwaukee and he's the only one who might've actually worked.

And Peter Beard called and wanted us to okay a check from Cheryl Tiegs that he was trying to get cashed at Brownies because he wanted to go around the corner to Paragon and buy some sports equipment. So I guess he's being kept by Cheryl. She's really got the bucks, she's got the Sears contract.

And Lorna Luft came down because Liza's giving her her portrait for Christmas. And she had no makeup on and she looked beautiful. She's on the Cambridge diet, and she really is pretty. Her portrait will be like Marilyn. If she just kept her regular brown haircolor and her regular looks, she could be a big serious actress. But instead she tries to look the opposite of Liza, to get an identity.

Christmas is so confusing. Jon left for New Hampshire.

Friday, December 24, 1982

I made people come in to work and Brigid spent the whole day like Madame Defarge, she sat around needlepointing, thinking about not having the day off. My nerves were shattered, I couldn't put anything together. Worked at the office trying to wrap paintings up for the Halston group. Had Benjamin meet me at home.

Went to pick up Sondra Gilman, her kids are grown up now. The girl's a model type. The boy is tall, too. They're beautiful, like *Village of the Damned* kids. The girl said how these old photographers tried to pick her up and one took her to dinner at Le Relais and tried to impress her, saying he'd made this one and that one—made their careers—and this young girl was telling me about it and laughing at him.

So then finally we went to Halston's and Halston wasn't anywhere in sight. It was odd. Although we were four hours late. But finally we found him upstairs with Steve Rubell, next to the tree.

Halston gave me—*maybe*—two Elsa Peretti candlesticks from Tiffany, but I had to sign a note saying that I would return them to Halston if it turned out that he couldn't get another pair for himself. So that's a new one. And I was a wreck, trying to figure out what size paintings to give to who. It was harrowing.

And Steve Rubell gave me five cassettes. And he kept saying it over and over: "I gave you five cassettes. Isn't that just the greatest gift?" I mean, they were just tapes that you can buy, like a Michael Jackson tape, that cost $3 apiece. I mean, Steve was cheap when he *had* money, and now that he doesn't have any . . .

Saturday, December 25, 1982

Got up late. Went to church. Had a miserable Christmas. Got Benjamin to come into the office before he went home to San Francisco (cab $5). Worked with him all afternoon trying to get my bills paid. Heard about the big snow out in Denver. Gave Benjamin cash for working that day ($100).

Tuesday, December 28, 1982—Aspen, Colorado

At 8:30 Barry Diller invited us to have cocktails with Calvin Klein and Marina Cicogna and Diana Ross. Diana came in and she had just bought a cowboy hat and big white shoes and she was out for action.

We all got in cars and followed Barry, he's a bad driver. Then Barry invited us out to dinner to Andre's. The food there was disgusting. Jon lost part of his Kieselstein-Cord belt. Diana was dancing on top of the table and everybody wanted to dance with her and she said, "I'm dancing with *all* of you!" That was a great line.

Thursday, December 30, 1982—Aspen

John Coleman told us Barbi Benton was giving a party so I just casually called her and said, "Hiiiii," and she said, "Hiiiiiii," and so then I said, "Oh I was just calling because we had so much fun last year, you know . . ."—playing it that way. And so she said she was having a party and would I like to come, and I said, "Oh why yeeeesssss."

We arrived at 7:00 and I met her parents and they were adorable. I found out about her being born in New York and about her having a grandfather who bought her fifty dolls and the mother wouldn't give them to her. And they moved to Sacramento when Barbi was three.

Met Zev Bufman again.

Buzz Aldrin came, from the moon. The astronaut. Took a lot of photographs of him. He's aged but he was cute and glad to meet us. We decided to start lying that night—Chris told people he had a twelve-month-old baby and that he was watching it while his wife was back in New York

and they all believed him. And I told them I was a deep-sea fisherman, and this lady invited me to Boca Raton. I haven't been drinking at all.

Friday, December 31, 1982—Aspen

Chris went skiing with Cornelia on Buttermilk. Mark Sink called. He's the bicycle racer who does circulation for *Interview* in Denver.

Drove over to Jimmy Buffett's. As soon as we got in Couri Hay had taken one of our tables and filled it up with boys—Tab Hunter and a mincy boyfriend. But then Jamie Buffett gave us another table and then the party started getting good. Barry Diller arrived with Diana Ross, and Jack Nicholson with Anjelica Huston—Jack's got a big fat belly now. It was all country-western.

Five minutes before New Year's we decided, Jon and I, that we didn't want to be in a crowd and so we went right outside, not to hear them singing "Auld Lang Syne." Then we watched the fireworks outside and went in ten minutes after. So it was great, nobody even knew we were gone, and they had finished all their kissing and stuff.

Saturday, January 1, 1983—Aspen

Something strange happened, I thought Jon was trying to kill me. We were on a snowmobile and he pushed me over a cliff. I thought he did it on purpose. But somehow there were trees there and I fell off into a deep snow. We rode to the house, that was fun, but I didn't realize till I got back how scary going off the cliff was. Then it sunk in what had happened. So I confronted Jon, and he told me I was just being crazy and I was relieved.

Sunday, January 2, 1983—Aspen—New York

I didn't have one drink the whole time I was away. And I didn't gain weight, either. I just got weighed and I'm 126 still.

Monday, January 3, 1983

The LeFraks called and said they still hated their portrait. Mr. LeFrak said why weren't Mrs. LeFrak's eyes hazel in the portrait, and then he said his nose was too bulbous. So maybe if we fix those two things it'll get by.

Bob still wasn't back from Santo Domingo from the Cisneroses. And *Time* magazine has Cornelia as Deb of the Year.

Tuesday, January 4, 1983

I had dinner with Chris at the Post House on 63rd Street to decide once and for all what his money participation in my Decorative Photography portfolio would be, and we hashed it out. And Chris is so cheap—cheap in ways you'd never even dream of. And it's like Bob. And Paul Morrissey. They want more and more. And Bob was just back from a grand weekend and he gets these ideas that he should live like royalty, and he gets very unhappy if he doesn't get more and more, and I mean, he should just marry one of these old bags and get everything he wants (dinner $130).

Thursday, January 6, 1983

When I got to the office Vincent handed me a letter. It was from Bob. He quit. No one at the office knows except Gael and Robert and Fred. And I hear he has the agent named Janklow, a big literary lawyer. I wonder if Jann Wenner's offered him a job because he's been having meetings with him lately, but I don't think so, because they'd never get along. I'm happy for Bob. Really I am. But I mean, he should have kept working until we found a replacement. It's awful of him to just leave with no notice. Fred called and talked to him but nothing changed. I think Thomas Ammann must have encouraged him. Thomas has gotten so grand, too. I mean, I see people that I knew so long ago, and suddenly they have airs.

So nobody at the office knows except the people I said. But *(laughs)*, everybody outside the office knows. But this has been building up for a while. Before Bob went away for the holidays I'd told him he could have any painting he wanted for Christmas and he said a Hammer & Sickle, and I only have two of those and I said, "Gee, Bob, just anything but that," and he got mad. But Bob has gotten so grand, he goes to these rich people's places and he thinks he should have it all, too. But magazine editors don't make that much. And Bob made so much off other things— he got commissions on the portraits and he has 50 percent of that Bruno photography portfolio. But what he really wanted was 50 percent of *Interview*—at least I think he said 50, I couldn't really hear if he was saying 50 or 15. I told him then that he could have a percentage of the *profits*, when *Interview* started making some profits, but it's not making any yet. And then he said that it *was*. But it's just not. And if Bob was smart, he could have just hired someone to do the routine things that he does for *Interview* and just overseen the magazine, do it freelance. I think maybe that's what Fred's going to ask him to do. Anyway, I think he'll be back.

And John Powers brought a possible portrait by—a plastic surgeon from Florida. And Mr. LeFrak came while they were there and John was great, he embarrassed Mr. LeFrak into finally accepting the portraits—he told him what more do you want, and then later he told me, "I can't believe you made him look so good."

So I got home about 7:00, dropped Jay (cab $5). Decided to stay home, talked on the phone to Christopher and Fred.

You know, about Bob leaving, it's not about money, because he was making a lot. And it's not about the Hammer & Sickle, because if it wasn't about that it would have been about something else. He's been leading up to this for a long time. Maybe he's going into business with Thomas

Ammann, too. Because Bob is good at selling art. If a person says they don't want a portrait, Bob will just make a face and walk away. And he's not shy about asking people to pay their bills. Even Fred is a little shy about that. But Bob isn't. If he's got a good new job I'm happy for him. He just shouldn't have quit with no notice. That's the bad thing, it's not professional.

Friday, January 7, 1983

The newspapers had a lot of Bob Colacello items and the office was still buzzing about it. Jane Holzer called and said that Steve Rubell had told her and then I changed the subject and asked her what was new with her, and she said, "You're so cool about all this," and what else can I be? I mean . . . but it's a big savings for the office payroll. Fred doesn't think we should rush into hiring a new editor—Robert Hayes has been so nice we'll just see what he can do.

Nick Rhodes of Duran Duran came to the office and he brought his girlfriend, Julie Anne. He's twenty and she's twenty-three. He was wearing twice as much makeup as she was, although he's half as tall.

Saturday, January 8, 1983

It was a day of buzzing on the phone about Bob. There were more items in the paper saying that Bob was taking my favorite secretary, Doria Reagan, away. Bob's drunk with this newspaper power, getting items in the columns, because I mean, people just forget this stuff in a minute.

Tuesday, January 11, 1983

Vincent broke the news that the LeFrak portraits were coming back down, that the pupils were left out of the eyes and there was a spot on the face. So just when I thought I'd seen the last of them . . . It's like *Night of the Living Portraits*.

And Gael Love came to tell me how well the magazine's doing, but I never know whether to believe her because she's always so enthusiastic about everything. And Robert Hayes is being really sweet, I guess because he thinks he might be upped to editor.

Grace Jones came by in her macho outfit with a big raving beauty Swedish guy, like 6'6". Hans Lundgren. And we shook hands and it was strange because he had such a weak handshake, really wimpy. And Grace looked great.

Talked to Jon who's in L.A.

Wednesday, January 12, 1983

Chris was at the office and showed me the photographs he took in Aspen and he wants to use them for his monthly page of photographs in *Interview* and I told him he had to fix some things. I mean, he had Barry Diller in photographs with people he wouldn't want to be in photographs with, and Barry's Jon's *boss*.

And Grace Jones came by with her Swedish boyfriend. And I gave her a speech about how she should look more normal or no one would hire her. It's the same speech I gave Debbie Harry after I saw *Videodrome*, that she should just be normal-looking, keep her hair red so she could get the Faye Dunaway parts.

Then Barbara Allen also came down, she's now going with this really rich multi-multi-guy Henrik de Kwiatkowski, and everybody's hoping she'll this time get married. But Barbara's really changed a lot. She's like one of these older women now. Like the Roxanne Pulitzer one. She still looks good, but it's the attitude. I'm not putting her down, she's really sweet, but it's just an attitude change. They go from being a girl to this kind of woman. So this is the guy C.Z. was dating for a little while after her husband died.

We went to see *Peter Pan* (tickets $10). And that was great. Disney still holds up, the drawing and the color (food $5). And then on the way out I opened a door and knocked over a little girl. What's wrong with her parents, taking her to the movies at 10:00 at night! I felt so horrible—it happened because of those doors that go two ways.

Friday, January 14, 1983

Got to the new building and I thought everything would be all done, but it was the same old workmen still working. I couldn't stand it. And I saw where my painting area will be—it's down there in the dark, in the basement. I thought that was just going to be for storage. It looks like something we shouldn't be doing. I mean, when I go down to 860 Broadway it's sunny and so bright in the front that you feel good. I may just find another place to paint in. The Great Jones Street building might be good. Or I may move up to the "Entertainment Area" on the third floor, which is the terrace covered with glass, because it's light there. But I don't know what we're doing with all this space! Fred has this huge area and what's he going to do in it? Nobody will ever see anybody anymore. Brigid has this huge entranceway, and Vincent has this big area for his TV things. It's fine for *Interview* to have a lot of space because it makes sense, but I don't know why we don't just go into the real estate business and rent most of it out.

And I thought we were going to have a huge great elevator, but the elevator is 1" × 1". I didn't want to think about it, so I just began screaming at everybody.

So I got home and I watched *Rebel Without a Cause*, and gee, it was so strange to see Sal Mineo looking like a baby, just a real real baby, and James Dean and Dennis Hopper look like grown men. You can't figure out what this young thing is doing with them, and yet they're all supposed to be the same age. And James Dean looked so modern—the jeans and the Lacoste shirt and the red windbreaker, and leaning over with no underwear showing. And Natalie Wood looked her best in this, an American Teenager. And Dennis looked so good. And it was sad. The maid was left over from *Imitation of Life* and she had the St. Christopher medal and she said, "Why couldn't *he* have somebody?" about poor little Sal Mineo. It was sad. Because James Dean had his head on Natalie's lap and then Sal Mineo came and put his head on James Dean's stomach and then he fell asleep and then James Dean and Natalie tiptoed away because they wanted to go kiss and be romantic, and it was sad, he didn't have anybody.

Tuesday, January 25, 1983

I saw the tape I did for the first of the TV shows Vincent's shooting. They're for the Madison Square Garden Network and they'll be on cable TV. It's interviews with people talking into the camera. Susan Blond was a little corny and I was terrible. Reeeallly reeeallly peculiar. I'm just a freak. I can't change it. I'm too unusual. It was really bad—I was on top of the Empire State Building introducing the guys who light the buildings.

Thursday, January 27, 1983—
New York—Atlantic City, New Jersey—New York

I was going down later to Atlantic City, my first time, with Diana Ross to see the Frank Sinatra show and bring a print of the portrait I did of her down to the guy who owns the Golden Nugget. Diana had just signed a contract with the Golden Nugget to play in this room, they're paying her a lot, and she's never played a small room before, so she wanted to see it.

And I had a fight with the assistant art director girl at *Interview*, I called her dumb, but then I cooled down. It was like Mr. Brodovich, the famous art director at *Bazaar*, when he used to scream at me. You know, it was just people doing what they want to do after you tell them what to do. But Fred told me that you can get more out of people if you tell them they're dumb in a nice way, so the situation cooled down.

And the Twiggy cover came out so bad—it was so ugly, Twiggy in a snood—that we're going to use a Robert Risko caricature for the cover. Because *Vanity Fair* is coming out and they're stealing all our artists, so we wanted to get this look out first since it's going to be their look.

Then suddenly it was 5:00 and I had to be home by 5:15 when Diana Ross was picking me up to go to the helicopter (cab $5.50). Just had time to put my contacts in. The doorbell rang and it was just Diana alone, so I was nervous. Then we went to the 60th Street place and got a Pan Am helicopter that the Golden Nugget was paying for.

We had to wait a few minutes for her lawyer, and also going down with us was Frank Sinatra's tailor who had an Italian name but looked Jewish. And I liked the lawyer, there was something adorable about him. I've noticed that all these people on top have a twinkle in their eye, their eyes twinkle. And he kept calling Los Angeles all night because of the big floods there, to find out if his house had gone down the drain with his wife and kids. As a matter of fact, everybody from California was calling to find out if their houses were still there. Diana called, too. And you'd hear things from the phone like, "Oh no! The neighbor's house just went!"

I told Diana she should really marry Barry Diller and she said how could she take a girlfriend's man—meaning Diane Von Furstenberg. I told her she really had to do more movies.

And we talked about David Geffen. I told her she should really be friends with him again because he was in with that crowd, and she said that they had been really good friends, that he was so great to her when her mother had cancer, he took her to Sloan-Kettering when she had no idea at all what to do, and I asked her when this was and she said, "Last year." So I said, "Well, what happened?" And she sort of said *Dreamgirls*, the musical that's about the Supremes

but they don't call them the Supremes. Geffen produced it. She said that at first she was going to sue but then she didn't.

And Diana tips people herself and does everything herself. It's really great.

And as we left New York the skyline was so beautiful.

When we got to Atlantic City the guy who met us was somebody who Edmund Gaultney had brought to the office once. He took us to the Golden Nugget and it turns out his brother, Steve Wynn, owns it. He was there with his wife and kids, and they're a good-looking American family—I couldn't tell if they were Italian or Jewish.

And Diana couldn't decide which of two outfits to wear. I said I'd be her hairdresser and decide, but then I couldn't decide, either. She finally put on a skimpy white dress, but then later changed her mind and wore tight black pants and a top. So I got a tour of the Golden Nugget and that was exciting. There were literally eighteen restaurants, and Victorian was the style for everything. I asked the guy why everything was Victorian and he said nobody gambled if it looks modern.

We went up an escalator five stories high. They said they'd send a plane for me whenever I wanted, but when I said I wasn't a gambler they dropped me. Diana is a big gambler, though, but she hasn't gambled there yet.

Then they said that Frank Sinatra always goes on on time and so we got to the room and it's about 500 seats. They sell 200 and then give 300 to the high rollers. Frank came on and he did all his songs and it was great.

And he introduced Diana Ross and me in the audience, he said, "We have two fabulous, famous people in the audience, each in their own fields, one an artist, one a singer," and the introduction went on for a long time. And Barbara Sinatra was between us. She was wearing a little black dress, she looks great. I couldn't think of what to say so I asked her if her son was still dating Barbara Allen, although I knew he wasn't.

Afterward we went to their suite and for the first time Frank shook hands with me. And gee, he looks great. How old is he? About sixty-seven? And he doesn't wear a toupee. I'm sure. I'm an expert, and I really would say absolutely not—I think he's maybe had transplants and that they look really good. And the tailor was there measuring for suits, and he was straight but he was kissing and hugging all these guys like a gay seamstress. It was so camp. And I didn't have my camera so I didn't take pictures, but anybody who tried to, the security people put their hands over the camera in sort of a great way.

Frank said he was doing a song on his next album with Michael Jackson, and Diana said, "Why don't you do one with *me*?"

When Diana and I were alone for a moment, I told her that there were so many people with "funny names" here, and she pushed her nose sideways and said, "You mean like this?" And it was funny, it looked so Mafia. Home at 12:00.

Friday, January 28, 1983

Benjamin picked me up and we went on the usual rounds. We went over to Madison and I spotted Bob Colacello walking along the street. My first reaction was to change my direction and go the other way, but then I decided to catch up to him and talk to him, get it over with. I followed

him into the chic little brick colonial Bank of New York on Madison. At first the guard tried to kick me out, but I made it over to Bob. This is Benjamin's bank, too, which is funny, because he has to come up from the dumpy Lower East Side to go to it.

So I said, "Oh hi, Bob. I was with Diana Ross last night and she took me to see Frank Sinatra and gee, I know you've been trying to interview him for so long and last night he said he'd probably do it, so do you still want to do it?" I was just trying to bring everything back to a friendly level, but Bob was so sour. I guess he does hate ... well, so he said, "My agent, Mort Janklow, would never permit me to do that." So I said, "Well, uh, gee, okay Bob, it's great to see you, really great." So I left the bank feeling so moody. And then to make it worse, it was one of those times I tried to give people *Interviews* and they refused them (cab $4.50, phone $.50).

I was then in the neighborhood of Doc Cox and so I stopped in to chit-chat. Rosemary is out for a couple of months, he said, because she got hepatitis. And did I ever mention that she once told me that a man came in with a vacuum cleaner attached to his cock? That's a good one. So I tried to get Doc Cox to confirm what I'd been hearing about Henry Post, that he has AIDS and now he's sinking fast. He picked up a virus from his cat. He's in New York Hospital.

Monday, January 31, 1983

I watched *Chinatown* on TV. Why isn't Robert Towne writing great things like that now?

Went to meet Lidija (cab $6) and worked out. Then had an appointment to see Keith Haring in Soho (cab $3.50). Went with Chris and Peter. He rents a huge studio without a bathroom for a thousand dollars, and it's great. And there was this Puerto Rican kid sitting there, and I asked what he did and Keith said the kid does the writing in Keith's graffiti paintings, so I got confused, I don't know what *Keith* does. He paints *around* the words, I guess.

Wednesday, February 2, 1983

Was dropped by Benjamin (cab $10) at 277 Park, the Chemical Bank building with the big solarium on the ground floor. A meeting about financing our new building. You can really see how these banks are spending all the money. About thirty executives were eating with us—Fred and Vincent met me there—and for each one there was a black waiter.

And the bank buys all this cheap art, like it's from a drugstore or something, and then they put a plaque in. I don't know, maybe this will be the art to collect, who knows, but God....

And they put in stairways going from one floor to the next, as if you're getting married. Those kind of stairways.

Fred was going off to California with Gael Love and Barbara Colacello to promote *Interview*. Fred's reading all his old *Vogues* and *Vanity Fairs* again for ideas, which is great, he's working more with *Interview*.

Thursday, February 3, 1983

Went to Antonio's show at Parsons with Jon (cab $4). It was really crowded and I got mobbed for autographs, and I was signing away, and Grace Jones was refusing to sign autographs, telling the girls and boys to get lost, but then when she saw me signing so much, I think she got embarrassed, so she came over and explained that her public liked it better when she treated them that way. I couldn't believe her.

Then to the Keith Haring opening (cab $4). It was on the Lower East Side, at the Fun Gallery, it's called. So we walked into the place and there's René Ricard, and he's screaming, "Oh my God! From the sixties to the eighties and I'm *still* seeing you everywhere!" And I said how could he have said all those awful things about me in the *Edie* book and he said that I should have seen it *before* they cut it.

And Keith's show looked good, it was his pictures hanging on a background of his pictures. Like my Whitney retrospective show was—all hung on top of my Cow wallpaper. We left there and Chris and Peter wanted to go to the Coach House, naturally, because it was the most expensive place.

Friday, February 4, 1983

It was freezing out.

Steve Rubell called and said he was sending tickets to the Joan Rivers thing at Carnegie Hall that night and invited me to Calvin's for drinks before the show. He also told me that he'd sent Bob over to see about the Page Six job at the *Post*, but that they couldn't believe the expense account he was asking for. I knew these places don't pay much, just from the days when I used to work for *Harper's Bazaar*. I guess you get perks, but ten years ago *The New York Times* sent a letter to all the writers saying that they could accept absolutely nothing for a gift. I guess Diana Vreeland, though, used to get so much, so many shoes and dresses.

Went to Calvin's on Central Park West (cab $4). I asked Steve if he'd invited Bob Colacello and he said no, that since Bob wasn't working for anyplace why invite him. Calvin had fourteen boys and one girl—Sue Mengers. Barry Diller was there and Sandy Gallin, the big agent.

It was fun talking to Sue, she's such a pig. Then we went in limos to Carnegie Hall. Steve gave us two seats way off, separated from the center seats that he had.

Joan Rivers came on with her boa, and she's funny, but I don't know how she can say the things she does and get away with it, how she's not sued. Like she said that Richard Simmons is carrying Rex Reed's baby, and she says that Christina Onassis looks like an ape, and she did a thing about Nancy Reagan picking her nose with a breadstick. But then afterwards everybody was talking like her, so I guess she's popular.

Saturday, February 5, 1983

Catherine Guinness is in town. She's staying at her old apartment, she kept it. And she's getting married to the lord who dresses like the nineteenth century, Jamie, so there's dinners for her. She's been calling every day, she wants to go out.

Sunday, February 6, 1983

Went to church. Worked some more on drawings. Went to bed early. The phone didn't ring all day.

Monday, February 7, 1983

Went to get black-tied for the *Newsweek* party. Lincoln Center by cab ($4). It was a boring party. No stars. Just Nancy Reagan and President and Mrs. Carter. Basically it was a big office party. The show of past *Newsweek* covers was interesting. Through all these years, it was all war war war. We wanted to leave early to go to Marianne Hinton's party for Catherine on East 57th Street (cab $5).

Catherine's husband-to-be was there, Lord Neidpath. He was in *Interview* once as a "First Impression." I met him a few years ago. He has long black curly hair and he looks like he stepped out of the sixties, like right off the King's Road—britches, and a silk jacket. And Fred was there and Shelley Wanger and Steve Aronson. So Catherine's going to be a lady.

Thursday, February 10, 1983

I invited Jane Holzer to the Rolling Stones' party for their movie opening because she was the one who introduced me to them in the sixties in the first place and she wanted to feel young again. Jane looked great. Cab to the Corso on East 86th Street, got there right at the right time. There were 100 policemen ($3).

And a freelance photographer kid took my picture and said that the *National Enquirer* had called him about getting a picture of me for the cover. What can that be for? A palimony suit? Dying of cancer? It made me nervous trying to think.

Missed a call from Jon in Las Vegas where Paramount was having their seventieth anniversary party.

Friday, February 11, 1983

The snow hadn't started at the beginning of the day and I just didn't believe it would, the weather reports are always wrong. But by 12:30 it'd started (cabs $5, $3, phone $.50).

Interview was having a screening of *The Lords of Discipline* at Paramount and I was afraid we wouldn't be able to get around so I hired a limousine. And then I went into *Interview* and invited some of the kids to ride up with me, and then Fred screamed at me that I had destroyed the office protocol. I keep forgetting that at *Interview* they have all these levels of who gets invited to what with who, based on how important your title is. Like a regular office. And I didn't invite Robert Hayes to ride up with me because he was with his sister and his boyfriend Cisco, and Cisco has AIDS so I didn't want to be that close to him.

People in the streets were laughing and throwing snow.

The movie was great, I enjoyed it so much, it's so decadent. There are no girls in it, and all these boys fighting. Mitchell Lichtenstein looks great, just like his father, Roy, twenty years ago, and I do think David Keith is going to be the new John Wayne.

Sunday, February 13, 1983

It was all snow outside and it was beautiful, not too cold. Went to church.

Nelson Lyon called and we gossiped. And he said that Paul Morrissey had talked to Bob Colacello this summer on some Greek island where they were freeloading off Thomas Ammann and Bob told Paul that he was thinking of quitting because I still didn't know how to spell his name. Well listen, I always thought it was stupid for him to change how he spelled his name, and then not *really* change it—to just drop the "i" from "Colaciello." I mean if Bob expected me to spell it, he should have made it a really *simple* name—something that I *could* spell.

Tuesday, February 15, 1983

Woke up with the same old unhappiness and crud. Oh, but Lucy is making me happy this morning. *I Love Lucy.* She's so funny. She's at the Brown Derby with Ethel and Fred, and she stared at William Holden so he's staring at her while she eats spaghetti and Ethel has to cut off the strands. Oh it's good. She's disguised and her fake nose catches on fire! It's the funniest one.

Called Catherine about the lunch we were having for her that afternoon at the office. She invited about thirty people.

Was picked up by Benjamin and went to Doc Cox's and saw Rosemary who's back. She says she stays up listening to Mahler and reading icon books and she goes to work at 4:00 in the morning and finishes at 10:00.

Left there and went to Sotheby's but they tried to make me check my bags, and I told them no, and then they wouldn't let me in so I walked out, I told them they were losing my business for good. I mean, it's my "purse." Ladies don't have to check their purses, so why should I?

Forgot to say that Diana Ross sent me a big bowl of candy kisses and she's so sweet, I have to send her something. It looked like she could have wrapped this up herself.

Oh, and Crazy Matty had been up at 860 and left the worst letter, it was crazy like Hinckley or something.

And Bob Colacello was invited to our lunch for Catherine but he turned it down by saying, "I have to go to a meeting with my agent."

Wednesday, February 16, 1983

Another lunch at the office for Catherine. She said she became great friends with Bob Dylan in England. I guess she's doing a lot of entertaining, showing her houses. She's wild, Catherine. She learned a lot from Tom Sullivan.

Watched *Dynasty*. Joan Collins is so good. And they took the bandages off the fairy son's face, and it's so funny, it's like the men are now doing all the old Bette Davis and Joan Crawford things—like when you "remove the bandages."

Thursday, February 17, 1983

It was a beautiful spring day, almost. I had a lunch date with Lady Sharon and Jill Fuller at "21," it was Jill's birthday and I brought her a Dollar Sign. I was surprised to look at her hand and not see a wedding ring, and she said that it was over already—he was just some kid she'd met in a discotheque. He called her an old bag or something and she threw him out.

I told them the real story of Bob's quitting after I wouldn't give him the Hammer & Sickle painting. And when I later got back to the office and told Fred that I'd made a mistake and told it, he got mad and he said that now it'll be in the papers. Which I guess is true. And Jill and Sharon said that people were going to drop Bob. And actually, Jill and Sharon are the kind of people who *would* drop Bob. And Sharon said, "Bob's a friend of mine, but he *is* moody and it's hard to take."

But you know, it's true, all those people are really going to drop Bob if he doesn't have a column someplace. They just want to be in a column—that's what they have him over for!

Oh, and that Iranian lady, you know, Bob's friend, Mercedes Kellogg, Sharon was telling me what a fat thing Mercedes was and that Sharon helped her and got her to lose forty pounds and now she's dyed her hair blonde and is a big hostess, and she doesn't even call Sharon.

Saturday, February 26, 1983

The night of the Roy Cohn party. Cab to Studio ($5). Ethel Merman sang "Happy Birthday." And Ivana Trump was there and she came over and when she saw me she was embarrassed and she said, "Oh, whatever happened to those pictures?" and I had this speech in my mind of telling her

off, and I was undecided whether to let her have it or not, and she was trying to get away and she did.

Poor Earl Wilson must have had a stroke. He was there and he can hardly walk, he just sort of scratches his feet along the ground, so I guess that's why he's not doing his column so much anymore.

Monday, February 28, 1983

Benjamin picked me up and we tried to feed the big gingerbread house that little Berkeley Reinhold had given me for Christmas to the pigeons in the park. But they didn't like gingerbread and they didn't like candy. And I tried to get rid of some fruitcake, too, and they didn't like that, either, so I feel like just letting them starve. I mean, what do they *want*? They do like nuts though, so maybe I'll bring them some peanuts sometime. Okay, so then we went downtown ($6).

Then met Lidija, worked out, then joined the lunch that was going on for Tom Armstrong, Sandy Brant, David Whitney, and Philip Johnson. They were there to try to talk me into giving the Whitney all my old movies and they'd restore them and catalogue them and show them, but I don't know. Vincent says I have to because these people are friends. But I think maybe we should work ourselves on somehow trying to make them commercial. I told these people that when you describe these movies they always sound better than they actually are, and that if people really saw things like *Sleep* and *Eat* they'd think they were boring. I also told them that I wouldn't be an easy sell, that Tom Armstrong would have to entertain me at the Knickerbocker Club. Which is what was supposed to be happening, anyway, but Vincent just wanted to get this lunch out of the way fast. So they said sure, and we'll do that, so I guess they think that I'll do it, but I don't know if I actually will or not. I'm deciding.

Then I was meeting Paige Powell after that at the Berkshire Hotel, the one where the Rolling Stones stayed, because there was a menswear convention there, and she thought it would be a good place to leave *Interviews* and try to sell ads. I like Paige (cab $4). It was incredible there— every jacket was the same, every sweater was the same. Five floors of clothes and they were all the same.

Cabbed to meet Chris and Peter and Maura Moynihan. Then down to the Bottom Line to see Lou Reed (cab $8). And Lou's lyrics you can understand now (drinks $140.08) and the music was really loud. He did a lot of familiar songs but you didn't recognize them, they sounded different. Lou's in A.A. now, and he's also working out, getting definition, getting trim. Chris was trying to clean Maura's fingernails because they were dirty. And she had a spot on her dress that she said she just got but it looked old. I mean, she's Irish.

Wednesday, March 2, 1983

Victor told me he saw Jon at a gay club but I didn't say anything to Jon. And Chris keeps wanting to know if he can collect on the watch that I promised him if Jon would . . . and I told him no, not yet. [*NOTE: Although Jon Gould continued to keep an apartment of his own, he was now living in*

Andy's house, in the fourth-floor guest room.] And I was worn out from Victor telling me all the gossip about Halston, it made me nervous, about Halston throwing him out of the car and about Liza wearing a YSL. And this is the night I was going to the party for Liza's father at MOMA.

And it was strange, because as Victor was telling me about all these fights with Halston he was screaming at me for not being a close close friend to Halston, accusing me of remaining on the surface and taking the benefits without the responsibility. Which I do do because I just don't want to be that close to Halston because he can really turn on you.

Steve Rubell called while I was talking to Victor and he wanted to go to MOMA with us, and so I told him that Jane Holzer and I first were going to the Claus von Bulow party for Catherine.

Called Victor and he said he was going to MOMA as Mrs. Halston. The new secretary said that Halston wouldn't be providing transportation, so I guess the times are changing.

Thursday, March 3, 1983

How could Tennessee Williams choke on a bottlecap, do you think? How could that happen?

Friday, March 4, 1983

Mrs. Vreeland called for Fred and she was talking in a lower-than-usual voice. I think about her and think what it'll be like, thirty more years of life.

Monday, March 7, 1983

I went to Dr. Silver the pimple doctor (cab $7) and he said I should drink more water, and I will, but I'm not sure I like peeing a lot, because then I'd have to go home more because I don't like to use public bathrooms at all.

Tuesday, March 8, 1983

Jon called from California and said he'd make it on time for the Bette Midler show and he did. At the end she did a serious thing where she broke down and thanked the kids who'd slept in line to get tickets. Jann Wenner was behind me and he said, "What is Bob Colacello doing?" and then he tried to make it sound intriguing that he had lunch with him. I said, "Why don't you hire him?"

The show was over at 11:30 and I was home at 11:45. Didn't go to the Club A party for Bette.

Wednesday, March 9, 1983

Brigid had a fight with the whole office about stealing a grapefruit and then Paige screamed that someone had stolen her scarf.

At 3:30 I went to 35 West 31st Street to a big studio where I was being shot for a commercial for the city for the Brooklyn Bridge. And I guess they got me on the rebound from Woody Allen, because on my dialogue sheet all the lines said "WOODY." The lines were: "That's art," "Perhaps in red," and "A masterpiece."

Thursday, March 10, 1983

At the office the phone rang and they told me it was Henry Post's friend Todd and I got goosebumps. Somehow I knew what it was. And he told me Henry had died—he got another cyst in his head from the virus that he got from his cat. I may have forgotten to tell the Diary that I called him last week in the hospital and I woke him up, and I felt so bad. I asked him what I could get him and he said nothing, that there was nothing he wanted. He told me he was really weak and had to get off and he said that he didn't know if he was going to make it.

And I begin to wonder if Doc Cox is any good. I don't even know if they really check my blood right. Maybe Henry would have been better off with one of those boy-disease specialists.

And *Lords of Discipline*—Paramount's decided not to advertise it anymore because it won't take off. It's just doing okay, $9 million. But then what I don't understand at all is why on *Entertainment Tonight* they put down the Paramount movie *Lords of Discipline* when they could just not mention it, since *Entertainment Tonight* is Paramount's. I just wish I could understand the psychology but I'm baffled. Why should they go on TV and say their own movie was slipping when they could just ignore it? I just wish I could get it.

Friday, March 11, 1983

Brigid's knitting away, making a replacement for the cashmere Halston scarf that I lost last spring that I loved so much. How is it possible to lose a nine-foot scarf? I still don't know. And Christopher was with me and he didn't see me lose it, either. Nine feet of red scarf and nobody noticed.

Sunday, March 13, 1983

Halston called to invite me over to dinner. He's getting so grand, he was saying things about "$3 billion" and "J.C. Penney" and I don't know what it means, except he let things slip about "selling out" and I guess he *has* actually sold out and will be having his name on cheap stuff. I guess that's what it's all about and that's what he's worried about, he's not sure he's doing the right thing.

I get so nervous with Halston because I don't want to say the wrong thing and get him mad,

because he's our tenant in Montauk and I don't want to blow it. He wanted to gossip, but I just said things that I knew were out already.

Monday, March 14, 1983

I went to 47th Street to see Boris who hasn't had anything new in so long, he was crying poor. Nobody's buying and nobody's selling for some strange reason. And no auctions, either.

Rupert called and said Ron Feldman wanted me to come right down to the gallery on Greene Street and sign prints. I said to tell him to fuck off, that I'd be down when I felt like it. And then Ron called himself and said that he would give me my check if I came down, and then I felt like it. He said he'd send someone for me, because I said I didn't want to go down alone, so Rupert came up in a cab for me—I'd thought he was going to send a limo. So I went down there and Ron took me into his office and said, "And now we're going to talk about sheets and pillowcases." I said, "No. We're not." I said, "Well sonny, I've turned down millions of dollars in deals for sheets and pillowcases and I'm not going to do it for *you*."

I left with Robert who works for Rupert (cab $5).

Tuesday, March 15, 1983

It was a beautiful day. Walked on the street and a little kid, she was six or seven, with another kid, yelled, "Look at the guy with the wig," and I was really embarrassed, I blew my cool and it ruined my afternoon. So I was depressed.

Monday, March 21, 1983

Benjamin walked me over to the Knickerbocker Club where I was having lunch with Tom Armstrong and Sandy Brant who flew up from Florida just for the lunch, and David Whitney and Fred and Vincent. They're all still trying to get my movies for the Whitney Museum, but I haven't said yes yet. I don't want to, but Vincent and Fred are against me.

The Knickerbocker Club is really chic, really rich. I guess I made a mistake saying "cock" in the big room because David Whitney almost died, but then *he* said "fuck" about five times. We had drinks in the dining room and then went into our own little dining room. The food was great. We had champagne and that finished me off for the rest of the day. They toasted me, although I haven't given my answer yet (cab $6).

Interview was moving to the new building, and they were complaining because they had to move in the rain. Seeing *Interview* move made me have to face the fact that I'll have to move out of 860 soon, too. But after they left, seeing all that clear empty space, it was just so beautiful that now I don't want to leave. With all my stuff, I could probably fill up the whole new building.

Wednesday, March 23, 1983

It was great having this big empty place now. Like the loft I always wanted. Jennifer is answering the phones at the office because she's on Easter break, and she's mostly sitting on Robyn's lap. We got tickets for the opening of the New Art show at the Whitney, the Biennial. And the show is just like the sixties. And Keith Haring is so big, he flew from Japan to New York for three days and then to Paris. These kids are selling everything—Jean Michel Basquiat's show sold out in Los Angeles.

Friday, March 25, 1983

Princess Pignatelli came down, her husband has 200 photographs of me that he wants me to sign. And I talked to him on the phone and I was talking to a wall. I said, "But they're *your* photographs, why do you want me to sign them?" and he'd say, "But they're of you," and I'd say, "But they're your photographs." Two hundred prints. So we left it that way.

And Ina Ginsburg was there and her son Mark, and she wants the portraits redone and one thing she wants me to change is the color of her hair. And Mark took me aside and said, "It's because it reminds her of the concentration camp. She doesn't want to think of herself as that brown-haired person."

Decided to see *The Outsiders* which was just opening, and I loved it, it was like watching *Lonesome Cowboys*. You can't believe it—young boys with dyed hair reading poetry in the sunset. The Sal Mineo type. And then they're in this old church hiding and the boy says, "All I really want you to do is read *Gone with the Wind* out loud to me." And all the boys are so cute. And this schmaltzy music playing as if the boys are going to kiss. Things were all cut up so they didn't make sense. It was like seeing Bruce Weber photographs. Every boy was a raving beauty.

Sunday, March 27, 1983

I got a cab to the Whitney in the rain (cab $4, admission $5) to see the Biennial again. And it's sure different from when I used to go in the fifties—then it was small paintings and—now it's —well, it's an interesting show. There were two Frank Stellas, two Jasper Johnses, and then Keith Haring is the only one of the young artists in it that I know. When kids like Ronnie start to paint badly, everybody starts to copy it. It's strange. We were there for about two hours. I only had to sign a couple of autographs (cab $5). It was still raining.

Decided to stay in and watch *The Thorn Birds*. It was sick, all these people trying to make one priest.

Tuesday, March 29, 1983

I'm trying to figure out if these episodes of *I Love Lucy* where they go to Europe were done before or after *Auntie Mame*. They were about the same time, I think, but I wish I knew which was first.

Oh, the day before Julian Schnabel called and he was in the hospital where his wife just had a baby girl. And he was trying to sound excited. Because everybody really only wants a boy. He already has a girl (supplies $40).

And oh, I love my *Enquirer* gift subscription that someone gave me for Christmas. Everything they say is true. But I have to hide them—I'm not allowed to have them in the house, Jon doesn't like me to read them.

Oh and I don't think I've said yet how odd it was to see Nelson Lyon's name in *Time* a couple of weeks ago. As if he were a real person! *(laughs)* Do you know what I mean? When they talk so importantly about someone you know, it always looks so fake. Geraldine and I were talking about it. She said, "Nelson won't even talk to anybody now that he's been in *Time*." He's going to be a key witness in the Belushi death trial—he was with Belushi and De Niro the night Belushi O.D.'d.

Wednesday, March 30, 1983

Had a lunch for Susan Sarandon to interview her. She was so great. She's a liberal, from a big family, an ex-hippie, and she talked her head off till 4:00. She's like Viva, but she's intelligent.

Thursday, March 31, 1983

Christopher called from the airport, he was on his way to his photography opening in Washington at the Govinda Gallery. He was hoping for cherry blossoms but I don't think they're there yet.

People are on Easter vacation. Stopped at the new building and got *Interviews* to pass out. It was busy, worked at the office.

I arm-wrestled with Jay Shriver and he's really strong. We don't know what from. He doesn't work out. I could never beat him, I had to bite his fingers. And he can do one-hand pushups and I can't.

Friday, April 1, 1983

I had to meet Miguel Bose (cab $6). He came to be photographed and to work on the video thing. His mother's a famous actress in Spain, and his father's a bullfighter.

He told me that his good friend was Joe MacDonald, so I guess maybe he was trying to tell me something. But when I told him that Joe had AIDS, I think I really told *him* something because he looked nervous and scared.

I see that Veronica and Muhammad Ali have split up, and I bet it's because of the big spending

habits she learned from her best friend Ronnie Levin because she went shopping all the time with him in Beverly Hills for antiques and Muhammad would get all the bills.

Tuesday, April 5, 1983

Benjamin picked me up and we went over to Columbus Circle to the Coliseum for the Art Expo to do an appearance with the mayor for the signing of the Brooklyn Bridge posters for the city. And it's such a different crowd of people at these things. The photographers they send are different, and the people from *Time* are different—it's just a whole other league. I guess we're just spoiled, more sophisticated, you don't realize these other ways. And everything's so organized, every last move. "Mayor walks in. Mayor sits down. Mayor presents award"—everything is planned out. Henry's not working for the city now, but he was there. Bess Myerson took his place, she's the new cultural affairs commissioner.

I asked Jon if he wanted to see a screening and he said no, that he was going off to a class. I don't know what kind of class. He starts them and he drops them. Writing, maybe.

Thursday, April 7, 1983

Jed called. It's the first time in two years I've had a regular conversation with him. He said Keith Richards wants to buy Patti Hansen a ruby and wants to know where to get it appraised, but really, any place might switch a stone on you. The only one I was sure wouldn't is John Reinhold. Because it happened to him in San Antonio—somebody switched a stone in what he'd sold them and then said that he'd done it and so there wouldn't be trouble, he paid. Because you can never prove it. And even the reputable places I think do it. Where it really happens is at auctions. You take it over in a corner and look at it and you can switch it.

Benjamin picked me up and we went over to meet Paige Powell at Dino De Laurentiis's big store on Columbus (cab $3). I told the manager I knew Dino and he took us to the basement and through the kitchen area which is a block long. I asked them what they do with the leftovers and they said they have poorhouses who come and take them. But I would think the employees take most of it. Do you think at the poorhouses they're eating *pâté de foie gras*? And there was a lady cutting pasta as if it were a dress, really big.

Then we went to Salou florist. Gave an *Interview* to a cop. Went to Charivari across the street. I was dropped off by Benjamin and Jay ($5).

Met Chris, Peter, and a friend of theirs who raises money for Democratic candidates, he makes a thousand a week doing that. His last candidate lost. He said the wife of the guy would put on her diamonds and her designer dresses to go into the poor neighborhoods because she wanted him to lose—she didn't want to leave town and go to Washington. And she would say, "I know how it must hurt all you poor people to see us come down here in our rich clothes. . . ." He said she was nuts. He told me that they have a machine that puts stamps on letters crooked because then you get a better response—more homey.

Monday, April 11, 1983

Found out that Joe MacDonald died.

Cornelia was going with her boyfriend Roberto to the Xenon Oscar thing we were hosting together—he's the real estate developer that she goes with who's sweet, the one she went with seven empty suitcases to Milan with and came back with eight filled ones, he bought her everything.

At Xenon Cornelia's brother Alexander came by and so I sat with him and he's really dumb, I think. He's in the jewelry department at Sotheby's. I guess he got the job because they thought with his name he could bring in good estates. I asked him about what I was talking to Jed about the other day—how stones can get switched when people take them over in a corner to look at them, and he said that now they have a machine they put them under after you're done looking and before you take them to make sure they're the same stone.

I hated the awards, Meryl Streep was so cornball, and I couldn't stand *Gandhi* getting everything. I wish I hadn't put my name as a host on this party, though—you just make enemies of people you forget to invite. I got away upstairs and sat with a kid from Germany I'd met.

Tuesday, April 12, 1983

Everyone was calling because the *Village Voice* ran a three-page putdown of my wig. It was a writeup of the Studio 54 party for our TV show.

I was being picked up at 4:00 by Ron Feldman and his wife in a limo to go up to the Museum of Natural History for my Endangered Species opening. So they picked me up and she was wearing plastic jewelry, the kind I collected years ago.

Rupert is getting tanner and tanner every day. Instead of working, he's going to the tanning places.

There was a crowd in front of the museum when we got there and I thought it was for me, but they were filming a Disney movie. And then later when we were coming out, the movie people were chasing a big rat that had gotten into one of the actors' trailers.

Originally they were going to have my show in the lobby, but then they put it way back, so you had to go through the rooms of dinosaurs and finally get to this little room where I was. But it looked great, really beautiful. White-framed.

Thursday, April 14, 1983—New York—St. Martin

And I started the Isabel Eberstadt novel and the names sounded phony so I only got ten pages into it and I stopped.

Easy ride, arrived (cab $10) in St. Martin at the Hotel La Samanna.

It's the most beautiful place ever. Blue and white. So Jon, Chris, Peter, and I had a house, Villa "M," and checked in and ordered piña coladas. I applied sun block and left it on the whole time. Dinner at the hotel was really grand overlooking the balcony. You feel like a tourist the first day,

but then other people arrive after you and you feel like a veteran. Peter Martins the dancer was there, he said hi (dinner $214.45).

Friday, April 15, 1983—St. Martin

The most beautiful day in the world. Photographed all day.

Saturday, April 16, 1983—St. Martin

It was a raving day. Blue sky and blue sea. Chris and Peter and Jon went snorkeling. I walked to a wrecked ship and took pictures.

I finished *White Mischief*, it was about Kenya in the forties and the English colonial swingers who were the Peter Beards of their day, living there and being rich and wife-swapping. The woman wasn't beautiful, though—she was *(laughs)* a blonde who wore lipstick in Africa. You know?

After dinner we went to a gambling casino and started with $10 and Jon won some money and I made him stop, I told him it was better to leave with a few pennies in your pocket.

And I don't know, I don't know how I could be friends with Christopher. He's just like this aunt I had in Pittsburgh who I never wanted to see who was always touching everything and had too much energy. The wife of my uncle, my father's brother. She just drove me crazy. And Chris is like that, always touching everything. But he is there if you need him and he does organize things, which is so much work in itself.

You know, I was thinking lately about my nice aunt, my mother's sister, and something that happened to me at her house once—she always gave me pennies for candy and so I used to like to visit her, she was good to me, she lived in a house on the North Side. And one day I remember she had a lady over who had no teeth and the lady was eating a bowl of soup and she didn't finish it, and my aunt gave it to me and made me finish it, I guess because she had no money and didn't want to waste food . . .

Oh, and something funny about La Samanna! Outside were all these beautiful red flowers on the bushes and then we looked close and saw that they were *taped on!* They were real flowers, but taped on.

Sunday, April 17, 1983—St. Martin—New York

There was a fight at the Villa M between Chris and Jon and then Jon screamed at Chris, "I could have your job!" meaning he could snap his fingers and turn me against Chris and it made everybody feel odd.

Had to pay a tax to get off the island (4 × $5 = $20). St. Martin was half French and half Dutch and the French half was cleaner.

Tuesday, April 19, 1983

Nona Summers called inviting me again to the dinner she was giving at Regine's that night. Maura met me there and she told me that Page Six had asked her if I was sick. And I was shocked. I said, "Well, tell them I'm not! You know I'm not! You can *see* I'm not!" And I know they meant AIDS and it was too scary, and she said, "Oh they just meant flu." But I'm sure they didn't. And then Marsia Trinder was there and she's finally married to Lenny Holzer, and she said, "Oh don't get near me, I just had a baby." I said, "Marsia, you know, I mean . . ."

Wednesday, April 20, 1983

After asking Alexander Guest the other week how they make sure stones don't get switched at the auction house, I pick up the *Post* and it's a big front-page thing: "500G Diamond Stolen in Auction Switcheroo." So I'm half expecting the police to come and question me about why I was pumping Alexander for information. And what happened was someone painted a regular diamond with clear pink nail polish and switched it for the expensive pink one.

Oh, and I look so bad I need a facelift. Makeup doesn't do it, you still see the sunken cheeks and the neck—you can't hide the neck even with a turtleneck.

The Debbie Harry wrestling play *Teaneck Tanzi* was at 6:45. I invited John O'Connor from *Interview* and then Gael Love called up and said that he could not go anywhere with me because he had to go to the *Interview* party at Reginette's. She was really trying to push me around, she said, "And I want *you* there, too." I said, "Oh fine, Gael, sure." Gael is so pushy now, Bob must have really kept her down.

Monday, April 25, 1983

The new issue of *Interview* with Chris Atkins on the cover really is a great issue. Steve Aronson's column is really good. We're paying him a lot but it's the best writing we've had yet.

In the magazine section of the Sunday *Times* it was all the new young Italian painters and it looks like America is really out. I'm going to have a hard time now not getting put down.

Thursday, April 28, 1983

Cabbed to the Perry Ellis fashion show ($5.50) and right as we walked in we ran smack in to Bob Colacello. And he was very pleasant. So pleasant, and that was nice. He just got a job with *Parade*, that Sunday supplement for newspapers.

Friday, April 29, 1983

Went to Si Newhouse's on 70th off Lexington, and everybody from the art past was there—Jasper and Roy and Leo—and it was so nutty, I couldn't take it, I got nervous and depressed and left before eating.

Sunday, May 1, 1983

Edie's on the sides of the buses. The ads for the paperback. Poor Edie—when she went out she'd never even take a cab, it had to be a limo, and now they've got her on the bus.

Monday, May 2, 1983

Fred's going to California soon for when Mrs. Vreeland gets the Rodeo Drive award.

And I forgot to say that at the Newhouses' the other night before I got freaked out and left, Jasper and I talked and he was really nice, he said he had a house on St. Martin and when I said I'd just been there he said his house was right next to La Semana and that I could stay there anytime I wanted.

Cabbed ($3) to Mr. Chow's and had drinks with Diane Von Furstenberg, Barry Diller, and Mrs. Chow, and next to my place was a place card that said "Joan" and I asked, "Joan who?" and I couldn't believe it when they said Joan Collins. And she arrived and was wearing a fake white Halston. She said she's known Halston for years. And she did not have a line or blemish on her face. She said she didn't give interviews or do Carson or anything, but that she would do one for *Interview*. But then later Robert Hayes told me she's been on the cover of everything. *(laughs)* I should start telling people who invite me to things that I *never* go out but that I will go out for *them*.

Wednesday, May 4, 1983

Did the routines with Benjamin. It started out warm but then got colder (phone $.20). Had lunch at John's Pizzeria and at the end they did something great, they said, "This is on the house," and I couldn't believe it, that never happens in regular places (tip to waiter $5)! This is the place where Ara Gallant had us take Mary Tyler Moore to be interviewed.

Bought the *New York Native* because there's a review of my Endangered Species show in it ($1.25). Bought a copy of Steve Aronson's book, *Hype* (book $15.95, cab $4). Worked on art things. Then decided to go to Steve Aronson's party at Kathy Johnson's house. She's the one who's so rich but it's not from Johnson & Johnson (cab $4). Everyone was there and it was jammed. Lily Auchincloss. And Tom Wolfe, and Farley Granger, Jean Vanderbilt, Terry Southern, the Hearsts, Dorothy Schiff. And just everybody. And lots of young beauties. Had Steve autograph the book I bought and I mean, why didn't they send me a free copy? Baird Jones was there and he said he'd read his

father's copy two weeks ago, so that's when I got mad. And Steve looked sort of scared. And there are other parties for him coming up.

Saturday, May 7, 1983

Benjamin picked me up and then picked up John Reinhold and we went to 78th and Madison to that expensive Italian place, Sant Ambroeus. And because they're so expensive they do everything slllowwwly. They wrap everything chicly ten times and you pay for their chic slowness.

And oh, my sister-in-law is in town and she calls and says she's going to come over some evening, but I keep saying I'm out of town. Her son James doesn't call anymore—he's been in New York for about two years. He got a place right across the 59th Street Bridge in Long Island City. So he's sticking it out. He does art freelance, he draws sort of Conan the Barbarian-looking things.

Sunday, May 8, 1983

Decided to work at home on boxes. When you flatten out product boxes they're so beautiful.

I've noticed that *People* is putting people with problems on the cover. Like the David Soul wife-beating cover, and now Kristy McNichol with her breakdown. And I can see we're going to be having problems getting people for *Interview* covers from now on, because I think *Rolling Stone* is putting the pressure on, telling people that if they want the *Rolling Stone* cover, they can't do *Interview*. But you know, our *Interview* with Sting on the cover was the biggest seller yet, and all the music covers sell well, like Michael Jackson and Diana Ross. And the reason I'm thinking that *Rolling Stone* is starting to play tough is because we can't get Travolta and we couldn't get Sean Penn. So we need to think of people to put on the cover, young people, new kids. It's got to be at the exact right time, not too early or late.

Monday, May 9, 1983

Karen Burke called and I didn't want to take the call, she was that girl who used to come down with Hoveyda, and she likes older men or something. But then she told Brigid she was almost a doctor and that she was a collagen and hair-transplant expert so I took the call, and she said she wanted to become my personal doctor for all this stuff. She said she'll be getting her license to practice in three months. She came down with about 4,000 free samples. She said she worked with Orentreich. She's the one that Rupert got the human heart from when I was doing the Hearts. She took it from a cadaver, I guess. Those Hearts of mine weren't a hit because I didn't figure out how to do them right. I was beginning to use my abstract look. Worked all afternoon.

Watched cable TV looking for *Andy Warhol's TV* on MSG-TV but it wasn't on, so called Vincent and he was in bed already and didn't know why it hadn't been on.

Tuesday, May 10, 1983

Karen the almost-doctor came by, and I think I will become her first patient when she gets her office in three months. I am thinking of a facelift but she said to wait and she'd give it to me. I never went back to Dr. Rees after that consultation, I still owe him $200.

Then Steve Aronson came in with a girl named Evgenia, she's a Guinness but she has a Polish last name and she's Robert Lowell's stepdaughter—a short dark-haired English girl, she's trying to be a model. And we all went to Worth Street, just near Canal, and I let the girl pay for the cab. Somehow I didn't want to, somehow I wanted her to. The three of us were being photographed together, I didn't know why, for the English magazine *Ritz*, which I hear David Bailey's sold, but it's still hanging on. Somebody was getting something, but I couldn't figure out what was going on. And you could tell the photographer was an amateur because he took too many pictures, too many rolls. Left there. Dropped Steve off ($5.50) and then I finally put it together what it was all about. The girl wanted pictures to use in her modeling portfolio and the *Ritz* wanted pictures of me, so she used Steve to get me down there by telling him they needed me to represent *(laughs)* "hype" because they're running an interview with Steve on his book *Hype*. In the cab Steve said the picture they took of the three of us was going to be on the *cover* and so then I just *looked* at him—I mean, if it's for the cover, they'll just crop him out anyway and they'll use a picture of me and say, "Mr. Hype." So that was a real waste of time for everybody but the girl.

Wednesday, May 11, 1983

You know, you begin to wonder if there isn't something to these Polish jokes. I mean, the Polish Institute is next door and they have a sign on the door that says to use the next door, and they have an arrow pointing to the second door. Well they walk right by that second door and come to my house and ring my bell. It really makes you wonder.

My sister-in-law Ann just got me on the phone, and she keeps wanting to come over here and I keep telling her I'm going out of town. And they just had a forty-year reunion and I was the only one in the family not invited because they knew I wouldn't come. And she just told me her daughter now sells mortuary plots, and she said, "She's married to a 6'4" guy and he's Lutheran and he's very nice, what a nice guy, uh, he's not working at the *moment*, but . . ." I always hated this sister-in-law. She made her one son become a priest and I guess he really didn't want to. I always thought she should be a nun herself. And the daughter, Eva, when she was taking care of my mother when I was in Paris making *L'Amour*, she made me rush right back to New York saying she just had to leave and get on with her life, and I told her, "*What* life?" She could have just lived in New York and kept taking care of my mother, but she wouldn't, she went to Denver. Well, she's still out there. And here's my sister-in-law telling me all things I don't want to hear, like, "Do you realize it's the anniversary of your father's death? Did you go to church for Assumption?" *[Note: Andy's father died in May 1942 when Andy was thirteen.]*

Saturday, May 14, 1983

It was sunny, warm. The tree in front of the house didn't make it through the winter and I asked people what I can do about it and they said you have to call the city and tell them about it and they probably won't do anything until the fall.

Met Benjamin and we went downtown to the Sandro Chia show at the Castelli Gallery (cab $5). And then went over to Tony Shafrazi's and saw the works of somebody named . . . I forget. It's Fred Flintstone graffiti, that's what he's known for—Kenny somebody. Scharf. And so I was thinking of buying a work of this artist and I figured it would be $4,000 or $5,000. So we left there and when I called later on after thinking about it they said it cost $16,000. I mean, these are kids right off the street getting these prices!

Went to the office and John O'Connor came to help. Did two big Rorschachs and they looked kind of good, I don't know. I get so confused looking at art, you don't know whether to change or stay the same. Oh *(laughs)* I know, I won't change, I won't change.

Sunday, May 15, 1983

Called PH and she'd just interviewed the guy who directed *War Games*, and he told her that when he directed *Saturday Night Fever*, John Travolta didn't want to wear the famous white disco suit because he didn't think white was cool—he wanted to wear a *black* one. But then the guy pointed out to Travolta that if he wore black he'd fade into the background and you'd only be able to see the girl he was dancing with, so he changed his mind fast. That'll be a good scoop for *Interview*.

Went over to the Criterion to see *Breathless* (tickets $10). It's strange to see Richard Gere doing this. If it'd been somebody like Matt Dillon it would have been like a James Dean movie. It's that Sartre way, the nothingness thing. You would think existentialism would be still modern, but it isn't. He does bad things and you see his ass all the time, he just drops his pants every chance he gets. But it's strange to see someone that age doing that, but maybe that'll bring back that kind of person. It was written by our old friend, Kit Carson. The movie had an old-fashioned feeling to it.

Monday, May 16, 1983

Brigid just told me that Mickey Ruskin O.D.'d at 3:00 in the morning. Mickey had been calling her for months, wanting her to give an interview on Max's Kansas City and the sixties for a book he was doing on Max's.

Called Julian Schnabel ($.50) and then went over there. He has four floors in the building that Les Levine bought years ago and then co-op'd. Schnabel used to be his assistant. Julian's following my philosophy of doing a painting a day, he's trying to be the new Andy Warhol, so that made me nervous so I left and worked very hard at the office until 8:00.

Wednesday, May 18, 1983

Benjamin had invited Keith Haring and Kenny Scharf for lunch. I tried to get Keith on the *Interview* cover, I was thinking it would be good to have an artist on the cover, art is so big now, but they wouldn't let me. It looks like we're going to use Miguel Bose.

Richard Gere hasn't returned *Interview* phone calls about being on the cover, so I guess he's not a friend.

Oh, and Paige is upset—Jean Michel Basquiat is really on heroin—and she was crying, telling me to do something, but what can you do? He got a hole in his nose and he couldn't do coke anymore, and he wanted to still be on something, I guess. I guess he wants to be the youngest artist to go. Paige gave him a big art show uptown last month and she's the reason he's been around the office—they're "involved."

Thursday, May 19, 1983

The papers were full of Lord Jermyn getting busted for "trafficking in heroin."

Friday, May 20, 1983

A day for more newspaper shockers, Monique Van Vooren was charged with cashing her dead mother's Social Security checks for years, ever since she died.

Decided to go to the Fiorucci party at Studio 54 and it was so embarrassing to at this point get into a cab and say *(laughs)*, "Studio 54, please."

And Peter Beard was there, he's back from Africa, but he said not to tell Cheryl.

Monday, May 23, 1983

I decided to take Chris to Europe again because I get nervous being alone there while Fred's off doing business.

Then Chris was having John Sex at his place with his boa constrictor—he uses it in his act— so I went over there to take pictures, took about three rolls, but I was scared of the snake. And the snake sleeps with him. And John has the most unusual hair, the most extreme style—a very big big exaggerated pompadour, dyed blond and hair-sprayed, and he said that when he got into a cab one day his hair was just this big mess and standing out all over the place and the cab driver said to him, "What's that? An Andy Warhol wig?"

Monday, May 30, 1983

Memorial Day. It was dreary, started to rain. Had to meet Bruno Bischofberger at the Jockey Club in the Ritz Carlton on Central Park South, so I walked over there. Bruno was waiting inside with Julian Schnabel and Francesco Clemente.

And Julian Schnabel's painting just went for $96,000 at auction. Clemente is another one of those new Italian painters, like Chia and Cucci. And somehow Julian is in this category, too—he really is determined to be a big star.

Later, I was getting calls from Victor and he was crying and hysterical and saying he had no friends and that when Halston came home "something" was going to happen at 6:00. And I said, "Oh, Victor, I mean, I just don't want to be involved because the last time I was involved you told me to mind my own business. Just don't do anything crazy." And he said that he would drag Halston's name through the papers and ruin his image, and I said that *he* would be the one who got hurt. And I think this is all because Victor's new boyfriend just jilted him and people transfer these things.

Tuesday, May 31, 1983

Fred told me that as he was going by 63rd Street and Park, he saw these two guys hugging and kissing in the middle of the street and it turned out to be Victor and his boyfriend, so I guess I don't have to worry about Victor for a while again.

Wednesday, June 1, 1983

Bruno came to lunch, and Jean Michel Basquiat. And after Paige'd been crying away that he was destroying himself on drugs and was going to die, here he showed up as healthy as a horse, he's put on twenty pounds, and he was just in Jamaica, and he looked actually handsome. He gets his hair cut at this shop on Astor Place that's gotten so chic, it used to be $2.50 for a haircut and now it's $4 something.

Thursday, June 2, 1983

Liz Smith did a whole column on Calvin, saying that she sat next to him the other night and he absolutely denied the rumor that he had AIDS and that he looked healthy and happy and that he was now off in Morocco.

And I forgot to say that yesterday on the *Today Show* Steve Aronson was on to promote *Hype*, and they quoted my "In the future everyone will be famous for fifteen minutes" line. The girl who interviewed him was the blonde who's replacing Jane Pauley for the week. She attacked Steve but he deserved it—he went too far in the book, he was too mean. How is it that someone so smart and so funny can't figure out that being mean always backfires?

And Chris said that he visited Tony Perkins and Berry. I guess *Psycho II* will make a lot of money this summer. He said that when Berry went into the other room Tony started pointing to Chris's crotch and saying, "I'd like to see you," and all Chris could say was, "All right, Norman." I never really liked Tony because he treated me badly once when he was with Tab Hunter.

At 1:30 Curley called and said he was just sitting there with his dog thinking about me.

Friday, June 3, 1983

The city is just teeming with beautiful kids who all look like models. They must come from everywhere. And the *Post* today had the headline: "Fashion Designer Dies of AIDS." But it wasn't Calvin, it was a South American. And I heard that last night at the Santo Domingo wedding party which I didn't go to, someone was saying to Zara who works for Calvin, "Okay, enough is enough, you've got to tell me, what's the story with Calvin?" And just at that moment he walked in looking so healthy and he said, "I just got back from Marrakesh."

Saturday, June 4, 1983

It's now around the time of the fifteenth anniversary of the day Robert Kennedy was killed and I was shot. They found a letter at the new building saying "Welcome to the neighborhood," and it was from Crazy Matty. He's living at the Hotel Seville, just a few blocks away. Went to bed early and that was that.

Sunday, June 5, 1983

Cabbed to the Water Basin on 32nd Street and the East River near where the helicopters take off ($6) to go to Brooke Shields's eighteenth birthday party. Brooke was sweet, her mother thanked me for coming. The usual people were there, Cornelia with her beau. Couri Hay and Scavullo and Sean Byrnes. And Ted Kennedy, Jr. came and said hello. Brooke ate with us, and it's just so funny to see her with her little girlfriends, because here's this 6' goddess and then these short little ducklings who're smart—I mean they're smarter than Brooke, but it's just like two such different things. She looks twenty-five. If she could only get her voice down to sounding less feminine she could really make it in the movies.

And Brooke thanked me for the present of putting her on the cover of *Interview*, but I'd already given her a painting, so she was just being nice saying that.

And she gave out pictures of herself in a little silver frame, which was a cute idea. The food looked good, everybody looked pretty. Slipped out at 12:00 and went home to walk the dogs.

Monday, June 6, 1983

The morning was great. Chris called and said that Coleco was going up ten points by the minute. He and I both have some.

And I love seeing the new *People* magazine with Tony Perkins on the cover, and it talked about him being gay, as if it were all in the past. Isn't that funny? And it talked about Brigitte Bardot and Ingrid Bergman and Jane Fonda trying to make him. Left out Tab Hunter and Chris Makos,

but it didn't say that he used to hire hustlers to come in through the window and pretend to be robbers. I wonder if Chris had to do that. I guess maybe he did. Chris did get wild.

Tuesday, June 7, 1983

It was really busy at the office. Jay came in the back to where I was working and told me that Sidney Poitier's son was there. And everybody at the office, they all believed it. It was like believing in the Du Pont twins or something. Jay *really* fell for it. Finally we got him out when he said that his mother Diahann Carroll was coming to meet him there, so I said, "Oh, you might miss her if you don't wait for her downstairs." Oh, and Diana *Ross* was going to be coming *with* her. I forgot. Diana Ross, too. And *still* they all believed it.

So cabbed up to the Museum of Natural History ($8) in traffic. Saw Halston's show then went to his place. And when I got there Halston said, "A very strange thing happened. My doorbell rang and there was this boy who claimed he was the son of Sidney Poitier and Diahann Carroll and he said he was meeting *you* here for dinner, and I told him, 'Listen, darling, you're not invited.'" I guess when this kid was at the office in the afternoon he must have overheard that I was going to Halston's for dinner.

Wednesday, June 8, 1983

The fake Poitier kid called the office and said *(laughs)* he was coming for lunch. He's beautiful, like a mulatto girl. Lispy. I screamed at Jay and said that if he let him set one foot in the door I'd kick them *both* out. Jay still isn't convinced the kid isn't real! But then he never did come.

Thursday, June 9, 1983

Got up early because I had a 10:00 appointment at the office that Fred had made with Wayne Gretzky of the Oilers (cab $6). When I got there they said that Gretzky had just called and said he was coming right down. Meanwhile Fred who had made this early, early meeting wasn't there yet. By 12:30 I was still the only one there, and I was mad. I found out from Brigid that the reason Fred was late was because he'd brought home a black girl and she'd Mickey Finn'd him and taken all his watches, so I didn't yell at him. And finally Gretzky arrived and he was adorable, blond and twenty-two and cute. He doesn't wear shoulder pads when he plays. I told him he should go into the movies and he said that he was going to be in a *Fall Guy* and a Tom Selleck. He dates a Canadian singer.

Brigid went up to Jennifer's graduation from Spence, and I couldn't go, I disappointed Jennifer, because I had the Gretzky thing and then Iolas to tape. But I called her and told her to bring her father down afterwards for lunch. Sent Brigid out for desserts ($20) and had champagne with Jennifer and her father. And then after they left, that's when Benjamin told me that her father

had been Edie's psychiatrist! Jennifer didn't tell her father until a few days ago that she was working here. Jennifer stayed on and worked.

Sunday, June 12, 1983

Up early, it was a beautiful day. Went to church. Then Jon and I cabbed up to the Bronx Zoo where I'd never been in my life ($20, admission $5). And it was really great. Took a lot of pictures, it was fun. Decided to go on the Safari Trail ride, and ran into Ron Galella who was there with his wife who'd also never been. Then Ron gave us a ride to the Grand Concourse and we got— a subway ($1.50). The subway made a lot of stops at first, but then it was express. Got off at Columbus Circle and walked home.

 The day had been mostly black. Originally, the city was having Puerto Rican Day, so that was one of the main reasons to get away. But P.R. Day was 98.9 percent black. The subway was 85 percent black. The zoo was 80 percent black, the park was 99.5 percent black. Whites are really a minority.

Monday, June 13, 1983

Eddie Murphy's person called and said he turned us down for the cover. I wonder if this is all on purpose. Is *Rolling Stone* putting the word out? Well, I'll remember. An old dog never forgets.

Tuesday, June 14, 1983

Got up early. Benjamin went to Boston without even telling me. He went up to perform with fifteen girls and him as a drag queen. He still goes in drag. On request. He lip-synchs to records.

 At 10:00 I had an appointment to do a modeling job for the Jordan Marsh catalogue at Scavullo's. I used my own makeup after reading the AIDS piece in *New York*. I forgot my lip gloss, though. And for the first time in a long time I haven't had one pimple. Karen Burke's treatments are working. She gave me this stuff called Ten Percent, and it's benzoyl peroxide. Which is what Clearasil is. But then Clearasil has the coloring, so I can use it like makeup.

Wednesday, June 15, 1983

Chris called me up and was mad because Jon told him that I'd never take him and Peter to dinner again because they just order everything and have it wrapped to take it home. And I told him it was true. But later when I got home Peter had sent an orchid plant, so I felt bad.

Our old office architect Peter Marino was featured in *The New York Times* this week for doing Marella Agnelli's apartment. So I guess he's rolling in bucks now.

And Richard Gere is finally calling back, he says now he may do our cover. He must feel he has a flop movie coming out.

Thursday, June 16, 1983

Timothy Hutton came to be interviewed by Maura and me. Maura, I could tell, wasn't really hot for him, the sparks weren't flying. But *(laughs)* I was hot for him. He was so adorable. He looked scruffy. He's just finished *Daniel*.

Frank Zappa came to be interviewed for our TV show and I think that after the interview I hated Zappa even more than when it started. I remember when he was so mean to us when the Mothers of Invention played with the Velvet Underground—I think both at the Trip, in L.A., and at the Fillmore in San Francisco. I hated him then and I still don't like him. And he was awfully strange about Moon. I said how great she was, and he said, "Listen, I created her. I invented her." Like, "She's nothing, it's all me." And I mean, if it were *my* daughter I would be saying, "Gee, she's so smart," but he's taking all the credit. It was peculiar.

Then Stellan from Sweden was waiting and we went over to Sandro Chia's on West 23rd and 10th Avenue. And he has almost the whole building now. He has a lithographic press that he wants other artists to use. I guess he's making it like a foundation, a tax thing. And he's supposed to be giving me a picture, and that's why I wanted to go over there, but he gave me one I didn't like. I wanted a Floating Man one. And Benjamin said he looked in Chia's eyes and that they were "wild eyes." And afterwards I said to Benjamin, "Well what do you mean?" I said, "Look into *my* eyes and what do you see?" And Benjamin said, "Troubled eyes." I said, "Oh who do you think you are?"

Sunday, June 19, 1983

Victor called and I'm just afraid that drugs have taken over Victor's brain, because you know, you're emotional, and then you take all the drugs, and do all the fighting, and then suddenly it happens—you're over the brink. I'm afraid he's having a nervous breakdown. He said he was in a hospital and had all these stitches and bruises, and it was too crazy. And he said that the night before, the air conditioner had broken at Halston's, but I wasn't sure if it had really broken or if Halston had just wanted to drive him out. I guess it really must have been broken, though, because Halston wouldn't have wanted the orchids to die and they were dying.

And I've been thinking about these people who sell things on the street, because I watched on TV and this newscaster was just *beaming* doing this story about how the city confiscated $485,000 in street vendors' merchandise. But I mean, there were these black people out there working, trying to actually sell, and now they'll just start stealing! I mean, vendors are messy and dirty and they slop up the streets, but they're trying to do *work*! And here they're beaming on TV that they put them out of business. And they have the store owners on saying they

pay big rents and it isn't fair, but I mean, do the stores sell the same stuff as the people on the streets? Not really.

Monday, June 20, 1983

Timothy Hutton stood up the photographer and stylist for his *Interview* cover. He just left them waiting which I was surprised about, so that upset us. He called later and said he'd had an earache, and that they could do the cover in L.A. I guess when you get that successful at twenty-one . . .

Friday, June 24, 1983—New York—Montauk

We got on the plane to Montauk and I've never had anything like this happen before—this two-engine plane wouldn't start, and so they backed up another plane to it and tried to jump-cut the wires. I couldn't believe it. And Halston's saying, "Listen, darling, these pilots don't want to die, they know what they're doing." And I said, "I've flown in a lot of planes and I've never seen anything like this." And finally it got too ridiculous. They couldn't jump-start it and so we got off. And they *(laughs)* offered us pretzels and peanuts. They were embarrassed. So then we got another plane (food $5). Then we flew out and the ride was fast and beautiful—the moon was coming up full and we flew over all the big houses.

Halston's brother who's the attaché in Brussels was there with his wife and kids and stepkids. The kids were wearing Halston's new line from J.C. Penney. I think it's a hit.

Saturday, June 25, 1983—Montauk

Paul Morrissey said that someone called and offered to rent Montauk for $80,000. And Halston only pays $40,000. But it's so much better with Halston, he keeps everything up and doesn't have a lot of people out, and part of the reason he's paying $40,000 is because he put furniture in. And Liza doesn't come out anymore—she and Halston are still not on good terms. Because she didn't wear a Halston to the Oscars. And I keep asking people, "Why would she have done that?" But I think it's the Geros. They wanted to break her up with Halston so they'd have more control. I mean, when your husband tells you you don't look good in these clothes . . . I guess Mark knew that Liza was using Halston's to have assignations, too. But Liz Taylor will be coming out to visit Halston in Montauk soon—she's getting Saturdays and Sundays off from *Private Lives.*

Went into the town. And Halston was saying to me, "Oh darling, wouldn't it be grand if your paintings cost a dollar and you could just cover houses all over the world with them, and a big one for over the fireplace would cost $50—but think of all the homes in America that you could just fill up." The J.C. Penney concept.

Sunday June 26, 1983—Montauk—New York

We went over to Gurney's Inn and I'd never been there. It's next to Edward Albee's. Gurney's has the rustic look. It's modern with a cave in the wall. It has balconies that are 4' × 6', and when we were on one balcony looking down on another, we could see these two men counting out hundred-dollar bills on green felt. I guess a boat had just smuggled in some drugs.

Monday, June 27, 1983

This morning a big bridge from Greenwich, Connecticut to New York broke and four cars drove off it.

You know, I'm just not sure that people want to read interviews. Because when you read an article about somebody you find out all these things about their lives. Like the article this week in *People* on Jon's friend Katie Dobbs, who's the editor of *Muppet* magazine, and her boyfriend, Fred Newman. But then, since the sixties, after years of more and more and more "people" in the news, you still don't know anything more about people. Maybe you know *more*, but you don't know *better*. Like you can live with someone and not have any idea, either. So what good does all this information do you?

Wednesday, June 29, 1983

Richard Simmons has sort of disappeared. After being the biggest thing in America last year he's just on real early in the morning.

I was picked up by Ian Schrager and went out to Roy Cohn's annual party in Greenwich and traffic was bad because of the bridge that had collapsed, and now they say that it was a seven-inch pin that caused the whole thing to go. It's so abstract. People just kept driving onto it even when it wasn't there—until a big tractor-trailer blocked it off.

I talked to Bob Colacello. He's going to Europe to do an article for *Parade*. Sat in a corner by the pond. Ate a fast dinner. Saw Calvin and told him that Juan Hamilton was very upset that Calvin hadn't taken his call. I guess Juan and Georgia O'Keeffe feel that they treated Calvin so well when he was out there in New Mexico with them that he should be very friendly and do favors, but then I guess Calvin feels that he spent so much money buying Georgia's paintings that he doesn't have to do anything more.

Thursday, June 30, 1983

Let's see, I started off with *I Love Lucy* which was a good one—Lucy doing everything to Desi's scalp because he thinks he's going bald.

Stopped at the new building and Robert Hayes really dresses up in a suit now, a really good look, the Bob Colacello look, it looks nice. But I mean, there he is with his dog at the office, and

dogs can carry diseases. . . . And I think, Oh what am I doing with my dogs, letting them get so close to me after they've been out on the streets. Halston never lets Linda go to the street. She poops in the kitchen. The one time Halston let her go to the park she came back with those fleas that Archie got on the same day in the park (phone $.50, supplies $17.32).

And when people on the street turn me down when I offer them a free *Interview*, it just gets me right in the gut.

Our TV show got a mention in *Time* in an article about *Entertainment Tonight*.

Paige Powell had a big lunch for the Black Star & Frost jewelry guy, to try to get ads. And Victor called and asked me if I stole his book on St. Sebastian. And I had to say yes. But how can a person who's so drugged-out know that I stole his book?

Dropped Benjamin ($6). Then got another cab to the Olympic Tower to meet Halston, to go out to see Liza perform in New Jersey ($3). Nancy and Bill Dugan were coming, and Bill now wears his coat over his shoulders just like Halston.

So we got there and it was a place with a top but no sides and it was freezing. Liza's show was just great, two acts, better than *The Act*. She's fabulous. She wore her YSL for the opening but with an Elsa Peretti belt, and then after that the outfits were Halston. A hairdresser punked up her hair, she's decided to be punk. I was starved, hadn't eaten, and there were no hot dogs or food being sold.

And then Liza came in the car with us going back. And she said she didn't like a dark limousine, she had to have a light, and so she turned on a light and it was on me and I couldn't stand it and so then I turned the light so it was on her, and she liked that. She was in this spotlight all the way back.

Friday, July 1, 1983

Worked at the office all day. Fred was planning his trip to Europe. He's going on Tuesday—one of the Lambton girls is getting married. And then Catherine's getting married on July 16, she called me to ask if I was going and I'm not.

Got myself together and picked up Peter Wise. Cabbed to Keith Haring's ($8.50). And he had such beautiful painted kids there, all like Li'l Abner and Daisy Mae. Wearing earrings and punk fun clothes. And black 6' pickaninnies.

And this was a party because Keith just broke through into another apartment. He's just got a tent in it where he and his black boyfriend sleep. We're going to photograph it for *Interview*. Keith was such a good hostess. This is at like Bowery and Broome.

John Sex was there who has the beautiful hairdo. I took about fifty pictures. I shot without my contacts and I took one of a girl in the bathroom and she almost beat me up, and then when I left I found out I didn't have any film in the camera.

Saturday, July 2, 1983

Went over to Mr. Chow's for a birthday party for Jerry Hall who looks so stunning, so beautiful. White flowers and white roses were the decorations downstairs. Her sister who was in *Urban Cowboy* who married the Robin Lehman guy was there, and she had sort of a different attitude toward me, sort of cool. And I'd just seen *Urban Cowboy* on TV a couple of times and she was so slim in it and now she has those wide Texas hips.

Clarisse Rivers was there, really fun. And Earl McGrath was funny. Mick happened to sit near me. Jed was there and I think he was with Alan Wanzenberg, and actually I think it was Alan who was sitting next to me but I wasn't absolutely sure. The seating was a free-for-all. There was a big white cake with all the candles. The party went on and on. It was great. Left at 1:30, and was miserable.

Sunday, July 3, 1983

It was hot out. I went to church. Called Jay Shriver, cabbed down to meet him ($6). Opened up, worked all afternoon. Called Earl McGrath and asked if I could bring Jay to dinner. Cabbed to West 57th Street ($8).

It was very air-conditioned at Earl's. Camilla makes great food, a good Italian cook. Annie Leibovitz was there, and she said Jann Wenner's mad at her because she accepted a year's contract with *Vanity Fair* and he said she couldn't work for *Rolling Stone* and *Vanity Fair*, too.

Then everybody had to read poetry and that was the funniest thing. I didn't, but everybody else did. They took them off the bookshelves. Really, it was so sick. Earl's such a camp. I was laughing, everybody was. But reading straight. Like Jerry Hall reading straight like, "I am so-and-so, king of kings/Look at me and despair."

Tuesday, July 5, 1983

There was a party at the Statue of Liberty, but I'd already read publicity of me going to it so I felt it was done already.

Wednesday, July 6, 1983

I had an appointment with Karen Burke because she's leaving for Europe and she wants to test me to see if she can give me collagen and I'm going to do it because she worked out well for my pimples. I read that the collagen only lasts three to six months, but so what, then you just have it done again.

Christopher came back from California, and we talked an hour on the phone. Worked till 7:30 then decided to take the kids out on the town. We went to One Fifth because they've started to advertise again (drinks $59.47).

Christopher was depressed because he'd fallen in love in L.A. and saw the kid as a young version of himself. He said that the kid could have been the most successful hustler on Sunset Strip but instead he decided to become a busboy. And Chris said to me that he'd learned his lesson about bad manners when somebody invites you out to dinner because this boy ordered six desserts and then took them home, and Chris said he would never ever do anything like that to me again. And it wasn't until afterwards that Benjamin said to me, "But did you see that Chris had his steak wrapped up to go?" And I hadn't. But he was depressed, so I would have had to let him get away with it anyway. He was so melancholy he had tears in his eyes. He put on his sunglasses. He was carrying his bags under his eyes. I told him look, that he was so in love with Mark from Denver at one point that it was wrecking his life, and now he doesn't care a thing about him, so that he'd get over this, too.

Thursday, July 7, 1983

Well the news of the day was that Alfred Bloomingdale's Vicki Morgan was found beaten to death. So all I could think of was the CIA. Unless she was in an S&M thing.

Catherine called again to try to get me to come to her wedding. I just don't know what to do. I don't want to go. And Halston says he'll only go if I go. Richard Weisman is going on Wednesday and he's bringing her Halston wedding dress. Victor wants to go. Catherine says she's saving room in her car for me.

Sunday, July 10, 1983

Chris is driving everyone crazy being in love with Byron, the kid he met in California, saying, "He's so like me. It's like seeing myself. His mother died when he was nineteen. . . ." I said, "Uh, Chris, your mother's still alive."

And he said that when they were doing around-the-world the kid said, "Whatever happened to Chris and Byron?" Like whatever happened to those sweet kids. So there they were engaged in this salacious scene saying what happened to their innocence. Oh I guess "Byron" would be too much. *(laughs)* It's actually *Brian*. But it feels like Byron. Talked to John Reinhold. Stayed home and moped because I'm sick in the head. Too afraid to even walk the dogs because I don't want to bend over on the streets and pick up the poop. So now I send them just out to the backyard. Jed didn't take them this weekend.

Monday, July 11, 1983

Steve Wynn came by, the Golden Nugget guy from Atlantic City. He came with his wife, who's intelligent, but she's old enough that she could be traded in soon. They were in town because they were taking Frank and Barbara Sinatra to dinner at La Grenouille. And Steve Wynn had with him two checks that totalled a billion dollars, from some bank downtown—he showed them

to us. He's really sexy, he wears those kind of continental pants. When Benjamin went down to the car with him, it was a beat-up old limousine. Benjamin was expecting something flashy.

Walked the Village and then went to Tower Records and bought the Talking Heads album that Rauschenberg did the cover for. He was upset because he only got $2,000. And I told him he was right, he should've gotten $25,000.

Wednesday, July 13, 1983

Okay, well this was the night of the glittering event, the premiere of *Staying Alive*. Got up early.

Paige was having a lunch for two gay guys from Diener Hauser Bates. One had had my old friend George Clobber for a teacher at Pratt, so we talked about that. George Clobber was the first person who told me about the gay life.

Went to meet Maura at 6:45 (cab $7) at the Russian Tea Room. And then we went over to the Ziegfeld and there were the crowds lined up. And now there's a new thing—for *Good Morning America* when they photograph you they say, "Are you aware that you're being photographed for *Good Morning America*? And do you give your consent?'" I said, "I do."

And then eighteen bodyguards came in and Stallone and his wife arrived and I was on the aisle and he saw me and stopped and said he was glad I'd come. Then the lights went down and Frank Mancuso gave a speech. And then Sasha Stallone gave an emotional speech about their autistic child that the benefit was for, and all I could think of was *Bad* because we were the first to have an autistic kid in a movie.

I loved *Staying Alive*. Then the party at Xenon was at 11:45, so we went over there and on the way we ran into Garson Kanin and Ruth Gordon. I'd never met him and I had copies of *Interviews* with me, the new one, and he said, "Oh I already bought that one." And she doesn't have any wrinkles and she's like 110 years old or something.

Then coming out of Xenon were eighteen bodyguards and in the middle was John Travolta in his tuxedo and I caught his eye and he came over and said hello. So that was two in one night.

Thursday, July 14, 1983

We took our time getting to the theater to see Farrah Fawcett in *Extremities*. We thought we had plenty of time, but when we got there they were holding the curtain for us. Farrah was good, but not as good as Susan Sarandon had been. And it's funny, I hadn't liked Susan Sarandon in anything except *The Other Side of Midnight* until then, but then I saw that she was really good.

Some girls tried to pick Benjamin and me up. Then after the play we saw Farrah and Ryan backstage and they were gushy. It's so hard to talk to actors, all they want is to talk about themselves. And Ryan looks a little older, he's getting the same lines I have. And he was talking about Paul Morrissey and telling me I should work with him again. And he really wants the part of Dick Tracy that Warren Beatty's supposed to get. Ryan thought Jon was an important figure at Paramount so he was hustling him. Jon said they'd jogged together once on the beach at Malibu.

Friday, July 15, 1983

Maura came at 1:00 to pick me up so that we could go out to interview Richard Gere at the Astoria Studios where they're shooting *Cotton Club.*

We were nervous about our interview because we had a feeling it would be difficult. Maura had read Stanislavsky. And so we went through Dick Sylbert's sets for *Cotton Club* which was exciting. And Richard was back in this slum area watching old movies on TV. So what he does is he watches every old movie that has anything to do with what he's doing and copies details, the way other actors do things. He actually told us his first movie was *Days of Heaven* which I know it wasn't, but that's how uncooperative he was, he wouldn't give *anything*. The only interesting thing was telling us that he spent all of the time he wasn't working in the filthy trenches in Mexico in the hospital hooked up to an IV for dysentery—they'd disconnect him so he could go to work and then he'd be back. It was the movie with Michael Caine. *The Honorary Consul.* And he liked Maura, but she's a friend of Silvinha's so that complicated it.

Sunday, July 17, 1983

It was hot, another scorcher. I overslept.

Worked with Chris and Peter on working out their modern marriage. The kid Chris is in love with is being shipped in from California on Thursday.

Tuesday, July 19, 1983

Called John Reinhold and invited him for coffee (phone $.50, coffee $5). I told him I needed some toys because I was doing a project with them, photographing them, and he said he'd find some for me.

Victor and Farrah are now best friends because he told her how bad she was in *Extremities* and what she did wrong. And now she says her performance is so much better and she owes it all to Victor. But actually, she *was* really good, and Victor was so high when we saw it that he didn't know what was going on.

Thursday, July 21, 1983

I could never really describe the Diana Ross concert in Central Park. The sky darkened and the rain came and it was the most incredible thing I've ever seen. Just the event of the century—her hair blowing and soaking wet, and if only they'd had a covering on the place where she was, she could have kept on singing and the kids would have stayed and she would have had her concert for TV. But they stopped it in the middle of the storm and they're going to do it again tomorrow. She was crying, and Barry Diller was trying to get her to stop but she said that she'd waited for twenty years to do this. The lightning made it dangerous, I guess, but it was like a dream, like a

hallucination, watching this spectacle. It was like the greatest scene from a movie ever. When they do her life story in the movies you can just see this huge event and then later she's crying and saying, "Why did this happen to me?" and then drinking and slitting her wrists. But oh, the thunder and lightning looked so great. So beautiful.

We were in the VIP area, but because I'd had Benjamin bring an umbrella, we weren't sitting under the canopy. And Rob Lowe was with us and he's so beautiful. It's like his eyebrows are penciled on and his lips painted on—everything so perfect. And he's just like the kids we know, just regular, and he's looking for girls, that's all he can think about. I asked him to draw me a pussy and he drew a pussy and then I said, "What's that?" and I then drew him a cat. And he and his girl friend are sort of breaking up because whenever she called him on location in Canada the operator would say, "He's in Nastassia Kinski's room," so then when he would tell her the next day that his phone had been out of order she would tell him to stop lying. And he says he's not in love with Nastassia, though, that it's just sex. But he was wearing a toy snake around his waist which was a joke on her Avedon poster, so he was thinking about her so maybe he *is* in love. He's nineteen. And he was just after any old lady. Just anybody. Like Susan Sarandon. She was there with Richard Gere and Silvinha.

And oh you should have seen it. Jerry Zipkin in the soaking rain. And I felt so sorry for Jon because he's worked so hard on this, because Paramount owns Showtime which got the film rights.

And then finally people were leaving the park and so we followed the blacks and wound up coming out at 72nd Street near the Dakota. And we had to climb a wall and fall into three feet of mud. It was like being in a war zone. And then after we got out of the park I took Rob Lowe and Benjamin to Café Central—I said all the stars go there, Matt Dillon and Sean Penn—and then we got there and had drinks and absolutely nobody was there (drinks $83.50).

Then I got home and called Rob Lowe at the Sherry and he said that he was waiting for a phone call from Nastassia, so that I should just go ahead without him over to the Gulf + Western building for the party. So I went and when I got there, he was getting out of the cab. So that was kind of mean. I was hurt. I guess he didn't want to be seen with us again because we were being campy and outrageous. And I said to him, you know, "I just was going to give you a ride, that's all—it was no big deal."

And Cornelia had been at the park, too. And a newspaper photographer took her and pushed her next to one of the people who were stabbed, just to get that kind of a picture of a socialite and a stabbed person. Cornelia didn't know what was going on.

And at the party at the Gulf + Western Rob was after Cornelia and Maura. He and Cornelia kept going off alone.

I gave Diana Ross a Diamond painting. She was looking at tapes of the concert. Barry Diller came over and I told him the concert was so great and he said, "You always like disasters. You liked *Grease II*."

Harvey Mann who works for Liz Smith was there and he was asking me if I'd heard anything more about Calvin and AIDS. He said that they'd killed the rumor in their column. And then Calvin came in and he kissed me so hard and his beard was stubbly and I was so afraid that it was piercing into my pimple and being like a needle and giving me AIDS. So if I'm gone in three years . . .

And by the way, Rob Lowe also said that up in Canada where they were all shooting *Hotel New Hampshire*, Jodie Foster was reading the *Philosophy* book.

Friday, July 22, 1983

It was the day of the second Diana Ross concert because they decided to redo it (cab $8). Cornelia came. Rob Lowe didn't come. The concert was anticlimactic because it was just regular.

But then afterwards the kids started rioting, and if it weren't for the police the whole place would have gone crazy. It was 99 percent black. The guy who owns Café Central took us out of the park so we came out at the right spot uptown to go to Café Central. He had a cane.

And when we got there, Rob Lowe came and Andrew McCarthy who's also in the movie *Class*. He gets Jacqueline Bisset. And he's just regular, a nice kid.

At Café Central they're trying to treat people rotten to be like Elaine's. The waitress came to our table and said, "You've got to leave this table, it's reserved for Lorna Luft." And Cornelia just burst out laughing that anyone would ask her to move to make room for Lorna Luft. And it was so stupid because if they'd just been nice and said, "Would you mind since there's not so many of you now, moving to a smaller table?" I mean, they knew we were leaving anyway because we'd said we were going to the 11:00 show of *Class*, which Rob and Andrew had passes for. Maybe this kind of treatment makes some people want to go there, but it sure doesn't make *me* want to go there (dinner $100 with tip).

So then we went over to 66th and Second and Cornelia was chattering away, she repeats everything over and over, just like her mother, she has to keep talking. And Andrew was rolling his eyes.

The movie was so great and cute. Afterward I tried to sell Andrew and Rob's autographs in the lobby for a nickel, but nobody bought any.

Monday, July 25, 1983

Mrs. Winters's son, Al, who's the caretaker now, called and said that Paul Morrissey is out in Montauk in the little house and I don't think Halston and Victor know he's there. And he's following Al around and telling him what to do and driving him crazy. And Al says, "Call Vincent," and Paul says, "Listen, I own half this property." And now Paul wants me to sign a new piece of paper—he's decided that the one he drew up with his lawyers and made me sign is too advantageous to *me* or something. I told him, "No, forget it, I'm not signing anything more." All these years Paul made such stupid deals for us with other people and now here he's trying to be so "shrewd" in business with *me*, putting all this energy into that, as if I didn't give him better deals than anybody else all the time anyway, for all those years.

Tuesday, July 26, 1983

Christopher brought his new young live-in love that he imported from California to live with them over to the office and I gave them a cold shoulder. I've been trying to give Chris less work but he came and got all these assignments out of me. And the only reason I got all involved with Chris and Peter and giving them advice is because I thought if they could make their relationship

work, then there was hope for me. But now Peter is with this bank teller George and Chris is with his new kid Brian, and I don't believe in modern marriages.

Benjamin and I stopped in Bloomingdale's and the fairies were making the bread in the window—you could see it, kneading it and everything.

Wednesday, July 27, 1983

Cabbed to meet Lidija ($6). Did my exercises. Then Tim Leary came down because he was meeting Gordon Liddy and we were going to do a promotional interview, just a short thing because they're going around doing debates now together.

And Gordon Liddy talked about "takeovers." Like if you're walking down the street and someone thinks they're stronger than you they take you over. And he pulled a knife out of his waist, and I couldn't believe it. I was surprised that he's so small. He's about my size, and in a way he's like Mr. Milquetoast. And he pulled out these pictures of his three sons from a leather envelope. And here's the big bruisers in swimsuits and you can see the outlines of their dicks. These were like $8'' \times 10''$ color photographs—artistic, with ripples in the water! I mean, this is a very strange way to take pictures of your kids to carry around! And he was thrilled because one of the kids was going to be a Marine. They're all at Fordham. And he said his girls didn't want him to carry their pictures, but I'm sure he didn't care about the girls, he was just thrilled with the big bruisers. And one of the boys had a two-inch cat, a little kitten, that he was holding. And he also had pictures of his house, on the Potomac. And Tim was there with his hippie talk, and Gordon Liddy would spout facts about how many A-bombs have been exploded. And he's sort of lost, Liddy, it's odd. It's like he doesn't know what to do with himself. He liked me a lot, he wants us to see more of each other. Tim left and he stayed on for a while.

Thursday, July 28, 1983

Got up early and had to move fast because I had an early appointment at the office with Pia Zadora, so I was excited.

She arrived and was so cute. Her husband, Riklis, came and showed pictures. She's so sweet, and I think she's going to be a big star. Her skin is beautiful. They've got a new house in California and she liked some paintings.

Later the office was so busy, it was the day before Fred's birthday and he didn't want anyone to know, but (laughs) Suzie Frankfurt sent a huge balloon and carnations.

Monday, August 1, 1983

Peter Sellars and Lew Allen came to lunch and they've rented an apartment for the dummy. The robot of me who'll star in *An Evening with Andy Warhol*. And the play is scheduled to go on a year from November. And all these magazines like *Life* and everything are supposed to do big things

on it. And somewhere along the line Bob Colacello has a part of it—I guess we'll be linked together for life because of it.

Then Vincent picked me up (cab $6) in black tie, and we went over to the New York State Theater for the North American Watch banquet. Mr. Grinberg pushed me into General Haig and he was sweet, we talked about his interview in *Interview*. I wasn't at ex-President Ford's table, but I sat right behind him.

I ate because I was down to 121 and I got scared because when I get below 120 I lose my appetite, and you're more susceptible to things when you're that thin.

Haig made a speech about war and missiles and he's for all that, and after just hearing Gordon Liddy last week, well I guess you do need that stuff, but I don't know what I believe in, because fighting's wrong, but then if you *don't* fight . . .

And Ford made a speech about how he's happy being retired and how he's going to be working for Reagan's reelection, and how the economy is better and so people could buy more watches —he just about said that.

Friday, August 5, 1983

Bianca's trying so hard to marry Calvin because she doesn't have any money. She said that when she told him he was too heavy, two weeks later he'd lost all the weight. So Halston was just hating Bianca so much, and he told me to bring Jerry Hall to see him and he would just give her everything, just anything she wanted. He was saying about Bianca, "I'll fix her wagon," and that was scary. So awful. And Steve Rubell called from Fire Island and I was talking to him and then Calvin got on the phone and asked me to get Bianca and I said, "Bianca, it's Steve." And Halston looked up and said, "It's Calvin, Bianca."

Monday, August 8, 1983

Poor Monique Van Vooren was guilty of fraud, cashing her mother's checks for a total of $18,000. And it was just so peculiar because I saw her and she denied it to me. I mean, she should have just said she was guilty, she should have just said, "Oh my god, it's true, I'm a thief," something like that. And Jackie Curtis called me over the weekend to wish me happy birthday.

Cabbed to meet Lidija ($5). Chris came over and he's raving about the "expanded family" life they're having—their "modern marriage" where they're both seeing different people and acting like they live in a commune. I think it's all disgusting and I told him I don't want to hear about it. I'm now telling Vincent to give Christopher less darkroom work, I want to punish him.

Glued myself together and then went to Claudia Cohen's new apartment on Central Park South where she was having a party to look at the five seconds of fireworks that were going to be in the park because of Beethoven's overture. She was having a big fire on her balcony, I'm surprised she didn't get into trouble for it. She was barbecuing hamburgers. And I had some because I was starved.

Tuesday, August 9, 1983

It was interesting that when John Russell wrote about Schnabel on Sunday, the portrait of me was the only one he didn't mention. And I know Schnabel thought that mine would be the one that got him a lot of press.

Paige stayed overnight with Jean Michel in his dirty smelly loft downtown. How I know it smells is because Chris was there and said *(laughs)* it was like a nigger's loft, that there were crumpled-up hundred-dollar bills in the corner and bad b.o. all over and you step on paintings. The day Jean Michel came over to exercise with me he made a point of saying that Paige had made it to work on time, so that's how he was letting me know. He'd thought that Paige was Jay's girlfriend, which she was at one point, but then he asked her out and she went. And they had a date and this was the date—they rented a U-Haul and went out to Brooklyn to a black neighborhood and went to a White Castle and had eight hamburgers and then two people came in with big sticks and they thought they were going to kill them. You know, it was a "kooky date."

This was the day before he went to St. Moritz to see Bruno. Mary Boone and Bruno are both handling him. And Thomas Ammann without either one of them knowing had a few works of Jean Michel's to sell. I don't know where he got them. He said from some "secret source"—oh wait! I bet it was Paige! Oh Thomas is a creep, meeting all these people through us and then being secretive. I bet they were from Paige because she had that show a few months ago of Jean Michel's stuff!

Thursday, August 11, 1983

Tried to get the office to start packing. Worked all afternoon on Pia Zadora, called her and she was away for two weeks on a film.

Went to see *Mame* with Jon and Cornelia (tickets $120). The audience was just a bunch of old decorators. Went to Orso's, right next door, and Marion Javits walked in with Gil Shiva. And they had *La Cage aux Folles* programs and so did everybody in the place, and we had to hide our *Mame* programs because we were embarrassed.

Friday, August 12, 1983

Jerry Hall came to lunch to interview Bob Mackie for us (cab $6, supplies $102). And I told her that Halston wanted to see her and she said she's always been so nice to him but he's always snubbed her so why is he trying to be nice now. *(laughs)* She hasn't figured it out yet.

Sunday, August 14, 1983

Decided to go see *Private School* (cab $4, tickets $10, popcorn $6). I wanted to see Phoebe Cates. These movies are just like remakes of those French comedies of the sixties, where it's older women after young boys. In this one, it's ugly boys peeping in windows at girls and taking showers and

rubbing themselves, and these girls always have big tits. I guess that our movies didn't make it because our girls always had such small tits.

Monday, August 15, 1983

Cabbed to meet Jean Michel Basquiat at the workout with Lidija, he was doing it with us (cab $5). He's in love with Paige Powell.

Got a call from Pia Zadora who said she wanted a Dollar Sign and she'd take it with her if it fit into her husband's jet, so they were measuring it.

Oh, and one of the Ramones was having brain surgery yesterday because he was kicked in the head on West 10th Street in a fight over some cheap-looking girl.

Wednesday, August 17, 1983

I've been getting notes and letters slipped under the door at my house from people I've given *Interviews* to in the neighborhood and I don't know what to do about that.

Went down to meet Jean Michel and did a workout with him and Lidija (cab $5). And he has b.o. It's like Chris who also thinks it's sexy when you exercise to have b.o., but I want to say, it sure isn't. And all this b.o. has made me think about my life and how I'm not really missing anything great. I mean, I think of Paige having sex with Jean Michel and I think, how could she do it. I mean, what do you do, say some hint like, "Uh, gee, why don't we do something wild like take a shower together?"

John Sex came by. He said his python was home molting, so it was cranky.

Saw the show Vincent's working on and it looks really good. We got a great writeup in one of the video magazines.

Whitney Tower called and he was having a party at Club A (cab $5).

Whitney's going crazy because his father's young wife had another baby. Cornelia called him and said, "Congratulations, you're a brother again!" And his mind is dividing the fortune, watching his share go down one more time.

Then Madelaine Netter sat down and told me about how she'd been attacked in an elevator on West 96th Street. They had her on the floor and were ripping her clothes off and she was screaming, and suddenly she got the idea to say, "Jesus saves." And they freaked out and glued her back together.

Thursday, August 18, 1983

Went to meet Jean Michel Basquiat and did a workout with Lidija (cab $5).

The Scull kid called and yelled at me for messing up his limousine the last time, for spilling soda.

Chris called and said that Peter's mother wanted to adopt Brian, I mean . . .

Keith Haring came by with his black boyfriend and I took pictures. They were so lovey-dovey in the photos, it was nutty to see. The big chalk drawing of a pregnant woman on 53rd and Fifth that we thought was his—it turns out it is, and we're trying to get it. He did it a while ago.

Picked up Cornelia and Sean McKeon and Maura in the limo, to drive out to Shea Stadium to see the Police, and Cornelia had hundreds of sandwiches and champagne. The rain came down in buckets.

Ron Delsener was there and I guess he wants to be in society because he was smooching Cornelia and Maura. François de Menil came in with Laverne of *Laverne and Shirley*. And Cornelia just goes in and out. She falls asleep on your arm, she just passes right out, and then she wakes up and has this energy.

Sting came over and said hello, he looked a little old. He was with a girl, I think it was his wife. And Matt Dillon! Matt Dillon was there. Oh he's so good-looking. And the girls finally by the time it was time to go had just gotten to the point where they were talking to him and they didn't want to go. We may get him for a cover after all.

Left, dropped everyone.

My sister-in-law just called. She said that she came by my house last night right when it started raining. So I guess I just missed her. And she said she's stopping by today, but I told her I'm not going to be there.

Saturday, August 20, 1983

I was reading the *Life Extension* book and *Connoisseur* magazine, and I fell asleep, so I woke up with them on top of me.

Halston called, he said he'd left his vacation in Montauk because Victor was going crazy and he'd gone too far. He said he'd send a car for me to come to dinner, but I said I'd walk over, so I did. And we sat there and then in the other room were three bodyguards that Halston had hired because Victor threatened to come and break all the windows from the outside. You know, Victor is saying he loves Halston too much to stand by and let him get so grand but I mean it's Halston who works so hard, and if he wants to get grand then he can do it. I know, though, that the drugs do take over, so I guess that's what's wrong with Victor. And Halston called Victor's brother who lives in town to go and help him, but the brother said, "I don't want to interfere in my brother's life."

Oh and Chris had come over to the office and told me everything that I wanted to hear. He said, "Oh it's over between Brian and me. We're not doing it anymore because we're tired of each other." And you can really see what a good hustler Chris is, because everything I wanted to hear he was telling me.

Sunday, August 21, 1983

It was a beautiful day. No one was around. So I was all by myself, but I had courage enough to go down to the office. I take a sharp stick with me in case the elevator doors stick, so I can pry myself out. And if I go over there alone on the weekend I always tell someone I'm going.

Halston was trying all day to get Victor on the phone and finally he seemed calmed down because Dick Cavett and Bianca had come over and gone through *The Importance of Being Earnest*, playing the parts together, and that cheered him up. Worked till 7:00. Cabbed to meet Jean Michel Basquiat and Paige Powell ($5). And Paige is just so nutty, she laughs so loud at nothing. I would but her in the category of schizophrenia. Jean Michel said he never finished high school. I'm surprised, because I thought he went to college. He's twenty-two. Cabbed to Mr. Chow's ($5). And Lester Persky was there with the cute boy with white-blond hair who's training for the pentathalon. He wants us to put him in *Interview*. Lester's gotten so funny-looking, like a little fat Hitler.

Monday, August 22, 1983

Went to meet Jean Michel at the office and I took pictures of him in a jockstrap.

Chris called me and he's accusing me of just dropping him because I don't approve of Brian, and I mean, I guess that's true, but still ... and I don't know what to do about Chris. I mean, he can find a *new* sucker. And anyway he gets paid for his *Interview* pages every month. Worked till 7:00.

Picked up Cornelia at the Waldorf (cab $6). She had a copy of the new *Life* magazine that has the big spread on her and it all looked so glamorous, really kidnappable (tip to doorman $5).

Cabbed to the Gulf + Western Building to see Timothy Hutton and Amanda Plummer in *Daniel* ($5). The movie is absorbing. Cornelia got so absorbed. She's strange. I really don't know if she's smart or stupid. It's like it used to be with like Ingrid Superstar. Cornelia just goes in and out and sometimes she's a moron. But oh, she got so absorbed in this, it was like a history lesson for her, and I made a point of quizzing her on it later and she *had* understood everything. This is about the Rosenbergs but it's fictional so they call them the Isaacsons.

And we went to Mortimer's (cab $4) and Fred was there with his English accent really loud, so I know he was drunk, and I was getting scared because he was table-hopping, and I was dreading to think what he was saying at each table.

Tuesday, August 23, 1983

Cornelia wanted to go out, and I was invited to the opening of an escalator at Bergdorf Goodman, so I told her that and she got excited—"Oh what a great idea, I want to go. I want to go!"

Picked her up. Got to Bergdorf's (cab $7) and there was a waiter for every single guest. And at the top of each escalator a male model was waiting. John Duka from the *Times* was there so we were trying to be quotable and make the papers, telling him that we'd been to openings of doors, windows, envelopes, and now—an *escalator!*

Wednesday, August 24, 1983

It was a beautiful day. I left the house early in order to go see Karen Burke to get collagen injections. She wears high heels and rides a bike, which is so dangerous.

After the injections, Dr. Karen walked me all the way to 66th Street. The injections did make me bleed on my face. The lines on the sides.

Thursday, August 25, 1983

I will never forgive Rupert for taking me to *La Cage aux Folles* on "Gay Night." I didn't know it until we got there and it was nothing but faggots and lesbians. And I thought that for $40 tickets we'd be in the orchestra, but we were way up in the balcony because it was a benefit so the tickets downstairs were over $100 or something. And these gays, you know, they refuse *Interviews* and always pretend they don't know who you are, and then they go home and dish you. These two dykes came over and said hello, and I asked them what this event was all about, and they said it was for the "Islanders," and I said, "The Islanders hockey team needs a gay benefit?" and they laughed and said oh ha-ha no. And then Rupert nudged me that they were talking about *Fire* Island. They said, "How'd you wind up here in the balcony?" and I pointed at Rupert and said, "Because this creep brought me." Anyway the play was so boring that I fell asleep a couple of times. But this audience, this audience. I mean, they just jumped up and laughed and applauded every single gay line—I mean anytime anybody referred to *anything*, they clapped. And everyone had a mustache, eight out of ten people there. Finally it ended and we got out of there. The two dykes asked me *(laughs)*, "Are you going to Cracker-jacks? To the party?"

But all that was at night. In the morning Benjamin arrived and I wasn't ready. Didn't have enough *Interviews* to take around, just had a couple. As we were walking on Madison between 66th and 67th, Raquel Welch came bouncing out of a shop. She had on dark sunglasses so you almost didn't recognize her. She said she was looking for a Napoleon bed. I gave her Dr. Karen's card for collagen. Fred likes the way my treatment looks and he's going to get it done.

We were on Page Six because of our interview with Georgia O'Keeffe where she called Philip Johnson a minor architect, and we left it in where I was saying that he's not now, and she was saying that he was then, and so since she can't see now, she didn't know. So I'm bracing myself for a call from David Whitney.

Fred says he's not going to drink, that the other night was just too much.

Got home and there was a note that Ara Gallant called. So I called him back and he said that Debra Winger and the governor of Nebraska were over there, and he invited me over, but it was so late that I didn't want to go back out.

Talked to Jon in L.A.

Friday, August 26, 1983

Cab to meet Jean Michel Basquiat and we worked out ($6). He's going to rent the carriage house we own at 57 Great Jones Street. So Benjamin went over to get a lease and I hope it works out. Jean Michel is trying to get on a regular daily painting schedule. If he doesn't and he can't pay his rent it'll be hard to evict him. It's always hard to get people out.

Sunday, August 28, 1983

After getting bitten some more I decided that Archie must have fleas, so I checked and he did. Some years are good for fleas and this is one of them.

It was a hazy grey day. And in the park the Puerto Ricans were having some sort of event. It wasn't even Puerto Rican Day, they just create a party and call it some occasion and then they have the park all day with mounted policemen, beautiful mounted policemen on horses. Not one white person in the whole park.

Monday, August 29, 1983

I just stepped in dog shit. In my hall. And I'm usually wearing slippers but this time I wasn't. And usually you can smell it a mile away, but it just didn't smell, so I just finished cleaning it up. And I'm all fleabitten. When you know there's fleas, you keep feeling them all the time whether they're there or not. So I just took a shower to get the shit off my foot and now I'm thinking what disease I can pick up from this whole episode.

Jean Michel and I went over to Yanna's, and we had our nails done. And you know, my nails are getting better. The two of us would make a good story for *Vogue* (pedicures $30).

Victor came by with his brother who's so good-looking. And Victor says his brother's cock is so big he used to hit the table with it at breakfast. I guess they were naked at breakfast, you know these South Americans. It takes years to get nervous and live in an uptight situation like civilization. But Victor's actually made out better than his brother—his brother still has to work.

Tuesday, August 30, 1983

Chris came by the office and he was crying and saying that he wanted things to be back the way they used to be between us with me giving him lots of work, but I didn't know what to tell him because I don't. I don't call him at all. I suppose I should. But I think about boys too much when I associate with him.

The Argentine lady came and wrote out a fat check for her portraits, which was great, it pays a month's mortgage on the new building. And last month Pia Zadora's check did that, so that was a lift.

Fred went to Dr. Karen for his collagen test and he said that she's klutzy, and actually she is,

when I think about it. One thing she's got to learn is not to have people lie down. Because if you lie down, all the wrinkles go away, and how can you tell where to put the stuff? You should actually be hanging forward or something, so the wrinkles would really be exaggerated.

Wednesday, August 31, 1983

Cab to meet Lidija ($5). Worked out with Jean Michel who brought me some of his hair, cut off and put on a helmet. It looked great. He got Bruno to pay his first month's security and rent. He wanted to buy the Great Jones Street carriage house from me but I told him that together with our other one around the corner from it on the Bowery it was a nice lot, and that we might put a theater on it some day. He and Paige had a big fight because they had a date for 9:00 and he didn't show up till 1:00.

And I'm so mad at Scavullo. Those pictures he did of me for the Jordan Marsh catalogue, he made me look so ugly. He didn't air-brush at all, and he's an air-brush queen! But he didn't do it for me. I'd like to call him up and tell him off, but then he'd say, "We can only work with what you give us, darling."

Nelson called and said that Joe Dallesandro is driving a cab in L.A. Why can't Joe just get some woman to support him? Or somebody. He still has a big dick. He's stupid. S-T-U-P-I-D. And I don't know what happened with *Heat*. They were showing it on Friday night at the New York Film Festival—they were doing a series on movies that had opened there in the past. I didn't hear a thing about it.

Then Christopher wanted to have dinner. He said he hadn't eaten all day so he promised that he would actually eat the dinner and not have it wrapped to take home. We thought of the Water Club but then decided on the Jockey Club at the Ritz Carlton (dinner $250 with tip).

Friday, September 2, 1983

Jean Michel didn't show up for the workout because he was up all night. He was in love that day with Paige. Pia Zadora called to invite us to a party at Bob Guccione's on Tuesday. She wants me to present her with the portraits there.

And the new building, the new building. I'm trying to start to pack up at 860, but I just want to throw my hands up in the air.

Monday, September 5, 1983

Labor Day. Jean Michel called, he wanted some philosophy, he came over and we talked, and he's afraid he's just going to be a flash in the pan. And I told him not to worry, that he wouldn't be. But then I got scared because he's rented our building on Great Jones and what if he is a flash in the pan and doesn't have the money to pay his rent (supplies $35.06, $6)?

Pia Zadora called and said she was coming down. And they all came—her husband Riklis, his

mother, and some other guy. I'd done twelve portraits of her. And they just liked two and they weren't the ones that I thought were the best. So we have all these portraits left over. But we were lucky, she bought the Dollar Sign. Worked alone till 6:00. Got depressed. It was hot and muggy.

Tuesday, September 6, 1983

Sent Jay home early to dress up so he could come with Benjamin and me to the *Penthouse* party for Pia Zadora and carry the portraits. Walked over to the party at Bob Guccione's in my neighborhood. And Guccione said to me that the time seemed "right" now to really do porno photographs with celebrities, and I put my foot in it, I said *(laughs)*, "How about Cornelia Guest?" I don't know what made me say it. Guccione was wearing a shirt and tie, he had his gold chains covered over. I'd heard he was in the hospital for a head tumor or something like that, but maybe it was hair transplants.

Pia had on a beautiful ring—a diamond with blue sapphires, and she was wearing a Bob Mackie, red, white, and with a blue star. It really was a beautiful dress. Slit up to the ass and when the wind blew once, one of the photographers groaned, "Oh my God, I missed a pussy shot." And the funniest line was one Benjamin heard. When they showed the portraits, one of the photographers said, "How could Andy Warhol sink to such mediocrity?" and the photographer he said it to said, "What do you mean? He's *famous* for sinking to mediocrity."

And it's funny because there everybody is at this party for her and they still all put her down. Oh, but I was gushing because Riklis came over and said, "How can we get the rest of the portraits? Let's talk about it." I was thrilled.

I snuck out at 7:30. Left Jay there looking for Bunnies. Or whatever *Penthouse* has. Pets.

Wednesday, September 7, 1983

I called Robert Hayes. Told him about getting Matt Dillon for the cover and he was excited about that, but he didn't like my idea of Shirley MacLaine. I'm trying to sell magazines. Maybe those ladies who watch *Donahue* will buy *Interview* if they see Shirley on the cover.

Monday, September 12, 1983

Jean Michel was late and he had to go back downtown so he was missing his pedicure. So I went over there and took his appointment ($35). And Yanna's son came over from the School of Visual Arts around the corner, he was cute, he had blue eyes.

Then Mrs. de Menil was having a party for the Lalanne guy who did the sheep-to-sit-on furniture in the sixties. It's French week at Bloomingdale's. When we got there I said to Mrs. de Menil that gee, she was a great-grandmother—Tiya just had a baby—and I guess I shouldn't have said that

because she can't face it, but what I meant was that she looks so beautiful, much better than her kids.

I talked to Peter Schjeldahl the art critic who I know hates me, but I was working hard for him to like me, so we talked about Ted Berrigan dying from diet pills and Coke—the soda. He just wouldn't stop drinking it and it ate out his stomach.

And Jean Stein was there and I guess Peter believed everything in *Edie*. Then left there and Benjamin walked me home.

Tuesday, September 13, 1983

Jean Michel came over, he was drugged-out and excited, he brought a painting he wanted to show me. He told me a story about how he'd wanted to buy a pack of cigarettes so he did a drawing and sold it for $.75 and then a week later his gallery called up and said they had this drawing of his there and should they buy it for $1,000. Jean Michel thought it was funny. It is. And he was on his way upstairs to see if anybody would buy a painting of his for $2. I mean, because now his paintings go for $15,000 and so he wanted to see if anybody would give him $2 for one. Lidija was there, did a workout. Oh, and the girl Jean Michel took around the world and left in London arrived in New York and wanted a ticket back to California.

Saturday, September 17, 1983

Got up at 6:00 to go out on the second day of shooting the TDK ad in Queens. But it's worth it when you get a fat check. We were supposed to work until 5:30 but we finished by noon. We went out to 45th Boulevard or whatever it was in Long Island City. The twenty Japs were waiting. And the crew—ten American guys, so good-looking. Like Mafia or Irish. With the gay fashion look of bracelets and pink shirts and pink belts. They're straight, but that's how those film-crew guys dress now.

We decided to go to dinner at the Café Seiyoken at 9:30. Picked up Bianca who was staying at the house of Marcie Klein's boyfriend. And I guess Calvin really is trying to have a hot media affair with his assistant Kelly. And Bianca was trying so hard to get him.

So we went to Café Seiyoken and I introduced Bianca to Keith Haring. I bet she wants him to do a mural for free in her apartment. She says she wants to interview him for *Interview*, and she also wants to interview Rauschenberg and all the artists.

Rauschenberg was there. He was drinking Jack Daniel's and he came over and he was sweet. I think he said he's working on costumes for Laurie Anderson but the Cafe Seiyoken is so noisy, though, you can't talk to people (dinner $450). I don't think I'll go back again because of the noise, but they're advertisers, so it was good to go.

Then Steve sent his driver to pick us up to go to meet them at that VanDam restaurant. And so we went and in addition to Steve and Ryan and Farrah, Bob Colacello was there. And Bob looks good, he was his old story-telling self. Ryan is so desperate, he calls you "Baby" and "Honey" and he kisses all the boys on the lips, it's so sick. Farrah was also so peculiar. She made Keith

draw on her arm. And then Ryan and Farrah were nervous so they took a walk around the block to smoke a joint. Because I guess it was tense because Bianca had had an affair with Ryan.

Then I raved to Steve about Area, the new disco at 157 Hudson Street, and we went there. I'd been to the opening the other night, and so the guy let us in, but Steve shoved him aside and motioned us all in the door. It was funny, it was *(laughs)* like *he* was the club owner and letting us in, but he'd never even been there before. Marcie Klein was there and she could only talk about wanting to meet Rob Lowe.

Then it was 3:00 and Bianca wanted to go, so I dropped her at Marcie Klein's boyfriend's house, and then dropped Marcie on 83rd Street (cab $10).

Sunday, September 18, 1983

Couldn't get up after being up so late till 3:00. Saw the dogs off for the day. Nobody called because I guess I'd driven them crazy during the week. Went to church. Walked up to the Frick (admission $4) and gee, it's amazing how rich people were. One of the guards knew me, named Fayette, and he gave me a free catalogue.

Then Jon and I walked to the Castle in Central Park. Went to the Boathouse and we rented a rowboat ($20). We rowed for an hour and it was like modern Seurat, all these people on the lake. We got stuck on a rock and then four girls rammed into us, that was fun. And then they were gone and Jon and I were alone and then I thought I was Shelley Winters in *A Place in the Sun*. I can't swim.

Then went home. Decided to see the *Presented by Coppola* movie at the 57th Street Playhouse. It was boring. Like being at the Cinemathèque in the sixties, that kind of a movie. Cuts together, a guy cutting salami, eating a Twinkie, clouds going faster than they should through the sky— everything you never wanted to see. It was over quickly though. And it was packed, crowds waiting to get in (popcorn $5).

And then I couldn't sleep because I've been taking these things called taurine and l-argentine and cystine. And selenium. From the *Life Extension* book and from the nutritionist kid, Shea. S-H-E-A. I always spell it because he always spells it. He says, "I'm Shea. S-H-E-A." I had to get up three or four times to pee because of them.

Tuesday, September 20, 1983

Got picked up early by Benjamin. Went to Häagen-Dazs and got energized and walked all the way down to *Interview* on 32nd Street (phone calls $.60). Cab to meet Lidija ($4). Jean Michel didn't show up for the workout because he was up all night with Paige. He's going off to Zurich. He hasn't moved into Great Jones Street yet. It was a busy afternoon. Worked on the Cocteau drawings for Pierre Berge with Rupert. Painted. Worked until 7:30 (cab $6). Worked at home. Read magazines.

Thursday, September 22, 1983

Got up early and went to get collagen at 1050 Park Avenue at Karen Burke's. She talks your head off. She had people waiting but she rattled on for an hour. She did my neck and it was so painful, like going to torture. She gave me her life story while I was on the table.

When I got to the office Brigid had just had her cat Jimmy put to sleep. And I got so mad and told her how could she have done it when she didn't even take it to another doctor for a second opinion. And Rupert had offered to take it to Pennsylvania because sometimes things can just change and the cat can get better, but she didn't even tell him, so he never got the chance. She'd been having to shoot it up every day because it had kidney problems, and she was afraid it was going to start peeing on her rug. Jimmy was cute.

Decided to go to Richard Weisman's party for Catherine Oxenberg's birthday at Le Club. The last time I saw Catherine Oxenberg was at a party in Spain given by Marc Rich, and he was in the newspapers yesterday because he owes the government more evaded taxes than anybody in history, hundreds of millions or something. I took pictures of the birthday girl.

Friday, September 23, 1983

Then this was the night of Drue Heinz's big seventy-fifth birthday party for her husband Jack. It was at their townhouse on Riverview Terrace, off Sutton Place, outside in the back, and she had the whole waterfront lit up. There were crowds of people. About fifty tables with ten people at each table, and they were all in costumes of 1890, I was the only one in black tie. Ahmet Ertegun was in a fez. Jerry Zipkin had a mustache. I ran into Mrs. Heinz when I got there and told her my date Cornelia had cancelled, and she said, "Well in that case you'll be sitting next to no one." And I asked her where Malcolm Forbes was because I had something for him, and she said, "Oh just throw it over the wall." I didn't know what to think about that, she was just being glib. So I was supposed to be at table 2, which was a good table, but when I got there my name wasn't on any of the cards.

I ran into Jeane Kirkpatrick who I've been watching on TV because of the Korean flight 007 Soviet thing, and that was exciting.

So I'd been moved to Table 18 and there was no other person at this huge table except for some artist who was doing work for the Heinzes. It was so strange—there we were alone and all the really important people were up another level. Tom Wolfe was next to a man, too. But I mean, this artist and I, we were down there *alone*. He was actually cute and fun. I thought he was gay because he was alone, but he said they'd told him he couldn't bring a date so his girl didn't come. His name was Ned. And so we gave each other the presents we'd brought for Mr. Heinz. His is still wrapped—it's a drawing and I haven't unwrapped it because it looks so nice wrapped.

They had fireworks. And I got drunk. The food was good, not the canned stuff. They had 100 waiters, great-looking fairies, and they couldn't figure out why we were down there alone at this table. People came and asked us to go up, but I didn't. Henry Geldzahler was there and he asked, but I didn't. Then Ned said he had to go to the bathroom, and I said if he did I was leaving and

he said, "Tough"—he was drunk, too. But I didn't leave. It was so cold, I just lose my thinking when it gets cold. You just sit there like a bump. If all this had happened inside somebody's house I would have gotten up and left right away, but I just felt stuck. I just sat there in the cold. And then the artist came back and then I left. Before dessert. It was the strangest thing, and my last party at the Heinzes'.

Saturday, September 24, 1983

Worked with Benjamin till 7:00 (cab $6). Then the guy from Harper & Row who wants me to do the *America* book called and said he wanted to take me to dinner at Texarkana and we said we'd meet at 9:00. Cabbed there ($6). It'll be a book of photographs with just a little text—maybe just captions.

Ran into Ronnie Cutrone and a whole bunch of forty people and they had just come from Ronnie's show that said on the invitation "In memory of my father." And Benjamin and I had intended to go, but then we were carrying things home and just forgot, but you can't say, "I forgot." So it was really embarrassing. Tony Shafrazi was there and Keith Haring, and Lou Reed looking so glum, so peculiar. His wife looks more Puerto Rican every time I see her. I don't know if Lou is big or not. *Rolling Stone* gave his album four stars, but was it a hit? Ronnie said Lou's in A.A. so I guess he's not drinking. But Sam the next night was telling me that he saw Lou at the Ninth Circle drinking, but maybe he was just there picking up boys. But then he lived in that neighborhood, anyway, so maybe he was just hanging out. Ronnie said that when he goes to visit Lou in the country that he's always just bought another motorcycle and another piece of land.

So after I'd sat there so long with this Harper & Row guy, Craig Nelson, he still hadn't gotten the check and how long can you wait, so I asked for the check and he didn't offer to pay it. It was $100 with tip. Dropped Craig Nelson at his pad on Avenue A (cab $8).

Sunday, September 25, 1983

Woke up freezing. Went to church.

Called Curley and he discouraged me from having dinner with him and his friends saying that it was a great night to stay home, but that if I *really* wanted to come out they had reservations at this one place. So I could take a hint. Then I called Mark, the kid from the Pedantiks, and we arranged to meet at Texarkana. He said he was bringing the guy named Sam from his group. Then I called Jay Shriver and he said he'd fallen asleep and just couldn't drag himself out that night, so I said okay (cab downtown $6). Met Sam and Mark on the street on the way in.

Anyway, during dinner we talked about rock, I guess. Mark has blond hair and he looks regular, you'd never think he was gay. Sam's teeth are bad and he looks grey, but then I guess rock and roll isn't healthy and these kids do start to look like that. We were there for a while and suddenly over walked *Jay!* He'd been there for half an hour sitting at the bar and he thought I'd seen him but actually I hadn't. And then after drinking he got too paranoid and decided to come over and

face me. But I never would even have seen him. I can't see with my new contacts. I don't even know which ones I've got on. He was there to try to pick up the waitress he'd seen the night before. I felt really mad at him because he'd lied and said that he wasn't going out. I mean, all he had to do was tell the truth. I mean, I'm not a kid (dinner $120).

Called Benjamin a few times but he said he was tired because he'd worked till 5:00 at the Pyramid Club as a drag queen. But Mark is a doorman at the Pyramid and he said they close before that, so I don't know if Benjamin was lying to me, too.

So then dropped Mark and Sam off ($6) and when I got home I was just so mad at Jay and all these kids. I felt so used and abused and lied to. Watched a good TV show on HBO. For the first time I saw why Andy Kaufman was funny, so clever. He had a plant in the audience saying, "You don't do anything new—the same old routine for ten years," and then the guy is yelling the lines with him, and then Andy Kaufman really starts to sweat and you don't know if it's real or not. It was very, very good. Talked to Jon in Los Angeles.

Monday, September 26, 1983

I'd been hating the Republicans so much since the other night at Drue Heinz's, but I'll really change my mind today if we find out that Ron Jr. was able to get an interview with his father for *Interview*. For the January cover. I mean, wouldn't that just put *Interview* on the map? I'd even vote Republican. I know I don't vote but I'm thinking of registering again, because they just started getting the jury-duty lists from the tax rolls instead of the voter things, and so I got one.

Tuesday, September 27, 1983

Vincent is shooting Joanne Winship talking about her annual charity thing. You never hear about her since she got sick. It's so quick what happens in New York. You can just get forgotten in five minutes. Less. You can see millions of people all the time every night for years, and then they can forget you in a minute. Benjamin arrived early to pick me up. He wasn't in drag. I wish he would be. He looks so much more masculine when he goes into drag. It's strange because he looks so slight and girlish as a boy, and then he goes into drag and you notice his hands are so veiny and he has big shoulders and tough hands.

I'd like to start wearing lipstick at night so my lips look fuller, but I'm afraid I'd get stuck under a bright light someplace.

Wednesday, September 28, 1983

Bianca called and asked me to the lunch at Da Silvano that she was having for the Nicaraguan Sandinista cultural minister. A girl. There was an American guy who was like de Antonio, being Communist—Peter Davis, he did a movie called *Hearts and Minds*. And Clemente the

Italian artist was there, and gee, I like him a lot—he's picked up the American attitude. He understands American humor, which is so strange, because you don't understand how a person from another country can pick it up. He doesn't say much, he just sits and eats and watches. Bianca's trying to get him to do a free mural for her apartment. She's buttering up all the artists.

And this other guy at the lunch had been a political prisoner somewhere in South America I think, and now he works for Mitterrand.

It turned into a five-hour lunch. The Nicaraguan cultural minister girl didn't get there until late. She's almost as pretty as Bianca. And she says, "Oh yes, people think we don't have art in a revolution but even as the bombs are falling and the bullets are flying, people are still making art. We have dancers and painters and photographers, and we're becoming unionized. . . ." I mean . . . and then she was saying how the true revolution is really winning out, that "the people are having their day." And I don't know, it was all so abstract, but then being at that big Heinz party the other night with all those rich Republicans I got a creepy feeling there, too. It's like any people when they have the power, they don't want anyone else to ever get it. It's like women trying to keep their husbands away from seeing what young girls look like. But I guess that's not only the rich.

Anyway, they're saying they want us to come down to Nicaragua and, and I don't know, support their art cause. And Clemente is saying, "Oh yeah, sure, and lose the green card I went through so much to get." And then when we were finally done, the rebel girl got into her limousine, and the Socialist who works for Mitterrand got into *his* limousine, and we went down to Clemente's loft, which is right next to Tower Records, and his loft is just beautiful. It's really an artist's loft, big paintings all over. He produces a lot. So many paintings. And the Mitterrand guy was awful, he walked on one of them that was on the floor and pretended he thought it was a rug, but I just know he knew it was a painting.

Then they wanted to see my "studio" so we went to the office, and there was just nothing there. The contrast was so—evident. We've gotten so involved with fashion that we don't know about all these other things like wars and governments anymore. I didn't have any art to show them. They wanted to see movies, but I didn't have any movies, either.

So finally they all left. I worked till 7:30 and Cornelia called and asked where I was because she was ready, and I had a black tie down there, so I just stuck it on and went to the Waldorf Towers. I asked her to be downstairs since we were late, but she said, "I don't want to wait downstairs like a prostitute." So when I got there the doorman was so dumb, after fifteen minutes of me sitting in the cab he came out and said there was no Mr. Warhol staying there. So I did it myself, rang Cornelia's room and she came down in a red dress looking like a hooker. But beautiful. She's put on a little weight. Oh, and I saw Mrs. Douglas MacArthur while I was waiting and she was great. She's eighty-four or something and still has all her marbles. And me, I can barely walk. So then Cornelia came and we went to the Pierre (cab $8) to this fashion show for charity that Joanne Winship organized.

Oh, and at lunch I brought up the Liz Smith items about Calvin and his model Kelly to Bianca, saying the papers said they were such a hot item, and Bianca said, "Ha-ha! What a joke!" So that's her position.

Thursday, September 29, 1983

I woke up with flea bites and that made me hysterical. I ran out and bought flea collars for my ankles.

Cabbed downtown ($5) to the new chic supermarket at Park Avenue and 18th Street, the Food Emporium, but a gay guy there made my sandwiches and so I couldn't eat them.

Kenny Scharf came by, he just bought a $2,000 house in Bahia and eats coconuts all day. His wife's having a baby. His father must be a semi-rich producer. Kenny met his wife on a plane to Carnival.

Then Keith Haring came by after getting a B-12 shot from Dr. Giller, and it was like the sixties when the kids would get shot up and come back so bubbly. And Keith was ranting and raving about this black graffiti artist that's in the papers now because the police killed him—Michael Stewart. And Keith said that he's been arrested by the police four times, but that because he looks normal they just sort of call him a fairy and let him go. But this kid that was killed, he had the Jean Michel look—dreadlocks.

Worked all afternoon. Dropped Benjamin (cab $7). Glued myself and went over to Regine's alone, she was having a party for Julio Iglesias's birthday, and Lester Persky was arriving when I was, and we went in as a couple, and there were cameras but everybody said it was *(laughs)* just Spanish television. The usual people there, "Suzy" and Jerry Zipkin and Cornelia. And Julio Iglesias looks different than in pictures. He's 6'3" and very handsome with a very dark tan, and teeth that are practically fluorescent. He was very friendly as if he really knew me. Maybe he knows somebody that we know who talks about us all the time. And Cornelia sat near so she could catch his eye. Halston had called and said to come over to his place afterwards.

So I went to Halston's and Jane Holzer was there and Halston was doing the same "I'm so rich" routine, but I mean, he must be worried after that thing came out in *Fortune* where the guy who owns him now said he was thinking of selling him.

Oh, and Halston asked again about meeting Jerry Hall. He still wants to make Bianca jealous. But now that Jerry's pregnant, it'll be hard to dress her.

Saturday, October 1, 1983

Had to get up early. Maura and I were scheduled to interview Matt Dillon at Fred's house. Finally Matt came and sat in the kitchen and Maura interviewed him. He's only nineteen. Maura asked the same things she always asks: "Are you Catholic?" and "Are you Irish?" He said yes. It's going to be the same exact interview as Brooke Shields.

Wednesday, October 5, 1983—New York—Milan

Got up early, tried to pack, was picked up by Benjamin (cab $6.50). Jean Michel Basquiat came by the office to work out with Lidija and I told him I was going to Milan and he said he'd go, too, that he'd meet us at the airport. Worked all afternoon till 4:30.

I hadn't thought Jean Michel would come, but while I was waiting in line at the airport he appeared, he was just so nutty but cute and adorable. He hadn't slept in four days, he said he was going to watch me sleep. He had snot all over the place. He was blowing his nose in paper bags. It was as bad as Christopher. Paige has turned him into sort of a gentleman, though, because now he's taking baths. We arrived in Milan practically on time. Arrived at the famous hotel, I forget the name.

Thursday, October 6, 1983—Milan

Did five or ten interviews this day, they kept coming in one at a time. Went out to lunch at some great restaurant. Really good food, people looked so beautiful, think we did a lot of *Interview* advertising work. Had a big dinner at some new disco place with all the beautiful models.

Got home. Jean Michel came by and said he was depressed and was going to kill himself and I laughed and said it was just because he hadn't slept for four days, and then after a while of that he went back to his room.

Friday, October 7, 1983—Milan

Had to do some more press. Then we had an opening of a gallery with two paintings, and forty million people came to a little hallway to see them. Just too crowded. Had to get dressed for a big dinner party for Leandro Gualtieri and his wife, Regina Schrecker the designer. Jean Michel came back and I got him to do artwork on plates so we gave everyone a portrait on a plate. And it was glamorous and the kids went off dancing and Jean Michel made a big play for Joanna Carson who was in Milan.

Saturday, October 8, 1983—Milan—Paris

Jean Michel came in when we were leaving. He said he was staying on with Keith Haring to get publicity—Keith had come in from Spain with Kenny Scharf to paint Fiorucci (concierge $30, bellboys $20, maid $10, magazines $10, doorman $5, taxi to airport $30).

Tuesday, October 11, 1983—Paris—New York

When I got home to 66th Street I didn't shower because I knew that if I did I'd never get to work. I was wearing *(laughs)* "Essence of France"—b.o. There was a strange picture of Mayor Koch in the paper, sneering at Nixon at the Cardinal Cooke funeral. It was a weird picture (cab $6). Met Lidija. Had a lot of coffee.

Worked till 7:00 or 7:30. Ronnie Cutrone came by and said that he was in Milan when we were and that Jean Michel went off to Madrid. Jean Michel's trying to get so famous so fast, and if it works, he'll have it, I guess.

Wednesday, October 12, 1983

I tried to get Thomas Ammann all day but he wasn't around. He still wants to rent part of my house—the second floor—to show his paintings in and I don't know how to get out of it, because you can't keep that kind of thing a secret, people would know it was my house. It's just a little too hard.

And Paige is really upset because Jean Michel hasn't called her. He hasn't called us, either. She sells his paintings, she's been doing that for a while. And he dropped Mary Boone—she took 50 percent, Paige only takes 10 percent. He's still with Bruno, though, so that's how he'll still be shown. I told Paige that Jean Michel was after Joanna Carson in Milan, and maybe I shouldn't have. Paige said she might just forget him, that it had to be all or nothing. But naturally people are people and a fool is a fool so no matter what they say, they'll just go on being in love.

Thursday, October 13, 1983

Princess Caroline was getting to the office at 9:00 to pose for the December cover of French *Vogue*. She's the guest editor for this year's Christmas issue and I was asked to photograph her. So rushed (cab $6.50). She was already there, but it took her one or two hours to get dressed. And they wanted pictures of me taking the pictures of her so I called Chris and he came over. She's pretty but she looks forty. She looks like she's really been through the mill. But they know how to pull her together. She had a Japanese makeup guy.

Paul Morrissey was there driving us all up the wall. He wants to do a remake of *Pepe Le Moko* with children. Paul does have good ideas, though, so if we could just work with him and get him to not think the old-fashioned drug-trash way. . . . He had Brigid retyping some contracts.

Tuesday, October 18, 1983

Jean Michel came by and I slapped him in the face. *(laughs)* I'm not kidding. Kind of hard. It shook him up a little. I told him, "How dare you dump us in Milan!" Benjamin put me up to it.

Wednesday, October 19, 1983

The tree in front of my house hasn't grown an inch all season. The ginkgo. It's still green, but it hasn't grown. Benjamin says it has to dig its roots in first. It's pretty, though. Small and pretty and green.

There were articles in the papers about the police arresting the "Sidney Poitier and Diahann Carroll son" for being an imposter. He was staying at all these people's houses. Halston was smart that time, right away he told him to leave. You could just tell in a second that this kid was lying. But these other people all let him stay at their houses! I mean, he could have been anybody, he could have just wiped out a whole family.

Friday, October 21, 1983

There was a big lunch at the office for the English contingent and Tab Hunter and his new producer who wants me to do a poster for the movie, and an interviewer from Amsterdam. Jean Michel came in and Paige Powell was there with some clients. And Paige had set it up for Jean Michel to go to Vassar with Jennifer that night to give a talk—Jennifer goes to school there now—and the car was going to pick them all up.

But Jean Michel told me he didn't want to take Paige up to Vassar with him because he would be wanting to fuck the girls up there. So when I got home there was a message from Robert Hayes saying Paige was hysterical because Jean Michel had never come in the car to pick her up. So that was mean. And I told her that that's the way life goes and I said we'd go out for drinks and I called Sean McKeon to come with us so that I could handle it better. And Sean's had a crush on me for a few years, and it's nice to be around someone who likes you. That was him in the sunglasses in *People* this week.

So we went to the Mayfair and had two champagnes and a coffee ($40). And Paige was so upset—here she'd just handed Jean Michel a $20,000 check for selling some of his paintings. She said she'd never show or sell his stuff again. I told her I'd let her do an exhibit of my work called "The Worst of Warhol" where I would just go into my closets and find all the really horrible stuff that had never worked out, so then she cheered up a little. But then in a little while she left because she was still so nervous. Sean dropped me and I went to bed.

Sunday, October 23, 1983

There's a painting of mine going up for auction soon, and it's only estimated at $100,000. I think it's a Coke Bottle. And Roy's things go for five, six, or seven, and Jasper's go for a million.

Monday, October 24, 1983

It's freezing and the heat's not coming up. And I'm still having waterbug problems. I corner this one bug every night and then I can't bring myself to kill it. He's been eating my food for the past three years.

I was reading the Barbara Hutton book and the best thing is she had servants wiping her ass. This is at the end when they're robbing her blind. And in the end she was so poor from all these people taking her money that she had to go and ask the people she'd given gifts to if she could have them back—oh, but wait. It could have just been the people working for her who decided to do it. I didn't think of that . . .

I just keep worrying that I've made a mistake buying the 33rd Street building. Maybe we just should have bought it and turned it over right away. But it's the real estate key to that whole block, because of the T shape. There's a truck coming on Friday to move some things out of 860.

Tuesday, October 25, 1983

Went to that restaurant Santa Fe (cab $5.50) and Bianca was on time. Then Calvin arrived with the interviewer from *Playboy*. Jean Michel had his hand on Bianca's knee—she giggled. Then the greatest moment came when I went to pay the bill and Bianca said Calvin had paid.

Bianca said she wanted to go to where they were shooting *Rhinestone* on West Broadway, at one of the galleries. So we went down there and found Steve Rubell. Then Stallone came over. He's hot for Bianca, I think, he saw her and came right over. And I yapped about where was my role in *Rhinestone* that I'd paid $5,000 to get at some Marvin Davis charity auction out in Colorado. And they'd turned this art gallery into a bar for the movie. You could see how much money they're spending. It was the first time I'd been to a movie set where they'd really turned something into something else completely. Zooms and booms all over the street. I thought the cab that was sitting behind me was part of the movie, but then it turned out it wasn't, so I got in and took it home ($6).

Wednesday, October 26, 1983

Jean Michel was at the office all afternoon. Paige came in but left in a huff. I guess it's over between them because he wants to be free and easy and she wants to be involved.

Thursday, October 27, 1983

Gael Love called up screaming that the newsstand dealers were mad because I was out on the streets passing out complimentary new issues before it even got to their stands to sell and I told her I'd do whatever I wanted to do.

The Richard Gere issue was I think our biggest seller yet, even though the interview inside was so bad. So it doesn't matter, it's just if it's somebody they want to read about.

Tuesday, November 1, 1983

Cabbed to meet Lidija ($6). A German kid was at 860 and said he'd been to that bar Cowboys the night before and that the AIDS scare is over, that "the mood is back." And Robert Hayes's boyfriend who has it is in town staying with him. They can't give him chemotherapy because something else happens when they do.

And now Jean Michel has this blonde WASP girl that he's fucking. I think he hates all white women.

And Cornelia's taken my scarf. She always goes out with no clothes on and see-through dresses and then she complains she's too cold. So she took the great red scarf that I got at a fashion show, so that's the end of that. And it was finally the right red.

Thursday, November 3, 1983

Brooke Hayward called and wants to do an interview with me about Mick. She's doing the research for that book they gave Mick the big advance for. And she got tough with me. She said, "Listen here," and I thought if she's like that *already* . . . oh, she's no good, she can't do anything. I did like *Haywire*, but she's a one-book girl. And anyway, I hate her because I keep on remembering that it was her and Jean Stein that got me in all this IRS trouble because they're the ones that asked me to do a McGovern poster, and I wanted to do something clever, so I got that bright idea to do a green face of Nixon with "Vote McGovern" under it. And that's when the IRS got so interested in me.

Walked to the new offices on 33rd Street and picked up a phone and made my first phone call from there. I was there to scout corners where we could store props. It's filled up already and I haven't even moved *my* stuff in yet. And my house is starting to look so bad, too. I want to take pictures of the clutter, but my camera focuses on areas so small that everything just looks neat because I don't get the bigger picture of the big mess that the little areas are all part of.

Robyn decided to leave his job to go work for the Tower Gallery. I don't think it'll last, though. He wants to be an artist and he feels that's closer.

Tuesday, November 8, 1983

At the auction last night, my Triple Elvis went for $135,000, so that's good. It was estimated at $70,000–$90,000. But Thomas Ammann bid $440,000 for one of David Whitney's Rauschenbergs.

Thursday, November 10, 1983

A *Wall Street Journal* reporter called and said she was doing a story on "clubs" and wanted to go to Area and the Limelight and the Cat Club with me, but I think she's just got bongo drums in her pants and wants to run around to the clubs so she says she's doing articles on them.

Yes, I am happy about the $135,000 price for the Coke Bottle. Everybody thought it was good. Thomas told me that the Elvis went for $146,000. And Thomas bought a Flower painting for $40,000. It's worth a lot more, though. Someday . . .

I went to La Côte Basque to meet Mrs. Fortabat, the Argentinian lady who bought Whitney Tower's grandmother's Turner for $6 million. She's having her face treated by Karen Burke, too. She said she's starting a concrete business in the United States, and I told her that meant she'd be joining the Mafia, and she laughed and told me I was "charming."

Saturday, November 12, 1983

Ran into a neighbor from Montauk, the guy with the second house over from our place, and I told him that I was planning to do "a big earth work with parked trailers." And he didn't even laugh, he had no sense of humor, he didn't know I was kidding, he got upset. And he made a

point of telling me that he just spent $20,000 stopping the condos, so now I'm expecting a bill from him. I told him Lauren Hutton was building a house, and he told me Paul Simon was, too.

Went to see *Rear Window* and I was next to a black guy who wouldn't move, but when he saw it was me he said, "Us Leos do what we want to do, right?" He had b.o. He was intellectual, he laughed in the right places. I loved the movie, it was beautiful Technicolor like they don't make anymore.

Sunday, November 13, 1983

I've been trying to get Keith Haring and Thomas Ammann together for a dinner because Thomas wants to have it, and so I called Keith and he was just getting up, he and Juan had been to the Paradise Garage until 8 A.M. and they'd slept all day.

At 9:00 Thomas picked me up and he said Richard Gere and Silvinha would meet us at VanDam, so we went down there and it was empty on Sunday night. Had broiled fish but didn't eat it. Richard was wearing a little hat and a mustache, and that's his look from *The Cotton Club*. And he was screaming about newspapers never getting things right, he was grand. He said he only came because he wanted to meet Keith Haring. He's buying art. He told me how he threw a Come painting of mine into the fireplace. What happened was I'd given Jean Michel a Come painting and he had it with him when he and Richard got drunk together, and Jean Michel didn't have anything to write his phone number on for Richard Gere except this painting of mine, so he wrote it on that and gave the painting to Richard. Then when Richard woke up the next morning he said he saw it and thought it was disgusting and threw it into the fire. I told him it was *my* come but actually it was Victor's. And Richard said that if he had all the money he wanted, he'd buy all the paintings of Balthus, who does the little girls smiling like after sex. They cost over a million now.

Monday, November 14, 1983

Dolly Fox came by but she didn't bring her roommates or anything. She's a struggling girl trying to make it, only she lives on 61st and Park Avenue and she struggles from there.

Wednesday, November 16, 1983

Jay was upset because I said no to his idea of making the Madison Avenue side of the building a discotheque that he and Benjamin would run, so he was moody.

And Vincent was in a bad mood because he went to Madison Square Garden TV for a meeting and it looks like they're cancelling our show. They never got the point of our shows—they're a sports network and they *said* they wanted to branch out, but ...

Friday, November 18, 1983

I went to Karen Burke the collagen girl and with everything she said she put her foot in her mouth. She was saying that she wanted to do a study of the skin of homosexual men because of the sperm they would have swallowed, and she mentioned me as an example and I just looked at her and I told her, "Listen. I haven't swallowed any sperm." And she knew she'd made a mistake. And then I asked her if she was going to have collagen and she said oh no, that she was allergic. It was like, "Me take collagen? Are you crazy?" So she put her foot in it again. And then she said, "Oh, and I'll give you credit on the line of natural-foods cosmetics that I'll be developing." And I mean, this was the idea that *I* told *her* the week before! To have butter creams and all refrigerator cosmetics that you have to replace all the time. And so I just told her, "Well I'll be in business *with* you, so . . ."

Sunday, November 20, 1983

Cornelia called a couple of times, she was cancelling as my date for the "Marilyn" play opening. The show opened at 6:00 and it should have closed right then. It was silly. The girl playing Marilyn was very good, though, she has star quality and she could sing, but I guess it's the book that's so bad. When it was over, we lied and said how great it was. Ran into Lester Persky and Truman Capote who looked pickled. And Truman kissed my hand. What does that mean? And I asked him if he was going to the party afterwards and he said, "No. I can drink at home."

Got home and saw a little of the *Kennedy Years* thing on TV and Republicans must have done the script because it had Jackie worrying about the curtains when they were having the Cuban crisis. Fell asleep watching.

Wednesday, November 23, 1983

Had an appointment to go see Doc Cox, but when I got there, there really wasn't anything to do. Bubbles is just crazy. She said that the test that they took about ten gallons of blood out of me for the last time hadn't worked. But they couldn't do it again this time because they can only do blood tests in the beginning of the week. She said they charged me for it last time but that this second time would be free. And really, I think they just brought me up there in person because they didn't want to call and tell me to pay my bill, so they did it this way. Because there was really nothing that I was there for. The whole place has gotten sort of crazy. But then while I was there someone named "Saul Steinberg" called on the phone, so maybe it's the really rich one and so Doc Cox *does* have rich important clients. Then they told me that I hadn't had any X-rays since 1978 but I said the nurse had done them and then they did find them and I blamed Bubbles for losing them, but Doc Cox said that Bubbles never even went near that drawer.

Monday, November 28, 1983

I'm looking out my window ... there's a lady with her dog running away from the poop he just did ... she's leaving it ... she's gone, and she left it right in front of *my house!* And here comes a truck from the Happiness Cleaners and Laundry....

Fred hired a kid to replace Robyn and didn't even ask me. And I don't think this kid can be any good because he just sat there for five hours waiting for Fred to arrive instead of seeing what little things he could do, like sweep up. He's Italian with an English accent.

Tuesday, November 29, 1983

The New York Times had a big story on AIDS. The tourist business in Haiti is down to nothing. Probably the tourists were only there secretly for the big cocks. Because Jean Michel is half Haitian and he really does have the biggest one.

Went to the Trump Tower and laid out a stack of *Interviews* and watched people take them for free. A lady was shaking when she asked me for an autograph, and she said, "God bless you" and I hope she's right.

I heard that Peter Brant just bought *Antiques* magazine, I guess for Sandy to run. It's a good idea, it's a good magazine.

Wednesday, November 30, 1983

Went to go to the thing at Tavern on the Green that was to announce Don King taking over the management of the Jacksons.

And Don King started an hour-long speech, and he was outrageous, he was telling everybody that Dustin Hoffman was there, and Muhammad Ali, and everybody was booing because everybody knew they weren't really there *(laughs)*. And then he started talking about "a young man with a camera," and then Benjamin was hitting me and saying, "It's you! It's you!" And all the Jacksons had on dark glasses and wouldn't take them off and wouldn't say anything. And Mrs. Jackson is beautiful.

Sunday, December 4, 1983

Steve Rubell called and said he was picking me up at 6:30 with Bianca and Ian Schrager to go to the Helmsley Palace for the Philip Johnson retrospective exhibition with Jackie O. at the Municipal Art Society benefit in the Villard House. Got into black tie.

Went over there and talked to David Whitney. The photographers wanted a picture of me and Bianca, but she was being difficult. She was in a Calvin.

Then we went in Steve Rubell's car to the Four Seasons. Shook hands with Jackie O., she never invited me to her Christmas party again, so she's a creep. And now I wouldn't go if she did. I'd

tell her to go mind her own business. I mean, I'm the same age, so I can tell her off. Although I do feel like she's older than me. But then, I feel like everybody's older than me.

Philip was sort of cute. He said that it wasn't his exhibition, it was his execution. David Whitney was having martinis and he said that as soon as Philip popped off he and I could get together. I laughed it off, but later he said I had to kiss him on the lips. I really didn't know he actually felt this way about me! I always thought he was kidding. And Philip gave a speech and David laughed and clapped. He's smart, David.

Bob Rauschenberg had me kiss him on the lips, too. And then later a pretty girl groupie kissed me on the lips. So if I catch anything the Diary will know where it's from. I left Bianca there without saying goodbye (cab $7).

Wednesday, December 7, 1983

I'm talking like Bianca: "Helllllooo." You call her and you get this whole low voice and Euro-mumble. She's at the Westbury.

And Fred's new assistant's name is Sandro Guggenheim. The one Fred hired without asking me. Well, his name's not really Guggenheim, but he's Peggy Guggenheim's grandson. Peggy didn't leave him any money, though.

Thursday, December 8, 1983

Went up to Fiorucci to sign *Interviews* because *Interview* had arranged it. And when I got there (cab $6) it was so nutty because it was "Andy Warhol Look-alikes Day" and there were five guys at the store dressed in white wigs and clear pink-framed glasses and it really looked funny. So I signed about 250 *Interviews* and sold them.

Sunday, December 11, 1983

It was a grey day. Went to go look at the trees out at Averil's in Katonah, where her husband is an emergency-room doctor and she just had twins. They've lent Fred a little shack on their property, so we were going out there to see Fred's newest architectural adventure.

Peter Wise rented a car and we picked up Fred and went out there (tolls and gas $10). And Averil's husband's so handsome. They live in a big comfortable house with a live-in maid and it's rich but sort of the shabby way. And it's this perfect family with Christmas trees and a dog and her husband who loves her, and it's so amazing to think how wild she was just a few years ago.

Tuesday, December 13, 1983

It was raining hard yesterday. Benjamin and I walked down Madison Avenue and saw all the stuff I want but it's the same old problem—you don't know whether to get a lot of the cheaper little things or one big expensive thing. And this year I notice that people are back to new things. Last

year it was retro. If you had a thirties watch on last year it was chic. But now it's back to Corums and things. Pocket watches are out. Wristwatches are in, but they're sort of finishing. That's the second collecting trend that I started, the wristwatch one. The first was Deco. This year you can get pocket watches that were $12,000 last year for $4,000. And ones that were $85,000 you can get now for $35,000.

We went to the office and I read the *Rolling Stone* where Jann Wenner puts down all his best friends. He put me in with the most "Overrated People." And you'd think since he owns my Maos that he'd be putting me up. I wonder why not. Oh I know, maybe he sold them! And you know it was Joe Allen who sold the Silver Elvis! And he sold all his furniture and everything, the new wife is really moving in there. Jed is doing their apartment.

Decided to go to Peter Beard's party at Heartbreak. Peter was at the door showing slides. The usual. Africa. Cheryl on a turkey. Barbara Allen on a turkey. Bloodstains. *(laughs)* You know.

Wednesday, December 14, 1983

Bruno came and drove us crazy. He didn't bring Jean Michel's rent payment, so later I called Jean Michel about his rent being due and then I had a fight with Jay because he gave Jean Michel my home phone number. He said, "Oh, I didn't know you didn't want . . ." I yelled at him, "Are your brains still with you?" I mean, he knew I wouldn't have Jean Michel coming up to my house—I mean he's a drug addict so he's not dependable. You can't have—I mean, so then why would I want him to have my home phone? Jay should have known better.

And Richard Weisman sent us tickets to the hockey game because Wayne Gretzky invited us.

And since I'd called Jean Michel about the rent I felt bad so I invited him to the hockey game and I sent Jay home early so he could drop off the ticket to him.

And Robyn Geddes came by about getting his old job back, but Fred had to tell him he couldn't have it. And Fred called to remind me not to wear bluejeans to the hockey game because we were going to "21" afterwards.

So then I met the shiatsu guy who Richard Weisman recommended and he worked on me for an hour and a half and he was really good, a thorough professional. He told me that when I cross my legs I should cross them left to right or right to left—I forget which—because one side is weaker than the other, but I told him I *never* cross my legs *(laughs)*. But I'm looking now and here I sit talking with them crossed . . . anyway, so I made a standing appointment for every Wednesday at 7:30. His name is Eizo, and his philosophy is: "You are young you are young you are young, therefore you are young."

I lied about my age, I told him I was forty-four. And he said, "Oh that's *my* age, too!" I guess he knew I was lying. But I felt wonderful afterwards.

Thursday, December 15, 1983

Worked out with Lidija and I strained myself. Or maybe I have cancer of the groin, I don't know. I decided to start drinking water instead of coffee. The office was busy. Vincent paid bills.

Thomas Ammann showed a few paintings here at the house—Balthus, Picasso from 1923, and

Utrecht. And what should I do with these Christmas trees that Tommy Pashun sent? Five little ones. Last year all my trees died after I spent loving care on them, spraying them with water and everything.

Friday, December 16, 1983

Stopped at different places where I'd been the week before where I'd asked them to hold some things, and none of the places had held them. So I saved a lot of money. But on the other hand, I got really mad and hated them for not holding something for a regular customer. So—fuck 'em.

And Lorna Luft's so mean, she's having a baby because she knows Liza can't. And I'm working on a picture present for the Geros. Maybe one from the picture of Liza and Judy that ran in the *Post* last week.

Went out walking with Jon and we ran into Jann Wenner in the neighborhood—he saw me from a block away and came over and then invited us in for a drink. I said, "Gee, Jann, you put down all your best friends in your article on "Overrated People." And he said, "Oh yeah, I made them take Gilda Radner off that list." He didn't say a thing about me! And he's got a big pot belly and his hair is long again.

Saturday, December 17, 1983

There was lunch with Bo Polk at "21." I asked Jon if he wanted to go. Picked him up and we went to 52nd and Fifth. Got out of the cab ($5) and happened to turn my head and saw this car running down about fifty people. People were being thrown up in the air. It was like a movie scene. And when the car stopped there were people lying all over the sidewalk and other people screaming and running. It made me really sick. Jon ran over to try to help. Some people who weren't hit were trying to help the others, but there were other people trying to get Cartier packages away from people who'd been hit. Jon found this boy on the ground who didn't have anybody with him, he was from Yale, and he asked Jon to slip his Cartier package in his inside pocket so no one would steal it. Ambulances got there in just a second, though. Lots of Empire ambulances. Where do they come from so fast, I wonder. It was chaos. And I was standing next to George Plimpton and I asked him if he was going down to the lunch, but he didn't answer me, he was being grand. When Jon was done I thought he'd have blood all over him, but he didn't.

Then later on after seeing on the news about all these other disasters, the bomb at Harrod's and the fire in Madrid, it was great that not one person in this Fifth Avenue thing was badly injured. And what happened, it turned out, was that a traffic cop told this guy in the passenger seat of some car in front of Doubleday to move, and the guy couldn't drive but I guess his foot just went onto the accelerator accidentally because they didn't charge him with anything.

So it was all really odd and I can still see it in my eyes. It could have been us, or anything.

At "21" the hat-check girl said, "I know who you are." And I thought she was making a reference

to my dirty coat which the other day they hadn't even wanted to check, they just threw it on the floor. But later on she asked me for my autograph, so I guess that was why she said it.

After lunch walked up Madison still feeling peculiar because of the accident.

Sunday, December 18, 1983

Talked to Chris and Peter. They were decorating their tree and then they were going off to judge an underwear contest at the Pyramid Club on Avenue A. Cabbed to Chris's ($9). And Chris is so skinny that his eyeballs are sticking out. He's doing it for the same reason I was when I was down to 115—he thinks it makes him look young. But he doesn't look good thin. So when we get to Aspen I'll have to get him on an ice cream binge.

Monday, December 19, 1983

Cabbed to meet Lidija ($5). And while I was exercising two big sharp pains went through me, as if somebody stuck a sword through me angled down. I thought it was the end. Especially after seeing that accident on Saturday and how it could just all be over in a second. But it went away. It must have been some odd muscle spasm. Lidija was concerned. She does adjust things. Like we don't do stomach exercises anymore because it was making the bullethole in my stomach bigger. And we're going to make the weights less. I did used to lift weights when I was young. At Al Roon's. Before it became the Continental Baths and hosted Bette Midler. When it was just a regular gym. But I wasn't lifting them right. I was just lifting.

Tuesday, December 20, 1983

Jean Michel came up to the office but he was out of it. Clemente brought up some of the paintings that the three of us are working on together, and Jean Michel was so out of it he began painting away. Jean Michel and Clemente paint each other out. There's about fifteen paintings that we're working on together.

It was so freezing outside that I decided to stay home. Talked on the phone to John Reinhold for two hours. Fell asleep and then woke up. Then went and broke into Jon's cinnamon nuts and had them. Drank some cognac. I was sleeping with that kind of sleep where you're sleeping but you think you're awake. Then finally from 7:30 to 8:15 I did get some good sleep.

Was too lazy to put on the humidifier so I woke up with dry mouth and fingers.

Wednesday, December 21, 1983

Went to Fiorucci and it's so much fun there. It's everything I've always wanted, all plastic. And when they run out of something I don't think they get it again. It's the cutest kids, too.

Worked till 7:30 then glued myself and went over to Mick's party on West 81st, and it was

fun. They had a couple of security guys at the door. And it was the first time I saw his new house and I was disappointed because I thought it would be on Riverside Drive, and when I think of all the great houses they were looking at I don't know why they bought this one. Jed restored it, but the house is just a regular house.

And just the usual people were there. Ahmet, and Camilla and Earl McGrath, and Jann Wenner and Peter Wolf and Tom Cashin. I decided to sort of booze it up. They had good food. Maybe it was store-bought, but the best store-bought. And Jerry is huge. It's so funny to see these girls pregnant who were so slim. You can't believe it's the same person. It's like a truck. She had a tiara and a white wedding-type dress on.

Thursday, December 22, 1983

Benjamin picked me up and it was raining hard but it had turned warm. I was in a terrible awful Christmas mood. Nobody was in town.

Paige called and she'd sent me a chocolate TV set she'd had custom-made by one of the advertisers to celebrate our MSG-TV shows. She didn't know that earlier in the day we had just gotten the letter saying in black and white that the show was being cancelled.

Friday, December 23, 1983

Cabbed to *Interview* to the office party to try to feel Christmasy. Robyn Geddes was there and I could see he was feeling funny. And it seemed like there wasn't anybody big at the party. Robert Hayes was there and Cisco, his boyfriend, who's dying of AIDS, and I guess I got really freaked out and I couldn't deal with it. The kids had all gone to his house—he made Christmas dinner for Jay and Paige and they ate it. He's made dinner for them before. We used to go to his restaurant all the time.

Saturday, December 24, 1983

Halston's place was really Christmasy. Victor was behaving himself. Bianca was there with Jade, and Peter Beard and Cheryl Tiegs, and Jennifer and Jay from the office, and Halston's niece. No Steve Rubell. Dinner was delicious, cranberries and turkey, and I porked. Halston gave me an old dress, it weighed like 4,000 pounds. And the presents weren't really that great—it wasn't like the other Christmas Eves there. Bianca made a *faux pas*, she asked me if I was going to Diane Von Furstenberg's and I hadn't been invited. So I guess I'm off her list. She must have chosen Bob over me. Well, then she missed a Christmas present. I don't know, it was never that much fun there anyway. Benjamin was trying to get me to leave so he could go off and have fun, so he got me out of there by 12:00, and walked me home. I just lallied around feeling blue. Took a Valium and forgot about the world.

Sunday, December 25, 1983

Got up and it was Sunday. Tried to dye my eyebrows and my hair. I wasn't in the mood. Went to church. Got not too many phone calls. Actually none, I guess. Tried to wrap presents. I was going to have Peter and Chris over to plan our trip to Aspen the next day. I guess I took all day wrapping presents and I think by the time they came I'd watched a lot of terrible TV. Went through a lot of fuzzy paper.

Got a picture of Georgia O'Keeffe from Chris and a little painting from Peter and time really flew by. Nobody ate anything.

Monday, January 2, 1984—Aspen, Colorado—New York

Got back to New York and got a Scull limo ($20 to the driver). The driver said he'd picked up Jean Michel and drove him to the airport to go to Hawaii for two months. And I hope he paid his rent in advance. Got home and was really tired. Watched TV, took a Valium.

Never took a bath the whole time in Aspen, never changed clothes. Just lived like a pig. That's a good story, isn't it? But my perfume worked and my breathing was good but I was depressed because Jon is so aloof. He says he needs to be his own person, and I always feel like he's just about to leave, so I never can feel relaxed.

Wednesday, January 4, 1984

Vincent was upset because it was in the newspapers that I'm giving a party at Club A for Christopher on January 10, and now everybody is calling the office to get invited and driving him crazy. It's not *my* party—I told the person giving it that my name could only be used in a *minor* way, but the invitations arrived and they say, "Andy Warhol invites you to . . ."

Peter called and said it was Chris's birthday and was I going to take them out to celebrate. I couldn't face it so I started a fight about that to get out of having to do it.

Then I took Benjamin as my date to a party at Louise Melhado's. Jennifer had come to work for five minutes but it was just long enough to give us the wrong address. But we eventually found it. We were both dirty and in our bluejeans and it was hard explaining why Benjamin was there. But it was an old crowd so the old boys wanted to meet him. Decorators.

Dropped Benjamin (cab $20). I went home and watched *Dynasty*. Helmut Berger was good. Then went to bed early. But then I remembered the caviar in the kitchen that Calvin had sent so I started down the stairs—I was in my socks—and it was like a comedy, I slipped and fell three times. Just flopped down the stairs. And I got bruised. Macy's and Zabar's were having a caviar war this Christmas but Calvin got his at William Poll so he probably paid a lot for it.

Woke up in the middle of the night thinking of the exposé of my life that I hear *Women's Wear Daily* is doing.

Oh, and David Whitney called and said yesterday that Leo Lerman had been fired from *Vanity Fair* and the girl in England who does the *Tatler* was going to be editor. I don't know, I think they

should just make *Vanity Fair* like what *Vogue* used to be and downgrade *Vogue* to the *Mademoiselle* level and go on down the line downgrading.

Saturday, January 7, 1984

Had to go to see the Keith Haring closing (cab $8). Went all the way down there to see what people are doing and I got jealous. Bought Keith memorabilia and posters from the show ($95). This is at the Disco annex of the Tony Shafrazi Gallery. Ran into people and it was weird. This Keith thing reminded me of the old days when I was up-there.

And then we went to see Lichtenstein's show, and he did a mural! I just don't understand that. Right on the wall. Like picking up the graffiti thing from the kids, but I think it's so silly, why would he want to do that. But somebody told me they'll put sheetrock over it and it'll be underneath and then someday they'll peel it away. So then we went to a duck exhibit, a new kind of old art, primitives like duck decoys.

And then we went to Peter Bonnier's gallery and it was Steve Jaffee's paintings, and there's a portrait of Jean Michel in it and Jean Michel told me that this guy just does it the way I do—tracing.

Sunday, January 8, 1984

Calvin called and wanted to know if it was worth going to Chris's party at Club A on Tuesday. And I had a fight with Chris because he's saying that I can't bring whoever I want. I mean, my name's on the invitation as the host and I can't invite anybody I want? And then when I ask Chris who's coming he tells me the names and it's every boy he's ever had.

Monday, January 9, 1984

Fred walked in and the first thing he said was that I stole his Christmas scarf, which I did. Brigid must have told him. She told him and she got him all agitated. She has nothing better to do so she just went and told him I stole the scarf that was delivered for him while he was away. I think she's sick in the head.

Tuesday, January 10, 1984

This was the day of Christopher's grand party at Club A and so everyone was calling us to get in and Chris was being so grand and saying no no no, that it was so exclusive. Calvin and Steve Rubell called a few times and Calvin was asking *(laughs)* what he should wear.

I was waiting for Jerry Hall to come down to take her picture for a portrait, but she was a no-show, and she didn't call or anything, which was strange. She's usually reliable, Jerry. I don't know

when the baby is due. Wouldn't it be awful for Mick if it was another girl? If she has a boy, they'll get married in a minute, I'm sure.

Talked to Rupert and he gave me an idea—a Statue of Liberty portfolio.

Then had to leave and it was snowing by then. Finally got a cab ($4) and then when I got there, there was really nobody there. This party was supposed to be "Uptown Meets Downtown," but it was just dumb meets stupid.

Wednesday, January 11, 1984

Jerry Hall called and said, "Is this the day I'm supposed to come down?" and I just said yes.

Jean Michel called from Hawaii. He said it wasn't so primitive out there, that the first guy he saw said, "Aren't you Jean Michel Basquiat, the New York City graffiti artist?" And he said he met these hippies out there and mentioned my name and they said, "Oh you mean that death-warmed-over person on drugs?" And I mean, it's *him* they should be talking about.

Jerry came and she had Mick's daughter by Marsha Hunt with her, but the girl didn't talk, she just read a newspaper while Jerry and I worked.

Jean Michel called again from Hawaii. I told him to cut off his ear. He probably will. Went home and met the shiatsu guy for my weekly massage.

Sunday, January 15, 1984

I was a judge at the cheerleading tryouts for the New Jersey Generals, the team that Donald Trump bought. They were having them in the basement part of Trump Tower. It was the final tryout, and I was supposed to be there at 12:00 but I took my time and went to church and finally moseyed over there around 2:00. This is because I still hate the Trumps because they never bought the paintings I did of the Trump Tower. So I got there and they were already up to the fiftieth girl and there were only twenty left to go. Another guy had been filling in for me and he handed me his pad and I took over. I didn't know how to score. The girls didn't look special because there was no spotlight on them. Once in a while a camera light would go off and flash on one and then she would look good, but that was it. People like LeRoy Neiman were the other judges. He said he voted for anybody who could kick. Ivana voted for any of the girls who looked like her.

And there were so many different kinds of bodies—some with big hips and small waists and some with boy-type bodies, and some with really skinny legs so there were big spaces between their legs. And this cheerleading would be just something they'd do "for fun," they don't get paid. So they'd better get themselves a football player or they'll walk away with nothing. And somebody told Ivana she'd better watch her husband because she could lose him to these young girls, but then later somebody told me that he fooled around with all the girls anyway. And seeing these young things and then a sophisticated "lady" like Ivana, you'd think that some day they could be like that, too—if they marry right.

And they all had to dance to "Billie Jean" by Michael Jackson, so we all had to hear "Billie Jean" seventy times during the tryouts, so it was sick.

Went to Beulah Land on 10th Street and Avenue A (cab $6) to see the photography show of the kids at the office—Benjamin and Paige and Jennifer—and it was right near where I first lived when I came to New York, on St. Mark's Place and Avenue A. And I thought about how hard it was then, walking all that way home from the subway on Astor Place with my drawings and then dragging them up seven flights of stairs. And when we got to Beulah Land they said that I'd just missed everybody's mother and father and relatives, and I was so glad I had. Like Jennifer's mother and father and Paige's aunts and uncles. And Benjamin's photos were like my ideas—manhole covers that all looked the same but they were actually all different. And Benjamin is the only one who sold anything—Jeffrey Deitch from Citicorp bought them. And Paige has so much energy, she did the Peter Beard look—writing little things—and it's almost there but how many things can you do with photographs? Stayed there an hour then went to the party at Pyramid for it. And it was the same crowd there. And these two clubs are the only places I've been to where the kids actually do dress the Fiorucci way—like wearing three dresses at once.

Thursday, January 19, 1984

After Benjamin picked me up we passed a candy/newspaper shop and the woman said she'd consider getting *Interview*, and she gave us a box of candy-covered-chocolate-covered peanuts. And then we were passing the park and the pigeons were just going crazy, they were so starving, so we threw them the box of it. Usually they won't eat candy, but they were so starving they did.

Barbara Allen called from Barbados because she'd just been interviewed about the exposé that *Women's Wear Daily* is doing on me. She said she said "all the right things," so I can just imagine. Maybe they won't run it. She's still with the same guy, the Polish guy.

Friday, January 20, 1984

At 12:30 Mrs. Tisch was coming to be photographed for a portrait. At last someone I met from a party was getting a portrait done (cab to meet Lidija $6). She came in all her jewelry. She has such a bad nose job though. When I first saw her I didn't know it was one, but it is. And you think, with all that money, why can't they make it right? Why can't they fix what went wrong? She's pencil-thin and she doesn't like red lips because she says her jaw is big, but she wasn't much of a problem. Worked all afternoon.

Monday, January 23, 1984

Joan Quinn sent Vincent a clipping from the *Los Angeles Times* that said Ronnie Levin was arrested for stealing all this video equipment. Actually, he'd charged it to credit cards, though—some kind of scam.

And Jean Michel is meeting all these women in Hawaii and he's going to L.A. to paint Richard Pryor and then going back to Hawaii. And Paige is going out there and I told her that she should make sure he's really going to be there when she gets there. I mean, she'll make all these plans and she'll get there and he'll be gone.

Oh, and this kid came up who said he was Rupert Murdoch's nephew, and Jay, after his mistake with Sidney Poitier's "son," was saying this time, "He's a fake, I know it." But I think it was a real nephew because he left quickly, he didn't stay on and on.

Friday, January 27, 1984

We cabbed down to the Castelli Gallery to see the Jasper Johns show. When we got there Jasper was at the door letting some people out and I told him we were crashing and he let us in. I wasn't invited, I don't think—I never saw an invitation. Or to the lunch they had either. The paintings were wonderful, and every one was like $600,000. I think Jasper owns most of them, just sells one when he has to. Then we left there and went to the South Street Seaport to take pictures there, and that was strange, because right where Jasper and Bob Rauschenberg and Bob Indiana used to live, now there's this whole fake town with 100 million stores. Stopped at a Greek coffee shop ($24).

Saturday, January 28, 1984

Wandered to the East Village. Took a couple of rolls of film. Ran into René Ricard who's the George Sanders of the Lower East Side, the Rex Reed of the art world—he was with some Puerto Rican boyfriend with a name like a cigarette. We went to the Fun Gallery, then went to the Lochran Gallery which used to be a furniture store and now they've thrown paintings on the wall and it's a gallery. And then we went to Mary Garage. What's the name of that gallery? Gracie Mansion. On Avenue A. And there were five fakes of mine there. Electric Chairs. And some Jackson Pollock fakes. I didn't say anything. Left there and saw a sign that said "Funeral Home," and I thought it was a discotheque and started to go in, but then they were actually bringing a body in and I freaked out and crossed to the other side of the street.

Sunday, January 29, 1984

No one was available to accompany me to the office, and I was afraid the elevator would get stuck, so I didn't go down. Paige made it to Hawaii. Jean Michel did make it back from Los Angeles to meet her there, I guess, and they were going off to some ranch.

Tuesday, January 31, 1984

Dr. Karen Burke arrived, she thinks she knows what's making Brigid scratch, she thinks it's the cats. So she waited until Brigid went home at 5:00 and went with her. And I said to Brigid what if it turned out the cats had something and she said, "Oh, I'll just get rid of them, then." I don't know, she has no feelings.

Saturday, February 4, 1984

Did a personal errand with Jon, but he made me promise not to put anything personal about him in the Diary. [*Jon Gould was admitted to New York Hospital with pneumonia on February 4, 1984, and released on February 22. He was readmitted the next day, however, and released again on March 7. On that day Andy instructed his housekeepers Nena and Aurora: "From now on, wash Jon's dishes and clothes separate from mine."*]

Monday, February 6, 1984

Was picked up by Benjamin and it was a beautiful day. This was the first of me taking photographs for my assignment from French *Vogue*. I'm being paid $250 a day.

Got to our new building, 33rd and Madison (cab $4.50), and André Leon Talley was styling the shoots and had told the Guardian Angels to meet us there and the only room that looked sort of like a subway to photograph them in was the basement.

They were all nice kids. The leader, Curtis, and his wife were there and they're good-looking. And I guess they're still in trouble because they're accused of staging an incident and I wouldn't be surprised if they did because they *are* theatrical. I mean everything about them is so beautiful.

I went home and watched TV. Barbara Walters is just too goo-goo with that searching look and asking the same old questions: "How old were you when you realized you had sex?"

Tuesday, February 7, 1984

It was so exciting being at the new building with George the super and going to the rooms that don't have furniture, like the big ballroom. The kitchen's being put in and it looks so pretty. Stayed there about an hour.

Jean Michel called from Hawaii and talked a long time. Paige is back here now and she's in seventh heaven, overfucked, I guess. And now he's flying this other girl out there. Paige was stupid and paid her own way—she insisted because that's the way she is—and now he's paying for this other girl. He's paying $1,000 a week for this house. He owes us three months' rent and he's trying to get Bruno to pay.

Talked to Paul Morrissey a few times and we're sort of becoming friendly again, he was sort of normal.

Then cabbed uptown to change into a tuxedo and invited Benjamin to the Michael Jackson party (cab $7). Glued myself together and then cabbed to Halston's ($3) because he'd invited me to go in his limousine.

So we took the limo to the Museum of Natural History and we got there right as Michael Jackson was getting an award in the center hallway. And he talked and talked, it was a new personality.

The crowds of kids were kept on the opposite side of the street when we came in, that's how it was set up. And there was nobody really there. Just everybody you already knew, but nobody. Just all the record-business people but in black tie. Oh, and Bob Colacello was there and we finally made up. Because I was drunk. I'd had one drink at Halston's, and I told Bob how great his Larry Flynt article in *Vanity Fair* was and he was thrilled I liked it.

Oh and the best person at the party who I just love is Truman's niece who now works for *Interview* as the stylist, Kate Harrington, isn't that the greatest name? Kate Harrington. She's very pretty. Like what Holly Golightly should have looked like. And I just loved her because whatever man she wanted she just went right after them, she'd give them her card. And she's good—she styled the Goldie Hawn cover.

Monday, February 13, 1984

Got up in the morning knowing that I had another day of French *Vogue* ahead of me. Had to go downtown early to meet André Leon Talley. I was photographing Benjamin in his drag outfit. It was warm out, like fifty degrees.

Got there (cab $5) and Benjamin looked great, very fashionable, and I can really see why he gets so much drag work. Oh, and we got Lidija in the pictures, too, so it's all nobodies and the French will think they're somebodies. Which is a new thing because the somebodies are everywhere, you're sick of them.

Wednesday, February 15, 1984

Maura came by and said that she takes home $1,300 a week at her new job writing for *The New Show* at NBC, and that she's saving her money because she thinks that *The New Show* is going to fold fast. Her brother was with her and he's a sculptor who does things with ping-pong balls for eyes, so you can imagine. He went to Harvard. He doesn't use the name Moynihan.

Friday, February 17, 1984

The *W* exposé on me came out. Fred said it wasn't so bad, though. All the old ladies will be after me, it made me seem so rich. And I read *GQ* and Calvin with these new ads, the perfume, the girl in the jockstrap with—oh, he's going to be in the billions.

And Brigid, she was knitting. Just Madame Defarge. And if you ever want to know what's wrong

with you, don't look in a mirror, just give Brigid a glass of wine and she'll tell you: "Your wig's on crooked."

Thursday, February 23, 1984

I was picked up by Benjamin and we went out with *Interviews*, but I really don't like passing out this Jane Fonda issue because I just don't like the cover, it doesn't look like her and there's no black in it. The one that's coming next with Goldie Hawn looks good, though.

Oh, and I ran into Bob Colacello. And he asked me for an *Interview*. I asked if his building had gone co-op and he said no, that it went condo.

Well Jean Michel is coming back from Hawaii on the first and going to Sweden on the second. Just for a few days. Our old friend from Stockholm, Stellan, says he has Swedish girls lined up waiting for him over there.

Saturday, February 15, 1984

Bianca told me she'd just been in Japan doing an interview with Robert Wilson for *Vanity Fair* and I said how could she do that and not for *Interview*, and she said well would *Interview* have sent her for three weeks to Japan and paid her hotel bill. That must have been expensive. She said, "He's a genius." I did used to think he was good, too, but then that last time at Lincoln Center it was so boring. It's like artists who do things—well I don't know, maybe *I* fit into that category—but they're showing the mechanics of something instead of entertaining you. Rauschenberg's good, though. He'll put on his ice skates in a new way.

Monday, February 27, 1984

I was looking at the Christie's stuff, the jewelry. In every auction they have some stuff of Gloria Vanderbilt's. I guess she gave them lots of stuff and it's just little junk. I guess they like to have a name in every auction and anyway, if they'd put it all together in one auction it would have just been embarrassing.

And John Reinhold called and said he got another letter from the government about permission to drill holes in pennies. They'd told him on the phone it was okay, but he said, "I want it in writing." So the government sent him this abstract letter saying you could drill holes in them but you couldn't deface them. This is so I can make more of the penny belts like the one I made for Cornelia.

Was picked up by John and Kimiko and went to the Met and the opera was *Tannhäuser* by Wagner. Boring. There are no great singers. I guess all the strong singers go into rock and roll now. The opera audience is still filled with boys with older men, learning about the finer things in life.

I was looking at some magazine and there was an interview with Joe Dallesandro, done right

before he did *The Cotton Club*—the Lucky Luciano role that PH actually got him because she knew the producer—and there was Joe saying, "Oh, I *never* hung around with those Factory people, they weren't my *friends*."

Wednesday, February 29, 1984

Time sent down the picture of Michael Jackson and I was set to do the cover, but then stupid Hart upset Mondale in the New Hampshire primary, so they dropped the Michael cover. They said maybe they'd do it another week, but I doubt it. Maybe that was just a way of getting out of my price. Oh, but they *are* a news magazine, I guess.

Then Liza had invited me to come over to her theater and see the changes they'd made in *The Rink* and then watch the performance of this eight- or nine-year-old girl who'd been hanging around the stage door for weeks with her father trying to get Liza to watch her perform.

So cabbed with Benjamin ($5). And this little girl, after weeks of pleading, was late. And that made it sort of weird, because everybody thought she'd be right there. Then she came and she had a perfect little Barbie doll figure and long hair and this beautiful face. It was the Debra Winger look. She was Jewish. And she put on the Liza music to "New York, New York" and she sang that and we sort of sat there. Her father was in the background. The director was really sweet. And then after she did that, Liza talked to them and said, after saying how good she was and everything, "What do you want from me?" And the little girl was cute and nervous and everything, and she said, "I want to be Liza Minnelli." And "I want to further my career." Things like that. And Liza asked her what she'd done, and she said that she'd done a TV commercial. Then Liza started giving her pointers and I got goosebumps. It was memorable. One of those real scenes, it was show business but real. And it was like *All About Eve* or something.

Then we left there and Liza's new bodyguard is the Hell's Angel I met once at the Café Central. He has a hook hand.

Thursday, March 1, 1984

Jay called in the morning and said the Michael Jackson *Time* cover was back on.

Friday, March 2, 1984

Mick and Jerry had their baby. A girl. A girl named Elizabeth Scarlett.

And you know, it's so funny with all these protests now about Jane Fonda at the stores where she's trying to sell her exercise clothes. I don't understand why it would start now. I mean, all these years her movies have been doing big business and her exercise video is number one— Vietnam veterans complained but nobody listened. But now with the clothes it's all these protests and they're effective because Saks cancelled. But why haven't they been calling theaters all these years and saying, "We'll bomb the theater if you show her movie"? So it makes me think it's like

one person in the garment business that's gone after her. You know? Because it's all of a sudden and just focused on this one area. And I mean, what category do we fall into, having her on the *Interview* cover? Will that be an area that's just fine, like her videotapes where she's the "most respected woman in America"? Or will they be writing us threatening letters?

Monday, March 5, 1984

I read the book about Mrs. Chairman Mao called *White Boned Demon* and I decided to do paintings of her. It was great, about how she went from prostitute to Chairman Mao's wife. But I mean, how this guy wrote this stuff I don't know. I mean, going back to individual days in her childhood and remembering if she was happy or sad, I mean, they don't even know what happened to her mother, let alone if she was unhappy on Tuesday in May 1937! The Mrs. Mao book didn't have any pictures in it so now I have to find some.

Tuesday, March 6, 1984

Worked on the Michael Jackson *Time* cover until 8:00. Then watched some terrible TV. I saw Joan Collins in some old movie like *Caesar* and she was so bad, and now she's got the right part and she's so good. It was all just finding the right part.

Wednesday, March 7, 1984

Ran into the lady whose portrait I just did, Mrs. Tisch, and I was wondering why she looked so familiar. She said she loves the portraits but doesn't know how many she's going to take. Fred's going to call her.

I finished the Michael Jackson cover. I didn't like it but the office kids did. Then the *Time* people came down to see it, about forty of them. And they stood around saying that it should increase newsstand sales "by 400," so I guess they do think about this. Then later the *Time* guy called me—Rudy—and said they were going to use it. I think the yellow one. And I told him to cross his fingers that it wouldn't get bumped on Saturday and he said he would.

Friday, March 9, 1984

Ran into Adolfo. Benjamin said it was him, but I didn't recognize him. And Adolfo said that he sees me in church every Sunday, that he sits right next to me, so I was embarrassed that I've never recognized him.

Vic Ramos called and said he wanted to talk about something, so he's bringing Matt Dillon over for lunch on Tuesday. So that's something to look forward to, that'll be fun, seeing Matt again. I'm sure he wants us to produce a movie, that's got to be it. Because it wouldn't be *(laughs)*

to direct. That would be too easy, too good to be true. He asked if Paul was around and I said yes, he's around, and he said that we'd just have this meeting this way and then we could talk to Paul later about this project.

Sunday, March 11, 1984

I went to church and did see Adolfo next to me, just like he'd told me.

Monday, March 12, 1984

Time came out and the Jackson cover made it, it didn't get bumped. And the article inside was crazy. It had them asking if he was going to get a sex-change operation and he said no. The cover should have had more blue. I gave them some in the style of the Fonda cover I did for Time once, but they wanted *this* style.

Jean Michel came by, he's back from Hawaii, and he brought a rent check which was a good surprise. Vincent came down. Everybody was trying to get tickets to the Hard Rock Café, that place that Dan Aykroyd has something to do with. Rock Brynner is running it. Eddie Murphy was supposed to be there.

And I didn't tell the Diary that Michael Sklar died, did I? When I stopped in at Jean's to look at a brooch this guy there who follows my career showed me the obituary. About two days ago he died. It said he starred in Andy Warhol's *Trash* and *L'Amour*. It said he died of lymphoma. So is that AIDS? But gee, Michael didn't carry on. He was a hard worker.

Tuesday, March 13, 1984

Matt Dillon and Vic Ramos were coming to lunch. Jean Michel came by—he wanted to meet Matt because Matt had mentioned Jean Michel's art in the interview he did with us.

Matt arrived first. And then Vic came and he didn't like the idea of Jean Michel because in the seventies—I remember reading this in the papers—his apartment had been broken into and vandalized by a graffiti artist. Vic said he still hasn't gotten the paint off everything yet.

And after two hours we still didn't know why Vic had wanted to set up this lunch. Then finally Matt started to say something about wanting to do a movie about a sixties underground filmmaker.

Matt was wearing pink shoes that he said he got on St. Mark's Place. And he was talking about *Midnight Cowboy* and imitating the fag in it, putting on sort of an affected accent, like British or a little like Fred when he's Mrs. Vreeland. And Matt has the ear to be a very good actor. Vic Ramos was the casting person for *Midnight Cowboy* who put Paul and Jed and Ultra and everybody in the party scene. I wasn't in it because I was in the hospital, it was in the summer of '68 right after I got shot.

When I left work it was snowing and raining out. The dog had peed on my bed and I beat him up. Amos.

Wednesday, March 14, 1984

Ron Feldman came up to talk about the new project, the portfolio of old magazine ads. But he wants me to do corny ones—like the Judy Garland Blackglama ads. He doesn't want the Coke one, he says who would buy it.

Thursday, March 15, 1984

I was violently ill. I had carrot juice and some beans at lunch and by the time I got home yesterday I felt funny. And then there was a dinner at Shezan for Egon Von Furstenberg and Mrs. Egon, and so I had to decide whether I felt well enough to go, and I went—an hour late—and I was seated next to Mrs. Egon, but the second I smelled the food I started to get violently ill and had to leave. But I kept it down. And then I got home and the dogs sat on top of me all night, so I hoped they would pick it up and take it away from me. It was so weird to get sick like that. Vincent had caught the flu from his kids so I think I picked up this thing from him.

Friday, March 16, 1984

A sick day. I woke up, still sick, and decided to stay at home. The phone rang a lot. People kept checking in.

Saturday, March 17, 1984

Dolly Parton was coming to the office to be interviewed. She arrived and she was great. She had two people with her. She said she has a place in New York and goes out and around, but I don't know how she can unless she puts another kind of wig on. She talked nonstop for four hours. She's a walking monologue.

Jean Michel came by and he misunderstood something she said about "plantations" so he didn't like her but then I got him to come back in and she charmed him. She repeated herself a lot, called herself "trash" a lot. She said most of her groupies were lesbians and fags. She has a group of dykes that follows her around. She had her hairdresser and her girlfriend Shirley pick her up. They just came in a cab, not a limousine. I worked late.

Sunday, March 18, 1984

The phone didn't ring once. Oh wait, yes it did. Jane Holzer called and she's flying us to Palm Beach on Friday to help open her ice cream shop, "Sweet Baby Jane's." She called *People* magazine about it, so I guess they'll do a "Whatever happened to Baby Jane" about her.

Monday, March 19, 1984

Paloma called and we were invited that night to her dinner for her perfume. They didn't send perfume to men, but the bottle is kind of nice. She was having the dinner at the old Burden mansion on 91st Street that's now a Catholic school and they rent out the old ballroom for parties.

Dropped Benjamin. Glued and then was late. Cabbed uptown ($3.50). And because I was late I'd been bumped from the main table. So I wound up at the same table as Rosemary Kent! She's back around and working for the *Post!* I've been forgetting to tell the Diary. And Fred was at this table, too, so he was going nuts trying to look away from her. She's still with the same husband, Henry. And instead of running up to Paloma I ran up to horrible Rosemary Kent, who's still writing her stupid "What's In/What's Out" articles, you know—"Handbags! Shoes! Andy Warhol's wigs!"—and tried in my heart not to think she was awful, because God forgives so so should I. See, I'm sure I got sick the other day as punishment because I yelled at that lady. Didn't I tell the Diary? A real estate lady called the office and said she wanted to show our floor to some people and I screamed that she couldn't, that our lease wasn't up and that she better not set one foot on the premises until it was, and she said she couldn't believe that a nice person and an artist like me would be yelling at her. And then I got sick.

Paloma's party just missed. The people were too old or something. I've decided I'm just going to go to openings of stores and galleries, that's my new philosophy.

And the big news of the day was that Rupert's house in New Hope, Pennsylvania, burned down, so he didn't come in. A coal got caught in the chimney. I never had a priest exorcise my room that had the spontaneous fire. I blessed it myself—I got holy water. But I still think there's something funny about that room. I had the Picabia painting of the devil that fell down in there and also the ceiling fell down.

Tuesday, March 20, 1984

Went home and glued and then walked over to Jill Fuller's house, she was having a dinner for Henry McIlhenny who just sold a $3.9 million Cezanne. The auction house probably did a deal and settled for 2 percent or 1 percent or 5 percent or maybe even no percent just for the prestige of getting the painting. And it was an old evening, just old people, nobody young. Jill's ex-husband Gino Piserchio, one of our sixties superstars, was in the kitchen cooking. He's a caterer now. A chef. And Henry's got three stomachs now.

Friday, March 23, 1984—New York—Palm Beach, Florida

It rained all day, but by 6:00 when Jane Holzer picked us up it had stopped for a little bit. So we went over to the street where Sweet Baby Jane's ice cream parlor was, in the block Jane owns, I think—the one that has Van Cleef & Arpel.

I did interviews with the newspapers and *People.* Jane didn't even give me a full dish of ice

cream, just a little spoon. The place has the usual stuff you sell with ice cream. Oreos and things. Boring.

Monday, March 26, 1984—New York

New York Central sent the wrong paint over three times. And then Jay had a dislocated shoulder. He dislocated it playing basketball when somebody fell on him and his bone was sticking the wrong way and he'd spent the weekend at St. Vincent's and he'd just gotten out. And he was supposed to take a vacation starting at the end of this week, so I told him to take it starting immediately, but he refused. He doesn't want to waste vacation time being disabled, he wants to work disabled. So now we've got to be moving some things up to the new building and he won't even be able to help.

Tuesday, March 27, 1984

Benjamin didn't pick me up because he went directly to the office to help with moving. Jean Michel came by and Paige came in at the same time and they had a fight. And Paige has now been kicked out of the apartment she was staying in on West 81st Street, the board of the building wanted her out probably because they'd see dreadlocked blacks coming in there all the time and they were scared, they wouldn't know they were artists. Paige is so charming, though, I'm surprised she couldn't change their mind.

Somebody from the *New York Post* called, asking what was chic and what was un-chic. I guess they wanted someone else to write their article for them.

Wednesday, March 28, 1984

I'd forgotten that David Whitney was coming down with Jasper Johns to get a painting for Jasper's benefit, he's got a Jasper Johns Foundation for needy artists. I don't know who picks who's needy. Probably some idiot like Barbara Rose, right? Or Robert Hughes. Oh, I bet that's who it is. I just bet. I'm going to ask David. So they came and they wanted the biggest one. The Ink Spot painting. The Rorschach Blot. Jasper liked it.

Thursday, March 29, 1984

It was raining and snowing out and this was the day we had to film all day doing the Cars video for their song "Hello Again" at the Be-Bop Cafe on 8th Street. Benjamin came in drag to pick me up for the shooting. He was going to be in it, too.

I had to be a bartender and wear a tux. The crowd of extras looked like the old Factory

days—Benjamin in drag, and a bald-headed mime in a Pierrot outfit, and John Sex with his snake. And then there was Dianne Brill with her big tits and hourglass figure. The Cars were cute.

They finally got to my part at 8:00 and I had to sing a song but I couldn't remember the words. And I had to mix a drink while I was doing it, and with my contacts on I couldn't see the Coke button on the soda dispenser.

And that meant being face to face with the Cars for a while, and it was hard to talk to them, I didn't know what to say. I finished at 9:15. One of the kids gave me a ride home.

Sunday, April 1, 1984

It was such a beautiful day. The whole town came out of the woodwork. Walked toward the park and a woman lunged at me and said, "I'm Mary Rosenberg, you gave me my best advice, you told me, 'Hang in there,'" but I didn't know who she was. I just closed my eyes and headed through the park with people pointing at me all the way—"That's that famous artist."

So then at the other end of the park I met Jon and we walked. And I had with me all the corn flakes that were stale to give to the birds, but I found a spot without birds, so I guess I actually fed the rats.

Bought *New York* ($1.50). Looked at the movies, decided to see *The Ten Commandments* (cab $4, tickets $10, popcorn $10). And let me go on record: Cecil B. DeMille is the worst director ever. We'd missed an hour but it was still three hours to go and a half-hour intermission. And all those actors were terrible. I mean, Edward G. Robinson, forget it. And forget Yvonne DeCarlo and Ann Baxter, too. Charlton Heston was okay, he was good-looking. The orgy scene was *(laughs)* people dropping grapes on each other—it sounds like an old Andy Warhol movie, right? And then they would lift their skirt two inches off the floor. That was *it*. That was the *orgy*. Edward G. Robinson—you couldn't believe it. And Dustin Hoffman is going to wind up in his shoes, I just know it.

The movie finished. Benjamin had called in the afternoon and said that Victor was coming in from L.A. for a birthday party for him at Halston's. And that made me nervous, after hearing about Marvin Gaye's father shooting him. I could just picture Victor going nuts and jumping out a window or something dramatic. And by the way, last week when I was trying to clean up, I picked up a box and out fell the picture of Marvin and me that PH took in like 1976.

Went home, glued, then I went over to Halston's. Wait a minute, somebody's ringing my doorbell . . . it's those stupid Polacks again. They're still coming over and ringing *my* bell! So okay, at Halston's, at midnight, Victor arrived. I gave him a framed Keith Haring T-shirt and he hated it and threw it away, but then he said he wanted it back for the frame. He's staying at the Barbizon, I think.

And then Alana Stewart arrived and Bianca and Alana wrestled on the floor for fun and I would have gotten the best pictures but I'd forgotten my camera. Alana's in town for the opening of *Where the Boys Are*.

Monday, April 2, 1984

That Girl Marlo Thomas called me up and was like a bulldozer—"We want you to do Gloria Steinem's portrait and we want it right away." So I had her talk to Fred and I guess it's arranged. It's a benefit for battered wives or battered mothers. So I think it's going to be auctioned off and we split the money.

Tuesday, April 3, 1984

Got the new French *Vogue* with my stuff in it and the Polaroids looked okay. Ming Vauze had a full page. These magazines are like books now, they're so thick, so expensive. Then cabbed downtown with Ming himself to meet Lidija ($6). Worked out a few minutes, but I was an hour late for a portrait.

Did I tell the Diary Brigid gave Freddy the cat to Rupert, and so Freddy was caught in the fire when Rupert's house burned down in Pennsylvania, but he hid in the stove so he was safe.

Thursday, April 5, 1984

Fred got me so mad in the morning being so grand when I asked him what was happening with the Michael Jackson portraits. He was giving me these very calm, low-key stock answers, repeating them to me, like "I've got a grip on it," and "It's under control," and things like that, and I told him, "Oh don't give me that." So then when he started asking *me* questions, I decided to just give him his own medicine, and that's what I started telling him, "It's in my control. . . ."

And Gael Love said that Doria and Ron have gotten an apartment in L.A. and that Ron's going to be getting $6,000 for articles he writes, so they wouldn't be doing anything more for us.

Maura came by and made 14,000 calls to L.A., *The New Show* folded and she's going out there and wants to get to Barry Diller's party. And she was saying, "If you have any stocks sell them all, because with this national deficit, I mean . . ." And she just says what her father tells her. So I guess Senator Moynihan wants everybody to panic.

The press had called a while ago and asked what did I think about Campbell's soup having new plastic cans, the crushable kind, and I said, "Oh yeah, sure, great idea, great, great!" So now I just got the cutest letter from a person at Campbell's soup saying, "I'm so glad that you agree with us that we needed a new look." I should have said, "And I'm going to get a new wig."

Saturday, April 7, 1984

Benjamin and his roommate Rags heard that there was a birthday party for Julian Lennon at the Be-Bop Cafe so we decided to crash that. Got a limo that was $3 per person ($20). Got there and pretended we thought it was open for regular business. And somebody tried to introduce me to Julian Lennon but he just looked at me and didn't have much reaction, and so we left, and then on the street we ran into a kid who asked us if we were going to Area and we said yes and took him with us. And at Area I held up the walls for a few hours.

Tuesday, April 10, 1984

Benjamin picked me up and we went over to Sotheby's. And there was only one thing I wanted. Anything with any style will end up at Fred Leighton's. There was a Verdura pin of a big black Negro's face with cabochon ruby eyes and lots of stones.

Jean Michel called me twice this morning from L.A. and wouldn't speak when I answered because he didn't think it was me. Then on the third time he did and he told me that he'd been at the Roxy, Lou Adler's place, "with Jack and Shirley and Debra and Warren and Richard Pryor and Timothy Hutton." Just about thirty people. And then there were parties at Morton's and Spago, and he got home at 5:00, so he felt like a movie star.

Dr. Karen came to the office and she decided to set up an office at the office, so that was fun.

I made an appointment to see a nutritionist. Dr. Linda Li on the West Side.

Gael Love called a few times. Robert Hayes has been out with a cold for three weeks, and somebody put a bug in my head, like "What's wrong with Robert?" But Gael said, "No, no, it's nothing like that."

Went to pick up John Reinhold to take him to Yoko's black-tie birthday dinner for Vasarely's (cab $4). So we went to the Dakota and had to leave our shoes in the hallway. She had lots of pretty boys as waiters. I couldn't tell which one was Sam Havadtoy. Her live-in love. He's a decorator. And it was very chic. We ate in the kitchen, it was fresh vegetables and pasta and maybe something like veal. I couldn't recognize anybody but everybody was somebody. John Cage was there and Merce Cunningham.

And little Sean Lennon fell in love with me, just madly. He said, "Why is your hair like that?" I said, "Punk." He said, "What's your name?" I said, "Adam." Then I asked him to get me a double champagne and when he came back with it he said somebody had told him I was Andy Warhol, and then he went around to everyone telling them, "Do you know who that is? That's Andy Warhol." And I did my old trick, I tore a dollar bill in half for him. And he said, "You have to give me an autograph," and so I signed, "To Sean, Andy." And he said, "I'm not interested in your first name, I want your last one." And I told him that I wasn't so famous at all, that the other people were there *really* famous, like John Cage, and that he should get *his* autograph. So he did, and John signed the most beautiful signature. And then Sean had him sign a "J" and then he came over and ripped the "J" in half and gave me half. But John had done it on the back of the really beautiful signature so that was ruined—Sean could have had a beautiful John Cage autograph.

Oh, and when I was cleaning at home just the other week, out of a drawer fell pictures of John and Yoko that I'd taken in the sixties or early seventies, and two of the photographs were double exposures of their faces, and it killed me to give one of those up, but I did. The one where you could tell them apart I gave to her, and the one where the features were all together I kept. When could I have taken those photos? Let's see . . . I was going around town with John and Yoko when I was looking to buy a building downtown, so it was before I got the Bowery place, which was around '69, and there were three buildings on Greene Street, each for $200,000, that were all being sold together and Yoko was going to buy one and John was going to buy one and I was going to buy one. But then Yoko got greedy and wanted all three. And then they wound up not buying any of them. But by then I'd been pushed out of the picture. And that building would be worth millions today. I *think* that was the year she had that show in upstate New York where she flew everybody up there on one of those creaky airlines, like One-Way Air or something. She spent $25,000 to fly everybody up there but then she didn't have any other freebie for them— no food or anything. Just up there. And there was an "in" party and an "out" party, that kind of stuff. What year was that in? I can't remember if it was before I was shot or after. It could have been '67 or '68 or '69 or '71. I just don't know. What makes me think it was before I got shot was that it was just me who went up there and I think if it was after I was shot then Jed would have come, too.

Dinner was served and I sat next to Walter Cronkite and Sean, and I told Sean that if he wanted to be a host he should get us food. And I had him take pictures for me of all the shoes lined up in the hallway. And Sean had the flu and the girl next to Walter Cronkite had the flu and so I was being coughed on, so I just know I'll get it.

I talked to Walter Cronkite and that was interesting. I told him I'd just read the Jody Powell thing in *Rolling Stone*. He said he thought Carter was the most intelligent president. And he said that years ago when he went to interview Nixon one of those times he was running for president, they sat him outside the door and he heard Nixon on the phone saying "piss" and "cocksucker" and "fuck," and Walter Cronkite thought it was a setup to have him hear all this so he would think Nixon was really macho, but then years later when the Watergate tapes came out he was surprised to hear Nixon talking like that all the time.

And then I heard Sean talking to this guy and asking what his name was and he said, "Coppola," so then I told him how much I loved *The Outsiders* and *Rumble Fish*. And we talked about how he had so many great kids in those two movies, that it was like *American Graffiti*—all the kids would become the next generation of big stars.

And I didn't know Coppola was from New York. He said he went to Hofstra and I said that we'd done a lecture there once with Viva. And he said that his little girls miss me, I met them in Colorado skiing. He was with his wife who didn't say anything. And then Sean saw that I had bluejeans on and he started saying, "You're the only real person here, you're so cool, you're so cool." He's so cute.

And one of the waiters was somebody I'd discovered for *Interview* and he'd had a whole page as a bright young new star, he was in Jack Hofsiss's play, and he went to L.A. for a year and now he's back and being a waiter—it was really sad. I forget his name, although he told me again last night. From Georgia. Something like Bruce, maybe. I dropped John Reinhold (cab $6). Got home at 12:30. Decided to read the *Daily News* and got to bed at 2:00.

And Yoko looks really good.

Wednesday, April 11, 1984

I think Jean Michel called a couple of times before 8:00 but hung up. Then at 8:00 he called and we talked. He said he was coming to the office that afternoon but he never made it. I had a 10:30 appointment with Dr. Linda Li, who was recommended to me by Timothy Dunn, a model who came by, and by Joey the hairdresser (cab $4.50). She's a pretty Chinese lady, and she told me to hold out my arm and push and then she'd knock it away like karate, and she said I was fine, but I don't know what that meant. The Patty Cisneros lady, Bob's friend who's so grand, was waiting there and she looked fat. Then cabbed over to 720 Park Avenue to Emily Landau's lunch ($5).

Thomas Ammann was there and Fred arrived drunk, talking like Mrs. Vreeland and being grand, but he did talk about interesting things. Furniture and everything. She had beautiful black guys serving. She's the one who owned the apartment at Imperial House that Liza bought. I did her portrait but it never really looked good, and the reason I wanted to do it again was because she has all these great paintings like Rauschenbergs and Picassos and I didn't want to have mine looking bad there.

Thursday, April 12, 1984

Jean Michel came by. He'd been out all night. Got him to work on one of our joint paintings. He wanted spaghetti so we got some from La Colonna ($71.45). He fell asleep and then he got up and he was up front by the phones with a big hard-on, like a baseball bat in his pants. I guess that's being young, I forget about those things.

Gael's been doing double work since Robert Hayes has been out. And the kids say that they think it's mental with him more than anything, but that when they go over to see him he *is* actually coughing. And three weeks is a long time to have a cold, isn't it?

Friday, April 13, 1984

We photographed the street people in front of the Public Library and it was fun. One man with chains, and I gave him change ($2) and then people were interviewing me. And I'm going to do that more. I didn't get photo releases, but I think I'll start carrying some with me every day. Worked till 7:00. Then had to meet Jon, dinner at Woods ($80). Then ran up to see *Friday the 13th* on 86th Street (cab $3) and it was the most peculiar mix of a crowd—rich preppie kids and black kids and the whole theater was a constant screaming riot, everybody jumping up and down. It was the weirdest experience ever. And the murders were so gruesome. I want to do a movie called *Stalk the City* where there's a murder a minute. This movie opened in 1,500 theaters. It's *(laughs)* a Paramount picture.

Sunday, April 15, 1984

It was a miserable day, rain pouring down. The dogs were running around so that wasn't too peaceful. I stayed home and did research, looking at the Weegee pictures. He's so great. People sleeping and fires and murders and sex and violence. I want to do these kinds of pictures so much. I wish I could ride around with the police. But I figure I can just do setups—use plants in my pictures: I want to throw Benjamin in front of cars.

Monday, April 16, 1984

Jean Michel was at the office, he brought his lunch and he was on the floor painting and not talking much. I think he stays up all night and so that was his bedtime. Rupert came by and told me about the show at P.S. 1 where they created a replica of the old 47th Street Factory. They had a silver room and people passing out LSD and an Edie running around.

And Robert Hayes is now in the hospital with pneumonia. But I don't think he has what he's afraid he has. I think he's just run-down and scared because that's what Cisco has. I mean, I don't think you can catch it that easily.

I did a Dog painting in five minutes at five of 6:00. I had a picture and I used the tracing machine that projects the image onto the wall and I put the paper where the image is and I trace. I drew it first and then I painted it like Jean Michel. I think those paintings we're doing together are better when you can't tell who did which parts.

Then the streets were deserted and we finally figured out it was Passover. Dropped Benjamin ($7).

Tuesday, April 17, 1984

It was a beautiful day. Took pictures of the street people, of about eight artists who were doing portraits of people on the street. And there was a black ventriloquist with a crowd around him so I stuck my camera up to get the picture but the dummy saw me and yelled my name and then everybody turned around and I had to sign autographs. Took pictures of a couple of preachers, too.

Stopped at a Japanese place just to get some nourishment, and the waitress couldn't speak English but she wanted my autograph. So I guess my commercial's still running in Japan ($75). We had drinks, my first time in weeks, so that made life more bearable. And called John Reinhold. The 860 office said that Jean Michel was waiting there, but I went to the new office and since I was high I terrorized everybody.

Walked down to 860 and as we passed the new chic food place on 23rd Street a couple of black truck drivers yelled, "Hey faggots!" so that got me down. Especially because truck drivers are usually the ones who're cheerful and recognize me and wave. Maybe these were faggots themselves.

Got to the office and called Jean Michel and he came up and painted over a painting that I did, and I don't know if it got better or not.

Dropped Benjamin ($6). Glued myself, and cabbed to a dinner at Club A ($4). I was at a heavy-duty table next to Diane Von Furstenberg who's having Michael Graves do her new store that's next to Vieille Russie. And I told her not to count on a May opening, I told her how long it took Michael Graves to do John Reinhold's apartment and I said he'd probably take her little store and divide it into fifteen rooms with forty columns in each, and then she got scared. And she talked about a party she was giving for Michael Graves, but she didn't invite me.

Wednesday, April 18, 1984

I'm just on the phone with Christopher. Robert Hayes is in intensive care, his mother's coming down from Canada. He was coughing for weeks and pneumonia's really dangerous, you can go just like that. Before he went into the hospital he was home for weeks, he said from a bad flu. He came in for a business lunch once, though, and I asked Gael why he had round little bandages on, and she said he'd just had moles removed, and that sounded reasonable.

Then there was a lunch at the office for Charles Jourdan shoes (cab $6). Jay came to work glowing, he's in love with our fashion editor, Kate Harrington. And I said I thought she was going with John Sykes of MTV, and Jay said, "Listen, she broke up with him the day she met *me*," so I mean I didn't want to get into *that*. Kate has eyes for everyone. She's so bubbly, so pretty. Let's hope Jay stays in this good mood. And Jean Michel was after Kate, too—she styled an *Interview* shoot of him and de Antonio in Armani clothes and he left five joints for her.

Victor called a couple of times and now he always brings up that I said he could be dangerous and he always mentions Valerie Solanis. He's staying at the Barbizon now, he said Halston's changing the locks. He thinks Victor's stealing his Peretti candlesticks, but actually he just borrowed them to leave with the Barbizon as a security deposit. Victor gave me two at Christmas, but that was with Halston there and it was only on the condition that Halston could get more of them. If he couldn't, then I was supposed to give them back. But Tiffany *does* have more of them—I checked.

Sunday, April 22, 1984—New Hampshire—New York

I was up in New Hampshire just over the Massachusetts border in Hampton Beach with Jon's old friend Katy Dobbs, near where Jon's family has a beach house. Katy talks a mile a minute so it made things easier. It was so beautiful up there, I want to get a house there, too. It's like Montauk. On the ocean. But they've put in bigger windows so the whole view is a window. And they're winterizing the houses up there. And it was too hard to put the curtains down so I left them up so the sun woke me up every morning really early. I was reading the Ned Rorem diaries while I was up there. From the sixties to '71. He missed the whole scene that *we* were part of, though—he was back in the elegant forties and fifties still. He puts me down a couple of times, I guess.

It was Easter and we went to see a friend of Katy's. Fred, her boyfriend who's on the Nickelodeon

cable TV channel, was in Tennessee for a whistling contest. He's so talented and cute. They call him "Andy" because he looked like me with white hair—the Phil Donahue look—but after meeting me and seeing how old I actually am, now they call him "Son of Andy." He did the voices for two of the gremlins in the new Spielberg movie and he got $500 a day. That's not much. Three days' work. The gremlins are forty minutes of the movie.

Oh, and on Easter services, they got up at 4:30 to go, but I couldn't go. I didn't want to go because I would feel too peculiar in a church where they might see me praying and kneeling and crossing myself because I cross the wrong way, I cross the Orthodox way. And they would be looking.

Then when they came back we took a ride and then went to Jon's family's house for lunch. They had about ten people. Lunch was outside. They have Christmas-tree kind of trees. The twin brothers, Jon and Jay, were both wearing bright green pants. They're all macho but they like to freak for the weekend. The brother just broke up with a beautiful model who lives in New York who I met once. He's in his father's business. Insurance. He just bought a house of his own up there.

I haven't heard anything about Robert Hayes.

Ned Rorem met Anaïs Nin just so he could be in her diary and she could be in his. And I want to do that, too—I want to find somebody else who does a diary now so we can be in each other's. And also in the morning the Easter Bunny came and I ate chocolates in bed. And then it was time to get a ride to Boston and get the shuttle to New York (tickets $171, magazines and newspapers $5).

Monday, April 23, 1984

There was an earthquake Sunday night at 8:40 in New York. And we had one last year, too. It's really scary. I thought Manhattan was built on the stuff that wouldn't have it.

So my face broke out in pimples, I was being paid back for not going to church on Easter. And I was supposed to go on Monday, but then I went to Seaman Schepps instead. To look at a bracelet. Benjamin and I wandered around in the rain and the *Interviews* always look so awful when they get wet.

I still have a pain in my side and so I've changed my appointments with Dr. Linda Li to Tuesday so I won't have that and shiatsu on the same day, and I haven't gone to Doc Cox yet about the pain because I'm hoping it's a muscle spasm or something, but if it's not, I'm a goner.

Cabbed downtown ($7). Called Jean Michel and he came up and ordered Chinese food from a place on Sixth Avenue. And then Keith Haring wanted me to go and see his paintings before they got shipped out, because he said I influenced him—he's painting on canvas now. So we ate Chinese food and things from Pie in the Sky.

Victor called and invited me to a small birthday party for Halston's niece, and it's Halston's birthday, too.

And Robert Hayes is a little better, his temperature went down.

Dropped Benjamin ($7), went home, got dressed, then *(laughs)* crashed a dinner. It was for

Shirley MacLaine and I *thought* I was invited but it turns out I wasn't. I mean, I'd had Brigid call and she said, "Cocktails at 7:30 and dinner at 8:30." So when I got to the Limelight at 9:00 (cab $6) the doorman said, "Oh my, you're awfully early, aren't you?" And I said, "But I'm invited to dinner," and he said, "Oh, oh, sorry." And then we went in and dinner was just starting. The guy said, "Excuse me, Mr. Warhol, let me just go check something," and then he came back and said, "Sorry Mr. Warhol, yes, it'll be all right." So I still didn't know I was crashing. But I mean, finally I was getting the idea, because it was *really* intimate. Only like thirty people. Bella Abzug was there and later on Iris Love and Liz Smith came in. The theme of the party was "white" and Liz was in a white tuxedo and Iris talked to me about the dogs because that's all we have in common, and I just had a white turtleneck on but everybody else was in white tuxedos. And the food was really good. Exotic. A vegetable that I never saw before that looked like crinkled-up green beans. And some perfumed lamb that was interesting. And everybody gave speeches. I was the only one who didn't give a speech.

And her daughter was sort of pretty, Shirley's, she looks like Penelope Tree sort of, and she gave Shirley a kiss on the lips. And Bella got up and made a feminist speech, and her husband got up and then a three-tier wedding cake came out, and Shirley gave her dramatic speech. And then there was coconut ice cream. And Shirley came around and she patted me on the shoulder like a dog and said, "Hello there, Andy." Then finally it was time for me to leave and go to Halston's.

Cabbed up to 63rd Street ($8). Halston's niece is really pretty now. And Halston handed me a piece of paper in the shape of a boat and I was so thrilled, I knew it was the rent check for $40,000. So that made my evening. And since it was so rainy I didn't have any gifts with me so I wrote an I.O.U. to Halston and Victor and the niece. "I.O.U. One Art." Liza said that Mark's only doing his artwork now, that he's stopped producing plays and now he's just working at his studio on Prince Street. So I guess he must be having an affair down there. She said he's almost ready to have a show.

So anyway I went home and I opened up the paper boat and instead of a check, it was just nothing—like "Happy Birthday" or something. It wasn't a check and it should have been a check. All done up like a boat. It should've been a check.

Tuesday, April 24, 1984

I had an early appointment with Dr. Linda Li (cab $4.50). This is all to keep myself beautiful for business. Linda Li with her secret powers, it's all too crazy. And I can see why these Chinese women make out. It's all sex. She puts her hand on her cunt and pokes me in the gut through to the other side, and throws my whole body around. She said she's never dropped a patient, but I could've been the first. She has control over your body. She's not bad-looking. So I was there for a half-hour being tossed around. Then phone calls ($.50).

Jay's still cheerful, so I guess his affair with Kate is still okay. I went over to Yanna's for further beautification. I went past the cops at the Police Academy, and the girl cops are cute, they're not like dykes now.

Wednesday, April 25, 1984

The Kennedy kid, David, was the big headline. He's dead, and they put out an extra edition and they were screaming it, and it was selling newspapers fast. He was the one that everyone thought might be gay. Blond and pretty and fey and not like a dog—he didn't have those teeth. And this morning on the morning show they had Boy George on for fifteen minutes, and he was being a problem, saying he screams at people who want autographs now. And Count Basie was on for half an hour because he died.

Monday, April 30, 1984

Victor came by and he was putting me down, asking Jean Michel why he's hanging around with me. And they went off together to Victor's to look at some things. And I hate the paintings that I did yesterday.

Then Jean Michel called me. His show at Mary Boone is coming up this weekend and I guess he's nervous. Sent out for lunch ($44.25). And the gossip is that Julian Schnabel left Mary Boone for Pace because they gave him a million up front. And Jay's still in a good mood so he's working hard and looking around for a mover to help us move completely out of 860 and up to the new place.

Oh and in Ned Rorem's diary he talks about some girl named Jean Stein being so terribly in love with him. Something like that. I'd like to mail her that page anonymously, let her see how it feels to be put down in print. I think I will.

Tuesday, May 1, 1984

Got up early. Benjamin picked me up and we went to the Calvin Klein fashion show. We were late, but they'd saved my seat up front (cab $6). Nan Kempner didn't say hello, probably because she didn't invite me to her dinner that night for Jamie Wyeth, I guess she was embarrassed. But maybe it was my fault, because when you're late you rush in and you don't know who to look at first because everybody's there, so you're awkward. And Calvin's stuff was like Perry Ellis with touches of YSL. I guess Marina Schiano puts in her two cents. The colors were all somber. Blacks and greys.

It was a beautiful day, and I wanted to get out of the office but never did. Jean Michel came by and we worked. Went to the Coe Kerr Gallery for the Jamie Wyeth opening. Ran into Lacey Neuhaus and Doug Wick, and talked to Ted Kennedy, Jr. Jean Kennedy Smith was there and she was nice and smiling. Jamie invited me down to the farm this weekend but I said I had to be packing and moving.

Cabbed to the Ritz ($4) with Jon, we went in to see the Stephen Sprouse fashion show. It was early but it was mobbed already. My seat was gone, so I took Charivari's. Teri Toye the transvestite was in the show. And everybody was saying it was like the sixties. The show was great, really the

fashion is so good again with these disco kids, they have a real look. Like the boys with the straight cut over one eye. So extreme now.

Wednesday, May 2, 1984

It looked pretty out but then it was sort of windy. Was picked up by Benjamin and we went out on the highways and byways with our *Interviews*.

And John Reinhold called and said he was leaving town on a trip and wanted to tear a dollar in half like we do and then when he comes back we'll put the dollar together and spend it.

And Woody Allen won his suit against the look-alike just like Jackie Onassis did against hers. So now the poor Woody Allen look-alike can't work in commercials. They told him that unless *(laughs)* he became famous in his own right for something he couldn't pose for ads. Isn't that something? But I mean, why can't they just put "Model Joe Schmo" (cabs $3, $5).

And I just hate the Trumps because they never bought my Trump Tower portraits. And I also hate them because the cabs on the upper level of their ugly Hyatt Hotel just back up traffic so badly around Grand Central now and it takes me so long to get home (cab $6).

Robert Hayes is doing really well, he's recovering, it was double pneumonia, and he had a crying scene with Gael, told her that he'd been doing too much coke and let himself get run-down and that he'll never do it again and that he was going to write me a letter. So it was double pneumonia, not AIDS.

Jean Michel was there but he was nervous about his show and I had to push his hand around the canvas. For the first time in a while he'd taken heroin, I think, so he was moving slow (cab $7).

Then went home and Eizo gave Jon and me our shiatsu treatments. And my pain went away. Watched *Dynasty*, and it was the first time Diahann Carroll was on the show and it was so good. What a camp. She meets Alexis and she out-champagnes and out-caviars her—"This champagne is 'burned.' It's been frozen at one point."

I'm so sick of the way I live, of all this junk, and always dragging more home. Just white walls and a clean floor, that's all I want. The only chic thing is to have nothing. I mean, why do people *own* anything? It's really so stupid.

Thursday, May 3, 1984

Mary Richardson called and said that the only thing that the Kennedy kid who O.D.'d—David —had on the wall in his apartment was the napkin drawing I gave him—I don't remember if I drew a cock or just hearts.

Everybody at *Interview* was thrilled that Robert's gotten better. I'm going over to see him. Gael said he's happier and brighter and younger-looking than ever.

Jean Michel called and wanted us to come down to the Mary Boone Gallery to look at his show, so I said we would. So I took Jay and Benjamin and it looked great (cab $5). Jean Michel was very nervous. He was with a pretty Korean girl who's the secretary of Larry Gagosian, his

gallery person in L.A. But he'll just break her heart. All these pretty girls go for him. They were lovey-dovey, holding hands. Then Jean Michel wanted to go to dinner, so we decided to go down to Odeon because that way we'd be close to the Area party for Vincent Spano that Vic Ramos was having (cab $6). And Robert Mapplethorpe was there and something's wrong with the way he looks now. He's either lost his looks or he's sick (dinner $280).

Area was close by but we took cabs because it was raining (cab $3). And the only big draw was that Matt Dillon and Vincent Spano were going to be there, and Benjamin went up to Matt and said, "Andy's looking for you," but he said, "Andy who?" And then later I did talk to him and he was just mumbling and looking for girls. He really has to get a good movie soon, he needs one badly.

Saturday, May 5, 1984

It was beautiful and sunny, did a lot of work. Called Jean Michel and he said he'd come up. He came and rolled some joints. He was really nervous, I could tell, about his show opening later on at Mary Boone's. Then he wanted a new outfit and we went to this store where he always buys his clothes. He had b.o. We were walking and got to Washington Square Park where I first met him when he was signing his name as "Samo" and writing graffiti and painting T-shirts. That area brought back bad memories for him.

Later on his show was great, though, it really was.

Monday, May 7, 1984

Jonathan Scull just called to say that the lunch was cancelled at the Whitney that was going to be for his mother, Ethel, giving my portrait of her to them, because she fell off a ladder and broke her leg in two places. What was she doing on a ladder? And I saw her the other week walking on 66th Street, going along, talking to herself, swinging her hanky.

So went to the office and the office was busy. Bruno was there and Jean Michel was hiding our work from Bruno—the ones that just Jean Michel and I are doing. Bruno has the ones that Jean Michel and I and Clemente did, but he doesn't know about these that're just the two of us.

Bob Colacello called about the party that São's giving for his birthday, and Brigid talked to him. I have a feeling Brigid's still very friendly with him. I'm invited.

Tuesday, May 8, 1984

Went to pick up Benjamin and we took *Interviews* and went over to Christie's and the girl there was nice, she showed us the show. And there's a big fake of mine there, but I'd signed it. I don't know why I ever did. But it was Peter Gidal's and he'd done that book on me, so I wanted to be nice once and I'd signed it for him. It's four Jackies and I never put them together in a print, I don't think. No, my Jackies were all separate.

And then we left there and passed Regine's and Benjamin nudged me because Paul Anka was saying hello and I didn't recognize him. He's so suntanned. And Benjamin knew I did his portrait so he poked me. I just saw clips of him when he was young on TV this morning. He looks a lot better now than he did then—he must have had a lot done.

Jean Michel came up and was so paranoid, he smokes so much marijuana and then gets paranoid. Then he called me up in the middle of the night and said that his painting at auction went for $19,000. I bet mine went for nothing. Probably. My Liz. Probably $10,000. I can just see it. So his went for $19,000. And there were all these parties for the Museum of Modern Art and I was invited to all of them but I didn't go to any of them. Dropped Benjamin ($6.50). Woods for dinner with Jon ($100).

Wednesday, May 9, 1984

Got up early but Benjamin wasn't picking me up because they needed him for a moving day at 860, so I wandered around alone, and it's hard, I'm used to having him as a bodyguard. So I just fended people off by giving them *Interviews*, I had a lot with me. Oh and I got an invitation to a second Jackie Curtis wedding. He's marrying a boy again. A priest is doing it. And Jackie's picture is so air-brushed he looks fifteen. Blond hair and blue eyes.

The English advertising guy, Saatchi, who wants to buy the Marilyn wanted to pay for it over four years or something, so now I don't know. The whole point was to get money fast to pay off the construction guys at the new building.

Oh, and Ruth Ansel called and said that Marvin Israel died, but I didn't accept the call because I didn't want to accept that he died. He had a heart attack on Monday, in Texas, doing something with Avedon. He was the art director of *Harper's Bazaar*, I worked for him once.

Thursday, May 10, 1984

I went to Sotheby's to see how my drawings were going. Early 1962 drawings. Fred had been there bidding on them so that drove the price up, but some other guy got them. It's all dealers who put the stuff in and bid it up. It's their business. All the people who have the work just bid it up. Ran into Jed looking at Art Deco.

Friday, May 11, 1984

I got an invitation to a show of silkscreen portraits of Francesco Scavullo photographs—done in silkscreen by Rupert Smith! And Fred says I shouldn't yell at Rupert but I bet they look just like mine. I mean, Rupert knew he was doing something wrong or he would have told me, he would have said, "I'm doing this, I hope you don't mind."

Sunday, May 13, 1984

Thomas Ammann called and we went down to look at the work of the artist named Fischl who *Vanity Fair* just did a story on. He paints the things like a girl douching with another girl looking on with the pubic hair showing, and a monkey and a baby—sort of copies of Balthus.

Monday, May 14, 1984

I went over to Dr. Linda Li's and she did all the right spots and made the pain go away. But then in the *Enquirer* I read the way you can press and do it yourself, so I don't know, and then at the end of the article they say, "But call your physician."

Wednesday, May 16, 1984

I'm giving Rupert the cold shoulder. I mean, everybody who's seen that Scavullo show he did said—well I mean, he's colored the eyes and lips and done double portraits, everything just like mine. I'm *so mad*.

Went down to the Paradise Garage for Keith Haring's party and there were kids outside selling tickets to it, although it was a free party. John Sex performed. Madonna didn't start until so late that I only heard the beginning. And that kid Bobby who lives with Madonna was there, the one I got the job for in Paul's movie. And he's in the hospital for a leg operation—he had his hospital bracelet on—but he snuck out for *(laughs)* this party. And all these kids were wearing Stephen Sprouse outfits, I don't know where they get the money. Keith's Juan was in Day-Glo and it was like the sixties. And they have a phrase that's like "Mark me," when they want you to sign their stuff. Maybe it *is* "Mark me."

Thursday, May 17, 1984

Well the big shockeroo of the day was when we're all at the office and it's really busy and in walks my brother who I haven't seen in twenty years. Paul. He came up to buy a place for his son James who was with him, and James's girlfriend. James is the artist that I wouldn't help when he came to New York. He wanted to work for *Interview* and I told him to make it on his own. And now he's buying the apartment in Long Island City that my brother's giving him money for. He's got a Salvador Dali mustache, James does, and his girlfriend was bubbly.

And Brigid was loving it all. Plus I'd just gotten a letter from my sister-in-law. She said that George is getting a divorce and the wife is trying to take away the business that my brother gave him. They have two kids. It's a junk business. You know what I mean—like they get scrap and electronics machinery and melt it down, and they get a lot of gold out of it—you melt it down with blowtorches in acid and then the gold floats. They live in Pittsburgh. And they're buying up the black neighborhoods on the North Side.

And my brother speaks better than I do, he always was a good talker. He's a big gambler, too. And he's retiring and bought a farm up in Erie.

Ran into Bill Cunningham on his bike, I just wish I could do what he does, just go everywhere and take pictures all day. And he used to be a hat designer, but he went into photography when hats went out in like '64. I met him around Serendipity. When hats went out his whole life disappeared. And now he takes these photographs all day, I see him even in odd locations, like on 43rd and Lexington shooting people coming out of Grand Central. He's so meek and skinny, and he rides his bike, and you never see him eat or drink at these parties.

Cabbed to meet Lidija at 860 ($5). The place was emptying out. They were moving stuff up to 33rd Street all day. Worked all afternoon. Rupert came up and now he's meeker. Went to meet Jon at East-West for dinner (cab $10).

Friday, May 18, 1984

Went with Benjamin to the camera store and bought the new Olympus camera that Chris told me about ($410) where you can take 5,000 pictures on the battery and then it has to clear for a month. They have the old Polaroid models still with the boxes and everything, and I should buy them up.

Tonight at Danceteria they're putting on an "Andy and Edie" show—Ann Magnuson's playing Edie.

My cousins from Butler came to lunch. One of them had called and said they were coming to New York, so I invited them. She's nice. I don't mind her. They stayed all afternoon.

Monday, May 21, 1984

Peter Beard has the greatest commercial on TV now. It's for Kodak. He's on the outside of a helicopter taking pictures. He's got a new agent.

Went to a black-tie dinner at Mortimer's for the designer Enrico Coveri given by Florence Grinda. And Barbara and her Polish boyfriend were having a fight that I was in the middle of. Everything he said she contradicted. And I don't know why. And he's ended up buying a house out in Connecticut right next to Peter Brant. He plays polo like Peter. He has a good-looking face, like an old fairy would be good-looking like this, and he's the Joe Allen type—short and stocky with grey-black hair and I think capped teeth. He knows all the right people. And everybody says he bought his title, he's a Polish baron or something.

I had invited Jean Michel as my date and I was next to him, so maybe they thought it was a girl's name. Richard Gere's Silvinha moved her seat to sit next to Jean Michel. And Jean Michel gave me all his meat for the dogs, and Silvinha did, too.

I'm watching MTV right now. I don't know what else you can do to these videos to make them different. They're all the same. They're all like sixties underground movies, people running around. Like Stan Brakhage and all those kids used to make.

Tuesday, May 22, 1984

Benjamin called in the morning and we dished on the phone for a while and then he came up. I called the elevator man and told him about a spark I saw but he said the spark's always there, that it happens all the time. Then, since I had to go to the Doc's at 3:00 I couldn't eat because I was going to have tests. But we wandered around and I had a lot of energy because of the vitamins.

Jean Michel came down to the office early. He was reading his big review in the *Voice*. They called him the most promising artist on the scene. And at least they didn't mention me and say he shouldn't be hanging around with me the way the *New York Times* thing did.

I opened up one of the boxes in the back that's being moved and it had 16mm rolls of film and letters from Ray Johnson the artist and I think my bloodstained clothes from when I was shot.

I realized that the reason Tony Shafrazi hasn't gotten even one of the artists in his gallery into MOMA is because Tony's the person who defaced Picasso's "Guernica." But that's not fair. Keith Haring isn't at MOMA. And they just have *one* thing of mine, the little Marilyn. I just hate that. That bothers me.

Then in the afternoon I went to Doc Cox's (cab $7) and I protested over the thermometer that they used, because it just sits there in water and everybody uses it, it's not right. And Rosemary took my blood pressure, but I have the feeling they just throw these tests out. Bubbles was tan. And they have a new heart machine so now I don't have to run up and down the stairs in the hallway *(laughs)* to get my heart going—it's a big improvement. And Freddy won't take your blood if she doesn't know you.

We went to meet Paige and Benjamin ($4). And after dinner ($120) at Hisae and drinks at Jezebel's ($30) we went over to Stuart Pivar's because he was having people over and I wanted to learn about art. I brought a small bronze with me that I just bought, three inches, and Stuart said it was a piece of junk, so tomorrow I'm returning it. I had it on consignment.

And did I tell the Diary that Benjamin and I ran into Virginia Dwan and her daughter who's married to Anton Perrich who did all those videos and rented our old floor at 33 Union Square West when we moved out. They said Anton was home with his painting machine and I was so jealous. My dream. To have a machine that could paint while you're away. But they said he had to be there while it painted because *(laughs)* it clogs up. Isn't that funny?

Wednesday, May 23, 1984

I asked how Robert Hayes was and they said he's still in the hospital.

Benjamin was supposed to be in drag when he picked me up to go to the Karl Lagerfeld dinner at the Museum of Modern Art, but he wasn't. We walked right into the elevator with Karl, who was sweet. Wearing lipstick with his ponytail. My dinner partner was Fran Lebowitz. She was fun. She doesn't drink or eat dessert. She smokes constantly, though. She's moving out of that apartment in the Village. I guess she lost the case. She sublet it and had Jed do all that work but she never

had any signed agreement with the person. And I think Jed really warned her but she didn't listen. So now she's moving up to the Osborne across from Carnegie Hall. She was wearing black tie but without the tie.

I put a lamb chop in a napkin for the dogs and got blood on my pocket. Dinner was over at 10:30.

Then Jean Michel was waiting down at Odeon (phone $.90, cab $10). And the Fischl guy came over and said that as he was leaving the house, he had the TV show *College Bowl Championships* on, and I was the answer to a question and that the girl from the University of Minnesota got it in a second. It was, "Who painted Marilyn Monroe?" And I saw the dyke from *Artforum* who made me do all that free work—doing an original Dollar Sign, and then in the same issue she let some guy write the worst review of me that's ever been in the magazine.

Then we went over to Area and the theme was "Red." And Jean Michel's girlfriend Suzanne was there, the tiny makeup artist. And Shawn Hausman, one of the owners—he's Diane Varsi's son—was on a ladder, I thought it was part of the exhibit but he was fixing a fuse. Shawn told me that Eric Goode told him that he's so awed when he sees me that he gets goosebumps.

And Fred's been going out with Joan Collins who I guess is having a fling with Mick Flick. I guess that's how these girls get their baubles—as thank-yous after a big night.

Thursday, May 24, 1984

Jay and the crew were moving. I opened a Time Capsule and every time I do it's a mistake, because I drag it back and start looking through it. Like I found some film fragments in one and then you just wonder where the rest of the film is. The Whitney now has my old movies. I finally gave them to them—Vincent did. But they can't do anything with them without my permission. They're just looking through them now and cleaning them.

Jean Michel came by and he was in a pretty good mood. We had Chinese take-out food. He was painting some big black screaming people. Worked till 7:00. Jill Fuller picked me up outside in a limo and we went to see the Pink Floyd guy perform at the Beacon Theater.

And then afterwards there was a dinner that Lorne Michaels was giving at Cafe Luxembourg, so we went over there. Henry Geldzahler and Clemente were there and I felt bad because Jean Michel and I are doing the combined canvases now without him and they're coming out so good, whereas the ones we were doing with him, Bruno gave us so little for. But maybe we'll give Clemente some of our rejects and see if he can do anything with them. He's really sweet.

And Steve Martin came! That was exciting. He's so good-looking. I thought that he was going with Bernadette Peters but he was with this new girl and I didn't know who she was. He has such a good body, and he's really attractive. Someone started to introduce us and he said no, that we'd met already, that they didn't have to. He told me he'd had a Marlon Brando of mine for two days but then had to return it because it didn't go with his place, it didn't fit. The Jane Bonham Carter girl was there and she happened to call the girl with him "Vicky" and then it clicked who she was! It was Vicky Vanini, who used to be married to Peppo Vanini, and now she's the actress Victoria Tennant! And here I'd been looking at her across the table and not recognizing her for an hour. No wonder people think I'm on drugs. So then we began to blab and that was fun.

Friday, May 25, 1984

I called and screamed about that picture of Jean Michel in the Dolly Parton issue because it was so awful—cut in that arty way. And when I screamed Gael said Fred had done it, so I called and screamed at Fred and he said it was something that he'd done especially personally.

Robert Hayes is still in the hospital. John Reinhold called him but Robert's mother wouldn't let John talk to him. He still had a temperature. His family's been here for one and a half months. The hospital bill is going to be so big. I guess Blue Cross pays for 80 percent, but still. It must be like $500 a day.

Saturday, May 26, 1984

Got up early. Jean Michel called a couple of times. He calls at like 7 A.M. because he hasn't gone to bed yet. He wanted to go to the Jackie Curtis wedding so I got myself together. Cabbed to St. Mark's Church on Second Avenue ($9).

But the wedding was called off there because the priest was upset because Jackie had called the newspapers and done press, so he wouldn't do the wedding, and so it was moved to Mickey Ruskin's place at One University so we went over there. Jackie's relatives would come over and say things like, "I'm Jackie's aunt from Toledo." And then Jackie arrived, so late as usual, and it's the strangest thing, she's still telling everybody that we were roommates twelve years ago. I'm beginning to think maybe she really does believe that. Remember when he used to tell interviewers that we were roommates and it was a big joke? Well now I wonder did he believe it then, or did he start to believe it later, or did he just have a hallucination for a *minute* and it stuck? Anyway, for some reason he now really does believe it. There were a couple of people there who looked like Valerie Solanis who came over and said hello. Jackie was wearing a beaded cut-short dress and his teeth were so bad-looking. The groom was a good-looking Czechoslovakian boy, maybe twenty-one or twenty-two, and maybe mentally retarded, I don't know. He didn't open his mouth. So then we left there and went to the Village, and it was the Art Fair time and so many people stopped me for autographs.

Sunday, May 27, 1984

Went to church.

John Reinhold picked me up and we walked from 66th Street to 96th Street and back, and by that time I was so tired that I couldn't face going down to the Village or anywhere. My bones were aching so I decided to stay in and ate half a watermelon because Eizo told me watermelons are good for you, that they wash out your kidneys. And I still have the pain. Doc Cox thinks it might be a kidney stone, he doesn't know. It's like a muscle spasm. I think Lidija had me doing too many strenuous things—she kept making my routine harder and harder. But I think that a person my age instead of doing harder things should do repetitions of the same level more.

Tuesday, May 29, 1984

Benjamin and I wandered and went into a Japanese restaurant and called John Reinhold to meet us, but then they said they wouldn't give us a table until he came. Then when he came they said they didn't *have* a table and we got mad and left in a huff and we were going to go to Pearl's but then we went to Raga, and we go in and there's a "hostess" who thinks she's so grand, and there's absolutely nobody in the place—eighteen empty tables, and she's putting on these grand airs, like a drag queen or something, floating around with these sleeves. And she takes a phone call and has us stand there waiting as if the phone call is more important. So we ate, and it was really expensive for just what was going to be a run-in-quick lunch ($125, and I didn't tip much, either). "Yes, we *may* have a table for you. . . ." I mean, what are these people *thinking* about? Left there, cabbed to meet Lidija ($6).

Jean Michel was there, he'd gotten pizza but then didn't want it. Then we painted an African masterpiece together. One hundred feet long. He's better than I am, though. Worked till 6:30.

Wednesday, May 30, 1984

Tina Chow was having a lunch at Mr. Chow's at 1:00. So we went over there (phone $.80, newspapers and magazines $4.50). And the best thing was Jerry Hall. She looked sort of voluptuous, and she had pictures of the baby who looks just like Mick. And Jerry said to me, "I'm so glad I'm sitting next to you because you know, to open my own beauty salon/dress place, it would only cost a million dollars and I could go to Europe and get all these dresses and do all kinds of beauty treatments—it would be like Giorgio's—and Mick won't give me the money, he said it would be too easy to get the money from him, that I should go out and do it on my own, so isn't it wonderful that I'm next to you?" So that was the laugh of the day—for a mere million I could invest in her business that Mick won't give her money for.

Thursday, May 31, 1984

Went over to see Victor's new apartment at the Barbizon. This has a terrace and it's beautiful. I guess about 20′ × 20′ but it costs $1,400 a week. You can get a room at the Barbizon, though, for $84 a night. Victor's almost an artist, I don't know why he doesn't become one. He saved every photo of every window display for Halston that he ever did.

I was in pain from the shiatsu treatment. Vincent was working on the contracts, we're selling a painting to try to get money to pay all these new kinds of bills we have with the new building. I'm so sick and tired of it all.

Went up to Dr. Linda Li's and she did her stuff and the pain was still there but this morning it's all gone. She saw some tea in my bag and said it was no good and she rejected me. She raises your hand and puts the vitamins on you and she says that from how hard your hand comes down she knows if the vitamins are any good or what you need. Stayed there till 8:00.

Oh, and did I say that I got this really serious letter from George Plimpton? I couldn't believe

it. Because I'd given little Charlie Evans an interview for his high school paper and in it I said something about how George told me he didn't have anything to do with all the bad things that were said about me in the *Edie* book. So *(laughs)* he writes me this totally serious letter about how it had been out of his hands and nothing to do with him. Oh, and I noticed this "quote" from me in *Edie* where they have me saying "perhaps," and it looks so funny. *I* don't say "perhaps"— *George Plimpton* says "perhaps." I mean, if they're going to fake quotes from me they should know I'd say "maybe."

Sunday, June 3, 1984

Went to the eleven o'clock mass. I always cringe when it gets to the part of "Peace, peace be with you," and you have to shake hands with the people next to you. I always leave before that. Or I pretend to be praying. I don't know how long they've done it because I went to the Greek Catholic church when I was young. But there was a cute little boy dancing around, clapping his hands during the hymn.

Watched the Tonys. It was really sort of shocking when Chita finally got her award and she didn't thank Liza. I mean, *The Rink* wouldn't have gotten done without Liza. And Chita didn't mention her daughter, either. She thanked her mother who she said hadn't seen it.

Monday, June 4, 1984

I worked around the office, it got busy. I had to ship off the Marilyn, so that was sort of upsetting. To the Saatchi guy in England. It'll help with mortgage payments and stuff like that, but I don't know if it was a good idea to sell it.

Tuesday, June 5, 1984

Went to meet Benjamin at the jewelry auction at Sotheby's and the Seaman Schepps thing that we wanted to pay like $1,000 for went for $21,000.

There's a big fly in here and I'm going to open the window to let it out . . . there's this black guy across the street with plastic bags going from door to door ringing. Could he really be a dry cleaner? One door just opened . . . I'll wait to see if he comes out with more bags . . . but if I pull the shade so the fly will stay out, then I won't be able to see out . . . oh, here he comes, yes, he's got another bag, but . . . he's going toward Park with it.

Jon said there's a big shakeup today at Paramount, they want to get rid of people.

Poor Arthur Bell, the columnist for the *Village Voice* died, and he had two ages. *The Voice* gave forty-four and the *Times* said fifty-one.

Wednesday, June 6, 1984

Rupert said that Rosemary from Doc Cox called and told him he has a leaking heart.

Oh and Keith Barish called and wanted me to do a walk-on in 9½ *Weeks*, which is with Mickey Rourke. So he said $250 and then he went to $500 and then he went up to $2,000 but in the end we said no. Should I do it? I don't know, I was so exploited in *Tootsie*. They didn't even pay me a cent. Oh it's not worth it, you have to sit around all day. Or night. I think it's a night scene.

Thursday, June 7, 1984

Diane Lane was coming to the office to be interviewed and so I had to meet Gael Love (phone $.50, cab $5). I asked Gael about Robert Hayes and she said don't ask or she'd start to cry. She said, "After you've worked with somebody for eight and a half years . . ." And then I did ask and a tear started forming. So I guess he has what everybody thought he had. She said his sister came to see her and said there's "always a chance."

Diane Lane came and she's beautiful and sweet, but she didn't have much to say. She has a good philosophy about her movies, though—she feels that if she did a good job then it was a good movie. She has to do some more shots with Richard Gere when he gets back from *King David* and she doesn't want to cut her hair again, so she'll have to do the big love scenes with a wig. And she said that whenever she didn't feel "in the mood" Coppola gave her a fatherly talk and said, "There are no moods."

Gael was being too analytical so I asked Diane, "How's your sex life?" And she laughed and said I was just like Joan Rivers. I said, "Did you ever sleep with Warren Beatty?" And then she came out and said that she actually *had* gone out with him and that he'd sat her on his knee and told her not to be afraid of sex, gave her "fatherly advice" and everything. She said that she was chaperoned by her father.

Yoko Ono's having a sale at Sotheby's but it's all junk—Art Deco jewelry she's had lying around and, you know *(laughs)*, toilet paper that John touched.

Friday, June 8, 1984

Lunch at 860 was for the dean from Carnegie-Mellon whose suit smelled of mothballs. He wanted me to donate some print or something or give money and they'd give me a chair, and this whole other stuff about scholarships for young kids, I don't know. It was *(laughs)* the most serious conversation I've had at the office in eight years. He wants me to do benefits and things. He said he went to the acting school but then didn't make it as an actor and went back there and became a dean.

Monday, June 11, 1984

The air conditioning at home was broken and the plumbing and the TV all at the same time. And we found out why the house is so hot—the *heat*'s been coming up all during this heat wave!

I talked to Rupert and he went to another doctor who said his heart isn't leaking, that there was nothing wrong with it.

And I just can't face calling Robert Hayes. I just can't.... Look, I called Henry Post and we talked and then he was dead and I don't know what it means, it's too abstract. I just can't do it. And I was never really friends too much with him anyway. I mean, it would be different if it were Christopher or something.

PH called in the afternoon and said it looks like we'll be doing our book on parties for Crown, half pictures, half text.

Sunday, June 17, 1984

Was going to go to 860 but they were moving a lot of stuff to 33rd Street, so went there instead. And it was fun. I didn't realize that our part is a lot bigger than *Interview*'s part. *Interview* is actually only a small area. Ours is really big with a lot of places I didn't even know about.

Went home and watched the thing they did on me on MTV. They showed *Heat* and a little of *Kiss*. Don Munroe talked and they had clips of the "Hello Again" video we did for the Cars. And I talked and I was okay.

I tried sleeping without a Valium but the wine I'd drunk at dinner drove me insane. Valium's the perfect drug for me.

Saturday, June 23, 1984

It was a sad day at 860 because the furniture was being packed up and shipped out. We have the company called Nice Jewish Boys moving us and they really all are Jewish boys. One blond one was so cute but he's going back to Israel. They all wanted books, so I gave them some of the *Philosophy* books. I went through one old box from '68 and a picture inside was so strange. We were at a college and we were the only freaks there. It was Viva and twenty of us. Before I was shot. We really were the only freaks there. These kids didn't have long hair, and yet they didn't have normal-looking clean-cut short hair like now, either. Today everybody goes down to Astor Place and gets a great haircut, but these kids didn't even have any fashion. It must have been in a strange place because by '68 practically everybody did have long hair. And they were pudgy. Maybe we were at this Catholic college, St. Paul's. Maybe that was it, but it was so sad to see— and seeing these pictures of myself!

I ran into Bob Colacello on Friday. He's like a dapper rich person now.

Sunday, June 24, 1984

Well Fred is on hold at the doctor's for multiple sclerosis and I'm on hold for lympho . . . lympho-something. I don't know why they scare us like this. They told Rupert he had a leaking heart and then he didn't, and Fred fell off a horse and went and had a brain scan because he has numbing of the hand and tingling of the legs and now they're doing all these checks on him.

Bought makeup at Patricia Field's (makeup $28.70, cab $7.50). Got Japanese red. But I like that stuff at Fiorucci that just is a stain that gives your lips like a natural brown. Because my lips used to be so full and now they're not, they've just disappeared and where did they go?

We went and watched the Gay Day parade. The Gay Cops and me got the biggest clap and (laughs) I took photos. Got film (film $6.90, lunch $60). And they had the contingents of Gay Docs and Dykes, the groups from Oklahoma City and Virginia. And the Men & Youth organization. So sick. The float that got the most attention was the S&M float where the big guys were in leather with the keys and everything. All the beauties must've been shopping in Soho or out on Fire Island, 'cause they sure weren't in this parade. And there were guys in wheelchairs being pushed by their lovers. I'm serious! It looked like Halloween but without the costumes. And they had a Kate Smith record playing.

Monday, June 25, 1984

Dr. Linda Li was back in town and I had an 11:00 appointment with her. So I went over there and she'd been away at a seminar or a conference, so she had some new tricks. She put a lot of ball bearings on me and she hit me with hammers and it was fun.

Oh and the office was so sad, all empty. They even moved the coffeepot uptown to the new place, and so Brigid wanted to buy another one for the transition period and I told her to go to hell.

Grace Jones had called and invited me to a screening of *Conan the Destroyer* at 6:00, so I went (cab $4), but Grace was late so it didn't start on time. Richard Bernstein was there and he made me feel terrible—he said he went to see Robert Hayes in the hospital and they all had to wear masks. And he's also been to see Peter Lester and Peter's got the kind of AIDS with spots. Richard said Robert looked terrible but that Peter Lester looked great except that he had a shirt on to cover the spots.

Oh and I had to call Doc Cox's office to find out the results of my tests, so finally I braced myself and decided to be brave and that if it was anything horrible I'd just take it in stride. So I called and they said nothing was wrong. After all that drama they made, and then nothing was wrong. So I hung up feeling that health sure was wealth.

So anyway, Grace was just great, she's a real presence. She had a big acting scene where she sees a mouse and gets hysterical, which is so stupid.

Tuesday, June 26, 1984

I've been getting a lot of commercial portraits to do lately—like liquor bottles and things instead of people.

Thursday, June 28, 1984

Brigid made me write a letter to Robert Hayes. A note. So I copied down what she wrote and she sent it off to him. He's going home to Canada to die.

Steve Rubell called to say that he hadn't seen me in a long time and that he was sending a car to pick me up and take me to the Go-Go's party at Private Eyes, and it was just the party of the year, kind of exciting. Paige took photos. And they gave you yellow stickers and that meant you could have free drinks. Isn't that funny?

Monday, July 2, 1984

Jean Michel called at 8:00 in the morning and we philosophized. He got scared reading the Belushi book. I told him that if he wanted to become a legend, too, he should just keep going on like he was. But actually if he's even on the phone talking to me, he's okay. And the phone calls from pay phones are now $.25. I'm just not going to make calls anymore. All the pay phones uptown were converted already to $.25; downtown there are still some $.10 ones left.

Tuesday, July 3, 1984

Chris walked in right when his ex-assistant Terry was there—she was picking up a photograph printing assignment from me. So that was almost a big confrontation, but Benjamin saved the day saying they were *his* pictures.

Saturday, July 7, 1984

When I was walking on the West Side one of these days, from a block and a half away I saw this little figure walking toward me, and you know, I never recognize anybody, but somehow I picked him out because he had that walk that's like folded inside of itself that says, "I will walk straight ahead, I will not look at anybody, I will not make eye contact." But I just felt like saying, "Hi, I think you're great," so I did, and he unfolded. Sean Penn. I don't know if he knew who I was or not.

Tuesday, July 10, 1984

Got up on the wrong side of the bed. Had a big fight with PH. Picked up by alias Ming Vauze and we did the streets. Got magazines and newspapers ($4).

Paige was having a big lunch at the 33rd Street building for the black kids from Ralph Cooper's Amateur Night at the Apollo with their mothers and a couple of grandmothers (cab $6). And the kids all had these elaborate names—like Latosha and Emanon—and then the mothers and grandmothers were Grace, Mary, Ann. And the boy, Emanon, rapped with noises instead of words. They were all really cute.

And it looks like I'm going to be painting in the ballroom for now because the basement where I was supposed to be put to paint is now filled up with prints and paintings. Good. I didn't want to paint in a dark dump. But eventually we'll have to use the ballroom for big lunches and parties.

Grabbed Benjamin and we ran uptown and I just threw a bag in and we went right over to the theater where the *Muppets Take Manhattan* was screening and Frank Oz who wrote and directed the movie—and he does the voice of Miss Piggy and another one, too—came over and said, "You won't remember me, but I was one of your friends during the Filmmakers' Co-op days." And he said he just loved the *Philosophy* book. He said he reads it all the time, he called it "gentle."

Wednesday, July 11, 1984

Went around to stores promoting *Interview*, and now I ask to use the phone at places so I won't have to pay the $.25 for phone-booth calls. And later in the afternoon Chris came to the office and *(laughs)* was doing the same thing.

Gee, I'm looking at MTV right now and they use my paintings in a lot in videos. I just saw my Liz Taylor and I've seen my Joseph Beuys in another one.

Tuesday, July 17, 1984

Decided to work until 7:00. Then cabbed to the Limelight ($3). And it was boring. Chris had T-shirts made up with his photographs on them and he *gave* a shirt to everybody, but me he told to go *buy* one. I couldn't believe it. And I'm looking at these slobs he's *giving* them to. It was air-conditioned and freezing there. One of Sidney Lumet's daughters, either Amy or Jenny, sat next to me and she's a spoiled Black Jewish Princess. But she's sweet and I shouldn't put her down, but oh God, she's so dumb. She was being world-weary. She said, "I did everything when I was thirteen and now I don't even go out anymore," those kinds of things. But I guess she's likable, she tries hard. She said how when she was younger she used to hate her grandmother, Lena Horne, but now she adores her.

Wednesday, July 18, 1984

Si Newhouse is coming down to lunch. He called and said he wanted to talk about *Interview*. But I invited him to 860, not the new building, so he wouldn't see it was grand in case he was wanting to buy it. I'll try to sell him art instead. But you know how these things always turn out—he'll probably say he wanted to ask me what kind of ink *Interview* uses! He owns *Vogue* and *Vanity Fair* and 1,000 newspapers, but he'll be asking me where do we buy our pencils or something.

The Democratic Convention is too boring. I sat next to Jesse Jackson at a *Time* magazine dinner, and he was too serious. He was "above" all of us.

Thursday, July 19, 1984

Si Newhouse came to lunch at 860 which we're almost moved out of so there's nothing there, and he offered to buy *Interview*. But after I was thinking about it, I think they just want to buy it to get rid of the competition. I don't know how much he would offer. Nobody was around. Fred was in L.A. and Vincent was at lunch so I didn't want to hear any offer. He's coming to lunch again and Fred will be there. I showed him old art and new art and he's interested in a Natalie. He said to stretch it for him.

Friday, July 20, 1984—New York—Aspen, Colorado

I was picked up by Benjamin really early. Flew directly to Aspen for the celebrity auction. Marty Raynes paid for the trip. Richard Weisman was involved. Howard Cosell did the auction. They sold a $400,000 apartment. And then they sold four portraits by me so I raised $160,000 for cerebral palsy.

Saturday, July 21, 1984—Aspen

Got congratulated on raising $160,000 worth of art for them. John Forsythe told me he bid on a portrait but dropped out at $25,000. Now would be such a good time to really go after the Hollywood crowd, because now they see that the portraits at this auction went for $40,000, so they would know that $25,000 was a bargain. If we only had somebody in L.A. to follow up on this. Bob Colacello would have been so good at this.

Jack Nicholson was there all weekend, we saw him everywhere. He's fat now. Jack Scalia gave me his phone number for Italian dinner at his house in L.A.

Afterwards I told Dionne Warwick that I met her twenty years ago at a Brooklyn Fox rock and roll show and she remembered and I'm not surprised because it was so odd—I was with Isabel Eberstadt who was doing an article for maybe *Vogue* and she was talking to Dionne in her breathy society voice like Jackie's.

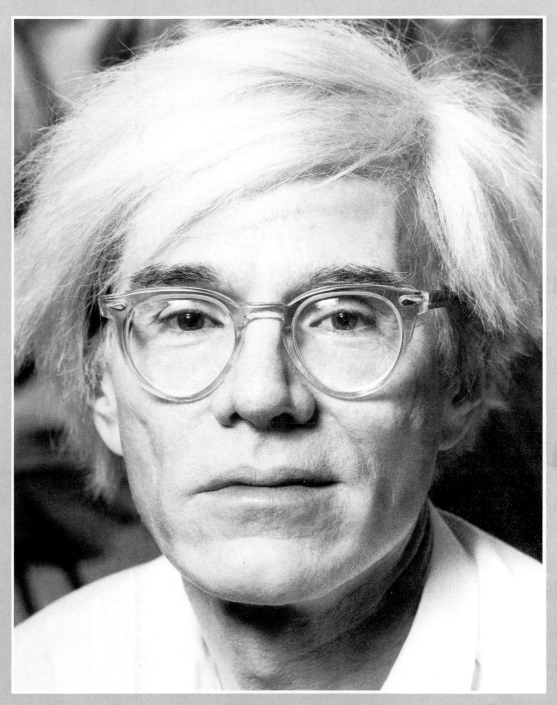

Andy, 1981. (photo Ralph Lewin copyright ©1989)

"MONTAUK"

Then-best friends Truman Capote
and Lee Radziwill in 1974.
(*photo Peter Beard*)

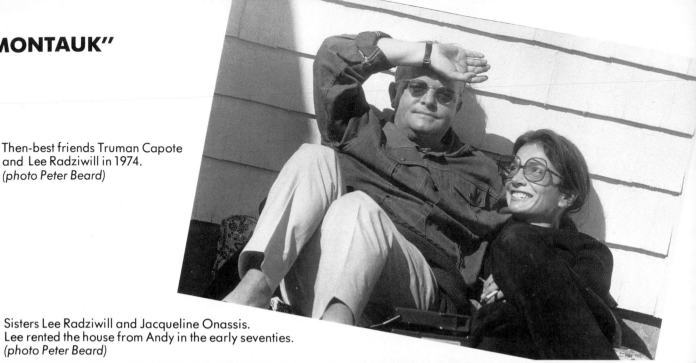

Sisters Lee Radziwill and Jacqueline Onassis.
Lee rented the house from Andy in the early seventies.
(*photo Peter Beard*)

Mr. Winters, the caretaker.
(*photo Andy Warhol*)

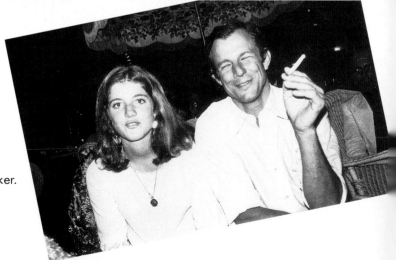

Caroline Kennedy and photographer Peter Beard.
(*photo Andy Warhol*)

Halston in the kitchen.
(photo Andy Warhol)

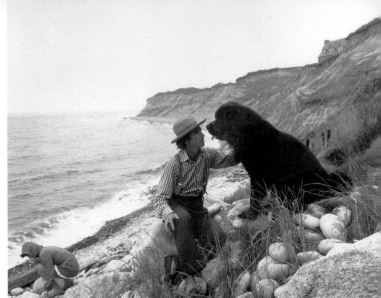

Steve Aronson and
his Newfoundland,
Magnus, on the beach
at Montauk in 1974.
(photo Peter Beard)

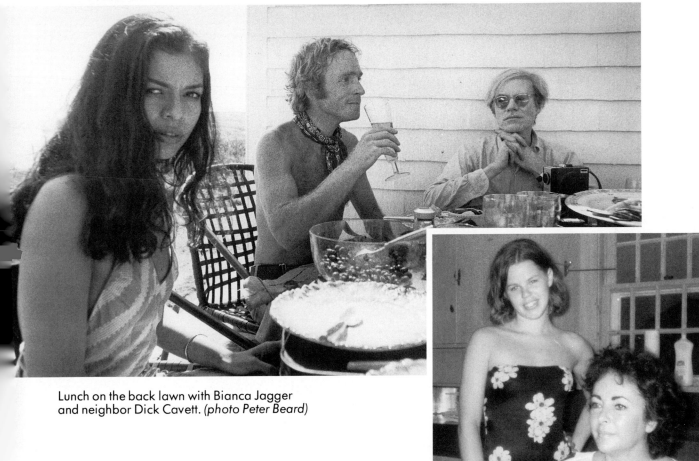

Lunch on the back lawn with Bianca Jagger
and neighbor Dick Cavett. *(photo Peter Beard)*

Liz Taylor in 1976 in the kitchen of the main house.
Susan Johnson stands behind her. *(photo Tom Cashin)*

Billy Boy in
London, 1986.
*(photo
Andy Warhol)*

In Germany on the set of *Querelle* with director
Fassbinder and star Brad Davis in March 1982.
(photo Christopher Makos)

Fred Hughes lounging in a European hotel room.
(photo Andy Warhol)

In Berlin with artists Robert Rauschenberg and
Joseph Beuys in March 1982. *(photo Christopher Makos)*

Gloria and Johannes von Thurn und Taxis in London,
July 1986.

Visiting the Great Wall
of China in 1982.
(photo Christopher Makos)

Fred Hughes, Jed Johnson,
and Andy pass time in Kuwait.

With friends in Kuwait,
in 1976.

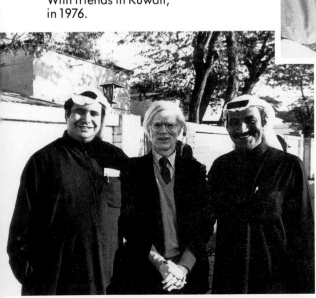

(photo Andy Warhol)

Sylvester Stallone
studying the
Polaroid photos
Andy had just
taken of him.
(photo Andy Warhol)

Farrah Fawcett at
860 Broadway, posing
for a Polaroid photo
that Andy will use
in making her portrait.

Liza Minnelli posing
for her portrait Polaroid, 1978.
(photo Andy Warhol)

Jerry Hall posing
for her portrait
Polaroid. *(photo
Andy Warhol)*

With New York Met
Tom Seaver
in July 1977.
*(photo Christopher
Makos)*

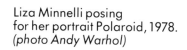

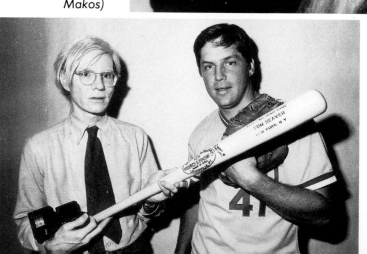

Tinkerbelle and Divine.
(*photo Andy Warhol*)

Robin Williams
thrift-store shopping
in the Village
April 17, 1979.
(*photo Andy Warhol*)

Jon Gould, Philip Johnson,
and David Whitney.
(*photo Andy Warhol*)

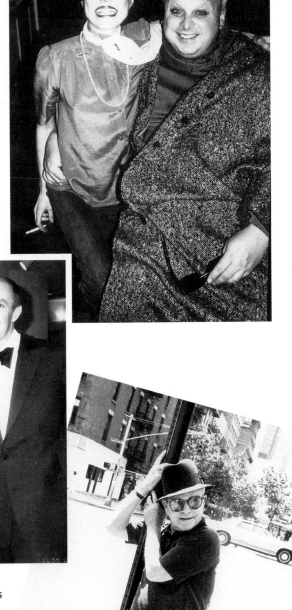

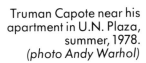

Truman Capote near his
apartment in U.N. Plaza,
summer, 1978.
(*photo Andy Warhol*)

*Bruce Springsteen,
August 21, 1978.*
(*photo Andy Warhol*)

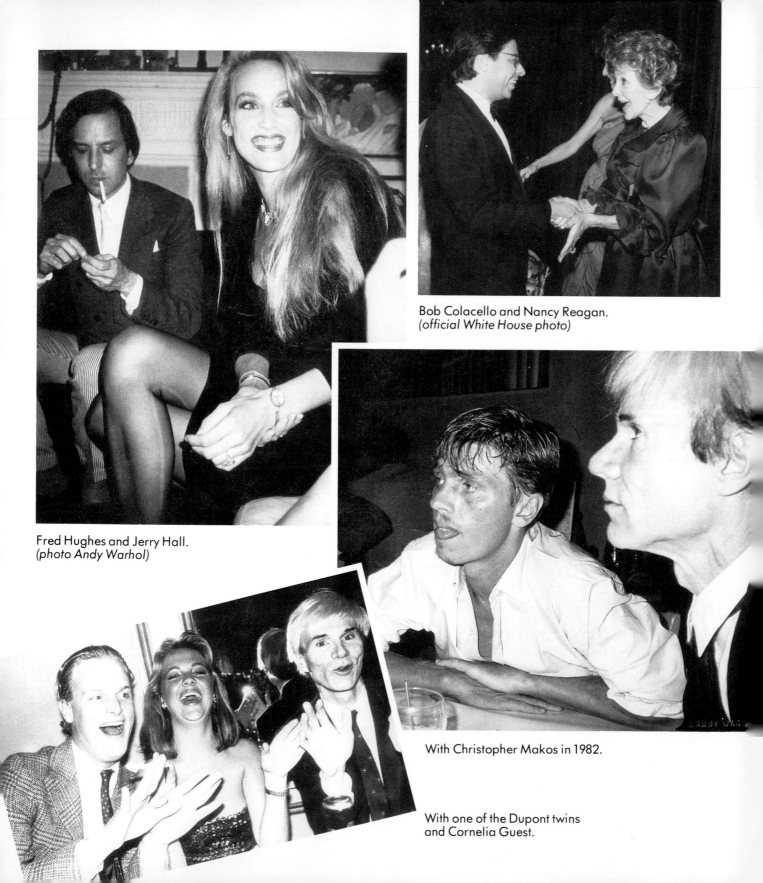

Fred Hughes and Jerry Hall.
(*photo Andy Warhol*)

Bob Colacello and Nancy Reagan.
(*official White House photo*)

With Christopher Makos in 1982.

With one of the Dupont twins
and Cornelia Guest.

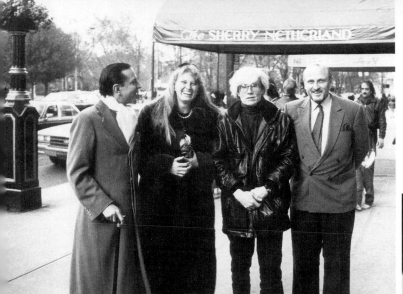

On Fifth Avenue with Fred Hughes and Yoyo and Bruno Bischofberger.

With Jodie Foster.
(photo Christopher Makos)

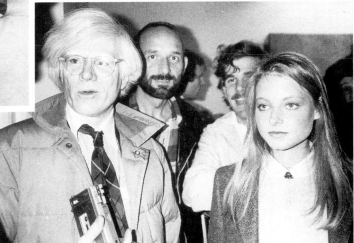

Getting weightlifting instructions from his trainer, Lidija.
(photo Christopher Makos)

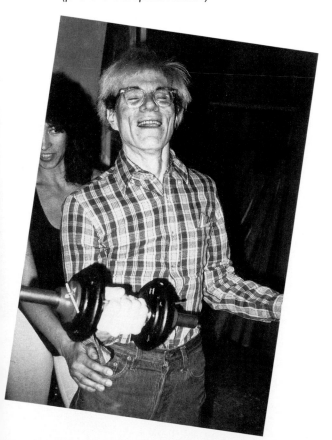

On a snowmobile with Jon Gould in Colorado on January 1, 1983. (photo Mark Sink)

Jean Michel Basquiat going into a show of his paintings at the Mary Boone Gallery. *(photo Andy Warhol)*

Jean Michel Basquiat's portraits of himself and Andy, done in October 1982. *(photo Andy Warhol)*

Peter Martins, January 1987. *(photo Andy Warhol)*

Artist Francesco Clemente. *(photo Andy Warhol)*

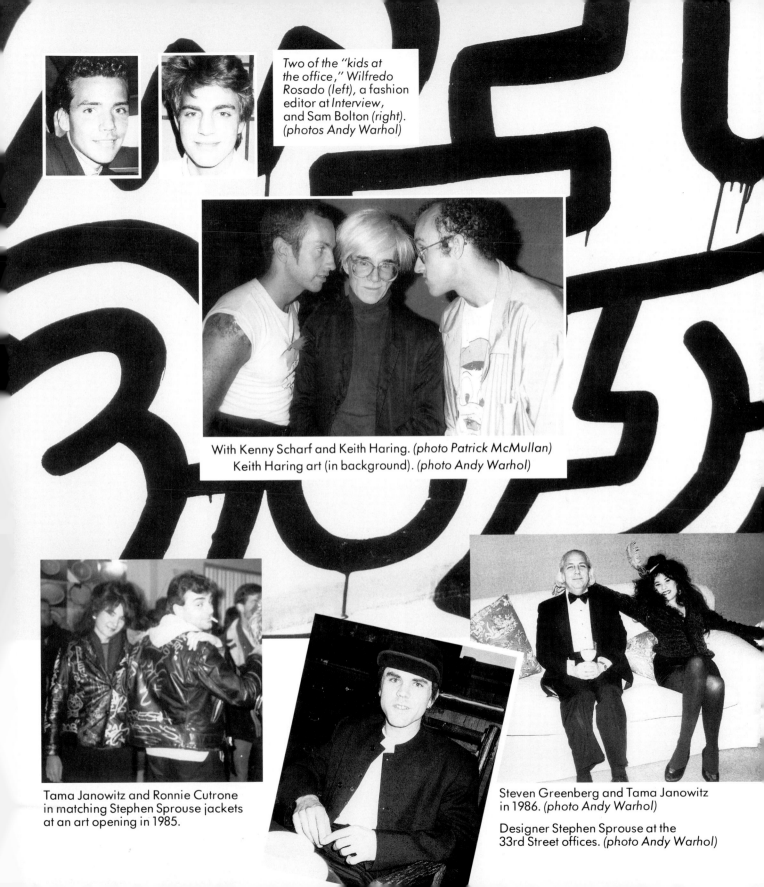

Two of the "kids at the office," Wilfredo Rosado (left), a fashion editor at *Interview*, and Sam Bolton (right). *(photos Andy Warhol)*

With Kenny Scharf and Keith Haring. *(photo Patrick McMullan)* Keith Haring art (in background). *(photo Andy Warhol)*

Tama Janowitz and Ronnie Cutrone in matching Stephen Sprouse jackets at an art opening in 1985.

Steven Greenberg and Tama Janowitz in 1986. *(photo Andy Warhol)*

Designer Stephen Sprouse at the 33rd Street offices. *(photo Andy Warhol)*

With model/actress Paulina Porizkova, Ric Ocasek, and Vincent Fremont, July 18, 1986. *(photo Pat Hackett)*

Record producer Jellybean and Madonna. *(photo Andy Warhol)*

At a manicuring installation at Area in August 1985. *(photo Patrick McMullan)*

Alba Clemente with Julian Schnabel. *(photo Andy Warhol)*

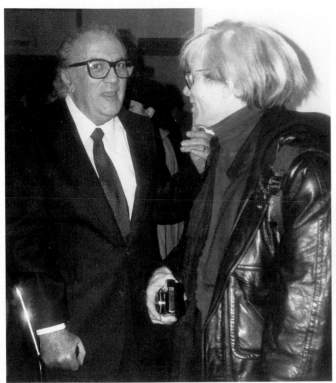

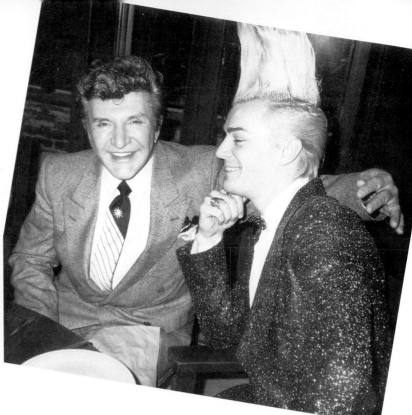

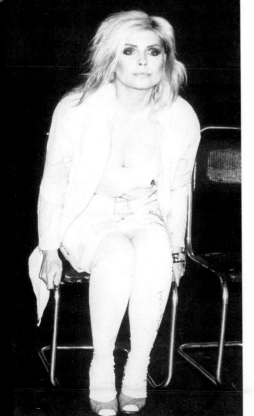

(Top Left)
With Federico Fellini,
March 26, 1986. (photo
Patrick McMullan)

(Top Right)
Liberace and John Sex
at Andy's 33rd Street
offices, December 6, 1984.
(photo Andy Warhol)

Yoko Ono, Sean Lennon,
and Sam Havadtoy.
(photo Andy Warhol)

Debbie Harry wearing
Stephen Sprouse,
summer 1986.
(photo Andy Warhol)

Kate Harrington, Jane Sarkin, Don Munroe, Glen Albin, and Marc Balet at Kate's birthday party in 1985. *(photo Pat Hackett)*

With Pat Hackett in 1986 at the Hard Rock Café. *(photo Sam Bolton)*

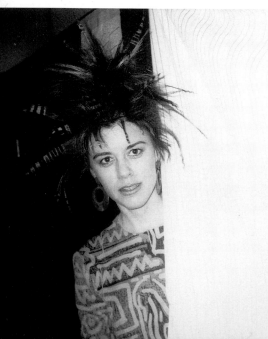

Paige Powell and Jean Michel Basquiat in Hawaii in February, 1984. *(photo by Janine Basquiat)*

Paige Powell styled for an appearance in the movie of the novel *Slaves of New York*. *(photo Tama Janowitz)*

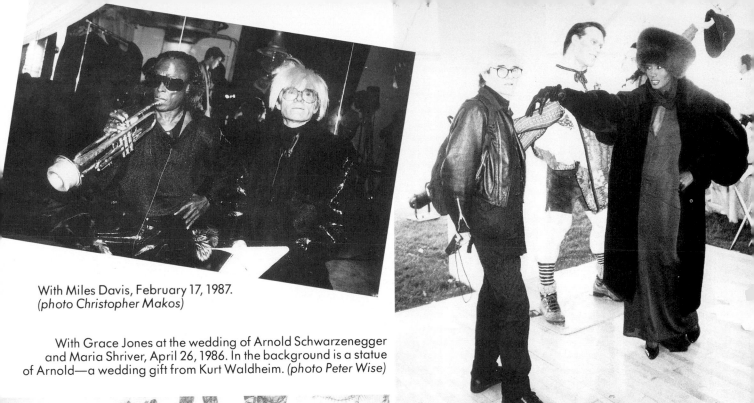

With Miles Davis, February 17, 1987.
(photo Christopher Makos)

With Grace Jones at the wedding of Arnold Schwarzenegger and Maria Shriver, April 26, 1986. In the background is a statue of Arnold—a wedding gift from Kurt Waldheim. *(photo Peter Wise)*

Stuart Pivar. *(photo Andy Warhol)*

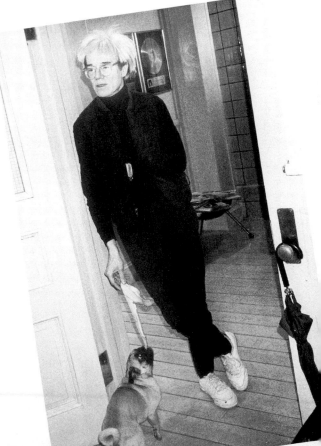

In 1985 with Brigid Berlin's dog Fortune in the first-floor office area of the former Con Edison building that Andy bought and moved into at the end of 1984. *(photo Paige Powell)*

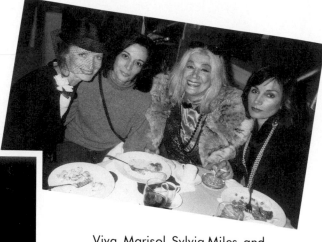

Viva, Marisol, Sylvia Miles, and
Geraldine Smith at a lunch following
the memorial service for Andy at
St. Patrick's on April 1, 1987.
(*photo Patrick McMullan*)

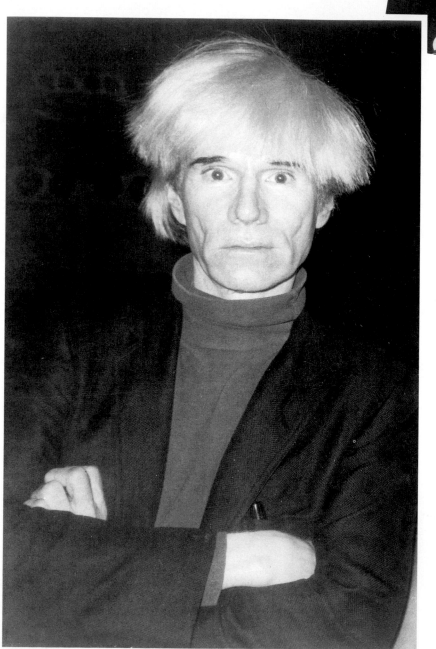

Andy, 1986.
(*photo Patrick McMullan*)

Sunday, July 22, 1984—Aspen—New York

Benjamin showed me that his seat on the plane converted into a toilet—if you had to go to the bathroom, you would have to ask him to get up and then a curtain would come around you. So that scared me into not drinking anything on the flight—you would've had to say, "Excuse me, but I would like to use your seat for a toilet." But Vitas had about six sodas and still he didn't have to use it.

So anyway, this small plane had to add fuel in Denver because a load big enough to get us to New York would've been too heavy to get us over the mountains, it's a regulation. And then we stopped in Pittsburgh for a minute (candy $3). There were six seats plus the toilet seat that Benjamin sat on. Got to New York.

Monday, July 23, 1984

Cabbed to meet Lidija ($6.50). And all the gym equipment had been moved out over the weekend so we just had the bare essentials left at 860. I packed some boxes and that tires me more than anything, more than doing ten paintings. Because it's emotional.

The big news came about Robert Hayes and I didn't want to think about it. The kids at *Interview* were all upset. Fred says we have to do a page on him, but I just don't know if that's a good idea. But Fred says we have to.

Walked over to Private Eyes and started talking to John-John Kennedy and he's so big and handsome now. Then this kid started taking pictures and John-John said it would be okay if it wasn't too obvious, but then it was obvious, so John-John walked away. So many pretty people. Timothy Hutton came in and that was so exciting, and Antony Radziwill. It was a party for the Cars.

Tuesday, July 24, 1984

Got woken up by Jean Michel talking about his girlfriend things. She has an infection in her tubes. This is the tall tall blonde, Ann. He's working his way up. He started with short girls and he's getting more confidence and now he's with tall blondes that are just average-looking, but he'll go on to the Swedish beauties, I just bet. Then he'll have a white baby with one and then dump her for a black girl, right?

Went down to meet Grace Jones at the office and we waited for three hours. Benjamin went out and made calls and finally tracked her down at Bergdorf's getting a fur coat out of the Revillon cooler. She spends all her money on fur coats. She says it's all she cares about, that she doesn't care about money, just furs. I told her it's crazy, that you can't resell them or anything, and that she should buy jewelry, but she just loves furs. It's that insane. She buys them and stores them all in the cooler. I was taking pictures of Grace for *Vogue*, and we were interviewing her for the cover of *Interview*. But anyway, she was really late, and we were putting her down for hours and then suddenly she appeared and it was all, "Oh darling!" So that would be funny to have all the

put-downs in the interview and then show when it all changed when she walked in (Benjamin's phone calls $5).

André Leon Talley asked Grace if she thought she was white and she said yes. He's just low-key and good. Sent out for champagne, but then we didn't have ice. Everything's gone from the office.

Wednesday, July 25, 1984

Walked around a little and then cabbed to meet Fred on Spring Street and Sixth Avenue to sign prints for the building I did (cab $8). And the woman who owns the place is 5' × 5'. And she was so grand. I kept asking her how much the building cost and she said, oh well she just couldn't remember, you know, so offhand, and I mean, this is a person who would know to the penny in one second how much she paid for every floorboard. And it was a glamorous reception room and I was jealous of the setup, so neat and orderly, and she's been printing Norman Rockwell for years.

Then Fred said may we have our check, please, and they didn't even have it. And then the 5' × 5' lady had an extra print there and she said, "Oh it would be so sweet of you to sign it to me," and I just said no. And then later I took it all out on Fred. I mean she was so grand, the fat slob, and they didn't even have our check.

But I'm sure they do make up a lot of extras, these things are always showing up in Macy's or somewhere. Prints are so easy to fake. And I mean, museum posters? Forget it! *Anybody* can do a poster from this or that show at this or that museum. I mean, I see my Brooklyn Bridge print being sold everywhere and where's *our* part of that money?

And Fred, since he stopped drinking, his grandness is appearing again, and it's kind of scary. It only used to appear when he was drinking and now it's there without drinking. He's going to Linda Li. And he doesn't know if she really believes this stuff or if she's just out to make a hundred bucks. I guess she jangled up his nerves. He said he just wanted to see what I was into now.

Thursday, July 26, 1984

Cabbed to meet Lidija ($6). Worked out and then packed boxes, tried to, all afternoon at 860. I'm just going to try to stay on there as long as possible until they kick us out because I love it now with the whole place empty and it's so sunny up front and I hate to leave Union Square Park—I'll miss the trees. As long as I have a phone, that's all I need.

Saturday, July 28, 1984

Went to Soho to go to Robert Mapplethorpe's shooting session of Grace Jones for *Interview* that Keith Haring was doing special makeup for (cab $6). Stopped at Central Falls for lunch because they advertise, they were thrilled to have us (lunch $40). Then wandered around Soho, knowing

that Grace would be good and late. Signed autographs. Called Keith and he said to come in forty minutes. So to kill time we went over to Avenue D and 2nd Street where Keith had done a thing called "Candy Store"—he painted a brownstone with a storefront red and green and blue and purple and inside the kids sell drugs. Like heroin. Keith said he wanted to be around "hot kids."

Went to Mapplethorpe's on Bond Street. Keith did Grace's makeup and Mapplethorpe shot her and we were there for three hours. Then went home to watch the opening of the Olympics on TV and it was thrilling, then (cab $3) to Grace's dinner that she was giving at Holbrook's.

David Keith was there. He's sublet Jon's old apartment on 76th Street when Jon bought that one-bedroom apartment in the Hotel des Artistes. David Keith's career was so hot for a few minutes there. That's when Jon met him, from *Officer and a Gentleman*. He'd gotten there on time at 9:00—he didn't know the Grace Jones Story. So we explained to him that two hours late usually timed it right for Grace, but *still* she got there half an hour after we did. And Grace's mother was there. She was just a normal mother.

David left and came back with Twiggy. Grace insisted on waiting until he got back, which was 2:30 A.M., and then we went down to Private Eyes.

Sunday, July 29, 1984

I took all my old bread to the park and tried to give it to the birds but they didn't come around and I just hated them for that. Went to church. Then was picked up by Jon, he had a car, and we went out to the Brants' big spread in Greenwich. Jed decorated the house and everything, and it was my first time seeing it. Rolling hills and white columns. It's impressive. Peter's so into polo and horses, still. It was a lot of polo players at the place. I was underdressed because Sandy told me it would be all right to just come like that, and then I felt crummy, especially when I saw Jed was there. Fred came with Averil and her husband, and it was his birthday. I saw a couch that was a copy of the one that I have on my first floor, and they'd had it done for $2,000, and I told them that they could get one that was the real thing from the Roosevelt estate for $85,000. They have one of my paintings in every room. And Peter had paid I think $500,000 for a new Jasper Johns that didn't look like a Johns, it's his new stuff, it looks like an illustration.

Barbara Allen was there with the Polish guy, Kwiatkowski, and he does have capped teeth. I mean, she could have just had Joe Allen's teeth capped, if that's what she wanted. I don't get it. And Joe Allen was there with his new wife, Rhonda.

They had a dance band that played during dinner and everybody danced. PH was with Jed.

And I went into the big room where they had a Marilyn over the mantle in a gold frame and it looked just beautiful. Really beautiful. It looked like a million-dollar painting. It looked so right in that room with all the America stuff. I wish I'd painted better in those days, though. The painting on it—it's not painted too well. I didn't know how then. And they had my Merce Cunningham in the same room where the Jasper Johns was. And they had my Mona Lisa on the way up to the stairs. I tried to take Jon back to see the Marilyn but then there were Glorious Food waiters telling people not to go into the rooms.

Monday, July 30, 1984

I didn't want to go to Robert Hayes's memorial service, I was thinking of giving his family a painting of him, but in the end I decided it'd be easier to just go so people wouldn't talk.

And Chris just called me up to talk about the service saying that it was all a fantasy and why didn't Robert's old boyfriends get up there and talk. He said he should have worn a black veil and gotten up there and said he was the first Mrs. Hayes. I told him that eulogies are *always* a fantasy, but that that's what you do. I think he must be nervous, too, though, about Robert dying. I think we're going to have to do something for this disease, though. I mean like a benefit, because it's like polio or something. I mean, they don't know that it's sexually transmitted for sure—it's just a virus!

Chris is so outrageous, though. After getting months of free lessons from Lidija by being with me, when she needed a photo for the ad she wants to run, he said it would cost her $750!

At 4:00 we went over to 22nd and Park to the church for the service for Robert Hayes, and the place was completely filled.

Tuesday, July 31, 1984

Susan Blond called and wanted to know who the people were who I wanted to get the Michael Jackson tickets for, if they were anyone who could do anything for her. And she said that Michael might want to go to an art gallery with me while he's here. She said that they'd close the Museum of Modern Art for him, so that might be fun. Steve Rubell said *(laughs)*, "Michael might want to see a little art."

A couple of people called about Bill Pitt—he died. I think maybe he committed suicide. His best friend called and we talked. He thought maybe Bill had gone to a doctor to get a test for AIDS and that maybe he found out he had it and decided to take an overdose. He wasn't happy. Worked till 7:00. Went to bed at 11:30.

I'm going to go to a doctor who puts crystals on you and it gives you energy. I asked Dr. Li to recommend one and she gave me a name. Jon's gotten interested in that kind of stuff—he says it gives you "powers," and I think it sounds like a good thing to be doing. Health is wealth.

Wednesday, August 1, 1984

Somebody told me there's a thing in the Sunday *New York Times Book Review* about me in a review by an Iranian guy, saying that the Shah and somebody else got together and talked about how unattractive I was. That ruined my day, hearing that.

I went to the crystal doctor and it takes fifteen minutes and the three people in the waiting room I knew, even. It cost $75 and he told me my pancreas was the only thing still giving me pimples. It was fascinating. Really fascinating. He and the secretaries wear crystals around their necks. He said his was very special because it was programmed by the head person of the crystal

place. And the secretary's was blinking like a light show. He didn't give me a crystal, he gave me the name of a place to go to buy one and then I'll bring it to him and he'll check it out.

Christopher came by the office. He saw a lot of pictures and he said, "Oh, do you have work for me?" He still doesn't know that I'm using his ex-assistant Terry, but I'm going to have to sit him down and break it to him one day. I mean, she does it for half the price, for $3 a print— and he charges $6. I mean, after all those free trips he got and everything, he's just crazy. Well, *I'm* crazy. Why did I *take* him?

Oh, and Dotson Rader is doing a book on Tennessee Williams and he interviewed Chris for it. Chris used to work for Tennessee—he got $400 a week for taking care of his dog, he says. Remember, I first met Chris at my Whitney Retrospective in '71 when Dotson Rader brought him, and Dotson was a friend of Tennessee's.

Friday, August 3, 1984

Went to Bernsohn, the crystal doctor, and he worked on my pancreas.

Saturday, August 4, 1984

Worked all afternoon till 7:00. Susan Blond called and said that we could go to maybe meet Michael Jackson in a hotel room before his concert at Madison Square Garden. So we cabbed to the Penta Hotel ($5). It's the hotel that was called the Statler Hilton until last week or something and now it's the Penta. But the cab wouldn't go near the place because of the mobs for Michael, so he let us off and we had to walk.

Finally we found the place, we got Elevator B and went up, and Calvin was there, and he was mad that he'd come so early. And Marina Schiano was with him and his girlfriend Kelly. And Rosanna Arquette, the actress, came up and was so sweet, and I asked her if we'd ever done anything on her in *Interview* and she said, "No, and you've just *got* to!" But then I remembered that we *had* done something—but just a "First Impression." Little Sean Lennon was there and that was exciting. And then this apparition appeared and it was Michael Jackson.

Susan Blond pushed me into his arms and he was shy, and then people pushed me away, and Keith gave him T-shirts and everybody was meeting everybody and then I was pushed back at him and it was anticlimactic and then it was over. I shook his hand and it was like foam rubber. The sequined glove isn't just a little sequined glove, it's like a catcher's mitt. Everything has to be bigger than life for the stage.

We went to the show and it was laser beams and a movie where a sword had to be pulled out of a stone and Michael pulled it out. Bianca arrived late and the Jackson father was in her seat and she didn't know who he was and tried to kick him out, but Susan Blond got up and gave her *her* seat.

And then after the concert we called Mr. Chow's to see if they'd be open and they said yes, that they had leftover food. And at Mr. Chow's we were next to Anthony Quinn and he said hi and I didn't know if I should go over to his table, I never know, so I played it shy, but then when

he was leaving he came over and sort of hugged me, and I remembered that he's an artist, that he paints.

Sunday, August 5, 1984

Jean Michel wanted to go to the Jermaine Jackson party at Limelight. So we went down there (cab $7). And it was one of those parties where the bouncers were all dumb Mafia-type guys who didn't know anybody. Jean Michel took us to the wrong section and they told us to beat it, and he said, "Now you see how it is to be black." And all the people who I don't know, Jean Michel's just sitting there and then he'll say, "Hi, man." He went to school with them or something. He told me he went to a school in Brooklyn, St. Ann's, that's sort of chic because you had to pay. And then he said that when his father lost money he had to be bussed to a public school that was a lot of Italians and the boys there used to beat him up and he didn't like it. But I guess the education was good, though, and that's why he's smart.

Then we got to the VIP room and it was like a remake of an old party. Janet Villella was there and Linda Stein, and it was free drinks (tip $10). Then they came in and told everybody to leave and get out because Jermaine was coming in, and that we could come back later, that (laughs) some of us would be selected to come back. There were some sort of drag queens there with jewelry on, and so we all had to get out, it was so stupid. And you have to walk for a block to get to the next room. And the photographers there are so bored with seeing me, they don't even say hi anymore. Hold on, the other line's ringing. . . .

Oh gee, that was Benjamin calling and he said that he and Paige were at the Limelight and they heard I was in the VIP room and they tried to get in but couldn't. And—this is funny— he said that there were three Olympic guys there wearing their gold medals. So I guess those were the ones I thought were drag queens with jewelry! Gee.

So anyway, Jean Michel wanted me to see his paintings down on Great Jones Street, so we went there and it's a pigsty. His friend Shenge—this black guy—lives with him and he's supposed to be taking care of the place, but it's a sty. And the whole place just smells so much of pot. He gave me some paintings to work on. Left there (cab $8).

Monday, August 6, 1984

The unmentionable day. I'd told everyone I didn't want to hear the word "birthday." Benjamin picked me up and we cabbed to 70th and Broadway ($4). Dr. Li said that she'd been at the Michael Jackson thing and I was surprised. Then I put it together—Benjamin had said he saw Roberta Flack at the concert, and Dr. Li has a picture of Roberta Flack in her office, so I asked her if she was with Roberta Flack, and she said yes. So now I'm trying to figure out if they could be dykes.

Then cabbed to the Whitney where there was the lunch for the presentation by Ethel Scull of

the portrait of her that I did in the sixties (cab $4). They were serving lunch in front of the painting.

Ethel hadn't arrived yet and when they called her she was in the bath, she thought the lunch was Tuesday. Finally she arrived in a wheelchair and a hat with the big cast on her leg. It was so sad. Like a movie moment where everybody's waiting. The painting's not very good, even. It was just—I don't know. And she said all these things about how I'd wanted $1,200 cash for the painting. In cash, she said, and I mean, I don't remember that—I wouldn't have even discussed money. I can't even do it now, so I can't see myself saying, "I want $1,200 cash." It must have been one of the Bellamy Gallery people or Ivan Karp or something who got paid. And she said she came to my house and my mother answered the door, but why would my mother answer the door if I was expecting somebody—I'd be right there. I don't know, it was nutty.

And I ran into one of the old kids from Max's and they told me they finally read *Edie* over the weekend and that they weren't shocked by the drugs or anything anybody said about me—that the only thing that shocked them in it was reading that I *sold* some of my early films to somebody, that they couldn't believe I wouldn't be keeping them for myself. But, see, I *didn't* really *sell* them—I have them *back* now, the guy's contract expired.

Oh, it's all Fred's fault that I'm in that book. He kept after me to talk to Jean Stein. Because she was "social," my dear, and was having parties. So me talking to her made it look like I sanctioned her book.

So it was so boring and gee it's such a sad family—Ethel doesn't speak to her sons. David Whitney gave us a tour of the Fairfield Porter show, though, and I looked at Mondrian, and he just took tape and painted it and then Sidney Janis owned these things and it became a business.

Then at 3:00 went downtown (cab $6). Drue Heinz called to wish me a happy birthday. So did some other people. I got a big twelve-foot weed from Renny the florist.

Paige picked out a place to have dinner and I invited Jay but then he called back and Benjamin got the phone and Jay asked would I mind if he brought Kate Harrington, and I didn't say anything, and then he asked Benjamin, "Did Andy just make a face?" He just wanted to start trouble. He does these things so people will feel guilty when he doesn't want to come anyway. But Benjamin was great, he just said, "Here's the address—if you want to come, come." And I *would* have yelled at Kate if she came, since she'd left work at *Interview* that afternoon saying she was sick.

Well, we went to 79th and Lexington to this place called Jams that we go by all the time and never knew was there, this chic place. It was expensive, but the food was so good. The whole thing was like the Four Seasons used to be when the guy was there who used to grow the garden stuff in his own patch in Connecticut. The dessert was incredible. Jean Michel ordered a lot of champagne and he said he'd pay for it but I wouldn't let him (dinner was $550). It was underplayed, nobody said "Happy Birthday" and it went smoothly. Paige had a strapless pink dress on and she took her camera into the kitchen to do movies. Jean Michel dropped me off and it seemed like being with Jean Michel didn't bother Paige too much, she's more recovered from him. Then when he was dropping me off he said that he wanted to go fuck her. I told him that that would just start trouble again. I told him he should give her some artwork because she's the only girl who ever really helped him out, gave him his first uptown show and sold so many of his paintings. And she never would let him pay for her, she was being very independent, paying her own fare to Hawaii and things like that, and I don't know why he never liked that, somehow.

And it was nice to see little Suzanne the makeup girl the night before at Limelight wanting not to get stuck with him—it was refreshing to see a girl trying to get away for a change.

Tuesday, August 7, 1984

Went to see Dr. Bernsohn. I told him that after seeing him the last time I went out of alignment and he said that maybe it was a good thing. He was sort of putting down Dr. Li. She sent me to him. He was saying he doesn't believe in vitamins. I'm going to stop taking them and see if I feel better.

I was meeting David Whitney and Philip Johnson for dinner at the Four Seasons. Invited Keith and Juan and Jean Michel. Philip goes to bed at 9:00, so he wanted to have dinner at 6:30 but I made it 7:30.

The Four Seasons was jammed. I expected good food, I'd been spoiled by Jams the night before, but the food was terrible. Doc Cox was there. I'd put on my Stephen Sprouse neon tie. I really looked like the sixties.

Helen Frankenthaler was at another table with André Emmerich and she sent a note to Philip that she was keeping an eye on him with all the boys, and I've got that note and it goes into the archives. Everyone was sort of quiet, not much chit-chat.

Then David got drunk and started what he always starts when he's had a few drinks, that when Philip kicks the bucket he'll move in with me. It's scary.

Keith wanted to go to Rounds, the gay place at 53rd and Second, and I didn't, so I said I'd never been there because I hadn't in five years, and so we walk in the door and the first thing the waiter says is *(laughs)*, "Mr. Warhol! It's so nice to see you again!" Jean Michel wouldn't go to Rounds. He called this morning and told me that in the old days when he didn't have any money he would hustle and get $10 and he didn't want to remember that.

So Jean Michel went downtown with Keith. I walked the Doc uptown and he kissed me on the cheek, which was so tender.

Wednesday, August 8, 1984

There were eighteen trucks parked on my street and sitting on my stoop was this guy from a movie company, and I asked him what they were shooting and he said, "*Brewster's Millions.*" And then he said he was Carol LaBrie's half-brother—Carol, our star of *L'Amour*. He took us into the big truck near us and there was Richard Pryor. And he was a lot better-looking than I remember when I last met him. Actually handsome. With this blonde. I don't know if she was in the movie, too.

It was really hot and muggy in the truck, the air conditioner wasn't working too well, and I was going to invite them into my house but the air-conditioning there wasn't much better. I was considering it, really I was. And it was hard to hear because the air conditioner in the truck was

going. He said he'd just seen *Bad* a couple of months ago. I wonder if the little gold cross he was wearing was his own or for the movie.

Thursday, August 9, 1984

Cornelia called while the auction for her debutante book that she's doing with Jon and another person was going on, and it first was twenty-eight, and then it was thirty-seven with a smaller royalty and then it was thirty-five but with a bigger percentage.

Went to the movies with Keith and Bobby, Madonna's ex-boyfriend who's sort of Keith's friend now. I had to sign autographs and they were amazed that so many people yelled my name and would know an artist. I should have asked the people who yelled if they knew what I did for a living. All the blacks know me, I must be in their consciousness. It's the white hair.

It was almost empty in the theater but it should've been completely empty. This movie, *NeverEnding Story*, my God ... and it's a big hit in Germany. It's sort of my philosophy—looking for the nothingness. The nothingness is taking over the planet. It was like *Alice in Wonderland* and *E.T.* and "Rumpelstiltskin."

Then afterwards Bobby knew all the places in the area, because Madonna had taken him to all of them. So we went to Jezebel's and then Jezebel came over and she was this fancy black lady. And then in walked guess who? Mickey Rourke. Who PH just interviewed for the cover of *Interview*. But he didn't see me and I didn't say hello.

Monday, August 13, 1984

Jane Fonda called and I took the call and that was dumb because she always wants something. It's funny the way she just calls people and asks them to do things for her. She wants me to go up to Boston with the paintings I did of her, which she never even bought—she borrowed one but it's back, and the prints were made to sell for her husband's campaign—but he can't be running again, can he? That was just last year, wasn't it?

Tuesday, August 14, 1984

Brigid's pug walked across the painting I'd just done. He had orange and purple feet. Madame Defarge kept knitting away. Worked till 7:00. I didn't go to dinner with Edmund Gaultney and the people who want to do a portfolio. Hedy and Kent Klineman. She's a friend of Jane Holzer's. But I just get this feeling about it: People finance a portfolio and then start to get nervous and dump all the prints (cab $7).

Home at 10:30. Watched Ann Jillian play Mae West and she was good. They always give them a big love affair, they make that the big thing.

Wednesday, August 15, 1984

I'm still looking for ideas. This fall it'll be a whole new look, new people. Because five years into the decade is when it really becomes a decade. The eighties. They'll be looking over all the people and picking the ones from the last five years that'll survive as the eighties people. It's when the people from the first five years will either become part of the future or part of the past.

Worked till 4:30. Cab to the crystal doctor and this time it was a real experience. This session was like an exorcism. He had me lie down on his table and close my eyes, and then he asked me, "Do you know where you are?" and I kept saying, "Well what do you mean?" and he kept saying, "Do you know where you are?" And I kept saying, "What do you mean?" and finally I said I was lying on his table and he said, "Oh, I thought you might not know because your eyes were closed." And he would touch me here and there and when I wouldn't have any reaction he said that I wasn't in touch with my pain. But it didn't hurt is the thing. But he said it was because I wasn't sensitive to the pain yet and that I would have to become sensitive to it. And he took my crystal and asked it, "How long? One minute? Two minutes? One hour? One day?" And at four days the crystal told him yes, so that's how long it's going to take for this crystal to be programmed. I said that I could go and get another one that'll be ready sooner. He said no. So I'm going to wait four days and then I have to have it with me always and not more than ten feet away when I'm asleep. I really do believe that all this hokum-pokum helps, though. It's positive thinking. And it's why people wear gold and jewels. It *does* have something. And if you wear pearls around a stone it *does* do something for you. He said I had some negative powers in me and I asked him how long I would have to come to him and he didn't tell me. It's so abstract. But you do feel better when you get out.

And the funniest thing was I picked up some chiropractor magazine and Jack Nicholson, our *Interview* cover boy, was on the cover of that, too. Standing with this chiropractor to the stars.

I had a fight with Fred. His attitude is so—it's like he's a magazine-editor-on-the-phone. And I don't know if he's on the ball or not. I know he's doing his best, but . . .

Thursday, August 16, 1984

DeLorean got freed, he's thanking the Lord.

Monday, August 20, 1984

Jean Michel called at 7:30 A.M. from Spain but I was in the shower and I missed it. He was in Ibiza and now he's in Majorca, he's the new darling of the Bruno set. And I'm just expecting him one day to come in and say, "I hate all these paintings, rip them up," about the ones we've done together, or something. Oh and Keith told me that the name Jean Michel used to use, SAMO, stood for "Same Old Shit," and he said that Jean Michel was the biggest influence on the new artists.

Cabbed to Jams to meet Philip and David and Keith and Juan ($6). The food was so good,

fish cooked with the right spices, coriander or sage—it makes such a difference when you cook right with spices.

I tried to get a design out of Philip for a one-room house. They cried poor. I cried poor. Keith cried poor. It was everybody crying poor. So crazy. David had three martinis but was normal, somehow. We were there from 7:30 to 10:00. I asked Philip how it was to be in an airplane crash and he said exciting. This was about seven years ago. He was the only one not hurt. They landed in cherry trees (dinner $400).

Philip's having dinner at the Newhouses' and Sandy and Peter Brant will be there, too, and Si Newhouse has the Natalie picture there and we're just hoping he buys it. And with that group there it could go either way. Because Peter and Sandy might just try to sell him one of mine that they have instead. Or else they could want him to pay a lot for the Natalie so that it would make the value of *theirs* go up. I have another Natalie somewhere, but I can't find that Warren. It's missing from the Factory. I mean it must be around somewhere rolled up. And if Newhouse doesn't buy it I think I should write a letter to Robert Wagner. I think they're bringing his series *Hart to Hart* back because people have been writing in.

Wednesday, August 22, 1984

Gael Love called and said she signed the deal with the Swatch people where if you buy two subscriptions to *Interview* you get one Swatch and if you buy two Swatches you get one subscription. She thinks it'll bring in 30,000 new subscriptions.

And this morning I woke up to *The Toy* with Richard Pryor and it's funny. I asked PH to write him a letter from me saying that I wanted her to do the first part of an interview with him when she's in L.A. next week, and that I'd then do the second half myself when he comes to New York, and I signed the letter and sent a *Philosophy* book so we'll wait to hear.

Tuesday, September 11, 1984

PH finally got back from L.A. The Richard Pryor people told her Richard was "in seclusion" in Hawaii and that they were going to "wait to give him his mail when he gets back in October." She was out there trying to get a screenplay she wrote sold—Coppola's Zoetrope studio had it for two years and didn't get it financed and then they went bankrupt. While she was out there she wrote up the treatment I asked her to about a sixties "Girl of the Year" because I want to show it to Jon and maybe he can get Paramount interested.

And it's a good thing she's back because she was about to get fired from her one-minute-a-day job. While she was gone Truman died. His old boyfriend Jack Dunphy got $600,000 and was carrying the ashes in a golden book with "TC" engraved on the side. And Brigid figured out that Kate "Harrington" isn't Truman's *niece*—she's actually Kate O'Shea! The daughter of Truman's old boyfriend Jack O'Shea. The one who lived on Long Island and had a wife and lots of kids. And I'm doing paintings now of Truman for the cover of *New York* magazine.

So Jean Michel just called me and I haven't heard from him in two days. Now he's staying all

the time at the Ritz Carlton instead of down on Great Jones, and his room is like $250 a night. Fred went off to Lord Jermyn's wedding. Jay's on jury duty and Kate broke up with him and I don't know, he seems sort of relieved.

I read the article in the *Times*, very low-key, that said that Barry Diller was leaving Paramount to go to Fox! And that he was getting $30 million. So Jon will probably now work for Frank Mancuso there at Paramount or something. It'll actually be better for him. Barry did make the place great, though.

I worked on Judy Garland for Ron Feldman. The "What Becomes a Legend Most" advertisement.

Wednesday, September 12, 1984

Richard Weisman called and said dinner was on with Kathleen Turner from *Body Heat* and *Romancing the Stone*. Went to Richard's and Kathleen Turner in real life is so chic and worldly. She says she's about to star opposite Jack Nicholson in something that I didn't get the name of because I felt I should know it. And she just got married to this guy, Jay, and they're a funny couple. He's about my height but with heels on she was taller than him. He started out in Lance Loud's band the Mumps, and then he worked for his father and then he went into business with this friend of his and bought all these real estate properties in the slump of '74 when they were cheap and he became a millionaire.

And Richard had a girl there who was like Judy Holliday, but dumb for real. Really dumb. I haven't met a girl like this for a long, long time. I don't know where she would come from. She was an airline stewardess. She said to me, "Gee you look peculiar," and they said, "He's an artist," and she said, "I have a sister who's an artist, yeah, and she looks peculiar like you, too." And then she asked me if I did something to my hair. And then Richard took her upstairs to talk to her.

Thursday, September 13, 1984

Went to Dr. Bernsohn's and I asked him if we could put him in *Interview* and he said, "I'm not doing the kind of things I would want people to know about." But you do feel energy when you leave there. And the same with Dr. Li—you feel energy. So something is happening. That guy Christopher made me go to, I didn't feel different at all. But these ones do something. Like when Eizo made his hand sweat just by concentrating. Dr. Bernsohn is strange, he said he was living with his parents until just recently. Now he's buying a co-op. He said he'll give me stones that've been programmed for him but he'll reprogram them for me. And he said he wants to come down and look at my paintings to see the vibrations he gets from them, but I'm afraid he'll see a $50,000 one and say, "I want that." And then what will I do? If I say no he'll want to cure me of negativity. It's like a—what's that word?—a "scam." But then you do feel energy, so it's working. And the healing people do have such hot hands. There must be something to it.

Cabbed to 52nd and Lex to meet Jonas Mekas and Timmy Forbes at Nippon (cab $6). They're trying to raise money for the Filmmaker's Co-op. I asked Jonas if he'd seen any movies lately and

he said no, that he was just trying to raise money. And really *(laughs)* he *never* saw movies. He never did.

Worked on the Truman Capote cover for *New York*.

Friday, September 14, 1984

The MTV awards were so exciting, it was like the Brooklyn Fox shows in the sixties with so *many* stars. Diana Ross was my date, but she was in another row, the first row, because she was picking up Michael Jackson's awards. Lou Reed sat in my row but never even looked over. I don't understand Lou, why he doesn't talk to me now. Rod Stewart and Madonna and Cyndi Lauper and Bette Midler and Dan Aykroyd and Peter Wolf were there.

After it was over it was raining so hard. Like a repeat of the Diana Ross concert in Central Park. We went over to Tavern on the Green and everyone had to stand in the rain for twenty minutes with everyone's umbrellas dripping down your neck, and then inside it was wall-to-wall celebrities but they'd been so humiliated by standing in the pouring rain that all everybody did was complain to each other.

Saturday, September 15, 1984

Had dinner with Jean Michel who brought a woman who's doing a cover article on him for *The New York Times Magazine*. He's getting the cover! And he told her all this stuff about being a male prostitute before but she can't use it. I guess he told her because he wanted to be fascinating. The right woman can get anything out of him.

Sunday, September 16, 1984

By the way, John Reinhold told me that he keeps a really personal diary. He hides it in a closet and he took it out and read last year's entries. It's dangerous, but he only uses initials, like, "I went with B." If I did it that way, though, I'd forget who "B" was.

Jean Michel called and he told me about the problems he's having with Shenge, who takes care of his place on Great Jones Street. Shenge has his own place downstairs but then he goes up and uses Jean Michel's bath and bed, and now after staying at the Ritz Carlton, Jean Michel is used to having his bed tucked in. He found Shenge on the streets, he wasn't living anywhere. He's like a Rastafarian. He's married, he has a wife and little boy in the Bronx, I think. Shenge's bed used to be right by the front door so it was like he was just yanked in off the street, it was so peculiar.

Got a cab and picked up PH to go to the Odeon to have dinner with our *Interview* photographer Matthew Rolston and the Holland boy—he's Joanna Carson's son—who PH just met in L.A. ($10). He was very good-looking and I offered to make him a "First Impression" with Matthew doing the photograph. Matthew said that when he shot Joan Rivers for *Interview* she told him she used to be a photo stylist and worked for Cecil Beaton. And Matthew wears brooches. He's the

one who started Michael Jackson wearing them. When he photographed Michael for *Interview* he gave him his own brooch and Michael then started wearing them all the time. But Matthew must like women, because when he photographs them he makes them look gorgeous (dinner $150).

Monday, September 17, 1984

Vincent picked up the small Truman Capote portraits that I'd done for *New York*. When they saw them they said they'd thought I was going to do something new, but I'd done them my usual way because that's what I thought they wanted. They're going to pay a user's fee. But I don't know about these low prices I get when I do stuff for magazines, because I think of the time Carl Fischer took my picture for the *New York* cover for the *Philosophy* book—I mean, he had a whole *set* built, and then he had eight assistants or something, so look how much they probably spent on *that*. So I got all worked up thinking about how cheaply I work, and it made me call *Vogue* and ask them where the money they owe me was.

Keith told me that he rented a store for $1,500 across from the Puck Building. So I guess he *is* a little like Peter Max. But then Peter Max never did get in the good art collections that Keith's in. And he said he won't sell his stuff to any other store, it'll just be in his own store.

And Nick Rhodes buys art, but he doesn't listen to anybody, and I told him that it's stupid not to, that it's just like buying stocks. But he said, "I just buy what I like." And I remember Kaye Ballard saying the same thing when she bought pictures twenty or thirty years ago and then couldn't even get back what she paid for them.

And Bruno had called earlier. These combined paintings of Jean Michel and me and Clemente that he said were "just a curiosity that nobody would want to buy" that he paid $20,000 for like fifteen pictures for, he's now selling for $40,000 or $60,000 apiece! Yes! And I have a funny feeling that he's actually giving Clemente more because I can't see him doing this for this little. And *I* should get more because I bring up the prices . . . oh but well, Jean Michel got me into painting differently, so that's a good thing.

Tuesday, September 18, 1984

I got home and watched Tyrone Power in *Jesse James*. And that's really looking at something. Maybe he couldn't act, but gee.

Thursday, September 20, 1984

Well this was the day of big plans to see the chief crystal doctor who was in town, Dr. Reese.

Cabbed ($3) there to 74th between Park and Madison. They make you pay beforehand. And they give you your fifteen minutes and then get you out fast. And so I went into the room and it was like *Invasion of the Body Snatchers*. An old lady like in her sixties, pudgy and like a meat market guy, and the doctor was a big guy like from Hick City. And the room was so little. And

they run their hand over you in funny places and say code letters, you know, and they'll say they've run into a "hole" or something like "There's a hole here escaping," and they'll say, "C-85, 14, 15 D-23, circumvent 18, 75 dash 4...." And then he said something and Dr. Bernsohn said, "Oh he doesn't have any feeling"—about me. And the doctor said to me, "I'll tell you about it next week," after the other doctor said, "I didn't know I had such an extreme case." But afterwards I wasn't spaced-out or anything. When we'd walked in, there was a guy in a daze. Afterwards Benjamin and I we went to Fraser Morris and got lunch and ate it on the ledge at the Whitney Museum, we didn't even know it was the Pop Art show inside.

And a woman came by and saw me eating chicken and said, "That's a no-no," and she was right. I'm not supposed to eat meat. But I'm trying to be more normal. I signed a lot of autographs. Then we went up to Vito Giallo's store and ran into Paloma Picasso, who's just in town for a day, to promote her perfume. She's so skinny again, it's incredible, and no lines.

Good newspaper headlines about Muhammad Ali having some disease. I got them for the new Front Page paintings I want to do. And John Reinhold called me yesterday morning and said that the Polish Institute next door to me was being sold and that he'd gone to look at it—$2.7 million.

Then I went to Judy Green's party at 555 Park.

Arlene Francis was there and her little husband Martin Gabel who's still alive who she has to push around like a toy.

C.Z. invited me to the memorial for Truman.

Saturday, September 22, 1984

Called Jon at Paramount and asked him to meet me at MOMA. Got in free to the primitive art show where they have the old primitive stuff and the new stuff beside it to show what had been taken from what. Then went to see the Irving Penn show, and it was all the photographs that I remember so well that were what made me come to New York in the first place. It was fun to see them again, they weren't anything so different, but . . . And I kept thinking that I should have bought a camera when I first came to New York, because photography was wide open, and if you could just do what was "as good as" you could be big. I mean, you took a picture of a famous person and how could you go wrong? I would be doing TV commercials today. Things would've been different. It's just something to think about. And Irving Penn's photos, it's funny to see that the models were all older, like thirty-five. He used his wife a lot—Lisa Fonssgrives. And I remember so well that one photo where the things spill out of the girl's purse and it's tranquilizer pills and things. The shows were wonderful.

And Steve Rubell asked if we wanted to see his new club-to-be. It's the Palladium Theater on 14th Street, that was originally the Academy of Music. So he took us over there and it was, "Do you love it? Do you love it?" And it's *huge*. Some famous Japanese architect is doing it.

Sunday, September 23, 1984

Tried Jean Michel because he'd wanted to go to the Pop Art show at the Whitney and then work together, but he wasn't around. Jon and I went there without him (tickets $5). I autographed a lot of the postcards they sell there, people handed them to me. Of Marilyn and the others. I don't

think I get any money from these. I had a fight with Fred because he wants me to sign with a card company because he said that then that card company will stop the other card companies from putting them out, but I don't know if that's true.

Rauschenberg was the best in the show, somehow his stuff looks new. I don't know why. And Jasper Johns's stuff was good, too. The Segal looked good because it was big, but it was so ugly. The tires outside looked so terrific that you thought the rest of the show would be on that scale or something, but the Whitney is small. There's some early stuff of mine, a lot of mine. Jean Michel had told me he thought my stuff looked the best, but you know . . .

So then wandered the streets, went home and Jean Michel called. Now he has rooms in *two* hotels. One at the Ritz Carlton and then he moved to the Mayfair Regent on 65th Street. I guess he was competing with me to live in the chic East 60s. I told him that the TV was terrible around here and he didn't believe me, but when he got to the Mayfair and found out he couldn't get the Showtime channel or anything like that he learned his lesson. Good TV means a lot. So he went back to the Ritz Carlton. He has a big Jacuzzi there.

Monday, September 24, 1984

In the morning I rushed to Dr. Li (cab $4). Took some blood tests and she threw it on my body, the blood. I'm now supposed to eat rice three times a day, but I'm cheating, I'm eating rice *crackers*.

I have to go to Truman's memorial. Afterwards there's going to be a party at C.Z. Guest's. Steve Rubell had the best line, he said to me, "You don't go to mine, I won't go to yours." That's the best deal. Jay's going—I guess he and Kate are back together.

I asked Paige if she wanted to go with me to Ahmet Ertegun's party at the Carlyle (cab $3). Ahmet was at the door. Same usual people—Jerry Zipkin, Mica and Chessy. The lights were so low. Mrs. Buckley was there and Charlotte Curtis, and Charlotte screamed at me, "Oh your eyebrows are dyed!" So what could I say? "Yeah. They're two-tone." Charlotte always looks so sour. But I do like her. She did those great columns in the sixties. Paige was the youngest one there.

Tuesday, September 25, 1984

I forgot that while I was at Dr. Linda Li's Roberta Flack came in and she said, "Oh I saw you at St. Vincent's church on Sunday." She said she was going to a Baptist church and just wandered into mine.

Wandered down Fifth Avenue.

Crazy Matty came by the office and Brigid got him to leave. He's thin again but he's okay, not more crazy than usual—just normally crazy. I don't think he still has that girl living with him in his hotel room. Oh, but why is it that crazy people can get boyfriends and girlfriends and normal people can't? Can you tell me?

I got invited to the Malcolm Forbes boat with Mrs. Marcos. I really want to get her portrait

before, you know, something happens over there. Fred Leighton must be so glad when he hears she's in town. She goes into his jewelry store and drops millions of bucks. Worked till 7:00.

Wednesday, September 26, 1984

I was picked up by Benjamin and we walked out and right into the arms of—Crazy Matty. We got a cab and he left and then two blocks later he came up to our cab that was waiting at the light and he opened the front door—I'd locked the back door—and he asked for money. So now he knows how to—extort.

Thursday, September 27, 1984

Talked to Keith Haring who said he was depressed so he went to the Whitney and that he saw the Pop Art show and saw my Dick Tracy and loved it and I said it'd just been sold for $500,000 and he said that wasn't enough, that it was worth a million and that if he'd had a million he would have bought it. That was sweet of him to say. And it was sweet to hear. Si Newhouse bought it from Irving Blum.

Went to meet the Brants for dinner at Jams (cab $6). I told the guy we wanted to be downstairs, but he put us upstairs again, but then later I saw why—Robert Redford was right behind me, with maybe his wife and daughter, I think. I didn't say anything because that's not cool, but when I got home I happened to read an old *Playboy* interview with him and then I decided I *should* have said hello because it turns out he'd tried to be a painter at one point, and he talked about how he was a magazine art director in the fifties in New York. I didn't know any of that! So then he would know about me.

Did I tell the Diary, by the way, that Merv Griffin turned down our TV show? He did.

Saturday, September 29, 1984

Talked to Keith and Jean Michel. Wanted Jean Michel to come over and paint, but he was giving his mother a birthday party so I went to meet him and met his mother. She's a nice-looking lady, a little matronly, but she looked good. He sort of resents her, though—he said she's been in and out of mental hospitals and he felt neglected. But he doesn't have to be ashamed of her, she was really nice and everything. His father was a no-show. They're divorced and the father is living with another woman. He's an accountant.

And Jean Michel still keeps a room for $250 a day at the Ritz Carlton. And that fifty-foot concrete table that he had Freddy the architect do up special for the Great Jones place, it filled the whole room and Jean Michel just broke it up into pieces. And I found out from Robert Laughlin who's next door to Freddy's place that used to be Kenny Scharf's, that when Freddy moved into Kenny's apartment there were just Kenny Scharf paintings everywhere, all over the

walls and Freddy *painted them out!* He painted it all white! He didn't even remove the doors that had paintings on them, which would've been so easy to save!

Monday, October 1, 1984

It was so cold out. And what do you do when these pushy old broads shove you out of the way and grab your taxi? Finally got a cab ($8) but the traffic was so slow.

Oh, and all afternoon we were waiting for Stuart Pivar to call because Michael Jackson was supposed to call him and come over to see Bouguereaus. But Stuart went out for a minute and missed the call, but he might come today. If this is real. Those Bouguereaus are now $2 million apiece and Stuart has about four. They went up so suddenly. It's funny, they're just the perfect paintings for Michael Jackson—like ten-year-old boys with fairy wings, around beautiful women. And Stuart Pivar is really into young bodies. That's what he thinks keeps you young, is the hormones. He wants seventeen-year-olds, but he can't get them.

Tuesday, October 2, 1984

Jean Michel came over to the office to paint but he fell asleep on the floor. He looked like a bum lying there. But I woke him up and he did two masterpieces that were great.

Wednesday, October 3, 1984

Jean Michel called three or four times, he'd been taking smack. Bruno came by and saw a painting that Jean Michel wasn't finished with yet, and he said, "I want it, I want it," and so he gave him money and took it, and I felt funny, because nobody's done that for me in so long. That's the way it used to be.

I was going to the party on Malcolm Forbes's boat for Imelda Marcos. It was sort of embarrassing because I thought I was late but I was early. Most of the people were so old and they were all from my street, East 66th Street—I guess it must be the richest street in the world. Imelda lives on it between Fifth and Madison. Lee Radziwill came. She looked good in a short haircut. Imelda's gotten a little too fat, though, so if I did her picture I'd want to do it from the old days, when she was Miss Philippines in the pageant. She was being a hostess and she sang, later on after dinner she sang about twelve songs—"Feelings," and then that song from the war, you know, the oozy-doozy-bowsy-lowsy one. Oh, what is it? "Mares Eat Oats." Everybody said that once Imelda gets started partying you can't stop her, that she's always the last to leave, and it was true, she was going strong.

Then cabbed to Mr. Chow's where Jean Michel was having a birthday party for this girl who'd talked him into having it for her. He had Diego Cortez and Clemente and people and when I got

there he was asleep, snoring actually. We woke him up to pay the check, because I wasn't going to get this one.

Got home and I turned on the *Letterman* show and there was—Malcolm Forbes! Talking about everything. And I thought, Gee, what a great name for a magazine, *Forbes*. They just named it their name. And I started thinking about a magazine called *Warhol*. *(laughs)* No no, I don't love my name so much. I always wanted to *change* it. When I was little I was going to take "Morningstar," Andy Morningstar. I thought it was so beautiful. And I came so close to actually using it for my career. This was before the book, *Marjorie Morningstar*. I just liked the name, it was my favorite.

Friday, October 5, 1984

Jean Michel came by. Worked all afternoon. Rupert came and he's using the back area now at 860 to collate the new prints. The Details. I hate them. Like details of the Botticelli "Venus." But people are loving these best. It makes you wonder. Like they loved the James Dean cover for the David Dalton book that I did. They're buying it in prints.

Sunday, October 7, 1984

It was a beautiful day. Talked to Jean Michel and he wanted to go to work, so we planned to meet at 860. I went to church and then there were no cabs, so I wound up walking halfway to the office (cab $3.75). I let Jean Michel in downstairs. He did a painting in the dark, which was great. This was the day of Susan Blond's wedding to Roger Erickson, and the thing was at the Café Luxembourg and I didn't want to take Jean Michel home with me to pick a painting up for a present, so we both made her a painting there. Jean Michel is so difficult, you never know what kind of mood he'll be in, what he'll be on. He gets really paranoid and says, "You're just using me, you're just using me," and then he'll get guilty for getting paranoid and he'll do everything so nice to try to make up for it. But then I can't decide what he has fun doing, either. Like when we got to Susan's he didn't like it, I don't know if it's because of the drugs or because he hates crowds or because he thinks it's boring. And I tell him that as he becomes more and more famous he'll have to do more and more of these things (cab $10).

I met Roger's mother and she looks and acts just like Susan. Jonathan Roberts flew in from California and I asked him why he bothered. I said, "Just because you had a date once with Susan?"

Danny Fields was the best man, he gave a little speech. And Steve Rubell was there and he wasn't that friendly. I mean, he was really friendly, but sometimes he's really really really friendly. So he wasn't friendly enough.

A woman at the party was from Los Angeles and she was complaining about a table she bought from Ronnie Levin and saying that he took the money and didn't get her the table, and so she called his mother, and the mother said that Ronnie's disappeared. I asked PH about it and she

said it's serious, that nobody's heard from him for weeks, and that with his big mouth, if he were alive, he would've called someone by now.

Monday, October 8, 1984

Picked up Jean Michel and he has people ringing his bell every fifteen seconds, it reminded me of the old Factory. He says things like, "Listen man, why don't you call before you come over." A guy he'd given fun drawings to once when he was needing a place to stay sold them now for a fortune—$5,000 or something. So Jean Michel's finding out how you have to be a business, how it all stops being just fun, and then you wonder, What is art? Does it really come out of you or is it a product? It's complicated.

Oh, I forgot to say that Dr. Rossi's kid who's just out of Yale wants to do videos and so I'm sending him to talk to Vincent. Dr. Rossi's the doctor that saved my life in '68 when I was shot.

Tuesday, October 9, 1984

I made up some things for Sean Lennon's birthday and the painting was still wet—a little heart candy-box that said "I love you"—and I also brought a "paint brush" that instead of bristles had strips of red colored paper in a stack. And a bracelet I'd made out of pennies. PH picked me up and we went to the Dakota (cab $6.50). There were fans outside in honor of the day still on the "vigil." Because the ninth is Sean *and* John's birthday. Inside Yoko's door everybody had taken their shoes off so there was a line of shoes. I wouldn't take mine off, though, and I didn't want PH to, either, so that I wouldn't be alone. PH said that when she went to the Royal Palace once in Hawaii that the tour guides gave you booties to put *over* your shoes and *that* would be a better way to keep the house clean, I think. So then when we heard a glass drop and break, that was our excuse—that we didn't want to be in our socks when there might be glass. Yoko ran to call Sean and he came in and said, "Did you bring my dollar?" Yoko said that he'd been remembering and wanting the other half of the dollar I tore in half the last time. So I gave him a whole bunch of torn bills that I'd brought for him and he went off to try to find the match to the half *he* had. Keith was there and he brought Kenny Scharf as his date. Walter Cronkite was there, and John Cage and Louise Nevelson and Lisa Robinson.

On purpose for fun I had spelled Sean's name "Shawn" on a couple of his gifts, and so when Sean autographed napkins for me he signed it that way, too. He was wearing Michael Jackson-type gloves, but on both hands, that his friend little Max Leroy, Warner Leroy's son, had given him. Michael Jackson is his favorite singer. He said he likes Prince, too, and he must like Boy George, too, because later on his computer he did a drawing of Boy George. Sean and Keith hit it off. Keith is very good playing with kids—he was playing really well with another baby that was there, too, coming after her with a stuffed animal. Sean sat between me and Roberta Flack.

The cake was a big blond grand piano. Sean was the one who had the idea that it should be a piano. He has a piano in his bedroom. And he cut the cake. Harry Nilsson led everyone singing

"For He's a Jolly Good Fellow," and later Sean made a really nice speech and said that if his father were there we'd be singing "For *They're* Jolly Good *Fellows*."

After dinner Yoko and Sean and some of the people went over to the WNEW broadcast that they were originally going to do inside the building, but at the last minute the Dakota wouldn't let them. But most of the people stayed behind. We went into Sean's bedroom—and there was a kid there setting up the Apple computer that Sean had gotten as a present, the Macintosh model. I said that once some man had been calling me a lot wanting to give me one, but that I'd never called him back or something, and then the kid looked up and said, "Yeah, that was me. I'm Steve Jobs." And he looked so young, like a college guy. And he told me that he would still send me one now. And then he gave me a lesson on drawing with it. It only comes in black and white now, but they'll make it soon in color. And then Keith and Kenny used it. Keith had already used it once to make a T-shirt, but Kenny was using it for the first time, and I felt so old and out of it with this young whiz guy right there who'd helped invent it.

Sean's bedroom had two mattresses on the floor and lots of Beatles pictures and the big Rupert Smith picture of Yoko on the wall. There was wrapping paper and presents all over the floor, and lots of robot toys on the shelves.

After we left I was so blue because before *I* was Sean's best grownup friend and now I think Keith is. They really hit it off. He invited Keith to his party for kids the next day and I don't think I was invited and I'm hurt.

Saturday, October 13, 1984

Got up early and it was nice out. Jay's back with Kate Harrington and he's too happily married to go to work, too. Benjamin's too happily married to go to work. So I went alone ($6). The only person who was called was Michael Walsh, the kid from Newport who wants me to look at his work. Worked till 8:00 all alone. Went uptown ($6).

Cabbed to Mick and Jerry's for dinner on West 81st Street (cab $4). There were three butch bodyguards outside. Jack Nicholson was there, and he's into Bouguereau now—he has all these Remingtons and now he's buying Bouguereaus.

The baby wasn't there. Jerry's sister Rosy was, and she had her two tits almost popping out, which is so odd, because I don't know why she would dress like that when she has this big butch sexy great husband. And I talked to Wendy Stark and she had three pictures of her kid, so it looked like triplets. Whoopi Goldberg came and the Garfunkel guy was there and Mike Nichols. Tina Chow was in the kitchen with the food, they'd done it. And I approached Jack Nicholson about being in the Jackson Pollock story that PH and I are now thinking of buying the book rights to from Ruth Kligman, and then Fred came up and said it was a terrible idea, that Ruth Kligman was another Crazy Matty, and so Jack said, "Well I'll let you two movie moguls fight it out." Jack was wearing a suit that he'd had made in London that made him look like a box.

Mick was drunk and really friendly, came over and hugged me a few times. I was sort of glad that I didn't bring Cornelia, because she'd be "a threat" to Jerry. I was surprised to see Whitney Tower there because Jerry always accused him of getting girls for Mick. There was a whole other room with more stars in it.

Monday, October 15, 1984

I had an appointment with Dr. Linda Li. I was fifteen minutes late and so I had to wait. She told me that I was allergic to potatoes, and I don't know if she's magic or if she smelled them, because I had had some. And she told me not to eat them for a while, the white ones. Left there (phone $2, newspapers $3).

After work I went with Jean Michel to finally check out of his hotel room at the Ritz Carlton, but when we got there he decided it was too beautiful to leave.

Tuesday, October 16, 1984

Jackie Curtis called and said that Alice Neel died. I'd been meaning to call her for a while. She was a sweet old lady. I guess she was old enough, though, in her eighties, I think. It seems like I just saw her on the Johnny Carson show. Jackie wants to take an ad in *Interview* for a play he's opening, but how can we trust him to pay?

Jean Michel, me, John Sex, and Fab Five Freddy cabbed uptown to the Lyceum and the Whoopi Goldberg show ($8). We were late and in the second row. Whoopi was great, for one and a half hours just a blank stage but she held your interest. She's really intelligent and everything. She does a thing where she asks for quarters from the audience, but then she didn't give them back. So when it was over and we went back to see her she said that she usually gives them back—I asked her—but that a guy had given her a dollar bill and that threw her off, and now she had about $4 and so she might just now give the money to a Catholic charity. She really liked Jean Michel and I invited her to dinner, but she said she had cramps or something.

Wednesday, October 17, 1984

Our lawyer, Risa Dickstein, was on the cover of the *Post*, because she's the lawyer for the Mayflower Madam, so that shows you what kind of a lawyer we're so fortunate enough to have.

Then Gloria von Thurn und Taxis, the fairy princess, came to the office for lunch with her husband, the fifty-eight-year-old fairy prince that she married when she was twenty or something and got on the cover of every German magazine because he's the billionaire who needed kids for heirs. And now they have three kids. And Betsy Bloomingdale was there, too.

Prince Johannes von Thurn und Taxis started some dirty talking. He said that when he was young and he went to Hollywood and met Marilyn Monroe that she came on to him and invited him over for dinner, but he said he wasn't into women then—he said this out loud. They talk like that. And the wife talks about boys, and then he talks about boys with big cocks. It's very abstract. So anyway, he said that he asked Marilyn Monroe who else was going to be there and she said a few names, and he arrives and Marilyn comes out in a décolleté negligee and he said, "Where are the other people?" and she said, "They all cancelled." So they had pink champagne and then dinner and then she pulled a little string and she was standing there stark naked and

he couldn't . . . so he said he just banged her on the knockers and said, "See you later, toots." He said that he could've pretended and they could've just wrapped themselves around each other, but that—he repeated it again—he wasn't into women then. She must've known how rich he was. Or else maybe he was good-looking. Because he did also say that Pablo Picasso once saw him and wanted to do his portrait, and said he'd do two and give him one, but he thought it was just some old guy after his body. This was on the beach. But I don't know if his stories are true. They probably are, but he remembers some things about me that I don't, so . . . Like he says he once invited me out and that I said I was sick and that then he called me at home and I wasn't there, but I know I never gave him my home phone number.

And then I walked them to their limos and Gloria wanted a cock drawn on her *Interview*. And Fred said this was our first society party in the new building. But it would've been great in the ballroom. But it's leaking up there. And Fred had tables built on the roof! I don't know why. And his little dining room is nice, but it's not the same.

Monday, October 22, 1984

Went to the new offices and met the construction person that Vincent and Fred are liking so much. I got mad at him when I heard that it was going to be $100,000 for a terrace on the roof, and I just said, "We want just a plain old roof." And I laughed in his face when he told me it would be done by Christmas. Oh sure. I'll have to think about this.

Rupert said that his apartment was robbed so not to get upset if those unsigned prints start showing up at auction. But then the police called and said they'd gotten some things back.

Worked till 7:30.

Cabbed home ($6) and glued then went to dinner at the Sacklers' on Park Avenue and it was for Princess Michael of Kent. And you were supposed to get there before she arrived but I was late. It was dinner for only eight people. And there was a lady stuck in the bathroom and everyone ignored her for half an hour and when she got out she accused Jill of hearing her and not doing anything, and Jill said she hadn't, but I mean, *I* heard her, so . . .

Friday, October 26, 1984

Victor came by. Halston's working at home now.

Julian Schnabel was having a birthday party at Mr. Chow's and invited me but Jean Michel and I didn't want to call him back because we knew he wanted to come and see what we were working on. Worked till 7:50 (cab $6). John Lurie who starred in *Stranger Than Paradise* came over and we had champagne and that was a mistake. Dropped him at 12:30 (cab $7).

Saturday, October 27, 1984

Kate's picture was big in part one of the Truman Capote article in *New York* magazine, and part two is about to come out so I'm wondering if it's going to say how she's actually the daughter of the old boyfriend, Jack O'Shea.

Monday, October 29, 1984

This was the day of the New York marathon, and it was hot and humid so the runners had a bad time. One man from France died—the first one to die in the marathon. And the girl who won was pooping in her pants, she had diarrhea, and they tried to brush over it, but they said, "She's tugging at her pants again."

Kenny Scharf called and invited me out for a ride in his Cadillac that he drove here from L.A. and painted. Now he's got champagne glasses and monsters on it. He and Keith came along and the car looked like really something and the police were in back of them because they were just curious, like everybody else. So we drove uptown to 90th Street and East River Drive to see the mural that Keith had done. It's like 2½' wide × 200' long, like three blocks long. He painted it white and sprayed little black and red figures, but it would've been better just silver. It doesn't make the city look better, really.

Halston called and invited me to dinner at his house where Jack and Anjelica and Steve Rubell and Alana were going to be, and Bianca, and I said sure and watched TV and then at 9:00 walked over there. Ann Turkel who was married to Richard Harris was there. Bianca was kissing her boyfriend as if she were Jade or something, in front of Alana, who was talking about money settlements. These girls. It's so strange, like over the hill, talking about "settlements." Bianca was putting down Alana's house in L.A. and saying it was so trashy and in the worst taste and she and Alana almost had a fistfight. They're friends.

And the big person at the party was Peter Wolf and I told him how all the girls were so crazy about him, they love him in his music video. Dinner was good. Halston's hair is receding a little. His house doesn't have the flair that it had when Victor lived there.

Tuesday, October 30, 1984

Ferraro was on the news. I was liking her a lot in the beginning, but now she's more like all the rest of them, like mechanical.

Jean Michel was in bed with some new girl and didn't show up. Bruno arrived and surprised us. And his wife—Yoyo. And they looked at the big paintings that Jean Michel has been doing silkscreens on, and they had a sour look, they said it ruined his "intuitive primitivism." But he'd always *Xeroxed* before and nobody knew, it just looked like new drawings, and put on with that stuff. Worked till 7:30.

Then there was a party for Van Johnson at Limelight. When we got there he was leaving already. It was a party he was giving for Janet Leigh. And he was such a camp. He said, "Oh, I've been dying to meet you forever!" He seems like a big boozer. I guess there weren't enough cute boys in there. Then in the middle of the room was a shower and a girl in it and blood all over and a guy like Tony Perkins in a grandmother's outfit. And in the middle of all this was the real Janet Leigh in a blue sequined dress.

Wednesday, October 31, 1984

Bruno just called—at the Christie's auction Jean Michel's painting went for $20,000. I think he's going to be the Big Black Painter. It was one of his sort of big paintings. I think Jean Michel's early stuff is sort of better, because then he was just painting, and now he has to think about stuff to paint to sell. And how many screaming Negroes can you do? Well, I guess you can do them forever, but . . . And he bought a $700 mask for Halloween yesterday. Mexican. He just spends money. He did give up the room at the Ritz Carlton and he doesn't take limos now, so that's an improvement. But what he should do—and I've told him this—is keep his early paintings and store them so that he'll have them to sell later on. Because Bruno just buys up everything and then sells them off slowly. But Jean Michel really should be keeping them for a nest egg. The paintings that get good prices are Rauschenberg's early pieces and anything by Jasper and Cy Twombly. Wesselmann's sort of selling off . . . Rosenquist's prices are just medium, but I think he's the best, I really do.

I guess I'm going to finally face moving out of 860 because Stephen Sprouse has rented the place.

Glued myself together, picked up Gael, and we walked to Jams to meet Fred. And this dinner was really horrible. It was just me complaining. I should've been like a cheerleader, saying, "What can we do to make our magazine even better than the wonderful thing it is?" But it didn't turn out that way. Gael was explaining the printing costs. And really, I should have been positive. I know that you get more out of people by encouraging them. Although I did encourage someone once—Chris Makos. And what I got out of that is that this week they're auctioning off a picture of me in drag from the ones he took. And Gael wasn't eating so I thought it was because I'd made her upset, but it turned out that she was just trying to diet because she's gotten really fat. But she just rubs me the wrong way—she thinks she's so great or something. We just don't communicate. I don't know if she's stupid or if she just plays dumb so she won't have to do what you're telling her to do (dinner $140).

Then we talked about the covers, when would be the Mick, when the Health issue, when Mickey Rourke. It was just a very frustrating dinner, nothing was accomplished, just arguing. It was all my fault. We all would've been better off going to a Halloween party. Fred walked us both home.

Thursday, November 1, 1984

Julian Schnabel called and said he was coming by with that rock person, Captain Beefheart. And we didn't want him to, and then I got worried that Julian might have heard what I'd been saying about him—that he goes around to other artists' studios to find things to copy.

I had to leave early to see Christophe de Menil's first fashion show. She's becoming a clothes designer (cab $8). Went to 79th and Fifth, the French consulate. And the dresses were all just linen and the sleeves were like folded napkins, a 1914-style look. Funny sleeves. I don't know why she would want to go into the dress business—it's not like she has a "statement" to make. Bianca was there and Steve Rubell told me that the reason she didn't want anyone at the birthday party she gave for Jade was because Jade's gotten chubby. So I slipped out (cab $4).

Then Cornelia and I walked over to the Pierre for the ASPCA benefit thing. I talked to C.Z. Guest and she said that Truman got her out of being just a housewife and showed her that she could do things. And she said that she never told Truman anything personal, but I mean, we were standing there for five minutes and she told *me* every personal thing you could think of about her family . . . I mean you'd bring up drinking, and she's saying, "I lived with a drunk for years, so I know."

Friday, November 2, 1984

Worked till 7:00. Then there was an opening of Schnabel. So went to it (cab $6). I was putting his painting down, being funny, and then I saw he was next to me but I don't think he heard me. There were a lot of plates on the wall. Schnabel said that he was a short-order cook at Mickey Ruskin's restaurant on University Place for a while. Gee, poor Mickey. Nobody even mentions him now. He's just forgotten. The show was interesting but I had to leave because Cornelia was picking me up for the horse show.

Sunday, November 4, 1984

Went to meet Alba Clemente, the beautiful wife of Francesco Clemente at their loft in the Tower Records building. She studied acting, she has a great laugh, and she's rich. They live in India six months a year. That's why his paintings look the way they do, I guess. Then we went to the Odeon (cab $10). It was fun, we chit-chatted about art. There were big silences, though. Jean Michel is so hard to talk to. His thing is he's in love with waitresses, so he gets quiet and watches them. Alba said that her girl who was minding the children had a crush on him (lunch $90). And then we went back to her place so that Jean Michel could meet the girl, Monica, but she'd taken the kids out. And then Jean Michel was getting inspired from seeing Clemente's work and wanted to go do some painting himself.

So we went to the studio (cab $3.50) and worked two hours. Jean Michel was painting back in the images he'd painted out when he was on smack and he came up with some masterpieces. Then he called the girl, Monica, and invited her to dinner. She wanted to go to the Lone Star because her semi-boyfriend who's Schnabel's assistant was going to be there, but Jean Michel didn't want to go there because he was afraid if there was competition that he would lose the fuck.

Tuesday, November 6, 1984—New York—Washington, D.C.

Election Day. It was the worst start imaginable. I was up at 7:00, ready at 8:00. I called Fred and he was just out of it. It drove me crazy. He was rambling. Maybe he'd just slept for fifteen minutes, I don't know.

Anyway, an hour later we were in Washington. Went to the Madison Hotel. Princess Elizabeth

of Yugoslavia came with us. Her daughter, Catherine Oxenberg, starts on *Dynasty* next week and she was coming down later. And then some of the people went off to the White House but we weren't invited so we stayed in our rooms.

So we ordered lunch and that was expensive. Jean Michel ordered a '66 Château Latour wine for $200 (lunch $500). Then we limoed to the *Sequoia*, the presidential yacht, and it was cold and miserable and getting dark. Same old people. Peter Max and his girlfriend, who's so beautiful, tall and Texan, and I don't know why she's with him. She was at the beginning and ending of *Heaven's Gate*. A top model, I forget her name. I talked to Chip Carter while I was there.

Then we went back to the hotel and Jean Michel rolled a joint. Then we ordered dinner, which was disgusting (tip $5). Fred didn't realize that he had only yellow socks and brown shoes, so he couldn't wear his black suit. *Entertainment Tonight* got me on the way in and asked me who I voted for and I said, "For the winner," and they said, "Who's that?" and I said, "The winner is the winner." I don't even know what I meant. If they ever put all the clips they've ever gotten of me together they'd see that I'm a moron and finally stop asking me questions.

I took pictures of Melvin Laird dancing. Jean Michel was so hard to deal with, he gets so paranoid. This was a "Non-partisan Party" that the Weismans were having because at the last election they gave a party for the Democrats and this time everybody was a Democrat but pretending to be a Republican.

Wednesday, November 7, 1984— Washington, D.C.—New York

I called Jean Michel's room and said we'd be leaving in one second. And I went into his room and photographed him getting out of bed with a hard-on. And then he began rolling a joint. Jean Michel ordered a whole meal but it never came. Cabbed to the airport ($20).

Jean Michel and I went to the back of the plane and he was smoking joints, and I realized that he'd left his brand-new Comme des Garçons coat in the hotel room when he'd been rolling, and he called and I called but they'll never send it. He knows just what looks good on him. He's 6′ —or 6′1″ with his hair. He's really big.

Got a cab into Manhattan ($22). Then went to 33rd Street and sat in my room and made phone calls. The boiler was broken and it was freezing in there. And I want to take the key away from those two bathrooms outside my office because every other minute somebody's going in and out and I can't stand it, the constant production of peeing all day. I'm going to make the *Interview* kids go upstairs to one of those bathrooms or something, because who wants to hear that all day.

I went to Private Eyes (cab $7). Scott was at the door, so he let us right in. Madonna was on the platform and since Jean Michel had once been involved with her, we started to go up, and the bouncer said, "Step aside for Mr. Warhol," and then tried to block Jean Michel and I said that it was okay, he was with me. And Madonna kissed Jean Michel on the mouth but she was with Jellybean, who said he'd heard his pictures in *Interview* made him look 6′ tall so he was thrilled because he's 2′. And Jean Michel was moody because Madonna got so big and he'd lost her. And Dianne Brill tried to get on the platform and the guy just pushed her back and I said, "Don't you

know who that is? It's Dianne Brill," but he still wouldn't let her up. And she was so conspicuous in her rubber outfit and Frederick's of Hollywood stuff and everything, so she was really humiliated and that's the way things go—you think you have so much pizzazz and then something like that happens in front of your friends. It's happened to me. Sometime, someplace, it happens to every-body. And I told her I'd talk to the P.R. girl but she said no, that it was okay.

Thursday, November 8, 1984

Went to Diane Von Furstenberg's and in the same little room were Bianca and her boyfriend, and Mick and Jerry and her two sisters, and everybody was trying to stand with their backs to each other. And so finally to break the ice Bianca went over to Mick and said, "Oh, you've slept with everybody in this room," and she was giggling, and he said, "Oh yes, why look! There's Mark Shand! And Andy Warhol! I've had them all!" He was funny.

Marina Schiano was there and Jean Michel asked me if she was a drag queen. And Annina Nosei was there. She had a gallery in Soho and Jean Michel used to do paintings in her basement. She would bring people down to look at him like an attraction and he would yell, "Get the fuck out of here!" He destroyed twenty paintings once, he ripped them off the walls. And after she reminded him of all these old days he felt funny being at this chic uptown place. He's not happier now that he's uptown because it's all before him now and he doesn't know what to do. I told him, "Look, those tantrums weren't real anyway." He's confused. Stayed till 11:30.

Monday, November 12, 1984

Went to see *Stranger Than Paradise*. It isn't good.

Oh and the day had started out with Eugenia Sheppard dying of cancer. She invented fashion and gossip together. I guess she started in 1955. Is that when Princess Grace got married?

Wednesday, November 14, 1984

Went to Dr. Karen Burke's new office on 94th and Park and had my collagen treatment and it really, really hurt. There's supposed to be novocaine in the stuff as it goes in but it doesn't feel like there is. There must be a way to have this done without pain. The last time I had it done was a year ago. Fred said he screamed in pain while he was having his face done. I mean, there's a thousand needles sticking in your face.

Cabbed to Mr. Chow's for Jean Michel's party ($7). And it was great. I feel like I wasted two years running around with Christopher and Peter, just kids who talk about the Baths and things, when here, now, I'm going around with Jean Michel and we're getting so much art work done, and then his party was Schnabel and Wim Wenders and Jim Jarmusch who directed *Stranger Than Paradise* and Clemente and John Waite who sang that great song, "Missing You." I mean, being

with a creative crowd, you really notice the difference. It's intriguing both ways, and I guess both ways are right, but . . .

And now Chris is thanking me for not using him anymore to print up my photographs, because he says it's made him hustle more and work harder. And Bianca who I'd invited called and wasn't coming and then was coming, and finally she arrived, and she acted grand as if she wasn't looking for movie work. She changed her seat and took Alba's when Alba went to the ladies room and when she came back Alba said in a voice loud enough for Bianca to hear, "She's taken my place *again,*" meaning like with her husband Clemente, but it seemed from how they were acting here like Bianca and Francesco didn't know each other.

And Jean Michel became the hostess with the mostest last night. He said it cost him $12,000 —the Cristal was flowing.

Thursday, November 15, 1984

Vincent said I had a big video shoot to do and I said that my face was still all marked up from the collagen thing the day before and he promised that he wouldn't shoot my face.

There were a lot of parties this night but Dustin Hoffman called and said he'd left tickets for *Death of a Salesman* so Benjamin and I got to the theater and met Jean Michel there at 7:58. At intermission the people behind us tapped Jean Michel and asked if I was really who I was. Dustin was actually good, but the play is so old-fashioned. I'd seen it years ago with Lee J. Cobb and Mildred Dunnock, and they were more like real old people.

And afterwards we went backstage and there was coffee and everything and Dustin was really up up up, he was camping and screaming, "Andy Warhol is here! Andy Warhol is here!" And he came over and told us this story about seeing a girl at Sotheby's who was exactly like the first girl he ever fucked, and he invited her to the show and then on that exact same night, the first girl he ever fucked that she looked exactly like came to see the play. And he took the two of them to dinner and they got to talking and one said she didn't have a place to stay and the other said she could stay with her and they went off into the sunset together. They still looked alike, he said. And Dustin has a sidekick who writes everything down. He's collecting art and wrote down Jean Michel's number, and when I saw his hair and everything shaved off, I don't know why he does the play in so much makeup when he could just do it straight. And he told me that one day when he saw me on the street and we talked it was the day he'd broken up with his first wife, which I didn't know then, and he remembered every word of our conversation because it was such a traumatic day for him.

Friday, November 16, 1984

Lucio Amelio wanted me to hear an opera singer singing falsetto and so they came to the office and the guy sang and I thought it was supposed to be comedy—it was like the *castrati* singing— but when I started to say how funny it was Fred kicked me. And this boy is very good-looking,

he's supposed to be straight. We were all stunned. It was like the old days at the old Factory when once in a while somebody with real actual talent would shock everybody with it.

Saturday, November 17, 1984

Got to the office by 12:00 (supplies $11.96, $3.50, $4.20).

Cabbed downtown to Keith's ($5). Madonna arrived with a black wig on. Downstairs there were three limos and we went out to see the "Greener Pastures" thing at BAM in Brooklyn. Keith had done the sets and Willi Smith did the clothes. I was next to Stephen Sprouse and he's so hard to talk to, but I'm just crazy about him, he's adorable. And we were all wearing Stephen Sprouse. It was really a great show. And they had really good hair in the show. Like brown underneath and red on top and they used twine. I talked to Stephen about doing show-biz stuff. Then that was over.

We went to Mr. Chow's for dinner. Then we went to Area and saw Keith make dresses on John Sex. I asked Madonna if she would be interested in doing a movie and she was smart, she said that she wanted more specifics, that she just didn't want to talk and have her ideas taken. She's very sharp. She's really hot right now. Stayed till 3:00, too many people coming up to me to talk (cab $8).

Tuesday, November 20, 1984

We went to the perfume department at Bloomingdale's and this old lady next to me kept saying, "I'm standing next to him. I never dreamed it would happen. I'm standing next to him." And I didn't even have an *Interview* left to give her, I'd given them all out. We left and I told Benjamin I'd had my fame fix for the day. We went to 47th Street and got hustled into some silver junk. Benjamin got a piece himself, actually—it's only the second time that's happened. He saw it and wanted it first. I should have gotten it for him but it was too awkward. I remember when I was with John Lennon and he was buying thousands of dollars' worth of clothes and didn't say, "Do you want a shirt?" Years ago. And I've found more Polaroids of him and Yoko Ono, only I did that thing that Brigid did, I glued them onto wood and they wrinkled.

Vincent just called and said there's a picture of me—of the robot—in *People*. The dummy that's going to star in the *Evening with Andy Warhol*. They're getting an awful lot of mileage out of nothing yet.

Thursday, November 22, 1984

Thanksgiving. Went to see Boy George at the Garden with Jean Michel and Cornelia. I just couldn't like him because it reminded me of what Jackie Curtis could have been, but Jean Michel really liked him. Boy George is so fat.

And then Jean Michel started remembering Halston's last Thanksgiving for turkey and wanted to get there, so we left (cab $6).

The turkey was already put away and dessert was out. Bianca started punching Jean Michel and me really hard, I actually got a black and blue mark. She was screaming about how we had to contribute to the Brooklyn Academy of Music. And I mean, this cheapo—this cunt! Why should she be asking artists when she should be out whoring herself to get money from rich people! Who does she think she is! I mean, she thinks she knows all about artists, and she knows—shit! She puts on this serious face and interviews them and she thinks something's happening, I mean . . . She's like a teenager, too, with this boyfriend, Glenn Dubin—she's always rubbing up against him and kissing him. I can't figure out what she's using him for. Maybe just a place to stay.

Sunday, November 25, 1984

The big call of the day was from Nelson Lyon, and the news with Nelson is that he's engaged to Barbara Steele now. She's not an actress anymore, she's a producer. And he said he's so humiliated and embarrassed by all the stuff about him in the Belushi book, *Wired*, that he can't face anybody. I told him nobody cares, that it's chic to be in it and to forget about it.

They're selling Halston's floor in the Olympic Tower out from under him. It's so sad. Where did Halston go so wrong when he sold his name? What should he have done that he didn't? That's what I want to know. And I want to know it from *him*, I want to sit down and find out what I should do if I ever sell myself. Find out when and where he made his mistakes. In case I ever want to let a big corporation buy me out and just be a figurehead. Because there's got to be a way to do it where you don't lose all your power the way Halston did.

Monday, November 26, 1984

Dr. Linda Li can't find out what's causing my allergies. She said my spleen was traumatized fifteen years ago.

Had a talk with the Harper & Row editor, Craig Nelson, and had to tell him what I thought of what he'd written for the *America* book: He can't write.

Wednesday, November 28, 1984

Did the East Side with Benjamin. Passed out the Christmas issue. Went to Dr. Bernsohn and he said he and Dr. Reese went to the pyramids and that he threw these big crystal balls around that he'd taken with him. I went to see him to get rid of a cold and then *(laughs)* he had one, too (cabs $4, $5, $5).

I went to Regine's for Cornelia's birthday. Barry Landau was there. Barry's as bad as Cornelia for attracting sleazes. And I guess that means me because I'm right in there. But Cornelia's smart, she sat Marty Bregman next to her and Roy Cohn on the other side. I sat next to the guy who

gives the after-hours party in Aspen after the Jimmy Buffett party. And for a present to Cornelia he offered her his credit card for a couple of hours.

Thursday, November 29, 1984

Jean Michel came in and painted right on top of the beautiful painting that Clemente did. There was lots of blank space on it that he could've painted on, he was just being mean. And he was in slow motion so I guess he was on heroin. He'd bend over to fix his shoelace and he'd be in that position for five minutes.

Friday, November 30, 1984

It was final moving hell day, leaving 860 Broadway forever. Stephen Sprouse's friend came for the keys and I asked if I could stay and paint, and so I did, until 8:30. And Stephen Sprouse called and thanked me for the air conditioners we're leaving in the windows for him. So then Jay dropped me off and I just stayed home, exhausted.

Saturday, December 1, 1984

Picked up Jon and cabbed down to the Tony Shafrazi Gallery for Kenny Scharf's show ($8). The blond kid who tells people he's my lover was there. And the kid told me that he's the one who's been planting flowers outside my house. I pretended that I didn't even know anybody was putting them in, but I've seen him there. And Kenny's paintings are now going for $30,000 and so Keith felt funny because they're both with Tony's gallery, but Keith's never wanted his prices to be too high. His go for eight, ten, fifteen.

Then afterwards there was a dinner for Kenny at Area. The new theme over there is "Religion," they're trying to take over the Limelight theme.

And the front page of the Sunday *Times* "Arts and Leisure" section is plastered with Schnabel, Grace Glueck calling him better than Pollock.

The dinner was fun. Kenny sold all his pictures. Then I went to the dance floor and toured, saw the burning crosses and things. Benjamin's friend Bernard was St. Sebastian. Keith and Kenny were going to do more work on their article for *Interview*. Gael told me she took out the part where Kenny asked Keith if it was true he went to bed with Chris Makos in order *(laughs)* to meet me.

Sunday, December 2, 1984

And I forgot to say that on Friday, Sean Lennon sent down the tablecloth from his birthday party in October for a souvenir. Maybe he wants a Christmas present. What can I get him? I was so disappointed when his song didn't make it to the top ten—I thought it would.

Monday, December 3, 1984

It was the first day of going to the new building for a full day's work. No more Union Square. It's going to be hard to get cabs in the new area. I'm taking that whole big floor up there. And it was great to see Brigid frazzled, not knowing what phone buttons to push, really working finally—not knitting. I'll miss ordering out from Brownies, all the carrot juices and stuff. What're we going to do for food in this new neighborhood? I've only seen greasy coffee shops.

Jean Michel had a date with Paige last night and I think they made it again, which would be a mistake.

And I was just on the phone talking to Gael, there's a thief at *Interview*—$20 was stolen from petty cash. *I* should do that, it's an easy way to make money. Just go into Brigid's wallet and take money out.

Julian Schnabel called and said that Arne Glimcher has "an empty spot" for Jean Michel and me at the Pace Gallery. I mean, poor Leo. Everybody's trying to get us away from Leo.

Wednesday, December 5, 1984

The Boston Museum came and looked at 100 pictures and then offered half of the asking price for one.

Waited till 7:00 for the nighttime armed guard that we hired while the building's still under construction. Worked on ideas, sorted through the mail. Left, couldn't get a cab until I'd walked a long time. I think I may just start taking the bus up Madison. How much is it now—$.90? Yeah, that would be so much easier.

Thursday, December 6, 1984

Fred called and reprimanded me because I'd invited a lot of people down to the office for lunch. Very grand about it, very calm: "You shouldn't do that, you know." And I invited John Sex to come and do the Liberace interview with me. Liberace wanted me to do him. He seems to think we know each other, but I don't remember ever meeting him. But he came and he was just wonderful. He walked in like a butterball because of the big fat coat he was wearing, but he's very normal, nothing like his show-business personality, which explains why he's so big, because if he were really that kind of person he'd be too crazy to make it. But gee, he must have a lot of money—he has like eighteen houses. He said he taught Elvis how to dress. Badly. Glenn O'Brien was originally going to do him, but then John Sex has been idolizing him for years and he came and then he just had such dumb questions like "What's your favorite color?" that I was going to then go back to having Glenn do it. But when John Sex and Liberace saw each other *(laughs)* they fell in love, sparks flew. But Liberace's so normal, you can see why he won all his court cases.

Sunday, December 9, 1984

Well I wanted to go down to work, but in the morning Jed called and said he was coming over in an hour to get the dogs, so an hour later when the bell rang I opened the door without looking and who should be standing there but Crazy Matty! God, after all these months and months of trying to convince him I didn't live there, and everybody's been trying to tell him he had the wrong house. And I just couldn't believe it. He laughed and said, "You're in trouble." So then the whole day I didn't leave the house, I was too nervous.

Tuesday, December 11, 1984

Got up early, talked to PH who was in L.A. Maybe that's where we should move the big offices of the magazine. She said her Harrison Ford cover interview is still up in the air, he probably won't do it but he hasn't given Gael a definite no.

Interviewed Chris Reeve yesterday, Maura and I did, and he was good, he was still drunk from the night before. He's got a good attitude now, not like he had when he started. Now he'll take any role.

Fred's been so crabby lately. We haven't been hitting it off. I don't know if he's bored and wants to be a decorator or if he's just crabby. He gets these attitudes. And it's scary because he used to have the best memory in the world and now he says softly to me, "Now tell me, who is this person you introduced me to?" And he's talking about Dawn Mello who he *knows*! It's scary.

Burt Reynolds was on *Letterman* and was so funny because there he was acting so straight and copying Clark Gable and then he said that he arrived in New York with George Maharis! So now I'm so surprised I never knew him in the fifties in New York.

Wednesday, December 12, 1984

Went to Dr. Bernsohn's and who should be there in the waiting room but the star of my movie, *Blowjob*. I never did know his name. He goes to Bernsohn, too.

Friday, December 14, 1984

And Fred's gone off to Europe. Fred and I still aren't getting along and I still don't know what he wants. All I can figure is that he really wants to become an architect, because the only time he really likes credit is when it's for architecture. I remember one time years ago when I wanted Fred to direct a Jackie Curtis play and he went crazy, he literally went crazy and said, "No no no no!" But architecture he wants to do.

Saturday, December 15, 1984

Got up early, had to go to work. Had Jay come in and Rupert. During the week it's impossible to work at the new place, it's just people coming through and gawking all the time.

I bought three Cabbage Patch dolls on the street with their birth certificates. A boy and two girls (3 × $80 = $240). And they wanted to wrap them so that I wouldn't be attacked for them on the street. Got research books ($180).

Sunday, December 16, 1984

Kenny Scharf called and said he was picking me up and that Sean Lennon was in the car with him. So I said in an hour, but then I couldn't seem to be ready, so then I heard a commotion out in front and I knew they were there, but then I was afraid to go out.

And while this was going on, the phone rang and it was Jean Michel from Sweden and when he heard these other kids were at my house, he began to go crazy because he's never been there. But it's just that I don't like anything pre-planned. If he just dropped in or something it'd be okay. So finally I went out and I had a camera with me and Sean took it and was taking pictures of me and said that he was waiting until I got sick of smiling and then he'd take one. He got that technique from Yoko. And he dissertated on how he never knew what to do when photographers were around, whether to smile or act or freeze. He's so smart.

So we went to the West Side and we were going to pick up the Mia Farrow kids who live across from the Dakota—Sean plays with them—but then they didn't come. And Yoko came, and people just kept a distance from this car—it was great—with all these famous people in it. And we picked up Jon.

We were thinking of a place to have lunch and I said the Odeon and she said oh yes, so it seemed like she went there a lot but then she said she'd never been, that she didn't really go out that much. And we picked up her I guess boyfriend, although I can't figure it out if it's her boyfriend or what. Sam Havadtoy.

You know, if anything ever happened to Sean that'd be the end of her, I think. It really would. And I was telling her what a wonderful host Sean was at his birthday party and she said that the first time he had to do a party he hid under the couch. Yoko wanted to pay, but I did (lunch $200). Her boyfriend was very nice. And Kenny's paintings are selling like crazy. His wife and son were along, and they just bought a house on Suffolk Street way downtown where Ray Johnson used to live. Around Orchard, over there. So he's being a man. A provider.

I dropped Jon ($8). Then stayed home.

Tuesday, December 18, 1984

I went to the office and went in the *Interview* side. It was busy there. Gael was excited because they'd gotten 600 subscriptions that day from the Swatch watch thing. So she was hoping that would keep up. In the old days that's how much we'd get in a year.

Paige is breaking up with her seventeen-year-old boyfriend. She's going off to Haiti.

Ran into one of those kids from Harvard in the sixties, one of Edie's friends, I can't remember his name. And I showed him my crystals and told him about crystal power and he was just standing there with his mouth open. He said he couldn't believe that someone as smart as me would start believing in crystals after I made it all through the sixties and everything and laughed at all the hippie stuff and that this is just the recycle of it. But really it's not the same, and you do have to be positive, not negative. He said he's developing land deals in Washington State.

Wednesday, December 19, 1984

Fred called from Europe. Bruno wanted twenty-eight pictures in his four-year contract, but I decided he could only have twenty-five, and then I give him one for himself, so that's twenty-six. This is for Jean Michel's and my things. But I don't get it, these are *huge* paintings he's getting for *peanuts*.

And it's funny, because only my Disaster paintings are the "in" paintings. Even the Campbell's Soup Cans are "out." And I really have only two collectors. Saatchi and Newhouse a little bit. Whereas Roy Lichtenstein and those people have fifteen or twenty. I guess I'm just not . . . a good painter.

It got busy at the office. Sean Lennon was coming at 4:00 so I could give him a Christmas present, a portrait of himself, but I don't know if it'll be done in time.

Then at home I ate things I wasn't supposed to and I got scared and got pains.

The *Interview* Christmas party's on Friday and I'll just give scarves or something.

Thursday, December 20, 1984

When I was coming back from the dentist this good-looking lady ran out of Martha's screaming my name and I looked and it was Claudia Cohen's mother from Palm Beach. She said Claudia was inside getting her dress for her wedding to Ron Perelman. When I met him originally I thought he was a bodyguard because he looks a little Mafia. But he owns Technicolor or something. So I was trying to get myself invited to the wedding.

Gerry Grinberg from North American Watches came for lunch. He said that the economy isn't good. I guess people aren't buying watches. He said people were buying more expensive gifts but only for themselves. Bob Denison only sent me half of what he sent me the year before, but then Park Avenue does have five times more trees planted on it than last year.

Eizo, my shiatsu massager, wrote me a note thanking me for introducing him to Yoko Ono. She wants to see him every day, but he can't do that, and anyway your body needs a week to rest. He's doing little Sean tomorrow. And Eizo's wife's poetry teacher wrote me a Pop poem that I don't know what to do with. It's like, "I touch you and you touch me and we have feelings." And you really learn all the gossip about everybody through this shiatsu network. Eizo told me that Yoko's boyfriend Sam has a soft body. And he said Yoko's been sick and has a bad back.

And then went to 990 Fifth Avenue to the party Judy Peabody was giving for Peter Allen. I was talking to this art student and suddenly Peter came over and said to him, "I'm leaving and you're coming *with* me!" He thought I was stealing his boyfriend! Can you imagine? That's the first time *that's* ever happened to me. So I didn't know what to do, but then I guess Peter felt silly because later he was trying to entertain me. I left at 12:30, the party was just getting going.

Saturday, December 22, 1984

Went to David Daine's, the hair stylist. Kent Klineman, Hedy's husband, was there, and all he sees in me is a tax shelter and all I see in him is a check. I don't know if the deal for a Cowboys and Indians portfolio he wants to commission is going to fall through because I won't do it as a tax shelter. We'll see.

Sunday, December 23, 1984

I caught up on church after missing three Sundays because of wanting to avoid Crazy Matty. So I peeked out and then made a dash for it. It's so funny to think that Matty was married to Genevieve Waite once. Are Genevieve and John Phillips still together? And I'm trying to think, has Matty *ever* had a job? No, I don't think so. Except for a few months there in the sixties when he was a vice-president or something at Fox—when all those movie companies wanted the "youth market" so they were hiring freaks. I remember somebody there was always flying Matty back and forth from L.A. to New York.... Oh I forgot, he was in *Bad*. So that was a day's work. I forgot he was the cripple in the wheelchair....

So went to church, came home, started cleaning, and got exactly one drawer done. Made carrot juice and made a big mess. Watched *The Jewel in the Crown*. Read an article from an L.A. newspaper on Ronnie Levin's murder. They haven't found his body but they think this bunch of rich kids killed him and also killed the father of one of these kids—an Iranian—they found *his* body in the desert and they think Ronnie's is nearby. It was fascinating, read it twice.

Monday, December 24, 1984

Stephen Sprouse came by and brought two wigs for me. But I thought they would be some kind of wild style or color, which I would have preferred—a new look. But they were grey. Stretch. And we never know what to say to each other, it's always awkward.

Called a cab and Benjamin dropped me. Then called Halston and it was weird, he said not to come by, that he really wasn't doing anything this Christmas.

Called Chris Makos and he was having a party for his neighbors and it sounded sort of bad. Christmas parties always are. Except at Halston's—they were always sort of nice. Went by and

rang Claudia Cohen's bell on 63rd Street because I want to get invited to her wedding to Ron Perelman because Liz Taylor is going to be the matron of honor and her husband-to-be Dennis Stein is going to be I think best man. He works for Perelman, that's where I met him. Every light in the house was on but they weren't home. Dropped their scarves off.

Benjamin picked me up and we went to Steve Rubell's new hotel, Morgan's, to the penthouse (cab $4). Steve's letting Bianca live there. And her personal stuff was all over the room where the party was so anybody could have taken anything. And I gave her and Jade scarves and hers was framed, and then later I saw it on the bed and she'd taken it *out* of the frame, and I don't know why. I mean, even if she didn't like it, it was art.

And Dianne Brill asked me if I knew Jayne Mansfield and I guess I lied when I said yes because I couldn't remember if I really did or not. Because I've read so many books about her. Dianne wanted to know if it was voodoo that killed her.

Thursday, December 27, 1984—Aspen, Colorado

Talked to Dr. Bernsohn. He said that the secret to sleeping was to scratch the crystal and brush it and put it on your forehead.

Patti D'Arbanville and Don Johnson gave a big party, and my dear, Patti is now a lady. She's come a long way from the Max's Kansas City back room days when she was best friends with Geraldine Smith and Andrea Whips. She and Don Johnson gave the best party I've been to since we've been coming to Aspen. She's the cream of the crop. She still can't dress, though. She never could. Even when we filmed her in Paris in our movie *L'Amour*—even in Paris she had no fashion. Jane Forth and Donna Jordan had all the style in that movie because the boys dressed them. At the party Patti was wearing eighteen-inch earrings and a white dress that didn't show off the shape of her body. Don looks sort of old, not the fresh young boy I remember meeting way back when he was in *The Magic Garden of Stanley Sweetheart*. Before his comeback in *Miami Vice* and everything, when he wasn't acting much, he was hanging around with musicians and he remembered that time during the Jimmy Carter days when we were both in Nashville when that guy who supported Carter, Phil Walden from Capricorn Records, had the whole hotel down there booked for us. That time I was there with Catherine Guinness.

Monday, December 31, 1984—Aspen

Met the Dowager of Aspen, the Grand Dame. Went to her house. Her name is *(laughs)* Pussy Paepcke. She's eighty-two and she's very beautiful, she looks like Katharine Hepburn. Her house was great, next to Jack Nicholson's and Lou Adler's. An immaculate house and she runs up and down stairs to get ginseng tea, she's spry. She and her husband who was this big industrialist had a ranch in Denver and then they went and founded Aspen.

Jack Nicholson's not around this year. He's filming that *Prizzi's Honor* thing in L.A.

Wednesday, January 2, 1985—Aspen—Los Angeles

We're at the Mondrian Hotel. And it does look like a Mondrian. They've got valuable Miro paintings in the lobby and art all over. It's on Sunset near La Cienega. It's not Beverly Hills.

You know what's fascinating is that Hollywood's still filled with all these delicate ladies who look like they were beauties, all glued up and in their cars, driving around. Not with drivers, just driving themselves. And you wonder what they used to do, what star they were, what roles they had. Everybody reminds me of Jane Wyatt out there. Those skinny, petite beauties who wear turbans and they're at premieres and things. And they're like eighty years old. How do these ladies live? I mean, if they were contract players they didn't make much. I guess one of their husbands must have been rich. But wasn't that before community settlements? But I guess you don't need much to live. Like you don't pay rent if you have your own house. And food, well, you can eat at McDonald's or there's always some fairy fan who'll take you around.

We went out driving, took a lot of pictures on Melrose. Went to the *Interview* office out there, talked to Gael and I was really upset when she told me that Peter Lester had died in Los Angeles. That's two *Interview* editors dead of AIDS.

Thursday, January 3, 1985—Los Angeles

We went over to a studio across from the Formosa Restaurant, they shoot Doug Cramer's TV show *Dynasty* there. The *Love Boat* writers are working on my episode which is going to film on March thirtieth and I started to get scared, I don't know if I can go through with it. The guy was really gay. And Joan Collins got done shooting and I said hi, and she said I still owed her a painting. She was great. And Ali McGraw waved. There were like 500 people there working. And it's directed by Curtis Harrington who was an underground filmmaker in the sixties who did voodoo kind of stuff, and now he's doing this.

Then we went to the *Interview* offices and I got excited about *Interview*. I think I do want to buy a building out there, because they'll only give you leases to rent for a few months. Gael said that Third Street is going to be the next street that's big. I got excited on Melrose. Jon's trying to move into production at Paramount, so he has to be out here more. And gee, I can't believe that it gets dark here at the same time it does in New York. It seems like since it's sunny it should stay light longer. I was shocked.

Then we went out to the premiere of the redone *Wings* that Paramount was releasing and it was absolutely great. And you look and you think why can't they make movies like this now. Buddy Rogers who was married to Mary Pickford was there. And Clara Bow was just great in it. The fashions look like today. And it was a big event. Got home around 11:30 or 12:00.

Saturday, January 5, 1985—Los Angeles

Did Melrose. It was warm and beautiful and sunny. Oh, and I heard about about a way to shoplift at the supermarket which I think I'm (*laughs*) going to do—switching the price stickers at the supermarket.

Went to the new museum way downtown. It was an automobile show. Real cars mixed in with Matisses and Rosenquists. And they had a painting of mine in it that they had labeled a "Car Crash." But when I saw it, it wasn't a Car Crash it was a Disaster. The one with the fireman. Should I tell them? How could they not even notice it didn't have a car in it. And the show's going on to Detroit. In *Detroit* they'll notice there's no car. But really, should I tell them?

Sunday, January 6, 1985—Los Angeles—New York

Jon invited me to breakfast at the Beverly Hills Hotel and it was a grey day but we ate outside anyway, they put heaters all around you, so you don't know it's cold.

Flew to New York. And at the baggage you see how pushy people are. This guy with polished nails just pushed everybody aside, and then there was a girl in a wheelchair and when her luggage came down the shoot she just got up out of the chair and ran and got it. *(laughs)* That's a real scene. Home at 1:30 (tip to driver $20).

Tuesday, January 8, 1985

Vincent just called on the other line and said we have to make half a million by March to make our payments on the new building.

Went over to Earl McGrath's for the birthday party of Jann Wenner and Sabrina Guinness, a double. And Jerry Hall was there, she looks just great. She looks like these girls who could marry big Texas millionaires. She's so stupid to have married Mick. Not to have *married*, even.

And by the way, Fred looks good, I wonder if he had a facelift when he was in Europe. It's nothing drastic, he just looks rested. If I had a lift, though, I'd go for the really tight-pulled look. I wouldn't care if I couldn't shut my eyes. Like Monique Van Vooren.

Thursday, January 10, 1985

Fred said that Si Newhouse passed on buying my painting. I guess I was hot before Christmas and now I'm not. This was for another painting, not the Natalie that he already got.

And Fred told me that he'd called down to Leo's and asked the kids who work there why Leo had said such bad things about me in that *USA Today* article on me on Monday and they said they'd find out. And they told Fred that Rauschenberg left Leo to go to Blum-Helman. Isn't that something? Well it's that Leo's getting senile. I know that's why he said those things, he's getting senile.

Benjamin dropped me at Jean Michel's and he has like twenty people working for him, getting big canvases ready. It's really neat and clean there now and it looks great. And he has a $5,000 TV set that's really big.

Then we cabbed to Julian Schnabel's on Park Avenue South and 20th. Bryan Ferry was there. Julian has all his own art in the place and he tells you about each one, he stands there and reads

into his own work. I mean, he literally stands there and *(laughs)* tells you what his paintings mean. And this was the first time in a long time I wished I was tape recording.

Schnabel also makes his own furniture. He made his own bed. Cast iron, gunmetal, really heavy. If you ever fell on it you'd kill yourself. His little girl was there and she was pulling her nightgown up and showing her pussy. *(laughs)* It was weird. And all his paintings are just everywhere, all the plate canvases—he used to be a short-order cook. And he has the best furniture from the fifties.

Schnabel has so much energy and balls, he really does. We drank red wine. It's the newest thing to drink red wine all through the meal, you don't have to have white wine with fish and things anymore. It's such a camp when they do the tasting and the lip-smacking. So then we went over to Clemente's.

The table there was one that Schnabel had made and actually it was great. The legs were all from different things and the top is hand-colored plaster. And all through dinner they played Maria Callas records! It was incredible. There's this new collection of forty records of everything she ever did and it comes in two cases and they sell them at newsstands in Italy. And it was just like the sixties. I could almost see Ondine whisking around in the shadows. And you could hear all the booing and the clapping on the record.

The food was good and it smelled so terrific. Alba Clemente did it. She could be the best movie star, her voice is so low and so loud and so sexy and interesting and she's pretty. And the talk was all about art. Julian was putting down de Kooning and I said oh no, that he was wrong, that de Kooning was a great painter, and then finally Clemente said yes, that he really was.

Thomas Ammann called and said that it was really cold in Switzerland. Bruno wants me to go there for Jean Michel's opening. Someone was saying that when all these dealers heard there was a really talented black artist who would probably die off soon from drugs, that they hurried to buy his things and now I guess they're frustrated because he's staying alive. I think Jean Michel will be the most famous black artist after this *New York Times* thing comes out.

Saturday, January 12, 1985

Jean Michel called and said he was coming by to work and he did, and he brought his mother. Jean-Michel's mother is a sweet mother, she brought him a birthday present that said from Mami—M-A-M-I. Then we went to Shafrazi's and Ronnie Cutrone was there with his girlfriend Tama Janowitz who they said just wrote a novel that some publishers are interested in. Ronnie said it was like *Terms of Endearment* but then other people said it was about downtown, which was what interested me. Ronnie was in a red Day-Glo Stephen Sprouse jacket.

Wednesday, January 16, 1985

The office got busy. I get so much exercise running up and down those stairs.

I talked to Jean Michel and invited him to the party that Fred was giving for Natasha Grenfell at Le Club. And he asked if he could bring—he said, "My girlfriend," and I was shocked. I said

he'd never called anybody that before, and he said her body was so hot that he would come five times in a night. This is a black girl he met who works at Comme des Garçons. Worked till 8:00.

Thursday, January 17, 1985

I heard snow shovels hitting the pavement at 6 A.M. And there's a big bus of students coming up from Carnegie-Mellon for a tour of the office. They probably got up at 6:30 and they're zipping along on the highway right now. Oh God, oh God . . .

I talked to Gael for about an hour and she said, "Tell me how wonderful I am," and so I said, "How wonderful you are." And she said she turned down a big job with cable TV and if it *was* big, she should've taken it, but if I'd said that to her she would've gone home crying.

Tuesday, January 22, 1985

Talked to Jean Michel and he was in a funny mood. He thinks his "girlfriend" doesn't love him and so he's taking heroin again. The black girl. Charlotte. I told him I would come and visit him. Cabbed to pick him up ($8).

We went to Odeon and had two tables and there were twelve of us. Boy George had that boy Marilyn with him. Jean Michel was nodding out. There was a little kid with Keith who didn't say anything, and Keith didn't say much, and I didn't say anything, so Boy George had to do all the talking and he's really intelligent, really a smart kid, and he does talk a lot.

He said he doesn't know who his friends really are. Like he doesn't know if Joan Rivers really is a friend or not, so he thinks some day he'll call her up "just to talk" and then he'll find out. He didn't like the line about him and his boyfriend in her interview in *Interview* and I said that I hadn't wanted that to go in. He takes out a powder puff all the time and puffs his face. His eye makeup was done beautifully.

Friday, January 25, 1985

Cabbed to 74th Street ($2) to see Dr. Bernsohn and he was going on about his phones being tapped by the FBI. Are these crystal things real or not? Dr. Reese is from near Kansas City. He's a chiropractor and so is Dr. Bernsohn. And the crystals come from Arkansas, and they're supposed to heal you. The Czech cut-glass one that I wear is to protect me. It's a "third eye" (cab $6).

Had to meet a lady for her portrait. She's just somebody who saw somebody else's. I don't know her name. She was pretty. And Jon interviewed Shirley MacLaine for the cover of *Interview*'s Health issue, he's transcribing it himself so he can edit it, I guess, before he gives it in.

It was a day of running up and down stairs. I was looking at Fred to see if he still had a hangover, to see if he could still do the business. I don't know. I was going to tell him that his face fell.

Wednesday, January 30, 1985

It was Benjamin's last day before going off to L.A. for a week to visit his mother.

I found out that I'd missed the Kansai lunch at the Four Seasons where I would have sat next to Kansai because Brigid forgot to tell me about it. I screamed at her, so now this morning she just called and very efficiently woke me up to tell me that there was nothing to do today. *(laughs)* To make sure I knew.

Jean Michel invited me to dinner with his father at Odeon (cab $6). And the father was this thin normal-looking man in a business suit, smart, and so you can see where Jean Michel gets his smartness.

And now Jean Michel doesn't even like his girlfriend from Comme des Garçons, Charlotte, because she borrowed money from him. He likes to give people money but then he resents them for taking it. He'll say, "They're using me." It's a funny attitude. And in a moment of passion once he told her he loved her and she told him that she was a "free woman," so he tied her up and told her how dare she think that he *meant* it.

Friday, February 1, 1985

Tab Hunter called about going to the screening of *Lust in the Dust* that John Springer was doing for him and Divine (cab $4). The movie was awful but I had to lie to Tab and say I loved it. He was literally trying to act! He tried to be Clint Eastwood when all he should have done was be Tab Hunter.

Tuesday, February 12, 1985

Washed and went to the Waldorf for the Barbie doll party (cab $4). Oscar de la Renta was there, he was doing the clothes for the Barbie doll. It's so sick, this whole world so involved with this stupid little doll. I was at table 1 by the runway. Sat with Joan Kron and also at the table was Beauregard something, a Southern not-quite-in-drag queen who writes for *Details*, he's smart, like a Jackie Curtis-type but meeker. He told me when Joan left that he lives with Joan Kron's stepson.

Friday, February 15, 1985

Dolly Fox came by to see me. She's back from living in L.A. with these two other girls. And one of them is going to marry Bruce Springsteen. And the other one is her blonde girlfriend Dana, and she introduced her to Eric Roberts and now Eric Roberts left Sandy Dennis for her.

And Gael is upset because one of the *Interview* editors is leaving for a better job. Jane Sarkin. She's going to *Vanity Fair*. But *Interview* has so many people now that I can't even figure out what each one does, so to me they're all dispensable. Except for Paige. I really like Paige. And Marc

Balet. I would miss Marc—he's talented and he does a lot, although he'd do even more if he weren't so busy with all his freelance stuff, the Armani ads and things.

Wednesday, February 20, 1985

This life insurance doctor came to examine me. Another one of those weird doctors giving me a weird insurance exam. The same old questions about your mother and your father and I lie all the time, I always give them different answers. And he asked me my age and I said I couldn't face saying my age, that I would leave the room and he could ask Vincent. Then I noticed that he was wearing a bracelet and I said, "Why are you wearing a bracelet?" and he said, "Well, I will tell you why I am wearing a bracelet." And then he started this long thing about how in 1592 something happened, and how this is somehow related to why the pope was shot, and why the Russians shot down the Korean airliner because they'd lost 200 people in some Siberian explosion, and all this went on for twenty minutes. And then I asked him where he *got* his bracelet, and he said, "Teepee Town." And I said, "Teepee Town went out of business." And he said, "No, it just moved off 42nd Street—now it's in the Port Authority bus terminal." And then he told me to put my urine in this little bottle. And I just could think that he probably goes to the Port Authority and collects urine in bottles. He's about 6'6" and his eyes are weird, like a little brain-damaged or milky. He took my blood pressure and did my heart. It was the most fun part of the day. Worked till 7:30.

Saturday, February 23, 1985

Got up and it was one of the most beautiful days in the world. Madison Avenue was five-deep every step. Called Jon and picked him up and asked him what was new in Hollywood. Nothing, he said.

And everybody keeps saying what's wrong with Steve Rubell, because his hair has fallen out and his eyebrows, too, because that's what happens when you get chemotherapy.

Tuesday, February 26, 1985

I don't understand why Jackie O. thinks she's so grand that she doesn't owe it to the public to have another great marriage to somebody big. You'd think she'd want to scheme and connive to get into history again.

And Gael had a fight with Glenn O'Brien because he sold the same interview he did for *Interview* to the new magazine, *Spin*, that Bob Guccione's son is doing that's competing with *Rolling Stone*, and Glenn's telling her it was all the stuff that she had cut out, so what difference did it make.

I invited Benjamin to this *Forbes* opening at their building on 13th and Fifth Avenue now that they've turned the lobby into a museum (cab $4). Malcolm Forbes was there and I gave him a Dollar Sign painting and he was thrilled, he loved it. Talked to a kid who worked there and told

him that what I wanted for Christmas was Malcolm Forbes's junk mail, and he said he'd get me some. I wish Truman had given me his junk mail like he promised he would.

Friday, March 1, 1985

The other day a call came collect from Ingrid Superstar. I didn't take it. I mean, if she's still calling *collect* . . . I couldn't face hearing about her life—kids/no kids, married/not married. And David White called and asked me if it was okay with me if Rauschenberg sold the Popeye for a million dollars that I gave him in '62. I said sure . . . I don't know to who. David said that after the deal's done he'll tell me. So *we* can sell whoever it is something, too.

Wednesday, March 6, 1985

Harper & Row called me at work and said that Jane Fonda had sent a turn-down for our request to use her picture in the *America* book. I just couldn't believe it! What nerve! I mean, just wait —the next time she calls up and wants something for free, it's just going to be *no*.

Gaetana Enders called about eight times to see if our dinner at Le Cirque was still on. She drives me crazy, but she's working for us getting portraits, so . . . she smokes this tiny cigar and she thinks she's this big man's woman, so smart and tough and great—this twerp! I mean, her husband's 6'6" and she's 2'2". I don't know where she gets this idea of herself. I can't even think of who to say it's like. A little like Diane Von Furstenberg. Where you think you're so smart and beautiful.

Saturday, March 9, 1985

Talked to Jean Michel and he said he was straight, but he sounded like he was on something. He was with Jennifer, Eric Goode from Area's sister, who's his new girlfriend. He's got three or four girls on the string now, but he's only still in love with Charlotte, from Comme des Garçons.

And Jean Michel was complaining about the show that we're having with Bruno . . . oh, I don't know, I think that whole period is over, with him coming up to paint. He hasn't come that much to the new building, just a few times, and—well, he's feeling on top now that his show is running downtown, but I don't know if he's working.

Tuesday, March 12, 1985

Went up to Sotheby's to look at the art and the lady there stopped me and asked if I had a few minutes to look at a few paintings of mine for authenticity, so I did, and one of them was one of those fake Electric Chairs, the ones Gerard denies doing. A blue one. It wasn't stretched right. The people get greedy and they want a bigger picture, so it's got a border on it. They'd buy it

rolled and then stretch it that way. And there were four big Flower paintings. I guess everybody's selling my work, getting rid of it (phone $1.50, newspapers $3). Cabbed to meet Lidija ($4).

Thursday, March 14, 1985

It was the night of Dino De Laurentiis's dinner at Alo Alo. And I called Cornelia to see if she wanted to go.

The new issue of *Interview* came in, the Health issue, and it's thick and serious. It looks good.

Told Cornelia 8:30 and she came in a limo ($25). And Dino's new restaurant, this one that he's done with the guy from Club A, it's in the Trump Plaza on 62nd Street and Third. And Geraldine Smith was there, she was with some producer guy and she looks cute still. And Cornelia was working the room. Chris Walken was there and then Mickey Rourke arrived and he told me about the part in his *Interview* interview that PH cut out where he had a big fight with her. PH had already told me all about it, but I played dumb. And Geraldine said she wished *she* had interviewed Mickey Rourke because she loves him and I reminded her of her interview with Harrison Ford when she was sitting on his lap for twenty minutes before she figured out he was the person she was supposed to interview. She was fun. And Mickey is just so adorable. Dumb, but with some magic. And then these girls came in for him and they were all the same types, about 5'4" and pretty, but nothing special. And he and Chris Walken kissed each other goodbye on the lips so tenderly, it looked so gay. And Chris Walken was really drunk, he said he was tired of his hair, he'd dyed it blond, and now it needed retouching, and Cornelia gave him the name of a hair place to go to.

Monday, March 18, 1985

I'm getting more nervous by the minute about being on *The Love Boat*. It turns out I'm going to be there for ten days. Now that Jon's working in L.A. most of the time, he's buying Joan Hackett's old house on Angelo Drive in Benedict Canyon. It's cheap for Beverly Hills, only $100,000, next to really expensive ones—Jon said the son of Charles Bludhorn, the chairman of Gulf + Western, got one on the same block for $1.2 million.

Time magazine sent down the Iacocca picture, and if I can only make a great portrait out of this picture then I could get a lot of corporation presidents. If they use it they have to pay a lot, but if they don't use it they just pay a little bit.

Tuesday, March 19, 1985

Paige said she had tickets for *Desperately Seeking Susan*, which was screening on 86th Street. So she waited and then we went to Nippon (cab $4). Madonna doesn't have much to do. She doesn't talk in the first part. But later on she does some good things, she sleeps in the bathtub and dresses up and shoplifts. It's like those sixties movies but the opposite—the sixties movies

had too much sixties and not enough story, and this has too much story and not enough eighties. It was boring.

Wednesday, March 20, 1985

Amos has a crushed vertebra. At first the vet said it was a sore leg and then he said a slipped disc. So I slept on the floor with him last night. I'm on the floor now, still, with the phone, being a martyr.

So then I was working on the Joan Collins portrait and on some other stuff, and then a big four-page telegram came from *The Love Boat* saying that they wanted to show all my art on *The Love Boat*, too. The story is that I go on *The Love Boat* and there's a girl on the boat named Mary with her husband, and she used to be a superstar of mine, and she doesn't want her husband to know that she used to be "Marina Del Rey." And I just have a few lines, things like "Hello, Mary." But one of the lines I have to say is something like "Art is crass commercialism," which I don't want to say.

PH will be in L.A. then, too, so we can do some work there on the *Party* book—photograph the Academy Awards and the *Love Boat* thing. I'll be at the Bel Air.

Then went to the Whitney for the opening of the Biennial and waited outside for Jean Michel. He had a new smile on his face. We went downstairs and upstairs and saw Kenny Scharf and his wife and it was wall-to-wall four floors. And a woman stopped Jean Michel and was raving and raving about him saying, "This is my favorite artist. My husband and I, you're our favorite artist," and I'm standing there, and I offer her an autographed *Interview* and she says, "No."

Then we went down to this place on Eighth Avenue and 14th Street, where Jean Michel gets rice and beans, just one of those dirty ratholes that I say I would never eat in, but it was so good that I did.

And then we called up Paul, the exercise trainer who works for Lidija, and we were right near his apartment which is right off Abingdon Square down there, a nice neighborhood, and so we went over there, and God, it's so strange when you finally see where a person lives, and it's just so . . . I mean, it's this one room, and he's been subletting it for a year or so, and now the woman who he sublet it from is back and she's about forty, and like a hippie who wants to get backing for a restaurant, and their beds are just like next to each other, and they aren't in the apartment at the same time, like you feel you can't go home when the other one is there, so you feel like you're not really living anyplace. . . . I guess that that's when your life is really interesting, though, because it keeps you out there in action and getting into weird situations. But I mean, I go from that, and then I come back up here to *(laughs) this*, it's so abstract. You know? But I don't understand why he could leave the place like such a dump. They should just get futons and not waste space with the beds. And it would really only have taken a couple of hours to pick the place up once while she was gone in Europe all that time.

And then we went to Area. Jean Michel has the right walk to pass right through the crowd. He made me go to the bathroom there, the men's room, and it's so funny there, there are girls putting on makeup in the mirrors and the men are pissing in the urinals and it'd be great if it weren't that it smelled like shit. It's just my kind of movie. I guess the ladies room is the same

way except without the urinals. Then I got out of there and went home. Oh, and that lady at the Whitney who was so thrilled over Jean Michel, she got him to sign a picture of the painting. That's as good as signing it, and then you paste it to the back. That's why Leo sends me up photographs sometimes.

Saturday, March 23, 1985

Worked, went to Karen Burke's (cab $4). And I followed Garbo around the streets. Took pictures of her. I'm pretty sure it was her. She had the dark glasses and the big coat and pants on and the mouth, and she went into a Trader Horn store to talk to a woman about TVs. Just the kind of thing she would do. So I took pictures of her until I thought she would get mad and then I walked downtown. *(laughs)* I was alone, too.

Stayed up all night until 5:10 getting ready for the next day to go to California for *The Love Boat* and now maybe a Coke commercial, too.

Sunday, March 24, 1985—New York—Los Angeles

Placido Domingo was on our plane and he was nice, he came over and talked (newspapers $6). Beverly Sills was on, too. And Fred said Alan King was on and said hello but I didn't see him. Then a white limousine picked us up and took us to the Bel Air Hotel. And as we were going in Philip Johnson and David Whitney were walking out. Philip's here to give a lecture at one of the colleges. Went to the Beverly Hills Hotel pool, and everybody from New York was there—Laura Landro who writes the movie stuff for the *Wall Street Journal* and Susan Mulcahy, and Ahmet Ertegun and Mark Goodson.

Monday, March 25, 1985—Los Angeles

Got up early and *The Love Boat* at first wasn't sending a car. They said it "wasn't in the contract." They wanted me to take a cab. But Fred talked to them. And when we got here, since they didn't have a room reserved for Fred, I'm wondering if they're paying for his. I think they must be. So I went to the wardrobe place and ordered a pair of Reebok shoes, but I only ordered one and I should've ordered more. And the kid who came to pick me up, I asked if he was trying to be an actor, and he said, "Oh no, I'm Captain of the Cars." He was very cute. We drove to the old Goldwyn Studios on Santa Monica near La Brea.

These places are so cold, you sit around freezing all day in these soundstages, and it's no wonder people want to be actors because the only place it's warm is under the lights.

So then I was done there and they brought me back to the hotel, and then Suzanne Somers had told Doug Christmas that she just *had* to have lunch with us, so we went to meet her at Ma Maison and then she cancelled. But Orson Welles was there at his own table and he said he wanted to meet me and I went over and he was just great, really great, and he's a person I would

like to interview myself. And then afterwards we went to Doug's place and Roy Lichtenstein was there signing some things, so that was exciting.

And then Jon met us and took us to the Beverly Hills for drinks. The taxis from there to the Bel Air are expensive ($8). Got dressed and went over to Spago where Swifty Lazar was having his party for the Academy Awards. And the traffic was so bad, it took so long to get over there. It's on Sunset above Tower Records. I had to sign like 800 autographs. All the press was there like Susan Mulcahy and Barbara Howar. And Cary Grant and Jimmy Stewart came and just everybody came after the awards. Faye Dunaway and Raquel Welch and just everybody.

Tuesday, March 26, 1985—Los Angeles

Got up really early. The paper had me as the big star at Swifty's. Got picked up to go to *The Love Boat* set. Had to do my "Hello, Mary" line, and the gay director is saying, "Give it some pizzazz—Hel-*lo*, *Ma*-ry!" And I say, "Hel-lo, Ma-ry."

PH met me there and we sat in the dressing room for a couple of hours while they rearranged the lights or whatever they do. My Stephen Sprouse jackets were there on the wardrobe rack and when I wear them, I think I finally look like people want Andy Warhol to look again, and now I'm thinking I should've worn the silver one the night before to Spago and that when I'm out of New York I should forget all this black-tie stuff and just go for flash. Talked with PH about movies and abstract ways to do scripts.

Made a phone call to Jon and he said that Shirley MacLaine was trying to call me because she was really upset about the little banner headline on the interview he did with her in the Health issue. It said: "Metaphysical Madam." And Jon shouldn't have gone over to her and said, "It's not my fault," because that's the wrong negative thing to do. She never would've even noticed it or thought about it, probably, and now she's up in arms. I don't even know why. What does "Madam" mean? I mean, it's just a regular word. And the introduction I guess Gael wrote, and it's just all stuff from other places. Jon wrote one and they didn't like it, they said it had too much of himself in it—Gael told him, "You are not Arianna Stassinopoulos."

Went back to the Bel Air and had dinner there with Vincent and Andrew Friendly, Fred Friendly's son, who's trying to sell our TV show. And he talks about his "lady" and who in their right mind would talk that way. It was a good dinner and he paid.

And Joanna Carson came over to say hello and she's so beautiful. We talked about her son and his career.

Wednesday, March 27, 1985—Los Angeles

Shirley MacLaine was calling me and I didn't call her back, so then she called Gael Love in New York and told the receptionist, "Let me talk to Gael Hate." And now she's telling Gael that she wants to see the sources for everything that was in the introduction to her interview. Fred said he'd call Shirley and smooth it out.

So I finally finished shooting that day's scenes on *The Love Boat*. Got back to the hotel so late,

and then Fred and I went over to Doug Cramer's, right above the Bel Air Hotel in this big house that they're adding rooms to to make it even bigger. And Linda Evans was there and Joan Collins and Morgan Fairchild and James Brolin, and the ship captain from *The Love Boat*—the bald guy.

And Calvin came in right from a plane and said that he wasn't going to have his big party at Steve Rubell's new club for its opening. He said he's spent six months trying to get a new image and he doesn't want to blow it. I told him that I'd bought a bottle of Obsession, one of the first, and he said why did I go and do that when he'd sent me one and I said that I'd gotten the one he sent after I'd already bought one.

It was 10:30 before dinner started. And Shirlee Fonda is still in love with the playwright guy, Neil Simon. And Doug Cramer's friend made me take pictures with his 3-D camera. Marcia Weisman was with her new friend. There were beautiful dogs. Thomas Ammann was there, and Jody Jacobs from the *L.A. Times*, and the Spellings.

And then we went to Mr. Chow's because Jean Michel had decided to give his own party there since he hadn't been invited to the Cramer one. And he had all these really cute boys and girls there.

Thursday, March 28, 1985—Los Angeles

Jean Michel was really sweet and sent over a drawing for me. He's gone off to Hawaii.

Had a day off from *The Love Boat*.

The couple from A&M records, the Mosses, came for a portrait, and the wife was puffy around the eyes and we had to wait for her eyes to go down.

Went over to Tony and Berry Perkins's in one of the canyons. They have a big house, six bedrooms. There's really a lot of traffic. Where Jon's house is there's absolutely no traffic. And Tony cooked the dinner and listen to what it was—meatloaf and polenta and bread pudding. It's been so long since I've eaten like that. Not since the fifties when people were poor. He uses this new cookbook that has a lot of recipes from the forties and fifties like Rice Krispies Squares. It's called something like short-cut cooking. Wendy Stark was there and she wasn't so cheerful, maybe it was just because she wasn't drinking. Sue Mengers was fun, blabbing away, and her husband was with her. They have Indian rugs. And Tony asked after Chris Makos. Berry was kissy and huggy. Nick and Lisa Love were there. We stayed until about 11:00 and then went back to the hotel.

Friday, March 29, 1985—Los Angeles

They picked me up at 6:00 to take me to the set. The same cute driver. I wish he was a fairy, but he isn't. He's trying to make all the girls. And they all have Barbie doll bodies! You can't believe them. No hips and big tits. He's just divorced and says he's a "country boy," he lives "in the Valley" or someplace like that. Jay is his name. The Captain of the Cars. And he sits there and does crossword puzzles all day when he's not driving. And I said, "Don't you want to further your career? If you can do crossword puzzles, you can *direct*."

I had to sign autographs for all the girl actresses and dancers. I was finished by 9:30. Marion Ross from *Happy Days* plays the ex-superstar, and she's a little old to play an ex-sixties superstar, but I really love her so much. She's a wonderful person, and she helps me, she has so much love. And when we do a scene together, she does great facial things that help me do my lines. And actually, though, Ultra Violet's probably older than Marion.

And then we went over to the *Dynasty* soundstage and tried to see Catherine Oxenberg but she said she was in an accident and was crying and didn't want to see us, I don't know. I bet she just had a fight with her boyfriend.

Then they took me downtown to do the Diet Coke commercial. And there was a float and about eight ex-Miss Americas or Miss Universes and all the police were lusting after them, and I was wearing my Stephen Sprouse jacket. And one of the girls in a bathing suit said that she had been in Walter Steding's group. And I went and waited in my own private mobile trailer and I used the bathroom and that was fun, and then I guess the word the crew uses for the actors is "talent" and so one girl opened the trailer door and said, "Where's the talent?" and she looked around and didn't see any I guess, so she left. I don't know, I guess she didn't recognize me. And we were on a big float with pansies. The girls sat on the pansies, and I had to say, "Diet Coke," and I drank it for the first time.

Later went to Wendy Stark's dinner for Sharon Hammond. Dennis Hopper was there, very straight. I asked him to reshoot all the photos he took in the sixties and we would run them in *Interview*. Shoot Peter Fonda again and all those people. Wouldn't that be good?

And Wendy made curry with her own hands. Nobody ate it except Fred. And they brought out banana-cream cake for Sharon's birthday. In the day we were shopping for a present for her and all I did was get things for myself, so I gave her an I.O.U. It's so strange to see Sharon away from New York and Southampton. She was wearing a dress from North Beach Leather, it looked like rubber.

Oh, and Ron Perelman is out here and he said, "I want to have a big talk with you. I want to buy your magazine for my wife. Who do I talk to?" And I said, "Fred." For Claudia, he wants it.

Saturday, March 30, 1985—Los Angeles

Went to be photographed for an L.A. Eyeworks ad at 4:00. And one of the women owners was there and this fat queen named Teddy was doing my hair and after he left someone told me that that was the one Joe Dallesandro was living with for years and may be back living with again, and I went crazy—because it would've been so much fun if only I'd known. Joe *would* go and live with a fat queen hairdresser just to be perverse.

Went to Spago for dinner. Gene Kelly was there with his son, and his son said he'd see us later at Brad Branson's party (dinner $300). So after dinner we went to Crenshaw Avenue way in the black area of L.A. where Brad Branson who does photographs for *Interview* was giving his second weekly party. He's doing it like a club, but with friends' names on the list. And it was actually great, he had all the cute kids there and it was two floors and a garden part and some people said that Madonna had been there right before we got there. Fred was with Rupert Everett, and Nando Scarfiotti was there, and Susan Pile and Paul Jasmin and Toni Basil. And all these kids

were coming over to me, and it was fun. I was keeping an eye out for someone to fill the new vacancy as my New York Wife. And Mary Woronov was there and I never have anything to say to Mary. I can't ever really forgive her for being such a creep about *Chelsea Girls* in the sixties, for demanding money—saying she wouldn't sign a release until she got it. She squeezed around $1,000 out of us. She was talking to that screenwriter named Becky Johnson—she's a friend of Jon's. She and Mary were both in the GQ article on "The Most Eligible Women in Hollywood." Whatever that means. The most desperate, I guess.

Sunday, March 31, 1985—Los Angeles

In the morning we went to look at buildings all along Sunset for a new *Interview* office. We looked at one big elephant that's $800,000 and there's one for $1 million and one for $400,000. So that took a long time.

Then it was the night of the big *Love Boat* Thousandth Guest Star party at the Beverly Hilton. Fred was taking Rupert Everett but at the last minute Rupert cancelled, he said, "My tuxedo is crumpled." And Jon picked me up and we went over there. Had my picture taken for fifteen minutes with Joan Collins, who then never went in to the dinner, I don't think, because nobody saw her in there. But it was just packed.

One of Aaron Spelling's daughters was at our table, in her teens or twenties, and Troy Donahue who now has short blond-white hair. I reminded him of that time in the early seventies when he came up to 33 Union Square. He said, "What you guys did to me that day! Your elevator was broken so I had to go up in the freight elevator in the back, and it opened into this dark room where you were screening a movie and I had to walk out from *behind* the projection screen, and everybody was *facing* the screen watching movies, and I stumbled over everybody sitting on the floor in the dark, and I was on acid...."

They introduced a lot of stars and then finally out came Lana Turner, the thousandth guest star, who had given them a hard time by being so late, and that's why dinner was late. And then they brought me up on the stage with Carol Channing and Ginger Rogers and Mary Martin. And for some reason they didn't mention the portrait they commissioned me to do of Lana. But it's finally scheduled for me to shoot the picture on Thursday.

Peter Duchin's orchestra played. He's another one of the guest stars on the boat this week. So it's Peter Duchin, Tom Bosley, Marion Ross, Cloris Leachman, Andy Griffith, Raymond St. Jacques, Milton Berle, and me.

And signed a lot of autographs for the kooky autograph hounds of Hollywood. PH and I both took pictures for the *Party* book.

Monday, April 1, 1985—Los Angeles

Got picked up at 8:15 to go to *The Love Boat*. Flubbed my lines in the morning, felt bad about it. Worked all day. Andy Griffith seems bitter to be on *The Love Boat*. PH came by about 2:00 and we went into the makeup room and she opened up her mouth and said, "So who's playing your

drag queen?" and Raymond St. Jacques whirled around in his chair and gave her a withering look and said, "It's *not* a 'drag queen.'" And there he was with lipstick on and everything, and in the original script it had *called* the role a drag queen.

Then went back on the set and did the scene where I had to walk up to the reception desk with Raymond St. Jacques and my "entourage," and then as we're walking off, the *Love Boat* girl asks Raymond St. Jacques, "How does an artist know when a painting is really successful?" And he says, "When the check clears." And once they did it wrong and it was better—she said, "When is a painting really *finished*." Finally I was done there, about 6:00.

Tuesday, April 2, 1985—Los Angeles

Got up at 5:00 and was picked up by my driver, Jay, at 6:15. Worked all day, had a scene with Tom Bosley. Got done pretty early, then went to a big signing of *Interviews* at a bar called Nippers in the Rodeo Mall, and it was jammed. I sat upstairs and signed and signed. And Fred was downstairs and he started drinking and continued drinking, I don't know why. Some people brought old issues for me to sign—like from the first year—the Helmut Berger *Damned* one, and the Elvis one and the Raquel Welch one. And actually I think they were ruining them to have me sign them. And John Stockwell/Samuels was there looking really good, and he was just in from North Carolina where he was shooting a miniseries, *North and South* with Liz Taylor.

It was just mobbed with people. Lots of young kids, didn't know many of them. Molly Ringwald came. Lots of champagne. And then went back to the Bel Air with PH who was keeping me company because I was depressed. Jon went back to New York, I guess he didn't want to be linked with me in L.A. He never gave me keys to his new house, so I guess I'll never be staying there, and I'm . . . Oh, I don't know. Life is interesting, I guess.

Wednesday, April 3, 1985—Los Angeles

Got driven to *The Love Boat*. Talked to Ted McGinley until we broke for lunch. He's so good-looking and really charming, all these people out here are. The wardrobe guy at the studio is really nice to all the stars and never has a bad word to say. He told PH, "Everyone here just loves Andy," so that made me feel good.

And then PH and I walked to Melrose and to the antique stores. And then we went to L.A. Eyeworks and I picked out some more glasses. About six pairs.

Had to work until 9:30 on the set, and then the driver took me back, and gee those guys are so nice. And Fred had already gone to dinner at Sue Mengers's, so I followed, and Barbra Streisand was there and she was dropping names like Archipenko, the sculptor, and she said that Steve Ross sends them to her, sends her all these valuable things after she admires them in his place. And she asked how much a portrait was, and I said I just couldn't talk about price, and she asked Fred and he said $25,000 and she said, "Oh really? So cheap?" And she turned to her Baskin-Robbins boyfriend, and said, "Maybe we should buy one for Steve."

Barbra's really skinny but she had three helpings of curry. And she looks great. She has her

hair straight now and her dress showed everything in the right way. But I think this boyfriend is the one who directed the horrible video for the song she has out now, "Emotion," but I'm not sure. And she's suing her building in New York because of the roof—it leaks. It's at 92nd and Central Park West and she didn't even remember that she'd invited me to a party there, this was about seven or nine years ago—Jed and I went—and she said, "I knew you? Were you famous then, when you came to my party?" As if she would've invited me if I weren't. And I felt like telling her, "Yes I was there, and you had name tags stuck on all the food like a delicatessen—'chopped liver' and 'gefilte fish,' and I don't know, 'halvah.'" It was getting to that point where I might as well have. I told her, "Oh your jewelry is so small, Barbra, why don't you get bigger things?" And she said, "Oy! I bought diamonds for $60,000 a carat and the next day they dropped to $20,000!" And it's true, it really happened like that about three years ago. But I told her that the day they went down to $20,000 she should've bought three more and cut her losses. And Sean Connery was there but I didn't talk to him. And Alan Ladd, Jr., who looked sensational.

And they all talk about Jews trying to be WASPs and they were talking about Woody Allen and Mia Farrow and really putting down Mia.

Thursday, April 4, 1985—Los Angeles

Went to *The Love Boat* just to drop off some posters, the Indian posters, because there's a lot of people I'd missed when I gave them out the day before, and I could tell who they were because they stopped speaking to me, they thought I'd passed over them.

Then we went back to the hotel to meet Lana. And she was adorable to me. She was tipsy and it was like a whole different person. I closed my eyes and it was like being with Paulette, that kind of attitude. She said, "Give me a kiss." And Lana does crystals, too. And she had a cracked rib which she blamed on a Nolan Miller dress she had that made her trip, but I think she must have been drunk. She wears a little quarter-inch cross.

Oh, and on *The Love Boat* the last day, Andy Griffith suddenly got really happy, very friendly to everybody, and nobody could figure it out after he'd been so bitter all week. He must've had a drink.

Friday, April 5, 1985—Los Angeles—New York

So twelve days of bliss at the most beautiful hotel in the world were coming to an end and then they *really* came to an end when we got the $9,500 hotel bill. We had to pay half of it. I think we were charged for service and for Fred's room. But we got lots of portraits. The Spelling wife and Doug Cramer and Lana.

So the car came and took us to Regent Air. It's just $100 more than first class. It's $800. There were only fifteen people. And you really feel the turbulence on a small plane. On the 747s you don't feel anything. The only famous person was Mark Goodson. The rest were just grand types—a woman who looked like Milton Berle and a guy with gold chains so he must have been a Hollywood writer or something (tip $50). They'd showed two movies in succession on the

flight—*Protocol* and *The Cotton Club*—and both of them weren't hits, but you could see quality in them so it was sad. And the bathrooms on Regent are three times the size of a normal bathroom. And there was a girl with a portfolio, either a model or a whore or something, just bubbling and enthusiastic. And they come and scramble your eggs right in front of you. When we arrived in New York the airline had twenty limos waiting. Tipped the driver $20.

So got in and it was 6:00 in the evening in New York and that really throws you off. I hate it. You're dead tired but you feel like you have to have your day. And you call people up but it's Easter weekend and everybody's out of town. But then the phone rang and it was Cornelia inviting me to dinner at Le Cirque with Jane Holzer. Cornelia is now going out with Eric Goode of Area, she says he's trying to break up with Elizabeth Saltzman whose mother runs Saks.

Monday, April 8, 1985

Went to Dr. Bernsohn. I'm supposed to arrange a date with Dr. Karen Burke for him. He's straight. The last girlfriend he had was a body builder but then he dropped her when she became a healer, because he said he couldn't see her healing other people and absorbing all their things and then putting her hands all over his body after sucking all that up. It's interesting, isn't it? Left twenty-five copies of *Interview* there. I couldn't have him included in our Health issue because treating with crystals isn't legit.

Jean Michel's still away on his vacation with Eric-from-Area's-sister Jennifer. They went to Hong Kong, maybe. I wonder when they're coming back? I mean, how long can you suck dick? . . . Oh, I don't know, I guess I've missed out on a lot in life—never pickups on the street or anything like that. I feel life has passed me by (phone calls $2).

Then it was busy at the office. Iolas was coming. Then it was too light on the top floor to trace, then it got dark and rained and then it got light again.

Ran into Crazy Matty on 74th Street and he gave me $.25 and he went crazy because *(laughs)* I took it.

Cabbed home ($6) and got off at the corner because I like to walk in from the block but I'm not going to do it anymore because out of the shadows jumped Matty, he was waiting in a doorway, and I couldn't get in fast enough, he caught me. He went away easily, but I'm not going to risk it anymore. It means that *anybody* could come after me like that. He said he needs a job. So I went in and I had four Reese's peanut butter cups and a garlic sandwich and I left the TV on and woke up to *Sunrise News*.

Thursday, April 11, 1985

Somebody came by the office and was telling me about the book Dotson Rader wrote on Tennessee Williams so I sent Michael Walsh out to get it ($18.75). And he had all this made-up stuff in it, like that Edie was giving a blow job to somebody and also eating a girl's pussy, which would never be true. And then he said that Tennessee just loved Joe Dallesandro so when Joe went up to see him Tennessee did his fainting number so Joe would have to hold him in his arms. God, I just

always thought Dotson Rader was a CIA person. Just that creepy type. And now he's gone from the Carters to walking Pat Lawford. I mean, how we met him, in like '69, was he took *Blowjob* up to screen at Columbia where he said he was going to school. But even then he looked too *old* to be a student, so it always made me wonder.

Lidija came by and I'm all out of shape after not working out for the two weeks in California.

And there's a radiologist in the building next door to me. He just bought a million-dollar machine and they had to knock a wall out to get it in, and I keep wondering if the radium stuff can get to me, because we share steam heat. Everybody says the machines are "foolproof." Sure. And the Polish Embassy next door, now they want $4 million for it. I guess I should've bought it, when then were asking $1.3.

Had to leave early, cabbed to Radio City Music Hall ($6). The guy writing the book on Liberace was next to us and he said that Liberace was really in love with that chauffeur who gave all the interviews to the *National Enquirer* and that it really crushed him—Scott Thorsen. Now he has a new chauffeur. And the show is just magnificent. A rhinestone cape that shined to the stars. Lots of gay jokes and dirty jokes, and he has all these little kids who are his protégés who play the piano while he goes on a break. And the little boys he introduces as "my dear little friend, my best little friend . . ." but not the little girls. And he showed a film of his fingers and talked about each ring.

Sunday, April 14, 1985

Went to church and then went to meet Stephen Sprouse at the Mayfair and he was nervous about what he was going to ask me and finally he just blurted it out and I thought he'd been about to ask for my hand in marriage, but he asked *(laughs)* for a loan of a million and a half dollars. And I actually was so happy, it would be great to be in the fashion business. I'm not going to give him the million and a half myself, but I said I would talk to Fred about finding investors for him, and then we could have a part of the business for setting it up.

And Stephen gave me two wigs (tea $25) and went home and talked to Fred and he agreed it was a good idea.

Called Jon who's in town and staying at his own apartment on the West Side, and then walked over across the park to meet him and ran into Archie and Amos on their day off and they didn't even recognize me. I was—crushed. They were off their leashes and they were with Jed and they didn't give me a thought. And so met Jon and we went to the Cafe Luxembourg and had dinner and we didn't talk much about his new life ($75).

Monday, April 15, 1985

Read about ten different magazines and got so nervous because everything is so glamorous. Even all the sick people look glamorous in magazines.

Oh, and the Tennessee Williams book that Dotson wrote. Chris Makos told me that he sees

a lot of himself in "David," the hustler who Dotson says had both Tennessee Williams and "the Movie Star"—Tony Perkins—paying his rent. They each thought they were paying it all. So *that* sure does sound like Chris, but most of it, I don't know, it sounds like Dotson just made it up.

Wednesday, April 17, 1985

Fred was working on the Stephen Sprouse thing, he's gotten Richard Weisman interested.

And Eric Goode invited me to a party at Area for *(laughs)* the "unicorn." The unicorn that's been in all the papers from the circus. PH and I should cover that for the *Party* book. It's funny.

Friday, April 19, 1985

It was an all-day crystal day. The big cheese, Dr. Reese, was in town, and my appointment was for 12:30 at Bernsohn's—he was taking me to lunch with Reese and they were going to do my cranium. I asked Reese how he started in crystals and he said that when he was little, "Mr. Morning" came to see him. When he was a baby. He saw "Mr. Morning," but nobody else did. And then in the army he got interested in electricity and the body and all this stuff. Reese was talking about his trip where he went around sticking crystals all over the pyramids and the Wailing Wall. And he eats things like coffee and doughnuts. But he cures the coffee by passing the crystal over it ten times. And he says he knows somebody in South Africa who went to the Wailing Wall who now wants to get his money out of South Africa and do movies. Reese is Episcopalian, so I feel better with him than with the Jewish crystal people, somehow, because knowing he believes in Christ I don't have to worry that crystals might be somehow against Christ. And his assistant —this girl—kept asking him, "Should we tell him? Should we tell him what we want him to do?" And finally Reese said, "Yes." So the girl said, "Your forces are with us. You've got to come to Tibet with us. You have the ability to do great things." And then they do talk about needing people to support their studies. So do you think they're going to ask me for money? That that's it? Bernsohn *is* so materialistic—the new laser-beam record players and the new apartment. Then they tell me I was Chinese in my other life and that I have to go to Tibet with them. . . . Look, I *know* the people are ridiculous, but it's the crystals I believe in. They *do* work. When you think that these crystals were in the center of the earth and have all this energy. . .

Oh, and I got a letter from my niece Eva in Denver that said, "God Bless You, and by the way I stole your drawings ten years ago, do you want them back?" In like 1970 when she was living here and taking care of my mother. She told me she rolled up some of my Flower prints and took them and they've been in her basement. But her letter is so full of God Bless Yous and Our Blessed Home and Our Blessed everythings that she sounds like one of the Moral Majority. And my nephew Paul is still in Denver—the ex-priest who's married to the ex-nun, and they have two children.

Saturday, April 20, 1985

I got a call from Keith, he wanted to work all day on painting the elephant. Fred had it painted white so Keith could do a painting on it. This is the elephant I had to buy for Diana Vreeland's costume show at the Met for "Marilyn Monroe" to be riding on. It was pink, and then after the show it came to Fred at the Factory, and then Jean Michel and Victor painted some stuff on it, but not much, but still I would've kept it a Jean Michel even though it wasn't much of one, but Fred thought it would be better as a Keith Haring, and so Keith is going to paint it, now that it's white.

Cabbed up for dinner with Cornelia at Mortimer's ($4). She wasn't there, but Cosima von Bulow was there with her father, Claus. He's handsome. He said, "Thank you for being nice to me before I was a star." I don't know if he was being funny. I guess he means when he used to come to lunch at the office when Catherine Guinness was working there. And then he left and said that he knew Cosima was in good hands. And she's so beautiful. I had a good talk with her. She said she didn't want to be an actress because her teacher at one of those schools like Brearley discouraged her after she was in a play—said she was no good or something. Everybody just comes over to her and asks her about her father. Absolutely everybody. People who don't even know her. But she *is* a good actress, she handles it well.

Monday, April 22, 1985

My weight is up to 128, I want to get back to 125.

Went over to Sotheby's, it's jewelry auctions all week, and the place is eight-deep in this category now. It seems like everybody is buying at auction just instead of in the stores. So I guess the stores will be suffering or they already are. But I'm sure they send people to buy and bid their category up. And ran into Ivana Trump in the basement looking at the cheap stuff there.

Oh! And who should I run into at this jewelry auction but my worker who I can never find, Rupert Smith! I said, "So *this* is where you spend your days." He was shocked to see me.

Oh, and gee, I saw Lee Radziwill on an old cover of *Life* and she really was pretty and I could see why Truman wanted her to be an actress.

Wednesday, April 24, 1985

The big news on TV is that Coke is changing their formula. Why would they do that? It doesn't make sense. They could've just come out with a new product and left Coke alone. It seems crazy. And all the TV news shows love it, they're doing all these stories of people sitting around taste-testing.

In the morning went to Dr. Bernsohn's and Bernsohn said that Reese felt I was a "Janooky," that he felt I could be the really big one. "Janookys" are the head crystal people.

Left there and ran into David Whitney and invited him to lunch to find out about the art business. He said that Peter Brant paid $40,000 for a Jasper Johns print. For a *print!*

Vincent was upset because Polygram called and said that Lou Reed doesn't want to get back with the Velvets. And Polygram wants to buy our tapes for $15,000 which isn't enough. And I mean, I just don't understand why I have never gotten a penny from that first Velvet Underground record. That record really sells and I was the producer! Shouldn't I get something? I mean, shouldn't I? And what I can't figure out is when Lou stopped liking me. I mean, he even went out and got himself two dachshunds like I had and then after that he started not liking me, but I don't know exactly why or when. Maybe it was when he married this last wife, maybe he decided that he didn't want to see peculiar people. I'm surprised he hasn't had kids, you know?

I worked on the Lana Turner portraits, turning this sixty-year-old into a twenty-five-year-old girl. It took a long time. I wish I had been able to just work from an old picture and it would've been this beautiful painting. But this way it's not really a good picture.

Thursday, April 25, 1985

Dr. Bernsohn says he doesn't want to be associated just with crystals because he could lose his license—he said that in Massachusetts people *have* lost their licenses. But I mean, if you really believe in something, it seems kind of funny if you won't take the consequences.

I'm trying to find another store that sells the sculpture of the Last Supper that's about one-and-a-half feet—they're selling it in one of those import stores on Fifth near Lord & Taylor but it's so expensive there, about $2,500. So I'm trying to find it cheaper in Times Square. I'm doing the Last Supper for Iolas. For Lucio Amelio I'm doing the Volcanoes. So I guess I'm a commercial artist. I guess that's the score.

Friday, April 26, 1985

Worked all afternoon and was going to work until 8:00 but my light burned out on the tracing machine so I had to stop. I called Jean Michel to see if he was invited to Schnabel's because then I would pick him up, and Shenge answers and I say I want to know if he's invited and Shenge says, "Oh, he's invited? That's nice. I'll go tell him." And I'm screaming, "No no no!" It was a birthday dinner for Schnabel's wife, Jacqueline.

Glued. Cabbed to East 20th Street ($6). And it was great to be back in the old Union Square neighborhood. Philip Niarchos was there and he told me he had a baby. And I'd forgotten that he'd gotten married and couldn't really remember to who. But then I remembered it's Victoria Guinness. On the banking side, I think.

The birthday cake was Italian. Time went fast. Home at 12:15, fell asleep watching TV.

Saturday, April 27, 1985

I'm trying to think where we could have some videotapes of the Velvet Underground. Because I mean now with Lou not wanting to get back for a reunion with the others, I just am thinking that I really should figure out a way to get money out of that first album. I mean, I *produced* it!

And now Vincent just found the master tapes! *We* have the masters! And I'm not going to worry whether we have the right to use the masters or to make a video out of our old film clips of them. Just let them try to sue me. You know?

Keith came to the office to paint on the big elephant, and he did a beautiful job on it. It's black and white with a red base. I think I would've liked it better just black and white, but it's great. Keith's great. He really is a cartoonist. And they say he's like Peter Max, but he's really not. He has something else. Peter Max was just a businessman trying to be an artist. He copied me a lot. And now he gets $100,000 for a portrait. Look. Here's how it all works: You meet rich people and you hang around with them and one night they've had a few drinks and they say, "I'll buy it!" Then they tell their friends, "You *must* have his work, darling," and that's all you need. I mean, it's like Schnabel sitting there with Philip Niarchos. That's all it takes. So you get your price established. Get it?

Monday, April 29, 1985

Fred's gone to Zurich, I don't know what for. It's a mysterious trip. Maybe he's having his eyes done, or getting those sheep glands. But I don't know why he's doing all these things and not getting his nose done.

Cornelia and also Jay have told me that they've seen my Diet Coke commercial on TV and that I'm in it a lot.

Went to the Tuileries and got the big table in the back, and then this homely woman came in and a girl came over and said, "You have to be nice to Roxanne," and it dawned on me that it was Roxanne Pulitzer and that this is really the eighties. I mean, after seeing von Bulow, having him come over and talk to me the other night, and then seeing him on TV crying about going back to the house at the trial, and now this one, it's too abstract, you know—all these courtroom celebrities. I like this. It must be like the gangsters in the twenties.

Tuesday, April 30, 1985

Went to the Calvin Klein opening. Got there at 11:05 and there was Bob Colacello standing there looking preppie. His clothes are always perfect and immaculate, I don't know how he does it. Calvin's girls were meaty—small waists and big hips, that was the new look.

Went to Sotheby's. Ran into Patricia Neal in the elevator and I asked her if she was still seeing Barry Landau and she said yes so I didn't put him down. She was selling a Bacon and she was upset with the low reserve, she said—$250,000. I guess she needs the money. She said they sold another Bacon to send the son to baking school which she said was a waste because he doesn't bake. She was walking with a cane. She looks great.

Ran into John Richardson and I began asking him about Andrew Crispo, and then the TV cameras were around us so we didn't want them to know what we were talking about so I began calling Crispo "her" and John got it right away. He said, "I never knew her really well, I just thought she was a sleazebag." And John was talking about the Hellfire Club and I'm surprised

I've never been there, I'm surprised I never wound up there some night. But I can't stand the smells of those places—even the preppie Surf Club is tough to take.

I got catalogues, and the painting I did of Happy Rockefeller, an early one from '64, was up for sale. It's estimated at $30,000 or $40,000, and if she'd donated it to one of the museums she could've gotten a $500,000 writeoff because of the new prices, so I don't know why she's selling it. Maybe it's the kids. She sold that Nelson Rockefeller one, too, months ago.

And it's Fashion Week and all around town, everyone's just a beauty, it's so depressing.

Oh, and Victor called me and I said he doesn't come to visit, and he said he'll start coming tomorrow. He lives on 57th Street—he's with somebody, he'll always get by, he still has his big dick.

And I don't know why *Interview* is having all these Bruce Weber editorial photos of naked people. I mean, all those pages with no clothes—no *fashion* credits?! What's the point? I don't get it! We have advertisers to think about. I'm going to lay down the law: "No more birthday suits."

Wednesday, May 1, 1985

Went into Vito Giallo's to look at rare books. Then went to lunch with David Whitney, and Peter Brant's back into art again. He bought a Rosenquist. They're still underpriced. But they'll run out of people and give him a big show and then his prices will go up. I mean, they're selling David Salles for as much as Rosenquists!

Thursday, May 2, 1985

Cabbed to 82nd and First ($4) for Bianca's birthday party. Her boyfriend Glenn Dubin had called. And Bianca was driving me crazy, saying how she's researching my days in Pittsburgh for her book on Great Men, and she went on and on about how I broke the system, broke the system, broke the system, and I felt like saying, "Look, Bianca, I'm just *here*. I'm just a working person. How did I break the system?" God, she's dumb.

Friday, May 3, 1985

It was raining out in the morning. Ran around with Benjamin. Had a 1:15 appointment with Stephen Sprouse to see a fashion show that he was putting on for *Vogue* and me (cab $6). Went to 860 Broadway, our old loft space, and it was great to give a cabdriver that address again: "17th and Broadway."

They'd divided it into some rooms, and then the front was all painted gold and there were beautiful models to show the stuff to us and it was fun and really exciting, and I just want to buy all his clothes.

Then, I'd promised Jean Michel this dinner at Le Cirque. So Benjamin dropped me and I glued and went over there. He'd invited Eric Goode and his girlfriend and Clemente and his wife Alba

and then when he ordered the most expensive wine they said they were out of it, and then when he ordered the next most expensive, they were out of it, too. I don't think they wanted to give it to us, see, because it was a *free* dinner. Sirio's been telling me for years he wanted to give me one, so here it was. And they gave all these excuses and apologies, and then Jean Michel ordered the cheapest wine, and *that* they had. And it was actually good. And the next day when Paige and I went there with *Interviews*, Sirio was still apologizing. But anyway, it cost me in tips ($200). Oh, and last time I was at Le Cirque there was this model there who said he was a friend of Tom Cashin's and seeing him there with this slightly older man, at Le Cirque, I mean, it really made me decide that you can't go to straight restaurants with just boys, it looks too funny. You wonder what they're doing there, they're a sore thumb.

Monday, May 6, 1985

Ronnie looks so good these days and his art's still really selling. He's going with that Tama Janowitz girl who's such a fast writer, she writes so many stories. He's like Gerard Malanga. They both stay emotionally immature. Ronnie has a big cock. He services these girls, and he stays young, just like Gerard—they don't grow up.

And Debbie Harry called and said that it was a big secret but that she just signed with David Geffen. And Stephen Sprouse is so happy about that because he's been turning down people like Madonna who wanted him to do clothes for her because Debbie was the one who really started Stephen and he wanted to be loyal to her, that's the kind of person he is. So now she'll be out there again.

Tuesday, May 7, 1985

Fred called from Europe and said he was coming in today.

Jean Michel said he decided not to do anything for Steve Rubell's new club because he asked what he was going to get out of it, and Steve told him, "It's for the glory, the prestige." Can you imagine hearing this from Steve? I'm still trying to get the drink tickets I'm designing for him together, so I'll ask about which day PH and I can tape him for the *Party* book as soon as I give them to him so he'll feel guilty.

Wednesday, May 8, 1985

There was a big Area party. Jean Michel picked me up and we went down there. And my display window had my Invisible Sculpture in it and Jean Michel's stuff looked great—a big record—and Keith and everybody was there. And the installations were great. And Steve Rubell was walking around saying, "Great, great," being so jealous, wishing it were his club.

Thursday, May 9, 1985

I see there's a Soup Can dress in one of the shows on Broadway because I see it in the TV ad. I can't tell which show, maybe it's *Grind*. Went to Jean Michel's, picked him up (cab $6). And he's working again and his work is wonderful, it's so exciting, and I think he will last.

We went to the Odeon and had dinner and talked with Steve Rubell and Eric Goode about the club openings and everything and it was fun, and Steve is getting artists to do things for his new club, the Palladium, and Keith did a backdrop that can be lowered from the ceiling down to the dance floor and Steve is sitting there saying, "If it isn't any good we just won't bring it down too often." I mean ... (dinner $240).

And then Steve's driver took us over to the Palladium and it's what the movies in the thirties were all about—dirty on the outside and then inside these white pristine columns, and everything big and lacquered, blue poles and stairs like Ziegfeld Follies girls would come down. And Clemente's painting a ceiling. But I mean, still, it's just another place to go, and Area is already so successful at this, and they change themes all the time, so I don't know. He and Ian are just "managing" the club because you can't have a police record and own a club. Like we had to be fingerprinted and checked out when we had our club, The Dom, in '65. Everyone went on to Area and I went home (cab $6).

Gee, Madonna was just a waitress at the Lucky Strike a year ago.

Sunday, May 12, 1985

Jean Michel called, he's working on his painting for the Palladium. But it's collapsible and he can take it away any time he wants.

Monday, May 13, 1985

Ian Schrager called and I finally finished the design for the drink tickets and Vincent got them Xeroxed and I went over to the Palladium with Benjamin and showed it to Steve Rubell and PH and I taped Steve for the *Party* book for an hour and a half. Got a good tape and went back to the office.

Tuesday, May 14, 1985

The day of the opening night of the Palladium. The day started off with the problem of Amos being sick. And then the guy painting the roof across the street came over and said mine needed doing. He got my name from the super over there, I guess, and I gave him the go-ahead to do it and he did it. Then he gave me a bill for $4,900. I hadn't remembered to get an estimate. My fault. Then I get a note from the neighbor saying my roof is now *silver* and that they just can't stand looking at it. They're telling the right guy, right? No silver. Anyway, I told him to repaint

it and I asked him how much *that* would be and he says it'll take thirty gallons to spray it and it'll cost $1,200. And he does it in five minutes. *Five minutes!* I thought it would take hours. And then later he says *$1,500* and I reminded him that he'd said $1,200 before.

So in the midst of all those problems, Benjamin picked me up early and we cabbed to the office ($4) and the place is so big and spread-out, I ran up and down stairs, up and down and sideways up and down and sideways. That's my life there. That's what I do for a living since we moved there.

Keith showed up. We were waiting for Kenny Scharf to call to say if he wanted to go to Stephen Sprouse's to get an outfit, but then he went on his own. He got pink Stephen Sprouse low-riders and wore them with a blouse made by his wife, Teresa. But I don't think it's attractive, seeing the crack in the ass. On girls either. I don't like it, really.

Then we picked up PH and went down with Keith to the Palladium and went in the back door on 13th Street and the electricians and construction people were working fast. We went up to Steve Rubell's office and the phones were ringing and he was saying, "There's no door list, the invitations all were delivered yesterday and there *is* no list." And in between people were coming in with the list. Then I left after taping some more for the *Party* book and taking some pictures. Dropped PH ($5). Went home and glued.

Picked Cornelia up and she looked beautiful, she got this idea to wear a long braid and she looked like Britt Ekland or something (cab $6). And Halston came out for this, that was a big thing. So, anyway, we went in and stood in a couple of places. And Benjamin was there as Ming Vauze in a grape-colored strapless with a tulle skirt. And Beauregard who writes for *Details* was in drag, too. Boy George was there with Marilyn who's always obnoxious, she had a camera. Eric and Shawn from Area were there looking glum. Chris in a striped outfit was there, he was complaining that the drinks weren't free, but Cornelia was getting the Cristal from Dan, Steve's driver from New Hampshire, who's now the "general manager" there, but I don't think that's going to work out because he's too nice, he'll never be the type to manage a place.

And Jean Michel was in a dark mood. He'd bought Jennifer a dress to wear to the opening and then he didn't even bring her, he left her home. And I didn't lecture him about the heroin he takes because I didn't want to have a fight. And I'm worried about Ming turning into an alcoholic, because I saw what happened with Curley—it starts very happy and lots of fun but it doesn't end up that way. And the Palladium, I don't know, it was good for opening night but they're going to have to have the bridge and tunnel people in there all the time to fill it up. And if it is a success, then we'll know there's no recession.

And the funny thing about putting art in a disco is that in the end, when you pack all the people in, it doesn't make a bit of difference. It really doesn't. You don't even see things. And like that *Saturday Night Fever* "discotheque room" they have—when it filled up you couldn't even see what it was supposed to be, it's just all bodies dancing and you don't notice what anything is.

So Steve Rubell really has a story now, jail and then the Big Comeback. "I never lost faith," he says. But he lost hair. Left at 2:30.

Wednesday, May 15, 1985

Well, it was an awful day.

Went to 80th and Second to Dr. Marder's to see Amos. They've still got him there today. I hope he's all right. And Dr. Marder made a *faux pas* and said he remembered my "beagle."

Then called the office and they said that the Talking Heads were waiting for me and I'd forgotten and by the time I got down there (cab $6) the lead one had left. They've friends of Don Munroe's and he and Vincent were trying to get them to do video work. But I always felt I've known them for so long. They went to the Rhode Island School of Design.

Cornelia called about eighteen times.

Then right before we left the office, somebody called and said that Jackie Curtis O.D.'d. He's gone. And that wasn't something I wanted to hear.

Monday, May 20, 1985

After work got ready for the Claudia Cohen party at the Palladium. I was late picking up Cornelia, she was waiting downstairs. And we cabbed to 14th Street, and it was all limousines.

Saul Steinberg was there with his third wife, Gayfryd, who's so beautiful, she looks like the "Draw Me" girl in old magazines. And Claudia's mother was there, so glamorous and really beautiful, whereas Claudia is just "cute." But it'll be a while before Ron Perelman trades her in, and she can help him a lot in the meantime.

The party was all these old guys dancing around with their new young wives that they traded in for.

And when you came in the door there was a guy holding a candle, and all along the way up, at intervals, would be another guy with a candle and then another. And they had drinks in the Mike Todd Room, and then out on the dance floor they had tables, with flowers on them, and each high flower had a spotlight on it, and it was beautiful. Like if the flower was blue, it would have a blue light and be bluer. It looked like glitter. And if it was pink, it would have a pink light on it and be pinker. And there were chairs sprayed silver. Five glasses for each person. And at the Palladium the sound is really good. A big stage with a great sound system. And Peter Duchin played all night. He came over and said hello, but said he was working. But I think he did stop to have dinner.

Steve Rubell said the other day that Claudia was paying the Pointer Sisters $100,000. They came on after the dessert and did six or eight songs. And I had the best seat, right in front of them at table 7. Cornelia was at table 1 with Roy Cohn and his boyfriend, who was wearing a blue tuxedo that was half leather. Boy George and Marilyn came in at the end. Cornelia and Marilyn hit it off and instead of leaving with me she went off dancing with them.

The food was pretty good—Glorious Food. But they don't have the real beauties for waiters anymore. You aren't knocked out. Now they have sort of the thirty-five look. Somebody else must be picking them because they used to look like Steve Rubell had hand-picked them—that look. And the Glorious Food waiters wear white gloves now, I guess Glorious makes them in order to prevent the fist-fucking from spreading. It's a good idea because I spotted a friend of Victor's among them. The only glittering personality there was Geraldo Rivera.

Tuesday, May 21, 1985

My day started off with destruction. I picked up this rug and the moths had eaten it right through. They're all in the back. I'm going to spread more moth stuff. So far they only got an Indian rug, but they could eventually get to my Stephen Sprouse things.

Benjamin came and we decided to walk down Madison to the office. We didn't have any *Interviews*. Rupert arrived at 6:30 and worked a little. His boyfriend picked him up in Rupert's Rolls Royce, he was out there waiting like a nagging wife, I guess Rupert wants that, though. Poor Rupert is henpecked. And I'm just waiting for them to have the big fight. The guy is taking him for a ride. So there he was waiting in this grand left-side-driving Rolls. And they gave me a ride home because it was raining and hard to get a cab.

And during the day I bought lots of newspapers for the front pages—they had the sextuplets on ($2). And *People* magazine has the article on the artists and it has "Andy Warhol, fifty-eight." And then "Keith Haring, twenty-two." So if anybody asks, just tell them I'm eighty. Always, "He's eighty."

Wednesday, May 22, 1985

I found more moths.

Andy Friendly still won't give the money for our TV show, so I guess we'll just do it on our own with Paige trying to get advertisers.

Went down to Keith's party at the Palladium and it was packed, that huge place—*packed!*

Then decided to go to Private Eyes, the video club. It was their Gay Night and jammed, wall to wall. These kids, if you saw them on the street you would never think they were gay. They look like L.A. kids. Stayed there a few minutes. Then got home at 2:00 (cab $6).

Thursday, May 23, 1985

Somebody told me that Jackie Curtis had a long obituary in *The New York Times*. I still keep wanting to think it was a put-on like his weddings. They said he was thirty-eight, so I must have met him when he was what? Eighteen?

Hete from Düsseldorf, the partner of Hans Mayer, came to lunch at the office. And Fred and I had words because he was being so elegant and grand and said to me in right front of Hete, "Why don't you tell Hete how you really feel about the gallery not paying you." You know, so I was stuck. Fred really is bored. He wants to do a change, I guess. Like Paul Morrissey did.

And then Paige picked me up, but she was only in a taxi, not a car. And I said I'd said to get "a car" and she said, "Well this *is* a car" (cab $9). Then got to the Apollo and there were millions of cops. It was the Hall and Oates taping and it was benefit for the Negro College Fund. Hall and Oates came on and they were great, did all their hits. Boy George arrived with Cornelia and they were in a box and he was throwing kisses. And then two of the Temptations came on and jammed with them, and they were great, and you could really see that that's who Hall and Oates copied.

And when it was over we left and the cops were just crazy for Boy George. I've never seen anything like it. They just all wanted his autograph so much, and Marilyn said to one of them, "I want to have an affair with you," and he said, "I have someone you'll really like." I mean, I really have never seen that kind of thing going on with the cops.

Saturday, May 25, 1985

Walked to work. Kenny Scharf came by. And he said he doesn't know what to do because he likes to feel free and do whatever he wants but he does love Teresa and the baby, but he feels he has to have that free feeling. So Kenny was there for hours and then left at 7:00.

And you know, in the pizza place next to the office on 33rd Street, the one that's owned by Koreans or Chinese, it was so sad, because they were cleaning up and throwing out all the stuff from, maybe, the basement, books and things, and I wanted to go through it all but I didn't. And this woman was holding these two big white dogs and I don't know if she belonged there or if she didn't. You don't know about people. Everybody just does their own stuff on their own scale. There was a naked baby in the middle of the floor.

Sunday, May 26, 1985

Another hot day. Rode around the city and over to New Jersey with Chris and Randall. Peter and Chris are trying to decide whether they should keep it together or not. And Randall is a gymnast who came to New York to see the world and the first person he sees is Chris so you know what part of the world he's seeing.

Then went home and watched TV. *Deceptions* with Stefanie Powers. I went to sleep, facing life alone.

Wednesday, May 29, 1985

Was picked up by Benjamin and there was a note from Crazy Matty at the door. He's been leaving notes for Brigid at the office.

Then cab ($4) to meet Paige for her lunch at the office with some advertisers. And the reason Paige sells so many ads is she actually enjoys the people she meets from selling ads, she *likes* entertaining them for business, which not many people can do.

Then Jean Michel came over to paint and he was laughing and kidding around and Paige called up to me on the phone and screamed, "Get him *out* of here!" And I just didn't know what to say, she hung up before I could even think, and then she just left the office. She was calling Jean Michel a creep and everything.

Cabbed to Canastel's ($5) to Katie Ford's dinner where she said she'd have male models. And this is the place where the guy wanted me to do a mural for the wall but wasn't going to give us enough credit—I was going to do it with Jean Michel, but eventually the wall would've been

worth more than the whole restaurant. But this place was great, just jammed, and pink lights and just really good food and steamed vegetables for appetizers that were as big a serving as the main course at the Odeon. Like California food.

So I was with this model with blond hair and piercing black eyes, and he knew all about "walk-ins." They're when somebody else *walks into* your body. It makes sense. It happens if you're having this trauma or if you're sick or something. And you know, when I was little I remember I was really sick and didn't like school and had to be dragged there and then one day I changed—after that I loved school and everything, so I think somebody may have walked into me then.... I'm not clear on who the walk-ins are. Souls. And I'm not clear on where they come from.

Monday, June 3, 1985

Benjamin picked me up and we went to the West Side to Dr. Linda Li. She told me Fantastik is poison, not to use it (phone $2). Decided to stay out as long as possible because it'd been a couple of days of me being cooped up, and it was a beautiful day. Went to Bagel Nosh ($10) and stood in line for scrambled eggs and it was so dirty but it was okay, I faced it. Wandered to 46th Street. Saw the sights. Took pictures of drunken ladies sleeping on park benches and felt that life was just so awful. And I don't know what I try to look good for. Everybody when you look at them really close is so awful-looking. So animalistic.

And then it was time to go to the opening of my Reigning Queens show down on West Broadway and Greene Street. This is the show that George Mulder got together. Some one-night Dutch benefit thing. Rupert's "wife" picked us up in the Bentley and the missus was disgruntled. And then we got down there and parked next to Victor's limousine. Victor just got some kind of settlement from Halston. I think he had to sign a paper saying he wouldn't talk about Halston ever, but I mean, what does *that* mean? He's happy now that he's got this wad of money, but when it's gone ...

And I've hit rock bottom. This show, I have sunk to the bottom of the gutter. The rock bottom of the skids of the end of the line. It was like having an opening in somebody's rent-controlled apartment. I mean, they had a paper covering a mirror! And they had hors d'oeuvres that I think they were making in the kitchen. And these Dutch TV people were all around. It was so low-down and tacky. Fred wasn't there. He'd already left, didn't want to face me, I guess he was in shock. We found him dazed, wandering along Christopher Street later on, on his way up to the Ballroom for the Scavullo benefit for the church in Greenwich Village. We just ran into him on a fluke and gave him a ride.

So we left there and went up to the Scavullo thing and I sat down but then Cornelia was screaming that there was a fashion show and that I was supposed to be in it, so somebody grabbed me and took me to the basement, and it was every famous beautiful model and the tits were flying all over the place. And I was in Stephen Sprouse, and Cornelia and I got the biggest applause. And Boy George was in the audience and Marilyn, and they said let's go to dinner, they had a limo, but I went in a cab anyway, up to Mr. Chow's (cab $6).

It was me and Benjamin and Boy George and Marilyn and Cornelia and Couri Hay and they all act like horrible brats—Couri screamed across the restaurant to Dianne Brill, "Get your pussy

over here," and this is a place with just regular people, and then Cornelia would say to somebody who'd told them to please be quiet, "You look like a dried duck," or something like that. Just awful. And then Marilyn saw Mary Wilson sitting at a table and went over and Benjamin just collapsed because she's his favorite singer, and then she came over and thanked me for going to her comeback concert a few years ago (dinner $400).

And Boy George and Marilyn like me I think because they can say mean things and then I'm not quick enough to think of a comeback, so I'm not a threat to them.

Wednesday, June 5, 1985

Picked up by Benjamin. Put out all the mothballed things onto the street and was shocked by how much there was. Dr. Linda Li and Dr. Bernsohn both told me that mothballs were absolute poison. Bernsohn said he wouldn't get within forty feet of them.

And I asked Bernsohn for ideas for paintings. And I brought up "walk-ins" and told him how I think somebody might have walked into me when I was shot, in addition to somebody maybe walked into me when I was little. But somehow these walk-in theories don't make total sense to me. He said that if your body is really weak and sick nobody will walk into it. And then I said, "But then people could be walking into you the rest of the time." I don't get it yet.

Cabbed with Jon who's back in town for a couple of days to 32nd Street to see *Rambo*. And the movie was ridiculous. It was like *Friday the 13th* but with explosions.

Thursday, June 6, 1985

Went over to Macy's to judge the Madonna look-alike contest. They expected 200 girls but there were only 100. They'd spent a fortune, these girls, on the clothes and jewelry. It was over pretty fast, by 5:10, and it'd started at 4:30.

Went to Radio City Music Hall for Madonna's concert (cab $6). And the show was so great. Just so simple and sexy and Madonna is so pretty. Now she's thinner and just so great. And afterwards we went downstairs where there was a private party, the level with the ladies' rooms. And Madonna came down with Jean Michel—I guess he'd gone backstage. And she was fun. She said she was going to the Palladium and might go to Keith's dinner, and she was so sweet and nice. So we went and drove to Iso on 11th Street and Second and then Madonna did arrive, she came in a truck. And they sat her next to me, and she was just great. They were teasing her about her false eyelashes, saying they were bigger than Louise Nevelson's. And everyone was so thrilled, the waiters were on the floor. She was drawing cocks on Futura's pants.

Monday, June 10, 1985

The morning started off with the doorbell ringing so loud and it was Crazy Matty and the neighbors are really getting upset from him hanging around all the time. When Benjamin came he went out to talk to him and Matty has his days all mapped out—his schedule is as big as mine. Like at

1:00 he's going to go bother Warren Beatty at the Carlyle, at 3:00 he's going to make a nuisance call to Woody Allen, then at 8:00 he has the Emmys to attend where he'll stand behind the police lines and scream at Celeste Holm on her way in, things like that. I gave him $.25 to call Brigid at the office and divert him away from me.

I just don't know what to send Leo for the show he's doing. Anything I send it'll just look like the stuff by the kids who're making it that way now, only they do it *better* than me. So nobody will even want to copy it. And Jean Michel said he got a huge bill—like maybe I think $100,000—from his dealer in L.A., Gagosian, for his stay there when he was living so high.

Thursday, June 13, 1985

Then got a cab and the driver knew all about me, said he'd just seen *Bad* on video and knew all about the building on 33rd Street. He said, "You made my night." That's a good song title *[singing]*: "I made your night, I made your night," so I had to give him a big tip ($7).

Friday, June 14, 1985

During this morning I went down to the Seagram's building for that "How to Paint" video thing that the computer company, Commodore, wants me to be a spokesman for. And I guess I got the job. I was afraid that they were going to put a spotlight on me and have me draw in front of 700 people, but it was okay. It's a $3,000 machine that's like the Apple thing but can do a hundred times more.

Wednesday, June 19, 1985

In the morning Amos still wasn't feeling well. I'd given him part of a Valium when he was yelping the day before and I thought he'd be fine. When I called to ask Jed to take him to the vet he wasn't in town, so I took him myself (cab $3). Dr. Marder wasn't there so we saw Dr. Greene, then dropped Amos back home. Then went up to Bernsohn's and that was interesting. I told him that the crystal I'd put in the kitchen at the office to repel roaches wasn't working, that we were getting more roaches than ever. He said he was going to call Dr. Reese about it, and later, in the afternoon, he called and said that the crystal was now reprogrammed to un-reverse itself, so now we'll see the proof. But anyway, while I was still there, the most interesting thing was that he told his secretary Judy to get up on the table and pretend to be Amos and he asked her what was wrong with her and she said that she had a crushed vertebra on her left or right side. And I hadn't told him! And she told him that farther down she also had maybe an ulcer. And then Judy said she didn't want to be a dog anymore, that she wanted to go back to human, so she did. He said to give Amos comfrey for the ulcer.

There was a big lunch at the office. The Mosses were coming, from A&M records—the wife I did the portrait of. Their son is going to acting camp.

Thursday, June 20, 1985

Amos still wasn't feeling well. I let him run around but I don't know if I should have.

Ran into David Whitney and Michael Heizer and they said to come along to the Whitney to look at what they were doing. And I did and I got so jealous. People can walk on it. Silkscreened textures on big pieces of cardboard. Big like a house. And they're just going to throw it out after the show's over. It's a hill formation.

And somebody told me that my old friend Ted Carey who I once split the cost for a Fairfield Porter portrait with—he painted us both together—has you-know-what.

I left work early (cab $6) and when I got home Paige was calling, crying hysterically that the big opening she was having that night for her Mexican artist Julio Galan was banned by the board of directors of the co-op building where she was having it. It was in the same building that got mad when she gave the black graffiti artists a show. I told her that she just had to buck up and reschedule the show someplace else.

So I cabbed down to Indochine for a dinner for Elizabeth Saltzman. Shawn Hausman had a beautiful fifties car and after the dinner he drove us over to Area where they had these kids on skateboarding loops. It looks so dangerous, like a twenty-five or thirty-foot arc, fifteen feet high. One kid fell when the light went in his eye.

Wilfredo who used to work for Armani who works for us was there and his brother was picking him up to take him home to New Jersey. Because Wilfredo got kicked out of his apartment and now he's got to go home to New Jersey every night, and his mother's very careful and makes his brother come into the city to pick him up and the brother likes it because that way he gets to go to all the clubs *with* Wilfredo. So then went to the Palladium. Wilfredo's brother drove. Cornelia was there with Philippe Junot. Stayed five minutes and went home (cab $6).

Friday, June 21, 1985

I yelled at Brigid a lot yesterday. She threw out an important piece of artwork. It was a doodle that Michael Viner wanted made into a painting for his wife Deborah Raffin.

Lunch was for the Krizia people. And Paige by then was a new person, completely recovered from the night before when she had to stand in front of the building for four hours telling people as they arrived that the art show was cancelled, and somebody who was there said that each time Paige would have to say it, she'd burst out crying all over again. I asked her how she was able to recover so quickly and she said it was part of her job. So that was good. I told her she should put her advertising commission money into a loft and have four or five art shows a year there.

I decided to go to the Whitney Tower wedding which was at 5:00 at St. Bart's. Fred was an usher (cab $3.50).

The bride looked beautiful. I was sitting next to Charles Evans. Nick Love from L.A. read a good paragraph from the Bible. He's got the style of the thirties which I think will come back sometime for actors. I wasn't invited to the reception. Had tennis shoes on and walked uptown with Joan Quinn.

Called Jean Michel but he hasn't called me back, I guess he's slowly breaking away. He used to call me all the time from wherever he was.

Saturday, June 22, 1985

Changed into black tie before Roy Cohn's birthday party. Called PH to say I was leaving immediately to pick her up but then noticed a note from Matty outside the door so I waited a few minutes and peeked out the window and didn't see him, made a dash to Park and got a cab. Picked up PH. Got to the Palladium (cab $5.50). We were at a table with Vera Swift and Philippe Junot and Jacqueline Stone and some prince from Austria and Vera's daughter Kimberly and a man I didn't know and two women I didn't know. Said hello to Barbara Walters who just announced her engagement a few weeks ago, and she looks really good.

And everybody was saying how sick Roy looked, and that he was dying. Steve Rubell told me the other week that Roy had cancer and was in remission—that it wasn't AIDS, but regular cancer. He didn't look well.

And Jacqueline Stone was going on, worried about her son, Oliver, who's now in El Salvador directing a movie he wrote and nobody's heard from him in a week. And I remembered later that Boaz Mazor was the star of Oliver Stone's first movie and he once told me that Oliver's mother was a stage mother on the set handing out poppers to the actors to help them act.

And then after dinner the politicians' speeches started. Stanley Friedman from the Bronx gave a speech and mentioned Lebanon and the hostages there from flight 847 and said we can't forget the trouble spots in the world like Afghanistan and Nicaragua, while we're having our nice dinner at the Palladium.

And Philippe Junot during all the political talk just sat there practically asleep. But when somebody at the podium introduced a "twenty-nine-year-old Donald Trump," Philippe's head popped up and he said, "Donald's not twenty-nine!" And then the last speaker was Roy himself and before he started to talk the two big blocks of TV monitors came down and they were all filled with vintage footage of Roy's face from the fifties giving his anti-Communist speeches. And that was exciting, it was the best thing. And they brought out a big fat cake and then a Kate Smith record was blasting over the speakers with "God Bless America" and the "flag up there" that all the speech-givers kept referring to came down and it was actually shredded red, white, and blue banners. Plastic. Talked to Richard Turley and the lady who invented Weight Watchers. And then the dancing music started and everybody got up. And by this time the kids they'd let into the club were overhead looking down from the balcony on the dinner.

Wednesday, June 26, 1985

Went into the Whitney to see the Michael Heizer show because I wasn't invited to the dinner that night for the opening, which I thought was so strange, because there it was my good friends David Whitney and Michael Heizer planning this whole dinner with a list and everything and I wasn't even on it. And David was cool to me. I mean, here's this man who wants to marry me when Philip Johnson kicks the bucket and he didn't even invite me to the dinner. He was wearing the Stephen Sprouse tie I gave him. And Tom Armstrong doesn't invite me to anything anymore because he doesn't have to court me now that the Whitney's got all my old films (phone $4, cab $5.50).

Thursday, June 27, 1985

Stuart Pivar is casting bronzes for Stallone and he doesn't know what to do because he just saw an *original* of the one he's casting going at auction for cheaper than he's casting the *copy* for Stallone for *(laughs)*, so he doesn't know what to do, he's afraid Stallone will see it, too. And Stuart's girlfriend Barbara Guggenheim was out there in L.A. selling art to Stallone for hours and hours when PH was trying to wring just twenty more minutes out of him for her cover interview for our Movies issue.

Oh and I forgot to say that on 45th Street I ran into a lady who said her father delivered Ted Carey and his brother and she asked how he was and I didn't have the heart to tell her he had AIDS.

Friday, June 28, 1985

The doorbell was ringing and the rain had started and Benjamin came to pick me up, but then Matty was waiting for me outside. I gave him a dollar and told him to *(laughs)* call Warren Beatty. He's really skinny now. We gave him an *Interview* and he followed us to Versace and he read it outside while he was waiting and he became so engrossed that we were able to slip past him, he didn't even see us. Little did we know that he'd be waiting for us downtown on 33rd Street when we got to the office. Benjamin reasoned with him and now Matty's going to consider giving me the weekends off.

Cornelia called and she tried to tell me a "secret" but I told her don't bother, that it was so obvious that she was seeing Philippe Junot. All these girls want to see what Caroline gave up.

Saturday, June 29, 1985

Bianca was hit by a car in East Hampton while she was trying to learn how to ride a bike. Gold and Fizdale hit her. They're those two old dual pianists who write about cooking together now. Steve Rubell sees a big settlement.

Sunday, June 30, 1985

It was Gay Day parade day. Got in a cab and the driver was a happy faggot, he said, "Hi! Did you go to the parade?" and I just said, "*What* parade?" and he dropped the subject, talked about the weather (cab $5). And on the news the hostages from TWA 847 were free, and then they weren't free and then they were free.

Stephen Sprouse called and we made plans to meet. I said I'd pick him up at 9:00 and we'd go down to Odeon for dinner (cab $7). It was sort of empty (dinner $70). Then we walked over to Area. Then I remembered there was a Gay Day party at the Palladium. We started to walk up. Saw some cops by the stable where they keep their horses on Varick Street. They were just back

from the parade, laughing. One of them had his nightstick pointing out from his basket and they were laughing about their experiences of the day. A cute one said hi to me (cab $7).

Tuesday, July 2, 1985

It was Emanon the fourteen-year-old rapper and the little Latosha girl at the office for lunch, and Emanon's so cute, he really is. I think he should expand from rapping into singing. And Latosha does sing like Ella Fitzgerald. I want to adopt little black kids.

Keith called me and wanted to know if our date for Jerry Hall's birthday party was still on. He said he'd pick me up at 9:00. Worked till 8:00. Keith picked me up in red patent-leather shoes and we went to Mr. Chow's (cab $9). Mr. Chow's is fighting having to unionize, because he said he needs the kind of young attractive waiters that you just get off the street. I had a glass of champagne. Jed was there with Alan Wanzenberg. And I notice that Jerry's birthday parties have gotten more hardcore every year. It used to be her model girlfriends and their boyfriends, but now it's heavy-duty, no model friends.

Thursday, July 4, 1985

Stayed home during the day, the dog was sick. Watched the soaps and they're all great, handsome guys and good-looking girls, and they really know how to kiss.

The Forbes boat was parked at 30th Street and the East River, not the Hudson River like I thought. And when Stephen Sprouse and Cornelia and I got there there were all people on the highway screaming my name as I went in so that distracted me and I didn't take pictures.

Peter Brant was on the boat, he told me that he'd tried to buy the *Voice*, that he'd really wanted it, but that he lost out when Leonard Stern paid $55 million because he'd only offered $51 million.

Anne Bass was there with her husband Sid and kids, and I didn't make a fuss over them which I should have. I sat with Mick and Jerry while I ate. Watched the fireworks and it was like they were floating by the boat. "Suzy" was there with her son, and I didn't know she had one. Then the boat left and sailed around the tip of Manhattan up to where it usually docks on 23rd Street in the Hudson. Going fourteen miles an hour.

And Cornelia's still with Philippe Junot and Mrs. Vreeland is mad at her for wasting her life, which she is, but she says she doesn't want to get married, she just wants to have fun.

After I got home Stephen called and said, "Thank you for a really good time," and for a few seconds I *(laughs)* couldn't think who it was.

Saturday, July 6, 1985

Got up to get to work but decided it wasn't going to happen and I stayed in and read. Tried to read Dominick Dunne's book *The Two Mrs. Grenvilles* but it's too boring because it's not real and it's not fiction. Then I started reading the copy of *Savage Grace* that Steve Aronson autographed

for me. It's about the Bakelite woman and her beautiful fairy son who killed her, and it's all the real society people talking and these fascinating letters from the father—I guess someone will make a good movie out of it because the people are glamorous and it's a good story—mothers who want their sons to be fairies so they sleep with them.

Told Stephen to meet me at 7:30 sharp at Diana Vreeland's for dinner. It was a huge rainstorm but it stopped at 7:40 and I walked over. Stephen Sprouse was already there and sweet. He'd brought Mrs. Vreeland some outfits. I had my tape recorder on and she came in and said, "What's that?" and I *(laughs)* told her, "A camera," because I thought she couldn't see. And she said, "No it's not." So then I told her it would be like old times, taping again, and she said okay. She said she has a girl sit in the room with her while she sleeps. I thought that was so strange, that she would want that. But then, I guess she is sick, so . . . She had four vodkas and she smoked about fifteen cigarettes.

André Leon Talley was coming the next day to read the Rothschild book to her, she said. She can't remember names, but then she never *could.* And the funniest thing was she said that someone who was going through things for her found her birth certificate, and it was August 29th and not September 29th, the date she'd been celebrating all her life because that's when her parents had told her her birthday was. So she's a Leo, she finds out.

Monday, July 8, 1985

I forgot to say that over the weekend I saw an old *Naked City* episode from the sixties on TV that had Sylvia Miles and Dennis Hopper, and it was during the filming of this episode that I met Dennis, when Henry Geldzahler took me up to 128th Street on the East Side where they were shooting it, and I guess Sylvia must have been there, too, but I didn't know her then. And she was playing old whores *already.*

Fred was just back from L.A. and we may be getting the building off Doheny and Melrose for our *Interview* office out there. It's a house, but it's zoned for business. Down from a million to $500,000. And he'd said at first that it didn't need work, but now he said that it needs air conditioning and wiring.

Dr. Bernsohn told me that Jon is going to Tibet with Dr. Reese—for his health, maybe, I guess. And to research his scripts on crystals, I guess. I don't know . . . he's completely gone from New York now. He's just working out there in L.A. I guess I'll find someone better to work on movie projects with. I mean, that was the main reason I got so involved with him, so . . .

Anyway, Dr. Bernsohn said he'd been to Sedona, Arizona, that and his back was cured. I didn't know anything was still wrong with it. Sedona is one of the three big points. The others are the pyramids and the the Bermuda Triangle.

Went and looked at the September Movies issue of *Interview* that they're working on, and I didn't like the illuminated manuscript kind of lettering that heads each category—I think they should've just done a new kind of *modern* type, not the curlicue look. And the Stallone pictures that Herb Ritts took don't look any different than movie stills, there's nothing that makes them unique, because Stallone's just in his boxing trunks. Why didn't Ritts at least have him hold a *hanky* in one shot or something, to establish that it was *our picture,* not just some still from *Rocky IV.*

Tuesday, July 9, 1985

I met a guy from Paramount last night named Michael Bessman, and I guess he has the job that everybody wants—in charge of development. I think he must have just gotten the job that Jon was wanting. I don't know if Jon would have been good at it. He never liked any of the projects I thought of, but now that he's trying to go into production, I'm just waiting—I'll probably see *my ideas* being announced as *his* new projects. Like the "Music Hotel," that one I was doing with Maura Moynihan. Jon always thinks it was *his* idea after the movie comes out. Like *Footloose*. He knew Dean Pitchford, the friend of Peter Allen's, and he remembered that they were all talking about it at a party once and then after Dean Pitchford did it as a movie Jon would always say it'd been his idea, too. But these things are all in the weather, and it's whoever *does* it that counts.

They were telling me that Cosima von Bulow cancelled her shoot for *Interview* because she got a sunburn. But I mean, she lives in Newport, and she doesn't know about the sun?

Sent Benjamin out on a simple errand and it cost me a thousand dollars! I'd given him $2,000 to go get the large-size sculpture of the Last Supper that we'd bargained the guy down from $5,000 to $2,000 on. So he went there and it wasn't there anymore. The Last Supper comes in small, medium, and large. So then at this other place, I'd gotten the guy down from $2,500 to $1,000 for the medium. But Benjamin forgot we'd gotten them *down*, and he bought the medium one for $2,000! He *didn't remember!* It was actually the size I really wanted, anyway, but he wound up giving the second store for the medium one what he was supposed to buy the large one for. So this means he hasn't got a head for figures—a thousand dollars is a lot to waste. I just couldn't believe it, after I'd haggled so hard.

Went to Marylou's on 9th Street for a models dinner (cab $5). Joey Hunter was there. And all the boy models at one end of the table were desperate that they didn't have girlfriends, and then the girl models were at the other end of the table tired and complaining that they didn't have boyfriends.

Wednesday, July 10, 1985

I'd redone the portrait of a lady from Boston and we had lunch for them so they could see the new ones. I learned a lesson: I should never show a portrait when I *know* it isn't right. The first time around I knew that I'd made her look like a horse, and still I showed it to them. And the thing is, this woman's actually nice-looking, it's just one of those people who photographs all the wrong way—all the bumps are in the wrong places. Like the bump of her nose just goes the complete wrong way in pictures, and it's actually a perfect nose in life. But now they loved them, they took three.

Jean Michel came by and did a masterpiece upstairs. He wants to get work done before he goes away again. He had Jay filling in paintings, and I'm going to have Jay fill in, too. He tried to hire Jay away, but Jay didn't want to work for him.

Saturday, July 13, 1985

Watched the Live Aid thing on TV. Bobby Zarem's office had been calling, wanting me to go down there, but when you're with that many big celebrities you never get any publicity. Later on that night Jack Nicholson introduced Bob Dylan and called him "transcendental." But to me, Dylan was never really real—he was just mimicking real people and the amphetamine made it come out magic. With amphetamine he could copy the right words and make it all sound right. But that boy never felt a thing—*(laughs)* I just never bought it.

Someone gave me a copy of Leo Ford's sex video and I put it on when I got into bed and he was massaging this limp sausage of his for so long and there was another guy there doing the same thing with *his* limp one, and I fell asleep and when I woke up they were *(laughs)* still doing it.

Monday, July 15, 1985

Saw Dr. Li and had fun. We were going to go back to the East Side but it was such awful muggy weather that we just went downtown. A girl came by with the Edie look, but I told her there wasn't anything I could do for her. I guess she wanted me to wine and dine her and change her life, but I mean . . .

Gael came in and she's losing weight. I told her she should start going on TV shows to promote *Interview* and make it sound glamorous.

Tina Chow went out today and got her crystal. The crystal in the kitchen at the office still isn't working—it still isn't repelling the roaches. Vincent says the roaches even run around the clock in the stove, under the glass. I'm going to bring it back to Bernsohn again.

Thursday, July 16, 1985

Cabbed to meet Ric Ocasek of the Cars who's doing a solo album, and we were filming him for our MTV pilot show, *Andy Warhol's Fifteen Minutes* (cab $6).

And there was a big rainstorm with big hailstones and that was exciting. We ran around with buckets, putting them under all the holes in the roof. Worked with Rupert until 8:00.

Then I went to dinner with Susan Mulcahy of the *Post*'s Page Six. And you know, I realized watching her last night that she's gotten more tough. She's still sweet and everything, but the job has put her into a power position, which is weird. She does have to fill up the page and I see her becoming more like Bob when Bob got aggressive and tough. She acts more like a man now, and she's now accepting the idea that she's beautiful.

Wednesday, July 17, 1985

Ran into Sylvia Miles and I told her that we really had to go together to the opening of Marianne Hinton's tromp l'oeil gallery show this coming Tuesday because it's called "Opening of a Loo." So then Sylvia and I can both finally say we've been to the opening of a toilet.

Monday, July 22, 1985

Went up to the *Kiss of the Spider Woman* screening (cab $5). This is the movie Jane Holzer produced with that David Weisman, the *Ciao Manhattan* person. I can't stand him so I hate to say it, but I liked the movie. And I guess people are wanting arty movies now, or something, it's the right time.

I had to get home early and dye my hair because of my public appearance at Lincoln Center for Commodore Computers the next day. Dyed my eyebrows, too. Black. I always dye it black first, and then leave some white and everything. I'm artistic, sweetheart.

Tuesday, July 23, 1985

The day started off with dread as I woke up from my dreams and thought about my live appearance and how nothing is worth all this worrying, to wake up and feel so terrified. Had to be over at Lincoln Center at 9:00, so I was up at 7:30 (cab $4). Debbie Harry got there before I did. She's a blonde again and she's lost another ten pounds. And she was wearing the outfit from Stephen Sprouse that I've never seen anybody else wear yet—the shoes glued into the leg stocking. We ran through it, and the easiest part is running through our thing for the press, that's so easy. They said we had to be back there at 5:30.

The whole day was spent being nervous and telling myself that if I could just get good at stuff like this then I could make money that way and I wouldn't have to paint.

Then when I went back there at 5:30 we went on and I thought I was going to pass out. I forced myself to think about the next job I could get if I didn't. Went along and the drawing came out terrible and I called it "a masterpiece." It was a real mess. I said I wanted to be Walt Disney and that if I'd had this machine ten years ago, I could have made it. Then afterwards people saw the portraits of Debbie and thought those were *(laughs)* the Xeroxes.

And the news is full of Rock Hudson having AIDS in Paris. And now I guess people will finally believe Rock Hudson's gay. When you'd tell them before, they wouldn't believe it.

Thursday, July 25, 1985

The doorbell rang, it was Doc Cox picking me up for the dinner at Il Cantinori with Chris and some *Interview* contest winners. And I told him that even though I haven't been to see him for a while, I've been examined by insurance company doctors so not to worry. These kids looked great

until a real model came along, and then you could see the difference and you realize that a model is a model.

Then I took everybody over to the Palladium for the sixties party there, and it was easy to get them all in because Steve Rubell was right at the door. So we went in and God I hate that place, so packed, so hot. And I never sweat. Never. But at this thing I started to a little. Every girl who said hello was an "Edie." And somehow they never get the hair right—Edie's was straight back and dyed like a boy and really white, but they usually give themselves bangs or something. Everybody gets the Edie look wrong and I don't know why. They do something different that's not the way (drinks $20).

Martin Burgoyne came over and invited me to be his date to the Madonna wedding in L.A. in August.

Saturday, July 27, 1985

I called Keith to tell him I was invited by Martin to Madonna's wedding. Keith's invited, too. We cabbed with Paige down to Wooster and Broadway ($5). It was a party for Clemente that the *Artforum* girl was giving in a big beautiful loft. Bianca was there on crutches so I was glad I'd sent her flowers. She thanked me for telling her about Eizo because he helped her leg. Rammellzee the black graffiti artist was there and he threw me by saying, "Entertain me, show me why you're great." And I froze up. He has long long eyelashes. We decided to go to Il Cantinori to dinner.

We got there and we were waiting for Jade and her boyfriend. And Jade, she really has to grow another head or she's finished—you know what I mean? She's really beautiful but she's still smaller than Bianca. And for a while she'd been the tallest girl in her class. She was saying how everybody thinks she's the luckiest girl in the world for having these two great parents, but that they just don't know how hard it is. She also said that she couldn't wait to get married and have a baby who'll scream "Grandma!" and "Grandpa!" at Bianca and Mick. I told her she should marry Steve Rubell and she said, "He wouldn't be faithful," and Steve said, "Well would *you* be faithful to *me*?" and she said, "I'd have to think about it." Which was a good answer.

Keith said he was going up to 108th Street for an acid party, so he dropped us off.

Monday, July 29, 1985

Keith called and said that Calvin told him that the Bel Air was for old ladies and that Steve Rubell was trying to get a deal at the Beverly Hills. For Madonna's wedding. I guess they want to be able to bring people home and I guess you can't at the Bel Air.

I went to see Dr. Li and she took everything out of my pockets and tested the phone numbers that I had there for black magic. She does do that stuff. She puts your hand on your chest and you see if the energy is there. You put your arm out in front of you and she tests for resistance—you're lying there like a horizontal Hitler youth. Last week she took the stuff out and it was the same stuff I always carry. Two keys, stuff from Japan that John and Kimiko Powers gave me, and some phone numbers.

Went over to Café Luxembourg (cab $4). Carl Bernstein was there and waved across the room. He was with three girls. And David Byrne the Talking Head was there but I never know how to talk to him. Martin Burgoyne was with us and he put his hair up and looks like a girl. He's twenty-one but he looks jaded. And Keith said that when Madonna was staying at Keith's, sleeping on his couch, the stories he could write about the people she had sex with. . .

Tuesday, July 30, 1985

Ran to meet Patty Raynes and the baby. This is Marvin Davis's daughter (cab $4). She was sweet. She told me Tatum was also going to get her portrait done, so that was exciting.

Fred decided he'd go to L.A. for Madonna's wedding with us.

And later on that night Keith told me that he'd asked Yoko Ono for $200,000. I was shocked. He wanted it for his store. I said, "But Keith, you've got enough money," but he said he didn't want to sell his paintings now to get money because he thinks they'll be worth more later. And he said she said all her money was tied up, that yes, she had a lot but that it wasn't at her fingertips, and I was just shocked that he would ask, I really was, but he seemed to think nothing of it.

Ran into Yoko and her boyfriend Sam Havadtoy and went back to the Dakota with them. He's Hungarian, it turns out, and he's going back to buy a big house there. And he doesn't let Yoko push him around. He eats sugar and drinks and doesn't pay attention to her, and I guess she wants to be pushed around now. And he was saying that he didn't want Sean to be an actor, that he felt he should go into something else, so he was sounding like a father. I guess he just takes care of Yoko. But that's hard. There were three cats in the apartment and Yoko said that the cats hadn't talked since John died until she put a record on. And Sam gave us a tour of the place and it's so big. I'd never seen *all* the rooms. The bedroom and everything, so I guess they do sleep together. But he's looking for an apartment of his own, too, so I don't know what that means. Sam made hot chocolate but then nobody sort of wanted it. Sean's away at camp and loves it.

Friday, August 2, 1985

The Tina Turner concert was great. I thought she was copying Mick Jagger but then somebody told me *she* taught *him* how to dance. And oh, what is Ron Delsener's problem? He never got us backstage passes and he's complaining to me about Cornelia wanting free tickets, and I felt like saying to him, "Look, you want to get into society—well, someday she might invite you to that big party, you know?"

The wife of Glenn Frey of the Eagles came over to me, and Cornelia screamed. "Get away, you groupie!"—so mean and rude. She picked all that up from hanging around with Boy George and Marilyn.

Monday, August 5, 1985

The *Enquirer* and *Star* and *People* and *Newsweek* and *Time* all had Rock Hudson on the cover. We should've had him on *Interview*'s cover. It would have been funny to have a phony baloney interview with him on all the newsstands now—"Why I'm Straight," by Rock Hudson.

Gael called and said that Kim Basinger is going to be the cover for November and I said, "Whaaat?" I mean, she's older and she's not going to be anybody and even if she is, so what, you know? I'm just so bored with movie-stars-for-yuppies.

I was at Dr. Li's and she told me to give up bananas and wheat and broccoli and hot food.

And I want to do a Madonna headline—the *Post* one: "MADONNA ON NUDE PIX—'SO WHAT?'"—and use a photograph of her from a different day that would fit right in, but Keith wants to use a photo *he* took of her and Sean Penn. Which is kind of grey. But I'll do it both ways. We're doing a painting together for her wedding present.

Walter Stait called and said that Ted Carey had passed on in East Hampton. He was having an opening on Saturday out there of all his paintings. I didn't know he lived in Jed's building on West 67th. In Stuart Pivar's building. With this Italian kid. I knew he was about to go, Walter had called me last week.

Tuesday, August 6, 1985

In the morning Benjamin picked me up and it was a pretty day. And since it was my birthday I decided to do all sugar, just an all-sugar day, not deny myself anything (cab $6).

All this Happy Birthday stuff. Bernard the drag performance artist brought me the greatest present, he's really clever. A beautiful package from Van Cleef & Arpels, and inside was a big beautiful bracelet box, just everything perfect and beautiful, and I was so excited, and inside the bracelet box was a typed card and it said, "Andy Warhol wants nothing for his birthday," because that was what I told a magazine was the best present. "Nothing." I don't know if he had to pay for the packaging or what. So I came face to face with my own philosophy and I was *(laughs)* so let down. It was great. It's worse than eating your own words, getting them back in a Van Cleef & Arpels box.

Cornelia called and was so sour. She never even sent a gift or anything and didn't mention my birthday.

Stephen Sprouse brought me a gift, one of his old paintings. Keith asked me who I wanted for the dinner. He said his birthday present was to take me down to Glenn O'Brien's softball team's game where Matt Dillon was going to be playing down on Leroy Street with the graffiti artists against them, so that was something to look forward to.

Glenn's team was playing against Futura's graffiti team with Matt Dillon. And Ronnie was on Glenn's team and then this girl was walking by with a little dog, and she stopped and said hi, and guess who it was. Gigi! She said she and Ronnie have been back together for two weeks. And I just looked at that dog and all I could think of was how Ronnie drowned the cats when he and Gigi were breaking up. And now he's broken up with Tama Janowitz who was really nice. And Marla the jewelry designer was nice, too. Gigi said that she works for the movies.

And Matt Dillon struck out with three people on base, but he was cute. And then Lidija came by, they'd told her at the office that I'd be there. Jay wasn't playing because he'd hurt his arm or leg. And Wilfredo is so crazy about Matt Dillon that he carries around a paperback called *(laughs) The Life of Matt Dillon*. I'm not kidding, it's a real book.

Wednesday, August 7, 1985

Somebody told me that Jon Gould has gotten a rich South African to finance movies and has a deal where Paramount will match the money the South African invests.

I had a dinner date with Fred last night, and Bob Denison and his new wife, so I couldn't go with Karen Lerner and Steve Aronson to see John-John Kennedy in his play at the Irish Theater—it's invitations only, you have to be invited by someone in the cast. John-John turned us down for the *Interview* cover. I guess he would have to give away too much talk to be on our cover, but with *People* he'll just get a big story and not have to say a thing.

Bob Denison married the kind of girl that his kind of person should marry—upturned nose, blonde, sort of the Joan Lunden-type, a little past thirty, she was in a Valentino dress and she had a good sapphire ring on. She does the morning *Today Show*, the segments on beauty and fashion. I don't know her name. And I was complaining so much about money that Bob gave me a dollar and I had the wife sign it so I could find out her name, but then I couldn't read her name and Bob never called her anything. And Fred's still talking with a British accent. He *is* smart, though, that's the good thing. He knows how to bring up topics, which I don't know how to do. And we talked about the chic-est perfume and the chic-est man and the chic-est show and the chic-est car.

On the way home from Le Cirque this well-dressed guy with a briefcase stopped Fred and me and said his wallet had just been stolen and everything and Fred believed him and gave him money. I didn't though, because a real person wouldn't ask, they'd do something else, go someplace else. But Fred gave him money and he went toward the subway. But then Fred realized he'd left his umbrella so we went back, and there was the guy doing the same thing to somebody else. And Fred screamed at him that he was a crook.

Thursday, August 8, 1985

Tama Janowitz came by the office to see Paige. Tama's upset because Ronnie's gone back with Gigi and I kept slipping and bringing up Ronnie without meaning to. She seemed like she was holding up well but then later she broke down and said she was still so in love, that she didn't know what to do, and I told her that she was so talented and pretty, and that she had everything and I didn't know why Ronnie would leave her to go back to a really awful person like Gigi, and she said she was thrilled to hear me say that. I told her she had to get over her romance and just use it for material to write about.

Monday, August 12, 1985

Cornelia looked great last night at the party for the movie *Key Exchange*. It was at Harry Winston's jewelry store on 55th Street and Fifth because his son Ronnie Winston helped produce it I think. Cornelia was in a golden yellow dress and she was wearing her long blonde braid. A few weeks ago she saw somebody with it, and she's good that way, she finds out right away where they got it and goes the next day and gets it. And the dress was $40 from Bloomingdale's and on her it looked like it cost thousands. Floppy on top and a miniskirt. She was the best-looking girl there. She's got to lose her champagne double chin, though, that's the only thing. And they were making her feel bad about not being in Hollywood.

 And she was in a sweet mood last night, not being a brat. She was saying that her mother never helps her—that she competes with her and she won't get her on the cover of *Town and Country*—and I told her that she could get herself on the cover but she should wait until she's selling something or it'll be a waste. And I told her not to be hard on her mother, I explained to her, "You know, when you're old and you don't *feel* old, you want to be in with the new generation and be part of it. . . ." And she said that she really misses her father because he was the only one who cared about her. So I think she's going to go out to Hollywood for a month and try to get parts.

Tuesday, August 13, 1985

Dolly Fox came by the office and I wanted her to meet Cornelia. And they got along great, they were talking about the people they've introduced that then fall in love and why can't it happen to them and Dolly came up with that it was because they were rich. Because Dolly had to talk Julianne into going to see Bruce Springsteen and then they went backstage and Bruce and Julianne's eyes met and that was it. I asked Dolly if she'd fucked Bruce before she introduced him and Julianne, and she said no, but that she'd been just about to. And I asked if Julianne had done it with Bruce on the first night and she said no, not on the first night. And Dolly also introduced her friend Dana to Eric Roberts and he immediately left Sandy Dennis and now they're going to get married. Dolly looked beautiful—her eyebrows are so perfect and so is her eye makeup.

Wednesday, August 14, 1985

Keith came by yesterday and he wanted to use my tracer, so I guess he knows I had one, so *(laughs)* I had to admit it. He had a baseball player with him. And my date for the Madonna wedding, Martin Burgoyne, is being wined and dined by *People* magazine because they're trying to get information about the wedding out of him—he and Madonna used to be roommates. Nobody knows where the wedding's going to be, yet. And Martin is going to have to be at the door to let all the right people in, like the important ones Sean and Madonna are running into and inviting at the last minute.

And I picked up the phone yesterday and it was Dolly Parton and she was cute, she said, "Hey, Andy! You know who this is?" And I said, "Oh God, with that voice ..." And what she wants to give her agent Sandy Gallin is a portrait of her and she asked how much it was, and I just was too embarrassed, I said she'd really have to talk to Fred or Vincent for that. She said she was leaving for L.A. Friday afternoon so we made a date to take the picture at 11:00 on Friday morning, so I hope it works out.

They should be getting the Stallone issue in today. Everybody was talking about the Stallone interview—they said he sounds smart. Is that possible?

Thursday, August 15, 1985—New York—Los Angeles

We were on the ground for twelve hours. We couldn't get the go-ahead because of storms in the areas we'd be flying through. And then Diane Keaton had a fight with the stewardess, she wanted to get off the plane and they wouldn't let her because they were finally second in line, and the captain by the end almost was crying and saying it was his worst experience, and that he wasn't going to turn it around at this point to let them off. And Steve Rubell had a big fight with the stewardess. Not while we were on the ground because he didn't want to get thrown off, but as soon as we were in the air, he started, "You bitch, give me your name." It was Pan Am.

Finally we got to L.A. at about 1:30 and went to the Beverly Hills Hotel.

Friday, August 16, 1985—Los Angeles

It was just the most exciting weekend of my life. Martin went down to the hairdresser earlier in the day to have his hair done. We rode in a limo out to Malibu and when we saw helicopters in the distance we knew we were at the wedding. Somebody had tipped the reporters off about where the wedding was and about ten helicopters were hovering, it was like *Apocalypse Now*. And one helicopter had a girl hanging off with a camera and they were all trying to get in close. And the security people found camouflage-outfitted photographers in the bushes. And I looked really close at Madonna and she *is* beautiful. And she and Sean are just so in love. She wore white, and a black bowler hat, I don't know what that was supposed to mean. And someone said that Sean had shot at the helicopters the night before. The only boring celebrity there was Diane Keaton, really. And it was the right mixture of nobodies and celebrities. Sean came over to say hello, and the good-looking family of Madonna was there, all the brothers. And you can see Madonna and Sean love each other so much. Really, it was the most exciting thing ever.

And at the wedding Steve Rubell was really out of it on I guess Quaaludes. And I think I saw Madonna kick him away from her and later he threw up in the car. She was dancing with the only little boy there. And you could see everybody who was there, it was under a tent, it wasn't too crowded. And those young actors seemed like they were in their fathers' suits, like Emilio Estevez and Tom Cruise. All those movie-star boys with the strong legs who're 5'10" or so. I guess that's the new Hollywood look. Like the actors in Matthew Rolston's big photo spread in the Stallone issue. Have I said how great that looked? Matthew is our best photographer now—he

uses good locations and gives the kids "a look." He made these new kids look stunning—like *stars*—he gave them all class. Oh, and as we were leaving I just couldn't believe my eyes because Tom Cruise jumped into our car to get away from photographers. His car was down the road. I took a picture of him.

Fred and I thought Marisa's wedding was more glamorous, but this one was spectacular because of the helicopters.

Saturday, August 17, 1985—Los Angeles

I just hated the Beverly Hills Hotel. There were two TVs but no clickers. And the bathroom was worse than a 1950s Holiday Inn. I don't know how a girl could manage in it—I wasn't doing too well myself. There was no light. But they had a new gadget in there, I think it might have been a hairdryer. Or maybe it was just a phone. And the security at the Beverly Hills looks like it—at the Bel Air they just blend in.

Steve Rubell decided not to go over with us to see Dolly Parton. He stayed in bed and made phone calls. You know, it's odd to watch Steve, because it's like he's trying so hard to be "a character." Like the way he eats his ketchup and his Coca-Cola and he repeats over and over that these are the things he likes and that this is the way he likes them. So that people will remember him as "a character." It's like he might have read a book on how to be remembered and make an impression and he's doing everything it said. He'll order the food and then let it sit there. And we all ordered ice and he made this big thing about waiting till the bottom melted and then sucking it out, saying that's what he liked to do because when his father used to buy him ices when he was little, that's what he did.

Got a cab over to see Dolly Parton at Sandy Gallin's. Dolly doesn't want anyone to know where she lives because she's had death threats. So we were there and I guess Dolly was appalled that we brought as many people, but Keith and everybody had wanted to have a totally star-filled day. Sandy Gallin had the spots measured where he wanted the portraits to go on the walls and everything. And then we walked back to the hotel.

Called Cher's number and it was a recording that said that anyone calling this private number was automatically invited to the barbecue going on there.

So we went over to Cher's and the door opened and they let us in, but we could see that Cher and her boyfriend were shocked to see us. And Cher served good pork and beans and she wouldn't say what the secret was, and finally she admitted it was that she opened a can of Campbell's and poured in a lot of hot sauce. The little Allman boy, Elijah, was being a brat and going around cutting the buds off every flower, any one that was just about to open. And Cher was funny, she told a story about this crane that came and stayed two days and ate all the fish. And then later on we went to Lisa Love's and she said, "Gee, a crane just landed in my yard and he's eating all the fish." So the crane gets around. And she told us that at the wedding Madonna had asked her how to cut the cake. Cher said, "As if I know." And then Madonna was asking people if she should put the cake on plates, and she was just handing it to everyone in her hand. You know, being "earthy."

And there was a copy of the *Star* there that had this story about Cher in it. And somehow

everybody wound up reading it. And Cher was upset because it said she never bathed. And it said, "Next week: Cher's meeting with Jackie Kennedy." And nobody wanted to ask if she'd ever had one or not. And Cher talked about meeting me in an airport in someplace like Atlanta in '65. On one of our first tours. She was with Sonny.

David Horii, that new *Interview* illustrator, came to dinner with us at Mr. Chow's, and I was telling Fred that David was very good, and Fred was in one of those moods, he said, "I'd have to see his work. I haven't seen his portfolio." And I said, "Well Fred, *I* am *telling* you, this person is very good" (dinner $530).

And then we went to Brad Branson's. He was Paul Jasmin's assistant and now he's a photographer, too. It turned out they had the best time there because they took Keith and everybody to a porno store where they got a spray called "Fart" and they sprayed it in the car and everybody had to jump out (hotel tips $50).

Sunday, August 18, 1985—Los Angeles—New York

We got back to New York and I had the limo (my share $50) drop me on my corner and as I walked down 66th Street to my house some girl yelled, "Andy!" And when I didn't turn around she screamed, "Your mother's a whore." That's a strange thing for a girl to yell. It brought back bad memories of Valerie Solanis and getting shot.

Thursday, August 22, 1985

Talked to Sandy Gallin about the Dolly Parton thing. Fred asked him to send a deposit and he said he would.

Monday, August 26, 1985

Looked at the TV kiss of Linda Evans and Rock Hudson in the *Enquirer*.
It was so muggy out.
I tried to read *Final Cut* but it was like reading *The Wall Street Journal*.

Tuesday, August 27, 1985

Stayed at work till 7:15.
Susan Blond called and said she had tickets for Boy George that night in Asbury Park and she said I could have two and Keith could have two. It was a benefit for B'nai Brith. Ron Delsener did it, and he was there and wanting me for publicity, and I said, "Oh what about that night at Tina Turner where you just couldn't get us backstage?" And he said, "Uh-uh-uh, oh it was impossible." I didn't tell him off but I wanted to. So we went out there with Susan and we were

late, we missed his first number. We went backstage. And then we went back out and the kids were screaming, "An-*dee*, An-*dee!*" To be funny. George did three encores. And he signed a million autographs now that he's come down in the world—he always refused to before. He was thrilled to see us. Marilyn wasn't around and we were told by Susan not to mention him in front of George's boyfriend because I guess he's jealous of him.

And Keith and everybody were making fun of Asbury Park, of George being there, and it was, "Oh! The Asbury Park news is here." And "Oh, the Asbury Park TV station is doing an interview!" And George said to Keith, "Where's my painting?" Because when it was Keith's birthday George had he said he'd sing "Happy Birthday" if Keith would give him a painting. And Keith said he would give him a painting but because he wanted to, not because George sang "Happy Birthday."

Wednesday, August 28, 1985

Miami Vice called and offered me $325 to be in an episode. And Fred just sort of laughed and said when they raise more money to call back. Anyway they sent the script over and I couldn't figure out which part would be mine. They said I was a "Puerto Rican crook," but *everybody* on *Miami Vice* is a Puerto Rican crook.

Gael looks really great now, thin. She came in, and Chris predicted it was going to be about a birthday present, and *(laughs)* it was.

Asked Wilfredo to the dinner that Paige was giving at Texarkana for advertisers (cab $5). This is part of Paige's new strategy because she got so sick of all the under-people stalling for so long about ads that she decided to only invite the presidents of the companies out, and it turns out a lot of times they don't have anything to do, they're bored, and they're just dying to go out.

Dropped Wilfredo (cab $10). And then I got home and watched some *Letterman*, and he had on Eddie Murphy who was cool and casual, and then Dick Cavett came on and he was really funny. He's gotten more gay-looking and -acting, and Letterman was nervous because Cavett was so funny, he just sort of faded out of the picture. Dick was really working his ass off, using funny intellectual words and making puns.

Sunday, September 1, 1985

We got to the Meadowlands for the Springsteen concert and it was so exciting, a sea of people. We had tickets for the press room, but we stayed out on the floor. Dolly Fox and Keith couldn't believe how many autographs I had to sign for the Jersey kids.

The concert was long, from 7:00 to 11:30. The Boss talks dumb and he's a Democrat but he doesn't exactly say so—he just talks about getting jobs back for the steel mills and things. He's a real little fireball. And the choreography, well, if this is choreography, then I can do choreography. And by the way, slam dancing, I think I could really be good at. I really do think so. Bruce's laugh is the cute thing, he giggles. And he's gotten good-looking. He wasn't good-looking when he was younger. And then we came back to the city and went to P.J. Clarke's. Got home about 2:00 (dinner $110).

Tuesday, September 3, 1985

Benjamin arrived and we ran into Crazy Matty and I said why didn't he go bother Greta Garbo over on East 52nd Street, so he took down the address. And I can just see it in the papers now after he kills Greta Garbo: "Andy Warhol gave me the address."

Oh, you know, I was talking to somebody yesterday, and I found out that Bruce Springsteen really does give a lot of his money away, so I do like him now. Maybe we can get him for a cover when he's wanting to publicize Farm Aid.

Saw *American Flyer*. I was looking at this girl in the movie with this hooked nose and I realized it was Jennifer Grey. I mean, it's really sad, her father got himself a new nose and didn't send her for one. Isn't that mean? Oh, but go to the movie for the nose—you *have* to see it. And for Kevin Costner, he'll have a big career. The movie's really good.

Wednesday, September 4, 1985

I can't tell which nights Fred's been drinking and which nights he hasn't. I don't know if he's grand when he drinks or grand when he doesn't. It's like he thinks he's Condé Nast or something. And I said that the Stallone issue of *Interview* was great, but that I can't see it paying for itself. And he said yes, yes, that he knew very well how much it cost, that he knew ev-er-y-thing. And I said, "Oh, well, okay if you know everything, you know everything. But I remember that time when we had a big debt nobody knew about, but if you know everything, that's great."

Went to Keith's party in his new loft (cab $3). And Keith had a good group, too, a lot of girls. Martin Burgoyne was there and he told me that Madonna was upset because we let *People* photograph the paintings Keith and I gave her for a wedding present. They'd called me and I said no but then I told them that if they wanted to try Keith they should just call him. So Martin said Madonna hates us for that and I told Martin he should've made her *not* hate us.

Thursday, September 5, 1985

Jean Michel had called and said he wanted to go with us to see Susan Blond's act, Luther Vandross, at Radio City Music Hall (cab $3). And a black girl said she'd show us to our seats, and she took us down an aisle and had me sign something and then left us standing there and then I realized she had just wanted an autograph, that she wasn't even an usher. That was funny. But I mean, she could've taken us down the *right* aisle, anyway. So we found our seats and Eddie Murphy they said was somewhere but I didn't see him.

So Luther sang and his songs were all long long stories. But very good, the audience loved him. Then we cabbed to Area ($7).

And Lester Persky was there, drunk, kissing everybody, saying how I'd picked him out of the gutter and made him somebody and *(laughs)* I guess I've told him that so often that he's started to believe it. And he wanted to meet Boy George, so he had me introduce him, and then when

I left them alone I guess Boy George lost interest because Lester came over and wanted to be reintroduced.

And Lester's friend Tommy Dean was there who I just can't stand. I remember when he told Lester not to give us the money to make *Bad*. And he did it so smugly. Oh, I remember that. So smug.

Benjamin walked me to a cab and I went uptown ($8).

Friday, September 6, 1985

Jean Michel came in and our show is on Saturday. But really, the shows that get noticed are in October and November, so it's still kind of early, but it'll be okay, just a little thing. And in his stupor Jean Michel knocked paint onto the Dolly Parton portrait and messed it up. And Sandy Gallin keeps calling, saying he wants it right away, and I wish they wouldn't rush me because I want to make it really good and it's not ready.

Saturday, September 7, 1985

I was going to go to Dr. Karen Burke's for collagen but it was too hot out and I didn't want the pain.

Wilfredo came by the office and helped me. It seems like *Interview*'s doing Madonna for the Christmas cover. She'll be interviewed by Sean Penn and another person. I got my pictures of the wedding back from Chris's ex-assistant Terry who's making prints for me now, and Madonna really knows how to do her makeup in that great Hollywood way. Somebody must have showed her or always does it for her—everything painted just perfectly. Sean's going to be the new Dustin Hoffman. He'll be around a long time.

Then decided to go to the Pyramid club to see Ann Magnuson. She does "Edie and Andy" and "Gala and Dali" and "Prince and Fallopia." Like Apollonia, get it? The intellectual girl of downtown. She wasn't funny, but she's a good actress and she's a hard worker—there's something there.

Monday, September 9, 1985

Today on *Donahue* they have Betty Rollins killing her mother. She and her husband told the mother what pills she could use to kill herself in what combination and how many, and they sat in a room with her while she did and now Betty Rollins has written a book.

Had calls about the Dolly Parton portrait—"Is the beauty mark in or out?" I'd taken it out and they want it in, so I called Rupert and told him it was in again.

Then went with Paige over to La Colonna because Estée Lauder has a new perfume called "Beautiful." Isn't that great? Someone was telling me that today people want to wear a smell that you know right away what it is. Like Giorgio. It's a status thing. Isn't that interesting? I was next to the editor of *Elle*, and I'd bought a copy the other day and it's good.

Went home and called PH to tell her about my "Beautiful" day because we want to do a perfume line together, and we had great ideas for names and packaging for three different smells.

Tuesday, September 10, 1985

Chris sold a picture of me to *In Touch* magazine which has an interview inside. He'd sell you to a gutter. I'm going to have to remember when I sign releases for him to specify that it's only for the one occasion.

Sandro Chia came by to visit, he was really sweet. And the news was that Carl Andre the artist may have pushed his wife out the window in the apartment in the high rise in the Village where they lived. The big headline said that he was suspected, but then the article was all about how she'd probably fallen. And Sandro said, "Good, good, they should kill all women." He's getting divorced from his wife.

Wednesday, September 11, 1985

Some of the Dolly Parton portraits came out light and some were dark. And then they kept calling me from L.A. about were they ready were they ready, and they wore me down so I finally just said yes, they're ready. But I could've done better.

Thursday, September 12, 1985

Pete Rose is on *Donahue*. I wish I could do another portrait of him. Now in looking at him, he's really good-looking, a good nose and good hair—I could do a really good one of just his head.

Jean Michel called and I'm just holding my breath for the big fight he'll pick with me right before the show of our collaboration paintings at the Shafrazi Gallery. The opening's on Saturday.

Oh, and I'd given a $1,200 bid to the girl at the auction place for a bracelet, and so after the auction she called to say that it went for $850 but that she just didn't get my bid in on time. And I said, "Oh, isn't that great." I mean, I can live without it, because I can live without anything, but it was nice. And I keep going to that lady who has the earrings that match the ring I gave PH, and instead of coming down on the price, she's going *up* all the time. It's one of these desperate people that they get something in their head. She's stubborn. I should try to get her on a day when she has to pay her bills.

I called Stephen Sprouse to have dinner at Il Cantinori (cab $6). And then Paloma came in with Fran Lebowitz and with her husband. And I said to them, "Why don't you join us?" And Fran piped up with, "No! We're waiting for someone." And they weren't. No one ever showed up. So I think Fran is just horrible because they could have made the dinner *fun*—I haven't talked to Paloma in a long while.

Friday, September 13, 1985

Jean Michel called and said he was invited to the MTV awards thing. Keith called, same thing. MTV must want artists to do their logos for them. And Keith was upset because his tickets were up on the mezzanine. Jean Michel arrived in a limo. He said he didn't want to go with Keith because Keith was too pushy. And it did get sick later on—Keith just wanted to be photographed *so* badly. And he wanted to go with me so he'd be sure to be photographed.

So we got to Radio City and it was just the biggest mob there, but the TV cameras had already left so Keith was really upset.

My date last year was Maura Moynihan. She's in India for eight months now. She's got an Indian boyfriend and Sam Green said she's wearing saris and bending low—it sounds awful.

Eddie Murphy's act was cute, he said "piss" and "shit" a lot and he went to the ladies' room and picked up a girl, and then went outside and got a guest host. You know, the Letterman man-in-the-street thing, the old Steve Allen thing. But it was boring. It wasn't young enough.

Then it was over and we were starved. We went down to the Odeon. But Keith wanted to go right to the Palladium because he didn't want to miss the stars, he wanted to see Cher again. So we got to the Odeon and he was immediately wanting to leave. He said he wasn't hungry, he said, "I've already eaten," but we knew he hadn't, because we'd all been together not eating for *hours*. I mean, I like Keith, but it was so sick. Dinner was cheap, I guess because nobody drank ($135).

Then we went in the limo to the Palladium. Stayed an hour or two. The only person I saw was David Lee Roth.

Saturday, September 14, 1985

One of those abstract days you just want to block out. Worked until 7:00. Called Jean Michel and said I'd pick him up and did.

Went over to the Tony Shafrazi Gallery (cab $5) and it was wall to wall. They had a Danceteria doorman. They walked you in and walked you out. Gerard Malanga asked me for my autograph. Taylor Mead was there. René Ricard. The paintings looked really great, everyone seemed to like them. Iman was on the scene, she's broken up with her husband. Tony had people downstairs for champagne, but it was the same old people and the same old talk. My dates were two stores— Lee from Matsuda and Philip from Fiorucci plus Benjamin. Talked to Madelaine Netter who was in running clothes. Fred had Sabrina Guinness bring David Lee Roth.

I was wearing the Stefano jacket with Jean Michel's picture painted on the back, but I've decided I can't wear odd things, I look like a weirdo. I'm going to stay in basic black.

Monday, September 16, 1985

Fred's going off to L.A. because the building on Doheny fell through, they couldn't get the zoning changed. And the new issue of *Interview* came out with the Schwarzenegger cover which I love, it has the comic-book look. And the whole issue I like. It looks the way *Vanity Fair* should look. Just the right amount of odd things.

Laura Ashley died, after falling down her daughter's stone steps. But she never advertised. I was just thinking about these English people who just take take take and never do anything for you. We never got a thing from Fred's best friend, Lord Jermyn. But you know, those Mick Jagger prints that the Heskeths were going to dump on the market? It worked out well—we bought them back and now they're the most popular after the Marilyns so that was a good thing.

Paige had people for lunch and I was looking at their jewelry and thinking it was costume, and they were telling me how much it was, and I was saying *(laughs)*, "Gee, that's like what the *real* stuff costs." And actually it *was* real.

And Gael took the Jewish holiday off although she's told me she's Catholic and then once she said Episcopalian.

Tuesday, September 17, 1985

Benjamin and I went to Sotheby's to see the big Indian show. Millions of things. I missed Kenny Lane's lunch for Jackie O., some maharani's in town and Jackie did the India book. It was a busy day.

Worked till 7:30, was late.

Went down to Pier 17 for a party where all the rock and roll kids were going to be (cab $7). This new, huge restaurant on the water, a whole block long. The party was just sort of ending. Jellybean was leaving. Matt Dillon was drunk with his friends, and he showed off for them, "Hiii, Andy," and was shaking my hand and gave me a big manful feel around the shoulder. And then he sort of gave me a kiss.

Wednesday, September 18, 1985

Benjamin and I walked out and there was my bodyguard, Matty. I handed him a dollar and told him to beat it, but he didn't, he stayed with me. And he's skinnier and dirtier and he had a sore leg and was limping, so that was sad—he's been walking the streets too much. And then I went to Dr. Bernsohn's.

I was in there a long time finding out about the ghost they were throwing out. Judy the secretary wouldn't come in for three days and then she did and caught Dr. Bernsohn crying because the force was so strong. And they said he shouldn't have called the ghost because he's Jewish, that Judy should have done it because she's Catholic and more easygoing, and it's different than if

they were telling you some phony stuff. I mean, why would they make this kind of stuff up? It *must* be real. So I left there. And Matty was still waiting.

I told Matty he should go to museums and auctions and be learning things. He should get a job at one of these places and stop being on the outside and he had a long answer for that—something about being in a plane and zeroing in on Madison Avenue and killing the Jews. He was talking about that a lot. The thing is, we have the same life. We go to all the same places. He kept saying how attractive I am. But all I'm attracting is *him* (magazines and newspapers $4).

And the Campbell Soup Company hated the painting they commissioned. It turns out they wanted exactly what they'd said—a painting of their new *box*. I'd tried to do something clever and make it more, but they hated it and now I have to do it over again.

And the horrible news of the day was that finally after not hearing from Sandy Gallin about the Dolly Parton portraits, I called, and the secretary got on and said, "Ohhh, Sandy's soooo embarrassed," and saying that it just doesn't look like my art. Sandy just doesn't like the pictures, she said. And after fifteen minutes, she popped the question of could he get his $10,000 back. And I said, "Well, sure, you know but doesn't he want me to do it *again*?" She said they'd thought it would be more colorful, more Pop. But I mean, I should have known, because it all started out so strange, with Dolly calling and saying that *she* was the one who wanted to buy it—as a gift for Sandy—and then that was just so they could get a better price, I guess, because when I said, "Well, I'd like to give *you* one, Dolly, for being so nice to Sandy to give these to him," they called back and said, "Well, since you were going to give a *free* one, why not just knock down the price instead?" You know? Hollywood. Well, I've learned things. Next time I'm going to make them work for it, like come in and see if they like the pictures and everything every single step of the way—make them work hard. Oh, and then they even said that I could try to sell it. They said they'd give "permission." So that was horrible.

Thursday, September 19, 1985

It was a busy day at the office. Fred was meeting with Bruno. Rupert had an idea to stretch canvas over a box for the Campbell's thing. Left early, saw the dog doctor (cab $6).

And I missed Paige's opening for her Mexican artist. This is the second try and poor Paige, just as it was happening they get word about the Mexican earthquake which was really bad—maybe a 7.8. This kid has no luck, this artist.

Jean Michel picked me up in a limo and we went to Rockefeller Center to a party that this Steven Greenberg guy was giving in his office which is two floors above the Rainbow Room. Two terraces, and the art was worth around $10 million. This Greenberg—he has a white pageboy hairdo—is the one who got me the live demonstration job with the Commodore computer at Lincoln Center. The Debbie Harry thing. He's an investor, I guess. Someone said he gives business advice to companies and takes stock as payment. He also got Clive Davis to use us. And there were so many young kids, just great. Beautiful makeup, androgynous boys, just beautiful. Downtown kids. And I was just thinking if only the Rainbow Room could get revitalized, it would be so great.

On the way to Area we decided to go to Odeon. When we were at Odeon I asked for the

paper, and there in Friday's *Times* I saw a big headline: "Basquiat and Warhol in Pas de Deux." And I just read one line—that Jean Michel was my "mascot." Oh God.

Friday, September 20, 1985

I had my opening at Leo Castelli's to go to, of the Reigning Queens portfolio that I just hate George Mulder for showing here in America. They were supposed to be only for Europe—nobody here cares about royalty and it'll just be another bad review. And I told Jean Michel not to come to this. I asked him if he was mad at me for that review where he got called my mascot, and he said no.

Sunday, September 22, 1985

Went to church. I always go for five minutes. Ten or five minutes. It's so empty, but sometimes there's a wedding. Then cabbed down to Sixth Avenue and 26th Street to the flea market (cab $6). It was such a pretty day. You can still get Fiestaware cheap. It never went anywhere, I guess.

Monday, September 23, 1985

Benjamin passed out *Interviews* while I saw Dr. Li. She told me she'd talked to Jon Gould and that he said he had a $100 million production deal—that that South African crystal guy is giving him $50 million and that Paramount will match it.

Got a note from Sandy Gallin saying, "Thanks for being so patient." And I have no idea what that means.

And Fred doesn't want me spoiling his new secretary from Newport, Sam Bolton, by taking him places, but he's a good kid to go around to movies with.

Tuesday, September 24, 1985

The Campbell's soup people loved the painting—the pink one of the soup box.

I had a message to call Sandy Gallin's secretary at home, so I did, and she was so bright and asking me if I got the flowers—they were the smallest orchids ever—and being so up and everything and I just wanted to say, "Oh cut it out and give me the real story." But I know she was just doing her job and didn't really want to do it and she kept bubbling and gave her fake speech and asked for his money back. I said well sure I'd send it to him.

Fred enjoys confronting people sometimes so maybe he should do this, and then I can still stay a nice guy. I mean, what was all that about, having me rush rush rush the job and everything? And so after that I had some chocolate and watched TV and fell asleep.

Friday, September 27, 1985

Watched Hurricane Gloria all morning on TV because there was nothing else to watch. For some reason they decided to cancel the *Today Show* and everything to bring constant storm updates and they made it sound so horrible. But then it never really hit New York.

Sunday, September 29, 1985

The sun was really hot, I may have gotten sunburn. Went to 86th and Third, to Doyle's for the joint auction of Louis Armstrong's stuff and James Beard's. It was weird, the two different lives put together and every little whisk and pot and piece of sheet music was for sale, with people hovering over them. I'm surprised they don't do it right there in the apartments. Bought two catalogues ($20).

Monday, September 30, 1985

Nobody cared about me yesterday. I was in the same spots looking the same way, but where I was mobbed before, nobody cared. It's funny, what makes some days different (newspapers $2, phone $1)?

Thursday, October 3, 1985

Ohhh, why do we have to get old? *The Enquirer* article that Frank Sinatra is suing over said that when he gets up in the morning he's so worried about aging that he asks his wife Barbara, "How do I look *today*?" Oh, Frankie. I remember when I walked all the way into Pittsburgh to see him to see what all the girls were swooning about, and there weren't any girls there swooning. I went in and met this other kid to go see him sing with Tommy Dorsey. It was one of my first things that I did alone, going into town and seeing him.

Went to the Whitney. I was there to "advertise" my Campbell's Soup Box painting. And for all the work and publicity, I should've charged them like $250,000—I mean, they're a huge company—instead of just the cost of a portrait. We must be getting desperate. Me standing there twenty years later and still with a Campbell's soup thing, it felt like a *New Yorker* cartoon. And Rita Moreno was there, I guess she's a spokesman for Campbell's and they were treating me more important than her, saying they only wanted to photograph *me*, and she said, "But he asked me to be in the picture," and they said, "We only want *him*." Because it's just that it's a different category. It's like when I've done the portrait of a big baseball player, they photograph *him* and I'm shoved aside.

And I was so hurt—I saw Dolly Parton's picture in the paper, she's in town, she and Sandy Gallin went to a Broadway show, and they didn't even call me. I haven't gotten the real story of the portrait yet. I'll get it out of Steve Rubell sometime when he's drunk.

All the headlines were that Rock Hudson died.

Keith called to tell me that Grace Jones would be performing at the Garage at 4:00 in the morning. So how can I do that? Go to bed and get up early?

Monday, October 7, 1985

The woman in the stationery store said, "So you're a TV star." She must have read something that said I was going to be on *The Love Boat* this Saturday. Bought newspapers ($2). They had stories about Rock Hudson that said there were two baseball stars in his life and *(laughs)* forty truck drivers.

Tuesday, October 8, 1985

Paige and I decided that we would start having "blind-date dinners" because that's a good way to meet new people and entertain advertisers at the same time. Tama Janowitz's date will be Dr. Bernsohn, I think she could get material from him, and I'm lining up a Ford model for Paige.

Steve Rubell called about the Dolly Parton/Sandy Gallin thing. He said that it was really *Geffen* who was getting the painting. He said that Dolly never saw the painting, and that she didn't understand that it was going to be over the fireplace, but I said no, that she knew *exactly* where it was for because she was standing right there when Sandy showed me.

I got a cab at 8:00 to pick Cornelia up. Went to Regine's ($4) and I just had a light jacket and all these places have such strong air conditioning, it really is frightening (doorman $5, limo $25). It was a costume party and Anthony Quinn was there and Pelé and Lee Radziwill, and it was an old crowd.

And Mariel Hemingway's husband, Steve Crisman, was very friendly, so nice, and then he started being hip with me, like saying, "Give me two," and doing the two fingers, and I said I didn't know all that hip talk, and he said oh, that he didn't really, either. He talked about the Mandrexes and going to India and that type of thing.

Cornelia wanted to go to the Zulu Lounge so we left and went up there. Gael Love was sort of embarrassed because I saw her there dancing with that guy who's big and acts butch who writes for the magazine. Somebody Bob discovered about five years ago—Chuck Pfeiffer. Someone said he's married, but he's never with a wife and he's too—*much*, you know?

Tama was with Gael and she said that her romance with Bob Guccione, Jr. hadn't worked out, that he was supposed to take her to L.A. and didn't.

Wednesday, October 9, 1985

The news was all about the boat trouble, the *Achille Lauro* seajacking in Egypt. And now probably everybody will be watching *The Love Boat* this week because of it, with my episode on it. So many people are telling me they're planning to watch it.

Gael came in and sighed and said she was trying so hard to find someone for Tama. Why is everyone so worried about Tama getting a new boyfriend? But blind date dinners *are* a fun idea. You find someone, they don't even have to be any good, you just *bring* them and somebody may actually like them, you never know.

And I killed a roach and it was a trauma. A very big trauma. I felt really terrible.

So then it was time for the blind-date dinner. I was actually doing it because I want Tama to write about me in one of her stories, I want to get into them. And it's a great new way to meet new crowds. Everybody brings a blind date for somebody else. I brought Dr. Bernsohn for Tama, and she's funny, like a Jewish mother—she dressed in Chinese clothes because we were going to Mr. Chow's and she had on crystal earrings so that the crystal doctor would look at them. But now I'm afraid she *will* write about Bernsohn and that he'll get into trouble. Because see, using crystals to heal and stuff isn't really legit. Oh and the night before when Tama was standing next to Sylvia Miles, I just thought, *give her twenty more years and she'll be Sylvia*—she'd had a few drinks and her hair was disheveled.

And Tama is desperate—she said she got a phone call that was a wrong number but she made a date with the guy anyway. The guy was trying to call his ex-girlfriend who was getting married, and then after he talked to Tama, he did get the ex-girlfriend and he told her about what had happened, and now she's coming on the date with Tama and him. This is how desperate people are (cab $5, dinner $350).

And my guy, oh God, I just hated him from the start. The one they brought for me. It was this gay kid Paige had met the other night and he was a student at Columbia.

I ran into Gerard, he works for the Parks Department now in the zoo building opposite 64th Street.

And Dr. Bernsohn was interested in Paige at the beginning, because Tama looks like his mother, that type. I've met his mother. And the guy from the wrong number that Tama's going to see is in the Egyptian delegation at the U.N., so you can imagine. They originally had a doctor for me, but he had to go on duty at the last minute. And my date went off to call his boyfriend. But it is fascinating to meet new people. Then the Ford model I got for Paige disappeared. But she was disappointed anyway, because he was an airhead, he could only talk model talk. And we ran into Holly Woodlawn who was celebrating her facelift—yes, she had one! She's telling everyone. With all her problems, she got a *facelift!* She never did get a sex change, I don't think. Paige dropped me off.

Thursday, October 10, 1985

Yesterday was the day for reading all about Yul Brynner, they made him sound so big. And then late in the day the news was that Orson Welles had died, and they were putting them up as if they were both equal. Oh, but it was such a pleasure to meet Orson Welles before he died. He was really great. I don't mean his movies, I mean *him*.

All the governments were just lying so much about the *Achille Lauro* thing yesterday. If I were the Klinghoffers I'd just go to the trial and shoot them, the four of them. I wouldn't be able to get off four shots in a courtroom, but then I'd just get one. I wouldn't care which one. *One* would

be enough. I know, I know—yesterday I was so worried about killing a cockroach. But this is different—the cockroach didn't do anything to anybody, and I didn't kill it right so it was squirming and it was so big, it'd lived to be so *big*. Oh, listen, there's going to be a war. Let's stockpile things. Silk stockings. Candy bars (cab $4.30, phone $1.50, newspapers $2).

The Coleco Cabbage Patch guy came by. And he didn't like the paintings of Cabbage Patch dolls I did, but he's paying anyway. And we were talking and he said that Peter Max was his inspiration, that he used to be an illustrator and now he's an executive. He proposed that he do an Andy Warhol line of clothing with me and that we could both make lots of money. He said that his computer had told him that I was the most famous living artist. I told him I knew a person who was ready to go with clothes, Stephen Sprouse. He'd never heard of him. And I told him about Keith Haring and the T-shirts and Keith's store, and he'd never heard of him, either.

Oh, and everybody's talking about *The Love Boat*. The ad for it in *TV Guide* only shows the Mermaid Dancers, not me. Why didn't they get me on the *cover*?

Friday, October 11, 1985

Milan the partygiver called and said he'd organized a dinner for the crown prince of Belgium at Tuileries, and that the crown prince wanted to meet Mick Jagger, and Fred happened to be talking to Mick on the phone and Mick said he'd go. Worked till 8:30 (cab $5). The crown prince didn't open his mouth, he was so boring. Dinner was awful, and everybody was all coked up. They started talking about "millions" of photographers outside and spent about two hours deciding how to get out of the place, and it was just Ron Galella! When you're not high you can't believe these people. If you didn't know they were on something and you heard the way they were talking, you'd think it was something real.

Then we went to the Palladium, a Film Festival party. A girl was trying to take me home in her limo, but I didn't go because it would be one more person to know and then I'd have to see her. Got home about 2:30 or 3:00.

Sunday, October 13, 1985

Went to Sotheby's and they had my painting of Ten Lizzes up. It was a preview of an auction coming up. They'd cut this one down a lot, I guess they stretched it to make it "look good." They'll have other paintings of mine in it—$200,000 or $300,000 pictures. The Liz is $400,000. They're all from Philippa and Heiner Friedrich, from their Dia Foundation. Ran into a lot of old ladies who said they saw me on *The Love Boat*.

And then I walked home and called that kid Stephen Bluttal from MOMA who invited me to the closing night of the Lincoln Center Film Festival (cab $3). And the movie at the Film Festival was five stories hung together by a bird with a bell on it. And it was in Italy in those beautiful empty towns they find to film in.

Monday, October 14, 1985

Tama had another date with Dr. Bernsohn and I asked Paige what happened and she said she didn't think they hit it off. There's another blind-date night next week. And they have a construction owner and a doctor for me, and I decided I don't really want to meet anybody, it's just fun doing it for *them*, being Gramps and seeing the kids have a good time.

And oh, I really missed Jean Michel so much yesterday. I called him up and either he was being distant or he was high. I told him I missed him a lot. He sees a lot of Jennifer Goode, and I guess when they break up he'll be available again.

And oh, for Paige's next blind date, I said I've got a 6'3" black instructor from Lidija's gym for her and she said that wasn't "marriage material." So I don't know. He's straight. Although he came from *(laughs)* Dmitri Fashions. But he says he's not gay and you have to *believe* people, don't you?

When I was walking home I passed all the security people that still guard the Nixon house on 65th Street. I thought he'd sold it. And there were policemen nearby, and policemen always know me, so I would have asked them who lived in this house now that they were still guarding it, but then they would write it down that I asked, so I didn't.

Tuesday, October 15, 1985

Went to Sotheby's. It's so awful, you see people pulling up the upholstery on chairs there and everything, just ripping it up, and you're allowed to, to check to see things like if it's the original American wood all through it. It's so nutty.

Then cabbed to meet Paige at the office ($5, newspapers $2, phone $1.50). And Paige and I had a big scene about these chocolates that this Neuchatel chocolate woman brought down. I mean, Paige is just absolutely a weirdo. I had a talk with Fred and he says it's not good to be so involved with people from the office, and maybe he's right, because I see one side, but then there's other sides.

So this woman brings down all this chocolate, and Paige has been telling her how much everyone there loves chocolate, and Paige *won't even have one piece!* And I'm saying, "Paige, *have* a piece," and she's shrieking and laughing hysterically and absolutely refusing, and finally *I* ate lots of pieces but nobody else would. Here this woman's an *advertiser* and it's all these secret chocolate-eaters and they *won't touch one piece!* So finally I took all the chocolate upstairs and *then* Paige came and wanted some and I refused to give it to her.

And I finally read a Xerox of Tama's story from *The New Yorker* and it was fun reading all about what life was like living with Ronnie—she calls him "Stash" in the story—and she made herself "Eleanor," and not a writer but a jewelry designer.

And none of the people that I'm with a lot now drink or anything. Wilfredo doesn't drink and Paige doesn't. And last night PH reminded me about how I used to put people down for not drinking, that I'd say, "They think they're too good to drink," and it's true, I did used to feel that way, but when you don't drink yourself, you sure see things differently.

Thursday, October 17, 1985

Called Rupert early in the morning and got his "wife" on the phone and I'm going to tell Rupert he's really got to get rid of him. I can just see the whole thing—he'll want a house and a dog and a car in a settlement. I mean, this is a real nag. But when you tell people, they don't listen to anything when they're in love. Instead they go tell the person you're talking about what you said. It's human nature. They're in love and they don't see it and they blab.

Vincent said the *Times* was going to write about our TV show, *Fifteen Minutes*. And it got a great review in the *Voice* this week.

Went over to the Forbes boat for the annual benefit for Jonas Mekas's archives. Jonas bought a new building. I saw him and he laughed and said his horoscope had said don't buy real estate and he bought it for $50,000 and now it's worth a million. I don't know why these Hollywood people don't give Jonas prints of just *everything*. He's one of the only people who still really cares. They should just give him things. I can't believe that Hollywood doesn't even have *one* film museum. It's just disgusting. You'd think they could at least do that. And Shirley Clark was there looking the same as she did fifty years ago.

And the returns came in—the Stallone issue of *Interview* was our biggest seller ever.

Saturday, October 19, 1985

I got a cab downtown ($5.50) to meet Vincent who had opened up and his mother who's in town for a visit for two weeks from California and then after she leaves his father's coming. And you can't believe how energetic she is. She says she's my age, but she looks like she could be Vincent's sister. And she does beautiful paintings, really tight, good stuff. She wants to be the new Alice Neel. I guess she saw her on some TV show.

Ran into that artist Bill Katz who raved about the show of Jean Michel and me at Tony Shafrazi's. It was coming down this weekend. Jean Michel was getting all the good press, not me. And Tony's not too happy, I guess he didn't sell many. They were expensive—$40,000 or $50,000. It was too early, I think. I'm hanging on to my Piss paintings.

Sunday, October 20, 1985

It's the fortieth anniversary of the U.N. and I think Mrs. Marcos is in town. It's getting so scary in the Philippines. Some papers say the Marcoses are buying up everything in the U.S., but that could be not true, the papers can lie. Our government must want them out, though. Like the U.S. must have wanted the Shah to fall. But let's see, did we want to lose in Vietnam? No, but after everything that's in the papers this week, I guess the Kennedys were just too busy having an affair with Marilyn to worry about Vietnam.

Monday, October 21, 1985

I called Keith and he couldn't come down, but he invited us down, he had George Condo, the artist, working there. Bruno's just signed him and it turns out this "poor artist" has a room under Nick Rhodes now at the Ritz Carlton—Bruno bought all of his paintings! Like 300 (cab $5)!

Wednesday, October 23, 1985

We're calling in Europe to try to locate the Mao that Mr. Chow wants, and it's a solid sale if we can find it, but it's one of the paintings Leo loaned out that was never sent back. My deal with Leo now is that if he sells something he gets a commission. But he's never worked to get my prices up. I don't know, I guess Roy and Jasper keep the gallery going. He could've had that show of Jean Michel's and mine, but he didn't want the paintings. Tony Shafrazi was the one who really wanted them.

Thursday, October 24, 1985

Cabbed to the Palladium for Debbie Harry's party ($6) for her song that Jellybean produced, "Feel the Spin." When Debbie arrived, she saw us in the balcony and came up there because she thought it was the place to (laughs) be, and then it was the place to be because all the photographers came after her. She looks great. Debbie actually was the first Madonna.

Friday, October 25, 1985

That receptionist Gael just hired, for the second time when I called she didn't know who I was, and she should be fired immediately (telephone $2, taxis $3, $4).

Saturday, October 26, 1985

Keith Haring was having an opening, so cabbed to the gallery (cab $4). Keith said that when they had walked into the gallery earlier he was with his mother and Joey Dietrich—I guess it must have been around noon—and two white kids threw tar and feathers at them and the only one who got hit was Joey. And we were trying to figure out what that meant—tar and feathers. When do you do that and what kind of person would do that? What was the message?

Oh, and the tabloids say that there's a big TV producer who's got AIDS and who could it be? I'm telling you, I don't want to know anybody ever in my life. It's so much better just going to dinner. There's different ways to have fun, different kinds of people to have fun with. I don't need romance.

Monday, October 28, 1985

Puttered around, went over to the West Side (cab $4). Got a free lesson on how to stand on my toes from this lady called Ann Marie who Dr. Li wants me to take lessons from on alignment, $75 a lesson. But I just can't see it. She's fifty-five trying to look thirteen. Like me. It's just paying someone to care about you. Got a cab (cab $5.50, newspapers $2, phone $2).

Went to the office. I was nervous about going down to the book signing at B. Dalton's on 8th Street and Sixth Avenue after what happened to Keith on Saturday.

And I'm having a very hard time sending that $10,000 back to Sandy Gallin. I keep losing the address.

Cabbed to B. Dalton's ($5). It wasn't a big, shoving crowd, it was orderly the whole time, a long spaghetti line that lasted for two and a half hours and we sold 150 books, and Craig Nelson from Harper & Row was acting like a star. Chris Makos came by and he was impressed with my popularity. And Christopher was looking at the *America* book and saying, "Oh God, half these pictures were taken in *Europe!*" *(laughs)* And he was so right! And it was so nice to hear him putting down Craig. I enjoyed it. And the book costs $16.95 and there was a 10 percent discount and one girl bought six copies and I had to sign long things for her like, "Dear Harry, I hope you have a good season in the Adirondacks...."

I've been forgetting to say that the new "Disco" installation at Area has me and Diana Vreeland waiting to get into Studio 54. It's funny.

Tuesday, October 29, 1985

I broke something and realized I should break something once a week to remind me how fragile life is. It was a good plastic ring from the twenties. I walked on Madison and it was cold in the shade and warm in the sun. I had on the coat that Marina gave me which I love, the Calvin Klein one with the hood, but the pockets aren't useful. They're so big but the way they're made, everything slips out. Walked all the way down to the office and the sun was so bright in people's eyes that I didn't get recognized a lot. Fred is coming back from L.A.

And Craig Nelson called a few times, I'm hating him so much that I think I'll take Christopher with me to some of the cities I have to do the book tour in just to drive Craig crazy.

I read in "Suzy" about the Kluge party that I missed in Virginia, everyone went to it. I just didn't want to break my rut, but boy I should have—it was every portrait I should ever be doing.

And Paul Morrissey's movie *Mixed Blood* is still packing them in, they say. We got the rights to *Trash* back from Cinema 5, and it's funny, we have to go someplace and physically pick them up.

And my big Mao painting is still lost somewhere in Europe, they think Nice. It's Leo's fault. And Leo is getting as bad as Huntington Hartford—they say he just says yes to any girl who asks him for anything.

Wednesday, October 30, 1985

I guess I can't put off talking about it any longer.

[NOTE: For days Andy postponed giving the Diary his account of this day. Finally, on November 2, he did.]

Okay, let's get it over with. Wednesday. The day my biggest nightmare came true.

The day started with Benjamin not picking me up (phone $2, magazines $2). I didn't go to the Matsuda fashion show. I'm just going to talk through this quickly because otherwise I can't face it.

Nobody from the office would go with me to the Rizzoli Bookstore in Soho, but Rupert's old assistant Bernard had stopped by to visit and he said he would. Rupert dropped us off. The store is long and the signing was on the second floor in the balcony.

I'd been signing *America* books for an hour or so when this girl in line handed me hers to sign and then she—did what she did. The Diary can write itself here.

[She pulled Andy's wig off and threw it over the balcony to a male who ran out of the store with it. Bernard held the female while the store called the police but Andy declined to press charges. The staff at Rizzoli asked him if he'd like to stop, but there were people with books still waiting so he said no, that he would finish. The Calvin Klein coat he was wearing had a hood, so he pulled it up over his head and kept signing.]

I don't know what held me back from pushing her over the balcony. She was so pretty and well-dressed. I guess I called her a bitch or something and asked how she could do it. But it's okay, I don't care—if a picture gets published, it does. There were so many people with cameras. Maybe it'll be the cover of *Details*, I don't know. If I would've hit the girl or something then *I* would've been wrong and there would be lawsuits and everything. It's getting violent out there again, like the sixties. I usually stand up at those things but there I was sitting down and people were above me and the setup was all wrong and I was so worn out and hating Craig Nelson and I wasn't fast enough and it just happened so fast and Bernard was really sweet. But you know, you're in this place and everybody's being so nice and you don't think anything will happen. She was really pretty, a nice-looking well-dressed girl. They had her cornered for a while and then they let her go. It was too unusual. I guess these people had gone around *telling* everybody they were going to do it, because a lot of people later said they'd heard things. It was so shocking. It hurt. Physically. And it hurt that nobody had warned me.

And I had just gotten another magic crystal which is supposed to protect me and keep things like this from happening. So I was too nerve-racked, it was like in a movie. I signed for one and a half hours more I guess, pretending that it didn't mean anything, and eventually it doesn't. You have to live with it. It was like getting shot again, it wasn't real. I was just the comedian there, pleasing the people. And it was so close to Halloween. Then Bernard dropped me and I gave him $10.

And I got home and had two English muffins with margarine which isn't so good, and garlic, and two cups of tea and carrot juice and I tried the Campbell's dry soup. It was good. And no accessories in it.

And then PH called to see what time I was leaving for Washington in the morning, but I got off the phone fast, I didn't tell her what happened because I couldn't face it.

She found out, though, I guess, because she called back an hour later and told me she was

proud of me and that I was "a great man." And *(laughs) that* sure was a first. So that's that and now I never have to talk about it again.

Thursday, October 31, 1985—
New York—Washington, D.C.—New York

Got up at 5 A.M. with my nerves still jumping from the day before. Christopher was picking me up at 7:00. I hadn't fallen asleep until 2 A.M. and I had to get up so early but somehow I pulled myself out of bed. To have to get right up is so horrible without talking to the Diary for an hour or so, just quietly getting used to it. But I did it and the driver Chris had gotten was nice (driver $40).

And we got to LaGuardia and Craig Nelson was standing out there (magazines $8) and we got the shuttle to Washington. We were picked up at the airport by a lady who had a small car. She took us to a radio show and this guy was supposed to be the neatest guy in town, and it was the most horrible interview. I was still too upset about the night before and I couldn't think of anything funny, and he wanted to know about the book and I didn't know anything and he said, "I guess you didn't write the book," and I said, "I guess I didn't." It was one of his most difficult interviews. He will remember it.

And on these trips, God, I hate Craig so much. He's there saying, "Andy and I are both interested in sex." And I'm saying, "Craig, *I'm* not interested in sex." I mean, Chris is like a piece of heaven compared to Craig. Although *(laughs)* actually they're alike. They just think food food food and what they can take home. Although Craig is fatter. And they're both pigeon-toed. But Christopher is finally paying his dues, coming with me to these things—he's not even taking pictures and getting phone numbers, he's actually working, taking care of me and organizing me.

The lady with the small car drove us to the airport and the plane was late, left at 8:50, and we ran into Susan Mulcahy. She didn't seem to have heard what had happened to me at Rizzoli, she'd been away from work at the *Post* I guess, maybe she hadn't gone in that day, so I didn't know what to do. When you're friends with the person are you supposed to tell them and are they then supposed to not write it or what? I didn't know what you do. So I didn't say anything and she was self-conscious because I'd caught her down there. I guess maybe she was seeing a person that she's having an affair with and she was all feminine and looked so pretty, like she was just through with a hard day of making out. So she wasn't thinking about me, she was worried about herself.

And so then Chris and Craig dropped me off, and I knew when I left the cab that they were going to dish me, even though they don't get along. Craig'd been telling people what had happened on Wednesday all day. And I was exhausted and I ate garlic bread and went to bed at 1:00.

Friday, November 1, 1985—New York—Detroit—New York

Got up at 5:00, just tortured. Again it was horrible having to wake up and get right up. Christopher picked me up with the same limo service. Craig got out to the airport on his own. Got to the airport around 7:00. Fred's ex-secretary—Vera, the richest girl from Portugal—was there with a group of rich Mexicans going to Acapulco.

Got the tickets and newspapers for Chris ($7). And I looked at the *Daily News* and there in Liz Smith's column was the item on what happened to me, and it was nice, she did it in a nice way. And there was a news story about the hot dog man on 33rd and Park who got attacked by a roving band of kids and his money was stolen and his cart overturned. But the next day he was back on his corner because he had to earn a living, even though he had second- and third-degree burns.

Got on the plane and went to Detroit. There was a fat girl holding up the *America* book to show she was our driver. About 200 pounds. Sweet. And Detroit is all sprawled out. It looks like L.A. And everybody working everyplace is black. We went to the top floor of this hotel, the dining room overlooking Detroit, and had lunch.

I had to go to the bathroom and there was a black guy there so friendly, it seemed like a sex thing, and I left quickly. And then Craig went to the bathroom and didn't come back for twenty-five minutes.

And then we went to the Detroit Museum and book-signed there. And the guy who gave that Detroit wedding we went to in the sixties came! And he had the advertisement for it and the old Velvet Underground cover signed by all the Velvets, except, I think, Lou. And my signature's changed so much since those days. I'd signed it with a ballpoint pen and ... the Mick Jaggers I signed with pencil and then after that I *always* signed with the felt-tips.

Then we went to Bloomington. Sold 400 books and 190 *Interviews*. Sold everything. Had to leave at 7:30 to get the 8:30 plane. I think people get in line again and become repeaters. And so on the way to the airport, after a whole day of nothing but signing, the girl who'd been driving the car all day suddenly came up with a *stack* of books that *she* wanted autographed! It was like a movie scene, really.

Got on the plane. It was a clear beautiful night when we got into New York.

Saturday, November 2, 1985

Everybody's being so *(laughs) nice* to me. Nobody mentions what happened on Wednesday.

Sunday, November 3, 1985

I decided not to go to the office, to just stay in. Stephen Sprouse called and said he'd been in L.A. and that there was a store there called "Andy Warhol's Wigs" and he wanted to know if it was mine.

Oh, how do you escape this aging factor? My mother was the age I am now, when she came

to New York. And at the time I thought she was really old. But then she didn't die until she was eighty. And she had a lot of energy.

Monday, November 4, 1985

Saw Dr. Li and didn't tell her about the horrors of the past week, and she checked me out and pulled on my fingers and said I was perfectly aligned. So after what I went through either I'm very strong or *(laughs)* *she* is. She said my crystal had been invaded. That it was low on energy and that I had to put it in the sun to recharge it. You put the "share" on with your head back. You can't be standing up. You throw your eyes back until you see yellow. . . . She's worried about the same things Bernsohn is—liver, kidneys, large intestine. . . . And instead of my brother being the invader, I think it was that girl in the bookstore. They'd said my brother was going to invade the crystal soon, and I thought well, *maybe*, because I'd said things in some interview about my nephew who left the priesthood to marry a Mexican nun and I thought maybe that had made my brother mad. But I think what invaded was the girl.

Li and Bernsohn don't overlap. Dr. Li is better. She could have gone into crystals but she went into kinesiology and she massages pressure points and she's a nutritionist.

After work I went in my silver jacket and dark glasses to the benefit for Sloan-Kettering and when I got there the P.R. guy who had been the one calling to see if I was coming took me aside and said, "There's no card for you, Mr. Warhol." *(laughs)* And this is the guy Brigid *swore* she called to RSVP.

I wound up leaving and actually it was great to leave. But if I hadn't gone in the first place I could've had a nice evening just going to the movies with the kids or something. So that was that.

And Edmund Gaultney went to a real doctor yesterday after going to a homeopathic one for a long time. He's sick, it's scary. I don't know. You know, I wouldn't be surprised if they started putting gays in concentration camps. All the fags will have to get married so they won't have to go away to camps. It'll be like for a green card.

Wednesday, November 6, 1985—New York—Boston

The prices were really low at the Philippa de Menil and Heiner Friedrich auction last night. Thomas Ammann had offered Dagny Corcoran $350,000 for the blue Liz but she thought it would go for $500,000 so she put it in the auction and it didn't sell, the highest it went was $250,000. And the Jasper Johns that should have gone for $2 million went for $700,000.

I don't know why the de Menils and Dagny didn't sell the paintings privately, why they put them at auction. Oh, and Philip Johnson bought the Stamps for $150,000. He was bidding against Thomas Ammann. That should've gone for $500,000, though.

Wednesday, November 13, 1985—New York

Benjamin picked me up and we went over to Bernsohn's. And I told him that Dr. Li had said that my crystal and my share had been infiltrated. The difference between a "crystal" and a "share" is that the share is a healing thing, and that's the round crystal that I wear around my neck. The crystal is a protective thing. Preventative. Although it didn't help me in the bookstore with that girl. Or maybe it did. I don't know. I did just keep signing. I didn't panic.

And the girl who did it called the office yesterday. She said she doesn't know why she did it. Maybe she's having a nervous breakdown about it. It'll probably become the biggest thing in her life, you know?

And then we went to 15th Street and Fifth Avenue to meet Paige at the advertising agency that does the Rose's Lime Juice ads. They do the ads with the semi-nobodies, and they say they're really doing well with them. The John Lurie ad they said did even better than the James Mathers one, and this time they wanted a girl. The semi-celebrities get $5,000 and Paige was trying to get it for Tama. I guess it's Tama who's made Paige be desperately looking for boyfriends—that attitude. And Paige is demanding to meet John Lurie—she thinks he's attractive. I guess she'll go after him as if he were an ad.

Then went back to the office. Worked there till 7:30. The Cabbage Patch Doll guy came by.

Thursday, November 14, 1985

Yoko Ono's boyfriend or husband Sam called and said Yoko was having an impromptu dinner for Bob Dylan. I invited Sam Bolton, Fred's secretary, to go with me.

Went home and watched *Entertainment Tonight* while I got ready. And they had on the thing for Dylan at the Whitney the night before which I hadn't gone to, but after seeing this program I felt like I had. They were asking all these people how Dylan had influenced them. And I didn't know that he's sold thirty million records. Sam picked me up and we went over there (cab $8).

And we had to take off our shoes and now I do, but I had a hole in my sock. And we went in and it really was heavy-duty, everyone in a circle. The food was all store-bought—cut-up chicken. And David Bowie was there and I was disappointed, his suit was too modern. Everybody had champagne but nobody really drank it. Madonna arrived and she had just seen Paul's movie *Mixed Blood* because that friend of hers is in it. Bobby. She said she was so relieved her husband Sean wasn't with her so she could really have fun. And she felt uncomfortable without her shoes because she didn't have socks—she said she'd feel more comfortable with her top off than her shoes off.

Yoko had Sean bring out a poster for everybody to sign, a donation for someplace, and he looked closely at every signature because he was confused who all the people were.

Friday, November 15, 1985

At 3:00 I went up to Fiorucci because Richard Bernstein was there signing his *Megastar* book. Divine was with him, dressed like a man (cab $4). Went back to the office. Worked till I had to meet Keith at Nippon with Grace Jones. Took Sam (cab $5).

Grace was waiting for her boyfriend Dolph who's changed his name from Hans. He's in town to promote *Rocky IV*. And Dolph has almost no accent left, and he's lost twenty-five pounds and Grace says that now his thighs don't sound like he's slushing through water when he's coming toward her. She was so funny, imitating the sound of his legs making the flesh sound. Grace pulled out a big wad of hundreds and was going to pay and then I said that I would (dinner $280).

Monday, November 18, 1985

Oh, and the other day when I was reading in bed Halston dialed my number by mistake and asked for Bianca, so when I recognized his voice I said, "Oh yes, she's right here in bed with me." So that was funny.

Cornelia called and said I should pick her up for the Marty Raynes dinner at "21." Every rich guy was at this dinner and all the right models, every ex-model who'd made it. Married a rich guy. Every guy with a million millions, chic, and in black tie with these beautiful girls. Me, I was a mess. They had caviar by the truckload. I ate everything because I was nervous. Dropped Cornelia off. And just as we were arriving at the Olympic Tower where she's living now, so was Khashoggi, and she had never met him and neither had I. She's a friend of his daughter, Nubila's. And he's a big guy. He doesn't look foreign. Really big. He was nice.

Wednesday, November 20, 1985—Dallas—New York

Up at 6:00 after signing 1,200 books the night before. Went to the airport. I was disappointed that nobody in Dallas wears cowboy hats anymore. The cowboy look is dead, I guess.

Got back to New York. And Chris is so pushy, he said he had a meeting and he's telling the driver of the limo that *I'm* paying for that *he's* in a big rush, and he tells *me* I don't mind getting dropped a couple of blocks from my house and walking, do I. And he booted Craig out, he told him, *(laughs)* "I'm sorry but you'll have to take a bus or something" (limo $100).

Chris, by the way, is fat again. He has a two-inch tire around his middle. Because he's back together with Peter so it's the homemade pumpkin pies and the apple pies.

Thursday, November 21, 1985

Picked up by Benjamin. Walked down Madison. Stopped at the nice chocolate store way in the back of the AT&T building and they gave us some free candy so I hope they make it.

Edmund Gaultney came in and he's put some weight back on and he's looking good again. He's off macrobiotic. Peter Wise is cooking food for him.

And then the Sacklers were doing this thing at the Metropolitan Club and I was figuring out who to bring, and I should have brought Dr. Li, I guess, because I wound up sitting with Dr. Linus Pauling, but I brought Paige and she had a really good time. Dr. Karen Burke would've been all

over every man and the wives would've gotten mad at her. There's nobody to go after portraits for me, though. We're still missing a Bob Colacello.

So cabbed to the Metropolitan Club ($5). And there's Paige sitting downstairs in the hallway. Those horrible doormen there wouldn't let her in because she didn't have a fur coat! And we ran into Richard Johnson who works at the *Post* and he said that Susan Mulcahy just quit. He would be a good eligible person to invite on our blind-date nights.

And Dr. Pauling took my arm, he was getting an award. Upstairs I was next to Jill Sackler, across from Martha Graham, and Jill said, "Martha's been dying to meet Linus Pauling for years and now she's next to him and doesn't know it."

I met a man who said he invented vitamin B or C.

And Dr. Pauling was telling us that the only real killer is sugar, and then Paige and I were dumbfounded later when they brought dessert and he sat there eating all these cookies. Paige dropped me off.

Sunday, November 24, 1985

Jean Michel hasn't called me in a month, so I guess it's really over. He went to Hawaii and Japan, but now he's just in L.A. so you'd think he'd call. But maybe he's getting tight, maybe he's not throwing money around the way he used to. I heard he locked the door to his bedroom when he left so Shenge can't get in, and he didn't leave him any money, either. Can you imagine being married to Jean Michel? You'd be on pins and needles your whole life.

Then Philip Johnson had gone to Dallas and David Whitney was having a dinner for Michael Heizer and me at Odeon (cab $8). David was having his first of about seven martinis and a beer. And he was talking again about "when Pops pops off." But David will probably pop off before Pops. He wears the same glasses that Philip does, now. He looks like Philip did twenty years ago when I first met him. And David did Mike Heizer's show at the Whitney, and he did my show, and next he's doing Eric Fischl's, who's the hot new top artist, I guess.

Wednesday, November 27, 1985

I ran into the model I fixed Paige up with and gee, he's so good-looking. Paige said that he was just an airhead, but here is this beautiful boy with muscles and a chest and perfect teeth and from New Jersey and you could mold him into anything, get him started reading or anything.

Thursday, November 28, 1985

Victor called and said that Halston was inviting me for Thanksgiving dinner, and that he had a possible portrait coming. And I called Paige and she picked me up and we went over to Halston's and Jane Holzer was there and Bianca was looking soulful on her crutches, I told her about Dr. Li because she's going to a homeopathic thing and they can be dangerous if it's not the right one.

And then this lady was there and she said she had a check in her bag for $999 million to give to Revlon. She said she'd been meeting with lawyers all day and we said how could you get them on Thanksgiving, and she said, "Money talks."

Halston always has the best mince pie with a circle in the center—I don't know where he gets it. Nobody ever eats it, and he's the one who likes it but he doesn't eat it, either. Then Paige walked me home and I watched TV.

Saturday, November 30, 1985

Got up and went down to the kitchen and ate the turkey that Nena and Aurora had cooked. I was going to call Dr. Karen but I couldn't face being tortured with collagen needles. I didn't even call to wish her a Happy Thanksgiving.

So I'm at the office and the phone rings and it's Geri Miller calling from the women's shelter and she goes back and forth from "You scumbag!" to being sweet. And she's screaming in the background calling some policeman "You nigger!" and I could hear him getting mad and then later she's screaming at this social worker, "You black lesbian nigger, get away from me!" And she's saying that Mario Cuomo is her father—the other day she called and said Muhammad Ali was—and then she knows everything—like she knew the cover I did of Cuomo for *Manhattan, inc.* magazine. And she's saying, "He has a birthmark there and I have a birthmark there, so he's my father!" It's like talking to Crazy Matty. And they both have all this energy. She said, "When you saw me on the street I was working in real estate for Alice Mason." That's *exactly* what she said. And I have a funny feeling she's a young senile person. After seeing these *Donahue* shows. Because she says they say it's schizophrenia, but I don't think so. A Jewish girl who came from New Jersey—in her *Trash* days she was our most sensible superstar—then in the seventies she suddenly got crazy. One day she was very down to earth, worrying about her topless dancing career, and then the next week she showed up barefoot at 860, saying that the Mafia gave her LSD because she knew too much! From working in all those topless bars they own on 45th Street, I guess.

And so she's calling from shelters and the odd thing is, she remembers all these details of things that happened to her way in the past. Like she brought up when she had sex with Eric de Rothschild in the sixties and she said that after they had sex he called up Jane Holzer to go for a walk in the park, and she said, "Why did he have to call up Jane Holzer—why didn't he take *me* for a walk?" I mean, every *detail*. Does that mean nothing's happened in her life since then?

Oh, and more sixties updates: My sixty-year-old cousin called and she was in town with her son and said they wanted to come and see the office, so they came down. And her son is the one who knew Ondine in Pittsburgh. He once took the film courses that Ondine was *(laughs)* giving there, and he told me that Ondine is now selling hot dogs at Madison Square Garden. I'm serious. You know, Ondine "rented" all those films from us and then never returned them. *Loves of Ondine, Chelsea Girls*. And there was a story about Gerard Malanga in *New York*, about him being the new archivist for the Parks Department and for some reason Vincent was upset that Gerard was saying he was thirty-eight. I took a picture of Gerard the other week, though, and he does

look great. But how old is he really? About forty-two or forty-three? And oh, God, on my Blue Cross I just scribble and make it up all the time and then I get these things that say my birthday is August 28, 1982, so if I have an accident I probably won't get *(laughs)* my money.

I'm starting to think that crystals don't work. Because look what's happened lately when they're supposed to be *protecting* me—my rug has cancer from the moths, I stepped on a beautiful old plastic ring and crushed it, and I was assaulted at the book signing. But I've got to believe in *something*, so I'll continue with the crystals. Because things could always be worse.

Sunday, December 1, 1985

It was rainy out and I sort of wanted to just sleep in. The dogs went away with Jed. I thought about the moths in my rug and I puttered around.

Went to meet Wilfredo, Bernard, and PH at the Matt Dillon play, *Boys of Winter* (cab $4). And the play, I mean, after *Apocalypse Now*, what can you do? If it'd come out eight years ago it would've been a smash hit. Everybody got killed, and it was so sad, but the ending was just too corny, because the guy would never have killed his friend like that. And it's the gayest play on Broadway. One of the reviews should say that and then maybe it would be a hit. Because it's all men caring about each other.

It was raining out and we walked toward Eighth Avenue. Got a limousine that was going by ($20). So we went to the Hard Rock and Matt was already there. He introduced me to his mother, and remember I said the last time I saw him he gave me a pat on the shoulder and a kiss? Well last night he just gave me a pat on the shoulder. Maybe because it was in front of his mother. But then I started thinking that when he saw me the last time he was probably rehearsing for this play and he wanted to see how it felt to kiss a fairy in public.

Sat with Linda Stein and she talked about trying to sell Stallone a house. He called her from his plane and said, "Linda? Sly. Just one thing before we talk at length later: If Elvis were alive today, would he live in an *apartment* or a *house*?" And I'm trying to decide if I should try to sell him my house for $5 million. She says she'll have to see it first. The house next door only went for $1.9, but who knows what she could get?

Bernard went and got lost, talking to Susan Dey at the bar. He's a would-be starfucker. Susan Dey was emotional about the play and said she was protesting war now. I don't know *which* war. Nicaragua, I guess.

We left and the rain had turned into a sparkling mist. And we passed a guy in a camouflage jacket going toward the Hard Rock and PH yelled, "Harry Dean!" because she thought it looked like Harry Dean Stanton and it was, so we talked for a minute. I always thought he was this teenager who just looked really bad because he'd taken a lot of drugs, but it turns out he's *not* a teenager—he's almost sixty, so gee, he looks *good!* Then Bernard and Wilfredo dropped me and I gave them a twenty because that's all I had.

And then at work that afternoon I'd spilled some tea on a stack of Polaroids of some portrait and then I couldn't unstick them, they were all stuck together. With all those signs I'd put up all over, like "Do Not Carry Water Into the Print Room" and *I* wound up doing it.

Tuesday, December 3, 1985—
New York—Richmond, Virginia

We had to go down because the Lewises gave a wing to the museum down in Richmond. Fred and I went out to Butler Aviation and I expected a few people on a private plane, but it was about 100 people. And it was everybody from the past I really wanted to see, right? The creepiest feeling. I said to Fred, "I want to go home." And Corice Arman said the same thing when she saw all the people. Like seeing Mr. and Mrs. Philip Pearlstein just brought me back to '49, when I first came to New York on the bus with the Pearlsteins. Durangelo who does those highway paintings was there. And Michael Graves. And Venturi appeared in Virginia, but I don't know if he'd come down on this plane. Tom Wolfe was there with his wife.

Lucas Samaras was on the plane, and he was the only one I felt like talking to. I always think these kids are rich now, but he said he still lives in the same old place. He was putting Schnabel down. And I told him he was the Schnabel of twenty years ago. You know how Schnabel won't shake somebody's hand when they put it out, and then a minute later somebody else will come along who's better and then he will? Arne Glimcher was there, he's producing a Robert Redford movie about the art world.

We went to the Lewises' house. We chit-chatted and then people had to change into black tie at the Lewises' to go over to the museum. I was just in a turtleneck and my coat, so all day it looked like I was about to leave. My Calvin Klein with the hood. But for some reason nobody thought it was unusual. They told me that at 6:00 I'd have to be on TV live, so I got nervous about it being live. But then I didn't care and I got it over with.

Julian Schnabel and his wife came, they'd missed the plane, and Alex Katz had missed his, too.

And I had to go to the bathroom because of all the vitamin C I'm taking now, and the bathroom was full of guys with cigars and I'm really going to have to get over this bathroom phobia because I just feel so . . . I mean, there was a stall but somebody was in it and I tried to wait, but . . . And they said, "Oh, you're Andy Warhol," and I'm trying to pee, and then right after you pee they want to shake your hand.

Leo Castelli was there with Toiny and she's a lost soul and he's really out of it. But the horrible thing was seeing everybody looking thirty years older. I'm so spoiled from going around with nineteen-year-olds. At least Ivan Karp has a lot of energy and he's fun. Oh, and Ivan says he's *(laughs)* collecting Barbarian jewelry now, he gets it at a store in the East 90s. The tribe—the original hordes.

Friday, December 6, 1985—New York

There was a screening of *Young Sherlock Holmes* at the Gulf + Western Building but I want to avoid that place—Jon Gould comes to town now and doesn't even call me.

Worked till 8:30, then went to Schnabel's at 20th and Park. It was so glamorous, the Christmas tree was up. Fred was there, in an art mood. Dinner was catered by Il Cantinori. The girls were absolutely all wearing the shortest shirts ever and then the Madonna stockings. Marisa Berenson was in a black miniskirt. She has the right body. Those boy asses. And Schnabel's wife, too, she had one twenty inches above her knee.

Sunday, December 8, 1985

Went to church. Paige called and she's thinking of going to a place uptown to get treatment for being a chocolate addict, some treatment they give heroin addicts. And she said she finally is completely over Jean Michel. It happened to her at the Comme des Garçons fashion show. She said he looked like a fool out there on the runway modeling the clothes and that's when she finally was over him.

Bob Colacello was having a dinner for São Schlumberger at Mortimer's at 9:00. Got there when they were just starting to eat. I was next to an Indian lady named Gita Mehta and a Brazilian Portuguese woman who's married to an Irishman.

And I was talking to Fred who'd been to the galleries and things with Twinkle Bayoud and her husband Bradley the day before and he told me I had to start getting new ideas to paint. He said Roy Lichtenstein's selling every painting, that they all have red stickers on them, and they're all $200,000 or $300,000.

Monday, December 9, 1985

Jean Michel called me early in the morning to tell me about the fight with Philip Niarchos he had at Schnabel's on Friday night. I guess he still remembers some funny comment Philip made once about how now they're "letting niggers into St. Moritz."

The two McDermott-McGough artist kids came by to visit. They're living down on the Lower East Side, and since they do everything nineteenth-century style, they haven't had a phone or a kitchen, but now they're having that stuff installed in just one room of the apartment. So they're coming around. But they were still dressed in nineteenth-century. They said they had just had meetings at Paramount with Jon Gould and this is about those stories that *I* taped them telling and had Brigid type up. Now they say *he* wants to produce that movie with them. Well, I predicted this, right? What a swell guy.

Thursday, December 12, 1985

The Boston Museum returned the Electric Chair painting because they said the shade of red was off. It was slightly different, and I told them that would make it more interesting, but they still wanted to send it back for me to think about it. If they had it next to the black panel it wouldn't matter anyway. I think they're just procrastinating. But it costs around $4,000 every time you ship it somewhere with the insurance and everything. And Fred was going to Atlanta.

Sunday, December 15, 1985

After seeing the Sam Shepard play the night before, I got up and read the transcripts of those days with Truman that I'd taped where he's going to the masseur, then to the psychiatrist, then for drinks, then for dinner, but by talking in them so much myself, I ruined them. I should've

just kept my mouth shut. I was, you know, saying everything's wonderful and everybody's wonderful—the usual. I thought I could turn these tapes into plays and they'd be my little fortune, but they're not, they're just awful.

Paige said that she and PH were going over to Stuart Pivar's musicale because PH wanted to cover it for the *Party* book. The reason I don't want to go over there is because I just can't take hearing Archie and Amos barking in Jed's apartment next door on their weekends off. Do you know what I mean?

PH called me afterwards and said it was the kind of event like in a comedy movie where the boy would bring his girlfriend there to prove he was sensitive, that the men and women were very intellectual and dreamy, sitting on the nineteenth-century chairs and things listening to the beautiful music.

Monday, December 16, 1985

Brigid just called on the other line and she's reading me an article in *The New York Times* and I think it's about Rupert's boyfriend. Hold on . . . it says "Patrick McAllister," and I don't know if that's his last name, but he has AIDS and it doesn't give Rupert's name but it says he has a boyfriend who works for a "famous artist." And now I feel bad because I've always been so mean to Patrick. He found out he had AIDS in August—oh, but I've hated him for years. But still I do feel bad now, and that would explain a lot of things that Rupert does now like going into macrobiotics and things and taking courses like EST.

Chrissy Berlin was at the office and she loved her portraits. It was sort of busy. Fred was going off to Europe to sell art.

My old model date Sean McKeon's back in town, he's been away about a year doing plays in France. And this girl asked me about Sean, she said, "Is he straight?" And I told her yes. Because I mean, how do I know different? I met him when he was with a *girl!* And you have to believe what people *tell* you, don't you?

Worked till 8:20, then walked to the Ritz Café, which is the new restaurant where La Coupole was. I was going to meet a Ford model that Paige invited for me. He was just back from Japan and he hated it there, and it was just like listening to an exact copy of every other model—from New Jersey, talks about motorcycles, modeling, eating, and hating Japan. But they're good-looking and that's enough. The perfect nose and so much like Sean McKeon you would think they're from the same mold. And if you put glasses on them they could look distinguished, but they're brainless.

Paige brought a black Jewish lawyer named Rubin for Tama and he looked *(laughs)* black and Jewish. And Tama brought for Paige a novelist who's written four novels and he was jealous because Tama was in *The New Yorker* and Tama was jealous because he's had four novels published.

And this was all about looking for new faces and brains and ideas. We were in a booth for six people and it was fun.

Home before 12:00 and didn't watch *Letterman*. I'd seen the news earlier, about the Mafia shooting in midtown which is so abstract. They're just doing it on better streets now.

Wednesday, December 18, 1985

There's somebody ringing my bell really long. Really long. Maybe it's Crazy Matty. He hasn't been around in a long time. Oh, it's the chocolate man. He's trying to deliver chocolates. Hold on . . .

They were calling it the coldest day of the year, but it wasn't bad in the sun. Went over to Dr. Bernsohn's and he put me in a negative mood. He showed me this crystal and he said, "I paid a thousand for it and it usually costs $5,000, but it's worth millions to me, there's nothing like it in the world." And I said okay, that maybe I would trade him a print or something and he said, "A print? A print? I was thinking more like two portraits, one for my mother and one for me." He wants $50,000 worth of portraits! He said I have to let him know by Friday because Dr. Reese would be "programmed out" if I waited longer.

I think I'm just not going to call him. You have to draw the line somewhere.

Thursday, December 19, 1985

After reading that big article on Carl Andre and whether he pushed his wife out the window or not, it's so easy to imagine a fight. I wonder if they were having a fight and she went to jump out the window and he tried to stop her. He said he got the scratches on his face "moving furniture." Which he shouldn't have said. I'll be disappointed if he's guilty. I would think if he was that he would say so, because there's something about him with integrity. So if he's guilty why is he trying to save himself? I would be disappointed in him. I would think he would just say so.

And Lady Ann Lambton is in a movie about Sid Vicious and his girlfriend. She'd gone to the audition disguised as a punk rocker and she got the job.

Tina Chow called and said there was a dinner for Jean Michel at 9:00, just really small. Jean Michel had his mother and her friend there. I brought him a present, one of my own hairpieces. He was shocked. One of my old ones. Framed. I put "'83" on it but I don't know when it was from. It's one of my Paul Bochicchio wigs. It was a "Paul Original."

You know, I heard the kids at the office talking about my wigs, and when I think how much work time they spend gossiping about me . . . I mean, like now Brigid has Sam to hate, because I take him around with me, but I mean, he's just a babysitter for me. And Wilfredo's really the best babysitter. He's sweet but he's street-smart. And he takes numbers and follows up on business contacts. But he's so busy with his styling work at *Interview* and he still works Saturdays at Armani.

Dropped Sam. Gave the driver a big tip because it's Christmas ($10).

Saturday, December 21, 1985

Called PH and said I'd gone to Jean's and gotten her the earrings she was in love with and that I'd pick her up to go to Vincent's Christmas party and give them to her (cab $6.50). I didn't like these earrings at first, but I now think they may be Schiaparelli, I really do. She was thrilled, she

didn't think she'd be getting the pin, too. And when she put them on, they did something for her, they're unusual—strands of gold that bounce around with rubies in the center.

Sunday, December 22, 1985

Stuart Pivar called and invited me to rummage for ideas with him. Went to church (cabs $4, $3). Went to the flea market on 76th Street, and that one's indoors. Bought another Santa Claus sculpture. I just don't know what to paint.

Fred does help me all the time getting ideas. He really does. But in the end ideas are actually just physically working it all out. You'd think it's easy once you have an idea, but it's not. It's just like writing. Like the Truman Capote play I wanted to do—if I'd only looked at it at all before he died, I would've followed him some more for three days and kept *my* mouth shut and really gotten something. So we walked around and people nudged each other when they saw us.

Then went over to Jean Michel's birthday lunch at Mortimer's that Marsha May from Texas was giving. And finally I gave Jean Michel a gift he really loved—the rhythm and blues six-album set, that Atlantic just put out. And Ahmet Ertegun wrote some of the songs, those were his big years. Jean Michel was reading the liner notes all through lunch.

And then afterwards Jean Michel wanted to go to Bloomingdale's, it was 4:30. So we went over there. He wanted to get a $3,000 gift certificate for his mother and when he took out his gold Amex card one guy asked to see ID but the other guy nudged him and said, "It's okay."

Monday, December 23, 1985

I asked Jay what he wanted for Christmas and he said that in February when there's business to take care of in Paris, he wants to go and do it for me, so I said good, because that will free me up to stay working here.

I have a real take-all-give-nothing attitude this year. I'm going to give the kids at *Interview* who I know Keith Haring watches and autographed *America* books.

Worked till 8:30. Sean McKeon stopped by but these days I'm happy just with my two children—Sam and Wilfredo. Benjamin is just so busy with all his other stuff lately. Doing P.R. for fashion designers. But he's such a good companion. I wish I could think of a way to mesh the things he does so that he would still be working for us. He doesn't want too much steady responsibility, though. He's a free spirit.

Saw *The Color Purple* and the men in it are so cruel to the women. A real tearjerker. And Whoopi Goldberg reminded me so much of Jean Michel. The hands over her mouth when she laughed, just everything (tickets $18).

Tuesday, December 24, 1985

Was picked up by Benjamin. It was fifty-five out, but it felt like sixty, real nice. Went everywhere and had a lot of fun. When we got to the office the *Interview* party was in full swing. I never went over to it, but people drifted onto our side of the building. It was over right about 4:00.

And I told Gael to come up and pose for pictures because I was going to do a drawing of her because Fred told me that I had to. She looks good now, very thin. Her hair's beautiful and her skin is strong and she doesn't wear makeup. Peter, her husband, had come to pick her up and she was wearing a pale pink leather dress and I said, "Oh, where'd you get that pretty dress?" and the first thing she says is, "Well, you know, I *never* ever take anything for *free*, but they sold this to me for $10 because nobody wanted it!" She was very defensive right away to tell me that, as if she knew that I was hearing about all the stuff she gets for presents from her business admirers in L.A., sending her flowers and candy and stuff. I forget that these *Interview* editors actually are *powerful*. And I told her she should be going out to dinner with people constantly like Annie Flanders from *Details* does, and she said, "I'm not a hustler."

And Greg Gorman the photographer from L.A. was at the *Interview* party and told me that Joe Dallesandro's got a big role in a new TV cop series that's starting in January. Then went home and Gael and Peter dropped me off.

I ran into the 6'5" son of my neighbor, Dr. Hamilton. He got so tall suddenly this year now that he went off to college. He's handsome. He's the one that used to play ball in the street with the father and the one who said he used to see Yul Brynner run into the building across the street to see some woman and this kid would time how long it took them.

Took a gang to Nippon for Christmas Eve dinner and I gave out the little Be Somebody with a Body paintings (dinner $280).

And then we went down to Kenny Scharf's loft on Great Jones. In the bedroom Kenny had these original Flintstones and Jetson cartoon drawings, and he said, "Jon Gould got these for me." He actually said that to *me*. That was so odd to hear. He said Jon got them at an auction. I mean, you know somebody, they're living in your house, and then suddenly they don't know you anymore but they still see all your friends. I didn't know the people there, they were a bunch of weirdos.

I dropped off PH and Paige and Bernard (cab $20).

Wednesday, December 25, 1985

Went to 90th and Fifth (cab $4) to meet Paige at the soup kitchen at the Church of the Heavenly Rest. Episcopalian. Tama had already left because I guess it was too hard. And Paige was upset because she felt the food was so horrible for the people. But it's just that we're used to such unusually good stuff. It wasn't worse than high school cafeteria food. And you see people with bad teeth and everything. And we're so used to all these beautiful perfect people. It's such a different world.

And the minister was having a bourbon and he was really cute. The church keeps about twenty people overnight and feeds them but I don't know if it's the same ones every night and how they choose them. Passed out *Interviews*.

Friday, December 27, 1985

You know, I still get things from the Czechoslovakian church because I guess they don't know that my mother's gone to heaven, and I look down this list of names and they're so simple and so great, I don't know if they've shortened them or what. Like Coll. Or Kiss. I don't know what they made them from. And then there's the Warholas and the Varcholas and the Varhols....

And at Christmas time I really think about my mother and if I did the right thing sending her back to Pittsburgh. I still feel so guilty. *[NOTE: See Introduction]*

Saturday, December 28, 1985

Susan Blond called and we made a date for dinner and by the end of the day I'd invited ten or eleven people, and I decided that Bud's would be cheaper than, say, Jams, and so we decided to go there (cab $6).

George Condo came and he's that new artist. He makes these small things. And George and Paige were hitting it off but then Kenny Scharf had invited this actress Carole Davis, for George, and she got there late, after dinner—and she played the Jewish girl in *The Flamingo Kid*. So George got confused about who was his date. And this girl was the hit of the dinner. She was really funny. She just broke up with an Armenian or Indian plastic surgeon in L.A. who'd done three generations of noses, she said, and she talked about her chin job, but I think she's had a nose job, too. She said her best scene was cut out of *The Flamingo Kid*, when she tries to give Matt Dillon an ice-cube blow job. She said Matt didn't relate to her (dinner $600 including tip).

Bernard dropped me off ($10). And there's really no American cabdrivers anymore. This one was from Afghanistan or something. Is it that these people are willing to risk their lives and Americans aren't?

Sunday, December 29, 1985

Went to church. Then went to meet James Brown, the artist, at the flea market. And one guy said he had a book jacket that I'd done for a book called the *Adventures of* . . . somebody, I forget. A New Directions book. It was the English edition of it and it didn't have my name on it or anything, and I *know* New Directions never paid me for an English edition of anything. It was a good all-over pattern of African masks and my mother's writing, but they ruined it by making me draw a cutesy lady on it. For "commercial appeal." I had handed it in without it and then they told me to add this lady in. I don't know how he knew it was mine. Maybe he'd seen the original American edition that had my name on it.

And then we went to James Brown's studio near Katz's delicatessen, and he lives on the third floor of a building and on the ground floor is a whorehouse and it'd been raided three times that day and all these Puerto Rican ladies were running around in like *(laughs)* silk corsets and the madam looked sort of like Regine. And she had a guy assistant who was really good-looking, like a fairy assistant. And these guys just go there, I guess, it's like eating. They do it just so they

don't go crazy and they get off in five minutes and it's over. Like buying a lottery ticket. It's a renovated building and the madam had a hand-standing mirror in the hallway tilted to see who was coming. That reminded me so much of Billy Name—angled mirrors. Paige was fascinated with the whorehouse. She wanted to film it.

Tuesday, December 31, 1985

Well, it was a pretty starless New Year's Eve. I feel left out. I think Calvin had a party and didn't invite me, and Bianca's in town and I didn't hear from her, she never even called to say she was coming by for her Christmas gift. And I mean, she doesn't have many *other* friends. But New Year's was easy and unemotional. Nobody was mushy.

During the day, Jay was moping around the office but he's been better since I had the talk with him about all his negativity probably causing the cold sores on his mouth.

Bought the papers and saw that the eyeglass place had given an item to the newspapers that I buy my glasses there and that they're bulletproof like the president of Nicaragua's (newspapers $5, cabs $3, $2). I mean, I'm not going to go there anymore. Why would they make that up? I mean, what are *bulletproof* eyeglasses? What could they do for you?

I was going to call lots of people and wish them Happy New Year but then I couldn't get it together to call anybody.

Sam picked up PH and they came to pick me up (cab $10). So we got to Jane Holzer's and of course she wasn't ready, after telling me she wanted to get to Roy Cohn's party at 9:00 so she could really work the room for her real estate. She was still in her bathrobe. So then she got into her makeup and a black Armani jacket and pants. She's a little heavier.

And so we went to Roy Cohn's townhouse, and it was sad to see him like that, it really was. He didn't look old but God, he looked so sick. I don't know what to describe it as. And it was people like Joey and Cindy Adams.

Steve Dunleavy the Australian journalist said, "Give me a *bon mot* for the new year," and I couldn't think of one. Roy's ninety-year-old aunt was there, she owns Van Heusen shirts, she was the one who gave permission for me to use Ronald Reagan's old Van Heusen ad in my painting. She was like a WASP dowager, only with a hook nose, and she still has every one of her marbles. Jane went over to her and said, "I'm sure you don't remember me," and she said, "Oh yes I do, Jane, and how is your wonderful son Rusty and his horseback riding?"

And Doris Lilly was there. And Roy's nephew or something from Palm Beach who writes for the *Miami Herald* and wants to write for *Interview*. Monique Van Vooren was there, she walked into the front room shielding her face, she said, "Oh my, it's the same wonderful lighting as always." Because it was horrible and bright and with this old crowd it was really a horror show.

And then Regine was there and she invited us to the $2,000-a-plate Julio Iglesias dinner-concert right afterwards at the Essex House, so we got ourselves excited for that.

Oh, and I got a Christmas card from Jann Wenner and his wife and a baby. Did they have a baby or did they adopt one? The name was "Wenner." I don't remember her being pregnant.

At Essex House the best thing was a girl came over and gave us all brass key chains that were engraved concert tickets that said: "Julio Iglesias, Essex House, December 31, 1985, $2,000." And

Angie Dickinson was there, who's always so nice. Sam went over and took her picture and told her he worked for me and she said, "Oh, I love him." Regis Philbin did a comedy introduction about people calling him Phoebus Region and Rebus Philbin and things like that and then he introduced the celebs and the spotlight went on me, and I froze. And then at midnight they shot big spangles out of the cannons. And there were orchids and it was fun, and Julio's great line was he comes out on stage and says, "I FEEL GUILTY! I LOVE YOU!" And he kept talking about how we were all one family. And everybody who heard the price of this thing said that it must be a benefit, but it wasn't, it was just for Julio.

Left there and went over to the Hard Rock Café and the rock and roll crowd there was the most corny crowd in the world. It always is. Some CNN people interviewed me on what I was going to be doing next year and I said I was working on a Barbie doll. And then somebody who came in told us that Ricky Nelson had just been killed in a plane crash in Texas.

Wednesday, January 1, 1986

Sam is so devoted to me, and I guess it's because I've spoiled him. Fred warned me not to turn Sam's head, but on our first outing I took him to Yoko Ono's and he got to sit there with Dylan and David Bowie and Madonna and that put the zap on his head and now he's starstruck.

Anyway, he called and was eager to work but I just felt like staying home and resting, so I did, decided to just watch TV and take a holiday. Killed some moths.

Thursday, January 2, 1986

Worked at the office. Painted some Hamburgers. Went home. Made myself a potato. Sitcoms have the highest ratings on TV now—*The Cosby Show* and *Family Ties. Dynasty* slipped to eighth and *Dallas* is down to ninth—they should turn them into sitcoms. Wouldn't that be funny?

Friday, January 3, 1986

Paul's movie *Mixed Blood* is playing midnights at the Waverly, so Sam and I went over (tickets $10, popcorn $5). And I just loved the movie. It was everything he's done before, but it was photographed well and he seemed to know so much about the Lower East Side and the Alphabet—avenues A, B, C, and D—for someone who hadn't been in New York for so long.

Saturday, January 4, 1986

Sunny day. Karen Burke finally passed her doctor's exam. She sent me a card that said so.

Got to work at 4:00. Looked through some *Soldier of Fortune* magazines because I want to do war pictures. I was Xeroxing from them, having Sam do it, and when I went and looked he had

about a thousand pages in the trash! He'd been Xeroxing on the wrong size paper and not getting the whole picture in and I said something and he can't take criticism, he screamed, "Don't make me nervous!" And I mean, he knows about money, I don't know why he'd waste so much.

Tuesday, January 7, 1986

I was going to Earl McGrath's party for Jann Wenner's fortieth birthday, but first went with Benjamin to this new building in the jewelry district that's marble but done cheap. It was a fashion show at a place called Bill Robinson's Men's Clothes. And the male models were all on pedestals! It looked so great, really wonderful, and the girls were trying to pick them up and the guys were just on their pedestals staring and underneath them everybody else—wasn't perfect. And you'd go to feel the clothes and your face *(laughs)* would be right in their crotch. The party was over at 7:30 and the models came down off their pedestals.

Met Wilfredo there and we walked up to 61st and Fifth to Fereydoun Hoveyda's art opening at the David Mann Gallery. The wind was so bad, really strong and cold. I hope I didn't get a cold. Fereydoun was thrilled to see us. His drawings which used to be abstract now look like illustrations for *The Arabian Nights*. They're representational now.

Then cabbed to 57th and Seventh to Earl's ($6). Ahmet was so cool to me. He used to kiss me and tell me stories but the last couple of times he's been really cool, like I raved to him about his seven-record-set album and he just listened and then got bored and left. I'll have to send him a painting or something. Try to find out what I did wrong. Half the people had just come back from a cruise with Jann Wenner. Talked to Jane, his wife, who said they'd been married nineteen years. And they did just adopt a baby. And Jann is so so so so fat, incredible.

Fred gave me a ride and I got home at 12:00. And Jean Michel had his opening in L.A. and I feel just terrible, I forgot to call him.

Wednesday, January 8, 1986

My sister-in-law called me in the morning, she's in town. She wants to sell me a $90 vibrator because she bought three and doesn't need them all. She's a reflexologist. She rubs people's feet for five hours and gets rid of all their sickness. And it's just like these people that I go to, but I think that if I were going to her, it would turn me off the whole thing, you know? And my brother Paul, who's the junkman, he's doing well, he's got a farm, a real working farm. They just killed six pigs and they made sausages out of them and stuff. And he's buying real estate in the black neighborhood and it's really going to go up. On the river on the North Side. And the wife of my nephew George is still suing him. She's remarried already. And George went to see the kids, he has two cute little boys, and she ran out of the house and took a picture of his Cadillac to try to get more money out of him. He doesn't have a girlfriend, he's still despondent over the marriage breaking up, he's a nice kid. And the wife I guess was cute. Irish or something. George is the good-looking one in the family, I guess (cab uptown $5).

Called Jean Michel in L.A. and he said no stars had been at his opening, and he said Jon Gould had been there but he wouldn't talk about him to me for some reason.

Thursday, January 9, 1986

Worked all afternoon. Left at 5:00 to go uptown to Sabrina Guinness's birthday party at Ann Ronson's fifteen-room apartment at the San Remo on Central Park West—she's married to Mick Jones of Foreigner.

Each room was done in a different style. One room was English, the other room was Art Deco, the next room was trompe l'oeil. There was no food. Just three pieces of chicken sushi. I found some caviar on a tray in the corner of a room where you would never look.

And there was a black girl there who was one of these over-bubbly girls that I can't stand— from Africa, she said, but then she said it was so good to be out with people because she lives so shut up in Greenwich with her family, so what do you suppose that means? She said she went to the best London schools. And I guess Michael Douglas likes black girls because he said, "Listen sweetheart, give me your number before you leave," and when he got up to do something he told her, "I'll be right back."

Earl McGrath was there, sour, until he finally got a joint from John Taylor of Duran Duran. And then he introduced me to Randy Hearst, Patty's father, and then it turned out Patty was there with her cop husband, and I met him, and then Patty came over and was very friendly and sweet, she looks great. And Nile Rodgers was there, the record producer. He's a fashion plate, his hair's cut square like Grace Jones's, and he's really nice.

Friday, January 10, 1986

Richard Weisman called and said he was getting married, and it's next Saturday in town.

Thursday, January 14, 1986

Chris told me that what Edmund was actually sick with was TB but that he's getting over it now. My mother had it after she came to New York, and you just have to take a lot of antibiotics. She never coughed or anything, and I don't know how she got it in New York, I guess it's just a virus. Doc Cox found out she had it and she got over it in a month. And the Department of Health people kept coming around for years.

Brigid said she's going to Paris for two weeks with Charles Rydell. She said her mother's bought the coffin for her father. They expect him to go any day now. They've got a turkey baster stuck in his throat to feed him.

Saw *Jewel of the Nile* which was a bore (tickets $18, popcorn $7). Michael Douglas's nose is getting hooked. I wonder if his father had a nose job.

Wednesday, January 15, 1986

An English guy came in and wants me to do new Self-Portraits. I'm working on the War pictures and they're so hard, I don't know what they should look like. I'm doing Guns, but I've done guns before.

Saturday, January 18, 1986

I got myself into black tie, took a cab to U.N. Plaza for Richard Weisman's wedding (cab $4.50). And who was sitting there in the lobby but Crazy Matty. They weren't even kicking him out or anything. Richard was sort of out of it. His youngest daughter was with the son of the woman who Richard lived with for about five years and didn't marry. And then I guess he met this girl and decided to get married right away. And when she came down I was shocked because he hadn't said she was Oriental, and his father, Fred Weisman, just had a horrible experience with an Oriental woman and now Richard's marrying one himself. She's a model. She's half American and half Korean.

The wedding itself only took a second. You hardly noticed. "Do you take this woman?" "Yes." That was about it. And then I had about four pieces of wedding cake. And I asked why Suzie Frankfurt wasn't there and somebody said that she and Richard had had a falling-out because he gave her $20,000 to get the stucco off the walls and she hasn't done it.

And everybody was saying they hadn't known if this wedding was really going to happen. John Martin from ABC said that just before he got into his tuxedo he called to make sure. And Richard's wife told him that for her wedding present all she wanted in the world was to go to the Superbowl. Yeah, right—"The Superbowl, darling, that's all I want." And so then I left and Matty was still in the lobby. And I said to the doorman, "How can you let that person stay here so long and not kick him out?" and he said, "He works for Interview magazine."

Monday, January 20, 1986

Jean Michel woke me up at 6:00 this morning and I went back to sleep and now my tongue can hardly move. He's got problems because he's trying to get Shenge out of the house, he says he's been supporting him for three years, but the main reason is that (laughs) Shenge is now painting like he is. They're copies of his paintings. Jennifer's away. And oh, Jean Michel must be so hard to live with. I told him I'd had dinner with Kenny and the Chows and he wanted to know why I didn't invite him and I said that I'd called him three days ago and he didn't call back.

Fred said that the Boston Museum people were still vague about whether they were going to buy the big Electric Chair or not.

Tuesday, January 21, 1986

I think I forgot to tell about the girl on 57th at Park who took off all her clothes and peed in the middle of the street and then walked over and put her clothes on again. In front of that luggage store that I never see anybody in. The southwest corner, you know? Everybody pretended like nothing was happening. She had high heels on.

Benjamin picked me up and on the way downtown we ran into Jimmy Breslin who was just in a sweater, he said he'd just walked through the park, that he walks to the *Daily News* every day from the West Side and he said he'd walk with us, but we panicked because we were on our way to Bulgari, and can you imagine the column he would write about *that*? And so we told him we had to go and work on some advertisers, and it was hard to shake him. But gee, that's a long walk he does every day, isn't it?

Grace Jones arrived at the office to pick up her portrait and she was wearing Issey Miyake and she had a hat on that was like Rasta hair and she has big kisses on the mouth for everybody, like even Sam. And she's so excited that she's going to Hollywood to play a woman Dracula. I mean how many more women Draculas can they have? She's so excited. She said they gave her "artistic control." She was saying that she was going to turn yellow and then white and then green, and so then I thought that maybe they just gave her artistic control of her face.

Saturday, January 25, 1986

Went down to Julian Schnabel's. The food was already gone and back in the kitchen when we got there. I guess when they said 7:30 they meant it. So Julian took us into the kitchen and we sat around there eating couscous. It was so good. He gave me a copy of his book to read to see what I thought. And what I thought was that he was really influenced by *Popism*. It starts off with how he arrived from Waco, Texas, and then being at Max's and who he met. Everybody but me. It was sort of interesting because he'd go back and forth from then to later, like he'd say, "August, 1983" and put something in. I don't know if it's a prologue to a book or if it's a catalogue or what. It'll sell a lot.

Then they brought out the birthday cake. And I was shooting with my camera and this person pulls down her hat and walks away and I didn't even know who it was and I went into the kitchen and then Diane Keaton comes in and said, "Hi kids, how are you?" And I mean, who does she think she *is*? I was taking pictures of the *cake*. And I mean, she goes around the city doing *her* photographs of anybody she wants, so where does she have the *nerve* to act like that? And then she went downstairs and I was talking in a loud voice about how I thought she was a phony and maybe she heard, but I don't care. If I see her again I'm going to tell her off once and for all, what a big phony-baloney she is. Julian had a lot of new work around. He's buying back his early work that he sold for $600 or something, for about $40,000, because he knows he should. He doesn't know how to deal with me and Jean Michel. He owes us some pictures (supplies $1).

He had a lot of Joseph Beuys stuff around. Joseph Beuys just died on Friday. And Tinkerbelle died. It was in the Friday papers. It said that she died on Tuesday when she jumped out of a window.

Edit deAk was wearing one of these Afghan hats and she said that she told Diane Keaton once to "stop wearing those stupid hats," and then she comes in wearing a stupid hat herself and runs into Diane Keaton, so she was really embarrassed.

And the Music issue is coming up and I really have to call Eric Andersen back, he's been calling me, and get him into the issue. *Interview* doesn't ask me to do interviews myself anymore or anything. They used to ask me to do a person now and then. Were my interviews bad, or . . .

Sunday, January 26, 1986

Went to the flea market and it was raining. Then went over to the East Side to the armory show. At Sotheby's they'd just sold a table for $1.2 million. A record. And at the armory there were all these people that I used to buy junk from for $35, and if I'd only bought the $100 stuff, that stuff would be worth a lot now, but I bought the cheap stuff. And now what people want is only one of a kind. My art is just the opposite.

Tuesday, January 28, 1986

Brigid came in and said that her father had died and that she wanted to go home, and I told her to keep on working. Paige was very sympathetic, but I was trying to just, you know, make it less traumatic for her.

Thursday, January 30, 1986

Benjamin Liu came and gave me the tragic news that his costume jewelry business is soaring and that he's going into it full-time and won't be coming by for me in the mornings anymore. So an era has ended. I guess I'll just be going straight to work, which is just as well, I'll get more work done. There are other possibilities of people to try out, but Benjamin was special.

George the secretary at Yoko Ono's called and invited me to a dinner party for her big screening of the movie she and John made in 1972 and a benefit concert at Madison Square Garden, I think for Bangladesh. And there were a lot of other things to do but I decided to do that. I asked if I could bring someone to Yoko's and later they called and said okay, so I asked Sam Bolton. He's only interested when it's big celebrities.

Was picked up by Sam and we cabbed to Amsterdam and 64th or 65th for the screening and I was next to Jann Wenner (cab $4). And John was such a great comedian, so natural on stage and those funny little movements and good lines. Yoko was just screaming, it was one of her early performances.

Then there was a dinner at Jezebel's and Jann gave us a ride in his limo. Roberta Flack was there and Earl and Camilla McGrath and we all walked in and they were shocked with this glamorous place that they didn't know about. Jezebel redid it and it looks cleaner now. She kissed

me hard on my cheek. I was next to Roberta Flack and one of the Spinks brothers came in wearing a big fur coat. And Michael Douglas came later.

And I guess I don't know how to talk to little Sean Lennon. I'm too abstract. Because Roberta Flack was so great with him. He said, "Roberta, what is a torch singer?" And she said, "Well, Sean, a torch singer is someone who sings with not too much music playing, very softly, and with a lot of feeling." And then he felt he understood. The sweet potato pie was really good and then I realized it must have had bacon lard in the crust.

Afterwards Jann Wenner offered me a ride home and so Sam and I went with him and I said he didn't have to drive Sam downtown, that he'd get out on 66th Street with me and just get a *cab* home, and Jann made comments like he didn't care what I did in my private life. So we got out at 66th and Park and I gave Sam money to get a cab and I walked home ($5).

Saturday, February 1, 1986

Paige and I went to Global Furniture—they advertise. There was an umbrella thing as big as a whole room that I'm thinking we should get for the Madison Avenue part of the building so that the people across the street can't look down and see me painting. It's such a huge umbrella, about 20' × 20'. It's only about $800. We were there all afternoon.

Sunday, February 2, 1986

I puttered around and then went to church, and while I was *praying* this guy comes over to sell me a $100 raffle ticket. Can you believe that? For the church. He forces this ticket on me and it's this queeny decorator and then I hear him back there telling somebody how he just sold it to me, and I think he was actually getting rid of *his* ticket that he bought and didn't want. And they're selling 300 tickets at $100 each, so that's what, $30,000? And they're giving a $10,000 cash prize, so you just know what that means—if you win they'll want it back as a donation. He said, "I hate to disturb you while you're praying, but . . ."

Wednesday, February 5, 1986

I picked up a copy of *Status* magazine from the sixties, and it was so interesting, all these people who were social climbing then and they *still* are. And Wyatt Cooper was the editor. Gloria Vanderbilt's last husband.

Paige was having a business dinner for Janet Sartin and Steven Greenberg who was bringing Margaux Hemingway as his date. He picked us up in his limousine and when Paige and I went out we caught him and Margaux really kissing in the car and they got embarrassed when we saw them. Went to Mr. Chow's.

And the best thing was Burgess Meredith was there and I sort of know him from years ago, he dated a girl who lived in the big apartment that I shared with all those kids on 103rd Street. And

when he was leaving he came over to say hello, and he said "How's your ex-wife, Paulette?" I think he actually thinks that I was married to her, too. He was with a beautiful girl, I couldn't really see. It could have been a daughter or a date, I don't know.

Monday, February 10, 1986

At 7:30 the Mattel car came to take me to Pier 92 at 55th and Twelfth Avenue where Billy Boy's big Barbie doll exhibition was, and they were going to unveil my portrait and the portrait looks so bad, I don't like it. Barbie *(laughs)* has problems. The fifties Barbie had a more closed mouth and beautiful sensual lips, but the eighties Barbie has a smile. I don't know why they gave her a smile. I could never relate to Barbie because it was too puny. Someone told me that the Arabs have just commissioned a bigger Barbie. Fred said it was through Billy Boy that I got the portrait. I think he asked Billy Boy to suggest it to Mattel. I'll have to get this straight from Fred, it was a surprise to me. I didn't know how it happened. And I guess Billy Boy has a lot of great sixties stuff because all those pictures in the display cases were his—of Edie and me and all the *Vogue* things, and the Cow poster. How does he have time to do this—collect his antique couture clothes and design his jewelry? I think Bettina has done a lot for him. Fred said Bettina was who the original Barbie was based on. I talked for a minute to Mel Odom who designed a lot of the stuff in the show, he's very talented.

And they unveiled my painting and the Mattel president said he just couldn't wait to see it and I just cringed.

Then left and went to the Peter Allen birthday party at Bud's on Columbus and 77th Street. Liberace came and he looked great. The papers say he's been sick but he doesn't look it. He called me over to be photographed with him but then it still looks like you're pushing your way in.

Wednesday, February 12, 1986

Paige was having a big business dinner at the Café Condotti. Rupert gave us a ride up there, to 38 East 58th Street, and the place was cute, but kind of like a Coca-Cola stand, that size. And I got a shock when I walked in and Jed was there. I had my dates, the nutritionist Tama and Paige introduced me to a couple of weeks ago at a blind-date dinner who I thought was blond but he turned out in that light to be grey, and Bernsohn. Steven Greenberg and Margaux Hemingway came. And Bettina came with Billy Boy and she had on a black Azzedine outfit. His clothes look good on her. Jed designed the restaurant and he put my Grape prints on the walls.

And then afterwards, Stephen Sprouse walked me home, and he said that The Limited wanted to give him a contract but that he wasn't going to do it.

Thursday, February 13, 1986

Went to Martin Poll's apartment on Park Avenue for his party for Sylvester Stallone and Brigitte Nielsen (cab $5). Everyone was supposed to wear red and black so she wore green. Stallone used my kind of lines on me. He said, "I read about you in every paper." I told him the same thing

and he said that the *Star* was now even doing interviews with his mother, and I said that I was reading them. That's about all he said, and that was only at the end, when they were going to the door.

And for a present I gave Stallone one of those paintings, Be a Somebody with a Body, and he liked it a lot.

Friday, February 14, 1986

Worked a little bit and then went to Fiorucci from 4:00–6:00 to sign *America* books and signed 185. And Billy Boy came by the store and then Paige came and took us over to the Café Condotti for tea. And that was fun. When we sit underneath all my Grape prints, it seems like it's *our* place or something.

And meanwhile, Jean Michel is really unhappy—Shenge is having his one-man show. And I mean, he's *(laughs)* just as good as Jean Michel. And Jean Michel kicked him out and changed the locks, but then finally he let him in to get his paintings.

Monday, February 17, 1986

I screamed at the *Interview* girls because one of them set off the alarm and it costs $50 every time the alarm company comes. Even if you call them one second after it starts and say it was a mistake, they want the $50 so they tell you "The guy already left," and he comes.

Rupert dropped me off. Heard about the Tylenol mystery on the news. I watched *Letterman* and he's suddenly gotten too sure of himself. Too cocky. It's not becoming on him. He had Raquel Welch on. Oh, and Sandra Bernhard was on and she had some Diane Von Furstenberg-brand towel paper, and she said, "Andy Warhol calls Diane Von Furstenberg and says, 'Let's go dancing,' but she says, 'No, I've got to clean up with my Diane Von Furstenberg towel paper.' "

Wednesday, February 19, 1986

No Benjamin, so I guess it's really over. And I'm also losing Lidija because now that she's opening her own gym she can only give workouts in the mornings, which I don't want, so I'm going to have to find someone else. I walked to work.

Went to 50/50 and then went to Speakeasy. Then we went up to the office (cab $4).

Then I heard that Rupert's friend Patrick had died that morning at 3 A.M. when he was taking a shower. He was in the hospital in Maryland and he used to go to Rupert's in New Hope, Pennsylvania for the weekends. And usually he had two people with him, but he decided to take a shower and he died in it. He was a guinea pig for a new treatment, so they don't know exactly what happened with him. So that was the bad news. The good news was that Edmund got out of the hospital. Peter Wise was going over there to cook. And I wish I could help him, somehow, but it was good to hear that he got out.

Kent Klineman was at the office talking to Fred and me about the Cowboys and Indians portfolio he's commissioning.

Went to the Eric Fischl show at the Whitney and it was really interesting. The paintings are off, the perspectives are wrong, but somehow they're right. They're like *Playboy* illustrations. Talked to Eric. Thanked Mary Boone for having us.

Thursday, February 20, 1986

There was a lunch at the office for three of Paige's advertisers and also for Billy Boy to give him a Barbie portrait. Bettina was with him. Rupert came up with some work before he was going off to Patrick's funeral. Anthony d'Offay was there from London to check on the Self-Portraits.

Ended up the day watching the *Letterman* show with Ron Reagan, Jr. on and he's really changed. I was surprised he was so forward. And Letterman was just so thrilled to have him on. And the daughter's got a *People* cover for her trashy book, so the whole family is out there hustling.

Friday, February 21, 1986

Worked all afternoon. Rupert didn't come because he was still at the funeral. Live for today, Dear Diary. Worked really late.

Saturday, February 22, 1986

At the office Sam tried to take pictures of me that I need to work from for the Self-Portraits for the English show, and I'd done my hair in curlers and everything and he just couldn't get it right, and when Sam can't get something right right away he gets frustrated and quits and has sort of a tantrum and I can see why he never finished school.

Sunday, February 23, 1986

I went to church. I still haven't paid the guy for the raffle. I didn't win, and so do you think I should mail it to him, the $100? I don't know, I guess I will.

Fred called and said the Hammer & Sickles went low. My prices were up until that de Menil auction and that brought them down. And Tony Shafrazi's show was bad for everyone. If he'd only waited and done it this year. There was no rush, and then it would've been that we'd be still painting together. But then all shows are like that—you have a show and then it's over, and you've used up all your material.

Monday, February 24, 1986

Cabbed to the office to meet Rupert and he was back from the funeral ($5). I didn't talk about it until later that night because I didn't want to bring it up, but he said it was weird. And Edmund calls Rupert all the time, at all hours, because he's so nervous. I invited Rupert to a movie after work.

It was a busy afternoon with people coming by. Gael came in to show me pictures of Joe Dallesandro that Greg Gorman took for *Interview*, and God, he's still so handsome, he looks really good—his skin is really strong, I guess.

Oh, and Dolly Fox is dating Steven Greenberg and asking me to find out what the story on him and Margaux is. She said he picked her up at 8:00 and she was with him till 5:00 and he wants to see her again on Tuesday.

Saw the Rob Lowe skating movie, then took Rupert to Serendipity for cake and the waiters sang and he felt better ($20).

Tuesday, February 25, 1986

Jean Michel called and said he found a dead person in his backyard yesterday. He called the police and they were in the backyard all day, and by 6:00 they still hadn't taken the body away. He was from the flophouse next door. And Jean Michel sent the cat that didn't catch rats down to Atlanta, he sent it on a plane for $100 down to some gallery there. The poor cat probably never got taken care of—I mean, can you imagine being a cat in the hands of Jean Michel?

Tried to work with Fred and with Vincent, but my room is so filled with junk, I can't pull out of it. I tried on wigs from Fiorucci but it looked like too much of a big-hat wig, too outrageous. This is for the Self-Portraits. Paige called a couple of times from the fat farm she went to and it was fun talking to her. The Music issue is going to cost us a lot. Cyndi Lauper is the cover.

Thursday, February 27, 1986

Oh and that lady Halston was supposed to bring down for a portrait cancelled, but I mean, anybody who keeps telling you she's got a check for $999 million in her pocketbook is either having a nervous breakdown or she's on coke.

And Arnold Schwarzenegger never called back. He was going to have Maria Shriver's portrait done for a wedding present and then her mother and cousins, too.

Friday, February 28, 1986

Sam and I went to the Eastside Cinema to see *Hollywood Vice* (tickets $12, popcorn $5). The people behind us complained that they couldn't see over my hair, so that threw me and we moved over two seats. I didn't move my backpack with me, though. During the movie the Exit door opened

a few times. After it was over, we left, and when we got outside I realized that I hadn't taken my bag, so Sam went back in to get it and it was gone. So then we looked everywhere, in all the bathrooms and things, and in all the trash baskets, and we told the people at the theater, but it wasn't anywhere and they don't care. It had bank statements and makeup and an ashtray from a restaurant and receipts. No keys. Three oranges, telephone bills, my Prudential health insurance cards, some money. So we ran around the block checking every trash basket, Sam felt terrible, and a big truck almost ran into us but missed us and ran into a lamppost. So I went home and I felt violated. They stole the monkey off my back. But it's actually a relief. I've decided I won't replace it.

And my brother told me that Victor Bockris has taken out an ad in the Pittsburgh paper about getting people who knew me to talk to him for the book he's writing about me.

Sunday, March 2, 1986

Went to church and saw Adolfo and felt a little hurt because he walked right by and didn't say hello. In my mind I always picture him in a little Chanel-type suit. I believe they should wear some version of what they design.

Went to Christie's and Phillips, and since my bag was stolen I've had invasion dreams. Nutty dreams with invasions. Went home.

Sam and PH picked me up and we went to the Hard Rock Café for Paul Shaffer's live radio show (cab $7). And Paul had Christopher Reeve there, and he said he loved the Greg Gorman pictures of him in *Interview*. And Peter Frampton was there and two Grateful Deads and two Cars. And we met Steve Jordan, the drummer in Paul Shaffer's band on *Letterman*, and he's just adorable—he's intelligent and sexy.

I was mobbed by little girls on the way out and signed autographs and then we got a cab and I gave Sam money to drop us off ($7).

Wednesday, March 5, 1986

Jay's back from Paris and he said he had a good time there. All the de Menil family was there, too, because Pierre Schlumberger died (phones $2, newspapers $2).

When I got to the office I caught the tail end of a lunch for this guy named Stringfellow who was opening a club on East 21st Street and he acted funny and left in a weird way, so I began to think that maybe it was because I hadn't been at the whole lunch. And Fred didn't understand, either, what the problem was, but then later Paige called the girl who was with him and found out that that *was* the problem, that he was offended that I wasn't there. He's English. But then later on he called and did take an ad.

Friday, March 7, 1986

It was freezing out. Went with the nutritionist I met on the blind date to see *Out of Africa* at the Greenwich Theater. It was two and a half hours long. It's another one of those movies where nothing happens—they do this and then they do that and then they do this and then they do that, but there's no action.

Saturday, March 8, 1986— New York—New Hope, Pennsylvania—New York

John Reinhold picked me up with his Japanese car and we went to New Hope to talk to Rupert about art projects. His house is like a stage set. Rupert is the grand man around town with two Bentleys. The house was a mill, it looks like old Rome with the ruins in parts. Four Persian cats. Fireplaces working all the time. His cousin, a girl, came from New York to make a cake for us and she baked bread, too, which was the best thing.

New Hope is 90 percent gay. We went to a place called Ramona's and a drag queen served us and people were there drinking at 2 P.M. Gay old guys. It was too gay for me, it drove me crazy. Like a time warp. A gay hotel-motel. The drag queen looked like Rupert's mother with the blonde beehive. She had on pants but a four-inch leather belt really tightening in her waist. And a guy came over and said Rupert was an alien and Rupert said, "I am not an alien. I am Rupert Jason Smith" (lunch $60). And then Rupert said I had to leave the drag queen a big tip since she stayed open for us (tip $25). Gave me goosebumps. Then we went to places run by gay sons and fat mothers. Antiques places. Then we went back to the house and the girl had made a dessert, and we ate lots of bread. Then at 7:30 we left for New York and then after John dropped me off I remembered that I'd been invited to Chastity Bono's birthday party.

So I cabbed downtown to Sixth Avenue between 9th and 10th, a Mexican restaurant ($6). The party was in full swing. Every girl was like a movie star, I mean, she'd copied a look. Some looked like Molly Ringwald, there were three or four Madonnas. Cher didn't come to the party because she and Chastity had a fight. Chastity goes to the School of Performing Arts. Stayed till 12:30 (cab $7).

Sunday, March 9, 1986

In the *Times* it said that Imelda Marcos left 3,000 pairs of shoes in the Philippines. Maybe she *was* trash, I mean when I think about the type of people they were wining and dining. And they found porno in Marcos's room. It's like if somebody went through your apartment and wrote about it *(laughs)* in *The New York Times*. "This Is Your Apartment." That's a good TV show. "Here are two cups that were apparently taken from the Plaza Hotel. Tell us about them." They could do it in Russia. In Russia they could *really* do it. "So, you like wearing ladies' perfume, Mr. Warhol?"

Ran into Billy Boy at the flea market buying old bottles of Schiaparelli and Chanel perfume in

his powder-green coat. He really puts out the money and just pays whatever they say, he spent about $1,000 I think. He has a good eye, he can really pick out the good stuff.

Thursday, March 13, 1986

It was raining hard. Paige and I went over to the Paris Theater and saw *Room with a View*. Nothing really happens, an *Out of Africa*-type thing, but it's beautiful. Good views of Florence.

Friday, March 14, 1986

Gee, these artists who're living the life of Riley. Keith's just off in Brazil and I hear Fischl's getting $100,000 a canvas now, more than Schnabel.

I was picked up by Steven Greenberg in his limo and we went over to Stuart Pivar's for an advertising dinner. And Paige was in her Chinese robe so Stuart put his on and then Dennis Smith the ex-fireman who wrote a bestselling book put on a *caballero* hat with a rose in his teeth and he's Irish, so he was singing and getting ready for St. Patrick's Day and that was unusual, it was fun. Then he mentioned having five kids, and I don't know what happened to the wife, so Paige had been interested, but when she heard "five kids" that was too much. But he's really great, very intelligent. He's now looking for a hostess.

Sunday, March 16, 1986

I went to church. Adolfo was in the last row. Gave the doorman at one of the buildings on the way an *Interview*, and he was black and I always feel good giving black people the magazine when it's a black cover like the Grace Jones issue and the Richard Pryor one this time.

And the Marcoses are still all in the news. Now they've found 3,000 black panties. And it's funny to hear a congressman say, "Why did she need so many panties?" I wish I had the shirt that the Marcos son once gave me right off his back a couple of years ago. And their Bulgari bill was for a million.

Tuesday, March 18, 1986

Arnold Schwarzenegger called and said the portraits of Maria were on again.

Paul Morrissey's doing movies with David Weisman now.

I bumped my head yesterday and got dizzy. I think I might have got a mild concussion.

Then cabbed to meet Paige and Henri Bendel at a Chinese restaurant on 44th and U.N. Plaza (cab $5). Mr. Bendel owned Bendel's till he sold out in 1955. Now he just has the handmade shoe company, Belgium Shoes. He said he's lonely so I said why didn't he get a dog and he said that he had a beagle and then he was walking it on the leash and it went to the curb and a cab

just ran it over on the leash. And he had to go back and tell his wife who was still alive that the dog was killed. He's from Louisiana.

Went home and watched *Letterman* and he had some good pet tricks on.

Wednesday, March 19, 1986

It was a beautiful day. I had a meeting with Martin Poll and I didn't know why. I walked over to 57th and Seventh Avenue to his office and he said, "We want to do your life story," and he started talking about the sixties and interweaving four stories, and I told him that a wonderful movie had already been made on the sixties, and that he should just remake it—*The Magic Garden of Stanley Sweetheart*—and he said, "I made that movie." I completely forgot that he had. I didn't know that. He discovered Don Johnson. He was going to use Richard Thomas and then changed to Don Johnson. So then I mentioned money and he said, "Money? Money? What money? It's publicity for you." So I told him he should talk to Fred, that what he should do is just buy the rights to *Popism* and that we'd be consultants on the movie. PH would do the script. And then he started talking about Viva and Joe Dallesandro and everything and I ran out of there (newspapers $2, cab $6).

Went to Walter Stait's dinner party on East 57th Street (cab $6). Then took Sam to Serendipity. Had a hot fudge sundae and the sugar made me tip so much. I felt generous ($25).

Got home, turned on *Letterman* and saw the show they wanted me to be the guest on, the one with the monkey with the camera, and they had Dr. Ruth Westheimer on. Wouldn't it be funny if Dr. Ruth didn't really have an accent?

Brigid just called and said that at A.A. everybody in the office was there—Don Munroe, and Yoko Ono's maid who I like, and Kate Harrington and Sue Etkin and no wonder nothing gets done—we have a bunch of drunks working for us.

When I called the office yesterday and asked Michael Walsh for a phone number from the Rolodex he was gone two minutes and came back and told me my *own number!* So I screamed, and he said, "Oh sorry, I guess hearing your name made me look up your number."

Thursday, March 20, 1986

Si Newhouse came to the office and he's not sure about buying the Elvis and the Tuna Fish.

Monday, March 24, 1986

On the news they busted a porno ring, and they were leading the Boy Scout master and the teacher out tied with rope. *(laughs)* It was odd-looking.

Went home after dinner with Jean Michel and caught the Academy Awards. Saw Geraldine

Page saying she deserved it, and all those old ladies coming out in eight yards of material—Debbie Reynolds and Cyd Charisse and June Allyson and Ann Miller and Katherine Grayson.

Tuesday, March 25, 1986

Maria Shriver called and postponed until next week because she said she'd broken four toes.

Went to the Grand Hyatt to the Emmys with Keith. I told them I didn't want to say any lines, so they announced I had laryngitis and that's why I wasn't saying anything. But when they announced that, some people laughed—they knew. And then this guy who said he was the doctor of the Emmys came and said he'd fix my laryngitis, so I explained I didn't really have any.

After this thing was over, walked over to the office and there was a lunch going on. Mrs. de Menil was with Iolas there, and Fred gave them a tour and he got mad at me because I wasn't with her enough. Iolas's bags were lost but he says he loves shopping at Alexander's to replace the things.

Wednesday, March 26, 1986

Oh, these commercials on TV for the *Enquirer*. Carroll Baker's doing them this week talking about the book she just wrote about her experiences in Africa in 1970. I honestly think it's made up. She probably read a nature book and said those things happened to her. Who would know? She talks about being so hungry she bit off a lizard's head and sucked out the fluid. But I mean, maybe she was giving a blow job in a tent and a lizard walked by and she fantasized.

I'd invited Sam to the opening of the Fellini movie *Fred and Ginger* at MOMA. I get so involved with Sam, you can waste a whole day with somebody and their dumb little problems.

And then Fred said, "Why am I working here if you're not going to be a good artist!" He doesn't like my work. And I told him that if I did this other stuff, the young kids do it better. Really, what is life about? You get sick and die. That's it. So you've just got to keep busy.

We got to the museum really early. And after it was over, Fellini was being photographed and he saw me and he was great, he called me over and kissed me on both cheeks and introduced me to his wife who really looks good in person.

Thursday, March 27, 1986

Went to Le Cirque to meet Paige and Gael and someone from Young & Rubicam for dinner and Claire Trevor came in with Donald Brooks and she told me I was wonderful and I told her she was and she said, "No, you're more wonderful," and I said no, she was. And she ate like Paulette and those women—she had shad roe with three strips of bacon and cigarettes and vanilla ice cream. Then Keith Haring was having a party for his TV segment on 20/20 (cab $6). We got there just as it was over.

Sunday, March 30, 1986

Easter Sunday. Woke up and it was a beautiful day again. Paige called and said she'd be ready at 12:30 and then Wilfredo called—I'd asked him to come, too. We were going up to help serve the Easter meal to the poor people at the Church of the Heavenly Rest at 90th and Fifth Avenue. Picked up Paige and she said Stephen Sprouse was in the subway on his way (cab $3). It turned out we were really needed because if we hadn't been there they wouldn't have had enough helpers. I never made eye contact with the people, I looked sideways and up and down. It went fine. And people were stocking up with oranges and apples and Easter eggs and with shopping bags, taking stuff, and some people were collecting cups and even plastic knives and forks.

And let's see what else . . . a lady had her teeth in a napkin and the guy went to clear it away and she got excited. It was a lot of hard work. Wilfredo was good, he handed out the ham, he worked hard. They used six of those restaurant urns of coffee. And the four of us prayed and we saw a lady bring in a potted plant and trade it in for one of the better ones there. A lot of the ladies looked like my mother. A man looked like something from *Arabian Nights*, all wrapped up. It was fun, had a good time. Outside it was sunny and bright and we ran out.

And James Cagney died.

Monday, March 31, 1986

It's funny but after seeing Dr. Ruth in person at the Emmys she doesn't look like she seems on TV. The magic of TV is what makes her look crunchy. In person she's just a normal person you want to kick around.

Cabbed to the West Side ($3) and Dr. Linda Li. She was messing up my wig, my brain wasn't functioning. I don't know what she does, but you do feel better when you get out of there (phone $2).

The Folk Art Museum kicked me off the board of trustees! It was ridiculous anyway, but I mean, they never even bothered to send me a *notification*!

Tuesday, April 1, 1986

Stuart and I went up to see Rock Hudson's exhibit at the William Doyle Gallery (cab $3). And the whole thing was so nelly, not one good thing. You'd like to think that a big brute movie star would have had great fifties stuff, like maybe big rugged Knoll pieces, but it was just comfortable nelly junk from his New York apartment. There was only one sort of nice thing, a wooden box that was so ugly and Elizabeth Taylor had written on it.

Fran Lebowitz came by to pick up some art that Bob Colacello promised her when she was writing for *Interview*. She came in her beige Marathon Checker cab and she drove off with it.

Thursday, April 3, 1986

Went right downtown because Maria Shriver was coming at 11:00 (cab $5). And she's really pretty and she took good pictures. She's a little heavy on the bottom. She was cute, she talked a lot.

Paige and I wanted chocolate on the way home so we stopped at Neuchatel, and they gave us free quarter-pound bags and we just walked up Madison eating it. Dr. Li gave Paige some flower-water stuff and after she eats the candy she's supposed to say, "I love what I just did, but I won't do it again," and then drink the purple Flowers of Providence.

Friday, April 4, 1986

Rupert made some printing mistakes. He has a new boyfriend who goes to Princeton and this one looks exactly like him. Exactly. It's so odd. Elizabeth Saltzman invited us to a surprise birthday party for Wilfredo out in Coney Island. She had an All-City cab pick us up.

It was kind of exciting out there at this place called Carolina's, a Mafia-style place. Spaghetti. Coney Island was closed up and rainy. It was just Wilfredo and Benjamin in drag and Kate Harrington. The Italian owner found out who I was and got autographs. Then the lights went out, totally, and then they came in with a lighted birthday cake singing "Happy Birthday" and these big butch fifty-year-old waiters came in, and Wilfredo groaned and resigned himself and braced for it, and then we waited and—they went right by us to another table! *(laughs)* It was so shocking. It was like when you think you're getting an Academy Award and it goes to somebody else. It was worth the whole evening. It was just great. We couldn't believe it. And then later on they did come for Wilfredo.

Sunday, April 6, 1986

Jean Michel was picking me up to go see Miles Davis at the Beacon and it was rainy and cold, and I curled up and watched TV for a while, and ate some garlic and then he called and said to meet him over there (cab $4). His cab arrived after mine and he had Glenn O'Brien with him and some other people. He and Glenn are friends again. B.B. King played first and he's just great. And then Miles Davis came out, blond, in gold lamé, and he plays really terrific music. High heels. Then we went to Odeon for dinner.

Tuesday, April 8, 1986

Worked till 8:00. I have to have the Maria Shriver thing done soon. I guess I can't go to her wedding because they won't let me bring anybody. And I'd have to stay in Boston and then go alone to Hyannis. Fred wasn't invited. He wasn't even invited to Caroline's. I think hers is before Maria's.

Wednesday, April 9, 1986

Was picked up by Paige at 11:00. We went over to Elektra Records, and she was in a funny mood all day and never got out of it. Then, at the end of the evening, she handed me her video camera and said she didn't want it, that she wasn't going to take pictures anymore.

Thursday, April 10, 1986

Missed lunch at the office, but got in a few good hours of work. Paige gave me the rest of her camera, the attachments, and I told her I couldn't use that voltage in Europe but she said to do whatever I wanted with it, that she was through with it.

Saturday, April 12, 1986—Paris

The gallery was pretty nice, and I guess the guy's just trying to make a name for himself (cab $5.00). Lavignes-Bastille. The dollar's gone down now in Paris so people are more interested in art. I had done the 10 Statues of Liberty thing (cab $6). Wandered around Paris with Chris Makos and Fred. Went to the Café Flore and didn't meet anyone (dinner $100). Stayed in and watched TV, caught up on sleep.

Tuesday, April 15, 1986—Paris

We were going to do live TV on this very famous Johnny Carson-type show. When we got there they were setting up. All of a sudden they heard about Libya being bombed, so the main guy had to leave and he left some lady there, so then they weren't interested in me anymore but they had to pretend to still be, and I don't know if they were really doing it or just going through the motions. I think they just faked it. They didn't even ask me anything and it sounded like they just made it up. They said they put it on tape but I don't think they did (cab $10, $5).

Went to an Arab restaurant or Libyan, one of those kinds of restaurants in the rich area, near YSL. It was fun, started to rain more. Couscous (lunch $75).

We had dinner with Billy Boy and all the people from the gallery and it was like a twenty-course dinner and Billy Boy said he was a health-food person, that he didn't drink, but there he was drinking right in front of me while he was telling me. He ate meat while he told me he didn't, too. He was great company because all you had to do was say "Barbie," and he just talked away and that solved everything, nobody had to worry about conversation. We had a good time and then Chris went off with Billy Boy and did the nightclub scene.

Monday, April 21, 1986—New York

Sam didn't call. Paige didn't call.

Cabbed to 33rd and Fifth ($6) and then the party problems started. I was planning to have a surprise birthday party for Sam, but then Paige had already organized one, but Paige wasn't talking to me. I called her at *Interview* and she said, "I'm working, I can't talk." I said, "Paige, it's *me*." And she said, "Yes, well, I'm very busy." And so she was mad at me, but I knew she was mad at me before we went to Europe because she gave me the camera, and now Paige without a camera just isn't herself, there's no more darting around and being hysterical. And this went on all afternoon, and then Jean Michel called and came over and Paige came in while we were sitting together, and that was tense, and then she said that she would set up the dinner for Sam's birthday at Odeon but that she wouldn't be going to it, and she left work early. And then somebody at the office talked to Paige and told me what was wrong and we straightened everything out—she was mad that I didn't call all the time I was over in Europe, since *she* always calls *me* when she's on vacation, and also because she said I led her on right up until the last minute, letting her think I would make it okay with Fred that she could go on the Paris trip and then instead we took Chris. Fred just didn't want the extra work—it's so easy to dump Chris at a hotel and with Paige it would've meant finding her a nice hotel and then picking her up and having dinner and seeing advertisers, and all that. And Fred was so grouchy on this trip and I told him he was and he said, "I'm old enough to be rotten if I want."

And so at the office I talked to the girl from the Schwarzenegger wedding and they won't let me bring somebody so I told them I just couldn't go alone, and so she started giving me my choice of people to go with and she said, "You can go with Grace Jones." I said, "Grace is not reliable. And if she did go she'd bring her own people, anyway." And then they said, "Well Abe Schmuck is coming, you can go with him," and I said, "I don't know Abe Schmuck." And then they said, "Joanne Schmuck is going," and I said, "I don't know Joanne Schmuck." And then they said, "Lady Schmuck is going, you can go with her," and I said, "I do not know Lady Schmuck." And I mean who are these nobodies? I said, "I guess I can't go." So I guess I'm not going. And Fred said not to try to get him invited, since he hadn't been invited on his own. And Maura Moynihan called and said she hadn't been invited to the thing but that she was going up anyway, to Boston, because Kerry Kennedy and Mary Richardson were going to be there.

So anyway, Paige and I sort of made up and so it was over, it was interesting. It's weird that Paige would get so emotional about me. And then I had to be creative to think of birthday presents for Sam during the fight with Paige. I stuck money in that grandmother-type birthday card, and I did a canvas that had dollars pasted onto it and then I remembered they even make those sheets of money, but this you can just rip money off when you need it, like for tips. Went home and Geraldo Rivera was starting to open Al Capone's secret rooms on live TV in Chicago, but it was going to go on for two hours.

Sam picked me up (cab $10) and we went to the Odeon. And Paige had some advertisers there to do some business, and I told her to invite Keith and his new Juan, and then Billy Boy had just arrived in town from Dallas and Paige invited him, so it was actually fun and not strained. And Keith gave Sam a radio from the Pop Shop which he just opened, and Paige gave him a book on the White House and Wilfredo gave him boxer shorts from Armani.

Tuesday, April 22, 1986

Dilly-dallied around. Went to the office. Gael came up and made those mm-mm noises she makes and she mmm'd and looked at her portrait. I decided to make it a portrait, not a drawing, just because it was easier. She was hard to do. She has good eyes but her jaw was difficult. She was thrilled, I guess. Grace Jones called with laryngitis and I said that maybe I'd rent a plane for the Schwarzenegger wedding on Saturday, so maybe we'll go up together.

Wednesday, April 23, 1986

I didn't call Grace yesterday but I guess we're going to the Schwarzenegger wedding because the weather's supposed to be nice.

Walked down for a while then cabbed ($3) and there was a huge lunch going on. There were Whitney Museum people and Shiseido cosmetics people and someone from Guy Laroche. And the Laroche people told about being in the same building with Adolfo and how the Adolfo people spray their perfume in the lobby and then the Guy Laroche people come and scrub it down and put *theirs*, and back and forth.

Billy Boy came by to see Gael for something and I caught him before he left and invited him up, and it was a good thing I did because he entertained those Shiseido people, he just filled up the lunch with Barbie talk.

Thursday, April 24, 1986

Brigid came rushing into the middle of the Fiorucci lunch and I don't know what was wrong with her—she had this gold bracelet and she said, "I got the guy on the street down from $60 to $40." And I just looked at her and said, "Are you serious?" She said, "Look, it's got 14K in four places." And Jay laughed and asked her, "Was it a black guy?" and she said yes. And I said, "Don't you know that they just sit there on the street with a little stamper machine and stamp on the 14Ks?" And she wouldn't believe us, and I told her to go to the jewelry store on the corner and ask the guy. I bet her $5, and then when she came back from the place she sent $5 upstairs to me because the jeweler just *looked* at it and said, "No." I didn't want the money, though—I just wanted her to have it tested. And Jay was wearing a suit. He looks nice when he wears a tie and jacket, but then you can't ask him to *do* anything.

I called Rupert to find out where he was and he said Edmund Gaultney was rushed to St. Vincent's. He just came back from Taos. He was going to move there. I don't know why he was taking these plane trips, you really pick up viruses on planes. Like he went to Key West before. And they thought he'd had a heart attack, but it was an epileptic seizure. Now he's in a coma.

Friday, April 25, 1986

I talked to Dolly Fox and she said that Charlie Sheen sent her a ticket to go to the Philippines. So that's exciting. I read in the papers that Grace Jones was taking me up to the Shriver-Schwarzenegger wedding in *her* plane, so I guess Grace called her press agent and put that in so I guess that means we're going. And I called her a few times during the day and she'd answer the phone and say hello in this low slurred voice and then hang up. She'd stayed up all night I guess and was answering the phone in her sleep.

Peter Wise agreed to fly up with us—the wedding's right near his house on the Cape, and then drive us back to the plane, so that'll be good.

Went over to Bernsohn's and it was sort of fun. He gave me a bear hug and asked if anybody'd ever given me one, and I said no. But I didn't tell him I didn't want one.

Worked on drawings of Maria Shriver to give for a wedding present.

Saturday, April 26, 1986—
New York—Hyannis, Massachusetts—New York

I got up at 6:00, called Peter at 7:00. The doorbell rang half an hour early and it was Peter with no Grace. He said he went to pick her up and woke her up and she said to come back in an hour. The weather was just a little off. Slightly cloudy.

We went to pick up Grace in the Village and she came out in Norma Kamali black wool underwear. Also a fur Kenzo hat. She put her makeup on in the car and in the plane. We arrived an hour late to the airport. The flight was so easy, through this grey fog all the way and nothing happened, whereas on a clear day sometimes you hit an air pocket and go diving. Grace put on a green Azzedine in the ladies' room of the airport. Peter rented a car, a yellow station wagon, and he knew where the church was and drove us there. Then he went to check on his house in East Falmouth.

The crowd outside the church screamed, "Grace!" and "Andy!" There was the biggest mob I've ever seen around a church. We went in and they had folding chairs near the door. Oprah Winfrey gave a speech. Jamie and Phyllis Wyeth were in front of us and they turned around and said that we'd caused too much commotion outside, they were funny. And at the car rental we'd seen all these glamorous names like "Clint Eastwood" and "Barbara Walters" and the St. James girl, but they weren't there. And watching this storybook wedding, you just wonder about what it'll be like when the divorce comes.

Jackie got communion so she walked all the way around the church with John-John to show herself off, she looked beautiful. The church service was an hour, and the wedding ceremony was fifteen minutes. They had a girl singing "Ave Maria." Peter was waiting outside and later he told us that when Arnold and Maria went out they were nice for the photographers, they rolled down the window and smiled and posed. But Jackie never smiled at anyone, she was a sourpuss. And I guess they'd had parties for three days or something, because everyone told me that at a thing the night before, Arnold gave my portrait of Maria to the Shrivers and said, "I'm gaining a wife and you're gaining a painting." And everyone was telling me how great it was, they really loved

it. And then a friend of Arnold's brought in a sculpture that Kurt Waldheim sent them and it was really ugly. And Arnold's always giving all these speeches, and he said, "My friends don't want me to mention Kurt's name because of all the recent Nazi stuff and the U.N. controversy, but I love him and Maria does too and so thank you, Kurt."

Outside the church there was a limo and a guy shoves us in and we couldn't see Peter. Then we got to the compound and Peter had seen us get in the limo and followed us so he was right there. He handed me the drawings I did of Maria, but then I didn't know what to do with them. But Eddie Schlossberg saw me and he said he'd put them in the house and I thanked him.

It was freezing. Ran into an Austrian and he took us to a tent where oyster openers were getting oysters ready and Grace wanted some right then and there but they said they were being served to people in the other tent, but then someone came over with a plate of them just for her and she ate thirty oysters and then twenty more, just slurping them down.

And Christopher Kennedy was around, he's so cute. Jackie was sitting with Bettina. And Marc Bohan. I didn't look at Jackie, I felt too funny. Then there was dancing and music. Peter Duchin and his wife. He was *(laughs)* going off to do another party. He works so hard. Grace began dancing and it was like in a movie, everybody stopped to watch. She was dancing with a little boy. We were at Joe Kennedy's table with his wife. Talked to Nancy Collins. I asked her if she was covering it and she said, "Oh no no no. This is a personal thing." She was best friends with Maria, I don't know when. We talked about the Stallone piece she did for *Rolling Stone*, which wasn't much, and she was annoyed with Stallone, she said he put her off six times and then didn't give her much time. But he only gave PH an hour and *Interview*'s was really great, unusual. I was trying to take pictures but I couldn't get in there and really shove. Arnold's body-building friends had cameras and so the Kennedys couldn't really stop *them*, but they had their own photographer and they would say, "Oh, Chuck, would you come and take this picture?" And so then the pictures all belonged to the Kennedys.

Like at Madonna's wedding, they should have let guests take pictures because people at a wedding, they'd just be doing it for themselves anyway. Maybe *years* later you'd use them but you wouldn't rush them to the *New York Post* in the morning.

The food was so good, raw vegetables that they steamed while you watched. Grace and Ted Kennedy danced. Then Grace and Arnold were having a talk about what she should do about Dolph because he's fucking all her girlfriends. I told her she should marry Dolph just for a minute, because it'd be such a great wedding. But I always give Grace the wrong advice. I'm the one who told her she'd never make it unless she toned down her look, that people would never go for anything so extreme.

The cake was six or ten feet high. Everybody was coming up and telling me how they loved the painting. Shriver gave a speech, he was in tails. And he was talking about "losing a daughter." Well, I mean, she's twenty-nine—he's lucky to lose her.

And Arnold gave a speech and was saying wonderful love things like that he'd make her happy. It was the first time I've seen really announceable love, saying everything all out loud.

Then it was time to leave and two Kennedy boys had Grace by the door and one was rubbing his cock against her and then we went to the airport.

Sunday, April 27, 1986

The day started out early with my brother John and his wife. And it's so odd, it's two people you don't really know who look so different from you and their ideas are so weird and it's one more thing to make you think what is this life all about. Their son Donald is still in college, he'll get out in August and he's a computer expert so maybe we should hire him at *Interview* if it's not too late, if we don't need somebody before then.

Went to the flea market and ran into Billy Boy with Mel Odom. When the sun was out it was hot, but when it was in it was cold. Billy Boy wasn't in a money-spending mood. They really see him coming and jack the Schiaparelli prices up. He could be good-looking, he has good proportions, but he stoops over and he's pigeon-toed, so you don't notice. But then he is about 6'2" and he had on a leopard jacket and tights and pointed shoes and a Chanel-type cross and dark glasses and no makeup.

Imelda Marcos was on the news crying that she's still in Hawaii and it's like those English movies where the relatives come into the dungeon and say, "We love you darling, but we have to cut off your head because it's the thing to do."

Monday, April 28, 1986

Went over to see Dr. Li and she said, "You've had champagne and cake," because obviously she'd seen in the papers that I'd been at the wedding. So she blew it.

Then went to the office (cab $6). Fred ranted and raved at me when I walked in, with his teeth showing and everything, saying that he couldn't entertain these people, that it was me they were waiting to see. And I said, "Well I was at my doctor's."

Some lady was getting made up for a portrait. She's one of those people plastic surgery couldn't help because it wouldn't be much different. But she has a nice pretty smile, and an open and loving personality. It was a lunch from Café Condotti and there was so much of it. I screamed the other day at Valerie from *Interview* who was dumping into the garbage all these beautiful fresh tomatoes and basil, and she said she was doing it because it was 3:00 and nobody had eaten it yet. These kids are so spoiled.

Then a TV crew with fifty people came to film me for a one-second thing for Chemical Bank and they set up for so long and I did it.

Suren Ermoyan called and asked me to do the cover of *Madison Avenue* magazine of Ted Turner and I said yes because he gave me one of my first jobs, he was the art director at Hearst in the fifties, and then Fred screamed at me. I feel bad because I also turned down doing an American flag for them once.

Tuesday, April 29, 1986

Got to the office and had a talk with Fred about his mood the day before. He's still referring to what I told him in Paris, it stuck with him, about how he should have a young attitude and stop being grouchy.

Keith called and said he was picking me up at 6:00 for the AIDS benefit that Calvin was giving at the Javits Center, where they were going to take a huge picture—done in sections—with Liz Taylor there and lots of celebrities.

Got to the center, there were 100 students from F.I.T. and Parsons. The place is huge and then it snakes around. Liz Taylor was late because she was getting a dress from Calvin. And the little boy from Indiana was there who they say has AIDS so they won't let him go to school. He was really cute. Brooke Shields there looking so glamorous. She's the most beautiful living breathing doll I've ever seen. And I always thought Cornelia was beautiful, but when she stood next to Brooke she looked like an ugly duckling, everything was wrong, and she was saying things sort of to Brooke but under her breath like, "Get away!" She didn't want to stand near her—she *knew*.

The mayor finally arrived and got in the center and Liz hadn't shown yet. It was supposed to be a shot of her and Calvin and the mayor. I was talking to a kid and then he said he was an AIDS patient and you don't know what to say—"Gee, what a great party?" And then you looked and there were spots, and that was back to reality.

Then Liz came in and everybody went crazy and mobbed her, and Keith said, "What do you have to do to be that famous?" And then they dragged her across the room and then all the photographers rushed at her and smothered her and crushed her and when they had used her up, they just dumped her and she was left standing there, alone, they'd gotten what they wanted. It was so strange to see.

Jumped in the limo and went to Mr. Chow's and said hello to all the people we'd just said goodbye to. Grace Jones was making phone calls to Rome—I don't think Tina knew.

Thursday, May 1, 1986

Fred was being nice to me and then it came out what he wanted. He said, "If you come to Europe to the Thurn und Taxis party it'll ruin my whole trip." Because he thinks he'd have to take care of me. I guess he wants to kick up his heels or something. But I can just take someone else with me, I don't know what he's so worried about, I don't have to go with *him*. It's the huge birthday party Johannes's wife Gloria is giving for him—it's days and days of events.

And Sam was in a foul mood so we had a fight, I asked him to get me some potato chips and he turned me down. He was just moping. And Vincent asked him to do something and he didn't. He says he wants a more "important" job.

Saturday, May 3, 1986

Stopped at Sotheby's. Looked at my paintings. Somebody put one of my Ticket to Studio 54 paintings up for auction and somebody's going to make $5 or $7,000, that's the estimate on it . . . I wonder who's selling it. I gave them to Halston and Barbara Allen, people like that.

Paige picked me up and we went to Kenny's opening, but first we went to the Pop Shop, Keith's store that opened the other week that I still hadn't been to. And he has five people working there,

two bosses and three kids. And they get paid $8 an hour. But the store is hard to find, it's that little bit out of the way that makes a big difference. I don't know if people will go, but there were people in it. Bought watches.

Went to Kenny's. It was a good party. They had three cooks there making pasta under the right kind of light and it looked so chic. Kenny was unusually high.

Monday, May 5, 1986

Cabbed to the office ($6) and it was really busy. Anthony d'Offay from London was there and he's decided he loves the Self-Portraits. They acted so unsure before that I didn't think they were going to take them, so when Keith saw them and wanted to use them on T-shirts for his Pop Shop I said sure, and I think they've made up 200 of them, so now I guess we have to buy them all back.

And Bruno came by, and Senator Dodd, I don't know why, and Peter Beard dropped in and everything just all converged. I gave tours.

Then Sylvia Miles said to pick her up at 8:00 for the Liz Taylor tribute at Lincoln Center. Cabbed uptown ($5). And Sylvia was all dressed up and we walked over to Lincoln Center. Liz was an hour and a half late. Finally she came and they showed clips and gave speeches. And I don't know how she gets work, she's so *late*. And her mother was there looking so beautiful. She was the one person Liz thanked. And Liz's one beauty problem now is that when she lost the weight her nose never did get smaller. The liquor's still in it. She has a twenty-inch waist now, though.

Tuesday, May 6, 1986

Wilfredo picked me up and we went over to Calvin Klein's on 38th and Broadway which seemed like a firetrap, you wait for the elevator for hours. John Fairchild was twenty minutes late and they held the show for him. It was great to read in Page Six that Jerry Della Femina's ad agency did a Perry Ellis ad and the boy model was reading a book and there was the word "fuck" and Fairchild wouldn't run it in *WWD* and Della Femina said something like, "Who does John Fairchild think he is? He may be able to push Jerry Zipkin and all the other walkers around, but not the ad agencies." So that was kind of great, hearing Fairchild get told off.

I thought the show was like mild Halston, with the sweaters tied around the shoulders and things like that, coats and hats and pants and all lengths, but Fred said it was "Rich Wasp."

Tried to get work done (cab $4). Bruno had left candy for me and it was all I could think about, sitting there, so I ate it and it gave me energy.

Rupert came up and he still has the same cough, but he said his psychiatrist says it's just a way of hanging on to the boyfriend who died.

Wednesday, May 7, 1986

Ran into Bianca and she thanked me for saving her life by sending her to Eizo for shiatsus and now he gave her another person who'll do additional work on her. She's not walking with the cane now.

Claudia Cohen Perelman was giving a party for Bill Blass, I went up at 7:30 (cab $5). It was heavy-duty. Their house is so chic, she had Jerry Zipkin and Nan Kempner and Carolina Herrera. Do you think they're buying Bill Blass? A girl from *WWD* was there, and she's the type who wears no lipstick and asks tough questions, she's going to go far.

And the big media news of the day was that Joan Rivers was going into competition with Johnny Carson, and it was Barry Diller who got her for the Fox network. She's going to go on a half-hour earlier than Johnny. I don't know, though, it could backfire. You can get sick of people, it can be overexposed, that same style over and over. Poor Johnny—one more woman to worry about.

Thursday, May 8, 1986

Wilfredo picked me up and we went to the Perry Ellis show at 40th and Seventh (cab $6). And at the end there was a pause and they carried Perry out. And some people were crying, they said he had AIDS. Before they'd been saying that he was just upset and having a nervous breakdown because his boyfriend died of it.

Went to the Palladium for the late version of the Andre Walker fashion show. And as we were standing looking over the balcony my crystal fell out of my stomach onto the dance floor and I had to go down and find it. Wilfredo actually found it. Tony Shafrazi was next to me when it fell. It could've killed somebody. I wear it over my stomach between the surgical corsets and it just fell out.

Saturday, May 10, 1986

On Madison Avenue all the people filing into the doorway of the new Ralph Lauren store on 72nd—it looks like people walking into the subway entrance at rush hour.

I had a weird confrontation with Tama at a blind-date business dinner at Odeon. She started saying things to me like, "Do you believe in children?" and "You can always adopt" and "You should get married." And then she said, "Maybe this is too personal for you, we can go into it another time." So now I'm thinking that maybe Tama has put ideas about me into Paige's head, because it was odd when Paige got so upset that I didn't call her from Europe. But then I thought maybe Tama's doing this for *herself*. I don't know, it's too odd. What's wrong with them? Can't they see they're barking at the wrong tree? Someone should set them straight.

Thursday, May 15, 1986

Vincent on the other line just said our *Fifteen Minutes* show won the Fashion Show Video Award at the Palladium thing last night. I was avoiding Paige because I felt strange about all that stuff Tama was saying to me the other night.

Oh, and I'd talked to Halston and he said that I should get the "art press" for the Martha Graham benefit and I told him, "Uh, Halston *(laughs)*, art doesn't really have a 'press.'" And he said, "No art press? No art press?" This was news to him. He said, "Well then we'll have to get UPI and AP."

Friday, May 16, 1986

Worked till 8:00. Was picked up by Thomas Ammann at 8:45 to go to dinner at Aurora on East 49th. Joe Baum who had the Four Seasons and Windows on the World and the Brasserie has it. Met Stuart Pivar and Barbara Guggenheim there and the place had sixty lamps, it seemed like a lamp store. Stuart loved it, though. Why is Stuart looking for other girls, with Barbara so in love with him and she's pretty and intelligent and now is even making lots of money? Why? It's crazy. I mean, why did he leave his family to just live alone the way he's doing and worry all the time about finding girls to have sex with? And actually, I think he's only interested in twelve-year-old girls. I see him looking at them. It's sick. Creepy. I have a feeling he likes to do things like smell dirty underwear, though. I just *(laughs)* have that feeling about him. Barbara likes him because she says it's like not being with anybody, that he's just absorbed in his own things. He's really interesting, though, he knows so much about art and music and history and everything. The food was cold, but it came with those covers on it like it was supposed to be hot.

Saturday, May 17, 1986

Fred was upset because I'm doing the Martha Grahams, that 300 more prints of mine will be in circulation. And I'm upset because the Kent Klineman contract for the Cowboys and Indians gives Klineman "final approval" and I can't believe Fred would let that happen.

And there's that problem with that John Wayne print, they can't get permission for it because nobody can give it. It's a still from a Warner's movie and I don't know why it was even *called* a John Wayne because otherwise you couldn't tell *who* it is.

Ran into Tama, she said, "I'm sorry for asking you all those personal things the other day."

Sunday, May 18, 1986

We went to the Javits Center for the accessories show. Gave out 250 copies of *Interview*. And I was so shocked at the show because I had just bought some balls from a girl at the antiques flea market who had become sort of a friend, she was from Max's and everything, and she even told

me this *story* about how she got these one-of-a-kind balls, and then I go to the accessories show and there was a *whole crate of them!* I was so hurt because I thought she was a *friend.*

It's why I stopped buying American Primitive, because people could just paint it and bury it for a day and sell it to you. That's when I got into Art Deco because it was with a label and in books. But Stuart thought of a great way to get even with her, he's going to tell her, "You know that horse I bought from you for $12? I sold it for $10,000. It turned out to be the *prototype* for all those fakes." He'll just tell her that. Isn't he smart? Isn't that great?

Oh, and did I say that Tama told me she once knew a girl who worked for Stuart at his apartment, and this girl thought he was so peculiar because he kept a quart of sour milk in the refrigerator and he would go to it once an hour and smell it.

Wednesday, May 21, 1986

Anthony d'Offay flew in from London and he said he didn't like my Self-Portraits. Here's a gallery owner being an art director. He said he liked the other ones that I did but he didn't like these where my hair's up like Jean Michel's. And Rupert's been working so hard on these. Edmund is still in a coma. They're talking about pulling the plug out. I'm so afraid I'll get senile and how will I know? I told PH it was up to her, that she's the one I'm assigning to tell me when I get senile, and she said, "I promise I will tell you but I promise you won't believe me."

Stephen Sprouse called and he was going to the Palladium to Keith's birthday party. We went over to pick up Debbie Harry at the Chelsea (cab $5). The party was fun, except that a cute actor named Tim stole my date, Sam *(laughs),* because when Tim said he was staying, Sam said, "I think I will, too." I wasn't upset, though, I was glad because then that means I don't have to feel guilty about going places with Wilfredo. Really I was relieved because I don't want to get involved. It's so nice not to get bothered by anybody. Somebody asked me if Sam is homosexual or just immature. I don't know. He likes older women, but maybe he wants to be mothered. Who knows? I wish I were twenty and could go through all this again but I never want to go through anything or anybody again in my whole life. Sam and I just kid around. But he cleans up well and he learns things fast. But when somebody corrects him he gets an attitude sometimes and that's hard to change.

Thursday, May 22, 1986

I just read the interview the guy from *Splash* magazine did with me and I don't know how he made it so good because *I* wasn't good when he was doing it.

There was a camera crew waiting at the office, some English thing that d'Offay set up, I don't know what it was. I mumbled.

Left early. Was picked up at 8:00 by Sam (cab $8). Got to the Beacon for the stage show Yoko was doing and she was on already. Met Stephen Sprouse there. She was doing the happy years from 1980–81 in men's clothes and Reeboks, and I don't know why she's doing this. She looks great but this is so stupid, she should be up there in furs and Armanis and looking really rich.

And she should let John rest in peace. All I can think of is that Sean must really want his mother to stop this. He must be embarrassed.

Then went down to Grace Jones's birthday party at Stringfellow's, it was like a trip back into the seventies, neon dance floor and Bunnies with asses. And there was no dinner, so we left there, we just wanted something to eat, we were all hungry, so we went over to the Caffe Roma for just something quick and quiet and we walked into this big scene, it was a dinner for Prince Albert and Bob Colacello was there and Cecilia Peck and Cornelia Guest. A hundred people to say hello to. Took the cheese off and ate the pizza.

Monday, May 26, 1986

Memorial Day. I went out with Stuart again and we went to the same places, the auction houses, and it's so great to go back more than once because then the stuff starts to look bad to you and you get sick of it without even buying it. Ran into Tom Armstrong and his wife.

Tuesday, May 27, 1986

Fred's going to Europe on Friday to the big Thurn und Taxis thing. I'm not going—he doesn't want to take care of me.

Worked until 6:45 and then all the dishes from the lunch were still in the kitchen and I told Fred that the kitchen was dirty and he looked at me and said, "Well I'm not going to do the dishes." Diana Vreeland has been really a bad influence on him. I should've broken that up. In the old days Fred would have been the first person to roll up his sleeves and start scrubbing. I had already called for a car so I just had time to clean the coffeepot and I guess Jay cleaned up the rest. Jay's in a good mood lately. Maybe he has a new girlfriend. Thomas Ammann saw Jay's art and loved it, but that was a one-time painting—he's not painting like that now. The young artists are all now doing abstract paintings because they're making fun of *that* now. They're going through *everything*, making fun of every period.

Went to see Martha Graham with Jane Holzer and Halston. Halston did the costumes. They did ballets from like 1906 and 1930 and it was funny to see what dancers were like then—they were like hoochy-koochy girls. *(laughs)* Ballet needs a new defector—you watch these Russian dancers and we don't have anything like that here. I was watching a Russian group do "Swan Lake" and it was just such a difference.

Thursday, May 29, 1986—New York—Boston—New York

Read an article about the "Billionaire Boys Club" kids who're going on trial in L.A. for killing Ronnie Levin.

At 2:30 was picked up by Fred and Kate Harrington because we had to go to Boston. Cabbed

to the airport. New York Air. I was reading this Peggy Guggenheim book and the best part in it was when Iris Love finds out *(laughs)* she's Jewish—they take her aside and tell her in school.

Ted Turner's on *Donahue* right now. He's so smug. I hate him. Ever since he wouldn't say hello to me once at the White House.

When we got to Boston Mary Richardson picked us up and took us to a Hilton Hotel. And Joe Kennedy came out and gave a speech and he's not a good speaker. He said, "That great American artist who brought art down"—and Fred almost fainted—"to the American people." Well I guess Pop Art did, but he really is a bad speaker. He sounded so false, no heart to it.

Sunday, June 1, 1986

Edmund Gaultney and Perry Ellis both died this past week.

Monday, June 2, 1986

Joe Kennedy came by with Michael Kennedy and I don't know how he can be running for things, he's kind of weird. And they had a bodyguard with them, they'd been down on Wall Street. And after they left I was having trouble blow-drying a painting.

Wednesday, June 4, 1986

There was a lunch for forty-five at the office for Cris Alexander because he's retiring. Peggy Cass was there and I told her she should do a movie about when they operated on her leg and it was the wrong one and then she was crippled in both. And it was all because she wanted to be a good Catholic and be able to kneel, that's how she won the case.

Kent Klineman came by the office and he didn't like the Annie Oakley, and I said how could he not like it since that's the way he *made* me do it. And so then I asked him if he got the John Wayne thing worked out and he said oh yes, that the son, Patrick Wayne, would give permission if I gave him a painting that he could donate to charity, so that was all worked out, and I said, "Uh, what?" He said Fred had agreed, but I know Fred never would have. I mean, this was Klineman's responsibility and I'm not going to take it on for him. If Patrick wants a painting Kent can pay me to do it and then *he* can donate it. And then it was time to go up to the Museum of the American Indian to my opening, so I had to ride up to Broadway and 155th Street with him after this fight, just forgetting about it and putting it behind us because you have to—these days you have business fights and then just have to go on being friendly.

And Crazy Matty's there to greet me, drinking wine. It's a courtyard and small buildings. Really nice, and they did a nice show. It was packed.

Friday, June 6, 1986

There was a dinner for the Oreo cookie at the Waldorf, and I really want to do the cookie's portrait. It's having its seventy-fifth birthday.

I decided to take Wilfredo. All the cookie sellers were around, they were all dressed to the hilt, and it's sad to see these people who have to come from all over the country and put on beautiful clothes to go to a cookie party. As we were edging in, the security man said *(laughs)*, "Mr. Warhol? Are you crashing this party?" The P.R. lady had to come to tell him it was okay. And the big cookie looks so great. The new giant-size Oreo that comes just one-to-a-package. About five times the size of the regular one and lots of cream and the chocolate's so black and bitter, just great.

I was dressed in black and white so I looked like an Oreo, and when the cameras were on I ate the cookies and said, "Miss Oreo needs her portrait done." So I hope the bigwigs get the hint. Oh, it would be so good to do. Jerry Lewis was the emcee.

Wednesday, June 11, 1986

Rupert and I had a big confrontation at the office about Edmund's memorial service, about if I was going, so I went. The traffic was so bad and now I know why commuters get heart attacks from stress, not that I was rushing to get there, but if I had been it would've been awful. We got there at the end. Edmund's father looked like a Southern preacher, a movie character. He was peculiar.

Then Paige and I walked to the Plaza for the Yoko Ono thing and she had her shoes off and I told her she was crazy. I had her turn her *Interview* T-shirt around because it was black tie (cab $4). Yoko and Sean were there. Nona Hendryx was, too, and Roberta Flack got there an hour late. Cab Calloway got a medal. It was a benefit to get Harlem kids adopted. And when you see these kids you do really want to adopt one. They're so cute. I'll give money to anyone who'll raise one of these kids. Spread the word.

Then went to Hunter College where there was a party for the Rodney Dangerfield movie *Back to School*. Got there and saw Sam and PH in the thick of it, and my God, what groupies. They were packed in around him with cameras and PH asked him to take a picture with me, and he was really nice, he said, "Andy, I gotta give it to anybody who's hung in there as long as you." Paige walked me home and everybody else went down to the Harley-Davidson Biker Night at Area.

Sunday, June 15, 1986

Fred said at that the Thurn und Taxis party the birthday cake was one of those old-fashioned cock cakes from the seventies—you know, with hundreds of cocks on the cake and everybody got their own!

Monday, June 16, 1986

A crew that was filming me for English TV was at the office and I told them that they should just follow me around the city and do it without sound, so they said okay, and so I took Brigid's dog Fame and we went around the block. Fame shit and I cleaned it up so that was a good scene, and then we walked to 27th Street looking for stores and there were two guys standing there and one said, "I took pictures of you and Brooke Shields," and the other one said under his breath *(laughs),* "Cocksucker." It was really good. I don't know if he really knew me or what, but there's a lot of color out there on the street.

Keith had a limo and I decided to go with him to the Carlyle for a party for the Ellis kid who wrote *Less Than Zero.* He graduated from Bennington. And as we were going in a bald girl with a fashionable ugly dress was going in. I wonder if regular nonfashion clothes are out forever, if these kids will ever dress normally like, you know, Phil Donahue again. It was such a cute party. I never read his book, but someone sent it to me. All the kids had the right fashionable hair and the fashionable right clothes. And I always think California kids are tall, but these kids were all three feet.

Nick Rhodes called from London and said to call him when I got there, and Julie Anne is expecting the baby in August. He said, "We're expecting a piece of sculpture."

Tuesday, June 17, 1986

Fashion show at the Pierre of Bernard Perris clothes. Paige picked me up. And these clothes, they're like costume clothes. Like somebody just drew this stuff and then somehow it got made. Hookers from Harry's Bar wear this kind of stuff, it's expensive and you look at it and you know it cost money, but you can't figure out who would have designed it. Well, now you know— Bernard Perris, they're all wearing Bernard Perris. It's sort of like Nolan Miller's stuff, like TV clothes. And next to me was Hebe Dorsey, she writes for the *International Herald Tribune* and she raved about Peter Marino. I just love her name. Hee-bee. If I ever have a child I'm naming it Hebe.

Thursday, June 19, 1986

Got to the office and the lady from Florida, Dorothy Blau's friend, was there, and she didn't like her portrait, she wants me to make her hair fluffier which I know is not going to work. And Dorothy sent some of that really good candy. Finally I left and went up with the crew to 42nd Street. Why do these crews and everybody always want to go *there*? I mean, there's nothing there.

Went home and saw there was a party Mark Goodson was having for Norman Lear, so I went over there, to One Beekman Place (cab $4). Bianca was there with Carl Bernstein. Cindy and Joey Adams were there and I brought up Roy Cohn and she said he was on his last legs, that she'd seen him when he came into the city for a small cocktail party someone gave for him. And a lady was there and she said she's so bored since she stopped working and her kids grew up and I said,

"Why don't you adopt a Harlem baby?" I told her how they're so cute and that if you go up there and plunk your money down it's cash and carry.

Monday, June 23, 1986

Fred went to Doc Cox for a blood test, he believes you should know everything, I don't know why. But Rosemary wasn't there to give it.

And Iolas called from the airport and said he'd be at the office in twenty minutes and he was! How could he get there that fast? And Brooks Jackson was with him, and he looked really bad. I didn't want to ask about his wife Adrianna, I hear she's dying now. The cancer.

Jay gave his ticket to the premiere of *American Anthem* to Len, the new receptionist, who's seventeen and about to go to Brown, so then Sam asked Len if he wanted to go with us, which surprised me, because he usually doesn't do that, and Sam was shocked to find out that Len was only seventeen and that he wasn't the youngest kid at the office anymore. But Len is really smart for a seventeen-year-old.

Wednesday, June 25, 1986

There was a screening of *Ruthless People* and that Danny DeVito is so cute, we should all marry him, really. He's just adorable.

Sunday, June 29, 1986

It was Gay Day so the parade was on. Went down to the flea market and ran into Corky Kessler, who I haven't seen in thirty years. Maybe forty. She's the one who once gave me modern dance lessons. She's fifty-five or maybe even fifty-eight. She had a nose job and everything so she has that out-of-town look but she has a great young body. But then I don't know if her body is pulled together by bras and things. You never know. She asked me about the rest of the old gang.

There were millions of girls in the Gay Day parade.

Stuart called and said Mario Amaya died of AIDS, and he was so upset about it and I tried to make it light and he was just so upset saying Mario was the most important person in his life and that he'd taught him everything about art. And I said, "But Stuart, you're not gay, why are you so upset?" And for some reason I always forget that it was Mario who got shot by Valerie Solanis, too, the day she shot me—he just happened to be at the Factory visiting. Just sort of a skin wound, though.

Monday, June 30, 1986

PH got back from her weekend in Miami interviewing Don Johnson, and the most fascinating thing was it turned out that in his down-and-out days Don used to do scams in L.A. with the disappeared-and-probably-murdered Ronnie Levin!

Tuesday, July 1, 1986

Arnold Schwarzenegger was having a party for the Statue of Liberty at Café Seiyoken and I wasn't even invited. And I wasn't invited to Caroline Kennedy's wedding, either.

Friday, July 4, 1986

Sam picked me up at 2:00 in an All-City cab and we rode down to Tenth Avenue and 23rd Street. Bought some souvenirs ($20). Didn't seem like the Fourth of July, there were millions of people all over town. The MTV boat left at 3:15. Everyone got drunk. There were no really big stars. Vitas Gerulaitis was there and Janet Jones, the actress from *Flamingo Kid* and *American Anthem*. No rock people except a Bananarama girl. Annie Leibovitz took pictures but only of the boats. Vincent and Shelly were there.

I had to hit a gong and I was terrible. The food was horrible, Dorito chips and undercooked hamburgers from the Hard Rock and pork and beans.

The MTV boat was the only ugly one—balloons all over it. The other boats were all plain and elegant. We watched the president's speech on two TVs. At 7:30 Don Johnson came. A little boat brought him out to the MTV boat and he had fifteen bodyguards and he was in a big fat hat and he wouldn't come on board unless they put steps down. He was with a girl who looked like Patti D'Arbanville—but it wasn't—holding his baby, and then they came on board and went into a room and never came out to talk to anybody.

And at 9:45 the fireworks started, and we were pretty far away from it. Finally the boat docked and they whisked Don Johnson into a limousine and we looked around and found a couple of gypsy cabs.

Oh, and the best thing was that when we were getting off, the Z Z Tops saw us and took us into the Z Z Top room and that was fun, they want to visit us when they come back in August (cab $30). Dropped Sam.

Sunday, July 6, 1986—New York—London

Chris picked me up so early (limo $70, magazines $30, porter $10). Got the Concorde. Was met by Anthony d'Offay, went to the Ritz Hotel (porters $20). I had a really big double room, like three rooms. The phone ran and it was Billy Boy. Then Tina Chow called and said that dinner was on. I told her not to have a party for me but she did it anyway.

Cabbed to Mr. Chow's ($7.50). It was fun, and she had all these great people. Mick and Jerry Hall, Nick Rhodes, Billy Boy, and all the English swells. Everybody was really sweet to us. Tessa Kennedy, Jennifer D'Abo, Ramon, Robert Tracy, Rifat Ozbek, Manolo Blahnik, Jerry Zipkin.

Monday, July 7, 1986—London

Billy Boy was around constantly. Went to the gallery and it was great, looked at the pictures, it was kind of exciting (cab $5). Before dinner I ordered tea sandwiches. Cabbed to Mark Birley's club, Mark's, for dinner (cab $7).

Tuesday, July 8, 1986—London

Went to lunch at the gallery because it was my opening that night. And then went back to the hotel (tip $5). Had more tea sandwiches. Got some jewelry from Billy Boy to wear to the opening. Then went to the gallery and it was really crowded, so I autographed for two hours. Those cute kids were there who want us to do their music video—"Curiosity Killed the Cat." Chris followed up on them, kept calling. Lots of photographers. Then there was a big dinner after that at some old arts club called Café Royale where artists would have big openings, like Augustus Johns. D'Offay had about a hundred people, it must've been expensive. Then Fred took me home. Ordered up tea sandwiches.

Wednesday, July 9, 1986—London

This is the week in between Wimbledon and Fergie's marriage, so it was exciting. The week Boy George was being in the papers for his heroin problem and they were trying to find him, big headline news.

Chris and Billy Boy came to my room for breakfast (tip $10). Then did the same old thing—wandered around London (cab $8).

Thursday, July 10, 1986—London

Took pictures of Big Ben and things. All the funny English spots. Bought some magazines ($20). Went to dinner and then had to go to Heaven and met Gloria Thurn und Taxis and her husband Johannes. She was sort of cruising for him. Billy Boy and Chris were there.

Fred and I snuck out. Billy Boy had a fight with the paparazzi *(laughs)* because he wanted to be *in* the pictures (cab $10). I asked him to come to the room to chit-chat and he said no, that he just wanted to "go home and go to bed."

Friday, July 11, 1986—London

I found out Billy Boy ran right back to the disco and was up all night social climbing.

A society lunch at Marguerite Littman's on Chester Square (waiter $5, cab $8). It was really fun. She's so together. Her husband's the lawyer for the queen. Dagny Corcoran was there and

some other glamorous ladies. So after that we went off to the King's Road with Chris. We didn't invite Billy Boy.

Saturday, July 12, 1986—London

Our outing to Catherine's. Had breakfast, got in a car and drove for two and a half hours to Gloucestershire. Catherine was fun. She's now Lady Neidpath. She took us around and gave us a tour. She dropped a whole bowl of spaghetti at lunch and just picked it up and put it back in another bowl with the glass in it and everything, and then served it to the people who came later like Kenny Lane. They barbecued beef but it started raining. They dropped a bowl of raspberries and picked them up, too. Pretty table setting and grand. So dirty in the kitchen with children and dogs and maids. People with babies serving. Catherine really did a lot of the work herself.

Sunday, July 13, 1986—London—New York

Got up at 7:30, I don't know how I did it. I'd been reading the biography of Cecil Beaton. I'm in it a lot when I knew him. And Sam Green was in *everybody's* life, such a big part—he's had Yoko Ono and John Lennon and Cecil Beaton and Greta Garbo and me.

We got lots of work, sold a lot of paintings in London—one to Carnegie-Mellon—and Anthony d'Offay even said he'd pay for Chris's hotel bill, which he'll die over when he sees that Chris made eighteen phone calls a day to New York. And Chris got *five jobs* over there—one from Polaroid—and he actually *thanked* me for the trip. I only wish I could think of a more deserving person to give these opportunities to. But in his own way Chris does take care of me.

The show. The show. I mean, walking into a room full of the worst pictures you've ever seen of yourself, what can you say, what can you do? But they're not the ones I picked. D'Offay "art-directed" the whole show—he'd tell me he wanted a certain picture, and then I'd think he'd never remember, so I'd do the one *I* liked instead, and when he'd come back to New York he'd say that that wasn't the one *he'd* picked. And he didn't want the big camouflage, he wanted the little ones. But he had class, he arrived at the hotel with his wife at 7:30 in the morning to say goodbye. I thought they were going to ride with us to the airport, but they didn't, so that was good. His hotel bill for us will be about $10,000, I think. Yeah, he was nice.

Oh, and God, Billy Boy turned out to be a nightmare! By the end of the trip everybody hated him. It was worse social climbing than anything Suzie Frankfurt ever did and as Fred said, at least Suzie was always an old friend. Everyone we'd introduce him to he'd have their phone number in a minute and be inviting them to lunch and giving them his earrings and everything! I mean, he was on *my* TV show for *hours!* One they did on me. And he was popping into every picture and one photographer told him to get out of it and Billy actually hit the guy *(laughs)* with his own camera. And I'd be up so late reading, like to 5 A.M., and then I'd get calls early in the morning—"Is Billy Boy there?" He'd tell people he could be reached in my room for breakfast! He did bring me flowers one morning, though. He's like a more together Jackie Curtis. And Chris really hates him now, too. They had a big fight because when we ran into Gloria Thurn und

Taxis and her husband at Heaven, Billy was so sweet to them but after they left he said, "I hate those fascists," and Chris got mad at him. I guess Billy Boy felt he should've been invited to their party or something.

Tried to make phone calls but my hands could hardly move. Fred said that all the chic people were in Europe, that they'd skipped the Statue of Liberty thing. Like Jerry Zipkin and Ahmet. How would that happen? Do they call up Nancy Reagan and ask her, "Will the Statue thing be any good?" and she says, "No"?

Monday, July 14, 1986

It was good to see the good old New York papers again (newspapers $4). I read in "Suzy's" column about the party Tina Chow had for us in London and it sounded so great.

Paige still seems to be mad at me. I guess she's just living her own life now. It's better that way.

Gael said that Albert Watson got the job as the queen's photographer. And after I just am reading Cecil Beaton and how much that meant to him.

Tuesday, July 15, 1986

Wilfredo styled Milton Berle for *Interview* and got his autograph for me, which I hadn't gotten when I did *Love Boat*. He was just on one of the morning shows and he walks on TV like he owns it, it's so great to be that confident. He asked Wilfredo, "Should I sign it with my dick?" He looks like an old tailor.

Victor came by and he said that Halston wants to meet with me without Paul about Montauk. But we're not making any money off renting it to Halston, it just pays the mortgage.

Wednesday, July 16, 1986

Cabbed to the Palladium ($6). John Sykes was up on stage. And they were showing the TV show that this MTV kid had gotten together in five hours and it was great. It was everybody saying things, putting down John, like a roast.

And Steve Rubell was there, he bought the Diamond Horseshoe that used to belong to Billy Rose. Which is I guess in the West 40s near Eighth Avenue. I took Dolly Fox to this and got gossip out of her. She's still living with Charlie Sheen, he gave her some pearls which were beautiful—I think they're dyed black, though, but they're beautiful—and he gave her a diamond ring.

Oh and yesterday Gael told me to check into whether Ron and Doria Reagan were breaking up. I told her that if she had a scoop she should call *People* magazine and make $150. *(laughs)*

Brigid was just on the other line, and she said that her mother doesn't have much more time. She doesn't seem sad at all, just like she wasn't really when her father died. She seems sort of thrilled. *(laughs)* I don't know why I say that, but I do. She's going to be getting millions.

How do these doctors really feel about sick people? Do they care about you and really want you to get better or is it just a business? I mean, I think about doing portraits and do I really care if they look good or is it just a job? And that's just a superficial thing—it's not life and death.

In the morning I'd gotten Stuart to go to the crystal doctor with me. He said how could I be going to these people when I'm supposed to be smart. So we went to Bernsohn's and there was a visiting doctor there, American, but he lives in Japan. And he has a new crystal that's for rolfing, a big round one. It does what rolfing does when they knead every muscle, but without doing that. And the doctor tried it on me and told me to think of white light and white arrows, and Bernsohn and the doctor were in a circle holding their hands up around me and Stuart's eyes were just rolling up, he couldn't believe it.

I always wear two crystals—a "vitalizer" and another one. They look like diaphragms. Dr. Reese's son manufactures the crystals. They're called Harmonics.

Thursday, July 17, 1986

Worked till 7:00. And then Ric Ocasek was picking us up to take us over to Madison Square Garden. Ric has a girlfriend, Paulina, who's a big model and Czechoslovakian and her mother was with them, and she looks even younger than the daughter. And I guess maybe I'm not really Czech, because I didn't understand it when they were talking.

And we went to the Garden and I didn't know this could be done but the limo drove right into the Garden. You drive right (laughs) onto the stage. Yes, you really do. Ric and Dylan have the same manager. And he kept saying to me, "You have total freedom, total freedom. Go anywhere, take pictures anywhere—in the bathrooms, on the stage, anyplace." And they took us into the room and Dylan was there and Tom Petty and Ron Wood. And Tom Petty's daughter was around, or maybe it was his wife. She looked just like him.

And Dylan looks good, he had silver-tipped cowboy boots on and he was drinking Jim Beam. And even though they'd told me I had "total freedom," I'm glad I asked before I took a picture of the three of them there, because Dylan said no. And then later Ric found out that Dylan was in a bad mood because he had just had a big fight with his girlfriend who's forty or fifty who I think works for the record company and at the end of the fight she'd said something to him like, "Oh go out and play your 'Mr. Tambourine Man' or whatever." And that would kill your mood—when your lover calls all your work you've done in your life (laughs) "whatever." So I guess he was left without an ego with a show to do.

And the Pressman kid who owns Barneys was there, he'd been at the MTV party the night before, he goes to all these music things, I don't know why. I lied and told him that I'd seen the Statue of Liberty windows at Barneys.

I didn't get any good pictures, really, so I just took four rolls of atmosphere. And Ron Delsener was running, he went crazy at the end because if you go past 11:00 then it costs $1,000 extra a minute for the unions.

Afterwards, at that new restaurant on 81st and Columbus, Metropolis, Dylan came in with his whole family—all his kids and his mother, who was nice-looking with white hair. She didn't look

Jewish, but everybody else did. I asked Dylan's manager if Dylan was Christian now or Jewish again, and he said Dylan's Orthodox and that's why he wasn't doing a show the next night—that he didn't work Friday nights unless the money was *really* good.

Keith Richards was supposed to come to the concert, but Patti Hansen was having their baby. Oh, also, the road manager liked Ric Ocasek's girlfriend Paulina's mother and so she was giving him her address. He was Indian. Paulina said, "We've got to get my mother laid before she has to leave New York."

Friday, July 18, 1986

Grace was so good on the *Today Show* that I should call and tell her.

This is the day I lost my camera somewhere. And the roll that was in the camera was the magic roll—the one of Dylan with his whole family, the kids and the mother. All the other rolls were just at the concert and things.

Vincent had set up dinner with Ric Ocasek and his girlfriend Paulina, and his manager who's Dylan's manager, Elliot Roberts, and his wife or girlfriend, Sylvia, a blonde who represents a Japanese designer. After work Rupert drove me uptown.

Called PH, picked her up at 8:30, went over to Caffe Roma. And Paulina's mother didn't come because she went out with the Indian road manager. Ric won't be in the same picture with Paulina because he's still married.

Ric asked if we wanted to go down to Electric Lady, the recording studio on 8th Street. And we walked down Fifth Avenue, and it started to rain and everybody was first recognizing Ric—he's 6'4"—and then me, so their minds were blown, and we did autographs and this is when I realized that my camera was gone. Listened to Ric's album and now I finally understand how they just make your voice up. It's twenty-four tracks.

He played the album and you could hear every little thing, and you really hear what lots of studio time and work can do for a record although I don't know what it all means—you're not making it a better song, just more commercial, I guess, or . . . But every little thing is so *clear*. Ric said he's been renting the basement there for *two years* and you know how much it costs to rent studio time! He said he's spent millions. Called the Caffe Roma to see if my camera was there, I was in that lost-something mood (phone $.50).

Saturday, July 19, 1986

Went to Dr. Burke's (cab $5) and the chubby little girl, Diana Balton, who used to work at *Interview* was there having a facial, and she now works for *Elle*, she had on pink shoes and a tight-fitting dress and she's turning attractive. She said that after she gave *Interview* her notice *Time* cancelled the job they'd offered her and she was too embarrassed to tell us, so she just left anyway and then she got a job at *Elle*. So had those collagen treatments and then my face was bleeding and red.

Sunday, July 20, 1986

I had to take the dogs out and they pooped on the sidewalk at the corner, and then I picked it up but on my way back a few minutes later, the people inside the store had already washed down the sidewalk, I guess they saw from inside. So I was embarrassed. Ran into the doctor and his family who live next door. And they had a wheelchair with a cake in it and they said that the daughter was getting married at 4:00. And the cake looked beautiful. It'd been made three days before out of marzipan so it was turning yellow, but it was great. I got a picture for the *Party* book.

Tuesday, July 22, 1986

I've been watching this stuff on Fergie and I wonder why doesn't the Queen Mother get married again. This English journalist was so mean to Fred. We read her article and she used four words I'd never seen before in my life to describe him and Sam had to get a dictionary and they all came out to mean "slave." One was "a beautiful amanuensis." But she was nice to me, she didn't put any of the dumb things I said in.

Paige came in and talked to me, so I guess she's finally not mad at me. You know all these Wall Street businessmen types are always crazy about Paige because they think she can make their lives more glamorous, which they're right about—she could. But she's never interested in them —she only likes the young artist types. The drug addicts.

And I want to put *(laughs)* Ann Lambton on the cover of *Interview*. Everyone just screams at me when I say so, but I really do. I think she's going to be a big star and she's really interesting, so we'd have the first big interview with her.

Went to the premiere of *Heartburn* and when we got there the lady said, "Will you step over to the right for photos?" And I did and not one person *(laughs)* took a picture. Except Ron Galella, because it was too odd not to so he was being nice.

The good scene in the movie was Jack singing "My Boy Bill." He's just magic, you really want to fall in love with him, even though he's old. He's just got it. And the other night when I saw Carl Bernstein I asked him about the movie and he said, "I made them change it all." But he still comes out a stinker.

Then we went to Metropolis to the party. Mike Nichols introduced me to Nora Ephron and she did the early article on Edie for—what would it have been for? *The Herald Tribune*, maybe? She was looking off into the clouds, she didn't want to talk. She looks the same, I was surprised at how good she looks. I had three desserts. Wilfredo dropped me (cab $6).

Wednesday, July 23, 1986

Oh, and it seems like Paige is her same old self because she just got the new Polaroid camera with all the different lenses and she's excited again. I never did really know what was wrong.

Our phone lights were broken so I picked up a line by mistake and Brigid was talking to her mother on it and it was so sad. I just had to listen. Her mother was talking about pulling her wig off her head and the bumps on her head. Here she took care of this man all her life and the second he dies, she gets cancer. She never had a chance to then go out and have fun.

Then Rupert drove us over to 14th and Eighth where the Odeon guy, Keith McNally, is opening Nell's with Nell Campbell from *The Rocky Horror Picture Show* as the hostess. And he wanted our opinions on the food, and if he should charge $15 or $5 to get in. It's a disco downstairs and upstairs quiet and no noise. I said the downtown people would resent the charge and that it'd just turn into a disco, not anything higher, it wouldn't be a private club or anything. The downstairs looked like a real firetrap.

Thursday, July 24, 1986

The Robert Miller Gallery and the Pace-MacGill both want to do a show of my stitched-together photographs in October. I think Fred wants Miller. But I'm having a Piss painting show in October at Larry Gagosian's great new gallery in the Sandro Chia building on 23rd Street, and there's also a Dia show in October and I think having so much going on at once is too put-downable, so maybe the photography show should be later.

Anthony d'Offay came by with his wife and if they're so rich, I don't know why she's missing a tooth. Their seventeen-year-old son sent me a letter that was simple and so adoring and it shows what you can say with a letter, it was so effective. He mentions Billy Boy, though, so I don't know if he has a problem.

I was supposed to be picked up by limo for Elliott Erwitt's photo for *Travel and Leisure*. They decided they wanted Grace, too, so then it became Waiting for Grace.

The kids got me a cab and we went up to Erwitt's apartment on Central Park West because he had called and said the light was going, not to wait for Grace. Grace lives down by the Anvil. She arrived and even if she *is* the latest person in the world, she's sweet, and she was fun. She thinks we should become a couple and that she could make me happy. Can you imagine her cocaine friends running through my house? She still can't get over Dolph dumping her and she said he's not going to make it without her, and I think she's right, he should've gotten more out of her before dumping her. She says he goes around the swimming pools in his little shorts and the girls go crazy. And she was complaining because Jean-Paul Goude doesn't even see their kid who's five or six now. Grace felt he needed a father figure, though, so she *(laughs)* found a fairy to live in.

Monday, July 28, 1986

I cabbed up to Peter Marino's birthday party for his dog which was unreal ($5). And a *Daily News* guy was there covering it, so we'll see the angle he takes. There were two dishes that said "Archie" and "Amos" but I hadn't brought them, I just wanted to take photos for the *Party* book. Peter's wife, Jane Trapnell, does the costumes on *Kate & Allie*, the TV show, so Jane Curtin had her dog there. Walked around Peter's office which is really big, he has building models and fabric samples all over the place and he must have about forty people working for him. And Jed's decorating business is doing good, too—he's billing millions.

Tuesday, July 29, 1986

Joan Quinn called. She said, "When are you going to do my drawing and portrait?" and I said, "What do you mean?" And she said, "Well, you promised me and I've been the West Coast editor of *Interview* for seven years now." And I said, "Aren't you the West Coast editor because you're social climbing? And aren't you getting *paid*?" And she said that I told her in the Polo Lounge at the beginning when she first started that I would do her portrait. And I just would never mean that. Maybe I made some *joke* about it when she was wangling all these free portraits out of other artists, but I never said anything serious. So then I just told her point-blank that I wasn't going to. I mean, with art especially I always keep my word and I *remember* when I say things. And then I called Gael and Gael said, "Listen, I don't want to get involved." So that really upset me. And I don't know whether I get sick because I get mad, or get mad because I get sick.

And then this kid drops off fifty invitations to this soap opera party at Area that say "Andy Warhol invites you . . ." and I just got furious. I mean, he'd called *once* and asked if he could use my name along with a whole bunch of *other* names, so I said yes just to help Area out, and here I'm the *only name*! And I don't do that for *anybody*, so why should I do it for this kid I don't even *know*?

Then I had to go to Sue Etkin's loft for the Curiosity Killed the Cat video that Vincent and Don Munroe were shooting, and they had rented a half-block van. The group is staying at the Chelsea and loving it. They were such cute, fresh-looking kids.

Then cabbed to Mr. Chow's (cab $8) for a dinner with Gael and Paige and Steven Greenberg—he'd invited us. And he had this big bruiser Irish guy, Bob Mulane, there from Bally Casino in Las Vegas and he said he collected autographs, like Mini Ha-Ha's and then he said he had Patrick Henry's, and he said the quotation, "I regret I have but one life to give for my country," and after he finished, Stuart said, "I have to tell you, that was Nathan Hale." So I *(laughs)* knew right then it was going badly. I could have it backwards, maybe it was the other guy and it was "Give me liberty or give me death," but anyway it was Nathan Hale when it should've been Patrick Henry or vice versa. I don't know. Stuart knew. And we were downstairs instead of upstairs and the noise was so loud, and I started to feel sick. And I really knew it had gone down wrong when I offered to pay and Steven Greenberg didn't stop me (dinner $300).

Thursday, July 31, 1986

Was picked up by Stuart Pivar. We went to the Robert Miller Gallery which is where the old Andrew Crispo Gallery used to be. They said if I let them have the show of my sewn photos there they'd give me extra space. Steve Aronson was there doing a story for *Vanity Fair* on the gallery, and he'd also just finished an article on Stuart for *Architectural Digest*. And Stuart for weeks had been playing it so cool, telling me how he didn't really want the publicity, how he wanted to stay "low profile," how he just wanted to be a "private person," but then when he was talking to Steve you could see he wanted it *desperately*.

Anyway, the photography show they had there was so interesting and I'd forgotten *(laughs)* you can steal ideas. I liked the ones where Bruce Weber had the dyed colors—blue, pink . . . I guess it's like they used to do with sepia. And superimpositions are coming back. Paige is using that new Polaroid like crazy, the flashes are starting to bother my eyes.

I didn't send Liza a note or anything when her father died on Friday. I thought it'd fade away and I could say I didn't know about it, but they're making a big thing, so I'll have to write something, but what? Maybe do another picture of him. But I've already done so many.

And then I noticed the weird thing Stuart does with his hands—he exercises each finger like the piano players do. Like the tendon in the middle fingers he says goes all the way to the back. And he had me feel his fingers, he's been doing it about four months, and they feel like claws. I couldn't even move them.

The Pace-MacGill guy came by, and it's so weird being wanted by two galleries at once, that's never happened like this before, and they're both offering the same things, and it's like having two boyfriends or girlfriends after you. What do you do?

Saturday, August 2, 1986

Wilfredo had gotten tickets for Prince, and so cabbed over to Madison Square Garden ($3). We passed Debbie Harry and Stephen Sprouse who were there, and we sat down just as Prince jumped out naked, or almost, and it's the greatest concert I've ever seen there, just so much energy and excitement. I saw Ron Delsener and he invited us to the party for Prince at the Palladium. Prince left in a limo the second the show was over.

We went into the Mike Todd Room and it was just almost empty, tables set up, reserved, and there, in a white coat and pink bellbottoms, like a Puerto Rican at a prom, *all by himself*, was Prince. He was just great, that image of him being weird and always with the bodyguards and everything was just dispelled, and he came over to each and every person and shook their hand and said he was so happy they came, and he danced with each and every girl—all these weird girls in sixties dresses. Literally with *every girl*, and he wasn't even a good dancer. And he remembered *names*, like he said, "So glad you came, Wilfredo." What manners! And Wilfredo was in heaven. We asked Prince if he would be our December cover and he said we'd have to talk to his manager and we said that we'd asked the manager and the manager said to ask him, and so they said they'd work it out. We were just shaking, it was so exciting. And Billy Idol was there and you know, seeing these two glamour boys, it's like boys are the new Hollywood glamour girls, like Harlow and Marilyn. So weird.

Sunday, August 3, 1986

Turned on TV and saw Jimmy Swaggart preaching and he had a huge auditorium of people, bigger than Prince.

Went to church and it was just organ music, and then went to 26th Street to the flea market and while I was there I verified a fake—that a fake was a fake. It was a portrait of me, actually a good copy. They did a good job, they just didn't frame it right and some of the cotton canvas with the white was showing.

Monday, August 4, 1986

Went to the office. The Hare Krishna kid from Max's in the sixties stopped by—the one who was just in *Hannah and Her Sisters*. He'd been to Gimbel's which is going out of business and he said it's such a shame to see a store that's such a tradition go out of business, that this great name was going down. But it's just a name. So what. And here's this Hare Krishna saying it, it was funny. I guess Macy's will be the only thing happening over on Herald Square.

I read Cindy Adams's obituary of Roy Cohn. She said she knew he was dying at that party at the Palladium when they had to help him up to the podium and that when she shook his hand his weight fell on her. Fred's mad because my name is linked with Roy's in all his obituaries as one of his good friends. And Roy's stuff is going to look just like Rock Hudson's at auction. All weird things that you don't know why they'd be in a house, like things people gave him. His house in town was always just on the verge of being a slum, but the one in Greenwich was more decorated, more chintzed-up.

Wednesday, August 6, 1986

All day people just whispered Happy Birthday, they didn't say it out loud. Paige was getting together an advertising dinner for that night, which I was afraid was just going to be a birthday dinner disguised, so I told her she'd better have at least four advertisers there or there'd be trouble.

The day got strange when Kenny Scharf called and said that Martin Burgoyne was with his family in Florida, sick. That what they thought was the measles wasn't. And I said that the people we knew who had "it" had had the best care money can buy, and they were the first to go, so I didn't know what to say. And Florida seems like a healthy place to be. Madonna was in the papers buying books on Columbus Avenue for "a sick friend" so I guess that was Martin.

Got to Caffe Roma at 8:00 and it was Stephen Sprouse and Debbie Harry and Chris Stein who looked handsome, and Debbie had to leave early to go work on her new record. And there was a Polaroid guy there, and I finally told him that if Polaroid didn't advertise at this point, I was never going to use their name again in my life, and he said, "Oh don't say that, don't let it mean we can't be friends." And he gave me something he said was very meaningful to him *(laughs)*— it was a Polaroid. Of a sunset.

Tama's going to be rooming with Paige when she comes up from Princeton University on

weekends, she's going to be "in residence" down there. We bought the rights to all of Tama's stories in *Slaves of New York* about living with Ronnie—I mean, with "Stash," and Vincent is looking for financing to make it into a feature movie.

Friday, August 8, 1986

Just like old times because Benjamin picked me up. We stopped in at E.A.T. and saw our favorite girl that gives us free stuff. Isa. She used to work in a commune in the sixties, so *(laughs)* I think *that's* why she gives us so much extra food, really dishes it out. Tipped her (food $35). Benjamin and I talked about the jewelry business and it was fun.

Sunday, August 10, 1986

At the flea market I ran into Dolly Fox's mother, who's a Miss America from the fifties. And I also ran into Little Nell buying stuff to furnish her new club with.

Tuesday, August 12, 1986

Kent Klineman was around. He brought a forty-page contract for me to sign about the John Wayne thing. He's there saying, "I don't like the color. What color will the lips be?" And I mean, it's a *blue face!* What difference does the color of the lips make when it's a *blue face*? I mean, he's ridiculous.

Wednesday, August 13, 1986

Went out and the construction workers whistled so I gave them *Interviews*. And I saw myself in a store window and I do stand out like a sore thumb on the street.

Beauregard from *Details* came by and left a new issue, they're going national.

Went to see *Stand by Me* at the Coronet or Baronet. These four little kids and there's the Fat kid, and the Brilliant kid and the Crazy kid. The only disappointing thing was that the kid who's a writer they show writing about it later in life, and this really cute little kid has turned into Richard Dreyfuss! It should've been Richard Gere. Then I would've been happy.

Thursday, August 14, 1986

I originally stopped eating meat to see if I was allergic and I wasn't, but now I just don't eat it much because I didn't miss it.

Candy Pratts came by the office, she was really upset about Way Bandy, she'd been with him

the week before and said he looked great. There's a rumor that he drank Clorox to commit suicide. But I saw him once on TV talking about he always washed his food in Clorox, so do you think that's how the rumor got started?

Friday, August 15, 1986

Read the weekend section of *The New York Times* which had really interesting art stuff in it, about a kid who draws dollar bills and pays for meals with it, then gets change.

Saturday, August 16, 1986

Went to dinner with Wilfredo and Len and Beauregard at Barocco ($165) and then we walked up from Church Street to a new place called Saturday's that's called something else during the week. We got there and it was all beautiful straight models, dressed to the hilt, accessorized with jewelry and T-shirts torn just the right way, like Weber photographs, and they all look like they just fell out of a magazine. And the right age, like twenty-eight to thirty. They parked their motorcycles out front. And beautiful girls, too. This place overflowed onto the sidewalk, it was so chic. I could've stayed there longer but we left at 2:30 (drinks $40).

Sunday, August 17, 1986

My nephew's in town, and he's graduated from the University of Pittsburgh, and he wants a job setting up our office and *Interview*'s with computers. Donald. He has a friend who'll advise us on the hardware and he'll advise on the software, the applications. I had him talk to Gael, call her in the country. He'd probably do a good job. He'll probably like one of those *Interview* girls. He's a good catch—he's cute and smart. If he works for us, he'll have to change his name to Warhol—I couldn't take a "Warhola" running around the office. Oh, and Beauregard told me that *Details* is running a thing on people's real names. Like Annie Flanders was just something like Schwartz. It really worked for her. And Beauregard's real name was Billy Stretch.

Went to the Cooper-Hewitt Hollywood show and there were so *many* people there looking at movie-star stuff. I can't believe there's not a movie museum anyplace. They had a Marlon there, but somehow the placard had come off so I don't know who had loaned it.

Monday, August 18, 1986

The day started with Jean Michel calling from Josie's, she's the South African Calvin Klein model. He's not in a gallery now. He left Mary Boone and they're both glad. He wants to be with Leo, but I don't think Leo's taking anyone on. Jean Michel would just like to have one show there, though, even though he knows Leo won't sell anything.

Tuesday, August 19, 1986

I got Wilfredo invited to the Tama Janowitz dinner that everybody wanted to go to, but then he said he was going to see the guy who plays the harp at Radio City Music Hall. I couldn't believe that. He said he'd come after dinner.

Sam picked me up. I was working on my Wig painting. Jumped in a cab and went to 73rd and First Avenue to Petaluma for Alan Rish's dinner for Tama, and it was a really great crowd. Alan Rish finally gave a really great party. Paul Morrissey was being funny, he knows I've hated David Weisman ever since *Ciao Manhattan* so he brought him over and said to me, "Andy, may I present David Weisman," and I just—I couldn't do it. I couldn't let bygones be bygones. I looked away from him, I didn't want to do it. Weisman's now a producer on *Ironweed*, Jack Nicolson's going to star. Paul Shaffer came over and said why didn't we work on a TV special together, produce it. I told him he could be the new Ed Sullivan and he liked that. The party began when Dianne Brill arrived with her tits and a big better-looking version of her ex, Rudolf, and the Savitt girl had a not-as-attractive version of Rudolf with *her*. It was the crème de la party scene. Patrick McMullan and I talked, he said he's really getting into girls now.

They put me with Tama at her publisher's table, Crown. Which is also our publisher for the *Party* book, I guess, but nobody said anything to me like that they knew about it. It was a wild party, lots of table-hopping, and Tama had her Texas millionaire boyfriend there. Paul Morrissey's acting discovery from *Mixed Blood*, little Rodney Harvey, was there, and René Ricard and Susan Blond and her husband. Anita Sarko, and Michael Musto wearing a slave costume. Billy Norwich from the *Daily News* was there and Lou Reed's wife, Sylvia. And Steve Aronson with Kathy Johnson. So it was fun. Tama left, I guess she went home to fuck her boyfriend. Some people were going down to a party at Revolution. Sam walked me home and we bought the *Enquirer* and a Dove Bar at the Food Emporium. Got home and PH called to find out if I saw anyone near her gold Fiorucci bag—it got stolen at the party and her camera and keys were in it.

Monday, August 25, 1986

Martin Burgoyne called and he asked me to do a drawing of him for a benefit to help pay his hospital bills.

Gael brought me the Don Johnson Miami/Las Vegas issue which had just come in. It looks sort of exciting, and I told her that. Then Fred told me to be sure to tell that to all the *Interview* kids, so as I saw them, I did. I even told Robert Becker I liked the art part, which I actually did for the first time—it had young stuff in it, the clubs and things. Oh, and the best quote in the issue was John Sex's—that the Fountainebleau hotel made a big impression on him when he was little so he's been trying to wear the lobby ever since.

Tuesday, August 26, 1986

Martin Burgoyne called and said he'd come over with a photograph of him and Madonna that I could use for my drawing, but I said he should rest and save his energy, that I'd have it picked up for him.

Thursday, August 28, 1986

Linda Stein cancelled my tickets to see Madonna in the David Rabe play. *Goose and TomTom*. She said her ex-husband Seymour said I was "press" and wouldn't let me come. They're all alike, those record people, so she's on my shit list now. Martin and Keith are going.

Fred's clipping out all the pictures of this Chambers kid who killed the girl in the park, I don't know why. And he said he's rehiring Robyn Geddes! It's like hiring Brigid, it'll be another zombie. I mean, if he was really recovered from his problems *(laughs)* he wouldn't want to work for us anyway, right? Fred said Robyn was "the best worker" he ever had.

And Paige was upset because Fred criticized her about this thing she does during lunches when she gets nervous—she sort of leafs through the magazine—and she said that was her style of selling and if he was going to criticize it, that in that case she just wouldn't do lunches anymore. She said not to tell Fred she was upset, but I did call Fred and reminded him that she sells more ads than anybody, and he said that he hadn't said it in a bad way.

Nick Rhodes called from London the other day and said they had a girl. I think he was disappointed. They're coming here in September.

People from Denmark talked to Fred and want me to do a Hans Christian Andersen portfolio.

Saturday, August 30, 1986

Martin called me in the morning and he wanted to give me his ticket to Madonna's play. He'd already seen it and was too tired to sit through it again, but he said he'd meet me afterwards and take me to the party at Sardi's. Worked till 7:00. Went to the Mitzi Newhouse Theater (cab $6).

The best thing about the play was the costumes which were done by Kevin Dornan who was once the fashion editor at *Interview*, our first. Madonna changes outfits all the time, from one beautiful one to another one. And Sean Penn wore a gun holster and fuschia socks and shoes. The play was like a Charles Ludlam, abstract. Madonna was good when she wasn't trying to be Judy Holliday or Marilyn. She chewed gum through the whole two hours and I did, too. She was blowing bubbles and everything. They didn't do any curtain calls. Liza was there and I went over and said hello, and after reading in the *Enquirer* that she weighed 200 pounds, she wasn't fat at all, really. Marc Balet was there and I got mad at Kevin because here he'd gotten Marc *two* tickets and hadn't offered me one.

After the play Martin met me backstage and there was a big candy chocolate leg there from Krön and everybody was eating it, and Martin was, too. And it's so sad, he has sores all over his

face, but it was kind of great to see Madonna eating the leg, too, and not caring that she might catch something. Martin would bite and then Madonna would bite. I like Martin, he's sweet.

We went in Madonna and Sean's limo to Sardi's. The big bodyguards were with them and they said to the photographers, "If you take one picture we'll kill you." And there was Ron Galella and I felt bad, but what could I do?

Warren Beatty came over and said, "Hi, how are ya?" He looks old, he doesn't look good, but I think he looks unattractive on purpose, because if he just did a few things he could be a knockout again.

At 2:00 I left and went to Broadway myself and got a cab, and none of the photographers cared because I was alone (cab $6).

Sunday, August 31, 1986

It was a weekend of illness. It was Martin, and that rabbit's foot that Stephen Sprouse gave me last Christmas—when I picked it up it just disintegrated. I'd left Martin at the party, he was having fun, even still at 2:00. The dogs weren't feeling well. Jed was in London, I guess, and they miss their weekend vacations.

Tuesday, September 2, 1986

Fred turned down the big licensing deal, it was kind of a relief. He said so, too. He said he couldn't put all that time in.

Wednesday, September 3, 1986

The morning started off with the bad news that our Ric Ocasek video was cancelled after Vincent had worked for a week scouting locations.

Stephen Sprouse came and brought me the Debbie album he did the cover for and it looks great, clever, he really is a good art director, he knows how to use his handwriting and everything. Ric Ocasek came by, he felt guilty.

Robyn came by, and Fred got mad at me for not wanting him to work there again. Fred says Robyn's a changed person, but there's so much action in New York, I don't know if he's doing a smart thing to come back. Now he knows how to silkscreen. Then my nephew who knows the software came and he was waiting for the other kid who knows hardware, and they were going to talk to Gael. His friend's name is David Patowsky or something like that. He's from Pittsburgh, too. These kids should change their names before they come to New York.

Yoko called and invited me to the *Medea* Japanese thing in the park. I invited Jay and we cabbed up to Yoko's and the traffic was so bad it took an hour to get to West 72nd Street (cab $7.50). When we got to the Dakota we saw the limo was still there, we went upstairs and they were all

just leaving, they'd called and found out it was a "rain or shine" concert, and it was really raining, I forgot to say that.

So we went, and we sat in the park and it was the first day I didn't wear my double jacket and it was pouring. Sean left. I started chewing gum just to keep warm. It was a modern version of a Japanese group doing *Medea*. It stopped raining. Afterwards we had to go backstage and the Japanese are so interested in me for some reason. They interviewed me and Yoko. Ran into a lot of friends I haven't seen in forty years.

Then got into the limo and went back to Yoko's and she had store-bought food, it was like the way we entertain at the office. Sean talked to us, he was being friendly, but he was bored. But Jay knew the secret of how you tear a phone book in half—you bake it in the oven until it gets dry and then you can tear it, and I said, "Well Sean, if you're bored, why don't you learn how to read the phone book. I mean, do you know the *last* person in the phone book? Do you know the *first* person?" So then we started looking and he called information and asked them for the number of AAAAAAAA Bar and they would say, "The AAAAAAAA Bar? Yes, sir." And then we called and asked for Richard M. Nixon's number and they said, "Wait a minute," and then there was a click like they were tracing us and Sean got scared and hung up, and then I scared him by telling him that it wasn't *really* hung up, even when you hang it up. And then Sam— Yoko's Sam—called the White House and a recording said if you wanted to talk to President Reagan to call back between 1:00 and 5:00 in the afternoon. And then we dialed F-U-C-K-Y-O-U and L-O-V-E-Y-O-U to see what happened, so we had so much fun.

Thursday, September 4, 1986

A lady came to pick up her portrait and I noticed a scratch on it and I'm standing in front of the scratch trying to hide it when Rupert walks in and makes a big speech about it. About the scratch. One of those days.

Worked till 8:00. Took Wilfredo and Sam with me to dinner at Castellano with Philip Johnson and David Whitney. David wasn't drinking so he was reserved. Philip was thrilled with the young kids. We walked back to Philip and David's apartment and they invited us up, it was the first time they were having people, and some kids were coming out of the building as we were going in and they yelled dirty things like, "You're going up to fuck."

It was great up there, my Cow wallpaper in the bathroom. And it's kind of great, their life, eating at the same restaurant every night. Then we went downtown to the benefit for Martin Burgoyne at the Pyramid on Avenue A (cab $8, admission $30). Martin gave us big kisses and that threw me for a loop. Stayed five minutes. Madonna had been there and left.

Friday, September 5, 1986

Picked up by Benjamin, forgot he was coming. We took *Interviews*.

Worked all afternoon. Steve Rubell called and said that at 7:45 he was having people backstage and for something to eat before the MTV awards which were at the Palladium. No cabs. I kept

walking and I had bundles that filled up my hands. And in the pouring rain with my hands full people were stopping me for *autographs!* So stupid. Dropped my packages off and got a cab down to the Palladium. They had it all roped off and you needed a ticket *(laughs)* to get on the sidewalk (cab $8).

Our seats were in the balcony. Grace Jones was at my table, but of course she wasn't there yet. Her manager asked me would I accept her award for her if she wasn't there on time and I said, "No!" Grace finally appeared just seconds before she had to go up, she had a five-foot hat on, it hit people two feet in either direction.

Went home (cab $6) and read the Tony Zanetta book that said David Bowie got his ideas from copying Andy Warhol in the beginning, about getting the media's attention.

Monday, September 8, 1986

Vincent called and said that the record company wanted us to do the Ric Ocasek video after all, if we could get it done by the sixteenth.

Couldn't get a cab. Then these two ladies stopped for me and said, "Get in the car," so I did. One said, "I'll take you anywhere, I'm just a housewife from out of town." She said she was looking for a job and I told her to call Gael. Maybe she could be a driver. They took me to the West Side, and it was great, they didn't talk much (newspapers $6).

Wednesday, September 10, 1986

I have a new bodyguard, finally. Agosto's brother, Tony. He's going to walk me in the morning and then help around the office in the afternoon. Agosto's upset because I guess he'll have to be on good behavior, but they'll never even see each other.

And Sam's reading *Popism* and he asked me who "The Duchess" was. He didn't know. He sits next to Brigid at work all day and he didn't have a clue it was her.

Susan Pile called from L.A. and she was talking about how Jon Gould is in the hospital out there.

Friday, September 12, 1986

Paige took the Dolly Parton portrait to be taped for the *Today Show*, in a segment on the Neiman-Marcus catalogue.

I'm doing the Gotti cover for *Time*.

The lawsuit against the Gitano clothes company is going on. They're the ones that were making "Interview" clothes, and even came to us wanting to do a joint ad campaign—that's how we found out about it. To file papers it cost $30,000 and we weren't going to do it if the bond we had to post was really high, but it was only $10,000, so we did, and then Gitano changed it to "Innerview." And they said they were going to use *block* letters for their logo, but then they

changed it to *script* letters, so then it *really* looked like *Interview* anyway, Gael said, so we continued suing.

Saturday, September 13, 1986

Walked downtown a little and then cabbed ($5). Sam was already there, he had to do paperwork for Fred. He showed me his high school equivalency diploma and so he really did stick with it and get it, that's good. I worked on the Gotti drawing.

Left at 8:00 to go to Madison Square Garden to see Elton John (tickets $40). He came out like an angel in a halo with a red wig, plus a tommy-hawk wig. And oh God, is he fat. He had on a silver-lamé caftan, but tight—a skintight *caftan*—and the audience loved him. People were coming up to me the whole time for autographs. This big butch guy thanked me for giving his girlfriend one and then he walked her to the bathroom and she's so lucky, it's so nice to have someone care about you. When they came back he thanked me again. At 10:00 Elton was still going strong but I had to leave to go to Indochine to meet Wilfredo.

Monday, September 15, 1986

I think *Time* probably wants a painting of Gotti but I did a collage because I think it'll look more interesting, more abstract. But they probably won't like it, they'll probably say they wanted a canvas.

Gerry Grinberg from North American Watches doesn't like my design idea of hanging lots of the same watch faces off of one bracelet. You know, "multiples," like my paintings. He says men wouldn't buy that. They just want one watch face on a band.

My tuxedo has moth holes in it. Now they're in *that* closet, too, but I don't want to take the clothes out of there and risk maybe spreading the larvae around. I'll have to do a big vacuuming.

Went to a screening at the Coronet of the new Blake Edwards movie. Behind us was Tony Bennett with his art teacher. Tony said he's doing a portrait of Frank Sinatra.

Tuesday, September 16, 1986

Went to the Calvin Klein thing at Bergdorf's. They had covered the whole fountain in Grand Army Plaza with a tent and then there was another tent, too, and it was a fashion show for Calvin's first one-of-a-kind clothes. It was really rich. It reminded me of one of Halston's shows, and so that was really sad. Calvin's gone from bluejeans to couture. Fred was there and Kate Harrington.

Paige walked me home.

Wednesday, September 17, 1986

Charles Rydell was at the office one day last week and he lives in Port Jervis, New York, and there was a kid also coming in from Port Jervis on the bus, and they happened to start talking about Bridgehampton and they talked for about half an hour and then the kid said, "I only know one person in Bridgehampton—Charles Rydell." And Charles told him, "But *I'm* Charles Rydell." And the kid looked at him closely and said, "Oh yes, it's you, isn't it." I mean, this was so abstract. Charles comes in for French lessons once a week and he brought this kid with him to the office.

And everybody's talking about the Bass husband, Sid, leaving his wife for Mercedes Kellogg. And at the Calvin Klein thing I ran into the *Daily News* columnist Billy Norwich who said his real name was Billy Goldberg but that he's *from* Norwich, Connecticut, and he said he kept calling Mercedes in Paris to try to get a comment and she wouldn't return his calls, so finally he left a message with the desk that it was Mick Jagger, and she called him back in five seconds—"Hi, Mick! And he said, "It's not Mick, Mercedes—it's Billy Norwich," and she said, "You devil, how dare you do this!" And he said, "You're talking to the press anyway, so why not give me a tidbit." It was "Suzy" who broke the big story. If I were Anne Bass I'd take a gun and shoot Mercedes. Can you imagine just stealing another woman's husband?

Friday, September 19, 1986

You know, I do think I started this whole bluejeans-with-a-tuxedo-jacket thing because years ago after I wore that to a few big events and was photographed, all the kids began doing it and they're *still* doing it.

Sam and I had a fight, he was mad and not speaking to me. He wants to be a big shot so he gives anybody who wants to show me portfolios *appointments* with me and then I get stuck looking at them and wasting all this time so Sam can act like he's very important.

And the MTV deal—Vincent says it's happening, they're sending us contracts this week, we'll be doing half-hour weekly shows.

Saturday, September 20, 1986

I waited for my new bodyguard Tony but he didn't show up. He forgot. I went myself and passed out magazines uptown. A boy picked me up and I took him into Christie's with me, his name was O'Riley and he said he'd written a paper on me in school, but then after being so thrilled he talked about a "girlfriend" so I was let down, but I didn't care, he was a nice kid.

Walked all the way to the office. Called Jean Michel and he was going to a party at Madam Rosa's, that club downtown, so went there (cab $6) and it's a cool place—when somebody famous comes in nobody cares. Then we left to walk over to Odeon for dinner and there was this "hooker" on the street and it turned out to be Jane Holzer. She was so fat, I couldn't believe it. She said, "We're shooting a Lou Reed video. I'm in it." She was in costume. I hate Lou Reed more and

more, I really do, because he's not giving us any video work. She was getting $100 for the day and she'd been working since 9:00. He wasn't even there, he was doing his part the next day.

Sunday, September 21, 1986

Kenny Scharf called and said there was a party for his wife Teresa's birthday in the park near the rowing bridge you go over to get across the lake.

Met Stuart and went up there and finally found the party and not too many people were there, but in a few minutes suddenly everybody arrived and there were seven birthday cakes. Keith showed up and Alba Clemente was with her little girl and Maripol was there and she's going bankrupt, there's a sale of her stuff on Tuesday.

Ann Magnuson was there and I like her. Nobody's talking about her in the movies yet. I guess they're waiting to see reactions.

Susan Pile called and said she got a job at Twentieth Century Fox that starts in October, so she's leaving Paramount. And the Diary can write itself on the other news from L.A., which I don't want to talk about.

[NOTE: Jon Gould died on September 18 at age thirty-three after "an extended illness." He was down to seventy pounds and he was blind. He denied even to close friends that he had AIDS.]

Stephen Sprouse called with good news—he said that he signed a deal with Andrew Cogan and that I'm responsible because he met him through me and so he wanted me to be the first to know. Isn't that great? He'll have his own store and a collection.

Monday, September 22, 1986

Tony picked me up and we went to the Liza Minnelli memorial for her father at MOMA (cab $4). Stood in the back next to Bobby De Niro but I didn't recognize him with a ponytail.

Doug Cramer who gave me the job on *Love Boat* was there and he said that when I go to L.A. on December third that Shirlee Fonda would give a party for me, and I don't know anything about this trip and I have a feeling it conflicts with something. I guess the whole place there was filled with movie stars, but they look so different in the morning. Martin Scorsese made a speech and they showed clips from *The Pirate* with Judy and *Some Came Running* and it was just great.

Read in the papers about the woman who fell nineteen floors down an elevator shaft, and it turns out she'd come to one of Paige's advertising lunches at the office. She worked for Chanel. She was in the elevator with her husband and another couple and it got stuck and there was nobody around so she crawled up and she fell. Can you imagine how horrible it was being in the car and *knowing* she was falling?

And Sam's still mad at me, so to teach him a lesson and make him feel he was missing out on so much glamour by being mad, when I got to the office I had Wilfredo write in my date book for every night this week: "John Travolta . . . Diana Ross . . . Warren Beatty," but he did it all in

the same handwriting, he wasn't clever enough to vary it, so I guess Sam will realize it's a fake. Because, see, Sam always checks my book and when he sees I'm doing something glamorous that night he plays it goody-goody all day so I'll invite him.

My nephew Don and his friend David were around, working on the computer things at *Interview*. I don't know if they really know what they're doing or not. And then Donald says he's not sure he wants to go into business with David, that he's kind of hard to be with—I'm letting them stay in that apartment I own downtown on Hanover Square, the one Richard Weisman said was a good investment to buy when it went co-op.

Tuesday, September 23, 1986

Was picked up by Tony and we went over to the Animal Medical Center to see the specialist for the dogs. And they have to go back next week for a blood test. Went back downtown. Bought extra *Time* magazines ($6). With my Gotti cover, they picked a nice one for the cover, and it's one of those weeks where *Time* and *Newsweek* actually have different covers.

Cabbed downtown ($6) and Sam had read my appointment book so he saw that I was having "dinner with Cher" and he immediately started talking to me again. I guess he actually does believe I'm seeing John Travolta and Diana Ross this week, too.

Wednesday, September 24, 1986

I hear Diane Keaton came to the office early one morning at 9:00 or 9:30 because she wanted to see the building. She wouldn't come for lunch. Who does she think she is?

Worked till 8:00. Sam stayed on. Fred looked in the book and saw all the Diana Ross and Cher and Warren stuff and started to tell me that when I saw Warren to behave myself or something —*he* thought it was real, too—and I just cut him off. Sam must have told him about my "big week"—he still doesn't know it's all a joke. I regret doing it now because it's all going to turn out to be cruel, because Wilfredo is laughing behind his hand about it and everybody at the office is in on the joke, watching Sam being nice to me, waiting to be invited to these dinners, and oh, I'll just have to tell him that these dinners were all cancelled at the last minute or something.

Thursday, September 25, 1986

Calvin Klein got married to Kelly in Rome. Got to the office and Sam asked about my upcoming dinner that night with Warren and Cher and I just said I couldn't make it and did he want to go to dinner and a movie and he accepted that. And nobody better tell him.

The Beverly Hills police detective in charge of the Ronnie Levin case called *Interview* looking for PH because he read her Don Johnson interview where Don talks about knowing Ronnie. So she gave him the names of two people he should talk to in L.A. to help prove that Ronnie isn't

still alive somewhere, which is what the "Billionaire Boys Club" kids who're on trial for his murder are saying.

Called Keith to get Martin Burgoyne's number. I said we really wanted Sean Penn for the cover and Martin offered to talk to him.

Cabbed to 52nd Street to meet Sam to see *Shanghai Surprise* ($5). I was the only one awake in the theater but the movie isn't bad. Madonna was beautiful, the clothes were great. Sam dropped me (cab $4).

Sunday, September 28, 1986

Paige was going out to Brooklyn to see Christopher O'Riley, the cute pianist who's Stuart Pivar's friend and she didn't invite me to go, too, so she must be interested in him.

I'm seeing Lincoln Kirstein's name in all these Anne Bass articles and gee, I'd really like to do a good interview with him myself. These old guys will pop off soon and they're so interesting. I went over to his house once on 19th Street. Jamie Wyeth took me.

Monday, September 29, 1986

I asked Sam to get lunch and he sort of refused. He's starting typing lessons, we're paying for it, and he's taking French, too.

Cabbed to 59th and Park to Nippon ($6). Sam and I talked shop (dinner $77). Then went to the Baronet (tickets $12). There was no line so we thought it would be empty inside for *Blue Velvet* but we got in and it was packed. And what a good movie, so weird and creepy. A lot of couples walked out. And Dennis Hopper was finally good. Now he should do straight roles. He's handsome, he could get the old Rock Hudson roles. Isabella Rossellini could've been so beautiful without that awful wig. I can't believe she could do a movie like that without breaching her Lancôme contract. Went home, looking out for weirdos.

Watched a Betty Grable movie on TV and the color was so great, she was such a beauty, and they just can't color like that now. Great color and great makeup.

Tuesday, September 30, 1986

Took a few time capsule boxes to the office. They are fun—when you go through them there's things you really don't want to give up. Some day I'll sell them for $4,000 or $5,000 apiece. I used to think $100, but now I think that's my new price.

I got the paper and there was an item about *(laughs)* how Lancôme loved Isabella Rossellini in *Blue Velvet* so much that they renewed her contract for another five years.

Thursday, October 1, 1986

Fred called me in the morning really mad, he said how could Paige and Vincent and I have put an ad for Andy Warhol portraits in the Neiman-Marcus catalog. He was in Europe or something when we did it and he was so mad, saying how tacky it was and that we're the laughingstock of Texas. I just said life was too short to get so upset about a stupid mistake.

I went to see Bernsohn and he said he'd just bought $2,500 worth of Charivari clothes and that he was going to fill up his closet with Armani, and I'm thinking, "God, so this is why he charges so much."

Invited Sam and Wilfredo to James Brady's New York Deli party for his book. Got stuck at the door with Steve Rubell talking at me and spitting in my face the way he does. Claus von Bulow's girlfriend Andrea Reynolds was there. She said she throws a chicken in the pot for Claus because she believes rich people should cook. She's so stupid. God. It was a funny nothing party.

After dinner we went down to the Puck building for the party for the first issue of *Spy* magazine (cab $7). Dropped Sam (cab $6). Wilfredo, too. Home at 12:00, and watched *The Tonight Show* and all these TV people have these white white teeth and there's nothing else that white on the whole show. It drives me crazy. Can't they make them more natural?

Thursday, October 2, 1986

Steve Rubell also told me while he was spraying spit all over me that Barry Diller was giving a big party for Calvin Klein's new marriage and where should he have it?

I took Sam to the Whitney Museum party for Keith and Kenny that I was hosting. Michel Roux of Absolut Vodka was giving it. Keith asked me what big movie stars I was bringing. He said Nick Rhodes was in town and I don't know why Nick hasn't called me. I know he's been here a while. He's being distant.

Got to the Whitney early, had to do some press. Some museum people were there but Tom Armstrong wasn't. Later he said he didn't come down because he was "upstairs hanging Sargents." Another distant person. And Cornelia was distant, too. And then we went upstairs because it was cooler there. Jane Holzer came around 8:30 and we walked to Mortimer's and the block was roped off for the party.

Peter Allen sang inside but I missed it and later when he asked me if I heard it and I said no, he turned away. *Another* distant person. If I run into Sylvia Miles and *she's* distant, I'll know I'm really in trouble. Then at 9:15 we left. Jane and I went to La Reserve at 4 West 49th for the dinner that Michel Roux was giving for Keith and Kenny, they've both done paintings of the Absolut Vodka bottle. Had fun there.

Jane walked me home. I watched *Letterman* and I liked the lady admiral he had on. Oh, and Quentin Crisp was at the Whitney and he looks younger than ever, just great. He told me that Letterman, when you're on his show, it's like being out with a gay guy—you know how they're always looking *past* you, looking around for somebody *better*. He said that's what Letterman's like on the air.

And I took my quarter-Valium and went to bed. And I guess I have to confess to the Diary that I am a Valium addict. I'm addicted. Because I read in the paper the symptoms and I've got them. And starting in December you're going to need more signatures to get them, so I'll have to stock up now.

Friday, October 3, 1986

Talked to my nephew, Donald. His friend David is doing the social New York bit and Donald's more serious. David's going after the girls at *Interview* and not thinking enough about work.

Sunday, October 5, 1986

Stuart couldn't decide whether to go to the flea market or go give a lecture in Bridgeport, Connecticut and earn $200 but he decided to go to Bridgeport because he *(laughs)* wanted the money so he gave this lecture and I guess he's good at it and in Bridgeport he found some garage sales and got a nature encyclopedia for just $3 and here I paid $75 for a regular kind and his has all drawings and everything. This was his "trip to the country." He never leaves town. Stuart is a real weirdo. Full of knotted nerves. And he was excited later because a pipe cleaner was coming over. That's what he calls the girls who come over for sex.

Got stuck in the Polish Day parade. Nick Rhodes was calling during the day but I missed the calls. One of the Taylors isn't in the group anymore but Nick owns the name so it's still Duran Duran.

Billy Boy I hear is in town but he hasn't called me or Chris. And I really hate him now—his jewelry breaks! Every gingerboy broke! Every one! But I can't imagine why he didn't call. He's a social climber, so he must be after somebody better.

Then went to meet that kid named Steven Bluttal from the Museum of Modern Art and went to the closing night of the Lily Tomlin play. Had really good seats. The Campbell's Soup Can was all through it and the play seemed a lot like the *Philosophy* book. She does a bag lady that really sounded like a bag lady. She has a great body. At the end Jane Wagner came out and they were crying and kissed, very feminine. There was a party afterwards but I didn't go to it.

Bianca and Glenn Dubin broke up. I never understood why they were together in the first place, what she could get from him. Because she *is* a hustler and she really was after Calvin—I saw her just be *so* after him. But then marrying Bianca wouldn't kill gay rumors, and Kelly was a real girl. But Bianca should've gone after someone like Sid Bass. I mean, if Mercedes Kellogg can get him—she's just such a dog, that kinky hair. . . .

Tuesday, October 7, 1986

There was a party for Beverly Johnson at Mr. Chow's. Every person in the world was there. Beverly Johnson asked me to go sit at Eddie Murphy's table but I just couldn't. There was just one chair and I wouldn't have known what to talk about. I'd have to be macho. It's funny how you haven't

heard his name in a year, isn't it? I think people want to see lots of cheap quickie B movies. The big stars do these few big expensive movies, and they're away for a whole year. He's got the new movie coming out, *Golden Child*. Grace Jones arrived late and made an entrance.

Peter Beard was there and looks really good. And his new girlfriend is nothing like all his other girlfriends, she's from Afghanistan. And I heard that Robert Mapplethorpe and Sam Wagstaff are *both* in the hospital. Paige dropped me (newspapers $6).

Wednesday, October 8, 1986

Sam's being nice to me because I haven't taken him anyplace in a few days. And Paige told me that now Sam doesn't speak to *her* anymore. I don't know why he gets that way. Surly. He told me that Paige doesn't like him. He wants to be wanted in such a funny way. Instead of working *(laughs)* he wants to be wanted. But if he worked, he *would* be wanted. And Fred is really tough on Sam. And on everybody. Fred is unbelievable. I can't believe how he's changed. When something's done wrong, he just says, "Get out!" Just like that. "Get out!" Just like Mrs. Vreeland.

Steven Greenberg was taking a whole group of us to the *Color of Money* Actor's Studio benefit, and he was picking me up in his limo so I was trying to lock up and there was a problem so I left Vincent there with it and went to the Ziegfeld with Steven Greenberg. We walked in right behind Tom Cruise and Paul Newman, so nobody paid any attention to us. Paige got me popcorn. Saw Aidan Quinn and Mariel Hemingway and her husband. I sat with Cornelia who was more like her old friendly self, and Jane Holzer and Rusty came. And Victor Hugo was there and Ellen Burstyn made a speech and Paul Newman did. And the movie, I slept through most of it. I just wasn't interested in pool, and nothing was explained. And Paul Newman should've had sex with the girl, then at least there could have been conflicts. You didn't know why anybody was doing anything and you didn't care, but there were funny lines. Everybody "in" was there.

And then I rode down to the party at the Palladium with Halston and they'd done the place up like a big gambling casino—huge pool-ball balloons on the ceiling, different colors, it was like walking into Studio 54 in the old days because they really did a big theme number. But it was so boring. Then Paige insisted on escorting me home. I don't know why she gets that way. I'm not a baby—as long as I get a cab, I'm fine.

Monday, October 13, 1986

I got the *Enquirer* with Sean and Madonna on the cover and it was about Martin, how he was once Madonna's roommate and how he now has AIDS. And then Martin called me, and it must be so horrible to read this article about yourself where it says you're dying.

And then I read Steve Aronson's article in *New York* magazine on the Sid Bass and Mercedes Kellogg affair and it was riveting, he really got all the information. He even had about Mercedes returning Billy Norwich's call because she thought it was from Mick Jagger. It was day-by-day how the romance progressed. I have a funny feeling that Mercedes will never make it all the way to

the altar. The divorce'll take two years and you can't spend all that time in bed. Should we all make bets?

The alarm went off and I'd like to know if they can trigger it off from where they are, the alarm company.

Tuesday, October 14, 1986

Had a fight with Fred. He's getting more and more like Diana Vreeland every day. I say that *Interview* is a small magazine and he says no no, it's not, it's not. And he won't let me put my two cents in about it. I tell him, "Fred, *Time* is a 'large magazine.' They get $75,000 a page. We get $3,000." And he said, "No no, we get $3,100." I mean, what's the difference?

Paige said there was the opening of Nell's and that Steven Greenberg had a date with somebody she introduced him to and that he'd take us all to Le Bernardin, the expensive fish restaurant in the Equitable building. We went and it's so elegant, so grand, and the food is sort of ordinary, but very expensive. My fish was cooked in sauerkraut, so it was good, just like eating a hot dog on the corner.

Then we went with Steven to pick up Donna McKechnie who's back starring in *Chorus Line*. Steven knows all these same types of girls in their late thirties or forties who're on the prowl. Like Elizabeth Ray and Margaux Hemingway. Donna McKechnie was giving an interview to Frank Rich, and she's actually beautiful, but she's in a category that you can't do much with—forty-four and with a beautiful body, but it's hard to find another show to dance in. She was kind of classy in a whorey way, and she had a dress that was showing her nakedness. She was too grand for me, but she was sweet.

Then we went down to 14th Street to the opening of Nell's and that was really exciting. Rupert Everett came in with a costar of his. And Nell was sweet, she said I would be the only one allowed to take pictures. But I didn't want to move around, really. Bianca was there and Lauren Hutton and Schnabel and everybody who'd ordinarily be at the Odeon. Paige went downstairs dancing with Benjamin and Schnabel and Alba Clemente and all those people. Peter Beard was there with his entourage. They'll charge $5 admission. I don't know if those downtown kids will put it down because they're so used to freebies. Then we left and I feel funny when Steven takes us out because although he spends so much money on us, I have the feeling in the back of my mind that he may be *(laughs)* a secret cheap person. You know? I haven't figured out yet how he thinks. But he is always so generous to us. He dropped me off. And Steven and Nell both do the same thing—they carry a hairbrush and pull it out and brush their hair all the time. I guess Steven Greenberg's George Washington hair is his fortune, his trademark.

Wednesday, October 15, 1986

Had a call from Chris Makos. Peter Wise is going off to Europe with Hedy Klineman to get her known in the galleries, she's so desperate to be famous as a painter. And the kid from the air force who was a bartender down in Florida when Chris went to Key West a few weeks ago, he's

bringing him up here. The kid is really good-looking, he could be the best of all those models. Chris, you know, as usual *(laughs)*, sees himself as a young boy in this kid. His name is Ken.

Walked to work. Stuart called and wanted to be sure we were coming to the party at Buccellati's to raise money for his art school. I told Paige I'd meet her there at 8:00. Her and Wilfredo. Sam had a typing class.

So at 8:00 Paige called and said where was I? And I went to Buccellati's (cab $3) and outside I said to Wilfredo, "I'm afraid to go in," and this man who was standing nearby *(laughs)* came over and said, "That's very interesting. I am a psychiatrist and I'm staying at the Waldorf if you want to get in touch with me about this, because I specialize in phobias." It was just like a Peter Sellers movie.

So Stuart was there and Paige made a *faux pas* and told Barbara Guggenheim about all the musicales Stuart's been having, and Barbara didn't know anything about them. And when Paige realizes she's made a *faux pas* she laughs hysterically.

Thursday, October 16, 1986

Brigid's really upset because her mother's really bad, and she finally is realizing she'll be an orphan.

Had to leave the office early at 6:30 because it was the night of a Japanese boat ride party, and it was black tie and I had a black tie with me but I only had white Reeboks but Fred and I went over anyway.

Rupert came by with finally some good paintings that I've done. I could actually have a good show, 10' × 36' Camouflages. So the car picked us up. I couldn't close the alarm and I looked like a mess and I just knew it was one of those things where they treat you like royalty to get you there, but then when you step off the boat at the end of the ride, they won't even hand you a token for the subway, they've already "had" you.

Mr. Kuraoka from Nippon was so cute, it was all his food. And Dick Cavett got Bianca to talk on mike and she took a look at me and said, *"What* are you wearing?" I'm telling you, I was *really* a mess. My buttons didn't button, my tie wasn't straight, the turtleneck was showing through the white shirt. And Skitch Henderson was there and I told him how much I missed him on TV and how he really developed that whole format of the host talking to the bandleader that they still use. And all I could think of was that big tax problem he'd had.

It lasted till 9:30 and Fred was his old self, charming and nice to everyone. But at the end he whispered, "Let's be the first off the boat." And sure enough, there was no car for us. They do absolutely everything to get you there and absolutely nothing to get you home. So we paid a limo ($25) to take us and Fred dropped me.

Saturday, October 18, 1986

Stuart called and said that he was interested in a platinum flute at Christie's that was going at auction, and he was trying to get me interested in the gold one. I met him and Sam there and looked at it and it would've made a good necklace. Stuart decided he wouldn't go above $120,000

for the platinum one. The silver one went for $4,400, and then I started bidding on the gold one but my last bid was $22,000 and it went for $40,000. The platinum flute was estimated at $40,000 but the bidding kept going up and up. Stuart kept his paddle up and I could feel his whole body next to me shaking as if he was having an orgasm. He was in a panic to see who the other person was who was bidding, but we looked around and couldn't figure out where the other bids were coming from but when the bidding was over it was Stuart's flute for $170,000, which with the tax and commission is about $200,000. Stuart was in shock. Just in shock.

Everybody there thought it was me who'd bought it, not Stuart. People ran over and started giving me their cards and handing me copies of *Flutist* magazine. It was really funny. Then reporters came and asked why I wanted it, and to some of them I said because it had the World's Fair emblem on it so I needed it for my collection of World's Fair plastic knives and forks, and to some others I said I was buying it to melt down. Stuart couldn't even open his mouth to tell them it was *his* flute, he was still shaking, so I dragged him out of there. The other guy bidding turned out to be from New Hampshire and he looked rich. I told Stuart to invite him to one of his musical soirées and try to sell him something. The flute had a whole story, some man willed it to his mistress but then after he died his family couldn't believe he'd have a mistress so they held it up for ten years. It's American. Boston. Kincaid.

Then Stuart wanted two double martinis and four hot chocolates, so we went and got them.

Then we went to the Antiques Center to see if we could find another flute for $2. Stuart's trying to think of how to pay for this. Then he went home and I cabbed ($6) downtown. I'd made plans to see *Sid and Nancy* with Stephen Sprouse. It was at the 57th Street Playhouse (tickets $18, popcorn $5). Ann Lambton played herself, the movie was sick, real—nobody would ever want to be a punk after they saw it.

Sunday, October 19, 1986

Stuart was still in a daze over the $200,000 flute.

Monday, October 20, 1986

Stuart's flute was on the front page of *USA Today* but they didn't use his name. It just said *(laughs)*: "Record Price Paid for Flute." And he's funny, he pretends he doesn't want publicity, but then you can see he's so crushed when he doesn't get it. Like that story Steve Aronson wrote, he's so excited about it but he still pretends not to be.

John Powers called me from Japan and he's looking for an Elvis to buy. There's one coming up at auction and the reserve is so low. It says "Three Elvises" but I don't know if it's a really big one or just where the images overlap three times.

Tuesday, October 21, 1986

Diane Von Furstenberg was having a party for her boyfriend, Alain Elkann, who was married to the Agnelli daughter. He's French. He's written four books, and in France if you're an intellectual, you don't have to work, they just treat you like this big—"intellectual." Like Loulou de la Falaise's husband who's supposed to be a novelist but I don't think he's ever finished anything. So Diane's going the Marilyn Monroe route of marrying one person for the name, and now she's going with this guy who'll write books about her.

Worked. Fred decided to come along. Closed up fast. Went to the Carlyle, ran into Sue Mengers in the elevator who'd been at the party, she was with her same husband and she's thin and I don't know what she's doing. She lives here now. The cake was in the shape of a book. Bob Colacello was there. I read his article on Bianca in the new *Vanity Fair*. She's back big again, the pictures of her walking with the Salvadorean children in the fields.

Jean Michel called, back from the Ivory Coast. He said they sell meat with four million flies on it—they cut off a piece and just sell it with the flies. He sounded normal, like he was off drugs and missing old times, he wants to do prints together.

Friday, October 31, 1986

Benjamin was supposed to pick me up but he never showed. I wandered around. This was the day of the surprise birthday party Steven Greenberg was giving for Paige at Nell's. For days I'd just been shuffling papers for Paige's party, trying to help Tama do a good guest list, and I couldn't get it together, and then Gael took over and did it all really fast. Worked all afternoon. I went home and then Paige picked me up, and as far as she knew, we were just going to a blind-date dinner at Nell's.

So we get to Nell's and Paige still doesn't suspect anything and then right at the last second, right outside at the door Glenn O'Brien's wife Barbara was getting out of a cab and said, "Hi, Paige, we're here for your surprise party." We couldn't believe it, but Paige was distracted enough so it didn't really sink in and I think she actually was really shocked when she walked into the club and everybody screamed, "Surprise!"

Gael did a really great job pulling it all together and the party was so nice. I sat right where I did on the opening night—right by the front door—and I didn't move once. The party took up the whole street-level floor, and then they let the public in at 10:00 but they sent them downstairs. And it's the new look in restaurants—going for the sort of phony rich look. Dark with stuffed furniture.

And let's see, Thomas Ammann was there and Tama, and Nick Love from L.A. who's staying at Fred's. And Larissa was there, and Jay, and Wilfredo, and Gina and Peter Koper. And the new kid who works for *Interview* who was at Paramount, Kevin Sessums.

Halloween has really turned into a big holiday. It just used to be for kids but now it's the whole city. All the drag queens came in and I didn't recognize Kenny Scharf, I didn't at all. I finally recognized Joey Arias. I figured him out. And Jean Michel came late with his face wrapped in tin foil and nobody knew who he was *(laughs)*—Paige was even talking to him because she didn't know.

Let's see who else was there. Calvin came with Kelly and Bianca and Steve Rubell came and Doug Henley. And Jimmy Buffett's wife. It was a lot of great people. I wanted Martin Burgoyne to come, but he said he had cancer all through his body, so that was ... it was sad.

Sunday, November 2, 1986

Richard Turley called to tell me that Monique Van Vooren was on TV in a Tarzan movie. So I turned it on and it was just incredible—there she was with dark hair and a different nose and so ugly, and it was with Lex Barker. In the end she was shot in the belly.

Ran into Janet Sartin on Park Avenue when I was throwing out bread for the pigeons in the middle of the avenue. She said she did it, too.

Monday, November 3, 1986

Went over to the West Side to Dr. Li's (cab $5, newspapers $6). It was a really nice day. Kind of busy at the office. Sam was depressed, what else is new. He had big circles under his eyes, it seemed like he spent the night out. Vincent had been up till 6 A.M. working on a video.

The Dia Foundation was having my opening. And there was the sixties party that Jane Holzer was having at the Ritz, Fred said we had to go to that. Doc Cox had called in the afternoon and wanted a ticket to the Ritz thing. I was surprised he wouldn't pay because it was a benefit for displaced or disabled kids.

So after the Dia Foundation thing we went to Jane's party and Jane didn't show the whole time we were there. We were walking out and Stephen Sprouse was there and he's really broke. He may be getting kicked out of his apartment. The deal he was going to sign got complicated. Everything always sounds so great until you start talking to the lawyers.

Wednesday, November 5, 1986

Stuart picked me up and we went over to Christie's and they *(laughs)* wouldn't give him a paddle because he hadn't paid for his flute yet. I bought Stuart lunch at Sotheby's ($3.15). He had a bologna sandwich and it looked so good. Remember sandwiches like that? With mustard. And the slices were so thick. Like ³/₈". The girl serving coughed in my tea, but I figured that since the tea was so hot, it'd be sterilized.

Then Stuart's driver drove me down to the office and he's great, the Brazilian bandleader, he got me there really fast.

It was pouring rain. Sam was going to go with me on the Forbes yacht but he didn't bring a jacket and tie like I'd told him to the day before so I disinvited him and took Fred who was thrilled to go.

So we went to the boat. This party was to publicize a new line of underwear. James Brady was a lot of fun, and Susan Mulcahy was there and Fred was in a skirt-pulling mood. And I talked to

Mr. Tisch and his wife and *(laughs)* we were standing there saying oh-how-tacky something was and right at that moment this lady from Texas came over to me and said that she'd just seen the ad for my portraits *(laughs)* in the Neiman-Marcus Christmas gift catalogue. So that cut me down to size and I started to laugh and Fred gave me a look like, "I hope you're happy," but he was laughing, too. He's still so mad that I okayed it for their catalogue while he was away in Europe. So that was really funny.

Thursday, November 6, 1986

This was the night Larry Gagosian was supposed to be giving a pre-opening dinner for me, I thought, but then Fred sort of told me it was cancelled. Somehow he didn't want me at it, I'll get to that later. So when Paige called and said there was a business dinner at Chantilly's which is a good restaurant on Park and 57th, I said I'd go to that.

Paige picked me up and we got to the restaurant forty minutes late. Steven Greenberg and Margaux Hemingway were invited and Michael Gross from the *Times* and Barbara Hodes who he just got married to, she used to design for Paraphernalia and she still looks the same as she did in the sixties. Sonia Rykiel was there, too.

Then Steven wanted to go to Nell's so we went down there, and we walk in and I saw Larry Gagosian and then I saw Fred sitting with Faye Dunaway and Jerry Hall! I'm not kidding! I don't know how that happened, if they were there and just coincidentally were sitting with him, but it seemed like *this* was the dinner that Larry was supposed to be giving for *me*. Fred was mumbling something like that he'd wanted to talk business with them alone or something. But I do think this dinner was supposed to be for me and that he'd told me it was cancelled just so I wouldn't go.

And Gagosian told me, "I got your Rorschach Test for my California show," and I said, "Where did you get it?" He said, "From Leo," and I said, "Oh, really? Did you *buy* it?" and he said, "No, it's consigned." I said, "Well you can't have it." I got mad and tough. Because it's just one more show not to have. And Larry, I don't know, he's really weird, he got in trouble for obscene phone calls and everything. He's weird.

Friday, November 7, 1986

It was a messy day, raining and everything. Saw a great video on MTV by the Models, it's done sixties and it's like underground movies and there's an Edie and a me, and the me looks so cute, he's in a striped shirt, it's great. I don't know the title of the song.

My opening was happening at Gagosian's and Stuart sent his car and I locked up and we went over there and ran into Stellan from Sweden who has a girlfriend who works on fashion at *Interview*, Marianne. And Yoko Ono was there. And we saw the show and Stuart was saying, "They're masterpieces," and I don't know if he was just buttering me up or what. These are the Piss paintings, the Oxidations. And then these nice older women were asking me how I'd done them and I didn't have the heart to tell them what they really were because their noses were right up against them. And it was so crowded.

Then went to Nippon with Sam and Wilfredo and Benjamin and Stuart and Barbara Guggenheim (dinner $280).

Saturday, November 8, 1986

Sam called and said he'd been to four clubs with Benjamin: Rolodex, Beat the Zombie—something like that—and Save the Robot. Dolly Fox called and said that we were on for the Demi Moore play that night. Stuart called and picked me up and we went to a skeleton place on 14th Street, where they had bones from a one-year-old up to a twenty-six-year-old. Then I went to the office and worked all afternoon.

Closed up and went to Seventh Avenue and 4th Street (cab $5, tickets $30) and after the play we went "backstage" which turned out to be *(laughs)* outside. I got Demi Moore to invite me out to her wedding on December 13th to Emilio Estevez, so that'll be a good time to go out, it's the big art time there.

Elizabeth Saltzman had invited me for dinner at Indochine. She was inviting Barry Tubbs and I was the draw. She's with Jellybean now, though. Cabbed to Indochine ($6). Barry Tubbs never came. Elizabeth didn't pay, which was odd because she'd invited us (dinner $200). Somebody came in and told us the whole story of the night before at Nell's, how Fred had stood on a table and pulled down his pants in front of the whole restaurant.

Then we went down to Nell's and there were eight of us (admission $40) and they got us the table in the back. We were there for a couple of hours and then I ran out without paying the check at Nell's. I just felt like it (cab $10).

Sunday, November 9, 1986

Donald was coming over, my nephew, and he's going back to Pittsburgh, giving up his job at the office, and I told him he was giving up a big opportunity. He never changed his name from Warhola to Warhol, that should have given me the clue. He just doesn't like New York, I guess. I never took him out to anything. I don't know if that would have made a difference. I don't think so, but I don't know. He said he's going back to take care of his mother and father because they've been so good to him. I told him oh sure, who're you kidding. His father John is the one who worked for Sears, he just retired.

I called Fred and he was acting grand with me, telling me off. I just couldn't take it. I told him he was sounding very grand for somebody who'd dropped his pants at Nell's and then when I said that he became a different person—he didn't think I knew about that and it stopped him cold.

Watched MTV—the rebroadcast of our *Fifteen Minutes* show—to see if it had aged well, and it did still look current, it looked modern. We've got to get the colors brighter, though. I've got to work on that. It should look the way Madonna looks in her "Papa Don't Preach" video where

she's dancing like Marilyn or Kim Novak. Those strong colors. Blond hair and orange lipstick on black.

Monday, November 10, 1986

Iolas came by, he's having a prostate operation and so my Last Supper show is being changed to December 15, which I'd hoped would be postponed even more, to March. Talked to Michel Roux about doing paintings of the bottles for his new mineral waters.

It was the night of the Barneys fashion show benefit for AIDS in the women's shop. Wilfredo was going and at first Sam said he didn't want to go but then when he heard Madonna was going to be there he felt he might.

We went over (cab $8) and we asked if Madonna was there yet and they said no, but she must have come in some disguise because when Iman came down the stairs, Madonna swooped in front of her and then all the photographers swooped after Madonna. The show was good, great jackets. Good ideas. Everybody was in the show—Joey Arias and John Sex and the girl with the shape, Dianne Brill, and Teresa Scharf. Madonna had on Martin Burgoyne's denim jacket. And then as we were leaving Chris Makos shoved some nuns at me for a picture and then somebody else started to take the picture and he screamed at the guy, "It's *my* picture, *I* set it up!" They were from St. Vincent's, the benefit was for them.

Howard Read from the Robert Miller Gallery was there and he'd just been at the auction where Jasper Johns's painting went for $3.3 million! Which is $3.6 with tax and commission and stuff. So it's the highest price ever paid for a painting of a living artist. And it wasn't even that great a painting, there were better ones. It wasn't a Target or—it was maybe the Numbers. I had Dollar Bills in this sale and it went for $385,000, and a Mona Lisa went for $70,000.

Wilfredo and Paige dropped me (cab $6). I got home and watched the channel 4 news rerun with Sue Simmons talking about me being at Barneys. God, she's a beauty. I met her once at some dinner at the Plaza and she was eating really greasy food, a lot of it.

Wednesday, November 12, 1986

The art auctions were still going on. A Rosenquist went for $2 million. A drawing of Jasper's went for $800,000. A drawing! But Rauschenberg's drawing went for only $90,000. And I guess David Whitney must be a multimillionaire, he has so many Jasper Johnses.

Thursday, November 13, 1986

Fred said that Nell is going to be on the cover of *Vanity Fair* and here we are with all the wornouts—Cybill Shepherd, Diane Keaton. . . . People do like the Cybill Shepherd interview though —they say she's really honest in it. I haven't read it yet.

Friday, November 14, 1986

Julian Schnabel came by with his little girl. We're talking about me maybe doing some different image on top of a fake of mine that he bought—one of those paintings I think Gerard Malanga did. Julian didn't know it was a fake when he bought it.

Mr. Murjani called and invited me to dinner and I asked if I could bring Benjamin and he said why didn't I bring Paige, too. So Stuart picked us up and we went to Murjani's place at U.N. Plaza. And when I walked in I immediately saw this box with a microphone on top and recognized it right away because it was the kind Imelda Marcos took on the Forbes boat and sang with, and then Mr. Murjani started playing it, and he sang "Feelings" with it. It's the box that enhances your voice and you pick from a few songs and then it's a whole orchestra playing behind you. And he has a really good voice, it was like that Indian teenage idol from the sixties, Sajid Khan, or something. and then Stuart did it and it was fun, Stuart can make himself sound like any Broadway star.

Then Mr. Murjani took us to this place that I guess he goes to regularly to meet girls. It was on 77th and Second, I think. And at dinner there was this table of girls next to us and Mr. Murjani and Stuart went over and tried to pick them up. The girls were in their early twenties, and they were going on to a party at the Union Club. And Mr. Murjani told Paige that the other night at the dinner that *he'd* invited *them* to, Gael thought it was one of Paige's dinners so she said to him, "Well since we're entertaining you so lavishly with all these dinners, how about advertising?" I don't know about Gael, is she stupid or not? But then, it was memorable, he'll always remember it, so that's good. The food was just awful—spaghetti—it was uneatable.

Katharine Hamnett was working with Vincent till really late on the video but then she came to dinner, too, and she was sweet. But the odd thing was, there was this boy with her who just stood behind her chair and didn't eat, and there was an empty chair beside her and everything. Finally I said, "Well, uh, wouldn't he like to sit down?" And she said, "What? Oh yes, sit down." It was her assistant. He must have been starving.

Then Murjani and Stuart dropped me and Paige off and then they went to the Union Club to try to get in and find those girls but then they didn't get in because it was black tie and they couldn't remember what the girls looked like.

Saturday, November 15, 1986

Went to Saks and there was a big crowd for the Swatch event. Keith and I did our autographing act together.

Stuart picked me up and Michael Jackson was staying across the street at the Helmsley Palace and we went to a gallery near there to look at Bouguereaus. Stuart's going to try to see him this time. The last time he blew it. Michael Jackson was coming to his apartment at 3:30 but Stuart got home *after* 3:30 so he missed him. But now Michael is in town again and he's wearing a brown wig and dark glasses, and a white gas mask, so if you see *that* coming down the street ...

Sunday, November 16, 1986

Bruno called and invited me to lunch. Went to church, then cabbed to Harry Cipriani's in the Sherry ($4). The food tastes like it's done in a microwave, and I bet it is.

Wilfredo called, he'd been to see *The Mission* for the third time. Isn't that weird? He wanted to be a Jesuit priest once.

Tuesday, November 18, 1986

Stuart was picking me up at my house, so I waited for him inside the door. And now we have a video camera to see outside and I could see a man trying to get in the door with keys and everything and it looked just like Stuart, somehow. It had his attitude. But then it *wasn't* Stuart and he was *still* trying to use a key to get in. I decided to open the door and see who he was and so I did and I think he was drunk or something. He asked for the lady of the house a few times and I kept telling him that *I* was the lady of the house. And then I went back inside and the phone rang and it was Stuart to tell me that there was a man on my doorstep trying to get in and I told him I knew, and then Stuart came to pick me up again, and I went out to the car and past the man who was still there and I got into the limo and Stuart was crying. Literally crying. The tears were streaming down his face. It was shocking, just absolutely shocking. I said, "It was so odd, I thought he was *you* at first." And Stuart was sobbing, saying what if it *were* him and how could I just *leave* him there? And I said, "Well, I think he's drunk and what can I do anyway?" So he said to take him somewhere, put him in a cab and get him where he was going, but how could you *know* where he was going? So I borrowed $20 from Stuart and gave it to a cabdriver to take him where he was going, but he probably just dumped him in another neighborhood. But he was well-dressed. Like a Spanish man in cream-colored Spanish boots and kind of natty. By the way, Michael Jackson never did show up, he called and cancelled right before he was supposed to be there.

Thursday, November 20, 1986

At the end of work it was pouring so hard. Paige called and said that Steven Greenberg would take us to Missoni in his car and we got there late, and I think it's actually the best time to arrive someplace, really late, after everybody's resistance is worn down and they're tired, and then you hit them for an ad. It's like in the fifties when I had to go around and see art directors looking for jobs. If you went early in the morning you never got anything, so I'd wait till 12:00, lunchtime, because by then they had stopped getting calls and they were tired and you had a better chance. People really do stop calling offices at lunchtime because they assume the people will be out.

So we went to the Missoni thing and then went to Le Cirque. Gael was there having dinner with Steven's friend, Mr. Mulane, the Bally Casino guy. He's really nice, he knows everybody.

It was pouring rain. Got home and turned on TV and saw that John Tesh, our old friend who used to be on the news here, is the new main guy on *Entertainment Tonight* with Mary Hart.

Friday, November 21, 1986

Sam just ran out at 5:00 and didn't arrange for Fred to get home from the hospital from his five-hour knee operation. He'd gone in at 8:15 that morning. And when I got home he called and said he'd just gotten home by himself, that he'd been in the waiting room until noon, and he was kind of high. He said he thought he'd "joked with" the doctor while he was under anesthesia, and oh God, I can just imagine what he said. Fred really could be bad under those circumstances. And I complained a lot to Fred about my personal life which I shouldn't do. I should just always say everything's cool. He told me that I shouldn't get involved with these kids' personal lives, like Sam's and Len's, because it's none of my business. And he's right. I was going to scream at Len for not telling me the truth about Sam spending the night a few weeks ago at Jill's boyfriend's apartment—but then it's none of my business. And then I guess Sam got involved with Victor the other night because Victor called and said, "I have someone you know very well here . . ." and I couldn't imagine, and he said, "The blond boy who works for you . . . Sam." And that stunned me.

Saturday, November 22, 1986

I watched *Young Bobby Kennedy*, a documentary, in the morning. They put it on because it was the JFK death anniversary, I guess.

I'm always surprised that one of the Kennedy kids wouldn't want to know what really happened, who really killed JFK and Bobby Kennedy. You'd think Caroline would get interested and say, "I don't care if I get killed, I want to know."

Went to Doyle's and then to Sotheby's and got catalogues (cabs $4, $5). This is right before they closed. And they told me there that I'd just done very well. The Soup number two went pretty high at $6,600. I forgot we'd sent Jay to bid on Ladies and Gentlemen, a set of those, and some Flowers. Jasper's Numbers set went for $140,000.

There was a dinner at 7:30 at River House and Paige said she'd pick me up. She arrived and had a basket on her head with flowers on it. It was left over from the photo session for Tama's book, *A Cannibal in Manhattan*, that they'd done that afternoon at Tavern on the Green. Paige is art-directing the book, setting up the photos in it. Stuart had told me how beautiful the "hat" looked, but it was just—ridiculous. She'd had on a silver outfit, but for the dinner she changed into a black Gaultier but kept the hat on. The dinner was for Francesco Clemente, it was given by the Angela Westwater lady who has the Sperone Westwater Gallery, and the first person whose hand I shake turns out to be Alan Wanzenberg—I didn't recognize him right away. And then I realized Jed was right across from me. Then Edit deAk came over and told Paige and me, "Oh, the two of you should be married." A Tama-type line. I made a *faux pas*, I said to Alba Clemente, "Is Bianca coming?" I forgot that Bianca had had an affair with Clemente. She said, "No. She's not a friend of mine." And Thomas Ammann said Mary Boone wants to represent me and that I should think about it. Keith and his friend Juan were there. And then about thirty-five people were going down to Nell's. I didn't want to go and Paige did so I told her to go ahead but she insisted on dropping me off—I can just feel all the weird problems starting again.

When we got to my house, Paige's flowers had fallen out so she was going home with an empty basket on her head.

Tuesday, November 25, 1986

The second day of the auctions at Sotheby's—Renaissance. Was picked up by Benjamin. Stuart arrived late and looked like Dracula. We lost out on everything, which was fun—it was all learning and seeing and touching and feeling, and it didn't cost a penny. Left there and walked for a while.

Oh, and Stuart told me I'm the only one who talks to all the black guys who work at the auction houses, asking them what they think of the things. *(laughs)*

Went back to the office and worked from 6–9:00 and everybody else was working late, too. Fred's walking with a cane. Then invited Paige and Rupert to Nippon. It's nice not to have Sam to worry about anymore. Since I found out he has a secret life and sleeps out a lot, I don't feel responsible for him.

Thursday, November 27, 1986

Thanksgiving. The phone rang and it was Wilfredo saying he couldn't come with us to feed the poor, that he was going home to New Jersey. Paige called and said she'd pick me up in ten minutes, but it was half an hour before she and Tama and Stephen Sprouse arrived.

Victor had called in the meantime and I invited him to feed the poor with us. I don't know if he's on drugs or if now he's just always paranoid.

So we went to the Church of the Heavenly Rest on Fifth Avenue and 90th, and the good-looking priest had moved to St. Thomas's, that big chic church. And it looked overstaffed—like they had one volunteer for every eater. Everybody had their own waiter. So we went upstairs and there was this big dykey Irish woman giving the helpers their assignments and she said, "Are you here for food?" And Victor got offended and that started him off insulting people in the line, saying, "Just eat fast and fuck off and get out so we can clean up." This is in a *church!* And finally I told him, "Victor, we're here because we *want* to be." And there were a lot of photographers, I don't know if they were from the newspapers or what. So this dykey lady says to me, "I'm putting you on security, to keep people in order." And I said, "I can't do a thing like that." And she said, "Well that's what you're going to do." And I said, "No, I'm not." So I ignored her and we served the food, and it's such a great church, there was food for people to take home, too, and I was giving everybody a lot. If there's this many hungry people there's really something wrong. A lot of people looked like they just came for a meal so they wouldn't be *lonely*, though. Maybe they even lived on Park Avenue, you can't tell.

And at the end it was sick, the councilmen came in and waved their arms around to show they cared, in case there were people taking pictures.

We left there and Victor dropped me and said he hated Stephen and Paige and Tama, that they were phonies and balonies, and then later he called and was saying he *knew* I was taping him on the phone and so he was talking "to the people on the other side of the tape recorder," and

I don't know if he's on drugs or if he's just hallucinating on his own. There's something wrong with him.

I saw our Cars video, "Hello Again," on MTV. They ran it again, and it still looks really good. I can't believe it came out of our place. And I can't believe nobody else had us to do their videos after that. Oh, and I bought some magazines. A lot of them ($25). I walked the dogs and Paige called but I was too cozy to go out to dinner. And then Jean Michel called and he's furious at Paige because he finally found out about his father playing the cannibal in Paige's pictorial spread for Tama's book, *A Cannibal in Manhattan*, he'd just seen the item on Page Six about it. He said, "What is she trying to do? Is she after my *father*?" And he said his father's writing a book, and he said *(laughs)*, "He's not even a drug addict—how can he write a book? About *what*?" That's the first time I ever heard Jean Michel say something funny. I wonder if that's his sense of humor. And he didn't go to Germany for his big show.

Friday, November 28, 1986

Tony picked me up and we passed out *Interviews*. Cabbed to the office ($7). Fred was working, waiting for the call from Hamburg from Hans Mayer saying when he was coming the next day. The German lady came in with her boyfriend for me to take pictures of for a portrait. And they have a stuffed gremlin, you know, from the *Gremlins* Spielberg movie, that they sleep with and *that* has to be in the portrait, too. She's about thirty-six and he's about eighteen. The gremlin doesn't actually look so bad when you see it, it's not quite as bad as you'd think.

Fred made a reservation to take them to Nell's. I think he became a member. It's $200 a year, I think, but it hasn't gone through yet. I'm not going to join. I think it stinks, joining.

And I don't call Sam anymore, everything is different now—my eyes are opened. I guess he was taking drugs when he used to lose things. I don't know when it started, maybe he always was. Maybe he would always go out after he dropped me off. Looking back now, I guess I wasn't seeing what I didn't want to see. Again. Does it ever end? Do you ever get smart?

Saturday, November 29, 1986

Fred called and said we had a lunch with Hans Mayer and the Mercedes-Benz guy at Harry Cipriani's bar. And the guy was handsome and lunch was fun. I think I'll try *(laughs)* to get a car and driver out of them, to get the "feel" for the paintings. I'm painting old Mercedeses for them.

Then Katy Ford and her husband Andre Balazs took me to the Miss Olympia contest at the Felt Forum, and afterwards we went to Tommy Tang's down on Duane Street. It was fun. Richard Johnson of Page Six was with us and he said that when he was working at the newsroom of the *Post* he got a phone call and it was Timothy Hutton saying, "Hello, this is Timothy Hutton. Did anyone there call me?" And Richard asked around and everybody said no. And then Timothy Hutton asked, "Well did anyone call Madonna?" I guess she was with him. You know how these things are, you get a message with a number. And they said no. And so then he said, "Well where

is it that I'm calling?" And they said, "*The New York Post*. And since we've got you on the phone, what are you doing with Madonna?" And he hung up fast.

Sunday, November 30, 1986

Stuart had a car and we went to Christie's and Stuart had to hide so they wouldn't see him—he still hasn't paid for the flute, they call him every day. Stuart regrets buying it because, I mean, what would he get for it if he tried to sell it? And then we went over to the piers to the Antiques and Collectibles Exposition (tickets $15). And it's just the same stuff everywhere. Small and the same, no character. Nothing dramatic. That Modernism show at the armory last week was great, though. But the guy wanted $5,000 for a World's Fair service for eight or twelve! I couldn't believe it. I was asking if I could buy the big spoon because I have a big service and I wore the big spoons out and so he told me the price and I said in that case could I sell him *my* set?

Then we went down to the flea market. And we ran into one of the *Interview* editors, the new one, Kevin Sessums. He was alone, buying a picture of a girl with cleavage, which was odd (research materials $210). Then they dropped me.

Then I heard that Martin died. He died in his new apartment that he got in the Village with all the money they raised for him at that benefit at the Pyramid. He bought whatever he wanted. He was such a sweet kid, and so friendly and generous. With his affection, too, he was generous.

Tuesday, December 2, 1986

Worked with Rupert then the rains came and they went on all day. I asked Wilfredo to Cornelia's birthday party so he had to go home and change. Cornelia's on the cover of *Spy*. Worked till 8:30. Talked to Keith. There was a wake for Martin that I guess Madonna was giving. It was too hard to get around, though, so I skipped all that. Put black tie on, and Wilfredo picked me up and we went to Cornelia's and it was such a horrible party (cab $8). They treated Wilfredo badly, he had to sit on the side and I was next to Tony Peck. He said he'd been on a cruise with Dianne Brill and when I just asked if he fucked her he got upset, I don't know why.

Wednesday, December 3, 1986

Stuart picked me up after work and we went down to an anatomy class on East 23rd Street because they were cutting up cadavers and it was formaldehyde and one was hanging by its head and one was on its back. The skin was half on and half off and art students were drawing the muscles. It was just disgusting.

Friday, December 5, 1986

Archie and Amos were sick last night. Jed picked them up and took them to the doctor's. Ran into him later, he was with Katy Jones, and he was talking about what was wrong with the dogs. They're just really getting old. I told Jed I'd give him one of the Dog paintings. Life's so short and a dog's life is even shorter—they'll both be going to heaven soon.

Sunday, December 7, 1986

Stuart said he'd take me to the Liz Taylor night at his art school. Joseph Papp had rented the building for the night—it was the Creo Society organizing a benefit for AIDS. Stuart thought it was black tie and then he was the only one in black tie so he looked like a waiter. There was an hour of cocktails first at Papp's place next door in the Public Theater, and then they put up a plastic sidewalk for the people to get to Stuart's school, and they had it done up so beautifully with flowers and food. I told Stuart to just look at what his dump could really look like. And the first people I saw were Anne Bass and Peter Martins and Jock Soto. And I stiffened because I'd eaten so much garlic and I didn't want to breathe on anybody.

Leonard Bernstein was there, and he cried. He always cries. He's such a weirdo. The Hamlisch guy played, and Eileen Farrell was singing and Marilyn Horne and Linda Ronstadt and a guy sang "Ave Maria" in be-bop or rap or rock and roll and it was like an *Ed Sullivan Show*. And there were no speeches because Liz Taylor didn't show up. A *New York Times* reporter asked me what I thought of the performance and I said why didn't these stars do this show on Broadway because most of them were out of work—that since there's no more *Ed Sullivan* we don't ever see them all anymore. And then Papp came over and he said oh no, these people are much too *big* to work on Broadway, that they just got together for this one special night. And I mean, how can you be "big" if you're *not working!*

And then Bernadette Peters was there with her tits hanging out of her dress and I had already said hello but Stuart wanted to meet her, he insisted, and so I interrupted her and he started talking and then his violining fingers started moving all over her and as much happened as she'd let happen. And Stuart's standing there with so much tension, he said to her, "Can I give you a ride?" and she said, "No thanks, darling, I have my own car."

Monday, December 8, 1986

Cab to the West Side to Dr. Li ($4) and did my business there.

Then Paige was having a ballet lunch at the office (cab $5, newspapers $2). Anne Bass was coming with Peter Martins and Heather Watts and Ulrik Trojaborg and Bruce Padgett. And they want me to design a curtain and a poster and I should've told them to talk to Fred. I won't be able to do anything with that little gold Noguchi lion medallion that Peter Martins brought to show me—if that's what they want, they should just have *Noguchi* do something. But if they want *me* to do something it should be more American.

Oh, and Jock said that after the AIDS thing Sunday night, the reason they didn't go to Indochine was because Mercedes Kellogg and Sid Bass go there so Anne Bass didn't want to run into them, so they went to Nell's.

Fred came in with Mary Boone in her fur coat and she wants me to go with her gallery, I didn't talk to Fred yet about what they talked about at the lunch. She sits there and smiles. The Ileana Sonnabend kind of smile.

And Fred after another fight last week that I guess I forgot to talk about, with Paige and everything, he called me and said that he decided to change, and so he's done a ninety-degree turn and he's trying to be a different person.

Tuesday, December 9, 1986

Tony picked me up and we went to the chiropractor that Prudential Insurance wanted me to see. Our office health insurance company. He was in an old hotel on West 72nd Street on the second floor (cab $4). And the guy didn't believe in vitamins, he didn't believe in anything. He had fifteen framed things on the wall but I don't know what they could've been for. I lied about my age on the insurance thing, I said I was born *(laughs)* in 1949. And then later Stuart told me it's a federal offense.

Watched *Letterman* and God, I hate it when he puts his tongue in his teeth and tries to be handsome for the camera. It's like he's doing what he does when he's home looking in the mirror.

Wednesday, December 10, 1986

I thought I was going to have to take photos of Tatum in the morning for the portrait I'm doing so I lugged all the camera stuff home and everything but then when I called her it was too difficult for her to schedule, she said why didn't we wait until after Aspen. I think the O'Neal family is probably a really stupid family where the father just happened to make it big in one movie. Because here's this little girl who thinks she's so smart, she just thinks she's so intelligent. And when she was a little girl she was advanced, but . . .

A portrait guy came to the office in the afternoon and he was one of those cigar-smoking guys who talks about himself and looks fresh, like he's just come out of a gym. About fifty-five. Like what Mike Todd probably looked like.

The other day Victor sounded so sick I thought he had the magic disease, but yesterday he sounded fine, totally recovered. I think Elsa Peretti's dropping lumps of money into his account. He knows when not to go overly too far. I guess he's bored living out in East Hampton. He has a whole house there for $1,500 a month. He's being supported in the style to which he's accustomed.

Odd people keep telling me how much they love the TV show.

Steven Greenberg had a car and we went to the ballet to see "The Nutcracker." I'd sent flowers to Heather and Jock and Ulrick . . . Paige did it for me. The little kids in the audience there were all so rich, in just the right clothes with the right hair and eating the right *(laughs)* chocolates.

They looked the way Sandy Brant would dress her kids. Jock and Heather were the leads. Heather's getting tired-looking, but she's a really good dancer. The performance was wonderful. Really, dancing is only good when the kids are fifteen and you get that skinny frail pinpoint look.

Thursday, December 11, 1986

Tony didn't pick me up. I wish I could figure out how in his mind he decides when he's going to and when he's not. Walked the streets and it was a nice vigorous walk. Stopped in at B. Altman's and it was so jammed for a change. For once it looked like they were really doing business, and so many salespeople wanted to help me I had to get out of there.

Corice Arman called about helping me get a French visa. I mean, those French are so awful, making only the Americans get them and they let everybody else in the world right in. The office was busy, worked around there. It began to rain and snow and get really horrible out.

I went to Liza's husband Mark Gero's opening at the Weintraub Gallery, which is just a small gallery. Liza was upstairs getting photographed. Then I picked up Paige at 8:30 and we went over to Liza's apartment on East 69th Street for the party. And there was a big crowd. Halston was there, and Calvin and Kelly and Steve Rubell. And Bob Colacello was really nice, just saying how he'd gotten so much training at *Interview* and how it did so much for his writing. He had the breath he gets when he drinks, so I guess he's drinking again. Like champagne fermenting.

Liza had people from *Vogue* and *Details* and *Vanity Fair* there so she was doing her best to publicize Mark's paintings. And the paintings used to look like sensual vaginas, but now they look like they're having trouble. They're holes with blood around them and they've got names like "Death of a Baby." It's like Liza's life.

And Steve Aronson was there and he was fun, carrying on about how he didn't get his Christmas bottle of champagne from *Interview* in 1977. And Ethel Scull was there and I said she should start living it up and she said she was going to, soon. Ethel's either had too much of a facelift or else she's had a stroke, I can't tell which.

Paige and I talked about our blind-date dinner the night before and nobody made out except Steven Greenberg. Tama's date, Amos and Archie's vet, Dr. Kritsick, did nothing but complain to her—that his book didn't make money, that his pipe had a leak in it—everything. And Paige's date overcomplimented her, and mine, well . . . I think my dates on these things should be good talkers who can entertain the table because I don't talk and Paige doesn't talk and Tama doesn't and it gets so boring.

I told Steve Aronson he should write the real Revlon story, the story of the three Lachman wives—Ruth, Rita, and Jaquine—and he said that was a good idea.

And Calvin and Halston were sitting on the same chair, so cozy. It was odd, and then Calvin said wouldn't it be fun to go to Halston's, a gas, and so we all got into cars and we went over there and Dick Cavett came, he was at the party with Bianca. And Bianca looked a little fat in the bottom but she said she was thin. And she was looking her age. I don't know what the age *is*, but she was looking it.

Friday, December 12, 1986

Thomas Ammann called and told me I had a running invitation to Gstaad for Christmas, that was nice. Nick Rhodes called and wanted to go to dinner. I was seeing Keith and Kenny and Ann Magnuson. Nick and Julie Anne wanted to eat so early, though. They were insisting on 7:30 and we finally made it 8:00 (cab $5). Went to Mr. Chow's and of course Nick and Julie Anne didn't get there until 9:00 or 9:15. Ann agreed to do a four-minute thing about art and fashion for our TV show. Then all the wives—Julie Anne and Teresa—got up and went to Nell's in one car, knowing the husbands would have to follow, they wanted to kick up their heels, they'd been cooped up.

I walked home and there were drunks all over, falling down. It was the beginning of office parties. It was nice weather, though. Walked up Park Avenue. Benjamin had gone down in the first car with the girls. Bought magazines ($7).

Saturday, December 13, 1986

Benjamin picked me up and we went down to Arman's on Washington Street. It was supposed to be for lunch but since I told them I don't eat lunch, there *(laughs)* wasn't any and I was starved. And I got so jealous, he showed me the jewelry he's doing, he gets little hearts and redoes them in gold and glues them down. I asked him to be on our TV show. And then I got even more jealous when he told me about the dresses he's making—a "sleeve dress" all made of sleeves, a "pocket dress" all made of pockets. I mean, why couldn't *I* have thought of those?

In his drawings he repeats images, but not in his paintings. And he's doing paintings now that are just brushstrokes across. But I always wonder if he copies Cesar. Cesar was the artist in the fifties and sixties, a short French guy, the one who made the big hands you sit in and things like that. He's still alive. He did the plastic that got bigger and bigger and looked like poop and he sold it by the piece. I wish I'd thought of that. I was thinking about that dress that I made for that Rizzoli show that was called "Fantasy in Fashion"—the one in the early seventies. My thing in it was a dress made out of sewn-together pieces of designer clothes. Somebody wore it to a ball eventually. But the timing was just too early I guess, because the bluejean jacket thing a few weeks ago at Barneys for the AIDS benefit, that was sort of the same thing. Corice set it up for me to get a French visa.

I took Benjamin to lunch, the lady cut the sandwich in half and it fell on the floor and she laughed, and I don't know if she charged me for it ($19). We ate in the car on the way to the studio. Paige was meeting me there before we went down to Dennis Hopper's show at Tony Shafrazi's gallery.

And Dennis's show, the photographs were nothing special, I guess Tony just wanted publicity with a movie star. Met Keith and Kenny there, they were fun. Paige was peeved when *she* took a picture of Keith and then he said *(laughs)*, "Oh Andy, why don't *you* sign this for me?" Matt Dillon was there with a blonde girl who looked like a young Diane Lane. Diane Lane's only like twenty, but this girl was even younger. Everybody kept telling Dennis how great he was in *Blue Velvet*. I tried to get him to be on our TV show but he was leaving town the next day.

Monday, December 15, 1986

Tony was coming to pick me up but I didn't know he was coming with a car. I don't know how he decides these things, he's very abstract, there's no pattern. John Powers called, he's back from Japan, he said he had a new magic watch that has a crystal instead of a battery, but he sounds older all the time so I don't know if these crystals work. It's funny about voices, Diana Vreeland still has a young voice. Strong.

Keith was putting down Schnabel, saying that he sat himself right down next to Dennis Hopper at Tony Shafrazi's dinner for Dennis over the weekend and then made the speech about Dennis although he didn't even know him.

Oh, and Dennis told me the other night that they cut the scene out of *Blue Velvet* where he rapes Dean Stockwell or Dean Stockwell rapes him and there's lipstick on somebody's ass.

Then went up to the Metropolitan Museum for the Shiseido party. I guess maybe they funded the Vreeland costume show and so then they got to give a party there. They had two big Flower paintings of mine. Peach with black outlines. One was a gift from Peter Brant and one was a gift from Irving Blum who I didn't even know had one. The museum should get *all* of them—I mean, that's how they're supposed to be—*all together*.

Then from the museum Steven Greenberg gave us a ride down to the first party at the Tunnel on Twelfth Avenue and 28th Street, the club that's built in the tunnel of some abandoned railroad tracks. I'm the one that told the Bonjour jeans guy to just keep the name the "Tunnel." And it was fun there, good music and Glorious Food. Serge the Glorious headwaiter came over and said hi. Haoui was the doorman, Rudolf was there, it's a great building.

Ian Schrager was there but he walked out of one of my pictures. I guess he didn't want to be photographed at somebody else's club. He was in this beautiful blue suit and tie, and he's gained some weight, so he's got that hefty, stocky, prosperous look. Handsome. Like James Caan. Steve Rubell was in a business suit the other night saying, "I'm still in my business clothes, I just closed a deal."

Talked to Stuart. He said that this one guy was giving so much of his time to do charity work for Stuart's school, but I told him, "Look, there's a *reason* a person will give up so much time, it's not for nothing—either he's down there using your phones or he's getting away from his wife or he's using your limousine or he's drinking up your liquor—it's always *something*, it's never for nothing."

Tuesday, December 16, 1986

I was picked up by Tony and had to go to Schnabel's. He drove me to West 11th Street, to his huge studio. So huge. And a balcony and a roof. And he has beautiful girl secretaries answering the phone and I asked him if Jacqueline got jealous and he said, "You have to have beautiful boys and girls working for you." He's still making his plate paintings so I guess that's what's selling. And he gets on the phone and says, "Dahling! Come right down!" and it'll be Al Pacino who's tearing himself away from Diane Keaton to come down and see *him*. Or it'll be Dustin Hoffman.

And the secretaries say things to him like, "You can either see your editor at Random House

at 2:44 and get out by 3:32 or at 3:46 and get out by 4:34," and Julian says, "I will take the 2:44."

And he's painting over beautiful Japanese backgrounds and ruining them. And he's got tarpaulins with words glued on them and he says, "These are from my San Salvadorean exposition."

It was the most pretentious afternoon I've ever had. And I left there completely convinced I should buy a Schnabel. Fred thinks so, too. I told Julian I'd give him a ride uptown and we went outside and there's a limousine parked and he's striding toward it and I said, "Uh, Julian, that's not my car," and I pointed to Tony in the little Japanese one. So we dropped me off, and I said Julian could "have the car"—I was grand and Tony took him where he was going.

Wednesday, December 17, 1986

So Tony picked me up and we went to Rockefeller Center and I had my photograph taken for my visa. Then we went to Calvin Klein's to drop off his wedding present. Went to the office. It was busy there. Lisa Robinson was interviewing Ric Ocasek. Gael came in and said they were doing Charlie Sheen for the February cover. Greg Gorman shot him already and they're doing the second half of the interview today. I have the feeling he won't marry Dolly.

Ric didn't want to be on our video. And Ann Magnuson is weird, she'd said she would be our emcee for the show and now she isn't even sure she wants to do a little thing on art and fashion. I don't understand her—she does all these free things downtown and then she won't do something when we're trying to help her.

And Gael called Sydney Biddle Barrows and asked her would she be a "Christmas present" for Steven Greenberg and she was insulted and said how dare you. I mean, I'd said to Gael, "What makes you think she'd do that?" It's like if somebody was arrested for selling secrets and they got off and then you asked them, "Could you steal a secret for me, too?" I mean, what did Gael *say to her*? "Since you're a whore *anyway* . . ." And Gael had been saying, "She'll do it for me, she'll do it for me." I mean, just because Gael had Cris Alexander photograph her in a good light for *Interview* doesn't mean she'll give a freebie.

And I'm letting the Caffe Roma use my name as a host for New Year's Eve.

Sunday, December 21, 1986

Jed called and said he'd rushed Amos to the hospital over the weekend because he had a bad toothache, and I felt terrible, I didn't see this coming. By 3:00 he was still waiting to have three teeth out. Dr. Kritsick gave Jed the name of a doctor who works twenty-four hours. They said it was a bad case, but I didn't even notice anything was wrong.

Didn't get out of the house until 4:00 and went over to church. Stuart picked me up and we went to the flea market but couldn't find any fleas.

Then John Gruen and his wife, Jane Wilson the painter, were having a retirement party for Ulrik who's moving to an executive position at the New York City Ballet. Went over to the West Side to that (cab $4).

Everybody was so friendly to each other it was like we're not part of this crowd.

Heather said right in front of Peter Martins that she was so tired of seventeen years of waiting for him to give her a band. And Anne Bass is in Texas.

Monday, December 22, 1986

Went to Dr. Li (cab $4, newspapers $2, phone $.50, cab $6). Read the newspapers, passed out *Interviews*, and went to the office. I decided to get involved with the covers. Gael came by my room to say how great she is. This cover of Charlie Sheen is by Greg Gorman, and he did the pictures inside, too, and it's the same old thing, a nice face and nice clothes. But Charlie kisses so well that I wanted something different, like him kissing a girl, and we could still use the same pictures inside, but just something different for the cover and Gael said that she'd been looking at Weegee things, that she wants a new look, too.

The office was busy. Fred's agitated, he was going to go to Paris a day or two early to get away from Christmas, he hates it. He saw me doing a business gift list and yelled at me that we weren't a regular office and that I did not have to do boring things like that and that he wanted me to stop it that very moment. So I said *(laughs)*, "Okay."

And the bigger the box, the less the present, I've noticed this year.

Rupert drove me home. Then Sam called and wanted to go out so I met him at Nippon (cab $5, dinner $50) and talked about what work he should be doing at the office. And it's so funny, I made up things and accused him. Like of attacking somebody in the corridor, and it turned out to be *true!* He began admitting things, saying, "It was pure sex." But maybe he was kidding. It was like *Dynasty*, people overhearing people in the hallways. I actually said *(laughs)*, "I heard you in the hallway."

Tuesday, December 23, 1986

Fred cancelled his trip to Europe, he finally got in the Christmas spirit. And he loved the two cast-iron disks I got him that were from the West Side Highway. I got them at Doyle's. Maybe I should go back and get more. The kid there likes me, and he gives me things really cheap. They have the best fabrics there, antique fabrics. I should've gotten Fred a lot of those. And Fred gave me a great book, an old one on beautiful Greek statues, for my new paintings. Paige and Fred are the best of friends now. He gave in and she gave in. I got Paige something she really loved, I guess, because she squealed, and it was just a book on Clemente. But the book was just an extra—I owe Paige a lot of money. I hope she doesn't think I've forgotten (phone $2, newspaper $2, cab $7).

Thursday, December 25, 1986

I got up early and walked to Paige's and she and Stephen Sprouse and I went to the Church of the Heavenly Rest to pass out *Interviews* and feed the poor. It wasn't as crowded as it was at Thanksgiving. Afterwards Stephen and I walked down the street, and I had told John Reinhold

we'd come by and he could take us to tea and he did, at the Carlyle, and that was sort of, I don't know, young guys waiting for their grandmothers to die. Stephen dropped me. Got a lot of calls to go to Christmas parties but I just decided to stay in and I loved it.

Sunday, December 28, 1986

The day before I watched a great show on something like channel J. It was *(laughs)* a nobody interviewing three other nobodies. One said she was a friend of Milton Berle's and she was in every chorus of every movie you could ever think of. And then there was another one who was also in the choruses and she would say, "I played the Red Room of the Downstairs Club, and the Blue Corner of the Uptown Spot," things like that. It was so sad. Then she'd say, "Show the picture, show the picture, that's the one they're going to use when they use me. . . ." And there was a black girl who sang off key, oh it was sad.

And I finally saw Debbie Harry's video that was made in L.A., she's at the Beverly Hills pool and she didn't wear the camouflage dress that we made for her, the Stephen Sprouse thing. I guess the director didn't want her to wear it, and it would've been so good. My ambition if I were to really go and have a facelift and everything would be to come out like Debbie. Her song grows on you, "French Kissing."

I had leaking water and went into a closet and in it were the dresses I'd bought at the Joan Crawford auction in 1977 and it turns out that the label on one says Nolan Miller! Can you believe it? The *Dynasty* designer! And now I do remember that at the auction I'd said, "Whoever heard of this nobody?" So now I would like to write to him and say I'll sell it back to him for like $4,000. We'll find out what he sells a Joan Collins dress for and make it for that amount. The others don't have labels, but they all look the same so I'm sure they're all Nolans.

Monday, December 29, 1986

Benjamin picked me up and we went to the West Side to Dr. Li. I told her to get me off some of these vitamins she's got me on but she gave me six new vitamin pills and I don't know if she took me *off* any. I think all the vitamins I'm taking may be what's making me have so much trouble sleeping. Over the holidays, for two days, I finally did get sleep and one day I even slept till 10:45. And on those days I did feel rested. But usually when I wake up in the morning I feel aches and pains. And I *am* addicted to Valium. It's only a quarter of one that I take at night, but when I was really trying for over a month not to take any, I felt lightheaded and that's a withdrawal symptom. So I started again.

Wednesday, December 31, 1986

Went to Bernsohn's alone, got cured for a moment, walked downtown (phone $2, newspapers $2). Paige was upset there were no good-looking boys coming along on our New Year's Eve party, and her excuse is always that we need to find somebody for Tama, but she wants to meet them,

too. I don't know why Paige has us doing all this for Tama—"We have to find Tama a boyfriend." *Why*? I mean, everybody in *town* needs a boyfriend. The whole *world* needs a boyfriend. Anyway, so Stephen Sprouse was coming. Poor Stephen, they're even after *him*, I think, and he's scared.

Worked till 7:45. The ballet kids came down and I took their pictures. It's so funny that when you look really close you see that Heather Watts actually has a sort of deformed body—and she's the number-one ballerina in New York. And her nose is too big and it may have been fixed from being even bigger, but her eyes are really beautiful. They're like gorgeous movie-star eyes, the kind with the dark circle around the blue.

So Steven Greenberg was giving his New Year's Eve party at the River Café in Brooklyn. It was black tie and I was just in my crummy scarf. We left at 11:55 and we rode over the Brooklyn Bridge and that was the most fun part of the night with Paige telling Harold the driver to honk his horn louder and Paige was doing her piercing whistle that comes from her throat and as we came over the bridge, the fireworks were going. And then Tama came in the other car and she told us that Steven and Elizabeth Ray had just had a fight, and so later I said to Steven, "So have you had a fight with Elizabeth yet?" and he said *(laughs)*, "No no, not yet, not yet."

And then we went to Scott Asen's house in Turtle Bay and there wasn't much happening there. Peter Martins was using the phone in the toilet and his son was just leaving—he's beautiful, he dances. And Sirio from Le Cirque was there, and we took him down to Nell's with us and he was fun. Nell took her clothes sort of off and threw herself on the table for a photograph and I told Sirio that he had to do that, too, if he wanted to make Le Cirque the really "in" place. He said his wife and kids were away so he was just on his own this New Year's. He invited us for dinner on Sunday.

Paige and Tama went on to the Tunnel, we dropped them there, and then got home around 4:00, walked the dogs, and it threw my whole day off, it was so stupid to stay out late just because it was New Year's.

Thursday, January 1, 1987

The weather was raining and awful. Stayed in and had a rest day.

Sunday, January 4, 1987

The ballet kids wanted to take us to dinner at Indochine. Paige picked me up. Stephen Sprouse was there and it was Ulrik and Jock and Bruce Padgett and Heather and Scott Asen and Julie Gruen—Peter Martins was the only one missing. It's such a wonderful group, they have everything down. And Heather said that she always thought Stephen was passive, but that since he's started doing ballet costumes she's changed her mind. Everybody else always gave her what she wanted, she said, but when Stephen gave her her dress and she said, "Oh I don't want this," he told her, "You're going to get what I *say* you get." So she liked that and now she wants to marry him. So that's another girl who's after him. Heather paid.

Monday, January 5, 1986

There's a cable news show that I see at 5:30 in the morning when I get up to pee that's good. I don't know what it is I'm allergic to. Dr. Linda Li says it may be the paint I use, but I'm hardly ever near it now. I think it's something in this house. Or maybe it's something in the buildings on either side of me, maybe radiation from the doctor's building. Maybe it's the teddy-bear coat I sleep in, although the label says it's all cotton, I don't know. It's Armani. I somehow feel it might have a little polyester, it has that fuzzy feeling. And I also sleep under the Larissa leather coat that Jane Holzer gave me, it's so great. Jane keeps saying I never wear it and I tell her I wear it every night.

Paige picked me up and we went to the St. Regis for the Adolfo show. The clothes are beautiful but it's so abstract to me that somebody should copy Chanel suits for years, that you'd make a career out of copying somebody else's suit. It's been decades and it's still the same suit. There was a tall lady next to us and I didn't smile at her or anything, I didn't know who it was, and then later I realized it was Evangeline Bruce. There were so many ladies there that I just should be doing portraits of, just every one was one of those rich ladies. And they still have all their energy from not having hard lives.

You know, Heather Watts is so interesting. She's in this "reading group" that Anne Bass is in, they all read the same book every month and then they meet and discuss it. And it's all these rich ladies like Brooke Astor and Mrs. Rupert Murdoch and Drue Heinz. And they meet at a different member's house every week with the butlers and cooks and maids, and Heather says she's the only poor one and that she's the only one who reads the books. She dropped out of school at fifteen. And you know how vivacious she is, she said she heard about Anne Bass's group at a party and she said, "I want to be in it! I want to be in it!" Heather can't wait for the group to have to come to her loft and they'll all sit on the floor.

Then Paige and I went to the Robert Miller Gallery and the show of my photographs looks absolutely great. Terrific. The catalogue looks good but Stephen Koch's essay throws in the same old names like Duchamp and Brassaï. Brassaï!!! And if they'd had some young person do it it would've been different names and fresher.

I decided not to go out and just rest up and be fresh for the opening of the show.

Tuesday, January 6, 1987

Everybody wanted to give me their limo—Steven Greenberg, Stuart Pivar, the glamour days—and Paige gave the gallery fifty more people to call and invite at the last minute. Had a full day at work. Got to the gallery at 5:00 and then there was only a scattering of people, but it got to be more and more and I worked myself to death. The show looked great. Then we went to dinner with Steven Greenberg and then I went home and went to bed early, I thought I would shake this cold, but then Jean Michel called at 3:00 in the morning and I talked to him and it just ruined my sleep.

Oh, and I've just been watching the new Joan Rivers show a few times and it's just only about sex all the time—so boring.

Wednesday, January 7, 1987

Lost my cold when I went to Bernsohn in the morning. I walked in and didn't tell him I had a one but he said I felt congested and then he worked on me and for the first time used a lot of crystals on me like the long skinny ones and for the first time I really completely totally believed in it, because my cold was absolutely gone when I left there. And he said to me, "Do you mind if I raise my price $10?" And I said, "Yes!" I mean, he's telling me about all the clothes and records he's buying. And so he said, "Well, then how about $5?" And I said, "Well, what can I say?"

Thursday, January 8, 1987

Sam told me gossip about Fred that I'm not supposed to know. He wrote a letter to Nell apologizing for pulling his pants down there. And then I also heard that one night at Area he took out his cock and was standing there like one of the installations until somebody realized it.

Paige was in a really bad mood because I had Sam dial her number and make the arrangements to go to the Mary Tyler Moore play that Barry Tubbs is in—she came over and said that she didn't want my little messengerettes calling her for me. She really has another personality when she wants to, she can really be mean.

Oh, and Len Morgan came back from his ten-day cruise with Thurn und Taxis so he was answering the phones. And the prince still makes up stories about me. He told Len that once I said to him, "If you're supposed to be so exciting, *do* something exciting," and that then I stepped on his toes. Which I don't remember at all.

Went to the theater (cab $4). Lynn Redgrave is a good actress because she played down her role to give Mary Tyler Moore the stage. And the other young guy in the play showed his cock and then afterwards at the party his parents said how *(laughs)* proud they were of him.

Friday, January 9, 1987

I'm deciding when to go to Milan. My show is the Thursday after next.

Fell asleep with MTV on and had rock-video nightmares.

Sunday, January 11, 1987

Pee-Wee Herman is being sued for $130,000 because he didn't pay his *(laughs)* video bill. His whole show's all video effects.

These two kids have been ringing my doorbell all weekend. A boy and a girl. I guess they saw me come in and there's been nobody in the house with me—Nena and Aurora were away—and it's creepy. I just don't answer.

Went to church, then Paige called and said she'd pick me up for the ballet (cab $5). The ballets were great. "Symphony in C" which I haven't seen in years, and then two Jerome Robbins ones.

We had Peter Martins's seats. Jock and Heather were up there just flying around. And they said I could photograph the company for as long as I want, so I'm going to start that.

Anne Bass wasn't at the ballet but she came to the dinner afterwards that Paige had arranged at Baton. And Paige and I are fighting. She keeps making these digs about Jean Michel, she said, "Are you starting up your gay affair again with Jean Michel?" and so I got *my* dig in and said, "Listen, *I* wouldn't go to bed with him because he's so dirty, and I can't believe that anyone would. I mean, *you're* the one who had the affair with a dirty, unwashed person." And then we had a fight about Eizo and shiatsu because her guy went on vacation so she's been using Eizo and she asked me if he ever did a thing on my stomach and she described how he'd put his hands and was shaking it and she got nervous and took his hand away, and so I said, "No, but he told me how fat you are"—I was kidding—and so she said, "Okay, that does it, I'm not using him anymore." And then I tried to tell her he *didn't* say she was fat, but she wouldn't believe me.

And Peter Martins who commissioned me to do the ballet curtain, he actually *does* have great ideas. I didn't think so before but now I do. He talked to Stephen Sprouse about the Touch Tag thing where the kids who play football use clothes with Velcro so that instead of tackling and wearing shoulder pads, they have to tear the Velcro off, so they're working on the "Fluorescent Orange" ballet, and then the kids thought of fluorescent snow.

And when Ulrik told me he hadn't had time that night to walk his dog, I used Heather's aggressive personality and I said, "Why didn't you just put the dog on stage and have him do it there and no one would notice." And I was telling everyone about my idea for a "Shower" ballet that I've always had—nude dancers getting into the shower after a heavy dance number and then shaking the water off on the audience.

The ballet kids were quiet at first but after ten glasses of wine they were really funny. And Stephen Sprouse was showing how he writes backwards, he's so clever and he had such beautiful writing. And then something really surreal happened. A busload of eight-year-olds came into this restaurant, about fifty of them, and filled it up, at the bar and everyplace. And we asked them what they were doing there and they said they were going from bar to bar researching a school paper. It got really loud and noisy. They said they were going on to Nell's.

Monday, January 12, 1987

Sean Lennon came down. I'm doing a portrait of him every year, one a year. And he was fun. Went to Castellano's for dinner (cab $6) with David Whitney, but without Philip who was off having dinner with some swells. And David still reminds me that he wants us to get married, and now that I hear how many Jasper Johnses he has, it would be really worth it. He's doing the David Salle show at the Whitney. He said that Jasper fell out of a tree at La Samanna but that he just broke a wrist. He and Rauschenberg have given up drinking so I guess they'll live forever.

Tuesday, January 13, 1987

Had to go to a Food Emporium on 70th and West End Avenue for an Easter Seals thing that Dr. Kritsick the handsome veterinarian helped organize where Almond Delight breakfast cereal was putting hundred-dollar bills in the boxes and you had to go through the store finding them. Like an Easter egg hunt (cab $4). And there were no celebrities, really, although there were supposed to have been. Just a karate guy. But the great and only celebrity was Eddie Fisher and he was *so much fun!* He looks young but ugly, but he's *so much fun!* I can see why Carrie Fisher married the Simon guy because he's like Eddie without curls. If I'd ever met Eddie in the sixties we would've been best of friends. Now he just does charity work. The first thing he said was, "You did a picture of me." The one I did in 1962—the newspaper front-page of him and Liz. And I told him about all my crystal doctors and chiropractors and he was really interested and then later as I was leaving the office at 5:00—I had to leave early—he was calling, he'd looked up the *Interview* number, and so I'll call him back. He was so much fun.

Anyway, back at the thing, we went through the store and I only found one box but Kritsick found ten and Eddie found two so I gave him mine to make it three. So then I was leaving and they offered me a car but I was grand and said no, but I should've taken it because it was so windy out (newspapers $5, phone $2, cab $5).

Wednesday, January 14, 1987

It was a beautiful warm day. Went to the office and Ian McKellen was there for lunch, it was Fred's lunch, and Sarah Giles from *Vanity Fair*. And he was so cute, he's so sexy, his play *Wild Honey* just closed on Broadway and I really wanted to see it, it looked so good in the TV ads.

Went to the Dolly Parton party with Sam and Len down to the Gotham (cab $3.50). Dolly was arriving right when we got there and she gave a speech saying that this was a party to celebrate signing with CBS Records after being with RCA for twenty years. She just turned forty and she looks absolutely beautiful, but like everything's been done. She's really tiny but her tits are so huge they *have* to be implants because you just can't get that thin and still have those big tits— I'm sure they would've shrunk. Barry Diller came with Calvin and Kelly, and David Brenner came.

Dolly was sweet. Danny Fields was there and I told him I want to tape his life story and he said he would let me.

All the *Details* people were there and they had the new issue with Stephen Saban's pictures that he took in a photo booth in '65 when we were down at the University of Pennsylvania for my first art show. I guess at the time he was a student and he had me sign one picture and Edie signed another and Gerard signed another. It's a full page and it looked great. Annie Flanders was there and Michael Musto. James St. James was wearing four-inch heels and so was Dolly. And a black guy named Childs was there and he said, "I'm Cedar Bar," meaning he was somebody who used to hang around there, and he looked at young Sam sitting there with his snotty attitude and said, "I see these young kids and all I can think is, 'Pay your dues.' " And he was right, Sam has a lot to learn and I hope he learns it. I spoiled him, taking him to glamorous places when his mind wasn't ready for it. Now he thinks that's what he deserves and he's fresh to everybody.

And then Paige and I walked over to Nell's. It was beautiful weather, in the forties or fifties. And Nell's was so glamorous. Fred was there with Ian McKellen and his I guess boyfriend Sean. And against the wall was Claus von Bulow and Cosima and Andrea Reynolds, and Nell just goes around taking pictures of people like Fred passed out on the divans. She has a funny picture of Taki whispering in Bob Colacello's ear and Anthony Haden-Guest trying to hear it. And Sting was there, he wears Cerutti clothes now, and Nell asked him how his career and all started and he said this and that happened and then he said, "And then Andy made me a star." Maybe we were the first to put him alone on a magazine cover. He said he wants to do plays now. I don't know why Sting would ever do that Frankenstein movie, *The Bride*. If it had been a *singing* Frankenstein, that would've been something.

And then Nell left her chair and then Bob Dylan came over and sat down and he said he'd just seen my photography show at the Miller Gallery—that he'd literally just come from there. And then Nell came back and pretended she didn't know who he was and said that that was *her* seat.

I want Nell to take pictures for *Interview*, but she only takes color pictures so I left her some of my black and white film.

I introduced von Bulow to Nell and then to Dylan. I lost my scarf and I was glad because I hated it. But then I found it. That cashmere scarf I ordered from Brigid's friend who knitted it on a machine and it was supposed to be like the red Halston one I'd lost, but the Halston one was somehow so light and this one is so heavy. Paige dropped me off at 2:00.

And poor Bess Myerson's on suspension. She's really in trouble because they say she sort of bribed a judge to reduce her married boyfriend's alimony payments. I can't believe all these men fighting over this sixty-year-old lady.

Friday, January 16, 1987

I just can't face going to Europe. And the TV news said they're smearing themselves with bear grease in Russia this week, it's so cold over there.

Rode uptown to the David Salle opening. Bruno and Yoyo were there. It's sixties work all from Jim Dine and Rauschenberg and Jasper and me—all put together and beautiful. It's intellectual.

And Sam Wagstaff died the other day.

Then cabbed to Mr. Chow's for the Salle dinner ($5). All the art dealers were there. And Mary Boone who wants to give me a show, the Rorschach things. And the *Voice* gave my photography show a good review.

I still want to do the "Worst of Warhol," all the stuff that didn't come off. I'll *(laughs)* have to do more, though.

Bruno wanted to sit with Robert Mapplethorpe but I didn't want to. He's sick. I sat at another place.

Saturday, January 17, 1987

Did a last Diary with PH before the European trip where it's still so cold. Went to the office and worked until 7:00, and then Paige picked me up and we went down to Keith Haring's opening.

Keith's show was interesting, the work looked different, it was as if he wanted to have a lot of things to show so he worked faster, it's not so planned-looking. Yoko and her Sam were there but Sean wasn't, Yoko said he had gone off to a birthday party, that he was old enough now to be making his own plans. Later I said to Keith, though, "Oh, gee, where's Sean?" To make sure he noticed that Sean hadn't come. To rub it in. I guess it was mean but (laughs) I'm still jealous that Sean likes Keith better than me.

Sunday, January 18, 1987—New York—Paris

The weather in New York was great and I hated to leave it. Got up at 6:00 and packed. I tried not to think. The bag was too heavy, don't know why. I never change clothes over there and never take a shower. I always wind up just sleeping in my clothes every night. Chris Makos picked me up at 10:00. Picked Fred up, he was on time. Got to the airport (driver $60). Wore layers, everything on my back.

Got to Paris. A driver named Freddy picked us up. Checked into Hotel Lenox. Chris had the better room, naturally, what else is new? My room was freezing but it was cute. Small but cute. All that nice old kind of French wood. We walked on the ice to the Café Flore. Had some sandwiches and that was it. We were the only ones there, we closed it ($35). Back at the hotel I fell asleep with all the lights on. Chris was smart, he had two heaters sent up to his room.

Monday, January 19, 1987—Paris

We went to the Beaubourg and Chris got us in free and we saw the Schnabel show there and it looked great, he looked like a talented artist, and then we went up to the Japanese show, it looked like they copied everything from the West, a lot of Frank Lloyd Wright. Lunch at this chic cafe ($35). I went down to pee and it was a wonderful bathroom, a big sheet of glass with water running behind it and you piss on the glass. So modern, so weird. If Chris hadn't told me, I wouldn't have known where to pee. It looks like a fountain.

Tuesday, January 20, 1987—Paris

Ran into Art Kane, the photographer, and spent some time with him. He said he was married again, to a French wife. Ran into Fred, had something at Café Flore ($15). Bought magazines, caught up on the good ones ($20). Tried calling some kids for dinner but nobody seemed to answer their phone—James Brown and all those kids. Chris looked at our plane tickets and noticed

that they went to Rome instead of Milan, so I decided we were going to fire our travel agent. Chris worked on the phone getting it straightened out. Stayed up reading magazines.

Wednesday, January 21, 1987—Paris—Milan

Met by the police and they took us right through customs and everything because Lisa Soltilis was with Iolas and she'd gotten the police to do everything for us. If we'd been sneaking in marijuana or drugs it would've been so easy. She was so friendly, but later we began hearing wild stories about how her husband was keeping Iolas in a sanitarium. Found Iolas in the VIP room. He was like a little old lady wrapped up in fabric. We found out later he'd come out of the hospital just to pick us up. Then the whole story began unraveling. Iolas was just *presenting* me at the bank Credito-Valtellinese. "Alexander Iolas Presents Andy Warhol." He must've gotten all this money to "present" us. My Last Supper show was closing down that day and my other show was opening, so there was lots of publicity. Iolas was really sweet. He had to be driven back to the hospital. Lisa took us to the hotel. Our rooms were beautiful. The Principe di Savoy. Christopher took the best room with the TV. Fred was down the hall (bag man $10, magazines $25, waiter $5). Daniela Morera called and began taking over. She said she had the flu and I knew I was going to get it from her. Went to the gallery to do press and TV. We had a car of our own, twenty-four-hour service.

Thursday, January 22, 1987—Milan

Went to the gallery for the 11:00 press conference, 250 press people. Scary and stupid. Got that all over with. Signed a lot of posters. Then we had free time. Lunch with Gianni Versace, went to his castle. Rizzoli's old castle. Big Roman and Greek statues that Suzie Frankfurt got Versace to buy. It was grand, huge, so glamorous. We had a good time.

Then had to go back to the gallery to do another press conference at 4:30. Stayed till 8:30 with Daniela coughing in my face and me signing autographs. Gianni did the costumes for Bob Wilson's *Salome* at La Scala. He got us tickets so I could slip away from my opening when I got tired. Finally Fred grabbed my pen and whisked me away.

Sat in a box seat watching the opera, then had to go to this dinner for me. Saw Gerard Malanga's first girlfriend there who he wrote all the poems about, Benedetta Barzini. She was with her husband and being so grand. I ate a lot and Daniela was coughing into my food. I'd been resisting her flu for two days straight while she talked into my face, but finally I gave in and got it. Went home just exhausted.

Friday, January 23, 1987—Milan

Woke up feeling a little funny, read the newspapers (waiter $5). Daniela was going to come and take us to lunch but I was exhausted and I decided I'd stay in and nap a little. My temperature went up to 100 so I began taking vitamin Cs and my stomach got sour. Then Iolas called to say

he was coming over and I'd never really gotten a good night's sleep. Daniela went out with Chris and Fred and they brought me back drugstore medicines which turned out to be antihistamines which kept me up instead of putting me to sleep, so it was a day of horror but it went by fast.

Iolas looked all right. And Fred stayed on an extra day to do business with him. Chris came by and ordered soup, taking my temperature every minute. It went up and down. He went out and had a good time discoing and I kept taking Valiums and not being able to sleep. My temperature went down. Watched TV and tried to sleep, getting ready to get up at 6:00.

Saturday, January 24, 1987—Milan—New York

Got up in Milan. I hadn't slept all night after taking the pills that Daniela got me. All they did was dry me up and the suppository didn't do anything, but my fever was going so I think I just had the twenty-four-hour flu, after all. I'd taken vitamin C and even aspirin. Christopher got me some soup and bread. But those pills sort of hung there all night, just stuck, and didn't go anywhere. I hate Daniela for giving me the flu and I hate her for those pills. But I'd also taken Valium like crazy and nothing happened, but then in the morning everything was fine. Left the place (concierge $50, doormen $25, baggage $10, driver $100, magazines $20). Got to the airport easily.

And on the plane a milestone happened—I was in the *International Herald Tribune* and I didn't even bother to clip the article. I just—didn't—care. So I've gotten to that point. Maybe it was just that I felt so sick, but still I didn't bother. And Chris pointed out that this lady in Milan who was so nice and sweet and glamorous when she was interviewing me wrote horrible mean things.

We got to New York and the driver was waiting (car $70). I didn't get a receipt. I really wasn't feeling well.

Sunday, January 25, 1987

Paige was sweet, she brought over soup and bread and dessert from the Café Condotti. She really goes out of her way and she's got so much energy, she's like Chris, except that Chris only does it for himself, and Paige does it for other people. I can see why she gets upset when things happen, because she puts so much into other people.

And Mrs. Aquino's being so grand in the Philippines, smiling away, and her guards killed thirteen people at the palace. Why didn't they shoot over their heads? Or use tear gas. It makes you think that Communists did it to other Communists just to start trouble. Or something.

It was Superbowl Sunday and seeing the people in the stands, football games are really the best places to meet macho guys. If Paige wants to meet men and get married she should be going to football games, not to the ballet! Go bowling in Brooklyn—Manhattan is too sophisticated.

Then there were tickets put aside for me at the Joyce Theater where Robert LaFosse was doing a guest appearance in Karole Armitage's ballet. This is the thing that her boyfriend David Salle did the costumes for, he's the artistic director. And then Paige had arranged dinner at Indochine with the New York City Ballet people to talk about the curtain they want me to design. That was at 9:45 or 10:00.

The phone kept ringing and my stomach was a mess, I shouldn't have eaten the dessert Paige brought. Kenny Scharf called trying to get me to buy land in Brazil and I'd been ready to send him a check but then Fred had screamed at me about it while we were in Europe. He was insisting that it's just black-market sales and you don't have a contract or really proof that you own it. But it's so cheap. And Paige wanted to go in on it with me and she was going to go down for a week and check it out. You get *(laughs)* your own coconut tree. But they say there are too many killings there and that they could just take the land away from you at any time. But gee, it's so *cheap.*

Stuart and I went to Sotheby's and it was packed, they had Americana. Jamie Wyeth was there but not Phyllis, and he looks older, he's lost his boyish charm, he's grander. Then I felt worse so I went to the drugstore and got some Maalox.

And Peter Wise called up, I knew he would call because I heard he wants a job with Stuart Pivar. But ever since that time he wouldn't accept my word over Kent Klineman's, I just think he's stupid.... Didn't I ever tell the Diary about this? About the big fight I had with Peter? I mean, here I'd been good friends with him for six years and I'm telling him a fact and suddenly he was saying, "Well that's not what *Kent* says," and I said, "Well if *I* say something's red and you can see that it's not, you should *still* believe me because we're friends." So I told him that if he didn't want to believe me he should just ask Fred and he did and it turned out I was right, but he hadn't believed *me alone*, and that made me so mad, I just thought it was so awful. And when he called yesterday we never got around to talking about the job he wants to get working for Stuart, but I know that's what he wanted.

And now somehow I've hired Chris's friend Ken to pick me up in the mornings, he's going to be my new bodyguard. He's a really good-looking tall blond kid. The one from Florida.

So then I went over to the Joyce Theater and Tama met us there, she came in from Princeton (tickets $40). The production was stinkeroo, but Robert LaFosse is really professional.

Then after the ballet I couldn't face dinner at Indochine so I just went to a fruit stand and I got a pineapple and bananas and apples and I went home. The driver asked me for an autograph so I had to tip big (cab $9). And then I made juices out of the stuff and by the time I was done it had taken so long I could've gone to the dinner—after squeezing everything and washing out the juicer. Took a sleeping pill and slept all night. Woke up at 6:00.

Monday, January 26, 1987

Ken picked me up and it was too cold to pass *Interviews* out so we didn't even take any (magazines $6). Went to the West Side to Dr. Li's (cab $4).

Our Charlie Sheen cover is really good timing. *Platoon* is the big thing. And *Interview*'s coming down an inch, Gael said. With the new postage rates it'll save $20,000 a month. I guess a big-size magazine doesn't mean anything—I don't know what does.

Paige said there were big advertising dinners on Wednesday and Thursday, and Nikki Haskell called and invited me to a couple of parties at the Tunnel on those nights. I don't know about these advertising dinners—you give up a night of your life just to try to get one ad. But on the other hand you do meet people, and sometimes it turns into *other* business with them.

Nick Rhodes called and wanted to go to dinner. Cabbed to Il Cantinori ($5). And when Pino doesn't do the food it's just awful. It was also with Elizabeth Saltzman and her new boyfriend—*Glenn Dubin!* And it was so odd to see him there making out with her. And I guess he does have money after all, I wasn't sure when he was with Bianca. They had just flown to the Superbowl in a private plane and stayed at the Beverly Hills and come back the next day. Simon LeBon and Nick Rhodes arrived (dinner $240).

Oh, and I talked on the phone to Glenn O'Brien about why the sixties were coming back or something, he was doing an article for *Elle*, he was fun.

Got home and at 12:00 the phone rang and it was Billy Name. Have I forgotten to say that he's been calling? He's up there in Poughkeepsie and he's organizing a sixties reunion and he has like three jobs up there, deputy sheriff and everything, and he was just chattering away—"You know how deeply I love you, honey"—about how Gerard is coming up and Ingrid Superstar and how I'd be picked up and taken to Stephen Shore's house—he works at Bard College now—and all this stuff. But I'm going to just have to tell Billy that I can't face the past. And I'd walked into the house and didn't look where I stepped and so I was talking to him with dog poop all over my shoes.

Tuesday, January 27, 1987

Manson was on the *Today Show* and he was saying why did he kill so few people—that he could've been *really* big and killed everybody. Here's all this money wasted on keeping him alive when he should just be killed.

Michelle Loud came to work, she's back from vacation and she's working on the sewing machine stitching together the porno photos I've been taking, but I have to call the office and say to hide them because those kids we've got around the office now—the ones from *Interview* who I don't even know—they'd probably report me to the police. It'd be the sixties all over again. I bet they could still arrest you for taking porno pictures, if they *wanted* to.

Wednesday, January 28, 1987

Howard Read said Victor Bockris came to interview him for his book about me. I'm surprised Howard could give an interview—he doesn't know anything about me.

I met a boy named Cal who's cute but only has half his teeth, he's a messenger, and messengers really are the best dressers, but I guess they already did the Kevin Bacon movie about a bike messenger, but nobody's done a print spread on them yet. He's been hit by a bus a couple of times.

Thursday, January 29, 1987

At 9:30 A.M. I was already rushing out because I'd promised Phoebe Cates I'd go to the Hard Rock Café for a benefit for Covenant House which is for runaway kids. Went with Ken. He's nice but he's real slow. But he's a better walker than Tony because he picks out good-looking *Interview*-type people and hands the magazine to them. Mathilda Cuomo was there.

After that I cabbed to Chris Makos's to photograph more nudes ($4, modeling fees $300). Did that from 1–3:00 and while I was there I heard Chris call Paige so I got on the phone to tell her that La Vie en Rose might want to advertise and she started screaming at me that I hadn't shown up for an important advertising lunch, and it was like having a nagging wife. And then she accused me of just being down at Chris's to take male porno photographs, which I was, but I mean, it was for *work!* I mean, I'm just trying to work and make some money. I mean, there's a lot of hungry mouths to feed at the office! I have a business to keep going! I mean, the porno pictures are for a *show*. They're *work*.

Saturday, January 31, 1987

Paige had an advertising dinner planned at Caffe Roma. I worked till 8:00 (cab $7). Heather Watts wanted to meet the poorest kid in New York because she's been spending so much time with Anne Bass, so Stephen Sprouse brought her a cute messenger who has a twelve-inch tattoo. They put two tables together for us in the front, and there was a Mafia-type guy at the bar who said stuff about Stephen's punk hair, and Stephen got so scared he left and then Paige went over and started telling the guy off, and she almost got it, she really almost was history. He was a greaseball, a big ox, about 6'5". Huge. So then Peter Martins was obligated to go over and defend Paige and then Jock Soto got up, too, and all I could think of was that the whole New York City Ballet company would be wiped out by this Mafia bruiser at the bar. It was scary. A lot of talk like "asshole" and all those words. Heather *loved* it.

So Peter was a man and defended Paige but after the bruiser left, he was so relieved that he sank in his chair and he told her, "Paige, I'm never going out with you again—you're too much *trouble!*"

Dropped Wilfredo off and went home to bed (cab $6.50).

Monday, February 2, 1987

Was picked up by Ken. Stuart's friend Christopher O'Riley, the pianist, got great reviews in *The New York Times* in an article on virtuosos.

And Liberace's dying. He looked so healthy when he came to the office last year, didn't he?

I called Nell to ask her to be that week's emcee for our TV show but she said she was on the other line talking to Australia and she'd call me right back but she never did, which I thought was weird.

A couple of people have called and said they were doing biographies of me. Fred told them we didn't want them to, but they said they'll do them anyway.

Worked and then they picked me up for the black-tie dinner at the Saint that Rado Watches was giving and it was all built around the painting I did and Sarah Vaughn singing. And we were all afraid to eat anything because the Saint has the gay taint from when it used to be a gay disco. It was so dark there and they were serving the food on *black plates*.

But Sarah Vaughn sang and she was great—fat and sweating but she's still got a voice. And then they wanted us to go to her room and so they took us there and it was past all the bad rooms where all the sex things used to happen. We were holding our breath. And we told Sarah she was great, but she was just interested in her drink, she told somebody, "Cap my brandy," or something like that. She'll be at the Blue Note in April.

Then we were hungry so Paige and Wilfredo and I went next door to that place called "103" on Second Avenue and *that's* where we should take people to dinner because it came to $11 for three teas, a Coke, a bowl of chili, and two sandwiches. Could that have been a mistake? Left a big tip ($20). And we picked up a couple of waiters for Wilfredo to use as models in the shoots he's setting up in Atlantic City for *Interview*.

Tuesday, February 3, 1987

Ken picked me up and he's good because he's big and strong so he can carry *all* the *Interviews*, I just have to sign them. It was such a beautiful day out. It was hard to think about going to work so we went to eat ($15, phone $2, newspapers $2, cab $7.50). Didn't run into anybody.

Nell finally called back and when I asked her to do the TV show she said she'd have to check with her partners, but I think she just wanted to think about it. I think she's like Ann Magnuson, that's why she just hasn't made it. I mean, in show business. They're both the same—at the last minute they get odd and don't want to "give it away," but they're not doing anything else *anyway*. They *need* more exposure.

Wednesday, February 4, 1987

And the *Post* had a picture of Ingrid Superstar with a big story: "Warhol Star Vanishes." I thought she was going to be at the reunion Billy Name is setting up. I wonder if Gerard gave this to the papers just to get his name in. Brigid never even told me they called about her. I would've *cared* that *Ingrid* was missing. *People* magazine had been calling because they're doing a story on Ivy Nicholson and they wanted me to give a quote and for *her* I did tell Brigid to tell *People* we'd "never heard of her," but that was only because it was *Ivy*—*Ingrid* I would've cared about. But I bet something did happen to her. It said she went out for a pack of cigarettes and never came back. This is in upstate New York. And *People* said Ivy was doing a "comeback," but I mean, what would it be *as*? Could she still model? I wonder how she looks these days.

Alba Clemente came to have her picture done for a portrait, and she's so beautiful. I photographed her nude.

Andre Balazs invited me to a *Details* screening of *Black Widow* with Debra Winger and Teresa Russell. Cabbed ($5) to 58th and Third. And the movie was nothing, a lesbian movie. The only thing I really wondered was whether that black-widow pin she got as a wedding present was real or costume, and I looked across the aisle to PH and she was wondering the same thing.

Thursday, February 5, 1987

Went to E.A.T. and our favorite girl gave us extra food (tip $15). I ate it all, which was a mistake (phone $.50, newspaper $1, cab $5).

And then at the office, Sam had potato chips with vinegar and salt and I ate so many of those because they were so unusual. Vincent was doing the TV show and there were no celebrity hostesses available so we used a cute girl model. But when I did my scenes with her, I sat in a funny position and I got a pain and it didn't go away.

Paige was home sick so I had a free night, no advertising dinners, and Sam and I decided to go to a movie and then John Reinhold wanted to join us so we could talk about the jewelry business at dinner first. So went to Nippon (cab $6). And we did that stuff, and then we decided to see the Bette Midler *Outrageous Fortune* movie since it was the big money-maker of the week, but as we were leaving the restaurant I felt a sharp pain and I couldn't go on. I got scared and said I couldn't go and they dropped me off. I was trying to think positively and mind-over-matter and when I got to my front door it was like a miracle, it suddenly went away. It was completely gone. And then I wished I'd hung on for a few minutes because then I wouldn't have had to tell anybody something was wrong. But I went inside and locked the dogs out of the room because they were bothering me and they got mad, they didn't understand I was mentally unstable. And I fell asleep and woke up when Joan Rivers was on and she was doing something odd on her show, solving a mystery of somebody being killed, like a game.

So now I'm throwing out all the junk food. I guess it was a gallbladder attack. And then I remembered that when I got the first one was when Fred took me to the Waldorf to meet the old Mrs. Woodward who was about ninety then—it was '73 or '74 I think—and he had to take me to the hospital, and then this week is when that novel Nick Dunne wrote, *The Two Mrs. Grenvilles*, is on TV, which was really the Elsie Woodward story, so I felt like there was a connection.

Friday, February 6, 1987

Ken picked me up and we walked up Madison with *Interviews*. It was a beautiful day. Then went to lower Broadway with Stuart and looked for stuff, then he dropped us off at the office. Rupert was closing down his office so he didn't come in. He finally unloaded the Duane Street building he owns for $1.1 million. These kids who were living there were so horrible, they wouldn't move out. Rupert offered to pay them off but they wouldn't move. He sold it to Israelis, and you can bet *they'll* get them out.

Worked all afternoon and then decided to try again to see *Outrageous Fortune*. Wilfredo came

and Len and Sam, and we went to Nippon first to discuss *Interview* articles that they're working on (dinner $175).

We couldn't get into *Outrageous Fortune*, the line was too long, and so we went and saw a movie about the KGB, an English movie, and we all fell asleep, it was absolutely boring (tickets $24, popcorn $5).

Wilfredo dropped everybody off ($10). And then watched MTV and waited for commercials for our show on Sunday, which I finally did see and the show looks like it might be interesting, it's on Romance.

Sunday, February 8, 1987

Stuart picked me up at church, and it was embarrassing to walk from the church steps into a big black limo. And we went to 76th Street to the flea market to get books. This one guy bought somebody's library so he's got forty boxes of books to sell and he brings one box in every week and people line up for it at 9:00. I got some books, even a Museum of Modern Art catalog from 1962 when the de Menils had a show, and I didn't even know them then.

Stuart always buys an old hat and always loses it. He loves old clothes, he loves to smell them.

We were going to see Johnny Mathis and we got Alba Clemente and John Reinhold tickets, too, so Stuart dropped me off and then Paige rang my bell and had pineapples for me and I had to just dump them in the hallway because I'd already locked up. She had high energy and it was, "Hi-i-i-i-i!" It's just too much. So we went to Radio City (cab $5). It turned out to be two hours of hits from Henry Mancini, he opened the show, so it was the *Pink Panther* and everything else and it was sooo boring, and Paige was going, "Isn't this greeeaaat!" She's *got* to get cooler, I wanted to slap her out, my nerves were jumping. Then Johnny Mathis came out and he's still got his voice. I never noticed that so much depends on how you hold the microphone. And then finally it was over, but then he came back and did an encore. And then we left. Paige dropped me and I watched MTV.

Monday, February 9, 1987

I went to the dentist really early in the morning. Dr. Lyons and his perfect American family are doing fine. Then Ken picked me up there. The temperature was dropping fast from the time I went out in the morning. Cabbed to the West Side to Dr. Li ($4, newspaper $3).

Cabbed downtown ($6). Brigid had to go home to give her mother a morphine shot. She was back in a couple of hours, it didn't take long—she's really upset at the idea that her mother's going to go in the winter and it'll be another funeral in the cold ground, she would rather it would be in spring. And I don't know why they didn't cremate Liberace right away and not give him an autopsy—they should've just rushed him through.

I asked Paige to go to the Dionne Warwick perfume thing at Stringfellow's and we went down there. She brought the issue of *Interview* to show to Dionne that had the writeup we gave her perfume last year when it came out, but then Jacques Bellini took it from Paige before she had

the chance to give it to her. And Dionne's distributing the perfume herself, it turns out. It smells like lemon chiffon pie. Very strong. And Stringfellow and his daughter were there, and it was just so easy—got photographed and got out of there. Tipped the doorman ($5) because I thought it was the guy who always got me cabs at the Palladium and Studio 54, but it wasn't him. Went to Nippon (cab $6). Had dinner, lots of free food—Paige paid. We talked about the shows I'll be having this year—another photography show at Robert Miller and then some new paintings at Mary Boone ... I don't know yet what they'll be.

Finally made it to see *Outrageous Fortune* and it wasn't much—they didn't even give Bette Midler one really great scene to do.

Tuesday, February 10, 1987

In the morning I bought so much big stuff—huge painted backgrounds that I'll have to find someplace to store at the office. Fred will scream when he sees them about the room they'll take up, they're huge.

I got to the office early. Vincent showed me the the video for this week's MTV show, and it looks interesting, different, kind of odd.

Cabbed to Clemente's ($5). I thought they entertained all the time but they said the last dinner party they had was the one we were at. Robert Mapplethorpe was there. He looked more healthy than I've ever seen him, he had color in his face. I think they're trying out a new drug on him, I hope he makes it. And we talked about the people from the seventies. I asked him about his old girlfriend Patti Smith and he said he'd just shot her and I said why didn't he give the pictures to *Interview*, and he said *Vogue* already had them. And then that reminded me that I'd bought *People* magazine and there was their article about Ivy Nicholson—she's now a bag lady in San Francisco and her twin sons are twenty-one years old. She looks like the most beautiful bag lady you'll ever see, though. It says she's fifty-three. She's up against the wall with her legs straight out and a form-fitting top. It's like with Nico—everything just looks *right* when she does it, so it's these raggy clothes, but they look great. And it's sort of the hippie look, really, with three crinolines and just the right *(laughs)* raggy bow. Left at 11:00, Paige dropped me.

Wednesday, February 11, 1987

Fred called to tell me that he heard Bob Colacello was writing a book "on the seventies" so that was, uh, swell to hear.

Oh, and Nancy Reagan was on TV reading one of her six billion drug letters and crying—big tears just whaling down her cheeks, it was the best acting ever—she'd never do it over Ron Jr. or Doria. And Ron Jr. still hasn't made it, and it's because he just isn't good-looking. If he were, he'd have a big career by now. And Prince Andrew has gotten so ugly, he's looking like his mother. And let's see what else ...

Okay, went to see Dr. Reese, he's in town. He looks a lot younger, like he's using Grecian Formula to get rid of his grey hair.

So I left there and Paige was having a lunch for condom advertisers, and she said that Sam had called her and said that she couldn't mix her *(laughs)* dirty condom people in with my Italian guy who was a shoe manufacturer from Italy who wants his portrait done. When I got to the office (cab $6) I told the condom people that I wanted a demonstration *(laughs)* and then they all took out their rubbers and they showed how the rim of it has adhesive so it wouldn't slide off. So I said *(laughs)*, "Oh great, so you can *reuse* it three or four times and not take it off!"

Then I made plans to go to dinner with Wilfredo and David LaChapelle, the *Interview* photographer, and Sophie Xuerbe's son who I think wants to talk because he read we're doing a movie of Tama's book and he wants to be in a movie. So we went to Provence, this is the restaurant that the guy who was at Le Cirque started. We talked about the magazine (cab $6, dinner $180).

Oh, and Dolly Fox called and she's at the Chateau Marmont because she and Charlie Sheen broke up.

Thursday, February 12, 1987

Paige was having an *Interview* dinner at Texarkana and I invited Victor Love from *Native Son* for her. Kenny and Teresa Scharf were coming to the dinner and Wilfredo. Keith is going to South America for the winter.

Ulrik came by to talk about the curtain I'm doing for the New York City Ballet. I've got to get working on that, it's due soon.

So went down to Texarkana (cab $5). Heather Watts was there, and Stephen Sprouse and T.T. Wachmeister, and Richard Johnson from Page Six and Freddie Sutherland. And Jeff Slonin from *Interview*, he's Tama's cousin, and he has perfect teeth, a beautiful toothpaste smile. Oh, and Howard Read from the Miller Gallery has been staying at the Gramercy Park Hotel because his apartment burned down and his cat was killed in the fire.

We were there till 1:00.

Friday, February 13, 1987

Ken picked me up. Went to Bloomingdale's (phone $.50, newspaper $.70). Lunch at the office was for Pat Patterson and the new president of Henry Bendel's and he brought me soap.

And Howard Read brought a lady by for a portrait, so that was fun, worked on that. Worked till 8:00. Then the birthday party at Raoul's for Barry Tubbs didn't start until 11:00 and what're you supposed to do until then. Called John Reinhold and Wilfredo. John picked me up and we went to Castellano's for dinner ($170). Then we went to Raoul's, and Barry had odd people there—like Larry "Bud" Melman and Judd Nelson and Lynn Redgrave and Tom Cruise's sister. She's sort of cute. She looks like *(laughs)* somebody's sister. We were there till 1:00.

Saturday, February 14, 1987

A really short day. Nothing much happened. I went shopping, did errands, came home, talked on the phone.... Yeah, that's all. Really. It was a short day.

Sunday, February 15, 1987

The house was freezing. Stayed upstairs in bed watching TV. Stuart kept calling, talked to him about ten times. Sam called and Wilfredo. And John Reinhold. It was a big day on the phone but nothing else. I didn't go out, didn't even go to church. It was just so cold. I watched *Agnes of God* three times and it was so boring. And I saw *The Story of Will Rogers* with Will Rogers, Jr. and Jane Wyman, and the son played his father. The son was on the *Today Show* at CBS when I did the weather drawings in the fifties.

Stayed up to watch *Andy Warhol's Fifteen Minutes* on MTV.

Monday, February 16, 1987

I'm reading *Dancing on My Grave*, the Gelsey Kirkland book, and I'm disappointed, I thought it would be more trashy.

I'm watching *Yankee Doodle Dandy* right now and you see these big statues of like Abraham Lincoln and you wonder if *these* movie sets are the things that *(laughs)* wind up in the antique stores—the things that you don't know *what* they are—and then some day somebody finally figures it out and they turn out to be worth fifty cents, not $2 million, and I mean, that's the art game. When I think of all those French "antiques" I've looked at that were probably just props from store windows. . . .

Ken arrived. I can tell what the temperature is outside by the temperature in my kitchen—it's so cold down there that they're always the same. Went to the West Side to see Dr. Linda Li (cab $4).

Then went down to the office and Julian Schnabel was there, he was being really charming to Fred, I can't figure out what he wants out of him. He was nice to Fred once before and I forget what it was he wanted then. He's being reeeally charming. His book is coming out. Who does he think he is? He's just pushy and energetic. Well, but that's all life is, being pushy and energetic. And he was just down in Miami and he met Gael there and he hated her. He came right out and said we should fire Gael and hire his wife to be editor, that Gael was stupid and pretentious and fat.

He took Fred down to his studio. I really wonder what he wants out of Fred.

And Brigid has disappeared for a *week*. On Friday she ate a whole cake in one second and then she announced she wasn't coming in the next week because she was going to London to a fat farm. Would she really go all the way to London for that? Well, I mean, she sure ought to be able to afford it—she charges $2,000 for each sweater she knits at the reception desk while she's supposed to be answering the phones, and she's selling so many of them—Paige even bought one.

Tuesday, February 17, 1987

In the morning I was preparing myself for my appearance in the fashion show Benjamin coordinated at the Tunnel. They'd sent the clothes over and I look like Liberace in them. Should I just go all the way and *be* the new Liberace? Snakeskin and rabbit fur. Julian Schnabel *(laughs)* would be so impressed with these clothes he would start wearing them.

Oh, and Brigid *is* at the English fat farm and she's going to be fired when she gets back. I'll give her a pink slip. I'll give her *dogs* pink slips—Fame and Fortune will be fired!

Vincent was going to tape the fashion show and he called to say a car would pick me up at the office at 2:00. Ken came and we went downtown (cab $6). Worked hard at the office.

Then went over to the Tunnel and they gave us the best dressing room, but still it was absolutely freezing. I had all my makeup with me. Miles Davis was there and he has such delicate fingers. They're the same length as mine but half the width. I'd gone with Jean Michel last year to see his show at the Beacon, and I'd met him in the sixties at that store on Christopher Street, Hernando's, where we used to go get leather pants. I reminded him that I'd met him there and he said he remembered. Miles is a clotheshorse. And we made a deal that we'd trade ten minutes of him playing music for me, for me doing his portrait. He gave me his address and a drawing—he draws while he gets his hair done. His hairdresser does the hair weaving, the extensions.

They did a $5,000 custom outfit for Miles with gold musical notes on it and *everything*, and they didn't do a *thing* for me, they were so mean. They could've made me a gold *palette* or something. So I looked like the poor stepchild, and in the end they even *(laughs)* told me I walked too slow.

And the clothes in the show really stank. Alligator, fur, and lace. And I really worked my ass off. The Japanese crew was more interested in me than in Miles. They were doing the show again at 10:00 but I didn't have to do the second one, I was only in the one that was for the press. And then afterwards Vincent had a taxi come.

When I got home I called Fred and explained that I was just too exhausted to go to the Fendi dinner, so when he called them to say I wouldn't be coming with him and that he'd bring a girl instead, they said don't bother, that they didn't want him without me.

Got into bed and Wilfredo called and then Sam called and then I fell asleep. But I woke up at 6:30 and I couldn't get back to sleep, so I took some Valium and a Seconal and two aspirin, and I was sleeping so heavily that I didn't wake up when PH called at nine o'clock. And when I didn't answer she got scared because that had never happened before, so she called on the other line and Aurora answered in the kitchen, and PH made her come up to my bedroom to shake me but I wish she'd just let me sleep.

[Andy did not tell the Diary, but on Saturday, February 14, he went to Dr. Karen Burke's for a collagen treatment; during the visit he complained of pains in his gallbladder. On Sunday, Andy stayed in bed all day and the pain subsided. On Monday he kept his appointment with Dr. Linda M. Li at the Li Chiropractic Healing Arts Center. That night Dr. Burke called Andy to see how he was and when he admitted that he was again feeling the sharp pains, she urged him to see his regular doctor, Dr. Denton Cox. Although on Tuesday he made his "celebrity appearance" in the Japanese fashion show, he was in pain for the rest of the night. Finally at 6:30 A.M. he took a painkiller and sleeping pill which made him sleep through the Wednesday 9 A.M. Diary phone call. On Thursday, when Andy answered the phone at 9 A.M. he was breathing heavily. He told me he

had seen Dr. Cox and that he was going to "the place" to have "it" done (Andy's fear of hospitals and operations was so great that he couldn't bring himself to say those specific words) because "they told me I'll die if I don't." He said he would resume doing the Diary after "it" was over, that he would call me from "the place."

On Friday, February 20, Andy was admitted to New York Hospital as an "ambulatory emergency patient." On Saturday his gallbladder was removed, and he appeared to be recovering well from the surgery—he watched television, and made phone calls to friends. But early Sunday morning, for reasons that are in litigation, he died.

A few weeks later, the woman who had admitted him to the hospital told me that Andy was the only person in her experience who had ever remembered his Blue Cross and health insurance identification-card numbers by heart.]